A Research Guide
to the Ancient World

A Research Guide to the Ancient World

Print and Electronic Sources

John M. Weeks and Jason de Medeiros

Rowman & Littlefield
Lanham • Boulder • New York • London

Published by Rowman & Littlefield
4501 Forbes Boulevard, Suite 200, Lanham, Maryland 20706
www.rowman.com

Unit A, Whitacre Mews, 26-34 Stannary Street, London SE11 4AB

British Library Cataloguing in Publication Information Available

Library of Congress Cataloging-in-Publication Data

Weeks, John M.
 A research guide to the ancient world : print and electronic sources / John M. Weeks and
Jason de Medeiros.
 pages cm.
 Includes bibliographical references and indexes.
 Summary: "Annotated bibliography of the ancient cultures of the Mediterranean world, as well as
Egypt and southwestern Asia"—Provided by publisher.
 ISBN 978-1-4422-3739-1 (hardcover : alkaline paper) — ISBN 978-1-4422-3740-7 (e-book)
 1. Civilization, Ancient—Bibliography. 2. Egypt—Civilization—To 332 B.C.—Bibliography.
3. Mediterranean region—Civilization—Bibliography. 4. Middle East—Civilization—To
622—Bibliography. I. Medeiros, Jason de. II. Title.
 Z5579.2.W44 2015
 [CB311]
 016.930—dc23 2014010977

∞™ The paper used in this publication meets the minimum requirements of
American National Standard for Information Sciences—Permanence of Paper
for Printed Library Materials, ANSI/NISO Z39.48-1992. Printed in the United
States of America

Contents

Introduction

The term *ancient world* is being used today with more and more frequency although the meanings assigned to it may differ greatly. The term is used most broadly to refer to antiquity throughout the world. More properly, and more specifically, it may refer to the ancient archaeological cultures of the Mediterranean basin, Egypt, and the adjacent Near East and the intricate complexity of relationships connecting these groups together. The ancient world has usually been considered a branch of the humanities rather than the social sciences, embracing numerous academic disciplines, such as archaeology, art history, ancient history, ancient languages, literature, philosophy, and related technical fields. For the purposes of this volume, chronological coverage of the ancient world is expanded to include generally the rise of civilization in the region ca. 4000 BCE through the Greco-Roman period in ca. 500 CE. This chronological coverage is consistent with the traditional organization of history; however, history is messy, and any static chronological scheme has its flaws.

The purpose of *A Research Guide to the Ancient World* is to provide a convenient and an easy-to-use guide to the enormous literature concerning the traditions of the ancient world. This book is authoritative, clearly written, and up-to-date. It will provide a good beginning point for research by high school and college students, scholars, and general readers, as well as by more advanced researchers and others. In addition to identifying the important reference tools, the book also includes several bibliographies for important archaeological sites, writing systems, and numismatics. This information should position the researcher with the ability to examine much of the archaeological world in a single volume.

Formats included in *A Research Guide* are limited to monographs and books and electronic resources (i.e., compact disks and Internet resources). Journal articles, essays in edited volumes, pamphlets, unpublished manuscripts, individual cartographic sheets, and more popular treatments are not included. This decision was based on an attempt to contain the potentially enormous size of the guide. Languages included in the guides emphasize Western European languages, including English, French, Spanish, German, Italian, and to a lesser extent, some Greek and Hebrew. These are generally the scholarly languages most used in the study of the ancient world.

This guide to the literature of the ancient world cannot be considered by any means comprehensive. By definition it attempts to give general bibliographic coverage to a large part of the scholarly world. The decision to include a title was based on criteria of availability, apparent scholarly significance, and subject matter. Because the criteria for inclusion are so amorphous there will undoubtedly be important titles omitted and less significant titles included in the guide. These problems are implicit in all bibliographic work, and since the recognition of significance is so subjective, such dilemmas can never be adequately resolved to the satisfaction of all.

The idea for this book came from many years' service as a librarian and field archaeologist. It has become increasingly obvious to many that there is a gradual paradigm shift away from rigidly defined geographic and disciplinary boundaries to one in which such limits are easing. Ancient or archaeological cultures are no longer examined in isolation but are considered in the context of larger regional and interregional perspectives. This is coincident with the gradual fading of traditional academic discipline as research becomes increasingly multidisciplinary or interdisciplinary in nature. In the traditional study of the ancient world the cultures of Greece, Rome, Egypt, and the Near East might be approached individually. However, here they are included within a single framework.

A Research Guide to the Ancient World includes seventeen chapters and five appendixes. Chapters 2 and 3 identify and describe important specialized libraries and museums with significant collections regarding the ancient world. The remaining chapters are devoted to the literature of the ancient world in traditional library formats. Chapter 4, Guides to the Literature of the Ancient World, includes subject gateways introducing readers to the key information sources in a given

field. Chapters 5 and 6 provide useful subject and regional bibliographies or systematic lists of books and monographs relating to a specific subject. Chapter 7 identifies sources for book reviews and yearbooks. These are good sources for locating summaries of research. Yearbooks are especially useful for periodic overviews of the field. Chapters 8 and 9 identify dictionaries and encyclopedias, both useful for obtaining quick definitions of terms and larger concepts. Chapter 10 lists handbooks, a kind of work intended to provide ready reference. Chapters 11 and 12 cover indexes, abstracts, and journal literature. An index is a regularly updated periodical publication, either print or electronic, that lists articles, books, and other information items, usually within a particular discipline. An abstract gives a brief summary of published research (e.g., article, book, thesis, conference proceeding) of a particular subject and is often used to help the reader quickly determine content. Chapters 13 and 14 cover biographical information and directories of organizations and associations. These are useful for locating information about individuals or institutions. Chapter 15 is atlases, including aerial photography. Chapter 16 is photographic and visual collections, both

in print and electronic format. Chapter 17 lists information on how to prepare and locate theses and dissertations submitted to colleges and universities.

These format-based chapters are supplemented by five appendixes. Appendix 1 is a summary of the library classification system used by most academic libraries throughout the world. Appendix 2 identifies many academic programs providing graduate-level coursework in the ancient world. Appendix 3 is a bibliography of some 2,000+ archaeological reports arranged geographically. Appendix 4 is a bibliography of some 1,000 studies on paleography and writing systems, including Akkadian, Aramaic, Assyrian, Babylonian, Egyptian, Linear A and B, Phoenician, Punic, and Sumerian, among others. Appendix 5 is a bibliography of almost 300 works on numismatics, or the study of ancient coinage, also arranged geographically.

The archaeological cultures of the ancient world continue to be popular subjects for college courses, study groups, tourism and national development, public lectures, and scholarly investigation. This resource is intended to be a guide to the best information resources.

1

What Is the Ancient World?

The study of the ancient world is usually, although not exclusively, a branch of the humanities, including the archaeology, art, history, languages, literature, philosophy, and related cultural disciplines that consider the ancient Mediterranean world, as well as adjacent Egypt and western Asia. The temporal boundaries traditionally extend from the beginning of the Bronze Age of ancient Greece (ca. 1000 BCE) to the fall of the Western Roman Empire (ca. 500 CE). This chronological coverage is consistent with the traditional organization of history; however, history is messy, and any static chronological scheme has its flaws. For the purposes of this volume, chronological coverage is expanded to include generally the rise of civilization in the region, ca. 4000 BCE through the Greco-Roman period (see table 1.1).

THE ANCIENT WORLD AND ITS SUBDISCIPLINES

One of the most remarkable characteristics of the modern study of the ancient world is its scope. Although traditionally focused on the ancient cultures of Greece and Rome, the investigation has gradually broadened to encompass the entire ancient Mediterranean world, including North Africa, and parts of southwestern Asia, including Egypt and Mesopotamia. Concomitant with this expansion is the recognition that none of these ancient civilizations developed in isolation and interrelationships and influences are wide, varied, and complex. Some of the academic subdisciplines considered within this geographic region are ancient history, archaeology, architecture, art, history, numismatics, mythology, paleography and philology, philosophy, religion, technology, and theater.

Archaeology. Archaeology is the investigation of the physical remains of the past great civilizations of the ancient world. The archaeologists' fieldwork, laboratory, library, and documentation work make available the extant literary and linguistic cultural artifacts to the field's subdisciplines, such as philology. Archaeologists rely upon the philology of ancient literatures in establishing historical contexts among the classic-era remains of Mesopotamia, Egypt, Greece, and Rome.

Art history. Some art historians focus their study of the development of art on the ancient world. Indeed, the art and architecture of the ancient world, and especially that of ancient Rome and Greece, are very well regarded and remain at the heart of much of our art today.

Civilization and history. With philology, archaeology, and art history, scholars seek an understanding of the history and culture of a civilization through critical study of the extant literary and physical artifacts in order to compose and establish a continual historic narrative of the ancient world and its peoples.

Philology. There is a surviving tradition of Latin philology in Western culture connecting the Roman Empire with the Early Modern period. The philology of Greek survived in the Byzantine Empire until the fall of Constantinople and was reintroduced in Western Europe in the Renaissance. Although less dominant than it used to be, philology retains a central role in traditional classical studies. One definition of classical philology describes it as "the science which concerns itself with everything that has been transmitted from antiquity in the Greek or Latin language. The object of this science is thus the Greco-Roman, or Classical, world to the extent that it has left behind monuments in a linguistic form" or alternatively as "the careful study of the literary and philosophical texts of the ancient Greek and Roman worlds." Before the invention of the printing press, texts were reproduced by hand and distributed haphazardly. As a result, extant versions of the same text often differ from one another. Some classical philologists, known as textual critics, seek to synthesize these defective texts to find the most accurate version.

LEGACY OF THE CLASSICAL WORLD

The classical languages of the ancient Mediterranean world influenced every European language, imparting to each a learned vocabulary of international application. Thus,

Table 1.1. General Chronology for the Ancient World

Approximate Chronology	Egypt	Mesopotamia	Nubia	Greece	Rome
4000–3150 BCE	Predynastic Period				
4000–3100 BCE		Uruk Period			
3700–2200 BCE			A-Group Culture		
3150–2686 BCE	Early Dynastic Period				
3100–2350 BCE		Sumerian civilization			
2686–2181 BCE	Old Kingdom				
2500–1500 BCE			Kingdom of Kerma		
2350–2193 BCE		Akkadian (Sargonic) Kingdom			
2300–1600 BCE			C-Group Culture		
2181–2041 BCE	First Intermediate Period				
2040–1782 BCE	Middle Kingdom				
1900–1750 BCE		Old Assyrian Period			
1900–1595 BCE		Old Babylonian Period			
1782–1570 BCE	Second Intermediate Period				
1600–1000 BCE		Middle Babylonian Period			
1595–1000 BCE				Mycenean Period	
1570–1070 BCE	New Kingdom	Middle Assyrian Period			
1130–1100 BCE					
1200 BCE				Destruction of Troy	
1069–332 BCE	Late Period				
1000–612 BCE		Neo-Assyrian Period			
1000–600 BCE			Napatian Empire		
1000–539 BCE		Neo-Babylonian Period			
753 BCE					Foundation of Rome
700–600 BCE				Era of colonization	
509 BCE					Expulsion of last king of Rome; foundation of the Roman Republic
500–330 BCE			Meriotic Empire		
490 BCE				First Persian invasion of Greece	
480 BCE				Second Persian invasion of Greece	
450–429 BCE				Age of Pericles; construction of Acropolis	
431–404 BCE				Peloponnesian War	

	
338 BCE	Philip II of Macedon conquers Greece
2336–323 BCE	Reign of Alexander the Great of Macedon; conquest of Persian empire, Egypt, and northern India Hellenistic Period
323–30 BCE	Ptolemaic Era
264 BCE	Roman conquest of Italy
218–201 BCE	Second Punic War
146 BCE	Rome destroys Carthage and Corinth
59–50 BCE	Gallic Wars
44 BCE	Assassination of Caesar
31 BCE	Octavian defeats Mark Antony and Cleopatra
27 BCE	Beginning of the Roman Empire
14–37 CE	Death of Tiberius; Christ crucified
37–41 CE	Reign of Caligula
54–68 CE	Reign of Nero
70 CE	Flavian dynasty of emperors established
79 CE	Pompeii and Herculaneum buried by eruption of Mount Vesuvius
96–180 CE	Reigns of Nerva, Trajan, Hadrian, Antoninus Pius, and Marcus Aurelius
284–305 CE	Reign of Diocletian
312–337 CE	Reign of Constantine
395 CE	Christianity official state religion of Roman Empire
518–527 CE	Reign of Justinian
1453 CE	Constantinople conquered by Ottoman Turks

Source: Salisbury, J.E., and G.S. Aldrete. 2004. *w* pp. 15–17. Westport, CT: Greenwood.

Latin grew from a highly developed cultural product of the Golden and Silver eras of Latin literature to become the international lingua franca in matters diplomatic, scientific, philosophic, and religious until the seventeenth century. In turn, the classical languages continued, and Latin evolved into the Romance languages and ancient Greek into modern Greek and its dialects. In the specialized science and technology vocabularies, the influence of Latin and Greek is notable. Ecclesiastical Latin, the Roman Catholic Church's official tongue, remains a living legacy of the classical world to the contemporary world.

NEAR EASTERN ARCHAEOLOGY

Near Eastern Archaeology (sometimes known as Middle Eastern archaeology) is a regional branch of the wider global discipline of archaeology. It refers generally to the excavation and study of the material culture of the Near East, from antiquity to the relatively recent past. The description "Near Eastern" for this branch of archaeology is, of course, highly Eurocentric, reflecting the origins and growth of the field in Western academic traditions. However, in the absence of better solutions and the continued heavy involvement of Western academics, the term has taken hold and remains in frequent use.

The definition of the Near East is usually based in the Fertile Crescent, that is, the geographic region between the Nile Valley in Egypt and Mesopotamia, including Iran, the Arabian peninsula and its islands, Anatolia, Cyprus, and North Africa west of Egypt. The history of archaeological investigation in this region grew out of the nineteenth century efforts, mostly by Europeans, to uncover archaeological evidence for Old and New Testament narratives. In recent years there has been movement by some archaeologists to dissociate their work from biblical frameworks.

Near Eastern archaeology is a term with a wide, often generalized application and is frequently divided into further regional sub-branches, the archaeology of modern states in the region, or along broad thematic lines. Regions can be loosely defined but are often based on recognizable entities that evidence cultural cohesion and coincide with topographical zones. Scholars may differ on the way the region is divided. Regional divisions also may change from period to period.

The most common fields of study are biblical archaeology dealing with the region and history of the Bible; Assyriology dealing with Mesopotamia; Egyptology dealing with the ancient history of what is today Egypt and parts of the Sudan; and prehistoric archaeology, which is not tied to a region but instead deals with the origins of culture before the invention of writing.

GEOGRAPHIC SUBDIVISIONS

For the purposes of this research guide, the ancient world includes the Mediterranean basin from Morocco and Spain in the west to the Holy Land in the east, Mesopotamia or the traditional Near East, and Egypt.

Mesopotamia is considered to begin more or less near the modern border with Iraq and refers to the flat valley of the southern Tigris and Euphrates rivers and their tributaries. These rivers empty into a waterway that forms the border between Iraq and Iran. Sumerology and Assyriology are highly specialized fields that deal with the history, language, and archaeology of the ancient Sumerians and Assyrians. Iran, also known as Persia, includes a large plateau and its periphery, including the Zagros Mountains. The Arabian Peninsula and its offshore islands are a separate geographic zone that has contacts with Sinai, the well-watered regions to the north, and by sea with the Far East.

Egyptology is an example of a specialized branch that deals with the Nile Valley cultures of Egypt and associated regions in sub-Saharan Africa, the Sinai Peninsula to the east, and parts of North Africa. It includes language studies, history, and archaeology and their related disciplines.

Israel and the Palestinian Territories is the term used to refer to the area adjacent to the east coast of the Mediterranean, including Israel, the West Bank, Gaza Strip, and part of Jordan. Palestine was its ancient Roman and Byzantine name, which was also in use during the Crusades (1095–1291), the period of Ottoman rule (1517–1917), and the British Mandate (1918–1948). The same region is also called the Holy Land, the Land of Israel, and Canaan because of biblical associations. The term *Israel and the Palestinian Territories* is not intended to reflect political overtones but rather should be perceived as a relatively neutral geographically based reference to this area without prejudice or political orientation. In many contexts the Sinai Peninsula may also be considered to be part of Israel and the Palestinian Territories although it is now part of the modern state of Egypt.

The landmass of *Anatolia*, most of modern Turkey, is bordered by several seas and includes parts of northern Mesopotamia. The Tigris and Euphrates rise in Turkey and flow south into Iraq. Hittitology is a highly specialized field concerned with the history, language, and archaeology of the ancient Hittites.

Cyprus, a large island in the eastern Mediterranean, was a separate cultural entity during most periods of human occupation. However, its proximity to both Anatolia and the northern and southern Levant was responsible for influences from and to both of these regions. This was especially the case, as Cyprus was an important source of copper for much of the region.

PURPOSE OF THIS BOOK

The purpose of this volume is to provide a convenient and an easy-to-use guide to the literature of the cultures of the ancient world. The emphasis is on material culture although some literary and inscriptional material have been included.

The content is based on the holdings of the library at the University of Pennsylvania Museum of Archaeology and Anthropology. The Penn Museum has a long history of excavation and archaeological survey throughout Mesopotamia, Egypt, and the Near East. The scope of collecting for the Museum Library is broad and supports the research and teaching programs for a variety of departments, including the Graduate Group in the Art and Archaeology of the Mediterranean World (AAMW) and, to a lesser degree, the Department of Classical Studies, the Department of Near Eastern Languages and Cultures (NELC), the Department of History of Art, and the Department of Anthropology. In addition, the resources of the Graduate School of Design, the Center for Ancient Studies, Department of Religious Studies, and the Center for Advanced Judaic Studies are frequently utilized as well. Drawing on the extensive resources of the Penn Museum, the academic programs incorporate fieldwork, museum internships, and university instruction into an interdisciplinary program leading to the master's and doctoral degrees.

In general, the library resources available to scholars and students at the University of Pennsylvania are outstanding. These have been assembled for over a century, and the university's commitment to build and maintain these collections has remained strong. Wherever possible or appropriate, collections are expanding rapidly to include digital and other formats. An introduction to research about the ancient world, based on the extensive collections at the University of Pennsylvania libraries, should meet the general needs of most students and scholars.

UNIVERSITY OF PENNSYLVANIA MUSEUM OF ARCHAEOLOGY AND ANTHROPOLOGY

The University of Pennsylvania Museum of Archaeology and Anthropology (also known as the University Museum or Penn Museum) has played an important part in the history and development of anthropology and archaeology since the late nineteenth century. Since that time the museum has fielded archaeological and ethnographic projects to all parts of the world, including all geographic regions included in this volume.

The University of Pennsylvania Museum expedition to Nippur from 1888 to 1900 excavated what remains still the largest collection of Sumerian cuneiform tablets recovered from a single archaeological site. Subsequent University Museum expeditions include the decade of work done at Ur (Iraq) between 1922 and 1934, carried out in conjunction with the British Museum. Collections of archaeological material and documentation at both institutions are currently being digitized to facilitate access to scholars in the United States as well as those in the United Kingdom (http://art-centron.com/2013/07/29). The site of Gordion (*Yassihöyük* in Turkish), the ancient capital of the eighth century BCE Phrygian kingdom, is located southwest of Ankara and has

been excavated by the Penn Museum since the 1970s. As in the case of Ur, records currently are being digitized for use by future scholars (http://sites.museum.upenn.edu/gordion/archaeology). Tepe Gawra, a small site in northern Iraq excavated by the Penn Museum in the 1930s, provided the first detailed sequence of prehistoric remains from the late sixth to the third millennium BCE in northern Mesopotamia. In the 1950s El Jib in Palestine was identified by James Pritchard as the biblical Gibeon described in the Book of Joshua. Other sites excavated in Syro-Palestine include Beisan, Beth-Shemesh (Ain Shems), and Sarepta. The University Museum also conducted important excavations in Egypt, including those at Abydos, Dendereh, Giza, Memphis (Mitrahineh), and Meydum. Its contributions to classical archaeology include excavations in Italy (La Civita, Minturnae, Sybaris, Torre Mordillo), Greece (Kastri, Porto Cheli), Crete (Ayios Antonios, Ayios Theorodus, Gournia, Kavousi, Pachyammos, Priniatikos Pyrgos, Pseira, Spho-ungaras, Vasiliki, Vrokastro), Cyprus (Curium [Kourion], Lapithos), and Libya (Cyrene, Leptis Magna).

The library of the University Museum of Anthropology and Archaeology began in 1887 as a small collection of curios packed into cabinets in the then University of Pennsylvania Library and has since grown to one of the premiere anthropology and archaeology museums in the world. The seeds of the Museum Library were sown in 1900 with the acquisition of the personal library of Daniel Garrison Brinton who served as professor of American archaeology and linguistics from 1886 until his death in 1898.

The Brinton Library along with the archaeological collections were housed for a while in the Furness Building until the opening of the present Lombardy Renaissance-style University Museum building in 1898. The library was then moved to the Elkins Library Room, where it remained until the collection was again moved to the newly completed academic wing of the museum. For more than forty years the book collections shared the Elkins Library Room with the museum's numismatics collections and pieces of sculpture and a few portraits. During that time the collection developed unsystematically through curatorial staff donations of their own publications, exchange arrangements made with colleagues or institutions around the world, and donations of other library materials. Until 1942 there was one part-time librarian, and use of the library was restricted to museum staff and a few scholars.

In 1971 the library moved to its present quarters, occupying 12,000 square feet on three levels of the new academic wing to the University Museum, where the library has a dramatic view into the Egyptian Gallery. As the Museum Library became integrated into the larger university library system, it did not lose its uniqueness and continues to serve specialists especially in the areas of its greatest strengths: Mesoamerican indigenous cultures; building on the collection of materials represented in the Brinton Library; and Egyptology, an early and ongoing focus of research for the museum.

The scope of the library collection has always emphasized anthropology, including prehistoric, classical, and Near Eastern archaeology; cultural and social anthropology; biological and physical anthropology; and anthropological linguistics, as well as related fields such as museology and numismatics. Special attention has always been given to the curricular and research requirements of the faculty in the Department of Anthropology and curatorial staff of the University Museum. The Museum Library presently possesses over 125,000 volumes, with an annual circulation of about 14,000 items, and maintains 549 active journal subscriptions.

As one looks to the future, a major goal of the Museum Library is to make its collections more responsive to the evolving needs of faculty and researchers alike by creating room for growth and working closely with faculty and museum staff to plan collection development.

SCOPE OF THIS BOOK

This guide to the literature of the ancient world cannot be considered in any manner to be comprehensive. It is intended to give general bibliographic coverage to a large part of the globe. The decision to include a title was based on availability, apparent scholarly significance, and subject matter. Because the criteria for inclusion are so amorphous there will undoubtedly be important titles omitted and less significant titles included in the guide. These problems are implicit in bibliographic work, and since the recognition of significance is so subjective, such dilemmas can never be adequately resolved to the satisfaction of all.

Formats included in the guide are limited monographs and books and electronic resources (i.e., compact disks and Internet resources). Journal articles, essays in edited volumes, pamphlets, unpublished manuscripts, cartographic sheets, and more popular treatments are not included. This decision was based on attempting to contain the potentially enormous size of the guide.

Languages included in the guides emphasize western European languages, including English, French, Spanish, German, Italian, and to a lesser extent, some Greek and Hebrew. These are generally the scholarly languages most used in the study of the ancient world.

Arrangement of entries is standardized according to the following format: (1) entry number; (2) title/author; (3) place of publication, publisher, and date of publication; (4) pagination; (5) Library of Congress and/or Dewey Decimal Classification call number; (6) annotation; and (7) World Wide Web address (if applicable).

REFERENCES

British Museum. 2013. British Museum and Penn Museum embark on a dynamic digital collaboration, July 29, 2013. http://artcentron.com/2013/07/29/british-museum-and-penn-museum-embark-on-a-dynamic-digital-collaboration/.

Salisbury, J. E., and G. S. Aldrete. 2004. *The Greenwood Encyclopedia of Daily Life: a tour through history from ancient times to the present: 1. The ancient world.* Westport, CT: Greenwood.

Weeks, J. M. 2003. *The library of Daniel Garrison Brinton.* Philadelphia, PA: University of Pennsylvania Museum of Archaeology and Anthropology.

2
Specialized Libraries

A library catalog is a register of all bibliographic items found in a library or group of libraries, such as a network of libraries at several locations. A bibliographic item can be any information entity (e.g., books, computer files, graphics, and cartographic materials) that is considered to be library material or a group of library materials or is linked from the catalog (e.g., a web page) as far as it is relevant to the catalog and to the users of the library. The traditional card catalog has been effectively replaced by the online public access catalog (OPAC). Some libraries with OPAC access still have card catalogs on-site, but these are now strictly a secondary resource and are seldom updated. Many of the libraries that have retained their physical card catalogs post a sign advising the last year that the card catalog was updated. Some libraries have eliminated their card catalogs in favor of the OPAC for the purpose of saving space for other use, such as additional shelving. An OPAC is an online database of materials held by a library or group of libraries. Users search a library catalog principally to locate books and other material physically located at a library.

Classical, Egyptology, and Near Eastern library materials are usually embedded within larger library collections. However, several specialized libraries are devoted exclusively to these topics. The online catalogs of these libraries are usually available to scholars and provide an excellent bibliographic tool to extend bibliographic coverage beyond one's home institution.

GENERAL LIBRARY CATALOGS

2.1. *WorldCat*. WorldCat is a global network of library-management and user-facing services built upon cooperatively maintained databases of bibliographic and institutional metadata. Access more than 200 million high-quality records across more than thirty formats and 479 languages. Discover resources from 35+ national li-braries. Worldwide Web restricted access. http://www.worldcat.org/.

2.2. *Franklin*. Franklin is the main catalog for librar-ies at the University of Pennsylvania. Franklin contains cataloging references to 98 percent of Penn's Library collections, including books, seri-als, journals, e-journals, newspapers, conference proceedings, sound recordings, video recordings, and computer files. Although all newly cataloged books are listed in Franklin immediately, the NewBooks+ feature of the website is an easy way to search most books and journals recently added to the Penn Library. http://www.library.upenn.edu/.

AFGHANISTAN

Kabul

2.3. *Afghan Institute of Archaeology Library, Kabul*. The Afghan Institute of Archaeology Library was comprehensively looted during the civil conflict of the 1990s and is still in the process of recon-struction. It has a small library of historic books, research papers, and current research publica-tions of both the Institute of Archaeology and the Centre for Kushan Studies. The library is used by researchers and students from the Depart-ment of Archaeology at the University of Kabul. However, there is no catalog system. http://www.afghanistan.culturalprofiles.net/?id=897.

AUSTRIA

Vienna

2.4 Vienna University Institute for Egyptology. Li-brary. http://www.univie.ac.at/egyptology/en/.

CZECH REPUBLIC

Prague

2.5. *Charles University in Prague. Czech Institute of Egyptology. Jaroslav Černý Library.* The library of the Czech Institute of Egyptology was founded in the year 1925. In the following years the library was enlarged by the transfer of the private Egyptological library of Jaroslav Černý after his death in the year 1971 and the estates of other scholars, including L. Matiegková. The library's collection currently contains over 900 monographs; 5,000 offprints; and about 2,500 volumes of periodicals. In terms of its scope, the library represents one of the most extensive Egyptology libraries in Europe and the only one of its kind in the Czech Republic. http://egyptologie.ff.cuni.cz/?req=doc:knihovna&lang=en.

EGYPT

Cairo

2.6. *American Research Center in Egypt. The Marilyn M. and William Kelly Simpson Library.* The Marilyn M. and William Kelly Simpson Library is one of the most successful outreach operations of the American Research Center in Egypt (ARCE). Available to ARCE members, staff, and fellows and members of ARCE-affiliated programs, it is also accessible to the staff of the Supreme Council of Antiquities, faculty of and students at Egyptian universities seeking higher degrees, and members of other foreign institutes and expeditions. The library's large volume of publications in Western languages, especially English, makes it a valuable resource to scholars in the Cairo area. Founded in 1978 to support research on all aspects of the history and culture of Egypt, the library has grown rapidly through a series of gifts, grants, exchanges, and ongoing acquisitions. Today the collection contains more than 25,000 volumes, approximately 5,000 of which are in Arabic. The collection is particularly strong in Egyptology and Islamic studies and includes all the standard scholarly reference works in these fields, as well as some 300 journal titles. The Simpson Library collection also includes a substantial number of rare books, including a complete set of the *Bulletins of the Comité de Conservation des Monuments de l'Art Arabe*, a first edition of the *Description de l'Egypte* (one of only five complete sets in Egypt), and the catalogs généraux of the Egyptian Museum and the Musée National de l'Art Arabe (the present-day Islamic Museum). The center is in the process of digitizing its card catalog through a collaborative effort sponsored and funded by the Council of American Overseas Research Centers. http://www.arce.org/main/library.

2.7. *Catalogue de la bibliothèque du Musée égyptien du Caire* / M. Henri Munier. Le Caire: Imprenta de l'Institut français d'archéologie orientale, 1928. Z3656.A2 C2 1928. Continued by: *Catalogue de la Bibliotheque du Musée Egyptien du Caire, 1927–1958.* Le Caire: Organisme General des Imprimeries Governementales, 1966– . 5 v. Z3659 .C35.

2.8. *Deutsche Archäologische Institut, Cairo.* The institute's library currently comprises ca. 31,000 titles in nearly 40,000 volumes and about 300 periodicals and series. The main focus of the collection is on Egyptology in the broadest sense and associated sciences; it is supplemented by an extensive Islamic collection and an exquisite collection of old travel literature. In addition, the library includes about 3,000 special offprints, maps, and nonbook media such as microfiche, CD-ROMs, etc. The core of the library is the 1957 acquired collection of the Egyptologist Ludwig Keimer (1892–1957), whose papers are preserved in the institute's archive. http://www.dainst.org/en/department/library-cairo?ft=all.

2.9. *Begegnung mit der Vergangenheit: 100 Jahre in Aegypten: Deutsches Archaeologisches Institut Kairo 1907–2007* / Günter Dreyer and Daniel Polz. Mainz: Von Zabern, 2007. 344 p. NA215 B444 2007. Biographical history of the Deutsches Archaeologisches Institut. Abteilung Kairo.

2.10. *Universiteit Leiden. Netherlands–Flemish Institute in Cairo.* The library of the NVIC is an academic reference library. The goal of the library is to support academic research and the teaching programs of the NVIC in the fields of Arabic studies and Egyptology. However, the collection contains publications for a more generally interested public as well. The collection consists of publications in Arabic and European languages. The library specializes in the following subjects: Arabic and Islamic studies (with special focus on Egypt in all its aspects), Egyptology/archaeology, Coptic studies, papyrology, and Greco-Roman Egypt. The library contains a considerable collection of periodicals as well as Egyptian daily and monthly newspapers and magazines. http://www.institutes.leiden.edu/nvic/library/.

FRANCE

Lyon

2.11. *Bibliothèque d'*égyptologie Victor Loret. Lyon: Maison de l'Orient et de la Méditerranée Jean Pouilloux, 5/7 rue Raulin, 69365 Lyon. http://www.victor-loret.mom.fr/?page_id=22.

Paris

2.12. *Collége de France. Library of Assyriology.* Founded in 1936 by Charles Fossey, this library brings together a collection specializing in the history of the ancient Near East, specifically in cuneiform, Sumerian, and Assyro-Babylonian documentation. It also boasts a large collection concerning Anatolia and Hittite and Hurrite studies. Archaeology of the Near East is also well represented, albeit less comprehensively. http://www.college-de-france.fr/site/en-librairies-archives/assyriologie.htm.

2.13. *Collège de France. Library of Egyptology.* This library boasts a specialized collection on the subjects of Pharaonic and Christian Egypt; hieroglyphic, hieratic, demotic, and Coptic philology; linguistics and paleography; the epigraphy, history, and archaeology of Egypt and Nubia; and, lastly, the portrayal of Pharaonic Egypt from the end of paganism up to the present day. http://www.college-de-france.fr/site/en-librairies-archives/egyptology.htm.

2.14. *Collège de France. Library of Semitic Studies.* The library of the Institute of Semitic Studies holds a collection specializing in Semito-Hamitic (Afro-Asiatic) linguistics; western and southern Semitic epigraphy; and the history and archaeology of the Near East, North Africa, and Ethiopia, and a large part of the collection concerns study of the Old Testament and the Qumran manuscripts. http://www.college-de-france.fr/site/en-librairies-archives/semitic_studies.htm.

GERMANY

2.15. *Deutsche Archäologische Institut.* The staff of the German Archaeological Institute carries out research under the auspices of the German Ministry of Foreign Affairs in the area of archaeology and in related fields and maintains relations with international scholars. There are offices in many cities, currently including Athens, Baghdad, Cairo, Damascus, Istanbul, Madrid, Rome, Sana'a (Yemen), and Tehran. Its Romano-Germanic Commission, including the world's largest library for prehistoric archaeology, is located in Frankfurt, its Commission for the History of Classical Antiquity in Munich, and its Commission for the Archaeology of Non-European Cultures in Bonn. http://www.dainst.org/en/libraries?ft=all.

2.16. *Catalogue of the German Archaeological Institute.* Zenon is the catalog of the Deutsches Archäologisches Institut. Much of the same information is found in DYABOLA, only through a free interface. Included in this catalog are not only books held by the libraries but a full index to the journals and collected volumes. You can also search by the DYABOLA subject headings (the "Systematic Access to the DAI Bibliographies, Thesaurus" link). "Search" allows keyword and browse (alphabetical list) searches. Results will be books or articles; results that are articles will have an "Uplink" link that will take you to the record for the journal or collected volume, from which a "downlink" will take you to the full table of contents of the volume. There is good coverage of Greek Turkish archaeology. This catalog is in Unicode, so you can search for Greek titles in Greek. http://zenon.dainst.org/.

2.17. *Zenon DAI.* Berlin: Deutsches Archäologisches Institut. Zenon offers freely available digital access to the complete inventory of the Romisch-Germanischen-Kommission (RGK). Zenon includes digitized journals, e-books, and databases from the RGK collections, including archaeological bibliography, bibliography of the archaeology of the Iberian Peninsula, subject catalog of the Roman-German Commission, and bibliography of the archaeology of Eurasia. The archaeological bibliography is expanded daily by the departments in Rome, Athens, and Istanbul and the head office in Berlin, and it comprises titles collected since 1956 (ca. 400,000 titles). The archaeological bibliography is being expanded additionally in the following areas: prehistory/Anatolia and among the oriental cultures: Hittites and Urartu. In the archaeological bibliography you can search for monographs and articles from ca. 2,700 journals and articles and from congress reports and festschrifts, etc. The bibliography contains the literature on Greco-Roman culture and its peripheral cultural and also literature on Etruscan, Minoan, and Mycenaean cultures and the Anatolian cultures, prehistory and ancient history including epigraphy and numismatics. http://zenon.dainst.org/.

Berlin

2.18. *Deutsche Archäologische Institut. Eurasia Department.* Berlin. The library contains about 70,000 volumes. The collection focuses on Central and East European pre- and ancient history and archaeology of the CIS states and the Iran/Indus region. http://www.dainst.org/en/department/library-eurasia?ft=all.

2.19. *Deutsche Archäologische Institut. Orient Department.* Berlin. The library houses more than 24,000 volumes, 101 journals, focus: Near Eastern archaeology, Assyriology, Islamic and Arabic studies. It is a chained library with a limited usership. http://www.dainst.org/en/department/library-orient?ft=all.

Heidelberg

2.20. Heidelberg University. Library. *Neuerwerbungen der Sondersammelgebiete Ägyptologie, klassische Archäologie, mittlere und neue Kunstgeschichte.* Heidelberg: Universitätsbibliothek Heidelberg. Z5134 .N383, no.1 (1975)–no.54 (1983).

GREAT BRITAIN

Cambridge

2.21. *Cambridge University. Classical Faculty Library.* The library supports the research of senior members, postgraduates, official visitors, and undergraduates in the university. http://www.classics.cam.ac.uk/library/.

2.22. *University of Cambridge. Faculty of Asian and Middle Eastern Studies. Faculty Library.* The Faculty Library contains around 70,000 monograph volumes and about 180 current journals. It is primarily an English (and European) language collection, but there are many publications in the various Asian and Middle Eastern languages taught in the Faculty. The subject content includes the languages, literature, history, philosophy, art, and archaeology of Asia and the Middle East from earliest times to the present. Though the library is primarily a working collection for students, because of its varied origins, it also contains a great deal of valuable material relevant to research students and to visiting scholars. http://www.ames.cam.ac.uk/faclib/index.html.

Chesterfield/Nottingham

2.23. *Society for the Study of Ancient Egypt. Roy Spence Library.* The collection comprises books on all aspects of Egypt, Ancient and Modern, together with videos of a similarly wide nature. Of particular interest and increasing value are the video recordings of the Society's own lectures, specially produced for use by those members who were unable to attend in person. http://www.ssae.org.uk/library-2010.htm.

London

2.24. *British Museum. The Department of Ancient Egypt and Sudan.* The British Museum houses an important collection of objects that illustrate every aspect of the cultures of the Nile Valley, from the Neolithic period (about 10,000 BCE) until the twelfth century CE. A comprehensive library of material relating to the cultures of ancient and medieval Egypt and Sudan is housed in the department, along with archival material relating to the collections and the cultures in general. http://www.britishmuseum.org/about_us/departments/ancient_egypt_and_sudan.aspx.

2.25. *British Museum. Department of Greece and Rome.* The Department of Greece and Rome at the British Museum has one of the most comprehensive collections of antiquities from the Classical world, with over 100,000 objects. These mostly range in date from the beginning of the Greek Bronze Age (about 3200 BCE) to the reign of the Roman emperor Constantine in the fourth century CE, with some pagan survivals. The department houses a library of books relating to the collection and associated cultures. http://www.britishmuseum.org/about_us/departments/greece_and_rome/facilities_and_services.aspx.

2.26. *Egypt Exploration Society. Ricardo A. Caminos Memorial Library.* The library contains about 22,000 books, journals, and pamphlets on Egyptology. As such it is one of the best libraries of its kind in the world. http://www.ees.ac.uk/archive/CaminosLibrary.html.

2.27. *University College of London. Institute of Archaeology. Library.* The UCL Institute of Archaeology Library was founded in 1937 to support teaching and research at the new Institute of Archaeology and has subsequently gained an international reputation as one of the finest archaeological collections in the world. It supports the taught programs offered by the Institute and provides research material on a wide variety of topics covering all aspects of archaeology, museum studies, and cultural heritage. The current library also contains the Yates Classical Archaeology library and the prestigious Edwards

Egyptology library. http://www.ucl.ac.uk/archaeology/about/library.

2.28. *University College of London. Institute of Archaeology. Edwards Library.* The Institute of Archaeology Library is home to a prestigious Egyptology collection, also known as the Edwards Library, having been established through a bequest of Amelia Edwards, a popular novelist, explorer, and patron of Sir Flinders Petrie. The collection covers all aspects of Egyptology and Coptic studies and includes a full range of Egyptological material: works on ancient Egyptian architecture, fine and applied art, religion, science and technology, epigraphy, history, language and literature (including Coptic), and Papyrology. Publications and excavation reports produced by leading Egyptological institutions are also included. http://www.ucl.ac.uk/archaeology/about/library/map/egyptology.

2.29. *University of London. School of Advanced Study. Institute of Classical Studies Library / Joint Library of Hellenic and Roman Societies.* The Hellenic Society, founded in 1879, began to build its library in 1880. The Roman Society, formed in 1910, also started a collection. In 1950 the libraries were administratively merged. The Institute of Classical Studies was founded as a postgraduate Institute of the University of London in 1953, from which time the two collections were housed and administered as a single unit. The collection numbers 111,000 books and almost 20,000 periodical titles, of which 650 are current. http://library.icls.sas.ac.uk/library/AboutCollection.htm.

Oxford

2.30. *Oxford University. Bodleian Library.* The Bodleian Library has, by virtue of its copyright library status, accumulated a comprehensive collection of books in the field of British Egyptology. There are also numerous works on travel in Egypt, especially before the twentieth century. There is also some manuscript material such as the Wilkinson Papers. http://libguides.bodleian.ox.ac.uk/egyptology.

2.31. *Oxford University. Sackler Library.* The premier research library for the study of Egyptology in Oxford University is the Sackler Library, which incorporates the Griffith Library, which was housed in the Griffith Institute wing of the former Ashmolean Library. The Sackler Library is home to the main research collections in Egyptology as well as Old World archaeology, art history, and numismatics. The collection covers all aspects of Egyptology, including all phases of the language,

archaeology, history, religion, and civilization up to and excluding the coming of Islam to Egypt. http://libguides.bodleian.ox.ac.uk/egyptology.

2.32. *Oxford University. School of Archaeology. Reading Room.* The Institute of Archaeology was established in 1960. The Institute forms a base for undergraduate and graduate students and has offices for academic and support staff; teaching rooms; and photographic, graphics, and computing facilities as well as a reading room and a common room. The reading room is located on the first floor of the Institute of Archaeology and is part of the common room. It houses a noncirculating library of specialist European and Classical archaeology books and periodicals. The holdings include legacies from Stuart Piggott, Sonia Hawkes, John Lloyd, Mervyn Popham, and others. There is also a map and reference section. http://www.arch.ox.ac.uk/institute.html.

GREECE

Athens

2.33. *American School of Classical Studies, Athens. Gennadius Library. Catalogue of the Gennadius Library, American School of Classical Studies at Athens.* Boston: G. K. Hall, 1968. 7 v. Z931 .A48. First Supplement, 1973. 852 p. Z931 .A48 Suppl.1; Second Supplement, 1981. 833 p. See also: *The Gennadius Library: a survey of the collections* / Francis R. Walton. Athens: American School of Classical Studies at Athens, 1981. 38 p. Z806.G45 W34 1981; *History of the American School of Classical Studies at Athens, 1939–1980* / Lucy Shoe Meritt. Princeton: American School of Classical Studies, 1984. 411 p. DF21000.5.A44 M47 1984; www.ascsa.edu.gr.

2.34. *Deutsche Archäologische Institut, Athens.* The Athens Department was established in 1872 by the German Reichstag and officially opened in Athens on December 9, 1874. Since 1888, it has been accommodated in a building commissioned by Heinrich Schliemann and built in a late classical style based on plans by Ernst Ziller and Wilhelm Dörpfeld. The department has at its disposal an extensive library of some 80,000 volumes encompassing all areas of the study of archaeology (its strongest area is the archaeology of Greece from the Bronze Age to the Late Antique). http://www.arch.ox.ac.uk/institute.html; http://www.dainst.org/en/department/library-athens?ft=all/.

IRAN

Tehran

2.35. *Deutsche Archäologische Institut, Tehran.* The Tehran Branch of the Eurasian Department houses a large library with more than 9,200 volumes on different aspects of near Eastern and Iranian Archaeology and History of Art, Ancient History, Iranian Studies, and Islamic Archaeology and History. Another 9,000 volumes are currently kept at the library of the Eurasian Department in Berlin. http://www.dainst.org/en/department/teheran?ft=16.

2.36. *Institute of Archaeology Library, Tehran University, Tehran.* The collection of the library contains 6,000 volumes. http://www.librarytechnology.org/lwc-displaylibrary.pl?RC=43322.

IRAQ

Baghdad

2.37. *Deutsche Archäologische Institut. Baghdad.* The Baghdad Branch was founded in 1955 as the Baghdad Department and has been a part of the Orient Department since 1996. Its working focus encompasses Mesopotamian cultures from prehistoric times to the Islamic Middle Ages. The Branch is currently directed from Berlin. Since 2003 the focus of the work is on the preservation of the cultural heritage of Iraq. Reference library has approx. 500 volumes and fifteen periodicals. http://www.dainst.org/en/department/baghdad?ft=all.

ISRAEL AND THE PALESTINIAN TERRITORIES

Jerusalem

2.38. *Hebrew University of Jerusalem. The Emery and Claire Yass Library of the Institute of Archaeology.* The holdings of the Library of the Institute of Archaeology primarily concern the Ancient Near East from prehistory through the biblical and classical periods and up to the Middle Ages. The library consists of three sublibraries, Archaeology, Prehistory, and Assyriology, and contains over 25,000 books, over 200 current journals, about 15,000 reprints, and some private collections that have been donated to the library. http://archaeology.huji.ac.il/libr/libr.asp.

Tel Aviv

2.39. *Tel Aviv University, Sonia and Marco Nadler Institute of Archaeology, Jacob M. Alkow Department of Archaeology and Ancient Near Eastern Cultures.* The Institute of Archaeology was founded in 1969 by the late Professor Y. Aharoni. Today it is a self-sufficient research facility with a large staff that provides the administrative and scientific assistance as well as the technical facilities necessary to carry out independent archaeological projects. The library's main role is to serve as an information and resource center for the students of the Department of Archaeology and Near Eastern Cultures and the staff of the Institute of Archaeology. The library houses over 16,000 books; 7,000 offprints; and about 100 periodicals, which focus on the subjects taught in the department. The library has access to useful databases via wire and WIFI Internet connection. The journals are chiefly acquired through exchange agreements with academic libraries worldwide. The computer catalog of publications can be searched via the Aleph system of Sourasky Central Library. Some of the earlier non-Hebrew material is still being computerized; it can be located via the card catalog. http://www.tau.atheil/humanities/archaeology/facilities/fac_library.html.

ITALY

Rome

2.40. *American Academy in Rome. School of Classical Studies. Arthur and Janet C. Ross Library.* The Arthur and Janet C. Ross Library of the American Academy in Rome contains over 135,000 volumes in the fields of classical studies and the history of art and architecture. Especially strong are the collections in ancient Mediterranean archaeology and art, Greek and Latin literature, ancient topography (including the history of the city of Rome), ancient religions, and related fields such as epigraphy, numismatics, and papyrology. The rare book collection comprises chiefly sixteenth to eighteenth century imprints in classical studies, archaeology, art, and architecture, including sizable collections of Roman guidebooks and early art treatises. The library acquires ca. 3,000 volumes per year and subscribes to more than 700 current periodicals. The library is open stack and contains working spaces for approximately ninety persons. Books do not circulate. The main users of the library are the fellows and

residents of the American Academy, but reading passes are also issued to Italian scholars, qualified Roman residents, and visiting artists and scholars. Persons applying for a reading pass are generally expected to have a graduate degree and to bring a letter of introduction, but exceptions are made for the use of publications not available elsewhere; see also: *The American Academy in Rome, 1894–1969* / Lucia Valentine and Alan Valentine. Charlottesville: University Press of Virginia. 1973. 237 p. DG1000.A8 V34. http://www.aarome.org.

2.41. *Deutsche Archäologische Institut, Rome*. The library collection consists of approximately 210,000 volumes and 1,895 journals, including ca. 1,000 current journals. The library collection focuses on the archaeology of the Mediterranean World but is supplemented with related disciplines, such as classical philology, ancient history, archaeology of the Roman provinces, archaeology of the Near East, and Egyptology. See also: *Die Bibliothek des Deutschen Archäologischen Instituts in Rom*/ Horst Blanck. Mainz: von Zabern, 1979. 49, 8 p. DE3.D48 1979 Bd. 7. http://www.dainst.org/en/department/library-rome?ft=all.

2.42. *Swedish Institute of Classical Studies, Rome. Library*. The library of the Swedish Institute of Classical Studies in Rome contains ca. 65,000 volumes and 300 current periodicals in the fields of classical archaeology and Mediterranean topography, with particular regard to Italy and Rome, Etruscology, classical art, ancient history, classical philology, prehistory, history of art and architectural history, and conservation and restoration of cultural property. The library also houses small collections in archaeology, art, history, and literature of Sweden. http://www.isvroma.it/public/New/English/index.php?option=com_content andview=articleandid=53andItemid=58.

Turin

2.43. *Biblioteca di S. M. il re. L'Egitto nei libri e nelle immagini della Biblioteca reale di Torino: Biblioteca reale Torino, 4 settembre–19 ottobre 1991*. [Roma]: Ministero per i beni culturali e ambientali, Ufficio centrale per i beni librari e gli istituti culturali, [1991]. 261 p. DT59.T675 B524 1991.

SPAIN

Madrid

2.44. *Deutsche Archäologische Institut, Madrid*. The library of the Madrid Department holds more than 60,000 volumes, including 450 current periodicals and a small collection of other media. The emphasis is the archaeology of the Iberian Peninsula from prehistory to the end of the Islamic period. A second significant area is the German language literature on the archaeology of the Mediterranean. http://www.dainst.org/en/department/library-madrid?ft=all.

SYRIA

Damascus

2.45. *Deutsche Archäologische Institut, Damascus*. The sphere of collections in the library of the Damascus office encompasses publications about the following fields: prehistoric archaeology, Near Eastern archaeology, classical archaeology, archaeology of the Roman provinces, and Christian archaeology as well as Islamic archaeology and art history. To date the library holds ca. 14,000 volumes. http://www.dainst.org/en/department/damaskus?ft=all.

TURKEY

Istanbul

2.46. *Deutsche Archäologische Institut. Istanbul*. http://www.dainst.org/en/department/library-istanbul?ft=al.l.

UNITED STATES

California

2.47. *Stanford University. Classics Library*. A branch library of the Stanford University Libraries, it is a noncirculating collection. http://www.stanford.edu/dept/classics/cgi-bin/web/sites/all/files/Classics %20 Library % 20Rules_0.pdf.

2.48. *University of California, Berkeley. Art History/Classics Library*. The Art History/Classics Library holdings comprise approximately 28,922 volumes and serve as a core research collection supporting UCB's graduate programs in History of Art, Classics, and Ancient History and Mediterranean Archaeology. http://www.lib.berkeley.edu/ARTH/.

2.49. *University of California, Berkeley. Baer-Keller Library of Egyptology*. The Baer-Keller Library of Egyptology is a noncirculating collection of approximately 9,000 volumes maintained by the Near Eastern Studies Department primarily for

the use of UC Berkeley students and faculty pursuing serious study of ancient Egyptian culture, Coptology, and papyrology. http://nes.berkeley.edu/lib_kb.html.

Connecticut

2.50. *Yale University. Library. Classics Library.* The Classics Library was organized in 1892 by the Greek and Latin Club of Yale University as the Classical Club Library. The library has been located at its present location since 1896. The collection, with more than 32,000 volumes, covers many disciplines, which include Greek and Latin texts, textual criticism, inscriptions, paleography, papyrology, epigraphy, Greek and Roman literature, philology, numismatics, history (prehistory, Greece and Rome, Byzantine and medieval), Greek and Roman law, classical archaeology and art, Greek and Roman mythology and religion, ancient philosophy and science, ancient music, classical scholarship, Byzantine studies, and the early history and literature of Christianity. The Classics Library constitutes an integral part of the curricular program in the Classics Department and functions in close and vital connection with its teaching and research program. All material is noncirculating. http://www.library.yale.edu/libraries/classics.html.

2.51. *Yale University. Library. Egyptology Reading Room.* In 2008 a new Egyptology Reading Room (ERR) was created within Sterling Memorial Library with funding from the William K. and Marilyn M. Simpson Endowment for Egyptology. The collection consists of two collections: an assortment of the most important reference books for the various fields of Egyptology, including philology, archaeology, architecture, history, religion, and Coptic studies, and the relevant journals and series within Egyptology, assembling important archaeological series dating back to the late nineteenth century, as well as recent periodicals. http://www.library.yale.edu/egyptology/.

Illinois

2.52. *University of Chicago. Oriental Institute. Library. Catalog of the Oriental Institute Library, University of Chicago.* Boston: G. K. Hall, 1970. 16 v. Z3013 .C45;.C45 1970. *First Supplement/Catalog of the Middle Eastern Collection, Formerly the Oriental Institute Library, University of Chicago,* 1977. 962 p. Z3013 .C45 Suppl.1. See also: *Buried history: publications of the Oriental Institute of the University of Chicago.* Chicago: University of Chicago Press, 1936. 19 p. DS56 .A12 C5 1936. http://oi.uchicago.edu/.

2.53. *University of Illinois at Urbana–Champaign. Classics Library.* http://www.library.uiuc.edu/clx/.

Massachusetts

2.54. American Schools of Oriental Research. *American archaeology in the Mideast: a history of the American schools of oriental research*/Philip J. King. Philadelphia: American Schools of Oriental Research, 1983. 291 p. DS56 .K56 1983. See also: *Symposia Celebrating the Seventy-Fifth Anniversary of the Founding of the American Schools of Oriental Research (1900–1975)*/Frank Moore Cross. Cambridge, MA: American Schools of Oriental Research. 183 p. DS121.55 .S95 1979. http://www.asor.org/.

2.55. *Harvard University. Hellenistic Studies Library.* Washington, DC. Ancient Greek literature, civilization, and culture; ancient philosophy, history, art, and archaeology; and Latin authors with critical apparatus. The library does not collect in prehistory; postclassical and modern Greek history, literature, and civilization; current reports of archaeological sites; and serials of the foreign academies. Size of collection: 44,000 volumes, 110 periodicals. Approximately all texts of Greek classical authors and many texts of Latin authors, both categories in the original language, with translations and critical apparatus in English, German, French, or Italian depending on the edition. Secondary literature in history, philosophy, and religion. Less substantial holdings in art, archaeology, and architecture and the social sciences (all relating to classical Greece or Rome). Some materials in the period of later antiquity. Periodical holdings in all these areas often go back to the earliest issues. http://lib.harvard.edu/libraries/0069.html.

2.56. *Harvard University. Herbert Weir Smyth Classical Library.* Cambridge, MA. Primarily intended for Classics undergraduate and graduate students. Size of collection: 9,000 volumes. Collection includes course readings and standard works such as *Paulys Real-Encyclopädie der classischen Altertumswissenschaft, Thesaurus Linguae Latinae,* leading classical periodicals, critical editions, commentaries, concordances, and selected critical monographs on Greek and Latin authors. Special collections: Palaeography. The bulk of the Palaeography collection was transferred to Smyth Library in 1995, when Room D became the Medieval Studies Library. Limited access.

New York

2.57. *Brooklyn Museum. Wilbour Library. Catalogue of the Egyptological library and other books from the collection of the late Charles Edwin Wilbour* / William Burt Cook, Jr. Staten Island, NY: Maurizio Martino, [1997?] 795 p. Z7064 .B87 1997. http://www.brooklynmuseum.org/opencollection/archives/copy/history.

2.58. *Columbia University.* Avery Library. The Avery Classics Collection is the rare book collection of Avery Library and one of the largest architectural rare book collections in the world. It contains approximately 35,000 printed volumes published over seven centuries. The Classics collection also has important holdings of graphic suites, periodicals, manuscripts, broadsides, photographs, and printed ephemera. Its strengths reflect the library's original subject scope, established by Avery's founders in 1890, that is, architecture, archaeology, and the decorative arts. All Avery books that were produced before 1801 are in Classics. The collection also includes significant editions of major works created after 1800, as well as works that possess distinctive physical characteristics, such as special bindings, exceptional printing, innovative design, autograph inscriptions, or other signs of former ownership. http://library.columbia.edu/content/libraryweb/indiv/avery/classics.html#consulting.

2.59. *New York Public Library. Reference Department. Dictionary catalog of the oriental collection.* Boston: G. K. Hall, 1960. 16 v.; 30 Microfilm reels; Z7050 .N57. See also: *Ancient Egypt; sources of information in the New York Public Library*/Ida A. Pratt. New York: New York Public Library, 1925. 486 p. Z3656 .A2 N5 1925. Continued by: *Ancient Egypt: Sources of information in the New York Public Library; Ancient, Egypt, 1925–1941. A Supplement.* New York: New York Public Library, 1940. 340 p. 913.32B N489 Suppl. http://www.nypl.org/.

2.60. *New York University. The Institute for the Study of the Ancient World (ISAW). Library.* The institute is a center for advanced scholarly research and graduate education that cultivates comparative and connective investigations of the ancient world from the western Mediterranean to China. ISAW faculty conduct historical, archaeological, sociocultural and linguistic research and offer doctoral and postdoctoral programs. A key component of the mission of ISAW is to develop a working library covering the full range of relevant fields. As well as providing coverage across a wide range of subjects, the library aims to develop strengths in areas otherwise currently poorly represented in New York area libraries. ISAW also aims to play an active role in developing and providing access to electronic resources for the ancient world. As a central feature of this effort, the Ancient World Digital Library will formulate, fund, and sustain a digital collection of the most important research materials for the use of the general scholarly community. It will constitute a collection of digital material of the highest quality and usefulness to scholars working within the cross-boundary, interdisciplinary, synchronic, and diachronic fields of study within ISAW's mandate. The AWDL will function in close cooperation with other ISAW initiatives such as Backstop (ISAW's project to facilitate the preservation and long-term maintenance of born-digital scholarly works for ancient studies), a planned Ancient World Image Bank (AWIB). http://isaw.nyu.edu//.

Ohio

2.61. *University of Cincinnati, John Miller Burnam Classics Library.* John Miller Burnam Classics Library is named after a former faculty member of the Classics Department, whose private library became the nucleus of the present library in 1921. Collection efforts focus comprehensively on all aspects of the ancient Greek and Roman world, including the Bronze Age in the Eastern Mediterranean region. Library materials, in print and other formats, cover history, archaeology, language and literature, art, numismatics, science and technology, papyrology, epigraphy, and patristics. The Classics Library offers extensive coverage in materials on Byzantine and Modern Greece and strong coverage in titles on Egypt and the Ancient Near East and on paleography. Library holdings currently total over 244,000 items in the library facility. http://www.libraries.uc.edu/libraries/classics/.

Pennsylvania

2.62. *Bryn Mawr College. Rhys Carpenter Library.* Carpenter Library supports Bryn Mawr College's programs in History of Art and Architecture; Classical and Near Eastern Archaeology; Greek, Latin, and Classical Studies; and Growth and Structure of Cities. Noncirculating collection. http://www.brynmawr.edu/library/carpenter.html.

2.63. *University of Pennsylvania. Library. Classics Resource Room.* The Classical Studies Resource room, located on the third floor of the Van Pelt

Library, houses a noncirculating collection of primary, secondary, and reference material useful to the study of ancient texts, including Collection Budi, or the Collection des Universitis de France, Bibliotheca Teubneriana, Loeb Classical Library, New Pauly, and Cambridge Ancient History. http://www.library.upenn.edu/collections/medieval/classics.html.

Rhode Island

2.64. *Brown University. Couch Room Library.* The Herbert Newell Couch Library in Classical Philology was established in 1959. The library, which is independent of the holdings of the Brown library system, now contains over 4,000 volumes and is accessible to classics students and faculty. A searchable catalog of the volumes in the Couch Room Library is available. http://brown.edu/academics/classics/couch-library-search.

2.65. *Brown University. Library. Dickerman Collection on Egyptology.* In 1910, Lysander Dickerman, a Congregationalist minister and amateur archaeologist, bequeathed 1,200 books on ancient Egypt, establishing the foundation for Brown's exceptional holdings in the field of Egyptology. The collection includes some travel narratives by Egyptologists and accounts documenting archeological excavations that have taken place in Egypt since 1900, as well as works interpreting archeological findings. http://library.brown.edu/collatoz/info.php?id=141.

Tennessee

2.66. *Seventh Adventist University, Collegedale, William G. Dever Research Library.* The library consists of four major collections: (1) William G. Dever Collection, one of the most significant libraries for Near Eastern archaeology; includes all of William G. Dever's publications, and long-out-of-print final reports of excavations include Akko, Beth Shean, Jericho, Jerusalem, Megiddo, Lachish, Hazor, and Gezer, among many others. These site reports provide researchers with first-hand access to the primary sources of archaeological research, such as the architecture, pottery, and important objects found at type sites throughout the region. With these resources, comparative analysis with new discoveries can be made as the database for these ancient finds increases. (2) Kent Weeks Library Collection, consists of a large segment of Egyptologist Kent Weeks's personal library collection, including Egyptian site reports and specialized studies, with the latest reports on Egyptian Old Kingdom, Middle Kingdom, and New Kingdom sites. The library provides the necessary resources for the ongoing research projects of the institute in understanding eastern Mediterranean peoples, places, and polities in the Egyptian New Kingdom. (3) Archaeology Synchronisms Research Foundation has added several thousand volumes in addition to the Kent Weeks Library. The foundation's purpose is to grow the library with a specific focus on the ancient Near East, Egyptology, and Classical Studies. (4) William G. Dever slide collection consists of nearly 15,000 slides from the ancient Near East taken from 1956 to 2000. It documents the major excavations and developments in the field over a period of nearly fifty years. The collection is in the process of being digitized and will be added to a database of another 20,000 digital images from the ancient Near East. http://www.southern.edu/archaeology/williamgdever-researchlibrary/Pages/default.aspx.

2.67. *University of Memphis. Institute of Egyptian Art and Archaeology. Egyptology Library.* The institute was founded in 1984 as a component of the Department of Art in the College of Communication and Fine Arts. The current holdings in the IEAA's Egyptology Library total more than 6,000 volumes (many rare and out of print). Its permanent collection of over 1,400 Egyptian antiquities, including ancient Egyptian sculpture and relief carving, mummies, and objects of daily life, is the only such collection in the mid-South. The collection is housed in the Art Museum of the University of Memphis and is free and open to the public. http://www.memphis.edu/egypt/mission.php.

Texas

2.68. *Southern Methodist University. Bridwell Library. Steindorf Collection.* Bridwell Library purchased the Steindorff Collection in 1952 from the widow of the eminent German Egyptologist, Dr. Georg Steindorff (1861–1951). The collection consists of 1,700 books, over 2,000 reprints and pamphlets, several hundred photographs, and a collection of clippings and private correspondence. http://www.smu.edu/bridwell/specialcollections/steindorff/steindorff.html.

2.69. *University of Texas at Austin. Classics Library.* This library primarily serves the needs of faculty, graduate students, and upper-division majors in classics, archaeology, art history, philosophy, architecture, and comparative literature. The Classics Library is an open and closed stack facility. Material on archaeology, art, and numismatics is kept in closed stacks. http://www.lib.utexas.edu/classics/about.

3
Specialized Museum Collections

Guides to archives and manuscript collections are important sources frequently overlooked by students. These guides can help identify research material appropriate to a research project. Because archives and some specialized libraries are not always accessible to the public, it is frequently necessary to make an appointment before considering a research visit. Local restrictions regarding the reproduction of materials and the use of computers, pens, and cameras should be investigated in advance.

The number of museums with collections from the ancient world is impressive. Some of these institutions are identified in this chapter. Arrangement is by nation, followed by city.

AFGHANISTAN

Ghazni

3.1. Ghazni Provincial Museum was opened in 1966 within the Sultan Abdul Razaq Mausoleum complex and contained numerous marble carvings, some of animals, ceramic tiles, and bronzes from the region, as well as pieces from the Ghaznavid Empire (977–1186). The uprising in the provinces forced the Soviet regime to transfer some of the objects to Kabul. Rumors persist that part of the collection is hidden and will be installed in the new museum when peace is restored. http://portal.unesco.org/culture/en/ev.php-URL_ID=37019&URL_DO=DO_TOPIC&URL_SECTION=201.html.

Jalalabad

3.2. Nangarhar Provincial Museum. http://www.bam-dad.af/index.php/english/text/story/1183.

Kabul

3.3. Kabul National Museum. Kabul Museum is the national museum of Afghanistan. It is a two-story building located in the historic city of Kabul. Its collection was once one of the finest in Central Asia with over 100,000 items dating back several millennia. The museum was founded in the 1920s. In 1973, a Danish architect was hired to design a new building for the museum, but the plans were never carried out due to political instability. http://en.wikipedia.org/wiki/Kabul_Museum.

Mahmud-i-Raqi

3.4. Kapisa Provincial Museum and Archaeological Site.

Mazar-i-Sharif

3.5. Balkh Provincial Museum. This museum of religious artifacts is located within the mosque, and currently there is some question about who runs it. Both the Ministry of Haj and the Ministry of Culture and Youth Affairs claim responsibility for it. Examples of calligraphy and miniatures have been installed by the Monuments Department of the Ministry of Culture and Youth Affairs. A tomb contains the body of Hazrat Ali and members of the exalted royal families of Emir Sher Ali (1863–1879) and Mohammad Akbar Khan (1816–1845). http://en.wikipedia.org/wiki/Balkh_Provincial_Museum#Balkh_Museum.

ALBANIA

Apolonia

3.6. The Archaeological Museum of Apolonia was founded in 1958 in the monastery's surroundings, which is within the territory of the ancient town, and was reconstructed in 1985. It gives broad information on all aspects of life of this town, which together with the monuments discovered in the center of the town give a complete understanding of its historical development. http://www.coe.int/t/dg4/cultureheritage/cooperation/SEE/IRPPSAAH/BP/AL_24_BP_approved.pdf.

Butrint

3.7. Zona Arkeologjike e Butrintit. The Archaeological Museum of Butrint was founded in 1950 in the surroundings of the Butrint's Venetian fortress. The archaeological material exhibited here shows the phases of the town's life and the periods of its prosperity and collapse. http://www.butrint.org/explore_15_0.php.

Durrës

3.8. The Archaeological Museum of Durrës was founded in 1951 with objects gathered after War World II in the town. Systematic research for over fifty years added to this collection a great variety of objects (now over 20,000). The museum presents the life of this ancient town from its foundation until the Middle Ages and is organized according to a combined chronological/topical criterion. http://argophilia.com/albania/durres-archaeological-museum.html.

Elbasan

3.9. Elbasan Museum. A museum relating the history of the Elbasan district is located in the fortress. Its exhibits include the tombs of an Illyrian warrior, with helmet, arms, and household utensils and two statues of Apollo. http://www.albanian-folklore.com/seminar-2011/photos-2011/picture-412.html.

Korca

3.10. Prehistoric Museum of Korca. It was founded in 1988 based on very rich prehistoric material, especially of the Korce and Kolonje areas. http://www.inyourpocket.com/albania/korca/ Sightseeing/Archaeology/Kamenica-Tumulus_44864v.

Tirana

3.11. National Archaeological Museum. The National Archaeological Museum is one of the best museums in Albania. This museum has a very rich collection of about 1,800 objects excavated from different sites in Albania. http://marvaoguide.com/index.php/Albania/Tirana-Archaeological-Museum.html.

ALGERIA

Djemila

3.12. Musée Archéologique de Djemila. http://www.saravoyages.com/saratravels/djemila.html.

Tazoult

3.13. Musée de Tazoult. http://www.mellaoui-smail.com/2011/10/26/musee-archeologique-de-tazoult-le-26102011/.

Tipasa

3.14. Musée de Tipasa. Built in 1955, the Museum of Tipasa presents a collection of related remains of civil and religious life and funerary furniture updated on two main sites of the city. In the courtyard are exposed architectural elements such as bases, drums, and capitals of columns and Punic Stelae. In the exhibition hall, the mosaic adorning the wall facing the entrance is impressive. This is the "mosaic of the captives" (second century) from the apse of the Basilica judiciary. It represents three captives surrounded by heads symbolizing the African races. Another mosaic, representing fish and bearing the inscription "In WD, Pax and Concordia sit convivio nostro," refers to a funeral meal. The museum also contains a fine collection of ancient glass, the sarcophagi of marble (Pelops and Hippodamia, sailors and néreides Centaures), mortuary tables, fragments of Punic Stelae to the cult of Tanit, Roman statues, coins, ceramics, and jewelry. http://www.musee-tipasa.art.dz/.

ARMENIA

3.15. Eskijian Museum. Aside from art, artifacts, and world-class museum items of several civilizations, the museum contains full displays of ancient Armenian coins, stamps, and currency of the Armenian Republic from 1918–1920; maps

dating back several years, describing the existence of Armenia in present-day Turkey, as well as Hittite and Urartu civilizations; and a library containing rare Armenian history and genocide books. http://www.ararat-eskijian-museum.com/.

Erebuni

3.16. Erebuni Fortress Museum. The Urartian kingdom centered on Lake Van in Eastern Turkey gave Yerevan its first major impetus. The Urartians built the citadel of Erebuni on the hill of that name in southeast Yerevan. A substantial museum at the base of the hill, formerly known as Arin Berd, houses many of the finds, including a few examples of Urartu's splendid metalwork. http://www.erebuni.am/index.php?option=com_content&view=frontpage&Itemid=68&lang=en.

Yerevan

3.17. Middle East Museum. Accessible from the street running behind the State History Museum is the Middle Eastern Museum and Museum of Literature. The former has an interesting collection, including a carpet-weaving display. http://www.erebuni.am/index.php?option= com_ content& vi ew=frontpage&Itemid=68&lang=en.

3.18. Sardarapat Ethnographic Museum. Bearing left before the Sardarapat battle monument, a driveway skirts the monument ridge to reach a tourist pavilion (refreshments) and the highly attractive Sardarapat museum. The director is the head of the Armenian Communist Party. The ground floor central hall contains commemorative material from the battle. http://www.haytour.am/museum.asp?lngid=2.

AUSTRIA

Dölsach

3.19. Museum Aguntum. The Roman settlement Aguntum is located about five kilometers from Lienz in East Tyrol and provides an insight into the former Roman city, which belonged to the province of Noricum and flourished in the first and second centuries. The Roman town was destroyed in 612 CE. Several years ago several elements were laid open and examined from an archaeological point of view. In the course of time the area of the former Roman settlement has become an open air museum. http://www.tyrol.tl/en/highlights/sights/roman-city-and-museum-aguntum.html.

Fliess

3.20. Archäologisches Museum und Dokumentationszentrum Via Claudia. http://www.cusoon.at/archaeologisches-museum-fliess-und-dokumentationszentrum-via-claudia-augusta.

Graz

3.21. Archäologische Sammlung der Universität Graz. http://www.simskultur.net/steiermark/graz/archaeologische-sammlung-der-universitaet-graz.

Petronell

3.22. Archäologischer Park Carnuntum. http://www.carnuntum.co.at/visiting-carnuntum/your-visit-in-carnuntum.

3.23. Freilichtmuseum Petronell. http://www.carnuntum.co.at/park/auf-den-spuren-der-zivilstadt/freilichtmuseum-petronell.

Pischeldorf

3.24. Archäologischer Park Magdalensberg. http://www.landesmuseum-ktn.at/Landesmuseen/Magdalensberg/magdalensfr.html.

Ratschendorf

3.25. Römerzeitliches Museum. http://webmuseen.de/roemerzeitliches-museum-ratschendorf.html.

Seggauberg

3.26. Tempelmuseum Frauenberg. http://www.seggauberg.at/Tempelmuseum-Frauenberg.15.0.html.

Völs

3.27 Museum Thurnfels. http://www.voels.at/tourismus/museum.htm.

Wien

3.28. Ephesos Museum. http://www.ephesus.us/ephesus/ephesos-museum-vienna.htm.

3.29. Kunsthistorisches Museum. http://www.khm.at/.

3.30. Papyrusmuseum und Papyrussammlung. http://www.onb.ac.at/sammlungen/papyrus.htm.

3.31. Römermuseum. http://www.wienmuseum.at/en/locations/location-detail/roemermuseum-1.html.

3.32. Universität und Professor Franz v. Matsch Universität. http://www.univie.ac.at/.

AUSTRALIA

Melbourne

3.33. Hellenic Antiquities Museum. http://www.bing.com/?pc=Z006&form=ZGAPHP.

BELGIUM

Arlon

3.34. Musée Archéologique. http://www.arlon.be/index.php?id=91.

Blicquy

3.35. Musée Gallo-Romain. http://www.uluberlu.be/joomla/index.php?option=com_content&view=article&id=1846:musee-gallo-romain-de-blicquy&catid=349:musees&Itemid=4.

Brussels

3.36. Musées Royaux d'Art et d'Histoire. http://www.kmkg-mrah.be/.

Charleroi

3.37. Musée Archéologique. http://www.charleroi.be/node/189.

Jambes

3.38. Musée Vivant de l'Egypte pour Enfants. http://musee-vivant-des-enfants.com/.

Liege

3.39. Grand Curtius. http://uk.eurostar.com/uk/travel-to-belgium/travel-to-wallonia/travel-to-liege/attractions/grand-curtius-museum-idp-8331819.

Montauban-sous-Buzenol

3.40 Musée Archéologique et Lapidaire de Montauban. http://www.musee-lapidaire.org/.

Remagen

3.41 Römisches Museum. http://www.plurio.net/4/bid,12587/musee-gallo-romain-de-waudrez.html.

Waudrez

3.42. Musée Gallo-Romain de Waudrez. http://www.opt.be/informations/attractions_touristiques_waudrez__musee_gallo_romain/fr/V/17044.html.

Zottegem

3.43. Provincial Archeologisch Museum van Zuid-Oost-Vlaanderen. http://www.museum-info.be/bdr65361-Provinciaal-Archeologisch-Museum-Van-Zuid-Oostvlaanderen.html.

CANADA

Saskatoon

3.44. Museum of Antiquities. http://www.usask.ca/antiquities/.

Toronto

3.45. Royal Ontario Museum. http://www.rom.on.ca/.

CRETE

3.46. Historical Museum of Crete. http://www.historical-museum.gr/en/index.html.

CROATIA

Nin

3.47. Arheoloska Zbirka. http://www.lotos-croatia.com/en/croatia/1393/croatia-dalmatia-the-museum-of-nin/.

Pula

3.48. Arheoloski Muzej Istre. http://www.planetware.com/pula/archeological-museum-of-istria-hr-is-puam.htm.

Sinj

3.49. Zbirka Franjevackog Samostana. http://museum.com/jb/museum?id=21644.

Split

3.50. Muzej u Splitu. http://www.mdc.hr/split-arheoloski/hr/index.html.

CYPRUS

Kantara

3.51. Sipahi Ay. Trias Bazilikasi ve Kantara Kalesi.

Lefke

3.52. Soli Archaeological Museum.

Lefkosia

3.53. Cyprus Museum. http://www.kypros.org/P10/reference/museums.html.
3.54. Museum of the George and Nefeli Giabra Pierides Collection. http://www.cs.ucy.ac.cy/projects/museums/team9/museum.php?langId=2.

Lemesol

3.55. Limassol District Museum. http://www.limassol-municipal.com.cy/museum/buton1-eng.html.

CZECH REPUBLIC

Prague

3.56. Musée National. http://www.pis.cz/a/prague/museums.html.
3.57. Université Charles. http://www.pis.cz/a/prague/museums.html.

DENMARK

Copenhagen

3.58. Musée National. http://www.natmus.dk/.
3.59. Thorvaldsens Museum. http://www.thorvaldsensmuseum.dk/en.

EGYPT

Alexandria

3.60. Alexandria National Museum. The Alexandria National Museum has grown in importance and is considered to be one of Egypt's finest museums. The museum is located in a restored palace and contains about 1,800 artifacts, which narrate the history of Alexandria throughout the ages, including the Pharaonic, Roman, Coptic, and Islamic eras. http://www.ostamyy.com/museums/Egypt.htm.
3.61. Greco-Roman Museum. This museum was created in 1892. It was first built in a five-room structure. In 1895, it was transferred to another building that had only eleven rooms. More rooms were added later to this building, now located near Gamal Abdul Nasser Street. http://www.ostamyy.com/museums/Egypt.htm.

Aswan

3.62. Elephantine Island Museum. The Elephantine Museum is located on Elephantine Island in the River Nile, just downstream of the First Cataract at the southern border of ancient Egypt, and has artifacts primarily related to that area in the midst of spectacular subtropical gardens. The building that houses the collection belonged to the architect of the Aswan Dam, Sir William Wilcocks. http://users.stlcc.edu/mfuller/elephantineMuseum.html.
3.63. Nubian Museum. The International Museum of Nubia/The Nubian Museum is located in Aswan on an area of 50,000 square meters, 7,000 of which are devoted to the building, while the rest are designed to be the yard of the museum. The building has three floors for displaying and housing, in addition to a library and information center. The largest part of the museum is occupied by the monumental pieces, reflecting phases of the development of the Nubian culture and civilization. http://www.numibia.net/nubia/intro.htm.

Cairo

3.64. Coptic Museum. The Coptic Museum is a museum in Coptic Cairo, Egypt, with the largest collection of Egyptian Christian artifacts in the world. It was founded in 1910 to house Coptic antiquities. The museum traces the history of Christianity in Egypt from its beginnings to the present day. It was erected over land offered by the Coptic Orthodox Church of Alexandria under the guardianship of Pope Cyril V. http://www.coptic-cairo.com/museum/museum.html.
3.65. Egyptian Museum. The Egyptian Museum in Cairo exhibits over 120,000 ancient objects, including artifacts from the palaces and tombs of kings and members of the royal families and items of great historical value. http://www.egyptianmuseum.gov.eg.
3.66. *Catalogue général des antiquités égyptiennes du Musée du Caire.* Le Caire: Imprimerie de l'Institut Français d'Archéologie Orientale, 1901– . DT57 .C2. Contents include:
Musée du Caire—Catalogs
Die entstehung des generalkatalogs und seine entwicklung in den jahren 1897–1899/L. Borchardt. Berlin: Reischsdruckerei, 1937. 12 p. DT57 .C2 v.99.
Musée du Caire—Catalogs—Alexandria
Iscrizioni greche e latine/Evaristo Breccia. Le Caire: Imprimerie de l'Institut Français

d'Archéologie Orientale, 1911. 273, 61 p. DT57 .C2 1911.

Musée du Caire—Catalogs—Alexandria—Tombs

La necropoli di Sciatbi/Evaristo Breccia. Le Caire: Imprimerie de l'Institut Français d'Archéologie Orientale, 1912. 2 v. DT57.C2 v.63, etc.

Musée du Caire—Catalogs—Amulets

Amulets/G. A. Reisner. Le Caire: Imprimerie de l'Institut Français, 1907–1958. 2 v. Ctr for Adv Judaic Studies Lib Stacks Folio DT62. A5 M38 1907. See also *Amulets* [electronic resource]/G. A. Reisner. Worcester, UK: Yare Egyptology, 2006. DT57 .C2 v.35 2006.

Musée du Caire—Catalogs—Archaic Objects

Archaic objects/M. Quibell. Le Caire: Imprimerie de l'Institut Français d'Archéologie Orientale, 1904–1905. 2 v. DT57 .C2 v.23/24.

Musée du Caire—Catalogs—Art, Coptic

Koptische Kunst/Josef Strzygowski. Vienne: Imprimerie A. Holzhausen, 1904. 362 p. DT57 .C2 v.12.

Musée du Caire—Catalogs—Bronze, Greek

Greek bronzes/C. C. Edgar. Le Caire: Imprimerie de l'Instiut Française d'archéologie orientale, 1904. 99 p. DT57 .C2 v.19.

Musée du Caire—Catalogs—Coffins

Cercueils anthropoïdes des pretres de Montou/Henri Gauthier. Le Caire: Institut français d'archéologie orientale, 1913. 2 v. DT57.C2 v.62, etc.

Cercueils des cachettes royales/G. Daressy. Le Caire: Imprimerie de l'Insitut Français d'Archéologie Orientale, 1909. 247 p. DT57 .C2 v.50.

Graeco-Egyptian coffins, masks and portraits/C. C. Edgar. Le Caire: Imprimerie de l'Institut Français, 1905. 136 p. DT57 .C2 v.26.

Sarcophages de l'époque bubastite à l'époque saite/Alexandre Moret. Le Caire: Institut Français d'Archéologie Orientale, 1913. 2 v. DT57 .C13 1913; DT57.C2 v.61, etc.

La seconde trouvaille de Deir El-Bahari (sarcophages)/Émile Chassinat. Le Caire: Imprimerie de l'Institut Français d'Archéologie Orientale, 1909. DT57 .C2 v.44.

Musée du Caire—Catalogs—Coffins, Anthropoid Clay

Anthropoid clay coffins/Lisa K. Sabbahy. Cairo: Supreme Council of Antiquities Press, 2009. 75 p. 89, 33 p.

Musée du Caire—Catalogs—Deir el-Bahri—Coffins

The second find of Deir El-Bahari (coffins)/Andrzej Niwiński. Cairo: Ministry of Culture, Supreme Council of Antiquities of Egypt, 1999. DT57.C2 v. 2, fasc. 1.

Musée du Caire—Catalogs—Denkmaler

Denkmäler des alten Reiches (ausser den Statuen) im Museum von Kairo/Ludwig Borchardt. Berlin: Reichsdruckerei, 1937. 3 v. DT57 .C2 v.97.

Musée du Caire—Catalogs—Funerary Statues

Funerary statuettes and model sarcophagi/Percy E. Newberry. Le Caire: Imprimerie de l'Institut Français d'Archéologie Orientale, 1930–1957. 435 p. DT57 .C2 v.86.

Musée du Caire—Catalogs—Jewelry

Bijoux et orfèvreries/Émile Vernier. Le Caire: Imprimerie de l'Institut Français d'Archéologie Orientale, 1907–1927. 2 v. DT57.C2 v.38, etc. See also Bijoux et orfèvreries [electronic resource]/Émile Vernier. Worcester, UK: Yare Egyptology, 2006. CD-ROM. DT57 .C2 v.38, etc. 2006.

Musée du Caire—Catalogs—Magic

Textes et dessins magiques/G. Daressy. Le Caire: Imprimerie de l'Institut français d'archéologie orientale, 1903. 60 p. DT57 .C2 v.9.

Musée du Caire—Catalogs—Metalwork

Metallgefässe [electronic resource]/W. von Bissing. Worcester, UK: Yare Egyptology, 2006. CD-ROM. DT57 .C2 v.2 2004.

Musée du Caire—Catalogs—Mirrors

Miroirs/Georges Bénédite. Le Caire: Imprimerie de l'Institut Français d'Archéologie Orientale, 1907. 64 p. DT57 .C2 v.37. See also Miroirs [electronic resource]/Georges Bénédite. Worcester, UK: Yare Egyptology, 2006. CD-ROM. DT57 .C2 v.37 2006.

Musée du Caire—Catalogs—Mummies

Graeco-Egyptian coffins, masks and portraits/C. C. Edgar. Le Caire: Istitut Français d'Archéologie Orientale, 1905. 136 p. DT57 .C2 v.26.

Musée du Caire—Catalogs—Mummies—Animal Remains

La faune momifiée de l'antique Égypte/M. M. Gaillard et Daressy. Le Caire: Imprimerie de l'Institut Français d'Archéologie Orientale, 1905. 159 p. DT57 .C2 v.25.

Non-human mummies/Salima Ikram and Nasry Iskander. Cairo: Supreme Council of Antiquities Press, 2002. 100 p. DT62.M7 M38 2002.

Musée du Caire—Catalogs—Obelisks

Obélisques/Charles Kuentz. Le Caire: Imprimerie de l'Institut Français d'Archéologie Orientale, 1932. 81 p. DT57 .C2 v.91.

Musée du Caire—Catalogs—Ostraca

Griechische Ostraka/Ulrich Wilcken. Le Caire: Service des antiquités de l'Egypte, 1983. 157 p. DT57.C2 v.104.

Ostraca hiératiques/Jaroslav Cerný. Le Caire: Imprimerie de l'Institut Français d'Archéologie Orientale, 1930–1935. 2 v. DT57.C2 v.87, etc.

Musée du Caire—Catalogs—Ostraka, Coptic

Coptic monuments/W. E. Crum. Le Caire: Imprimerie de l'Institut Français d'Archéologie Orientale, 1902. 160 p. DT57 .C2 v.4.

Musée du Caire—Catalogs—Papyri, Byzantine

Papyrus grecs d'époque byzantine/Jean Maspero. Le Caire: Imprimerie de l'Institut Français d'Archéologie Orientale, 1911–1916. 3 v. DT57.C2 v.51, etc.

Musée du Caire—Catalogs—Papyri, Coptic

Manuscrits coptes/Henri Munier. Le Caire: Imprimerie de l'Institut Français d'Archéologie Orientale, 1916. 213 p. DT57 .C2 v.74.

Musée du Caire—Catalogs—Papyri, Demotic

Die demotischen Denkmäler/Wilhelm Spiegelberg. Leipzig: W. Drugulin, 1904–1932. 3 v. DT57.C2 v.16, etc. See also *Die demotischen Denkmäler* [electronic resource]/Wilhelm Spiegelberg. Worcester, UK: Yare Egyptology, 2006. CD-ROM. DT57 .C2 v.16, etc. 2006.

Musée du Caire—Catalogs—Papyri, Egyptian

Papyrus hiératiques/Woldemar Golénischeff. Caire: Imprimerie de l'Institut Français d'Archéologie Orientale, 1927. DT57 .C2 v.83.

Musée du Caire—Catalogs—Papyri, Greek

Greek papyri/B. P. Grenfell and A. S. Hunt. Oxford: Printed at the University Press by H. Hart, 1903. 116 p. DT59 .M38 1903; DT57 .C2 v.10.

Papyrus grecs d'époque byzantine/Jean Maspero. Le Caire: Imprimerie de l'Institut Français d'Archéologie Orientale, 1911–1916. 3 v. DT57.C2 v.51, etc.

Papyrus de Ménandre/Gustave Lefebvre. Le Caire: Imprimerie de l'Institut Français d'Archéologie Orientale, 1911. 46 p. DT57 .C2 v.52.

Zenon papyri/C. C. Edgar. Le Caire: Imprimerie de l'Institut Français d'Archéologie Orientale, 1925–1940. 5 v. DT61 .M38 1925.

Musée du Caire—Catalogs—Pottery

Fayencegefässe/F. W. Bissing. Vienne: A. Holzhausen, 1902. 114 p. DT57 .C2 v.6.

Tongefässe/F. W. Bissing. Vienne: A. Holzhausen, 1913. DT57 .C2 v.66.

Musée du Caire—Catalogs—Sarcophagi

Sarcophages antérieurs au Nouvel Empire/Pierre Lacau. Le Caire: Institut Français d'Archéologie Orientale, 1904–1906. 4 v. DT57 .C2 v.11, etc.

Sarcophages des époques persane et ptolémaïque/Gaston Maspero. Le Caire: Imprimerie de l'Institut Français d'Archéologie Orientale, 1914–1939. 3 v. DT57.C2 v.41.

Musée du Caire—Catalogs—Sculpture

Funerary statuettes and model sarcophagi/Percy E. Newberry. Le Caire: Imprimerie de l'Institut Français d'Archéologie Orientale, 1930–1957. 435 p. DT57 .C2 v.86.

Greek moulds/C. C. Edgar. Le Caire: Imprimerie de l'Institut Français, 1903. 89, 33 p. DT57 .C2 v.8.

Naos/Günther Roeder. Leipzig: Breitkopf & Härtel, 1914. 191, 91 p. DT57 .C2 v.75.

Sculptors' studies and unfinished works/C. C. Edgar. Le Caire: Imprimerie de l'Institut Français d'Archéologie Orientale, 1906. 91 p. DT57 .C2 v.31.

Statues et statuettes de rois et de particuliers/G. A. Legrain. Le Caire: Imprimerie de l'Institut Français d'Archéologie Orientale, 1906–1925. 3 v. DT57.C2 v.30, etc.

Statuen und Statuetten von Königen und Privatleuten im Museum von Kairo, Nr. 1–1294/Ludwig Borchardt. Berlin: Reichsdruckerei, 1911–1936. 5 v. DT57.C2 v.53, 77, 88, 94, 96.

Statues de divinités/Georges Daressy. Le Caire: Imprimerie de l'Institut Français d'Archéologie Orientale, 1905–1906. 2 v. DT57.C2 v.28, etc. See also *Statues de divinités* [electronic resource]/Georges Daressy. Worcester, UK: Yare Egyptology, 2006. CD-ROM. DT57 .C2 v.28-29 2006.

Statues of the XXVth and XXVIth dynasties/Jack A. Josephson and Mamdouh Mohamed Eldamaty. Cairo: Supreme Council of Antiquities Press, 1999. 116. 50 p. DT59.C243 J68 1999.

Musée du Caire—Catalogs—Sculpture, Greek

Greek sculpture/C. C. Edgar. Le Caire: Imprimerie de l'Institut Français d'Archéologie Orientale, 1903. 83 p. DT57 .C2 v.13.

Musée du Caire—Catalogs—Ship Models

Models of ships and boats/G. A. Reisner. Le Caire: Institut Français d'Archéologie Orientale, 1913. 171 p. DT57 .C2 v.68.

Musée du Caire—Catalogs—Stele

Grab- und Denksteine des Mittleren Reichs im Museum von Kairo/H. O. Lange und H. Schäfer. Berlin: Reichsdruckerei, 1902–1925. 4

v. DT57.C2 v.5, etc. See also *Grab- und Denksteine des Mittleren Reichs im Museum von Kairo* [electronic resource]/H. O. Lange und H. Schäfer. Worcester, UK: Yare Egyptology, 2006. CD-ROM. DT57 .C2 v.5, etc. 2006.

Stèles ptolémaiques et romaines/M. Ahmed Bey Kamal. Le Caire: Imprimerie de l'Institut Français d'Archéologie Orientale, 1904–1905. 2 v. DT57 .C2 v.20/21.

Musée du Caire—Catalogs—Stele, Greek

Greek inscriptions/J. G. Milne. Oxford: Printed at the University Press by H. Hart, 1905. 153 p. DT57 .C2 v.18.

Musée du Caire—Catalogs—Stone Carving

Steingefässe/Fr. W. von Bissing. Vienne: A. Holzhausen, 1907. 2 v. DT57.C2 v.17, etc.

Musée du Caire—Catalogs—Stone Implements

Stone implements/Charles T. Currelly. Le Caire: Imprimerie de l'Institut Français d'Archéologie Orientale, 1913. 278 p. DT57 .C2 v.69.

Musée du Caire—Catalogs—Thebes

Fouilles de la vallée des rois (1898–1899). Le Caire: Institut Français d'Archéologie Orientale, 1902. 311 p. DT57 .C2 v.3.

Musée du Caire—Catalogs—Tombs of Yuya and Tjuya

Tomb of Yuaa and Thuiu/J. E. Quibell. Le Caire: Imprimerie de l'Institut Français d'Archéologie Orientale, 1908. 80 p. DT57 .C2 v.43.

Musée du Caire—Catalogs—Tud

Trésor de Töd/F. Bisson de la Roque. Le Caire: Imprimerie de l'Institut Français d'Archéologie Orientale, 1950. 58, 29 p. DT57 .C2 v.102. See also *Trésor de Töd* [electronic resource]/F. Bisson de la Roque. Worcester, UK: Yare Egyptology, 2006. CD-ROM. DT57 .C2 v.102 2006.

Musée du Caire—Catalogs—Ushabti

Funerary statuettes and model sarcophagi/Percy E. Newberry. Le Caire: Imprimerie de l'Institut Français d'Archéologie Orientale, 1930–1957. 435 p. DT57 .C2 v. 86.

Musée du Caire—Catalogs—Valley of the Kings

Fouilles de la Vallée des rois (1898–1899) [electronic resource]/M. G. Daressy. Worcester, UK: Yare Egyptology, 2006. CD-ROM. DT57 .C2 v.3 2005.

Musée du Caire—Catalogs—Vases, Greek

Greek vases/C. C. Edgar. Le Caire: Imprimerie de l'Institut Français d'Archéologie Orientale, 1911. 92 p. DT57 .C2 v.56.

Musée du Caire—Catalogs—Votive Offerings

Tables d'offrandes/Ahmed Bey Kamal. Le Caire: Imprimerie de l'Institut Français d'Archéologie Orientale, 1906–1909. 2 v. DT57 .C2 v.46/47.

Musée du Caire—Catalogs—Weights and Measures

Weights and balances/Arthur E. P. Weigall. Le Caire: Imprimerie de l'Institut Français d'Archéologie Orientale, 1908. 69 p. DT57 .C2 v.42.

3.67. Museum of Islamic Art. Although recognition of Pharaonic art was signaled in Cairo by the establishment in 1858 of the Department of Antiquities and the Egyptian Museum, the appreciation of Arab and Islamic art lagged behind. The Khedive Ismail approved a proposal to establish a Museum of Arab Art in the Courtyard of the Mosque of Baibars, but this was not carried out until 1880, when Khedive Tawfiq ordered the Ministry of Endowments to set it up. http://www.ostamyy.com/museums/Egypt.htm.

3.68. National Museum. The National Museum has a variety of displays covering all of Egyptian history. The museum, which was opened in Port Said in 1987, has exhibits on the first floor covering prehistory and the Pharaonic period, including several mummies and sarcophagi along with various statues and other artifacts. On the next floor is Islamic and Coptic material, including textiles, manuscripts, and coins, as well as artifacts from the Khedival family. http://www.touregypt.net/nationalmuseum.htm.

Giza

3.69. Grand Egyptian Museum. The Grand Egyptian Museum (GEM) plans to open in 2015 and is sited on fifty hectares of land in Giza as part of a new master plan for the plateau. On January 5, 2002, Egyptian President Mubarak laid the foundation stone. The museum site is two kilometers from the Giza pyramids. The building is designed by Heneghan Peng Architects, Buro Happold and Arup. http://www.gem.gov.eg/.

3.70. Pharaonic Village. Visitors sail on motorized barges down a network of canals and view accurate tableaux of the re-creation of ancient Egyptian life. Though the city of Cairo surrounds the island, not a trace of it penetrates the thick wall of trees planted around the island. Sights include recreations of industries, games, arts, and moments from history and legend. http://pharaonicvillage.com/.

Ismailia

3.71. Ismailia Museum. The Ismailia is a small museum but has over 4,000 artifacts from Pharaonic through the Greek and Roman era. It includes

information on the first canal built by the Persian Darius between the Bitter lakes and Bubastis and a masterpiece mosaic of the fourth century illustrating classic characters from Greek mythology. Other items include statues, scarabs, stelae, and such. http://egyptianmuseums.net/html/ismailia_museum_.html.

Karanis

3.72. Karanis Museum. Many artifacts found within the Fayoum region are housed in the Karanis Museum. Displays include delicate glassware and pottery, female heads (as found in Alexandria), which are thought to have been used to model hairstyles, and a Fayoum portrait. Many of the mummies found in this area had portraits of the deceased painted on them. The museum is well laid out and has recently been renovated. http://www.ostamyy.com/museums/Egypt.htm.

Luxor

3.73. Luxor Museum of Ancient Art. Luxor Museum is located in the Egyptian city of Luxor (ancient Thebes). It stands on the corniche, overlooking the River Nile, in the central part of the city. Inaugurated in 1975, the museum is housed in a small purpose-built building. The range of artifacts on display is far more restricted than the country's main collections in the Museum of Antiquities in Cairo; this was, however, deliberate, since the museum prides itself on the quality of the pieces it has, the uncluttered way in which they are displayed, and the clear multilingual labeling used. http://www.ostamyy.com/museums/Egypt.htm.

3.74. Mummification Museum. The Mummification Museum is located in the Egyptian city of Luxor. It stands on the corniche, in front of the Mina Palace Hotel, to the north of Luxor Temple, overlooking the River Nile. The museum is intended to provide visitors with an understanding of the ancient art of mummification. The Ancient Egyptians applied embalming techniques to many species, not only to dead humans. Mummies of cats, fish, and crocodiles are on display in this unique museum, where one can also get an idea of the tools used. http://www.ostamyy.com/museums/Egypt.htm.

Port Said

3.75. National Museum. The National Museum has a variety of displays covering all of Egyptian history. The museum, which was opened in Port Said in 1987, has exhibits on the first floor covering prehistory and the Pharaonic period, including several mummies and sarcophagi along with various statues and other artifacts. On the next floor is Islamic and Coptic material, including textiles, manuscripts, and coins, as well as artifacts from the Khedival family. http://www.ostamyy.com/museums/Egypt.htm.

Saqqara

3.76. Imhotep Museum. The Imhotep Museum is located at the foot of the Saqqara necropolis complex, near Memphis, in Egypt and was built as part of strategic site management. The museum was opened on April 26, 2006, and displays finds from the site, in commemoration of the ancient Egyptian architect Imhotep. Professor Zahi Hawass said: "I felt that we should call it the Imhotep Museum in tribute to the first architect to use stone rather than perishable materials for construction on a large scale. This man was second only to the King and in the late period was worshiped as a god." http://www.ostamyy.com/museums/Egypt.htm.

FRANCE

Aoste

3.77. Musée Antiquirés Gallo-Romain. http://www.isere-annuaire.com/musees/musee_aoste.htm.

Alise-Sainte-Reine

3.78. Musée Alésia. The Alesia Museum was laid out by the Semur Society of Sciences in 1910 and holds mementos of the Siege of 52 BCE, as well as items of architecture, many sculptures, and a very rich collection of objects from daily life found in the excavations of the Gallic-Roman town. http://www.musees-bourgogne.org/les_musees/musee_bourgogne_resultat.php?id=20&theme=archeologie.

Antibes-Juan-les-Pins

3.79. Musée d'Archéologie. http://www.antibes-juanlespins.com/les-musees/darcheologie.

Avesnes-sur-Helpe

3.80. Musée de l'Institut Villien. http://www.monnuage.fr/point-d-interet/musee-de-linstitut-villien-davesnes-sur-helpe-a92840.

Biesheim

 3.81. Musée Gallo-Romain. http://www.tourismepaysdebrisach.com/museegalloromain_a_biesheim.html.

Chateau Gontier

 3.82. Musée Municipal, Musée d'Art et d'Archéologie. http://www.keskeces.com/muses/chateau-gontier/musee-d_art-et-d_archeologie-hotel-fouquet.html.

Compiègne

 3.83. Musée de Compiègne, Musée Vivenel. http://www.cr-picardie.fr/uk/page.cfm?pageref=culture~patrimoine~musees~vivenel.

Die

 3.84. Musée d'Histoire et d'Archéologie de Die et du Diois. http://www.france-voyage.com/communes/die-7328/musee-histoire-archeologie-die-5211.htm.

Enserune

 3.85. Musée National. http://enserune.monuments-nationaux.fr/en/.

Faverges

 3.86. Musée Archéologique de Viuz-Faverges. http://viuz.sav.org/.

Fréjus

 3.87. Musée Archéologique Municipal de Fréjus. http://www.frejus.fr/Musee_Archeologique__155.html.

Gareoult

 3.88. Nécropole de Louis Cauvin. Exhibit of Gallo-Roman sculpture and funerary objects. http://www.la-provence-verte.net/decouvrir/patrimoine-necropole-louis-cauvin_438.html.

Laon

 3.89. Musée de Laon. Important collection of Egyptian and Cypriot objects. http://perso.wanadoo.fr/jpjcg/musee/muse_acc.html.

Lillebonne

 3.90. Ancienne Mairie-Musée Annexe.

 3.91. Muséosite de l'Amphithéatre Gallo-Romaine.

Limoges and Vannes

 3.92. Musée Adrien Dubouché et Musée de la Société Polymathique.

 3.93. Musée Adrien Dubouché de Limoges. http://www.musee-adriendubouche.fr/documents/E2M_dossier_icono.pdf.

 3.94. Musée Municipal de l'Èvechè.

 3.95. Musée de la Société Polymathique de Vannes. http://perso.wanadoo.fr/clp.vannes/LeHezo.html.

 3.96. Mouret Collection, Fouilles d'Ensérune.

Lyon

 3.97. Musée Gallo-Romain de Lyon-Fourvière. http://www.gralon.net/tourisme/musee-musee-gallo-romain-de-lyon-fourviere-366.htm.

Mandeure

 3.98. Exposition Archéologique Gallo-Romaine.

Marseille

 3.99. Marseille History Museum (Musée d'Histoire de Marseille) is the local historical and archaeological museum of Marseille in France. It was opened in 1983, the first town historical museum in France to display the major archaeological finds discovered when the site was excavated in 1967 for commercial redevelopment and the construction of the Centre de la Bourse shopping center. The museum building, which is entered from within the center, opens onto the "jardin des vestiges," a garden containing the stabilized archaeological remains of classical ramparts, port buildings, a necropolis, and so on. http://www.marseille.fr/siteculture/les-lieux-culturels/musees/le-musee-dhistoire-de-marseille/informations-pratiques.

 3.100. Musée des Docks Romains. http://www.marseille.fr/siteculture/jsp/site/Portal.jsp?page_id=56.

Mazamet

 3.101. Musée Mémoires de la Terre et Horizons Cathares.

Nantes

3.102. Musée Dobrée. http://www.discoverfrance.net/France/Museums/Dobree.shtml.

Narbonne

3.103. Musée Horreum Romain. http://www.aude-cathare.fr/musee/musee_horreum_narbonne.htm.
3.104. Musée Lapidaire. http://www.amisdesmusees-narbonne.org/musees/lapidaire.html.

Nice

3.105. Musée et Site Archéologiques de Nice-Cimiez. http://www.culture.gouv.fr/culture/archeosm/archeosom/en/nice-mus.htm.

Paris

3.106. Bibliothèque Nationale, Cabinet des Médailles. http://www.bnf.fr/PAGES/collections/coll_mma.htm.
3.107. Musée de Bible et Terre Sainte. http://www.123musees.fr/Musee-Bible-et-Terre-Sainte-de-Paris.
3.108. Louvre Museum. Established in 1793 by the French Republic, this is one of the earliest European museums. Divided into seven departments, its collections incorporate works dating from the birth of the great antique civilizations right up to the first half of the nineteenth century. There is access to ATLAS, a database of works on display at the Louvre. This site allows visitors to search the Louvre collection, read basic information that accompanies the work in the museum as well as expert commentary on the work, and create a personalized album. info@louvre.fr. www.louvre.fr/llv/commun/home.jsp?bmLocale=en; http://cartelen.louvre.fr/cartelen/visite?srv=crt_frm_rsand langue=frandinitCritere=true.
3.109. Musée du Louvre. http://www.louvre.fr/.
3.110. Musée du Louvre: Antiquités égyptiennes. http://www.louvre.fr/departments/antiquit%C3%A9s-%C3%A9gyptiennes.
3.111. Musée du Louvre: Antquités grecques, étrusques et romaines. http://www.louvre.fr/departments/antiquit%C3%A9s-grecques-%C3%A9trusques-et-romaines.
3.112. Musée National Rodin. http://www.musee-rodin.fr/.
3.113. Musée du Quai Branly. The Musée du Quai Branly, known in English as the Quai Branly Museum, nicknamed MQB, is a museum in Paris, France, that features indigenous art, cultures, and civilizations from Africa, Asia, Oceania, and the Americas. The museum is located at 37, quai Branly—portail Debilly, 75007 Paris, France, situated close to the Eiffel Tower. It is named after its location (not after the physicist Édouard Branly).
3.114. Palais des Beaux—Arts (Petit Palais), Collection Dutuit. http://www.paris.org/Musees/Palais/info.html.

Petit-Bersac

3.115. Musée Gallo-Romain. http://www.valdedronne.com/Musee-Gallo-romain.html.

Rennes

3.116. Musée des Beaux—Arts et d'Archéologie. http://www.discoverfrance.net/France/DF_museums.shtml.

Rom

3.117. Musée Archéologique de Rom-Sainte-Soline.
3.118. Musée de Rauranum. http://blogs.paysmellois.org/rauranum/.

Saint-Martin-de-Bromes

3.119. Musée Archéologique. http://www.alpes-haute-provence.com/content/musee-gallo-romain.

Saint-Pulien

3.120. Musée Archéologique. http://saint-paulien.fr/patrimoine/musee-gallo-romain/.

Saint-Rémy de Provence

3.121. Glanum. http://glanum.monuments-nationaux.fr/fr/.

Saint-Romain-en-Gal

3.122. Musée et Site Archéologiques de Saint-Romain-en-Gal-Vienne. http://www.rhonetourisme.com/fr/Culture-histoire/Musees/Musee-et-site-gallo-romain-de-Saint-Romain-en-Gal-Vienne.

Sallèles-d'Aude

3.123. Musée Amphoralis. http://tourisme-corbieres-minervois.com/sites_remarquables/Amphoralis.php.

Sanxay

3.124. Site Gallo-Romaine de Sanxay. http://sanxay. monuments-nationaux.fr/.

Seltz

3.125. Musée Celte-Gallo Romain.

Sèvres

3.126. Musée National de Ceramique de Sevres. http:// www.stay.com/paris/museum/10899/musee-na-tional-de-ceramique-de-sevres/.

Soulosse-sous-Saint-Élophe

3.127. Musée Archéologique. http://www.lor-raineaucoeur.com/modules/compte/item. php?itemid=3771.

Tours and Bourges

3.128. Musée des Beaux—Arts à Tours, Musée du Berry à Bourges. http://www.discoverfrance. net/France/Museums/Beaux-Arts-Tours.shtml France.

Vaison-la-Romaine

3.129. Musée Archéologique Théo Desplains. http:// www.vaison-la-romaine.com/spip.php?rubrique =32.

Villeneuve d'Ascq

3.130 Musée d'Egyptologie.

GEORGIA

Armazi

3.131. Armazi is a locale in Georgia, two kilometers northwest of Mtskheta and twenty-two kilome-ters north of Tbilisi. A part of historical Greater Mtskheta, it is a place where the ancient city of the same name and the original capital of the early Georgian kingdom of Kartli or Iberia was located. It particularly flourished in the early centuries of the Anno Domini and was destroyed by the Arab invasion in the 730s. The area is now a state-protected field museum administered as a part of the National Archaeology Museum-Reserve of Greater Mtskheta.

Kaspi

3.132. Kaspi Local Museum. The museum houses an archaeological collection of materials ex-cavated at Kaspi, Rene, Metekhi, and Teza, dating to the Early and Middle Bronze Age, III-I Millennium, Late Bronze Age earthenware, XIV-XII BCE. http://www.georgianmuseums. ge/?lang=eng&id=1_1&sec_id=8&th_id=206.

Tbilisi

3.133. Archaeological Museum. http://tbilisiguide.ge/ w/c_info.php?id=189.

3.134. Simon Janashia Museum. Simon Janashia Mu-seum of Georgia, formerly known as the State Museum of History of Georgia, is one of the main history museums in Tbilisi, Georgia, which displays the country's principal archaeo-logical findings. http://www.georgianmuseums. ge/?lang=eng&id=1_1&sec_id=1&th_id=19.

GERMANY

Adolphseck

3.135. Schloss Fasanerie. http://www.schloss-fasanerie. de/.

Altenberg

3.136. Staatliches Lindenau Museum. http://www.phil. uni-erlangen.de/~p1altar/ausstellung_html/linde-nau/lindenau_1.html.

Bergheim

3.137. Archäologisches Museum.

Freiburg im Breisgau

3.138. Archäologische Sammlung der Universität.

Berlin

3.139. Antikensammlung (Pergamonmuseum). http:// www.smb.spk-berlin.de/ant/e/s.html.

3.140. Antiquarium. http://www.smb.spk-berlin.de/ smb/de/sammlungen/details.php?objectId=3.

3.141. Ägyptisches Museum und Papyrussammlung. The Egyptian Museum in Berlin owns one of the world's most important collections on An-cient Egypt. The works of art from the time of King Akhenaton (around 1340 BCE) from Tell

el Amarna are of international renown. www.egyptian-museum-berlin.com.

3.142. Vorderasiatische Museum.

Bonn

3.143. Akademisches Kunstmuseum. http://www.antikensammlung.uni-bonn.de/museum.htm.

Braunschweig

3.144. Herzog Anton Ulrich Museum. http://www.museum-braunschweig.de/.

Burgheim

3.145. Archäologisches Museum.

Erlangen

3.146. Antikensammlung der Friedrich—Alexander Universität. http://www.phil.uni-erlangen.de/~p1altar/aeriahome.html.

Frankfurt am Main

3.147. Universität und Liebieghaus. http://www.uni-frankfurt.de/Germany.

Freiburg im Breisgau

3.148. Archäologische Sammlung der Universität.

Giessen

3.149. Antikensammlung der Universität.

Gotha

3.150. Schlossmuseum. http://www.gotha.de/gotha_schloss.htm.

Göttingen

3.151. Archäologisches Institut der Universität. http://wwwuser.gwdg.de/~archaeo/.

Hamburg

3.152. Afghan Museum. The Afghan Museum is a museum in Hamburg, Germany, storing Afghan history. It is a private museum founded by Afghani Nek Mohammed and was opened in 1998. The museum is located in a century-old warehouse in "Speicher-stadt." http://www.greatarchaeology.com/museum_details.php?museum=Afghan_Museum.

3.153. Museum für Kunst und Gewerbe. http://www.mkg-hamburg.de/.

Hamm, Westfalen

3.154. Gustav-Lübcke Museum. http://www.hamm.de/gustav-luebcke-museum.

Hannover

3.155. Museum August Kestner. http://www.alfeld.de/wrisbergholzen/kestner-museum-e.htm.

Heidelberg

3.156. Antikenmuseum und Abgussammlung des Instituts für Klassische Archäologie Universität Heidelberg. http://www.urz.uni-heidelberg.de/.

3.157. Sammlung des Seminars für Ägyptologie. http://www.universitaetssammlungen.de/sammlung/248.

Hildesheim

3.158. Roemer- und Pelizaeus Museum. http://www.rpmuseum.de/.

Jena

3.159. Hilprecht-Sammlung Vorderasiatischer Altertümer der Friedrich-Schiller-Universität Jena. http://www.uni-jena.de/hilprechtsammlung-path-1,20,87,787,817,951.html.

Karlsruhe

3.160. Badisches Landesmuseum. http://www.landesmuseum.de/.

Kassel

3.161. Antikenabteilung der Staatlichen Kunstsammlungen.

Kelheim

3.162. Archäologisches Museum. http://web2.cylex.de/firma-home/archaeologisches-museum-1224103.html.

Kellmünz an der Liler

3.163. Archäologischer Park mit Museums-Turm.

Kempten

3.164. Archäologischer Park Cambodunum. http://www.apc-kempten.de/.

Kiel

3.165. Kunsthalle, Antikensammlung. http://www.uni-kiel.de/klassarch/antisa.htm.

Köln

3.166. Roman-Germanic Museum. The Roman-Germanic Museum is an important archaeological museum in Cologne, Germany. It has a large collection of Roman artifacts from the Roman settlement on which modern Cologne is built. Of particular interest is the large Dionysus Mosaic. Most of the museum's collection was formerly housed at the Wallraf-Richartz Museum in Cologne until 1946. In the front of the museum the former town gate of Cologne with the inscription CCAA (for Colonia Claudia Ara Agrippinensium) is shown. http://www.museenkoeln.de/roemisch-germanisches-museum/.

Krefeld

3.167. Kaiser Wilhelm Museum. http://www.artofmonet.com/Galleries/Galleries_Kaiser_Wilhelm_Museum_Krefeld.htm.

Leipzig

3.168. Antikenmuseum der Karl-Marx-Universität.
3.169. Archäologisches Institut der Karl-Marx-Universität.
3.170. Ägyptisches Museum der Universität Leipzig-Interim.

Mainz

3.171. Römisch-Germanisches Zentralmuseum. http://www.mainz.de/kultur/museen/kul009.htm/.
3.172. Universität. http://www.uni-mainz.de.

Mannheim

3.173. Reiss Museum. http://www.mannheim.de/museen-archiv/reiss-engelhorn-museen/index.de.htm.

München

3.174. Archäologische Staatssammlung München. http://www.archaeologie-bayern.de/.
3.175. Museum Antiker Kleinkunst.
3.176. Staatliches Museum Ägyptisher Kunst.

Nassenfels

3.177. Archäologische Ausstellung der Universität. http://www.pointoo.de/poi/Nassenfels/Archaeologische-Ausstellung-2177989.html.

Neuss

3.178 Clemens Sels Museum. http://www.clemens-sels-museum.de/.

Nordrhein-Westfalen

3.179. Düsseldorf, Hetjens Museum. http://www.duesseldorf.de/hetjens/.

Nuremberg

3.180. Germanisches Nationalmuseum. The Germanisches Nationalmuseum, founded in Nuremberg, Germany, in 1852, houses a significant collection of items relating to German culture and art extending from prehistoric times through to the present day. With current overall holdings of about 1.2 million objects, the Germanisches Nationalmuseum is Germany's largest museum of cultural history. http://www.gnm.de/index.php?id=384.

Perl

3.181. Archäologische Ausgrabung Borg. http://www.pointoo.de/poi/Perl/Roemische-Villa-Borg-Archaeologische-Ausgrabung-196051.html.

Schwerin

3.182. Staatliches Museum. http://www.museum-schwerin.de.

Seefeld

3.183. Museum Schloss Seefeld. http://www.aegyptisches-museum-muenchen.de/index.php?id=368.

Stuttgart

3.184. Württembergisches Landesmuseum. http://www.stuttgart.de/englisch/culture/museum/landesmuseum.html.

Tübingen

3.185. Ägyptische Sammlung der Universität/Museum Schloss Hohentübingen.

3.186. Antikensammlung des Archäologischen Instituts der Universität. http://www.universitaetssammlungen.de/sammlung/163.

Würzburg

3.187. Martin von Wagner Museum. http://www.uni-wuerzburg.de/museum/.

GREECE

Abdera

3.188. Abdera Archaeological Museum. Abdera Archaeological Museum is a museum in Abdera, Greece. The museum houses archaeological artifacts found in the city, which date from around the seventh century BCE to the thirteenth century CE. The museum was established in January 2000, and the building was designed by the architects Y. Polychroniou and N. Filippidis of the Directorate of Museum Studies of the Hellenic Ministry of Culture. http://www.greatarchaeology.com/museum_details.php?museum=Abdera_Archaeological_Museum.

Aegina

3.189. Aegina Archaeological Museum. Aegina Archaeological Museum is a museum in Aegina, Greece. Founded in 1828 by Ioannis Kapodistrias, the museum contains a variety of ancient vessels, pottery, ceramics, alabasters, statuettes, inscriptions, coins, weapons, and copper vessels. These objects are located in three rooms in which are all the exhibits. http://www.greatarchaeology.com/museum_details.php?museum=Aegina_Archaeological_Museum.

Agios Nikolaos

3.190. Agios Nicholaos Archaeological Museum. http://www.agiosnikolaos.com/museums.php.

Agrinion

3.191. Archaeological Museum. http://greecemuseums.com/archaeological-museum-of-agrinion/.

Aiani

3.192. Archaeological Museum. http://www.macedonian-heritage.gr/Museums/Archaeological_and_Byzantine/Arx_Aiani.html.

Amorgos

3.193. Archaeological Collection.

Andros

3.194. Archaeological Collection.

Archaia Nemea

3.195. Archaeological Museum.

Argos

3.196. Archaeological Museum.

Argostolion

3.197. Archaeological Museum.

Arhala Olympia

3.198. Archaeological Museum.

Asklepieion Lygourio

3.199. Archaeological Museum.

Asciano

3.200. Museo Etrusco.

Astypalaia

3.201. Archaeological Museum.

Atalanti

3.202. Archaeological Museum.

Athens

3.203. Acropolis Museum (Mouseio Akropoleos). The Acropolis Museum is an archaeological museum located in Athens, Greece, on the archeological site of Acropolis. It is considered one of the major archaeological museums in Athens and ranks among the most important museums of the world. Due to its limited size, the Greek government decided in the late 1980s to build a new museum.

http://www.greatarchaeology.com/museum_details.php?museum=Acropolis_Museum.

3.204. Ancient Agora Museum.

3.205. Athens Numismatic Museum. The Athens Numismatic Museum is one of very few of its kind in the world and the only one in Greece and the Balkans. It has around 600,000 coins, which range chronologically from Greek antiquity through the Roman and Byzantine periods and the Middle Ages in Western Europe into Modern times. The collection also includes ancient coin hoards, excavation records, lead sealings, medallions, and precious stones, either donated or bought by the museum itself. http://www.greatarchaeology.com/museum_details.php?museum=Athens_Numismatic_Museum.

3.206. Byzantine and Christian Museum. http://www.byzantinemuseum.gr/en/.

3.207. Epigraphical Museum (Athens). http://www.athensguide.org/athens-museums.html.

3.208. Goulandris Museum. The Goulandris Museum of Cycladic Art is one of the great museums of Athens. It houses a magnificent collection of artifacts of Cycladic art. An example of the collection: Cycladic female figurine, Canonical type, early work of the Spedos variety. The museum was founded in 1986 to house the collection of Cycladic and Ancient Greek art belonging to Nicholas and Dolly Goulandris. Starting in the early 1960s, the couple collected Greek antiquities, with special interest in the prehistoric art from the Cyclades islands of the Aegean Sea. http://www.cycladic.gr/frontoffice/portal.asp?cpage=NODE&cnode=2&clang=1.

3.209. Herakleidon Museum. The Herakleidon Museum, under the patronage of the German ambassador Dr. Wolfgang Schultheiss and in cooperation with the Goethe Institute, the Hellenic Speleological Society, and the German Archaelogical Institute. http://www.herakleidon-art.gr/index.cfm.

3.210. Mouseio Ethnikon Archaiologikon.

3.211. Mouseio Kerameikos.

3.212. Mouseio Mpenaki.

3.213. Musée National. http://www.namuseum.gr/wellcome-en.html.

3.214. Museum of Byzantine Culture. The Museum of Byzantine Culture aims to present various aspects of life during the Byzantine and post-Byzantine periods: art, ideology, social structure, and religion, as well as how historical changes and the political situation were affecting people's everyday life. http://mbp.gr/html/en/.

3.215. National Archaeological Museum, Athens. This is the most important archaeological museum in Greece and one of the richest in the world concerning ancient Greek art. Its collections are representative of all the cultures that flourished in this ancient land. http://www.culture.gr/h/1/eh151.jsp?obj_id=3249; http://www.athensguide.org/athens-museums.html.

3.216. New Acropolis Museum. The New Acropolis Museum is a purpose-built museum built by architect Bernard Tschumi to house the archaeological findings related to the Acropolis Hill in Athens (Greece). It is located near the Acropolis. http://www.athensguide.org/acropolis-museum.html.

3.217. Numismatic Museum of Athens. The Numismatic Museum of Athens is a museum in Athens. It is housed in a neoclassic building, the Iliou Melathron ("Palace of Ilium"), which used to be the residence of the renowned archaeologist Heinrich Schliemann. The main exhibitions of the museum on the first floor narrate the history of coinage: the construction, dissemination, usage, and the different iconography of coins in the Ancient Greek world. On the second floor are exhibitions of the Hellenistic, Roman, Byzantine, Medieval, and modern eras. http://www.athensguide.org/athens-museums.html.

3.218. P. and A. Canellopoulos Museum.

3.219. Pierides Archaeological Museum of Tripolis.

3.220. Tactual Museum of Athens. The Tactual Museum of Athens was founded in Athens in 1984 so that visually impaired people may become familiarized with the cultural heritage of Greece. The museum's exhibits are copies of original artifacts of the Mycenaean, Geometric, Archaic, Austere, Classical, Hellenistic, and Roman periods. There are also exhibits from the Byzantine era and works of art from visually impaired people. This initiative began from the association Faros of Visually Impaired people of Greece in Doiranis Street in Kalithea, Athens. The museum is open daily from 9:00 am to 2:00 pm and on weekends after making the necessary arrangements with the museum's management. http://www.tactualmuseum.gr/.

Chaironeia

3.221. Archaeological Museum.

Chalkida

3.222. Archaeological Museum.

Chania

3.223. Archaeological Museum.

3.224. Chania Byzantine and Postbyzantine Collection.

Chios

 3.225. Archaeological Museum.
 3.226. Chios Museum Byzantine and Postbyzantine Art.

Chora

 3.227. Archaeological Museum.

Corfu

 3.228. Archaeological Museum.
 3.229. Byzantine Museum of Antivouniotissa. http://www.antivouniotissamuseum.gr/index.php/en.

Corinth

 3.230. Archaeological Museum. http://www.ancientcorinth.net/museum.aspx.

Delphi

 3.231. Archaeological Museum of Delphi.

Dion

 3.232. Dion Archaeological Museum.

Drama

 3.233. Drama Archaeological Museum.

Elefsina

 3.234. Archaeological Museum.

Eressos

 3.235. Archaeological Museum.

Eretria

 3.236. Archaeological Museum.

Ermoupolis

 3.237. Archaeological Museum.

Farsala

 3.238. Archaeological Collection.

Florina

 3.239. Archaeological and Byzantine Museum Florina.

Galaxidi

 3.240. Archaeological Museum.

Geraki

 3.241. Archaeological Museum.

Gythio

 3.242. Archaeological Museum.

Ioannina

 3.243. Archaeological Museum. http://www.amio.gr/.
 3.244. Ionnina Byzantine Museum.

Iraklion

 3.245. Archaeological Museum. http://www.dilos.com/location/11159.

Isthmia

 3.246. Archaeological Museum.

Kalamos

 3.247. Amfiaraion Archaeological Museum.

Kalymnos

 3.248. Museum of Kalymnos.

Kampos

 3.249. Archaeological Museum.

Karystos

 3.250. Archaeological Museum.

Kastellorizo

 3.251. Megisti Museum.

Kastoria

 3.252. Kastoria Folklore Museum.
 3.253. Kastoria Byzantine Museum.

Kastro

 3.254. Archaeological Museum.

Kavala

3.255. Archaeological Museum.

Kea

3.256. Archaeological Museum.

Kiato

3.257. Kiato Archaeological Museum.

Kilkis

3.258. Archaeological Museum.

Kimolos

3.259. Archaeological Museum.

Komotini

3.260. Archaeological Museum.

Kórinthias

3.261. Archaeological Museum.

Kos

3.262. Archaeological Museum.

Kozani

3.263. Archaeological Collection.

Kythiira

3.264. Collection of Byzantine and Postbyzantine Art.

Lamia

3.265. Archaeological Museum.

Lárissa

3.266. Archaeological Museum.

Limenaria

3.267. Archaeological Museum Papageorgiou.

Lindos

3.268. Archaeological Museum.

Loutra Aidipsou

3.269. Archaeological Collection.

Marathon

3.270. Marathon Museum. http://gogreece.about.com/od/museumsingree2/a/marathonmus_2.htm.

Megalopolis

3.271. Archaeological Museum.

Megara

3.272. Archaeological Museum.

Milos

3.273. Milos Archaeological Museum. As we enter the main exhibition hall of the Archaeological Museum, the striking statue of the Venus de Milo meets our gaze. Unfortunately it is only a copy—although a very fine one—produced by the Louvre Museum workshop. Among the more important exhibits in the same room is a sixth-century BCE funeral urn with a chariot race represented in relief pattern, a robed third-century BCE statue, a lion decoration used as a table support, and a female bust.

Molyvos

3.274. Archaeological Collection.

Monemvasia

3.275. Monemvasia Archaeological Collection.

Mykonos

3.276. Aegean Maritime Museum. Aegean Maritime Museum is a maritime museum in Mykonos, Greece. The founder and chairman of the museum, George M. Drakopoulos, received the Athens Academy Award and the World Ship Trust's Award for Individual Achievement for the foundation of the museum. http://www.greatarchaeology.com/museum_details.php?museum=Aegean_Maritime_Museum.

3.277. Mykonos Archaeological Museum. The Archaeological Museum of Mykonos Greece. Located near the quay, this museum was built in 1902 to house archaeological finds excavated in 1898 from the "Purification Pit" made by Athens.

Myrina

3.278. Archaeological Museum.

Mytilini

3.279. New Archaeological Museum.

Mystras

3.280. Museum Mistra.

Néa Anchialos

3.281. Archaeological Museum.

Olympia

3.282. Archaeological Museum of Olympia. http://www.olympia-greece.org/museum.html.

Ouranoupoli

3.283. Tower Museum of Prosphorion.

Paleopoli

3.284. Archaeological Museum.

Paramythia

3.285. Archaeological Museum.

Paros

3.286. Archaeological Museum.

Patras

3.287. Archaeological Museum.

Pella

3.288. Archaeological Museum.

Perachora

3.289. Archaeological Museum.

Piraeus

3.290. Archaeological Museum.

Platanos

3.291. Archaeological Collection Panagia Kastrou.

Polygyros

3.292. Archaeological Museum.

Pylos

3.293. Antonopouleion Archaeological Museum.

Pythagorion

3.294. Archaeological Collection.

Poros

3.295. Archaeological Museum.

Rethymon

3.296. Archaeological Museum.

Rhodes

3.297. Archaeological Museum.

Samos

3.298. Archaeological Museum.

Serres

3.299. Archaeological Museum.

Sicyon

3.300. Archaeological Museum.

Sikinos

3.301. Sikinos Archaeological Collection.

Siteia

3.302. Archaeological Museum.

Sparti

3.303. Archaeological Museum.

Spetses

3.304. Spetses Archaeological Museum.

Stavros Ithakis

3.305. Archaeological Museum.

Thassos

3.306. Archaeological Museum.

Thebes

3.307. Archaeological Museum. http://www.travelinfo. gr/viotia/museum.htm.

Thera

3.308. Archaeological Museum.

Thermo

3.309. Archaeological Museum.

Thessaloniki

3.310. Archaeological Museum. http://www.greeka.com/ macedonia/thessaloniki/thessaloniki-museums/archaeological-museum.htm; http://www.amth.gr/.

3.311. Museum of Casts and Archaeological Collection.

Tinos

3.312. Archaeological Museum.

Veria

3.313. Archaeological Museum.
3.314. Veria Byzantine Museum.

Vitsa

3.315. Archaeological Museum.

Volos

3.316. Athanassakeion Archaeological Museum.

Vravrón

3.317. Archaeological Museum.

Zakynthos

3.318. Mouseio Zakynthou.

HUNGARY

Budapest

3.319. Aquincumi Múzeum.
3.320. Fürdö Múzeum.

3.321. Herkules Villa.
3.322. Musée des Beaux Arts. http://www.members.aol. com/JWFvase2/page/listcoll.htm
3.323. Táborvárosi Múzeum.

Fertörákos

3.324. Mithrász-Szentély.

Pécs

3.325. Régészeti Osztályés Állandó Régészeti Kiállitás.
3.326. Román Kori Kötar.

Tac

3.327. Gorsium Szabadtéri Meum.

Tata

3.328. Görög-Római Szobormásolatok Kiállitása.

Zalalövo

3.329. Villa Publica Romkert.

IRAN

Gorgan

3.330. Gorgan Museum. http://www.caroun.com/Museums/IranMuseum/IranMRegion2/GorganMuseum.htm.

Shiraz

3.331. Hakhamaneshi Museum.
3.332. Takht-e-Jamshid (Persepolis). http://whc.unesco. org/en/list/114.

Tabriz

3.333. Azarbayezan (Azerbaijan State) Museum. The Azerbaijan Museum is the major archaeology museum in the northwestern part of Iran, near Khaqani Park and Tabriz Blue mosque. It is located in Tabriz and contains objects obtained from excavations in Iranian Azerbaijan. There is also a place for recent sculptural works of artists. http://www.bakupages.com/pages/museums/museum-of-art_en.php.

Tehran

3.334. G.S.I Museum. The G.S.I Museum contains samples of rocks, minerals, fossils, and ancient

mining tools from different parts of Iran and other countries. Nearly 400 rock samples, 1,300 mineral samples, more than 1,200 fossils, and sixty-five ancient mining tools discovered from Persian mines with archaeological objects have been preserved in the museum. http://www.gsi. ir/General/Lang_en/Page_50/Museum.html.

3.335. Golestan Palace. The oldest of the historic monuments in Tehran, the Golestan Palace (Palace of Flowers) belongs to a group of royal buildings that were once enclosed within the mud-thatched walls of Tehran's Historic Arg (citadel).

3.336. National Museum of Iran. The National Museum of Iran is an archeological and historical museum located in Tehran. It preserves ancient Persian antiquities, including pottery vessels, metal objects, books, coins, etc. It was inaugurated in 1937. The museum consists of two buildings. Building 1 is dedicated to the pre-Islamic collection, while Building 2 has post-Islamic artifacts. http://www.nationalmuseumofiran.ir/.

3.337. Reza Abbasi Museum. http://www.rezaabbasimuseum.ir/.

Uroomieh

3.338. Uroomieh Museum.

IRAQ

Assur

3.339. Assur Museum. http://www.akkadica.org/musdir/iraq.htm.

Babylon

3.340. Babylon Museum. http://www.akkadica.org/musdir/iraq.htm.

Baghdad

3.341. Iraqi Museum. The national museum of Iraq contains priceless relics from Mesopotamian civilization, some of which were looted in 2003 during the Iraq War. http://www.akkadica.org/musdir/iraq.htm.

Basrah

3.342. Basrah Museum. http://www.friendsofbasrahmuseum.org.uk/.

Diwania

3.343. Diwania (Al-Qadissiyah) Museum. http://www.akkadica.org/musdir/iraq.htm.

Dohuk

3.344. Dohuk Museum. http://www.akkadica.org/musdir/iraq.htm.

Falouja

3.345. Falouja (Al-Anbar) Museum. http://www.akkadica.org/musdir/iraq.htm.

Kirkuk

3.346. Kirkuk Museum. http://www.akkadica.org/musdir/iraq.htm.

Kufa

3.347. Kufa Museum. http://www.akkadica.org/musdir/iraq.htm.

Kut Al-Amara

3.348. Kut (Wassit) Museum. http://www.akkadica.org/musdir/iraq.htm.

Misan

3.349. Al-Ammara (Misan) Museum. http://www.akkadica.org/musdir/iraq.htm.

Mosul

3.350. Mosul Museum. http://www.akkadica.org/musdir/iraq.htm.

Nasiriya

3.351. Nasiriya Museum. http://www.akkadica.org/musdir/iraq.htm.

Nimrud

3.352. Archaeological Site Nimrud (Calah). http://www.akkadica.org/musdir/iraq.htm.

Nineveh

3.353. Al Mawsil Museum. http://www.akkadica.org/musdir/iraq.htm.

3.354. Nergal Gate Museum. http://www.akkadica.org/musdir/iraq.htm.

Samarra

3.355. Samarra Museum. http://www.akkadica.org/musdir/iraq.htm.

Sinjar

3.356 Sinjar Museum. http://www.akkadica.org/musdir/iraq.htm.

Sulaimaniyah

3.357. Sulaimaniya Museum. http://www.akkadica.org/musdir/iraq.htm.

IRELAND

Dublin

3.358. University College Dublin Classical Museum. http://www.ucd.ie/classics/classicalmuseum/.

ISRAEL

Akko

3.359. Akko Municipal Museum. http://www.planetware.com/tourist-attractions-/acre-isr-nr-ak.htm.

Arad

3.360. Arad Museum. http://www.museumarad.ro/eng/pages/ex_arh.htm.

Ashkelon

3.361. Ashkelon Khan and Museum. http://www.israel-traveler.org/en/site/haan-museum-ashkelon.

Be'eri

3.362. Ne'eri Archaeological Collection.

Beit Shearim

3.363. Ancient Synagogue and Necropolis Museum.

Galilee

3.364. Archaeological Museum of Hatzor. http://www.ilmuseums.com/museum_eng.asp?id=114.

3.365. Museum of Prehistory. http://www.ilmuseums.com/museum_eng.asp?id=98.

3.366. Museum of Regional and Mediterranean Archaeology. http://www.ilmuseums.com/museum_eng.asp?id=152.

3.367. Museum of Yarmukian Culture. http://www.ilmuseums.com/museum_eng.asp?id=120.

Haifa

3.368. Haifa Museum. The Haifa Museum, established in 1949, houses the Museum of Ancient Art, which specializes in archeological finds discovered in Israel and the Mediterranean basin, and the Museum of Modern Art. Also under the museum's aegis are the Museum of Prehistory, the Israeli National Maritime Museum, and the Tikotin Museum of Japanese Art. http://hma.org.il/Museum/index.asp.

3.369 Reuben and Edith Hecht Museum. The Reuben and Edith Hecht Museum at the University of Haifa was inaugurated in 1984. It was the initiative of the late Dr. Reuben Hecht, founder of the Dagon Silos in the port of Haifa and a founding member of the University of Haifa Board of Governors. http://mushecht.haifa.ac.il/Default_eng.aspx.

3.370 Shtekelis Prehistory Museum. http://www.israeltraveler.org/en/site/museum-of-prehistory-in-the-name-stekelis.

Hof Dor

3.371. Hamizgaga (Nahsholim) Museum. http://www.antiquities.org.il/article_Item_eng.asp?sec_id=5&subj_id=83.

Jerusalem

3.372. Bible Lands Museum. The Bible Lands Museum Jerusalem illustrates the cultures of peoples mentioned in the Bible, such as the Philistines, Arameans, Hittites, Elamites, Phoenicians, and Persians. It is a historical and archaeological museum, not a museum of religion. The museum aims to put the lands in which the Bible originated into historical context. http://www.israeltraveler.org/en/site/jaffa-antiquities-museum.

3.373. Burnt (Katres) House. http://www.ilmuseums.com/museum_eng.asp?id=108.

3.374. Herbert E. Clark Collection of Near Eastern Antiquities. http://mushecht.haifa.ac.il/Default_eng.aspx.

3.375. City of David. http://www.ilmuseums.com/museum_eng.asp?id=233.

3.376. Davidson Excavation and Virtual Reconstruction Center. http://www.ilmuseums.com/museum_eng.asp?id=177.

3.377. L.A. Mayer Institute for Islamic Art. The L.A. Mayer Institute for Islamic Art was established by the late Mrs. Vera Bryce Salomons in 1974 and is situated near the president's residence and the Jerusalem Theater. The museum is situated in Jerusalem and exhibits pottery, textiles, jewelry, ceremonial objects, and the like, covering a thousand years of Islamic art, from Spain to India. http://www.islamicart.co.il/en/.

3.378. Pères Blancs-Saint Anne. http://peres-blancs.cef.fr/ste_anne_de_jerusalem.htm.

3.379. Pontifical Biblical Institute Museum.

3.380. Rockefeller Archaeological Museum. The Rockefeller Museum, formerly the Palestine Archaeological Museum, is an archaeological museum located in East Jerusalem that houses a large collection of artifacts unearthed in the excavations conducted in Palestine beginning in the late nineteenth century. The museum building is also the head office of the Israel Antiquities Authority. http://www.israeltraveler.org/en/site/rockefeller-museum.

3.381. Saint James Museum and Library.

3.382. Shrine of the Book. The Shrine of the Book, a wing of the Israel Museum near Givat Ram in western Jerusalem, houses the Dead Sea Scrolls, discovered 1947–1956 in eleven caves in and around the Wadi Qumran. (The shrine was initially to be built, but was not, on the Givat Ram campus of the Hebrew University, adjoining the National Library.) http://www.english.imjnet.org.il/htmls/page_899.aspx?c0=14389&bsp=14162.

3.383. Siebenberh House. http://www.ilmuseums.com/museum_eng.asp?id=22.

3.384. Tower of David Museum. Set in the magnificently restored ancient Citadel, first constructed 2,000 years ago by Herod the Great, the Tower of David Museum traces Jerusalem's long and eventful history through state-of-the-art displays and exhibits utilizing the most advanced technologies. http://www.towerofdavid.org.il/English/The_Museum/About_the_Museum.

3.385. Western Wall Tunnels. http://www.ilmuseums.com/museum_eng.asp?id=24.

3.386. Wohl Archaeology Museum. http://www.ilmuseums.com/museum_eng.asp?id=18.

3.387. Herodian Mansions Museum. http://israelseen.com/2011/08/29/herodian-mansions-and-the-burnt-house-jerusalem-holiness-of-beauty-or-beauty-of-holiness/.

Katzrin

3.388. Ancient Katzrin Park. http://www.ilmuseums.com/museum_eng.asp?id=90.

Kibbutz Ein Dor

3.389. Archaeological Museum. http://www.ilmuseums.com/museum_eng.asp?id=180.

Kibbutz Hanita

3.390. Hanita Museum. http://ilmuseums.com/museum_eng.asp?id=113.

Kibbutz Maabarot

3.391. Local Museum.

Kibbutz Palmachim

3.392. Beit-Miriam Museum. http://www.betmiriam.co.il/text.asp?pid=7.

Kibbutz Sasa

3.393. Local Museum.

Kibbutz Sdot Yam

3.394. Caesarea Museum. http://www.ilmuseums.com/museum_eng.asp?id=108.

Nazareth

3.395. Terra Sancta Museum.

Nir-David

3.396. Museum of Regional and Mediterranean Archaeology. http://www.israeltraveler.org/en/site/museum-of-regional-and-mediterranean-archaeology.

Qatzrin

3.397. Golan Archaeological Museum. http://www.ilmuseums.com/museum_eng.asp?id=89.

Ramat Aviv

3.398 Eretz Israel Museum. The Eretz Israel Museum was established in 1953 in Ramat Aviv, Israel. The museum displays comprehensive archeological, anthropological, and historical artifacts. The Museum Park comprises many exhibition pavilions within a huge campus. Each pavilion is dedicated to a different subject: glassware, ceramics, coins, copper, and more, as well as a planetarium. http://www.eretzmuseum.org.il/e/.

Tel Aviv

3.399 Archaeological Museum Beit Miriam. http://www.ilmuseums.com/museum_eng.asp?id=80.

3.400. Archaeological Museum of Kfar-Saba. http://www.ilmuseums.com/museum_eng.asp?id=170.

3.401. Israel Museum. The Israel Museum is the largest cultural institution in the State of Israel and is ranked among the leading art and archaeology museums in the world. Founded in 1965, the museum houses encyclopedic collections, including the most extensive holdings of biblical and Holy Land archaeology in the world. In just forty years, the museum has built a far-ranging collection of nearly 500,000 objects, thanks to a legacy of gifts and the support from its circle of patrons worldwide. http://www.english.imjnet.org.il/.

3.402. Jaffa Museum of Antiquities. http://www.israel-traveler.org/en/site/jaffa-antiquities-museum.

3.403. Qedem Museum. http://www.ilmuseums.com/museum_eng.asp?id=154.

3.404. Tell Qasile Archaeological Site. http://www.eretzmuseum.org.il/e/101/.

ITALY

Acqui Terme

3.405 Civico Museo Archeologico.

Adria

3.406. Museo Civico. http://www2.regione.veneto.it/cultura/archeologia/musei-elenco.htm.

3.407. Museo Archeologico Nazionale.

Afria

3.408. Museo Archeologico Nazionale.

Alba

3.409. Civico Museo Archeologico e di Scienze Naturali Federico Eusebio.

Amendolara

3.410. Museo Archeologico Statale V. Laviola.

Aquileia

3.411. Museo Archeologico Nazionale.

Assisi

3.412. Collezione Archeologica e Foro Romano.

Asolo

3.413. Museo Civico.

Asti

3.414. Cripta e Museo di Sant'Anastasio.

3.415. Museo Archeologico e Paleontologico.

Bagnara Calabra

3.416. Museo A. Versace.

Baranello

3.417. Museo Civico.

Bari

3.418. Museo Archeologico Provinciale.

Bedonia

3.419. Museo del Opera Omnia R. Musa e Pinacoteca Parmigiani.

Bernalda

3.420. Museo Archeologico Nazionale di Metaponto.

Bitonto

3.421. Museo Civico Rogadeo.

Bra

3.422. Museo Archeologico e Storico Aristico.

Brescello

3.423. Antiquarium.

Brindisi

3.424. Museo Archeologico Provinciale F. Ribezzo.

Cabras

3.425. Museo Civico.

Cagliari

3.426. Museo Archeologico Nazionale di Cagliari.

Campobasso

3.427. Nuovo Museo Provinciale Sannitico.

Capaccio

3.428. Museo Archeologico Nazionale.

Carmignano

3.429. Museo Archeologico Comunale di Artimino.

Carveteri

3.430. Museo Archeologico Nazionale Etrusco.

Casamari-Veroli

3.431. Museo dell'Abbazia.

Cassano allo Jonio

3.432. Museo Archeologico Nazionale della Sibaritide.

Castiglione a Casauria

3.433. Museo dell'Abbazia.

Catania

3.434. Museo Civico Casteno Ursino.

Catanzaro

3.435. Museo Provinciale.

Cecina e Marina

3.436. Museo Archeologico.

Centuripe

3.437. Museo Civico.

Cesena

3.438. Museo Archeologico.

Cherasco

3.439. Museo Civico G.B. Adriani.

Chieti

3.440. Museo della Civitella.

Chiusi

3.441. Museo Archeologico Nazionale. http://www.mega.it/archeo.toscana/samuchi.htm.

Cingoli

3.442. Museo Archeologico Statale.

Cividate Camuno

3.443. Museo Archeologico di Vallecamonica.

Como

3.444. Civico Museo Archeologico 'Giovio.' http://www.comune.como.it/comohtml/MuseoGiovio/.

Crotone

3.445. Antiquarium di Torre Nao.
3.446. Museo Archeologico Nazionale.

Desenzano del Garda

3.447. Villa Romana a Mosaici.

Ercolano

3.448. Scavi di Ercolano.

Esino Lario

3.449. Museo delle Grigne.

Faenza

3.450. Museo Archeologico.

Falerone

3.451. Museo Antiquarium Archeologico.
3.452. Museo Civico e Teatro e Serbatoio Romano.

Feltre

3.453. Museo Civico.

Ferrera

3.454. Museo Archeologico Nazionale. http://www.museionline.it/ita/cerca/museo.asp?id=2210.
3.455. Museo Lapidario.
3.456. Museo Nazionale. http://www.teknemedia.net/architettura_design/dettaglio_architettura_design.html?newsId=6088.

Fiesole

3.457. Collezione Costantini. http://www.fiesolemusei.it/italiano/areamuseale/antiquarium.asp.

Florence

3.458. R. Museo Archeologico. The National Archaeological Museum of Florence is an archaeological museum in Florence, Italy. It is located at one piazza Santissima Annunziata, in the Palazzo della Crocetta (a palace built in 1620 for princess Maria Maddalena de' Medici, daughter of Ferdinand I de Medici, by Giulio Parigi).

3.459. Stibbert Museum. The Stibbert Museum is located on via Frederick Stibbert on the hill of Montughi in Florence, Italy. The museum contains over 36,000 artifacts, including a vast collection of armor from Eastern and Western civilizations. http://www.museostibbert.it/en.

Foligno

3.460. Museo Archeologico e Pinacoteca Comunale.

Formia

3.461. Museo Archeologico e Antiquarium Nazionale.

Gela

3.462. Museo Archeologico Nazionale (Collezione Navarra). http://www.correrenelverde.it/musei/museisicilia.htm.

Genova

3.463. Museo Civico d'Archeologia Ligure di Genova—Pegli e Collezione del Castello d'Albertis. http://www.archeocarta.com/liguria/files/genova/musei/civico_archeologia.htm.

Gioa del Colle

3.464. Museo Archeologico Nazionale. http://web.tiscali.it/no-redirect-tiscali/logos-wolit/musei/cities/gioia/museoa.htm.

Girifalco

3.465. Museo Tolone Azzariti.

Grosseto

3.466. Museo Archeologico e d'Arte della Maremma. http://www.girando.it/grosseto/museo_archeologico.htm.

Guardiagrele

3.467. Museo Civico.

Isei

3.468. Museo Civico.

Isernia

3.469. Museo nazionale di Santa Maria delle Monanche e Paleolitico.

Laterza

3.470. Museo Didattico Archeologico.

Lecce

3.471. Museo Provinciale. http://atlante.clio.it/grecia/castro mediano.html.

Locri

3.472. Museo Archeologico Nazionale di Locri Epizefiri.

Lucca

3.473. Museo nazionale di Villa Guinigi.

Lugagnano Val d'Arda

3.474. Antiquarium e Zona Archeologica.

Magliano Sabina

3.475. Museo Civico.

Manduria

3.476. Antiquarium.

Marzabotto

3.477. Museo Nazionale Etrusco Pompeo Aria.

Melfi

3.478. Civico Museo Archeologico. http://www.tolentinonline.com/inglese/archeologico/home.html.
3.479. Museo Archeologico Nazionale della Melfese.

Napoli

3.480. Museo Archeologico Nazionale. The Naples National Archaeological Museum is located in Naples, Italy, at the northwest corner of the original Greek wall of the city of Neapolis. The museum contains a large collection of Roman artifacts from Pompeii and Herculaneum. The collection includes works of the highest quality produced in

Greek, Roman, and Renaissance times. http://cir. campania.beniculturali.it/museoarcheologicon-azionale/.

Milano

3.481. Civico Museo Archeologico.

Nocera Inferiore

3.482. Museo Archaeologico dell'Agro Nocerino.

Numana

3.483. Antiquarium.

Orbetello

3.484. Museo Archeologico Nazionale di Cosa.

Orvieto

3.485. Museo Civico (Museo dell'Opera del Duomo). http://www.thais.it/scultura/ormdodd.htm.
3.486. Museo Claudio Faina. http://www.emmeti.it/ Arte/Umbria/ProvTerni/Orvieto/museo_claudio_ faina.uk.html.
3.487. Museo dell'Opera del Duomo. http://www.thais. it/scultura/ormdodd.htm.
3.488. Palazzo Faina.

Ostia Antica

3.489. Museo Ostiense.

Palazzolo Acreide

3.490. Antiquarium.

Palermo

3.491. Banco di Sicilia. http://www.comune.palermo.it/ musei/mormino/.
3.492. Museo Nazionale.
3.493. Museo Archeologico Regionale A. Salinas.

Palestrina

3.494. Museo Archeologico Nazionale di Palestrina.

Palmi

3.495. Antiquarium.

Parma

3.496. Museo Archeologico Nazionale.
3.497. Museo Nazionale di Antichita. http://www. parma.euroweb.it/musei.html.

Patti

3.498. Antiquarium.

Pesaro

3.499. Museo Archeologico Oliveriano.

Piazza Armerina

3.500. Raccolta d'Arte e Archeologia.

Pieve di Cadore

3.501. Museo Paleoveneto.

Policoro

3.502. Museo Nazionale della Siritide.

Pompei

3.503. Scavi di Pompei.

Porto Torres

3.504. Antiquarium.

Potenza

3.505. Museo Archeologico Provinciale.

Quarto d'Altino

3.506. Museo Archeologico Nazionale.

Rhodes

3.507. Museo Archeologico dello Spedale dei Cavalieri di Rodi.

Rivello

3.508. Mostra Permanente di Archeologia.

Rome

3.509. Antiquarium Comunale.
3.510. Museo Capitolini. The Capitoline Museums are a group of art and archeological museums in Piazza del Campidoglio, on top of the famous Capitoline Hill in Rome, Italy. The museums are contained

in three palazzi surrounding a central trapezoidal piazza in a plan conceived by Michelangelo Buonarroti in 1536 and executed over a period of over 400 years. http://www.museicapitolini.org/en/index_msie.htm.

3.511. Museo delle Mura.

3.512. Museo Nazionale Etrusco di Villa Giulia. The National Etruscan Museum is a museum of the Etruscan civilization housed in the Villa Giulia in Rome, Italy. http://www.roma2000.it/zvilagiu.html.

3.513. Museo Nazionale Romano—Terme di Diocleziano.

3.514. Museo Nuovo; Museo del Conservatori.

3.515. Museo Palatino.

3.516. Museo Preistorico L. Pigorini. The Luigi Pigorini National Museum of Prehistory and Ethnography is a public and research museum located in Rome, Italy. Established in 1876, it is currently directed by Maria Antonietta Fugazzola. One important collection the Pigorini houses is Neolithic artifacts from Lake Bracciano. http://www.emmeti.it/Arte/Lazio/ProvRoma/Roma/museo_luigi_pigorini.uk.html.

3.517. Museo Torlonia. The Torlonia Museum was a museum in Rome. It had a collection of 620 marble and alabaster statues and sarcophagi dating to the Roman Empire period. The collection also included a bust of Julius Caesar, sculptures of the gods from Roman mythology, and Roman copies of Greek statues. http://www.welcometuscany.it/museums/florence_area.htm.

3.518. Museum of the Roman Civilization. The Museum of the Roman Civilization is a museum in Rome (Esposizione Universale Roma district), devoted to the aspects of the Ancient Roman civilization. It was designed by the architects Pietro Ascheri, D. Bernardini, and Cesare Pascoletti (1939–1941). Its fifty-nine sections illustrate the history of Roman civilization, from the origins to the fourth century, with models and reproductions, as well as original material. The premises are shared with a planetarium. http://en.museociviltaromana.it/.

3.519. National Museum of Rome. The National Museum of Rome is a set of museums in Rome, Italy, split between various branches across the city. It was founded in 1889 and inaugurated in 1890, during the Risorgimento, with the aim of collecting antiquities from between the fifth century BCE to the third century CE. http://www.roma2000.it/munaro.html.

3.520. Pontifical Museum of Christian Antiquities. The Pontifical Museum of Christian Antiquities is a museum founded by the popes housed in the Lateran Palace, adjacent to the Basilica of St. John Lateran in Rome, Italy. In 1854 Pius IX added the Pio Christian Museum to the Lateran Profane Museum, which is made up of sculptures, especially sarcophagi, and ancient Christian inscriptions, and later added two rooms of artifacts taken from the excavations of Ostia carried out in San Ercolano and San Aurea (1856–1869), as well as from Prince A. Torlonia in Porto in 1866.

Ruvo di Puglia

3.521. Museo Nazionale Jatta.

Santa Flavia

3.522. Antiquarium.

Santa Maria Capua Vetere

3.523. Antiquarium.

Sant'Antioco

3.524. Antiquarium.

Sarsina

3.525. Museo Diocesano di Arte Sacra.

3.526. Museo Nazionale Archeologico.

Savignano sul Rubicone

3.527. Museo Archeologico San Giovanni in Compito.

Scalea

3.528. Antiquarium Torre Cimalonga.

Sesto Calende

3.529. Museo Civico.

Sirmione

3.530. Antiquarium delle Grotte di Catullo.

Sorrento

3.531. Museo Correale di Terranova.

Spoleto

3.532. Museo Civic http://www.archeopg.arti.beniculturali.it/English/musei/spoleto.htm.

Sutri

3.533. Antiquarium Comunale.

3.534. Museo del Patrimonium.

Syracuse

3.535. Museo Archeologico Nazionale.

Taranto

3.536. Museo Archeologico Nazionale. http://museotaranto.it/.

Tarquinia

3.537. Museo Nazionale. http://sights.seindal.dk/sight/ 581_Museo_Nazionale_Tarquiniense.html.

Termini Imerese

3.538. Antiquarium di Himera.

Terni

3.539. Museo Comunale.

Tiriolo

3.540. Antiquarium Comunale.

Tivoli

3.541. Antiquarium del Serapeo.

Todi

3.542. Museo Comunale. http://portal.regione.umbria.it/ cultura/musei/.

Torino

3.543. Museo Egizio.

Torre Annunziata

3.544. Scavi di Oplontis.

Tortona

3.545. Museo Romano

Trapani

3.546. Museo di Preistoria e del Mare.

Trieste

3.547. Civico Museo di Storia ed Arte. http://www. retecivica.trieste.it/triestecultura/musei/civicimu- sei/storiaearte/storiaframe.htm.

Turin

3.548. Museo di Antichita. http://www.emmeti.it/Arte/ Piemonte/ProvTorino/Torino/mus_anti_torino. uk.html.

3.549. Museo Egizio. The Museo Egizio is a museum in Turin, Italy, specializing in Egyptian archaeology and anthropology. It is home to what is regarded as one of the largest collections of Egyptian antiquities outside of Egypt. http://www.museo- egizio.it/.

Umbria

3.550. Musei Comunali. http://www.umbriabest.com/ musei.htm.

Vasto

3.551. Musei Civici di Palazzo d'Avalos.

Venosa

3.552. Museo Archeologico Nazionale di Venosa.

Ventimiglia

3.553. Museo Archeologico Girolamo Rossi.

Verona

3.554. Antiquarium Civico.

3.555. Museo del Teatro Romano. http://www2.regione. veneto.it/cultura/musei/inglese/pag436e.htm.

Vibo Valentina

3.556. Museo Archeologico Statale Vito Capi- albi.

Volterra

3.557. Museo Etrusco M. Guarnacci.

JAPAN

Atami

3.558. Moa Museum of Art. http://www.takenaka.co.jp/ takenaka_e/t-file_e/b_first/moa.

Fukuoka

3.559. Fukuoka Art Museum. http://www.fukuoka-art- museum.jp/english/index.html.

Kamakura

3.560. Kamakura Otari Memorial Art Museum. http://www.kaman.co.jp/.

Kyoto

3.561. Hashimoto (2). http://www.kyohaku.go.jp/.

3.562. Hashimoto (Kyoto National Museum collection). http://www.kyohaku.go.jp/ or http://www.kyohaku.go.jp/indexe.htm.

Osaka

3.563. National Museum of Art. http://www.nmao.go.jp.

3.564. Tenri Sankokan Museum. http://www.tenrikyo.or.jp/index.html.

Shigaraki

3.565. Miho Museum.

Tokyo

3.566. Bridgestone Museum.

3.567. Eisei Bunko Museum. http://www.miho.or.jp/english/inform/eisei/eisei2.htm.

3.568. Gotenba, Museum für Antike Mittelmeerkultur.

3.569. Kyoritsu Women's University.

3.570. Matsuoka Museum of Art. http://www.matsuoka-museum.jp/english-information.htm.

3.571. Museum der Universität. http://www.geidai.ac.jp/english/facilities/museum.html.

3.572. Nationalmuseum. http://www.tnm.go.jp/.

JORDAN

Ajloun

3.573. Madaba Archaeological Museum. http://www.visitjordan.com/default.aspx?tabid=189.

Amman

3.574. Anthropological Museum/University of Jordan. The idea of establishing an anthropological museum at the University of Jordan started in 1977, to serve as an application grounds for theoretical courses taught at the Department of Sociology concerning social life in Jordanian society. The museum houses collections of modern Jordanian heritage, tools made by Jordanian people from their natural environment to meet their needs and demand.

3.575. Jordan Archaeological Museum. The Jordan Archaeological Museum was built in 1951 on the Citadel Hill in Amman. It houses artifacts from all the archaeological sites in the country. The collection is arranged in chronological order and represents ancient items of daily life, such as pottery, glass, and flint and metal tools, as well as monumental materials such as inscriptions and statuaries. The museum also houses several jewelry inscription statuary and coin collections.

3.576. Jordan Folklore Museum. The Jordan Folklore Museum is located within the western section of the Roman Theater in Amman. This museum was founded by the Department of Antiquities and officially opened in 1975.

3.577. Jordanian Museum of Popular Traditions. The Jordanian Museum of Popular Traditions was established in 1971. The museum is located within the eastern section of the Roman Theater in Amman. Its aims are to collect Jordanian and Palestinian folk heritage from all over Jordan, to protect and conserve this heritage, and to present it for future generations. The museum is also concerned with introducing their popular heritage to the world.

3.578. Museum of Jordanian Heritage. The Museum of Jordanian Heritage is part of the Faculty of Archaeology and Anthropology at Yarmouk University. The museum recounts the story of mankind in Jordan from its earliest stages until today. It was opened in 1988 in cooperation with the German government. The museum reflects the research and field projects conducted by the faculty researchers and technicians whether independently or in cooperation with other local and foreign institutes.

3.579. Numismatics Museum Central Bank of Jordan. The area of the Central Bank of Jordan Museum exceeds 400 square meters, and its collections include over 2,200 coins. The museum was officially opened in 1988.

Aqaba

3.580. Museum of Aqaba Antiquities.

Irbid

3.581. Irbid Archaeological Museum.

Jarash

3.582. Jarash Archaeological Museum.

Um Qais

3.583. Umm Qais Archaeological Museum.

LEBANON

Beirut

3.584. Musée National/National Museum of Beirut. The National Museum of Beirut is the principal archaeology museum in Lebanon. The museum's collection was begun at the turn of the twentieth century, and it was officially inaugurated in 1942. The museum houses antiquities and treasures found during excavations undertaken by the Directorate General of Antiquities. The National Museum in Beirut contains an extensive cross-section of historical materials discovered in Lebanon, which cover the prehistoric, Phoenician, Hellenic, Roman, and Arabic periods. www.beirutnationalmuseum.com.

3.585. Musée Archéologique de l'Université Americaine. The AUB Museum, founded in 1868, is the third oldest museum in the Near East. Begun with a donation from General Cesnola, the American Consul in Cyprus, the collection has since grown steadily. Today the museum exhibits a wide range of artifacts from Lebanon and neighboring countries tracing man's progress in the Near East from the Early Stone Age to the Islamic period.

Byblos

3.586. Byblos Wax Museum. The Byblos Wax Museum is a wax museum in Byblos, Lebanon. This museum displays wax statues and life scenes from the Phoenician era to modern times.

Jounieh

3.587. Lebanese Heritage Museum. The Lebanese Heritage Museum is a museum in Jounieh, Lebanon. It contains objects related to the history and culture of Lebanon from the Phoenician era to modern times. http://www.lebaneseheritagemuseum. org/.

MACEDONIA

3.588. Macedonian Museum of Natural History. The Macedonian Museum of Natural History was founded in October 1926, following an initiative of the well-known biologist Dr. Stanko Karaman. The museum collects, studies, and exhibits the natural treasures of Macedonia. The permanent exhibitions of the museum comprise an area of 1,700 square meters, and about 4,000 original exhibits are displayed in glass showcases and dioramas.

Bitola

3.589. Archeoloski Muzej Cherakleja.

Negotino

3.590. Archeoloski Grad Stobi.

MALTA

Ghar Dalam

3.591. Ghar Dalam Cave and Museum. Ghar Dalam Cave is a highly important site, as it was there that the earliest evidence of human settlement on Malta, some 7,400 years ago, was discovered. What makes the site even more fascinating is that it was in use during World War II, when it served first as an air raid shelter and later as a fuel storage depot.

Gozo

3.592. Gozo Museum of Archaeology. The Gozo Museum of Archaeology Display Project stems directly from the objectives of Priority 4 (Regional Distinctiveness—Gozo Special Needs) of the Single Programming Document. The project aims at upgrading the Gozo Museum of Archaeology. Apart from providing secure and state-of-the-art display cases for Gozo's unique archaeological treasures, it will contribute to the development of a cultural tourism niche market and attract more tourists to the island year round.

Rabat

3.593. Domus Romana. The mosaic pavements in the Roman house at Rabat rank among the finest and oldest mosaic compositions from the western Mediterranean, alongside those of Pompeii and Sicily. They were discovered in 1881 just outside Medina in the remains of a rich and sumptuously decorated town house of the Roman period. The mosaic pavement, surrounded by a Doric peristyle, can be found in the lower floor of the museum.

Valletta

3.594. National Museum of Archaeology. The National Museum of Archaeology displays an exceptional array of artifacts from Malta's unique prehistoric periods starting with the first arrival of man in the Ghar Dalam phase (5200 BCE) and running up to

the Tarxien phase (2500 BCE). The collection is housed in the Auberge de Provence, one of the first and most important buildings to be erected in Malta's baroque capital city, Valletta, after the Great Siege in the late sixteenth century. http://www.cityofvalletta.org/cityofvalletta/content.aspx?id=45561.

MONTENEGRO

Budva

3.595. Arheoloski Muzej.

MOROCCO

Kechla

3.596 National Ceramics Museum. The Kechla citadel built by the Portuguese in the sixteenth century offers a spectacular view over the roofs of the medina, which descend in a cascade to the Atlantic. But this is only one of its attractions, since the Kechla also has on display the very finest pieces of the famous Safiot pottery.

Marrakech

3.597. Ameziane Museum. The museum is controversial, as it is dedicated to the Maréchal Mohamed Ameziane, a former military chief of staff during the Third Rif War in the early twentieth century, whom many believe helped the Spanish army in Spanish Morocco against the guerrilla revolutionary Abd el-Krim. Berber people in the Rif region have been waiting instead for a museum dedicated to Abd el-Krim or at least bring the remains of him from Cairo, Egypt, where he died in asylum in 1963.
3.598. Museum of Marrakech. The Museum of Marrakech is in the old center of Marrakech. The museum is housed in the Dar Menebhi Palace, built at the end of the nineteenth century by legendary Mehdi Menebhi. The palace was carefully restored by the Omar Benjelloun Foundation and converted into a museum in 1997. http://www.museedemarrakech.ma/plan_musee_de_marrakech.htm.

NETHERLANDS

Amsterdam

3.599. Allard Pierson Museum. http://www.channels.nl/amsterdam/allardp.html.

Elst

3.600. Museum onder de N. H. Kerk.

The Hague

3.601. Musée Scheer.

Leiden

3.602. Rijksmuseum van Oudheden. http://www.rmo.nl/new/home.html.

Meerlen

3.603. Thermenmuseum.

Ouddorp

3.604. Ouddorps Raad-en Polderhuis.

Sint Michielsgestel

3.605. Oudheidkundig Museum.

Utrecht

3.606. Archaeologische Verzameling der Rijksuniversiteir.

OMAN

Muscat

3.607. Bail Muzna Gallery.
3.608. Museum of the Madhaa District. This is one of the most important private museums in Oman. Established by citizen Mohamed Bin Salem Al Madhani, who started his collection in 1976, the museum reflects his passion for and interest in this country's deep-rooted history. Despite the simplicity in the exhibitions of this museum, it houses several rare antique pieces dating back to prehistoric times, such as tombstones, stone sculptures, and farming tools used before Christianity.
3.609. National Museum. The National Museum opened in 1978 and was previously known as the Museum of the House of Sayyid Nadir Bin Faysal Bin Turki. It includes a number of sections. Among them is the main hall, which houses a variety of exhibits, such as bangles, pendants, rings, copper tools, and aspects of traditional Omani life. The museum has a section for the exhibition of some of the belongings of Al Sayyidah Salimah Bint Said Bin Sultan, consisting

of silver items, such as pendants and "natls." It also houses a special section for the exhibition of specimens of traditional Omani ships, documents, and postal stamps of some of Zanzibar's sultans.

Qurm

3.610. Qurm Museum.

Sohar

3.611. Sohar Fort Museum. The Sohar Fort Museum opened in 1993, and its subject is the history of the old Sohar city and its ties with several civilizations. It focuses on the role played by the copper trade in Sohar and the city's ties with the city of Canton in China. The museum has an exhibition of some archaeological pieces found during excavations in parts of the fort.

PAKISTAN

Islamabad

3.612. Islamabad Museum.

PALESTINE

Jerusalem

3.613. Musée de l'Ecole Biblique et Archéologique Français.

POLAND

Bydgoszcz

3.614. Chateau du Comte Zdzislaw Tarnowski.
3.615. Musée Municipal.

Dzikow Lwów (Leopol)

3.616. Musée Lubomirski.

Goluchow

3.617. Musée Czartoryski.

Lancut

3.618. Châteaux du Comte Potocki.

Lwów (Leopol)

3.619. Musée Lubomirski

Nieborow

3.620. Château du Prince Janusz Radziwill.

Poznan

3.621. Muzeum Wielkopolskie.

Warsaw

3.622. Bibliothèque Krasinski.
3.623. Musée Archéologique d'État.
3.624. Musée Majewski.
3.625. Musée National. http://www.mnw.art.pl/MNW_ang/glowna_ang.html.

Wilanow

3.626. Château du Comte Branicki.

Wilno

3.627. Musée de I'Université.
3.628. Société des Amis des Sciences.

PORTUGAL

Condeixa-a-Nova

3.629. Museu Monográfico de Conimbriga.

Lisboa

3.630. Museu do Teatro Romano.
3.631. Museu Nacional de Arqueologia.

QATAR

Doha

3.632. Museum of Islamic Arts. The Museum of Islamic Arts is a museum located in the Qatari capital of Doha. The museum was designed by the architect I. M. Pei, one of the twentieth century's most successful architects. The museum draws much influence from ancient Sumerian, Babylonian, and Assyrian architecture, giving it a unique design. The museum will be the first of its kind in the gulf and is expected to have a very large collection of some of the best Islamic art, as well as

a study, a library, and several restaurants. http://www.mia.org.qa/.

3.633. Qatar National Museum. Qatar National Museum is the largest museum in Doha, Qatar, and includes many displays relating to the geological history of Qatar as well as a collection of Islamic artifacts and relics. The museum is located in the eastern part of the Doha Corniche and includes a maritime museum as well as a small lagoon where a traditional dhow is moored. http://www.qma.com.qa/en/collections/national-museum-of-qatar.

ROMANIA

Baile Herculane

3.634. Museul Statiunil Baile Herculane.

Bucharest

3.635. Institut d'Archéologie, Musée National des Antiquités. http://www.cimec.ro/Arheologie/arom/Arhtextf.htm.

3.636. Musée de la Ville de Bucarest. http://ibelgique.ifrance.com/romania/buh.htm.

3.637. National Museum of Romanian History. The National Museum of Romanian History (Muzeul National de Istorie a României) is a museum on Calea Victoriei in Bucharest, Romania, which contains Romanian historical artifacts from prehistoric times up to modern times. The permanent displays include a plaster cast of the entirety of Trajan's Column, the Romanian Crown Jewels, and the Pietroasele treasure. http://www.mnir.ro/.

Campulung

3.638. Muzeul si Rezervatia Arheologica de la Castrul Roman Jidava.

Constanta

3.639. Edificiul Roman cu Mozaic.

Deva

3.640. Museum of Dacian and Roman Civilisation is a museum in Deva, Romania. A brief history of Deva and its neighboring citadels and extensive archaeological discoveries from the numerous sights in and around the Ortie Mountains are exhibited in the museum.

Istria

3.641. Museul Arheologic Istria.

Piatra Neamt

3.642. History & Archaeology Museum. The History & Archaeology Museum in Piatra Neamt, Romania, was founded at the beginning of the twentieth century by Constantin Matas, minister and amateur archaeologist. The museum shelters the most important collection of Cucuteni culture artifacts and is the home of the Cucuteni Research Centre. The famous piece, Hora de la Frumuica ("The Frumuica Dance," the symbol of Cucuteni culture), can be found here.

Sibiu

3.643. "ASTRA" National Museum Complex (Complexul National Muzeal "ASTRA") is a museum complex in Sibiu, Romania, which gathers under the same authority four ethnology and civilization museums in the city, a series of laboratories for conservation and research, and a documentation center. It is the successor of the ASTRA museum that has existed in the city since 1905.

Topalu

3.644. Museul de Arheologie.

RUSSIA

Moscow

3.645. Pushkin State Museum of Fine Arts. http://www.museum.ru/gmii/.

SAUDI ARABIA

Jeddah

3.646. Abdul Raouf Khalil's Museum. This museum consists of 10,000 items pertaining to the historic civilization, which the city of Jeddah went through. The Abdul Raouf Khalil's Museum in Jeddah has been classified into three sections. The first section deals with the old Saudi heritage, the second one deals with the Ottoman Empire, and the third one is concerned about the European development.

Riyadh

3.647. National Museum of Saudi Arabia. The National Museum of Saudi Arabia, which opened in Riyadh in 1999 to celebrate the centenary of Saudi unification, was the result of an international design competition. As a member of the competition team, Moriyama & Teshima Planners Limited developed the urban design and landscaping for the eighty-three-acre site of the King Abd Al-Aziz Historical Centre. http://www.national-museum.org.sa/index.aspx.

3.648. Riyadh Museum. Located to the west of Al-Bathaa, the museum's eight sections explore the diverse history, architecture, and archaeology of Saudi Arabia. Clothing, musical instruments, weapons, and jewelry dating back to the Stone Age are on display here. Other themes on focus include the Arabian Kingdoms, The Prophet's Mission, and Hajj and the Two Holy Mosques.

SLOVAKIA

Bratislava

3.649. Anticka Gerulata v Rusovciach.

SLOVENIA

Ajdovscina

3.650. Muzejska Zbirka.

SPAIN

Alcoy

3.651. Museo Arqueológico Municipal Camilo Visedo Molto.

Alcúdia

3.652. Museo Arqueológico Municipal.

Albacete

3.653. Albacete Provincial Museum. The Albacete Provincial Museum (Museo Provincial de Albacete) is a museum of archaeology and fine art located in Albacete, Spain. The museum has existed in various incarnations since 1927 and settled in its present building in Abelardo Sánchez Park in 1978. Its exhibits emphasize the development of regional civilization and art, and the museum is divided into subsections for archaeology, fine arts, and ethnology.

Alicante

3.654. Archaeological Museum of Alicante. The Archaeological Museum of Alicante (Museo Arqueologico Provincial de Alicante) is an archaeological museum in Alicante, Spain. The museum won the European Museum of the Year Award in 2004, when it was only two years old. It houses eight galleries that use multimedia to allow visitors to interact with the lives of past residents of the region. http://www.marqalicante.com/.

Antequera

3.655. Museo Municipal.

Astorga

3.656. Museo Romano de Astorga.

Asturias

3.657. Archaeological Museum of Asturias. The Archaeological Museum of Asturias is housed in the sixteenth century Benedictine monastery of Saint Vicente in Oviedo, Asturias, Spain. Its findings include collections of the Asturian Neolithic and Megalithic periods; Bronze Age; Iron Age; Astur hill fort culture; Roman period; and Gothic, Pre-Romanesque, and Romanesque periods of the Kingdom of Asturias. The museum also includes sections of Asturian ethnography, heraldry, medieval and modern epigraphy, Spanish numismatics, European medals, and armor. http://www.museoarqueologicodeasturias.com/en.

Badajoz

3.658. Museo Arqueológico Provincial.

Barcelona

3.659. Museu d'Arqueología de Catalunya. The Archaeology Museum of Catalonia (abbreviated MAC, for Museu d'Arqueologia de Catalunya) was created under the Museums of Catalonia Act in 1990 by the Department of Culture of the Government of Catalonia. The head office is located in the former Palace of Graphic Arts, which was built for the 1929 World's Fair, in Barcelona, Catalonia. http://www.mac.cat/.

3.660. Museu Barbier-Mueller d'Art Precolombí. The Museu Barbier-Mueller d'Art Precolombí (its local name in Catalan; Spanish: Museo Barbier-Mueller de Arte Precolombino; English: Barbier-Mueller Pre-Columbian Art Museum) is a museum devoted to a collection of artifacts and the artistic legacy of the pre-Columbian cultures of the Americas, located in the Catalonian capital of Barcelona, Spain. It was established in 1997 to house the pre-Columbian art collection formerly held by its parent museum, the Barbier-Mueller Museum in Genève, Switzerland. http://www.barbier-mueller.ch/?lang=en.

3.661. Museu Egipci de Barcelona. http://www.museue-gipci.com/index.php?index&lang=en.

Cádiz

3.662. Museo de Cádiz.

Carmona

3.663. Conjunto Arqueológico de Carmona.

Eivissa

3.664. Museo Monográfico y Necrópolis Punica de Puig des Molins.

Elche

3.665. Museo Arqueológico Municipal Alejandro Ramos Folqués.

Granada

3.666. Archaeological Museum of Granada. The Archaeological Museum of Granada hosts artifacts from the many different civilizations that settled in Granada, including Carthaginians, Phoenicians, Romans, and Arabs.

Irún

3.667. Museo Romano Oiasso. http://www.irun.org/oiasso/home.aspx?tabid=317.

Jérica

3.668. Museo de Jérica.

León

3.669. Museo de la Comisión Provincial de Monumentos.

Linares

3.670. Museo Monográfico de Cástulo.

Madrid

3.671. Museo del Prado. The Museo del Prado features one of the world's finest collections of European art, from the twelfth century through to the early nineteenth century, based on the former Spanish Royal Collection. http://www.museodelprado.es/en/.

3.672. Museo Nacional de Antropología. The Museo Nacional de Antropología (or National Museum of Anthropology) is considered the oldest anthropology museum in Spain, formally inaugurated on April 29, 1875, during the reign of Alfonso XII. http://www.mna.inah.gob.mx/index.html.

3.673. National Archaeological Museum. The National Archaeological Museum (Museo Arqueológico Nacional) was founded in 1867 by a Royal Decree of Isabella II, and its purpose was to be a depository for numismatic, archaeological, ethnographical, and decorative art collections compiled by the Spanish monarchs. http://www.man.es.

Murcia

3.674. Museo de la Catedral.

Peñalba de Castro

3.675. Museo Monográfico de Clunia.

Roda de Ter

3.676. Museu Arqueológic de l'Esquerda.

Santiponce

3.677. Conjunto Arqueológico de Itálica.

Tarragona

3.678. Museu Nacional Arqueològic de Tarragona. http://www.mnat.cat/.

Tossa de Mar

3.679. Museu Municipal. http://www.tossademar.com/museu/home.htm.

Ullastret

3.680. Musée Monographique.

SWEDEN

Göteborg

3.681. Antikmuseet.

Lund

3.682. Lunds Universitets Antikmuseum.
3.683. Museum of Classical Antiquities. http://www.lu.se/klass/klasspr/museum/museng.html.

Stockholm

3.684. Medelhavsmuseet and National Museum. http://www.medelhavsmuseet.se/.

Uppsala

3.685. Museum Gustavianum. http://www.gustavianum.uu.se/.

SWITZERLAND

Avenches

3.686. Musée Romain. http://www.aventicum.org/fr/index.php.

Baden

3.687. Historisches Museum der Stadt Baden. http://www.museum.baden.ch/xml_11/internet/de/intro.cfm.

Basel

3.688. Antikenmuseum. http://www.antikenmuseumbasel.ch/.

Bellinzona

3.689. Museo Castello di Montebello. http://www.bellinzona.ch/Cultura/cultura.htm.
3.690. Museo di Castelgrande.

Brugg

3.691. Vindonissa-Museum. https://www.ag.ch/de/bks/kultur/museen_schloesser/vindonissa_museum/vindonissa_mus eum.jsp.

Chur

3.692. Rätisches Museum. http://www.rm.gr.ch/.

Fribourg

3.693. Bibel und Orient Museum. http://www.bible-orient-museum.ch/.

Geneva

3.694. Musée d'Art et d'Histoire. http://mah.ville-ge.ch/.

Locarno

3.695. Museo del Castello Visconteo. http://www.inrete.ch/ti/societa/cultura/musei/musei_ti/castello_locarno/castellovisconteo.htm.

Martigny

3.696. Musée Gallo-Romain d'Octodure.

Nyon

3.697. Musée Romain.

Pully

3.698. Musée de la Villa Romaine de Pully.

St. Gallen

3.699. St. Gallen Historisches Museum. http://www.st.gallen.ch/historischesmuseum/.

Vallon

3.700. Musée Romain.

Winterthur

3.701. Archäologische Sammlung. http://www.muenzkabinett.ch.

Zürich

3.702. Archäologisches Institut, Universität Zürich. http://www.archinst.unizh.ch/.
3.703. Verein Zürcher Museen. http://www.museen-zuerich.ch/.

SYRIA

Aleppo

3.704. Aleppo National Museum. The Aleppo Museum contains an important collection of items from

many periods, with a strong emphasis on the Iron Age and classical period but including many items from the Late Bronze. It contains a small selection of some of the 20,000 or more early second millennium cuneiform tablets found at Mari. The middle section of the rear hall is dedicated to two northern sites, Tell Hajib and Arslan Tash. The third section displays finds from Tell Ahmar, excavated by the French in the 1920s. The large gallery that runs along the third side of the building is used to house finds from several sites, including Ebla and Ain Dara. The second floor contains numerous artifacts found during the major excavations carried out by multinational expeditions in the flooded region of Lake Assad on the Euphrates. http://cdli.ucla.edu/collections/syria/aleppo_en.html?section=3.

Ar-Raqqah

3.705. Museum of ar-Raqqah. Museum of ar-Raqqah was opened to the public in 1981 and consists of a two-story building devoted to regional archaeology. http://cdli.ucla.edu/collections/syria/raqqa_en.html?section=3.

Damascus

3.706. Azm Palace. Azm Palace was originally built in 1750 as a residence for the Ottoman governor of Damascus As'ad Pasha al-Azem. The palace now houses the Museum of Arts and Popular Traditions. In 1925, the building was heavily damaged by French artillery during the Syrian revolution. It has since been restored and became a museum of arts and folk traditions. It received the Aga Khan Award for Architecture in 1983.

3.707. National Museum of Damascus. The National Museum of Damascus is a large museum in the heart of Damascus, Syria. The most popular part of the museum is the second century CE Synagogue, which has been reconstructed there. The National Museum of Damascus lies in the west of the city, between the University of Damascus and the Tekkiye Mosque Complex. http://cdli.ucla.edu/collections/syria/damascus_en.html?section=3.

Deir ez-Zor

3.708. Deir ez-Zor Museum. The museum of Deir ez-Zor was founded in 1974 and then rebuilt and re-inagruated in 1996 to meet the needs of perservation and exhibition of the ever-growing collections. The main goal of the museum is to promote the study, education, and tourism of the Syrian Jezirah and its history. The museum's collections, currently composed of some 25,000 objects, cover the long history of the region, ranging from Stone Age sites, such as Bouqras, through the Chalcolithic Uruk culture settlements of Tell Bderi and the Bronze Age Syrian polities of Mari and Ebla and finishing with the periods of Akkadian, Roman, and Islamic domination. http://cdli.ucla.edu/collections/syria/deir_en.html?section=3.

TAJIKISTAN

Chudzand

3.709. Osorkhonai Bostonshinosii Khujand.

Pandzakent

3.710. Mamnu'gohi Bostonshii Panjakernt.

TUNISIA

Carthage

3.711. Musée National de Carthage.

El-Jem

3.712. Musée d'Institut National de Archéologique d'El-Jem.

Makthar

3.713. Musée Archéologique de Makthar.

Utique

3.714. Musée National d'Utique.

TURKMENISTAN

Ashgabat

3.715. Ashgabat National Museum of History. The Ashgabat National Museum of History is a history museum in Ashgabat, the capital city of Turkmenistan. It contains over 500,000 exhibits, particularly archaeological and ethnographical finds throughout the country, including rare works of ancient art, paintings, drawings, sculptures, carpets, rugs, fabrics and clothing, household utensils, musical instruments, weapons, jewelry, medals, historical documents, horn-shaped vessels made of ivory, statuettes of Parthian goddesses, and colorful Buddhist vases.

Kaka

3.716. Taryhy Yer Abiwerd.

Mary

3.717. Taryhy we Etnografiki Muzey.

Nusay

3.718. Taryhy Yer Nusay.

TURKEY

Ankara

3.719. Ethnography Museum of Ankara. The Ethnography Museum of Ankara, built by architect Arif Hikmet Koyunoglu, is located on the site of a Muslim cemetery on a hill in Namazgah, Ankara. http://www.etnografyamuzesi.gov.tr/en/.

3.720. Museum of Anatolian Civilizations. The Museum of Anatolian Civilizations (Turkish: Anadolu Medeniyetleri Müzesi) is located on the south side of Ankara Castle in the Atpazari area in Ankara. It consists of the old Ottoman Mahmut Paa bazaar storage building and the Kurunlu Han. Because of Atatürk's desire to establish a Hittite museum, the buildings were bought upon the suggestion of Hamit Zübeyir Koay, who was then culture minister to the national education minister, Saffet Arkan. After the remodeling and repairs were completed (1938–1968), the building was opened to the public as the Ankara Archaeological Museum. It is one of the richest museums in the world. http://www.anadolumedeniyetlerimuzesi.gov.tr/ana-sayfa/1-54417/20131209.html.

Antalya

3.721. Antalya Müzesi. The Antalya Museum or Antalya Archeological Museum is one of Turkey's largest museums, located in Konyaalt, Antalya. It includes thirteen exhibition halls and an open air gallery. It covers an area of 7,000 square meters and has 5,000 works of art exhibited. In addition 25,000 to 30,000 artifacts, which cannot be displayed, are in storage. As a museum exhibiting examples of works that illuminate the history of the Mediterranean and Pamphylia regions in Anatolia, Antalya Museum is one of the most important of Turkey's museums. The museum won the "European Council Special Prize" in 1988. http://www.muze.gov.tr/antalya.

Aydin

3.722. Aphrodisias Müzesi. http://www.muze.gov.tr/afrodisias.

3.723. Aydin Müzesiin. http://www.aydinkulturturizm.gov.tr/belge/1-57308/aydin-muzesi.html.

Bodrum

3.724. Bodrum Sualti Arkeolojisi Müzesi. http://www.muze.gov.tr/bodrumsualti.

Çanakkale

3.725. Çanakkale Müzesi. http://www.canakkaleili.com/canakkale-arkeoloji-muzesi.html.

Denizli

3.726. Hierapolis Arkeoloji Müzesi.

Eregli

3.727. Eregli Müzesi.

Hatay

3.728. Hatay Müzesi. http://www.hatayarkeolojimuzesi.gov.tr/HatayMuzeWeb/flash/main_EN.html.

Istanbul

3.729. Istanbul Archaeology Museum. The Istanbul Archaeology Museum (Istanbul Arkeoloji Müzesi) is located in the Eminönü district of Istanbul, near Gülhane Park and Topkap Palace. http://www.istanbularkeoloji.gov.tr/.

3.730. Turkish and Islamic Arts Museum. The Turkish and Islamic Arts Museum is located in Sultanahmet Square in the Eminönü district of Istanbul, Turkey. Constructed in 1524, the building was formerly the palace of Ibrahim Pasha, who was the first grand vizier to Suleiman the Magnificent. http://muze.gov.tr/turkishislami.

3.731. Great Palace Mosaic Museum. The Great Palace Mosaic Museum (Büyük Saray Mozaikleri Müzesi) is located close to Sultanahmet Square in Istanbul, Turkey, at Arasta Bazaar. The museum houses mosaics from the Byzantine period, unearthed at the site of the Great Palace of Constantinople.

Konya

3.732. Arkeoloji Müzesi.

Kütahya

3.733. Kossuth Müzesi.

Manisa

3.734. Manisa Müzesi. The Archaeological Museum of Manisa is situated in the historic kulliye of Muradiye Mosque. Local and regional artifacts from antique Magnesia, Sardes, and other regional towns are displayed. Museum displays cover the prehistoric times to the twentieth century. The Ethnography Museum is in a nearby building.

3.735. Karun Treasure. Karun Treasure is the name given to a collection of 363 valuable Lydian artifacts dating from the seventh century BCE and originating from Uak Province in western Turkey. They were the subject of a legal battle between Turkey and the New York Metropolitan Museum of Art between 1987 and 1993 and were returned to Turkey in 1993 after the museum admitted it had known the objects were stolen when it had purchased them. The collection is alternatively known as the Lydian Hoard.

Nigde

3.736. Nigde Müzesi.

Selçuk

3.737. Efes Müzesi.

Side

3.738. Side Müzesi. http://www.muze.gov.tr/side.

Silifke

3.739. Silifke Müzesi. http://www.kenthaber.com/akdeniz/mersin/silifke/Rehber/muzeler/silifke-muzesi.

Tire

3.740. Tire Müzesi. http://www.kenthaber.com/ege/izmir/tire/Rehber/muzeler/tire-muzesi.

TURKMENISTAN

Ashgabat

3.741. Ashgabat National Museum of History. The Ashgabat National Museum of History is a history museum in Ashgabat, the capital city of Turkmenistan. It contains over 500,000 exhibits, particularly archaeological and ethnographical finds throughout the country, including rare works of ancient art, paintings, drawings, sculptures, carpets, rugs, fabrics and clothing, household utensils, musical instruments, weapons, jewelry, medals, historical documents, horn-shaped vessels made of ivory, statuettes of Parthian goddesses, and colorful Buddhist vases.

UKRAINE

Odessa

3.742. Odessa Virtual Museum of Numismatics. The Odessa Numismatics Museum preserves and exhibits ancient relics from the Northern Black Sea Region and Rus-Ukraine. The museum has two branches located in Odessa: an exhibition of ancient and medieval coins, old and modern Ukrainian banknotes, antique pottery of the Northern Black Sea region, and fine art of Kievan Rus' and an exhibition of modern coins and monetary tokens of Ukraine. http://www.museum.com.ua/.

Sevastopol

3.743. Nacional'nyj Zapovidnyk Chersonesw Tavrijs'kyj.

UNITED ARAB EMIRATES

Abu Dhabi

3.744. Al-Ain National Museum. Museum in Al Ain, Abu Dhabi, run by the Department of Antiquities and Tourism, has two sections: archaeological and ethnographical. The site has information on recent discoveries and a chronology of UAE history. http://www.adach.ae/en/portal/heritage/alain.nationalmuseum.aspx.

Ras al-Khaimah

3.745. Ras al-Khaimah Museum looks after all aspects of Ras Al Khaimah's heritage. Collections include recent archaeological finds, silver jewelry, ethnography, and natural history.

Sharjah

3.746. Sharjah Museums. Includes Sharjah Archaeology Museum, Sharjah Natural History Museum and Desert Park, Sharjah Science Museum, Sharjah

Islamic Museum, and Sharjah Heritage Museum. http://www.sharjahmuseums.ae/.

UNITED KINGDOM

Baginton

3.747. Lunt Roman Fort. http://www.luntromanfort.org/.

Blackburn, Lancashire

3.748. Blackburn Museum and Art Gallery.

Bolton

3.749. Bolton Museum and Art Gallery.

Brading

3.750. Brading Roman Villa. http://www.bradingromanvilla.org.uk/.

Caerleon

3.751. National Roman Legionary Museum. http://www.museumwales.ac.uk/en/roman/.

Caernarfon

3.752. Segontium Roman Museum. http://www.segontium.org.uk/se_1mus.htm.

Cambridge

3.753. Fitzwilliam Museum. http://www.fitzmuseum.cam.ac.uk/.

Cheltenham

3.754. Chedworth Roman Villa Museum. http://www.nationaltrust.org.uk/chedworth-roman-villa/.

Chicester

3.755. Fishbourne Roman Palace and Museum. http://www.picturetheuk.com/uk-tourism/things-to-do/fishbourne-roman-palace-museum-west-sussex-1028.html.

Chollerford

3.756. Clayton Collection Museum. http://www.britainsfinest.co.uk/museums/museums.cfm/searchazref/80001250CHEB.

Colchester

3.757. Castle Museum. http://www.cimuseums.org.uk/venues/colchester-castle-museum.html.

Corbridge

3.758. Corbridge Roman Site and Museum. http://www.nationaltrail.co.uk/hadrianswall/site.asp?PageId=56&SiteId=352&c=.

Dorchester

3.759. Tutankhamun Exhibition.

Dover

3.760. Roman Painted House. http://www.theroman-paintedhouse.co.uk/.

Durham

3.761. Oriental Museum. http://www.english-heritage.org.uk/daysout/properties/lullingstone-roman-villa/.

Edinburgh

3.762. The National Museums of Scotland. http://www.nms.ac.uk/royal/index.htm.

Eton

3.763. Myers Museum of Egyptian and Classical Art.

Eynsford

3.764. Lullingstone Roman Villa. http://www.english-heritage.org.uk/daysout/properties/lullingstone-roman-villa/.

Glasgow

3.765. Burrell Collection. http://www.clyde-valley.com/glasgow/burrell.htm.
3.766. The Glasgow Museum and Art Gallery, Kelvingrove. http://www.glasgowlife.org.uk/museums/our-museums/kelvingrove/Pages/home.aspx.
3.767. Hunterian Museum. http://www.hunterian.gla.ac.uk.

Grays

3.768. Thurrock Museum. http://www.thurrock.gov.uk/heritage/museum/.

Greenhead

3.769. Roman Army Museum. http://www.northumberlandnationalpark.org.uk/visiting/placestovisit/hadrianswallvisiting/romanarmymuseum.

Hereford

3.770. Hereford Museum and Art Gallery. http://www.herefordshire.gov.uk/leisure/museums_galleries/2869.asp.

Housesteads

3.771. Housesteads Roman Fort and Museum. http://www.english-heritage.org.uk/daysout/properties/housesteads-roman-fort-hadrians-wall/.

Lichfield

3.772. Wall Roman Site and Museum/Letocetum. http://www.english-heritage.org.uk/daysout/properties/wall-roman-site/.

London

3.773. British Museum, London. The British Museum holds in trust for the nation and the world a collection of art and antiquities from ancient and living cultures. Housed in one of Britain's architectural landmarks, the collection is one of the finest in existence, spanning two million years of human history. www.thebritishmuseum.ac.uk.

3.774. British Museum, London. Department of Greek and Roman Antiquities. Website allows online access to the museum's collection of Greek and Roman artifacts. http://www.britishmuseum.org/the_museum/departments/greek_and_roman_antiquities.aspx.

3.775. Old Speech Room gallery. http://www.harrowschool.org.uk/1574/public-facilities-and-holiday-courses/old-speech-room-gallery-and-museum/.

3.776. Petrie Museum of Egyptian Archaeology. http://www.ucl.ac.uk/museums/petrie.

Macclesfield

3.777. West Park Museum.

Malton

3.778. Malton Museum. http://www.maltonmuseum.co.uk/.

Maryport

3.779. Senhouse Roman Museum. http://www.senhousemuseum.co.uk/.

Newcastle-upon-Tyne

3.780. Hancock Museum.

Newport, Isle of Wight

3.781. Newport Roman Villa. http://www.iwight.com/council/departments/museums/newport_roman_villa/.

Northampton

3.782. Castle Ashby. http://www.castleashby.co.uk.

Nottingham

3.783. Nottingham University Museum of Archaeology. http://www.nottingham.ac.uk/museum/.

Oxford

3.784. Ashmolean Museum, Oxford. The Ashmolean Museum of Art and Archaeology is a museum of the University of Oxford. Founded in 1683, it is one of the oldest public museums in the world. www.ashmolean.org.

Reading

3.785 University of Reading. http://www.reading.ac.uk/Ure.

3.786. Ure Museum of Greek Archaeology. http://www.reading.ac.uk/Ure/index.php.

Ribchester

3.787. Ribchester Roman Museum. http://ribchesterromanmuseum.org/.

Sandwich

3.788. Richborough Castle; Roman Fort. http://www.english-heritage.org.uk/daysout/properties/richborough-roman-fort-and-amphitheatre/.

South Shields

3.789. Arbeia Roman Fort and Museum. http://www.twmuseums.org.uk/arbeia/.

Swansea

3.790. Egypt Centre. http://www.egypt.swan.ac.uk/. Wallsend

3.791. Segedunum Roman Fort, Baths, and Museum. http://www.twmuseums.org.uk/segedunum/.

Winchester

3.792. Winchester College. http://www.visitwinchester.co.uk/site/p_3401.

Wroxeter

3.793. Viroconium Museum. http://www.history-tourist.com/V2//wroxeter-viroconium_S0229.html.

Yanworth

3.794. Chedworth Roman Villa. http://www.nationaltrust.org.uk/chedworth-roman-villa/.

UNITED STATES

California

Beverly Hills

3.795. California Museum of Ancient Art. The California Museum of Ancient Art (CMAA) was established to gather the first significant collection of ancient art from Egypt, Mesopotamia, and the Holy Land in the western United States. http://cmaa-museum.org/.

Los Angeles

3.796. Los Angeles County Museum of Art. Possesses significant collections in the art of the ancient Near East, Egypt, Greece, Rome, and Etruria. http://www.lacma.org/.

Malibu

3.797. J. Paul Getty Museum. The J. Paul Getty Museum opened in 2006. As a museum and educational center dedicated to the study of the arts and cultures of ancient Greece, Rome, and Etruria, the Getty Villa serves a varied audience through exhibitions, conservation, scholarship, research, and public programs. The villa houses approximately 44,000 works of art from the museum's extensive collection of Greek, Roman, and Etruscan antiquities, of which over 1,200 are on view. http://www.getty.edu/museum/.

San José

3.798. Rosicrucian Egyptian Museum. The Rosicrucian Egyptian Museum houses the largest collection of Egyptian artifacts on exhibit in western North America and offers school tours and expeditions. http//egyptianmuseum.org.

Illinois

Chicago

3.799. Hellenic Museum and Cultural Center. http://www.greektownchicago.org/.

Urbana-Champaign

3.800. University of Illinois. http://www.uiuc.edu/.

Maryland

Baltimore

3.801. Robinson Collection. http://www.olemiss.edu/depts/classics/gkmosaics.html.

3.802. Walters Art Gallery. http://www.thewalters.org/html/home.asp.

Massachusetts

Boston

3.803. Museum of Fine Arts. http://www.mfa.org/.

Cambridge

3.804. Harvard University Fogg Museum. http://www.artmuseums.harvard.edu/fogg/index.html.

3.805. Harvard University Semitic Museum. http://www.semiticmuseum.fas.harvard.edu/icb/icb.do.

Michigan

Ann Arbor

3.806. University of Michigan at Ann Arbor. http://www.umich.edu.

3.807. University of Michigan. Kelsey Museum of Archaeology. http://www.lsa.umich.edu/kelsey/.

Nebraska

Omaha

3.808. Joslyn Art Museum. Joslyn Art Museum opened in 1931 as the Society of Liberal Arts. Since that time, the museum's collection has grown to include over 11,000 works representing artists and

cultures from antiquity to the present. Highlights include a highly regarded collection of Greek pottery. http://www.joslyn.org/.

New York

New York

3.809. Metropolitan Museum of Art. Its extensive collections include over two million works of art, which span more than 5,000 years of world culture, from prehistory to the present. Searchable database of works on display at the MET. www. metmuseum.org.

Ohio

Cleveland

3.810. Museum of Art. Collections include ancient Egyptian art, ancient Near East, and Greek and Roman objects. http://www.clevelandart.org/.

Columbus

3.811. Ohio State University. Center for Epigraphical and Palaeological Studies. A collection of Greek and Latin inscriptional digitized squeezes (accurate paper impressions) from the Center for Epigraphical and Palaeographical Studies at the Ohio State University. http://dmc.ohiolink.edu/ cgi/i/image/image-idx?page=index;c=squeezes.

Pennsylvania

Bryn Mawr

3.812. Bryn Mawr College, Ella Riegel Memorial Museum. The Classical and Near Eastern Archaeology Collection, also known as the Ella Riegel Memorial Museum and the Ella Riegel Study Collection, houses over 6,000 objects from ancient Greek and Roman empires, Mesopotamia, Egypt, Cyprus, and Mycenae. http://www.bryn-mawr.edu/Acads/Arch/information.html.

Philadelphia

3.813. University of Pennsylvania Museum. Since its founding in 1887, the Penn Museum has collected nearly one million objects, many obtained directly through its own field excavations or anthropological research. The Babylonian section houses a collection of almost 30,000 clay tablets inscribed in Sumerian and Akkadian cuneiform, making it one of the ten largest collections in the world. The vast majority of the texts derive from the museum's excavations at Nippur in the latter part of the nineteenth century along with smaller excavated groups of tablets from Ur, Billa, Malyan, and Fara. The collection contains the largest number of Sumerian school tablets and literary compositions of any of the world's museums, as well as important administrative archives ranging from 2900 to 500 BCE. The museum houses one of the largest collections of Egyptian and Nubian material in the United States, numbering in excess of 42,000 items. Assembled through nearly a century of archaeological research, this collection is unusual in that the vast majority of the objects were obtained through archaeological investigations in Egypt and entered the museum through a division of finds with Egypt's Antiquities Service. The European collection holds an estimated 20,000 objects, most of which are exclusively archaeological. The major prehistoric periods represented are Paleolithic (ca. 3,900 objects), Neolithic (ca. 7,950 objects), and Bronze Age (ca. 1,049 objects). Additionally, some historic Iron Age (236 objects), Italic (15 objects), Roman (78 objects), and Medieval (76 objects) have also been identified. The collections of the Mediterranean section of the Penn Museum comprise some 34,000 objects of Greek, Roman, Etruscan, Cypriot, and Bronze Age Aegean origins, as well as small numbers of artifacts from related culture areas. The classical world and the acquisition of objects from classical lands, especially excavated archaeological material, was a primary interest of the museum at its founding in 1887 and during its formative years. This was a reflection of a general intense interest in classical antiquity in the late nineteenth and early twentieth centuries in America. This interest was fostered by an educational system that emphasized classical literature and languages and was fueled in the 1870s by a fascination with Heinrich Schliemann's search for Homer's Troy. The majority of the objects from excavations sponsored by the museum were acquired before World War II, when the laws governing the export of antiquities from the country of origin made it possible. A large body of archaeological material from Kourion and Lapithos became part of the museum's collection, with the permission of the Department of Antiquities of Cyprus. Material from Crete, particularly from the site of Gournia, was acquired by the museum through a permit from the Greek government at the time of excavation. The Roman site of Minturnae, between Rome and Naples, was excavated by the museum under the direction of Jotham Johnson, and the museum received a division of the finds. See also *Adventures in photography: expeditions of the University of Pennsylvania Museum of Ar-*

chaeology and Anthropology/Alessandro Pezzati. Philadelphia: University of Pennsylvania Museum of Archaeology and Anthropology, 2002. University Museum Library GN36 .U62 P486 2002; *Preserving field records: archival techniques for archaeologists and anthropologists*/ Mary Anne Kenworthy. Philadelphia: University Museum, University of Pennsylvania, 1985. 102 p. GN14 .P74 1985; *A guide to the University Museum Archives of the University of Pennsylvania*/Mary Elizabeth Ruwell. Philadelphia: University Museum, University of Pennsylvania, 1984. 72 p. CD3479 .P5 nU55 1984. http://www.museum.upenn.edu/.

Rhode Island

Providence

3.814 Rhode Island School of Design. http://www.risd.edu/.

Texas

Dallas

3.815. Dallas Museum of Art. http://dallasmuseumofart.org/index.htm.

URUGUAY

Montevideo

3.816. Museo Egipico de la Sociedad de Egiptologia. http://www.egiptoforo.com/antiguo/Uruguay._Museos_y_Colecciones_del_Antiguo_Egipto.

CITTÀ DEL VATICANO (VATICAN CITY)

3.817 Etruscan Museum. Founded in 1837 by Pope Gregory XVI, the museum contains vases, bronzes, and other archaeological findings from southern Etruria; a large collection of Hellenistic Italian vases; and some Roman pieces (Antiquarium Romanorum). In Room II is the notable Regolini-Galassi tomb, and Rooms IV–VIII, known as the "Precious," exhibit gold jewelry realized by Etruscan goldsmiths during the ten centuries of their civilization.

3.818. Museo Gregoriano Egizio. Pope Gregory XVI had the Gregorian Egyptian Museum founded in 1839. It houses monuments and artifacts of ancient Egypt partly coming from Rome and from Villa Adriana (Tivoli), where they had been transferred mostly in the Imperial age, and partly from private collections that were purchased by nineteenth century collectors. The pope's interest in Egypt was connected with the fundamental role attributed to this country by the Sacred Scripture in the History of Salvation. http://mv.vatican.va/2_IT/pages/MEZ/MEZ_Main.html.

3.819. Vatican Museum Online. Allows online access to various aspects of the Vatican's collection. http://mv.vatican.va/3_EN/pages/MV_Musei.html.

YEMEN

Al-Mukalla

3.820. Al-Mukalla Museum. http://english.hadramaut.info/view/605.aspx.

Ataq

3.821. Ataq Museum possesses a valuable collection of antiquities from different areas of Shabwa, especially the ancient city of Shabwa, the capital of the ancient kingdom of Hadhramout. Also in the museum are objects from the archaeological sites of the ancient Qataban and Osan kingdom.

Baihan

3.822. Baihan Museum.

Sanaa

3.823. National Museum. http://en.wikipedia.org/wiki/National_Museum_of_Yemen.

YUGOSLAVIA (FORMER)

Belgrade

3.824. Musée National de Belgrade/Musée du Prince Paul. http://fr.wikipedia.org/wiki/Mus%C3%A9e_national_de_Belgrade.

Sarajevo

3.825. Musée National de la République Socialiste de Bosnie Herzégovine. http://www.zemaljskimuzej.ba/english/about_us.htm.

Zagreb

3.826. Archaeological Museum. http://www.saatchi-gallery.co.uk/museums/full-museum-details/profile/ac_id/821.

4

Guides to the Literature of the Ancient World

A guide to the literature of a discipline (or a bibliographic guide, a literature guide, a guide to reference materials, a subject gateway, etc.) is a kind of meta-bibliography. Ideally it is not just a listing of bibliographies, reference works, and other works but more like a textbook introducing users to the information sources in a given field (or in general). Such guides may have many different forms: comprehensive or highly selective, printed or electronic sources, annotated listings or written chapters, etc.

Guides can often lead the researcher to sources that may have been overlooked. These reference sources can identify many kinds of discipline-specific materials, including encyclopedias, dictionaries, journals, and other types of periodical literature, bibliographies, indexes, abstracts, and so forth. This chapter identifies some of the more useful guides to the literature of the ancient world.

SUBJECT GUIDES

Archaeology

4.1. *Archaeology: a bibliographical guide to the basic literature*/Robert F. Heizer, Thomas R. Hester, and Carol Graves. New York: Garland, 1980. 434 p. CC165 .H43.

4.2. *Keyguide to information sources in archaeology*/Peter Woodhead. London: Mansell, 1985. 219 p. CC120 .W66 1985.

4.3. *Laboratory techniques in archaeology: a guide to the literature, 1920–1980*/Linda Ellis. New York: Garland, 1982. 419 p. CC75 .E44 1982.

Classics

4.4. *Accessing antiquity: the computerization of classical studies*/Jon Solomon. Tucson: University of Arizona Press, 1993. 186 p. PA50 .A23 1993.

4.5. *Bits, bytes, and biblical studies: a resource guide for the use of computers in biblical and classical studies*/John J. Hughes. Grand Rapids: Zondervan Publishing House, 1987. 643 p. BS600.2 .H84 1987.

4.6. *Classical scholarship: an annotated bibliography*/Thomas P. Halton and Stella O'Leary. White Plains: Kraus International, 1986. 396 p. DE59 .H34 1986.

4.7. *Classical studies: a guide to the reference literature*/Fred W. Jenkins. 2 ed. Westport: Libraries Unlimited, 2006. 401 p. PA91. J46 2006. Supersedes: *Classical studies: a guide to the reference literature*/Fred W. Jenkins. Englewood: Libraries Unlimited, Inc. 1996. Lists and describes the best specialized reference sources for the classics. Covers Greek and Roman civilizations from the Bronze Age through the sixth century CE and includes works on art, archaeology, history, languages, literature, and philosophy. An excellent overview of research sources on all areas of Classics. Along with many printed reference books, bibliographies, dictionaries, periodicals, etc., it includes listings for numerous Internet resources.

4.8. *Guide to research in classical art and mythology*/Frances Van Keueren. Chicago: American Library Association, 1991. 307 p. N7760 .V3 1991.

4.9. *Introduction to classical scholarship: a syllabus and bibliographical guide*/Martin R. P. McGuire. Washington, D.C.: Catholic University of America, 1961. 204, 86 p. 470 M175. Supersedes: *Introduction to classical scholarship: a syllabus and bibliographical guide*/Martin R. P. McGuire. Washington, D.C.: Catholic University of America Press, 1958, 1955. 204, 86 p. 470 M175.

4.10. *International guide to classical studies*. Darien: American Bibliographic Service, 1966–1973. 7 v. 4/yr. Z7016 .I5, v.6–12, 1966–1973.

4.11. *Introduction to ancient history*/Hermann Bengston. Berkeley: University of California Press, 1970 213 p. Reference Z6202 .B413; Z6202 .B413.

4.12. *Medieval Latin: an introduction and bibliographical guide*/ F. A. C. Mantello and A. G. Rigg. Washington, D.C.: Catholic University of America Press, 1996. 774 p. PA2802 .M435 1996.

4.13. *Perseus 2.0: interactive sources and studies on ancient Greece*/Gregory Crane. New Haven; London: Yale University Press, 2000. 8 p. + 3 CD-ROM. DF77 .P457 2000.

REGIONAL GUIDES

Afghanistan

4.14. *Afghanistan: a companion and guide*/Bijan Omrani and Matthew Leeming. Hong Kong: Odyssey Books and Guides; New York: W. W. Norton, 2005. 768 p. DS351.5 .O46 2005.

Africa, North

4.15. *A guide to the archaeological sites of Israel, Egypt, and North Africa*/Courtlandt Canby with Arcadia Kocybala. New York: Facts on File, 1990. 278 p. DS111 .C36 1990.

4.16. *Handbook for travellers in Algeria and Tunis: Algiers, Oran, Constantine, Carthage, etc.*/John Murray. 2 ed. London: J. Murray, 1878. 308, 68 p. DT274 .M986 1878.

Albania

4.17. *Albania*/James Pettifer. 2 ed. London: A&C Black; New York: W. W. Norton, 1996. 288 p. DR909 .P48 1990.

4.18. *Albania & Kosovo*/James Pettifer. 3 ed. London: A&C Black; New York: W. W. Norton, 2001. 511 p. DR909 .P48 2001.

4.19. *Albanien: Kunst und Kultur im Land der Skipetaren*/Guntram Koch. Köln: DuMont Buchverlag, 1989. 335 p. DR909 .K62 1989.

Canada

4.20. *Near Eastern and classical antiquities: a guide to the antiquities collection of the Department of Classics at the University of Alberta*/J. J. Rossiter and D. E. Dillenbeck. Edmonton: University of Alberta Press, 1976. 73 p. DE46 .U54 1976.

Corsica

4.21. *Monuments préhistoriques de Corse*/Laurent Jacques Costa. Paris: Errance, 2009. 159 p. GN812.C6 C67 2009.

Egypt

4.22. *Alexandria: historical and archaeological guide*/ Yousrya Abdel-Aziz Hoszi. Cairo: Supreme Council of Antiquities, 2010. 178 p. DT73.A4 H67 2010.

4.23. *Alexandria: a history and a guide*/E. M. Forster. Garden City: Anchor Books, 1961. 243 p. DT73. A4 F6 1961; 916.211 F778 1961. Supersedes: *Alexandria: a history and a guide*/E. M. Forster. Alexandria: W. Morris Limited, 1922. 227 p. 916.211 F778.

Denmark

4.24. *Oriental and classical antiquity: Egypt, western Asia, Greece and Rome*. Antiksamlingen, Copenhagen: Nationalmuseet, 1950. 107, 32 p. 913.07 C794.

Germany

4.25. *Aachen und das Dreiländereck: Fahrten rund um die Karlsstadt und ins Maasland nach Lüttich und Maastricht*/Gabriele M. Knoll. Köln: DuMont, 1993. 315 p. DD901.A26 K58 1993.

Great Britain

4.26. *A guide to the archaeological sites of the British Isles*/Courtlandt Canby. New York: Facts on File, 1988. 358 p. DA90 .C36 1988.

4.27. *A guide to the Department of Greek and Roman Antiquities in the British Museum*. 6 ed. London: Printed by order of the Trustees, 1928. 205, 18 p. 913.36 B778.3b; N5335.L7 B7 1928. Supersedes: *Guide to the Department of Greek and Roman Antiquities in the British Museum*. 5 ed. London: Printed by order of the Trustees, 1920. 196 p. 913.36 B778.3a; 913.36 B778.3a; *Guide to the Department of Greek and Roman Antiquities in the British Museum*. 3 ed. London: Printed by order of the Trustees, 1908. 219 p. 913.36 B778.3; 913.36 B778.3.

Greece

4.28. *Handbook for travellers in Greece: including the Ionian Islands, continental Greece, the*

Peloponnese, the islands of the Ægean Sea, Crete, Albania, Thessaly, & Macedonia, and a detailed description of Athens, ancient and modern, classical and mediæval. London: J. Murray, 1854. 2 v. DF716 .M9 1854.

Aegean Islands

4.29. *Greece the Aegean Islands*/Nigel McGilchrist. London: Somerset, 2010. 680 p. DF895 .M34 2010.

Athens

4.30. *Archaeological promenades around the Acropolis.* Athens: Association of Friends of the Acropolis, 2000. 7 v. DF287.A2 A74 2000.

4.31. *The Athenian Agora: a guide to the excavation and museum.* 4 ed. Athens: American School of Classical Studies at Athens, 1990. 292 p. NA283. A27 A43 1990.

4.32. *The Athenian Agora: a short guide*/Homer A. Thompson. Princeton: The School, 1976. 32 p. DF287.A23 A322.

Corinth

4.33. *Ancient Corinth; a guide to the excavations.* 4 ed. Athens: Hestia Press Studies at Athens, 1947. 127 p. 913.381 C814A 1947. Supersedes: *Ancient Corinth; a guide to the excavations.* 3rd ed. Athens: Hestia Press Studies at Athens, 1936. 121 p. 913.381 C814A 1936; *Ancient Corinth; a guide to the excavations.* 2 ed. Athens: American School of Classical Studies at Athens, 1933. 112 p. 913.381 C814A 1933; *Ancient Corinth; a guide to the excavations and museums.* Macon, France, Protat Brothers, 1928. 83 p. 913.381 C814A; 913.381 C814A.

Delos

4.34. *Guide de Délos*/Philippe Bruneau and Jean Ducat. 4 ed. Athènes: Ecole Française d'Athènes, 2005. 339 p. DF261.D3 B7 2005.

Mycenae

4.35. *A guide to the Palace of Nestor: Mycenaean sites in its environs and the Chora Museum*/Carl W. Blegen and Marion Rawson. Princeton: American School of Classical Studies at Athens, 2001. 68 p. NA277 .B54 2001.

Israel and the Palestinian Territories

4.36. *The Holy Land: an archaeological guide from earliest times to 1700*/Jerome Murphy-O'Connor. 2 ed. Oxford; New York: Oxford University Press, 1986. 382 p. DS111 .M8 1986.

Italy

Abbazia di Fossanova

4.37. *L'Abbazia il Museo medievale Fossanova*/Francesca Ceci and Giovanni Maria De Rossi. Roma: Istituto Poligrafico e Zecca dello Stato, Libreria dello Stato, 2006. 96 p. 5621.P8875 C43 2006.

Abruzzo

4.38. *Lazio e Abruzzo*/Amilcare Bietti and Renata Grifoni Cremonesi. Forlì: ABACO edizioni, 1995. 270 p. GN818.L39 L39 1995.

4.39. *Abruzzo Molise: con 9 carte geografiche, 13 piante di città, 23 piante di antichità ed edifici, e 26 stemmi.* 4 ed. Milano: Touring Club Italiano, 1979. 534, 32 p. DG416.C742 A3 1979.

4.40. *Abruzzi e Molise*/Luigi V. Bertarelli. 2 ed. Milano: Unione tipografica, 1938. 400 p. 914.571 T649.

Albe

4.41. *Alba Fucens*/Fiorenzo Catalli. Roma: Istituto poligrafico e zecca dello Stato: Libraria dello Stato, 1992. 119 p. DG70.A53 C38 1992.

Altamura

4.42. *Museo archeologico nazionale, Altamura.* Roma: Istituto poligrafico e Zecca dello Stato, Libreria dello Stato, 2002. 38 p. DG975.A33 M984 2002.

Alto Adige

4.43. *Museo archeologico dell'Alto Adige: la guida*/Stefan Demetz. 2 ed. Bolzano: Folio, 2000, 1998. 43 p. DG975.A342 D46 2000.

Aosta and Piemonte

4.44. *Lombardia occidentale, Piemonte e Valle d'Aosta*/Marica Venturino Gambari, Raffaella Poggiani Keller, and Franco Mezzena. Forlì: A.B.A.C.O. edizioni, 1995.176 p. GN818.A58 L65 1995.

Lazio; Appian Way

4.45. *Via Appia*/Andrea Carbonara and Gaetano Messineo. Roma: Istituto poligrafico e Zecca dello Stato, Libreria dello Stato, 1998. 3 v. DG29.A6 C37 1998.

Rome

4.46. *Classical Rome*/H. Stuart Jones. New York: H. Holt, 1910. 372 p. 913.37 J71000.

4.47. *Guide to the public collections of classical antiquities in Rome*/Wolfgang Helbig. Leipsic: K. Baedeker, 1895–1896. 2 v. 913.37 H367.

4.48. *Ruins of Rome: a guide to the classical antiquities*/C. Wade Meade. Ruston: Palatine Publications, 1980. 256 p. DG807 .M4.

Malta

4.49. *The Tarxien temples, Tarxien*/Anthony Pace. Sta. Venera, Malta: Heritage Books; Heritage Malta, 2006. 47 p. DG999.T37 .P33 2006.

Syria

4.50. *La citadelle d'Alep et ses alentours: (édition 1930)*/Georges Ploix de Rotrou. Paris: Acanthe, 2007. 142 p. DS99.A56 P58 2007.

4.51. *Guide d'Apamée*/Jean Ch. Balty. Bruxelles: Centre belge de recherches archéologiques à Apamée de Syrie; Paris: Diffusion De Boccard, 1981. 224, 244 p. DS99.A7 B34 1981.

Turkey

4.52. *Eastern Turkey: an architectural and archaeological survey*/T. A. Sinclair. London: Pindar Press, 1987. 4 v. DS51.E27 S62 1987.

Adalar Ilcesi

4.53. *The Princes' Isles: a guide*/John Freely. Istanbul: Adalı, 2005. 120 p. DR738.5.P74 F74 2005.

Ankara

4.54. *Ankara: Haiidar-Pacha, Ankara; Bogaz-Keuy, Euyuk, Sivri-Hissar et environs, Tchangri, Yozgat, etc.: guide touristique*/Ernest Mamboury. Ankara, 1933. 314 p. DS51.A6 M36 1933.

4.55. *Ankara: the ancient sites and museums*/Vedat Idil. Istanbul: NET Turistik Yayınlar Sanayi ve Ticaret A.S., 1993. 118 p. DS51.A6 I35 1993.

Aphrodisias

4.56. *Afrodisyas*/Cengiz Bektas. Istanbul: Arkeoloji ve Sanat Yayınları, 2008. 128 p. D156.A558 B45 2008.

4.57. *Aphrodisias: a guide to the site and its museum*/Kenan T. Erim. Istanbul: NET Turistik Yayinlar, 1990, 1989. 119 p. DS156.A558 E76 1990.

Side

4.58. *Side*/Serhat Kunar. Istanbul: Net Turistik Yayinlar, 1995. 79 p. DS156.S53 K8513 1995.

United States

Massachusetts

4.59. *Greek and Roman antiquities: a guide to the classical collection*/George H. Chase. Boston, 1950. 169, 230 p. 708.1 B65.10.

New York

4.60. *A guide to the classical collections of Cornell University*/Peter I. Kuniholm, Nancy H. Ramage, and Andrew Ramage. 2 ed. Ithaca: Cornell University Press, 2010. 79 p. N5603.I8 H47 2010. Supersedes: *A guide to the classical collections of Cornell University*/Peter I. Kuniholm, Nancy H. Ramage, and Andrew Ramage. Ithaca: Herbert F. Johnson Museum of Art, Cornell University, 2003. 79 p. N5603.I4 H47 2003.

Pennsylvania

4.61. *Guide to the Etruscan and Roman worlds at the University of Pennsylvania Museum of Archaeology and Anthropology*/Donald White. Philadelphia: University of Pennsylvania Museum of Archaeology and Anthropology, 2002. 100 p. DG12.3.P48 U55 2002.

Washington, D.C.

4.62. *Library of Congress Near East collections: an illustrated guide*. Washington, DC: Library of Congress, 2001. 71 p. CC165 .H43; DS44 .L523 2001.

5
Subject Bibliographies

A bibliography is a list of books and other types of information pertaining to a particular subject. Bibliographies range from works cited lists at the end of books and articles to complete, independent publications. As separate works, they may be in bound volumes or computerized bibliographic databases.

A library catalog, while not referred to as a bibliography, is bibliographic in nature. Bibliographic works are almost always considered to be tertiary sources. Bibliographic works differ in the amount of detail, depending on the purpose. In the past, bibliography mostly focused on books. Now, bibliographies cover works in other formats, including recordings, motion pictures and videos, graphic objects, databases, CD-ROMs, and websites.

A library may have a list of its holdings published as the Library of Congress in Washington, D.C., does in its *National Union Catalog*. There are many specialized subject bibliographies of interest to ancient world scholars located throughout the holdings of a library collection. The increased amount of publication and disciplinary specialization has led to the production of bibliographies of increasingly narrow subjects. Another form of subject bibliography that has assumed importance in recent years is the reproduction of catalogs of special collections in large libraries. Often representing a body of materials on a subject acquired over a long period of years, they are significant for their rich collections.

One type of bibliography that deserves special consideration is the guide to the literature of a specific subject field. These guides have developed as a result of the increased number and complexity of reference materials in various fields and are intended to guide the novice researcher in the selection of key sources.

ANGLO-SAXONS AND CELTS

5.1. *Anglo-Saxon and Celtic bibliography, 450–1087/* Wilfrid Bonser. Oxford: B. Blackwell, 1957. Z2017 .B6.

ARCHAEOLOGY

5.2. *Bookman's guide to archaeology/*Richard Hand. Metuchen: Scarecrow Press, 1994. 1022 p. CC165 .H358 1994.

ARCHAEOLOGY, BIOLOGICAL

5.3. *Bioarchaeology of Ancient Egypt and Nubia: a bibliography/*Jerome C. Rose. London: British Museum, 1996. 110 p. CC79.E85 R67 1996.

5.4. *Bibliography of Egyptian mummification/*Betty Jones. Greeley: University of Northern Colorado, Museum of Anthropology, 1981. 26 p. GN37 .G743 no.42.

ARCHAEOLOGY, GERMAN

5.5. *Bibliographie zur archäologischen Germanenforschung. Deutschsprachige Literatur 1941–1955/*Institut für Ur- und Fruhgeschichte der Humboldt-Universität zu Berlin. Berlin: VEB Deutscher Verlag der Wissenschaften, 1966. 220 p. 913.43B B458.

ARCHAEOLOGY, MARITIME

5.6. *Coastal and maritime archaeology: a bibliography/*Jordan Kerber. Metuchen: Scarecrow Press, 1991. 400 p. CC77. U5 K47 1991.

ARCHAEOLOGY, MORTUARY

5.7. *Vestiges of mortality and remembrance: a bibliography on the historical archaeology of cem-*

eteries/Edward L. Bell. Metuchen: Scarecrow Press, 1994. 418 p. Z5133.R46 B45 1994; CC77. B8 .B45 1994.

ARCHITECTURE

5.8. *Ptolemaic temples of Egypt*/Lamia Doumato. Monticello: Vance Bibliographies, 1980. 10 p. NA215 .D69.

ART

5.9. *Greek and Roman art, architecture, and archaeology: an annotated bibliography*/William D. E. Coulson and Patricia N. Freiert. 2 ed. New York: Garland, 1987. N5610 .C68 1987. Supersedes: *Annotated bibliography of Greek and Roman art, architecture, and archaeology*/William D. E. Coulson. New York: Garland, 1975. 135 p. N5610 .C68.

ASSYRIOLOGY

5.10. *Ancient Near Eastern literature, a bibliography of one thousand items on the cuneiform literatures of the ancient world; partly annotated, and with a special section on literary contacts and interrelations between Greece and the Near East*/Louis L. Orlin. Ann Arbor: Campus Publishers, 1969. 113 p. Z7055 .O74.

5.11. *Bibliographie analytique de l'assyriologie et de l'archéologie du Proche-Orient.* Leyde: E. J. Brill, 1956. Reference Z7055 .B5, v.1(A/B)– v.2(A). Z7055 .B5.

ATHLETICS

5.12. *Greek and Roman athletics; a bibliography*/Thomas F. Scanlon. Chicago: Ares Publishers, 1984. 142 p. GV21.X1 S326 1984.

BOOK OF THE DEAD

5.13. *Bibliographie zum altägyptischen Totenbuch*/Svenja A. Gülden and Irmtraut Munro. Wiesbaden: Harrassowitz, 1998. 189 p. PJ1557 .G85 1998; coverage extended by *Bibliographie zum Altaegyptischen Totenbuch*/Burkhard Backes. 2 ed. Wiesbaden: Harrassowitz, 2009. 249 p. Z3658.L5 B53 2009.

CLASSICS

5.14. *Altertumskundliche Publikationen erschienen in der Deutschen Demokratischen Republik, 1945–1955*/Helga Kopstein. Berlin: Deutsche Akademie der Wissenschaften Verlag, 1957. 194 p. 470.6 Ak12 Bd. 11.

5.15. *Bibliographical guide to classical studies*/Graham Whitaker. Hildesheim; New York: Olms-Weidmann, 1997– . DE59 .W455 1997. 5 v. Volume 1 covers general works, history of literature, and literature Accius–Aristophanes. Set is currently up to volume 5, Seneca–Zosimos, of a projected nine volume set.

5.16. *Bibliography on the survival of the classics.* London, 1934–1938. 2 v. Z5579 .L62.

5.17. *Hand-list of books relating to the classics and classical antiquity*/J. A. Nairn. Oxford: Blackwell, 1931. 161 p. 470B N147.

5.18. *Bibliografia: sino al 1997*/Giancarlo Susini. Faenza: Fratelli Lega, 1997. 126 p. DE9.S87 R54 1997.

5.19. *Bibliographie zur klassisch-archäologischen Denkmalerkunde*/Konrad Hitzl. Subsidia classica, Bd. 9. Rahden: VML Verlag Marie Leidorf, 2007. 574 p. DE60 .H58 2007.

EGYPT, TEXTS

5.20. *Topographical bibliography of ancient Egyptian hieroglyphic texts, reliefs, and paintings*/Bertha Porter and Rosalind L. B. Moss. rev. ed. Z7064 .P84 1972. Supersedes: *Topographical bibliography of ancient Egyptian hieroglyphic texts, reliefs, and paintings*/Bertha Porter and Rosalind L. B. Moss. 2 ed. Oxford: Clarendon Press, 1960. 4 v. PJ1051 .P67 1960; Desk CD-ROM PJ1051 .P67 2004; *Topographical bibliography of ancient Egyptian hieroglyphic texts, reliefs, and paintings*/Bertha Porter and Rosalind L. B. Moss. Oxford, England: Clarendon Press, 1927. Z7064 .P84 1927.

HERODOTUS

5.21. *Herodot-Bibliographie, 1980–1988*/Frank Bubel. Hildesheim: Olms-Weidmann, 1991. PA4004 .B834 1991.

HITTITES

5.22. *Éléments de bibliographie Hittite*/G. Contenau. Paris: P. Geuthner, 1922. 137 p. Z3008.H6 C7

1922. Continued by: *Supplément aux Eléments de bibliographie hittite*/G. Contenau. Paris: P. Geuthner, 1927. 76 p. Z3008.H6 C7 1927.

5.23. *Hittites: a list of references in the New York Public Library*/Benjamin Schwartz. New York: New York Public Library, 1939. 94 p. Z3008.H6 N5 1939.

5.24. *Systematische Bibliographie der Hethitologie, 1915–1995*/Vladimír Soucek and Jana Siegelová. Praha: Národní muzeum, 1996. 3 v. DS66 .S94 1996.

INSCRIPTIONS

5.25. *Jo. Alberti Fabricii SS. theol. d. and prof. publ. Bibliographia antiquaria, sive, Introductio in notitiam scriptorum: qui antiquitates Hebraicas, Graecas, Romanas et Christianas scriptis illustraverunt: accedit Mauricii Senonensis De S. Missae ritibus carmen, nunc primum editum.* Hamburgi et Lipsiae: Impensis Christiani Liebezeit, Anno MDCCXIII [1713]. 648 p. YY.1.10. See also: *Jo. Alberti Fabricii . . . Bibliographia antiquaria, sive Introductio in notitiam scriptorum, qui antiquitates hebraicas, graecas, romanas et christianas scriptis illustraverunt.* Hamburgi et Lipsi, impensis Christiani Liebezeit, 1716. 64 p. Z5131 .F12 1716; *Jo. Alberti Fabricii . . . Bibliographia antiquaria, sive, Introductio in notitiam scriptorum: qui antiquitates Hebraicas, Graecas, Romanas et Christianas scriptis illustraverunt.* Hamburgi: Apud Ioannem Carolum Bohn, 1760. 117 p. Z5131 .F12 1760.

KASSITES

5.26. *Catalogue of cuneiform sources pertaining to specific monarchs of the Kassite dynasty*/J. A. Brinkman. Chicago: Oriental Institute of the University of Chicago, 1976. 469 p. Z3038.A3 B74 1976; Z3038.A3 B74 1976.

MUSIC

5.27. *Bibliography of sources for the study of ancient Greek music*/Thomas J. A. Mathiesen. Hackensack: Joseph Boonin, 1974. 59 p. ML114 .M3.

NUMISMATICS

5.28. *Bibliography for Aegean glyptic in the Bronze Age*/John G. Younger. Berlin: Gebr. Mann, 1991. 118 p. CD5363 .Y68 1991.

5.29. *Numismatisches Wörterbuch. Deutsch-englisch, englisch-deutsch*/Hermann Krause. München: E. Battenberg, 1971.

5.30. *Byzantine numismatic bibliography, 1950–1965*/Joel L. Malter. Chicago: Argonaut, 1968.

RELIGION

5.31. *Mentor: Guide bibliographique de la religion grecque; bibliographic survey of Greek religion*/André Motte, Vinciane Pirenne Delforge, and Paul Wathelet. Liège: Universitè de Liège, 1992. 781 p. BL782 .M46 1992.

REMOTE SENSING

5.32. *Remote sensing: aerial anthropological perspectives: A bibliography of remote sensing in cultural resource studies*/Thomas R. Lyons, Robert K. Hitchcock, and Wirth H. Wills. Washington, D.C.: Cultural Resources Management, National Park Service, U.S. Department of the Interior, 1980. 25 p. CC76.4 .L96 Suppl. no.3.

TROY

5.33. *Ensayo de una bibliografía de las leyendas troyanas en la literatura española*/Agapito Rey and Antonio García Solalinde. Bloomington: Indiana University, 1942. 103 p. 16.8609 R3321.

5.34. *Archaeology of Heinrich Schliemann: an annotated bibliographic handlist*/Curtis Runnels. 2 ed. Boston: Archaeological Institute of America, 2007. 81 p. DF212.S4 R86 2007. Supersedes: *Archaeology of Heinrich Schliemann: an annotated bibliographic handlist*/Curtis Runnels. Boston: Archaeological Institute of America, 2002. 81 p. DF212.S4 R86 2002.

UGARITIC

5.35. *Analytic Ugaritic bibliography*/Manfried Dietrich and Oswald Loretz. Kevelaer: Butzon und Bercker; Neukirchen-Vluyn: Neukirchener Verlag, 1996– . PJ4150.Z5 D548 1996. Supersedes: *Ugarit-Bibliographie*/Manfried Dietrich. Kevelaer: Butzon und Bercker, 1973–1986. 5 v. Z3013 .U35.

6
Regional Bibliographies

Bibliographies identified in Chapter 5 have a subject or topical emphasis. In this chapter, bibliographies with a more regional or geographic emphasis are presented.

AFGHANISTAN

6.1. *Afghanistan*/Schuyler Jones. Oxford: Santa Barbara: CLIO Press, 1992. 279 p. Z3016 .J66 1992.

AFRICA, EAST AND NORTHEAST

6.2. *East and northeast Africa bibliography*/Hector Blackhurst. Lanham: Scarecrow Press. 1996. 301 p. DT365.18 .B55 1996.

ALBANIA

6.3. *Albania*/Antonia Young. rev. ed. Oxford; Santa Barbara: CLIO Press, 1997. 293 p. DR910 .Y68 1997. Supersedes: *Albania*/William B. Bland. Oxford; Santa Barbara: CLIO, 1988. 290 p. DR910.Z99 B55 1988.

ALGERIA

6.4. *Algeria*/Richard I. Lawless. rev ed. Oxford; Santa Barbara: CLIO Press, 1995. 309 p. DT275 .L38 1995. Supersedes: *Algeria*/Richard I. Lawless. Oxford; Santa Barbara: CLIO Press, 1980. 215 p. DT275 .L38 1980.

6.5. *Archéologique de l'Algérie*/Stéphane Gsell. 2 ed. Alger: Agence nationale d'archéologie et de protection des sites et monuments historiques, 1997. DT281 .F73 1997.

6.6. *Bibliographie critique de sociologie, d'ethnologie et de géographie humaine du Maroc: travaux de langues anglaise, arabe, espagnole et française: arretée au 31 décembre 1965*/André Adam. Alger: Centre de recherches anthropologiques, préhistoriques et ethnographiques, 1972. 353 p. DT521 .C4 no. 20A.

6.7. *Dictionnaire géographique, administratif, postal, statistique, archéologique, etc. de la France, de l'Algérie et des colonies*/Adolphe Joanne. 2 ed. Paris: Hachette, 1872. 2,551 p. DC14 .J62.

ARMENIA

6.8. *Armenia*/Vrej Nersessian. Oxford; Santa Barbara: CLIO Press, 1993. 304 p. DK682.3 .N47 1993; DK682.3 .N47 1993.

ASSYRIA

6.9. *Nouvelles assyriologiques brèves et utilitaires.* Rouen: F. Joannès, 1987– . 4/yr. DS69.5 .N338; 2002–2007, 2009.

6.10. *Sumerologie: Einführung in die Forschung und Bibliographie in Auswahl*/W. H. Ph. Römer. 2 ed. Münster: Ugarit-Verlag, 1999. 250 p. PJ4008 .R66 1999.

6.11. *Untersuchungen zur Assyriologie und vorder-asiatischen Archäologie.* Berlin: De Gruyter, 1960– . irreg. 913.35 Un83.

AUSTRIA

6.12. *Austria*/Michael Mitchell. rev. ed. Oxford; Santa Barbara: CLIO Press, 1999. 271 p. DB17 .M58 1999. Supersedes: *Austria*/Denys Salt. Oxford;

Santa Barbara: CLIO Press, 1986. 318 p. DB3
.S35 1986.

BAHRAIN

6.13. *Bahrain*/P. T. H. Unwin. Oxford; Santa Barbara:
CLIO Press, 1984. 265 p. DS247.B2 U58 1984.

BELGIUM

6.14. *Belgium*/R. C. Riley. Oxford; Santa Barbara:
CLIO Press, 1989. 271 p. DH418 .R54 1989.

BULGARIA

6.15. *Bulgaria*/Richard J. Crampton. Oxford; Santa
Barbara: CLIO Press, 1989. 232 p. DR55 .C72
1989.

CORSICA

6.16. *Corsica*/Grace L. Hudson. Oxford; Santa Bar-
bara: CLIO Press, 1997. 198 p. DC611.C81 H8
1997.

CRETE

6.17. *Crete*/Adrian Edwards. Oxford; Santa Barbara:
CLIO Press, 1998. 134 p. DF901.C82 Z994
1998.

CROATIA

6.18. *Croatia*/Cathie Carmichael. Oxford; Santa Bar-
bara: CLIO Press, 1999. 194 p. DR1510 .C37
1999.

CYPRUS

6.19. *Cyprus*/Paschalis M. Kitromilides and Marios L.
Evriviades. rev. ed. Oxford; Santa Barbara: CLIO
Press, 1995. 264 p. DS54 .K58 1995. Supersedes:
Cyprus/Paschalis M. Kitromilides, Marios L.
Evriviades. Oxford; Santa Barbara: CLIO Press,
1982. 193 p. DS54 .K58 1982.

CZECH REPUBLIC

6.20. *Czech Republic*/Vladka Edmondson. rev. ed.
Oxford; Santa Barbara: CLIO Press, 1999. 430 p.
DB2012 .E36 1999.

DENMARK

6.21. *Denmark*/LeeAnn Iovanni. rev. ed. Oxford; Santa
Barbara: CLIO Press, 1999. 277 p. DL109 .I58
1999. Supersedes: *Denmark*/Kenneth E. Miller.
Oxford; Santa Barbara: CLIO Press, 1987. 216 p.
DL109 .M55 1987.

EGYPT

6.22. *Aegyptologie: Abriss der Entzifferungen und Forsc-
hungen auf dem Gebiete der aegyptischen Schrift,
Sprache und Alterthumskunde*/Heinrich Brugsch.
Leipzig: A. Heitz, 1897. 535 p. 913.32 B833.

6.23. *Analytical bibliography of the prehistory and the
early dynastic period of Egypt and northern Su-
dan*/Stan Hendrickx. Louvain: University Press,
1995. 328 p. DT85 .H46 1995.

6.24. *Ancient Egypt: sources of information in the New
York Public Library: a supplement, 1925–1941*.
New York: New York Public Library, 1942. 340
p. 913.32B N489 Suppl.; Supersedes: *Ancient
Egypt; sources of information in the New York
Public Library*/Ida A. Pratt. New York: New
York Public Library, 1925. 486 p. Center for
Advanced Judaic Studies Library Z3656.A2 N5
1925; reprint: *Ancient Egypt: sources of informa-
tion in the New York Public Library*/Ida A. Pratt.
New York: Kraus Reprint Corp., 1969. 486 p.
Z3656.A2 N5 1969.

6.25. *Annual Egyptological bibliography/Bibliogra-
phie égyptologique annuelle*. Leiden: E. J. Brill.
Egyptian Collection DT57 .A558.

6.26. *Bibliographie Altägypten, 1822–1946*/Chris-
tine Beinlich-Seeber. Wiesbaden: Harrassowitz,
1998. 3 v. DT56.9 .B45 1998.

6.27. *Egypt*/Ragai N. Makar. Oxford; Santa Barbara:
CLIO, 1988. 306 p. DT46.Z99 M35 1988.

6.28. *Egyptian bibliography (Jan. 1, 1939–Dec. 31,
1947)*/Walter Federn. Roma: Pontificio Istituto
Biblico, 1948–1950. 913.32B F313.

6.29. *Études et publications parues entre 1939 et
1954; répertoire bibliographique*/N. Sauneron.
Le Caire, 1956. 194 p. 913.32 C128.7 t.14.

6.30. *Grande histoire de l'égyptologie*/Erik Hornung.
Monaco: Editions du Rocher, 1998. 251 p.
PJ1071 .H614 1998.

6.31. *Historical bibliography of Egyptian prehistory/* Kent R. Weeks. Winona Lake: American Research Center in Egypt; Eisenbrauns, 1985. 138 p. GN865.E3 W43 1985.

6.32. *Litteratur pa svenska om faraonernas Egypten: en bibliografisk oversikt/* Bengt Peterson. Stockholm: Medelhavsmuseet, 1984. 12 p. DT60 .P39 1984.

6.33. *Modern Egypt, a list of references to material in the New York Public Library/* Ida A. Pratt. New York: New York Public Library, 1929. 320 p. Z3656 .N53.

6.34. *Online Egyptological bibliography.* Oxford: Griffith Institute, Faculty of Oriental Studies, University of Oxford, in cooperation with the International Association of Egyptologists. World Wide Web. Supersedes: *Egyptological bibliography/Aegyptologische bibliographie/Bibliographie Égyptologique* (1822–1997). Leiden: Netherlands Institute for the Near East, 2001– . CD-ROM DT57 .A562.

ENGLAND

6.35. *England/* Alan Day. Oxford: CLIO, 1993. 591 p. DA27.5 .D29 1993; DA27.5 .D29 1993.

ERITREA

6.36. *Eritrea/* Randall Fegley. Oxford; Santa Barbara: CLIO Press, 1995. 125 p. DT393 .F44 1995.

ETHIOPIA

6.37. *Ethiopia/* Stuart Munro-Hay and Richard Pankhurst. Oxford; Santa Barbara: CLIO, 1995. 225 p. DT373 .M867 1995.

ETRURIA

6.38. *Bibliography of Etruscan culture and archaeology, 1498–1981/* George E. Fay. Greeley: University of Northern Colorado, 1981. Z2367 .E87 1981.

6.39. *Bibliography Saggio di bibliografia etrusca/* Mario Lopes Pegna. Firenze: L. S. Olschki, 1953. 89 p. 937.5B L883.

6.40. *Etruscan painted tombs in Etruria: a bibliography/* Erik Poulsgaard Markussen. Odense: Odense Universitet, 1979. 253 p. DG223.7.T6 P68 1979. See also: *Etruria painted tombs in Etruria: catalogue/* Erik Poulsgaard Markussen.

Roma: L'Erma di Bretschneider, 1993. 192 p. DG223.7.T6 P682 1993.

6.41. *Latium, Etruria bibliographical guide to Latium and southern Etruria.* 3 ed. Rome: American Academy in Rome, 1933. 34 p. 913.456B V275. Supersedes: *Bibliographical guide to Latium and southern Etruria/* A. W. Van Buren. Rome, American Academy in Rome, 1916. 27 p. DG52 .A53 1916.

FRANCE

6.42. *France/* Frances Chambers. rev ed. Oxford; Santa Barbara: CLIO, 1990. 290 p. DC17 .C44 1990. Supersedes: *France/* Frances Chambers. Oxford; Santa Barbara: CLIO Press, 1980. 175 p. DC17 .C44 1980.

GAUL

6.43. *Bibliographie générale des Gaules: répertoire systématique et alphabétique des ouvrages, mémoires et notices concernant l'histoire, la topographie, la religion, les antiquités et le langage de la Gaule jusqu'à la fin du Ve siècle; suivi d'une table alphabétique des matières. Ire période: Publications faites depuis l'origine de l'imprimerie jusqu'en 1870 inclusivement/* Ch.-Émile Ruelle. Bruxelles: Culture et Civilisation, 1964. 944.01B R836.

GERMANY

6.44. *East Germany: the German Democratic Republic/* Ian Wallace. Oxford; Santa Barbara: CLIO Press, 1987. 293 p. DD261.Z9 W35 1987.

6.45. *West Germany: the Federal Republic of Germany/* Donald S. Detwiler and Ilse E. Detwiler. Oxford; Santa Barbara: CLIO, 1987. 353 p. DD259 .D36 1987.

GIBRALTAR

6.46. *Gibraltar/* Graham J. Shields. Oxford; Santa Barbara: CLIO Press, 1987. 100 p. DP302.G36 S56 1987.

GREAT BRITAIN

6.47. *Gazetteer of archaeological investigations in England.* York: Council for British Archaeology, 1998– . 1/yr. DA90 .G39.

6.48. *Wales*/Gwilym Huws and D. Hywel E. Roberts. Oxford; Santa Barbara: CLIO Press, 1991.247 p. DA708 .H8 1991.

GREECE

6.49. *Greece*/Thanos Veremis and Mark Dragoumis. rev ed. Oxford; Santa Barbara: CLIO Press, 1998. 388 p. DF717 .V47 1998. Supersedes: *Greece*/Mary Jo Clogg and Richard Clogg. Oxford; Santa Barbara: CLIO Press, 1980. 224 p. DF717 .C65 1980.

HUNGARY

6.50. *Hungary*/Thomas Kabdebó. Oxford; Santa Barbara: CLIO Press, 1980. 280 p. DB906 .K28 1980.

INDIA

6.51. *India*/Ian D. Derbyshire. rev. ed. Oxford; Santa Barbara: CLIO Press, 1995. 356 p. DS407 .D473 1995. Supersedes: *India*/Brijen K. Gupta and Datta S. Kharbas. Oxford; Santa Barbara: CLIO Press, 1984. 264 p. DS407 .G87 1984.

IRAN

6.52. *Iran*/Reza Navabpour. Oxford: CLIO Press, 1988. 308 p. DS251.5 .N38 1988.

6.53. *List of works in the New York Public Library relating to Persia*/Ida A. Pratt. New York: New York Public Library, 1915. 151 p. Z3370 .N56.

IRAQ

6.54. *Archaeology of Upper Mesopotamia: an analytical bibliography for the pre-classical periods*/Stefano Anastasio. Turnhout: Brepols, 1995. 247 p. Z3039.A8 A53 1995. Bibliography of archaeological excavations conducted in Iraq, Syria, and Turkey.

6.55. *Bibliography of Mesopotamian archaeological sites*/Richard S. Ellis. Wiesbaden, O. Harrassowitz, 1972. 113 p. Z3039.A8 E44.

6.56. *Iraq: a bibliographical guide*/C. H. Bleaney and G. J. Roper. Leiden; Boston: Brill, 2004. 522 p. DS79.65 .I72 2004; Supersedes: *Iraq*/C. H. Bleaney. 2 ed. Oxford; Santa Barbara: CLIO Press, 1995. 237 p. DS70.6 .A27 1995; *Iraq*/A. J. Abdulrahman. Oxford; Santa Barbara: CLIO Press, 1984. 162 p. DS70.6 .A23 1984; DS70.6 .A23 1984.

ISRAEL

6.57. *Israel and the West Bank and Gaza Strip*/C. H. Bleaney. 2 ed. Oxford; Santa Barbara: CLIO Press, 1994. 367 p. DS102.95 .B43 1994. Supersedes: *Israel*/Esther M. Snyder. Oxford; Santa Barbara: CLIO Press, 1985. 272 p. DS102.95 .S66 1985.

ITALY

6.58. *Italy*/Lucio Sponza and Diego Zancani. Oxford, Santa Barbara: CLIO Press, 1995. 417 p. DG467 .S66 1995.

6.59. *The history of archaeological research in the Melfese: a bibliography from the sites of Lavello, Melfi and Ripacandida*/Pasqualina Iosca. Oxford: Archaeopress, 2010. 79 p. DG55.B36 I67 2010.

JORDAN

6.60. *Jordan*/Vartan M. Amadouny. rev. ed. Oxford; Santa Barbara: CLIO Press, 1999. 278 p. DS153 .A63 1999. Supersedes: *Jordan*/Ian J. Seccombe. Oxford; Santa Barbara: CLIO Press, 1984. DS153 .S42 1984.

6.61. *Jordan, Lebanon, and Syria: an annotated bibliography*/Raphael Patai. New Haven: HRAF Press, 1957. 289 p. 956.9B P272.

KUWAIT

6.62. *Kuwait*/Frank A. Clements. rev. ed. Oxford; Santa Barbara: CLIO Press, 1996. 340 p. DS247. K82 C54 1996. Supersedes: *Kuwait*/Frank A. Clements. Oxford; Santa Barbara: CLIO Press, 1985. 195 p. DS247.K82 Z992 1985.

LEBANON

6.63. *Jordan, Lebanon, and Syria: an annotated bibliography*/Raphael Patai. New Haven: HRAF Press, 1957. 289 p. 956.9B P272.

6.64. *Lebanon*/C. H. Bleaney. rev ed. Oxford; Santa Barbara: CLIO Press, 1991. 230 p. DS80 .B53 1991. Supersedes: *Lebanon*/Shereen Khairallah. Oxford; Santa Barbara: CLIO Press, 1979. 154 p. DS80 .K46.

LIBYA

6.65. *Bibliographie deutschsprachiger Literatur über Libyen*/Camilla Dawletschin. Hamburg: Dokumentations-Leitstelle Moderner Orient, 1980. 90 p. Van Pelt Z3971 .D38 1980.

LIECHTENSTEIN

6.66. *Liechtenstein*/Regula A. Meier. Oxford; Santa Barbara: CLIO Press, 1993. 123 p. DB886 .M45 1993.

LUXEMBOURG

6.67. *Luxembourg*/Jules Christophory and Emile Thomas. rev. ed. Oxford; Santa Barbara: CLIO Press, 1997. 327 p. DH905 .L89 1997. Supersedes: *Luxembourg*/Carlo Hury and Jules Christophory. Oxford: Santa Barbara: CLIO Press, 1981. 184 p. DH905 .H87.

MACEDONIA

6.68. *Britanska bibliografija za Makedonija; British bibliography on Macedonia*/Hristo Andonov-Poljanski. Skopje, 1966. 512 p. 949.7B An26.

MAGHREB

6.69. *Maghreb*/Anthony G. Pazzanita. Oxford; Santa Barbara: CLIO Press, 1998. 328 p. DT185 .P39 1998.

MALTA

6.70. *Malta*/David M. Boswell and Brian W. Beeley. rev. ed. Oxford; Santa Barbara: CLIO Press, 1998. 274 p. DG989 .B67 1998. Supersedes: *Malta*/John Richard Thackrah. Oxford; Santa Barbara: CLIO Press, 1985. 163 p. DG990 .T45 1985.

MONACO

6.71. *Monaco*/Grace L. Hudson. Oxford; Santa Barbara: CLIO Press, 1991. 193 p. DC945 .H8 1991.

MOROCCO

6.72. *Morocco*/Anne M. Findlay and Allan M. Findlay. rev. ed. Oxford; Santa Barbara: CLIO, 1995. 178 p. DT305 .F56 1995. Supersedes: *Morocco*/Anne M. Findlay, Allan M. Findlay, and Richard I. Lawless. Oxford; Santa Barbara: CLIO Press, 1984. 311 p. DT305 .F56 1984.

NETHERLANDS

6.73. *Netherlands*/Peter King and Michael Wintle. Oxford; Santa Barbara: CLIO Press, 1988. 308 p. DJ18 .K56 1988.

OMAN

6.74. *Oman*/Frank A. Clements. rev. ed. Oxford; Santa Barbara: CLIO Press, 1994. 346 p. DS247.O6 C45 1994; *Oman*/Frank A. Clements. Oxford; Santa Barbara: CLIO Press, 1981. 216 p. DS247. O6 C58 1981.

PAKISTAN

6.75. *Pakistan*/David Taylor. Oxford; Santa Barbara: CLIO Press, 1990. 255 p. DS376.9 .T39 1990.

POMPEII

6.76. *Nova bibliotheca pompeiana: 250 anni di bibliografia archeologica: catalogo dei libri e degli scritti riguardanti la storia, l'arte e gli scavi di Pompei, Ercolano, Stabia ed Oplonti con numerose referenze per l'eruzione vesuviana del 79 d.C., i papiri ercolanesi, le raccolte del Museo Nazionale di Napoli e per i libri dei viaggiatori in Campania: ad uso degli studiosi, degli amatori, dei collezionisti e dei i*/Laurentino Garcia y Garcia. Monografie, 14. Roma: Bardi, 1998. 2 v. DG70.P7 Z994 1998.

PORTUGAL

6.77. *Archaologischer Wegweiser durch Portugal*/ Thomas G. Schattner. Mainz am Rhein: P. von Zabern, 1998. 236 p. DP528 .S33 1998.

6.78. *Portugal*/John Laidlar. rev. ed. Oxford; Santa Barbara: CLIO, 26.00. 293 p. DP517 .L35 26.00. Supersedes: *Portugal*/P. T. H. Unwin. Oxford; Santa Barbara: CLIO Press, 1987. 269 p. DP502 U58 1987.

QATAR

6.79. *Qatar*/P. T. H. Unwin. Oxford; Santa Barbara: CLIO Press, 1982. 162 p. DS247.Q3 U59 1982.

ROMANIA

6.80. *Romania*/Peter Siani-Davies and Mary Siani-Davies. rev. ed. Oxford: Santa Barbara: CLIO Press, 1998. 347 p. DR205 .S52 1998. Supersedes: *Romania*/Andrea Deletant and Dennis Deletant. Oxford; Santa Barbara: CLIO Press, 1985. 236 p. DR217 .D45 1985.

SAUDI ARABIA

6.81. *Saudi Arabia*/Frank A. Clements. rev. ed. Oxford: CLIO, 1988. 354 p. DS223 .C54 1988.

SCOTLAND

6.82. *Scotland*/Dennis Smith. rev. ed. Oxford; Santa Barbara: CLIO Press, 1998. DA757.5 .S65 1998. Supersedes: *Scotland*/Eric G. Grant. Oxford; Santa Barbara: CLIO Press, 1982. 408 p. 757.5 .G72 1982.

SICILY

6.83. *Sicily*/Valentina Olivastri. Oxford; Santa Barbara: CLIO Press, 1998. 188 p. DG866 .O44 1998.

SLOVENIA

6.84. *Slovenia*/Cathie Carmichael. Oxford; Santa Barbara: CLIO Press, 1996. 176 p. DR1360 .C37 1996; DR1360 .C37 1996.

SPAIN

6.85. *Spain*/Graham J. Shields. 2 ed. Oxford; Santa Barbara: CLIO, 1994. 448 p. DP3.5 .S53 1994. Supersedes: *Spain*/Graham J. Shields. Oxford; Santa Barbara: CLIO Press, 1985. 340 p. DP3.5 .S53 1985; DP3.5 .S53 1985.

SUDAN

6.86. *Sudan*/M. W. Daly. rev. ed. Oxford; Santa Barbara: CLIO Press, 1992. 194 p. DT154.6 .D34 1992; DT154.6 .D34 1992. Supersedes: *Sudan*/M. W. Daly. Oxford; Santa Barbara: CLIO Press, 1983. 175 p. DT154.6 .D34 1983.

SWITZERLAND

6.87. *Switzerland*/Heinz K. Meier and Regula A. Meier. Oxford; Santa Barbara: CLIO Press, 1990. 409 p. DQ17.Z99 M4 1990.

SYRIA

6.88. *Archaeology of Upper Mesopotamia: an analytical bibliography for the pre-classical periods*/ Stefano Anastasio. Turnhout: Brepols, 1995. 247 p. Z3039.A8 A53 1995.

6.89. *Bibliographie der archäologischen Fundstellen und Surveys in Syrien und Libanon*/Gunnar Lehmann. Rahden, Westf.: Leidorf, 2002. 718 p. CD-ROM. DS94.5 .L42 2002.

6.90. *Bibliography of Syrian archaeological sites to 1980*/Howard Bybee and Conrad L'Heureux. Lewiston: E. Mellen Press, 1994. 236 p. DS94.5 .B93 1995. Arranged alphabetically by site. Chronology, prehistory, and survey. Alphabetical list of sources. Author and heading indexes.

6.91. *Éléments d'une bibliographie française de la Syrie (géographie, ethnographie, histoire, archéologie, langues, littératures, religions)*/Paul Masson. Marseille: Typographie et lithographie Barlatier, 1919. 528 p. 913.392B M388.

6.92. *Syria*/Neil Quilliam. rev ed. Oxford; Santa Barbara: CLIO Press, 1999. 284 p. DS93 .Q55 1999. Supersedes: *Syria*/Ian J. Seccombe. Oxford; Santa Barbara: CLIO Press, 1987. 341 p. DS93. Z99 S4 1987.

TUNISIA

6.93. *Tunisia*/Allan M. Findlay, Anne M. Findlay, and Richard I. Lawless. Oxford; Santa Barbara: CLIO Press, 1982. 251 p. DT245 .F55 1982.

6.94. *Bibliographie ethno-sociologique de la Tunisie*/ André Louis. Tunis: Imprenta N. Bascone, 1977. GN649.T8 L68 1977.

TURKEY

6.95. *Turkey*/Cigdem Balim-Harding. rev. ed. Oxford; Santa Barbara: CLIO Press, 1999. 407 p. DR417 .B35 1999. Supersedes: *Turkey*/Meral Guclu. Oxford; Santa Barbara: CLIO Press, 1981. 331 p. DR417 .G83.

UNITED ARAB EMIRATES

6.96. *United Arab Emirates*/Frank A. Clements. rev. ed. Oxford; Santa Barbara: CLIO Press, 1998. 248 p. DS247.T8 C57 1998. Supersedes: *United Arab Emirates*/Frank A. Clements. Oxford; Santa Barbara: CLIO Press, 1983. 162 p. DS247.T8 C57 1983.

UZBEKISTAN

6.97. *Uzbekistan*/Reuel Hanks. Oxford; Santa Barbara: CLIO, 1999. 204 p. DK943.12 .H36 1999.

WESTERN SAHARA

6.98. *Western Sahara*/Anthony G. Pazzanita. Oxford; Santa Barbara: CLIO Press, 1996. 259 p. DT346. S7 P39 1996.

YEMEN

6.99. *Yemen*/Paul Auchterlonie. rev. ed. Oxford; Santa Barbara: CLIO Press, 1998. 348 p. DS247.Y4 A93 1998. Supersedes: *Yemen: the Yemen Arab Republic and the People's Democratic Republic of Yemen*/G. Rex Smith. Oxford; Santa Barbara: CLIO Press, 1984. 161 p. DS247.Y4 S6 1984.

YUGOSLAVIA

6.100. *Yugoslavia*/John J. Horton. rev ed. Oxford; Santa Barbara: CLIO Press, 1990. 279 p. DR1214 .H67 1990. Supersedes: *Yugoslavia*/John J. Horton. Oxford; Santa Barbara: CLIO Press, 1977. 194 p. DR305 .H67.

7
Book Reviews and Yearbooks

BOOK REVIEWS

A book review is a form of literary criticism in which a book is analyzed based on content, style, and merit. A book review could be a primary source opinion piece, summary review, or scholarly review. It is often carried out in periodicals or on the Internet. Reviews are usually published in professional journals. Length may vary from a single paragraph to a substantial essay.

7.1. *Bryn Mawr classical review* (Bryn Mawr College). PA1 .B78, v.1-9, 1990–1998; World Wide Web. Contemporary reviews of scholarly works (1990 to the present) in classical studies, including archaeology. Full-text book reviews searchable by author, title, reviewer, and keyword. Boolean searches possible. Supersedes: *Bryn Mawr Electronic Resources Review*.

7.2. *Classical review*. World Wide Web, 1887– ; five-year moving wall. *The Classical Review* publishes informative reviews from leading scholars on new work covering the literatures and civilizations of ancient Greece and Rome. Publishing over 150 high-quality reviews and fifty brief notes every year, *The Classical Review* is an indispensable reference tool, essential for keeping abreast with current classical scholarship.

YEARBOOKS

A yearbook, also known as an annual, is a book to record and highlight and commemorate significant events of the past year or a book published annually. The term may also refer to a book of statistics or facts published annually.

7.3. *Archeoarte*. Cagliari: Università degli studi di Cagliari, Dipartimento di scienze archeologiche e historico-artistiche, 2010– . http://ojs.unica.it/index.php/archeoarte/.

7.4. *The archaeologists' year book*. Park Ridge: Noyes Press, 1973–1977. 3 v. CC15 .A724, 1973, 1975.

7.5. *British archaeological yearbook*. York: Council for British Archaeology, 1995– . One per year. DA20 .A725, 1978–1990, 1992; continues *Archaeology in Britain*. London: Council for British Archaeology, 1977–1992.

7.6. *British Museum yearbook*. London: British Museum Publications, 1976– . AM101 .B844, v. 2, 4, 1976, 1978. Continues *British Museum quarterly*.

7.7. *Recent archaeological work in Palestine*/Nelson Glueck. New York: Central Conference of American Rabbis, 1929. 31 p. DS111.R3 G69 1919.

7.8. *Scripta classica Israelica*. Jerusalem: Jerusalem Academic Press, 1974– . PA1 .S3. 2011. Yearbook of the Israel Society for the Promotion of Classical Studies.

8
Dictionaries

A dictionary (also called a wordbook, lexicon, or vocabulary) is a collection of words in one or more languages, usually listed alphabetically, with usage information, definitions, etymologies, phonetics, pronunciations, and other information or a book of words in one language with their equivalents in another. Specialized subject dictionaries do not contain information about words that are used in language for general purposes but instead describe concepts in specific fields. In theory, general dictionaries are supposed to link a word to a definition, while specialized dictionaries are supposed to identify concepts and then establish the terms used to designate them. In practice, the two approaches are used for both types.

ABBREVIATIONS

8.1. *Dictionary of bibliographic abbreviations found in the scholarship of classical studies and related disciplines* / J. S. Wellington. rev. ed. Westport: Greenwood Press, 2004. 684 p. PA99 .W44 2004. This is an excellent resource for deciphering abbreviations of journals and other publications, especially older and highly specialized publications. Supersedes: *Dictionary of bibliographic abbreviations found in the scholarship of classical studies and related disciplines* / J. S. Wellington. Westport: Greenwood Press, 1983. 393 p. PA99 .W44 1983.

LANGUAGE DICTIONARIES

Arabic

8.2. *Dictionary of Arabic and allied loanwords: Spanish, Portuguese, Catalan, Galician and kindred dialects* / Federico Corriente. Leiden, Boston: Brill, 2008. 601 p. PC307.A7 C67 2008.

8.3. *A dictionary of Egyptian Arabic: Arabic-English* / Martin Hinds and El-Said Badawi. Beirut: Librairie du Liban, 1986, reprinted 2009. 981 p. PJ6795 .H56 2009.

8.4. *Everyday Arabic dictionary*. Chicago: Harper Collins, 2011. 229 p. PJ6640 .E94 2011.

Aramaic

8.5. *Aramaic (Assyrian/Syriac) dictionary & phrasebook: Swadaya-English, Turoyo-English, English-Swadaya-Turoyo* / Nicholas Awde, Nineb Lamassu, and Nicholas Al-Jeloo. New York: Hippocrene Books, 2007. 300 p. PJ5805 .A934 2007.

8.6. *Comprehensive Aramaic lexicon*. http://cal1. cn.huc.edu/. This dictionary, while still in progress by the Jewish Institute of Religion, Hebrew Union College in Cincinnati, is searchable online. "The CAL is a text base of the Aramaic texts in all dialects from the earliest (ninth century BCE) through the thirteenth century CE, currently with a database of approximately 2.5 million lexically parsed words, and an associated set of electronic tools for analyzing and manipulating the data, whose ultimate goal is the creation of a complete lexicon of the language."

8.7. *A dictionary of Jewish Babylonian Aramaic of the Talmudic and Geonic periods* / Michael Sokoloff. Ramat-Gan: Bar Ilan University Press; Baltimore: Johns Hopkins University Press, 2002. 1582 p. PJ5305 .S6 2002.

Assyrian

8.8. *al-Mujam al-mismari: mujam al-lughat al-Akadiyah wa-al-Sumariyah wa-al-Arabiyah* / Nail Ḥannun. Baghdad: Bayt al-Ḥikmah, 2001– . PJ3540 .H36 2001. Dictionary of Akkadian and Sumerian.

8.9. *Assyrian dictionary*. Chicago, v. 1– , 1956– . PJ3525 .C5. Indexing provided through *English-Akkadian analytical index to the Chicago Assyrian dictionary* / Jack M. Sasson. Chapel Hill: University of North Carolina, 1977, 1973. PJ3525 .C52 1973.

8.10. *Assyrian dictionary: intended to further the study of the cuneiform inscription of Assyria and Babylonia* / Edwin Morris. London: Williams & Northgate, 1868–1872. 3 v. N67 1868; 492.33 N794; PJ3525 .N6 1868.

8.11. *Assyrian-English-Assyrian dictionary* / Simo Parpola. Helsinki, Finland: Neo-Assyrian Text Corpus Project, Institute for Asian and African Studies, University of Helsinki, 2007. 289 p. PJ3525 .A848 2007.

8.12. *Assyrisches Handwörterbuch* / Friedrich Delitzsch. Leipzig: Zentralantiquariat der Deutschen Demokratischen Republik, 1975. 730 p. PJ3540 .D4 1975. Supersedes: *Assyrisches Handwörterbuch* / Friedrich Delitzsch. Leipzig: J. C. Hinrichs; Baltimore: John Hopkins Press, 1896. 730 p. PJ3540 .D4 1896; supplemented by *Supplement zu den Assyrischen Wörterbüchern*. Leiden: E. J. Brill, 1898. 105, 32 p. PJ3540 .D4 1898; 492.33 M47; PJ3540 .M436 1898; *Assyrisches Handwörterbuch* / Friedrich Delitzsch. Leipzig: J. C. Hinrichs; Baltimore: The Johns Hopkins Press, 1896. 730 p. 492.33 D376.

8.13. *Beiträge zum Assyrischen Wörterbuch* / Bruno Meissner. Chicago: University of Chicago Press, 1931–1932. 2 v. PJ3540 .M4 1931, v. 1. PJ3540 .M4.

8.14. *Chicago Assyrian Dictionary Project*. "The Chicago Assyrian Dictionary, initiated in 1921 by James Henry Breasted, is compiling a comprehensive dictionary of the various dialects of Akkadian, the earliest known Semitic language that was recorded on cuneiform texts that date from c. 2400 BCE to CE 100 which were recovered from archaeological excavations of ancient Near Eastern sites." http://oi.uchicago.edu/research/projects/cad/.

8.15. *A concise dictionary of the Assyrian languages* / W. Muss-Arnolt. Berlin, Reuther & Reichard; New York, Lemcke & Buchner, 1905. 2 v. PJ3523 .M8 1905; PJ3525 .M7.

8.16. *Contribution au dictionnaire sumérien-assyrien (supplément à la "classified list" de Brünnow)*. Paris: E. Leroux, 1907. 442 p. PJ3223 .F7 1907.

8.17. *Contribution au thesaurus de la langue sumérienne* / Raymond Jestin and Maurice Lambert. Paris: Collège de France, Cabinet d'assyriologie, 1954– . PJ4035 .C75 1954, fasc. 2.

8.18. *A dictionary of Assyrian botany* / R. Campbell Thompson. London: British Academy, 1949. 405 p. PJ3547 .T4 1949; 580.9352 T375; PJ3547 .T4.

8.19. *A dictionary of Assyrian chemistry and geology* / R. Campbell Thompson. Oxford: Clarendon Press, 1936. 266 p. 509.352 T375; Q127.A7 T5; PJ3547 .T42.

8.20. *L'écriture cunéiforme: syllabaire sumérien, babylonien, assyrien* / Lucien-Jean Bord and Remo Mugnaioni. Paris: P. Geuthner, 2002. 253 p. PJ3193 .B66 2002.

8.21. *Materials for a Sumerian lexicon, with a grammatical introduction . . . letters A–Z, followed by a reference-glossary of Assyrian words* / John Dyneley Prince. Leipzig: J. C. Hinrichs, 1908. 414 p. PJ4037 .P7.

8.22. *Petit lexique du sumérien à l'usage des débutants* / Lucien-Jean Bord. Paris: P. Geuthner, 2001. 181 p. for PJ4037 .B58 2001.

8.23. *Reallexikon der Assyriologie* / Erich Ebeling and Bruno Meissner. Berlin: de Gruyter, 1981. 13 v. DS69.1 .R4 1981.

8.24. *Répertoire Assyrien: traduction et lecture* / Ed. de Chossant. Lyon: Impr. A. L. Perrin et Marinet, 1879. 2 v. PJ3540 .C46 1879.

8.25. *Wörterverzeichniss zu den babylonischen Inschriften im Museum zu Liverpool nebst andern aus der Zeit von Nebukadnezzar bis Darius: Veröffentlicht in den Verhandlungen des VI. Orientalisten-Congresses zu Leiden* / J. N. Strass. Leipzig: J. C. Hinrichs, 1886. 65 p. PJ3540 .S873 1886.

Assyrian/Egyptian/Etruscan

8.26. *An archaic dictionary: biographical, historical, and mythological: from the Egyptian, Assyrian, and Etruscan monuments and papyri* / W. R. Cooper. Detroit: Gale Research Co., 1969. 668 p. DS61 .C65 1969. Reprint of: *A dictionary from the Egyptian, Assyrian, and Etruscan monuments and papyri biographical, historical, and mythological* / W. R. Cooper. London: S. Bagster, 1882. 668 p. DS61 .C65 1882.

Babylonian

8.27. *Old Babylonian text corpus*. Pilsen, Czech Republic: Cuneiform Circle. The Old Babylonian Text Corpus (OBTC) comprises a large text database of the Old Babylonian Akkadian language (currently 144,097 text lines, letters, documents, legal texts, royal inscriptions, omina, mathematical texts, etc.). http://klinopis.cz/.

Chaldean

8.28. *Chaldean-Arabic dictionary* / Eugene Manna. Piscataway: Gorgias Press, 2007. 853 p. PJ5493. A7 M366 2007.

Coptic

8.29. *A compendious grammar of the Egyptian language as contained in the Coptic and Sahidic dialects: with observations on the Bashmuric: together with alphabets and numerals in the hieroglyphic and enchorial characters* / Rev. Henry Tattam. London: J. and A. Arch, 1830. 152, 24 p. 493.1 T18.

Egyptian

8.30. *Archaic dictionary: biographical, historical, and mythological: from the Egyptian, Assyrian, and Etruscan monuments and papyri* / W. R. Cooper. Detroit: Gale, 1969. 668 p. DS61 .C65 1969. Supersedes: *Dictionary from the Egyptian, Assyrian, and Etruscan monuments and papyri biographical, historical, and mythological* / W. R. Cooper. London: S. Bagster, 1882. 668 p. DS61 .C65 1882.

8.31. *A dictionary of Egyptian Arabic Arabic-English* / Martin Hinds and el-Said Badawi. Beirut: Librairie du Liban, 1986. 981 p. PJ6795 .H54 1986; PJ6795 .H56.

8.32. *An Egyptian hieroglyphic dictionary: with an index of English words, king list, and geographical list with indexes, list of hieroglyphic characters, Coptic and Semitic alphabets, etc.* / E. A. Wallis Budge. New York: Dover Publications, 1978. 2 v. PJ14PJ1425 .B8 1978. Supersedes: *An Egyptian hieroglyphic dictionary: with an index of English words, king list and geographical list with indexes, list of hieroglyphic characters, Coptic and Semitic alphabets, etc.* / E. A. Wallis Budge. London: J. Murray, 1920. 1356 p. PJ1425 .B8 1920.

8.33. *Etymological dictionary of Egyptian* / Gábor Takács. Leiden; Boston: Brill, 1999. 3 v. PJ1351 .T35 1999.

8.34. *A hieroglyphic dictionary of Egyptian coffin texts* / Rami van der Molen. Leiden; Boston: Brill, 2000. 912 p. PJ1554 .M65.

8.35. *Kleines Wörterbuch der Ägyptologie* / Wolfgang Helck and Eberhard Otto. Wiesbaden: O. Harrassowitz, 1956. 418 p. 913.32 H367.

8.36. *Lexikon der Ägyptologie* / Wolfgang Helck und Eberhard Otto. Wiesbaden: O. Harrassowitz, 1972– . 7 v. PJ1031 .H4.

Egyptian, Late

8.37. *A dictionary of late Egyptian* / Leonard H. Lesko. Berkeley: B.C. Scribe Publications, 1982. 5 v. PJ1425 .D53 1982.

Egyptian, Middle

8.38. *A concise dictionary of middle Egyptian* / Raymond O. Faulkner. Oxford: Griffith Institute; Ashmolean Museum, 1996. 327 p. PJ1425 .F3 1996. Supersedes: *A concise dictionary of middle Egyptian* / Raymond O. Faulkner. Oxford: Griffith Institute, Ashmolean Museum, 1986. 327 p. PJ1425 .F38 1986; 493.03 F274; *A concise dictionary of middle Egyptian* / Raymond O. Faulkner. Oxford: Printed for the Griffith Institute at the University Press by V. Ridler, 1962. 327 p. PJ1425 .F3; 493.03 F274. See also: *English-Egyptian index of Faulkner's concise dictionary of middle Egyptian* / David Shennum. Malibu: Undena Publications, 1977. 178 p. PJ1425.F38 S53 1977; PJ1425 .S5.

Elamite

8.39. *Elamisches Wörterbuch* / Walther Hinz and Heidemarie Koch. Berlin: D. Reimer, 1987. 2 v. P943 .H56 1987.

8.40. *Peuple et la langue des Mèdes* / Jules Oppert. Paris: Maisonneuve, 1879. 296 p. 495.95 Op56.

Etruscan

8.41. *Dizionario della lingua etrusca* / Arnaldo D'Aversa. Brescia: Paideia, 1994. 69 p. P1078. Z5 D38 1994.

8.42. *La langue étrusque* / Jules Martha. Paris: E. Leroux, 1913. 493 p. 477.5 M364.

8.43. *La lingua etrusca: grammatica e lessico* / Massimo Pittau. Nùoro: Insula, 1997. 235 p. P1078 .P584 1997.

8.44. *Thesaurus linguae Etruscae* / Massimo Pallottino. 2 ed. Pisa: F. Serra, 2009– . P1078.Z5 T47 2009. Supersedes: *Thesaurus linguae Etruscae* / Maristella Pandolfini Angeletti. Roma: Consiglio nazionale delle ricerche, Centro di studio per l'archeologia etrusco-italica, 1978– . P1078.Z5 T47, v. 1(1-2), suppl. 1, 2.

8.45. *A vocabulary of Etruscan: including the Etruscan glosses* / Claudio R. Salvucci. Southampton: Evolution, 1998. 45 p. P1078 .S25 1998.

Gaelic

8.46. *Historical dictionary of Gaelic placenames* /
Pádraig Ó Riain, Diarmuid Ó Murchadha, and
Kevin Murray. London: Irish Texts Society,
2003. DA869 .H57 2003.

Greek

8.47. *Greek-English lexicon* / Henry George Liddell
and Robert Scott. Oxford: Clarendon Press; New
York: Oxford University Press, 1996. 2042, 320
p. PA445.E5 L6 1996b.

8.48. *Greek grammar* / William W. Goodwin. rev. ed.
Boston: Ginn, 1899, c1892. 451 p. PA258 .G66
1899.

8.49. *Greek grammar* / Herbert Weir Smyth. Cam-
bridge: Harvard University Press, 1984. 784 p.
PA254 .S59 1984; PA254 .S6 1984.

8.50. *Greek grammar of the New Testament and other
early Christian literature* / F. Blass and A. De-
brunner. Chicago: University of Chicago Press,
1961. 325 p. PA813 .B513 1961.

8.51. *A Greek-Hebrew / Aramaic two-way index to
the Septuagint* / T. Muraoka. Louvain; Walpole:
Peeters, 2010. 383 p. BS1122.H32 M87 2010.

8.52. *Lexicon historiographicum graecum et latinum*
/ Carmine Ampolo and Ugo Fantasia. Pisa: Ed-
izioni della Normale, 2004. 2 v. PA1139.I8 L49
2004.

Hebrew

8.53. *The concise dictionary of classical Hebrew* /
David J. A. Clines. Sheffield: Sheffield Phoenix
Press, 2009. 496 p. PJ4833 .C66 2009.

8.54. *Retrograde Hebrew and Aramaic dictionary* /
Ruth Sander and Kerstin Mayerhofer. Göttingen:
Vandenhoeck & Ruprecht, 2010. 258 p. PJ4825
.S36 2010.

Hittite

8.55. *Ankara Arkeoloji Muzesinde Bulanan Bogazkoy
tabletleri II = Bogazkoy tablets in the Archaeo-
logical Museum of Ankara II; Rukiye Akdogan;
katalog ve dizin; catalog and index* / Oguz
Soysal. Chicago: Oriental Institute of the Univer-
sity of Chicago, 2011. 52, 64 p. P945 .A2 2011b.

8.56. The *Chicago Hittite Dictionary Project* (CHD)
was officially started in 1975 . . . in answer to
a recognized need for a Hittite-English lexical
tool, a concordance for lexicographical research
for all parts of the corpus of Hittite texts. http://
oi.uchicago.edu/research/projects/hit/.

8.57. *Etymological dictionary of the Hittite inherited
lexicon* / Alwin Kloekhorst. Leiden; Boston:
Brill, 2008. 1162 p. P945 .Z8 2008.

8.58. *Hethitisches Handwörterbuch: mit dem Worts-
chatz der Nachbarsprachen* / Johann Tischler.
2 ed. Innsbruck: Institut für Sprachen und Lit-
eraturen der Universitaät Innsbruck, 2008. 337 p.
P945.Z8 T584 2008.

Hurrian (Language)

8.59. *Hurritischen Ritualtermini in hethitischem Kon-
text* / Volkert Haas. Roma: CNR-Istituto per gli
studi Micenei ed Egeo-Anatolici, 1998. 349 p.
P958 .C67 1984 Bd.9.

Indo-European (Languages)

8.60. *Indo-European etymological dictionaries online*
/ Alexander Lubotsky. Leiden; Boston: Brill.
http://iedo.brillonline.nl/dictionaries/.

Italian

8.61. *Oxford-Paravia Italian dictionary: English-Ital-
ian, Italian-English; Oxford Paravia il Dizion-
ario: Inglese/Italiano, Italiano/Inglese*. 3 ed. Ox-
ford: Oxford University Press; Milano: Paravia,
2010. 2,777 p. PC1640 .O94 2010.

Kurdish

8.62. *Yad dictionary: English-Arabic-Kurdish* / Pirs-
ing Heme Emin Ehmed. 3 ed. Tihran: Nesri Ihsn,
2006. 1237, 17 p. PK6906 .Y33 2006.

Latin

8.63. *Allen and Greenough's new Latin grammar:
founded on comparative grammar* / J. B. Gre-
enough. New Rochelle: Aristide D. Caratzas,
1992. 490 p. PA2087 .A525 1992.

8.64. *Botanical Latin: history, grammar, syntax, termi-
nology, and vocabulary* / William T. Stearn. 4 ed.
Portland: Timber Press, 1995. 546 p. QK10 .S7
1995.

8.65. *Cassell's Latin dictionary: Latin-English, Eng-
lish-Latin* / D. P. Simpson. London: Cassell; New
York: Macmillan, 1977. 883 p. PA2365.E5 C3
1977.

8.66. *Copious and critical English-Latin dictionary*
/ William Smith and Theophilus D. Hall. New
York: American Book Company, 1871. 754 p.
PA2365 .E5 S6 1871.

8.67. *Database of Latin dictionaries.* Online collection of Latin dictionaries, including 1. Albert Blaise, *Dictionnaire latin-français des auteurs chrétiens.* 2. *Firminus Verris Dictionarius / Dictionnaire latin-français* de Firmin Le Ver / B. Merrilees and W. Edwards. 3. C. du Fresne ("du Cange"), *Glossarium ad scriptores mediae et infimae latinitatis.*

8.68. *Etymological dictionary of Latin and the other Italic languages* / Michiel de Vaan. Leiden; Boston Brill, 2008. 825 p. PA2518 .V33 2008.

8.69. *Latin dictionary: founded on Andrews' edition of Freund's Latin dictionary.* rev. ed. London, New York: Oxford University Press, 1980. PA2365. E6 A6 1980.

8.70. *Oxford Latin dictionary* / P. G. W. Ware. rev ed. Oxford, England: Clarendon Press; New York: Oxford University Press, 1996. 2,126 p. PA2365. E5 O9 1996. Supersedes: *Oxford Latin dictionary* / P. G. W. Ware. Oxford, England: Clarendon Press; New York: Oxford University Press, 1968–1982. 2,126 p. PA2365 .E5 G44 1982; PA2365.E5 O9 1982; *Oxford Latin dictionary.* Oxford, England: Clarendon Press, 1968–1980. 8 v. PA2365 .E5 O9. Dictionary for classical Latin. Latin-English only.

8.71. *The pocket Oxford Latin dictionary: English-Latin-English* / James Morwood. Oxford; New York: Oxford University Press, 2003. Supersedes: *The pocket Oxford Latin dictionary* / James Morwood. 2 ed. Oxford: Oxford University Press, 2000. 357 p. PA2365.E5 P63 2000.

8.72. *Thesaurus linguae latinae.* Berlin: Walter de Gruyter. Online version of the *Thesaurus Linguae Latinae* (TLL), a comprehensive, ongoing scholarly dictionary of ancient Latin from the earliest times through CE 600. http://www.thesaurus.badw.de/english/index.htm.

8.73. *Vocabula francusia (CVP 2598) von 1409/10: ein Glossar aus dem Umkreis König Wenzels IV* / Oskar Pausch. Wien: Verlag der Österreichischen Akademie der Wissenschaften, 2010. 128 p. AS142 .V31 Bd.812.

Parthian

8.74. *Word-list of Manichaean Middle Persian and Parthian* / Mary Boyce. Téhéran-Liège: Bibliothèque Pahlavi; Leiden: E. J. Brill, 1977. 172 p. PK6177.E5 B69.

8.75. *Glossaire des inscriptions pehlevies et parthes* / Philippe Gignoux. London: Corpus Inscriptionem Iranicarem; Lund Humphries, 1972. 68 p. PK6177.F7 G5.

Persian

8.76. *Farsi: Farsi-English English-Farsi dictionary and phrasebook* / Nicholas Awde and Camilla Shahribaf. New York: Hippocrene, 2006. 219 p. PK6379 .A88 2006.

Phoenician

8.77. *A comparative Semitic lexicon of the Phoenician and Punic languages* / Richard S. Tomback. Missoula: Scholars Press for the Society of Biblical Literature, 1978. 361 p. PJ4185 .T65 1978a.

8.78. *Dictionnaire de la civilisation phénicienne et punique.* Turnhout: Brepols, 1992. 502, 16 p. DS81 .D533 1992.

8.79. *Phoenician-Punic dictionary* / Charles R. Krahmalkov. Leuven, Belgium: Uitgeverij; Peeters: Departement Oosterse Studies, 28.00. 499 p. PJ4185 .K73 2000.

Pushto

8.80. *Afghan English Pashto dictionary* / Mirwais Khan. Quetta: Siddiqi Booksellers, 2009. 432 p. PK6791 .K45 2009.

Sumerian

8.81. *Contribution au dictionnaire sumérien-assyrien (supplément à la "Classified list" de Brünnow)* / Charles Fossey. Paris: E. Leroux, 1907. 442 p. PJ3223 .F7 1907.

8.82. *Études orientales* / Hilaire de Barenton. Paris: P. Geuthner, 1920–1937. 10 v. PJ27 .H5 1920. Includes grammars and dictionaries for Egyptian, Etruscan, and Sumerian languages.

8.83. *Innsbrucker sumerisches Lexikon (ISL) des Instituts für Sprachen und Kulturen des Alten Orients an der Universität Innsbruck. Abteilung I, Sumerisches Lexikon zu den zweisprachigen literarischen Texten.* Innsbruck: Institut für Sprachwissenschaft der Universität Innsbruck, 1990. PJ4037 .I55 1990.

8.84. *Materials for a Sumerian lexicon, with a grammatical introduction . . . letters A–Z, followed by a reference-glossary of Assyrian words* / John Dyneley Prince. Leipzig: J. C. Hinrichs, 1908. 414 p. PJ4037 .P7.

8.85. *Mesopotamisches Zeichenlexikon* / Rykle Borger. 2 ed. Munster: Ugarit-Verlag, 2010. 736 p. PJ3223 .B62 2010. Supersedes: *Mesopotamisches Zeichenlexikon* / Rykle Borger. Münster: Ugarit-Verlag, 2004. 712 p. PJ3223 .B62 2004.

8.86. *Pennsylvania Sumerian Dictionary Project.* Allows one to search the dictionary, index to Sumerian secondary literature, and the sign list carried out in the Babylonian section of the University of Pennsylvania Museum of Anthropology and Archaeology. The Pennsylvania Sumerian Dictionary Project is easily searchable by sign. Every entry includes cuneiform logograms used for that word, a translation, historical period, translation in Akkadian, and additional forms attested and references used. http://psd.museum.upenn.edu/epsd/index.html.

8.87. *Sumerian dictionary of the University Museum of the University of Pennsylvania* / Ake W. Sjoberg. Philadelphia: Babylonian Section of the University Museum, 1984– . PJ4037 .S86 1984. v.

8.88. *Sumerian lexicon: a dictionary guide to the ancient Sumerian language* / John A. Halloran. Los Angeles: Logogram, 2006. 318 p. PJ4037 .H35 2006; PJ4037 .H35 2006. See also: *Sumerian lexicon v.3.0* / John A. Halloran. http://www.sumerian.org/sumerlex.htm. This online lexicon contains 1,255 Sumerian logogram words and 2,511 Sumerian compound words.

8.89. *Sümerisches Lexikon* / Anton Deimel. Roma: Sumptibus Pontificii Instituti Biblici, 1928–1950. 4 v. Reference Folio PJ4037 .D35 1930; Libra 492.39 D367, t. 1, 2(1-4), 3(1-2), 4(1-2); 492.39 D367, t. 1, 2(1-4); PJ4037 .D352, t.1, 2(1-4), 3(1-2).

8.90. *Sumerisches Lexikon zu "George Reisner, Sumerisch-babylonische Hymnen nach Thontafeln griechischer Zeit (Berlin 1896)" (SBH) und zu verwandten Texten* / Karl Oberhuber. Innsbruck: Verlag des Instituts für Sprachwissenschaft der Universität Innsbruck, 1990. 585 p. PJ4037 .O24 1990.

8.91. *Wörterverzeichniss zu den babylonischen Inschriften im Museum zu Liverpool nebst andern aus der Zeit von Nebukadnezzar bis Darius: Veröffentlicht in den Verhandlungen des VI. Orientalisten-Congresses zu Leiden* / J. N. Strassmaier. Leipzig: J. C. Hinrichs, 1886. 65 p. PJ3540 .S873 1886.

Syriac (Language)

8.92. *Aramaic (Assyrian/Syriac) dictionary & phrasebook: Swadaya-English, Turoyo-English, English-Swadaya-Turoyo* / Nicholas Awde, Nineb Lamassu, and Nicholas Al-Jeloo. New York: Hippocrene Books, 2007. 300 p. BCEPJ5805 .A934 2007.

Tajik

8.93. *Tajik practical dictionary: Tajik-English, English-Tajik* / Jon Jilani. New York: Hippocrene Books, 2009. 326 p. PK6976 .J55 2009.

Tamazight

8.94. *Amawal n tmaziyt tartar; Lexique de berbère moderne* / Mouloud Mammeri. Alger: CNRPAH, 2008. 154 p. PJ2349 .M364 2008.

8.95. *Dictionnaire des noms et prénoms berbères* / Shamy Chemini. Tizi Ouzou, Alger: L'Odyssée, 2006. 183 p. CS3080.B47 S43 2006.

Turkish/Hebrew (Language)

8.96. *Turkce-Ibranice/Ibranice-Turkce sozluk; Turkish-Hebrew/Hebrew-Turkish dictionary* / Israel Benyakar. Tel Aviv: Itahdut Yotsei Turkiya Be Israel, 2011. PJ4837 .B46 2011; PJ4837 .B46 2011.

REGIONAL DICTIONARIES

Afghanistan

8.97. *Historical dictionary of Afghanistan* / Ludwig W. Adamec. 3 ed. Lanham: Scarecrow Press, 2003. 585 p. DS356 .A27 2003. Supersedes: *Historical dictionary of Afghanistan* / Ludwig W. Adamec. 2 ed. Lanham: Scarecrow Press, 1997. 499 p.: map; 23 cm. DS356 .A27 1997; South Asia Reference DS356 .A27 1997; *Historical dictionary of Afghanistan* / Ludwig W. Adamec. Metuchen: Scarecrow Press, 1991. 376 p. DS356 .A27 1991.

Africa

8.98. *Historical dictionary of pre-colonial Africa* / Robert O. Collins. Lanham: Scarecrow Press, 2001. 617 p. DT17 .C65 2001.

Albania

8.99. *Historical dictionary of Albania* / Raymond Hutchings. Lanham: Scarecrow Press, 1996. 277 p. DR927 .H88 1996.

Algeria

8.100. *Historical dictionary of Algeria* / Phillip Chiviges Naylor and Alf Andrew Heggoy. 2 ed. Metuchen: Scarecrow Press, 1994. 443 p. DT283.7 .N39

1994. Supersedes: *Historical dictionary of Algeria* / Alf Andrew Heggoy. Metuchen: Scarecrow Press, 1981. 237 p. DT283.7 .H43.

Armenia

8.101. *Historical dictionary of Armenia* / Rouben Paul Adalian. 2 ed. Lanham: Scarecrow Press, 2010. 674 p. DS173 .A33 2010. Supersedes: *Historical dictionary of Armenia* / Rouben Paul Adalian. Lanham; Oxford: Scarecrow Press, 2002. 427 p. DS173 .A33 2002.

Austria

8.102. *Historical dictionary of Austria* / Paula Sutter Fichtner. 2 ed. Lanham: Scarecrow Press, 2009. Supersedes: *Historical dictionary of Austria* / Paula Sutter Fichtner. Lanham: Scarecrow Press, 1999. 301 p. DB35 .F53 1999.

Azerbaijan

8.103. *Historical dictionary of Azerbaijan* / Tadeusz Swietochowski and Brian C. Collins. Lanham; London: Scarecrow Press, 1999. 145 p. DK693.7 .H57 1999.

Belgium

8.104. *Historical dictionary of Belgium* / Robert Stallaerts. Lanham: Scarecrow Press, 1999. 303 p. DH511 .S73 1999.

Bulgaria

8.105. *Historical dictionary of Bulgaria* / Raymond Detrez. Lanham: Scarecrow Press, 1997. 466 p. DR65 .D48 1997.

Crimea

8.106. *Entsiklopediia krymskikh drevnostei: arkheologicheskii slovar Kryma* / G. M. Burov. Kiev: Stilos, 2006. 527 p. DK508.9.K78 B87 2006.

Croatia

8.107. *Historical dictionary of the Republic of Croatia* / Robert Stallaerts and Jeannine Laurens. Metuchen: Scarecrow Press, 1995. 341 p. DR1507.5 .S74 1995.

Cyprus

8.108. *Historical dictionary of Cyprus* / Stavros Panteli. Lanham: Scarecrow Press, 1995. 223 p. DS54. S28 P36 1995.

Egypt

8.109. *Historical dictionary of Egypt* / Arthur Goldschmidt, Jr. Metuchen: Scarecrow Press, 1994. 369 p. DT75 .G65 1994. Supersedes: *Historical dictionary of Egypt* / Joan Wucher King. Metuchen: Scarecrow Press, 1984. 719 p.

Eritrea and Ethiopia

8.110. *Historical dictionary of Eritrea* / Tom Killion. Lanham: Scarecrow Press, 1998. 535 p. DT394 .K55 1998. Supersedes: *Historical dictionary of Ethiopia and Eritrea* / Chris Prouty and Eugene Rosenfeld. 2 ed. Metuchen: Scarecrow Press, 1994. 614 p., 1994. DT381 .R57 1994; *Historical dictionary of Ethiopia* / Chris Prouty and Eugene Rosenfeld. Metuchen: Scarecrow Press, 1981. 436 p. DT381 .R57.

France

8.111. *Historical dictionary of France* / Gino Raymond. Lanham: Scarecrow Press, 1998. 347 p. DC35 .R39 1998.

Gaul

8.112. *Civilisation gallo-romaine de A à Z* / André Pelletier. Lyon: Presses universitaires de Lyon, 1993. 257 p. DC63.A3 P45 1993.

8.113. *Dictionnaire historique de la Gaule: des origines à Clovis: d'après des documents originaux et des textes du XIXe siècle et contemporains* / Jean-Pierre Picot. Paris: La Différence, 2002. 733 p. DC35 .P53 2002.

Germany

8.114. *Historical dictionary of Germany* / Wayne C. Thompson, Susan L. Thompson, and Juliet S. Thompson. Metuchen: Scarecrow Press, 1994. 637 p. DD84 .T48 1994.

Greece

8.115. *Historical dictionary of Greece* / Thanos M. Veremis and Mark Dragoumis. Metuchen: Scarecrow Press, 1995. 258 p. DF802 .V47 1995.

Gulf Arab States

8.116. *Historical dictionary of the Gulf Arab states* / Malcolm C. Peck. 2 ed. Lanham: Scarecrow Press, 2008. 397 p. DS247.A15 P43 2008. Supersedes: *Historical dictionary of the Gulf Arab States* / Malcolm C. Peck. Lanham: Scarecrow Press, 1997. 324 p. DS247.A15 P43 1997.

Hungary

8.117. *Historical dictionary of Hungary* / Steven Béla Várdy. Lanham: Scarecrow Press, 1997. 813 p. DB904 .V37 1997.

India

8.118. *Historical dictionary of ancient India* / Kumkum Roy. Lanham: Scarecrow Press, 2009. 431 p. DS451 .R66 2009.

8.119. *Historical dictionary of India* / Surjit Mansingh. 2 ed. Lanham: Scarecrow Press, 2006. 833 p. DS405 .M27 2006. Supersedes: *Historical dictionary of India* / Surjit Mansingh. Lanham: Scarecrow Press, 1996. 511 p. DS405 .M27 1996.

Iran

8.120. *Historical dictionary of Iran* / John H. Lorentz. 2 ed. Lanham: Scarecrow Press, 2007. 479 p. DS270 .L67 2007. Supersedes: *Historical dictionary of Iran* / John H. Lorentz. Metuchen: Scarecrow Press, 1995. DS270 .L67 1995.

Iraq

8.121. *Historical dictionary of Iraq* / Edmund A. Ghareeb. Lanham: Scarecrow Press, 2004. 459 p. DS70.9 .G47 2004.

Ireland

8.122. *Dictionary of Irish archaeology* / Laurence Flanagan. Savage: Barnes and Noble Books, 1992. 221 p. DA920 .F57 1992; DA920 .F57 1992.

Israel

8.123. *Historical dictionary of ancient Israel* / Niels Peter Lemche. Lanham: Scarecrow Press, 2004. 303 p. DS102.8 .L38 2004.

8.124. *Historical dictionary of Israel* / Bernard Reich and David H. Goldberg. 2 ed. Lanham: Scarecrow Press, 2008. 636 p. DS126.5 .R38 2008. Supersedes: *Historical dictionary of Israel* / Bernard Reich. Metuchen: Scarecrow Press, 1992. 353 p. DS126.5 .R38 1992.

Jordan

8.125. *Historical dictionary of the Hashemite Kingdom of Jordan* / Peter Gubser. Metuchen: Scarecrow Press, 1991. 140 p. DS154 .G83 1991.

Kyrgyzstan

8.126. *Historical dictionary of Kyrgyzstan* / Rafis Abazov. Lanham: Scarecrow Press, 2004. 381 p. DK918.12 .A23 2004.

Lebanon

8.127. *Historical dictionary of Lebanon* / Asad Abu Khalil. Lanham, London: Scarecrow Press, 1998. 269 p. DS80.9 .A34 1998; DS80.9 .A34 1998.

Libya

8.128. *Historical dictionary of Libya* / Ronald Bruce St. John. 3 ed. Lanham, London: Scarecrow Press, 1998. 452 p. DT223.3 .S7 1998. Supersedes: *Historical dictionary of Libya* / Ronald Bruce St. John. 2 ed. Metuchen: Scarecrow Press, 1991. 192 p. DT223.3 .S7 1991; *Historical dictionary of Libya* / Lorna Hahn. Metuchen: Scarecrow Press, 1981. 116 p. DT214 .H34.

Luxembourg

8.129. *Historical dictionary of Luxembourg* / Harry C. Barteau. Lanham: Scarecrow Press, 1996. 260 p. DH908 .B37 1996.

Macedonia

8.130. *Historical dictionary of the Republic of Macedonia* / Valentina Georgieva and Sasha Konechni. Lanham: Scarecrow Press, 1998. 359 p. DR2175.5 .G46 1998.

Malta

8.131. *Historical dictionary of Malta* / Warren G. Berg. Lanham: Scarecrow Press, 1995. 163 p. DG989.8 .B47 1995.

Moldova

8.132. *Historical dictionary of the Republic of Moldova* / Andrei Brezianu. Lanham: Scarecrow Press, 28.00. 274 p. DK509.37 .B74 2000.

Morocco

8.133. *Historical dictionary of Morocco* / Thomas K. Park. rev ed. Lanham: Scarecrow Press, 1996. 540 p. DT313.7 .P37 1996. Supersedes: *Historical dictionary of Morocco* / William Spencer. Metuchen: Scarecrow Press, 1980. 152 p. DT313.7 .S63.

Netherlands

8.134. *Historical dictionary of the Netherlands* / Arend H. Hussen Jr. Lanham: Scarecrow Press, 1998. 237 p. DH101 .H88 1998.

Pakistan

8.135. *Historical dictionary of Pakistan* / Shahid Javed Burki. 3 ed. Lanham: Scarecrow Press, 2006. 583 p. DS382 .B87 2006; Detroit: Gale Group, 2008. Supersedes: *Historical dictionary of Pakistan* / Shahid Javed Burki. Metuchen: Scarecrow Press, 1991. 254 p. DS382 .B87 1991; South Asia Reference DS382 .B87 1991; *Historical dictionary of Pakistan* / Shahid Javed Burki. 2 ed. Metuchen: Scarecrow Press, 1999. 403 p. DS382 .B87 1991.

Palestine

8.136. *Historical dictionary of Palestine* / Nafez Y. Nazzal and Laila A. Nazzal. Lanham: Scarecrow Press, 1997. 304 p. DS102.8 .N397 1997.

Portugal

8.137. *Historical dictionary of Portugal* / Douglas L. Wheeler and Walter C. Opello Jr. 3 ed. Lanham: Scarecrow Press, 2010. 396 p. DP535 .W44 2010. Supersedes: *Historical dictionary of Portugal* / Douglas L. Wheeler. 2 ed. Metuchen: Scarecrow Press, 2002. 271 p. DP535 .W44 2002; *Historical dictionary of Portugal* / Douglas L. Wheeler. Metuchen: Scarecrow Press, 1993. 288 p. DP535 .W44 1993.

Rome

8.138. *Ancient Roman writers* / Ward W. Briggs. Detroit: Gale Group, 1999. 438 p. PA6013 .A53 1999.

8.139. *Pictorial dictionary of ancient Rome* / Ernest Nash. 2 ed. New York, Praeger, 1968. 2 v. A general index of Roman sites, arranged in alphabetical order by name and containing a description of their location and history, as well as a bibliography. NA310 .N28 1968; Supersedes: *Pictorial dictionary of ancient Rome* / Ernest Nash. New York: Praeger, 1961–1962. 2 v. 913.371 R66Na.

8.140. *Topographical dictionary of ancient Rome* / Samuel Ball Platner; revised by Thomas Ashby. London, Oxford University Press, H. Milford, 1929. 608 p. DG16 .P685.

Romania

8.141. *Historical dictionary of Romania* / Kurt W. Treptow and Marcel Popa. Lanham: Scarecrow Press, 1996. 311 p. DR215 .T74 1996.

Saudi Arabia

8.142. *Historical dictionary of Saudi Arabia* / J. E. Peterson. 2 ed. Lanham: Scarecrow Press, 2003. 259 p. DS221 .P48 2003. Supersedes: *Historical dictionary of Saudi Arabia* / J. E. Peterson. Metuchen: Scarecrow Press, 1993. 245 p. DS221 .P48 1993.

Somalia

8.143. *Historical dictionary of Somalia* / Margaret Castagno. Metuchen: Scarecrow Press, 1975. 213 p. DT401 .C3.

Spain

8.144. *Historical dictionary of Spain* / Angel Smith. Lanham: Scarecrow Press, 1996. 435 p. DP12 .S59 1996.

Sudan

8.145. *Historical dictionary of the Sudan* / Richard A. Lobban, Jr., Robert S. Kramer, Carolyn Fluehr-Lobban. 3 ed. Lanham: Scarecrow Press, 2002. 396 p. DT155.3 .V64 2002. Supersedes: *Historical dictionary of the Sudan* / Carolyn Fluehr-Lobban, Richard A. Lobban, Jr., and John Obert Voll. 2 ed. Metuchen: Scarecrow Press, 1992. 409 p. DT155.3 .V64 1992. *Historical dictionary of the Sudan* / John Obert Voll. Metuchen: Scarecrow Press, 1978. 175 p. DT155.3 .V64; DT155.3 .V64.

Syria

8.146. *Historical dictionary of Syria* / David Commins. 2 ed. Lanham, MD; Oxford: Scarecrow Press, 2004. 340 p. DS94.9 .C66 2004. Supersedes: *Historical dictionary of Syria* / David Commins.

Lanham: Scarecrow Press, 1996. 300 p. DS94.9
.C66 1996.

Tajikistan

8.147. *Historical dictionary of Tajikistan* / Kamoludin
Abdullaev and Shahram Akbarzadeh. 2 ed. Lan-
ham: Scarecrow Press, 2010. 448 p. DK922.14
.A23 2010. Supersedes: *Historical dictionary of
Tajikistan* / Kamoludin Abdullaev and Shahram
Akbarzadeh. Lanham: Scarecrow Press, 2002.
284 p. DK922.14 .A23 2002.

Tunisia

8.148. *Historical dictionary of Tunisia* / Kenneth J.
Perkins. 2 ed. Lanham: Scarecrow Press, 1997.
311 p. DT244 .P47 1997. Supersedes: *Histori-
cal dictionary of Tunisia* / Kenneth J. Perkins.
Metuchen: Scarecrow Press, 1989. 234 p. DT244
.P47 1989.

Turkey

8.149. *Historical dictionary of Turkey* / Metin Heper
and Nur Bilge Criss. 3 ed. Lanham: Scarecrow
Press, 2009. 480 p. DR436 .H47 2009. Super-
sedes: *Historical dictionary of Turkey* / Metin
Heper. 2 ed. Lanham: Scarecrow Press, 2002.
343 p. DR436 .H47 2002; *Historical dictionary
of Turkey* / Metin Heper. Metuchen: Scarecrow
Press, 1994. 593 p. DR436 .H47 1994.

Turkmenistan

8.150. *Historical dictionary of Turkmenistan* / Rafis
Abazov. Lanham: Scarecrow Press, 2005. 240 p.
DK938.12 .A2 2005.

United Kingdom

8.151. *Historical dictionary of the United Kingdom* /
Kenneth J. Panton and Keith A. Cowland. Lan-
ham: Scarecrow Press, 1997–1998. 2 v. DA34
.P36 1997.

Western Sahara

8.152. *Historical dictionary of Western Sahara* / An-
thony G. Pazzanita and Tony Hodges. 2 ed.
Metuchen: Scarecrow Press, 1994. 560 p. DT346.
S7 P39 1994. Supersedes: *Historical dictionary
of Western Sahara* / Tony Hodges. Metuchen:
Scarecrow Press, 1982. 431 p. DT346.S7 H57.

Yemen

8.153. *Historical dictionary of Yemen* / Robert D. Bur-
rowes. 2 ed. Lanham: Scarecrow Press, 2010. 533
p. DS247.Y45 B87 2010. Supersedes: *Historical
dictionary of Yemen* / Robert D. Burrowes. Lan-
ham: Scarecrow Press, 1995. 507 p. DS247.Y45
B87 1995.

SUBJECT DICTIONARIES

Archaeology

8.154. *Archaeology field dictionary: English-Russian-
English; Anglo-russkii i russko-ankliiskii polevoi
arkheologicheskii slovar* / Nikita Khrapunov. 2
ed. Austin: Institute of Classical Archaeology,
University of Texas at Austin, 2007. 216 p. CC70
.K48 2007.

8.155. *Concise Oxford dictionary of archaeology* /
Timothy Darvill. 2 ed. Oxford; New York: Ox-
ford University Press, 2008. 547 p. CC70 .D37
2008. Supersedes: *Concise Oxford dictionary
of archaeology* / Timothy Darvill. Oxford; New
York: Oxford University Press, 2003. 506 p.
CC70 .D37 2003; *Concise Oxford dictionary of
archaeology* / Timothy Darvill. Oxford; New
York: Oxford University Press, 2002. 506 p.
CC70 .D37 2002.

8.156. *Denkmäler des Klassischen Altertums zur Er-
lauterung des Lebens der Griechen und Römer
in Religion, Kunst, und Sitte* / A. Baumeister
and B. Arnold. München und Leipzig, R. Old-
enbourg, 1889. 3 v. DE5 .B38 1889; 913.36
B327.

8.157. *Dictionary of archaeological terms: English-
Greek/Greek-English; Lexiko archaiologikon
oron: Anglika-Hellenika/Hellenika-Anglika*
/ Nikos Koutsoumpos. Oxford: Archaeopress,
2011. 92 p. CC70 .K68 2011.

8.158. *Dictionary of archaeology* / Warwick Bray and
David Trump. London: Allen Lane, 1970. 288 p.
CC70 .B73.

8.159. *Dictionary of archaeology* / Ian Shaw and Rob-
ert Jameson. Oxford, Malden: Blackwell, 1999.
624 p. CC70 .D53 1999. Includes short defini-
tions and longer articles on recent archaeologi-
cal theory and applications with bibliographies
of primary and recent sources. Some maps and
drawings. China, Japan, and Oceania are cov-
ered.

8.160. *Dictionary of artifacts* / Barbara Ann Kipfer.
Malden, Oxford: Blackwell, 2007. 345 p. CC70
.K55 2007.

8.161. *Dictionary of concepts in archaeology* / Molly Raymond Mignon. Westport: Greenwood Press, 1993. 364 p. CC70 .M45 1993.

8.162. *Elsevier's dictionary of archaeological materials and archaeometry in English with translations of terms in German, Spanish, French, Italian, and Portuguese* / Zvi Goffer. Amsterdam and New York: Elsevier, 1996. 445 p. CC70 .G64 1996. Old and New World; origins of civilizations, historical archaeology, twentieth century archaeology. Maps, chronologies/timelines, index.

8.163. *Oxford companion to archaeology* / Brian M. Fagan. Oxford; New York: Oxford University Press, 1996. http://www.oxfordreference.com/view/10.1093/acref/9780195076189.001.0001/acref-9780195076189.

8.164. *Penguin archaeology guide* / Paul Bahn. rev. ed. London: Penguin Books; New York: Penguin Putnam, 2001. 494 p. CC70 .P46 2001.

Architecture

8.165. *Dictionary of ancient Near Eastern architecture* / Gwendolyn Leick. London; New York: Routledge, 1988. 261 p. Entries include references. NA212 .L45 1988.

Art

8.166. *Dictionary of Greek and Roman antiquities* / William Smith. 3 American ed. New York: American Book Company, 1843. 1,124 p., 1914. 2 v. Supersedes: 913.36 Sm67.1c; *Dictionary of Greek and Roman antiquities* / William Smith. 3 ed. London: J. Murray, 1914. 2 v. DE5 .S6 1914; 913.36 Sm671a; *Dictionary of Greek and Roman antiquities* / William Smith. 3 ed. London: J. Murray, 1901. 2 v. H003 Sm68a; *Dictionary of Greek and Roman antiquities* / William Smith. 3 ed. London: J. Murray, 1890–1891. 2 v. 913.36 Sm671; *Dictionary of Greek and Roman antiquities* / William Smith. London: J. Murray, 1882. 1,293 p. DE5 .S75 1882; *Dictionary of Greek and Roman antiquities* / William Smith. London: J. Murray, 1878. 3 v. 30.1 Sm6D; *Dictionary of Greek and Roman antiquities* / William Smith. London: J. Murray, 1872. 1,293 p. DE5 .S6 1872; *Dictionary of Greek and Roman antiquities* / William Smith. 2 ed. Boston: C. Little and J. Brown, 1870. 1,293 p. DE5 .S6 1870; *Smaller dictionary of Greek and Roman antiquities: abridged from the larger dictionary* / William Smith. 4 ed. London: J. Murray, 1860. 437 p. DE5 .S6623 1860; *Dictionary of Greek and Roman antiquities* / William Smith. 2 ed. London: Taylor, Walton, and Maberly, 1848. 1,293 p. DE5 .S6 1848.

8.167. *Dictionary of pictorial subjects from classical literature: a guide to their identification in works of art* / Percy Preston. New York: Scribner, 1983. 311 p. N7760 .P68 1983.

8.168. *Oxford dictionary of art* / Ian Chilvers. 3 ed. Oxford: Oxford University Press, 2004. 816 p. Fine Arts Library N33 .O93 2004. Supersedes: *Oxford dictionary of art* / Ian Chilvers and Harold Osborne. 2 ed. Oxford; New York: Oxford University Press, 2001. 647 p. N33 .O93 2001; *Oxford dictionary of art* / Ian Chilvers and Harold Osborne. Oxford: Oxford University Press, 1997. 647 p. Fine Arts Library Reference N33 .O93 1997; *Oxford Dictionary of Art* / Ian Chilvers and Harold Osborne. Oxford, New York: Oxford University Press, 1988. 548 p. N33 .O93 1988.

8.169. *Oxford dictionary of art and artists* / Ian Chilvers. 4 ed. Oxford: Oxford University Press, 2009. 694 p. World Wide Web.

8.170. *Dictionary of Greek and Roman biography and mythology* / William Smith. New York: AMS Press, 1967. 3 v. DE5 .S7 1876. Supersedes: *Dictionary of Greek and Roman biography and mythology* / William Smith. London: J. Murray, 1880. 3 v. DE5 .S7 1880; *Dictionary of Greek and Roman biography and mythology* / William Smith. London: J. Murray, 1876. 3 v. DE5 .S7 1876; *Dictionary of Greek and Roman biography and mythology* / William Smith. New York: AMS Press, 1967. 3 v. DE5 .S7 1876; *Dictionary of Greek and Roman biography and mythology* / William Smith. Boston: Little Brown, 1870. 3 v. H003 Sm68b; *Dictionary of Greek and Roman biography and mythology* / William Smith. Boston: Little Brown, 1859. 3 v.; *Dictionary of Greek and Roman biography and mythology* / William Smith. London: Taylor and Walton, 1844–1849. 3 v. DE5 .S7 1844; 913.36 Sm67a.

Athens

8.171. *Bildlexikon zur Topographie des Athen* / John Travlos. Tübingen: E. Wasmuth, 1971. 590 p. N5650 .T7; DF261 .A8 T73 1988.

8.172. *Pictorial dictionary of ancient Athens* / John Travlos. New York: Praeger, 1971. 590 p. NA280 .T68. A general index of Athenian sites or monuments, arranged in alphabetical order by name and containing a description of location and history, as well as a bibliography.

Attica

8.173. *Bildlexikon zur Topographie des Antiken Attika* / John Travlos. Tübingen: Wasmuth, 1988. DF 261 .A8 .T74 1988. Essays, photographs, maps, site plans, architectural drawings, and extensive bibliographies.

Bible

8.174. *The Harper Collins Bible dictionary.* 3 ed. / Mark Allan Powell. New York: Harper One, 2011. 1,142, 32 p. BS440 .H235 2011.

8.175. *Zondervan dictionary of biblical imagery* / John A. Beck. Grand Rapids: Zondervan, 2011. 282 p. BS537 .B43 2011.

Botany

8.176. *A dictionary of Bible plants* / Lytton John Musselman. New York: Cambridge University Press, 2012. 173, 36 p. BS665 .M86 2012.

Byzantium

8.177. *Historical dictionary of Byzantium* / John H. Rosser. 2 ed. Lanham: Scarecrow Press, 2012. 591 p. DF552 .R67 2012. Supersedes: *Historical dictionary of Byzantium* / John H. Rosser. Lanham: Scarecrow Press, 2001. 479 p. DF552 .R67 2001.

8.178. *Oxford dictionary of Byzantium* / Alexander P. Kazhdan. New York: Oxford University Press, 1991. 3 v. DF521 .O93 1991. Covers all facets of Byzantine history and civilization from the fourth to fifteenth centuries including the late Roman period. Bibliographies at the ends of the articles emphasize major works.

Catalans

8.179. *Historical dictionary of the Catalans* / Helena Buffery and Elisenda Marcer. Lanham: Scarecrow Press, 2011. DP302 .C59 2011.

Classical World

8.180. *Classical dictionaries: past, present and future* / Christopher Stray. London: Duckworth, 2010. 229 p. PA51 .C54 2010.

8.181. *Cambridge dictionary of classical civilization* / Graham Shipley. Cambridge: Cambridge University Press, 2006. 966 p. DE5 .28 2006. Encyclopedia with 1,700 brief entries; illustrations.

8.182. *Civilization of the Ancient Mediterranean* / Michael Grant and Rachel Kitzinger. New York:

Scribner's, 1988. 3 v. DE59 .C55 1988. Articles and excellent bibliographies on all aspects of the ancient world. Unlike the *Oxford Classical Dictionary* or the *Oxford Companion*, the focus here is on broad themes, not isolated facts. Essay-length articles by leading American and British scholars on topics such as "Roman Divination," "Food and Foodstuffs," and "Book Production" are grouped under headings such as "Economy," "Private and Social Life," etc. Very brief chronological overviews of Greek and Roman history precede, along with a time line from 2000 BCE to 529 CE, giving historical and literary milestones.

8.183. *Dictionary of Greek and Latin authors and texts* / Manfred Landfester. Leiden, Boston: Brill, 2009. 694 p. PA31 .G4713 2009.

8.184. *A dictionary of Greek and Roman culture* / William Smith, William Wayte, and G. E. Marandin. London, New York: I. B. Tauris, 2008. 2 v.

8.185. *The Grove encyclopedia of classical art and architecture* / Gordon Campbell. Oxford, New York: Oxford University Press, 2007. 2 v. http://www.oxfordreference.com/view/10.1093/acref/9780195300826.001.0001/acref-9780195300826.

8.186. *Oxford Classical Dictionary* / S. Hornblower and A. Spawforth. 3 ed. Oxford, New York: Oxford University Press, 2003. 1,640 p. DE5 .O9 2003. Scholarly dictionary with both brief entries and longer survey articles covering all aspects of the classical tradition. Bibliographies accompany most articles. A compact edition, *The Oxford Companion to Classical Civilization* / Simon Hornblower, has the same articles, minus the bibliographies, with larger print and attractive illustrations. Supersedes: *Oxford Classical Dictionary* / N. G. L. Hammond. 2 ed. Oxford, England: Oxford University Press, 1970. 1,176 p. DE5 .O9 1970. Also available online via the database *Past masters*. The primary resource for names of places, people, and things, as well as any technical terms in either ancient or modern usage, in classical studies. Entries are short but fairly detailed.

8.187. *Oxford dictionary of the classical world* / John Roberts. Oxford: Oxford University Press, 2005– . 858 p. DE5 .O94 2005. Based on information in the *Oxford Classical Dictionary* with more than 2,500 entries on the civilizations of ancient Greece and Rome.

Egyptians

8.188. *A concise dictionary of Egyptian archaeology: a handbook for students and travellers* / M. Bro-

drick and A. A. Morton. 5 ed. London: Methuen, 1945. 193 p. DT58 .B8 1945; 913.32 B7831 1945. Supersedes: *A concise dictionary of Egyptian archaeology: a handbook for students and travellers* / M. Brodrick and A. A. Morton. 3 ed. London: Methuen, 1924. 193 p. DT58 .B8 1924; *A concise dictionary of Egyptian archaeology: a handbook for students and travellers* / M. Brodrick and A. A. Morton. 3 ed. London: Methuen; New York: Dutton, 1902. 198 p. DT58 .B8 1902.

8.189. *Dictionary of ancient Egypt* / Ian Shaw and Paul Nicholson. New York: Harry N. Abrams, 1995. 328 p. Entries include sites, biographies, objects, and cultural aspects. Most entries have a list of references in chronological order. Many illustrations, site plans, and maps. DT58 .S55 1995.

8.190. *Dictionary of Egyptian civilization* / Georges Posener. New York: Tudor, 1959. 323 p. 913.32 P843; DT58 .P65313 1959.

8.191. *Dictionary of Egyptian gods and goddesses* / George Hart. London; Boston: Routledge & Kegan Paul, 1986. 229 p. BL2450.G6 H37 1986. Supersedes: *The gods and symbols of ancient Egypt an illustrated dictionary* / Manfred Lurker. New York: Thames and Hudson, 1980. 142 p. BL2428 .L8713 1980.

8.192. *A dictionary of Pharaonic medicine.* Cairo: National Publication House, 1967. 509 p. R127.3 .K3.

8.193. *Dictionary of Egyptian civilization* / Georges Posener. New York: Tudor Publishing, 1959. 323 p. DT58 .P65313 1959.

8.194. *Dictionnaire de la civilisation égyptienne* / Guy Rachet. Paris: Larousse-Bordas, 1998. 268 p. DT58 .R33 1998.

8.195. *Historical dictionary of ancient Egypt* / Morris L. Bierbrier. 2 ed. Lanham: Scarecrow Press, 2008. 429 p. BCEDT83 .B56 2008. Supersedes: *Historical dictionary of ancient Egypt* / Morris L. Bierbrier. Lanham: Scarecrow Press, 1999. 303 p. DT83 .B56 1999.

8.196. *Historical dictionary of ancient Egyptian warfare* / Robert G. Morkot. Lanham: Scarecrow Press, 2003. l, 315 p. DT81 .M67 2003; DT81 .M67 2003.

8.197. *Papyrus Carlsberg nr.VII. Fragments of a hieroglyphic dictionary* / Erik Iversen. Kobenhavn: I kommission hos Munksgaard, 1958. 30 p. AS281 .D2144 bd.3 nr.1-2.

8.198. *The Routledge dictionary of Egyptian gods and goddesses* / George Hart. 2 ed. London; New York: Routledge, 2005. 170 p. BL2450.G6 H37 2005.

8.199. *Symbole der alten Ägypter: Einführung und kleines Wörterbuch* / Manfred Lurker. Weilheim: O. W. Barth, 1964. 152 p. 913.32 L978.

Etruscans

8.200. *Dizionario della civiltà etrusca* / Mauro Cristofani. Firenze: Giunti, 1999. 340 p. DG223.3 .D59 1999. DG223 .S776 2009. DG223.3 .B89 1984.

8.201. *Historical dictionary of the Etruscans* / Simon K. F. Stoddart. Lanham: Scarecrow Press, 2009. 320 p. DG223 .S776 2009.

Geography

8.202. *Dictionary of Greek and Roman geography* / William Smith. New York: AMS Press, 1966. 2 v. DE25 .S66 1966. Supersedes: *Dictionary of Greek and Roman geography* / William Smith. London: J. Murray, 1873–1878. 2 v. DE25 .S66 1878; *Dictionary of Greek and Roman geography* / William Smith. London: Walton, 1870. 2 v. 911.36 Sm67b; *Dictionary of Greek and Roman geography* / William Smith. Boston: Little, Brown and Co., 1854–1857. 2 v. 911.36 Sm67; DE25 .S662 1854; H003 Sm68d.

8.203. *International dictionary of historic places* / Trudy Ring. Chicago: Fitzroy Dearborn, 1995. 5 v. CC135 .I585 1995. Lengthy essays on selected sites with illustrations and bibliographies; contents. v. 1. Americas; v. 2. Northern Europe; v. 3. Southern Europe; v. 4. Middle East and Africa; v. 5. Asia and Oceania.

Greeks

8.204. *Historical dictionary of ancient Greek warfare* / Iain G. Spence. Lanham: Scarecrow Press, 2002. 391 p. U33 .S64 2002.

History

8.205. *Dictionary of ancient history* / G. Speake. Oxford; Cambridge: Blackwell Reference, 1994. 758 p. DE5 .D53 1994. Covering 776 BCE to 476 CE. This fairly comprehensive dictionary has a focus on history and does not exclude any topic except mythology.

Hittites

8.206. *Catalogue des documents royaux hittites du IIe millénaire avant J.-C.* / Hatice Gonnet. Paris: Éditions du Centre national de la recherche scientifique, 1975. 24 p. CD5357 .G66.

8.207. *Historical dictionary of the Hittites* / Charles Burney. Lanham: Scarecrow Press, 2004. 364 p. DS66 .B87 2004.

Islam

8.208. *Historical dictionary of prophets in Islam and Judaism* / Scott B. Noegel and Brannon M. Wheeler. Lanham: Scarecrow, 2002. 522 p. BM645.P67 N64 2002.

Ismaili

8.209. *Historical dictionary of the Ismailis* / Farhad Daftary. Lanham: Scarecrow Press, 2012. 265 p. BP195.I8 D323 2012.

Jews

8.210. *Historical dictionary of the Jews* / Alan Unterman. Lanham: Scarecrow Press, 2011. 225 p. DS114 .U58 2011.

Literature

8.211. *Metzler Lexikon antiker Literatur: Autoren, Gattungen, Begriffe* / Bernhard Zimmermann. Stuttgart: Metzler, 2004. 216 p. PA31 .M48 2004. Supersedes: *Metzler Lexikon antiker Autoren* / Oliver Schütze. Stuttgart: Metzler, 1997. 791 p. PA3005 .M489 1997.

8.212. *Metzler Lexikon Antike* / Kai Brodersen and Bernhard Zimmermann. Stuttgart: Metzler, 2006. 703 p. DE5 .M48 2006.

Mesopotamia

8.213. *Dictionnaire de la civilisation mésopotamienne* / Francis Joannès. Paris: R. Laffont, 2001. 974 p. DS69.1 .D53 2001.

8.214. *Historical dictionary of Mesopotamia* / Gwendolyn Leick. 2 ed. Lanham: Scarecrow Press, 2010. 269 p. DS70.82 .L45 2010. Supersedes: *Historical dictionary of Mesopotamia* / Gwendolyn Leick. Lanham, Oxford: Scarecrow Press, 2003. 187 p. DS70.82 .L45 2003.

Middle Ages

8.215. *Dictionnaire du Moyen Age* / Claude Gauvard, Alain de Libera, and Michel Zink. Paris: Presses universitaires de France, 2002. 1548 p. CB351 .D53 2002.

8.216. *Dictionary of medieval civilization* / Joseph Dahmus. New York: Macmillan, 1984. 700 p. CB351 .D24 1984.

Mythology

8.217. *Cassell dictionary of classical mythology* / Jenny March. London: Cassell, 1988. 416 p. BL715 .M37 1988.

8.218. *Concise dictionary of Greek and Roman mythology* / Michael Stapleton. New York: P. Bedrick Books; Harper and Row, 1986. 306 p. BL715 .S71986. Supersedes: *Illustrated dictionary of Greek and Roman mythology* / Michael Stapleton. New York: P. Bedrick, 1982. 224 p. BL715 .S7 1986b.

8.219. *A dictionary of ancient Near Eastern mythology* / Gwendolyn Leick. London; New York: Routledge, 1998. 199 p. BL1060 .L44 1998. Supersedes: *A dictionary of ancient Near Eastern mythology* / Gwendolyn Leick. London; New York: Routledge, 1991. 199 p. BL1060 .L44 1991.

8.220. *Dictionary of classical mythology* / S. C. Woodhouse. London: George Rutledge and Sons; New York: E. P. Dutton, 1900. 271 p. BL715 .W85 1900z. Substantive entries, some with photos, on the figures of classical mythology. Includes scholarly references and genealogical table.

8.221. *Dictionary of classical mythology* / Pierre Grimal. Oxford; New York: Blackwell, 1996. 603 p. BL715 .G713 1996. Supersedes: *The dictionary of classical mythology* / Pierre Grimal. New York: Blackwell, 1985, 1986. 603 p. BL715 .G713 1986. The best "one-stop" source for finding out the stories of individual figures in classical mythology. English translation of *Dictionnaire de la mythologie grecque et romaine*.

8.222. *Dictionary of classical mythology symbols, attributes, and associations* / Robert E. Bell. Santa Barbara: ABC-CLIO, 1982. 390 p. BL715 .B44; BL715 .B44.

8.223. *Lexicon iconographicum mythologiae classicae (LIMC)* / Fondation pour le Lexicon iconographicum mythologiae classicae (LIMC) / John Boardman. Zurich: Artemis Verlag, 1981–2009. 18 v. + index (2 v.) + supplements (2 v.). N7760 .L49.

8.224. *New century handbook of Greek mythology and legend* / Catherine B. Avery. New York: Appleton-Century-Crofts, 1972.

Near East

8.225. *Dictionary of the ancient Near East* / Piotr Bienkowski and Alan Millard. London: British Museum Press; Philadelphia: University of Pennsylvania Press, 2000. 342 p. DS56 .D5 2000. Covers Anatolia, Mesopotamia, the Levant, and the Arabian Peninsula from the earliest times to the fall of Babylon in 539 BCE.

Ottoman Empire

8.226. *Historical dictionary of the Ottoman Empire* / Selcuk Aksin Somel. 2 ed. Lanham: Scarecrow Press, 2012. 497 p. DR436 .S66 2012. Supersedes: *Historical dictionary of the Ottoman Empire* / Selcuk Aksin Somel. Lanham, Oxford: Scarecrow Press, 2003. 399 p. BCEDR436 .S66 2003.

Phoenicians

8.227. *Dictionnaire de la civilisation Phenicienne et Punique* / Edouard Lipinski. Turnhout: Brepols, 1992. 502 p. DS81.

Pottery

8.228. *Atlante delle forme ceramiche*. Roma: Istituto della Enciclopedia Italiana, 1981– . 2 v. N31 .E482.

8.229. *Pottery through the ages* / George Savage. Hammondsworth: Penguin, 1959. 247 p. Libra 738.3 Sa92.

Religion

8.230. *The concise Oxford dictionary of the Christian church* / E. A. Livingstone. 2 ed. Oxford; New York: Oxford University Press, 2006. http://www.oxfordreference.com/view/10.1093/acref/9780198614425.001.0001acref-9780198614425.

8.231. *The Cambridge dictionary of Christianity* / Daniel Patte. Cambridge; New York: Cambridge University Press, 2010. 1,343 p. BR95 .C24 2010.

8.232. *Dictionary of Roman religion* / Lesley Adkins and Roy A. Adkins. New York: Facts on File, 1996. 288 p. BCEBL798 .A35 1996; BL798 .A35 1996.

8.233. *Dictionnaire des antiquités grecques et romaines, d'après les textes et les monuments* / C. Daremberg and E. Saglio. Paris: Hachette, 1877–1919. 10 v. BCEDE5 .D21 1877; DE5 .D21 1877; Libra A903 D246.

8.234. *The Eerdmans dictionary of early Judaism* / John J. Collins and Daniel C. Harlow. Grand Rapids: William B. Eerdmans, 2010. 1360 p. BM176 .E34 2010.

8.235. *Gods, demons, and symbols of ancient Mesopotamia: an illustrated dictionary* / Jeremy Black and Anthony Green. 2 ed. London: Published by British Museum Press for the Trustees of the British Museum, 1998. 192 p. BL2350.I7 B57 1998. Supersedes: *Gods, demons, and symbols of ancient Mesopotamia: an illustrated dictionary* / Jeremy Black and Anthony Green. Austin: University of Texas Press, 1992. 192 p. BL2350.I7 B57 1992; BL2350.I7 B57 1992; BL2350.I7 B57 1992b.

8.236. *The Oxford dictionary of the Jewish religion* / Adele Berlin. 2 ed. New York: Oxford University Press, 2011. 934 p. BM50 .O94 2011.

8.237. *Untersuchungen zur altassyrischen religion* / Hans Hirsch. Graz, 1961. 104 p. BL1620 .H57.

Toponyms

8.238. *Guide to the ancient world: a dictionary of classical place-names* / Michael Grant. Bronx: H. W. Wilson, 1986. 728 p. BCEDE25 .G72 1986.

8.239. *Lexicon of the Greek and Roman cities and place names in antiquity, ca 1500 BCE-ca CE 500* / K. Branigan. Amsterdam: A. M. Hakkert, 1992– . Reference Room, DE25 .L49 1992, fsc. 1-2, 8; DE25 .L49 1992. Dictionary of names in classical geography.

8.240. *Lexicon topographicum urbis Romae* / Eva Margareta Steinby. Roma: Quasar, 1993– . 28.00. 6 v. BCEDG63 .L49 1993; Classics Resource Room DG63 .L49 1993. Continued by *Lexicon topographicum urbis Romae. Supplementum*, 1. Roma: Quasar, 2005. BCEDG63 .L493 2005; Classics Resource Room DG63 .L493 2005.

8.241. *Lexicon topographicum urbis Romae: Suburbium* / Adriano La Regina. Roma: Quasar, 2001– . 5 v. BCEDG63 .L492 2001; Classics Resource Room DG63 .L492 2001.

8.242. *New topographical dictionary of ancient Rome* / Lawrence Richardson. Baltimore: Johns Hopkins University Press, 1992. 458 p. Alphabetical arrangement of entries, the longer ones with bibliographies and ancient literary references. Illustrations and site plans. Chronological list of dated monuments. Fine Arts Library DG68 .R5 1992; DG68 .R5 1992; Classics Resource Room DG68 .R5 1992. Supersedes: *Topographical dictionary of ancient Rome* / Samuel B. Platner. Completed and revised by Thomas Ashby. London: Oxford University Press, H. Milford, 1929. 608 p. Fine Arts Library Rare Books DG16 .P685; DG16 .P685; DG16 .P685.

Vikings

8.243. *Historical dictionary of the Vikings* / Katherine Holman. Lanham: Scarecrow Press, 2003. 383 p. BCEDL65 .H62 2003; DL65 .H62 2003.

Warfare

8.244. *Historical dictionary of ancient Egyptian warfare* / Robert G. Morkot. Lanham: Scarecrow Press, 2003. 1,315 p. BCEDT81 .M67 2003; DT81 .M67 2003.

9

Encyclopedias

An *encyclopedia* (also spelled *encyclopaedia* or *encyclopædia*) is a type of reference work, a compendium holding a summary of information from either all branches of knowledge or a particular branch of knowledge. Encyclopedias are divided into articles or entries, which are usually accessed alphabetically by article name. Encyclopedia entries are longer and more detailed than those in most dictionaries. Generally speaking, unlike dictionary entries, which focus on linguistic information about words, encyclopedia articles focus on factual information to cover the thing or concept for which the article name stands.

AFRICA

9.1. *Cambridge encyclopedia of Africa* / Roland Oliver and Michael Crowder. Cambridge; New York: Cambridge University Press, 1981. 492 p. DT3 .C35 1981.

9.2. *New encyclopedia of Africa* / John Middleton. 2 ed. Detroit: Charles Scribner's Sons, 2008. 5 v. DT2 .N48 2008.

Africa, North

9.3. *Cities of the Middle East and North Africa: a historical encyclopedia* / Michael R. T. Dumper and Bruce E. Stanley. Santa Barbara: ABC-CLIO, 2007. 439 p. HT147.5 .C574 2007.

ANTHROPOLOGY

9.4. *The Routledge encyclopedia of social and cultural anthropology* / Alan Barnard and Jonathan Spencer. 2 ed. London; New York: Routledge, 2010. 855 p. GN307 .R68 2010.

ARCHAEOLOGY

9.5. *Archaeological method and theory: an encyclopedia* / Linda Ellis. New York: Garland, 2000. 705 p. CC75 .A654 29.00. Covers analytical technology, legislation, conservation techniques, and research from prehistoric to contemporary periods throughout the world. Contributed articles.

9.6. *Laboratory techniques in archaeology: a guide to the literature, 1920–1980* / Linda Ellis. New York: Garland, 1982. 419 p. CC75 .E44 1982.

9.7. *Cambridge encyclopedia of archaeology* / Andrew Sherrat. New York: Crown Publishers, 1980. 495 p. CC165 .C3 1980.

9.8. *Companion encyclopedia of archaeology* / Graeme Barker. London; New York: Routledge, 1999. 2 v. CC70 .C59 1999. Twenty-nine essays by individual authors are grouped under three headings: origins, aims, and methods; themes and approaches; and writing archaeological history. Each essay includes an extensive list of references and a short select bibliography. Photographs, drawings, tables, and plans.

9.9. *Encyclopedia of archaeology* / Deborah M. Pearsall. San Diego: Elsevier/Academic Press, 2008. 3 v. CC70 .E53 2008.

9.10. *Encyclopedia of archaeology: history and discoveries* / Tim Murray. Santa Barbara: ABC-CLIO, 2001. 3 v. CC100 .E54 2001.

9.11. *Illustrated world encyclopedia of archaeology: a remarkable journey around the world's major ancient sites from Stonehenge to the pyramids at Giza and from Tenochtitlán to Lascaux Cave in France* / Paul Bahn. London: Lorenz, 2007. 256 p. CC70 .I55 2007.

9.12. *Milestones in archaeology: a chronological encyclopedia* / Tim Murray. Santa Barbara: ABC-CLIO, 2007. 639 p. CC100 .M87 2007.

9.13. *The world encyclopedia of archaeology* / Aedeen Cremin. Richmond Hill, Ontario: Firefly Books, 2007. 400 p. CC70 .W68 2007.

ARCHAEOLOGY, HISTORICAL

9.14. *Encyclopedia of historical archaeology* / Charles E. Orser, Jr. London; New York: Routledge, 2002. 607 p. CC77.H5 E53 2002.

ARCHAEOLOGY, INDUSTRIAL

9.15. *Blackwell encyclopedia of industrial archaeology* / Barrie Trinder. Oxford; Cambridge: Blackwell, 1992. 964 p. T37 .E53 1992. Monuments, settlements, and landscapes of thirty-one countries in Europe, Canada, the United States, and Australasia from 1650 to 1950; bibliography of almost 3,000 sources.

ARCHAEOLOGY, PREHISTORIC

9.16. *Encyclopedia of human evolution and prehistory* / Eric Delson. 2 ed. New York: Garland, 2013. 753 p. GN281 .E53 2013. Supersedes: *Cambridge encyclopedia of human evolution* / Steve Jones, Robert Martin, and David Pilbeam. Cambridge; New York: Cambridge University Press, 1992. 506 p. Universit GN281 .C345 1992; *Encyclopedia of human evolution and prehistory* / Ian Tattersall, Eric Delson, and John Van Couvering. New York: Garland Publishing, 1988. 603 p. GN281 .E53 1988.

ARCHAEOLOGY, UNDERWATER

9.17. *Encyclopedia of underwater and maritime archaeology* / James Delgado. London: British Museum Press, 1997. 493 p. CC77.U5 E53 1997. Sites from prehistory to the modern era, legislation and legal issues, organizations, research themes, technology, etc., are covered in 450 alphabetically arranged entries. Worldwide coverage, illustrations, and extensive individual bibliographies.

ARCHITECTURE

9.18. *Encyclopedia of vernacular architecture* / Paul Oliver. Cambridge: Cambridge University Press.

3 v. NA208 .E53 1997. Vol. 1: Theories and principles; Vol. 2: Cultures and habitats (Asia, East and Central Australasia and Oceania, Europe and Eurasia, Mediterranean and Southwest Asia); Vol. 3: Cultures and habitats (Latin America, North America, Sub-Saharan Africa, glossary, lexicon, bibliography, indexes).

ASSYRIOLOGY

9.19. *Reallexikon der Assyriologie* / Erich Ebeling and Bruno Meissner. Berlin: de Gruyter, 1981, 1932. 13 v. DS69.1 .R4 1981.

BIBLICAL WORLD

9.20. *All things in the Bible: an encyclopedia of the biblical world* / Nancy M. Tischler. Westport: Greenwood Press, 2006. 2 v. BS440 .T57 2006.

9.21. *The Oxford encyclopedia of the books of the Bible* / Michael D. Coogan. New York: Oxford University Press, 2011. 2 v. BS440 .O93 2011.

CASPIAN SEA

9.22. *The Caspian Sea encyclopedia* / Igor S. Zonn. Heidelberg; London: Springer, 2010. 525 p. DK511 .C37 2010.

CELTS

9.23. *Celtic culture: a historical encyclopedia* / John T. Koch. Santa Barbara: ABC-CLIO, 2006. 5 v. CB206 .C45 2006.

CLASSICAL WORLD

9.24. *Brill's New Pauly: encyclopedia of the ancient world: antiquity* / H. Cancik and H. Schneider. Leiden; Boston: Brill, 2002– . DE5 .N4813 2002, v.1–16; *New Pauly Online*: http://referenceworks.brillonline.com/cluster/New%20Pauly%20Online., 2007– . See also: *Brill's New Pauly: encyclopaedia of the ancient world: Classical tradition* / Manfred Landfester, Hubert Cancik, and Helmuth Schneider. Leiden; Boston: Brill, 2006– . DE5 .P33213 2006, v.1-6; Uni-World Wide Web, 2005– . See also: *Brill's New Pauly: Supplements* / H. Cancik, M. Landfester, and Helmuth Schneider, eds. Leiden; Boston:

Brill, 2007. Ce DE5 .N4813 2007 suppl., v.1, 3, 4. An update of the original Pauly-Wissowa, translated into English and currently in progress. Supersedes: *Pauly's Real-encyclopadie der classischen Altertumwissenschaft* / A. F. von Pauly and G. Wissowa. Stuttgart: J. B. Metzler, 1894–1963; *Pauly-Wissowa, Real-encyclopadie der classischen Altertumswissenschaften.* Stuttgart: J. B. Metzler, 1996. 2 v. + CD-ROM. Reference Stacks. Commonly known as "Pauly-Wissowa," or just "Pauly," this encyclopedia has long, detailed essays, including extensive references, about a variety of specific topics in classical antiquity. This is an older, but still invaluable resource, and often handily summarizes the extensive nineteenth-century German scholarship on a topic. Articles are primarily in German but also in other European languages. See also: *Der neue Pauly: Encyklopädie der Antike* / Hubert Cancik und Helmuth Schneider. Stuttgart: J.B. Metzler, 1996–2003. DE5 .N48 1996, Bd. 1-16; *Der neue Pauly. Supplemente* / Hubert Cancik, Manfred Landfester, and Helmuth Schneider. Stuttgart: J. B. Metzler, 2004– . DE5 .N48 1996; *Der Kleine Pauly; Lexikon der Antike. Auf der Grundlage von Pauly's Realencyclopädie der classischen Altertumswissenschaft unter Mitwirkung zahlreicher Fachgelehrter* / Konrat Ziegler and Walther Sontheimer. Stuttgart: A. Druckenmuller, 1964–1975. 5 v. DE5 .K5, Bd.1–5; Munich: Deutscher Taschenbuch Verlag, 1979. 5 v. DE5 .P332 1979. Indexing provided by *Index to the supplements and suppl. volumes of Pauly-Wissowa's R.E.(2)* / John P. Murphy. 2 ed. Chicago: Ares, 1980. 144 p. DE5 .P33 Suppl. Index 1980.

9.25. *The Cambridge dictionary of classical civilization* / Graham Shipley. Cambridge: Cambridge University Press, 2006. 966 p. DE5 .C28 2006.

9.26. *Civilizations of the ancient Mediterranean: Greece and Rome* / M. Grant and R. Kitzinger. New York: Scribner's, 1988. A good introductory three-volume encyclopedia, with essays on a wide variety of topics from classical technology to politics to religion. Essays are by recognized scholars and include bibliographic suggestions.

9.27. *Enciclopedia dell'arte antica, classica, e orientale.* Roma: Istituto dell enciclopedia italiana, 1958–1966. 7 v. N31 .E48. *Supplemento,* 1970. Roma: Istituto della enciclopedia italiana, 1973. 951 p. N31 .E48 Suppl. 1970; *Secondo Supplemento,* 1971–1994. Roma: Istituto della enciclopedia italiana, 1994. 5 v. N31.E48 Suppl. 1994; *Enciclopedia dell'arte antica, classica e orientale*: [indici]. Roma: Istituto della enciclopedia italiana, 1984. 629 p. N31 .E48 Index;

Enciclopedia dell'arte antica, classica e orientale. Atlante dei complessi figurati e degli ordini architettonici. Roma: Istituto della enciclopedia italiana, 1973. N31 .E48 Atlas; *Enciclopedia Dell'Arte Antica: Classica e Orientale.* Roma: Instituto dell enciclopedia italiana, 1958–1966. 7 v. N31 .E48; *Enciclopedia dell'arte antica, classica e orientale: supplemento* 1970. Roma: Istituto della enciclopedia italiana, 1973. 951 p. N31 .E48 Suppl. 1970; *Enciclopedia dell'arte antica, classica e orientale: Segundo supplemento,* 1971–1994. Roma: Instituto della enciclopedia Italiana, 1994. 5 v. N31 .E48 Suppl. 1994. *Enciclopedia dell'arte antica, classica e orientale: indici.* Roma: Istituto della enciclopedia italiana, 1984. N31 .E48 Index. Heavily illustrated, eight-volume encyclopedia of ancient art. Although the articles are written in Italian, the photographs and architectural drawings make this set useful.

9.28. *Encyclopedia of Greece and the Hellenic tradition* / Graham Speake. London, Chicago: Fitzroy Dearborn, 2000. 2 v. DF757 .E53 2000. Articles on people and places as well as thematic essays covering Greece and the Greek world, ancient times to the present. Augmented by illustrations, maps, lists of further reading, and an index.

9.29. *Encyclopedia of the history of Classical archaeology* / Nancy Thomson de Grummond. Westport: Greenwood Press, 1996. 2 v. DE5 .E5 1996. Covers sites in ancient Greece and Rome, Bronze Age Aegean, Etruria, France, and Asia Minor and biographies of amateur and professional archaeologists, travelers, collectors, scholars, and artists. Also entries on important works of art and topics such as numismatics and computers in classical archaeology. A separate bibliography of 100 sources is arranged by topic.

9.30. *Encyclopedia of the Roman Empire* / Matthew Bunson. New York: Facts on File, 1992. 494 p. DG270 .B86 1992. Contains articles on the people, places, politics, religions, and customs of the Roman Empire. In addition to the alphabetically arranged entries, the book includes maps, illustrations, a list of the emperors, and imperial genealogies.

9.31. *Forma vrbis Romae. Consilio et avctoritate Regiae Academiae Lyncaeorvm formam dimensvs est et ad modvlvm 1:1000* / Rodvlphvs Lanciani. Mediolani: U. Hoepli, 1893–1901. 12 p.913.371 R66.L.1; DG807 .L36 1893.

9.32. *Greek and Roman dress from A to Z* / Liza Cleland, Glenys Davies, and Lloyd Llewellyn-Jones. London; New York: Routledge, 2007. 225 p. GT550 .C543 2007.

9.33. *Grove encyclopedia of classical art and architecture* / Gordon Campbell. Oxford; New York: Oxford University Press, 2007. 2 v. N5610 .G76 2007.

9.34. *Illustrated encyclopaedia of the ancient world* / Michael Avi-Yonah. New York: Harper and Row, 1975.

9.35. *Oxford companion to Classical literature* / Paul Harvey. 2 ed. Oxford: Clarendon Press, 1974. 468 p. DE5 .H3 1974. Intended to provide background information for readers of ancient literature: the composition and contents of individual authors' works (with reliable summaries and occasionally judgments as to quality) and sketches on myths and mythological characters. Includes a useful time line situating literary works in their historical context.

9.36. *Oxford encyclopedia of ancient Greece and Rome* / Michael Gagarin. Oxford; New York: Oxford University Press, 2010. 7 v. DE5 .O95 2010.

9.37. *Penguin encyclopedia of Classical civilizations* / Arthur Cotterell. New York: Penguin, 1993. 290 p. CB9 .P46 1995. Supersedes: *The Penguin encyclopedia of Classical civilizations*. London: Viking, 1993. 290 p. CB9 .P46 1993.

9.38. *Pianta marmorea di Roma antica: forma urbis Romae* / G. Carettoni. Roma: s.n., 1960. 265 p. DG63 .P5 1960a.

9.39. *Princeton encyclopedia of Classical sites* / Richard Stillwell. Princeton: Princeton University Press, 1976. 1019 p. DE59 .P7; University Museum Library Desk DE59 .P7. Summaries of excavation results with references to full reports; covers Europe, Middle East, and Africa to the sixth century AD; Christian sites of the fourth and fifth centuries are generally omitted. Glossary, maps, map indexes, illustrations.

9.40. *Riscoperta di Roma antica*. Roma: Istituto della enciclopedia italiana, 1999. 518 p. DG63 .R57 1999.

EGYPT

9.41. *Coptic encyclopedia* / Aziz S. Atiya. New York: Macmillan; Toronto: Collier Macmillan Canada; New York: Maxwell Macmillan International, 1991. 8 v. BX130.5 .C66 1991. Covers geographic regions of present-day Egypt, Nubia (Sudan), and Ethiopia. Two of the four main subject areas are archaeology and art and architecture. Includes extensive bibliographies, illustrations including site and building plans, cross-references, and index.

9.42. *Encyclopedia of ancient Egypt* / Margaret R. Bunson. rev. ed. New York: Facts on File, 2002. 462 p. Short entries and some drawings. DT58 .B96 2002. Supersedes: *Encyclopedia of ancient Egypt* / Margaret Bunson. New York: Facts on File Publications, 1991. 291 p. CDT58 .B96 1990.

9.43. *Encyclopedia of ancient Egyptian architecture* / Dieter Arnold. Princeton: Princeton University Press, 2003. 274 p. NA215 .A7613 2003. Includes more than 300 illustrations and 600 alphabetically arranged entries spanning every type of building and every aspect of construction and design.

9.44. *Encyclopedia of the archaeology of ancient Egypt* / Kathryn A. Bard. New York: Routledge, 1998. 938 p. DT58 .E53 1998. Entries on sites, figures, people, artifacts, techniques, and ancient culture. Thirteen historical overviews from Paleolithic cultures to the Roman period. Glossary and chronology.

9.45. *The illustrated encyclopedia of the pyramids, temples and tombs of ancient Egypt* / Lorna Oakes. London: Southwater, 2006. 256 p. DT63 .O35 2006.

9.46. *Oxford encyclopedia of ancient Egypt* / Donald B. Redford. Oxford; New York: Oxford University Press, 2001. 3 v. DT58 .O94 2001. Over 600 articles on Egyptology, land and resources, archaeological sites, history, state, foreign relations, economy, society, religion, and arts and sciences. http://www.oxfordreference.com/view/10.1093/acref/9780195102345.001.0001/acref-9780195102345.

FOLKLORE

9.47. *Folklore: an encyclopedia of beliefs, customs, tales, music, and art* / Charlie T. McCormick and Kim Kennedy White. 2 ed. Santa Barbara: ABC-CLIO, 2011. 3 v. 5 .F63 2011.

GREAT BRITAIN

9.48. *Early peoples of Britain and Ireland: an encyclopedia* / Christopher A. Snyder. Oxford, Westport: Greenwood World, 2008. 2 v. DA135 .E27 2008.

GREECE

9.49. *Encyclopedia of ancient Greece* / N. Wilson. New York: Routledge, 2006. 800 p. DF16 .E52 2006.

9.50. *Encyclopedia of the ancient Greek world* / David Sacks. rev. ed. New York: Facts on File, 1995. 306 p. DF16 .S23 1995.

HISTORY OF SCIENCE

9.51. *The encyclopedia of ancient natural scientists: the Greek tradition and its many heirs* / Paul T. Keyser and Georgia L. Irby-Massie. London; New York: Routledge, 2008. 1,062 p. Q124.95 .E53 2008.

9.52. *Encyclopaedia of the history of science, technology, and medicine in non-Western cultures* / Helaine Selin. 2 ed. Berlin; New York: Springer, 2008. 2 v. Q124.8 .E53 2008.

HOLY LAND

9.53. *Archaeological encyclopedia of the Holy Land* / Avraham Negev and Shimon Gibson. rev. ed. New York: Continuum, 2001. 559 p. DS111.A2 A73 2001. Supersedes: *Archaeological encyclopedia of the Holy Land* / Avraham Negev. rev. ed. Nashville: T. Nelson, 1986. 419 p. DS111.A2 N44 1986.

9.54. *New encyclopedia of archaeological excavations in the Holy Land* / Ephraim Stern. Jerusalem: Israel Exploration Society and Carta; New York: Simon and Schuster, 1993. 4 v. DS111.A2 N488 1993.

HOMER

9.55. *The Homer encyclopedia* / Margalit Finkelberg. Chichester, West Sussex, Malden: Wiley-Blackwell, 2011. 3 v. PA4037.A5 H58 2011.

INDO-EUROPEANS

9.56. *Encyclopedia of Indo-European culture* / J. P. Mallory and D. Q. Adams. London; Chicago: Fitzroy Dearborn, 1997. 829 p. CB201 .E53 1997. Alphabetically arranged and provides coverage of the major Indo-European language stocks and their origins, the conceptual range of the reconstructed Proto-Indo-European language, selected archaeological cultures with some relationship to the origin and dispersal of Indo-European groups, and some of the major issues of Indo-European cultural studies.

ISLAM

9.57. *Encyclopedia of Islam* / Juan E. Campo. New York: Facts on File, 2009. 750 p. DS35.53 .C36 2009.

9.58. *Encyclopaedia Islamica* / Wilferd Madelung and Farhad Daftary. London: Brill, Institute of Ismaili Studies, 2008. 3 v. BP40 .E524 2008. The *Encyclopædia Iranica* is a comprehensive research tool dedicated to the study of Iranian civilization in the Middle East, the Caucasus, Central Asia, and the Indian subcontinent. http://www.iranicaonline.org/.

9.59. *Encyclopedia of Islamic civilisation and religion* / Ian Richard Netton. London; New York: Routledge, 2008. 846 p. BP40 .E526 2008.

9.60. *Encyclopedia of women & Islamic cultures* / Suad Joseph. Leiden; Netherlands: Brill, 2006– . HQ1170 .E53.

9.61. *Encyclopedias about Muslim civilisations* / Aptin Khanbaghi. Edinburgh: Edinburgh University Press; Aga Khan University, Institute for the Study of Muslim Civilisations, 2009. 506 p. DS36.88 .E53 2009.

9.62. *The Grove encyclopedia of Islamic art and architecture* / Jonathan M. Bloom and Sheila S. Blair. Oxford; New York: Oxford University Press, 2009. 3 v. N6260 .G75 2009.

9.63. *Medieval Islamic civilization: an encyclopedia* / Josef W. Meri. New York: Routledge, 2006. 2 v. DS36.85 .M434 2006.

9.64. *The new encyclopedia of Islam* / Cyril Glassé. 3 ed. Lanham: Rowman & Littlefield, 2008. 718 p. BP40 .G42 2008.

9.65. *Oxford encyclopedia of the modern Islamic world* / John L. Esposito. New York: Oxford University Press, 2009. 6 v. DS35.53 .O96 2009. Supersedes: *Oxford encyclopedia of the modern Islamic world* / John L. Esposito. New York: Oxford University Press, 1995. 4 v. DS35.53 .O95 1995; DS35.53 .O96 2009.

JUDAISM

9.66. *Encyclopaedia Judaica* / Fred Skolnik. 2 ed. Detroit: Macmillan Reference USA; Keter Pub. House, 2007. 22 v. DS102.8 .E496 2007.

9.67. *Encyclopedia of the Jewish diaspora: origins, experiences, and culture* / M. Avrum Ehrlich. Santa Barbara: ABC-CLIO, 2009. 3 v. DS115 .E47 2009.

LANGUAGES AND LINGUISTICS

9.68. *The ancient languages of Asia Minor* / Roger D. Woodard. Cambridge: New York: Cambridge University Press, 2008. 185 p. P944.5 .A55 2008.

9.69. *Cambridge encyclopedia of the world's ancient languages* / Roger D. Woodard. Cambridge; New York: Cambridge University Press, 2004. 1,162 p. P140 .C35 2004.

9.70. *Concise encyclopedia of languages of the world* / Keith Brown and Sarah Ogilvie. Boston; Oxford: Elsevier, 2009. 1,283 p. P29 .C66 2009.

9.71. *Encyclopedia of Arabic language and linguistics* / Kees Versteegh. Leiden; Boston: Brill, 2006– . 5 v. PJ6031 .E53 2006.

MEDIEVAL WORLD

9.72. *All things medieval: an encyclopedia of the medieval world* / Ruth A. Johnston. Santa Barbara: Greenwood, 2011. 2 v. CB351 .J675 2011.

9.73. *Ancient Europe 8000 B.C.–A.D. 1000: encyclopedia of the Barbarian world* / Peter Bogucki and Pam J. Crabtree. New York: Thompson/Gale, 2004. 2 v. D62 .A52 2004.

9.74. *Encyclopedia of society and culture in the medieval world* / Pam J. Crabtree. New York: Facts on File, 2008. 4 v. CB351 .E53 2008. Covers all of medieval Europe from Scandinavia to Italy and from Ireland to Russia from the fall of the western Roman empire in the fifth century to the end of the High Middle Ages in 1500.

9.75. *Medieval archaeology: an encyclopedia* / Pam J. Crabtree. New York; London: Garland, 2001. 426 p. D125 .M42 2001.

MYTHOLOGY

9.76. *Creation myths of the world: an encyclopedia* / David A. Leeming. 2 ed. Santa Barbara: ABC-CLIO, 2010. 2 v. BL325.C7 L44 2010.

9.77. *A dictionary of creation myths* / David A. Leeming. New York: Oxford University Press, 2009. http://www.oxfordreference.com/view/10.1093/acref/9780195102758.001.0001/acref-9780195102758.

9.78. *Encyclopedia of Greco-Roman mythology* / M. Dixon-Kennedy. Santa Barbara: ABC-CLIO, 1998. 370 p. BL715 .D56 1998.

NEAR EAST

9.79. *Ancient Near East, c. 3000–330 B.C.* / Amelie Kuhrt. London; New York: Routledge, 1995. 2 v. DS62.23 .K87 1995. Intended as an introduction to ancient Near Eastern history, the main sources for reconstructing societies and political systems, and some historical problems and scholarly debate. Includes Egypt. General bibliography, maps, tables, figures, photographs, and index.

9.80. *Ancient Near East: an encyclopedia for students* / Ronald Wallenfels. New York: Scribner, 29.00. 4 v. DS57 .A677 29.00.

9.81. *Cambridge encyclopedia of the Middle East and North Africa* / Trevor Mostyn and Albert Hourani. Cambridge; New York: Cambridge University Press, 1988. 504 p. DS44 .C36 1988.

9.82. *Civilizations of the ancient Near East* / Jack Sasson. New York: Scribner, 1995. 4 v. DS57.C55 1995. Thematically arranged with broad topics such as ancient Near East in Western thought, environment, social institutions, etc. Illustrations, tables, time line, and maps.

9.83. *New encyclopedia of archaeological excavations in the Holy Land* / Ephraim Stern. Jerusalem: Israel Exploration Society and Carta; New York: Simon and Schuster, 1993. 4 v. DS111.A2 N488 1993. Extensive summaries of excavated sites with photographs, plans, maps, bibliographies, glossary, and chronologies.

9.84. *Oxford encyclopedia of archaeology in the Near East* / Eric M. Meyers. New York: Oxford University Press, 1996. 5 v. DS56 .O9 1996. Prepared under the auspices of the American Schools of Oriental Research. Alphabetically arranged signed essays on topics such as culture, language, theory, and practices, including 450 entries on individual sites or digs. Includes biographies of excavators.

OTTOMAN EMPIRE

9.85. *Encyclopedia of the Ottoman Empire* / Gábor Ágoston and Bruce Masters. New York: Facts on File, 2009. 650 p. DR486 .E53 2009.

RELIGION

9.86. *Dictionary of ancient deities* / Patricia Turner and Charles R. Coulter. New York: Oxford

University Press, 2001. 597 p. BL473 .T87 2001. Supersedes: *Encyclopedia of ancient deities* / Charles Russell Coulter and Patricia Turner. Jefferson, NC: McFarland, 2000. 597 p. BL473 .C67 29.00. *Encyclopedia of ancient deities* / Charles Russell Coulter and Patricia Turner. Chicago: Fitzroy Dearborn, 29.00. 597 p. BL473 .C67 2000b.

9.87. *Encyclopedia of medieval pilgrimage* / Larissa J. Taylor. Leiden; Boston: Brill, 2010. 835 p. BX2320.5.E85 E53 2010.

ROME

9.88. *Encyclopedia of ancient Rome* / Matthew Bunson. 3 ed. New York: Facts on File, 2011. 788 p. DG270 .B86 2011.

SOUTH ASIA

9.89. *Cambridge encyclopedia of India, Pakistan, Bangladesh, Sri Lanka, Nepal, Bhutan, and the Maldives* / F. Robinson. Cambridge: Cambridge University Press, 1989. 520 p. DS334.9 .C36 1989.

10
Handbooks

A handbook is a type of reference work, or other collection of instructions, that is intended to provide ready reference. Handbooks may deal with any topic and are generally compendiums of information in a particular field or about a particular technique. They are designed to be easily consulted and provide quick answers in a certain area. Following are the current standard handbooks in English. Each is arranged chronologically, and many include as an appendix short entries for major authors (very brief lives; list of known works, including those now lost; editions; translations into English; and bibliography).

ARCHAEOLOGY

10.1. *The Oxford handbook of Anglo-Saxon archaeology* / Helena Hamerow, David A. Hinton, and Sally Crawford. Oxford; New York: Oxford University Press, 2011. 1,078 p. DA155 .O84 2011.

Archaeology, Cemeteries

10.2. *Recording and analysing graveyards* / Harold Mytum. York: Council for British Archaeology in association with English Heritage, 2000. 176 p. CS21 .M97 2000.

Archaeology, Classical

10.3. *Encyclopedia of the history of classical archaeology* / Nancy Thomson de Grummond. Westport: Greenwood Press. 2 v. DE5 .E5 1996. This resource contains 1,125 entries by 171 scholars, covering Greco-Roman archaeological remains throughout the Mediterranean, including information on the Aegean Bronze Age and Etruscan remains.

10.4. *Handbook for classical research* / David M. Schaps. London; New York: Routledge, 2011. 466 p. DE71 .S27 2011.

Archaeology, Early Christian

10.5. *Christian art and archæology; being a handbook to the monuments of the early church* / Walter Lowrie. New York; London: Macmillan, 1901. 432 p. 249 L95.

10.6. *Monuments of the early church* / Walter Lowrie. New York: Macmillan; London: Macmillan, 1923. 432 p. N5333 .L69 1923. Supersedes: *Monuments of the early church* / Walter Lowrie. New York: Macmillan, 1901. 432 p. 249 L95a; A120 L955.

10.7. *The Oxford handbook of early Christian studies* / Susan Ashbrook Harvey and David G. Hunter. Oxford; New York: Oxford University Press, 2008. 1,015 p. BR121.3 .O99 2008.

Archaeology, Historical

10.8. *Handbook for historical archaeology* / John L. Cotter. rev. ed. Philadelphia, 1968. CC75 .C64.

Archaeology, Industrial

10.9. *Industrial archaeologists' guide.* Newton Abbot: David & Charles, 1970–1973. T26.G7 I52.

Archaeology, Landscape

10.10. *Handbook of landscape archaeology* / Bruno David and Julian Thomas. Walnut Creek: Left Coast Press, 2008. 719 p. CC75 .H35 2008.

10.11. *Historic landscape analysis: deciphering the countryside* / Stephen Rippon. York: Council for British Archaeology, 2004. 166 p. CC75 .R57 2004.

Archaeology, Maritime

10.12. *The Oxford handbook of maritime archaeology* / Alexis Catsambis, Ben Ford, and Donny L. Hamilton. Oxford; New York: Oxford University Press, 2011. 1,203 p. CC77.U5 O99 2011.

Archaeology, Medieval

10.13. *Medieval archaeology in England: a guide to the historical sources.* Isle of Wight: Pinhorns, 1969. 32 p. Z2017 .P55.

Archaeology, Religion

10.14. *Churches and chapels: investigating places of worship* / David Parsons. London: Council for British Archaeology, 1989. 78 p. BR133.G6 P37 1989.

10.15. *The Oxford handbook of the archaeology of ritual and religion* / Timothy Insoll. Oxford; New York: Oxford University Press, 2011. 1,108 p. BL65.A72 O94 2011.

Archaeology, Methodology

10.16. *Practicing archaeology: an introduction to cultural resources archaeology* / Thomas W. Neumann and Robert M. Sanford. 2 ed. Lanham: AltaMira Press, 2010. CC107 .N49 2010.

Archaeology, Postcolonial

10.17. *Handbook of postcolonial archaeology* / Jane Lydon and Uzma Z. Rizvi. Walnut Creek: Left Coast Press, 2010. 525 p. CC175 .H36 2010.

Archaeology, Underwater

10.18. *International handbook of underwater archaeology* / Carol V. Ruppé and Janet F. Barstad. New York: Kluwer Academic/Plenum Publishers, 2002. 881 p. CC77.U5 I55 2002.

10.19. *Protection of the underwater heritage.* Paris: UNESCO, 1981. 200 p. CC77.U5 P76 1981.

10.20. *Underwater archaeology: the NAS guide to principles and practice* / Amanda Bowens. 2 ed. Malden; Oxford: Blackwell, 2009. 226, 30 p. CC77.U5 U67 2009.

Archaeology, Urban

10.21. *The landscape of towns* / Mick Aston and James Bond. rev. ed. Stroud: Sutton, 2000. 259, 8 p. HT169.G7 A77 2000.

ARCHITECTURE

10.22. *Greek and Roman architecture* / D. S. Robertson. 2 ed. London: Cambridge University Press, 1969. 407 p. NA260 .R6 1969. A reprint of the 1929 work titled a *Handbook of Greek and Roman Architecture,* this resource covers all aspects of classical architecture in chronological order from Minoan Crete through the fourth century CE, including a selective chronological table of Greek, Etruscan, and Roman buildings from 1000 BCE to CE 330 and a glossary of architectural terms.

Architecture, Fixtures

10.23. *Fixtures and fittings in dated houses 1567-1763* / N. W. Alcock and Linda Hall. York: Council for British Archaeology, 1994. 75 p. TH6010 .A35 1994.

Architecture, Timber-Framed Buildings

10.24. *Recording timber-framed buildings: an illustrated glossary* / N. W. Alcock. 2 ed. York: Council for British Archaeology, 1996. 21, 33 p. NA4115 .R42 1996. Supersedes: *Recording timber-framed buildings: an illustrated glossary* / N. W. Alcock. London: Council for British Archaeology, 1989. 52 p. TH4818.W6 R43 1989.

ART

10.25. *Oxford history of classical art* / John Boardman. Oxford; New York: Oxford University Press, 1993. 406 p. N5610 .O84 1993. This work, designed as a companion to the *Oxford History of the Classical World,* is a general index of the history of classical art in pre-classical Greece, the classical period, the Hellenistic period, and Rome.

Art, Greek

10.26. *Handbook of Greek art* / Gisela M. A. Richter. 9 ed. London: Phaidon, 1987. 431 p. N5630 .R49 1987. Supersedes: *Handbook of Greek art, architecture, sculpture, gems, coins, jewelry, metalwork, pottery and vase painting, glass, furniture, textiles, paintings, and mosaics.* 2 ed. / Gisela M. A. Richter. London: Phaidon, 1960. 421 p. 709.38 R418.2 1960; *Handbook of Greek art, architecture, sculpture, gems, coins, jewelry, metalwork, pottery and vase painting, glass, furniture, textiles, paintings, and mosaics.*

3 ed. / Gisela M. A. Richter. London: Phaidon, 1963. 423 p. N5630 .R49 1963; 709 .R41 1963; *Handbook of Greek art* / Gisela M. A. Richter. 6 ed. London: Phaidon, 1963. 431 p. N5630 .R49 1969b; N5630 .R49 1969b. N5630 .R49 1969b; *Handbook of Greek art* / Gisela M. A. Richter. 7 ed. London: Phaidon, 1974. 431 p. N5630 .R49 1974; 709 .R41 1963. Divided into chapters by form and material, *Handbook of Greek Art* covers all aspects of Greek art from 1100 BCE to 100 BCE. Supplemental material includes maps, a bibliography, a chronology of Greek sculpture, and indexes of places and names.

Art, Roman

10.27. *Handbook of Roman art: a comprehensive survey of all the arts of the Roman world* / Martin Henig. Ithaca: Cornell University Press, 1983. 288 p. N5760. H36 1983. This handbook contains a survey of Roman art from early Roman art to that of the late empire, concentrating on different artistic forms and media; includes a guide to the major pottery forms, a glossary, an excellent bibliography arranged by topic, and a general index.

ASIA, SOUTHWEST

10.28. *Ancient Ararat: a handbook of Urartian studies* / Paul E. Zimansky. Delmar: Caravan Books, 1998. 332 p. DS156.U7 Z36 1998. Annotated bibliography under the following general topics: culture, history, and society; language and writing; material culture; archaeological surveys and site reports; and the rediscovery and legacy of Urartu. Author and subject indexes.

10.29. *Routledge handbook of the peoples and places of ancient western Asia: from the early Bronze Age to the fall of the Persian Empire* / Trevor Bryce. London; New York: Routledge, 2009. 887 p. DS57 .B89 2009.

BRITAIN AND IRELAND

10.30. *Handbook for British and Irish archaeology: sources and resources* / Cherry Lavell. Edinburgh: Edinburgh University Press, 1997. 480 p. DA90 .F34 1997. Information on organizations and societies, bibliography of books, general finding aids, abstracting and indexing services, sources of grants, archaeological touring guides, and Internet resources.

CONSERVATION AND RESTORATION

10.31. *Guidelines for evaluating and registering historical archeological sites and districts* / Jan Townsend, John H. Sprinkle, Jr., and John Knoerl. Washington, DC: U.S. Department of the Interior, National Park Service, Interagency Resources Division, National Register of Historic Places, 1993. 43 p. E159 .T69 1993.

Conservation and Restoration, Wood

10.32. *Conservation of wood artifacts: a handbook* / A. Unger, A. P. Schniewind, and W. Unger. Berlin; New York: Springer, 2001. 578 p. CC137.W6 U54 2001.

CUNEIFORM

10.33. *The Oxford handbook of cuneiform culture* / Karen Radner and Eleanor Robson. Oxford; New York: Oxford University Press, 2011. 805 p. DS69.5 .O84 2011.

DRAMA

10.34. *Crowell's handbook of classical drama* / Richmond Y. Hathorn. New York: Crowell, 1967. 350 p. PA3024 .H35. Concentrates on Greek classical drama. Includes entries for dramatists, dramatic forms, and individual plays with brief background notes and summaries.

GEOGRAPHY, CLASSICAL

10.35. *New century handbook of classical geography* / Catherine B. Avery. New York: Appleton, Century, Crofts, 1972. 362 p. DE25 .N48. Concise discussions of major geographic locations incorporating information from both archaeology and mythology.

GLASS

10.36. *Romano-British glass vessels: a handbook* / Jennifer Price and Sally Cottam. Walmgate; York: Council for British Archaeology, 1998. 234 p. NK3850 .P75 1998.

GREECE

10.37. *Greece: an Oxford archaeological guide* / Christopher Mee and Antony Spawforth. Oxford; New

York: Oxford University Press. 464 p. DF78 .M44 2001. This resource covers the geography, geology, and climate, as well as giving a historical and cultural overview, before surveying the archaeological sites organized by region.

HISTORY

10.38. *Cambridge ancient history* / J. B. Bury, S. A. Cook, and F. E. Alcock. New York: Macmillan, 1923–1939. 12 v. D57 .25 1923. 12 v.; 930 C143, v. 1–12. This edition is superseded by the following: *Cambridge ancient history* / J. B. Bury. 2 ed. New York: Macmillan, 1924–1927. 930 C143, v. 4, 6, 10; D57 .25 1924, v. 1–3; *Cambridge ancient history*. 3 ed. London: Cambridge University Press, 1970. 18 v. D57 .252 1970, 14 v. In 2008 an electronic version of *Cambridge Ancient History* was made available on the Penn Library Web: v. 1(1). *Prolegomena and prehistory* / I. E. S. Edwards, C. J. Gadd, and N. G. L. Hammond. 672 p.; 1(2). *Early history of the Middle East* / I. E. S. Edwards, C. J. Gadd, and N. G. L. Hammond. 1,003 p.; I. E. S. Edwards. 823 p.; 2(1). *History of the Middle East and the Aegean region, c. 1800–1380 B.C.* / I. E. S. Edwards; 2(2). *History of the Middle East and Aegean region, c. 1380–1000 B.C.* / I. E. S. Edwards. 1,045 p.; 3(1). *Prehistory of the Balkans and the Middle East and the Aegean world, tenth to eighth centuries B.C.* / J. Boardman. 1,007 p.; 3(2). *Assyrian and Babylonian empires and other states of the Near East from the eighth to the sixth centuries B.C.* / J. Boardman. 867 p.; 3(3). *Expansion of the Greek world, eighth to sixth centuries B.C.* / J. Boardman and N. G. L. Hammond. 512 p.; 4. *Persia, Greece, and the western Mediterranean, c. 525 to 479 B.C.* / J. Boardman. 886 p.; 5. *Fifth century B.C.* / D. M. Lewis. 566 p.; 6. *Fourth century B.C.* / D. M. Lewis. 1,077 p.; 7(1). *Hellenistic world* / F. W. Walbank. 602 p.; 7(2). *Rise of Rome to 220 B.C.* / F. W. Walbank. 771 p.; 8. *Rome and the Mediterranean to 133 B.C.* / A. E. Aston. 591 p.; 9. *Last age of the Roman Republic, 146–43 B.C.* / J. A. Crook, A. Lintott, and E. Rawson. 877 p.; 10. *Augustan empire, 43 B.C.– A.D. 69* / A. K. Bowman, E. Champlin, and A. Lintott. 1,137 p.; 11. *High empire, A.D. 70–192* / A. K. Bowman, P. Garnsey, and D. Rathbone. 1,161 p.; 12. *The crisis of empire, A.D. 193–337* / A. K. Bowman, P. Garnsey, and A. Cameron. 899 p.; 13. *Late empire, A.D. 337–425* / A. Cameron and P. Garnsey. 845 p.; 14. *Late antiquity: empire and successors, A.D. 425–600* / A.

Cameron, B. Ward-Perkins, and M. Whitby. 899 p. Extending from the Paleolithic to CE 324 (the year before the Council of Nicaea) and covering all ancient civilizations, not just the Greeks and Romans, this is the standard English handbook. Extensively illustrated with many maps; each volume ends with a chronological table.

10.39. *New century classical handbook* / Catherine B. Avery. New York: Appleton-Century-Crofts, 1962. 1162 p. DE5 .N4.

JEWELRY

10.40. *Ancient Egyptian jewellery*. London: Methuen, 1971. 266 p. NK7388.A1 W5.

10.41. *Greek and Roman jewellery* / R. A. Higgins. London: Methuen, 1961. 236 p. 739.27 H536.

10.42. *Western Asiatic jewellery c.3000–612B.C.* / K. R. Maxwell-Hyslop. London: Methuen, 1971. 286 p. NK7307 .M38 1971.

LITERATURE

10.43. *Crowell's handbook of classical literature* / Lillian Feder. New York: Crowell, 1964. 418 p. PA31 .F4. Factual information on authors, characters, themes, and stylistic conventions. Contains detailed summaries of individual works.

10.44. *Oxford companion to classical literature* / M. C. Howatson and Ian Chivers. Oxford; New York: Oxford University Press, 1993. 575 p. PA31 .H69 1993. Concise information on Greek and Roman writers, subjects, literary forms, and individual works.

METHODS

10.45. *Archaeological curatorship* / Susan M. Pearce. London; New York: Leicester University Press, 1990. 223 p. AM7 .P43 1990.

10.46. *Handbook of archaeological methods* / Herbert D. G. Maschner and Christopher Chippindale. Lanham: AltaMira Press, 2005. 2 v. CC75 .H337 2005.

Methods, Communication of Information

10.47. *Presenting the past* / Larry J. Zimmerman. Walnut Creek: Altamira Press, 2003. 162 p. CC75.7 .Z56 2003.

10.48. *Talking archaeology: a handbook for lecturers and organizers* / Lesley Adkins and Roy A. Ad-

kins. London: Council for British Archaeology, 1990. 42 p. CC82 .A23 1990.

Methods, Conservation and Restoration

10.49. *Treatment of archeological properties: a handbook.* Washington, DC: Advisory Council on Historic Preservation, 1980. 39 p. CC135 .T73 1980.

Methods, Data Processing

10.50. *Manuale di rilievo e di documentazione digitale in archeologia* / Marco Bianchini. Roma: Aracne, 2007. 378 p. CC76.3 .B43 2007.

Methods, Fieldwork

10.51. *The amateur archaeologist* / Stephen Wass. London: B. T. Batsford, 1992. 160 p. CC75.5 .W37 1992.

10.52. *Archaeological investigation* / Martin Carver. London; New York: Routledge, 2009. 424, 16 p. CC75 .C27 2009.

10.53. *The archaeologist's field handbook* / Heather Burke, Claire Smith, and Larry J. Zimmerman. Lanham: AltaMira Press, 2009. 425 p. CC76 .B87 2009.

10.54. *A complete manual of field archaeology: tools and techniques of field work for archaeologists* / Martha Joukowsky. Englewood Cliffs: Prentice-Hall, 1980. 630 p. CC76 .J68.

10.55. *Digging up the Ice Age: recognising, recording and understanding fossil and archaeological remains found in British quarries: a guide and practical handbook* / Simon Buteux, Jenni Chambers, and Barbara Silva. Oxford: Archaeopress, 2009. 189 p. GN805 .B874 2009.

10.56. *Excavation* / Steve Roskams. Cambridge; New York: Cambridge University Press, 2001. 311 p. CC76 .R67 2001.

10.57. *Standards of archaeological excavation: a field guide to the methodology, recording techniques and conventions* / Geoffrey John Tassie and Lawrence Stewart Owens. London: Golden House, 2010. 576 p. + CD-ROM. CC75 .T266 2010.

Methods, Geographic Information Systems

10.58. *GIS guide to good practice* / Mark Gillings and Alicia Wise. Oxford: Oxbox Books for the Arts and Humanities Data Service, 1990. 88 p. CC80.4 .G5 1990.

10.59. *Handbook of geographic information systems and archaeology* / Mark Aldenderfer. London: Equinox, 2007.

Methods, Geophysical

10.60. *Handbook of geophysics and archaeology* / Alan J. Witten. London; Oakville: Equinox, 2006. 329 p. QC808.8 .W58 2006.

Methods, Illustration

10.61. *Approaches to archaeological illustration: a handbook* / Mélanie Steiner. York [England]: Council for British Archaeology, 2005. 108 p. CC82.3 .S74 2005.

Methods, Interpretive Programs

10.62. *Visitors welcome: a manual on the presentation and interpretation of archaeological excavations* / Gillian Binks, John Dyke, and Philip Dagnall. London: H.M.S.O., 1988. 162 p. DA90 .B6 1988.

Methods, Repatriation

10.63. *Practicing archaeology: a training manual for cultural resources archaeology* / Thomas W. Neumann and Robert M. Sanford. Walnut Creek: AltaMira Press, 2001. CC107 .N49 2001.

10.64. *Mending the circle: a Native American repatriation guide: understanding and implementing NAGPRA and the official Smithsonian and other repatriation policies.* New York: American Indian Ritual Object Repatriation Foundation, 1996. 167 p. E98.M34 M45 1996.

Methods, Statistical

10.65. *Sampling in archaeology* / Clive Orton. Cambridge; New York: Cambridge University Press, 2000. 261 p. CC80.6 .O78 2000.

Methods, Stone Implements

10.66. *Manual for a technological approach to ground stone analysis* / Jenny L. Adams. Tucson: Center for Desert Archaeology, 1997. 81 p. GN434 .A32 1997.

Methods, Surveying

10.67. *The archaeological survey manual* / Gregory G. White and Thomas F. King. Walnut Creek: Left Coast Press, 2007. CC76.3 .W458 2007.

10.68. *Archaeological surveying and mapping: recording and depicting the landscape* / Phil Howard. London; New York: Routledge, 2007. 300 p. CC76.3 .H68 2007.

10.69. *Surveying of archaeological sites* / Peter E. Leach. London: Institute of Archaeology Publications, 1988. 52 p. CC76.3 .L43 1988.

MYTHOLOGY, CLASSICAL

10.70. *Crowell's handbook of classical mythology* / Edward Tripp. New York: Crowell, 1970. 631 p. BL303 .T75 1970.

MOSAICS

10.71. *Mosaics* / H. P. L'Orange and P. J. Nordhagen. London: Methuen, 1966. 92, 113 p. 729.7 L8881M.EK; NA3750 .L613.

NUMISMATICS

10.72. *A handbook of Greek and Roman coins* / G. F. Hill. London: Macmillan, 1899. 295 p. 737 H55.2; 737 H55.2.

10.73. *Understanding ancient coins: an introduction for archaeologists and historians* / P. J. Casey. Norman: University of Oklahoma Press, 1986. 160 p. CJ237 .C37 1986.

Numismatics, Greek

10.74. *Greek coins; a history of metallic currency and coinage down to the fall of the Hellenistic kingdoms* / Charles Seltman. London: Methuen, 1933. 311 p. 737 Se47.3.

Numismatics, Roman

10.75. *Roman coins from the earliest times to the fall of the western empire* / Harold Mattingly. London: Methuen, 1928. 300, 64 p. 737 M434.

PAPYROLOGY

10.76. *The Oxford handbook of papyrology* / Roger S. Bagnall. Oxford; New York: Oxford: University Press, 2009. 688 p. Z110.P36 O98 2009.

PETROGLYPHS

10.77. *Handbook of rock art research* / David S. Whitley. Walnut Creek: AltaMira Press, 2001. 863 p. GN799.P4 H333 2001.

PHOTOGRAPHY

10.78. *La préparation des publications archéologiques: réflexions, méthodes et conseils pratiques* / Jean Prodhomme. Paris: Editions de la Maison des sciences de l'homme, 1987. 183 p. CC79.P46 P76 1987.

Photography, Aerial

10.79. *Manuale di fotografia aerea: uso archeologico* / Fabio Piccarreta. Roma: "L'Erma" di Bretschneider, 1987. 281 p. CC76.4 .P53 1987.

PLANT REMAINS

10.80. *An archaeobotanical guide to root and tuber identification* / Jon G. Hather. Oxford: Oxbow Books; Bloomington: D. Brown Book, 1993. CC79.5.P5 H38 1993.

POTTERY

10.81. *Roman Samian pottery in Britain* / Peter Webster. London: Council for British Archaeology, 1996. 138 p. NK3850 .W44 1996.

Pottery, Greek

10.82. *Greek geometric pottery, a survey of ten local styles and their chronology* / J. N. Coldstream. London: Methuen, 1968. 465, 64 p. University Museum Library NK4645 .C64.

10.83. *Greek painted pottery* / R. M. Cook. 2 ed. London: Methuen, 1972. 390 p. LNK4645 .C6 1972. Supersedes: *Greek painted pottery* / R. M. Cook. London: Methuen, 1966. 395 p. 738 C775a; *Greek painted pottery* / R. M. Cook. London, Methuen, 1960. 391 p. NK4645 .C6 1960b; 738 C775.

10.84. *Greek terracottas* / R. A. Higgins. London: Methuen, 1967. 169, 68 p. NB155 .H5.

ROME

10.85. *Rome: an Oxford archaeological guide* / Amanda Claridge. Oxford; New York: Oxford University Press, 1998. 455 p. DG62 .C53 1998. This work includes a source guide and a glossary of building materials and architectural terms, as well as a survey of sites organized by region of the city.

SCULPTURE, GREEK

10.86. *A handbook of Greek sculpture* / Ernest Arthur Gardner. 2 ed. London: Macmillan, 1915. 605 p. 733 G17c. Supersedes: *A handbook of Greek sculpture* / Ernest Arthur Gardner. London: Macmillan, 1911. 591 p. 733 G17b.

SKELETAL REMAINS

10.87. *Animal bones in archaeology, a book of notes and drawings for beginners* / Michael L. Ryder. 2 ed. Oxford: Mammal Society by Blackwell Scientific, 1969. 65 p. QL821 .R96 1969.

10.88. *Handbook of forensic anthropology and archaeology* / Soren Blau and Douglas H. Ubelaker. Walnut Creek: Left Coast Press, 2008. 534 p. GN69.8 .H34 2008.

10.89. *The human bone manual* / Tim D. White and Pieter A. Folkens. Amsterdam; Boston: Elsevier Academic, 2005. 464 p. GN70 .W44 2005.

10.90. *Human remains in archaeology: a handbook* / Charlotte A. Roberts. York: Council for British Archaeology, 2009. 292 p. CC79.5.H85 R63 2009.

10.91. *Standards for data collection from human skeletal remains: proceedings of a seminar at the Field Museum of Natural History, organized by Jonathan Haas* / Jane E. Buikstra and Douglas H. Ubelaker. Fayetteville: Arkansas Archeological Survey, 1994. 206 p. E98.A55 S88 1994.

10.92. *Zooarchaeology* / Elizabeth J. Reitz and Elizabeth S. Wing. 2 ed. Cambridge; New York: Cambridge University Press, 2008. 533 p. CC79.5.A5 R45 200. Supersedes: *Zooarchaeology* / Elizabeth J. Reitz and Elizabeth S. Wing. Cambridge; New York: Cambridge University Press, 1999. 455 p. CC79.5.A5 R45 1999.

UGARIT

10.93. *Handbook of Ugaritic studies* / Wilfred G. E. Watson and Nicolas Wyatt. Leiden; Boston; Brill, 1999. 892 p. DS99.U35 H35 1999.

WRITING SYSTEMS

10.94. *Routledge handbook of scripts and alphabets* / George L. Campbell and Christopher Moseley. 2 ed. Milton Park, Abingdon, Oxon; New York: Routledge, 2012. 181 p. P211 .25 2012.

11
Abstracts and Indexes

ABSTRACTS

An abstract is a brief summary of a research article, thesis, review, conference proceeding, or any in-depth analysis of a particular subject or discipline and is often used to help the reader quickly determine the purpose of a paper. When used, an abstract always appears at the beginning of a manuscript or typescript, acting as the point of entry for any given academic paper. Academic literature uses the abstract to succinctly communicate complex research.

11.1. *AATA online*. Los Angeles: J. Paul Getty Trust. Abstracts of International Conservation Literature. Formerly *Art and Archaeology Technical Abstracts: Literature related to the preservation and conservation of material cultural heritage.* Abstracts of material cultural heritage management and conservation literature worldwide. Topics include methods of examination and analysis; conservation, including architectural conservation; archaeological methods; conservation and heritage management education and training; production techniques and history; and the analysis, treatment, and techniques of specific materials and objects for works of art, cultural objects, museum collections, archives, and library materials, architecture, historic sites, and archaeology. http://aata.getty.edu/Home.

11.2. *Abstracts of International Conservation Literature*, 1932– . Indexes journals covering the management and conservation of international material cultural heritage, broadly interpreted to include works of art, cultural objects, museum collections, archives and library materials, architecture, historic sites, and archaeology. http://aata.getty.edu/Home.

11.3. *Art Abstracts*. This database provides comprehensive indexing and abstracts for more than 450 international art publications, including periodi-

cals, yearbooks, and museum bulletins, published in English, French, German, Italian, Spanish, and Dutch and focused on a broad range of art topics, including advertising, archaeology, crafts, folk art, graphic arts, interior design, video, film, architecture, and art history. Indexing spans from 1984 to the present. http://www.ebscohost.com/academic/art-abstracts.

11.4. *Art Full Text*. Covers a wide range of topics from archaeology and architecture to sculpture and video art. Indexes and abstracts articles from periodicals published throughout the world. Periodical coverage includes English-language periodicals, yearbooks, and museum bulletins, as well as periodicals published in French, Italian, German, Japanese, Spanish, Dutch, and Swedish. In addition to articles, *Art Full Text* indexes reproductions of works of art that appear in indexed periodicals. Citations only (1984–1993); citations and abstracts (1994–); some full text (1997–). http://www.ebscohost.com/academic/art-full-text.

11.5. *Art Index*. Offers abstracts of journals, museum bulletins, and yearbooks in the fields of art, architecture, decorative arts, and photography. Covers abstracts from 1929 to the present and full-text articles from 1997 to the present. Quite good indexing of classical archaeology journals, including non-English journals. It is not as complete as Dyabola but is more up-to-date. http://www.ebscohost.com/academic/art-index.

11.6. *Art Index and Art Index Retrospective*, 1929– . Periodical coverage includes English-language periodicals, yearbooks, and museum bulletins, as well as periodicals published in French, Italian, German, Japanese, Spanish, Dutch, and Swedish. In addition to articles, indexes reproductions of works of art that appear in indexed periodicals. Subjects covered include archaeology, architec-

ture, art history, city planning, crafts, motion pictures, graphic arts, industrial design, interior design, landscape architecture, museology, and photography. For archaeology-related articles in business, education, humanities, science, and social sciences, search the WilsonWeb indexes, Business Full-Text, Education Full-Text, General Science Full-Text, Humanities Full-Text, and Social Sciences Full-Text at the same URL. http://www.ebscohost.com/academic/art-index-retrospective.

INDEXES

An index is a type of reference source that lists periodical articles by subject or author. If you have a topic in mind, an index can help you locate journals about that topic. An index will point you to the right periodical, the specific date or issue copy, and even the pages for a specific article. A periodical index works like a subject catalog for the articles within a group of magazines and journals. The process of using an index is similar to the process of doing subject or keyword searches for items in a library catalog. The information appearing in an index about an article is called a citation. The citation usually includes title of the article; author's name or names if there is more than one author (sometimes a shorter article or news item has no named author); title of the periodical (some indexes label the periodical title as the "source" [abbreviated as "so"] because the periodical is the source for the article); volume and issue numbers of the periodical in which the article appears (a volume often covers one year of publication and an issue is an individual copy within a volume; a volume and/or issue may not be included); date of the periodical issue in which the article appears; pages on which the article appears; and additional information about the article, such as illustrations, maps, and charts that appear in the article.

General

11.7. *Academic Search Premier.* Provides full text for 4,486 publications (3,718 peer-reviewed) covering academic areas of study including social sciences, humanities, education, computer sciences, engineering, language and linguistics, arts and literature, medical sciences, and ethnic studies. A total of 8,224 titles are abstracted and indexed, of which 7,132 are peer reviewed. http://www.ebscohost.com/academic/academic-search-premier.

11.8. *Humanities Index.* Indexes the major scholarly English-language journals in the humanities (including history and literature). http://www.ebscohost.com/academic/humanities-international-index.

11.9. *JSTOR.* Full text (in pdf format) of selected important scholarly journals in a number of fields. Note: journals in JSTOR usually do not include the most recent three to five years. For more recent articles, use one of the other indexes listed in this section. See also: *JSTOR: a history* / Roger C. Schonfeld. Princeton: Princeton University Press, 2003. 412 p. Van Pelt Library PM4836 .S36 2003. www.jstor.org.

11.10. *Periodicals Index Online* (Chadwyck). Very useful for locating older articles in journals in English and Western European languages. The major archaeology, art, and classics journals are indexed, and coverage is from the first volume of the journal. http://www.proquest.com/en-US/catalogs/databases/detail/periodicals_index.shtml.

11.11. *Project Muse.* Mid-1990s– (dates vary by title). Provides access to almost 250 journals published by the Johns Hopkins University Press and forty other scholarly publishers. Covers the fields of literature and criticism, history, the visual and performing arts, cultural studies, education, political science, gender studies, economics, and many others. One can search across all journals in the database, selected subsets of journal titles, or just a single title. http://muse.jhu.edu/.

11.12. *Web of Science Citation Databases.* Includes *Arts and Humanities Citation Index, Science Citation Index Expanded,* and *Social Sciences Citation Index,* 1975– . Multidisciplinary databases covering journal articles. Indexes articles and references cited in articles. Unique source permits authors to track prior research and monitor current developments, identify where articles have been cited, and generally navigate forward and backward through the literature. http://wokinfo.com/products_tools/multidisciplinary/webofscience/.

11.13. *WorldCat.* OCLC Online Union Catalog in a user-friendly version. It contains more than forty million records of items owned by libraries around the world. Every item in the catalog has a listing of libraries that own it. It contains records for books, journals, musical scores, computer programs, and much more. (It does not include records for individual articles or stories in journals, magazines, newspapers, or book chapters.) New records are added daily. www.worldcat.org.

French

11.14. *Francis,* 1984– . Institut de l'Information Scientifique et Technique du Centre National de la Recherche Scientifique. Multidisciplinary, multilingual index to journals with emphasis on humanities and social sciences. http://www.

proquest.co.uk/en-UK/catalogs/databases/detail/
francis-set-c.shtml.

German

11.15. *Internationale Bibliographie der Zeitschriften-literatur aus allen Gebieten des Wissens; International Bibliography of Periodical Literature (IBZ)*. Osnabrück: F. Districh, 1985. 2/yr. AI9. I5. V. 20. An international and interdisciplinary bibliography of academic periodical literature mainly from the humanities, social sciences, and arts, with some science. Contains over two million journal articles from almost 11,000 journals covering the years 1983 to the present. The article data in IBZ includes a subject classification in German and English based on the German Personennormdatei (name authority file—PND) and Schlagwortnormdatei (controlled vocabulary—SWD). http://www.degruyter.com/databas econtent;jsessionid=9D990A6932B8D4E614D4 2EAB007F3D18?dbid=ibz&dbsource=%2Fdb% 2Fibz.

Anthropology

11.16. *Anthropology Plus*. Combines anthropological literature from Harvard University and anthropological index from the Royal Anthropological Institute of the United Kingdom. Offers worldwide indexing of all core periodicals, in addition to lesser known journals, from the early nineteenth century to today. Broad geographic coverage emphasizes the Commonwealth and Africa and extends to Eastern Europe, the Americas, Asia, Australasia, and the Pacific. Covers fields of social, cultural, physical, biological, and linguistic anthropology; ethnology; archaeology; folklore; material culture; and interdisciplinary studies. http://www.ebscohost.com/academic/anthropology-plus.

Archaeology, Biblical

11.17. *Biblical Archaeological Society Online*. http://www.biblicalarchaeology.org/.

Archaeology, Classical

11.18. *Chloris*. Chloris is a searchable bibliography of the Bronze Age archaeology of mainland Greece and Crete. Its purpose is to fill a gap in the current bibliographies of this subject. Chloris is organized by site, that is, it allows one to search for published material concerning a specific site

(e.g., Tiryns) or region (e.g., Argolid). http://clvl. cla.umn.edu/chloris/.

11.19. *FastiOnline*. Roma: Associazione internacionale di Archeologia Classica. Between 1946 and 1987 the International Association for Classical Archaeology (AIAC) published the *Fasti Archaeologici*. AIAC's board of directors thus decided in 1998 to discontinue the publication and eventually developed FastiOnline. The site, supported by the Packard Humanities Institute and the Society for the Promotion of Roman Studies, provides a comprehensive record of archaeological and conservation initiatives in the participating countries (an archaeological database for current fieldwork in Italy, Serbia, Bulgaria, Romania, Macedonia, Malta, Morocco, Croatia, Albania, and Slovenia), searchable both in English and the language of the country. As of 2012, each record may also be illustrated with plans and photographs. Fastionline.org.

11.20. *Mnemotrix ArchaeoSearch; Database of Ancient Near East and Classical Studies*. Coral Springs: Mnemotrix Systems, 2001– . A resource application database for archaeologists working in the field of ancient Near East and classical studies. www.mnemotrix.com/arch.

11.21. *Nestor; Bibliography of Aegean prehistory and related areas*. Athens: Ohio University, 1957–2004. DF221 .M9 N37, v. 1(1957)– . An international bibliography of Aegean studies, Homeric society, Indo-European linguistics, and related fields, from the Paleolithic period through the end of the Geometric period, covering the Aegean. http://infotree.library.ohiou.edu/scripts/redirect. html?id=3239; *Nestor*. Bloomington: Program in Classical Archeology, Indiana University, 1957–
.

Archaeology, European

11.22. *British and Irish Archaeological Bibliography* (BIAB). Contains over 100,000 separate references for relevant publications issued from 1695 CE to the present day. References to material published from 1967 onward also include abstracts. The database comprises information gathered from several bibliographic sources, including the *Index of Archaeological Papers* produced by the Gomme family between 1892 and 1910, a retrospective compilation including the works of seventeenth- and eighteenth-century antiquaries; the *Archaeological Bibliography for Great Britain and Ireland*, published by the Council for British Archaeology between 1940 and 1980 as *Archaeological Bulletin for the British Isles*;

British Archaeological Abstracts, published by the Council for British Archaeology between 1968 and 1991; and the *British Archaeological Bibliography* (BAB) established as a separate organization in 1991 and began publication in 1992. BAB became the *British and Irish Archaeological Bibliography* in 1997 to reflect the addition of the Irish Heritage Council to the consortium that runs the bibliography. http://www.biab.ac.uk.

Archaeology, Near Eastern and Egyptian

11.23. *ABZU. An index to web resources in ancient Near Eastern studies: digitized and digital books, journals, websites, newsletters, etc.* / Charles E. Jones. Chicago: Research Archives of the Oriental Institute, 1994– . www.etana.org/abzubib.

Art and Architecture

11.24. *Avery Index to Architectural Periodicals (AVE).* Comprehensive coverage from the 1930s and more selective coverage dating back to the 1860s. Limited coverage of classical architecture and archaeology. http://www.csa.com/factsheets/avery-set-c.php.

11.25. *BHA and RILA.* Los Angeles: J. Paul Getty Trust, 2010– . Covers European and American art from the fourth century to the present. Areas addressed are painting, sculpture, drawings, prints, decorative and applied arts, architecture, and industrial art. http://library.getty.edu:7108/vwebv/searchBasic?sk=en_US_getty. Continues *Bibliography of the history of art* (BHA). Los Angeles: J. Paul Getty Trust, 1973– . 4/yr.; *Répertoire d'art et d'archéolgie* (RAA). Paris: Centre National de la Recherche Scientifique, 1996– . N2 .R3631, 1973/1989; *International repertory of the literature of art* (RILA). Santa Monica: J. Paul Getty Trust, 1996– . N1 .A1 R221. CD-ROM; *Répertoire international de la littérature de l'art; RILA; International repertory of the literature of art.* New York: College Art Association of America, 1975–1990. 15 v. N1 .A1 R22, v. 1–15, 1975–1989; *Répertoire d'art et d'archéologie.* Paris: Bibliothèque d'art et d'archéologie, 1910–1989. LN2 .R363, no. 1–60, 1910–1964; t. 1–25, 1965–1989.

11.26. *Bibliography of the History of Art (BHA).* A bilingual, international bibliographic database on the history of postclassical Western art, architecture, and decorative arts. It covers art history from late antiquity to the present. BHA began publication in 1991 as a result of the merger of the International Repertory of the Literature of Art (RILA) and Répertoire d'Art et d'Archéologie (RAA). Abstracts are available in both English and French, with full-subject indexes in both languages. www.getty.edu/research/conducting_research/bha.

11.27. *Oxford Art Online.* Oxford: Oxford University Press, 2007– . Formerly *Grove Art Online*; includes the *Grove Dictionary of Art* and other art reference sources. There is very good coverage of ancient art, with articles on archaeological sites, with plans and bibliography. www.oxfordartonline.com.

Classics

11.28. *Dyabola.* München: Verlag Biering und Brinkmann, 1958– . Dyabola is a complete programme for the administration of libraries, subject catalogues, inventory books, photograph archives, and any other form of text and image documents. Consequently the Dyabola project has started to register bibliographies. For classical archaeology it was logical to digitalize the Realkatalog of the German Archaeological Institute in Rome. The next step to be approached was a subject catalog of European pre- and early history and the archeology of the Roman provinces in the RGK (Roman-Germanic Commission) in Frankfurt. Contains several databases, the largest of which is the Archäologische Bibliographie, or "Realkatalog des Deutschen Archäologischen Instituts Rom," the most comprehensive database for classical archaeology. This database goes back to 1956 and succeeds the print *Archaologische Bibliographie*, which began in 1932. For bibliography on the Black Sea and everywhere east, choose the "Eurasienbibliographie des Deutschen Archäologischen Instituts." Journals, Festschriften, and collected studies are all covered; the main focus is on the Mediterranean world. Citations to articles on classical, Near Eastern, and Egyptian archaeology; Byzantine art history; epigraphy; and numismatics. Includes and continues Archaeologisches Bibliographie, which ceased print publication in 1996. www.dyabola.de.

11.29. CEFAEL digital library (French School at Athens). Full text of *Bulletin de Correspondance Hellenique, BCH* Supplements and most volumes in series published by the French School at Athens (including the *Fouilles de Delphes, Exploration archéologique de Délos,* and *Etudes Thasiennes*). http://cefael.efa.gr/site.php.

11.30. *Gnomon Online Bibliographische Datenbank.* Eichstatt: Universitatsbibliothek Eichstätt, 2001– . Selected data from a larger Gnomon

database on CD-ROM. 1990– . Includes all data from the CD-ROM from 1997 onward. Indexes books and articles. Gnomon-online.de.

11.31. *TOCS-IN.* Provides the tables of contents from a selection of mostly classics but also archaeology, religion, and Near Eastern studies journals. Subjects covered include Greek and Latin linguistics and literature, Greek and Roman history, archaeology, and mythology. About 10 percent of the entries link to the full text of the articles. Covers published works from 1992 to the present. http://projects.chass.utoronto.ca/amphoras/tocs.html.

Cultural Heritage and Conservation

11.32. *AATA Online: Abstracts of material cultural heritage management and conservation literature worldwide.* AM1 .A7, v. 1–36, 1955–2000. aata.getty.edu/Home. Abstracts for articles from more than 400 journals in more than thirty-five languages, reproducing *Art and Archaeology Technical Abstracts* and its predecessor, *IIC Abstracts,* from 1955 with current additions. Updates will include *AATA Supplements and Abstracts* produced from 1932 to 1955 by the Fogg Art Museum and the Free Gallery of Art. Topics include methods of examination and analysis; conservation, including architectural conservation; archaeological methods; conservation and heritage management education and training; production techniques and history; and the analysis, treatment, and techniques of specific materials and objects for works of art, cultural objects, museum collections, archives and library materials, architecture, historic sites, and archaeology. Print counterpart: *Art and Archaeology Technical Abstracts,* 1955–2000.

11.33. *Conservation Information Network* (BCIN). The Bibliographic Database of the Conservation Information Network is the web's most complete bibliographic resource for the conservation, preservation, and restoration of cultural property. A worldwide network of libraries and documentation centers contribute data on their combined holdings, including previously unavailable material from private sources. Cited literature includes books, published and unpublished monographs and serials, conference proceedings, technical reports, journal articles, theses, audiovisual materials, and software and machine-readable files. It currently includes nearly 200,000 citations, including the first thirty-four volumes of the *Art and Archaeology Technical Abstracts* (AATA), published between 1955 and 1997. http://www.bcin.ca/.

Egyptology

11.34. *Aigyptos: A Database for Egyptological Literature,* 1978– . From the Institute of Egyptology, Munich. Emphasis on subject indexing (called keyword here); excellent coverage of non-English journals. A collaborative project of the Institute of Egyptology, University of Munich, in cooperation with the Department of Egyptology, University of Heidelberg. http://www.aigyptos.uni-muenchen.de/.

11.35. *Online Egyptological Bibliography (OEB).* Oxford: Griffith Institute, Faculty of Oriental Studies, University of Oxford. World Wide Web. An international index of books and articles covering Egyptological literature published by the International Association of Egyptologists. Continues: *Annual Egyptological bibliography; Bibliographie égyptologique annuelle.* Leiden: E. J. Brill. DT57 .A558, 1947–1973, 1976–1979, 1981–2001; *Egyptological bibliography; Ägyptologische Bibliographie; Bibliographie Égyptologique.* Leiden: Netherlands Institute for the Near East, 2001– . 2/yr. DT57 .A562, 1822/1997; *Late reviews AEB 1947–1984* / L. M. J. Zonhoven. Leiden: International Association of Egyptologists in cooperation with the Nederlands Instituut voor het Nabije Oosten, 1989. 74 p. Z3656.A2 A62 1989. oeb.griffith.ox.ac.uk.

Festschriften

11.36. *Articles on antiquity in Festschriften: an index; the ancient Near East, the Old Testament, Greece, Rome, Roman law, Byzantine* / Dorothy Rounds. Cambridge, MA: Harvard University Press, 1962. Z6202 .R6. Indexes articles in works honoring individuals and institutions; covers 1863–1954.

History

11.37. *Historical abstracts.* Ipswich, MA: EBSCO, 1969– . Indexes articles, book reviews, and dissertations on the history and culture of the world (excluding the United States and Canada) from 1450 to the present. http://www.ebscohost.com/academic/historical-abstracts.

Numismatics

11.38. *American Numismatic Association.* Contains almost all the contents of *Numismatic Literature* through a searchable interface. http://www.numismatics.org/.

11.39. *Numismatics Literature*. New York: American Numismatic Society. Searchable version of American Numismatic Society's Numismatic Literature, the comprehensive bibliography of research on coins and coinage. Searchable version does not cover most recent years. http://www.numismatics.org/Numlit/Numlit.

11.40. *Roman Provincial Coinage Online*. Database describing Antonine period (138–192 CE) Roman provincial coinage, based upon holdings of major coin cabinets. Searchable by coin type imagery, mint city, minting date, and magistrate. http://rpc.ashmus.ox.ac.uk/.

Papyrology

11.41. *APIS: Advanved Papyrological Information System*. APIS is a collections-based repository hosting information about and images of papyrological materials (e.g., papyri, ostraca, wood tablets, etc.) located in collections around the world. It contains physical descriptions and bibliographic information about the papyri and other written materials, as well as digital images and English translations of many of these texts. When possible, links are also provided to the original language texts (e.g., through the Duke Data Bank of Documentary Papyri). www.columbia.edu/cu/lweb/projects/digital/apis/index.html.

Philology

11.42. *L'Anné philologique: bibliographie critique et analytique de l'antiquité gréco-latine*. 1925– . Paris: Société d'édition "Les Belles Lettres." Indexes all aspects of classical studies in one annual volume; international in scope. An index to journal articles, conference proceedings, and articles in collected studies. This database focuses on many subject areas relating to classical studies, including archaeology. Not as comprehensive as *Dyabola*, but easier to use. Contains citations of all known scholarly work published in any language anywhere in the world in the areas of ancient Greek and Latin language and linguistics, Greek and Roman history, literature, philosophy, art, archaeology, religion, mythology, music, science, early Christian texts, numismatics, papyrology, and epigraphy. Coverage begins in 200 BCE and ends roughly in 800 CE. Covers 1959 to the present. www.annee-philologique.com.

11.43. *Supplementum Epigraphicum Graecum* (SEG). Alphen aan den Rijn: Sijthoff & Noordhoff. Van PA25 .S866, v.1 (1923)– . The *Supplementum Epigraphicum Graecum* systematically collects newly published Greek inscriptions as well as publications on previously known documents. It presents complete Greek texts of all new inscriptions with a critical apparatus; it summarizes new readings, interpretations, and studies of known inscriptions and occasionally presents the Greek text of these documents. The online edition includes all SEG volumes and will incorporate all future volumes in the series. *Supplementum Epigraphicum Graecum Online* is automatically updated upon publication of the annual volume. http://www.brill.com/publications/supplementum-epigraphicum-graecum.

Religion

11.44. *ATLA Religion*. Chicago: American Theological Library Association. Index to books, journal articles, book reviews, and collections of essays in all fields of religious studies. Good coverage of Near Eastern studies. Continues: *Index to religious periodical literature*. Chicago: American Theological Library Association. 13 v. 2/yr. BL1 .R375, 1949/1952–1960, 1971, 1974, 1975, 1977. https://www.atla.com/products/catalog/Pages/rdb-db.aspx.

Rome

11.45. *Index to Aufstieg und Niedergang der römischen Welt*. Searchable database of articles in *Aufstieg und Niedergang der römischen Welt* (DG209. T36). http://www.cs.uky.edu/~raphael/scaife/anrw.html.

Technology

11.46. *History of Science, Technology, and Medicine* (HST, Wellcome Bibliography, History of Science, Technology, and Medicine). International bibliography on the history of science and technology from prehistory to the present, describing journal articles, conference proceedings, and books; 1975 to the present. Updated annually. http://www.ebscohost.com/academic/history-of-science-technology-medicine.

12
Journal Literature

There are many reasons for incorporating journal articles in research. Journals are usually published at regular intervals, either monthly, quarterly, annually, or every two years, and are therefore more current than books in their coverage. Journal articles are shorter in length than books and frequently contain detailed information on subjects that may not warrant an entire book. Finally, they enable the researcher to read the results and arguments of several different scholars more quickly than could be done by reading numerous books.

The terms *magazine*, *journal*, and *periodical* are used somewhat interchangeably. However, *magazine* usually refers to a popular publication, *journal* refers to a more scholarly publication, and *periodical* refers to anything that is published at regular intervals. Individual articles published in magazines, journals, or other periodicals are cited or referenced in library reference works known as *indexes*. Indexes of interest to scholars of the ancient world are discussed in Chapter 11.

Once a list of the pertinent journal articles on a subject has been compiled, the researcher will need to determine whether the library has each journal title and where it is located. *Ulrich's International Periodicals Directory* will indicate whether a particular journal has its own annual index. If not, *Ulrich's* will identify where it is indexed. It is also useful to determine which periodical indexing or abstracting service should be used to identify articles on similar or related subjects.

The journals identified here are based on the serial holdings of the University of Pennsylvania Libraries. Holdings may or may not be complete.

ELECTRONIC JOURNALS

Journals are increasingly available in electronic format. EBSCO MegaFile, JSTOR, Project Muse, and WileyInter-Science are examples of some important subscription-based collaborations between libraries and publishers to provide electronic access to digital humanities and social science content from university presses and scholarly societies. Anyone with Internet access can freely browse and search the journal tables of contents and abstracts. Authorized users at sites within the licensed consortia can view, search, print, and download complete articles without restriction for personal use and course packs.

REGIONAL JOURNALS

Afghanistan

12.1. *Afghan studies*. London. 2/yr. DS350 .A36, 1978–1982.

Africa, North

12.2. *Journal of North African studies*. London. 3/yr. DT160 .J687, v.1– , 1996– ; World Wide Web, 1997– .

Albania

12.3. *Studia Albanica*. Tirana. 1/yr. DR701.S49 S88, 1964–1973.

Algeria

12.4. *Academie d'Hippone. Bulletin*. Bone, Algeria. 913.61 .Ac12, 1865–1961.

12.5. *Academie d'Hippone. Comptes rendus des reunions*. Bone, Algeria. 913.61 Ac12.2, 1887–1902.

12.6. *Bulletin d'archéologie algérienne*. Alger. DT281 .B855, 1962–1979.

Armenia

12.7. *Aramazd: Armenian journal of Near Eastern studies.* Yerevan. 2/yr. DS161 .A616, v.1– , 1920– .

12.8. *Revue des etudes armeniennes.* Paris. World Wide Web, 1995– .

Austria

12.9. *Archäologie Österreichs.* Wien. 2/yr. DB29 .A734, Jahr. 1–19, 1990–2008.

Bahrain

12.10. *Dilmun.* s.l. 2/yr. DS56 .D57, no. 1– , 1973– .

Belgium

12.11. *Revue belge d'archéologie et d'histoire de l'art.* Bruxelles. N2 .R37, t.1– , 1931– .

12.12. *Société royale d'archéologie de Bruxelles. Annales.* Bruxelles. 913.06 B835.2, t.1–28, 1887–1919.

Bulgaria

12.13. *Archaeologia bulgarica.* Sofia. 3/yr. CC1 .A734, v.1–13, 1997–2009.

12.14. *Studia praehistorica.* Sofia. Irreg. DR62 .S88, v.1–2, 1978.

12.15. *Thracia.* Serdicae. DF261.T6 T47, t.6.

Crete

12.16. *Cretan studies.* Amsterdam, irreg. 1988–2003. DF261 .C8 C748, v.8–9, 2003.

Croatia

12.17. *Godisnjak Instituta za arheologiju.* Zagreb. World Wide Web, 2005– .

12.18. *Prilozi Instituta za arheologiju u Zagrebu.* Zagreb. 1/yr. World Wide Web, 2002– .

12.19. *Rad Jugoslavenske akademije znanosti i umjetnosti.* Zagrebu. Irreg. AS142 .J7, 1867–1991.

Cyprus

12.20. *Department of Antiquities, Republic of Cyprus. Annual report.* Nicosia. 1/yr. DS54.3 .A46, 1980–2008.

12.21. *Department of Antiquities, Republic of Cyprus. Annual report of the Chief Antiquities Officer.* Nicosia. 1/yr. DS54.3 .A46, 1960.

12.22. *Department of Antiquities, Republic of Cyprus. Annual report of the Director.* Nicosia. 1/yr. DS54.3 .A46, 1961–1979.

12.23. *Department of Antiquities, Republic of Cyprus. Report.* Nicosia. 1/yr. DS54.3 .C93a, 1934–1948, 1963–2009.

Czech Republic

12.24. *Archeologické rozhledy.* Praze. 4/yr. World Wide Web, 2001– .

Denmark

12.25. *Journal of Danish archaeology.* Odense. 1/yr. DL121 .J687, v.1–14, 1982–2006.

Egypt

12.26. *Aegyptus.* Milano. 1/yr. PA3339 .A4, v.1–75, 1920–1995; World Wide Web, 1920– .

12.27. *Ägypten und Levante: Zeitschrift fürägyptische Archäologie und deren Nachbargebiete.* Wien. 1/yr. DT57 .A267, no.1–14, 1990–2004; World Wide Web, 2003– .

12.28. *Australian Centre for Egyptology. Bulletin.* North Ryde. 1/yr. DT57 .B898, 1990–2006.

12.29. *Bulletin d'information archéologique.* Caire. 4/yr. DT57 .B855, no.1–6, 1990–1992; World Wide Web, 2001– .

12.30. *Bulletin d'information archéologique.* Le Caire. 4/yr. DT57 .B855, no.1–6, 1990–1992; World Wide Web, 2001– .

12.31. *Cahiers caribéens d'égyptologie; informatique et linguistique.* Fort de France, Martinique. 1/yr. DT57 .C345. no. 1–5/6, 2000–2003/2004.

12.32. *Chronique d'Égypte; bulletin périodique de la Fondation égyptologique reine Élisabeth.* Bruxelles. 2/yr. DT57 .C4, no.1–78, 1925–2004.

12.33. *Coptologia: studia coptica orthodoxa: a research publication in Coptic Orthodox studies; Gyptologia: epchisbo enremenkimi enorthodoxos.* Thunder Bay. 1/yr. BX130 .C668, v.1–19, 1981–2003.

12.34. *Discussions in Egyptology.* Oxford. 3/yr. DT57 .D483, no.1– , 1985– .

12.35. *Manchester Egyptian and Oriental Society. Journal.* Manchester. PJ3 .M3, no.1–19, 1911/12–1933/34.

12.36. *Papers for discussion; presented by the Department of Egyptology, Hebrew University.* Jerusalem. Irreg. DT57 .P273, v.1–2, 1981–1985.

12.37. *Prazské egyptologické studie.* Praha. 1/yr. DT57 .P73, v.1–2, 2002–2003.

12.38. *Revue de l'Égypte ancienne.* Paris. PJ1003 .R4, v.1–3, 1925–1931.

12.39. *Revue d'égyptologie*. Paris. 1/yr. PJ1003 .R35, t.1– , 1880– ; World Wide Web, 1995– .

12.40. *Revista de estudios de egiptología*. Buenos Aires. 1/yr. DT57 .R485, no.1–5, 1990–1994.

12.41. *Serapis*. Chicago. DT57 .S372, v.1–7, 1969–1982.

12.42. *Société francaise d'égyptologie. Bulletin*. Paris. DT57 .S62, no.1– , 1949– .

12.43. *Sphinx*. Uppsala. 493 Sp45, v.1–22, 1897–1931.

12.44. *Warsaw Egyptological studies*. Warsaw. DT61 .W377, no.1, 1997.

12.45. *Wepwawet: research papers in Egyptology*. London. 1/yr. DT57 .W378, v.1–3, 1985–1987.

12.46. *Zeitschrift fürägyptische sprache und altertumskunde*. Berlin. 2/yr. PJ1004 .Z4, Bd.1– , 1863– , World Wide Web, 1889– .

Great Britain

12.47. *Classics Ireland*. Dublin. 1/yr. World Wide Web, 1994– ; three-year moving wall.

12.48. *Historical and Archaeological Society of Ireland. Journal*. World Wide Web, 1868–1869.

Greece

12.49. *Aegean archaeology*. Warsaw. 1/yr. DF20 .A344, v.1–9, 1994–2008.

12.50. *Akoue: Newsletter of the American School of Classical Studies at Athens*. Princeton. DF11 .A495, v.1– , 1973– .

12.51. *Akroterion*. Stellenbosch. 1/yr. World Wide Web, 2000– .

12.52. *American School of Classical Studies at Athens. Annual Report*. Boston. 1/yr. DF11 .A49, v.1– , 1880- . DF11 .A49, no.1– , 1880– .

12.53. *American School of Classical Studies at Athens. Bulletin*. Boston. 913.06 Ar22.3, v.1–2, 4–5, 1883–1888; 913.06 Ar22.3,. v.1–5, 1883–1888.

12.54. *American School of Classical Studies at Athens. Newsletter*. Athens. DF11 .A495, 1973–2001.

12.55. *American School of Classical Studies at Athens. Papers*. Boston. 913.06 Ar22.3, v.1–6, 1883–1897.

12.56. *American School of Classical Studies at Athens. Supplementary Papers*. Boston. 913.37 Ar24, v.1–2, 1905–1908; World Wide Web, 1905–1908.

12.57. *Anistoriton*. Athens. World Wide Web, v.1– . 1997– .

12.58. *British School at Athens. Annual*. London. 1/yr. World Wide Web, 1894– ; five-year moving wall.

12.59. *British School at Athens Studies*. London. World Wide Web, 1995– ; three-year moving wall.

12.60. *British School at Athens. Supplementary Papers*. London. World Wide Web, 1923–1957.

12.61. *British School at Athens. Supplementary Volumes*. London. World Wide Web, 1966– ; three-year moving wall.

12.62. *Bulletin de Correspondence Hellenique*. World Wide Web, 1877–1949.

12.63. *Corinth: Results of excavations conducted by the American School of Classical Studies at Athens*. Cambridge. Irreg. World Wide Web, 1929–2004.

12.64. *Correspondance Hellénique de l'École française d'Athènes. Bulletin*. World Wide Web, 1877–1949.

12.65. *Journal of Greek linguistics*. Leiden. 1/yr. World Wide Web, 2000– .

12.66. *Journal of Hellenic studies*. London. 1/yr. DF10 .J8, v.1– , 1880– . World Wide Web, 1880– . Three-year moving wall.

12.67. *Kernos*. Liege. Irreg. World Wide Web, 1988– .

12.68. *Makedonika*. Thessalonike. 2/yr. DR701.M13 M44, v.1–27, 1989/90.

12.69. *Makedonika*. Skopje, 1985– . Z2854.M3 M3452 v.4, 1981/82.

12.70. *Society for the Promotion of Hellenic Studies. Archaeological reports*. London. 1/yr. World Wide Web, 1954– .

12.71. *Society for the Promotion of Hellenic Studies. Supplementary studies*. London. Irreg. 913.06 So13.2, v.1–12, 1892–1987.

Hungary

12.72. *Antaeus: Mitteilungen des Archäologischen Instituts der Ungarischen Akademie der Wissenschaften*. Budapest. 1/yr. DB920 .M272a, t.15, 1986.

Inscriptions

12.73. *Kadmos*. Berlin. 2/yr. CN1 .K3, Bd.1– , 1962– ; World Wide Web, 1998– .

Iran

12.74. *American Institute for Iranian Art and Archaeology. Bulletin*. New York. 913.355 Ir15, v.5, 1937–1938.

12.75. *American Institute for Persian Art and Archaeology. Bulletin*. New York. 913.355 Ir15, v.1–4, 1931–1936.

12.76. *Archäologische Mitteilungen aus Iran*. Berlin. 1/yr. DS261 .A1 A66 1929, v.1, 1929; DS261. A1 A72, Bd. 1–9, n.s. Bd.1–28, 1929–1996.

12.77. *Archäologische Mitteilungen aus Iran und Turan*. Berlin. 1/yr. DS261. A1 A72, Bd. 29–42, 1997–2010.

12.78. *Bastanshinasi va hunar-i Iran.* Tehran. Irreg. DS261 .B288, no.1–12, 1969–1974.

12.79. *Bulletin de la Délégation en Perse.* Paris. 508.55 F846.2, v.1–2, 1910–1911.

12.80. *Hunar va mardum; Art and people.* Tehran. 12/yr. N8 .H85, no.30–190, 1965–1977.

12.81. *Indo-Iranian journal.* The Hague. PK1 .I526, v.1–51, 1957–2008; PK1 .I526, World Wide Web, 1997– .

12.82. *Iran.* London. 1/yr. DS251 .I66, v.1– , 1963– . World Wide Web, v.1– , 1963– . Four-year moving wall.

12.83. *Iran and the Caucasus.* Yerevan. 1/yr. World Wide Web, v.1– , 1997– . Five-year moving wall.

12.84. *Iran Society. Journal.* London. 955 Ir12, v.1, 1950–1954.

12.85. *Iranica antiqua.* Leiden. DS251 .I77, v.1– , 1966– . World Wide Web, 1995– .

12.86. *Iranian Institute. Bulletin.* New York. 913.355 Ir15, v.5–7, 1942–1946.

12.87. *Iranian Studies.* New Haven. 5/yr. DS251 .I76, v.1– , 1967– ; World Wide Web, 1968– ; seven-year moving wall.

12.88. *Journal of Persianate Studies.* Leiden. 2/yr. World Wide Web, 2008– .

12.89. *Journal of Qur'anic studies.* London. BP130 .J687, v.1– , 1999– ; World Wide Web, 1999– .

12.90. *Majallah-I bastyan shinasi va tarikh; Iranian journal of archaeology and history.* Tehran. 2/yr. DS261 .M343, v.1, 1986.

12.91. *Nashrīyah-i Anjuman-i Farhang-i Īrān-i Bāstān.* Tehran. no.15–19, 1974–1977.

12.92. *Parthica.* Pisa. 1/yr. 2002– ; World Wide Web, 2002– .

12.93. *Stanshinasi va hunar-i Iran.* Tehran. 2/yr. DS261 .B288, no.1–12, 1969–1974.

Iraq

12.94. *ARAM.* Oxford. 2/yr. DS94.5 .A72, v.1– , 1989– ; World Wide Web, 1995– .

12.95. *British School of Archaeology in Iraq.* Newsletter. London. 6/yr. 1992– .

12.96. *Iraq.* London. 1/yr. DS67 .S76. v.1– , 1945– . World Wide Web 1934– ; five-year moving wall.

12.97. *ISIMU: Revista sobre Oriente Próximo y Egipto en la antiguedad.* Madrid. 1/yr. DS56 .I856. v.1–2, 1998–1999.

12.98. *Sumer.* Baghdad. 1/yr. DS67 .M376, v.1– , 1945– .

Israel and the Palestinian Territories

12.99. *American Schools of Oriental Research in Jerusalem. Annual.* New Haven. 1/yr. DS101 .A45 v.1–3, 1920–1923; World Wide Web, 1919–1921.

12.100. *British School of Archaeology in Jerusalem. Supplementary Papers.* London. 913.3945 .B778, v.1–4.

12.101. *Eshkolot.* Yerushalayim. 1/yr. v.1–7, 1954–1975; n.s. v.1–3, 1976–1978.

12.102. *Israel exploration journal.* Jerusalem. 2/yr. DS111 .A1 I87, v.1– , 1950– ; World Wide Web, 1950– . Three-year moving wall.

12.103. *Israel Museum studies in archaeology.* Jerusalem. 1/yr. N5460 .I873, v.1– , 2002– .

12.104. *Israel studies.* Bloomington. 3/yr. v.1–3, 1996–1998; DS101 .I867, v.1– , 1996– ; World Wide Web, 1996– . Three-year moving wall.

12.105. *Israel studies bulletin.* Philadelphia. 2/yr. DS101 .N497, v.7–15, 1992–1999.

12.106. *Journal of Palestinian archaeology.* Bir Zayt. 2/yr. DS111 .A M353, v.1– , 2000– .

12.107. *Journal of Palestinian studies.* World Wide Web, 1971– . Three-year moving wall.

12.108. *Tel Aviv: Journal of the Institute of Archaeology of Tel Aviv University.* Tel Aviv. 2/yr. DS111 .A1 T44, v.1– , 1974– ; World Wide Web, 1974– .

12.109. *Yediot ha-Ḥevrah la-ḥakirat Erets-Yiśrael ye-atiḵoteha.* Jerusalem. 4/yr. DS111.A1 I8 v.17–25, 1952–1961.

12.110. *Yerushalayim: ha-Ḥevrah la-ḥakirat Erets-Yiśrael ye-atiḵoteha.* Jerusalem. 4/yr. DS111 .A8 I8, v.26–31, 1962–1967.

12.111. *Zeitschrift des Deutsches Palastina-Vereins.* Wiesbaden. 2/yr. World Wide Web, 1878– . Three-year moving wall.

Italy

12.112. *American Academy in Rome. Memoirs.* Bergamo. Irreg. DG12 .A575, v.1– , 1917– . World Wide Web, 1917– ; five-year moving wall.

12.113. *American School of Classical Studies in Rome. Memoirs.* Bergamo. 1/yr. DG12 .A575, v.1– , 1915– ; World Wide Web, 1915– .

12.114. *American School of Classical Studies in Rome. Supplementary Papers.* Bergamo. Irreg. 913.37 Ar24, v.1–2, 1905–1908; World Wide Web, 1905–1908.

12.115. *British School at Rome. Papers.* London. World Wide Web, 1902– .

12.116. *École Française de Rome. Melanges de Rome. Mélanges d'archéologie et d'histoire.* 2/yr. World Wide Web, 1971–1999.

12.117. *Etruscan news.* New York. 2/yr. World Wide Web, 2002– .

12.118. *Etruscan studies.* Detroit. 1/yr. v.1– , 1994– ; World Wide Web, 1994– .

12.119. *Etruscans.* Detroit. DG11 .E87, no.1, 1967–1969.

12.120. *Etudes classiques.* Namur. PA2 .E882, t.1– , 1933.

12.121. *Journal of Roman archaeology.* Ann Arbor. DG11 .J687, v.1– , 1988– .

12.122. *Journal of Roman studies.* London. DG11 .J7, v.1– ; 1911– ; World Wide Web, 1911– ; three-year moving wall.

12.123. *Rasenna: journal of the Center for Etruscan Studies.* Amherst. 1/yr. World Wide Web, 2007– .

12.124. *Studi e materiali.* Firenze. DG11 .S686, v.5– , 1982– .

12.125. *Studi e materiali di etruscologia e antichita italiche.* Firenze. DG223 .R62. v.1– , 1970– .

12.126. *Studi etruschi.* Firenze. DG223.A1 S8, v.1– , 1927– .

12.127. *Studi storici.* Roma. 4/yr. DG401 .S89, anno 1– , 1959– ; World Wide Web, 1959– ; five-year moving wall.

Jordan

12.128. *Anba'.* Irbid. 2/yr. DS153.3 .Y365, no.1– , 1987– .

12.129. *Department of Antiquities, Hashemite Kingdom of Jordan. Annals.* Amman. DS153.3 .A3, v.1– , 1951– .

12.130. *Studies in the history and archaeology of Jordan.* Amman. DS153.3 .S75, t.1– , 1982– .

Lebanon

12.131. *Annales d'histoire et d'archéologie.* Beirut. 1/yr. DS567 .A68, v.1, 1982.

12.132. *Baal: Bulletin d'archéologie et d'architecture libanaises.* Beyrouth. 1/yr. DS80.3 .B335, v.1– 11, 1996–2007.

12.133. *Berytus.* Beirut. 1/yr. DS41 .B47, v.1– , 1934– .

12.134. *Chronos: Revue d'histoire de l'Université de Balamand.* Tripoli. 1/yr. DS41 .C46, no.1– , 1998– .

12.135. *Damaszener Mitteilungen.* Mainz am Rhein. 2/yr. DS99.D3 D252, Bd.1–15, 1983–2006.

12.136. *Musée de Beyrouth. Bulletin.* Paris. DS99.L4 A125, t.1– , 1937– .

Libya

12.137. *Libya antiqua.* Tripoli. 1/yr. DT221 .L42, v.1–16, 1964–1979; n.s. v.1– , 1998– .

12.138. *Libyan studies.* London. DT211 .S624, v.1– , 1969– .

12.139. *Libyca.* Algiers. 2/yr. DT281.L5, t.1–34, 1953– 1986.

Malta

12.140. *Museum Department of Malta. Report of the work.* Valletta. 1/yr. 913.458 M295, 1923–1970.

Morocco

12.141. *Bulletin d'archéologie marocaine.* Casablanca. DT311 .B855, t.1–18, 1956–1998.

12.142. *Études et travaux d'archéologie marocaine.* Rabat. DT328.M6 E8, v.1– , 1965– .

Near East

12.143. *Acta Sumerologica.* Hiroshima. 1/yr. PJ4001 .A257, v.1– , 1979– .

12.144. *al-Rafidan; journal of Western Asiatic studies.* Tokyo. 1/yr. DS41 .R234, v.1– ; 1980– .

12.145. *American Oriental Society. Journal.* New Haven. 4/yr. PJ2 .A6, v.1– , 1843– ; World Wide Web, 1843– . Three-year moving wall.

12.146. *American Schools of Oriental Research. Bulletin.* New Haven. DS101 .A6, no.1– , 1919– ; World Wide Web, 1921– ; three-year moving wall.

12.147. *American Schools of Oriental Research. Newsletter.* Philadelphia. 4/yr. DS101 .A46. v.1– , 1938– ; World Wide Web, 1996– .

12.148. *American Schools of Oriental Research. Supplementary Studies.* Missoula. DS41 .A55, no.1–27, 1945–1991. World Wide Web, 1945–1991.

12.149. *Ancient Near Eastern Society. Journal.* New York. 1/yr. DS41 .C65, v.1–32, 1968–2011; World Wide Web, 1982–2011.

12.150. *Annual review of the royal inscriptions of Mesopotamia Project.* Toronto. v.1– , 1983– .

12.151. *Asia Institute. Bulletin.* Shiraz. 4/yr. DS41 .P24, no.1–2, 1969–1977.

12.152. *Asia Institute. Bulletin.* Detroit. 1/yr. DS41 .B855, no.3, 1993; DS41 .B 855, v.1– , 1987– .

12.153. *Association of Graduate Near Eastern Students. Journal.* Berkeley. 2/yr. DS41 .J64, v.1–7, 1990– 1996.

12.154. *Association of Graduates in Near Eastern Studies. Journal.* Berkeley. 2/yr. DS41 .J64. v.1–10, 1990–2004.

12.155. *Aula orientalis.* Barcelona. 2/yr. DS41 .A852, v.1– , 2013– ; World Wide Web, 2013– .

12.156. *Bibliotheca Orientalis.* Leiden. 6/yr. DS1 .B425, Jahr.1– , 1943– ; World Wide Web, 1997– .

12.157. *British Journal of Middle Eastern Studies.* Exeter. 3/yr. DS41 .B75, v.1–34, 1974–2008; World Wide Web, 1991–2008.

12.158. *British Society for Middle Eastern Studies. Bulletin.* London. 6/yr. DS41 .B75, v.1–34, 1974– 2008; World Wide Web, 1991–2008.

12.159. *Bulletin on Sumerian Agriculture.* Cambridge. 1/yr. DS72 .B84, v.1–8, 1984–1995.

12.160. *Canadian Society for Mesopotamian Studies. Bulletin.* Toronto. 3/yr. DS70.9 .B855, no.1–40, 1981–2005.

12.161. *Canadian Society for Mesopotamian Studies. Journal.* Toronto. 1/yr. DS70.9 .B8553 v.1–5, 2006–2010.

12.162. *Canadian Society for Syriac Studies. Journal.* Toronto. 1/yr. DS56 .J68, v.1– , 2001– .

12.163. *Central Asia Survey.* Oxford. 4/yr. D471 .C877, v.1–28, 1982–2010; v.16– , 1997– .

12.164. *Contributi e materiali di archeologia orientale.* Roma. DS56 .C663, v.1–13, 1986–2007.

12.165. *Council for British Research in the Levant. Bulletin.* London. 1/yr. DS56 .N49, v.1– , 2006– ; World Wide Web, 2006– .

12.166. *Cuneiform Digital Library Bulletin.* Los Angeles; Berlin. Irreg. World Wide Web, 2002– .

12.167. *Current Contents of Periodicals on the Middle East.* Tel-Aviv. DS41 .C877, v.1–9, 1980–1988.

12.168. *Dead Sea Discoveries.* Leiden. 3/yr. BM487 .A62 D433, v.1–17, 1994–2010; World Wide Web, 1994– ; five-year moving wall.

12.169. *Electronic Journal of Oriental Studies.* Utrecht. 1/yr. World Wide Web, 1998– .

12.170. *Hallesche Beiträge zur Orientwissenschaft.* Halle. DS56 .O7, v.1–29, 1962–1990.

12.171. *Inner Asia.* Cambridge. 2/yr. DS327 .I549, v.1– , 1999– ; World Wide Web, 2000– .

12.172. *Inner Asia. Occasional papers.* Cambridge. 1/yr. DS327 .I664, v.1–2, 1996–1997.

12.173. *International Journal of Middle East Studies.* London. 4/yr. DS41 .I55, v.1– , 1970– ; World Wide Web, 1970– . Five-year moving wall.

12.174. *Journal of the Associated Graduates in Near Eastern Studies.* Berkeley. 2/yr. DS41 .J64, v.10–11, 2005–2006.

12.175. *Journal of the Economic and Social History of the Orient.* World Wide Web, 1957– .

12.176. *Journal of Near Eastern Studies.* Chicago. 4/yr. DS41 .J6, v.10, 1951; v.1– , 1942– ; World Wide Web, 1942– . Five-year moving wall.

12.177. *Levant.* London. 2/yr. DS56 .L48, v.1– , 1969– ; World Wide Web, 1969– .

12.178. *Mar sipry: Newsletter of the Committee on Mesopotamian Civilization, ASOR.* Boston. v.1–3, 1988–1990.

12.179. *Manchester Cuneiform Studies.* Manchester. 492.05 .M317, v.1–9, 1951–1964.

12.180. *Manchester Oriental Society. Journal.* Irreg. Manchester. 490.6 M313, v.1–19, 1912–1934.

12.181. *Manchester University Egyptian and Oriental Society. Journal.* Manchester. PJ3 .M3, no.20–25. 1935–1953.

12.182. *Mesopotamia.* Torino. 1/yr. DS67 .M376. v.1– , 1966– .

12.183. *Mesopotamia.* Baghdad. 4/yr. DS67 .M598. no.1– , 2004– .

12.184. *Middle East Journal.* Washington. 4/yr. DS1 .M5, v.1– , 1947– ; World Wide Web, 1947– ; three-year moving wall.

12.185. *Middle East Quarterly.* Philadelphia. 4/yr. DS41 .M5227, v.1– , 1994– ; World Wide Web, 1994– .

12.186. *Middle East Report.* New York. 2/yr. DS42 .M46a, v.16–34, 1986–2004; World Wide Web, 1986– . Three-year moving wall.

12.187. *Middle East Studies.* New York. 2/yr. DS41 .M533, v.1– , 1967– .

12.188. *Middle Eastern Literatures.* Basingtoke. 2/yr. v.1– , 1998– ; World Wide Web, 1998–2002.

12.189. *Museón.* Louvain. 2/yr. DS1 .M9, t.101– , 1988– ; DS1 .M9, t.4, 6– , 1885, 1887– ; World Wide Web, 1995– .

12.190. *Near Eastern Archaeology.* Atlanta. 4/yr. BS620 .A1 B5, v.1–60, 1938–1997.

12.191. *Near Eastern Archaeology.* World Wide Web, 1998–2008. Three-year moving wall.

12.192. *Northern Akkad Project Reports.* Ghent. Irreg. DS67 .N678. v.1–10, 1987–1996.

12.193. *Recueil de travaux relatifs à la philologie et à l'archéologie égyptiennes et assyriennes, pour servir de bulletin à la mission française du Caire.* Paris. 4/yr. 492.05 R243, v.1–40, 1870–1923.

12.194. *Revue archéologique de l'Oise.* Compiegne. 4/yr. World Wide Web, 1971– .

12.195. *Revue d'assyriologie et d'archéologie orientale.* Paris. 1/yr. PJ3103 .R4, v.1– , 1884– .

12.196. *Revue hittite et asianique.* Paris. DS66 .R4. v.1–36, 1930–1978.

12.197. *Royal Asiatic Society. Journal.* Cambridge. World Wide Web, 1991– ; five-year moving wall.

12.198. *Royal Asiatic Society of Great Britain and Ireland. Journal.* Cambridge. World Wide Web, 1835– . Five-year moving wall.

12.199. *Royal Historical and Archaeological Association of Ireland. Journal.* Dublin. World Wide Web, 1870–1889.

12.200. *Royal Society of Antiquaries of Ireland.* Dublin. World Wide Web, 1890– . Five-year moving wall.

12.201. *Revue d'assyriologie et d'archéologie orientale.* Paris. 1/yr. PJ3103 .R4.

12.202. *Saarbrücker Studien und Materialien zur Altertumskunde.* Bonn. 1/yr. D51 .S337, v.1, 1992.

12.203. *Shenaton le-mikra ule-heker ha-mizrah ha-kadu; Shnaton: An annual for Biblical and Ancient Near Eastern Studies.* Yerushalayim. 1/yr. BS410 .S48, v.1–11, 1975–1997.

12.204. *State Archives of Assyria Bulletin.* Padova. PJ3701 .S7, v.4–5, 1990–1991.

12.205. *Transoxiana*. Buenos Aires. Irreg. World Wide Web, 2000– .

Nubia

12.206. *Nubia Christiana*. Warszawa. BR1380 .N824, t.1.

12.207. *Sudan & Nubia: The Sudan Archaeological Research Society Bulletin*. London. 1/yr. DT154.8 .S836, no.9–14, 2005–2010.

Portugal

12.208. *Conimbriga*. Coimbra. CC37 .C645, v.38, 1999.

12.209. *Madrider Mitteilungen*. Heidelberg. DP44 .M2, Bd.1– , 1960– .

12.210. *Revista portuguesa de arqueologia*. Lisboa. 2/yr. World Wide Web, 1998– .

Romania

12.211. *Acta historica*. Rome. D6 .A3, t.1–11, 1959–1974.

12.212. *Cercetari arheologice*. Bucuresti. 1/yr. DR211 .C372, v.1–8, 1975–1982.

12.213. *Marisia*. Tirgu Mures. 1/yr. DR296 .T37 S772, v.1–9, 1965–1972.

12.214. *Materiale si cercetari arheologice*. Bucuresti. 1/yr. 913.498 M413, v.1–10, 1956–1973; DR211 .M37, n.s. 2–7, 2000–2011.

12.215. *Pontica*. Constanta. DR201 .P65, no.1– , 1968– .

12.216. *Studii si cercetari de istorie veche si arheologie*. Bucuresti. 1/yr. DR211 .S78, t.25–51, 1974–2000.

12.217. *Thraco-Dacica*. Bucuresti, 1/yr. DF261.T6 T472, v.1–26, 1981–2011.

Sardinia

12.218. *Archivio storico sardo*. Cagliari. DG975 .S29 A67, v.1– , 1938– .

12.219. *Bullettino archeologico sardo*. Cagliari. DG55 .S2 B91, anno 1–10, 1855–1864.

Saudi Arabia

12.220. *Adumatu*. Riyadh. 2/yr. DS56 .A386, no.1– , 2000– .

12.221. *Arabian Archaeology and Epigraphy*. Copenhagen. 2/yr. DS211 .A727, v.1–20, 1990–2009. World Wide Web, 1997– ; twelve-month embargo on full-text.

12.222. *Atlal: The Journal of Saudi Arabian Archaeology*. Riyadh. v.1–14, 1982–1996.

Serbia

12.223. *Starinar*. Beograd. DR311 .A1 S7, v.1– , 1950– .

Sicily

12.224. *Archivio storico per la Sicilia*. Palermo. 1/yr. DG861 .A57, v.1–9, 1935–1943.

12.225. *Archivio storico siciliano*. Palermo. 1/yr. DG861 .A6, v.1–3, 1873–1875; n.s., v.1–54, 1876–1934; ser.3, v.1–24, 1946–1974; ser.4, v.1– , 1975– .

12.226. *Kokalos*. Palermo. 1/yr. DE1 .K6, v.1– , 1955– .

12.227. *Sicilia antiqua*. Pisa. 1/yr. Fine Arts Library DG861 .S566, v.1– , 2004– ; World Wide Web, 2004– .

Spain

12.228. *Acta historica et archaeologica mediaevalia*. Barcelona. World Wide Web 1980– .

12.229. *Faventia*. Barcelona. 2/yr. PA9 .F283, v.1– , 1979– ; World Wide Web, 1979– .

12.230. *Hispania epigraphica*. Madrid. DS67 CN670 .H57, v.1–4, 1989–1994.

Switzerland

12.231. *Anzeiger für schweizerische Altertumskund; Indicateur d'antiquités suisses*. Zürich. World Wide Web, 1869–1938.

12.232. *Archäologie der Schweiz; Archéologie suisse*. Basel. 4/yr. World Wide Web, 1978– . Embargo on most recent three years.

12.233. *Helvetia archaeologica; Archäologie in der Schweiz; Archéologie en Suisse; Archeologia in Svizze*. Basel. DQ30 .H442, Jahrg.1–24, 1970–1993.

12.234. *Jahrbuch der Schweizerischen Gesellschaft für Ur- und Frühgeschichte; Annuaire de la Société suisse de préhistoire et d'archéologie*. Basel. 1/yr. v.1– , 1968– . World Wide Web, 1966–2005.

12.235. *Jahrbuch der Schweizerischen Gesellschaft für Urgeschichte; Annuaire de la Société suisse de préhistoire; Annuario della Società svizzera di preistoria*. Basel. World Wide Web, 1938–1965.

12.236. *Zeitschrift für schweizerische Archæologie und Kunstgeschichte [resource]; Revue suisse d'art et d'archéologie; Rivista svizzera d'arte e d'archeologia*. Basel. 4/yr. World Wide Web, 1939– . Most recent two years not available.

Syria

12.237. *Annales archéologiques de Syrie*. Damas. 2/yr. DS94.5 .A75, t.1–33, 1951–1983.

12.238. *Chronique archéologique en Syrie*. Damas. Irreg. DS94.5 .C476, v.1–2, 1992–1998.

12.239. *Mari, annales de recherches interdisciplinaires*. Paris. Irreg. DS99 .M37 M372 1982, v.1–5, 1982–1997.

12.240. *Revue archeologique syrienne.* Alep. World Wide Web, 1931–1938.

12.241. *Syria.* Paris. 1/yr. DS94.5 .S8, v.1– , 1920– ; World Wide Web, 1920– .

12.242. *Syro-Egypt; Notes on Discoveries.* London. 913.32 Sy85, no.1–4, 1937–1938.

Thrace

12.243. *Thracia.* Serdicae. DF261 .T6 T47, t.1, 1972.

12.244. *Thraco-Dacica.* Bucuresti. DF261 .T6 T472, t.1–23, 1981–2002.

Turkey

12.245. *Anadolu arastirmalari.* Istanbul. DS41 .A522, cilt 1– , 1955– .

12.246. *Anadolu Akdenizi arkeoloji haberleri; News of archaeology from Anatolia's Mediterranean areas.* Antalya. 1/yr. CC13.T8 A533, v.1– , 2003– .

12.247. *Anadolu Anatolia.* Ankara. 2/yr. DS155 .A59, v.1–22, 1956–1983.

12.248. *Anadolu Medeniyetleri Muzesi yilligi.* Ankara. 1/yr. DR431 .A633, 1992– .

12.249. *Anatolia antiqua: recueil de travaux publiés par l'Institut français d'études anatoliennes d'Istanbul; Anatolian archaeological studies.* Tokyo. 1/yr. DS56 .A438, v.1–6, 1991–1999; World Wide Web, 1991–1999.

12.250. *Anatolian archaeology: reports on research conducted in Turkey.* London. 1/yr. DR431 .A634, v.1–14, 1995–2005.

12.251. *Anatolian studies.* London. 1/yr. World Wide Web, 1951–2008.

12.252. *Arkeo atlas.* Istanbul. 1/yr. DS155 .A734 , Sayi 5– , 2006– .

12.253. *Arkeoloji dergisi.* Izmir. DR431 .A742, v.1– , 1994– .

12.254. *Arkeoloji ve sanat.* Istanbul. 6/yr. DR431 .A754, say 1– , 1978– .

12.255. *British Institute of Archaeology at Ankara. Annual report.* London. 1/yr. DR431 .B748, v.1–38, 1948–1986.

12.256. *British Institute of Archaeology at Ankara. Research reports.* London. 1/yr. DR431 .B753, 1994– .

12.257. *Colloquium anatolicum.* Istanbul. 1/yr. DR401 .C655, v.1– , 2002– .

12.258. *Epigraphica Anatolica.* Bonn. CN410 .E644, Hft.1– , 1983– .

12.259. *Eski Anadolu.* Istanbul. 1/yr. DR431 .D42, v.1– , 1991– .

12.260. *Eski eserler ve muzeler bulteni.* Ankara. 4/yr. DR431 .E855, 1985.

12.261. *European Journal of Turkish Studies.* Paris. 2/yr. World Wide Web, 2004– .

12.262. *Gephyra: Zeitschrift fürGeschichte und Kultur der Antike auf dem Gebiet der heutigen Turkei; Gunumuz Turkiyesinin antik devirdeki tarihi ve kulturu icin dergi.* Istanbul. DR431 .G474, Bd.1–7, 2004–2010.

12.263. *Istanbul Arkeoloji Muzeleri yıllıgı; Archaeological Museums of Istanbul. Report.* Istanbul. 1/yr. N3690.T8 A3, no.1– , 1949– .

12.264. *Istanbul Muzeleri yıllıgı; Annuaire des Musées d'antiquités d'Istanbul.* Istanbul. 1/yr. N3690.T8 A3, no.1–2, 1934–1937.

12.265. *Istanbuler Mitteilungen.* Tübingen. 1/yr. DS41 .I8, Bd.1– , 1950– .

12.266. *Newsletter for Anatolian studies.* New Haven. 2/yr. DR431 .N487, v.1– , 1985– .

12.267. *Palmet: Sadberk Hanım Muzesi yıllıgı.* Istanbul. DS155 .P356, v.1– , 1997– .

12.268. *Pazartesi.* Istanbul. 12/yr. World Wide Web, 1995–2005.

12.269. *Tuba-ar; Turkiye Bilimler Akademisi Arkeoloji dergisi; Turkish Academy of Sciences journal of archaeology.* Ankara. DS155 .T83, v.1–14, 1998–2011.

12.270. *Turk arkeoloji ve etnografya dergisi.* Ankara. 1/yr. DR434 .T337, sayi 2–8, 2001–2008.

12.271. *Turkish historical review.* Leiden. 2/yr. World Wide Web, 2010– .

12.272. *Yayla: report of the Northern Society for Anatolian Archaeology.* Newcastle upon Tyne. DS49.3 .Y285, v.1–5, 1977–1982.

12.273. *Yili Anadolu Medeniyetleri Muzesi konferanslari.* Ankara. 1/yr. DR431 .A635, 1991–1994.

SUBJECT JOURNALS

Ancient History

12.274. *Aeon.* Magdeburg. 1/yr. World Wide Web, 2009– .

12.275. *American journal of ancient history.* Cambridge. 2/yr. DE1 .A365, v.1– , 1977– .

12.276. *Ancient history bulletin.* Calgary. 6/yr. D51 .A467, v.1– , 1987– .

12.277. *Arachnion.* Torino. Irreg. World Wide Web, v.1– , 1896– .

12.278. *Dialogues d'histoire ancienne.* Paris. 2/yr. D51 .D425, v.1–23, 1974–1997; World Wide Web, 1974– .

12.279. *Dritto @ Storia.* 1/yr. World Wide Web, 2002– .

12.280. *Early Medieval Europe.* World Wide Web, 1997– . Twelve-month embargo on full text.

12.281. *Historia.* Milano. 4/yr. 913.05 .H625, anno.1–7, 1927–1933.

12.282. *Historia: Zeitschrift für Alte Geschichte*. Wiesbaden. four/yr. World Wide Web, 1950– . Four-year moving wall.

12.283. *Historische Zeitschrift*. Munchen. 6/yr. D1 .H6, Bd.1– , 1859– ; World Wide Web, 1859– .

12.284. *Klio. Beiträge zur alten Geschichte*. Berlin. v.1– , 1901– ; World Wide Web, 2008– .

Anthropology

12.285. *Anthropological Institute of Great Britain and Ireland. Journal*. London. 2/yr. GN2 .R88, v.1–36, 1871–1906; World Wide Web, 1872–1965.

12.286. *Anthropological Institute of Great Britain and Ireland. Proceedings*. London. 1/yr. World Wide Web, 1966–1974.

12.287. *Anthropology of the Middle East*. New York. 2/yr. GN635 .N42 A58, v.1–5, 2006–2010; World Wide Web, 2006– .

12.288. *Anthropology today*. London. 6/yr. GN1 .A7245, v.1–16, 1985–2000; World Wide Web, 2001– .

12.289. *Man*. London. 4/yr. World Wide Web, 1966– ; GN1 .M25, v.1–65, 1901–1965; v.1–29, 1966–1994; v.1–13, 1995–2007; World Wide Web, 1901–1994.

12.290. *Royal Anthropological Institute. Journal*. London. 4/yr. GN1 .J733, v.1– , 1848– ; World Wide Web, 1848–1869, 1995–2006.

12.291. *Royal Anthropological Institute news; RAIN*. London. 6/yr. GN1 .R682, no.1–65, 1974–1984.

12.292. *Royal Anthropological Institute of Great Britain and Ireland. Journal*. London. World Wide Web, 1907–1994.

12.293. *Royal Anthropological Institute of Great Britain and Ireland. Occasional papers*. London. Irreg. GN2 .A32, v.1, 8, 12, 15, 20, 31.

12.294. *Royal Anthropological Institute of Great Britain and Ireland. Proceedings*. London. 2/yr. University Museum 572.06 An8.5, 1965–1971, 1973; World Wide Web, 1965–1973.

Arab Civilization

12.295. *Arabica*. Leiden. 6/yr. PJ6001 .A7, t.52– , 2010– ; World Wide Web, 1954– . Twelve-month embargo on full text; five-year moving wall.

12.296. *Journal of Arabic and Islamic studies*. Bergen. Irreg. World Wide Web, 1997– .

12.297. *Journal of Islamic manuscripts*. Leiden. 2/yr. World Wide Web, 2010– .

12.298. *Journal of Islamic studies*. Oxford. 1/yr. World Wide Web, 1996– . BP1 .J687, v.1–18, 1990–2007.

12.299. *Miscelanea de estudios arabes y hebraicos*. Granada. 2/yr. PJ3001 .M5, v.3–43, 1954–1994; World Wide Web, 1996– .

12.300. *Quaderni di studi Arabi*. Venezia. 1/yr. World Wide Web, 1983– . Three-year moving wall.

12.301. *Welt des Islams*. Berlin. 3/yr. DS36 .W4, v.1–22, 1913–1939; n.s. v.1–33, 1951–1993; v.44– , 2004– ; World Wide Web, 1913– . Five-year moving wall.

Archaeology

12.302. *American antiquity*. Menasha. 4/yr. v.1– , 1935– ; World Wide Web, 1935– . Two-year moving wall.

12.303. *American journal of archaeology*. New York. 4/yr. v.1– , 1897– . World Wide Web, 1897– .

12.304. *American journal of archaeology and the history of the fine arts*. Boston. 4/yr. CC1 .A6, v.1–11, 1885–1896; World Wide Web, 1885–1896.

12.305. *Antiquity*. Gloucester. 4/yr. CC1 .A7, v.1–85, 1927–2011; World Wide Web, 1927– .

12.306. *Archaeological reports*. London. DF10 .A68, v.1– , 1954– ; World Wide Web, 1954– .

12.307. *Archäologischer Anzeiger*. Berlin. 2/yr. Bd.7– , 1892– .

12.308. *Archaeology*. Boston. 6/yr. GN700 .A725. v.1– , 1948– ; World Wide Web, 1999– .

12.309. *Arkheologicheskie issledovaniia v Krymu; Archaeological researches in the Crimea*. Simferopol, 1/yr. DK508.9.K78 A754, 1993, 1994.

12.310. *Deutsches Archaeologisches Institut. Jahresbericht*. Berlin. DE1 .A62, 2008–2009. World Wide Web, 2009– .

12.311. *Electronic antiquity*. Blacksburg. Irreg. World Wide Web, 1993– .

12.312. *Forum archaeologiae*. Wien. World Wide Web, 1996– .

12.313. *International journal of nautical archaeology*. London. 2/yr. CC77 .I58, v.20–39, 1991–2010; World Wide Web, 1995– .

12.314. *International journal of nautical archaeology and underwater exploration*. London. 4/yr. CC77 .I58, v.1–19, 1972–1990.

12.315. *Journal of field archaeology*. Boston. 4/yr. CC1 .J69, v.1– , 1974– ; World Wide Web, 1974– .

12.316. *Journal of island and coastal archaeology*. Philadelphia. 2/yr. CC77 .I84 J68, v.1– , 2006– ; World Wide Web, 2006– .

12.317. *Minerva*. London. 6/yr. N5320 .M564, v.1– , 1990– .

12.318. *Old World archaeology newsletter*. CC1 .O422, v.1–23, 1977–2001.

12.319. *Oxford journal of archaeology*. Oxford. 4/yr. CC1 .O936, v.1– , 1982– ; World Wide Web, 1982– .

12.320. *Society for American archaeology. Memoirs.* Menasha. Irreg. E51 .S7, no.1– , 1941– ; World Wide Web, 1941– .

12.321. *World archaeology.* London. 4/yr. CC1 .W67, v.1– , 1969– ; World Wide Web, 1969– .

Archaeology, Biblical

12.322. *Biblical archaeologist.* Atlanta. 4/yr. BS620 .A1 B5, v.1–60, 1938–1997; World Wide Web, 1938–1997.

Art and Art History

12.323. *Ars Islamica.* Ann Arbor. 1/yr. N6260 .A13, v.1–35, 1934–1954; World Wide Web, 1934–1954.

12.324. *Ars Orientalis.* Washington, DC. 1/yr. Ann Arbor. N6260 .A13, v.1– , 1954– ; World Wide Web, 1954– .

12.325. *Art bulletin.* New York. 4/yr. N11 .C4, v.1– , 1919– ; World Wide Web, 1919– .

12.326. *Art history.* Oxford. N1 .A452, v.1–32, 1978–2009.

12.327. *Art journal.* New York. N1 .A552, v.1– , 1875– ; World Wide Web, 1875– .

12.328. *Art journal.* London. N1 .A5, 1839–1912; World Wide Web, 1839–1912.

12.329. *College Art Association. Bulletin.* Providence. N11 .C4, no.1– , 1913– ; World Wide Web, 1913– .

12.330. *College Art Association. Newsletter.* New York. World Wide Web, 2002– .

12.331. *College Art Association. Reviews.* New York. World Wide Web, 1998– .

12.332. *College Art Association. Slides and photographs newsletter.* New York. World Wide Web, 1972–1973.

12.333. *College art journal.* New York. 4/yr. N81 .A887, v.1–19, 1941–1960; World Wide Web, 19, 1941–1960.

12.334. *Gesta.* Fort Tryon. 2/yr. N6280 .G4, v.1– , 1964– ; World Wide Web, 1964– .

12.335. *Journal of art historiography.* Glasgow. 2/yr. World Wide Web, 2009– .

Biblical Studies

12.336. *Aramaic studies.* London. 2/yr. BS410 .A736, v.1–4, 2003–2006; BS410 .A736, v.1– , 2003– .

Bibliography

12.337. *Annual bulletin of historical literature.* London. /yr. D16.4 .G7 H47, no.1– , 1994, 1911–2008; World Wide Web, 1962–1968, 1997– .

12.338. *Domes: digest of Middle East studies.* Milwaukee, 4/yr. DS41 .D654, v.1– , 1992– ; World Wide Web, 1994– .

12.339. *Gnomon.* Munchen. 8/yr. PA3 .G6, v.1–77, 1925–2005; PA3 .G6, v.78– , 2006– ; World Wide Web, 1925– .

British Museum

12.340. *British Museum quarterly.* London. 4/yr. 705 .B778, v.1–37, 1926–1973; World Wide Web, 1926–1973.

Civilization

12.341. *Ancient West and East.* Leiden. 1/yr. DE1 .A374, v.1– , 2002– ; World Wide Web, 2007– .

12.342. *Antike Welt.* Zurich. D51 .A578, Jahrg. 1– , 1970– .

12.343. *Antliche Berichte aus den Preuszischen Kunstsammlungen.* Berlin. 12/yr. World Wide Web, 1918–1919.

12.344. *Apeiron.* Clayton. 4/yr. B1 .A734, v.1– , 1966– ; World Wide Web, 1966– .

12.345. *Comparative studies in society and history.* Cambridge. 4/yr. H1 .C73, v.1– , 1958– ; World Wide Web, 1958– .

12.346. *Comparative studies of South Asia, Africa, and the Middle East.* Durham. 3/yr. DS335 .S57, v.15– , 1995– ; World Wide Web, 2000– .

12.347. *Frankfurter Elektronische Rundschau zur Altertumskunde.* Frankfurt. 3/yr. World Wide Web, 2006– .

Classics

12.348. *Antichthon.* Sydney. 1/yr. PA1 .A5, v.1– , 1967– ; World Wide Web, 2001– .

12.349. *Antiquité classique.* Bruxelles. 2/yr. DE1 .A43, t.1– , 1932– .

12.350. *Arethusa.* Baltimore. 3/yr. PA1 .A73, v.1– , 1968– ; World Wide Web, 1996– .

12.351. *Aries.* Paris. 1/yr. BL624 .A73, no.1– , 1982– ; World Wide Web, 2001– . Twelve-month embargo on full text.

12.352. *Arion: a journal of humanities and the classics.* Boston. 3/yr. PA1 .A72, v.1–9, 1962–1970; n.s., v.1–3, 1973–1976; 3 ser., v.1– , 1994– .

12.353. *Association Guillaume Budé. Bulletin.* Paris. 1/yr. 470.6 As75.2, t.1–13, 1942–1955.

12.354. *Association pour l'encouragement des etudes grecques en France. Annuaire.* Paris. 1/yr. DF11 .A7, annee 3–20, 1869–1886.

12.355. *Babesch: bulletin antieke beschaving.* Leiden. 1/yr. Jahr. 45– , 1970– ; World Wide Web, 1994– .

12.356. *Boreas.* Munster. CC5 .B673, Bd.1– , 1978– .

12.357. *Britannia*. London. DA145 .B758, v.1– , 1970– ; World Wide Web, 1970- . Three-year moving wall.

12.358. *Bryn Mawr classical review*. Bryn Mawr. 6/yr. PA1 .B78, v.1–9, 1990–1998; World Wide Web, 1990– .

12.359. *Bryn Mawr electronic resources review*. Bryn Mawr. World Wide Web, 1998– .

12.360. *Bryn Mawr medieval review*. Bryn Mawr. Irreg. World Wide Web, 1993– .

12.361. *Bulletin analytique d'histoire romaine*. Strasbourg. DG11 .B855, t.1–15, 1962–1976; n.s., t.2– , 1993– .

12.362. *Bulletin epigraphique*. Paris. CN350 .B855, 1938–1984.

12.363. *Bulletin epigraphique*. Vienne. 6/yr. 913.05 B874, t.1–6, 1881–1886.

12.364. *Bulletin van de Vereeniging tot Bevordering der Kennis van de Antieke Beschaving*. Leiden. 1/yr. DE2 .V4, Jahr. 22–44, 1947–1969.

12.365. *California studies in Classical antiquity*. Berkeley. 1/yr. PA1 .C3, v.1– , 1982– ; World Wide Web, 1968–1979.

12.366. *Canadian Classical bulletin / Bulletin Canadien des Etudes Anciennes*. Peterborough. 12/yr. World Wide Web, 1994– .

12.367. *Chiron*. Munich. 1/yr. D51 .C485, Bd.1–41, 1971–2011; World Wide Web, 2000– .

12.368. *Classical antiquity*. Berkeley. 1/yr. DE1 .C627, v.1– , 1982– ; World Wide Web, 1982– .

12.369. *Classical bulletin*. St. Louis. 2/yr. PA1 .C527, v.43– , 1966– ; World Wide Web, 1998– .

12.370. *Classical journal*. London. PA1. C35, v.1–40, 1810–1829.

12.371. *Classical journal*. London. PA1. C35, v.1–40.

12.372. *Classical journal*. Pittsburgh. 4/yr. PA1 .C4, v.1– , 1905– ; World Wide Web, 1905– .

12.373. *Classical philology*. Chicago. 4/yr. PA1 .C5, v.1– , 1906– ; World Wide Web, 1906– .

12.374. *Classical quarterly*. Oxford. 4/yr. PA1 .C6, v.1–44, 1907–1950; n.s., v.1– , 1951– ; World Wide Web, 1907– . Five-year moving wall.

12.375. *Classical receptions*. Oxford. 1/yr. World Wide Web, 2009– .

12.376. *Classical review*. London. 2/yr. PA1 .C7, v.1– , 1887– ; World Wide Web, 1887– .

12.377. *Classical weekly*. New York. 52/yr. PA1 .C8, v.1–50, 1907–1957.

12.378. *Classical world*. Pittsburgh. 4/yr. PA1 .C8, v.1– , 1900– ; World Wide Web, 1900–1922, 1957– .

12.379. *Greek and Byzantine studies*. San Antonio. 2/yr. v.1, 1958.

12.380. *Greece and Rome*. Oxford. 2/yr. PA1 .G733, v.1– , 1931– . World Wide Web, 1931– . Five-year moving wall.

12.381. *Greek, Roman, and Byzantine studies*. San Antonio. 4/yr. DE1 .G73, v.1– , 1959– ; World Wide Web, 2004– .

12.382. *Gymnasium*. Heidelberg. 6/yr. PA3 .G855, Bd.48– , 1937– ; World Wide Web, 1937– .

12.383. *Habis*. Sevilla. PA25 .H224, v.1– , 1970– ; World Wide Web, 2007– .

12.384. *Helios: journal of the Classical Association of the Southwest*. Lubbock. 2/yr. PA1 .H44, v.5–35, 1977–2008; World Wide Web, 1999– .

12.385. *Hesperia*. Princeton. DF10 .H4, v.1– , 1932– ; World Wide Web, 1932– . Three-year moving wall.

12.386. *Institute of Classical Studies of the University of London. Bulletin*. London. 1/yr. PA25 .L8, no.1– , 1954– ; World Wide Web, 1996– .

12.387. *International journal of the Classical tradition*. New Brunswick. 4/yr. PA3009 .I584, v.1– , 1994– ; World Wide Web, 1994– .

12.388. *Journal of late antiquity*. Baltimore. 2/yr. World Wide Web, 2008– .

12.389. *Journal of medieval and early modern studies*. Durham. 3/yr. CB361 .J687, v.30– , 2000– ; World Wide Web, 1997– . Twelve-month embargo on full text.

12.390. *Journal of Mediterranean archaeology*. Sheffield. 2/yr. DE1 .J685, v.1–23, 1988–2010; World Wide Web, 1997– .

12.391. *Kretika chronika*. Herakleion. DF901 .C78 K7, t.1–25, 1947–1973.

12.392. *Ktema: civilisations de l'Orient, de la Grece et de Rome antiques*. Strasbourg. 12/yr. CB311 .K74, no.30, 2005.

12.393. *Latomus: revue d'études latines*. Bruxelles. PA2002. L3, v.1– , 1937– .

12.394. *Leeds international classical studies*. Leeds. World Wide Web, 2002– .

12.395. *Materiali e discussioni per l'analisi dei testi classici*. Pisa. 2/yr. PA9 .M384, v.22–55, 1989–2006; World Wide Web, 1978– .

12.396. *Medelhavsmuseet: focus on the Mediterranean*. Stockholm. DE1 .S75a. no.1–31, 1961–1998.

12.397. *Medelhavsmuseet: focus on the Mediterranean*. Stockholm. DE1 .M445, v.1– , 2011– .

12.398. *Medieval review*. Kalamazoo. Irreg. World Wide Web, 1993– .

12.399. *Mediterranean historical review*. London. 2/yr. DE1 .M348, v.1–23, 1986–2008; World Wide Web, 1997– .

12.400. *Mnemosyne: bibliotheca classica batava*. Lugduni Batavorum. 4/yr. PA9 .M6, v.1– , 1852– ; World Wide Web, 1852– .

12.401. *Mouseion: journal of the Classical Association of Canada*. Calgary. 3/yr. v. 1– , 1957– ; World Wide Web, 1996– .

12.402. *Nestor*. Bloomington. 12/yr. v.1– , 1957– ; World Wide Web, 1957– .

12.403. *New York Latin leaflet*. New York. 52/yr. World Wide Web, 1900–1907.

12.404. *Nin: journal of gender studies in antiquities*. Groningen. 1/yr. HQ1101 .N564, v.q, 4, 2000, 2003.

12.405. *Oxford studies in ancient philosophy*. Oxford. 1/yr. B1 .O9, v.1– , 1983– .

12.406. *Pallas*. Toulouse. 1/yr. PA2 .P34, t.38– , 1992– .

12.407. *Pallas*. Geneva. 705 .P177, v.11–15, 1947–1951.

12.408. *Parnassus*. New York. 12/yr. 705 .P247, v.1–13, 1929–1941.

12.409. *Parola del passato: rivista di studi antichi*. Napoli. 6/yr. DE1 .P276, v.1–30, 1946–1975; DE1 .P276, v.31– , 1976– .

12.410. *Pegasus*. Berlin. World Wide Web, v.1– , 1999– .

12.411. *Phoenix*. Leiden. 2/yr. DS56 .P47, v.1– , 1955– .

12.412. *Phronesis: a journal for ancient philosophy*. World Wide Web, 1955– . Five-year moving wall.

12.413. *Plekos*. Erlangen. World Wide Web, 1998– .

12.414. *Polis*. Roma. DG11 .P655, v.1–3, 2003–2010.

12.415. *Pomoerium*. Borchum. 2/yr. World Wide Web, 1994– .

12.416. *Probus*. Dordrecht. 3/yr. PC1 .P7663, v.1–19, 1989–2007; World Wide Web, v.10– , 1998– .

12.417. *Quaderni urbinati di cultura classica*. Urbino. 3/yr. PA9 .Q82, v.1–29, 1966–1978; n.s. v.1–109, 1966–2005; PA9 .Q82, v.111– , 2006– ; World Wide Web, v.1– , 1966– .

12.418. *Revue des études anciennes*. Paris. 2/yr. PA12 .R4, t.1– , 1899– ; World Wide Web, 1899–1938.

12.419. *Revue des études grecques*. Paris. 4/yr. DF10 .R4, t.1– , 1888– ; World Wide Web, 1888.

12.420. *Revue informatique et statistique dans les sciences humaines*. Liege. Irreg. World Wide Web, 2003– .

12.421. *Revue internationale des droits de l'antiquité*. Bruxelles. 1/yr. v.1– , 1954–1967; K21 .I583, t.1–6, 1948–1951; 3 ser. t.1– , 1954– ; World Wide Web, 1997– .

12.422. *Rivista di cultura classica e medioevale*. Roma. 2/yr. PA9 .R55, anno 1– , 1959– ; World Wide Web, 2002– .

12.423. *Rivista storica dell'antichità*. Bologna. D51 .R484, anno 1– , 1971– .

12.424. *Scholia*. Durban. 1/yr. PA1 .S365, v.1– , 1992– ; World Wide Web, 1992– .

12.425. *Syllecta classica*. Iowa City. 1/yr. World Wide Web, v.20– , 2009– .

12.426. *Vita latina*. Budapest. 1/yr. PA2065 .H8 V473, t.6–10, 2004–2008; World Wide Web, 2008– .

12.427. *Yale classical studies*. New Haven. Irreg. Library PA25 .Y3, v.1– , 1928– .

12.428. *Zeitschrift der Savigny-stiftung für rechtsgeschichte; Romanistische abtheilung*. Weimar. 1/yr. KZ3472, Bd.1– , 1880– .

Cultural Heritage

12.429. *GCI newsletter*. Marina del Rey. 2/yr. World Wide Web, 1991– .

12.430. *Conservation*. Marina del Rey. 2/yr. Fine Arts Library N8554 .G47, v.6–24, 1991–2009.

12.431. *Conservation perspectives*. Marina del Rey. 2/yr. Marina del Rey. 2/yr. 1991– .

12.432. *Getty Conservation Institute newsletter*. Marina del Rey. 3/yr. Fine Arts Library N8554 .G47, v.1–5, 1986–1990.

12.433. *International journal of cultural property*. Berlin. 4/yr. CC135 .I594, v.1–12, 1992–2005; World Wide Web, 1998– .

12.434. *J. Paul Getty Museum journal*. Malibu. 1/yr. N582 .M25 A25, v.1–24, 1974–1996; World Wide Web, 1974– .

12.435. *Journal of conservation and museum studies*. London. Irreg. v.1–4, 1996–1998.

12.436. *Studies in conservation*. London. 4/yr. N8560 .S82, v.1– , 1952– ; World Wide Web, 1952– .

Geography

12.437. *Arab world geographer*. Toronto. 4/yr. DS36.58 .A733, v.1– , 2010– .

Inscriptions

12.438. *Annee epigraphique*. Paris. 1/yr. World Wide Web, 1889– .

12.439. *Epigraphica*. Faenza. 1/yr. CN1 .E8, v.1–73, 1939–2011.

12.440. *Forschungen und Berichte*. Berlin. AM101 .B389, Bd.1–31, 1957–1988.

Linguistics and Philology

12.441. *Afroasiatic languages and linguistics*. Leiden. World Wide Web, 2009– .

12.442. *American journal of philology*. Baltimore. 4/yr. P1 .A5, v.1– , 1880– ; World Wide Web, 1880– .

12.443. *American journal of Semitic languages and literatures*. Chicago. 4/yr. PJ3001 .A6, v.1–58, 1895–1941. World Wide Web, 1895– .

12.444. *American Philological Association. Newsletter*. New York. 4/yr. World Wide Web, 1999– .

12.445. *American Philological Association. Transactions and proceedings*. World Wide Web, 1897– . Five-year moving wall.

12.446. *American Philological Association. Transactions*. Baltimore. 1/yr. World Wide Web, 1869– .

12.447. *American Philological Association. Transactions and proceedings*. Cleveland. 1/yr. P11 .A5, v.28–103, 1897–1972; World Wide Web, 1897– .

12.448. *Glotta: Zeitschrift fur griechische und lateinische Sprache*. Goettingen. 1/yr. PA3 .G5, Bd.1– , 1909– ; World Wide Web, 1909– . One-year moving wall.

12.449. *Göttinger Forum für Altertumswissenschaft*. Gottingen. 1/yr. World Wide Web, 1998– .

12.450. *Hermes: Zeitschrift fur classische philologie*. World Wide Web, 1866– . Four-year moving wall.

12.451. *Historische Sprachforschung*. Gottingen. 1/yr. P501 .Z5, Bd.101–120, 1988–2007.

12.452. *Indogermanische Forschungen*. Berlin. 1/yr. P501 .I4, Bd.1–112, 1892–2007; World Wide Web, 1892– .

12.453. *Journal of Semitics*. World Wide Web, full text for 1995–1996 only.

12.454. *Königlichen Gesellschaft der Wissenschaften in Göttingen. Abhandlungen*. World Wide Web, 1838–1892.

12.455. *Philological Society. Transactions*. London. P11 .P6, 1842–1853; World Wide Web, 1842–1898.

12.456. *Philologus*. Berlin. 2/yr. PA3 .P5, Bd.151–154, 2007–2010; World Wide Web, 1920–2007.

12.457. *Philologus: Zeitschrift für classische Philologie*. Gottingen. PA4 .P6, Bd.1–17, 1869–1887.

12.458. *Zeitschrift für Vergleichende Sprachforschung*. Gottingen. 1/yr. P501 .Z5, Bd. 1, 1852– ; World Wide Web, 1852– .

12.459. *Zeitschrift für Vergleichende Sprachforschung auf dem Gebiete der indogermanischen Sprachen*. Gottingen. P501 .Z5, Bd.23–81, 1877–1967.

Literature

12.460. *Arabic and Middle Eastern literatures*. Abingdon. 2/yr. PJ7501 .A733, v.1–4, 1998–2001.

12.461. *Dictynna: revue de poetique latine* Lille. World Wide Web, 2004– .

12.462. *Edebiyat*. Philadelphia. 2/yr. Middle East Seminar PJ2 .E3, v.1–5, 1976–1980; n.s., v.1–13, 1987–2003; World Wide Web, 1997–2003.

Museums

12.463. *Museum management and curatorship*. Guildford. 4/yr. AM121 .I57, v.8–18, 1989–1997; World Wide Web, 1990– .

12.464. *Museum practice*. London. 3/yr. AM111 .M867, v.1– , 1996– ; World Wide Web, 1996.

Numismatics

12.465. *Arkeoloji ve sanat*. Cagaloglu, Istanbul. 2/yr. DR431 .A754, v.1, 1978– .

12.466. *American journal of numismatics*. New York. CJ1 .A6, CJ1 .A6, v.1–53, 1866–1919, 2nd ser.:3/4-2nd ser.:5/6-7/8 (1995/1996), 2nd ser.:10 (1998).

12.467. *American Numismatic and Archaeological Society. Annual*. New York. 737 .N483, v.27–48, 1885–1906.

12.468. *American Numismatic Society. Annual report*. New York. 737 .N483, v.68, 76–104, 1926, 1934–1962.

12.469. *American Numismatic Society. Museum notes*. New York. CJ1 .A63, no.1–33, 1945–1988.

12.470. *Caesaraugusta: publicaciones del Seminario de Arqueología y Numismática Aragonesas*. Zaragoza, 1954– ; Irreg. CC37 .S3, t.4, 1954–1981.

12.471. *Celator*. Lodi, WI: Clio's Cabinet, v.1– , 1987– . 6/yr. CJ201 .C453, v.17– , 2003– .

12.472. *Coin world*. Sydney, 1997– . World Wide Web, 1997– .

12.473. *Coin world almanac*. Sidney, 1976– . CJ1 .C576, v.1, 1976.

12.474. *Etudes numismatiques*. Bruxelles, 1960– . 737 Et83 t.1–4.

12.475. *Eulimene*. Rethymno, Crete: Mesogeiake Archaiologike Etaireia, v.1, 2000– . 1/yr. DE1 .E955.

12.476. *La Gazette numismatique*. Bruxelles: C. Dupriez. v.5(1–3, 5), 1900–1901. 737 G259.

12.477. *Journal international d'archéologie numismatique*. Athènes. CJ201 .J7, v.1–20, 1898–1921.

12.478. *Im Jahr . . . wochentlich herausgegebener historischer Munz-Belustigung: Darinnen allerhand merkwurdige und rare* / Johann David Köhler. Nürnberg, t.1–22, 1729–1750. 737 K816.

12.479. *Jahrbuch fürNumismatik und Geldgeschichte*. München. CJ31 .J3, Jahrg.1–60, 1949–2010.

12.480. *Numismatic and Antiquarian Society of Philadelphia. Report of the proceedings*. Philadelphia. 1878–1889. CJ15 .N7.

12.481. *Numismatic and Antiquarian Society of Philadelphia. Proceedings*. Philadelphia. CJ15 .N7, 1890/1891–1945.

12.482. *Numismatic chronicle*. London. 737 N917, v.1–2, 1836–1838.

12.483. *Numismatic chronicle*. London. 4/yr. Supersedes: *Numismatic journal*. CJ1 .N6. v.1–20, 1838–1858, n.s., v.1–20, 1869–1880; ser.3:v.1–20, 1880–1890; ser.4:v.1, 1901; ser.7:v.1–2, 1961–1962; ser.7:v.2– , 1962– .

12.484. *Numismatic digest*. Bombay. CJ3530 .N76.

12.485. *Numismatic Society of India. Journal*. Varanasi. 2/yr. CJ3530 .N82; v.1– , 1941– .

12.486. *Numismatica stockholmiensia*. Stockholm. CJ43 .N845, v.1– , 1975– .

12.487. *Numizmatika*. Leningrad. Irreg. CJ9 .N84, v. 6.

12.488. *Numismatische Zeitschrift*. Wien. 737 N92, 1877–1904.

12.489. *Oesterreichische Gesellschaft fuer Muenz- und Medaillenkunde. Monatsblatt*. Wien. 11 v. CJ19. O45 A2.

12.490. *Revue numismatique*. Paris. 12/yr. CJ3 .R6, ser.3:v.1–13, 1883–1895; ser.4:v.12–32, 1908–1922; ser.5:v.19, 1957; ser.6:v.36, 150– , 1958– ; World Wide Web, 1993– .

12.491. *Revue de la numismatique française*. Paris. 1838–1877, 1883– . World Wide Web, 1993– .

12.492. *Revue suisse de numismatique; Schwizerische numismatische Rundschau*. Bern. World Wide Web, v.1–24, 1891–1925.

12.493. *Rivista italiana di numismatica e scienze affini*. CJ9 .R6, ser.5:v.7– , 1959– .

12.494. *Steigerwalt's coin journal*. Lancaster. 737 .St34, 1878–1884.

Papyrology

12.495. *American Society of Papyrologists. Bulletin*. Ann Arbor. 1/yr. World Wide Web, 1963– .

12.496. *Zeitschrift fur Papyrologie und Epigraphik*. Bonn. Irreg. PA3339 .Z435, Bd.1– , 1967– ; World Wide Web, 1967– .

Philosophy

12.497. *Ancient philosophy. Bulletin*. North Ryde, N.S.W. 1/yr. DT57 .B898. v.17, 2006.

12.498. *Arabic sciences and philosophy*. Cambridge. 2/yr. Q127 .A5 A733, v.1– , 1991– . World Wide Web, 1997– .

12.499. *Museum Helveticum*. Basel. 4/yr. PA3 .M73, v.1– , 1944– ; World Wide Web, 1944– .

12.500. *Symbolae Osloenses*. Christianiae. 1/yr. World Wide Web, 1997– .

12.501. *Traditio: studies in ancient and modern history, thought and religion*. New York. D111 .T7, v.1– , 1943– ; World Wide Web, 1943– . Three-year moving wall.

12.502. *Wiener studien*. Wien. 1/yr. PA3 .W5, Bd.1–124, 1879–2011.

Theater

12.503. *Didaskalia: Ancient theatre today*. Hobart. 3/yr. World Wide Web, 1994– .

13
Biographical Information

It is often necessary to collect biographical information on individuals prominent in the ancient world. Biographical information about noteworthy scholars may appear as separately published books, articles in periodicals (usually as obituaries), or entries in biographical dictionaries and directories. The amount of information needed, either a book-length study or a brief summary, will determine the best approach to take.

Separately published biographies may be found by searching the library catalog under the name of the scholar (as subject) and other related headings. A number of general works will provide differing amounts of information about prominent individuals in the study of the ancient world. Others give data on professional and academic associations, councils, and organizations. Among the general reference works about important individuals and selected organizations, the following are useful:

13.1. *Dictionnaire des philosophes antiques* / Richard Goulet. Paris: CNRS, 1989– . v.1– . B112 .D52 1989.

Assyrian

13.2. *Prosopography of the neo-Assyrian empire* / Simo Parpola. Helsinki: Neo-Assyrian Text Corpus Project, University of Helsinki, 1998– . DS69.6 .P76 1998, v.1(1–2)–v.3(1–2).

13.3. *Voyages et voyageurs à l'époque néo-assyrienne* / Sabrina Favaro. Helsinki: Neo-Assyrian Text Corpus Project, 2007. 169 p. DS69.6 .F38 2007.

Biblical

13.4. *Who's who in biblical studies and archaeology.* Washington, D.C.: Biblical Archaeology Society, 1986. 272 p. BS501.A1 W47 1986.

Classical

13.5. *Ancient writers: Greece and Rome* / T. James Luce. New York: Scribner's, 1982. 2 v. PA3002 .A5 1982.

13.6. *Classical scholarship: a biographical encyclopedia.* / Ward W. Briggs and William M. Calder. New York: Garland, 1990. 534 p. PA83 .C58 1990.

13.7. *Greek and Latin authors: 800 B.C.–A.D. 1000* / Michael Grant. Bronx: H. W. Wilson, 1980. 490 p. PA31 .G7.

13.8. *Portraits: biographical representation in the Greek and Latin literature of the Roman Empire* / Mark Edwards and Simon Swain. New York: Oxford University Press, 1997. 267 p. PA3043 .P67 1997.

13.9. *Twelve Greeks and Romans who changed the world* / Carl J. Richard. Lanham: Rowman & Littlefield, 2003. 259 p. DE7 .R53 2003.

13.10. *Who's who in the ancient world: a handbook to the survivors of the Greek and Roman classics* / Betty Radice. Hammondsworth, England: Penguin Books, 1973. 335 p. DE7 .R33 1973.

Classical, Women

13.11. *A to Z of ancient Greek and Roman women.* / M. Lightman and B. Lightman, rev. ed. New York: Facts on File, 2008. 398 p. HQ1136 .L54 2008. Supersedes: *Biographical dictionary of ancient Greek and Roman women: notable women from Sappho to Helena* / M. and B. Lightman. New York: Facts on File, 213.0. 298 p. HQ1136 .L54 2000.

13.12. *Companion to women in the ancient world* / Sharon L. James and Sheila Dillon. Chichester: Wiley-Blackwell, 2012. 616 p. HQ1127 .C637 2012.

13.13. *Encyclopedia of women in the ancient world* / Joyce E. Salisbury. Santa Barbara: ABC-CLIO, 2001. 385 p. HQ1127 .S25 2001.

13.14. *Prosopography of the later Roman empire* / A. H. M. Jones, J. R. Martindale, and J. Morris. New York: Cambridge University Press, 1971–1992. 3 v. DG203.5 .J6.

13.15. *Women in the Athenian Agora* / Susan I. Rotroff and Robert D. Lamberton. Athens: American School of Classical Studies at Athens; Los Altos: Packard Humanities Institute, 2006. 56 p. HQ1134 .R68 2006.

13.16. *Women of classical mythology: a biographical dictionary* / Robert E. Bell. Santa Barbara: ABC-CLIO, 1991. 462 p. BL715 .B445 1991.

Cyprus

13.17. *Prosopography of Ptolemaic Cyprus* / Ino Michaelidou-Nicolaou. Göteborg: P. Aström, 1976. 172 p. DS54.6 .N52.

Greek

13.18. *Ancient Greek authors* / Ward W. Briggs. Detroit: Gale Research, 1997. 472 p. PA3064 .A63 1997.

13.19. *Athenian officials, 684–321 B.C.* / Robert Develin. New York: Cambridge University Press, 1989. 556 p. JC73 .D45 1989.

13.20. *Athenian propertied families: 600–300 B.C.* / J. K. Davies. Oxford: Clarendon Press, 1971. 655 p. CS738 .A73 D39.

13.21. *Classical Greeks* / Michael Grant. New York: Scribner's, 1989. 337 p. DF214 .G776 1989.

13.22. *Development of Greek biography* / Arnaldo Momigliano. Cambridge: Harvard University Press, 1993. 143 p. PA3043 .M6 1993.

13.23. *Greek biography and panegyric in late antiquity* / Tomas Hägg and Philip Rousseau. Berkeley: University of California Press, 213.0. 288 p. PA3043 .G74 2000.

13.24. *Lexicon of Greek personal names* / P. M. Fraser and E. Matthews. New York: Oxford University Press, 1987– . CS2349 .L48 1987. 4 v. Supplemented by: *The foreign residents of Athens: an annex to the lexicon of Greek personal names: Attica* / Michael J. Osborne and Sean G. Byrne. Lovanii: Peeters, 1996. 479 p. CS2349 .O76 1996.

13.25. *Portraits of the Greeks* / Gisela M. A. Richter. rev. ed. Ithaca: Cornell University Press, 1984. 256 p. N7586 .R53 1984. Supplemented by: *The portraits of the Greeks: supplement* / Gisela M. A. Richter. London: Phaidon, 1972. 24 p. N7586

.R52. Continues: *The portraits of the Greeks* / Gisela M. A. Richter. London: Phaidon, 1965. 3 v. N7586 .R5; 733.3 R418.4.

13.26. *Who's who in the Greek world* / John Hazel. New York: Routledge, 200. 285 p. DE7 .H39 2000.

13.27. *Who was who in the Greek world, 776 BCE–30 BCE* / D. Bowder. Ithaca: Cornell University Press, 1982. 227 p. DF208 .W48 1982.

Macedonia

13.28. *Makedonike prosopographia* / Demetrios Konstantinou Kanatsoules. Thessalonike, 1955. 183 p. DF261.M2 K355.

Near East

13.29. *Who's who in the ancient Near East* / Gwendolyn Leick. London; New York: Routledge, 1999. 229 p. DS61.5 .L45 1999. Biographical dictionary of people important in the history of the Near East, primarily kings and local rulers. Glossary; outline of main historical periods; bibliography; and separate indexes for personal names, toponyms and rulers, and dynasties, peoples, and groups.

Roman

13.30. *Chronicle of the Roman emperors: the reign-by-reign record of the rulers of Imperial Rome* / Chris Scarre. New York: Thames and Hudson, 1995. 240 p. DG274 .S28 1995.

13.31. *Essays on Plutarch's lives* / Barbara Scardigli. New York: Oxford University Press, 1995. 403 p. PA4385 .E87 1995.

13.32. *Roman emperors: a biographical guide to the rulers of ancient Rome, 31 B.C.–A.D. 476* / Michael Grant. New York: Scribner's, 1985. 367 p. DG274 .G73 1985.

13.33. *Roman historical portraits* / J. M. C. Toynbee. Ithaca: Cornell University Press, 1978. 208 p. NB1296.3 .T69 1978b.

13.34. *Who was who in the Roman world, 753 BC–AD 476* / Diana Bowder. Ithaca: Cornell University Press, 1980. 256 p. DG203 .W46.

Roman, Plutarch

13.35. *Plutarch* / Robert Lamberton. New Haven: Yale University Press, 2001. 218 p. PA4382 .L36 2001.

13.36. *Plutarch and the historical tradition* / Philip A. Stadter. London: Routledge, 1992. 187 p. PA4385 .P58 1992.

BIOGRAPHICAL INFORMATION

13.37. *AIA directory of professionals in archaeology: a preliminary survey* / Archaeological Institute of America. Dubuque, Iowa: Kendall/Hunt, 1995. 140 p. CC21 .A59 1995.

13.38. *Biographical dictionary of North American classicists* / Ward W. Briggs. Westport: Greenwood Press, 1994. 800 p. PA83 .B53 1994.

13.39. *Classical scholarship: a biographical encyclopedia* / Ward W. Briggs and William M. Calder. New York: Garland, 1990. 534 p. PA83 .C58 1990.

Archaeologists

13.40. *The adventure of archaeology* / Brian M. Fagan. Washington, DC: National Geographic Society, 1985. 368 p. CC100 .F33 1985.

13.41. *Archaeologists: explorers of the human past* / Brian Fagan. Oxford; New York: Oxford University Press, 2003. 191 p. CC110 .F34 2003.

13.42. *Dictionnaire biographique d'archéologie: 1798–1945* / Eve Gran-Aymerich. Paris: CNRS, 2001. 741 p. CC110 .G73 2001.

13.43. *Encyclopedia of archaeology: the great archaeologists* / Tim Murray. Santa Barbara: ABC-CLIO, 1999. 2 v. CC110 .E54 1999. Essays written by archaeologists on fifty-eight archaeologists presented chronologically from William Camden (1551–1623) to David Clarke (1938–1976). Portraits, illustrations, and both primary and secondary references are included.

13.44. *Encyclopedia of archaeology: history and discoveries* / Tim Murray. Santa Barbara: ABC-CLIO, 2001. 3 v. CC100 .E54 2001.

13.45. *Milestones in archaeology: a chronological encyclopedia* / Tim Murray. Santa Barbara: ABC-CLIO, 2007. 639 p. Major sections include archaeology before 1800, archaeology in the nineteenth century, and archaeology in the twentieth century and beyond. CC100 .M87 2007.

13.46. *Pastmasters: eleven modern pioneers in archaeology* / Glyn Daniel and Christopher Chippendale. London: Thames and Hudson, 1989. 176 p. CC110 .P37 1989. Scholars included are V. Gordon Childe, Stuart Piggott, Charles Phillips, Christopher Hawkes, Seton Lloyd, Robert J. Braidwood, Gordon R. Willey, C. J. Becker, Sigfried J. De Laet, J. Desmond Clark, and D. J. Mulvaney.

Archaeologists, Austrian

13.47. *Ephesus: 100 years of Austrian research* / Gilbert Wiplinger and Gudrun Wlach. Vienna: Böhlau and Österreichisches Archäologisches Institut, 1996. 189 p. DF261.E5 W5613 1996. Exhibition catalog on 100 years of excavations at the extinct site of Ephesus by Austrian archaeologists.

Archaeologists, Biblical

13.48. *Who's who in biblical studies and archaeology.* Washington, DC: Biblical Archaeology Society, 1986. 272 p. BS501.A1 W45 1986.

Archaeologists, British

13.49. *Dictionary of British classicists* / Robert B. Todd. Bristol: Thoemmes Continuum, 2004. 3 v. PA83 .D53 2004.

Archaeologists, Cyprus

13.50. *Who's who in Cypriote archaeology. Biographical and bibliographical notes.* Göteborg: P. Åström, 1971. 88 p. CC110 .A87.

Archaeologists, Egyptologists

13.51. *International directory of Egyptology.* Mainz am Rhein: Verlag Philipp von Zabern, 1979. DT57 .I583 1979.

13.52. *Who was who in Egyptology. A biographical index of Egyptologists; of travellers, explorers and excavators in Egypt; of collectors of and dealers in Egyptian antiquities; of consuls, officials, authors, benefactors and others whose names occur in the literature of Egyptology, from the year 1700 to the present day, but excluding persons now living* / Warren R. Dawson and Eric P. Uphill. 2 ed. London: Egypt Exploration Society, 1972. 315 p. DT58 .D3 1972.

Archaeologists, French

13.53. *Recherche archéologique en France, 1985–1989.* Paris: Ministère de la culture, de la communication, des grands travaux et du Bicentenaire, Direction du patrimoine, Sous-direction de l'archéologie, 1990. 286 p. DC31 .R43 1990.

Archaeologists, German

13.54. *Archäologen deutscher Sprache* / Reinhard Lullies and Wolfgang Schiering. Mainz am Rhein: Verlag Zabern, 1988. 341 p. Biographies of German archaeologists. CC110 .A86 1988.

13.55. *Archäologenbildnisse: Portrats und Kurzbiographien von klassischen Archäologen deutscher*

Sprache / Reinhard Lullies und Wolfgang Schiering. Mainz am Rhein: Verlag Zabern, 1988. 341 p. CC110 .A86 1988.

13.56. *Deutsche und antike Welt; Lebenserinnerungen* / Ludwig Curtius. Stuttgart: Deutsche Verlags-Anstalt, 1950. 531 p. 913 C944.

13.57. *Tradition und Fortschritt archäologischer Forschung in Greifswald* / Günter Mangelsdorf. Frankfurt am Main; New York: P. Lang, 1997. 273 p. GN722.G3 T73 1997. Biographies of archaeologists from Ernst-Moritz-Arndt-Universität Greifswald.

Archaeologists, North American

13.58. *Biographical dictionary of North American classicists* / Ward W. Briggs, Jr. Westport: Greenwood, 1994. 800 p. PA83 .B53 1994.

Archaeologists, Women

13.59. *Archeologia al femminile: il cammino delle donne nella disciplina archeologica attraverso le figure di otto archeologhe classiche vissute dalla metà dell'Ottocento ad oggi* / Laura Nicotra. Roma: "L'Erma" di Bretschneider, 2004. 302 p. CC110 .N53 2004. Includes biographic summaries for Laura Nicotra. Life and work of Ersilia Caetani Lovatelli (1840–1925); Esther Boise Van Deman (1862–1937); Kathleen Mary Kenyon (1906–1978); Raissa Gourevitch Calza (1897–1979); Semni Papaspyridi Karouzou (1898–1994); Gisela Maria Augusta Richter (1882–1972); Luisa Banti (1894–1978); and Alessandra Melucco Vaccaro (1940–2000).

13.60. *Breaking ground: pioneering women archaeologists* / Getzel M. Cohen and Martha Sharp Joukowsky. Ann Arbor: University of Michigan Press, 2004. 571 p. CC110 .B74 2004. Twelve women including Gertrude L. Bell, Winifred Lamb, and Kathleen Kenyon.

13.61. *Excavating women: a history of women in European archaeology* / Margarita Diaz-Andreu and Marie Louise Stig Sorensen. London; New York: Routledge, 1998. 320 p. CC110 .E93 1998.

13.62. *Women in archaeology* / Cheryl Claassen. Philadelphia: University of Pennsylvania Press, 1994. 252 p. CC110 .W66 1994. Forty-one women representing old and new world archaeology are discussed in individually authored chapters. Biographies of Harriet Boyd Hawes and Edith Hall; Dorothy Hughes Popenoe; Isabel Kelly, Frances Watkins, and Eva Horner; Marian E. White; and Madeline Kneberg Lewis are separate chapters.

Classicists

13.63. *Classical scholarship: a biographical encyclopedia* / Ward W. Briggs and William M. Calder III. New York: Garland, 1990. 534 p. PA83 .C58 1990.

13.64. *Einhundert Jahre Athener Institut, 1874–1974* / Ulf Jantzen. Mainz: von Zabern, 1986. 111 p. Biographical history of the Deutsches Archaologisches Institut Athener Abteilung. DF212.A2 J36 1986.

13.65. *Makers of classical archaeology: a reference work* / Linda Medwid. Amherst: Humanity Books, 2000. 352 p. DE9 .A1 M43 213.0. Entries for 119 men and women include education, appointments and awards, excavations, publications, short essay, and sources. Alphabetically arranged from Manolius Andronikos to Robert Wood.

13.66. *Men in their books: studies in the modern history of classical scholarship* / William M. Calder III. Hildesheim; New York: G. Olms Verlag, 1998–20xx. 2 v. PA83 .C35 1998.

Papyrologists

13.67. *Hermae: scholars and scholarship in papyrology* / Mario Capasso. Pisa: Giardini, 2007–2010. 2 v. PA83 .H47 2007. Biographical summaries of noteable Classicists, paleographers, philologists, and Eyptologists.

13.68. *He aparche tes hellenikes archaiologias kai he hidryse tes archaiologikes hetaireias* / Vasileiou Ch. Petrakou. Athenai: He en Atheais Archaiologike Hetaireia, 2004. 114 p. DF212.A2 P48 2004.

INDIVIDUAL BIOGRAPHIES AND AUTOBIOGRAPHIES

Aeschylus (c.525/524–456/455 BCE)

13.69. *Aeschylus.* http://www.poetseers.org/the_great_poets/the_classics/aeschylus/index_html/.

13.70. *Works by Aeschylus.* http://classics.mit.edu/Browse/browse-Aeschylus.html.

Akhet-aten (d. 1336 BCE)

13.71. *Akhet-aten home page.* http://katherinestange.com/egypt/index.html.

Alexander the Great (356–323 BCE)

13.72. *Alexander and Darius at the battle of Issus mosaic.* http://www.astro.rug.nl/~weygaert/alexandermosaic.html.

13.73. *Alexander the Great.* http://www.hackneys.com/alex_web/alexfram.htm.

13.74. *Alexander the Great.* http://wso.williams.edu/~junterek/.

13.75. *Alexander the Great home page.* http://european-history.boisestate.edu/westciv/alexander/01.shtml.

13.76. *Alexander the Great: King of Macedonia.* http://www.britannica.com/EBCEhecked/topic/14224/Alexander-the-Great.

13.77. *Alexander the Great Project.* http://1stmuse.com/frames/.

13.78. *Empire of Alexander the Great.* http://www.silkroad.com/artl/alex.shtml.

13.79. *In the Kingdom of Alexander the Great.* http://www.arsmagazine.com/news/top/20111005981/in-the-kingdom-of-alexander-the-great.

13.80. *Wars of Alexander the Great: Battle of the Granicus.* http://www.historynet.com/wars-of-alexander-the-great-battle-of-the-granicus.htm.

Ciriaco D'Ancona (1391–1452)

13.81. *To wake the dead: a Renaissance merchant and the birth of archaeology* / Marina Belozerskaya. New York: W.W. Norton, 2009. 308 p. CC115.C57 B456 2009.

Walter Andrae (1875–1956)

13.82. *Bilder eines Ausgräbers: die Orientbilder von Walter Andrae 1898–1919; Sketches by an excavator* / Ernst Walter Andrae and Rainer Michael Boehmer. Berlin: Gebruders Mann, 1992. 203 p. N6888.A595 A4 1992. Notebooks and sketchbooks by Walter Andrae of archaeological excavations at Babylon and Ashur. Supersedes: *Bilder eines Ausgräbers: die Orientbilder von Walter Andrae 1898–1919; Sketches by an excavator.* / Ernst Walter Andrae and Rainer Michael Boehmer. Berlin: Gebr. Mann Verlag, 1989. 174 p. NC251.A532 A53 1989.

Aphrodite

13.83. *Aphrodite.* http://www.theoi.com/Olympios/Aphrodite.html.

Archimedes (c.287–c.212 BCE)

13.84. *Archimedes.* http://www.cs.drexel.edu/~crorres/Archimedes/contents.html.

Aristophanes (c.448–380 BCE)

13.85. *Aristrophanes: the frogs.* http://classics.mit.edu/Aristophanes/frogs.html.

Arsinoe (between 68 and 56–41 BCE)

13.86. *Arsinoe II, Queen of Ancient Thrace and Egypt.* http://ancienthistory.about.com/od/womenbiography/ss/013008Queens_4.htm.

Thomas Ashby (1874–1931)

13.87. *Visions of Rome: Thomas Ashby, archaeologist* / Richard Hodges. London: British School at Rome, 213.0. 134 p. DG206.A84 H63 213.0.

Bernard Ashmole (1894–1988)

13.88. *Bernard Ashmole, 1894–1988: an autobiography* / Donna Kurtz. Malibu: J. Paul Getty Museum, 1994. 236 p. DE9.A84 A3 1994.

Athena

13.89. *Athena.* http://www.pantheon.org/articles/a/athena.html.

13.90. *Athena Nike frieze.* http://www.ancient-greece.org/images/museums/athena-nike/index.htm.

13.91. *Atlas of the Goddess Athena.* http://www.goddess-athena.org/Atlas/Minoan/.

J. D. Beazley (1885–1970)

13.92. *Beazley and Oxford: lectures delivered in Wolfson College, Oxford, 28 June 1985* / Dietrich von Bothmer. Oxford: Oxford University Committee for Archaeology, 1985. 71 p. DF212.B4 K8 1985.

Gertrude L. Bell (1868–1926)

13.93. *Daughter of the desert: the remarkable life of Gertrude Bell* / Georgina Howell. London: Macmillan, 2006. 518 p. DA566.9.B39 H63 2006.

13.94. *Gertrude Bell* / H. V. F. Winstone. rev. ed. London: Barzan, 2004. 504 p. Biography of a British Arabist. DS61.7.B37 W56 2004.

13.95. Gertrude Bell Archive (Newcastle University). The Gertrude Bell Papers comprise personal correspondence, diaries, and miscellaneous items, such as Review of the Civil Administration of Mesopotamia (1920), notebooks, obituaries, lecture notes and miscellaneous reports, memoranda, and cuttings. About 1,600 letters and diaries covering the years 1877–1879 and 1893–1900 can be found transcribed on this website, along with some 7,000 of her archaeological and travel photographs. http://www.gerty.ncl.ac.uk/index.php.

Giovanni Battista Belzoni (1778–1823)

13.96. *Belzoni: the giant archaeologists love to hate* / Ivor Noel Hume. Charlottesville: University of Virginia Press, 2011. 301 p. DT76.9.B4 N64 2011.

13.97. *Belzoni: viaggi, imprese, scoperte e vita: il risveglio dei faraoni* / Gianluigi Peretti. Padova: GB, 2002. 279 p. PJ1064 .B45 P47 2002.

13.98. *Il gigante del Nilo: storia e avventure del grande Belzoni, l'uomo che svelò i misteri dell'Egitto dei faraoni* / Marco Zatterin. Milano: Mondadori, 213.0. 316 p. PJ1064 .B45 Z37 213.0.

Luigi Bernabò Brea (1910–)

13.99. *In memoria di Luigi Bernabò Brea* / Madeleine Cavalier and Maria Bernabò Brea. Palermo: M. Grispo, 2002. 397 p. DG206.B43 I6 2002.

Frank Calvert (1828–1908)

13.100. *Finding the walls of Troy: Frank Calvert and Heinrich Schliemann at Hisarlik* / Susan Heuck Allen. Berkeley: University of California Press, 1999. 409 p. DF212.C35 A67 1999.

13.101. *Schliemann's silent partner: Frank Calvert (1828–1908): pioneer, scholar, and survivor* / Marcelle Robinson. Philadelphia: Xlibris Corporation, 2006. 700 p. DF212.C35 R63 2006.

Howard Carter (1873–1939)

13.102. *Golden pharaoh* / Philipp Vandenberg. New York: Macmillan, 1980. 328 p. Howard Carter and the excavation of the royal tomb of Tutankhamen. DT87.5 .V3413 1980.

13.103. *Howard Carter in the valley of the kings: the mystery of King Tutankhamun's tomb* / Daniel Meyerson. New York: Ballantine Books, 2009. 230 p. PJ1064.C3 M49 2009.

Isaac Casaubon (1559–1614)

13.104. *Isaac Casaubon, helléniste: des studia humanitatis à la philologie* / Hélène Parenty. Genève: Droz, 2009. 484 p. Biography of philologist Isaac Casaubon (1559–1614). PA85.C3 P37 2009.

Luigi Palma di Cesnola (1832–1904)

13.105. *Consul Luigi Palma di Cesnola, 1832–1904: life and deeds* / Anna G. Marangou. Nicosia: Cultural Centre of the Popular Bank Group, 213.0. 393 p. N610 .M367 2000.

Jean-François Champollion (1790–1832)

13.106. *Jean-François Champollion le jeune: répertoire de bibliographie analytique, 1806–1989* / Jeannot Kettel. Aubenas d'Ardèche: Imprimerie Lienhart and Cie; Paris: Diffusion de Boccard, 1990. 293 p. PJ1064.C6 K48 1990.

Louis Chatelain (1883–1950)

13.107. *Louis Chatelain (1883–1950): biographie et bibliographie* / Véronique Brouquier-Reddé and René Rebuffat. Rabat: Institut National des Sciences de l'Archéologie et du Patrimoine et Division des Sciences Humaines, 2004. 75 p. DT328. M6 E8 v.10.

V. Gordon Childe (1892–1957)

13.108. *Gordon Childe, revolutions in archaeology* / Bruce G. Trigger. New York: Columbia University Press, 1980. 207, 8 p. CC115.C45 T74 1980.

Agatha Christie (1890–1976)

13.109. *Agatha Christie and archaeology* / Charlotte Trümpler. London: British Museum Press, 2001. 471 p. English language translation of *Agatha Christie und der Orient*. PR6005 .H66 Z554713 2001.

13.110. *Come, tell me how you live* / Agatha Christie Mallowan. London: Collins, 1946. 192, 19 p. DS94.5 .C5 1946b.

Grahame Clark (1907–1995)

13.111. *Grahame Clark: an intellectual life of an archaeologist* / Brian Fagan. Boulder: Westview Press, 2001. 304 p. CC115.C53 F34 2001.

Cleopatra, Queen of Egypt (d. 30 BCE)

13.112. *Antony and Cleopatra: an annotated bibliography* / Yashdip S. Bains. New York: Garland, 1998. 527 p. PR2802 .B35 1998.

Joseph Déchelette (1862–1914)

13.113. *De l'art roman à la préhistoire des sociétés locales à l'institut, itinéraires de Joseph Déchelette* / Marie-Suzanne Binétruy. Lyon: LUGD, 1994. 222 p. DC36.98.D43 B56 1994.

Adolf Deissmann (1866–1937)

13.114. *Deissmann the philologist* / Albrecht Gerber. Berlin; New York: Walter de Gruyter, 2010. 649 p. BS410 .Z7 Hft.171.

Friedrich K. Doerner (1911–)

13.115. *Bei den Gottkönigen in Kommagene: Erlebnisse in einem deutschen Ausgrabungslager im Osten der Türkei* / Eleonore Dörner. Melle: E. Knoth, 1983. 174 p. DS156.C6 D63 1983.

Bernardino Drovetti (1776–1852)

13.116. *Bernardino Drovetti, epistolario (1800–1851)* / Silvio Curto. Milano: Cisalpino-Goliardica, 1985. 776 p. Corresopondence of Eyptologist Drovetti. CC115 .D76 1985.

Thomas Bruce, Earl of Elgin (1766–1841)

13.117. *Elgin affair: the abduction of antiquity's greatest treasures and the passions it aroused* / Theodore Vrettos. New York: Little, Brown, 1997. 238 p. NB92 .V7 1997.

13.118. *Ho lordos Elgin: kai hoi pro autou ana ten Hellada kai tas Athenas idios archaiologesantes epidromeis 1440–1837: historike kai archaiologike pragmateia* / Ioannou Gennadiou. 2 ed. Athenai: He en Athenais Archaiologike Hetaireia, 1997. 257 p. NB92 .G462 1997.

13.119. *Lord Elgin and ancient Greek architecture: the Elgin drawings at the British Museum* / Luciana Gallo. Cambridge; New York: Cambridge University Press, 2009. 344 p. NA2695.G7 E444 2009.

13.120. *Lord Elgin and the marbles* / William St. Clair. 3 ed. Oxford; New York: Oxford University Press, 1998. 419 p. NB92 .S7 1998. Supersedes: *Lord Elgin and the marbles* / William St. Clair. Oxford; New York: Oxford University Press, 1983. 311 p. NB92 .S7 1983; *Lord Elgin and the marbles* / William St. Clair. London; New York: Oxford University Press. 1967. 309 p. 733.3 Sa24.

13.121. *Memorandum on the subject of the Earl of Elgin's pursuits in Greece* / W. R. Hamilton. 2 ed. London: John Murray, 1815. 100 p. NB92 .H2 1815.

Epicurus (341–270 BCE)

13.122. *Epicurus.* http://www.philosophypages.com/ph/epiu.htm.

Arthur Evans (1851–1941)

13.123. *Arthur Evans, Knossos and the priest-king* / S. Sherratt. Oxford: Ashmolean Museum, 2000. 24 p. DF212.E82 S53 2000.

13.124. *Arthur Evans's travels in Crete, 1894–1899* / Ann Brown with Keith Bennett. Oxford: Archaeopress, 2001. 509 p. DF901.C8 E83 2001.

13.125. *Find of a lifetime: Sir Arthur Evans and the discovery of Knossos* / Sylvia L. Horwitz. New York: Viking Press, 1981. 278 p. DF212.E82 H67.

13.126. *Minotaur: Sir Arthur Evans and the archaeology of the Minoan myth* / Joseph Alexander MacGillivray. New York: Hill and Wang, 213.0. 373 p. DF212.E82 M33 2000.

13.127. *Sir Arthur Evans, 1851–1941: a memoir* / D. B. Harden. Oxford: Ashmolean Museum, 1983. 47 p. DF212.E82 H3 1983.

John Evans (1823–1908)

13.128. *Sir John Evans 1823–1908: antiquity, commerce and natural science in the age of Darwin* / Arthur MacGregor. Oxford: Ashmolean Museum, 2008. 326 p. CC115.E9 S57 2008.

Raffaello Fabretti (1618–1700)

13.129. *Raffaello Fabretti "archeologo" urbinate: principe della romana antichità* / Mario Luni. Urbino: Accademia Raffaello, 2001. 69 p. DG206. F33 L86 2001.

Giuseppe Fantaguzzi (1853–1932)

13.130. *Giuseppe Fantaguzzi: un pioniere dell'archeologia nell'Astigiano* / Loretta Tosello. Cavallermaggiore: Gribaudo; Asti: SE.DI.CO. Libraria di L. Fornaca, 1999. 176 p. DG975.A86 T67 1999.

Robert Forrer (1866–1947)

13.131. *Robert Forrer, 1866–1947: archéologue, écrivain et antiquaire* / Bernadette Schnitzler. Strasbourg: Publications de la Société savante d'Alsace: en coédition aves les Musées de Strasbourg, 1999. 213 p. CC115.F57 S45 1999.

William Matthew Flinders Petrie, Sir (1853–1942)

13.132. *Flinders Petrie: a life in archaeology* / Margaret S. Drower. 2 ed. Madison: University of Wisconsin Press, 1995. 500 p. PJ1064.P47 .D7 1995. Supersedes: *Flinders Petrie: a life in archaeology* / Margaret S. Drower. London: Gollancz, 1985. 500 p. CC115.P47 D76 1985.

13.133. *Letters from the desert: the correspondence of Flinders and Hilda Petrie* / Margaret Drower. Park End Place, Oxford: Aris and Phillips;

Oakville: David Brown, 2004. 261 p. CC115. P47 L48 2004.

Henri Frankfort (1897–1954)

13.134. *"Hans" Frankfort's earlier years: based on his letters to "Bram" van Regteren Altena* / Maurits van Loon. Leiden: Ned. Inst. v.h. Nabije Oosten, 1995. 65 p. N5335.F85 F85 1995.

Dorothy Garrod (1892–1968)

13.135. *Dorothy Garrod and the progress of the Palaeolithic: studies in the prehistoric archaeology of the Near East and Europe* / William Davies and Ruth Charles. Oxford: Oxbow Books, 1999. 282 p. CC115.G377 D67 1999.

Albert E. Glock (1925–1992)

13.136. *Palestine twilight: the murder of Dr. Albert Glock and the archaeology of the Holy Land* / Edward Fox. London: Harper Collins, 2001. 277 p. DS108.9 F65 2001.

Nelson Glueck (1900–1971)

13.137. *Dreamer in the desert: a profile of Nelson Glueck* / Ellen Norman Stern. New York: Ktav Pub. House, 1980. 158 p. BM755.G58 S73 1980.

13.138. *The Nelson and Helen Glueck collection of Cypriot antiquities, Cincinnati* / Gisela Walberg. Jonsered: Åström, 1992. 65, 36 p. NK4146.C9 W34 1992.

Hermann Grapow (1885–1967)

13.139. *Meine Begegnung mit einigen Ägyptologen* / Hermann Grapow. Berlin: Seitz 1973. 75 p. PJ1064. G68 A3 1973.

Georg Christian Gropius (1776–1850)

13.140. *Georg Christian Gropius als Agent, Konsul und Archäologe in Griechenland 1803–1850* / Christian Callmer. Lund: CWK Gleerup, 1982. 54 p. DF212.G76 C34 1982.

Carl, Freiherr, Haller von Hallerstein (1774–1817)

13.141. *Und die Erde gebar ein Lächeln: der erste deutsche Archäologe in Griechenland Carl Haller von Hallerstein 1774–1817* / Hans Haller von Hallerstein. München: Süddeutscher Verlag, 1983. 317 p. DF212.H3 H35 1983.

Hammurabi, King of Babylonia (d.1759 BCE)

13.142. *King Hammurabi of Babylon: a biography* / Marc Van de Mieroop. Malden: Blackwell, 2005. 171 p. DS73.35 .V36 2004; DS73.35 .V36 2004.

13.143. *Code of Hammurabi.* http://www.fordham.edu/ halsall/ancient/hamcode.asp.

13.144. *Code of Hammurabi.* http://avalon.law.yale.edu/ subject_menus/hammenu.asp.

Alexander Hardcastle (1872–1933)

13.145. *Passionate patron: the life of Alexander Hardcastle and the Greek temples of Agrigento* / Alexandra Richardson. Oxford: Archaeopress, 2009. 143 p. CC115.H37 R53 2009.

Jane Ellen Harrison (1850–1928)

13.146. *Invention of Jane Harrison* / Mary Beard. Cambridge: Harvard University Press, 213.0. 229 p. PA85.H33 B43 2000.

13.147. *Jane Ellen Harrison: the mask and the self* / Sandra J. Peacock. New Haven: Yale University Press, 1988. 283 p. PA85.H33 P43 1988.

13.148. *Life and work of Jane Ellen Harrison* / Annabel Robinson. Oxford; New York: Oxford University Press, 2002. 332 p. PA85.H33 R63 2002.

Zahi Hawass (1947–)

13.149. *Plateau: official site of Dr. Zahi Hawass.* http:// www.drhawass.com/.

Wolfgang Helbig (1839–1915)

13.150. *Wolfgang Helbig a Napoli, 1863–1865: archeologia e politica dopo l'annessione* / Anna Maria Voci. Napoli: Editoriale scientifica, 2007. 370 p. DG206.H45 A4 2007.

Helen of Troy

13.151. *About Helen of Troy.* http://www.english.illinois. edu/maps/poets/g_l/hd/abouthelen.htm.

13.152. *Helen of Troy.* http://ancienthistory.about.com/ od/helen/Helen_of_Troy_and_the_Trojan_War. htm.

Wilhelm Henzen (1816–1887); Eduard Gerhard (1795–1867)

13.153. *Wilhelm Henzen und das Institut auf dem Kapitol: aus Henzens Briefen an Eduard Gerhard* / Hans-Georg Kolbe. Mainz: P. von Zabern, 1984. 425 p. DE3 .D48 1979 Bd.5.

Susan M. Hopkins

13.154. *My Dura-Europos: the letters of Susan M. Hopkins, 1927–1935* / Bernard M. Goldman and Norma W. Goldman. Detroit: Wayne State University Press, 2011. 310 p. DS99.D8 H67 2011.

Hercules

13.155. *Hercules: Greece's greatest hero.* http://www. perseus.tufts.edu/Herakles/index.html.

Herodotus (484–425 BCE)

13.156. *Herodotus of Halicarnassus.* http://www.livius. org/he-hg/herodotus/herodotus01.htm.

Homer (ca. 850 BCE)

13.157. *Chicago Homer* (Northwestern University). The Chicago Homer is a multilingual database that uses the search and display capabilities of electronic texts to make the distinctive features of early Greek epics accessible to readers with and without Greek. In addition to all the texts of ancient Greek epics in the original Greek, the *Chicago Homer* includes English and German translations. http://digital.library.northwestern. edu/homer/.

13.158. *Homer: ancient Greek poet.* http://www.ancient-greece.com/s/People/Homer/.

13.159. *Homer and Hesiod.* http://repository.upenn.edu/ cgi/viewcontent.cgi?article=1006&context= classics_papers&sei-redir=1&referer=http %3A%2F%2Fwww.bing.com%2Fsearch %3Fq%3DHomer%2Band%2BHesiod%- 26qs%3Dn%26form%3DQBRE%26pq%3Dho mer%2Band%2Bhesiod%26sc%3D2-16%26sp %3D-1%26sk%3D#search=%22Homer%20He-siod%22.

Piet de Jong (1887–1967)

13.160. *Faces of archaeology in Greece: caricatures by Piet de Jong* / Rachel Hood. Oxford: Leopard's Head Press, 1998. 279 p. NC1429.J66 H66 1998.

Juba II, King of Mauretania (ca. 50 BCE–ca. 24 CE)

13.161. Cleopatra, Queen, consort of Juba II, King of Mauretania, b. 40 B.C.; *The world of Juba II and Kleopatra Selene: royal scholarship on Rome's African frontier* / Duane W. Roller. New York: Routledge, 2003. 335 p. DT198 .R65 2003.

Vassos Karageorghis (fl. 1963–2000)

13.162. *Lifetime in the archaeology of Cyprus; The memoires of Vassos Karageorghis.* Stockholm: Medlhavsmuseet, 2007. 226 p. DS54.93.K37 A3 2007.

Rodolfo Amedeo Lanciani (1847–1929)

13.163. *Rodolfo Lanciani: l'archeologia a Roma tra Ottocento e Novecento* / Domenico Palombi. Roma: L'Erma di Bretschneider, 2006. 356 p. DG206. L36 .P35 2006.

Jean Philippe Lauer (1902–2001)

13.164. *Lauer et Sakkara* / Claudine Le Tourneur d'Ison. Paris: Tallandier; Paris: Historia, 213.0. 143 p. PJ1064.L38 L48 2000.

Frank W. Kelsey (1858–1927)

13.165. *Dangerous archaeology: Francis Willey Kelsey and Armenia (1919–1920): an exhibition presented at the Kelsey Museum of Ancient and Mediaeval Archaeology, September 1990–February 1991* / Thelma K. Thomas. Ann Arbor: Kelsey Museum, 1990. 72 p. N5335.K29 T36 1990.

13.166. *The life and work of Francis Willey Kelsey: archaeology, antiquity, and the arts* / John Griffiths Pedley. Ann Arbor: University of Michigan Press, 2012. 468 p. PA85.K45 P44 2012.

Kathleen Mary Kenyon, Dame (1906–1978)

13.167. *Dame Kathleen Kenyon: digging up the Holy Land* / Miriam C. Davis. Walnut Creek: Left Coast Press, 2008. 280 p. DS115.9.K395 D38 2008.

Austen Henry Layard (1817–1894)

13.168. *From archaeology to spectacle in Victorian Britain: the case of Assyria, 1845–1854* / Shawn Malley. Farnham, Surrey; Burlington: Ashgate, 2012. 203 p. DS69.6 .M36 2012.

Agnes Smith Lewis (1843–1926); Margaret Dunlop Gibson (1843–1920)

13.169. *The sisters of Sinai: how two lady adventurers discovered the hidden gospels* / Janet Soskice. New York: Alfred A. Knopf, 2009. 316 p. BS2351.A1 S67 2009.

Giovanni Lilliu (1914–2012)

13.170. *L'archeologo e i falsi bronzetti* / Giovanni Lilliu; con la biografia dell'autore raccontata da R. Copez. Cagliari: AM&D, 1998. 123 p. DG55.S2 L54 1998.

Seton Lloyd (1902–1996)

13.171. *Foundations in the dust; a story of Mesopotamian exploration* / Seton Lloyd. London: Oxford University Press, 1947. 237 p. DS70 .L56 1947.

13.172. *Interval: a life in Near Eastern archaeology* / Seton Lloyd. Oxford: Alden Press, 1986. 186 p. CC115.L55 A3 1986.

Emanuel Löwy (1857–1938)

13.173. *Emanuel Löwy: ein vergessener Pionier* / Friedrich Brein. Wien: Verlag des Clubs der Universität Wien, 1998. 128 p. DF212.L68 E436 1998.

Victor Loret (1859–1946)

13.174. *Victor Loret in Egypt (1881–1899): from the Archives of the Milan University to the Egyptian Museum in Cairo* / Patrizia Piacentini. Cairo: Supreme Council of Antiquities, 2008. 140 p. DT61 .V54 2008.

James R. McCredie (1935–)

13.175. *Samothracian connections: essays in honor of James R. McCredie* / Olga Palagia and Bonna D. Wescoat. Oxford; Oakville: Oxbow Books, 2010. 239 p. DF261.S3 S26 2010.

Max E. L. Mallowan (1904–1978)

13.176. *Agatha Christie and archaeology* / Charlotte Trümpler. London: British Museum Press, 2001. 471 p. PR6005 .H66 Z554713 2001.

13.177. *Life of Max Mallowan: archaeology and Agatha Christie* / Henrietta McCall. London: British Museum Press, 2001. 208 p. CC115.M27 M38 2001.

Charles Masson (1800–1853)

13.178. *Charles Masson of Afghanistan: explorer, archaeologist, numismatist, and intelligence agent* / Gordon Whitteridge. Warminster, England: Aris and Phillips; Atlantic Highlands: Humanities Press, 1986. 181 p. DS367.M37 W45 1986.

David Masters (b. 1883?)

13.179. *Romance of excavation; a record of the amazing discoveries in Egypt, Assyria, Troy, Crete, etc.* / David Masters. London: J. Lane, 1923. 191 p. 913 M393.

John Izard Middleton (1785–1849)

13.180. *The Roman remains: John Izard Middleton's visual souvenirs of 1820–1823, with additional views in Italy, France, and Switzerland* / Charles R. Mack and Lynn Robertson. Columbia: University of South Carolina Press; South Carolina Library, 1997. 203 p. DG63 .M634 1997.

Mithridates VI Eupator, King of Pontus (ca. 132–63 BCE)

13.181. *Poison king: the life and legend of Mithradates, Rome's deadliest enemy* / Adrienne Mayor. Princeton: Princeton University Press, 2010. 448 p. DS156 .P8 M39 2010.

Charles Montagu Doughty (1843–1926)

13.182. *God's fugitive: the life of Charles Montagu Doughty* / Andrew Taylor. London: Harper Collins Publishers, 1999. 351 p. PR6007.O85 Z85 1999. Biography of British explorer of the Arabian peninsula.

Jacques de Morgan (1857–1924)

13.183. *Mémoires de Jacques de Morgan: 1857–1924: Directeur général des antiquités égyptiennes, Délégué général de la Délégation scientifique en Perse: souvenirs d'un archéologue* / Andrée Jaunay. Paris: L'Harmattan, 1997. 551 p. CC115. M68 M4 1997.

Nebuchadnezzar II, King of Babylonia (d. 562 BCE)

13.184. *Nabuchodonosor II: roi de Babylone* / Daniel Arnaud. Paris: Fayard, 2004. 385 p. DS73.92 .A782 2004.

13.185. *Images of Nebuchadnezzar: the emergence of a legend* / Ronald H. Sack. 2 ed. Selinsgrove: Susquehanna University Press; London; Cranbury: Associated University Presses, 2004. 175 p. Library DS73.92 .S23 2004. Supersedes: *Images of Nebuchadnezzar: the emergence of a legend* / Ronald H. Sack. Selinsgrove: Susquehanna University Press; London: Associated University Presses, 1991. 143 p. DS73.92 .S23 1991.

Arnold Nöldeke (1875–1964)

13.186. *Altiki der Finder: Memoiren eines Ausgräbers* / Arnold Nöldeke. Hildesheim; New York: Olms, 2003. 361 p. DS70.88.N65 A3 2003. German archaeologist who conducted excavations in Iraq.

13.187. *Briefe aus Uruk-Warka, 1931–1939* / Arnold Nöldeke. Wiesbaden: Reichert, 2008. 347 p. CC115.N65 A4 2008. Travel correspondence from Iraq.

Pelagio Palagi (1775–1860)

13.188. *Un aspetto della archeologia ottocentesca: Pelagio Palagi ed Eduard Gerhard* / Stefania Caranti Martignago. Imola: University Press Bologna, 1995. 111 p. DE59 .C372 1995.

J. D. S. Pendlebury (1904–1941)

13.189. *Rash adventurer: a life of John Pendlebury* / Imogen Grundon. London: Libri, 2007. 383 p. DF212.P46 G78 2007.

Pericles (495–429 BCE)

13.190. *Odeon of Pericles.* http://www.didaskalia.net/studyarea/visual_resources/pericles3d.html.

13.191. *Pericles.* http://ancienthistory.about.com/od/pericles/p/Pericles.htm.

Perseus

13.192. *Perseus.* http://www.greekmythology.com/Myths/Heroes/Perseus/perseus.html.

Boucher de Perthes (1788–1868)

13.193. *Boucher de Perthes, 1788–1868: les origines romantiques de la préhistoire* / Claudine Cohen and Jean-Jacques Hublin; préface d'Yves Coppens. Paris: Belin, 1989. 271 p. CC115.B585 C63 1989.

Philip II of Macedon (382–336 BCE)

13.194. Philip II of Macedon. http://www.historyofmacedonia.org/AncientMacedonia/PhilipofMacedon.html.

Philo of Alexandria (20 BCE–50 CE)

13.195. *Philo of Alexandria homepage.* http://www.iep.utm.edu/philo/.

Augustus Henry Lane-Fox Pitt-Rivers (1827–1900)

13.196. *General Pitt-Rivers: evolution and archaeology in the nineteenth century* / M. W. Thompson. Bradford-on-Avon: Moonraker Press, 1977. 164 p. DA3.P53 T46.

13.197. *Pitt Rivers: the life and archaeological work of Lieutenant-General Augustus Henry Lane Fox Pitt Rivers, DCL, FRS, FSA* / Mark Bowden. Cambridge; New York: Cambridge University Press, 1991. 182 p. DA3.P53 .B69 1991.

Plato (324–348 BCE)

13.198. *Plato.* http://www.philosophypages.com/ph/plat.htm.

13.199. *Plato and his dialogs.* http://plato-dialogues.org/plato.htm.

13.200. *Plato's apology.* http://classics.mit.edu/Plato/apology.html.

13.201. *Plato's allegory of the cave.* http://www.buzzle.com/articles/platos-allegory-of-the-cave-meaning-and-interpretation.html.

13.202. *Plato's laws.* http://classics.mit.edu/Plato/laws.html.

Ludwig Pollak (b. 1868)

13.203. *Römische Memoiren: Künstler, Kunstliebhaber und Gelehrte 1893–1943* / Ludwig Pollak. Roma: "L'Erma" di Bretschneider, 1994. 263 p. N7483.P65 A3 1994. Biography of an Austrian classicist and archaeologist.

Jean Baptiste Prosper Jollois (1776–1842); Charles Pensée (1799–1871)

13.204. *De l'Egypte aux Vosges: l'archéologue et l'aquarelliste: hommage à Prosper Jollois, 1776–1842 et à Charles Pensée, 1799–1871.* Epinal: Musée départemental d'art ancien et contemporain, 1998. 107 p. DC611.V962 D4 1998.

Ptolemy (90–168 AD)

13.205. House of Ptolemy. http://www.houseofptolemy.org/.

Froelich G. Rainey (1907–1992)

13.206. *Reflections of a digger: fifty years of world archaeology* / Froelich Rainey. Philadelphia: University Museum of Archaeology and Anthropology, University of Pennsylvania, 1992. 308, 16 p. CC115.R35 A3 1992.

Lugwig Ross (1806–1859)

13.207. *He Hellenike autapate tou Loudovikou Ross* / Vasileiou Ch. Petrakou. Athenai: He en Athenais

Archaiologike Hetaireia, 2009. 716 p. DF212. R67 P48 2009.

13.208. *Ludwig Ross und Griechenland: Akten des internationalen Kolloquiums, Athen, 2.-3. Oktober 2002; Ludwig Ross kai he Hellada: praktika tou diethnous synedriou, Athena, 2–3 Oktovriou 2002* / Hans Rupprecht Goette and Olga Palagia. Rahden, Westfalen: Verlag Marie Leidorf, 2005. 350 p. DF212.R67 L84 2005.

Donald P. Ryan (1957–)

13.209. *Beneath the sands of Egypt: adventures of an unconventional archaeologist* / Donald P. Ryan. New York: William Morrow, 2010. 286 p. DT60 .R95 2010.

Heinrich Schliemann (1822–1890)

13.210. *Archaeology of Heinrich Schliemann: an annotated bibliographic handlist* / Curtis Runnels. 2 ed. Boston: Archaeological Institute of America, 2007. 81 p. DF212.S4 R86 2007.

13.211. *Briefe von Heinrich Schliemann* / Ernst Meyer. Berlin: W. de Gruyter, 1936. 362 p. 925.7 Sch37.

13.212. *Correspondenz zwischen Heinrich Schliemann und Rudolf Virchow: 1876–1890* / Joachim Herrmann und Evelin Maass. Berlin: Akademie-Verlag, 1990. DF212.S4 A4 1990.

13.213. *Heinrich Schliemann: Archäologe und Abenteurer* / Justus Cobet. München: Beck, 1997. 127 p. DF212.S4 C63 1997.

13.214. *Heinrich Schliemann: Dokumente seines Lebens* / Wolfgang Richter. Leipzig: Reclam-Verlag, 1992. 461 p. DF212.S4 R53 1992.

13.215. *Heinrich Schliemann, Selbstbiographie: bis zu seinem Tode vervollständigt* / Sophie Schliemann. 9 ed. 1961, 144 p. 913.381 T75 S.6.

13.216. *Das Heinrich-Schliemann-Lexikon* / Hans Einsle and Wilfried Bölke. Bremen: Edition Temmen, 1996. 204 p. DF212.S4 E35 1996.

13.217. *Heinrich Schliemanns "Sammlung trojanischer Altertümer": Beiträge zur Chronik einer grossen Erwerbung der Berliner Museen* / Geraldine Saherwala, Klaus Goldmann, and Gustav Mahr. Berlin: Volker Spiess, 1993. 259 p. DF212.S4 A4 1993.

13.218. *Heinrich Schliemanns Weg nach Troia: die Geschichte eines Mythomanen* / Manfred Flügge. München: Deutscher Taschenbuch Verlag, 2001. 299 p. DF212.S4 F584 2001.

13.219. *One passion, two loves; the story of Heinrich and Sophia Schliemann, discoverers of Troy* / Lynn and Gray Poole. New York: Crowell, 1966. 299 p. 913.381 Sch37.yP.

13.220. *Schliemann of Troy: treasure and deceit* / David A. Traill. London: John Murray, 1995. 365 p. DF221.T8 T7 1995.

13.221. *Über Griechenland und Troja, alte und junge Gelehrte, Ehefrauen und Kinder: Briefe von Rudolf Virchow und Heinrich Schliemann aus den Jahren 1877–1885* / Christian Andree. Köln: Böhlau, 1991, 1990. 208 p. DF212.S4 A4 1991. Correspondence between archaeologist Heinrich Schliemann and pathologist Rudolf Ludvig Karl Virchow (1821–1902).

Richard Berry Seager (1882–1925)

13.222. *Richard Berry Seager: pioneer archaeologist and proper gentleman* / Marshall J. Becker and Philip P. Betancourt. Philadelphia: University of Pennsylvania Museum of Archaeology and Anthropology, 1997. 225 p. DF212.S44 B43 1997.

M. V. Seton-Williams (1910–1992)

13.223. *Road to El-Aguzein* / M. V. Seton-Williams. London; New York: Kegan Paul International, 1988. 160 p. N7483.P65 A3 1994.

Omm Sety (1904–1981)

13.224. *The search for Omm Sety: a story of eternal love* / Jonathan Cott. Garden City: Doubleday, 1987. 256, 16 p. PJ1064.O46 C6 1987.

Hershel Shanks (1930–)

13.225. *Freeing the Dead Sea Scrolls: and other adventures of an archaeology outsider* / Hershel Shanks. London; New York: Continuum, 2010. 251 p. CC115.S53 A3 2010.

Socrates (469–399 BCE)

13.226. *Last days of Socrates.* http://socrates.clarke.edu/.

13.227. *Socrates.* http://www.philosophypages.com/ph/socr.htm.

Aurel Stein (1862–1943)

13.228. *Aurel Stein: pioneer of the Silk Road* / Annabel Walker. London: J. Murray, 1995. 393 p. DS785. S84 W35 1995.

13.229. *Aurel Stein on the Silk Road* / Susan Whitfield. Chicago: Serindia Publications, 2004. 143 p. DS785.S84 W45 2004.

13.230. *Sir Aurel Stein, archaeological explorer* / Jean-nette Mirsky. Chicago: University of Chicago Press, 1977. 585 p. DS785.S84 M57.

13.231. *Sir Aurel Stein in The Times: a collection of over 100 references to Sir Aurel Stein and his extraordinary expeditions to Chinese Central Asia, India, Iran, Iraq and Jordan in The Times newspaper 1901–1943* / Helen Wang. London: Eastern Art Pub., 2002. 164 p. CC115.S83 S572 2002.

Thucydides (ca. 460–395 BCE)

13.232. *History of the Pelopennesian War* / Thucydides. http://classics.mit.edu/Thucydides/pelopwar.html.

Tutankhamen (d. 1323 BCE)

13.233. *National Geographic: At the tomb of Tutankhamen.* http://www.nationalgeographic.com/features/98/egypt/.

13.234. *Tutankhamen, boy king.* http://www.theboyking.com/.

13.235. *Tutankhamen's shrines.* http://www.king-tut.org.uk/tomb-of-king-tut/king-tut-shrines.htm.

Georges Vallet (1922–1994)

13.236. *Un archeologo nel suo tempo: Georges Vallet* / Jacques Nobécourt. Siracusa: Ediprint, 1991. 246 p. Biography of the excavator of Megara Hylaea in Sicily. CC115.V35 N63 1991.

Laurence A. Waddell (1854–1938)

13.237. *Rise of man in the gardens of Sumeria: a biography of L.A. Waddell* / Christine Preston. Brighton; Portland: Sussex Academic Press, 2009. CT788.W23 P74 2009.

Karl Jakob Weber (1712–1764)

13.238. *Rediscovering antiquity: Karl Weber and the excavation of Herculaneum, Pompeii, and Stabiae* / Christopher Charles Parslow. Cambridge; New York: Cambridge University Press, 1995. 394 p. DG70.P7 P37 1995.

Alfred Westholm (1904–1996)

13.239. *Fantastic years on Cyprus: illustrated extracts from Alfred Westholm's letters to his parents, 1927–1931* / Niki Eriksson. Savedalen: Paul Astroms, 2007. 100 p. DS54.3 .W48813 2007.

Mortimer Wheeler, Sir (1890–1976)

13.240. *Adventurer in archaeology: the biography of Sir Mortimer Wheeler* / Jacquetta Hawkes. New York: St. Martin's Press, 1982. 387 p. CC115.W58 H38.

13.241. *Still digging; interleaves from an antiquary's notebook* / Mortimer Wheeler. London: M. Joseph 1955. 236 p. 913 W563.2; CC115.W58 A3.

Hugo Winckler (1863–1913)

13.242. *Hugo Winckler: zwei Gedachtnisreden in der Vorderasiatischen Gesellschaft zu Berlin gehalten am 2. Juli 1913* / Alfred Jeremias and Otto Weber. Leipzig: J. C. Hinrichs'sche Buchhandlung, 1916. 48 p. D15.W565 J47 1916; DS41 .V8 v.20.

Leonard Woolley, Sir (1880–1960)

13.243. *As I seem to remember* / Leonard Woolley. London: Allen and Unwin; Shaftesbury and District Society and Museum Society, 1962. 112 p. CC115.W64 A33.

13.244. *Spadework; adventures in archæology* / Leonard Woolley. London: Lutterworth Press, 1953. 124 p. CC115.W64 A3 1953; 913 W883.3.

13.245. *Spadework in archæology* / Leonard Wooley. New York: Philosophical Library, 1935. 124 p. Egyptian Collection CC115 .W64 A3.

13.246. *Woolley of Ur: the life of Sir Leonard Woolley* / H. V. F. Winstone. London: Secker and Warburg, 1990. 314 p. CC115.W6 W5 1990.

Paola Zancani Montuoro (1901–1987)

13.247. *Paola Zancani Montuoro (1901–1987): giornata di studio in omaggio a Paola Zancani Montuoro . . . nel ventennale della scomparsa, Sorrento, 19 maggio 2007 . . .: Sorrento e la penisola sorrentina tra italici, etruschi e greci* / Mario Russo. Napoli: N. Longobardi, 2007. 79 p. CC115 .Z36 P36 2007.

Zeno (CE 425–491)

13.248. *Heraklitus Marcus Aurelius Plotinus Zeno of Cittium Aristotle.* http://edpa.tripod.com/history/greece.htm.

Zeus

13.249. *Zeus.* http://www.pantheon.org/articles/z/zeus.html.

14

Directories of Organizations and Associations

A directory is a list of names, addresses, etc., of specific classes of people or organizations, usually in alphabetical order or in some other classification.

GENERAL

14.1. *Annuaire des départements de sociologie, d'anthropologie, d'archéologie des universités et des musées du Canada. Guide to departments of sociology, anthropology, archaeology in universities and museums in Canada.* Ottawa: National Museum of Man, 1905 .A568, 1978/1979, 1981/1982.

14.2. *The archaeologists' year book.* Park Ridge: Noyes Press, 1973–1977. 3 v. CC15 .A724, 1973, 1975.

14.3. *Archaeology handbook.* London: Current Archaeology, 2001. 1/yr. CC1 .C98, 2001/2002–2005/2006, 2006–2007. Supersedes: *The archaeology handbook: a field manual and resource guide* / Bill McMillon. New York: Wiley, 1991. 259 p. CC76 .M38 1991.

14.4. *Handbook for British and Irish archaeology: sources and resources* / Cherry Lavell. Edinburgh: Edinburgh University Press, 1997. 480 p. DA90 .H34 1997.

14.5. *A professional directory of European scientific laboratories cooperating with archeology; Inventaria des laboratoires européens de sciences naturelles appliquées à lárchéologie* / Jean Claus, Tony Hackens, and W. G. Mook. Strasbourg: Conseil del Éurope, Assemblée Parlementaire, 1984. 365 p. Q183.4.E8 C5 1984.

14.6. *Les sociétés savantes et l'archéologie:répertoire et analyse* / Brigitte Lequeux, Monique Main-jonet, and Suzanne Roscian. Paris: Éditions du Centre national de la recherche scientifique, 1986. 355 p. CC25 .L46 1986.

FIELDWORK OPPORTUNITIES

14.7. *Archaeo-volunteers: the world guide to archaeological and heritage volunteering* / Fabio Ausenda and Erin McCloskey. 2 ed. Milan: Green Volunteers; New York: Universe, 2009. 239 p. CC75.7 .A718 2009. Supersedes: *Archaeo-volunteers: the world guide to archaeological and heritage volunteering* / Fabio Ausenda and Erin McCloskey. Milano: Green Volunteers; New York: Universe, 2003. 255 p. CC75.7 .A686 2003.

14.8. *Archaeology abroad.* London: Archaeology Abroad Service, 2005. Optical discs (CD-ROM). 2/yr., 2005. CC120 .A7242, no.32(2), 2005. Supersedes: *Archaeology abroad.* London: Archaeology Abroad Service, 1972. 3/yr. CC120 .A724, no.1– , 1972– .

14.9. *Archaeological fieldwork and opportunities bulletin* [electronic resource]. New York: Archaeological Institute of America. 1/yr. http://www.archaeological.org/fieldwork/afob.

PROFESSIONAL ORGANIZATIONS

Argentina

14.10. Amigos de la Egiptología en la Argentina. www.egiptologia.com/.

14.11. Centro de Estudios de Egipto y del Mediterráneo Oriental. www.ceemo.org.ar/.

14.12. Centro de Estudios de Historia del Antiguo Oriente. www.uca.edu.ar/index.php/site/index/ es/uca/facultades/buenos-aires/cs-sociales-politicas-y-de-la-comunicacion/investigacion/ cehao/.

Armenia

14.13. Armenian Egyptology Centre, Yerevan State University. www.a-egyptology.atspace.com.

Australia

14.14. Ancient Egypt Society of Western Australia. www.aeswa.org.au/.

14.15. Ancient History Department, Macquarie University, Sydney. Macquarie Egyptology. mq.edu.au/ about_us/faculties_and_departments/faculty_of_ arts/department_of_ancient_history/home/.

14.16. Australian Center for Egyptology, Macquarie University. The first Australian institution to introduce a full training program in Egyptology and to conduct Australian-based expeditions to excavate, record, and preserve Egyptian sites. Since 1980 the Macquarie teams, formed of staff and students, have worked annually on a number of important sites, including Thebes, Saqqara, Helwan, and Giza. www.mq.edu.au/research/ centres_and_groups/the_australian_centre_for_ egyptology/.

14.17. Centre for Archaeology and Ancient History, Monash University, Melbourne. www.arts.monash .edu.au/archaeology/.

14.18. Egyptology Society of Victoria. www.arts. monash.edu.au/archaeology/egyptology-society/.

14.19. Near Eastern Archaeology Foundation, University of Sydney. sydney.edu.au/arts/sophi/neaf/.

14.20. Rundle Foundation for Egyptian Archaeology, Sydney. www.egyptology.mq.edu.au/newsletters/98_2005.pdf.

14.21. University Students for Egyptological Research, Macquarie University. www.mq.edu.au/about_ us/faculties_and_departments/faculty_of_arts/ department_of_ancient_history/university_students_for_egyptological_research/.

14.22. Western Australian Museum Centre for Ancient Egyptian Studies. museum.wa.gov.au/research/ departments/anthropology-and-archaeology/ wamcaes.

Austria

14.23. Institute of Egyptology of the University of Vienna. www.univie.ac.at/egyptology/.

Belgium

14.24. Afdeling Egyptologie aan de faculteit Letteren, Katholieke Universiteit Leuven. www.arts.kuleuven.be/info/ONO/Egypte/homepage.

14.25. Association Égyptologique Reine Élisabeth. www.aere-egke.be/aere.eng.htm.

14.26. Egyptologica Vlaanderen. www.egyptologica-vlaanderen.be/.

14.27. Egyptologisch Genootschap Koningin Elisabeth. www.aere-egke.be/egke.htm.

14.28. Ptah-hotep a.s.b.l. ptahhotep.webfactional.com/.

14.29. Société Belge d'Études Orientales / Belgisch Genootschap voor Oosterse Studiën / Belgian Society for Oriental Studies. www.orientalists. be/.

Bulgaria

14.30. Bulgarian Institute of Egyptology. egyptology-bg.org/.

Canada

14.31. Association des études du Proche-Orient ancien / Society for Near Eastern Studies. www.aepoa. umontreal.ca/.

14.32. Bureau Egyptien des Affaires Culturelles et de l'Education, Montreal. www.egypt-edu-can.net/.

14.33. Canadian Society for the Study of Egyptian Antiquities. www.sseamontrealvip.homestead.com/ Project-EN.html.

14.34 Classical Association of Canada. www.cac-scec. ca/wordpress/. Information about the organization and its activities and publications is available at this site.

14.35. Département d'histoire, Université du Quebec à Montréal. www.histoire.uqam.ca/.

14.36. Department of Near and Middle Eastern Civilizations, University of Toronto. www.utoronto.ca/ nmc/.

14.37. Ontario Classical Association. The OCA is the only official advocate for students, teachers, and professors of Classics in the Canadian province of Ontario. Its mandate is the promotion and protection of Classical studies. The Ontario Classical Association home page has information about membership, the history of the organization, its online newsletter, and links to Classics resources. www.ontclassics.org/.

14.38. Near and Middle Eastern Civilizations Graduate Students' Association, University of Toronto. ulife.utoronto.ca/.

14.39. Society for the Study of Egyptian Antiquities. www.thessea.org/.

14.40. Survey and Excavation Projects in Egypt. www. deltasinai.com/.

Czechoslovakia

14.41. České národní egyptologické centrum, Univerzita Karlova, Praha / Czech National Centre of Egyptology, Charles University in Prague, The Aigyptos Foundation. egypt.cuni.cz/.

14.42. Cesky egyptologicky ustav Filozoficke fakulty Univerzity Karlovy (Czech Institute of Egyptology, Charles University in Prague and Cairo). egyptologie.ff.cuni.cz/.

Denmark

14.43. Dansk Ægyptologisk Selskab / Danish Egyptological Society. www.daes.dk/.

14.44. Department of Cross-Cultural and Regional Studies, Carsten Niebuhr Section, Egyptology. ccrs.ku.dk/.

Egypt

14.45. American Research Center in Egypt, Cairo Branch. www.arce.org/main/about/cairocenter.

14.46. Centre d'Etudes Alexandrines. www.cealex.org/.

14.47. Centre franco-égyptien d'étude des temples de Karnak. www.cfeetk.cnrs.fr/.

14.48. Deutsches Archäologisches Institut, Abteilung Kairo. www.dainst.org/en/home?ft=33.

14.49. Egypt Exploration Society, Cairo Office. www. ees.ac.uk/about-us/cairo-office.html.

14.50. Egyptian Antiquities Information System. giscenter.gov.eg/uploads/83/d1/83d18428d1e580 6281b024fb47ec5f1b/Establishment-of-a-Geographic-Information-System_documents-a.pdf.

14.51. Institut Français d'Archéologie Orientale du Caire. www.ifao.egnet.net/.

14.52. Institute of Nautical Archaeology, Egypt. www. adventurecorps.com/sadana/aboutinaegypt.html.

14.53. Italian Cultural Institute, Cairo. www.iiccairo. esteri.it/IIC_ilcairo.

14.54. Luxor Egyptology Society. www.luxoregyptology.org/.

14.55. Nederlands-Vlaams Instituut in Cairo. www. instituten.leidenuniv.nl/nvic/.

14.56. Supreme Council of Antiquities, Egypt. www. sca-egypt.org/.

14.57. Yale Egyptological Institute in Egypt. www.yale. edu/egyptology/.

Finland

14.58. Egyptologiska Sällskapet i Finland. www.tsv.fi/ jasenseurat/details.php?id=97.

France

14.59. Association Dauphinoise d'Egyptologie. www. champollion-adec.net/.

14.60. Association Égyptologique de Gironde. www-aeg.u-bordeaux3.fr.

14.61. Association France-Egypte. www.egypt.edu/ etaussi/adresses/franceegypte/france01.htm.

14.62. Association Francophone de Coptologie. www. coptologie.mmsh.univ-aix.fr/Decouvrir-AFC/default.aspx.

14.63. Association Internationale pour l'Etude du Droit de l'Egypte Ancienne. www.aidea-asso.com/.

14.64. Association Montpelliéraine d'Égyptologie "Néfrou." www.nefrou.free.fr.

14.65. Association Provence Égyptologie. www. provenceegyptologie.org.

14.66. Association Rennes Egyptologie. www.rennesegypto.free.fr.

14.67. Association de Sauvegarde du Ramesseum. www.asrweb.org/.

14.68. Centre d'Etude et de Documentation sur l'Ancienne Egypte. www.cedae.info.

14.69. Centre d'Etudes Alexandrines. www.cealex.org.

14.70. Centre franco-égyptien d'étude des temples de Karnak. www.cfeetk.cnrs.fr.

14.71. Cercle Lyonnais d'Egyptologie Victor Loret. www.asso.univ-lyon2.fr/cercle-egyptologie.

14.72. France: Ministry of Foreign Affairs' Directorate-General for International Cooperation and Development, the Department of Archaeology and Social Sciences._www.diplomatie.gouv.fr/ en/france-priorities_1/archaeology_2200/index. html.

14.73. Groupe de Recherche pour l'Archeologie au Levant. www.grepal.org/presentation.php.

14.74. Institut d'Egyptologie de Strasbourg. www.unistra.fr/index.php?id=349.

14.75. Institut d'Egyptologie François Daumas, l'Université de Montpellier. recherche.univ-montp3.fr/egyptologie/.

14.76. Institut de Papyrologie de la Sorbonne Université de Paris IV. www.papyrologie.paris-sorbonne. fr/.

14.77. Institut del Pròxim Orient Antic—IPOA. www. ub.edu/ipoa/ipoa1.htm.

14.78. Institut du Monde Arabe. www.imarabe.org/.

14.79. Institut Français d'Archéologie Orientale du Caire (French Institute, Cairo). www.ifao.egnet. net/.

14.80. Provence Égyptologie. www.provenceegyptologie.org/.

14.81. Rencontres Egyptologiques de Strasbourg. www. thotweb.com/portail/associations/rencontres_ egyptologiques_strasbourg.php.

14.82. Société Française d'Égyptology. www.egypt.edu/etaussi/adresses/sfe/sfe01.htm.

Germany

14.83. Ägypten-Forum-Berlin e.V. www.aefobe.de.

14.84. Ägyptisch-Deutsche Gesellschaft Nord e.V. www.adgn.de/.

14.85. Ägyptologie-Forum Würzburg e.V., Institut für Ägyptologie der Universität Würzburg. www.aegyptologieforum.uni-wuerzburg.de/.

14.86. Ägyptologie, Philipps-Universität Marburg. www.uni-marburg.de/cnms/aegyptologie.

14.87. Ägyptologische Forschungsstätte für Kulturwissenschaft (Ruprecht-Karls-Universität Heidelberg). www.aefkw.uni-hd.de/start.html.

14.88. Ägyptologisches Institut and Aegyptisches Museum. www.unileipzig.de/forsch97/13000/13210_V.htm.

14.89. Ägyptologisches Institut Tübingen. www.dainst.org/en/member/ingrid-gamer-wallert?ft=all.

14.90. Ägyptologisches Seminar, Freie Universität Berlin. www.fuberlin.academia.edu/Departments/Ägyptologisches_Seminar.

14.91. Ägyptologisches Seminar, Freie Universität Berlin. www.fu-berlin.de/einrichtungen/fachbereiche/fb/gesch-kultur/altwiss/aeg/index.html.

14.92. Archäologisches Institut, Arbeitsbereich V Ägyptologie, University of Hamburg. www.uni-hamburg.de/Wiss/FB/09/ArchaeoI/Aegypto/index.html.

14.93. Collegium Aegyptium e.V./Foerderkreis des Instituts fuer Aegyptologie der Ludwig-Maximilians-Universitaet Muenchen e.V. www.collegium-aegyptium.de/collegium.html.

14.94. Deutsches Archäologisches Institut, Abteilung Kairo. www.inst.academia.edu/Departments/Deutsches_Archäologisches_Institut.

14.95. Deutsches Archäologisches Institut, Abteilung Kairo. www.dainst.org/en/home?ft=33.

14.96. Forum Ägyptologie an der Universität Hamburg e.V. www.forum-aegyptologie.de/.

14.97. Freundeskreis Ägyptologie an der Johannes Gutenberg-Universität Mainz e. V. www.foerdern-und-stiften.uni-mainz.de/595.php.

14.98. Hobby Ägyptologische Gemeinschaft in Bremervörde. www.hagib.de/.

14.99. Institut für Ägyptologie, Johannes-Gutenberg-Universität Mainz. www.aegyptologie-altorientalistik.uni-mainz.de/.

14.100. Institut für Ägyptologie, Ludwig-Maximilians-Universität München. www.aegyptologie.uni-muenchen.de/index.html.

14.101. Institut für Ägyptologie, Universität Würzburg. www.aegyptologie.uni-wuerzburg.de/.

14.102. Institut für Ägyptologie und Koptologie, Westfälischen Wilhelms-Universität Münster. www.uni-muenster.de/IAEK/.

14.103. International Association of Egyptologists. www.Guenter.Burkard@aegyp.fak12.uni-muenchen.de; www.iae.lmu.de; www.rfreed@mfa.org.

14.104. Neferhotep e.V. www.neferhotep.de/.

14.105. Oriental Institute, University of Leipzig. www.orient.uni-leipzig.de/en/institute/.

14.106. Seminar für Ägyptologie and Koptologie, Georg-August-Universität Göttingen. www.aegyptologie.uni-goettingen.de/.

14.107. Seminar für Ägyptologie, Universität zu Köln. www.uni-koeln.de/phil-fak/aegypt/.

14.108. Seminar für Archäologie und Kulturgeschichte Nordostafrikas, Humboldt-Universität zu Berlin. www.hu-berlin.de/studium/beratung/sgb/aknoa.

14.109. Sudanarchäologische Gesellschaft zu Berlin e.V. www.sag-online.de/.

14.110. Uschebti e.V. (c/o Seminar für Aegyptologie, Universitaet zu Köln). www.uni-koeln.de/phil-fak/aegypt/uschebti/.

14.111. Verein der Freunde und Förderer der Bonner Sammlung von Aegyptiaca. www.aegyptisches-museum.uni-bonn.de/Foerderverein.

Great Britain

14.112. Ancient Egypt and Middle East Society. www.aemes.co.uk/.

14.113. Association for Roman Archaeology. The Association for Roman Archaeology promotes the spread of knowledge of Roman civilization, research on Roman sites in the United Kingdom, preservation of Roman antiquities, presentation of Roman sites and collections, and publication of findings from all our active archaeological archives. www.associationromanarchaeology.org/.

14.114. Association for the Study of Travel in Egypt and the Near East. www.astene.org.uk/.

14.115. Association of Archaeological Illustrators and Surveyors. The Association of Archaeological Illustrators and Surveyors (AAI and S) was formed in Britain in 1978 and is now an international body for those engaged in all aspects of professional archaeological illustration and survey. It is an independent body funded through membership subscription. As a professional body, one of the main aims of the AAI and S is to set standards within the profession and to promote these standards within the archaeological world at large. The association's membership reflects the wide range of specialist skills and disciplines that are required from today's professional archaeological illustrators and surveyors. www.aais.org.uk.

14.116. Association of Environmental Archaeology. The AEA promotes the advancement of the study of human interaction with the environment in the past through archaeology and related disciplines. www.greatarchaeology.com/Archaeology_organisation_review.php?organisation=AE.

14.117. Bolton and District Archaeology and Egyptology Society. www.allcommunity.co.uk/boltonarchaeologysociety.

14.118. British Archaeological Association. The British Archaeological Association was founded in 1843 to promote the study of archaeology, art, and architecture and preservation. www.thebaa.org/.

14.119. British Association for Near Eastern Archaeology. BANEA was founded to promote the study of archaeology, history, and languages of the ancient Near East at all levels; provide a forum for discussion; and enhance opportunities to study these subjects. www.banea.org.

14.120. British Centre for Egyptian Studies. www.cylex-uk.co.uk/company/the-british-centre-for-egyptian-studies.

14.121. British Institute at Ankara. The British Institute at Ankara (BIAA) is internationally renowned for over sixty years of work supporting, enabling, and encouraging world-class research in Turkey and the Black Sea region in the fields of history, archaeology, and related social sciences. www.biaa.ac.uk/home/.

14.122. British Institute for the Study of Iraq (Gertrude Bell Memorial). The British Institute for the Study of Iraq (BISI) was established as the British School of Archaeology in Iraq on January 14, 1932, to promote, support, and undertake research in Iraq and neighboring countries. In 2007 its members approved its name change. www.britac.ac.uk/institutes/iraq/.

14.123. British School at Athens. The school was founded in 1886 and, for most of its existence, has focused on supporting, directing, and facilitating British-based research in Classical studies and archaeology. In recent years, it has broadened that focus to all areas of Greek studies. www.bsa.ac.uk/.

14.124. British School at Rome. Britain's leading humanities research institute abroad and one of the most prestigious foreign academies in Rome. Its mission is to promote British knowledge of Italy, through a program of highly selective residential awards, by providing research-friendly facilities, including accommodation in Rome; lectures, exhibitions, and conferences by leading practitioners; dedicated archaeological services to support fieldwork projects; a world-class research library and access to other research libraries in Rome; and an internationally recognized peer-reviewed journal and monograph series. www.bsr.ac.uk/research/archaeology.

14.125. Centre for Computer-Aided Egyptological Research. www.intute.ac.uk/cgi-bin/fullrecord.pl?handle=humbul341.

14.126. Classical Association of Scotland. The Classical Association of Scotland was founded in 1902. It acts as a focus for classical studies in Scotland in general and in particular within three of the older Scottish universities (in chronological order, St. Andrews, Glasgow, and Edinburgh). The site provides general information about the association and its meetings, a listing of related societies in Scotland, links to other organizations in the United Kingdom, and a section on recent publications from Scottish universities. www.st-andrews.ac.uk/cas/.

14.127. Classical Association. The Classical Association is the largest association in Great Britain. It was founded in 1903 "to promote the development and maintain the well-being of Classical studies." The Classical Association supports Classics in local areas through school reading competitions, play readings, and outings to places of Classical interest. It provides conference bursaries and often contributes to major academic projects. As well as producing three academic journals a year, the association produces a biannual newsletter. Its website offers information about membership, the organization, its activities and journals, and benefits to its members. www.classicalassociation.org/.

14.128. Computer Applications and Quantitative Methods in Archaeology. CAA is an international organization bringing together archaeologists and mathematics and computer scientists. Its aims are to encourage communication between these disciplines, to provide a survey of present work in the field, and to stimulate discussion and future progress. www.caaconference.org/about/.

14.129. Council for British Archaeology. The CBA is an educational charity working throughout the United Kingdom to involve people in archaeology and to promote the appreciation and care of the historic environment for the benefit of present and future generations. www.britarch.ac.uk/.

14.130. Egypt Centre, Wales. www.egypt.swan.ac.uk/.

14.131. Egypt Exploration Society. www.ees.ac.uk/.

14.132. Egypt Society of Bristol. www.egyptsocietybristol.org.uk.

14.133. Egyptian Cultural Centre and Educational Bureau. www.egyptculture.org.uk/about.htm. The Egyptian Cultural Centre and Educational Bureau in London is mainly concerned with promoting the Egyptian culture in the United Kingdom,

developing links and exchanges between the two countries' cultural institutes, universities, and research centers to help increase cultural awareness and build positive cultural and educational relations. For more than sixty years now the bureau has remarkably contributed, through a broad range of cultural, intellectual, scientific, and educational activities, to the growing relations between Egypt and the United Kingdom.

14.134. Egyptian Society UK, Taunton, Somerset. www.communigate.co.uk/twc/egypt/links.phtml.

14.135. Egyptology Scotland. www.egyptologyscotland.com/.

14.136. Essex Egyptology Group. www.essexegyptology.com/.

14.137. Friends of Nekhen; Hierakonpolis Expedition. www.hierakonpolisonline.org/friends/friends.html.

14.138. Friends of the Egypt Centre, Wales. www.egypt.swansea.ac.uk/index.php/friends-of-the-egypt-centre.

14.139. Horus Egyptological Society. www.horusegyptology.co.uk/.

14.140. International Council on Monuments and Sites. ICOMOS works for the conservation and protection of cultural heritage places. It is the only global nongovernment organization of its kind, which is dedicated to promoting the application of theory, methodology, and scientific techniques to the conservation of the architectural and archaeological heritage. Its work is based on the principles enshrined in the 1964 International Charter on the Conservation and Restoration of Monuments and Sites. www.icomos.org/en/.

14.141. Kenyon Institute. Jerusalem. The Kenyon, which was officially launched in 2001, has sought to build on the rich legacy of the British School of Archaeology in Jerusalem (BSAJ), which has a much longer history, having been established during the British Mandate in 1919. Thus, while incorporating the activities of the BSAJ, the Kenyon has expanded to cater to the humanities, social sciences, and all the fields supported by the British Academy. http://www.kenyon-institute.org.uk/.

14.142. Leicester Ancient Egypt Society. www.egyptology-uk.com/LAES/.

14.143. London Centre for the Ancient Near East. www.soas.ac.uk/nme/ane/lcane/.

14.144. Luxor Egyptology Society. www.luxoregyptology.org.

14.145. Manchester Ancient Egypt Society. www.maes.org.uk/.

14.146. Mercia Egyptology Society. mercia-egyptology.weebly.com/.

14.147. Middle East Institute. www.mei.edu/.

14.148. Nautical Archaeology Society. The Nautical Archaeology Society is a nongovernment organization formed to further interest in underwater cultural heritage. It is a registered charity based in the United Kingdom with strong links to sister organizations around the world. www.nauticalarchaeologysociety.org/.

14.149. North East Lincolnshire Egyptology Association. www.nelea.co.uk/.

14.150. North East Manchester Egyptology Society. www.nemes.co.uk/.

14.151. North Yorkshire Ancient Egypt Group. http://www.digyorkshire.com/%28A%28PUeYW3Z-YzgEkAAAANjgyZWFmZDAtZWNjNi00NTQ1LTk3YmYtNDMxMGIzZGRlMzc0UAsG7jos7uwbQlU4YQgu6N_bLIM1%29S%28wpul-gfc-24walb55i4gdd3ac%29%29/PerformerListing.aspx?performer=6560&AspxAutoDetectCookieSupport=1#.UqiJaieYF8E.

14.152. Poynton Egypt Group. www.poyntonegyptgroup.org.uk/.

14.153. Society for Interdisciplinary Studies. www.sisgroup.org.uk/.

14.154. Society for Libyan Studies. www.societyforlibyanstudies.org/.

14.155. Society for Medieval Archaeology. The Society for Medieval Archaeology was established to study evidence of the medieval past, whether standing buildings, landscapes, buried remains, or artifacts in museums. www.medievalarchaeology.co.uk/.

14.156. Society for the Promotion of Roman Studies. The Archaeology Committee aims to promote the study of Rome and the Roman Empire through its exceptional archaeological remains. The committee fosters collaboration between archaeologists and historians and encourages closer links between the United Kingdom and the international community. The committee is keen to increase awareness of antiquity among young people too, particularly schoolchildren who otherwise might not experience the many wonders of Roman archaeology. www.romansociety.org/archaeology.html.

14.157. Society for the Study of Ancient Egypt. www.ssae.org.uk/.

14.158. Society of Antiquaries of London. The Society of Antiquaries of London (SAL) is the world's premier learned society for heritage. www.sal.org.uk/.

14.159. Southampton Ancient Egypt Society. www.southamptonancientegyptsociety.co.uk/.

14.160. Staffordshire Egyptology Society. www.staffordshireegyptology.org.uk/.

14.161. Sudan Archaeological Research Society. www.sudarchrs.org.uk/.

14.162. Sussex College of Egyptology. www.scaca.co.uk/.

14.163. Sussex Egyptology Society. www.egyptology-uk.com/.

14.164. Swansea University, Centre for Egyptology and Mediterranean Archaeology. www.swan.ac.uk/classics/research/researchcentres/cema/.

14.165. Tameside Egypt Group. www.egypt.cedar-view.co.uk/.

14.166. Thames Valley Ancient Egypt Group. www.tvaes.org.uk/.

14.167. Three Counties Ancient History Society. www.3cahs.org.uk/.

14.168. University College, London, Friends of the Petrie Museum of Egyptian Archaeology. www.ucl.ac.uk/museums/petrie.

14.169. University of Durham, Friends of The Oriental Museum. ww.dur.ac.uk/oriental.museum/contact/friends/.

14.170. University of Exeter, Center for Arab Gulf Studies. www.socialsciences.exeter.ac.uk/iais/research/centres/gulf.

14.171. University of Liverpool, School of Archaeology, Classics and Egyptology. www.liv.ac.uk/sace/.

14.172. University of London, Centre of Islamic and Middle Eastern Law, School of Oriental and African Studies (University of London). www.soas.ac.uk/cimel.

14.173. University of London, School of Oriental and African Studies. www.soas.ac.uk.

14.174. University of Oxford, Centre for the Study of Ancient Documents. The Centre for the Study of Ancient Documents was established in 1995 under the auspices of Oxford University's Faculty of Literae Humaniores to provide a focus for the study of ancient documents within Oxford. The centre provides a home for Oxford University's epigraphical archive, which includes one of the largest collections of squeezes (paper impressions) of Greek inscriptions in the world, together with the Haverfield archive of Roman inscriptions from Britain and a substantial photographic collection. The strengths of the epigraphical archive lie in its broad coverage of early Greek inscriptions, Attic epigraphy, and the Hellenistic world. Individual sites well represented in the archive include Chios, Samos, Priene, Rhodes, and Samothrace. The material in the archive is currently being reorganized and catalogued. Web products include Vindolanda Tablets Online, Romano-British Curses, Cairo Photographic Archive, Papyri in British Collections, Oxyrhynchus Papyri, Poinikastas, MAMA XI, and e-Science and Ancient Documents. www.csad.ox.ac.uk/.

14.175. University of Oxford, Faculty of Oriental Studies. www.orinst.ox.ac.uk/.

14.176. University of Oxford, Griffith Institute, Ashmolean Museum, Oxford. www.griffith.ox.ac.uk/.

14.177. University of Wales, Egyptology Department, Swansea. www.swan.ac.uk/classics/.

14.178. Valley of the Kings Foundation/Amarna Royal Tombs Project. virtualology.com/egypt/valley-of-the-kings.com/.

14.179. Wirral Ancient Egypt Society. www.waes.org.uk/.

Greece

14.180. American School of Classical Studies at Athens. Blegan Library. One of two libraries of the American School of Classical Studies at Athens, the Blegan Library focuses on all aspects of Greece and the Greeks from the earliest prehistory through late antiquity. The library currently has more than 90,000 volumes and 700 periodicals. In its field, it is one of the premier research libraries in the world and the best in Greece. The Blegan Library is open to members of the American School of Classical Studies and to approved visitors. www.ascsa.edu.gr/index.php/Blegen-Library/.

14.181. American School of Classical Studies at Athens. Founded in 1881, the American School of Classical Studies provides graduate studies and scholars from affiliated North American colleges and universities a base for advanced study in all aspects of Greek culture, from antiquity to the present day. First and foremost, the school is a teaching institution, introducing graduate students in an academic year program, as well as undergraduates and secondary school teachers in summer sessions, to the sites and monuments of Greek civilization. www.ascsa.edu.gr/.

14.182. American School of Classical Studies at Athens. Gennadius Library. Opened in 1927 with 26,000 volumes from diplomat and bibliophile, Joannes Gennadius, the Gennadius Library now holds a diverse collection of more than 120,000 books and rare bindings, archives, manuscripts, and works of art illuminating the Hellenic tradition and neighboring cultures. Located near the main American School campus, the library is an internationally known center for the study of Greek history, literature, and art, from ancient to modern times. www.ascsa.edu.gr/index.php/gennadius/.

14.183. Archaeological Society at Athens. An independent learned society, the Archaeological Society assists the Greek state in its work of protecting, improving, and studying Greek antiquities. Whenever necessary, it undertakes the management and execution of large projects. www. archetai.gr/site/eng_page_uc.html.

14.184. Hellênikê Etaireia Meletês Archaias Aigyptou / Hellenic Society for the Study of Ancient Egypt. www.eemaa.eu/en.

Ireland

14.185. Egyptological Society of Ireland. indigo. ie/~marrya/esii.html.

Israel

14.186. Israel Antiquities Authority. The Israel Antiquities Authority is in charge of the country's antiquities and antiquity sites and their excavation, preservation, conservation, study, and publication thereof, as well as the country's antiquity treasures. www.antiquities.org.il/.

14.187. Orion Center for the Study of the Dead Sea Scrolls and Associated Literature (Hebrew University of Jerusalem). Includes an extensive bibliography, conference announcements, papers, and e-mail discussion group. www.orion.mscc.huji. ac.il/.

14.188. W. F. Albright Institute of Archaeological Research. The W. F. Albright Institute of Archaeological Research (AIAR) in Jerusalem is the oldest American research center for ancient Near Eastern studies in the Middle East. The institute fosters North American contribution in, and provides support for, archaeological excavations and surveys and promotes working relationships with related institutions in Jerusalem and the neighboring communities. www.greatarchaeology.com/Archaeology_organisation_review. php?organisation=AIAR.

Italy

14.189. American Academy in Rome. Founded in 1895 as the American School of Classical Studies in Rome (which merged into the academy in 1913), the academy's scholarly division offers fellowships in all phases of Italy's history and culture, from the ancient world to modern times. Each year, through its Rome Prize competition, the academy awards twelve fellowships for research in ancient studies, medieval studies, renaissance and early modern studies, and Italian studies.

The academy also hosts the recipients of other fellowships in the humanities, including the Italian Exchange fellowships, Mellon East-Central European Visiting Scholar fellowships, and the Burkhardt fellowships of the American Council of Learned Societies. Other scholars are invited to apply to be part of the community at the academy through the Visiting Artists and Scholars program. www.aarome.org/.

14.190. Asociación Amigos de la Egiptología en Cantabria. www.amigosegiptologiacantabria.blogspot.com/.

14.191. Associazione Collaboratori Museo Egizio, Turin. www.museoegizio.it/pages/amici_museo.jsp.

14.192. Associazone Napoletana di Studi Egittologici. www.anse-egypt.com.

14.193. Centro di Egittologia Francesco Ballerini. www. cefb.it/home.htm.

14.194. Centro Italiano Studi Egittologici, Imola, Bologna. www.cise-imola.it/.

14.195. Centro Studi del Vicino Oriente. www.associazioni.milano.it/info/schede/pg_scheda. php?nome=vicinoriente.

14.196. Dipartimento di Scienze Storiche del Mondo Antico / Department of Ancient History, University of Pisa. sta.humnet.unipi.it/.

14.197. International Association for Coptic Studies. rmcisadu.let.uniroma1.it/~iacs/.

14.198. Istituto Internazionale del Papiro, Museo del Papiro. flash.237.it/web/www.museodelpapiro.it/.

14.199. Italian Cultural Institute, Cairo. www.iiccairo. esteri.it/IIC_ilcairo.

Japan

14.200. Institute of Egyptology, Waseda University, Tokyo. www.egyptpro.sci.waseda.ac.jp/.

14.201. Research and Information Center, Tokai University. www.tric.u-tokai.ac.jp/eindex1.html.

14.202. Society for Egyptology, Kansai University. www2.ipcku.kansai-u.ac.jp/~horus/.

Mexico

14.203. Sociedad Mexicana de Egiptologia, A.C. lasplazasvip.com/egipto/Actividades_del_Pasado. html.

Netherlands

14.204. Centre for Computer-Aided Egyptological Research. www.ccer.nl/.

14.205. Ex Oriente Lux, Dutch branch. eol.eurasianstates.org/.

14.206. Het Huis van Horus. Egyptologie Academie Nederland. www.huisvanhorus.nl/.

14.207. Nederlands Instituut voor het Nabije Oosten. www.nino-leiden.nl/.

14.208. Nederlands-Vlaams Instituut in Cairo. www.instituten.leidenuniv.nl/nvic/.

14.209. Netherlands Institute for the Near East (University of Leiden). NINO initiates, supports, and conducts scholarly research in the civilizations of the Near East, from the ancient to the early modern period. In particular, it concentrates on the archaeology, history, languages, and cultures of Egypt, Levant, Anatolia, Mesopotamia, and Persia. www.nino-leiden.nl/.

14.210. Opleiding Egyptische taal en cultuur, Onderwijsinstituut Talen en Culturen van het Midden Oosten (TCMO), Faculteit der Letteren, Universiteit Leiden. www.easyuni.com/courses/232894/egyptian-language-and-culture/.

New Zealand

14.211. Department of Classics and Ancient History, University of Auckland. www.arts.auckland.ac.nz/uoa/classics-and-ancient-history.

Poland

14.212. Center of Mediterranean Archaeology, Warsaw University. www.pcma.uw.edu.pl/index.php?id=175&L=2.

14.213. Oriental Institute, Warsaw University. http://www.orient.uw.edu.pl/index_en.html.

Russia

14.214. Center for Egyptological Studies, Russian Academy of Sciences. www.cesras.ru/eng/index.htm.

14.215. Databank of Eastern European Egyptology, Moscow. artinfo.ru/eva/EVA2000M/eva-papers/200007/Ivanov-E.htm.

14.216. Institute of Oriental Studies of the Russian Academy of Sciences / Institut Vostokovédenya Russ. Akad. Nauk. www.ivran.ru/about-institute/history/246.

South Africa

14.217. Afro-Middle East Centre. Afro-Middle East Centre (AMEC) is a research institute based in Johannesburg, South Africa. It focuses on the Middle East and Africa–Middle East relations. www.amec.org.za/.

14.218. Department of Ancient Studies, Stellenbosch University. sun025.sun.ac.za/portal/page/portal/Arts/Departments/ancient-studies.

14.219. Egyptian Society of South Africa. www.egyptiansociety.co.za.

Spain

14.220. Asociación Amigos de la Egiptología en Cantabria. amigosegiptologiacantabria.blogspot.com/.

14.221. Asociación Andaluza de Egiptología. www.egiptologos.com.

14.222. Asociación Española de Egiptología. www.aedeweb.com.

14.223. Asociación Española de Orientalistas. www.uam.es/web/buscar/asorient.html.

14.224. Centro Superior de Estudios de Asiriologia y Egiptologia, Departamento de Historia Antigua, Universidad Autonoma de Madrid. www.uam.es/otroscentros/asiriologiayegipto/default.html.

14.225. Institut del Pròxim Orient Antic. www.ub.edu/ipoa/ipoa1.htm.

14.226. Instituto de Estudios del Antiguo Egipto. www.ieae.es/.

14.227. Instituto de Estudios Islámicos y del Oriente Próximo. www.ieiop.csic.es/.

14.228. Instituto Egipcio de Estudios Islámicos. www.institutoegipcio.com/.

14.229. Instituto Valenciano de Egiptología. www.ivde.org/.

14.230. Societat Catalana d'Egiptología. www.egiptologia.com/sce/.

Switzerland

14.231. Ägyptologie-Forum, Universität Zürich. www.aegyptologieforum.ch.

14.232. Ägyptologisches Seminar der Universität Basel. www.aegyptologie.unibas.ch/.

14.233. Basler Forum für Ägyptologie. www.baslerforumaegyptologie.ch/.

14.234. Orientalisches Seminar, Universität Zürich, Ägyptologische Abteilung. www.ori.uzh.ch/index.html.

14.235. Schweizerische Gesellschaft für Orientalische Altertumswissenschaft / Société suisse pour l'étude du Proche-Orient ancient. www.sagw.ch/sgoa/die-gesellschaft.html.

14.236. Société d'Egyptologie de Genève. www.segweb.ch/.

Taiwan

14.237. Department of Archaeology and Anthropology, National Taiwan University, Taipei. liberal.ntu.edu.tw/Eng/e_03_01_05.htm.

Turkey

14.238. Institute of Turkish Studies. www.turkishstudies. org/.

United States

14.239. Amarna Research Foundation. www.theamarna-researchfoundation.org.

14.240. American Center for Oriental Research. www. bu.edu/acor.

14.241. American Classical League. American Classical League is an organization of teachers of Latin, ancient Greek, and Classics, which fosters the study of classical languages in the United States and Canada. www.aclclassics.org.

14.242. American Institute for Maghreb Studies. www. aimsnorthafrica.org.

14.243. American Numismatic Association. The American Numismatic Association was founded in 1891 by Dr. George F. Heath in Chicago, Illinois. The ANA was formed to advance the knowledge of numismatics (the study of money) along educational, historical, and scientific lines, as well as enhance interest in the hobby. www.money.org/.

14.244. American Philological Association. The American Philological Association (APA), founded in 1869 by professors, friends, and patrons of linguistic science, is the principal learned society in North America for the study of ancient Greek and Roman languages, literatures, and civilizations. The page provides information about the organization and access to APA publications; the directory of APA members, officers, and committees; and placement service and positions for classicists. The site also provides an electronic version of the annual meeting program (with links to abstracts) and links to other associations and resources for Classics. www.apaclassics. org/.

14.245. American Philosophical Association. The American Philosophical Association was founded in 1900 to promote the exchange of ideas among philosophers, to encourage creative and scholarly activity in philosophy, to facilitate the professional work and teaching of philosophers, and to represent philosophy as a discipline. Information and links to the APA electronic bulletin board; e-mail directory of APA members; sites of interest to philosophers, publishers, libraries, and bibliographies; grants and fellowships. www.apaonline. org/.

14.246. American Research Center in Egypt. The American Research Center in Egypt is remarkably active in supporting scholarship, training, and conservation efforts in Egypt. www.arce.org/.

14.247. American Research Center in Egypt Georgia Chapter. www.arce.org/chapters/georgia/Home.

14.248. American Research Center in Egypt New England Chapter. www.arce.org/chapters/NewEngland/home.

14.249. American Research Center in Egypt New York Chapter. www.arce.org/chapters/newyork/home.

14.250. American Research Center in Egypt North Texas Chapter. www.arce-ntexas.org.

14.251. American Research Center in Egypt Northwest Chapter. www.arce.org/chapters/northwest/home.

14.252. American Research Center in Egypt Oregon Chapter. www.arce.org/chapters/oregon/home.

14.253. American Research Center in Egypt Pennsylvania Chapter. www.arce.org/chapters/pennsylvania/home.

14.254. American Research Center in Egypt Tennessee Chapter. www.arce.org/chapters/tennessee/home.

14.255. American Research Center in Egypt Washington, DC, Chapter. www.arce.org/chapters/washingtondc/home.

14.256. American Schools of Oriental Research. The American Schools of Oriental Research supports and encourages the study of the peoples and cultures of the Near East, from the earliest times to the present. www.asor.org/.

14.257. American Society of Greek and Latin Epigraphy. Founded in 1996, The American Society of Greek and Latin Epigraphy is a nonprofit organization whose purpose is to further research in, and the teaching of, Greek and Latin epigraphy in North America. The society fosters collaboration in the field and facilitates the exchange of scholarly research and discussion, both in the public forum and published form. The society is associated with L'Association Internationale d'Epigraphie grecque et latine (AIEGL). The home page offers information about the society and its executive board and membership, as well as announcements of interest to epigraphers. www.case.edu/artsci/clsc/asgle/.

14.258. American Society of Papyrologists. www.papyrology.org/.

14.259. Ancient Egypt Research Associates. www.aeraweb.org/.

14.260. Archaeological Conservancy. The Archaeological Conservancy, established in 1980, is the only national nonprofit organization dedicated to acquiring and preserving archaeological remains. www.americanarchaeology.com/aawelcome.html.

14.261. Archaeological Institute of America. The Archaeological Institute of America promotes an

informed public interest in the cultures and civilizations of the past, supports archaeological research, fosters the professional practice of archaeology, advocates the preservation of the world's archaeological heritage, and represents the discipline in the wider world. Its home page offers information about institute meetings and events; a list of officers, staff, and board members; tour information; Archaeological Institute of America publications information; the Archaeological Institute of America Code of Ethics and the Archaeological Institute of America Code of Professional Standards; membership information; fellowship information; and a list of local societies and affiliates, each with a local contact person (linked to websites for local societies, where available), and current projects of the institute. The page is maintained by the Archaeological Institute of America Committee on Computer Applications and Electronic Data. See also: *Archaeology in American colleges.* New York: Archaeological Institute of America, 1974. 72 p. CC75 .A73 1974. Supersedes: *Archaeology in American colleges* / Pamela E. Brown and Christine M. Lesniak. 2 ed. New York: Archaeological Institute of America, 1970. 107 p. CC75 .A73 1970; *Archaeology in the classroom: a resource guide for teachers and parents* / Wendy O'Brien and Tracey Cullen. Boston: Archaeological Institute of America, 1995. 108 p. CC95 .O27 1995; *Committee, governing board and interest group directory.* Boston: Archaeological Institute of America. 1/yr. GN700 .A734, 2003/2004; *1995 AIA directory of professionals in archaeology: a preliminary survey* / Archaeological Institute of America. Dubuque, Iowa: Kendall/Hunt, 1995. 140 p. CC21 .A59 1995. www.archaeological. org/.

14.262. Association of Ancient Historians. The AAH is the premier organization of ancient-history professionals in the United States and Canada. Membership is open to all persons with an interest in ancient history. The association was founded with two essential objectives: to foster a regular forum for scholarly interaction among historians of the ancient Mediterranean, especially among those who study the Greeks and Romans, and to do so in a manner that emphasizes collegiality and social interaction. The home page of the Association of Ancient Historians contains information about the organization and its activities. www.associationofancienthistorians.org.

14.263. Classical Association of New England. The CANE home page includes news and announcements about programs and activities in the North-east, a directory of Northeast colleges and universities, an e-mail directory of CANE members and links to the *New England Classical Journal,* the CANE Latin Placement Service, and other materials. www.caneweb.org/.

14.264. Classical Association of the Atlantic States. The Classical Association of the Atlantic States (CAAS) offers an annual fall meeting in the region during Columbus Day weekend. Besides papers and panels on many classical topics, these meetings are notable for their sessions on new directions in teaching and research and their discussions and workshops on professional issues such as the state of Classics in other countries, preparation of professional abstracts, etc. All members receive the association's journal, *Classical World,* which publishes articles and reviews for the scholarly teacher and the teaching scholar. The home page of CAAS includes the program of its fall and spring meetings as well as general information about the association (its publications, scholarships, committees, officers, etc.). www. caas-cw.org/caashome.html.

14.265. Classical Association of the Middle West and South. CAMWS was founded at the University of Chicago in 1905 and incorporated in the state of Missouri on July 13, 1948. Its 1,500 members are primarily college and university professors, K–12 teachers, and graduate students whose specialty is Classics: Classical languages (Greek and Latin) and the world of ancient Greece and Rome. This page offers information about the association, CAMWS membership, the activities of state organizations, and the *Classical Journal.* www.camws.org/.

14.266. Classical Association of the Pacific Northwest (CAPN). The purpose of the Classical Association of the Pacific Northwest is to support and promote the study of Classical languages and civilization in the Pacific Northwest (Washington, Oregon, Montana, Idaho, California, Colorado, and several other states and British Columbia, Alberta, and Ontario). The association holds an annual two-day meeting, usually in early April, and publishes a bulletin twice a year (fall and spring). Its home page includes information about the activities of the association, a membership directory, links to its bulletin and other associations and sites of interest to Classicists. www.historyforkids.org/CAPN/capn.htm.

14.267. Foundation for Biblical Archaeology. BAF is a private foundation founded by Marvin and Renetta Wilson dedicated to sharing information and research that validates the literal messages recorded in the Bible. www.bafoundation.com/.

14.268. Society for American Archaeology. The SAA elevates interest and research in American archaeology; advocates and aids in the conservation of archaeological resources; encourages public access to and appreciation of archaeology; opposes all looting of sites and the purchase and sale of looted archaeological materials; and serves as a bond among those interested in the archaeology of the Americas. See also: Administrative and member directory / Society for American Archaeology. Washington, DC: The Society, 1996. 1/yr. CC21 .S4862, 1998; CC21 .S4862. See also: Archaeologists of the Americas: membership directory / Society for American Archaeology. Washington, DC: The Society, 1994–1995. 2 v. CC21 .S486, 1994–1995. www.saa.org.

14.269. Society for Historical Archaeology. www.sha.org/.

14.270. Society for Industrial Archaeology. Directory of members / Society for Industrial Archeology. Washington, DC: National Museum of American History. T37 .S622, 1997; T37 .S622, 1990, 2001. www.sia-web.org/.

14.271. Society of Biblical Literature. www.sbl-site.org/.

Arizona

14.272. American Research Center in Egypt Arizona Chapter. arce.arizona.edu/.

14.273. Archaeological Institute of America, Central Arizona Society. centralazaia.ning.com/.

14.274. Middle East Studies Association. The Middle East Studies Association is a private, nonprofit, nonpolitical learned society that brings together scholars, educators, and those interested in the study of the region from all over the world. www.mesa.arizona.edu/.

14.275. University of Arizona, Egyptian Expedition, University of Arizona. www.egypt.arizona.edu/.

California

14.276. American Research Center in Egypt Northern California Chapter. home.comcast.net/~hebsed/.

14.277. American Research Center in Egypt Orange County California Chapter. www.arce.org/chapters/orangecounty/home.

14.278. Archaeological Institute of America, San Diego Society. The Glyph. www.theglyph.com/.

14.279. Egypt Exploration Organization of Southern California. www.egyptexploration.org/.

14.280. University of California, Berkeley, California Classical Association. The California Classical Association was founded at the University of California, Berkeley, to promote the teaching and study of the Classics and to promote the personal interests of its members. www.ccanorth.org/about_us.

14.281. University of California, Los Angeles, Department of Near Eastern Languages and Cultures. UCLA Egyptology. www.nelc.ucla.edu/.

Colorado

14.282. Denver Museum of Natural History, Egyptian Study Society. www.egyptstudy.org/.

Connecticut

14.283. Yale University, Yale Egyptological Institute in Egypt. www.yale.edu/egyptology.

Illinois

14.284. American Research Center in Egypt Chicago Chapter. www.arcechicago.com/.

14.285. Illinois Classical Conference. The Illinois Classical Conference is a statewide organization of high school and college teachers of Latin and Greek. Its home page includes the current issue of the *Augur*, the ICC newsletter, information about upcoming events and conferences, and links to other classical organizations. www.icc.classics.illinois.edu/.

14.286. University of Chicago, Oriental Institute. The Oriental Institute is a research organization and museum devoted to the study of the ancient Near East. Founded in 1919 by James H. Breasted, the institute, a part of the University of Chicago, is an internationally recognized pioneer in the archaeology, philology, and history of early Near Eastern civilizations. www.oi.uchicago.edu/.

Maryland

14.287. Johns Hopkins University, Department of Near Eastern Studies. www.neareast.jhu.edu.

14.288. Maryland Junior Classical League. Maryland Junior Classical League is a branch of the National Junior Classical League, an organization dedicated to the study of Classics, namely Latin and Greek. Formed in 1936 and sponsored by the American Classical League, NJCL is the largest Classical organization in the world, encompassing over 50,000 junior and senior high school students. The Maryland Junior Classical League home page provides general information about the Maryland Junior Classical League, a real-time Java chat over the World Wide Web for students, teachers, professors, and enthusiasts of the Classics; the Certamen Questions Bank; the official web page of the Medusa Mythology

Exam; and a section called Fabulae (interactive stories set in ancient Rome and Greece). www.mdjcl.org/.

Massachusetts

14.289. Archaeological Institute of America, Worcester Society. www.archaeological.org/societies/worcester.

14.290. Center for Hellenic Studies, Harvard University. Harvard University's Center for Hellenic Studies, located in Washington, DC, was founded by means of an endowment made exclusively for the establishment of an educational center in the field of Hellenic Studies designed to rediscover the humanism of the Hellenic Greeks. This humanistic vision remains the driving force of the Center for Hellenic Studies. www.chs.harvard.edu/.

14.291. Vergilian Society. The Vergilian Society was founded in 1937 to celebrate the ties of culture between Italy and America. The purpose of the society is to promote the study of Vergil by means of lectures, conferences, publications, and reports of excavation that have a bearing upon Vergil's works. Membership is open to any person who is interested in the study of Vergil. Its website includes general information about the organization, as well as about Villa Virgiliana; the Classical Summer School; and *Vergilius*, the journal of the society. http://www.vergiliansociety.org/.

Michigan

14.292. American Oriental Society. It is one of the oldest learned societies in America and is the oldest dedicated to a particular field of scholarship. The support of basic research in Asian studies has always been central in its tradition. This tradition has come to include such subjects as philology, literary criticism, textual criticism, paleography, epigraphy, linguistics, biography, archaeology, and the history of the intellectual and creative aspects of Oriental civilizations, especially of philosophy, religion, folklore, and art. www.umich.edu/~aos/.

New Jersey

14.293. New Jersey Classical Association. The New Jersey Classical Association web page provides information about the organization, upcoming events in the New Jersey area, and scholarships and links to other Classics resources. www.chss2.montclair.edu/classics/njca/njca.html.

14.294. Seeger Center for Hellenic Studies, Princeton University. www.princeton.edu/hellenic/overview/.

New York

14.295. American Research Center in Egypt New York Chapter. www.arce.org/chapters/newyork/home.

14.296. Biblical Archaeology Society of New York. ggreenberg.tripod.com/basny/.

14.297. Classical Association of the Empire State. CAES, founded in 1964, is a not-for-profit professional organization of teachers and professors of ancient Latin and Greek, which seeks to advance interest in and the study of the classical languages and civilizations in the schools and colleges of New York state. Its website includes information about the association and links to other regional organizations, placement services, and Classics resources. www.caesny.org/.

14.298. Egyptological Seminar of New York. www.esnybes.org/.

14.299. New York University, Institute of Fine Arts, Egyptology Section. www.nyu.edu/gsas/dept/fineart/index.htm.

14.300. Institute of History, Archaeology, and Education. www.ihare.org/.

14.301. Institute of Nautical Archaeology, Egypt. www.adventurecorps.com/sadana/aboutinaegypt.html.

14.302. Metropolitan Museum of Art. www.metmuseum.org.

14.303. Brooklyn Museum, Wilbour Library of Egyptology. www.brooklynmuseum.org/opencollection/archives/copy/history.

North Carolina

14.304. North Carolina Classical Association. The North Carolina Classical Association is dedicated to promoting the study of Latin, Greek, Classical art and archaeology, and ancient history. Its website includes information about the organization and its meetings and newsletter and links to other Classics sites, scholarships, and a report on the international baccalaureate program and its effect on Latin in North Carolina. www.uncg.edu/cla/ncca.

Ohio

14.305. Ohio Classical Conference. The purpose of the Ohio Classical Conference is to promote the study of Classical language learning, to encourage the inclusion of Classical studies in the state of Ohio at all educational levels, and to promote the common professional interests of its members.

Its website includes information about the OCC Convention and e-mail addresses of OCC members, as well as other information. www.xavier.edu/OCC/.

Oregon

14.306. American Research Center in Egypt Oregon Chapter. www.arce.org/chapters/oregon/home.

Pennsylvania

14.307. American Research Center in Egypt Pennsylvania Chapter. www.arce.org/chapters/pennsylvania/home.

14.308. American Research Institute in Turkey. The American Research Institute in Turkey (ARIT) is a nonprofit educational institution dedicated to promoting North American and Turkish research and exchanges related to Turkey in all fields of the humanities and social sciences. ccat.sas.upenn.edu/ARIT/.

14.309. Pennsylvania Classical Association. Its website offers general information about the organization and its membership and officers, a job bulletin board, and links to web resources. www2.dickinson.edu/prorg/pca/.

14.310. Pennsylvania State University, Department of Classics and Ancient Mediterranean Studies, College of the Liberal Arts. www. cams.la.psu.edu/.

Rhode Island

14.311. Brown University, Department of Egyptology. www.brown.edu/academics/egyptology/.

Tennessee

14.312. Tennessee Classical Association. Its website includes information about the association and its officers and placement service; announcements; and links to other sites. www.vroma.org/~rsellers/tca.html.

14.313. University of Memphis. Institute of Egyptian Art and Archaeology. The Institute of Egyptian Art and Archaeology, founded in 1984, is a component of the Department of Art of The University of Memphis, in Memphis, Tennessee. It is dedicated to the study of the art and culture of ancient Egypt through teaching, research, exhibition, and community education. As part of its research and teaching objectives, the Institute of Egyptian Art and Archaeology is engaged with various field projects in Egypt. Currently, the IEAA supports an epigraphic survey in the Great Hypostyle Hall of the Karnak Temple in Luxor, Egypt, and partners with the Italian Archaeological Mission to Luxor at the tomb of Harwa at Thebes. www.memphis.edu/egypt/.

Texas

14.314. American Research Center in Egypt North Texas Chapter. www.arce-ntexas.org/.

Utah

14.315. Utah State University. International Plutarch Society. The International Plutarch Society, based at Utah State University, exists to further the study of Plutarch and his various writings and to encourage scholarly communication between those working on Plutarchan studies. The society maintains Ploutarchos, a home page with information about its journal and upcoming conferences. www.usu.edu/ploutarchos/contentsrecent.htm.

Virginia

14.316. Classical Association of Virginia. Founded in 1910, the Classical Association of Virginia is the promotion of Classical teaching and culture in Virginia. Its website includes announcements, information about the activities of the Classical Association of Virginia, and links to other Classical associations and web resources. www.cavclassics.org/.

Washington, DC

14.317. Washington Classical Society. The Washington Classical Society is an organization dedicated to promoting an appreciation of the cultural legacy of Classical Greece and Rome throughout the Washington, DC, area. Its home page provides information about the society and its members and links to other web resources. www.wccaucus.org/.

14.318. Washington Kurdish Institute. www.kurd.org.

14.319. American Research Center in Egypt Washington, DC, Chapter. www.arce.org/chapters/washingtondc/home.

Uruguay

14.320. Uruguayan Institute of Egyptology, Uruguayan Society of Egyptology. www.egyptologyforum.org/bbs/uruguay/UIE.htm.

15

Atlases

An atlas is a collection of maps, usually of a geographic region. Atlases have traditionally been bound into book form, but today many atlases are in multimedia formats. In addition to presenting geographic features and political boundaries, many atlases often feature economic, geopolitical, historical, religious, and social statistics.

ARCHAEOLOGY

15.1 *Atlas of ancient archaeology: the most comprehensive atlas of ancient archaeological sites* / Jacquetta Hawkes. London: M. O'Mara Books, 1994. 272 p. GN739 .A88 1994.

15.2. *Atlas of ancient civilizations* / Keith Branigan. New York: J. Day. 1976. 128 p. G1046.E6 B7 1976.

15.3. *Atlas of world archaeology* / Paul G. Bahn. New York: Checkmark Books, 2000. 208 p. CC165 .A85 2000.

15.4. *Penguin historical atlas of ancient civilizations* / John Haywood. London; New York: Penguin, 2005. 144 p. G1033 .H39 2005.

ARMENIA

15.5. *Armenia: a historical atlas* / Robert H. Hewsen. Chicago: University of Chicago Press, 2001. 341 p. G2164.61 .S1 H4 2001.

15.6. *Historical atlas of Armenia* / Garbis Armen. New York: Armenian National Education Committee, 1987. 50, 50 p. G2157.61.S1 A7 1987.

BALKANS

15.7. *Palgrave concise historical atlas of the Balkans* / Dennis P. Hupchick and Harold E. Cox. Hound-

mills, Basingstoke, Hampshire; New York: Palgrave, 2001. 128 p. DR36 .H876 2001.

CELTIC WORLD

15.8. *Atlas for Celtic studies: archaeology and names in ancient Europe and early medieval Ireland, Britain, and Brittany* / John T. Koch. Oxford: Oxbow Books; Oakville: David Brown, 2007. 215 p. CB206 .K634 2007.

15.9. *Historical atlas of the Celtic world* / Angus Konstam. New York: Checkmark Books, 2001. 191 p. CB206 .K66 2001.

CHRISTIANITY

15.10. *Historical atlas of Christianity* / Franklin H. Littell. 2 ed. New York: Continuum, 2001. 440 p. G1046.E4 L5 2001.

15.11. *Historical atlas of Eastern and Western Christian monasticism* / Juan María Laboa. Roseville: Liturgical Press, 2003. 272 p. G1046.E4 H5 2003.

CLASSICAL WORLD

15.12. *Atlas antiquus* / Heinrich Kiepert. Berlin: D. Riemer, 1902. 27 p. G1033 .K48 1902.

15.13. *Atlas antiques* / Karl Spruner von Merz. Gotha: I. Perthes, 1850. 1 p. 911.3 Sp86.

15.14. *Atlas of ancient geography, biblical & classical; to illustrate the Dictionary of the Bible and the classical dictionaries* / William Smith. London: Murray 1874. G1033 .S55 1874.

15.15. *Atlas of Classical archaeology* / M. I. Finley. New York: McGraw-Hill, 1977. 256 p. G1046

.E15 A8 1977. German translation: *Atlas de Klassischen Archäologie* / M. I. Finley. München: List, 1979. 255 p.

15.16. *Atlas of Classical history* / Michael Grant. 5 ed. New York: Oxford University Press, 1994. 132 p. G1033 .G65 1994. Supersedes: *Atlas of ancient history* / Michael Grant. rev. ed. New York: Dorset Press, 1985. 123 p. G1033 .G65 1985; *Ancient history atlas* / Michael Grant. rev. ed. London: Weidenfeld and Nicolson, 1974. 87 p. G1033 .G65 1974.

15.17. *Atlas of Classical history* / Richard J. Talbert. London; New York: Routledge, 1988. 217 p. G1033 .A833 1988. Supersedes: *Atlas of Classical history* / Richard J. A. Talbert. New York: Macmillan, 1985. 217 p. G1033 .A833 1985. Useful for quick reference for specific historical events and periods (Battle of Salamis, Greek colonization). Includes small-scale but detailed and easily photocopied maps. Illustrates historical events of the classical world in clear, black-and-white maps. Some maps address such topics as agriculture, religion, and commerce. Town plans are also included.

15.18. *Atlas of the Classical world* / A. A. M. van der Heyden and H. H. Scullard. London: Nelson, 1963. 221 p. DE29 .H463 1963. Supersedes: *Atlas of the Classical world* / A. A. M. van der Heyden and H. H. Scullard. London; New York: Nelson, 1959. 221 p. DE29 .H463.

15.19. *Atlas of the Greek and Roman world in antiquity* / Nicholas G. L. Hammond. Park Ridge: Noyes Press, 1981. 56 p. G1033 .A84 1981.

15.20. *Barrington atlas of the Greek and Roman world: map-by-map directory* / Richard J. A. Talbert, ed. Princeton: Princeton University Press, 2000. 2 v. G1033 .B3 2000. A project of the Ancient World Mapping Center at the University of North Carolina, Charlotte (http://www.unc.edu/awmc/, an excellent web source for all ancient geography, including free online maps), this is the definitive new Classical atlas. The latest and most comprehensive atlas of the Greek and Roman world, from 1000 BCE to 640 CE. Maps are based on modern aerial or satellite maps and cover what are now seventy-five modern countries, from the British Isles to North Africa and the Indian subcontinent. Ancient, usually Latin names, are used for map headings, place names, and features. Contours and elevations are shown along with aqueducts, temples, and roads. The table of contents and locator diagrams aid map selection. A lavish and magnificent atlas of the Greco-Roman world, ranging from Britain to Bactria. Covers ca. 1000 BCE to ca. 640 CE.

15.21. *Classical atlas, to illustrate ancient geography: comprised in twenty-five maps, showing the various divisions of the world as known to the ancients: composed from the most authentic sources with an index of the ancient and modern names* / Alexander G. Findlay. New York: Harper, 1849. 100, 44 p. 911 F49.

15.22. *Dictionary of Greek and Roman geography* / William Smith. London: Walton and Maberly, 1870. 2 v. Van Pelt Library 911.36 Sm67b. Supersedes: *Dictionary of Greek and Roman geography* / W. Smith. London: Walton and Maberly, 1854–1857. H003 Sm68d; 911.36 .Sm67. A very detailed treatment of classical places based on their descriptions in ancient sources; not an atlas, but useful for citations of ancient authors regarding places, with some illustrations.

15.23. *Everyman's atlas of ancient and classical geography.* rev. ed. London: Dent; New York: Dutton, 1952. 256 p. G1033 .A8 1952.

15.24. *Formae orbis antiqui* / Heinrich Kiepert. Berlin: D. Reimer, 1893–1915. 113 p. G1033 .K54; 911.3 K54.3.

15.25. *Ginn & Heath's classical atlas in twenty three coloured maps, with complete index.* Boston: Ginn and Heath, 188?. 36 p. G1033 .G5 1880z.

15.26. *Greek and Roman maps* / O. A. W. Dilke. Baltimore: Johns Hopkins University Press, 1998. 224 p. GA213 .D44 1998.

15.27. *Historical atlas, ancient, mediaeval & modern, comprising Muir's Atlas of ancient and classical history and Muir's Historical atlas, mediaeval and modern* / George Goodall and R. F. Treharne. New York: Barnes and Noble, 1956. 911 M897.2.

15.28. *Historical atlas of the classical world, 500 BC–AD 600* / John Haywood. New York: Barnes and Noble Books, 1998. DE59 .H427 2001.

15.29. *Murray's small classical atlas* / G. B. Grundy. 2 ed. London: J. Murray, 1917. G1033 .G7 1917.

15.30. *New Penguin atlas of ancient history* / Colin McEvedy. 2 ed. London; New York: Penguin Books, 2002. 1 atlas (128 p.): col. maps; 18 x 23 cm. G1033 .M17 2002. Supersedes: *The Penguin atlas of ancient history* / John Woodcock. Harmondsworth; Baltimore: Penguin Books, 1967. 96 p. G1033 .M17 1967.

15.31. *Orbis terrarum antiquus in scholarum usum descriptus.* Albert van Kampen. 2 ed. Gothae, Perthes, 1888. 2, 16 p. G1033 .K32 1888. Supersedes: *Orbis terrarum antiquus, a Christiano Theophilo Reichardo; Quondam in usam inventutis descriptus* / Christian Gottlieb Reichard. 5 ed. Norimbergae: F. Campe et fil, 1853. 20 p. 911 R272.

15.32. *Schul-Atlas der alten Geographie: zunachst zum Gebrauche der geograph. Lehrbücher von Dr. S. Chr. Schirlitz* / Georg Graff. 3 ed. Halle: R. Mühlmann, 1850. 15 leaves. G1033 .G64 1850.

15.33. *Standard classic atlas for schools and colleges with an alphabetical index giving the latitudes and longitudes of nearly 10,000 places.* New York, 1885. 30 p. G1033 .I95 1885.

15.34. *Student's atlas of classical geography* / Leonhard Schmitz. Glasgow; London; Edinburgh: W. Collins, 189?. 28, 10 p. 371.3XG Sch55.

15.35. *Tabula itineraria Peutingeriana* / Franc. Christoph de Scheyb. Lipsiae: Exhibet Libraria Hahniana, 1824. 63 p. GA304.Z53 S3 1824.

15.36. *Weltkarte des Castorius genannt die Peutingersche Tafel* / Konrad Miller. Ravensburg: O. Maier, 1887–1888. 2 v. GA304.C3 M5.

CRETE

15.37. *Aerial atlas of ancient Crete* / J. Wilson Myers, Eleanor Emlen Myers, and Gerald Cadogan. Berkeley: University of California Press, 1992. 318 p. DF261.C8 A35 1992.

EGYPT

15.38. *Atlas of ancient Egypt* / John Baines and Jaromir Malek. New York: Facts on File, 1980. 240 p. DT56.9 .B34.

15.39. *Atlas of ancient Egypt; with complete index, geographical and historical notes, Biblical references, Etc.* 2 rev. ed. Worcester, UK: Yare Egyptology. DT53 .E32 2005. Digital version of *Atlas of ancient Egypt; with complete index, geographical and historical notes, Biblical references, Etc.* 2 rev. ed. London: K. Paul, Trench, Trübner, 1894. 22 p. DT50 .E32.

15.40. *Atlas of Egyptian art* / E. Prisse d'Avennes. Cairo; New York: American University in Cairo Press, 2000. 161 p. N5351 .P8213 2000. Nineteenth-century traveler and draughtsman. Color plates of his drawings of monuments and objects. Supersedes: *Atlas of Egyptian art* / E. Prisse d'Avennes. Cairo: American University in Cairo Press, 1997. 146 p. P813 1997; *Atlas of Egyptian art; Atlas de l'art égyptien* / E. Prisse d'Avennes. Cairo: Zeitouna, 1991. 405 p. N5351 .P8 1991.

15.41. *Atlas of the Valley of the Kings* / Kent R. Weeks. Cairo: American University in Cairo Press, 2000. 30, 11 p. + 72 plates. G2492.V35 T44 2000.

15.42. *Penguin historical atlas of ancient Egypt* / Bill Manley. London; New York: Penguin Books, 1996. 144 p. G1033 .M36 1996.

EMPIRES

15.43. *Historical atlas of empires* / Karen Farrington. New York: Checkmark Books, 2002. 191 p. G1030 .F37 2002.

EUROPE

15.44. *Historical atlas of Central Europe* / Paul Robert Magocsi. rev. ed. Seattle: University of Washington Press, 2002. 274 p. DR36 .S88 v.1 2002.

15.45. *Historical atlas of East Central Europe* / Paul Robert Magocsi. Seattle; London: University of Washington Press, 1993. 218 p. G2081.S1 M3 1993.

GREAT BRITAIN

15.46. *Atlas of Roman Britain* / Barri Jones and David Mattingly. Oxford: Oxbow, 2002. 341 p. University Museum Library G1812.21 .S2 J6 2002. Supersedes: *An Atlas of Roman Britain* / Barri Jones and David Mattingly. Oxford: Blackwell, 1990. 341 p. G1812.21 .S2 J6 1990.

15.47. *Historical atlas of Britain* / Malcolm Falkus and John Gillingham. New York: Continuum, 1981. 223 p. G1812.21.S1 H5 1981.

15.48. *The National Trust historical atlas of Britain: prehistoric and medieval* / Nigel Saul. Dover: A. Sutton, 1994. 214 p. G1812.21.S1 N3 1994.

GREECE

15.49. *Atlas of the Greek world* / Peter Levi. New York: Facts on File, 1980. 239 p. DF77 .L43.

15.50. *Historical atlas of Ancient Greece* / Angus Konstam. New York: Checkmark, 2003. 189 p. DF214 .K66 2003.

15.51. *Mythological atlas of Greece* / Pedro Olalla. Athens, Greece: Road Publications, 2002. 1 atlas (500 p.). G2001.E627 O5 2002.

15.52. *Neuer Atlas von Hellas und den Hellenischen Colonieen* / Heinrich Kiepert. Berlin: Nicolaische Verlagsbuchhandlung; New York: L. W. Schmidt. 911.38 K547.1.

15.53. *Penguin historical atlas of ancient Greece* / Robert Morkot. London; New York: Penguin, 1996.

144 p. G1G1033 .M674 1996. Supersedes: *Penguin historical atlas of ancient Greece* / Robert Morkot. London; New York: Penguin, 1995.144 p. G1033 .M674 1995.

15.54. *Petit atlas de l'antiquite grecque* / Pierre Cabanes. Paris: Colin, 1999. 191 p. DF30 .C33 1999.

HOLY LAND

15.55. *Carta's illustrated history of Jerusalem* / Meir Ben-Dov. 2 ed. Jerusalem: Carta, 2006. 408 p. DS109.9 .B455 2006.

15.56. *Historical atlas of the Holy Lands* / Karen Farrington. New York: Checkmark, 2003. 191 p. Univ G2235 .F37 2003.

15.57. *Historical atlas of Jerusalem* / Meir Ben-Dov. New York: Continuum, 2002. 400 p. DS109.9 .B455 2002.

15.58. *Penguin historical atlas of the Bible lands* / Caroline Hull and Andrew Jotischky. London; New York: Penguin, 2009. 144 p. BS635.3 .H85 2009.

15.59. *Rand McNally historical atlas of the Holy Land* / Emil G. Kraeling. New York; Chicago: Rand McNally, 1959. 88 p. G2230 .K72 1959.

15.60. *Tübinger Bibelatlas: auf der Grundlage des Tübinger Atlas des Vorderen Orients (TAVO); Tübingen Bible atlas: based on the Tübingen atlas of the Near and Middle East* / Siegfried Mittmann and Götz Schmitt. Stuttgart: Deutsche Bibelgesellschaft, 2001. Atlas + booklet (95 p.). G2230 .T83 2001.

ISLAMIC WORLD

15.61. *Historical atlas of Islam* / William C. Brice. Leiden: Brill, 1981. 71 p. G1786.S1 B74 1981; G1786.S1 H57 1981.

15.62. *Historical atlas of Islam* / G. S. P. Freeman-Grenville and Stuart Christopher Munro-Hay. rev. ed. New York: Continuum, 2002. 414 p. G1786.S1 F7 2002.

15.63. *Historical atlas of Islam* / Malise Ruthven. Cambridge: Harvard University Press, 2004. 208 p. G1786.S1 R9 2004.

15.64. *Historical atlas of Islam; Atlas historique de l'Islam* / Hugh Kennedy. 2 ed. Leiden; Boston: Brill, 2002. 86 p.

15.65. *Historical atlas of the Islamic world* / David Nicolle. New York: Checkmark Books, 2003. 189 p. G1786.S1 N5 2003.

15.66. *Historical atlas of the Muslim peoples* / R. Roolvink. Cambridge: Harvard University Press, 1957. 40 p. G1786.S1 R6.

ITALY

15.67. *Atlante dei siti archeologici della Toscana* / Mario Torelli, Concetta Masseria, Mauro Menichetti, and Marco Fabbri. Firenze: Giunta Regione Toscana; Roma: "L'Erma" di Bretschneider, 1992. 590 p. DG735 .A87 1992.

15.68. *Carta archeological d'Italia, 1881-1897: materiali per l'Etruria e la Sabina* / Gian Francesco Gamurrini. Firenze: L. S. Olschki, 1972. 462 p. DG223.2 .C37.

JUDAISM

15.69. *Historical atlas of the Jewish people: from the time of the patriarchs to the present* / Eli Barnavi. rev. ed. New York: Schocken Books, 2002. 321 p. DS117 .J8513 2002. Supersedes: *Historical atlas of the Jewish people* / Eli Barnavi. New York: Knopf; Random House, 1992. 299 p. G1030 .J8513 1992; DS117 .J8513 1992.

15.70. *Historical atlas of the Jewish people* / Yohanan Aharoni. New York: Continuum, 2003. 482 p. DS116 .A54 2003.

15.71. *Historical atlas of Judaism* / Ian Barnes. Edision: Chartwell Books, 2009. 400 p. BM155.3 .B37 2009.

MESOPOTAMIA

15.72. *Atlas des sites du proche orient (14000–5700 BP)* / Francis Hours. Lyon: Maison de l'Orient méditerranéen; Travaux de la Maison de l'Orient méditerranéen, 24. Paris: Diffusion de Boccard, 1994. 2 v. DS56 .A8 1994.

15.73. *Atlas of Mesopotamia: a survey of the history and civilization of Mesopotamia from the Stone Age to the fall of Babylon* / Martinus Beek. London; New York: Nelson, 1962. 164 p. G2251.E6 B42 1962.

15.74. *Historical atlas of ancient Mesopotamia* / Norman Bancroft Hunt. New York: Checkmark Books, 2004. 190 p. G2251.S1 B3 2004.

15.75. *Historical atlas of Iraq* / Larissa Phillips. New York: Rosen, 2003. 64 p. G2251.S1 P4 2003.

15.76. *Historical atlas of the Middle East* / G. S. P. Freeman-Grenville. New York: Simon and Schuster, 1993. 144 p. G2206.S1 F7 1993.

MYCENAE

15.77. *Archaeological atlas of Mycenae*. Athens: Archaeological Society of Athens, 2003. 70 p. G2004 .M9 E15 2003.

MYTHOLOGY

15.78. *Historical atlas of world mythology* / Joseph Campbell. New York: A. van der Marck Editions; San Francisco: Harper and Row, 1983. 2 v. BL311 .26 1983.

NIPPUR

15.79. *Topographical map from Nippur* / Albert T. Clay. Philadelphia: Department of Archaeology, University of Pennsylvania, 1905. 3 p. 907 Un37 v.1.

15.80. *Late Babylonian field plans in the British Museum* / Karen Rhea Nemet-Nejat. Rome: Biblical Institute Press, 1982. 461 p. PJ3861 .N45.

ROME

15.81. *Atlas of the Roman world* / Tim Cornell. New York: Facts on File, 1982. 240 p. DG77 .C597.

15.82. *Carta archeologica di Roma*. Firenze: Istituto Geografico Militare, 1962. 3 v. DG63 .I83.

15.83. *Historical atlas of ancient Rome* / Nick Constable. New York: Checkmark Books, 2003. 189 p. DG209 .C6645 2003.

15.84. *Penguin historical atlas of ancient Rome* / Christopher Scarre. London; New York: Penguin Books, 1995. 144 p. G1033 .S28 1995.

15.85. *Petit atlas historique de l'antiquite romaine* / Odile Wattel. Paris: Armand Colin, 1998. 175 p. DG77 .W388 1998.

15.86. *Tabula imperii romani: Romula, Durostorum* / Nicolae Gostar. Bucarest, Academie de la République Socialiste de Roumanie, 1969. 79 p. G1033 .T33.

SPAIN

15.87. *Elementos de un atlas antroponímico de la Hispania antigua* / Jurgen Untermann. Madrid, 1965. 199 p. G6541.E15 U586 atlas.

15.88. *Tubinger Bibelatlas: auf der Grundlage des Tübinger Atlas des Vorderen Orients; Tübingen Bible atlas: based on the Tübingen atlas of the Near and Middle East* / Siegfried Mittmann and Götz Schmitt. Stuttgart: Deutsche Bibelgesellschaft, 2001. Atlas + booklet (95 p.). G2230 .T83 2001.

15.89. *Tabula Imperii Romani: Britannia septentrionalis* / Union Académique Internationale. London: Published for the British Academy by the Oxford University Press, 1987. 87 p. DG78 .F74 1987. Supersedes: *Tabula Imperii Romani: Condate-Gleuum-Londinium-Lutetia* / Union Académique Internationale. London: British Academy by the Oxford University Press, 1983. 109 p. DG78 .T335 1983.

16
Photographic and Digital Collections

This chapter presents information on photographic and digital collections from museums, universities, and private collections. Access to most of these is free, although some are subscription-based collections.

PHOTOGRAPHY

16.1. *Practical guide to archaeological photography* / Carol L. Howell and Warren Blanc. 2 ed. Los Angeles: Institute of Archaeology, University of California, 1995. 106 p. CC77.P46 H69 1995.

Film Catalogs

16.2. *Archaeology on film* / Mary Downs. 2 ed. Dubuque: Kendall/Hunt, 1995. 115 p. CC85.Z9 A4 1995.

16.3. *Catalogue de films d'intéret archéologique, ethnographique ou historique.* Paris: UNESCO, 1970. 546 p. GN320 .U55. Catalog of archaeological and ethnographic films.

16.4. *Middle East and North Africa on film: an annotated filmography* / Marsha H. McClintock. New York: Garland, 1982. 542 p. Catalog of North African and Middle Eastern films. DS44 .M32 1982.

Egypt

16.5. *Egypt as viewed in the 19th century* / Ekmeleddin Ihsanoglu. Istanbul: Research Centre for Islamic History and Culture, 2000. 233 p. DT47 .E43 2001.

16.6. *L'Egypte éternelle: les voyageurs photographes au siècle dernier* / Jean-Claude Simoen. Paris: J.-C. Lattès, 1993. 141 p. D47 .E456 1993.

16.7. Egyptian Mirage, a database of nineteenth-century "studio photographs" of Egypt. http://www.griffith.ox.ac.uk/gri/4mirage.html.

16.8. *Il fotografo dei faraoni: Antonio Beato in Egitto 1860–1905* / Antonio Ferri. Bologna: Pendragon, 2008. 183 p. DT58.9 .F68 2008. Photographic exhibition of photography of Egyptian antiquities by Antonio Beato (d. 1903?).

16.9. *Photographing Egypt: forty years behind the lens* / John Feeney. Cairo; New York: American University in Cairo Press, 2005. 47 p. DT47 .F44 2005.

16.10. *Photography and Egypt* / Maria Golia. London: Reaktion, 2010. 191 p. TR117 .G65 2010. A history of photography and Egyptian archaeology.

16.11. Photos of Archaeological Sites of Ancient Egypt. http://www.bing.com/images/search?q=Photos+of+Archaeological+Sites+of+Ancient+Egypt&qpvt=Photos+of+Archaeological+Sites+of+Ancient+Egypt&FORM=IGRE.

16.12. *Registry of the photographic archives of the Epigraphic Survey* / Epigraphic Survey; with plates from key plans showing locations of Theban Temple decorations by Harold H. Nelson. Chicago: Oriental Institute of the University of Chicago, 1995. 189, 38 p. PJ2.C5 no.27.

16.13. *Scholars, scoundrels, and the Sphinx: a photographic and archaeological adventure up the Nile* / Elaine Altman Evans. Knoxville: McClung Museum, 2000. 122 p. DT59.K565 E94 2000.

16.14. *Searching for ancient Egypt: art, architecture, and artifacts from the University of Pennsylvania Museum of Archaeology and Anthropology* / David P. Silverman. Ithaca: Cornell University Press, 1997. 342 p. DT61 .U557 1997.

16.15. *Stelae from Egypt and Nubia in the Fitzwilliam Museum, Cambridge: c. 3000 BC–AD 1150* / Geoffrey Thorndike Martin. Cambridge; New York: Cambridge University Press, 2005. 202

p. DT62.S8 M37 2005. Catalog of Egyptian and Sudanese stele in the Fitzwilliam Museum, Cambridge University.

16.16. *Voyages en Egypte de l'antiquité au début du XXe siècle* / Jean-Luc Chappaz and Claude Ritschard. Genève: Musées d'art et d'histoire; Chene-Bourg: La Baconnière/Arts, 2003. 346 p. DT56.2 .V69 2003.

Greece

16.17. *The Ancient city: life in classical Athens & Rome* / Peter Connolly and Hazel Dodge. Oxford; New York: Oxford University Press, 1998. 256 p. DE59 .C666 1998. Photographic coverage of ancient Athens and Rome.

16.18. *Athens, still remains: the photographs of Jean-François Bonhomme* / Jacques Derrida. New York: Fordham University Press, 2010. 73 p. BD444 .D465313 2010. Photography of Athenian sepulchral monuments.

16.19. *Venise, Alger, Le Caire, Constantinople: photographies de la collection Félix Ziem* / Sophie Biass-Fabiani. Martigues (France): Musée Ziem, 1998. 143 p. TR646.F72 M377 1998. Nineteenth century photography by François Georges Philibert Ziem (1821–1911) of Algeria, Egypt, Italy, and Turkey.

Iran

16.20. *Exploring Iran: the photography of Erich F. Schmidt, 1930–1940* / Ayse Gürsan-Salzmann. Philadelphia: University of Pennsylvania Museum of Archaeology and Anthropology, 2007. 102 p. CC79.P46 G87 2007. Archaeological photography in Iran by Erich F. Schmidt (1897–1964).

Israel and the Palestinian Territories

16.21. *The Allegro Qumran photograph collection* / George J. Brook. Leiden; New York: E. J. Brill; Leiden; IDC, 1996. Thirty microfiche.

Italy

16.22. *Antiquity & photography: early views of ancient Mediterranean sites* / Claire L. Lyons. Los Angeles: J. Paul Getty Museum, 2005. 226 p. TR775 .A58 2005. Exhibition of nineteenth-century daguerreotype and calotype images of archaeological sites.

16.23. *L'immagine di Roma, 1848–1895: la città, l'archeologia, il medioevo nei caloptipi del fondo Tuminello* / Serena Romano. Napoli: Electa Napoli, 1994. 352 p. DG806.8 .I45 1994. Architectural photography of Roman buildings from the collection of Piero Becchetti.

16.24. *Pitture e pavimenti di Pompei* / Irene Bragantini. Roma: Ministero per i beni culturali e ambientali, Istituto centrale per il catalogo e la documentazione, 1981–1992. 4 v. DG70.P7 P57. Photography of mural painting and mosaics from ancient Pompeii.

16.25. *The Roman remains: John Izard Middleton's visual souvenirs of 1820–1823, with additional views in Italy, France, and Switzerland* / Charles R. Mack and Lynn Robertson. Columbia: University of South Carolina Press; South Caroliniana Library, 1997. 203 p. DG63 .M634 1997. Nineteenth century photographs of Roman antiquities by John Izard Middleton (1785–1849).

16.26. *Ruines italiennes: photographies des collections Alinari* / Vincent Jolivet. Paris: Gallimard, 2006. 155 p. DG77 .J65 2006. Fratelli Alinari photograph collection in Florence of Italian antiquities.

16.27. *Secrets of Pompeii: everyday life in ancient Rome* / Emidio de Albentiis. Los Angeles: J. Paul Getty Museum, 2009. 196 p. DG70.P7 D3718 2009.

16.28. *Ugo Ferraguti, l'ultimo archeologo-mecenate: cinque anni di scavi a Vulci (1928–1932) attraverso il fondo fotografico Ugo Ferraguti* / Francesco Buranelli. Roma: G. Bretschneider, 1994. 107, 89 p. DG70.V9 B874 1994. Photography by Ugo Ferraguti (1885–1938) of ancient Etruscan Vulci.

Malta

16.29. *The National Museum of Archaeology, Valletta: the Neolithic period* / Sharon Sultana. Santa Venera: Heritage Books; Heritage Malta, 2006. GN776.22.M43 S85 2006. Forty pages of Maltese antiquities in the National Museum of Archaeology, Valletta, Malta.

Near East

16.30. *Minuscule monuments of ancient art: catalogue of Near Eastern stamp and cylinder seals collected by Virginia E. Bailey in memory of Katherine J. Hammersley: exhibition, March-May 1988* / Alice Glock. Madison: New Jersey Museum of Archaeology at Drew University, 1988. 55 p. CD5344 .M56 1988.

16.31. *Focus East: early photography in the Near East (1839–1885)* / Nissan N. Perez. New York: Abrams, 1988. 256 p. TR113.5 .P47 1988.

16.32. *Remembrances of the Near East: the photographs of Bonfils, 1867–1907, from the collections of the International Museum of Photography at George Eastman House and the Harvard Semitic Museum*. Rochester: International Museum of Photography, 1980. 20 p. DS44.5 .B65 1980. Catalog of the photography of Félix Bonfils (1831–1885).

Turkey

16.33. *Aphrodisias: city & sculpture in Roman Asia* / R. R. R. Smith. Istanbul: Ertugg & Kocabiyik, 2008. DS156.A63 S624 2008. Photographic record of excavations at Aphrodisias in Turkey.

16.34. *Imperial Istanbul in early photographs* / Nezih Basgelen. Richmond: Archaeology & Art Publications, 2011. 48 p. DR724 .B37 2011.

University of Pennsylvania Museum of Archaeology and Anthropology

16.35. *Adventures in photography: expeditions of the University of Pennsylvania Museum of Archaeology and Anthropology* / Alessandro Pezzati. Philadelphia: University of Pennsylvania Museum of Archaeology and Anthropology, 2002. GN36. U62 P486 2002. Photographic images from archaeological and ethnographic expeditions from the archives of the University of Pennsylvania Museum of Archaeology and Anthropology.

AERIAL PHOTOGRAPHY

16.36. *A view from the air: aerial archaeology and remote sensing techniques: results and opportunities* / Marc Lodewijckx and René Pelegrin. Oxford: Archaeopress, 2011. 182 p. CC76.4 .V54 2011.

Crete

16.37. *Aerial atlas of ancient Crete* / J. Wilson Myers, Eleanor Emlen Myers, and Gerald Cadogan. Berkeley: University of California Press, 1992. 318 p. DF261.C8 A35 1992.

16.38. *Kreta: in Flugbildern von Georg Gerster* / Margret Karola Nollé. Mainz am Rhein: P. von Zabern, 2009. 111 p. NA279 .C7 N644 2009.

Egypt

16.39. *Egypt: a view from above* / Christian Jacq. New York: Abrams, 2010. 333 p. DT47 .J23 2010.

16.40. *Egypt: antiquities from above* / Marilyn Bridges. Boston: Little, Brown, 1996. 128 p. DT60 .B747 1996.

16.41. *Egypt from the air* / Marcello Bertinetti. Vercelli, Italy: White Star, 2002. 320 p. DT47 .B478 2002.

16.42. *High above Egypt* / Marcello Bertinetti. Cairo: The American University in Cairo Press, 2004. 640 p. DT47 .B47 2004.

16.43. *In the eye of Horus: a photographer's flight over Egypt* / Marcello Bertinetti. Cairo, Egypt: American University in Cairo Press, 2001. 320 p. DT47 .B47 2001.

Europe

16.44. *Découvertes d'archéologie aérienne: Europe: 10000 ans d'histoire*. Dijon, France: Archéologia, 1980. 98 p. CC76.4 .D42 1980.

16.45. *Luftbildarchäologie in Ost- und Mitteleuropa; Aerial archaeology in Eastern and Central Europe: internationales Symposium, 26.-30. September 1994, Kleinmachnow, Land Brandenburg* / Aerial Archaeology Research Group, Edinburgh. Potsdam: Verlag Brandenburgisches Landesmuseum für Ur- und Frühgeschichte, 1995. 319 p. DJK23 .L84 1995. Aerial photography in the archaeology of eastern and central Europe.

France

16.46. *Atlas d'archéologie aérienne de Picardie: le bassin de la Somme et ses abords à l'époque protohistorique et romaine* / Roger Agache and Bruno Bréart. Amiens: Société Antiquaires de Picardie, 1975. 2 v. DC611.P586 A35. See also: *Détection aérienne de vestiges protohistoriques, gallo-romains et médiévaux: dans le bassin de la Somme et ses abords* / Roger Agache. 2 ed. Amiens: Musée de Picardie; Société de préhistoire du Nord, 1971. 230 p. DC611.P584 A34 1971.

Great Britain

16.47. *Aerial archaeology*. London: Aerial Archaeology Foundation, 1978– . CC76.4 .A345, v.3–4 (1979), 6 (1980), 10–11 (1984–1985).

16.48. *Aerial archaeology in Essex: the role of the National Mapping Programme in interpreting the landscape* / Caroline Ingle and Helen Saunders. Chelmsford: Historic Environment, Essex County Council, 2011. 198 p. DA670.E14 E27 no.136.

16.49. *Medieval England: an aerial survey* / M. W. Beresford and J. K. S. St. Joseph. 2 ed. Cambridge; New York: Cambridge University Press, 1979. 286 p. DA610 .B4 1979.

16.50. *Roman Britain from the air* / S. S. Frere and J. K. S. St. Joseph. Cambridgeshire; New York: Cambridge University Press, 1983. 232 p. DA145 .F83 1983.

16.51. *Rome's first frontier: the Flavian occupation of Northern Scotland* / D. J. Woolliscroft and B. Hoffmann. Stroud: Tempus, 2006. 254 p. DA777.7.G37 W66 2006.

16.52. *Silchester, the Roman town of Calleva; with a folding plan of the town showing details traced from aerial photographs* / George C. Boon. rev. ed. Newton Abbot, North Pomfret: David & Charles, 1974. 379 p. DA147.S54 B66 1974.

Greece

16.53. *Ancient Greece from the air* / Raymond V. Schoder. London: Thames and Hudson, 1974. 256 p. Includes 140 color photographs and 138 ground plans and one map. DF719 .S36.

16.54. *Mit den Augen der Götter: Flugbilder des antiken und byzantinischen Griechenland: das Festland* / Johannes Nolle and Hertha Schwarz. Mainz: Von Zabern, 2005. 204 p. DF78 .N655 2005.

Iran

16.55. *Flights over ancient cities of Iran* / Erich F. Schmidt. Chicago: University of Chicago Press, 1940. 104 p. http://oi.uchicago.edu/pdf/flights_over_iran.pdf.

Israel and the Palestinian Territories

16.56. *Flights into biblical archaeology* / Duby Tal. Herzlia, Israel: Albatross, 2007. 255 p. DS111 .T14 2007. Historical photography of archaeological excavations in Israel.

Italy

16.57. *Saggi di fotointerpretazione archeologica* / F. Castagnoli. Roma: De Luca, 1964. 73 p. 913 C279.

16.58. *Sulle tracce della via Traiana: indagini aero-topografiche da Aecae a Herdonia* / Giuseppe Ceraudo. Foggia: C. Grenzi, 2008. 119 p. DG29. T722 C47 2008. Aerial photography of Roman roads in Campania and Puglia, Italy.

Netherlands

16.59. *Air photography and Celtic field research in the Netherlands* / J. A. Brongers. Amersfoort: Rijksdienst voor het Oudheidkundig Bodemonderzoek, 1976. 2 v. DJ401.D735 B765.

Tunisia

16.60. *Tunisie vue du ciel* / Mohamed-Salah Bettaieb and Salah Jabeur. Aix-en-Provence: Edisud; Tunis: Alif, 1996. 156 p. DT250.2 .B48 1997.

Turkey

16.61. *Nemrut from the air* / Nezih Basgelen. Istanbul: Archaeology and Art Publications, 2000. DS156. N45 B37 2000.

16.62. *Turkey: an aerial portrait* / Guido Alberto Rossi, Orhan Durgut, and Ara Guler. New York: H. N. Abrams, 1994. 191 p. DR417.2 .R67 1994.

DIGITAL COLLECTIONS

In addition to the various electronic resources identified elsewhere in this book, there are numerous other digital resources and collections available for the study of the ancient world. Digitization is the representation of an object, an image, a sound, or a document by a discrete set of its points or samples. The life span for digital resources can be long or very short. Some are almost only temporary. The result is called digital representation, or, more specifically, a digital image, for the object.

Older print books are being scanned and optical character recognition technologies applied by academic and public libraries, foundations, and private companies such as Google. Upublished text documents on paper that have some enduring historical or research value are being digitized by libraries and archives, though frequently at a much slower rate than that for books. In many cases, archives have replaced microfilming with digitization as a means of preserving and providing access to unique documents.

Digital preservation in its most basic form is a series of activities maintaining access to digital materials over time. Digitization in this sense is a means of creating digital surrogates of analog materials, such as books, newspapers, microfilm, and videotapes. Digitization can provide a means of preserving the content of the materials by creating an accessible facsimile of the object in order to put less strain on already fragile originals. For sounds, digitization of legacy analog recordings is essential insurance against technological obsolescence.

While some academic libraries have been contracted by the service, issues of copyright law violations threaten to

derail the project. However, it does provide an online consortium for libraries to exchange information and researchers to search for titles as well as review the materials.

Digital Gateways

16.63. *Academic Info: Ancient History*. Well-organized gateway pages to many useful sites. http://academicinfo.net/histanc.html.

16.64. *Classics Etexts* (University of Florida). Provides links to Classics texts available on the web. Some starting points for exploring resources on the web. http://guides.uflib.ufl.edu/content.php?pid=6712&sid=1121458.

16.65. *Classics Resources* (Washington University in St. Louis). A well-organized list of links to Classics resources on the web, including Greek and Latin languages, Greek and Latin authors, maps and sites of the ancient world, Classics e-journals, medieval Latin language and culture, Classics publishers, and Classics associations, among others. http://artsci.wustl.edu/~cwconrad/classics.html.

16.66. *Classics Website* (University of Kentucky). Links to chronologies for ancient art, archaeology, and history. Neolithic through Roman. The UK Classics website has served its users and the Classics community worldwide by offering a clearinghouse of digital resources in Classics and the humanities. http://mcl.as.uky.edu/classics.

16.67. *EBSCO MegaFILE*. General multidisciplinary periodical database, covering all scholarly disciplines, with many general and popular magazines and news sources. Includes bibliographic citations with indexing and abstracts. Coverage varies: mostly 1990s to present. http://search.ebscohost.com/.

16.68. *Electronic Resources for Classicists: The Second Generation* / Maria Pantelia (University of California, Irvine). A well-organized list of web and other electronic resources for the Classics. http://www.tlg.uci.edu/index/resources.html.

16.69. *Romarch* (University of Michigan, Ann Arbor). Roman art and archaeology comprehensive listing of websites relating to Roman art and archaeology, as well as an archive of the Romarch listserv. Mirrors sites available at University of Sydney and University of East Anglia. http://www personal.umich.edu/~pfoss/ROMARCH.html.

16.70. *Stoa Consortium*. The Stoa Consortium for Electronic Publication in the Humanities has been edited since its creation in 1997 by Ross Scaife, professor of Classics at the University of Kentucky. The Stoa exists to serve several purposes: dissemination of news and announcements,

mainly via the gateway blog; discussion of best practices via discussion groups and white papers; and publication of experimental online projects, many of them subject to scholarly peer review. Open access to networked scholarship is a bedrock principle for this site. http://www.stoa.org/.

Art History

16.71. *ARTstor*. The ARTstor collection includes approximately 500,000 images of works of art, architecture, and archaeology along with the necessary software to view the images and create personal groups of images. Supplemental URLs include Help—technical help and Help—general index. http://www.artstor.org/index.shtml.

Maghreb

16.72. *e-Mediatheque*. In French and Arabic; manuscript facsimiles, archives of books and photos for the study of North Africa and the Mediterranean world. http://e-mediatheque.mmsh.univ-aix.fr/Pages/accueil.aspx.

Near East

16.73. *Archaeology, Mnemotrix ArchaeoSearch* (Database of Ancient Near East and Classical Studies). The Institute of Archaeology at Bar Ilan University in Israel has compiled a resource application database for archaeologists working in the field of ancient Near East. http://www.mnemotrix.com/arch/.

Pottery

16.74. *Corpus Vasorum Antiquorum*. Digitization of text and plates from all out-of-print volumes of the *Corpus Vasorum Antiquorum*. Online searchable database of digitized text and images, browsable by country and museum and searchable by fabric, technique, provenance, and other aspects. *Summary Guide to Corpus Vasorum Antiquorum* / Thomas H. Carpenter. 2 ed. Oxford: British Academy; Oxford University Press, 1984. 100 p. NK4640.C6 Z9 2000. Supersedes: *Summary Guide to Corpus Vasorum Antiquorum* / Thomas H. Carpenter. Oxford: Published for the British Academy by Oxford University Press, 1984. 77 p. NK4640.C6 Z88 1984. *Konkordanz zum Corpus Vasorum Antiquorum* / Jan W. Crous. Roma: M. Bretschneider, 1942 [i.e., 1943]. 244 p. NK4640.C6 Z9; NK4640.C6 Z9. An interesting summary of the project can be found in *Colloque interna-*

tional sur le Corpus Vasorum Antiquorum, Lyon, 3-5 juillet 1956 / Charles Dugas. Lyons: Centre National de la Recherche Scientifique, 1956. 50 p. 739 C815.yF. http://www.cvaonline.org/cva/museums.htm.

Print volumes of *Corpus Vasorum Antiquorum* series include:

Austria

Corpus Vasorum Antiquorum. Austria. Wien. Kunsthistorisches Museum. Antiken-Sammlung. Wien: A. Schroll, 1951– . NK4640.C6 A85 Bd.1–4.

Belgium

Corpus Vasorum Antiquorum. Belgique. Brussels: Musées royaux d'art et d'histoire, 1926– . NK4640.C6 B4 fasc. 1– .

Corpus Vasorum Antiquorum. Belgique. Bruxelles. Musées Royaux du Cinquantenaire. Paris: E. Champion, 1926–1949. NK4640.C6 B4 fasc.1–3.

Canada

Corpus Vasorum Antiquorum. Canada. Royal Ontario Museum, Toronto. Oxford; New York: British Academy and the Royal Ontario Museum; Oxford University Press, 1981– . NK4640.C6 C2 fasc.1.

Cyprus

Corpus Vasorum Antiquorum. Cyprus. Nicosia: Dept. of Antiquities, Ministry of Communications & Works, Republic of Cyprus, 1963– . NK4640.C6 C9 fasc.1.

Czechoslovakia

Corpus Vasorum Antiquorum. Tchecoslovaquie. Prague. Musée National. Prague: Academia Prague, 1990– . NK4640.C6 C95 fasc.2.

Corpus Vasorum Antiquorum. Tchécoslovaquie. Prague. Université Charles. Prague: Academia, 1978–1997. 2 v. NK4640.C6 C95 fasc.1, 3.

Denmark

Corpus Vasorum Antiquorum. Danemark. Copenhague: Munksgaard, 1924–1963. 8 v. NK4640.C6 D3 fasc.1–8.

Germany

Corpus Vasorum Antiquorum. Deutschland. Berlin, Antiquarium. München: Beck, 1938– . NK4640.C6 G4 Bd.2, etc. Bd. 2, 21–22, 33, 45, 53, 61–62, 74, 85–86, 89.

Corpus Vasorum Antiquorum. Deutschland (Deutsche Demokratische Republik). Berlin: Akademie-Verlag, 1972– . NK4640.C6 G45 Bd.1.

Corpus Vasorum Antiquorum. Deutschland. Bonn. Universität Bonn. Akademisches Kunstmuseum. Munchen: C. H. Beck, 1938– . NK4640.C6 G4 Bd.1, 40, 59.

Corpus Vasorum Antiquorum. Deutschland. Braunschweig. Herzog Anton Ulrich-Museum. München: C. H. Beck, 1940. 60 p. NK4640.C6 G4 Bd.4.

Corpus Vasorum Antiquorum. Deutschland. Frankfurt am Main. Munchen: C. H. Beck, 1964– . NK4640.C6 G4 Bd.25, 30, 50, 66.

Corpus Vasorum Antiquorum. Deutschland. Gotha. Schlossmuseum, Deutsche Demokratische Republik. Berlin, Akademie-Verlag, 1964–1968. 2 v. NK4640.C6 G4 Bd.24, 29.

Corpus Vasorum Antiquorum. Deutschland. Göttingen, Archaologisches Institut der Universitat. Munchen: C. H. Beck'sche Verlagsbuchhandlung, 1989– . NK4640.C6 G4 Bd.58, 73.

Corpus Vasorum Antiquorum. Deutschland. Hamburg—Museum für Kunst und Gewerbe. Munchen: Beck, 1976– . NK4640.C6 G4 Bd.41; NK4640.C6 G4 Bd.41.

Corpus Vasorum Antiquorum. Deutschland. Hanover. Kestner Museum / Anna-Barbara Follman. Munchen: Beck, 1971– . NK4640.C6 G4 Bd.34, 72.

Corpus Vasorum Antiquorum. Deutschland. Heidelberg. Universität. Archaologisches Institut. Munchen: Beck, 1954– . NK4640.C6 G4 Bd.10, 23, 27, 31.

Corpus Vasorum Antiquorum. Deutschland. Jena. Sammlung antiker Kleinkunst der Friedrich-Schiller-Universitat / Hadwiga Schorner. Munchen: C. H. Beck Verlag 2011– . NK4640.C6 G4 Bd.90.

Corpus Vasorum Antiquorum. Deutschland. Karlsruhe. Badisches Landesmuseum. Munchen: C. H. Beck, 1951– . NK4640.C6 G4 Bd.7, 8, 60.

Corpus Vasorum Antiquorum. Deutschland. Kiel—Kunsthalle (Antikensammlung). Munchen: Beck, 1988– . NK4640.C6 G4 Bd.55, 64.

Corpus Vasorum Antiquorum. Deutschland. Leipzig (Deutsche Demokratische Republik).

Leipzig, Archäologisches Institut der Karl-Marx-Universität. Berlin: Akademie-Verlag, 1959. 59 p. NK4640.C6 G4 Bd.14.

Corpus Vasorum Antiquorum. Deutschland (Deutsche Demokratische Republik). Leipzig. Antikenmuseum der Universität: Band 3: Attisch-Rotfigurige Schalen / Susanne Pfisterer-Haas. Munchen: Verlag C. H. Beck, 2006. 151 p. NK4640.C6 G4 Bd.80.

Corpus Vasorum Antiquorum. Deutschland (Deutsche Demokratische Republik). Leipzig. Antikenmuseum der Karl-Marx-Universitat. Berlin, Akademie-Verl., 1973– . NK4640.C6 G45 Bd.2.

Corpus Vasorum Antiquorum. Deutschland. Mainz, Römisch-Germanisches Zentralmuseum / Andrea Büsing-Kolbe. Munchen: C. H. Beck'sche Verlagsbuchhandlung, 1977. NK4640.C6 G4 Bd.42, 43.

Corpus Vasorum Antiquorum. Deutschland. Munchen: C. H. Beck'sche Verlagsbuchhandlung, 1938– . NK4640.C6 G4 Bd.1–82, 84–90.

Corpus Vasorum Antiquorum. Deutschland. München, Museum Antiker Kleinkunst. Munchen: Beck, 1939– . NK4640.C6 G4 Bd.3, 6, 9, 12, 20, 28, 32, 37, 48, 56, 57, 65, 77–78, 87–88.

Corpus Vasorum Antiquorum. Deutschland. Nordrhein-Westfalen. Munchen: C. H. Beck, 1982– . NK4640.C6 G4 Bd.49.

Corpus Vasorum Antiquorum. Deutschland. Schwerin. Staatliches Museum / Gottfried von Lucken. Berlin, Akademie-Verl., 1972. 42 p. NK4640.C6 G45 Bd.1.

Corpus Vasorum Antiquorum. Deutschland. Tübingen. Antikensammlung des Archäologischen Instituts der Universität. Munchen: C. H. Beck, 1973– . NK4640.C6 G4 Bd.36, 44, 47, 52, 54, 68, 69.

Corpus Vasorum Antiquorum. Deutschland. Wurzburg. Martin-von-Wagner-Museum. Munchen: Beck, 1975– . NK4640.C6 G4 Bd.39, 46, 51, 71.

France

Corpus Vasorum Antiquorum. France. Paris: Libraire ancienne H. Champion, 1923– . NK4640.C6 F7 fasc.1–38.

Corpus Vasorum Antiquorum. France. Paris. Musée du Louvre. Paris, E. Champion, 1923– . NK4640.C6 F7 fasc.1–2, 4–5, 8–9, 11–12, 14, 17–19, 21–23, 25–28, 31–35, 38.

Corpus Vasorum Antiquorum. France. Rennes. Musée des beaux-arts et d'archéologie de Rennes. Paris: Académie des inscriptions et belles-lettres (Fondation Dourlans); Éditions E. de Boccard, 1979. 68 p., 52 p. NK4640.C6 F7 fasc.29.

Corpus Vasorum Antiquorum. France. Tours. Musée des Beaux-Arts à Tours; Musée du Berry à Bourges. Paris: En vente aux Éditions E. de Boccard, 1980. 71 p., 56 p. NK4640.C6 F7 fasc.30.

Greece

Corpus Vasorum Antiquorum. Greece. Athens. National Museum: Attic black-figure skyphoi / Maria Pipili. Athens: Academy of Athens, 1993. 72 p. NK4640.C6 G75 fasc.4.

Hungary

Corpus Vasorum Antiquorum. Hongrie. Budapest. Musée des beaux-arts. Bonn: R. Habelt; Budapest: Akadémiai Kiadó, 1981– . NK4640. C6 H9 fasc.1.

Ireland

Corpus Vasorum Antiquorum. Ireland. Dublin. University College, University College Cork / Alan W. Johnston and Christina Souyoudzoglou-Haywood. Dublin: University College Dublin, Classical Museum Publications, 2000. 80 p. NK4640.C6 I73 fasc.1.

Italy

Corpus Vasorum Antiquorum. Italia. Adria. Museo archeologico nazionale / Simonetta Bonomi. Roma: "L'Erma" di Bretschneider, 1991– . NK4640.C6I7 fasc.65.

Corpus Vasorum Antiquorum. Italia. Adria. Museo civico. Roma: Libreria dello Stato, 1957– . NK4640.C6I7 fasc.28.

Corpus Vasorum Antiquorum. Italia. Agrigento. Museo archeologico nazionale Agrigento. Roma: "L'Erma" di Bretschneider, 1985– . NK4640.C6I7 fasc.61.

Corpus Vasorum Antiquorum. Italia. Bologna. Museo civico di Bologna. Milano: Bestetti e Tumminelli, 1929. NK4640.C6I7 fasc.5, 7, 12, 27, 33.

Corpus Vasorum Antiquorum. Italia. Chiusi, Museo archeologico nazionale. Roma: Multigrafica editrice, 1981– . NK4640.C6I7 fasc.59, 60.

Corpus Vasorum Antiquorum. Italia. Como. Civico museo archeologico Giovio. Roma:

L'Erma di Bretschneider, 1970– . NK4640. C6I7 fasc.47.

Corpus Vasorum Antiquorum. Italia. Ferrara. Museo archeologico nacional di Ferrara. Roma: Libreria dello Stato, 1963–1971. NK4640.C6 I7 fasc.37, 48.

Corpus Vasorum Antiquorum. Italia. Fiesole. Collezione Costantini. Roma: Multigrafica editrice, 1980– . NK4640.C6I7 fasc.57, 58.

Corpus Vasorum Antiquorum. Italia. Firenze. Regio museo archeologico di Firenze. Milano: Bestetti e Tumminelli. 1931?– . NK4640.C6I7 fasc.8, 13, 30, 38, 42.

Corpus Vasorum Antiquorum. Italia. Gela. Museo archeologico nazionale. Collezione Navarra / Marina Cristofani Martelli. Roma: L'Erma di Bretschneider, 1972– . NK4640.C6I7 fasc.52, 54, 56.

Corpus Vasorum Antiquorum. Italia. Genova-Pegli. Museo civico d'archeologia ligure di Genova-Pegli e collezione del Castello d'Albertis di Genova. Roma: Libreria dello Stato, 1942– . NK4640.C6I7 fasc.19.

Corpus Vasorum Antiquorum. Italia. Gioia del Colle. Museo archeologico nazionale / Angela Ciancio. Roma: L'Erma di Bretschneider, 1995– . NK4640.C6I7 fasc.68.

Corpus Vasorum Antiquorum. Italia. Grosseto, Museo archeologico e d'arte della Maremma / Elisabetta Mangani and Orazio Paoletti. Roma: L'Erma di Bretschneider, 1986– . NK4640.C6I7 fasc.62, 63.

Corpus Vasorum Antiquorum. Italia. Milano. Civico museo archeologico di Milano. Roma: Libreria dello Stato, 1959– . NK4640.C6I7 fasc.31.

Corpus Vasorum Antiquorum. Italia. Milano. Collezione "H.A." Roma: L'Erma di Bretschneider, 1971–1972. NK4640.C6I7 fasc.1, 2, 49, 51.

Corpus Vasorum Antiquorum. Italia. Musei comunali umbri. Roma: Libreria dello Stato, 1940. NK4640.C6I7 fasc.16.

Corpus Vasorum Antiquorum. Italia. Rodi. Museo archeologico dello Spedale dei cavalieri di Rodi. Roma: Libreria dello Stato, 2007. NK4640.C6I7 fasc.10.

Corpus Vasorum Antiquorum. Italia. Museo preistorico L. Pigorini. Roma: Libreria dello Stato, 1953– . NK4640.C6I7 fasc.21.

Corpus Vasorum Antiquorum. Italia. Lecce. Museo provinciale Castromediano di Lecce. Milano: Bestetti & Tumminelli, 1928– . NK4640.C6I7 fasc.4, 6.

Corpus Vasorum Antiquorum. Italia. Napoli. Museo nazionale di Napoli. Roma: Libreria

dello Stato, 1950– . NK4640.C6I7 fasc.20, 22, 24, 66, 69.

Corpus Vasorum Antiquorum. Italia. Orvieto. Museo Claudio Faina di Orvieto. Roma: L'Erma di Bretschneider, 1969– . NK4640. C6I7 fasc.41.

Corpus Vasorum Antiquorum. Italia. Palermo. Collezione Mormino. Banco di Sicilia. Roma: L'Erma di Bretschneider, 1971– . NK4640. C6I7 fasc.50.

Corpus Vasorum Antiquorum. Italia. Palermo. Museo nazionale di Palermo. Roma: Libreria dello Stato, 1938– . NK4640.C6I7 fasc.14.

Corpus Vasorum Antiquorum. Italia. Parma. Museo nazionale di antichità di Parma. Roma: L'Erma di Bretschneider, 1970– . NK4640. C6I7 fasc.45, 46.

Corpus Vasorum Antiquorum. Italia. Roma. Musei capitolini di Roma. Roma: Libreria dello Stato, 1962–1965. NK4640.C6I7 fasc.36, 39.

Corpus Vasorum Antiquorum. Italia. Roma. Museo nazionale di Villa Giulia in Roma. Milano: Bestetti e Tumminelli, 1925– . NK4640. C6I7 fasc.1–3, 64.

Corpus Vasorum Antiquorum. Italia. Roma: Istituto Poligrafico dello Stato, Libreria dello Stato, 1925– . NK4640.C6 I7 fasc.1, 4–5, 8, 11, 14–17, 19–21, 25, 28, 31–32, 34, 36–37, 41, 43, 45, 47, 49–50, 59, 61, 62, 64–70.

Corpus Vasorum Antiquorum. Italia. Siracusa. Museo archeologico nazionale di Siracusa. Roma: Libreria dello Stato, 1941– . NK4640. C6I7 fasc.17.

Corpus Vasorum Antiquorum. Italia. Taranto. R. Museo nazionale di Taranto. Roma: Libreria dello Stato, 1940– . NK4640.C6 I7 fasc.15, 18, 35, 70.

Corpus Vasorum Antiquorum. Italia. Tarquina. Museo nazionale tarquiniense. Roma: Libreria dello Stato, 1955–1974. 3 v. NK4640.C6I7 fasc.25–26, 55.

Corpus Vasorum Antiquorum. Italia. Torino. Museo di antichità di Torino. Roma: Libreria dello Stato, 1960–1969. NK4640.C6I7 fasc.32, 40.

Corpus Vasorum Antiquorum. Italia. Trieste. Civico museo di storia et arte di Trieste. Roma: L'Erma di Bretschneider, 1969– . NK4640.C6I7 fasc.43.

Corpus Vasorum Antiquorum. Italia. Verona. Museo del Teatro romano di Verona. Roma: Libreria dello Stato, 1961– . NK4640.C6I7 fasc.34.

Corpus Vasorum Antiquorum. Italia. Vibo Valentia. Museo statale "Vito Capialbi." Roma:

L'Erma di Bretschneider, 1991– . NK4640.
C6I7 fasc.67.

Japan

Corpus Vasorum Antiquorum. Japan. Tokyo:
Japan Society for the Promotion of Science;
Maruzen, 1981– . NK4640.C6 J3 fasz.1.

Netherlands

Corpus Vasorum Antiquorum. Netherlands.
NK4640.C6 N4 fasc.1–2. Continues: Corpus
Vasorum Antiquorum. Pays-Bas. Paris: H.
Champion, 1927–1931.

Corpus Vasorum Antiquorum. Netherlands. Am-
sterdam, Allard Pierson Museum. University of
Amsterdam / J. M. Hemelrijk. Amsterdam: The
Museum, 1988– . NK4640.C6 N4 fasc.6, 8.

Corpus Vasorum Antiquorum. Netherlands.
Leiden: Brill, 1972– . NK4640.C6 N4 fasc.3,
6–8.

Corpus Vasorum Antiquorum. Netherlands. La
Haye. Musée Scheurleer. Paris, H. Champion,
1927–1931. NK4640.C6 N4 fasc.1–2.

Corpus Vasorum Antiquorum. Netherlands.
Leiden. Rijksmuseum van Oudheden. Leiden:
Brill, 1972– . NK4640.C6 N4 fasc.3, 5, 7.

New Zealand

Corpus Vasorum Antiquorum: New Zealand.
Oxford: British Academy, Oxford University
Press, 1979– . NK4640.C6 N45 fasc.1.

Norway

Corpus Vasorum Antiquorum. Norway. Public
and private collections / Sverre Marstrander
and Axel Seeberg. Oslo: Norske Videnskaps
Akademi, 1964– . NK4640.C6 N6 fasc.1.

Poland

Corpus Vasorum Antiquorum. Pologne. Collec-
tions de Cracovie. Cracovie: Acádemie po-
lonaise des sciences et des lettres, 1935. 70 p.
NK4640.C6 P6 fasc.2.

Corpus Vasorum Antiquorum. Pologne.
Goluchów—Musée Czartoryski. Varsovie: Li-
brairie Gebethner et Wolff [préf. 1931] 40 p.
54 plates (in portfolio) NK4640.C6 P6 fasc.1.

Corpus Vasorum Antiquorum. Pologne. Collec-
tions diverses (Varsovie, Wilanów, Poznań,
Wilno etc.). Cracovie: Académie polonaise des

sciences et des lettres, 1936. 97 p. NK4640.C6
P6 fasc.3.

Corpus Vasorum Antiquorum. Pologne. Varso-
vie—Musée national. Publié par l'Académie
polonaise des sciences et des lettres.
[Warszawa] Państwowe Wydawn. Naukowe,
1960–1976. NK4640.C6 P6 fasc.4–10.

Corpus Vasorum Antiquorum. Pologne.
Warszawa: Państwowe Wydawnictwo Nau-
kowe, 1931–1995. 10 v. NK4640.C6 P6.
fasc.1–10.

Romania

Corpus Vasorum Antiquorum. Roumanie. Bucar-
est: Éditions de l'Académie de la Républic
Socialiste de Roumanie, 1965– . NK4640.C6
A87 fasc.9.

Russia

Corpus Vasorum Antiquorum. Russia. Roma:
L'Erma di Bretschneider, 1996– . NK4640.C6
R8 fasc.1–12, 14, 15, 17–18.

Corpus Vasorum Antiquorum. Russia. Pushkin
State Museum of Fine Arts. Roma: L'Erma di
Bretschneider, 1996– . NK4640.C6 R8 fasc.1,
7, 17.

Corpus Vasorum Antiquorum. Russia. St. Pe-
tersburg. State Hermitage Museum, St. Pe-
tersburg. Roma: L'Erma di Bretschneider, ca.
2005– . NK4640.C6 R8 fasc.8–12, 14, 15, 18.

Serbia and Montenegro

Corpus Vasorum Antiquorum. Serbie et
Monténégro. Belgrade. Musée National /
Ljubiša B. Popović. Belgrade: Académie serbe
de sciences et des arts, 2004. 43 p. NK4640.
C6 S4 fasc.1.

Spain

Corpus Vasorum Antiquorum. Espagne. Barce-
lona. Musée archéologique de Barcelone /
Bosch i Gimpera amd J. de C. Serra i Ràfols.
Barcelona: Institut d'Estudis Catalans, 1957–
1965. 2 v. NK4640.C6 S6 fasc.3–4.

Corpus Vasorum Antiquorum. Espagne. Bar-
celona. Musée monographique d'Ullastret.
Barcelone: Institut d'Estudis Catalans, 1984– .
NK4640.C6 S6 fasc.5.

Corpus Vasorum Antiquorum. Espagne. Madrid:
Ruiz Hermanos, Librería Gutenberg, 1930– .
NK4640.C6 S6 fasc.1.

Switzerland

Corpus Vasorum Antiquorum. Suisse. Basel. Antikenmuseum / Jean-Paul Descoeudres. Bern: P. Lang, 1981. 137, 56 p. NK4640.C6 S9 fasc.4.

Corpus Vasorum Antiquorum. Suisse. Basel, Antikenmuseum und Sammlung Ludwig. Bern: Verlag Peter Lang, 1984. 80 p. NK4640.C6 S9 fasc.6, 7.

Corpus Vasorum Antiquorum. Suisse. Bern: Verlag Herbert Lang, 1962– . 5 v. NK4640.C6 S9 fasc.1–5.

Corpus Vasorum Antiquorum. Suisse. Genève, Musée d'art et d'histoire. Berne: H. Lang, 1962. NK4640.C6 S9 fasc.1, 3.

Corpus Vasorum Antiquorum. Suisse; Ostschweiz; Tichino; Chur, St. Gallen, Winterthur, Bellinzona, Museo Civico, Collezione Lombardi, Locarno, Collezione Rossi / Ingrid R. Metzger, Matilde Carrara Ronzani, and Hansjörg Bloesch. Zürich: Archäologisches Institut der Universität, 1979. 93, 54 p. NK4640.C6 S9 fasc.5.

Corpus Vasorum Antiquorum. Suisse: Ostschweiz; Tichino: Chur, St. Gallen, Winterthur, Bellinzona, Museo Civico, Collezione Lombardi, Locarno, Collezione Rossi / Ingrid R. Metzger, Matilde Carrara Ronzani, and Hansjorg Bloesch. Zürich: Archäologisches Institut der Universitat, 1979. 93 p. NK4640. C6 S9 fasc.5.

Corpus Vasorum Antiquorum. Suisse. Zürich. Öffentliche Sammlungen / Hans Peter Isler. Bern: H. Lang, 1973– . NK4640.C6 S9 fasc.2.

Sweden

Corpus Vasorum Antiquorum. Sweden. Göteborg. Public collections / Paul Äström and Erik J. Holmberg. Stockholm: Kungl. Vitterhets Historie och Antikvitets Akademien; Almqvist & Wiksell International, 1985. 98 p. NK4640.C6 S8 fasc.3.

Corpus Vasorum Antiquorum. Sweden. Lund. Museum of Classical Antiquities. Stockholm: Kungl. Vitterhets historie och antikvitets akademien: Almqvist & Wiksell International, 1980– . NK4640.C6 S8 fasc.1.

Corpus Vasorum Antiquorum. Sweden. Stockholm: Kungl. Vitterhets histoire och antikvitets akademien. Almqvist & Wiksell, 1980– . NK4640.C6 S8 fasc.4.

Corpus Vasorum Antiquorum. Sweden. Stockholm. Medelhavsmuseet and Nationalmuseum. Stockholm: Kung. Vitterhets historie och antikvitets akademien. Almqvist & Wiksell International, 1983– . NK4640.C6 S8 fasc.2, 4.

United Kingdom

Corpus Vasorum Antiquorum. Great Britain. Castle Ashby, Northampton. Oxford; New York: British Academy, Oxford University Press, 1979. 42 p. NK4640.C6 G7 fasc. 15.

Corpus Vasorum Antiquorum. Great Britain. Cambridge. Fitzwilliam Museum. Oxford: Clarendon Press, 1930. NK4640.C6 G7 fasc.6, 11.

Corpus Vasorum Antiquorum. Great Britain. London. British Museum. Greek geometric pottery / J. N. Coldstream. London: British Museum Press, 2010. 64, 86 p. NK4640.C6 G7 fasc.25.

Corpus Vasorum Antiquorum. Great Britain. Northampton. Castle Ashby. Oxford; New York: British Academy, Oxford University Press, 1979. 42, 67 p. NK4640.C6 G7 fasc.15.

Corpus Vasorum Antiquorum. Great Britain. Winchester. Winchester College / John Falconer and Thomas Mannack. Oxford: Oxford University Press, 2002. 26, 16 p. NK4640.C6 G7 fasc.19.

United States

Corpus Vasorum Antiquorum. United States of America. Ann Arbor, MI. University of Michigan. Cambridge: Harvard University Press, 1933. 84 p. NK4640.C6 U5 fasc.3.

Corpus Vasorum Antiquorum. United States of America. Baltimore, MD. Robinson Collection. Cambridge: Harvard University Press, 1934–1938. 3 v. NK4640.C6 U5 fasc.4, 6, 7.

Corpus Vasorum Antiquorum. United States of America. Baltimore, MD. Walters Art Gallery / John H. Oakley. Baltimore: Walters Art Gallery, 1992– . NK4640.C6 U5 fasc.28.

Corpus Vasorum Antiquorum. United States of America. Berkeley, CA. University of California. Cambridge: Harvard University Press, 1936– . NK4640.C6 U5 fasc.5.

Corpus Vasorum Antiquorum. United States of America. Boston, MA. Museum of Fine Arts. Boston: The Museum, 1973– . NK4640.C6 U5 fasc.14, 19.

Corpus Vasorum Antiquorum. United States of America. Bryn Mawr, PA. Ella Riegel Memorial Museum. Attic red-figured vases / Ann Harnwell Ashmead and Kyle Meredith

Phillips, Jr. Princeton: Princeton University Press, 1971. 64, 42 p. NK4640.C6 U5 fasc.13.

Corpus Vasorum Antiquorum. United States of America. Cambridge, MA: Harvard University Press, 1926– . NK4640.C6 U5 fasc.1–24, 28–30.

Corpus Vasorum Antiquorum. United States of America. Cambridge, MA. Fogg Museum and Gallatin Collections. Cambridge: Harvard University Press, 1942. 116 p. NK4640.C6 U5 fasc.8.

Corpus Vasorum Antiquorum. United States of America. Cleveland. Cleveland Museum of Art / Cedric G. Boulter. Princeton: Princeton University Press, 1971– . NK4640.C6 U5 fasc.15.

Corpus Vasorum Antiquorum. United States of America. Malibu, CA. The J. Paul Getty Museum, Malibu. Malibu, CA: The Museum, 1988– . NK4640.C6 U5 fasc.23, 25–27, 30–31.

Corpus Vasorum Antiquorum. United States of America. New York, NY. Metropolitan Museum of Art. Hoppin and Gallatin Collections. Paris: Champion, 1927. 12, 20 p. NK4640.C6 U5 fasc.1.

Corpus Vasorum Antiquorum. United States of America. Omaha, NB. Joslyn Art Museum / Ann Steiner. Omaha: The Museum, 1986– . NK4640.C6 U5 fasc.21.

Corpus Vasorum Antiquorum. United States of America. Philadelphia, PA. University Museum. Philadelphia: The Museum, 1986– . NK4640.C6U5 fasc.22, 29.

Corpus Vasorum Antiquorum. United States of America. Providence, RI. Museum of the Rhode Island School of Design. Cambridge: Harvard University Press. 1933. 39 p. NK4640.C6 U5 fasc.2.

Corpus Vasorum Antiquorum. United States of America. San Francisco, CA. M. H. De Young Memorial Museum and California Palace of the Legion of Honor. Cambridge: Harvard University Press, 1943. 57 p. NK4640.C6 U5 fasc.10.

Corpus Vasorum Antiquorum. United States of America. Toledo, OH. Toledo Museum of Art. Toledo: Toledo Museum of Art, 1976– . NK4640.C6 U5 fasc.17, 20.

Corpus Vasorum Antiquorum. United States of America. Urbana, IL. World Heritage Museum, College of Liberal Arts and Sciences, Krannert Art Museum, College of Fine and Applied Arts / Sarah U. Wisseman. Urbana: University of Illinois, Urbana-Champaign, 1989– . NK4640.C6 U5 fasc.24.

Yugoslavia

Corpus Vasorum Antiquorum. Yougoslavie. Belgrade: Académie serbe des sciences et des arts, 1933–1975. 4 v. NK4640.C6 Y6 fasc.1–2, 4.

Corpus Vasorum Antiquorum. Yougoslavie. Sarajevo. Musée national de la République socialiste de Bosnie-Herzégovine. Belgrade: Académie serbe des sciences et des arts, 1975 [i.e., 1977]. 52, 24 p. NK4640.C6 Y6 fasc.4.

Corpus Vasorum Antiquorum. Yougoslavie. Zagreb, Musée national. Paris, Librarie ancienne Honoré Champion, 1933– . NK4640.C6 Y6 fasc.1–2.

Institutional Digital Resources (Selected)

16.75. Aegeus Society of Aegean Prehistory. Aegeus is a website created by several archaeologists specialized on Aegean prehistory. It provides current information about excavations and research, conferences, book reviews and dissertations, a library and a newsletter on Aegean and Cypriot prehistory (electronic journals and the Aegean library can be accessed by members only), and job vacancies. It offers a collection of useful links to other Aegean websites. www.aegeussociety.org/en.

16.76. American Research Center in Egypt. Home page includes research summaries of American Research Center in Egypt-sponsored research at Abydos (Abydos Paleolithic Survey; Ahmose and Tetisheri Abydos; El Amra, south Abydos; El-Mahasna; Shunet El-Zabib, north Abydos); Beni Sweif (preservation and conservation of the archaeological resources of Tell el-Hibeh, Beni Sweif Governate); Cairo (Aslam al-Silahdar; Old Cairo Archaeological Monitoring Project; wall paintings from the Temple of Amenhotep III at Wadi el-Seboua; conservation and documentation in the Egyptian Museum); Dakhla Oasis (Ain el-Gedida; Amheida); Esna (Deir el-Fakhouri Monastery); Fayum (Fayum Project: Wale Valley; Karanis Site Management Project); Giza (Epigraphic Survey of the Abu Bakr cemetery at Giza); Giza Mapping Project; Pyramid Fields Hinterland Project; Tomb of Akhet-Mehu and son, Ankh-Ir-Ptah; Luxor East Bank (Akhenaten Talatat at Karnak Temple, Mut Temple Precinct of Luxor, Salvage Archaeological Field School); Luxor West Bank (El-Kab and Valley of the Kings, Tomb of Menna Conservation Project); Middle Egypt (El-Qusiya in Middle Egypt Project); Nile Delta (Tell el-Tebilla, Tell Gabbara, Tell Tebila); Saqqara (Tomb of Teti); Sinai (Tell el-Borg, Tell el-Markha); Sohag (el-Ahaiway,

White Monastery); and South Sinai (El-Markha Plain Project). http://www.arce.org/expeditions/featuredexpeditions.

16.77. American School of Classical Studies. Athens. Since 1881 the American School of Classical Studies in Athens has amassed a large collection of published and unpublished information. This includes books, journals, photographs, notebooks, personal papers, maps, and scientific data sets. Increasingly these resources are now in electronic format. The collection may be browsed by using an index of categories on the website toolbar. Material that has been published is completely available to the public; unpublished material is available only to researchers who have obtained the necessary permission to study the material in person. www.sscsa.edu.gr.

Alison Frantz Photographic Collection, 1881–1940. The Alison Frantz Photographic Collection contains images by the photographer and archaeologist Alison Frantz (1903–1995). The photographs mainly depict Archaic and Classical sculpture, Greek archaeological sites, and various finds. The collection was created between the late 1940s and the early 1970s. The images have illustrated numerous publications, among them *Korai, Greek Archaic Maidens* (Gisela M. A. Richter, 1968); *The Archaic Gravestones of Attica* (Gisela M. A. Richter, 1961); *Olympia, The Sculptures of the Temple of Zeus* (Bernard Ashmole and Nicholas Yalouris, 1967); and *The Parthenon Frieze* (Martin Robertson and Alison Frantz, 1975). http://www.ascsa.edu.gr/index.php/archives/the-alison-frantz-photographic-collection.

Archaeological Photographic Collection, 1881–1940. The Archaeological Photographic Collection includes 3,655 items documenting the field activities of the American School, from its establishment in 1881 until WWII, with rare and valuable images recording the restoration work of architect Nikolaos Balanos at the Erechtheum on the Acropolis in the early twentieth century, the identification of the Choregic Monument of Nikias on the South Slope of the Acropolis, the discovery of the Sanctuary of Eros and Aphrodite on the North Slope of the Acropolis in the 1930s, the excavations at the site of Dionysus in northern Attica, and the restoration of the Lion of Amphipolis, as well as general views of Athens. http://www3.ascsa.edu.gr/archives/.

Athenian Agora Excavations. Excavations in the Athenian Agora are formally published through the Athenian Agora monograph series and articles in *Hesperia*, the journal of the American School. A number of digital resources are also made available free of charge for teaching and resource purposes. With the support of the Packard Humanities Institute (PHI) the Agora excavation has been involved over the past decade in an ambitious program of digitizing older materials and experimenting with the use of new technology to record continuing excavations. The excavations databases provide a valuable research tool for scholars far beyond the Stoa of Attalos. www.agathe.gr.

Corinth Excavations. The archive from nearly continuous excavation spanning three centuries is vast, and this website provides online access to a significant portion of it. Excavation journals, photographs, and architectural drawings contained herein document not only the history and archaeology of ancient Corinth but reveal much about the modern village, its inhabitants, and the excavators. Using day journal diaries, archaeologists began recording finds, monuments, and excavation, as well as their daily life in Greece. Often their thoughts and personalities are evident on the pages. More recent notebooks are more objective and standardized but offer no less to the interested reader. Photographs, including an extensive collection of glass plate negatives, focus on deep excavation trenches, ancient monuments, and magnificent objects but also shed light on the workmen and the changing landscape of ancient Corinth. The collection of drawings includes maps, monuments, and archaeological renderings and provides glimpses into ancient topography, architecture, and construction. The scanning and cataloging of a quarter million digital objects was made possible by the Greek Ministry of Culture and the Third Information Society program of the European Union. http://www.ascsa.edu.gr/index.php/excavationcorinth/.

Dorothy Burr Thompson Collection, 1923–1960. This collection includes 3,176 items. Dorothy Burr Thompson (1900–2001), who is known to the world of Greek archaeology as an excavator and leading expert in ancient terracottas, donated her photographic collection to the American School of Classical Studies at Athens. The collection, which covers the period 1923–1955, includes images from Thompson's travels in Greece, Turkey, and Italy. In addition to the archaeological

information, some of which has been lost or forgotten, the collection is a mosaic of information about architecture, landscapes, and customs that no longer exist. http://www3. ascsa.edu.gr/archives/.

Ion Dragoumis's Correspondence. Includes 11,409 digital images of letters. Ion St. Dragoumis served initially as a diplomat in Istanbul, Rome, and St. Petersburg, before becoming a member of the Greek Parliament. He was assassinated in 1920. The collection, which comprises 2,827 incoming letters and a small number of outgoing ones, covers the period 1895–1920. The Macedonian struggle, the Balkans and the Ottoman Empire, the Greek language, and the use of the Demotic are some of the issues that appear in the correspondence. http://www3.ascsa.edu.gr/archives/.

Mapping Mediterranean Lands. The Gennadius Library is a repository of an outstanding collection of about 3,000 historical maps on Greece, the Balkans, and Turkey, which clearly occupied an important position in the collection of Johannes Gennadius. Spanning a period from the late fifteenth to the twentieth centuries, these maps are either drawn in hand or were printed by noted cartographers and map publishers. Among many important maps may be noted the series of island maps in the Ionian and Aegean seas from a fifteenth-century manuscript of Buondelmonti's Liber Insularum (illustrated on this page), an early nineteenth-century chart of the Aegean by Nicolas Kefalas (possibly the first printed Greek nautical chart), and numerous maps concerned with the political development of the Balkan states in the late nineteenth century. http://www.ascsa.edu.gr/index.php/gennadius/mapping-mediterranean-lands.

Photographs from the Historical Archives. Feature 1,152 images, which were previously dispersed among the historical collections of the archives in the Gennadius Library. These images are of great interest since they document public and private moments of Greek history, from the late nineteenth century to the early decades of the twentieth century. The photos originated from the rich archive of the Dragoumis family and the papers of Athanasios Souliotis, Nikolaos Mavris, and others, as well as from the papers of author Stratis Myrivilis, who fought in the Balkan Wars and the Greek–Turkish War (1919–1922). http://www3.ascsa.edu.gr/archives/.

16.78. Bibliothèque Nationale de France. Paris. The French National Library digitizes Egyptological literature, primarily from French Egyptologists. There are currently around fifty volumes in the collection, which can be printed on request. Titles can be searched according to *mots du titre*, *auteur*, *sujet*, or *recherche libre*. In the section *dossiers* is the heading "Voyages en Afrique," which includes ancient Egypt. http://www.bnf.fr/fr/acc/x.accueil.html.

16.79. Brown University. Joukowsky Institute for Archaeology and the Ancient World. Includes summaries of current Brown University archaeological projects, including Petra Archaeological Project (Jordan), Abydos Project (Egypt), Labraunda Project (Turkey), Uronarti Project (Sudan), and Yalburt Yaylasi Landscape Project (Turkey). http://brown.edu/Departments/Joukowsky_Institute/fieldwork/projects.html.

16.80. Bryn Mawr University. Department of Classical and Near Eastern Archaeology. Includes research summaries for Emali (Turkey), Gritille (Turkey), Muweillah (United Arab Emirates), http://bascom.brynmawr.edu/archaeology/fieldwork/.

16.81. Bryn Mawr University. Department of Classics. Delian Temple Treasures. Annual lists or inventories of the contents of sanctuaries on the island of Deelos were inscribed on stone. A brief description of the inventories and the various treasures are presented. http://www.brynmawr.edu/classics/delian.html#intro.

16.82. Deutsches Archäologisches Institut. Berlin; Photo Library. "The Institute's collection of photographs dates back to the invention of photography. After the death of Walther Amelung (1927), the Institute inherited the collection that he had acquired for his own research purposes. From 1928 onwards, his successor, Ludwig Curtius, proceeded to systematically organize and expand the photo archive, thus giving it its current form. Today the Roman photo archive is a unique research tool in archaeology." http://www.dainst.org/en/department/photo-archive-rome?ft=all.

16.83. Deutsches Archäologisches Institut. Berlin; Arbeitsstelle für Digitale Archäologie, Köln. ARACHNE is a database that contains the image archives of the German Archaeological Institute and the photographic material of the former Forschungsarchiv für Antike Plastik (almost 250,000 objects). The aim is the contextualization of the recorded objects, for example, the linking with research literature. The interconnection with other database projects enables an increase of the recorded image data. A free registration on

the website is required. http://archaeologie.uni-koeln.de/node/23.

16.84. Ecole Française d'Athènes. Collections online of the French School at Athens contains more than 500 volumes of electronic literature, which has been published since 1877 by the École française d'Athènes (EFA). After having accepted the terms of use, the user has the choice to search or browse the collection. There is a page view, a view with two pages, and a panoramic view (several pages of one document are open). http://www.cefael.efa.gr/site.php?ce=7gpju7rnvpfcu2h0o2eqbivk7o01r2mh.

16.85. Freie Universität Berlin. Department of History and Cultural Studies. Institute of Classical Archaeology. Alongside the Ancient Sculpture Cast Collection, the Institute of Classical Archaeology maintains a collection of photographs (about 60,000 photos) and a collection of slides (about 110,000 large-format and small slides), both also focusing on ancient sculpture. http://www.digitalsculpture.org/casts/borbein/index.html.

16.86. Getty Museum. San Marino, California. Study Photographs of Ancient Architecture, 1900s. A collection of modern photographs assembled by the Getty Research Institute of architectural sculpture, mostly detached from the original location, concentrating on works of the Greek and Roman periods, from the Greek Archaic through the late Roman Empire (sixth century BCE–sixth century CE). Coverage is most complete for works from sites in Greece and Italy, but the collection includes images of architectural sculpture from monuments in other countries, including Albania, Algeria, Egypt, England, France, Germany, Lebanon, Libya, Romania, Syria, Tunisia, Turkey, and Yugoslavia. www.getty.edu/museum/.

Study Photographs of Ancient Coins, 1900s. A collection of photographs of ancient coins, predominantly Greek and Roman, assembled by the Getty Research Institute. http://www.oac.cdlib.org/findaid/ark:/13030/c85140m0/.

Study Photographs of Ancient Inscriptions, 1900s. A collection of photographs assembled by the Getty Research Institute of ancient inscriptions, predominantly Greek and Roman, with Athenian inscriptions constituting the largest portion of the collection. http://www.oac.cdlib.org/findaid/ark:/13030/c8cj8fv2/.

Study Photographs of Ancient Minor Arts Objects, 1900s. A collection of modern photographs assembled by the Getty Research Institute of ancient works of the minor arts, chiefly from the Greek and Roman periods, Greek Archaic through the late Roman Empire (sixth century BCE–sixth century CE). Object types include arms and armor, athletic equipment, furniture, jewelry, lamps, loomweights, masks, mirrors, models, molds, musical instruments, ornaments and appliqués, scales and weights, seals and stamps, textiles, toys, utilitarian objects, vessels, and votive objects. http://www.getty.edu/research/tools/photo/guide.html.

Study Photographs of Ancient Mosaics, 1900s. A collection of modern photographs assembled by the Getty Research Institute of ancient mosaics, both in situ and removed, concentrating on the Greek and Roman periods, Greek Archaic through the late Roman Empire (sixth century BCE–sixth century CE). http://findaid.oac.cdlib.org/findaid/ark:/13030/c8m046tv/entire_text/.

Study Photographs of Ancient Mural Painting, 1900s. A collection of modern photographs of ancient wall paintings, both in situ and detached, assembled by the Getty Research Institute. The collection's concentration is on works of the Greek, Etruscan, and Roman periods, sixth century BCE–sixth century CE. http://www.oac.cdlib.org/findaid/ark:/13030/c8r212r3/admin/.

Study Photographs of Ancient Portrait Sculpture, 1900s. A collection of modern photographs of ancient portrait sculpture, concentrating on the Greek and Roman periods, assembled by the Getty Research Institute. The collection's focus is on famous ancient persons, including Greek philosophers and statesmen, Hellenistic rulers, Roman Republican statesmen, and Roman emperors and empresses. http://www.oac.cdlib.org/findaid/ark:/13030/c80g3mj3/entire_text/.

Study Photographs of Ancient Relief Sculpture, 1900s. A collection of modern photographs assembled by the Getty Research Institute of ancient sculpture in relief, concentrating on the Greek and Roman periods, Greek Archaic through the late Roman Empire (sixth century BCE–sixth century CE). http://www.oac.cdlib.org/findaid/ark:/13030/c8474c7c/admin/.

Study Photographs of Ancient Sarcophagi, 1900s. A collection of modern photographs assembled by the Getty Research Institute of ancient sarcophagi with relief sculptural decoration, with concentration on examples from the Greek and Roman periods. http://www.oac.cdlib.org/findaid/ark:/13030/c8vq343n/admin/.

Study Photographs of Ancient Sculpture in the Round, 1900s. A collection of modern photographs assembled by the Getty Research Institute of ancient sculpture in the round, concentrating on the Greek and Roman periods, Greek Archaic through the late Roman Empire (sixth century BCE–sixth century CE). http://www.oac.cdlib.org/findaid/ark:/13030/c8gb25dh/.

Study Photographs of Ancient Vases. 1900s. A collection of modern photographs of Greek and Roman vases assembled by the Getty Research Institute. Photographs of Attic black- and red-figured vases attributed to particular vase painters by J. D. Beazley comprise the largest component of the collection. Coverage of South Italian red-figured vases is also significant. Coverage of other ancient vase-painting styles (including Corinthian, Lakonian, Etruscan, Boeotian, and East Greek examples) is less complete. http://www.oac.cdlib.org/findaid/ark:/13030/c8gh9kbz/entire_text/.

Study Photographs of Museum Displays of Ancient Art, 1900s. A collection of photographs of Greek and Roman art in museum galleries and displays assembled by the Getty Research Institute. A number of museums are especially well documented, including the J. Paul Getty Museum, Malibu, CA; the Museo archeologico nazionale in Naples; the Acropolis, Agora, and National Archaeological museums in Athens; the Galleria degli Uffizi in Florence; and several major museums in Rome as well as the Vatican Museums. http://www.oac.cdlib.org/findaid/ark:/13030/c8nz890t/entire_text/.

Louis Vignes (1831–1896). Vues de Phénicie, de Judeé, des pays de Moab et de Petra: photographiées par M. Vignes Lieutenant de vaisseau pendant son voyage, en 1864, avec le duc de Luynes de Beyrouth á la mer Rouge et son retour avec M. Lartet de Jérusalem á Damas par la rive gauche du Jourdain, 1864. The album records the Duc de Luynes's 1864 expedition to the Dead Sea with the photographs arranged according to the expedition itinerary, starting at Beirut and concluding with a view of the source of the Hasbany River. http://www.oac.cdlib.org/findaid/ark:/13030/c8th8nj6/.

Middle Eastern and North African Views and Portraits, 1870–1900. This collection of albumen prints dates from the last quarter of the nineteenth century and comprises views and portraits from North Africa and the Middle East, some of which are signed Bonfils.

http://www.oac.cdlib.org/findaid/ark:/13030/c87p90cx/.

Souvenir d'Algérie, 1889. Photographs taken by an amateur photographer of sights and everyday life in late-nineteenth-century Algiers are presented in two portfolios each titled Souvenir d'Algérie. http://www.oac.cdlib.org/findaid/ark:/13030/c87945h3/.

Souvenir du Sahara, 1901–1904. Album of photographs (seventy gelatin silver, thirty-eight albumen), probably created by an amateur photographer. Images document various sites in or neighboring the Sahara and feature the major cities of Algeria, including Oran, Tlemcen, Algiers, and Constantine, as well as the desert oases of Taghit, Biskra, and Beni Abbes. http://www.oac.cdlib.org/view?docId=kt2g5034pb;style=oac4;view=dsc.

Views of Greece, Egypt, and Constantinople, 1853–1857. The collection comprises sixty-nine photographs of Greece, Egypt, and Constantinople attributed to the British photographer James Robertson. The majority of these photographs record the ancient monuments of the city of Athens. The remainder document a small number of ancient Greek sites outside Athens, as well as various architectural monuments in Constantinople. Photographs of one ancient and one Islamic monument in Egypt are also included. http://www.oac.cdlib.org/findaid/ark:/13030/kt809nf7gk/.

J. G. Pilter Tour in Algeria, 1872. A detailed journal of text, photographic prints, maps, and letters documenting Englishman J. G. Pilter's trip to Algeria in 1872. http://www.oac.cdlib.org/findaid/ark:/13030/c8cf9r38/.

16.87. Getty Research Institute. The Getty Research Institute is dedicated to furthering knowledge and advancing understanding of the visual arts. Its Research Library with special collections of rare materials and digital resources serves an international community of scholars and the interested public. The Research Institute creates and disseminates new knowledge through its expertise, active collecting program, public programs, institutional collaborations, exhibitions, publications, digital services, and residential scholars program. The activities and scholarly resources of the institute guide and sustain each other and, together, provide a unique environment for research, critical inquiry, and debate. www.getty.edu/research/tools/digital_collections/index.html.

Åke Åkerström Papers, 1853–1991. Collections record the scholarly career of this Swedish classical archaeologist. Åkerström's research

interests and publications ranged from architectural terra-cottas in Asia Minor to Etruscan tomb typology to Mycenaean pottery in Greece, and this breadth is reflected in the research notes, photographs, postcards, drawings, correspondence, manuscripts, and typescripts that constitute the Åkerström papers. http://www.oac.cdlib.org/findaid/ark:/13030/kt7q2nf4dc/entire_text/.

Early Photography in Greece and the Mediterranean. A subject guide on early photographs of ancient Greek and Roman art and architecture from the Getty Research Institute. *Early Photography in Greece and the Mediterranean* details over 560 nineteenth and early-twentieth-century photographs of ancient Greek and Roman architecture. Focusing on Greece, Asia Minor, the Aegean islands, Cyprus, South Italy, and Sicily, the majority of the photographs depict Athens, particularly the Athenian Acropolis. Also represented are ancient monuments located elsewhere in Athens, selected site views in Greece and throughout the Mediterranean, and ancient sculpture. Most of these images belong to the Research Library's Gary Edwards collection of photographs of Greece, while other photographs belong to various smaller collections held by the library. http://chnm.gmu.edu/worldhistorysources/d/238/whm.html.

Charles Fellows Correspondence, 1820–1879. Collection comprises drafts and handwritten copies of letters, as well as notes and inventories, written and received by the British archaeologist Sir Charles Fellows (1820–1879). The letters and inventories describe Fellows's expeditions to Lycia, in present day Turkey, and most particularly, his excavation of Xanthus. Correspondence also concerns the display of Lycian artifacts at the British Museum. http://www.oac.cdlib.org/view?docId=kt6r29q504;query=;style=oac4;doc.view=entire_text.

Fotografi di Roma. The photograph album contains forty-one salt prints by Stefano Lecchi, depicting the siege of Rome and its defense by Giuseppe Garibaldi and ancient Roman monuments in 1849. It documents key battles in the movement for national unification, known as the Risorgimento. http://hdl.handle.net/10020/rights_repro.

Flowers and pictures of the Holy Land. Consists of thirty-two full-page color illustrations of landmark sites in the Holy Land with dried flower arrangements mounted on opposite pages. Each page is labeled with the name of the site and the source of the flowers. Bound in boards of olive wood with inlaid border and leather spine. The album was produced and sold by Boulos Meo at his antique shop at the Jaffa Gate in Jerusalem. http://hdl.handle.net/10020/2873_944.

William Gell Sketchbook of Pompeii, by Sir William Gell (1777–1836). This sketchbook appears to be part of Gell's research for the 1832 revised edition of Pompeiana. The drawings in pen, ink, and watercolor include general views, architectural details, frescoes, mosaics, house plans, inscriptions, and objects from the site. The sketchbook also includes extensive notes for the new edition. Both the drawings and the notes focus on material discovered during the excavations conducted between 1826 and 1829. Sixty leaves. Sir William Gell (1777–1836) was a traveler, archaeologist, and topographer. Gell first visited the Mediterranean in 1801. He spent the opening years of the century exploring ancient remains in Turkey and Greece but by 1815 turned his attention to Italy. He lived in Rome and Naples and concentrated on the archaeological remains of these areas. In both phases of his career, Gell documented his archaeological and topographic research, publishing more than ten books, often illustrated with his own drawings http://hdl.handle.net/10020/2002m16b425.

Einar Gjerstad Research Papers, 1806–1984. The Einar Gjerstad research papers document the long and prolific scholarly career of this Swedish classical archaeologist. The archive includes research notes, photographs, drawings, typescripts, and publication production materials for Gjerstad's extensive studies of the archaeology of Cyprus and early Rome. www.oac.cdlib.org/findaid/ark:/13030/kt3489r8tk/admin.

Ken and Jenny Jacobson Orientalist Photography Collection, 1850–1920. More than 4,500 images, including stereo views, photograph albums, illustrated books, and printed ephemera of the Middle East and North Africa, taken by 164 photographers and photographic studios. http://archives.getty.edu/R?func=collections-result&collection_id=1654.

Elisabeth Jastrow Papers, 1870–1971. The Elisabeth Jastrow papers document the life and scholarship of this émigré archaeologist who left Germany due to the anti-Semitic policies of the Third Reich. The archive contains personal and professional correspondence, unpublished manuscripts, extensive research

notes and photographic documentation on terracotta arulae from Magna Grecia, and teaching notes, as well as material related to her father, Ignaz Jastrow. www.oac.cdlib.org/findaid/ark:/13030/kt509nf2m9.

Orpheus Mosaic (Paphos, Cyprus) Project Files, 1986–1993. Dating from 1986–1993, materials comprise project files relating to the conservation of the third-century Orpheus Mosaic in Paphos, Cyprus, by the Getty Conservation Institute (GCI). Also included are records detailing the organization and implementation of training programs (focused on the conservation of local excavated sites and excavated archeological material) that were implemented by the GCI on site in Paphos. http://www.oac.cdlib.org/findaid/ark:/13030/c82b8zvd/.

Charles Percier, Sketchbook (1764–1838). The sketchbook, attributed to the architect Charles Percier, was conceivably created during his stay as a pensionnaire at the Académie de France in Rome. Sixty-two pages of the notebook contain pencil and/or ink and wash drawings of Roman architectural fragments, inscriptions, relief sculpture, Greek vases, ancient monuments, plans of Roman villas both ancient and contemporary, portraits, and landscapes. Seventy-six leaves. The date of August 26, 1790, is penciled on the inside cover. Annotations in red ink in an undecipherable shorthand or code were added after the completion of the drawings. http://www.getty.edu/research/special_collections/highlights/sketchbooks/index.html.

James Robertson, Views of Greece, Egypt, and Constantinople, 1853–1857. The collection comprises sixty-nine photographs of Greece, Egypt, and Constantinople attributed to the British photographer James Robertson. The majority of these photographs record the ancient monuments of the city of Athens. The remainder document a small number of ancient Greek sites outside Athens, as well as various architectural monuments in Constantinople. Photographs of one ancient and one Islamic monument in Egypt are also included. http://www.oac.cdlib.org/findaid/ark:/13030/kt809nf7gk/.

Stereographic Views of Italy. A series of 100 captioned stereographic views of Italy, ca. 1900, published by Underwood and Underwood. Included are thirty-one exterior views of the major architectural and ancient monuments in Rome and environs (twelve of these have people in native costume posed in the foreground); fifteen interior views of Rome's churches and galleries; nine exterior views of Venice; eleven exterior and interior views of Florence; and six exterior and interior views of Naples. Views of other cities and sites include Herculaneum (1), Amalfi (2), Genoa (4), the Carrara quarries (2), Pisa (3), Milan (2), Verona (2), and Majori (1). A major commercial publisher of stereographic views, in 1897 Underwood and Underwood became the first stereographic view company systematically to sell boxed sets, both in standard and custom formats. http://archives.getty.edu/R/?func=dbin-jump-full&object_id=5624423&local_base=GEN01.

Study Photographs of Ancient Architecture. A collection of modern photographs of ancient sites and monuments assembled by the Getty Research Institute, concentrating on Greek and Roman architecture from the Greek Archaic through the late Roman Empire (sixth century BCE–sixh century CE). Coverage is most complete for sites and monuments located in Greece and Italy, but the collection also includes photos of sites located in other countries, including Albania, Algeria, Egypt, England, France, Germany, Hungary, Israel, Jordan, Lebanon, Libya, Morocco, Portugal, Spain, Syria, Tunisia, Turkey, and Yugoslavia. http://www.oac.cdlib.org/findaid/ark:/13030/c8416zfs/entire_text/.

Halsted B. Vander Poel Campanian Collection, 1570–1997. The Halsted B. Vander Poel Campanian collection is an archive devoted to the historiography of archaeological investigations conducted around the Bay of Naples, with particular emphasis on Pompeii. Comprising manuscripts, photographs, maps, plans, drawings, and the papers of Matteo Della Corte and Tatiana Warscher, it is a comprehensive resource for researching the excavations at Pompeii and the surrounding area. http://www.oac.cdlib.org/findaid/ark:/13030/kt3s202081/admin/.

16.88. Gettysburg College. Gettysburg, Pennsylvania. Nineteenth Century Images of Greece and the Near East. A digital collection of nineteenth-century images of Constantinople, Jerusalem, and Athens from notable photography studios such as Maison Bonfils, Sebah and Joaillier, and Abdullah Frères. http://gettysburg.cdmhost.com/cdm/search/collection/p15059coll1.

16.89. Harvard University. Houghton Library. Digital Papyri at Houghton Library. Dating to the third century BC to the sixth century AD, Houghton

Library's collection of eighty-four papyri includes both literary and documentary texts, which comprise a unique primary source for the study of the political, administrative, and social history of Ptolemaic and Roman Egypt. Many of the literary manuscripts come from Oxyrhynchus, but the collection also includes material from Hibeh and the Fayûm, as well as papyri of Homer, Plato, Thucydides, Demosthenes, Menander, and the Gospels. Documentary texts include contracts, petitions, lists, tax receipts, and letters. The digitization of Houghton's manuscripts was directed by Francesca Schironi, assistant professor in the Department of the Classics, in collaboration with Houghton Library staff. http://hcl.harvard.edu/collections/digital_collections/papyri.cfm.

16.90. Harvard University. Divinity School. New Testament and Archaeological Slides. New Testament and Archaeological Slides from Harvard Divinity School is a collection of over 8,000 digital images for teaching and research in New Testament studies, Greek and Roman mystery religions, and early Christian history. The images are from photographic slides taken or collected by Professor Helmut Koester and his students during more than thirty years of travel to archaeological sites and museums in the Mediterranean area. The sites, which include Athens, Rome, Corinth, Ephesus, Sardis, Thessaloniki, Hierapolis, and Philippi, represent the most important cities and religious centers during the Hellenistic and Roman Imperial periods (ca. 300 BCE to 300 CE). The majority of the images document the architecture and layout of these sites, but there are also relevant images of inscriptions, statues, coins, and mosaics. These last picture the gods and rulers of the ancient world and help illustrate the overlapping iconography of divinity and kingship. The digitization and cataloging of these images was supported by a grant from the Harvard University Library's Library Digital Initiative (LDI), and the work was carried out as a joint project of Harvard Divinity School's Office of Information Technology and Media Services and Andover-Harvard Theological Library. http://www.hds.harvard.edu/library/collections/digital/nt_slides.html.

Digital Papyri. Dating from the third century BCE to the sixth century CE, Houghton Library's collection of eighty-four papyri includes both literary and documentary texts, which comprise a unique primary source for the study of the political, administrative, and social history of Ptolemaic and Roman Egypt. Many of the literary manuscripts come from

Oxyrhynchus, but the collection also includes material from Hibeh and the Fayûm, as well as papyri of Homer, Plato, Thucydides, Demosthenes, Menander, and the Gospels. Documentary texts include contracts, petitions, lists, tax receipts, and letters. The digitization of Houghton's manuscripts was directed by Francesca Schironi, assistant professor in the Department of the Classics, in collaboration with Houghton Library staff. http://hcl.harvard.edu/collections/digital_collections/papyri.cfm.

16.91. Harvard University. Center for Hellenic Studies. Home page includes material on the Derveni papyrus, the only papyrus (ca. 340–320 BCE) to have been found on Greek soil. The book contains the eschatological teaching of a mantis; the content is divided between religious instructions on sacrifices to gods and souls and allegorical commentary on a theogonical poem ascribed to Orpheus. http://chs.harvard.edu/wb/1/wo/iephXykNGGxjiaKW4WY4Qw/13.0.0.0.19.1.7.15.1.1.0.1.2.0.11.1.3.3.1.

Hellinon. This Greek website informs about the history and archaeology of ancient Greece, Asia Minor, Cyprus, Crete, and Macedonia and offers a broad range of articles in Greek open access (approximately thirty articles are also available in English). http://hellinon.net/.

16.93. Bundesarchiv (Koblenz), Deutsche Nationalbibliothek (Leipzig; Frankfurt, Main), Deutsches Museum von Meisterwerken der Naturwissenschaft und Technik (München). Multilingual Inventory of Cultural Heritage in Europe—Digital Collections: antiquity (MICHAEL). The subject gateway records online databases, web resources, and media of archives, museums, libraries on the Internet that contain digitized books, photographs, paintings, maps, and plans as well as other cultural artifacts. In this way, the material is made accessible to a wider public. One can browse through the collections by several categories: subject; location; or time period, for example, *antiquity*. http://www.michael-culture.org/.

16.94. Metropolitan Museum of Art. Amorium (Turkey), Dahshur (Egypt), Malqata (Egypt), Palaikastro (Crete), Tell el-Amarna (Egypt), Tell Mozan (Syria), Umm el-Marra (Syria). http://www.metmuseum.org/research/archaeological-fieldwork.

16.95. Museum of Fine Arts, Boston. Giza Digital Library. A comprehensive website resource for research in Giza. It contains photographs and other documentation from the original Harvard University/Boston Museum of Fine Arts Expedition (1904–1947); recent MFA fieldwork; and

other expeditions, museums, and universities around the world. http://www.gizapyramids.org/.

16.96. New York Public Library. The Middle East in Early Prints and Photographs. Several thousand prints and photographs contained in works from the seventeenth century to the beginning of the twentieth century. These include books illustrated with prints or photographs, photograph albums, and archival compilations; the processes represented range from engravings to lithographs and from salt prints to heliogravures. http://digitalgallery.nypl.org/nypldigital/explore/dgexplore.cfm?topic=cities&col_id=17.

16.97. New York University. Center for Ancient Studies. Home page includes research summaries of New York University Center for Ancient Studies research at Aphrodisias (Turkey), Yerobnisos (Cyprus), and Sicily. http://ancientstudies.as.nyu.edu/page/excavations.

16.98. New York University. Institute for the Study of the Ancient World. Home page includes research summaries of New York University Institute for the Study of the Ancient World–sponsored research at Bukhara (Uzbekistan), Amheida (Egypt), and Kinik (Turkey). http://isaw.nyu.edu/.

16.99. New York University. Institute of Fine Arts. Home page includes research summaries of New York University Institute of Fine Arts–sponsored research at Abydos (Egypt), Aphrodisias (Turkey), Samothrace (Greece), and Selinunte (Italy). http://www.nyu.edu/gsas/dept/fineart/academics/archaeology.htm.

16.100. Pennsylvania State University. Center for Online Judaic Studies. Digitization efforts include a module on the Dead Sea Scrolls. http://cojs.org/cojswiki/Dead_Sea_Scrolls.

16.101. Petras Excavations. This website informs about the excavations, surveys, and research on Minoan Petras from 1985 to the present. It gives information about the archaeological site, a bibliography, and a number of pictures. A news and forum category provides recent information about conferences. Some articles about specific subjects are provided open access. http://www.petras-excavations.gr/.

16.102. Princeton University. Seeger Center for Hellenic Studies. http://www.princeton.edu/hellenic/overview/.

16.103. Princeton University. Geniza Project. Initiated in the mid-1980s, the Computer Geniza Project of the Department of Near Eastern Studies at Princeton University seeks to extend the methodologies available to Hebrew, Judaeo-Arabic, and Arabic scholars working with the docu-ments found in the Geniza chamber of the Ben Ezra Synagogue in Cairo in the late nineteenth century. The project is dedicated to transcribing documents from film copies, photocopies, draft texts typed by S. D. Goitein, and printed editions to computer files, creating a full-text retrieval text base of transcribed documents, and developing new tools such as dictionaries, semantic categories, and morphological aids to further the study of Geniza texts. Finally, the project is committed to disseminating its materials as widely as possible to the international community of scholars with an interest in the life of the medieval Middle East, as well as to all with an interest in Judaica. Ultimately, the project hopes to provide links to digitized images of manuscripts in its corpus, as libraries pursue the imaging of their collections. It is hoped that by making materials from this very esoteric field widely available that new insights can be gained into the interaction of the peoples of the Middle East in past times. Funding has come from Princeton University and the Friedberg Genizah Project. http://www.princeton.edu/~geniza/.

16.104. Science Museum of Minnesota. At the beginning of the twentieth century, Edgar James Banks, an antiquities enthusiast, bought hundreds of cuneiform tablets in the Ottoman Empire and sold them in small batches to museums, libraries, universities, and seminaries across the United States. Charles W. Ames, one of the Science Museum's founders, purchased nine tablets from Banks and donated them to the museum in 1915. These make up most of the collection; two other tablets were added later, although it is not clear when, and one more was donated in 1988. http://www.smm.org/anthropology/cuneiform.

16.105. State University of New York at Stony Brook. The Iraq Digitized Book Project. The Iraqi Archaeology Digital Texts Collection was developed by the Stony Brook University Libraries in collaboration with Dr. Elizabeth Stone as part of a U.S. aid grant awarded to the university. The project sought to rebuild libraries and library collections within Iraq by providing research libraries within the country with remote access to digital representations of analog objects located in U.S. universities and libraries via the Internet and World Wide Web. The analog materials chosen for the collection consist of monographs, site reports, cuneiforms, and theses and dissertations on archaeology topics. Materials were solicited and purchased from private collections and loaned from leading libraries and archives from around the world for inclusion in the collection.

The project's good work and success served as the foundation for an expanded version of the project, which was exemplified in a successor 2008 U.S. aid grant award to create the AMAR Collection contained within this digital library. http://digital.library.stonybrook.edu/cdm/landingpage/collection/iraqiarcheology.

16.106. Staatliche Museen zu Berlin. Antikensammlung: Antike Bronzen in Berlin. This website offers an open access database to the collection of ancient bronzes at the Staatliche Museen zu Berlin, which were already published by Carl Friedrichs in 1871, as well as the bronzes achieved until 1945 by the Berliner Antikensammlung (inventories and deprivations). The database provides the bronzes in pictures as well as supplies information and literature. A digital version of Friedrichs's catalog is available open access. It is a result of two projects of the Antikensammlung der Staatlichen Museen zu Berlin founded by the DFG in 2004–2007 and 2008–2011. http://ww2.smb.museum/antikebronzenberlin/.

16.107. University College London. Digital Egypt for Universities. A learning and teaching resource developed at University College, London (UCL) for the Petrie Museum of Egyptian Archaeology. www.digitalegypt.ucl.ac.uk.

16.108. University of California, Irvine. The Thesaurus Linguae Graecae (TLG) is a research center at the University of California, Irvine. The TLG has collected and digitized most literary texts written in Greek, from Homer to the fall of Byzantium in AD 1453. Its goal is to create a comprehensive digital library of Greek literature. www.tlg.uci.edu.

16.109. University of California, Los Angeles. Library. Cuneiform Digital Library Initiative. A joint project of the University of California, Los Angeles, and the Max Planck Institute for the History of Science, Berlin. The Cuneiform Digital Library Initiative (CDLI) is an international digital library project aimed at putting text and images of an estimated 500,000 recovered cuneiform tablets created from between roughly 3350 BCE and the end of the pre-Christian era online. The first phase consisted of digitizing and progressively putting online the collections of the Vorderasiatisches Museum, the Institut Catholique de Paris, the Hermitage Museum, the Phoebe A. Hearst Museum of Anthropology, and the University of Pennsylvania Museum of Archaeology and Anthropology. A second phase focused on educational components and scalable access systems to the data. http://cdli.ucla.edu/.
Digital Karnak. The Digital Karnak Project aims to make the site of Karnak more accessible to students and instructors in the English-speaking world. The features of this website have been designed to provide easily accessible, up-to-date expert material relating to the temple precinct. As part of this goal, a three-dimensional virtual reality model of the temple was constructed, offering students a completely new way to view the temple: reign by reign, following the complex patterns of royal construction, modification, and destruction that are now obscured by the latest building phases at the site. http://dlib.etc.ucla.edu/projects/Karnak.
HyperCities Egypt. HyperCities is a collaborative research and educational platform for traveling back in time to explore the historical layers of city spaces in an interactive, hypermedia environment. http://egypt.hypercities.com/.
UCLA Encyclopedia of Egyptology. For thirty years the *Lexikon der Ägyptologie* (edited by Wolfgang Helck, Eberhard Otto, and Wolfhart Westendorf), seven volumes published between 1975 and 1992, has been the standard reference work in Egyptology. The target of the UEE is both the scholarly public and the popular interest in ancient Egypt. A key feature of this project is its innovative approach to data access by making use of hypermedia. http://uee.ucla.edu/index.htm.

16.110. University of Cambridge. Division of Archaeology. Home page includes research summaries of University of Cambridge–sponsored research at Amarna (Egypt), Bova Marina (Italy), Bury Farm (England), Canaanite Amphorae Project (Egypt), Cidade Velha (Cape Verde), Crustumerium (Italy), Etruria (Italy), Goksu Valley (Turkey), Gozo (Malta), Haua Fteah (Libya), Iran, Karnak (Egypt), Keros (Greece), Kilise Tepe (Turkey), Memphis (Egypt), Montelabate (Italy), Nepi (Italy), Pupicina (Greece), Szazhalombatta (Hungary), Tell Brak (Syria), Tiber River (Italy), and Tyrrhenian (Italy). http://www.arch.cam.ac.uk/.

16.111. University of Cambridge. Taylor-Schechter Genizah Research Unit. The Taylor-Schechter Genizah Collection is a window on the medieval world. Its 190,000 manuscript fragments, mainly in Hebrew, Judaeo-Arabic, and Arabic, are an unparalleled resource for the academic study of Judaism, Jewish history, and the wider economic and social history of the Mediterranean and Near East in the Middle Ages. They shed light on the mundane, as well as the religious and cultural, activities of that world, since the collection preserves a huge number of personal letters, legal

deeds, and other documents, alongside literary and sacred texts. The manuscripts were recovered from the Ben Ezra Synagogue in Fustat, Old Cairo, in 1897–1898 by the Cambridge scholar Dr. Solomon Schechter. In the 1970s Cambridge University Library established the Genizah Research Unit to carry out a comprehensive program of conservation, cataloging, and research on the manuscripts, which is leading to all manner of important discoveries about Jewish religious, communal, and personal life; Hebrew and Arabic literary traditions; and relations between Muslims, Jews, and Christians from as early as the ninth and tenth centuries CE. The Genizah Research Unit relies upon external support for its projects. http://www.lib.cam.ac.uk/Taylor-Schechter/. http://www.classics.cam.ac.uk/.

16.112. University of Cambridge. Faculty of Classics. Home page includes research summaries of University of Cambridge–sponsored research: Greek Colonization Project and Roman Burials Project. http://www.classics.cam.ac.uk/research/projects.

16.113. University of Cambridge. Museum of Classical Archaeology. Home page includes research summaries of University of Cambridge–sponsored research: Greek Lexicon Project, Mycenaean Epigraphy Group, Roman Colonial Landscapes, and Greek in Italy. http://www.classics.cam.ac.uk/museum/research-and-teaching/past-research-projects.

16.114. University of Chicago. Oriental Institute. Center for Ancient Middle Eastern Landscapes (CAMEL) is dedicated to facilitating the work of researchers by providing access to and examining an expanding archive of contemporary and historical spatial data pertaining to both ancient and modern Middle East. http://oi.uchicago.edu/research/camel/.

16.115. University of Chicago. Oriental Institute. Cuneiform Collection. The Oriental Institute and the Cuneiform Digital Library Initiative (CDLI), an international research project based at the University of California, Los Angeles, present a database of nearly 4,000 inscribed objects in the Oriental Institute collection. The cuneiform tablets here were digitized, using either originals in Chicago or published hand copies following the standard conventions of the CDLI. The full catalog of the collection, including transliterations and translations of the texts and word and sign glossaries, is currently under construction. The completed project will include administrative, literary, legal, letters, lexical, and royal/monumental texts. http://cdli.ucla.edu/collections/oi/oi.html.

16.116. University of Chicago. Oriental Institute. Individual Scholarship. Summarizes individual scholarship by scholars affiliated with the Oriental Institute, including Abbas Alizadeh, Robert Braidwood, James Henry Breasted, Miguel Civil, Billie Jean Collins, Peter Dorman, François Gaudard, Norman Golb, Thorkild Jacobsen, John Larson, John Nolan, Seth Richardson, Robert Ritner, Yorke Rowan, John C. Sanders, Foy Scalf, David Schloen, Jason Ur, and Edward Wente, as well as annual reports from 1954 to the current year. http://oi.uchicago.edu/research/is/.

16.117. University of Chicago. Oriental Institute. Integrated Database Project (IDB). The Oriental Institute's Integrated Database Project aims to provide public access to information about the diverse research- and object-based collections managed and cared for by the Oriental Institute. http://oi.uchicago.edu/research/idb/.

16.118. University of Chicago. Oriental Institute. Oriental Institute Archaeology Projects. The Oriental Institute has undertaken research throughout the ancient Near East. Summary reports are available for the following research initiatives: Abydos Project, Alalakh Expedition, Amuq Survey, Aqaba Project, Bir Umm Fawakhir Survey, Center for Ancient Middle Eastern Landscapes (CAMEL), Chogha Mish Project, Diyala Project, Epigraphic Survey, Galilee Prehistory Project: Marj Rabba; Giza Plateau Mapping Project, Göltepe/Kestel Project, Hadir Qinnasrin Project, Hamoukar Expedition, Iranian Prehistoric Project, Iraq Museum Database, Jericho Mafjar Project, Joint Prehistoric Project, Kerkenes Dag Project, Khorsabad Excavations, Landscape Studies in Upper Mesopotamia, Luxor-Farshût Desert Road Survey, Modeling Ancient Settlement Systems (MASS), Nippur Expedition, Nubia Salvage Project, Nubian Expedition, Oriental Institute Map Series, Persian Expedition, Tall-e Bakun Project, Tell Edfu Project, Tell es-Sweyhat Expedition, Yaqush Expedition, Yemen Project, and Zincirli Project. http://oi.uchicago.edu/research/projects/.

16.119. University of Cincinnati. Department of Classics. Home page includes research summaries of University of Cincinnati–sponsored research at Episkopi-Bamboula, Isthmia, Knossos Gypsades Geophysics Project, Knossos Little Palace North Project, Mallakastra Regional Archaeological Project, and Pompeii Archaeological Research Project: Porta Stabia, Pylos, and Troy. http://classics.uc.edu/index.php/research.

16.120. University of Heidelberg. Universitätsbibliothek. Egyptological literature—digital. This contains

selected digitized archaeological works from the special subject collection of Heidelberg University Library. Currently the collection comprises around 300 works dating from the sixteenth up to the early twentieth centuries. All titles are searchable via PropylaeumSEARCH. Since September 1, 2009, the offer of digitized works is systematically being expanded as part of a project by the German Research Foundation (DFG). All titles from Heidelberg, as well as further digitized works from project partners, can be searched via the thematic portal "Reception of Antiquity in a Semantic Network: Digital Books, Images and Objects." http://digi.ub.uni-heidelberg.de/en/sammlungen/aegyptologie.html.

Akademieschriften of the Berlin-Brandenburgische Akademie der Wissenschaften. Digitized treatises for the years 1804–1900 from reputable German Egyptologists, such as Borchardt, Erman, Lepsius, and others.

Altägyptisches Wörterbuch (of BBAW). Access to navigation within the *Digitalisierten Zettelarchiv* is possible via the headings list in the *Thesaurus Linguae Aegyptiae*. Use of the *Thesaurus Linguae Aegyptiae* requires registration, but use is free of charge. http://aaew.bbaw.de/, http://aaew.bbaw.de/tla/.

Atägyptisches Wörterbuch (with Belegstellen). The Altägyptisches Wörterbuch was published between 1926 and 1963 in seven volumes and five corresponding volumes of quotations. It is based on ca. 30 percent of all surviving texts from ancient Egypt.

Ernst Wahle (1889–1981). The website offers information on the life and work of the former lecturer and prehistoric archaeologist Professor Dr. Ernst Wahle. The site contains a full list of more than 600 publications and an outline and description of his scientific remains in Heidelberg University Library, as well as selected digitized photographs and historical documents. http://www.ub.uni-heidelberg.de/helios/digi/heidicon_wahle.html.

16.121. University of Heidelberg. Universitätsbibliothek. Propylaeum-DOK is the full text server of the Virtual Library Classical Studies. It serves as a place to go for publication and storage of literature related to eight branches of Classical studies. www.propylaeum.de.

16.122. University of Michigan. Kelsey Museum of Archaeology. Home page includes research summaries of University of Michigan Kelsey Museum research at Abydos (Egypt), Antioch of Pisidia (Turkey), Aphrodisias (Turkey), Apollonia (Libya), Carthage (Tunisia), Coptos and the Eastern Desert (Egypt), Cyrene (Libya), Dibsi Faraj (Syria), Dimé (Egypt), El Kurru (Sudan), Gabii (Italy), Karanis (Egypt), Leptiminus (Tunisia), Monastery of St. Catherine at Mount Sinai (Egypt), Paestum-Poseidonia (Italy), Pylos (Greece), Qasr al-Hayr (Syria), S. Omobono Sanctuary (Italy), Seleucia on the Tigris (Iraq), Sepphoris (Israel), Southern Euboea (Greece), Tel Anafa (Israel), Tel Kedesh (Israel), Terenouthis (Egypt), Vani (Georgia), and Vorotan (Armenia). http://www.lsa.umich.edu/kelsey/.

16.123. University of Michigan. Kelsey Museum of Archaeology. Egyptian Amulet Catalog is a collaborative project between the Kelsey Museum of Archaeology and the University of Michigan's Digital Library Production Service. Initially developed on a fairly small scale (roughly 360 items), the catalog's purpose was to demonstrate the feasibility and value of transferring the Kelsey catalog of artifacts from a proprietary database system to an SGML-based system providing ubiquitous web access.

16.124. University of Michigan. Kelsey Museum of Archaeology. Karanis Site Research. This collection contains an online version of the catalog of objects from the ancient world (coins, textiles, pottery, sculptures, etc.) that are held by the University of Michigan's Kelsey Museum of Archaeology. It includes descriptions of over 98,000 objects and fine art photographs. The database is being expanded to include images of many of the artifacts. http://quod.lib.umich.edu/k/kelsey.

16.125. University of North Carolina. Corpus of Attic Vase Inscriptions. The Corpus of Attic Vase Inscriptions is an attempt to catalog inscribed vases. It contains 8,173 entries and is the result of more than sixty years of research. Each entry is given a local identifier and indicates which collection the vase belongs to (and the inventory number where possible). The entries then have four parts: section A documents the type of vase, place of discovery if known, painter or potter or both, date, and bibliography; section B contains a short description of the paintings; section C contains the inscriptions; and section D offers free commentary. http://www2.lib.unc.edu/dc/attic/.

16.126. University of Oxford. Classical Art Research Centre. Beazley Archive. The website is part of the Beazley-Archive Internet platform. It contains reproductions of old photographs, glass slides, and digitized books. Search is possible by collection, photographer, sites, and monuments. https://www.beazley.ox.ac.uk/dictionary/Dict/ASP/dictionarybody.asp?name=Ketos.

16.127. University of Oxford. School of Archaeology. Home page includes research summaries of University of Oxford Faculty of Archaeology–sponsored research: Androna (Syria), Aphrodisias (Turkey), Dorchester-on-Thames (England), English Landscapes and Identities Project (England), Gallo-Belgic Pottery (England), Ianiculum Mills Excavation (Italy), Late Antique and Byzantine Miletus (Turkey), Le Yaudet (France), Lefkandi (Greece), Modelling Urban Renewal (England), Origins of Wessex (England), Oxford Roman Economy Project (England), Petra Excavations (Jordan), Pompeii and Herculaneum (Italy), Roman Provincial Coinage database (England), Sangro Valley (Italy), South Cadbury (England), Tunisian-British Utica Project (Tunisia), Vale and Ridgeway Project (England), Western Marmarica Coastal Survey (Libya). http://www.arch.ox.ac.uk/OCMA-fieldwork.html.

16.128. University of Pennsylvania. Penn Museum. Open Richly Annotated Cuneiform Corpus (ORACC). ORACC is a collaborative effort to develop a complete corpus of cuneiform whose rich annotation and open licensing support the next generation of scholarly research. Contents include Amarna Texts, Ancient Mesopotamian Gods and Goddesses (AMGG), Assyrian Empire Builders (AEB), Corpus of Ancient Mesoamerican Scholarship (CAMS), Royal Inscriptions of the Neo-Assyrian Period (RINAP), Cuneiform Digital Library Initiative (CDLI), Cuneiform Texts Mentioning Israelites, Judeans, and Other Related Groups (CTIJ), Digital Corpus of Cuneiform Lexical Texts (DCCLT), Digital Corpus of Cuneiform Mathematical Texts (DCCMT), Electronic Pennsylvania Sumerian Dictionary (ePSD), Electronic Text Corpus of Sumerian Royal Inscriptions (ETCSRI), Geography of Knowledge Corpus (GKAB), Hellenistic Babylonia: Texts, Iconography, Names (HBTIN), Imrud: Materialities of Assyrian Knowledge Production, Knowledge and Power in the Neo-Assyrian Empire (K&P), Lexical Texts in the Royal Libraries at Nineveh (DCCLT/Nineveh), ORACC Global Sign Liost (OGSL), Rimanum: Rim-Anum Corpus, Seleucid Building Inscriptions (SelBI), and State Archives of Assyria Online (SAAo). http://oracc.museum.upenn.edu/index.html.

16.129. University of Pennsylvania. Museum of Archaeology and Anthropology.
Babylonian Section
E Cuneiform Digital Library is a global cooperation for creating online resources about the ancient Near East for research and pedagogical purposes.

Egyptian Section
Saqqara Expedition. The pyramid complexes of the Old Kingdom were intended to perpetuate the immortality of pharaohs through continued rituals and offerings for the dead king.

Excavations at the Mortuary Complex of Pharaoh Senwosret III at Abydos. Abydos is the cult site of Osiris, king of the afterlife and god of the netherworld. It was a place of pilgrimage and considered sacred throughout Egypt's 3,000 year history.

Abydos Survey for Paleolithic Sites (ASPS). Examines early modern human behaviors in an area along the Nile Valley route out of Africa.

Mediterranean Section
The Roman Peasant Project. The Roman Peasant Project seeks to uncover the lived experience of the peasantry in the Roman period: their diet, economic activities, and social networks. We exploit a combination of field survey; geophysical exploration; and targeted, rescue-style excavation and place these results alongside evidence gleaned from historical, zoo-archaeological, archaeo-botanical, and geological sources. Our aim is to produce "thick descriptions" of the lives of the poorest rural inhabitants of this world, who formed perhaps as much as 90 percent of the population of the Mediterranean in antiquity.

Granicus River Valley Survey Project. The Granicus River Valley Archaeological Survey Project focuses on an area of northwestern Turkey that was controlled by both Greeks and Persians during the first millennium BCE. Looting there has become increasingly rampant due to the gold and silver objects still preserved in many of the tombs, and the new survey represents the first attempt to record and map both the settlements and burial mounds in this region.

Saronic Harbors Archaeological Research Project (SHARP) focuses on Kalamianos, a Mycenaean harbor town of the thirteenth century BCE, unique for the extensive surface preservation of architectural foundations and walls. Kalamianos may have been Mycenae's main Saronic harbor and is perhaps the Eionai listed in the Homeric Catalogue of Ships.

Gordion Archaeological Project. Gordion is one of the most important archaeological sites in the Near East, royal capital of King Midas and the place where Alexander the Great was said to have cut the famous Gordian Knot.

Archaeological and Ethnohistorical Survey of Jerba. The survey found major shifts in the

settlement patterns of the island. The Punic and Roman periods developed a landscape of several urban centers within a countryside of villas and farms.

Priniatikos Pyrgos Project. This project consists of an excavation and exploration of the environment and resources of the Bronze Age and historical harbor settlement of Priniatikos Pyrgos, located in the west-central Gulf of Mirabello area, eastern Crete.

Near East Section

Analysis of Skeletal Materials from Hasanlu and Tepe Hissar, Iran. Hasanlu and Tepe Hissar, both archaeological sites located in the modern country of Iran, have yielded the remains of hundreds of skeletal persons. Many students and researchers have worked on these skeletal collections yielding many types of reports and publications.

Bat Archaeological Project. Exploration of third-millennium structures and settlements at one of the most important sites in the Sultanate of Oman.

Hasanlu Project. Hasanlu is often called the Pompeii of the Iron Age Near East. The destruction level at the site offers a unique picture of the life of a large settlement in this period.

Jiroft Civilization: A New Culture of the Bronze Age on the Iranian Plateau. Excavations of the sites of Konar Sandal South and North near Jiroft in south-central Iran have revealed a hitherto unknown civilization of the Early Bronze Age that interacted with societies in Mesopotamia, the Indus valley, and Central Asia.

Naxcivan Archaeological Project. Naxcivan is one of the first projects in the least explored area of the Near East.

Tell es-Sweyhat. Tell es-Sweyhat was occupied throughout the third millennium BCE or Early Bronze Age (EBA).

Tepe Hissar, Iran: Ceramic Chronology of a Bronze Age Town. This project aims to analyze, interpret, and prepare for publication the Bronze Age ceramic assemblages of Tepe Hissar.

16.130. University of Pennsylvania. Pennsylvania Sumerian Dictionary Project. Welcome to the website of the Pennsylvania Sumerian Dictionary Project (PSD). The PSD is preparing an exhaustive dictionary of the Sumerian language, which aims to be useful to nonspecialists as well as Sumerologists. In addition, we are developing tools and data sets for working with the Sumerian language and its text corpora. All materials will be made freely available on this website. http://psd.museum.upenn.edu/epsd/index.html.

16.131. University of Washington. University Libraries. Ancient Near East photographs. This collection, created by Professor Scott Noegel, documents artifacts and archaeological sites of the ancient Near East. While the majority of the collection depicts structures and sites dating from 3000 BCE to 200 CE, the collection also has images of more recent sites, such as the al-Azhar Mosque and the modern creation, Lake Nasser. Currently, all images are of Egypt and Israel, although plans exist to eventually add images from Anatolia, Syria, Iraq, and Iran. The images were collected over a ten-year period by University of Washington scholars, and the images included in this database were chosen to facilitate research and to supplement general reading in a variety of disciplines. The richness of this image collection can be seen in the diversity of the topics represented by the images within. In addition to topic-specific images, one can find pictorial data to supplement the study of pharaonic history, daily life in ancient times, ancient art, architectural features, and the history of religions (Egyptian, Canaanite, Israelite, Judaism, Coptic Christianity, Early Islam, etc.). http://content.lib.washington.edu/neareastweb/index.html.

17
Theses and Dissertations

A thesis or dissertation is a document presenting an author's research and results submitted in support of candidacy for an academic degree or professional qualification. The term "thesis" is usually used as part of a bachelor's or master's program, whereas "dissertation" is applied to a doctorate.

All universities maintain comprehensive collections of all theses and dissertations submitted and accepted for academic degrees. They may be located in the library catalog under the author's name or key word. Subject access for these materials is often limited to department name, not Library of Congress subject heading, which is the usual procedure for most cataloged books. There are usually three or four copies available at the library: a cataloged copy, which circulates and is located in the stacks; an archival copy; a microfilm copy; and, for more recent dissertations, an online copy available in the local repository.

SCHOLARLY COMMONS

Scholarly Commons is a repository for the scholarly production of researchers at many universities. It promotes dissemination of their work and preserves it in an accessible, long-term archive. In an effort to alleviate recent pressures to restrict access to new knowledge, Scholarly Commons allows researchers and other interested readers anywhere in the world to learn about and keep up-to-date with scholarship produced at specific universities. Scholarly Commons contains materials chosen by participating units, departments, schools, centers, institutes, etc. Users have access to materials in Scholarly Commons free of charge.

Scholarly Commons also provides links to the electronic full text of dissertations by graduate students, although these dissertations are not part of the repository itself. All users have free access to the first twenty-four pages of these dissertations, but only members of the Penn community have free access to their entire contents. Others can purchase complete dissertations from ProQuest Dissertations and Theses Fulltext. In general, users of Scholarly Commons can expect that links to dissertations submitted since 1997 will be found there. Dissertations from 1996 and earlier may be identified using the online catalog.

PREPARING A THESIS OR DISSERTATION

17.1. *Developing and defending a dissertation proposal* / William B. Castetter and Richard S. Heisler. 4 ed. Philadelphia: Center for Field Studies, Graduate School of Education, University of Pennsylvania, 1984. 75 p. LB2369 .C37 1984. See also: *Writing a dissertation: a manual for doctoral students* / Allan A. Glatthorn. Philadelphia: Graduate School of Education, University of Pennsylvania, 1984. 81 p. LB2369 .G58 1984.

17.2. *Doing a literature review: releasing the social science research imagination* / Chris Hart. London: Sage, 1998. 230 p. H62 .H2566 1998.

17.3. *Guide to successful thesis and dissertation research: a handbook for students and faculty* / James E. Mauch. New York: M. Dekker, 1998. 335 p. LB2369 .M377 1998.

17.4. *Guide to writing empirical papers, theses, and dissertations* / G. David Garson. New York: Marcel Dekker, 2002. 350 p. LB2369 .G27 2002.

17.5. *Writing the qualitative dissertation: understanding by doing* / Judith Meloy. Mahwah, NJ: Lawrence Erlbaum Associates, 2002. 244 p. LB2369 .M38 2002.

Style Manuals

17.6. *The MLA style manual* / Walter S. Achtert and Joseph Gibaldi. New York: Modern Language Association, 1985. 271 p. PN147 .A28 1985. See also: *MLA handbook for writers of research papers, theses, and dissertations*. New York: Modern Language Association, 1985. 163 p.

17.7. *A manual for writers of term papers, theses and dissertations* / Kate L. Turabian. 6 ed. Chicago: University of Chicago Press, 1996. 308 p. LB2369 .T8 1987.

17.8. *Preparation of archival copies of theses and dissertations* / Jane Boyd and Don Etherington. Chicago: American Library Association, 1986. 15 p. Z701 .B79 1986. Provides standards for the physical production of a thesis, including mounting photographs, binding specifications, and oversized material.

17.9. *University of Pennsylvania doctoral dissertation manual* / Office of Graduate Studies for the Graduate Council of the Faculties, 2009. http://www.upenn.edu/provost/dissertation_manual.

CATALOGS OF DISSERTATIONS AND THESES

17.10. *Proquest dissertations and theses fulltext.* Indexing (since 1861) and abstracting (since 1980) for doctoral-level dissertations completed at North American universities. Page images or full-text pdf of all available dissertations from 1997 to the present. Of the more than 2.3 million dissertations and theses cited in the database, over 925,000 dissertations are available for download: citations to master's theses from 1962 to date and abstracts available from 1988 to date. Formerly known as *Digital dissertations, Dissertation abstracts, UMI, DAI, ProQuest dissertations and theses (PQDT)*, and *Proquest dissertations and theses fulltext.* http://www.proquest.com/en-US/catalogs/databases/detail/pqdt.shtml.

17.11. *Guide to the availability of theses* / D. H. Borchardt and J. D. Thawley. Munich; New York: K. G. Saur, 1981. 443 p. LB2381 .B68 1981. Worldwide in scope, this guide is arranged by nation and then by name of institution. Provides such information as types of theses deposited, availability of interlibrary loan, and lists of publications that include the institution's theses and dissertations. For each country, the national list of theses and dissertations is described. Supplemented by: *Guide to the availability of theses: II. Non-university institutions* / G. G. Allen and K. Deubert. Munich; New York: K. G. Saur, 1984. 124 p. LB2381 .AS5 1984.

17.12. *Guide to bibliographies of theses, United States and Canada* / Thomas R. Palfrey and Henry E. Coleman. 2 ed. Chicago: American Library Association, 1940. 54 p. Z5055 .U49 P3 1940.

17.13. *Guide to lists of master's theses* / Dorothy M. Black. Chicago: American Library Association, 1965. 144 p. Z5055 .U49 B55 1955.

17.14. *Guide to theses and dissertations: an international bibliography of bibliographies* / Michael M. Reynolds. rev. ed. Phoenix: Oryx Press, 1985. 263 p. Z5053 .A1 R49 1985. Arrangement is by broad subject category. Extensive subject, name, and institution indexes are included, and the work is meant to be comprehensive. It is especially useful for listings in journals and hard-to-find institutional lists. Helpful annotations are included. Supplemented by: *Bibliographic index.* Z1002 .B595.

Classical Studies

17.15. *A bibliography of dissertations in Classical studies; American, 1964–1972; British, 1964–1972; with a cumulative index, 1961–1972.* Hamden: Shope String Press, 1976. 296 p. PA91 .T52 1976.

Middle East

17.16. *American doctoral dissertations on the Arab world, 1883-1968* / George D. Selim. Washington: Library of Congress, 1970. 103 p. Z3013 .S43 1970; Z3013 .S43. Continued by: *American doctoral dissertations on the Arab world, 1883-1974* / George D. Selim. 2 ed. Washington: Library of Congress, 1976. 173 p. Z3013 .S43 1976; DS36.7 S44 1976. Continued by: *American doctoral dissertations on the Arab world. Supplement, 1975-1981* / George D. Selim. Washington: Library of Congress, 1983– . Z3013 .S43 1976 Suppl. 1–2; DS36.7 .S44 1976 suppl. 1–2.

17.17. *Der Vordere Orient in den Hochschulschriften Deutschlands, Österreichs und der Schweiz: e. Bibliogr. von Diss. u. Habil.-Schr. (1885-1978)* / Klaus Schwarz. Freiburg im Breisgau: Schwarz, 1980. 721 p. DS44 .S38.

17.18. *Dix ans de recherche universitaire française sur le monde arabe et islamique, de 1968-69 à 1979* / Association française des arabisants. Paris: Editions Recherche sur les civilisations, 1982. 438 p. DS44 .D59 1982.

17.19. *Index Libanicus* / Maurice Saliba. Antélias, Lebanon: Saliba, 1979– . 3 v. Z3466 .S24 1979.

INTERNATIONAL DISSERTATIONS

17.20. *Networked digital library of theses and dissertations.* Electronic theses and dissertations from approximately 200 international member universities and institutions. http://www.ndltd.org.

Canada

17.21. *AMICUS.* A free catalog listing the holdings of 1,300 libraries across Canada; contains over thirty million records for books, magazines, newspapers, government documents, theses, sound recordings, maps, and electronic texts as well as items in braille and large print. http://www.collections-canada.gc.ca/amicus/index-e.html.

17.22. *Theses Canada portal.* Full-text e-versions of Canadian dissertations and theses, 1998 to August 31, 2002. http://www.collectionscanada.gc.ca/thesescanada/index-e.html.

France

17.23. *Atelier National de reproduction des theses* (ANRT), 1970– . Catalog of the official French distribution center for dissertations issued by French universities in the humanities, social sciences (including law), and the arts. http://www.diffusiontheses.fr/.

17.24. *Dix ans de recherche universitaire française sur le monde arabe et islamique, de 1968-69 à 1979* / Association française des arabisants. Paris: Editions Recherche sur les civilisations, 1982. 438 p. DS44 .D59 1982. French language dissertations on the Middle East.

17.25. *Inventaire des thèses de doctorat soutenues devant les universités françaises* / Ministère de l'éducation nationale. Paris: Université de Paris I, Bibliothèque de la Sorbonne, Direction des bibliothèques, des musées et de l'information scientifique et technique, 1982–1993. 1/yr. Z7403 .I68 (latest five years only); Z5055. F69 I59. Continues: *Catalogue des thèses de doctorat soutenues devant les universités françaises* / Ministère de l'Education Nationale. Paris: Cercle de la Librairie, 1960–1980. Z5055 .F78 and *Catalogue des thèses et écrits académiques* / Ministère de l'Instruction Publique. Paris: Librairie Hachette et Cie, 1885–1958. Z5055 .F78.

Germany

17.26. *Deutschsprachige Dissertationen zur alten Geschichte: 1844-1978* / Hans-Joachim Drexhage. Wiesbaden: Steiner, 1980. 142 p. Z6207.G7 D73.

17.27. *Dissertationes latinae: Europische Hochschulschriften des 16.-19. Jahrhunderts* / Christian Helfer. Saarbrücken: Verlag der Societas Latina, Universitat des Saarlandes, 1994. Z5053 .H45 1994.

17.28. *Jahresverzeichnis der an den deutschen Universitäten und technischen Hochschule erschienenen Scriften.* Berlin: Behrend, 1914–1923. 11 v. Z5055 .G39 B5. Continues: *Jahres-verzeichnisder an den Deutschen Universitäten erschienenen Schriften.* Berlin: A. Asher, 1887–1913. 28 v. Z5055 .G39 B5.

17.29. *Der Vordere Orient in den Hochschulschriften Deutschlands, Österreichs und der Schweiz: e. Bibliogr. von Diss. u. Habil.-Schr. (1885-1978)* / Klaus Schwarz. Freiburg im Breisgau: Schwarz, 1980. 721 p. German language dissertations on the Middle East. DS44 .S38.

Great Britain

17.30. *Index to theses [UK and Ireland].* A comprehensive listing of theses with abstracts accepted for higher degrees by universities in Great Britain and Ireland since 1716, providing total bibliographic control of all theses ever produced by British and Irish universities. Abstracts are available for all theses from 1970 to the present. http://www.theses.com/.

17.31. *Index to theses with abstracts accepted for higher degrees by universities of Great Britain and Ireland and the Council for National Awards.* London: Aslib, 1986– . Z5055 .G69 A8. Continues: *Index to theses accepted for higher degrees by the universities of Great Britain and Ireland.* London: Aslib, 1950–1967. 17 v. Z5055 .G69 A8.

Switzerland

17.32. *Jahresverzeichnis der schweizerischen hochschulschriften; Catalogue des écrits academiques suisses.* Basel: Verlag der Universitätsbibliothek, 1898–1994. Z5055 .S89 J2.

Appendix 1
Library of Congress Classification Scheme

The Library of Congress Classification (LCC) is a system of library classification used by most research and academic libraries in the United States and several other countries. Most public libraries and small academic libraries, however, continue to use the older Dewey Decimal Classification (DDC).

Class	Subclass	Subject
A		General Works
	AC	Collections
	AE	Encyclopedias
	AG	Dictionaries and other reference works
	AI	Indexes
	AM	Museums; Collectors and collecting
	AN	Newspapers
	AP	Periodicals
	AS	Academies; Learned societies
	AY	Yearbooks; almanacs; directories
	AZ	History of scholarship
B		Philosophy, Psychology, Religion
	BC	Logic
	BD	Speculative philosophy
	BF	Psychology
	BH	Aesthetics
	BJ	Ethics
	BL	Religions; Mythology; Rationalism
	BM	Judaism
	BP	Islam; Bahaism; Theosophy, etc.
	BQ	Buddhism
	BR	Christianity
	BS	Bible
	BT	Doctrinal theology
	BV	Practical theology
	BX	Christian denominations
C		Auxiliary Sciences of History
	CB	History of civilization
	CC	Archaeology
	CD	Diplomics; Archives; Seals
	CE	Technical chronology; Calendar
	CJ	Numismatics
	CN	Inscriptions; Epigraphy
	CR	Heraldry

	CS	Genealogy
	CT	Biography
D		World History
	DA	Great Britain
	DAW	Central Europe
	DB	Austria; Liechtenstein; Hungry; Czechoslovakia
	DC	France; Andorra; Monaco
	DD	Germany
	DE	Greco-Roman world
	DF	Greece
	DG	Italy; Malta
	DH	Low Countries; Benelux Countries
	DJ	Netherlands (Holland)
	DJK	Eastern Europe
	DK	Russia; Soviet Union; Former Soviet Republics; Poland
	DL	Northern Europe; Scandinavia
	DP	Spain; Portugal
	DQ	Switzerland
	DR	Balkan Peninsula
	DS	Asia
	DT	Africa
	DU	Oceania (South Seas)
	DX	Gypsies
E		History of the Americas
F		History of the United States, and British, Dutch, French, and Latin America
G		Geography, Anthropology, Recreation
	GA	Mathematical geography; Cartography
	GB	Physical geography
	GC	Oceanography
	GE	Environmental sciences
	GF	Human ecology; Anthropogeography
	GN	Anthropology
	GR	Folklore
	GT	Manners and customs
	GV	Recreation; Leisure
H		Social Sciences
	HA	Statistics
	HB	Economic theory; Demography
	HC	Economic history and conditions
	HD	Industries; Land use; Labor
	HE	Transportation; Communications
	HF	Commerce
	HG	Finance
	HJ	Public finance
	HM	Sociology
	HN	Social history and conditions; Social problems; Social reform
	HQ	Family; Marriage; Women
	HS	Societies: Secret; Benevolent
	HT	Communities; Classes; Races
	HV	Social pathology; Social and public welofare; Criminology
	HX	Socialism; Communism; Anarchism
J		Political Science
	JA	Political science (general)
	JC	Political theory
	JF	Political institutions and public administration

	JJ	Political institutions and public administration (North America)
	JK	Political institutions and public administration (United States)
	JL	Political institutions and public administration (Canada, Latin America, etc.)
	JN	Political institutions and public administration (Europe)
	JQ	Political institutions and public administration (Asia, Africa, Australia, Pacific Area, etc.)
	JS	Local government; Municipal government
	JV	Colonies and colonization; Emigration and immigration; International migration
	JZ	International relations
K		Law in general, Comparative and uniform law, Jurisprudence
	KB	Religious law in general, Comparative religious law, Jurisprudence
	KBM	Jewish law
	KBP	Islamic law
	KBR	History of canon law
	KBS	Canon law of Eastern churches
	KBT	Canon law of Eastern Rite Churches in Communion with the Holy See of Rome
	KBU	Law of the Roman Catholic Church, The Holy See
	KD-KDK	United Kingdom and Ireland
	KDZ	America, North America
	KE	Canada
	KF	United States
	KG	Latin America, Mexico and Central America, West Indies, Caribbean area
	KH	South America
	KJ-KKZ	Europe
	KL-KWX	Asia and Eurasia, Africa, Pacific Area, and Antarctica
	KZ	Law of nations
L		Education (General)
	LA	History of education
	LB	Theory and practice of education
	LC	Special aspects of education
	LD	Individual institutions: United States
	LE	Individual institutions: America (except United States)
	LF	Individual institutions: Europe
	LG	Individual institutions: Asia, Africa, Indian Ocean islands, Australia, New Zealand, Pacific islands
	LH	College and school magazines and papers
	LJ	Student fraternities and societies, United States
	LT	Textbooks
M		Music
	ML	Literature on music
	MT	Instruction and study
N		Fine Arts
	NA	Architecture
	NB	Sculpture
	NC	Drawing; Design; Illustration
	ND	Painting
	NE	Print media
	NK	Decorative arts
	NX	Arts in general
P		Language and Literature; Philology; Linguistics
	PA	Greek language and literature; Latin language and literature
	PB	Modern languages; Celtic languages
	PC	Romanic languages
	PD	Germanic languages; Scandinavian languages
	PE	English language
	PF	West Germanic languages
	PG	Slavic languages and literatures; Baltic languages; Albanian language

	PH	Uralic languages; Basque language
	PJ	Oriental languages and literatures
	PK	Indo-Iranian languages and literatures
	PL	Languages and literatures of Eastern Asia, Africa, Oceania
	PM	Hyperborean, Native American, and artificial languages
	PN	Literature (General)
	PQ	French literature, Italian literature, Spanish literature, Portuguese literature
	PR	English literature
	PS	American literature
	PT	German literature; Dutch literature; Flemish literature since 1830; Afrikaans literature; Scandinavian literature; Old Norse literature: Old Icelandic and Old Norwegian; Modern Icelandic literature; Faroese literature; Danish literature; Norwegian literature; Swedish literature
	PZ	Fiction and juvenile belles lettres
Q		Science (General)
	QA	Mathematics
	QB	Astronomy
	QC	Physics
	QD	Chemistry
	QE	Geology
	QH	Natural history; Biology
	QK	Botany
	QL	Zoology
	QM	Human anatomy
	QP	Physiology
	QR	Microbiology
R		Medicine (General)
	RA	Public aspects of medicine
	RB	Pathology
	RC	Internal medicine
	RD	Surgery
	RE	Ophthalmology
	RF	Otorhinolaryngology
	RG	Gynecology and Obstetrics
	RJ	Pediatrics
	RK	Dentistry
	RL	Dermatology
	RM	Therapeutics. Pharmacology
	RS	Pharmacy and materia medica
	RT	Nursing
	RV	Botanic, Thomsonian, and Eclectic medicine
	RX	Homeopathy
	RZ	Other systems of medicine
S		Agriculture (General)
	SB	Horticulture; Plant propagation; Plant breeding
	SD	Forestry; Arboriculture; Silviculture
	SF	Animal husbandry; Animal science
	SH	Aquaculture. Fisheries; Angling
	SK	Hunting
T		Technology (General)
	TA	Engineering; Civil engineering (General)
	TC	Hydraulic engineering. Ocean engineering
	TD	Environmental technology. Sanitary engineering
	TE	Highway engineering. Roads and pavements
	TF	Railroad engineering and operation
	TG	Bridges

	TH	Building construction
	TJ	Mechanical engineering and machinery
	TK	Electrical engineering; Electronics; Nuclear engineering
	TL	Motor vehicles; Aeronautics; Astronautics
	TN	Mining engineering; Metallurgy
	TP	Chemical technology
	TR	Photography
	TS	Manufacturing engineering; Mass production
	TT	Handicrafts; Arts and crafts
	TX	Home economics
U		Military Science
	UA	Armies: Organization, distribution, military situation
	UB	Military administration
	UC	Military maintenance and transportation
	UD	Infantry
	UE	Cavalry; Armor
	UF	Artillery
	UG	Military engineering. Air forces
	UH	Other military services
V		Naval Science
	VA	Navies; Organization, distribution, naval situation
	VB	Naval administration
	VC	Naval maintenance
	VD	Naval seamen
	VE	Marines
	VF	Naval ordnance
	VG	Minor services of navies
	VK	Navigation; Merchant marine
	VM	Naval architecture; Shipbuilding; Marine engineering
Z		Books (General); Writing; Paleography; Book industries and trade; Libraries; Bibliography
	ZA	Information resources (General)

Appendix 2
Graduate Programs in Classics, Egyptology, and Near Eastern Studies

This appendix lists the web addresses for graduate programs in Classics, Egyptology, and Near Eastern studies. Special emphasis has been given to English-language programs in North America, Europe, and Australia.

DOCTORAL PROGRAMS

Ancient History

University of Auckland. www.arts.auckland.ac.nz/uoa/classics-and-ancient-history.

Ancient History and Mediterranean Archaeology

University of California, Berkeley. www.ahma.berkeley.edu/.

Ancient Near East Studies

University of Cambridge. www.ames.cam.ac.uk/anes/.

Ancient Near Eastern Civilizations (Arabic, Armenian, Hebrew, Iranian, Semitic, and Turkic)

University of California, Los Angeles. www.gdnet.ucla.edu/gasaa/majors/nela.html.

Ancient Studies

University of Liverpool. www.liv.ac.uk/study/postgraduate/research/faculty-of-humanities-and-social-sciences/school-of-histories-languages-and-cultures/ace/classics-mphil-phd/overview/.
University of Toronto. www.groups.chass.utoronto.ca/fine_arts/asp/.

Arabic Language, Literature, and Linguistics

Georgetown University. www.arabic.georgetown.edu/programs/grad/arabic/.

Arabic Studies

University of Leeds. www.leeds.ac.uk/arts/info/20051/arabic_and_middle_eastern_studies//.

Archaeology and Ancient History

Monash University, Melbourne. www.arts.monash.edu.au/archaeology/.
University College, London, Institute of Archaeology. www.ucl.ac.uk/prospective-students/graduate-study/prospectus/subjects/history.
University of Leicester. www2.le.ac.uk/departments/archaeology/.

Art and Archaeology of the Mediterranean World

University of Pennsylvania. www.sas.upenn.edu/aamw/.

Classical and Near Eastern Archaeology

Bryn Mawr College. www.brynmawr.edu/archaeology/.

Classical and Near Eastern Studies

University of Minnesota. http://cnes.cla.umn.edu/.

Classical Archaeology

University of Alberta. www.historyandclassics.ualberta.ca/en/GraduatePrograms/AreasofStudy/ClassicalArchaeology.aspx.

University of Oxford. www.arch.ox.ac.uk/graduate-classical-archaeology.html.

University of Swansea. www.swan.ac.uk/pgcourses/artsandhumanities/phdclassicalarchaeology/.

Classical Art and Archaeology

University of Michigan. www.lsa.umich.edu/ipcaa/.

Classical History

University of Birmingham. www.birmingham.ac.uk/schools/iaa/departments/classics/index.aspx.

Classical Languages and Literatures

University of Chicago. www.classics.uchicago.edu/graduate/classical-language-literature.

Classical Studies

Columbia University. www.classicalstudies.columbia.edu/.
Duke University. www.classicalstudies.duke.edu/.
Indiana University, Bloomington. www.indiana.edu/~classics/.
University of Michigan, Ann Arbor. www.lsa.umich.edu/classics/.
University of Missouri, Columbia. www.classics.missouri.edu/.
University of Pennsylvania. www.classics.upenn.edu/.
Washington University, St. Louis. www.classics.artsci.wustl.edu/.

Classics

Boston University. www.bu.edu/classics/.
Brown University. www.brown.edu/academics/classics/graduate-program/graduate-program.
Bryn Mawr College. www.brynmawr.edu/gradgroup/index.html.
Cambridge University (England). www.classics.cam.ac.uk/admissions/graduate_courses/.
Catholic University of America. www.greeklatin.cua.edu/.
City University of New York (CUNY). web.gc.cuny.edu/Classics/.
Columbia University. www.columbia.edu/cu/classics/program/graduate.html.
Cornell University. www.arts.cornell.edu/classics/graduate.asp.
Dalhousie University. www.classics.dal.ca/Educational%20Programs/Graduate_Degree_Prog.php.
Duke University. www.duke.edu/web/classics/graduate/index.html.
Florida State University. www.classics.fsu.edu/Program/Graduate-Program.

Fordham University. www.fordham.edu/academics/programs_at_fordham_/classical_languages_/graduate_program_5637.asp.
Harvard University. www.fas.harvard.edu/~classics/programs/graduate.html.
Indiana University. www.indiana.edu/~classics/.
Johns Hopkins University. www.classics.jhu.edu.
McMaster University. www.humanities.mcmaster.ca/~classics/graduate/index.html.
New York University. www.classics.as.nyu.edu/page/classics.gradprogram.
Ohio State University. www.greekandlatin.osu.edu/.
Oxford University (England). www.classics.ox.ac.uk/admissions/index.asp.
Pennsylvania State University. www.cams.psu.edu/.
Princeton University. www.princeton.edu/~classics/programs_graduate/index.html.
Rutgers University. www.classics.rutgers.edu/.
Stanford University. www.stanford.edu/dept/classics/home/Programs/programs_graduate.html.
State University of New York, Albany. www.albany.edu/undergraduate_bulletin/program_classics.html.
State University of New York, Buffalo. www.classics.buffalo.edu/programs/graduate/.
Tufts University. ase.tufts.edu/classics/.
University of Alberta. www.uofaweb.ualberta.ca/historyandclassics/graduate.cfm.
University of Arizona. www.classics.arizona.edu/graduate_program.
University of British Columbia. www.cnrs.ubc.ca/index.php?id=3738.
University of California, Berkeley. www.classics.berkeley.edu/programs/graduate/.
University of California, Irvine. www.humanities.uci.edu/classics/Tricampus/index.php.
University of California, Los Angeles (UCLA). www.humnet.ucla.edu/humnet/classics/programs/graduate.htm.
University of California, Riverside. www.classicalstudies.ucr.edu/about_us/index.html.
University of California, Santa Barbara. www.classics.ucsb.edu/graduate_study.php.
University of California, San Diego. www.ucsd.edu/catalog/curric/CLAS-gr.html.
University of Chicago. www.classics.uchicago.edu/graduate.
University of Cincinnati. www.classics.uc.edu/graduate/index.html.
University of Colorado, Boulder. www.colorado.edu/Classics/grad/index.html.
University of Florida. www.web.classics.ufl.edu/graduate.html.
University of Georgia. www.classics.uga.edu/.
University of Illinois at Urbana-Champaign. www.classics.uiuc.edu/programs/graduate/.
University of Iowa. www.lsa.umich.edu/classics/graduates/classicalstudies.
University of Kansas. www2.ku.edu/~classics/.

University of Kentucky. www.mcl.as.uky.edu/classics/graduate-studies.

University of Maryland, College Park. www.classics.umd.edu/grad.html.

University of Massachusetts, Amherst. www.umass.edu/classics/grad.htm.

University of Massachusetts, Boston. www.uiowa.edu/~classics/programs/graduate/graduate.html.

University of Melbourne. www.classics-archaeology.unimelb.edu.au/.

University of Michigan. www.lsa.umich.edu/classics/gradprogram.

University of Missouri-Columbia. www.classics.missouri.edu/grad/index.shtml.

University of North Carolina at Chapel Hill. www.classics.unc.edu/academics/graduate-programs-in-classics.

University of Otago. www.otago.ac.nz/classics/courses/postgraduate.html.

University of St. Andrew. www.st-andrews.ac.uk/classics/postgrads/index.shtml.

University of Southern California. www.cnes.cla.umn.edu/grad/.

University of Pennsylvania. www.classics.upenn.edu/programs/graduate/classical-studies ccat.sas.upenn.edu/anch/. (ancient history)

University of Pittsburgh. www.pitt.edu/~classics/gradprg.html.

University of Texas, Austin. www.utexas.edu/cola/depts/classics/Graduate/About.php.

University of Virginia. www.virginia.edu/classics/gradintro.html.

University of Washington, Seattle Campus. www.classics.washington.edu/.

University of Wisconsin, Madison. www.classics.lss.wisc.edu/.

Vanderbilt University. www.vanderbilt.edu/classics/graduate.

Yale University. www.yale.edu/classics/graduates.html.

Classics and Ancient History

University of Walesa, Swansea, Department of Classics and Ancient History. www.swan.ac.uk/classics/.

Classics and Egyptology

University of Liverpool, School of Archaeology, Classics and Egyptology. www.liv.ac.uk/sace/.

Egyptology

Brown University. www.brown.edu/academics/egyptology/.

Johns Hopkins University. www.neareast.jhu.edu/graduate/egyptology.

Macquarie University, Sydney, Australian Centre for Egyptology. www.mq.edu.au/research/centres_and_groups/the_australian_centre_for_egyptology/.

University of Birmingham. www.birmingham.ac.uk/students/courses/postgraduate/combined/iaa/egyptology.aspx.

University of California, Berkeley. www.nes.berkeley.edu/graduate_study.html.

University of California, Los Angeles. www.egyptology.ucla.edu/.

University of Liverpool. www.liv.ac.uk/sace/research/egypt/index.htm.

University of Memphis, Institute of Egyptian Art and Archaeology. www.memphis.edu/egypt/maprogram.php.

University of Toronto, Department of Near and Middle Eastern Civilizations. www.utoronto.ca/nmc/courses/egyptology.htm.

University of Swansea. www.swan.ac.uk/pgcourses/artsandhumanities/phdegyptology/.

Yale University. www.nelc.yale.edu/egyptological-institute.

Greek and Latin

Ohio State University. www.classics.osu.edu/.

Greek and Roman Studies

University of Victoria. www.web.uvic.ca/grs/web_pages/index.php.

Greek Archaeology

University of Birmingham. www.birmingham.ac.uk/students/courses/postgraduate/combined/iaa/greek-archaeology.aspx.

History and Classics

University of Edinburgh. www.ed.ac.uk/schools-departments/history-classics-archaeology.

Islamic Studies

McGill University. www.mcgill.ca/islamicstudies/.

University of Birmingham. www.birmingham.ac.uk/students/courses/postgraduate/taught/thr/islamic-studies.aspx.

University of Virginia. www.artsandsciences.virginia.edu/religiousstudies/graduate/areas/islamicstudies.html.

Islamic and Near Eastern Studies

Washington University, Saint Louis. www.jinelc.wustl.edu/graduate.

Jewish Studies

University of California, Berkeley, Graduate Theological Union. www.jewishstudies.berkeley.edu/.

Middle East and Mediterranean Studies

King's College, London. www.kcl.ac.uk/artshums/depts/mems/index.aspx.

Middle Eastern and Islamic Studies

Indiana University. www.indiana.edu/~islmprog/.
New York University. www.meis.as.nyu.edu/page/graduate.

Middle Eastern Studies

Harvard University. www.cmes.hmdc.harvard.edu/.
University of Manchester. www.alc.manchester.ac.uk/subjects/middleeasternstudies/.
University of Utah. www.mec.utah.edu/?pageId=59.

Near Eastern and Judaic Studies

Brandeis University. www.brandeis.edu/departments/nejs/.

Near Eastern Languages and Civilizations

Harvard University. www.nelc.fas.harvard.edu/icb/icb.do.
Yale University. www.nelc.yale.edu/.
Yale University. www.nelc.yale.edu/graduate-program.

Near Eastern Studies

Cornell University. www.neareasternstudies.cornell.edu/academics/graduate/index.cfm.
Johns Hopkins University. www.neareast.jhu.edu/graduate/.
New York University. www.anees.as.nyu.edu/page/home.
Princeton University. www.princeton.edu/nes/graduates/.
University of Arizona. www.grad.arizona.edu/live/programs/description/115.
University of California, Berkeley. www.neareastern.berkeley.edu/.
University of Michigan. www.lsa.umich.edu/neareast/graduatestudents/graduateadmissions.

Near Eastern Languages and Cultures

Ohio State University. www.nelc.osu.edu/.

Oriental Studies

University of London, School of Oriental and African Studies. www.soas.ac.uk/.
University of Oxford. www.orinst.ox.ac.uk/general/grad_subjects.html.

Semitic and Egyptian Languages and Literatures

Catholic University of America. www.semitics.cua.edu/graduateprograms.cfm.

MASTER'S PROGRAMS

Abrahamic Religions

King's College London. www.kcl.ac.uk/prospectus/graduate/abrahamic-religions.

Ancient Egyptian Culture

University of Swansea. www.swan.ac.uk/pgcourses/artsandhumanities/maancientegyptianculture/.

Ancient History

University of Arizona. classics.arizona.edu/graduate_program.
University of Auckland. www.arts.auckland.ac.nz/uoa/home/about/subjects-and-courses/ancient-history.
University of Liverpool. www.liv.ac.uk/sace/pgprosp/saah.htm.
University of St. Andrew. www.st-andrews.ac.uk/classics/prospective/ug/ancienthistory/.
University of Swansea. www.swan.ac.uk/classics/postgraduatestudy/.

Ancient History and Classical Culture

University of Swansea. www.swansea.ac.uk/artsandhumanities/artsandhumanitiesadmissions/classicsancienthistoryegyptology/postgraduatedegrees/taughtsmas/mainancienthistoryandclassicalculture/.

Ancient Mediterranean Cultures

Wilfrid Laurier University. www.wlu.ca/page.php?grp_id=296&p=10366.

Arabic Language, Literature, and Linguistics

Georgetown University. www.arabic.georgetown.edu/programs/grad/arabic/ma/.

Arabic Studies

University of Leeds. www.leeds.ac.uk/arts/info/20051/arabic_and_middle_eastern_studies/1011/postgraduate.

Archaeology of Rome and Its Provinces

University of Southampton. www.southampton.ac.uk/postgraduate/pgstudy/programmes/humanities/archaeology/ma_archaeology_rome_provinces.html.

Biblical Studies

University of California, Berkeley, Graduate Theological Seminary. www.gtu.edu/academics/areas/biblical-studies#m-a.

Classical/Ancient Art

Arizona State University. www.art.asu/edu/arthistory.

Boston University. www.bu.edu/ah/programs/graduate. html.

Brigham Young University. www.byu.edu/gradstudies/catalog/department.php?program=58.

Brown University. www.brown.edu/Departments/Art_Architecture/graduate/.

Bryn Mawr College. www.brynmawr.edu/gradgroup/historyofart/.

California State University, Long Beach. www.art.csulb. edu/index.php?section=academics-programs-AH.

Case Western Reserve University. www.cwru.edu/artsci/ arth/arth.html.

City University of New York Graduate Center. www.web. gc.cuny.edu/dept/arthi/.

Columbia University. www.columbia.edu/cu/arthistory/ html/dept_grad.html.

Duke University. www.duke.edu/web/art/phdprog/.

Emory University. www.arthistory.emory.edu/programs/ graduate.html.

Florida State University. www.fsu.edu/~arh/pages/graduate/.

Harvard University. www.fas.harvard.edu/~hoart/#.

Illinois State University. www.cfa.ilstu.edu/art/visual_culture/.

Indiana University, Bloomington. www.indiana. edu/~arthist/graduate/.

Johns Hopkins University. www.arthist.jhu.edu/grad-prog. html.

Louisiana State University. http://design.lsu.edu/artschool/ arthistory/program.html.

New York University, Institute of Fine Arts, Conservation Center. www.nyu.edu/gsas/dept/fineart/academics/ art_history.htm.

Northwestern University. www.wcas.northwestern.edu/ arthistory/graduate/index.htm.

Notre Dame University. www.nd.edu/~art/degrees/ma-ah. htm.

Pennsylvania State University. www.arthistory.psu. edu/?q=node/88.

Princeton University. www.princeton.edu/artandarchaeology/grad/.

Rice University. www.arthistory.rice.edu/content.aspx?id= 370&linkidentifier=id&itemid=370.

Rutgers University. www.arthistory.rutgers.edu/grad/.

San Francisco State University. www. ad.sjsu.edu/programs.php?page=programs/graduate&style=css/programs/graduate.

Syracuse University. http://finearts.syr.edu/graduate_artHistoryMA.html.

Temple University. www.temple.edu/tyler/programs/graddegrees.html.

Tufts University. http://ase.tufts.edu/art/programsGraduate. asp.

Tulane University. http://pandora.tcs.tulane.edu/art/degree. html.

University of California, Berkeley. http://ls.berkeley.edu/ dept/arthistory/graduate.html.

University of California, Irvine. http://www.humanities.uci. edu/visualstudies/.

University of California, Los Angeles. http://www.humnet. ucla.edu/humnet/arthist/the_program/graduate.html.

University of California, San Diego. http://visarts.ucsd.edu/ about/general.

University of California, Santa Barbara. http://www.arthistory.ucsb.edu/index.php?option=com_content&task=view&id=2&Itemid=4.

University of Chicago. http://arthistory.uchicago.edu/graduate/.

University of Cincinnati. http://www.daap.uc.edu/art/marthistory/.

University of Florida. http://www.arts.ufl.edu/art/Programs/ artHistory.asp.

University of Georgia. http://art.uga.edu/index.php?cat=22.

University of Illinois at Chicago. http://www.uic.edu/depts/ arch/ah/graduate.shtml.

University of Illinois at Urbana-Champaign. http://www.art. uiuc.edu/content/graduate/programs.

University of Iowa. http://www.art.uiowa.edu/art_history/ art_history.html?nav=overview.

University of Maryland. http://www.arthistory-archaeology. umd.edu/programs/grad.htm.

University of Massachusetts, Amherst. http://www.umass. edu/arthist/.

University of Memphis. http://deptart.memphis.edu/details. php?nav_id=92.

University of Michigan. http://www.lsa.umich.edu/histart/ grad.

University of Minnesota. http://arthist.umn.edu/grad/.

University of Missouri–Columbia. http://aha.missouri.edu/ programs.html.

University of Nebraska. http://www.unl.edu/art/masters. shtml.

University of North Carolina at Chapel Hill. http://www. webslingerz.com/depts/art/art_history/graduate/index.

University of Oregon. http://arthistory.uoregon.edu/index. cfm?mode=grad.

University of Pennsylvania. http://www.arthistory.upenn. edu/gradmain.htm.

University of Pittsburgh. http://www.haa.pitt.edu/graduate/ index.html.

University of St. Thomas. http://www.stthomas.edu/arthistory/graduate/.

University of Southern California. http://college.usc.edu/ ahis/home/.

University of Texas, Austin. http://www.finearts.utexas. edu/aah/art_history/graduate_program/index.cfm.

University of Utah. http://www.arthistory.utah.edu/g_intro. html.

University of Virginia. http://www.virginia.edu/art/artarch/.

University of Washington. http://art.washington.edu/index.php?id=388.

University of Wisconsin, Madison. http://arthistory.wisc.edu/graduate/index.htmlhttp://www4.uwm.edu/letsci/arthistory/grad.cfm.

Vanderbilt University. http://www.vanderbilt.edu/history-art/acad_grad.html.

Washington University in Saint Louis. http://www.artsci.wustl.edu/~artarch/sections/graduate/graduate_main.html.

Wayne State University. http://www.art.wayne.edu/art_history.php.

Williams College. http://www.williams.edu/gradart/.

Yale University. http://arthistory.yale.edu/graduate/.

Classical and Mediterranean Archaeology

Boston University. http://www.bu.edu/archaeology/graduate/.

Brown University, Joukowsky Institute for Archaeology and the Ancient World. http://brown.edu/Departments/Joukowsky_Institute/graduate/.

Bryn Mawr College. http://www.brynmawr.edu/gradgroup/archaeology/.

Cornell University. http://www.arts.cornell.edu/classics/Classicarxeo.asp.

Cornell University, Archaeology Intercollege Program. http://www.archaeology.cornell.edu/grad.html.

Florida State University. http://classics.fsu.edu/program/graduate_overview.html.

Harvard University. http://www.fas.harvard.edu/~classics/programs/graduate.html#Classical_Archaeology.

Johns Hopkins University. http://classics.jhu.edu/archive_site_2009/phdprogartandarchaeo.html.

New York University, Institute for the Study of the Ancient World. http://www.nyu.edu/isaw/graduateprogram.htm.

San Francisco State University. http://www.sfu.edu/~clas/?q=node/66.

Tufts University. http://ase.tufts.edu/classics/graduate/page3.html.

University of Alberta. www.uofaweb.ualberta.ca/historyandclassics/PhDClassicalArchaeology.cfm.

University of Arizona. www.classics.web.arizona.edu/ma_classical_archaeology.

University of British Columbia. http://www.cnrs.ubc.ca/index.php?id=3745.

University at Buffalo, State University of New York. http://www.classics.buffalo.edu/programs/graduate/.

University of California, Berkeley. http://classics.berkeley.edu/programs/graduate/.

University of California, Los Angeles. http://www.classics.ucla.edu/index.php/degreeprograms/grads.

University of California, Los Angeles, Interdepartmental Graduate Program in Archaeology. http://www.ioa.ucla.edu/archaeology-program.

University of Cincinnati. http://classics.uc.edu/index.php/graduate/gradarchaeology.

University of Michigan, Interdepartmental Program in Classical Art and Archaeology. http://www.umich.edu/~ipcaa/.

University of Minnesota. http://cnes.cla.umn.edu/grad/.

University of North Carolina. http://classics.unc.edu/grad/grad_description.html.

University of Pennsylvania, Interdisciplinary Graduate Group in Art and Archaeology of the Mediterranean World. http://www.sas.upenn.edu/aamw/program.

University of Tennessee. http://web.utk.edu/~classics/programs/ma_med.html.

University of Texas–Austin. http://www.utexas.edu/cola/depts/classics/Graduate/About.php.

Yale University, Council on Archaeological Studies. http://www.yale.edu/archaeology/.

Classical and Near Eastern Archaeology

University of British Columbia. http://www.cnrs.ubc.ca/index.php?id=3745.

Classical Archaeology

San Francisco State University. www.sfsuedu/~clas/?q=node/66.

Stanford University. www.stanford.edu/dept/classics/cgi-bin/web/programs/graduate-program.

Tufts University. www.ase.tufts.edu/classics/graduate study.

University of Alberta. www.historyandclassics.ualberta.ca/en/GraduatePrograms/AreasofStudy/ClassicalArchaeology.aspx.

University of Arizona. www.classics.arizona.edu/graduate_program.

University of Arizona. www.classics.web.arizona.edu/ma_classical_archaeology.

University of Oxford. www.arch.ox.ac.uk/graduate-classical-archaeology.html.

Classical Art and Archaeology

University of Colorado at Boulder. http://www.colorado.edu/Classics/grad/index.html.

University of Delaware. http://www.udel.edu/ArtHistory/grad.html.

Classical Humanities

University of Massachusetts, Amherst. www.umass.edu/classics/grad.htm.

University of Massachusetts, Boston. www.umb.edu/academics/cla/classics/grad/ma/.

Classical Philology

University of Arizona. classics.arizona.edu/graduate_program.

Classical Studies

Villanova University. www.villanova.edu/artsci/classical/graduate/.

Marshall University. www.marshall.edu/classical-studies/.

Classics

Boston College. www.bc.edu/content/bc/schools/cas/classics/graduate_program.html.

Hunter College. www.hunter.cuny.edu/classics/classics/graduate.

Memorial University of Newfoundland. www.mun.ca/classics/graduate.

Queen's University. www.queensu.ca/classics/index.html.

San Francisco State University. www.sfsu.edu/~clas/.

Texas Tech University. www.depts.ttu.edu/classic_modern/graduate/classics/.

Tufts University (Classics and Classics Archaeology). ase.tufts.edu/classics/graduatestudy.

Tulane University. www.tulane.edu/~classics/graduate.html.

University of Birmingham. www.birmingham.ac.uk/schools/iaa/departments/classics/postgraduate/index.aspx.

University of Edinburgh. www.ed.ac.uk/schools-departments/history-classics-archaeology/graduate-school/.

University of Georgia. www.classics.uga.edu/new/academic_programs/graduate.htm.

University of Kansas. www2.ku.edu/~classics/graduate.shtml.

University of Kentucky. www.uky.edu/AS/Classics/degrees.html.

University of Manitoba. crscalprod1.cc.umanitoba.ca/Catalog/ViewCatalog.aspx?pageid=viewcatalog&catalogid=60&chapterid=669&loaduseredits=False.

University of Nebraska. www.unl.edu/classics/.

University of Oregon. darkwing.uoregon.edu/~classics/programs/graduate/.

University of Texas, San Antonio. colfa.utsa.edu/pc/.

University of Western Ontario. www.uwo.ca/classics/index.html.

Washington University in St. Louis. classics.artsci.wustl.edu/graduate.

Wayne State University. www.clas.wayne.edu/unit-inner.asp?WebPageID=1751.

Yale University. www.yale.edu/classics/graduates_masters.html.

Egyptology

University of Liverpool. www.liv.ac.uk/sace/pgprosp/same.htm.

Greek

Boston College. www.bc.edu/content/bc/schools/cas/classics/graduate_program.html.

University of Georgia. www.classics.uga.edu/new/academic_programs/graduate.htm.

Greek and Latin

University of Vermont. www.uvm.edu/~classics/?Page=graduatehtmlandSM=gradsubmenu.html.

Greek and Roman Archaeology

University of Newcastle. www.ncl.ac.uk/postgraduate/courses/degree/greek-roman-archaeology.

Greek and Roman Art

Ohio State University. http://history-of-art.osu.edu/2_academics/graduate.php.

Islamic and Near Eastern Studies

Washington University in Saint Louis. jinelc.wustl.edu/graduate/masters_islamic.

Islamic Societies and Cultures

University of London. www.soas.ac.uk/nme/programmes/maislsoccult/.

Islamic Studies

McGill University. www.mcgill.ca/islamicstudies/category/tags/ma-islamic-studies.

University of Virginia. artsandsciences.virginia.edu/religiousstudies/graduate/areas/islamicstudies.html.

Judaic Studies

Jewish Theological Seminary. www.jtsa.edu/The_Graduate_School/Academics/The_MA_Degree.xml.

Latin

Boston College. www.bc.edu/content/bc/schools/cas/classics/graduate_program.html.

Kent State University. www.kent.edu/mcls/languageprograms/prog_classics.cfm.

University of Georgia. www.classics.uga.edu/new/academic_programs/graduate.htm.

University of Maryland, College Park. www.classics.umd.edu/grad.html.

University of Massachusetts, Amherst. www.umass.edu/classics/grad.htm.

Latin and Classical Humanities

Boston College. www.bc.edu/content/bc/schools/cas/classics/graduate_program.html.

Latin and Greek

University of Maryland, College Park. www.classics.umd.edu/grad.html.

Latin Pedagogy

University of Arizona. classics.arizona.edu/graduate_program.

Middle East and Mediterranean Studies

King's College, London. www.kcl.ac.uk/artshums/depts/mems/index.aspx.

Middle Eastern and Islamic Studies

New York University. meis.as.nyu.edu/object/middleeastern.1113.grad.progreq.ma.

Middle Eastern Studies

American University in Cairo. www.aucegypt.edu/gapp/mesc/Pages/default.aspx.
Harvard University. cmes.hmdc.harvard.edu/gradprograms/am.
University of Chicago. cmes.uchicago.edu/page/ma-program-middle-eastern-studies.
University of Manchester. www.alc.manchester.ac.uk/subjects/middleeasternstudies/postgraduatetaught/.
University of Utah. www.mec.utah.edu/?pageId=59.

Near Eastern and Judaic Studies

Brandeis University. www.brandeis.edu/departments/nejs/masters/nejsmasters.html.

Near Eastern Languages and Civilization

University of Washington. depts.washington.edu/nelc/graduate.html.

Near Eastern Languages and Cultures (Arabic, Hebrew, Persian, Turkish)

Ohio State University. nelc.osu.edu/academics/masters-program.

Near Eastern Studies

Johns Hopkins University. neareast.jhu.edu/graduate/.
New York University. neareaststudies.as.nyu.edu/page/ma.
Princeton University. www.princeton.edu/nep/graduate-introduction/.
University of Arizona. menas.arizona.edu/grads.

Roman Archaeology

University of Nottingham. www.nottingham.ac.uk/archaeology/research/historic/roman/index.aspx.

Semitic and Egyptian Languages and Literatures

Catholic University of America. semitics.cua.edu/graduateprograms.cfm.

POSTBACCALAUREATE PROGRAMS (CLASSICS)

Columbia University. www.columbia.edu/cu/classics/program/postbac.html.
Georgetown University. classics.georgetown.edu/postbac.html.
Loyola University Chicago. www.luc.edu/classicalstudies/postbacc.shtml.
University of California, Davis. classics.ucdavis.edu/postbac.
University of California, Los Angeles. www.classics.ucla.edu/index.php/post-baccalaureate-certificate-program.
University of Iowa. www.uiowa.edu/~classics/programs/postbacc/postbaccalaureate.html.
University of North Carolina at Chapel Hill. classics.unc.edu/academics/post-baccalaureate.
University of Pennsylvania. www.sas.upenn.edu/lps/postbac/classics.
University of Southern California. www.usc.edu/schools/college/clas/graduate/.
University of Texas at Austin. www.utexas.edu/cola/depts/classics/Graduate/About.php.
University of Toronto. www.chass.utoronto.ca/classics/neograd/graduatehome.php.
University of Virginia. www.virginia.edu/classics/classics.html.
University of Washington. depts.washington.edu/clasdept/graduate.html.
University of Wisconsin, Madison. classics.lss.wisc.edu/.
Vanderbilt University. www.vanderbilt.edu/AnS/Classics/grads.html.
Washington University in St. Louis. classics.artsci.wustl.edu/.
Yale University. www.yale.edu/classics/graduates.html.

Appendix 3
Archaeological Site Reports

This appendix of archaeological reports from Classical Mediterranean, Egypt, and the Near East is not comprehensive in scope but instead represents a highly selective and broad selection of site-based archaeological reports from the geographic area identified as the ancient world. The appendix is organized by modern political division (country) and then by region and/or archaeological site.

AFGHANISTAN

A3.1. *Italian archaeological researches in Asia: exhibition of discoveries of the missions in Pakistan and Afghanistan, 1956–1959* / Giorgio Gullini. Turin: Center for Excavations and Archaeological Research in Asia of Is.M.E.O. and Turin, 1960. 70, 39 p. 913.54 C324.2.

Ay Khanom

A3.2. *Le gymnase, architecture, ceramique, sculpture* / Serge Veuve. Paris: Diffusion de Boccard, 1987. 127 p. DS375.A95 F68 1973 6. An outpost Greek city (325 BCE) at the confluence of the Amu Darya and Kowkcheh rivers.

A3.3. *La trésorerie du palais hellénistique d'Aï Khanoum: l'apogée et la chute du royaume grec de bactriane* / Claude Rapin. Paris: Diffusion de Boccard, 1992. 463 p. DS375.A95 F68 1973.

Gandhara

A3.4. *Historical routes through Gandhara (Pakistan): 200 B.C.–200 A.D.* / Saifur Rahman Dar. Lahore: National College of Arts: Ferozsons, 2006. 292 p. DS392.G36. D37 2006. An ancient kingdom located in the Peshawar and Kabul River valleys and Pothohar Plateau of northern Pakistan and eastern Afghanistan.

Hadda

A3.5. *The fishporch* / Shahibye Mustamandy. S.l.: Information and Culture Ministry, Archaeology Institute, 1972. 21 p. A Greco-Buddhist site located near the Khyber Pass.

Kapisa

A3.6. *Untersuchungen zu den Gläsern und Gipsabgüssen aus dem Fund von Begram* / Michael Menninger. Würzburg: ERGON, 1996. 257 p. NK5107 .M46 1996. Also known as *Bagram*, a colony founded by Alexander the Great in the foothills of the Hindu Kush mountains and an important station in the Kapisayana wine trade.

Shahr-i Kohna

A3.7. *Excavations at Kandahar 1974 and 1975: the first two seasons at Shahr-i Kohna (Old Kandahar) conducted by the British Institute of Afghan Studies* / Anthony McNicoll and Warwick Ball. Oxford: Tempus Reparatum, 1996. 409 p. DS375.Q3 M35 1996. One of the major archaeological sites in central Asia, the original site of Kandahar (*Old Kandahar*), an important junction connecting India and Iran.

A3.8. *Excavations at Old Kandahar in Afghanistan, 1976–1978: conducted on behalf of the Society for South Asian Studies (Society for Afghan Studies): stratigraphy, pottery and other finds* / Svend W. Helms. Oxford: Archaeopress, 1997. 397 p. DS375.K36 H45 1997.

Shortugaï

A3.9. *Sondage préliminaire sur l'établissement protohistorique harappéen et post-harappéen*

de Shortugaï (Afghanistan du N.-E.) / H.-P. Francfort and M.-H. Pottier. Paris: Dépositaire A. Maisonneuve, 1978. DS374.T3 F72 1978a. An Indus civilization trading colony established by Greek colonists from Corfu and Corinth on the Oxus River near the lapis mines in northern Afghanistan.

AFRICA, NORTH

A3.10. *L'Afrique antique: histoire et monuments: Libye, Tunisie, Algérie, Maroc* / André Laronde. Paris: Tallandier, 2001. 223 p. DT167.L376 2001. North Africa includes Algeria, Egypt, Libya, Morocco, Sudan, Tunisia, and Western Sahara. The Sahara is a significant barrier between northern Africa and the rest of the continent to the extent that the maritime cultures (Phoenicians, Greeks, Romans) facilitated communication and migration and these cultures became closely connected to southwest Asia and Europe rather than to central or southern Africa. Over the years the region has been influenced by contact with Berbers, Nubians, Greeks, Phoenicians, Egyptians, Romans, and others.

A3.11. *Bauinschriften römischer Kaiser: Untersuchungen zu Inschriftenpraxis und Bautätigkeit in Städten des westlichen Imperium Romanum in der Zeit des Prinzipats* / Marietta Horster. Stuttgart: F. Steiner Verlag, 2001. 496 p. CN525.H67 2001.

A3.12. *The cities of Roman Africa* / Gareth Sears. Stroud; Gloucestershire: History Press, 2011. 159 p. DT170.S425 2011.

A3.13. *Los Foros romanos de las provincias occidentales*. Madrid: Ministerio de Cultura, Dirección General de Bellas Artes y Archivos, 1987. 236 p. NA312.F67 1987.

A3.14. *Platzanlagen nordafrikanischer Städte: Untersuchungen zum sogenannten Polyzentrimus in der Urbanistik der römischen Kaiserzeit* / Claudia Kleinwächter. Mainz: Verlag P. von Zabern, 2001. 386, 120 p. DT191.K54 2001.

A3.15. *The Romano-African domus: studies in space, decoration, and function* / Margherita Carucci. Oxford: Archaeopress, 2007. 289 p. NA3770. C37 2007.

A3.16. *Römische Villen in Nordafrika: Untersuchungen zu Architektur und Wirtschaftsweise* / Mareike Rind. Oxford: Archaeopress, 2009. 133 p. DT170.R56 2009.

A3.17. *Thermes romains d'Afrique du Nord et leur contexte méditerranéen: études d'histoire et d'archéologie* / Yvon Thébert. Roma: École Française de Rome, 2003. 733 p. D5.B4 fasc.315.

A3.18. *Ubique amici: mélanges offerts à Jean-Marie Lassère* / Christine Hamdoune. Montpellier: Université Paul Valéry-Montpellier III, Centre d'Études et de Recherches sur les Civilisations Antiques de la Méditerranée, 2001. 446 p. DT170.U25 2001.

ALBANIA

A3.19. *Archaeology Albania.* http://archaeology.about. com/od/albania/Albania_Archaeology.htm.

A3.20. *Archaeology in Albania.* http://webspace.webring.com/people/xa/albaland/.

A3.21. *Explorations in Albania, 1930–39: the notes of Luigi Cardini, prehistorian with the Italian Archaeological Mission* / Luigi Cardini. London: British School at Athens, 2005. 222 p. DR921. C37 2005.

A3.22. *Roma e l'Albania* / Domenico Mustilli. Roma: Edizioni Universitarie, 1940. 63 p. DR921.M87 1940.

Apollonia

A3.23. *Apollonia d'Illyrie: mission épigraphique et archéologique en Albanie* / Pierre Cabanes. Athènes: École Française d'Athènes; Rome: École Française de Rome, 2007. DR998.A66 A666 2007. An ancient Greek city in Illyria, founded in 588 BCE by Greek colonists from Corfu and Corinth, on a site originally occupied by Illyrians.

A3.24. *The complex of Tumuli 9, 10 and 11 in the Necropolis of Apollonia (Albania)* / Maria Grazia Amore. Oxford: Archaeopress, 2010. 878 p. DR998.A66 A46 2010.

Butrint

A3.25. *Butrint 3: excavations at the Triconch Palace* / William Bowden and Richard Hodges. Oxford, UK; Oakville: Oxbow Books for the Butrint Foundation, 2011. 382 p. DR998.B88 B68 2011. Originally a settlement within the ancient Epirus, Butrint was one of the major centers of the Greek Chaonians, with close contacts to the Corinthian colony on Corfu.

A3.26. *Butrinti helenistik dhe romak; Hellenistic and Roman Butrint* / Inge Lyse Hansen. London; Tirana: Butrint Foundation, 2009. 95 p. DR998. B88 H36 2009.

A3.27. *Byzantine Butrint: excavations and surveys 1994–1999* / Richard Hodges, William Bowden, and Kosta Lako. Oxford: Oxbow Books; Oakville:

David Brown, 2004. 424 p. DR998.B88 H63 2004.

A3.28. *Eternal Butrint: a UNESCO World Heritage Site in Albania* / Richard Hodges. London: General Penne, 2006. 255 p. DR998.B88 H639 2006.

A3.29. *Pagëzimorja e Butrintit dhe mozaikët e saj; the Butrint baptistery and its mosaics* / John Mitchell. London: Butrint Foundation, 2008. 95 p. DR998.B88 M58 2008.

A3.30. *Roman Butrint: an assessment* / Inge Lyse Hansen and Richard Hodges. Oxford: Oxbow Press for the Butrint Foundation, 2007. 214 p. DR998.B88 R66 2007.

A3.31. *Shkëlqimi dhe rënia e Butrintit bizantin; The rise and fall of Byzantine Butrint* / Richard Hodges. London: Butrint Foundation, 2008. 95 p. DR998.B88 H63 2008.

Phoinike

A3.32. *Phoinike III: rapporto preliminare sulle campagne di scavi e ricerche 2002–2003* / Sandro de Maria and Shpresa Gjongecaj. Bologna: Ante Quem, 2005. 250 p. DR998.P48 P47 2005. Poinike, or Phoenice, an ancient Greek city in Epirus and capital of the Chaonians, was the location of the Treaty of Phoenice, which ended the First Macedonian War; one of the wealthiest cities in Epirus until the Roman conquest.

A3.33. *Phoinike IV: rapporto preliminare sulle campagne di scavi e ricerche 2004–2006* / Sandro de Maria and Shpresa Gjongecaj. Bologna: Ante Quem, 2007. 255 p. DR998.P48 P4823 2007.

Saranda

A3.34. *Saranda, ancient Onchesmos: a short history and guide* / Richard Hodges. Tirane: Migjeni, 2007. 62 p. DR998.S37 H63 2007. Known as Onchesmos or Anchiasmos and inhabited by Chaonian Greeks, Saranda flourished as the port of the Phoenice (Finiq).

ALGERIA

A3.35. *Études d'épigraphie, d'archéologie et d'histoire africaines* / Louis Leschi. Paris: Arts et Métiers Graphiques, 1957. 441 p. 913.65 L568.

A3.36. *Villes do'r; villes, musées d Algérie*. Alger, 1951. 109 p. 916.5 AL32.

Afalou Bou Rhummel

A3.37. *Les cultures de l'homme de Mechta-Afalou: le gisement d'Afalou Bou Rhummel, massif des Babors, Algérie: les niveaux supérieurs, 13.000–11.000 B.P* / Slimane Hachi. Alger: C.N.R.P.A.H., 2003. 248 p. GN772.2.C3 H33 2003. An important late Pleistocene/Early Holocene archaeological site on the Algerian coast between Bedjaia and Jijel.

Cherchell

A3.38. *Caesarea de Maurétanie: une ville romaine et ses campagnes* / Philippe Leveau. Rome: École Française de Rome, 1984. 556 p. DT299.C5 L4 1984. Cherchell Lol or Jol was settled by Phoenicians from Carthage in the fourth century BCE; the town became part of the Berber kingdom of Numidia. The last Numidian king and his Greco-Ptolemaic wife were forced to flee because the king was too Romanized, causing civil unrest. Caesar Augustus intervened and divided the kingdom in to part of the Roman province of Africa Nova (Jol) and western Numidia and Mauretania (Iol, Caesaria, Caesarea). The kingdom of Mauretania became an important client state of the Roman Empire.

Constantine

A3.39. *Le sanctuaire punique d'El-Hofra à Constantine* / André Berthier and René Charlier. Paris: Arts et Métiers Graphiques, 1952–1955. 2 v. 913.65 B4681. A city, Sarim Batim, originally created by the Phoenicians and renamed Cirta by the Numidians, the Berber people, after the Phoenicians were defeated by Rome in the Third Punic War. The city later served as a base for Roman generals in the war against Jugurtha. Julius Caesar gave special rights to the citizens of Cirta, known as Colonia Sittlanorum.

Djorf Torba

A3.40. *Djorf Torba: nécropole saharienne antéislamique* / Michel Lihoreau. Paris: Editions Karthala, 1993. 135 p. GN865.A4 L48 1993. A pre-Islamic necropolis situated in the Saharan Guir valley, west of Colomb-Bechar.

Hippo

A3.41. *Hippone* / Xavier Delestre. Aix-en-Provence: Édisud; Paris: INAS, 2005. 256 p. DT299.H5 H57 2005. Hippo Regius, or Hippone, a major city in Roman Africa (modern Annaba).

Lambèse-Tazoult

A3.42. Lambèse-Tazoult. http://www.diplomatie.gouv.fr/fr/enjeux-internationaux/echanges-

scientifiques-recherche/archeologie-sciences-humaines-et/les-carnets-d-archeologie/europe-maghreb/algerie-lambese/.

Setif

A3.43. *La nécropole orientale de Sitifis (Sétif, Algérie): fouilles de 1966–1967* / Roger Guéry. Paris: Editions du Centre National de la Recherche Scientifique, 1985. 374 p. DT299.S48 G84 1985. Located in the Numidian region of Massaesyles in northern Algeria, Sitifis was founded by the Romans during the reign of Nerva as a colony for war veterans. The Romans built a circus at the site, and around 297 CE, the province of Mauretania Sitifensis was established, with Sitifis as its capital.

Thamugadi

A3.44. *L'album municipal de Timgad* / André Chastagnol. Bonn: Habelt, 1978. 109, 15 p. 99.T5 C44. An ancient Roman city located on the high plateau north of the Aures Mountains in northeastern Algeria.

Tiddis

A3.45. *Tiddis: cité antique de Numidie* / André Berthier. Paris: Diffusion de Boccard, 2000. 493 p. DT299.T46 B47 2000. Tiddis, or Castellum Tidditanorum, is an ancient Roman ruins located in northeastern Algeria. Unlike most Roman ruins, Tiddis was not built on flat ground but rather climbs up a hillside, with winding roads.

Tipasa

A3.46. *Le nymphée de Tipasa et les nymphées et septizonia nord-africains* / Pierre Aupert. Rome: École Française de Rome; L'Erma di Bretschneider, 1974. 167, 9 p. NA335.T62 A96. An ancient Punic trading post conquered by Rome and transformed into a strategic base for the conquest of the kingdoms of Mauritania.

A3.47. *Architecture romaine d'Afrique; recherches et mises au point* / Alexandre Lézine. Paris: Presses Universitaires de France, 1964. 153, 22 p. 913.3973 L599.

ARMENIA

Ani

A3.48. *Ani*. Milano: Edizioni Ares, 1984. 103 p. NA1474.D6 no.12. A ruined medieval Armenian city-site located in the Turkish province of Kars.

It was once the capital of an extensive Armenian kingdom that covered much of modern Armenia and eastern Turkey.

A3.49. *Ani 2004: indagini sugli insediamenti sotterranei; Surveys on the underground settlements* / Roberto Bixio. Oxford: Archaeopress, 2009. 82 p. DS51.A54 A55 2009.

A3.50. *Récit des malheurs de la nation arménienne* / Aristakès de Lastivert. Bruxelles: Byzantion, 1973. 148 p. DS186 .A714.

Metsamor

A3.51. *Metsamor 2. La necropole*. Neuchâtel; Paris: Recherches et Publications, Academie Nationale des Sciences d'Arménie, Institut d'Archéologie et d'Ethnographie, 1995. GN778.A7 M48 1995. A large urban complex, nearly 200 hectares in extent and including metallurgical processing and astronomical activities, was occupied ca. 50,000 BCE–1700 CE.

Tsaghkahovit Plain

A3.52. *Foundations of research and regional survey in the Tsaghkahovit Plain, Armenia* / Adam T. Smith, Ruben S. Badalyan, and Pavel Avetisyan. Chicago: Oriental Institute of the University of Chicago, 2009. 410 p. GN780.22.A76 S65 2009. There are many Urartian archaeological sites currently being excavated in the Aragatsotn province of Armenia.

AUSTRIA

A3.53. *Das römische Österreich* / Peter Pleyel. Wien: Pichler, 2002. 192 p. DB29.P64 2002.

Aguntum

A3.54. *Die Skulpturen der Stadtgebiete von Aguntum und von Brigantium* / Norbert Heger. Wien: Verlag der Österreichischen Akademie der Wissenschaften, 1987. 69, 15 p. A Roman site in the Drau valley of east Tirol built to exploit local copper, gold, iron, and zinc sources.

Aquileia

A3.55. *Roma sul Danubio: da Aquileia a Carnuntum lungo la via dell'ambra* / M. Buora and W. Jobst. Roma: L'Erma di Bretschneider, 2002. 308 p. DG70.A6 R66 2002. An ancient Roman city in Italy located about 10 kilometers from the Adriatic Sea.

Bregenz

A3.56. *Das römische Gräberfeld von Bregenz Brigantium* / Michaela Konrad. München: Beck, 1997. DB879.B5 K66 1997. In the fifth century BCE the Celts settled at Brigantion, a fortified site. The Romans conquered the site in 15 BCE, and it became a Roman camp. The site was later destroyed by the Alemanni, a Germanic people.

Carinthia

A3.57. *Die Römersteinsammlung des Landesmuseums für Kärnten* / Gernot Piccottini. Klagenfurt: Verlag des Geschichtsvereines für Kärnten, 1996. 223 p. DB290.L36 1996. The southernmost Austrian state (Land) noted for its mountains and lakes.

A3.58. *Die Rundmedaillons und Nischenporträts des Stadtgebietes von Virunum* / Gernot Piccottini. Wien: H. Böhlau, 1972. 55, 43 p. NB118.A9 C67 Bd.2 Fasc.2.

Carnuntum

A3.59. *Archäometrische Untersuchungen zur Keramikproduktion in Carnuntum* / Verena Gassner and Roman Sauer. Wien: Verlag der Österreichischen Akademie der Wissenschaften, 1991. 19 p. DB29. A5 hft.37. A Roman army camp located in Lower Austria on the Danube River in the Noricum province between Vienna and Bratislava.

A3.60. *Das Auxiliarkastell Carnuntum.* Wien: Österreichisches Archäologisches Institut, 1997. DB879.C3 A99 1997.

A3.61. *Die Bauperioden der antiken Bäder von Karnuntum* / Hedwig Gollob. Erlangen: Deutsches Institut für Merowingischkarolingische Kunstforschung, 1956. 16 p. 706 D4899 hft.13 1956.

A3.62. *Carnuntum im 18. Jahrhundert: ein archäologisch-numismatischer Bericht des Obersten von Below* / Wilhelm Kubitschek and Franziska Dick. Wien: Verlag der Österreichischen Akademie der Wissenschaften, 1979. 74, 22 p. AS142 .V31 Bd.349.

A3.63. *Das Heidentor von Petronell-Carnuntum: ein Führer* / Werner Jobst. Wien: Verlag der Österreichischen Akademie der Wissenschaften, 2002. 64 p. NA9340.C37 H44 2002.

A3.64. *Das Heiligtum des Jupiter Optimus Maximus auf dem Pfaffenberg/Carnuntum* / Werner Jobst. Wien: Verlag der Österreichischen Akademie der Wissenschaften, 2003. 2 v. DB879.C3 H45 2003.

A3.65. *Juni 172 n. Chr.: der Tag des Blitz- und Regenwunders im Quadenlande* / Werner Jobst. Wien: Verlag der Östereichischen Akademie der Wissenschaften, 1978. 35, 14 p. AS142.V31 Bd.335.

A3.66. *Legionslager Carnuntum: Ausgrabungen 1968– 1977* / Christian Gugl and Raimund Kastler. Wien: Verlag der Österreichischen Akademie der Wissenschaften, 2007. 554 p. DB879.C3 L44 2007.

A3.67. *Numismata Carnuntina: Forschungen und Material; die antiken Fundmünzen in Museum Carnuntinum* / Michael Alram and Franziska Schmidt-Dick. Wien: Verlag der Österreichischen Akademie der Wissenschaften, 2007. 3 v. + 1 CD-ROM. AS142 .V32 Bd.353.

A3.68. *Pannonische Glanztonware aus dem Auxiliarkastell von Carnuntum: Ausgrabungen der Jahre 1977–1988* / Kristina Adler-Wölfl. Wien: Österreichisches Archäologisches Institut, 2004. 192 p. DB879.C3 A35 2004.

A3.69. *Die Reliefs des Stadtgebietes von Carnuntum* / Marie-Louise Krüger. Wien: Böhlau in Komm., 1970–1972. 2 v. NB118.A9 C67 Bd.1 fasc.3–4.

A3.70. Die *römischen Lampen aus Carnuntum* / Eva Alram-Stern. Wien: Verlag der Österreichischen Akademie der Wissenschaften, 1989. 332, 48 p. DB29 .A5 hft.35.

A3.71. *Der römische Tempelbezirk auf dem Pfaffenberg/ Carnuntum: Ausgrabungen, Funde, Forschungen; The Roman temple district of Pfaffenberg/ Carnuntum* / Werner Jobst. Klagenfurt: JOBST-Media, 2006. 110 p. DB879.C3 J62 2006.

A3.72. *Die Rundskulpturen des Stadtgebietes von Carnuntum* / Marie-Louise Krüger. Wien: H. Böhlau, 1967. 48 p. NB118.A9 C67 Bd.1 fasc.2.

A3.73. *Untersuchungen zu den Gräberfeldern in Carnuntum* / Christine Ertel. Wien: Verlag der Österreichischen Akademie der Wissenschaften, 1999. DB879.C3 U5 1999, Bd.1.

Danube River

A3.74. *Römer an Donau und Iller: Neue Forschungen und Funde: Begleitpublikation zur Ausstellung . . . Ulmer Museum 23. Juni-6. Oktober 1996* / Brigitte Reinhardt and Kurt Wehrberger. Sigmaringen: J. Thorbecke; Ulm: Das Museum, 1996. 167 p. DD784.5.R66 1996. The Danube, once a long-standing frontier of the Roman empire, is a river in Central Europe that originates in the Black Forest of southern Germany and empties into the Black Sea at the Danube delta in Romania and Ukraine.

Flavia Solva

A3.75. *Fibeln von Flavia Solva aus Privatbesitz* / Walter Kropf and Heinz Nowak. Wien: Osterreichische Gesellschaft für Archäologie, 2000. 167, 79 p.

DB690 .K76 2000. The only Roman city in the modern Austrian province of Styria.

A3.76. *Die Porträtmedaillons und Porträtnischen des Stadtgebietes von Flavia Solva* / Erwin Pochmarski. Wien: Verlag der Osterreichischen Akademie der Wissenschaften, 2011. 127, 53 p. NB118.A9 C67 Bd.4. fasc.2.

Kapfenstein

A3.77. *Das Gräberfeld von Kapfenstein (Steiermark) und die römischen Hügelgräber in Österreich* / Otto H. Urban. München: C. H. Beck, 1984. 304, 66 p. DB879.K26 U7 1984. A municipality in the Feldbach district, Styria, Austria.

Magdalensberg

A3.78. *Römischen Gläser vom Magdalensberg* / Barbara Czurda-Ruth. Klagenfurt: Verlag des Landesmuseums fur Kärnten, 1979. 263, 13 p. AM101. K246 nr.65. An ancient trading center consisting of an administrative center (oppidum) on the summit of a mountain and a Roman trading colony below.

Noricum

A3.79. *Italische Terra Sigillata mit Appliken in Noricum* / Eleni Schindler Kaudelka, Ulrike Fastner, and Michael Gruber. Wien: Verlag der Österreichischen Akademie der Wissenschaften, 2001. 205, 105 p. + CD-ROM. AS142.V32 Bd.298. Noricum was an ally and a trading partner of Republican Rome; valued for its gold, iron, and agricultural produce.

Styria

A3.80. *Michlhallberg: die Ausgrabungen in der römischen Siedlung 1997–1999 und die Untersuchungen an der zugehörigen Strassentrasse* / Gerald Grabherr. Bad Aussee: Verein der Freunde des Kammerhofmuseums, 2001. 391 p. DB160.M53 2001. In early Roman times Styria was inhabited by Celtic tribes; after its conquest by the Romans, the eastern area of Styria was part of Pannonia, and the eastern area was part of Noricum.

Virunum

A3.81. *Virunum: das römische Amphitheater: die Grabungen, 1998–2001* / Renate Jernej and Christian Gugl. Klagenfurt: Wieser Verlag, 2004.

536 p. DB290.V57 2004. Virunum was founded by Emperor Claudius as the capital of the province of Noricum on the commercial route between the Adriatic and the Danube.

BAHRAIN

A3.82. *An archaeological guide to Bahrain* / Rachel MacLean and Timothy Insoll. Oxford: Archaeopress, 2011. 162 p. DS247.B23 M32 2011.

A3.83. *Search for the paradise land: an introduction to the archaeology of Bahrain and the Arabian Gulf, from the earliest times to the death of Alexander the Great* / Michael Rice. London; New York: Longman, 1985. 298 p. DS247.B23 R53 1985.

Barbar

A3.84. *The Barbar temples* / H. Hellmuth Andersen and Flemming Højlund. Hoejbjerg: Jutland Archaeological Society: Moesgaard Museum; Bahrain: Ministry of Information; Aarhus: Aarhus University Press, 2003. 2 v. DS247.B23 A64 2003, v.1, 2. An archaeological site located in the village of Barbar and considered to be derived from the Dilmun culture; temple structures to 3000 BCE.

A3.85. *The temple complex at Barbar, Bahrain: a description and guide.* Manama: Ministry of Information, State of Bahrain, 1985. 48 p. DS247.B23 T46 1985.

Madinat Hamad

A3.86. *Skeletons and social composition: Bahrain 300 BC–AD 250* / Judith Littleton. Oxford: Archaeopress, 1998. 154 p. DS247.B23 L57 1998. A settlement in northern Bahrain.

Muharraq

A3.87. *Arad Fort, Bahrain: its restoration, its history, and defences* / Archibald G. Walls. Bahrain: Directorate of Tourism and Archaeology, Ministry of Information, State of Bahrain, 1987. 113 p. DS247.B23 W24 1987. An ancient seafaring site that came to prominence during the era of Tylos when Bahrain was dominated by the Selucid Greeks.

Qalat al Ajaj, tell

A3.88. *The central monumental buildings* / Flemming Højlund and H. Hellmuth Andersen. Aarhus:

Jutland Archaeological Society; Aarhus University Press, 1997. 288 p. DS247.B23 Q35 1994 v.2. An archaeological site on the Arabian peninsula with Kassite, Persian, and Portuguese occupations. It was the capital of the Dilmun civilization.

A3.89. *Fouilles à Qal'at al-Bahrain; Excavation of Qal'at al-Bahrein* / Monik Kervran, Arlette Negre, and Michele Pirazzoli t'Sertsevens. Bahrain: Ministère de l'information, Direction de l'archéologie et des musées, Etat de Bahrein, 1982. DS247.B23 K41 1982, v.1.

A3.90. *The northern city wall and the Islamic fortress* / Flemming Hojlund and H. Hellmuth Andersen. Moesgaard: Jutland Archaeological Society; Aarhus: Aarhus University Press, 1994. 511 p. DS247.B23 Q35 1994 v.1.

A3.91. *Qala'at al-Bahrain.* Aarhus: Jutland Archaeological Society, 1994. DS247.B23 Q35 1994.

A3.92. *Qalat al-Bahrain: a trading and military outpost 3rd millennium B.C.–17th century A.D.* / Monique Kervran, Fredrik Hiebert, and Axelle Rougeulle. Turnhout: Brepols, 2005. 426 p. DS247.B23 K479 2005.

Sar al-Jisr

A3.93. *Excavations of the Arab expedition at Sar el-Jisr, Bahrain* / Moawiyah Ibrahim. Manamah: State of Bahrain, Ministry of Information, 1982. 224, 76 p. DS247.B23 I27 1982.

Saar

A3.94. *Early Dilmun seals from Saar: art and commerce in Bronze Age Bahrain* / Harriet Crawford. Ludlow: Archaeology International, 2001. 111 p. CD6365.B26 C72 2001. A temple site constructed during the Dilmun era; the temple was believed to have a role in marking the summer solstice.

A3.95. *The early Dilmun settlement at Saar* / Robert Killick and Jane Moon. Ludlow: Archaeology International, 2005. 367 p. DS247.B23 E27 2005.

BAHRAIN AND QATAR

A3.96. *Excavations in Bahrain and Qatar, 1987/8* / A. Konishi Masatoshi, Gotoh Takeshi, and Akashi Yoshihiko. Tokyo: Japanese Archaeological Mission to the Arabian Gulf, Rikkyo University, 1989. 22, 28 p. DS247.B23 K66 1989.

BALKAN PENINSULA

A3.97. *Before Knossos: Arthur Evans's travels in the Balkans and Crete* / Ann Brown. Oxford: University of Oxford, Ashmolean Museum, 1993. 96 p. DR16 .B76 1993.

Adriatic Coast

A3.98. Adriatic Islands Project. http://www.scribd.com/doc/27909939/Adriatic-Islands-Project. The Adriatic Sea is a body of water separating the Apennine peninsula of Italy from the Balkan peninsula and the Apennine Mountains from the Dinaric Alps and adjacent ranges. The earliest settlements on the Adriatic coast were Etruscan, Illyrian, and Greek. The area was under Roman Republican control by the second century BCE.

A3.99. *Ancient shipwrecks of the Adriatic: maritime transport during the first and second centuries AD* / Mario Jurisic. Oxford: Archaeopress, 2000. 169 p. DR1350.A35 J87 2000.

BELGIUM

A3.100. *Atlas des agglomérations secondaires de la Gaule Belgique et des Germanies* / Jean-Paul Petit and Michel Mangin. Paris: Errance, 1994. 292 p. DC63.A85 1994.

A3.101. *Les barbares de l'Occident romain: corpus des Gaules et des provinces de Germanie* / Hélène Walter. Paris: Diffusion les Belles lettres, 1993. 149, 52 p. DC63.W35 1993.

A3.102. *La Belgique au temps de Rome: des tribus celtiques au royaume franc* / A. Wankenne. Namur: Presses universitaires de Namur, 1979. 136, 16 p. DH574.W36.

A3.103. *La Belgique romaine.* Dijon, France: Éditions Faton, 2006. 141 p. CC3.H478 no.315.

A3.104. *De Belgische kustvlakte in de Romeinse tijd: bijdrage tot de studie van de landelijke bewoningsgeschiedenis* / Hugo Thoen. Brussel: Paleis der Academiën, 1978. 255 p. AS242.B624 nr.88. Includes English language summary.

A3.105. *Evolution de l'économie alimentaire et des pratiques d'élevage de l'antiquité au haut moyen age en Gaul du nord: une étude régionale sur la zone limoneuse de la moyenne Belgique et du sud des Pays-Bas* / Fabienne Pigière. Oxford: Archaeopress, 2009. 276 p. + 1 CD-ROM. DH451.P54 2009.

A3.106. *La Gaule septentrionale au Bas-Empire: occupation du sol et défense du territoire dans l'arrière-pays du Limes aux IVe et Ve siècles; Nordgallien*

in der Spätantike / Raymond Brulet. Trier: Selbstverlag des Rheinischen Landesmuseums Trier, 1990. 431 p. DH146.B78 1990.

A3.107. *Römisches Germanien: zwischen Rhein und Maas; die Provinz Germania Inferior* / Tilmann Bechert. München: Hirmer, 1982. 290p. DG59. G4 B38 1982.

Izel

A3.108. *La Tour Brunehaut a Izel-Pin* / G. Hossey. Bruxelles: Service National des Fouilles, 1981. 31, 2 p. DH811.I94 H68 1981.

BLACK SEA

A3.109. *Der Achilleus-Kult im nördlichen Schwarzmeerraum vom Beginn der griechischen Kolonisation bis in die römische Kaiserzeit: Beiträge zur Akkulturationsforschung* / Joachim Hupe. Rahden: M. Leidorf, 2006. 270, 58 p. DJK64.A29 2006. The Black Sea was an important waterway at the crossroads of the ancient world: the Balkans to the West, the Eurasian steppes to the north, Caucasus and Central Asia to the East, Asia Minor and Mesopotamia to the south, and Greece to the southwest.

A3.110. *Arkhaicheskii Torik, antichnyigorod na severovostoke Ponta* / N. A. Onaiko. Moskva: Izd-vo "Nauka," 1980. 179 p. DK509.O5.

A3.111. *North Pontic archaeology: recent discoveries and studies* / Gocha R. Tsetskhladze. Leiden; Boston: Brill, 2001. 530 p. DJK74.N67 2001.

A3.112. *Römische Importe in sarmatischen und maiotischen Gräbern zwischen Unterer Donau und Kuban* / Aleksandr Simonenko, Ivan I. Marcenko, and Natal'ja Ju. Limberis. Mainz: Philipp von Zabern, 2008. 400, 222 p. DJK64.R68 2008.

Neapolis Scythica

A3.113. *The Scythian Neapolis (2nd century BC to 3rd century AD): investigations into the Graeco-Barbarian city on the northern Black Sea Coast* / Yurij P. Zaytsev. Oxford: Archaeopress, 2004. 225 p. DK34.S4 Z35 2004. Hellenized Scythians created a kingdom in Crimea, its capital Neapolis Scythica, and dominated western Crimea until the time of Mithridates Eupator.

BOSNIA HERCEGOVINA

A3.114. *Anticka naselja i komunikacije u Bosni i Hercegovini* / E. Pasalic. Sarajevo: Zemaljski Muzej, 1960. 118 p. 913.497 P262.

Narona

A3.115. *Corpus inscriptionum Naronitanarum* / Emilio Marin. Tivoli (Roma): Tipigraf; Macerata: Università degli studi di Macerata, 1999. CN695. C87 C67 2000. An ancient Roman city located in the Neretva valley in modern Croatia; was part of the Roman province of Dalmatia.

A3.116. *Zur Geschichte und Topographie von Narona* / Carl Patsch. Wein: In Kommission bei A. Holder, 1907. 118 p. 913.398 P275.

BULGARIA

A3.117. *Bulgarian falsification of Macedonian history: the stone inscriptions case.* http://www.historyofmacedonia.org/MacedonianMinorities/BulgarianFalsification.html.

A3.118. *Bulgarie: Apollonia du Pont.* http://www.diplomatie.gouv.fr/fr/enjeux-internationaux/echanges-scientifiques-recherche/archeologie-sciences-humaines-et/les-carnets-d-archeologie/europe-maghreb/bulgarie-apollonia-du-pont/.

A3.119. Roman and Late Antique Archaeology in Bulgaria._http://www.nipissingu.ca/department/history/muhlberger/orb/bulgbib.htm.

Moesia

A3.120. *Die Grabstelen aus Moesia Inferior: Untersuchungen zu Chronologie, Typologie und Ikonografie.* Leipzig: Casa Libri, 2004. 280, 140 p. NB1880.B8 C65 2004. A Roman province situated in the Balkans, along the south bank of the Danube River, including southern Serbia (Moesia Superior), northern Macedonia, northern Bulgaria, Romanian Dobrudja, southern Moldova, and Budjak (Lower Moesia).

Nicopolis ad Istrum

A3.121. *Nicopolis ad Istrum: a late Roman and early Byzantine city: the finds and biological remains* / A. G. Poulter. Oxford: Oxbow; Society of Antiquaries of London; Oakville: David Brown, 2007. 320 p. DR98.N48 P69 2007. A Roman town founded by Emperor Trajan ca. 101–106 CE, at the junction of the Iatrus (Yantra) and the Rositsa rivers, after his victory over the Dacians.

A3.122. *Nicopolis ad Istrum: a Roman to early Byzantine city; the pottery and glass* / A. G. Poulter. London: Leicester University Press for The Society of Antiquaries of London, 1999. 400 p. DR98. N48 P68 1999.

A3.123. *Nicopolis ad Istrum: a Roman, late Roman and early Byzantine city: excavations, 1985–1992* / Andrew Poulter. London: Society for the Promotion of Roman Studies, 1995. 331, 45 p. DR98. N48 P67 1995.

Novae

A3.124. *Inscriptions grecques et latines de Novae, Mésie inférieure* / J. Kolendo and V. Bozilova. Bordeaux: Ausonius, 1997. 276 p. CN695.B8 I57 1997. A legionary base and late Roman town in the province of Moesia Inferior (Moesia II) on the Danube River in northern Bulgaria, ca. 4 kilometers east of the modern town of Svishtov.

A3.125. *Limes* / Giancarlo Susini. Bologna: Pàtron, 1994. 202 p. DR62.L553 1994.

A3.126. *The Roman and late Roman city: the international conference, Veliko Turnovo, 26–30 July 2000; Rimskiiat i kusnoantichniiat grad: mezhdunarodna nauchna konferentsiia, Veliko Turnovo, 26–30 iuli 2000* / Liudmila Ruseva-Slokoska, Rumen Ivanov, and Ventsislav Dinchev. Sofia: Prof. Marin Drinov Academic Publ. House, 2002. 438 p. DR98.N48 I58 2002.

A3.127. *Le trésor d'antoniniens et de folles des "principia"de la légion de Novae, Bulgarie* / Andrzej Kunisz. Warszawa: Uniwersytetu Warszawskiego, 1987. 152, 10 p. CJ893.N68 K86 1987.

Seuthopolis

A3.128. *The Thracian city of Seuthopolis* / Dimitur P. Dimitrov and Maria Cicikova. Oxford: British Archaeological Reports, 1978. 63, 60 p. DR98. S48 D5413. An ancient Hellenistic-type city founded by the Thracian ruler Seuthes III ca. 325–315 BCE. This was the only significant settlement in Thrace not built by Greeks.

CORSICA

A3.129. *Les enceintes pré- et protohistoriques de Corse: essai de comparison avec quelques sites de Toscane* / Sylvain Mazet. Oxford: Archaeopress, 2008. 508 p. DG735 .M39 2008.

A3.130. *Le grandi isole del Mediterraneo occidentale: Sicilia, Sardinia, Corsica* / E. C. Portale, S. Angiolillo, and C. Vismara. Roma: L'Erma di Bretschneider, 2005. 343 p. DG55.S5 P66 2005.

A3.131. *Monuments préhistoriques de Corse* / Laurent Jacques Costa. Paris: Errance, 2009. 159 p. GN812.C6 C67 2009.

Terrina

A3.132. *Terrina et le terrinien: recherches sur le Chalcolithique de la Corse* / Gabriel Camps. Rome: École Française de Rome, 1988. 397 p. DC611. C815 C3 1988. A Middle Neolithic and Chalcolithic site located 2 kilometers from Etang de Diane.

CRETE

A3.133. *Forschungen auf Kreta 1942* / Max Friedrich. Berlin: W. de Gruyter, 1951. 166, 122 p. 913.3918 M439.2.

Amnisos

A3.134. *Amnisos: nach den archäologischen, historischen und epigraphischen Zeugnissen des Altertums und der Neuzeit: Forschungen* / Jörg Schäfer. Berlin: Gebr. Mann, 1992. 2 v. DF221.C8 A54 1992. A Bronze Age Minoan settlement on the north coast of Crete was used as a port to the palace settlement of Knossos.

Dréros

A3.135. *La nécropole de Dréros* / Henri van Effenterre. Athènes: École française d'Athènes; Naples: Università degli studi Suor Orsola Benincasa; Paris: Edition-Diffusion distributor, 2009. 170, 23 p. DF221.C8 E4 t.8:2. Located near Neapolis in the Lassithi district of Crete, is a post-Minoan site initially colonized by mainland Greeks during the Archaic Period.

Gournia

A3.136. *Gournia: report of the American Exploration Society's excavations at Gournia, Crete, 1901–1903* / Harriet A. Boyd. 44, 1 p. 913.3918 H314; 21 .P52 v.1. A Minoan palace complex excavated in the early twentieth century by Harriet Boyd-Hawes.

A3.137. *New light on Gournia: unknown documents of the excavation at Gournia and other sites on the isthmus of Ierapetra* / Harriet Ann Boyd and Vasso Fotou. Liège, Belgium: Université de Liège, Histoire de l'art et archéologie de la Grèce antique; Austin: University of Texas, Program in Aegean Scripts and Prehistory, 1993. 126 p. DF220.A274 v.9.

A3.138. *The prepalatial cemeteries at Mochlos and Gournia and the house tombs of Bronze Age Crete* / Jeffrey S. Soles. Princeton: American School

of Classical Studies at Athens, 1992. 266, 40 p. DF221.C8 S66 1992; DF221.C8 S66 1992.

Knossos

A3.139. *Arthur Evans and the Palace of Minos* / Ann Brown. Oxford: Ashmolean Museum, 1983. 110 p. DF212.E82 B76 1983. A Bronze Age site at Heraklion, a modern port city on the north-central coast of Crete. The palace was excavated and partially restored by Arthur Evans in the early twentieth century. Its size far exceeded his original expectations, as did the discovery of two ancient scripts, which he termed Linear A and Linear B. The palace complex is the largest Bronze Age archaeological site on Crete.

A3.140. *British archaeological discoveries in Greece and Crete, 1886–1936; catalogue of the exhibition arranged to commemorate the fiftieth anniversary of the British School of Archaeology at Athens, together with an exhibit illustrative of Minoan culture, with special relation to the discoveries at Knossos, arranged by Sir Arthur Evans, London, Royal Academy of Arts.* London: Printed by W. Clowes, 1936. 113 p. 913.38 L842.

A3.141. *The Bronze Age palace at Knossos: plan and sections* / Sinclair Hood and William Taylor. London: British School at Athens, 1981. NA265 .H66.

A3.142. *The central palace sanctuary at Knossos* / Marina Panagiotaki. London: British School at Athens, 1999. 300, 45 p. DF261.K55 P363 1999.

A3.143. City of Knossos. http://unmyst3.blogspot.com/2009/05/great-ancient-city-of-knossos.html.

A3.144. *The destruction of Knossos, the rise and fall of Minoan Crete* / H. E. L. Mellersh. London: H. Hamilton, 1970. 205, 8 p. DF261.C8 M39 1970.

A3.145. *The destruction of the palace at Knossos: Pottery of the late Minoan IIIa period* / Mervyn R. Popham. Göteborg: P. Äström, 1970. 111, 50 p. NK3843 .P6.

A3.146. *An early destruction in the Mycenaean palace at Knossos: a new interpretation of the excavation field-notes of the south-east area of the west wing* / Jan Driessen. Leuven: Katholieke Universiteit Leuven, 1990. 151, 28 p. DF221.C8 D75 1990.

A3.147. *The funerary landscape at Knossos: a diachronic study of Minoan burial customs with special reference to the warrior graves* / Madelaine Miller. Oxford: Archaeopress, 2011. 118 p. DF221.C8 M45 2011.

A3.148. *Le grand palais de Knosses: Répertoire photographique & bibliographie* / Jacques Raison. Roma: Edizioni dell'Ateneo, 1969. 121, 245 p. DF221.C8 R3.

A3.149. *Index to the Palace of Minos; with special sections classified in detail chronologically arranged by Sir Arthur Evans* / Joan Evans. London: Macmillan, 1936. 221 p. 913.918 Ev14.6 Index; 913.3918 Ev12.5 Index.

A3.150. *Inscriptions in the Minoan linear script of class A; from the notes of Sir Arthur Evans and Sir John Myres* / W. C. Brice. Oxford: Printed at the University Press by V. Ridler for the Society of Antiquaries, 1961. 33, 88 p. 913.3918 Ev12.7.

A3.151. *Knossos.* http://archaeology.about.com/od/kterms/g/knossos.htm.

A3.152. *Knossos: a complete guide to the Palace of Minos* / Anna Michailidou. Athens: Ekdotike Athenon, 1989. 128 p. DF221.C8 M4713 1989.

A3.153. *Knossos: from Greek city to Roman colony: excavations at the unexplored mansion II* / L. H. Sackett. Athens: British School of Archaeology at Athens; London: Thames & Hudson, 1992. 2v. DF221.C8 S213 1992.

A3.154. *Knossos: the Little Palace* / Eleni M. Hatzaki. London: British School at Athens, 2005. 221, 38 p. DF221.C8 H389 2005.

A3.155. *Knossos: the sanctuary of Demeter* / J. N. Coldstream. London: British School of Archaeology at Athens; Thames and Hudson, 1973. 191 p. DF221.C8 C625.

A3.156. *Knossos: the south house* / P. A. Mountjoy. London: British School at Athens, 2003. 224 p. DF221.C8 M73 2003.

A3.157. *Knossos excavations, 1957–1961: early Minoan* / Sinclair Hood and Gerald Cadogan. London: British School at Athens, 2011. 327, 65 p. DF261.K55 H663 2011.

A3.158. *Knossos fresco atlas.* London: Gregg Press, 1967. 36 plates. DF221.C8 E84.

A3.159. *The Knossos labyrinth: a new view of the 'Palace of Minos' at Knossos* / Rodney Castleden. London; New York: Routledge, 1990. 205, 16 p. DF221.C8 C37 1990.

A3.160. *Knossos North Cemetery: early Greek tombs* / J. N. Coldstream and H. W. Catling. London: British School at Athens, 1996. 4 v. DF261.K55 K56 1996.

A3.161. *Knossos Palace.* http://www.heraklion-crete.org/knossos.htm.

A3.162. *Knossos pottery hand: Greek and Roman* / J. N. Coldstream, L. J. Eiring, and G. Forster. London: British School at Athens, 2001. 178, 43 p. NK3840.K5 C6 2001.

A3.163. *Knossos: protopalatial deposits in early Magazine A and the south-west houses* / Colin F. Macdonald and Carl Knappett. London: British School at Athens, 2007. 205, 49 p. DF261.K55 M33 2007.

A3.164. *The Knossos tablets* / John T. Killen and Jean-Pierre Olivier. 5 ed. Salamanca, España: Ediciones Universidad de Salamanca, 1989. 487 p. P1035 .M512 no.11.

A3.165. *The Knossos tablets; a transliteration of all the texts in Linear B script found at Knossos, Crete, based upon a new collation of photographs and originals* / John Chadwick. London: University of London, Institute of Classical Studies, 1964. 218 p. P1035 .K5 1964.

A3.166. *The latest sealings from the palace and houses at Knossos* / Mervyn R. Popham and Margaret A. V. Gill. London: British School at Athens, 1995. 65, 48 p. CD5363 .P67 1995.

A3.167. Map of Knossos Royal Palace. http://www.planetware.com/map/makritikhos-palace-of-knossos-map-gr-palknos.htm.

A3.168. Minoan archaeological sites. http://www.ancient-greece.org/archaeology/minoan-archa.html.

A3.169. Minoan architecture. http://www.ancient-greece.org/architecture/minoan-archi.html.

A3.170. Minoan art. http://www.ancient-greece.org/art/minoan-art.html.

A3.171. Minoan civilization. http://www.mlahanas.de/Greeks/History/Minoans.html.

A3.172. Minoan Crete map. http://www.ancient-greece.org/map/ancient-crete.html.

A3.173. Minoan culture. http://www.ancient-greece.org/culture/minoan-cult.html.

A3.174. Minoan history. http://www.ancient-greece.org/history/minoan.html.

A3.175. Minoan palaces. http://www.dilos.com/location/13405.

A3.176. *The Minoan unexplored mansion at Knossos* / M. R. Popham. Athens: British School of Archaeology at Athens; London: Thames and Hudson, 1984. 2 v. DF221.C8 P66 1984.

A3.177. *A new guide to the Palace of Knossos* / Leonard R. Palmer. New York: Praeger, 1969. 144 p. DF221.C8 P29 1969b.

A3.178. *On the Knossos tablets: The find-places of the Knossos tablets* / L. R. Palmer; *The date of the Knossos tablets* / John Boardman. Oxford: Clarendon Press, 1963. 251, 100 p. 913.3918 P183.

A3.179. *The Palace of Minos: a comparative account of the successive stages of the early Cretan civilization as illustrated by the discoveries at Knossos* / Sir Arthur Evans. London: Macmillan, 1921. 4 v. 913.918 Ev14.6; DF221.C8 E7.

A3.180. *Die Palaststilkeramik von Knossos: Stil, Chronologie und historischer Kontext* / Wolf-Dietrich Niemeier. Berlin: Mann, 1985. 271, 29 p. DF221.C8 N53 1985.

A3.181. *The people of Knossos: prosopographical studies in the Knossos Linear B archives* / Hedvig Landenius Enegren. Uppsala: Acta Universitatis Upsaliensis, 2008. 219 p. DF209.5 .L36 2008.

A3.182. *The prehistoric tombs of Knossos* / Arthur J. Evans. London: B. Quaritch, 1906. 172, 13 p. 913.3918 Ev12.

A3.183. *Scripta minoa: the written documents of Minoan Crete: with special reference to the archives of Knossos* / Arthur J. Evans. Oxford: Clarendon Press, 1909–1952. 2 v. 913.3918 Ev12.6. Catalog of Linear B inscriptions from Knossos.

Kommos

A3.184. *Kommos: a Minoan harbor town and Greek sanctuary in southern Crete* / Joseph W. Shaw. Princeton: American School of Classical Studies at Athens, 2006. 171 p. DF221.C8 S543 2006. A Bronze Age Greek port in southern Crete with trade connections to the Near East.

Máila

A3.185. *La poterie du Minoen Moyen II: production et utilisation: fouilles exécutées à Malia, le quartier Mu IV* / Jean-Claude Poursat et Carl Knappett. Athènes: École Française d'Athènes; Paris: Edition-Diffusion, 2005. 316, 76 p. DF221.C8 E4 t.33. A Middle Bronze Age palace site destroyed by an earthquake during the Late Bronze Age but later rebuilt.

A3.186. *Fouilles exécutées à Mallia. Exploration des nécropoles* / École Française d'Athènes. Paris: P. Geuthner, 1945–1963. 2 v. DF221.C8 E4.

A3.187. *Fouilles exécutées à Mallia . . . Premier-quatrième rapport* / École Française d'Athènes. Paris: P. Geuthner, 1928–1962. 4 v. DF221.C8 E4.

A3.188. *Palace at Malia.* http://www.ancient-greece.org/archaeology/malia.html.

Mycenae

A3.189. Aerial views of Mycenaean sites. http://www.awesomestories.com/assets/mycenaean-ruins-an-aerial-view. An archaeological site located 90 kilometers southwest of Athens in northeast Peloponnese. Mycenae was one of the major centers of Greek civilization and a military stronghold that dominated much of southern Greece.

A3.190. *Der Fries des Megarons von Mykenai* / Gerhart Rodenwaldt. Halle a/S.: M. Niemeyer, 1921. 4, 72 p. 913.381 M99R.

A3.191. Images of Mycenaean Greece. http://images.mitrasites.com/mycenaean-greece.html.

A3.192. Mycenae in images. http://www.bing.com/images/search?q=Mycenae+in+Images&qpvt=Mycenae+in+Images &FORM=IGRE.

A3.193. *Mycenaean tree and pillar cult and its Mediterranean relations; with illustrations from recent Cretan finds* / Arthur J. Evans. London; New York: Macmillan, 1901. 106 p. BL793.M8 E85 1901; 913.362 Ev13.

A3.194. *The shaft graves and bee-hive tombs of Mycenae and their interrelation* / Arthur J. Evans. London: Macmillan, 1929. 93 p. 913.381 M99E.

Phaestos

A3.195. *Cretan pictographs and prae-Phoenician script: with an account of a sepulchral deposit at Hagios Onuphrios near Phaestos in its relation to primitive Cretan and Aegean culture* / Arthur J. Evans. London: B. Quaritch; New York: G. P. Putnam's, 1895. 146 p. 913.3918 Ev12.4. A Bronze Age archaeological site at Faistos in south central Crete.

A3.196. *Phaistos* / Despina Hadzi-Vallianou. Athens: Ministry of Culture, Archaeological Receipts Fund, ca. 1989. 47 p. DF221.C8 H33 1989.

A3.197. *The plain of Phaistos: cycles of social complexity in the Mesara region of Crete* / L. Vance Watrous, Despoina Hadzi-Vallianou, and Harriet Blitzer. Los Angeles: Cotsen Institute of Archaeology, University of California, Los Angeles, 2004. 668, 70 p. DF901.M528 W37 2004.

Sybrita

A3.198. *Sybrita, la valle di Amari fra Bronzo e Ferro* / Luigi Rocchetti. Roma: Gruppo editoriale internazionale, 1994. DF221.C8 S93 1994, v. 1. A Minoan city site at Amari-Becken on Crete.

CROATIA

A3.199. *Aspects of the cult of Cybele and Attis on the monuments from the Republic of Croatia* / Aleksandra Nikoloska. Oxford: Archaeopress, 2010. 106 p. DR1521.N55 2010.

A3.200. *Die Fundmünzen der römischen Zeit in Kroatien* / Kommission für Geschichte des Altertums der Akademie der Wissenschaften und der Literatur Mainz; Arheološki Muzej u Zagrebu, Zagreb / Maria R.-Alföldi, Hans-Markus von Kaenel, and Ivan Mirnik. Mainz: P. von Zabern, 2002. CJ815. C87 F86 2002.

Liburnia

A3.201. *Hellenistic and Roman relief pottery in Liburnia (north-east Adriatic, Croatia)* / Zdenko Brusić. Oxford: Archaeopress: Hadrian Books, 1999. 254 p. DR1548.B78 1999. A region along the northeastern Adriatic coast in modern Croatia. Liburnian material culture is distributed throughout northern Dalmatia, Kvarner, and eastern Istria. In 33 BCE the Liburnians were defeated by the Romans and became a part of the province of Dalmatia.

Loron

A3.202. Croatie: Loron. http://www.diplomatie.gouv.fr/fr/enjeux-internationaux/echanges-scientifiques-recherche/ archeologie-sciences-humaines-et/les-carnets-d-archeologie/europe-maghreb/croatie-loron/.

Nesactium

A3.203. *Oppidum Nesactium: una città istro-romana* / Guido Rosada. Treviso: Canova, 1999. 221, 2 p. DR1645.N47 O68 1999. The pre-Roman capital of Histri was conquered by the Romans in 177 BCE and was occupied by the Romans until 46–45 BCE. The town was crossed by the ancient Via Flavia, which connected Triest to Dalmatia.

Pula and Istria

A3.204. *Pula-forum: arheološka građa 2006–2007, izložba; Archeological evidence 2006–2007, exhibition* / Kristina Džin. Pula: Arheološki muzej Istre, 2008. 63 p. DR1645.P85 D95 2008. In the Bronze Age (1800–1000 BCE) the hilltop fortress or gradine settlement type developed in the area of Pula. There appears to have been a Greek occupation, later subdued by the Romans in 177 BCE. It became a significant Roman port with a large surrounding area and was elevated to colonial rank as the tenth region of the Roman empire under Julius Caesar.

Salona

A3.205. *Salona: recherches archéologiques franco-croates à Salone* / N. Duval and E. Marin. Rome: École française de Rome; Split Musée archéologique de Split, 1994. N7251.S2 S25 1994, v. 1–4(1–2); N7251.S2 S25 1994, v. 1; N7251.S2 S25 1994, v. 1, 3. An ancient city on the Dalmatian coast. In the first millenium BCE

the Greeks established an emporium (market-place) there, and after conquest by the Romans, Salona became the capital of the Roman province of Dalmatia.

A3.206. *Salona IV: inscriptions de Salone chrétienne, IVe-VIIe siècles* / E. Marin. Rome: École Française de Rome; Split: Musée archéologique de Split, 2010. 2 v. CN695.C87.S24 2010.

CYPRUS

Agia Napa

A3.207. *Agia Napa: excavations at Makronisos and the archaeology of the region* / Sophocles Hadjisavvas. Nicosia: Agia Napa Municipality; Cyprus Dept. of Antiquities, 1997. 206 p. DS54.95.M34 C43 1997.

Akamas

A3.208. *Ancient Akamas* / Jane Fejfer. Aarhus; Oakville: Aarhus University Press, 1995. DS54.A2 A75 1995, v. 1. A promontory and cape in northwest Cyprus.

Alambra

A3.209. *Alambra: a middle Bronze Age settlement in Cyprus: archaeological investigations by Cornell University 1974–1985* / John E. Coleman, Jane A. Barlow, Marcia K. Mogelonsky, and Kenneth W. Schaar. Jonsered: Paul Äströms Förlag, 1996. 534, 175 p. DS54.95.A4 A4 1996. Excavations between 1974 and 1985 revealed the remains of a Middle Bronze Age (ca. 1900–1650 BCE) settlement.

Alashia

A3.210. *Alashia revisited* / R. S. Merrillees. Paris: J. Gabalda, 1987. 87 p. DS54.3 .M47 1987. Probable location of the kingdom of Alashia.

Amathonte

A3.211. Chypre: Amathonte. http://www.diplomatie. gouv.fr/fr/enjeux-internationaux/echanges-scientifiques-recherche/archeologie-sciences-humaines-et/les-carnets-d-archeologie/europe-maghreb/chypre-amathonte/.

A3.212. *Guide d'Amathonte* / Pierre Aupert. Athens: École Française d'Athènes; Paris: Boccard Edition-Diffusion, 1996. 224 p. DS54.95.A52 E36 1996.

A3.213. *Histoire des campagnes d'Amathonte*. Athènes: École Française d'Athènes, 2005. DS54.95.A52 H58 2005.

Apliki Karamallos

A3.214. *Joan du Plat Taylor's excavations at the late Bronze Age mining settlement at Apliki Karamallos, Cyprus* / Barbara Kling and James D. Muhly. Savedalen: Paul Äströms Förlag, 2007. DS54.95. A64 K56 2007. A copper mining region in northwest Cyprus; finds of slag and clay air blower nozzles indicate local smelting as early as Late Cypriot IIC-SCIIIA.

Athienou

A3.215. *Excavations at Athienou, Cyprus, 1971–1972* / Trude Dothan and Amnon Ben-Tor. Jerusalem: Institute of Archaeology, Hebrew University of Jerusalem, 1983. 147, 48 p. DS54.3.D67 1983; DS54.95.A8 D6711 1983. An archaeological site in south central Cyprus with Geometric, Archaic, Classical, Hellenistic, Roman, Byzantine, Venetian, and Ottoman occupations.

Ayía Irini

A3.216. *Le tombe dei periodi geometrico ed arcaico nella necropoli a mare di Ayia Irini, Paleokastro* / Luigi Rocchetti. Roma: Consiglio Nazionale delle Ricerche, Istituto per gli Studi Micenei ed Egeo-Anatolici, 1978. 120 p. DS54.95.A94 R6. A Bronze Age settlement, which reached its height in the Late Minoan and Early Mycenaean eras (1600–1400 BCE).

Dhenia

A3.217. *The Bronze Age cemeteries at Deneia in Cyprus* / David Frankel and Jennifer M. Webb. Sävedalen: Paul Åströms, 2007. 188, 97 p. DS54.95. D45 F73 2007. A village in the Nicosia district of Cyprus.

A3.218. *Eight middle Bronze Age tomb groups from Dhenia in the University of New England Museum of Antiquities* / Jennifer M. Webb and David Frankel. Jonsered: Paul Äströms, 2001. 51, 23 p. NK685.C9 C65 v. 21.

Enkomi

A3.219. *Corpus des cylindres-sceaux de Ras Shamra-Ugarit et d'Enkomi-Alasia* / Claude F.-A. Schaeffer-Forrer. Paris: Editions Recherche sur

les Civilisations, 1983–1992. 2 v. CD5391 .S32 1983. An important Bronze Age city, possibly the capital of Alasiya.

Episkopi Phaneromeni

A3.220. *The Kent State University expedition to Episkopi Phaneromeni*. Nicosia: P. Åströms, 1986. DS54.95.E65 K46 1986. A Late Middle to Late Bronze Age site.

Hala Sultan Tekke

A3.221. *Hala Sultan Tekke*. Göteborg: P. Åström, 1975. DS54.95.H34 H34. 12 v. Contents include (1) *Excavations, 1897–1971* / Paul Åström, D. M. Bailey, and Vassos Karageorghis. Göteborg: P. Åström, 1976. 134, 144 p. DS54.95.H34 H34 v. 1; (2) *Excavations 1972* / Paul Åström, Gunnel Hult, and Margareta Strandberg Olofsson. Göteborg: P. Åström, 1977. 200 p. DS54.95.H34 H34 v. 3; (3) *Excavations in area 8 in 1974 and 1975. The 1977 underwater report by Dan McCaslin* / Gunnel Hult. Göteborg: P. Åström, 1978. 157 p. DS54.95.H34 H34 v. 4; (4) *Excavations in area 22, 1971–1973 and 1975–1978* / Ulla Öbrink. Göteborg: P. Åström, 1979. 144 p. DS54.95. H34 H34 v. 5; (5) *Excavations in area 8 in 1977* / Gunnel Hult. Göteborg: P. Åström, 1981. 89 p. DS54.95.H34 H34 v. 7; (6) *Excavations 1971–79* / Paul Åström. Göteborg: P. Åström, 1983. 253 p. DS54.95.H34 H34 v. 8; (7) *Trenches 1972–1987: with an index for volumes 1–9* / Paul Åström. Göteborg: P. Åström, 1989. 142 p. DS54.95.H34 H34 v.; (8) *The wells* / Paul Åström. Jonsered: Paul Åström, 1998. 149 p. DS54.95.H34 H34 v. 1; (9) *Trial trenches at Dromolaxia-Vyzakia adjacent to areas 6 and 8* / Paul Åström. Jonsered: P. Åström förlag, 2001. 68 p. DS54.95.H34 H34 v. 11; (10) *Tomb 24, stone anchors, faunal remains and pottery provenance* / Paul Åström and Karin Nys. Sävedalen, Sweden: P. Åström, 2007. 62 p. DS54.95.H34 H34 v. 12. A prominent Muslim shrine near Lamaca on the south coast of Cyprus.

Idalion

A3.222. *American expedition to Idalion, Cyprus: First preliminary report, seasons of 1971 and 1972* / Lawrence E. Stager, Anita Walker, and G. Ernest Wright. Cambridge: American Schools of Oriental Research, 1974. 178 p. DS41.A55 no.18. An ancient city in Cyprus near modern Dali said to have been founded by the Achaean-Greeks after the Trojan War. Copper was mined, smelted, and traded throughout the Mediterranean.

Kalavasos

A3.223. *Bronze Age cemetery in Kalavasos Village* / Ian A. Todd. Goteborg: P. Åströms förlag, 1986. 306 p. DS54.95.K35 V37 1986 v. 1. A site transitional between the terminal Late Neolithic and Early Chalcolithic periods.

A3.224. *Cypriot village of late antiquity: Kalavasos-Ko-Pétra in the Vasilikos Valley* / Marcus Rautman. Portsmouth: Journal of Roman Archaeology, 2003. 296 p. DS54.95.K35 R38 2003.

A3.225. *Excavations at Kalavasos-Ayious* / Ian A. Todd and Paul Croft. Savedalen: Paul Åströms Förlag, 2004. 237, 66 p. DS54.95.K35 V37 1986 v.8.

A3.226. *Excavations at Kalavasos-Tenta* / Ian A. Todd. Göteborg: P. Åströms, 1987–2005. 2 v. DS54.95. K35 V37 1986 v.6–7.

Khirokitia

A3.227. Cyprus in the Aceramic Period—the Khirokitia Culture. www.aai.freeservers.com/cyprus_in_ the_aceramic_period.htm.

Kissonerga-Mylouthkia

A3.228. *Ceremonial area at Kissonerga* / Edgar Peltenburg. Göteborg: P. Åströms Förlag, 1991. 117 p. DS54.95.L44 L44 1985 v.2 pt.2. A Chalcolithic settlement in the Paphos region occupied between 3500 and 2500 BCE.

A3.229. *Colonisation and settlement of Cyprus: investigations at Kissonerga-Mylouthkia, 1976–1996* / Edgar Peltenburg. Savedalen: Paul Åströms, 2003. 320, 16 p. DS54.95.L44 L44 1985 v.3 pt.1.

A3.230. *Excavations at Kissonerga-Mosphilia, 1979–1992* / Edgar Peltenburg. Göteborg: P. Åströms, 1998. 267 p. DS54.95.L44 L44 1985 v.2 pt.1A.

Kition

A3.231. *Art and society in Cyprus from the Bronze Age into the Iron Age* / Joanna S. Smith. Cambridge; New York: Cambridge University Press, 2009. 397 p. DS54.95.K58 S65 2009. An ancient city-state on the southern coast of Cyprus, first established in the thirteenth century BCE and reestablished by Phoenicians in 800 BCE.

A3.232. *Kition de Chypre* / Marguerite Yon. Paris: Recherche sur les civilisations, 2006. 156 p. DS54.95.K58 Y65 2006.

Klavdhia-Tremithos

A3.233. *Klavdhia-Tremithos: a middle and late Cypriote Bronze age site* / Kjell Malmgren. Jonsered: Paul Äströms, 2003. 159, 46 p. DS54.95.K583 M34 2003. Late Bronze Age settlement (1650–1050 BCE) that traded extensively in raw materials, especially copper and other luxury goods.

Kourion

A3.234. A *guide to Kourion*. Nicosia: Bank of Cyprus Cultural Foundation in collaboration with the Department of Antiquities, 1987. 50 p. DS54.95. K68 C9 1987. A settlement with Hellenistic, Roman, and Christian occupations on the south shore of the island of Kouris.

A3.235. *Bamboula at Kourion, the stratification of the settlement* / J. L. Benson. Nicosia, Cyprus, 1969–1970. DS54.95.K68 B46.

A3.236. *Coins from the excavations at Curium, 1932–1953* / Dorothy H. Cox. New York: American Numismatic Society, 1959. 125, 10 p. 737 Am36 no.144–146.

A3.237. *Kourion: excavations in the episcopal precinct* / A. H. S. Megaw. Washington, DC: Dumbarton Oaks Research Library and Collection; Cambridge: Harvard University Press, 2007. 571 p. DS54.95.K68 M44 2007.

A3.238. *Kourion: its monuments and local museum* / Demos Christou. 7 ed. Nicosia: Filokipros, 1996. 93 p. DS54.95.K68 C48 1996.

A3.239. *Kourion: the search for a lost Roman city* / David Soren and Jamie James. New York: Anchor Press, 1988. 223, 16 p. DS54.95.K68 S67 1988.

A3.240. *The Sanctuary of Apollo Hylates at Kourion: excavations in the archaic precinct* / Diana Buitron-Oliver. Jonsered, Sweden: P. Äströms, 1996. 219, 150 p. DS54.95.K68 B85 1996.

A3.241. *The Temple of Apollo Hylates at Kourion and the restoration of its south-west corner* / S. Sinos. Athens: A. G. Leventis Foundation, 1990. 301 p. NA285.K68 S55 1990.

Kouris Valley

A3.242. *Excavations in the Kouris valley* / Pavlos Flourentzos. Nicosia: Dept. of Antiquities, 1991. 2 v. DS54.95.K69 F57 1991. Located in southwest Cyprus, settlement surveys indicate a lengthy sequence of occupation from the Early Bronze Age to the Roman period.

Lemba Lakkous

A3.243. *Excavations at Lemba Lakkous, 1976–1983* / E. J. Peltenburg and Douglas Baird. Göteborg: P. Äströms, 1985. 329, 136 p. DS54.95.L44 L44 1985 v.1. A Chalcolithic to Early Bronze Age site.

A3.244. *Lemba archaeological project*. Göteborg: P. Äströms, 1985. DS54.95.L44 L44 1985. v.1–v.2 pt.1A, v.2 pt.2, v.3 pt.1.

A3.245. Lemba Archaeological Research Centre—Cyprus. http://www.arcl.ed.ac.uk/arch/lemba/ homepage.html.

A3.246. *Prehistoric buildings of chalcolithic Cyprus: the Lemba Experimental Village* / Gordon D. Thomas. Oxford: John and Erica Hedges: Hadrian Books, 2005. 203 p. GN778.32.C9 T56 2005.

Maa-Palaeokastro

A3.247. *Excavations at Maa-Palaeokastro, 1979–1986* / V. Karageorghis and M. Demas. Cyprus: Dept. of Antiquities, 1988. 3 v. DS54.95.M33 K37 1988. An important terminal Late Bronze Age site situated on a small peninsula north of the town of Pafos.

Marki Alonia

A3.248. *The cemeteries at Marki: using a looted landscape to investigate prehistoric Bronze Age Cyprus* / Andrew C. Sneddon. Oxford: Archaeopress: Hadrian Books, 2002. 276 p. DS54.95.N53 S64 2002. An Early and Middle Bronze Age site in central Cyprus.

Maroni Petrera

A3.249. *The late Roman church at Maroni Petrera: survey and salvage excavations 1990–1997, and other traces of Roman remains in the lower Maroni Valley, Cyprus* / Sturt W. Manning and Andrew Manning. Nicosia, Cyprus: A. G. Leventis Foundation; Oakville: David Brown, 2002. 84 p. DS54.95.M37 M36 2002. Late Roman period site on the south coast of Cyprus.

Paphos

A3.250. *The conservation of the Orpheus Mosaic at Paphos, Cyprus*. Marina del Rey: Getty Conservation Institute, 1991. 69, 8 p. NA3770 .C65 1991. A Greco-Roman settlement on the southwest coast of Cyprus famed for the remains of the Roman governor's palace.

A3.251. Excavations at the Ancient Theatre of Paphos, Cyprus. http://sydney.edu.au/arts/archaeology/ paphos/.

A3.252. *Palaepaphos-Skales: an Iron Age cemetery in Cyprus* / Vassos Karageorghis. Konstanz: Univer-

sitätsverlag Konstanz, 1983. 2 v. DS54.3.K277 1983.

A3.253. *Paphos: history and archaeology* / F. G. Maier and V. Karageorghis. Nicosia: A. G. Leventis Foundation, 1984. 383 p. DS54.95.O43 M35 1984.

Phlamoudhi

A3.254. *Views from Phlamoudhi, Cyprus* / Joanna S. Smith. Boston: American Schools of Oriental Research, 2008. 145 p. DS101.A45 v.63; DS101. A45 v.63. Located in the foothills of the Kyrenia mountain range on the north coast of Cyprus, site components date to the Late Bronze Age (ca. 1650–1200 BCE), Archaic, Classical, Hellenistic, Roman, and Medieval periods.

Salamis

A3.255. *La basilique de la Campanopétra* / Georges Roux. Paris: de Boccard, 1998. 295 p. DS54.95. S2 S35 v. 15. An ancient city in eastern Cyprus; according to tradition it was founded ca. 1180 BCE by Teucer, a hero of the Trojan War; excavations have revealed Greek and Roman ruins.

A3.256. Cave of Euripides on Salamis. http://www.aka-mas.gr/uni/exc/cave_en.html.

A3.257. *La céramique a vernis noir du rempart méridional* / Laurence Jehasse. Paris: Diffusion de Boccard, 1978. 131 p. DS54.95.S2 S35 v.8.

A3.258. *Les dialectes néo-araméens de Salamâs: textes sur l'état actuel de la Perse et contes populaires publiés avec une traduction* Française / Rubens Duval. Paris: F. Vieweg, 1883. 144, 89 p. PJ5202 .D89 1883.

A3.259. *Excavating at Salamis in Cyprus, 1952–1974* / Vassos Karageorghis. Athens: A. G. Leventis Foundation, 1999. 206 p. DS54.95.S2 K345 1999.

A3.260. *Der Jüngling von Salamis: technische Untersuchungen zu römischen Grossbronzen* / Wolf-Dieter Heilmeyer. Mainz: Philipp von Zabern, 1996. 62, 68 p. NB142.7.C93 H45 1996.

A3.261. *Les Monnaies: fouilles de la ville 1964–1974* / Olivier Callot. Paris: De Boccard, 2004. 218 p. DS54.95.S2 S35 v.16.

Soli

A3.262. *The Basilica at Soli, Cyprus: a survey of the buildings and mosaics* / David S. Neal. Cyprus: SAVE, International Resources Group, 2009. 102 p. + 1 DVD-ROM. DS54.95.S64 N43 2009.

A3.263. *Soloi: dix campagnes de fouilles (1964–1974)*. Sainte-Foy: Presses de l'Université Laval, 1985. 2 v. DS54.95.S6 S64 1985.

Sotira Kaminoudhia

A3.264. *Sotira Kaminoudhia: an early Bronze Age site in Cyprus* / Stuart Swiny, George (Rip) Rapp, and Ellen Herscher. Boston: American Schools of Oriental Research, 2003. 600 p. DS54.95.S65 S68 2003. An important Early Bronze Age site in southern Cyprus.

Tamassos

A3.265. *Tamassos: ein antiker Stadtstaat im Bergbaugebiet von Zypern* / Hans-Günter Buchholz and Hartmut Matthäus. Münster: Ugarit-Verlag, 2010– . DS54.95.T36 B934 2010. An ancient Greek city-state in central Cyprus, which prospered mainly because of its copper mines.

CZECH REPUBLIC

Bohemia

A3.266. *Die Anfänge der römischen Kaiserzeit in Böhmen; Počátky doby římské v Čechách* / Karla Motyková-Šneidrová. Pragae: Museum Nationale Pragae, Sectio Praehistorica, 1963. 81, 36 p. 913.437 F777 v.6–10. In the second century BCE the Romans defeated the Boii at the battles of Placentia and Mutina in an area of northern Italy referred to as *Boihaemum*. This included parts of southern Bohemia as well as parts of Bavaria and Austria.

A3.267. *Die römischen Bronzegefässe in Böhmen* / Zuzana Karasová. Pragae: Museum Nationale Pragae, 1998. 118 p. GN705.F65 v.22.

A3.268. *Roman imports in Bohemia* / Vladimir Sakar. Pragae: Museum Nationale Pragae, Sectio Praehistorica, 1970. 72 p. 913.437 F777 v.11–15.

A3.269. *Weiterentwicklung und Ausklang der älteren römischen Kaiserzeit in Böhmen* / Karla Motykova-Sneideroya. Pragae, 1967. 54 p. 913.437 F777 v.11–15.

Pannonia

A3.270. *Inscriptiones Pannnoniae Superioris in Slovacia Transdanubiana asservatae* / Josef Češka and Radislav Hosek. Brno: Universitas Purkyniana Brunensis, 1967. 125 p. CN560 .C48. An ancient Roman province bounded north and east by the Danube, west by Noricum and upper Italy, and south by Dalmatia and Upper Hungary.

Rusovce

A3.271. *The Roman cemetery at Gerulata Rusovce, Czechoslovakia* / L'udmila Kraskovská. Oxford: British Archaeological Reports, 1976. 109, 3 p. GT3271.C95 .K713. A Roman settlement (Gerulata) was developed in the first century CE.

DACIA

A3.272. *Funerary monuments in Dacia Superior and Dacia Porolissensis* / Lucia Teposu Marinescu. Oxford: British Archaeological Reports, 1982. 244, 2 p. NB1880.R8 M38.

A3.273. *Siebenbürgen zur Zeit der Römer und der Völkerwanderung* / Wolfgang Schuller. Köln: Böhlau, 1994. 276 p. DR280.S55 Bd.29.

DENMARK

A3.274. *Crossing boundaries: an analysis of Roman coins in Danish contexts* / Helle W. Horsnæs. Copenhagen: National Museum of Denmark; University Press of Southern Denmark, 2010. CJ1118 .H677 2010.

A3.275. *Römischer Import im Norden: Warenaustausch zwischen dem Römischen Reich und dem freien Germanien während der Kaiserzeit unter besonderer Berücksichtigung Nordeuropas* / Ulla Lund Hansen. Kobenhavn: Kongelige Nordiske Oldskriftselskab, 1987. 487 p. DL23 .H24 1987.

Himlingoje

A3.276. *Himlingoje, Seeland, Europa: ein Gräberfeld der jüngeren römischen Kaiserzeit auf Seeland, seine Bedeutung und internationalen Beziehungen* / Ulla Lund Hansen. Kobenhavn: Kongelige Nordiske Oldskriftselkab, 1995. 576 p. A Roman burial site on southern Zealand.

Sjaelland

A3.277. *Material and interpretation: the archaeology of Sjlland in the early Roman Iron Age* / David Liversage. Copenhagen: The National Museum of Denmark, 1980. 206 p. DL271.Z5 L56. An island of eastern Denmark bounded by the Kattegat and the Baltic Sea and separated from Sweden by the Oresund; the largest island of Denmark and the site of Copenhagen.

EGYPT

A3.278. *Rapports relatifs à la consolidation des temples* / Gaston Maspero. Le Caire: Imprimerie de l'Institut français d'archéologie orientale, 1909–1911. 2 v. 913.32 T245.10.

Abu Rawwash

A3.279. *Rapport sur les fouilles d'Abou-Roasch (1922/1923–1924): Rapports préliminaires* / F. Bisson de La Roque. Le Caire: Impr. de l'Institut français d'archéologie orientale, 1924–1925. 2 v. 913.32 128.10, t.1(3), 2(1). Abu Rawwash (Abu Rawash, Abu Roach, Abu Roash), located 8 kilometers north of Giza, is the most northerly pyramid.

Abu Simbel

A3.280. *Abou-Simbel, chapelle de Re-Herakhty, textes hieroglyphiques* / J. Cerný and A. A. Youssef. Le Caire: Centre de documentation egyptologique, 1965. 11 p. PJ1097 .C47. The Abu Simbel temples are two massive rock temples in Nubia, southern Egypt. They are situated on the west bank of Lake Nasser, ca. 230 kilometers southwest of Aswan.

A3.281. *Abou Simbel et les temples de Nubie* / François-Xavier Héryt and Thierry Enel. Aix-en-Provence: Edisud, 1994. 174 p. DT73.A15 H479 1994.

A3.282. *Abou-Simbel et l'épopée de sa découverte* / Louis A. Christophe. Bruxelles, P.F. Merckx, 1965. 270 p. 913.32 C464.

A3.283. *Abu Simbel* / Nermine Choukry. Cairo: Farid Atiya Press, 2007. 47 p. DT73.A15 C56 2007.

A3.284. *Abu Simbel: die Felsentempel Ramses' II. von der Pharaonenzeit bis heute* / Joachim Willeitner. Mainz am Rhein: Verlag Philipp von Zabern, 2010. 144 p. DT73.A15 W555 2010.

A3.285. *Aswan and Abu Simbel: history and guide* / Jill Kamil. Cairo: American University in Cairo Press, 1993. 159 p. DT137.A8 K36 1993.

A3.286. *Grand temple d'Abou Simbel: la bataille de Qadech, description et inscriptions, dessins et photographies* / Ch. Desroches Noblecourt, S. Donadoni, and E. Edel. Le Caire: Centre de Documentation et d'Études sur l'Ancienne Égypte, 1971. 65, 47 p. DT73.A15 M37.

A3.287. *Grand temple d'Abou Simbel: les salles du trésor sud* / S. Donadoni, H. el-Achirie et Ch. Leblanc. Le Caire: Centre d' Études et de Documentation sur l'Ancienne Egypte, 1975. 2 v. DT73.A15 G73 1975.

A3.288. *Lire l'image égyptienne: les salles du trésor du grand temple d'Abou Simbel* / Benoit Lurson. Paris: P. Geuthner, 2001. 191 p. DT73.A15 L978 2001.

A3.289. *The mysteries of Abu Simbel: Ramesses II and the Temples of the Rising Sun* / Zawi Hawass. Cairo: New York: American University in Cairo Press, 2000. 88 p. NA216.A17 H38 2000.

A3.290. *Le petit temple d'Abou Simbel, "Nofretari pour qui se lève le Dieu-Soleil."* / Chr. Desroches-Noblecourt and Ch. Kuentz. Le Caire, 1968. 270 p. DT73.A15 D38, t.1.

A3.291. *Temples and tombs of ancient Nubia: the international rescue campaign at Abu Simbel, Philae and other sites* / Torgny Soderbergh. London: Thames and Hudson; Paris: UNESCO, 1987. 256 p. DT135.N8 T45 1987.

A3.292. *Wonders of Abu Simbel: the sound and light of Nubia* / Zahi Hawass. Cairo: American University in Cairo Press, 2010. 90 p. DT73.A15 W66 2010.

A3.293. *The world saves Abu Simbel* / Christiane Desroches-Noblecourt and Georg Gerster. Vienna; Berlin: Koska, 1968. 243 p. DT73.A15 D42.

Abu Sir

A3.294. *Abusir: realm of Osiris* / Miroslav Verner. Cairo; New York: American University in Cairo Press, 2002. 248 p. DT73.A14 V45 2002. Abu Sir is an extensive Old Kingdom necropolis near modern Cairo.

A3.295. Excavation site at Abusir-South. http://www.waseda.jp/prj-egypt/sites/Abusir-E.html.

A3.296. *The excavations of the Czechoslovak Institute of Egyptology at Abusir-I: the Mastaba of Ptah-shepses: reliefs I/1* / Miroslav Verner. Prague: Charles University, 1977–1986. 2 v. DT73.A14 V47 1986. Other volumes in the series include *Abusir II: Baugraffiti der Ptahschepses-Mastaba* / Miroslav Verner. Praha: Universitas Carolina Pragensis, 1992. 292 p. DT73.A14 V462 1992; *Abusir III: the pyramid complex of Khentkaus* / Miroslav Verner. Praha: Universitas Carolina Pragensis: Academia, 1995. 183 p. DT73.A14 V28 1995; *Abusir IV: the shaft tomb of Udjahor-resnet at Abusir* / Ladislav Bareš. Praha: Universitas Carolina Pragensis: Karolinum, 1999. 111, 23 p. DT73.A14 B37 1999; *Abusir V: the cemeteries at Abusir South I* / Miroslav Bárta. Praha: Set Out, 2001. 211 p. DT73.A14 B377 2001; *Abusir VI: Djedkare's family cemetery* / Miroslav Verner and Vivienne G. Callender. Prague: Czech Institute of Egyptology, Faculty of Arts, Charles University, 2002. 163 p. DT73.A14 V46 2002; *Abusir VII: Greek imports in Egypt: Graeco-Egyptian relations during the first millennium B.C.* / Kvĕta Smoláriková. Praha: Czech Institute of Egyptology, Faculty of Arts, Charles University, 2002. 122 p. DT73.A14 S66 2002; *Abusir VIII: die relieffragmente aus der Mastaba des Ptahschepses in Abusir* / Bretislav Vachala. Prague: Czech Institute of Egyptology, Faculty of Arts, Charles University, 2004. 296, 40 p. DT73.A14 V3342 2004; *Abusir IX: the pyramid complex of Raneferef: the archeology* / Miroslav Verner. Prague: Czech Institute of Egyptology, 2006. 521 p. DT73.A14 V466 2006; *Abusir X: the pyramid complex of Raneferef: the papyrus archive* / Paule Posener-Kriéger, Miroslav Verner, and Hana Vymazalová. Prague: Czech Institute of Egyptology, Faculty of Arts, Charles University in Prague, 2006. 495 p. DT85.P667 2006; *Abusir XII: minor tombs in the royal necropolis I (the Mastabas of Nebtyemneferes and Nakhtsare, Pyramid Complex Lepsius no. 24 and Tomb Complex Lepsius no. 25)* / Jaromir Krejčí, Vivienne G. Callender, and Miroslav Verner. Prague: Czech Institute of Egyptology, 2008. 284, 32 p. DT73.A14 K742 2008; *Abusir XIII: Abusir south 2: tomb complex of the vizier Qar, his sons Qar Junior and Senedjemib, and Iykai* / Miroslav Bárta. Prague Czech Republic: Czech Institute of Egyptology, Faculty of Arts, Charles University in Prague: Dryada, 2009. 364 p. DT73.A14 B3773 2009; *Abusir XIV: Faience inlays from the funerary temple of King Raneferef: Raneferef's substitute decoration programme* / Renata Landgráfová. Prague: Czech Institute of Egyptology, Faculty of Arts, Charles University in Prague, 2006. 120, 54 p. + CD-ROM. DT73.A14 L363 2006; *Abusir XV: stone vessels from the mortuary complex of Raneferef at Abusir* / Pétra Vlckova. Prague: Czech Institute of Egyptology, Faculty of Arts, Charles University in Prague, 2006. 152 p. + CD-ROM. DT73.A14 V52 2006; *Abusir XX: lesser late period tombs at Abusir: the tomb of Padihor and the anonymous tomb R3* / Filip Coppens and Kvĕta Smoláriková. Prague: Czech Institute of Egyptology, 2010. 139 p. DT73.A14 C6 2009.

A3.297. *Forgotten pharaohs, lost pyramids: Abusir* / Miroslav Verner. Praha: Academia Skodaexport, 1994. 244 p. DT73.A14 V46 1994.

A3.298. *Das Grabdenkmal des Königs Saḥu-re* / Ludwig Borchardt. Leipzig: J. C. Hinrich, 1910–1913. 2 v. 913.01 B458 Bd.14, 26.

A3.299. *Secondary cemetery in the Mastaba of Ptah-shepses at Abusir* / Eugen Strouhal and Ladislav

Bareš. Prague: Charles University, 1993. 179, 92 p. DT73.A14 S843 1993q.

Abydos (Abdju)

A3.300. *Abydos: description des fouilles exécutés sur l'emplacement de cette ville* / Auguste Mariette. Hildesheim; New York: Olms, 1998. 2 v. DT73. A16 M32 1998, v. 1/2, 3. One of the most ancient settlements of Upper Egypt, located about 11 kilometers west of the Nile River near the modern towns of el- 'Araba el Madfuna and al-Balyana.

A3.301. *Inscribed material from the Pennsylvania-Yale excavations at Abydos* / William Kelly Simpson. New Haven: Peabody Museum of Natural History of Yale University; Philadelphia: University of Pennsylvania Museum of Archaeology and Anthropology, 1995. 110, 31 p. DT73.A16 S572 1995.

A3.302. *The mortuary temple of Senwosret III at Abydos* / Joseph Wegner. New Haven: Peabody Museum of Natural History; Philadelphia: University of Pennsylvania Museum of Archaeology and Anthropology, 2007. 188 p. DT85.W446 2007.

Adaima

A3.303. *Adaima* / Béatrix Midant-Reynes and Nathalie Buchez. Le Caire: Institut Français d'Archeologie Orientale, 2002. DT73.A17 M54 2002. A Predynastic and early Dynastic settlement located in the Nile River valley 9 kilometers from modern Isna.

Akhmin

A3.304. *A mountain speaks: the first Australian excavation in Egypt* / Naguib Kanawati. Sydney, Australia: Macquarie University, 1988. 96 p. DT73. H34 K36 1988. A settlement in Upper Egypt on the banks of the Nile. The hill of Akhmin is filled with human burials in pits, which contain eight to ten small superimposed chambers.

A3.305. *A tomb from the reign of Tutankhamun at Akhmim* / Boyo G. Ockinga. Warminster; Wilts, England: Aris & Phillips, 1997. 66, 74 p. DT62. T6 O25 1997.

Al Hammamiyah

A3.306. *The Old Kingdom tombs of El-Hammamiya* / A. El-Khouli and N. Kanawati. Sydney: Australian Centre for Egyptology, 1990. 86, 80 p. DT62. T6 K48 1990. A Predynastic settlement in Upper Egypt.

Alexandria

A3.307. Alexandria: The Ptolemaic Dynasty. http://www. cartage.org.lb/en/themes/GeogHist/histories/ Oldcivilization/Egyptology/EgyptHisory/alexhis1.htm. Originally founded around a small Pharaonic town in 331 BCE by Alexander the Great, Alexandria was Egypt's capital for nearly 1,000 years until the Muslim conquest in 641 CE, when a new capital was founded at Fustat (Cairo).

A3.308. *Alexandria: the submerged royal quarters* / Franck Goddio. London: Periplus, 1998. 274 p. DT73.A4 A439 1998.

A3.309. *Alexandria: the sunken city* / William La Riche. London: Weidenfeld & Nicolson, 1996. 135 p. DT73.A4 L37 1996.

A3.310. *Alexandria rediscovered* / Jean-Yves Empereur. New York: G. Braziller, 1998. 253 p. DT73.A4 E4713 1998. English translation of *Alexandrie redécouverte*.

A3.311. Battle of Alexandria. http://www.fact-index. com/b/ba/battle_of_alexandria.html.

A3.312. *La céramique romaine tardive d'Alexandrie* / Mieczyslaw Rodziewicz. Varsovie: Éditions scientifiques de Pologne, 1976. Y72, 26 p. DT73.A4 A37 v.1.

A3.313. *Céramiques médiévales à Alexandrie: contribution à l'histoire économique de la ville* / Véronique François. Le Caire: Institut français d'archéologie orientale, 1999. 205, 18 p. NK3880. F72 1999.

A3.314. *L'eau dans les espaces et les pratiques funéraires d'Alexandrie aux époques greque et romaine: IVe siècle av. J.-C.-IIIe siècle ap. J.-C.* / Agnès Tricoche. Oxford: Archaeopress, 2009. 222 p. DT73.A4 T75 2009.

A3.315. *Fouilles polonaises à Kôm el-Dikka (1986–1987)* / Zsolt Kiss. Varsovie: Centre d'archéologie méditerranéenne de l'Académie polonaises des sciences, 2000. 143, 24 p. DT73.A4 A37 v.7.

A3.316. *Les habitations romaines tardives d'Alexandrie: à la lumière des fouilles polonaises à Kôm el-Dikka* / Mieczyslaw Rodziewicz. Varsovie: Editions scientifiques de Pologne, 1984. 453, 4 p. DT73.A4 A37 v.3.

A3.317. *Imperial baths at Kôm el-Dikka* / Wojciech Kolataj. Warszawa: Zaklad Archeologii Śródziemnomorskiej Polskie; Akademii Nauk, 1992. 217 p. DT73.A4 A37 v.6. English language translation of *Laźnie cesarskie na Kom El-Dikka*.

A3.318. *Katalog Alexandrinischer Kaisermünzen der Sammlung des Instituts für Altertumskunde der Universität zu Köln* / Angelo Geissen. Opladen: Westdeutscher Verlag, 1974. PJ1014.P3 vol.5, Bd.1, 2.

A3.319. Library of Alexandria. http://www.crystalinks. com/libraryofalexandria.html.

A3.320. *Nécropolis. 1* / Jean-Yves Empereur and Marie-Dominique Nenna. Le Caire: Institut Français d'archéologie orientale, 2001. 527 p. DT73.A4 N43 2001.

A3.321. *The Roman coins of Alexandria: quantitative studies: Nero, Trajan, Septimius Severus* / Erik Christiansen. Aarhus, Denmark: Aarhus University Press, 1988. 2 v. CJ1073.A4 C57 1988.

A3.322. *A short guide to the catacombs of Kom el Shoqafa, Alexandria* / Jean-Yves Empereuer. Alexandria: Sarapis Publishing, 1995. 26 p. DT73. A4 E4613 1995.

A3.323. *Taposiris Magna* / Győző Vörös. Budapest: Egypt Excavation Society of Hungary, 2001. DT73.A4 V67 2001.

A3.324. *La tomba di Alessandro: realtà, ipotesi e fantasie* / Achille Adriani. Roma: L'Erma di Bretschneider, 2000. 124, 38 p. DF234.2.A34 2000.

Amarna, tell el-

A3.325. Amarna: land of the Aten. http://ib205.tripod. com/amarna.html. An extensive archaeological site that represents the remains of the capital city of the Pharaoh Akhenaten of the eighteenth dynasty (ca. 1353 BCE).

A3.326. *Amarna palace paintings* / F. J. Weatherhead. London: Egypt Exploration Society, 2007. 386 p. DT57.E323 no.78.

A3.327. Amarna Project. http://www.amarnaproject. com/.

A3.328. *Amarna reports* / Barry J. Kemp. London: Egypt Exploration Society, 1984. DT73.T25 A43 1984.

A3.329. *The ancient textile industry at Amarna* / Barry J. Kemp and Gillian Vogelsang-Eastwood. London: Egypt Exploration Society, 2001. 498 p. DT57.E323 no.68.

A3.330. *Brilliant things for Akhenaten: the production of glass, vitreous materials and pottery at Amarna Site O45.1* / Paul T. Nicholson. London: Egypt Exploration Society, 2007. 393 p. + CD-ROM. DT57.E323 no.80.

A3.331. *Gefässverschlüsse aus Tell el-Amarna: Grabungen der Deutschen Orient-Gesellschaft 1911 bis 1914; sozioökonomische Aspekte einer Fundgattung des neuen Reiches* / Josefine Kuckertz. Saarbrücken: Saarbrücker Druckerei und Verlag, 2003. 154 p. DT73.T25 K835 2003.

A3.332. Mineralogical and Chemical Study of the Amarna Tablets. http://www.tau.ac.il/humanities/archaeology/projects/proj_amarna.html.

A3.333. *Nefertiti lived here* / Mary Chubb. London: Libri, 1998. 181 p. DT73.T25 C5 1998.

A3.334. *Late Roman pottery at Amarna and related studies* / Jane Faiers. London: Egypt Exploration Society, 2005. 283 p. NK3850.F343 2005.

A3.335. *Private religion at Amarna: the material evidence* / Anna Stevens. Oxford: Archaeopress, 2006. 365 p. DT73.T25 S84 2006.

A3.336. *The search for Nefertiti: the true story of a remarkable discovery* / Joann Fletcher. London: Hodder & Stoughton, 2004. 452, 24 p. DT87.45. F54 2004.

Antinoupolis

A3.337. *Antinoupolis* / Rosario Pintaudi. Firenze: Istituto papirologico "G. Vitelli," 2008. DT73.A7 A584 2008. A New Kingdom location of Pharaoh Ramesses II's great temple dedicated to the deities of Khmun and Heliopolis. A later settlement was founded by the Roman emperor Hadrian ca. 130 CE.

Armant

A3.338. *Predynastic settlement near Armant* / Boleslaw Ginter and Janusz K. Koslowski. Heidelberg: Heidelberger Orientverlag, 1994. 194, 68 p. DT73.A8 G56 1994. Armant (Iuny, Erment, Hermonthis) was an important Middle Kingdom settlement located on the west bank of the Nile River about 18 kilometers south of Thebes.

Ashmunayn

A3.339. *Vorläufiger Bericht über die Ausgrabungen in Hermopolis 1929–1930* / Günther Roeder. Hildesheim: Überreicht von der Deutschen Hermopolis-Expedition; Versandt durch das Pelizaeus-Museum, 1931? 126 p. DT73.H47 R63 1931. Continued by: *Vorläufiger Bericht über die Deutsche Hermopolis-Expedition 1931 und 1932* / Günther Roeder. Hildesheim: Überreicht von der Deutschen Hermopolis-Expedition; Versandt durch das Pelizaeus-Museum, 1932? 45, 18 p. 913.32 R623.2. Ashmunayn, el. Site of ancient Khmun; also known as Hermopolis Magna, Hermopolis, Hermopolis Megale, or Hermupolis.

Asyut

A3.340. *Ancient Asyut: the first synthesis after 300 years of research* / Jochem Kahl. Wiesbaden: Harrassowitz, 2007. 188, 16 p. DT73.A9 K34 2007. Asyut was the capital of the thirteenth nome of Upper Egypt around 3100 BCE. In Greco-Roman

times there was a dialect of Coptic spoken here (Lycopolitan).

Bacchias

A3.341. *The Bologna and Lecce Universities Joint Archaeological Mission in Egypt: ten years of excavations at Bakchias (1993–2002)* / Gabriele Bitelli. Napoli: Graus editore, 2003. 69 p. + CD-ROM. DT73.B3 M57 2003. Other volumes in the series include *Bakchias IV: rapporto preliminare della campagna di scavo del 1996* / Sergio Pernigotti e Mario Capasso. Pisa: Istituti editoriali e poligrafici internazionali, 1997. 111 p. DT73. B3 B38 1997; *Bakchias VI: rapporto preliminare della campagna di scavo del 1998* / Sergio Pernigotti, Mario Capasso, and Paola Davoli. Pisa: Istituti editoriali e poligrafici internazionali, 1999. 215 p. DT73.B3 B393 1999; *Bakchias VII: rapporto preliminare della campagna di scavo del 1999* / Sergio Pernigotti, Mario Capasso, and Paola Davoli. Imola (Bo) Italy: La mandragora, 2000. 133 p. DT73.B3 B396 2000; *Bakchias VIII: rapporto preliminare della campagna di scavo del 2000* / Sergio Pernigotti, Mario Capasso, and Paola Davoli. Imola (Bo) Italy: La mandragora, 2001. 150 p. DT73.B3 B395 2001; *Bakchias IX: rapporto preliminare della campagna di scavo del 2001* / Sergio Pernigotti, Mario Capasso, and Paola Davoli. Imola (Bologna): La mandragora, 2003. 118 p. DT73.B33 B34 2003. Bacchias (Bakchias, Kom el-Atl, Kopm al-Atel, Kom el-Asl) was a Ptolemaic village located near the town of Karanis (Kom Oshim) along the Ptolemaic period caravan route from Memphis to Medinet Fayoum.

Bahbit el Higara

A3.342. *Le temple de Behbeit el-Hagara: essai de reconstitution et d'interpretation* / Christine Favard-Meeks. Hamburg: H. Buske, 1991. 523, 37 p. DT73.B335 F38 1991.

Bahnasa

A3.343. *Oxyrhynchus: a city and its texts* / A. K. Bowman. London: Published for the Arts and Humanities Research Council by the Egypt Exploration Society, 2007. 407, 31 p. DT73.O8 O89 2007. Bahnasa, el (Oxyrhynchus, Pr-Medjed, Pemdje) is a settlement in Upper Egypt located about 160 kilometers south-southwest of Cairo. The site area has yielded large numbers of papyrus texts dating from the Ptolemaic and Roman periods.

Balamun, tell al- (Paiuenamon; Diospolis Inferior)

A3.344. *Excavations at Tell el-Balamun, 1995–1998* / A. J. Spencer. London: British Museum, 1999. 212 p. DT73.B34 S642 1999. Located on the west side of the Damietta branch of the Nile in the central delta, Tell al-Balamun is a large, relatively intact mound that covers the ancient town of Sma-Behdet, the most northerly city of Pharaonic Egypt.

Balat

A3.345. *Le monument funéraire d'Ima-Pepy/Ima-Meryre* / Michel Valloggia. Le Caire: Institut Français d'archéologie orientale, 1998. 2 v. DT73.B35 V36 1998. An Old Kingdom village located at the Dakhla oasis. Five mastabas surfaced here after a sandstorm.

Ballana

A3.346. *Noubadian X-Group remains from royal complexes in cemeteries Q and 219 and from private cemeteries Q, R, V, W, B, J, and M at Qustul and Ballana* / Bruce Beyer Williams. Chicago: Oriental Institute of the University of Chicago, 1991. 409, 83 p. DT135.N8 U54 v.9. A cemetery with more than 120 burials in lower Nubia, dating after the collapse of the Meriotic state.

A3.347. *Nubian treasure: an account of the discoveries at Ballana and Qustul* / Walter B. Emery. London: Methuen, 1948. 72, 48 p. 913.32 Em.35.3.

Baranis (Sallum, As Sallum, Sollum)

A3.348. *Berenike and the ancient maritime spice route* / Steven E. Sidebotham. Berkeley: University of California Press, 2011. 434 p. DT73.B375 S4 2011. A Roman port located on the north coast of Egypt near the border with Libya.

A3.349. *Documents from Berenike* / Roger S. Bagnall, Christina Helms, and Arthur M. F. W. Verhoogt. Bruxelles: Fondation Égyptologique Reine Élisabeth, 2000. DT73.B37 B35 2000.

A3.350. *Berenike 1995: preliminary report of the 1995 excavations at Berenike (Egyptian Red Sea Coast) and the survey of the Eastern Desert* / Steven E. Sidebotham and Willemina Z. Wendrich. Leiden: Research School CNWS, 1996. 483 p. DT73.B34 B49 1996.

Benha

A3.351. *Tell Atrib 1985–1995: stemple ceramiczne; Tell Atrib 1985–1995: pottery stamps* / Zofia Sz-

tetyllo. Warszawa: Wydawnictwo Neriton, 2000. DT62.P72 T45 2000. Located 348 kilometers north of Cairo on the east bank of the Damietta Branch of the Nile is the ancient settlement of Athribis (Athlibis), capital of the tenth nome (province) of Lower Egypt in ca. 1500 BCE.

Bersheh

A3.352. *Bersheh reports* / Edward Brovarski. Boston: Museum of Fine Arts, 1992. DT73.B437 B47 1992. A major provincial First Intermediate and Middle Kingdom period (2130–1630 BCE) cemetery.

A3.353. *Report of the 1990 field season of the joint expedition of the Museum of Fine Arts, Boston, University Museum, University of Pennsylvania, Leiden University* / Edward Brovarski. Boston: Museum of Fine Arts, Boston, 1992. 77 p. DT73. B437 B47 1992 v.1.

Bir Umm

A3.354. Bir Umm Fawakhir Project. http://oi.uchicago. edu/research/projects/faw/.

Bubastis, tell

A3.355. *Methodische Grundlagen für die Rekonstruktion der Tempelanlage von Tell Basta* / Christian Tietze. Potsdam: Universität Potsdam, 1994. 54, 20 p. DT73.B8 T538 1994. Bubastis (Tell Basta, Per Bast) was a settlement located in the Nile delta of Lower Egypt; it is identified with the biblical Phibeseth.

A3.356. *Rekonstruktion und Restaurierung in Tell Basta* / Christian Tietze. Potsdam: Universität, 2003. 272 p. DT73.B8 R45 2003.

A3.357. *Tell Basta.* Cairo: University of Zagazig, Institute of Ancient Near Eastern Studies, 1992. DT73.B8 T45 1992.

A3.358. *Tell Basta: Geschichte einer Grabung* / Mahmud Omar Selim and Christian Tietze. Potsdam: Universität Potsdam, 1997. 12, 42 p. DT73.B8 S455 1997.

A3.359. *Tell Basta: vorläufiger Bericht der XIV. Kampagne* / Christian Tietze. Potsdam: Universitätsbibliothek, 2003. 245 p. DT73.B8 T455 2003.

Buhayrah (Beheira)

A3.360. *The West Nile Delta Regional Survey, Beheira and Kafr el-Sheikh provinces* / Penelope Wilson and Dimitrios Grigoropoulos. London: Egypt Exploration Society, 2009. 490 p. + CD-ROM.

DT57.E323 no.86. A coastal governorate in the Nile delta.

Buhen

A3.361. *The Fortress of Buhen: the archaeological report* / Walter B. Emery, H. S. Smith, and A. Millard. London: Egypt Exploration Society, 1979. 225, 67 p. DT57.E32 v.49. An ancient Egyptian fortress, probably constructed during the rule of Senusret III around 1680 BCE, located on the west bank of the Nile north of the second cataract.

Buto (Butu, Butuis, Butosus, Tell al-Fara'in)

A3.362. *Tell el-Faraîn, Buto.* Mainz am Rhein: Philipp von Zabern, 1997. DT57.D47 no.83, 94. An ancient settlement located 95 kilometers east of Alexandria in the Nile delta.

Dandara

A3.363. *Dendereh, 1898* / W. M. Flinders Petrie. London; Boston: Egypt Exploration Fund, 1900. 74, 38 p. DT73.D4 P43. Dandara (Dendereh) was an important Old-Middle kingdom (2625–1630 BCE) cemetery site.

Dahshur

A3.364. *Expedition to Dahshur.* http://www.waseda.jp/ prj-egypt/sites/Dhshr-E.html.

Dimé

A3.365. *Soknopalou Nesos: the University of Michigan excavations at Dimé in 1931–32* / A. E. R. Boak, E. E. Peterson, and A. Haatvedt Rolfe. Ann Arbor: University of Michigan Press, 1935. 378.73 M582MH v.39. Dimeh al-Siba (Dime, Dimia, Qasr al-Sagha) was a Ptolemaic settlement founded in the third century BCE at the edge of Moeris Bay near the caravan route into the Western Desert.

Dispilio

A3.366. Dispilio Excavations. Presents the excavations at the Neolithic settlement of Dispilio near Kastoria in northern Greece. Includes a history of the excavation, "diary" by site director, and brief sections on its museum, excavation park, and information and documentation center. http://www. dispilio.org/dispilio/public/enter_eng.

Djoser

A3.367. Step Pyramid Complex of Djoser. http://www.
arthistory.upenn.edu//zoser/zoser.html.

Dongola Reach

A3.368. Dongola Reach Expedition-the Third Cataract.
http://www.anth.ucsb.edu/faculty/stsmith/re-
search/nubia.html.

El Adaïma

A3.369. El Adaïma, un site prédynastique de Haute-
Égypte. http://www.diplomatie.gouv.fr/en/
global-issues/education-research/archaeology/
archaeology-notebooks/africa-arabia/egypt-el-
adaima/.

El Alamein

A3.370. *Marina El Alamein: archaeological background
and conservation problems: the Polish-Egyp-
tian Preservation Mission at Marina, 1988, the
Polish Excavation Mission at Marina, 1987–
1989. vol. 1* / Wiktor A. Daszewski. Warsaw:
State Enterprise, the Ateliers for Conservation
of Cultural Property (PKZ), 1991. 54 p. DT73.
M256 M375 1991. El Alamein (al-Alamayn) is
located 105 kilometers west of Alexandria and
240 kilometers northwest of Cairo on the Medi-
terranean coast.

El Bersheh

A3.371. *El Bersheh* / Percy E. Newberry. London; Bos-
ton: Egypt Exploration Fund, 1893–1894. 2 v.
DT57.E323.

El-Derr

A3.372. *The temple of Derr* / Aylward M. Blackman.
Le Caire: Imprimerie de l'Institut français
d'archéologie orientale, 1913. 131 p. 913.32
T245.5. The temple of Derr is a speos or rock-cut
Egyptian temple built by Pharaoh Rameses II in
Lower Nubia.

El-Hagarsa

A3.373. *The tombs of El-Hagarsa* / Naguib Kanawati.
Sydney: Australian Centre for Egyptology.
Warminster: Aris & Phillips, 1993. DT73.E428
K35 1993. An Old Kingdom cemetery on the
west bank of the Nile River.

El-Kab

A3.374. *La Tombe De Setaou* / Jean-Marie Kruchten and
Luc Delvaux. Bruxelles: Musees Royaux d'Art
et d'Histoire; Turnhout: Brepols, 2010. 398 p.
DT73.E43 E44 v.8. A pre-Pharaonic and Phara-
onic settlement on the east bank of the Nile about
80 kilometers south of Luxor with extensive
rock-cut tombs of the early eighteenth dynasty
(1550–1295 BCE).

A3.375. *Die Felsinschriften des Wadi Hilal* / Hans
Vandekerckhove and Renate Müller-Woller-
mann. Turnhout: Brepols, 2001. 2 v. DT73.E43
E44 v.6.

A3.376. *The Naqada III cemetery* / Stan Hendrickx. Brux-
elles: Musées Royaux d'Art et d'Histoire, 1994.
259 p. DT73.E43 E44 v.5.

Elephantine (Abu, Yebu)

A3.377. *Die Dekorfragmente der ptolemäisch-römischen
Tempel von Elephantine* / Ewa Laskowska-Kusz-
tal. Mainz: P. von Zabern, 1996. 175, 114 p.
DT57.D47 no.73. An island at the border of
Egypt and Nubia was a defensive site and cargo
transfer point for river trade during the Second
Intermediate Period (1650–1550 BCE).

A3.378. *Elephantine XVII: die Dekoration des Chnum-
tempels auf Elephantine durch Nektanebos II* /
Hanna Jenni. Mainz: P. von Zabern, 1998. 159,
125 p. DT57.D47 no.90.

A3.379. *Kalabsha III, the Ptolemaic sanctuary of Kalab-
sha: its reconstruction on Elephantine Island* / G.
R. H. Wright. Mainz am Rhein: P. von Zabern,
1987. 92 p. DT57.D47 no.3 v.1.

A3.380. *Die Nachnutzung des Chnumtempelbezirks:
Wohnbebauung der Spätantike und des Früh-
mittelalters* / Felix Arnold. Mainz am Rhein:
P. von Zabern, 2003. 222, 43 p. DT57.D47
no.116.

A3.381. *Der Tempel der Satet: die Funde der Frühzeit
und des Alten Reiches* / Günter Dreyer. Mainz am
Rhein: P. von Zabern, 1986. DT57.D47 no.39.

A3.382. *Untersuchungen in der Stadt des Mittleren
Reiches und der Zweiten Zwischenzeit* / Corne-
lius von Pilgrim. Mainz: P. von Zabern, 1996.
364, 41 p. DT57.D47 no.91.

Deir Shalwit (Deir el-Shelwit, Deir Chalouit)

A3.383. *Le temple de Deir Chelouit* / Christiane M. Zivie.
Le Caire: IFAO, 1982. 2 v. DT73.D46 Z58;
DT73.D46 Z58. A Greco-Roman temple to the
deity Isis on the West Bank near Luxor.

Fayyum (Faiyum, Phiom, Crocodilopolis)

A3.384. *Living images: Egyptian funerary portraits in the Petrie Museum* / Janet Picton, Stephen Quirke, and Paul C. Roberts. Walnut Creek, CA: Left Coast Press, 2007. 318 p. ND1327.E3 L58 2007. A Middle Egyptian settlement located 130 kilometers southwest of Cairo. Founded ca. 4000 BCE, it is the oldest settlement in Egypt and one of the oldest cities in Africa.

A3.385. *Bibliografia del Fayyum* / Anna Morini. Imola: La mandragora, 2004. 222 p. DT73.F38 M67 2004.

Gilf Kebir

A3.386. *Ausgrabungen im Wadi el Akhdar, Gilf Kebir (SW-Ägypten)* / Werner Schön. Köln: Heinrich-Barth-Institut, 1996. 2 v. DT154.G55 S36 1996. Gilf Kebi (Gilf al-Kebir, Jiff al Kabir) is a plateau in southwest Egypt and southeast Libya known for its dramatic Neolithic rock paintings and petroglyphs.

Giza

A3.387. Giza Online. http://www.theglobaleducationproject.org/egypt/index.php.

A3.388. Giza Plateau Mapping Project. http://oi.uchicago.edu/research/projects/giz/,

Habua, tell el-

A3.389. *The inscriptions of the Ways of Horus* / Abdul Rahman Al-Ayedi. Ismailia, Egypt: Obelisk Publications, 2006. 166 p. PJ1526.S56 A53 2006. The possible location of Tjaru, a major Egyptian fortress located on the road from Egypt into Canaan.

A3.390. *Tell Heboua (1981–1991): enquête archéologique sur la deuxième période intermédiaiire et le nouvel empire à l'extrémité orientale du delta* / Mohamed Abd El-Maksoud. Paris: Ministère des affaires étrangères: Editions Recherche sur les civilisations, 1998. 313 p. DT73.H32 A22 1998.

Heliopolis

A3.391. *The predynastic cemetery at Heliopolis: season March–September 1950* / Fernand Debono and Bodil Mortensen. Mainz am Rhein: P. von Zabern, 1988. 57, 21 p. DT57.D47 no.63. The capital of the thirteenth nome of Lower Egypt was located 89 kilometers east of the Nile to the north of the apex of the Nile delta. Heliopolis was occupied during the Predynastic, Old and Middle Kingdoms. The ancient Egyptian component is beneath the northern Cairo suburb of Al-Matariyyah.

Heracléopolis Magna (Heracleopolis, Henen-nesut, Nen-nesu)

A3.392. *Excavaciones en Ehnasya el Medina (Heracleópolis Magna)* / María del Carmen Pérez-Die and Pascal Vernus. Madrid: Ministerio de Cultura, Dirección General de Bellas Artes y Archivos, Instituto de Conservación y Restauración de Bienes Culturales, 1992. 2 v. DT73.H44 P47 1992. Heracléopolis Magna (Heracleopolis, Henen-nesut, Nen-nesu) was the Greek name of the twentieth nome of ancient Egypt.

Hermopolis Magna

A3.393. *British Museum expedition to Middle Egypt: Ashmunein (1985)* / A. J. Spencer and D. M. Bailey. London: British Museum, 1986. 106 p. DT73.A85 S752 1986. Hermopolis Magna (Hermopolis, Hermopolis Megale, Hermupolis, Khmun) is located near the modern Egyptian town of El Ashmunein.

A3.394. *Reports from Ashmunein: Polish-Egyptian archaeological and preservation mission at El Ashmunein* / Jan Gromnicki. Warsaw: PKZ, 1989. DT73.A85 R47 1989.

Hiba (el-Hiba, el-Hibeh)

A3.395. *Archaeological investigations at el-Hibeh 1980: preliminary report* / Robert J. Wenke. Malibu, CA: Undena Publications, 1984. 141, 12 p. DT73.H62 W47. Hiba is the modern name of the ancient Egyptian city of Tayu-djayet. In antiquity the settlement was located in the eighteenth Upper Egyptian nome and a massive enclosure wall site from the Greco-Roman period known as Ankyronpolis.

Hierakonpolis (Nekhen)

A3.396. *Excavations in the Locality 6 cemetery at Hierakonpolis, 1979–1985* / Barbara Adams. Oxford: Archaeopress; Hadrian Books, 2000. 316 p. DT73.K453 A312 2000. Hierakonpolis was a religious and political capital of Upper Egypt at the end of the Predynastic (ca. 3200–3100 BCE) and Early Dynastic (ca. 3100–2686 BCE) periods.

Helwan

A3.397. *El Omari: a neolithic settlement and other sites in the vicinity of Wadi Hof, Helwan* / Fernand Debono and Bodil Mortensen. Mainz am Rhein: P. von Zabern, 1990. 154, 56 p. DT57.D47 no.82. Hebwan (Hilan, Hulwan, Holkwan) is a settlement opposite the ruins of Memphis on the banks of the Nile River.

A3.398. *Helwan I, excavations in the early dynastic cemetery: season 1997/98* / E. Christiana Köhler. Heidelberg: Heidelberger Orientverlag, 2005. 86, 69 p. DT73.H85 K64 2005.

A3.399. *Helwan II: the Early Dynastic and Old Kingdom funerary relief slabs* / E. Christiana Köhler and Jana Jones. Rahden/Westf.: Marie Leidorf, 2009. 203 p. DT73.H84 K652 2005.

Idfu (Edfu, Edfou, Behdet)

A3.400. *Ostraca Grecs et coptes des fouilles Franco-Polonaises sur le site de Tell Edfou: O. Edfou Copte 1–145* / Seyna Bacot. Cairo: Institut Français d'Archéologie Orientale, 2009. 209 p. PJ2195. B5 t.19. Idfu is the site of the Ptolemaic Temple of Horus and an ancient tell on the west bank of the Nile River.

Imu (Yamu)

A3.401 *The spatial structure of Kom el-Hisn: an old kingdom town in the Western Nile Delta, Egypt* / Anthony Cagle. Oxford: Archaeopress, 2003. 253 p. DT73.H57 C34 2003. A large New Kingdom mound site on the edge of the Nile delta west of Tanta.

Ismant el-Kharab

A3.402. *The Kellis agricultural account (P. Kell.IV Gr.96)* / Roger S. Bagnall. Oxford: Oxbow Books, 1997. 23, 20 p. S565.855.E3 K45 1997. Ismant el-Kharab (Kellis) was a Roman village in Upper Egypt located about 2.5 kilometers east-southeast of Ismant in the Dakhleh oasis.

Jilf al Kabir Plateau

A3.403. *Wadi Bakht: Landschaftsarchäologie einer Siedlungskammer im Gilf Kebir* / Jörg Linstädter. Köln: Heinrich-Barth-Institut, 2005. 327 p. GN776.42.E3 W33 2005.

Jizah

A3.404. *Die altägyptische Grabkammer Seschemnofers III. aus Gisa: eine Stiftung des Geheimen Ho-* frats Dr. h. c. Ernst von Sieglin an die Tübinger Universität / Emma Brunner-Traut. Mainz am Rhein: P. von Zabern, 1995. 34, 33 p. DT73.G5 B78 1995. Jizah (Gizah, Imu Giza) is famed as the location of the Giza plateau, the site of some of the most significant ancient monuments in the world, including a complex of ancient royal mortuary and religious structures, including the Great Sphinx, the Great Pyramid of Giza, and several other large temples and pyramids.

A3.405. *Giza: Ausgrabungen im Friedhof der Cheopspyramide von Georg Steindorf* / Antje Spiekermann and Friederike Kampp-Seyfried. Leipzig: Ägyptisches Museum, 2003. 87 p. DT63.S65 2003.

A3.406. *Giza Plateau Mapping Project: seasons 2006–2007 preliminary report* / Mark Lehner, Mohsen Kamel, and Ana Tavares. Boston: Ancient Egypt Research Associates, 2009. 176, 47 p. DT73.G5 L42 2009. Continued by: *Giza Plateau Mapping Project: season 2008 preliminary report* / Mark Lehner, Mohsen Kamel, and Ana Tavares. Boston: Ancient Egypt Research Associates, 2009. 72, 8 p. DT73.G5 L44 2009; *Giza Plateau Mapping Project season 2009: preliminary report* / Mark Lehner. Boston: Ancient Egypt Research Associates, 2011. 244, 30 p. DT73.G5 G59 2011.

A3.407. *Die Kultkammer des Ka-ni-nisut im Kunsthistorischen Museum Wien* / Regina Hölzl. Wien: Kunsthistorisches Museum Wien: Christian Brandstätter Verlag, 2005. 64 p. DT73.G5 H659 2005.

A3.408. *Nezlet Batran, eine Mastaba aus dem Alten Reich bei Giseh (Ägypten): österreichische Ausgrabungen 1981–1983* / Karl Kromer. Wien: Verlag der Österreichischen Akademie der Wissenschaften, 1991. 68, 46 p. AS142.A518 Bd.12.

A3.409. *The pyramid tomb of Hetep-heres and the satellite pyramid of Khufu* / Mark Lehner. Mainz am Rhein: P. von Zabern, 1985. 90, 6 p. DT73.G5 L44 1985.

A3.410. *Siedlungsfunde aus dem frühen alten Reich in Giseh: österreichische Ausgrabungen 1971–1975* / Karl Kromer. Wien: Verlag der Österreichischen Akademie der Wissenschaften, 1978. 130, 24 p. AS142.V32 Bd.136.

A3.411. *Slab stelae of the Giza necropolis* / Peter Der Manuelian. New Haven: Peabody Museum of Natural History of Yale University; Philadelphia: University of Pennsylvania Museum of Archaeology and Anthropology, 2003. 244 p. DT62.S8 D47 2003.

A3.412. *Untersuchungen zu Idu II, Giza: ein interdisziplinäres Projekt* / Bettina Schmitz. Hildesheim: Gerstenberg Verlag, 1996. 85, 30 p. DT73.G5 U67 1996.

Kafr al-Shaykh

A3.413. *The West Nile Delta Regional Survey, Beheira and Kafr el-Sheikh provinces* / Penelope Wilson and Dimitrios Grigoropoulos. London: Egypt Exploration Society, 2009. 490 p. + CD-ROM. DT57.E323 no.86. Kafr al-Shaykh (Kafr el-Sheikh) is located in a fertile plain about 40 kilometers north-northwest of Tanta in the central Nile delta, Lower Egypt.

Kalabishah

A3.414. *Debod bis Bab Kalabsche* / Günther Roeder. Le Caire: Impr. de l'Institut français d'archéologie orientale, 1911–1912. 3 v. 913.32 T245.8, 3 v. Kalabishah, a settlement located south of Edfu.

Karanis

A3.415. *Ancient textiles from Egypt in the University of Michigan collection* / Lillian M. Wilson. Ann Arbor: University of Michigan Press, 1933. 77 p. NK8988.W5 1933; 378.73 M582MH v.31. Karanis was a Greco-Roman agricultural town in the northeast corner of the Fayum, established by Ptolemy II Philadelphus to settle Greek mercenaries among indigenous Egyptians and to exploit the fertile Faun basin.

A3.416. *The archive of Aurelius Isidorus in the Egyptian Museum, Cairo, and the University of Michigan (P. Cair. Isidor.)* / Arthur E. R. Boak and Herbert Chayyim Youtie. Ann Arbor: University of Michigan Press, 1960. 478 p. Classics Resource Room PA3315.B63 1960.

A3.417. *L'archivio di Claudius Tiberianus da Karanis* / Silvia Strassi. Berlin; New York: Walter de Gruyter, 2008. 194 p. PA3315.K37 S77 2008.

A3.418. *Coinage in Roman Egypt: the hoard evidence* / Erik Christiansen. Aarhus: Aarhus University Press, 2004. 208 p. CJ893.E3 C527 2004.

A3.419. *Coins from Karanis, the University of Michigan excavations, 1924–1935* / Rolfe A. Haatvedt and Enoch E. Peterson. Ann Arbor: The Museum, 1964. 399, 11 p. CJ1369.M5 1964.

A3.420. *Columbia Papyri VII: fourth century documents from Karanis* / Roger S. Bagnall and Naphtali Lewis. Missoula: Scholars Press, 1979. 275 p. + 2 microfiche sheets. PA3305.C64.

A3.421. *Guardians of the Nile: sculptures from Karanis in the Fayoum (c. 250 BCE–AD 450): Kelsey Museum of Archaeology, the University of Michigan, Ann Arbor, October 14–December 17, 1978* / Elaine K. Gazda. Ann Arbor: The Museum, 1978. 80 p. DT59.M524 G39.

A3.422. *Karanis, an Egyptian town in Roman times: discoveries of the University of Michigan expedition to Egypt (1924-1935)* / Elaine K. Gazda. 2 ed. Ann Arbor: Kelsey Museum of Archaeology, University of Michigan, 2004. 50 p. DT73.K33 K37 2004.

A3.423. *Karanis excavations of the University of Michigan in Egypt, 1928–1935: topography and architecture: a summary of the reports of the director, Enoch E. Peterson* / E. M. Husselman and E. E. Peterson. Ann Arbor: University of Michigan Press, 1979.

A3.424. *Karanis, the temples, coin hoards, botanical and zoölogical reports, seasons, 1924–31* / A. E. R. Boak. Ann Arbor: University of Michigan Press, 1933. 378.73 M582MH v.30.

A3.425. *Karanis: topographical and architectural report of excavations during the seasons 1924–28* / A. E. R. Boak and E. E. Peterson. Ann Arbor: University of Michigan Press, 1931. 378.73 M582MH v.25.

A3.426. *Papyri and ostraca from Karanis* / O. M. Pearl, L. Amundsen, J. G. Winter, and H. C. Youtie. Ann Arbor: University of Michigan Press, 1944. 378.73 M582MH v.50.

A3.427. *Papyri from Karanis* / Edgar J. Goodspeed. Chicago: University of Chicago Press, 1900. 66 p. 470.6 C433 v.3.

A3.428. *Papyri from Karanis, third series* / Elinor M. Musselman. Cleveland: American Philological Association; Press of Case Western Reserve University, 1971. 152 p. PA3305.M5.

A3.429. *Pottery from Karanis: excavations of the University of Michigan* / Barbara Johnson. Ann Arbor: University of Michigan Press, 1981. 127, 80 p. DT73.K33 J63.

A3.430. *Roman glass from Karanis found by the University of Michigan archaeological expedition in Egypt, 1924–29* / D. B. Harden. Ann Arbor: University of Michigan Press, 1936. 378.73 M582MH v.41.

A3.431. *Tax list from Karanis (P. Cair. Mich. 359)* / Hinri Riyad and John C. Shelton. Bonn: R. Habelt, 1975. PA/3303 C35.

A3.432. *Tax rolls from Karanis* / H. C. Youtie, V. B. Schuman, and O. M. Pearl. Ann Arbor: University of Michigan Press, 1936. 378.73 M582MH v.42–43.

A3.433. *Terracotta lamps from Karanis, Egypt: excavations of the University of Michigan* / Louise A. Shier. Ann Arbor: University of Michigan Press, 1978. 219 p. DT62.L34 S53.

A3.434. *Textiles from Karanis, Egypt in the Kelsey Museum of Archaeology: artifacts of everyday life* / Thelma K. Thomas. Ann Arbor: University of Michigan, 2001. 48 p. NK8988.T486 2001.

Karnak

A3.435. Karnak, Centre franco-égyptien d'études des temples de Karnak. The construction of the

Karnak Temple Complex began in the reign of Sesostyris I in the Middle Kingdom and continued into the New Kingdom and Ptolemaic periods. It is part of the monumental city of Thebes. http://www.cfeetk.cnrs.fr/.

A3.436. *Karnak*. Le Caire: Institut français d'archéologie orientale du Caire, 1943. DT73.K4 C3, v. 1, 3, 4(1–2), 5(1–2), 6(1–2), 7(1–2), 8, 9.

A3.437. *La porte ptolémaïque de l'enceinte de Mout à Karnak* / Serge Sauneron. Le Caire: Institut français d'archéologie orientale, 1983. 69 p. DT57.F8 t.107.

A3.438. *Report on the pottery from the 1971 and 1972 excavations at the Temple of Osiris Heqa Djet at Karnak: field analysis and recording procedures* / John S. Holladay. Toronto: Society for the Study of Egyptian Antiquities, 1975. 23 p. NK3810.H64.

Kellia Kellia (al-Muna)

A3.439. *Explorations aux Qoucour el-Izeila: lors des campagnes 1981, 1982, 1984, 1985, 1986, 1989 et 1990* / Françoise Bonnet Borel. Louvain: Peeters, 1999. 2 v. DT73.K47 E93 1999. A fourth century CE Egyptian Christian monastic community.

Kharga

A3.440. *Le gisement épipaléolithique de ML1 à 'Ayn-Manawir: oasis de Kharga* / François Briois, Béatrix Midant-Reynes, and Michel Wuttmann. Le Caire: Institut Français d'archeologie orientale, 2008. 154 p. DT154.K6 B75 2008. Kharga (al-Hariga, al-Kharijah) is the southernmost of Egypt's western oases. It is located in the Libyan desert about 200 kilometers west of the Nile. The Darb el-Arbain trade route passes through Kharga as part of a long caravan route between Middle Egypt and the Sudan to transport gold, ivory, spices, wheat, animals, and plants.

Kom Abou Billou

A3.441. Necropolis of Kom Abou Billou. http://www.umich.edu/~kelseydb/Exhibits/PortalsToEternity/Necropolis.html.

Kom Firin

A3.442. *Kom Firin. 1, The Ramesside temple and the site survey* / Neal Spencer. London: British Museum, 2008. 226 p. DT73.K64 S77 2008. Kom Firin is a large settlement site near the western edge of

the Nile delta, occupied between the thirteenth century BCE and seventh century CE.

Kom Rabiah

A3.443. *Kom Rabia: the New Kingdom and Post-New Kingdom objects* / Lisa Giddy. London: Egypt Exploration Society, 1999. 391, 94 p. 57.E323 no.64. A New Kingdom component at Memphis.

A3.444. *Kom Rabia: the New Kingdom pottery*. London: Egypt Exploration Society, 2010. 508 p. DT57.E323 no.93.

A3.445. *Excavations at Kom Rabia (Site Rat): post-Ramesside levels and pottery* / David Aston and David Jeffreys. London: Egypt Exploration Society, 2007. 90, 58 p. DT57.E323 no.81.

Koptos

A3.446. From Koptos to Myos Hormos. http://www.diplomatie.gouv.fr/en/global-issues/education-research/archaeology/archaeology-notebooks/africa-arabia/egypt-from-koptos-to-myos-hormos/.

Kysis

A3.447. *La Nécropole: exploration archéologique, monographie des tombes 1 à 72: structures sociales, économiques, religieuses de l'Égypte romaine* / Fr. Dunand. Cairo, Egypt: Institut français d'archéologie orientale du Caire, 1992. 387 p. DT57.16 t.26. One of the oldest Roman ruins in Kharga Oasis, a border town commanded by a large garrison of Roman troops; includes a mudbrick fortress (Qasr Dush) and two temples.

A3.448. *Le Trésor: inventaire des objets et essai d'interprétation* / Michel Reddé. Le Caire: Institut français d'archéologie orientale, 1992. 66 p. DT57.16 t.28.

Lisht (el-Lisht)

A3.449. *The control notes and team marks* / Felix Arnold. New York: Metropolitan Museum of Art, 1990. 188 p. DT57.N5 v.23. Located south of Cairo, the site of Middle Kingdom royal burials, including two pyramids constructed by Amenemhat I and Senussret I.

Luxor (al 'Uqsur)

A3.450. *Das Statuenversteck im Luxortempel* / Mohammed El-Saghir. Mainz am Rhein: P. von Zabern, 1992. 75 p. NB75.E473 1992. The site of the ancient Egyptian city of Thebes. The temple

complexes at Karnak and Luxor are within the modern city. Across the Nile River are the monuments on the West Bank necropolis, including the Valley of the Kings and Valley of the Queens.

Luxor-Farshut

A3.451. Luxor-Farshût Desert Road Survey. http://oi.uchicago.edu/research/projects/des/.

Maadi

A3.452. *Maadi: excavations at the predynastic site of Maadi and its cemeteries conducted by Mustapha Amer and Ibrahim Rizkana on behalf of the Department of Geography, Faculty of Arts of Cairo University, 1930–1953.* Mainz am Rhein: P. von Zabern, 1987. 4 v. DT57.D47 no.64, 65, 80, 81. The site of a significant Predynastic settlement gradually being destroyed by modern building activity.

Magdolum

A3.453. *Le camp romain du Bas-Empire à Tell el-Herr* / Dominique Valbelle and Jean-Yves Carrez-Maratray. Paris: Errance, 2000. 256 p. DT73. M235 V25 2000. A migdol or migdal is a Hebrew term, which means a tower, or an elevated platform; physically it can refer to a fortified place (walled city or castle). Migdol appears in several places in the Bible (e.g., Ezekiel, Jeremiah, Joshua).

Marina (Marina El Alamein)

A3.454. *The architectural decoration of Marina el-Alamein* / Rafał Czerner. Oxford: Archaeopress, 2009. 132, 16 p. DT154.M37 C94 2009. A Greco-Roman port on the north coast of Egypt located 300 kilometers from Cairo.

Marsá Matruh

A3.455. *Marsa Matruh: the University of Pennsylvania Museum of Archaeology and Anthropology's excavations on Bates's Island, Marsa Matruh, Egypt, 1985–1989* / Donald White. Philadelphia: Institute for Aegean Prehistory Academic Press, 2002. 2 v. DT73.M254 W45 2002; DT73.M254 W45 2002. Marsa Matruh (Mersa Matruh, Marsa Matrouh). A Mediterranean seaport 240 kilometers west of Alexandria. It was known as Paraitonion during the reign of Alexander the Great, and as Paraetonium by the Romans.

Maydum (Medum)

A3.456. *Meidum* / Ali el-Khouli. Sydney: Australian Centre for Egyptology; Warminster; Wilts, England: Aris and Phillips, 1991. 51, 62 p. DT73.M29 K56 1991. An Old Kingdom Egyptian site near Memphis on the west bank of the Nile River; it is the location of the earliest funerary pyramid complex (2575–2130 BCE).

Medamud

A3.457. *Rapport sur les fouilles de Médamoud (1925– . Rapports préliminaires).* Le Caire. Impr. de l'Institut Français d'archéologie orientale. 1926. 913.32 128.10 t.3(1–2), 4(1–2), 5(1), 6(1), 7(1), 8(1–2), 9(1, 3), 13. A settlement with several structures dedicated to the war deity Monthu, located 8 kilometers northeast of Luxor.

Medinet Habu

A3.458. *Scarabs, scaraboids, seals and seal impressions from Medinet Habu* / Emily Teeter. Chicago: Oriental Institute of the University of Chicago, 2003. 247, 110 p. DT73.M3 T5 2003. The New Kingdom mortuary temple of Rameses II, located on the West Bank of Luxor.

Memphis

A3.459. *Survey of Memphis, 1.* / D. J. Jeffreys. London: Egypt Exploration Society, 1985. DT73.M5 J43 1985. Continued by: *Survey of Memphis, 3. Excavations at Kom Rabia (Site Rat): post-Ramesside levels and pottery* / David Aston and D. J. Jeffreys. London: Egypt Exploration Society, 1985. 90, 58 p. DT57 .E323 no.81; *Survey of Memphis, 4. Kom Rabia: the New Kingdom pottery* / Janine Bourriau. London: Egypt Exploration Society, 2010. 508 p. DT57.E323 no.93; *Survey of Memphis, 5. Kom Rabia: the new kingdom settlement (levels II–V)* / David Jeffreys. London: Egypt Exploration Society, 2006. 142, 2 p. DT57.E323 no.79; *Survey of Memphis, 7. The Hekekyan papers and other sources for the survey of Memphis* / D. J. Jeffreys. London: Egypt Exploration Society, 1985. 225 p. DT57 .E323 no.95. Memphis was the ancient capital of Aneb-Hetch, the first nome of Lower Egypt.

Mendes (Djedet, Per-Banebdjedet, Anpet, Tell el-Ruba)

A3.460. *City of the Ram-man: the story of ancient Mendes* / Donald B. Redford. Princeton: Princeton

University Press, 2010. 240 p. DT73.M54 R43 2010. The capital of the sixteenth nome of Lower Egypt located in the eastern Nile delta. It was replaced by Thmuis in Greco-Roman Egypt.

A3.461. *Excavations at Mendes* / Donald B. Redford. Leiden; Boston: Brill, 2004. DT73.M54 R44 2004, v. 1; DT73.M54 R44 2004.

Minshat Abu Umar (Minschat Abu Omar, Minshat Abu Omar, Minshat Abu 'Umar, Ash Sharqiyah, Sharkia)

A3.462. *Minshat Abu Omar: ein vor- und frühgeschichtliche Friedhof im Nildelta* / Karla Kroeper and Dietrich Wildung. Mainz am Rhein: P. von Zabern, 1994. 2 v. DT73.M72 K762 1994. A Pre- and Early Dynastic and Greco-Roman period necropolis and settlement located 150 kilometers north of Cairo. It was a hub for shipping and trade with Palestine.

A3.463. *The elite late period Egyptian tombs of Memphis* / Michael Stammers. Oxford: Archaeopress, 2009. 214 p. + CD-ROM. DT73.M5 S73 2009.

Mudiriyat al-Sharqiyah

A3.464. *Six archaeological sites in Sharqiyeh province* / S. R. Snape. Liverpool: Liverpool University Press, 1986. 93 p. DT73.S5 S611 1986. Al Sharqia governorate is located in northeastern Egypt.

Naucratis

A3.465. *Ancient Naukratis: excavations at a Greek emporium in Egypt* / Albert Leonard. Cambridge: American Schools of Oriental Research, 1997–2001. 2 v. DS101.A45 v.54–55; DS101.A45 v.54, 55. 2 v. Naucratis (Naukratis) was an ancient settlement on the Canopic branch of the Nile, 70 kilometers from the open sea. It was the only permanent Greek colony in Egypt for much of its early history and acted as an important point for the interchange of Greek and Egyptian culture.

A3.466. *Archäologische Studien zu Naukratis* / Ursula Höckmann. Möhnesee: Bibliopolis, 2006. DT73. N3 A73 2006, Bd.1, 2(1–2).

Narmer

A3.467. Narmer: Unifier of Egypt? http://www.philae.nu/ akhet/AbydNarmer.html.

Nile River

A3.468. *L'habitat prédynastique de la vallée du Nil: vivre sur les rives du Nil aux Ve et IVe millénaires* / Yann Tristant. Oxford: Hedges, 2004. 182 p. GN865.N66 T75 2004. The Nile River is a major north-flowing river in northeastern Africa. It has two major tributaries: the White Nile rises in the Great Lakes region of Central Africa, and the Blue Nile begins at Lake Tana in Ethiopia. The two rivers meet near the Sudanese capital of Khartoum. Most of the population and settlements of ancient Egypt are found along the riverbanks of the Nile River north of Aswan.

A3.469. *Le sceau et l'administration dans la Vallée du Nil: Villeneuve d'Ascq, 7-8 juillet 2000.* Lille: Université Charles-de-Gaulle, 2001. 215 p. DT60.S333 2001.

A3.470. *Du Nil à Alexandrie: histoires d'eaux* / Isabelle Hairy. Alexandrie: Editions Harpocrates 2009. 717 p. DT116.D8 2009.

Pi-Ramesse

A3.471. *Die Keramik des Grabungsplatzes Q I* / David Aston. Mainz am Rhein: P. von Zabern, 1998. 2 v. NK3810.A85 K4 1998. The capital of the nineteenth dynasty Pharaoh Ramesses II (1279–1213 BCE) at Qantuir near Avaris.

Qasr Ibrim

A3.472. *Qasr Ibrim: the hinterland survey* / Pamela Rose. London: Egypt Exploration Society, 1996. 162, 136 p. DT57.E323 no.62. An archaeological site originally positioned on a cliff above the Nile, but the flooding of the Nile after the construction of the Aswan High Dam transformed it into an island.

A3.473. *The cemeteries of Qaṣr Ibrim: a report of the excavations conducted by W. B. Emery in 1961* / A. J. Mills. London: Egypt Exploration Society, 1982. 94, 93 p. DT57.E323 no.51.

Qift (Keft, Kebto, Gebtu, Justinianopolis)

A3.474. *Excavations at Coptos (Qift) in Upper Egypt, 1987–1992* / S. C. Herbert and A. Berlin. Portsmouth, RI: Journal of Roman Archaeology, 2003. 231 p. DT73.Q54 H47 2003. An important ancient Upper Egyptian administrative center in the fifth nome of Harawi. Qift was the origin of many trading expeditions heading for the Red Sea and mining expeditions into the Eastern Desert. It was also the origin of caravan routes to the Red Sea coast toward Taaou (Myoshormos) and Shashirit (Berenice).

A3.475. *Le Temple d'El-Qal\a* / Laure Pantalucci and Claude Traunecker. Cairo: Institut français

d'archéologie orientale du Caire, 1990. 2 v. DT73.Q54 P36 1990.

Qina (Qena, Kaine, Cainepolis)

A3.476. *Mahgar Dendera 2 (Haute Egypte): un site d'occupation Badarien* / Stan Hendrickx, Béatrix Midant-Reynes, and Wim Van Neer. Leuven, Belgium: Leuven University Press, 2001. 112, 56 p. GN778.32.E3 H45 2001. An upper Egyptian settlement situated on the east bank of the Nile.

Qubbat al-Hawa

A3.477. *Funde aus dem Grab 88 der Qubbet el-Hawa bei Assuan (Die Bonner Bestände)* / Michael Höveler-Müller. Wiesbaden: Harrassowitz, 2006. 153 p. DT73.Q72 H69 2006. The site of a group of Old Kingdom rock-cut tombs on the west side of the Nile, opposite Aswan.

Quesir (Al-Qusayr, El Quseir, Quseir, Qusseir, Qosseir, Kosseir, Leucus Limen)

A3.478. *Quseir: an Ottoman and Napoleonic fortress on the Red Sea coast of Egypt* / Charles Le Quesne. Cairo; New York: American University in Cairo Press, 2007. 362 p. DT73.Q77 L4 2007. An ancient Egyptian settlement located on the Red Sea.

A3.479. Quseir al-Qadim Project. http://www.southampton.ac.uk/archaeology/research/projects/quseir_al_qadim_project.page.

Qusayt al-Qadim (Quseir al-Qadim, Leukos Limen)

A3.480. *Myos Hormos-Quseir al-Quadim: Roman and Islamic ports on the Red Sea* / David Peacock and Lucy Blue. Oxford: Oxbow Books, 2006. 2 v. CC78.M96 2006. A Roman port on the Red Sea important in the Indian Ocean trade.

Qustul

A3.481. *The A-group royal cemetery at Qustul: cemetery L* / Bruce Beyer Williams. Chicago: Oriental Institute of the University of Chicago, 1986. 338, 110 p. DT135.N8 U54 v.3. Location in Nubia of a Predynastic cemetery of thirty-three tombs possibly as early as 3800–3100 BCE.

A3.482. *Noubadian X-Group remains from royal complexes in cemeteries Q and 219 and from private cemeteries Q, R, V, W, B, J, and M at Qustul and Ballana* / Bruce Beyer Williams. Chicago: Oriental Institute of the University of Chicago, 1991. 409, 83 p. DT135.N8 U54 v.9.

A3.483. *Nubian treasure: an account of the discoveries at Ballana and Qustul* / Walter B. Emery. London: Methuen, 1948. 72, 48 p. 913.32 Em.35.3. Report of the Mission archéologique de Nubie, 1929–1934.

A3.484. *Twenty-fifth Dynasty and Napatan remains at Qustul: cemeteries W and V* / Bruce Beyer Williams. Chicago: Oriental Institute of the University of Chicago, 1990. 83, 15 p. DT135.N8 U54 v.7.

Ras al-Khaimah

A3.485. Excavations and research projects in Ras al-Khaimah. http://heritage.brookes.ac.uk/projects/current/ras-al-khaimah/.

Sa el-Hajar (Sais)

A3.486. *Sais. I, The Ramesside-Third intermediate period at Kom Rebwa* / Penelope Wilson. London: Egypt Exploration Society, 2011. 291, 97 p. DT57.E323 no.98. An ancient Egyptian town in the western Nile delta on the Canopic branch of the Nile dating to the twenty-fourth (ca. 732–720 BCE) and twenty-sixth (ca. 664–525 BCE) dynasties.

A3.487. *The survey of Sais (Sa el-Hagar) 1997–2002* / Penelope Wilson. London: Egypt Exploration Society, 2006. 336, 40 p. DT57.E323 no.77.

Saqqarah (Saqqara, Sakkara, Saccara)

A3.488. *The Anubieion at Saqqara* / D. G. Jeffreys and H. S. Smith. London: Egypt Exploration Society, 1988. DT57.E323 no.54, 56. A Third Dynasty burial ground serving as the necropolis for ancient Memphis, located 30 kilometers south of Cairo. The site features numerous pyramids, including the Third Dynasty step pyramid of Djoser, as well as several mastabas; includes Pharaonic, Ptolemaic, and Roman occupations.

A3.489. *Auf der suche nach dem verlorenen Grab: neue Ausgrabungen verschollener und unbekannter Grabanlagen aus der Zeit des Tutanchamun und Ramses II. in Memphis* / Geoffrey T. Martin. Mainz am Rhein: P. von Zabern, 1994. 283 p. DT73.S3 M36515 1994.

A3.490. *The Chapel of Niankhkhnum & Khnumhotep: scene details* / Yvonne Harpur and Paolo Scremin. Reading: Oxford Expedition to Egypt, 2010. 637 p. DT73.S3 H35 2010.

A3.491. *Les complexes funéraires d'Ouserkaf et de Néferhétepès* / Audran Labrousse, Jean-Philippe Lauer. Le Caire: Institut Français d'archéologie orientale, 2000. 2 v. PJ25.B6 t.130.

A3.492. *Découverte à Saqqarah: le vizir oublié* / Alain Zivie. Paris: Seuil, 1990. 194 p. DT73.S3 Z58 1990.

A3.493. *Etudes sur l'Ancien empire et la nécropole de Saqqara dédiées à Jean-Philippe Lauer* / Catherine Berger and Bernard Mathieu. Montpellier III: Université Paul Valéry, 1997. 2 v. DT73.S3 E88 1997.

A3.494. *Excavations at Saqqara: north-west of Teti's Pyramid* / N. Kanawati. North Ryde, NSW: Ancient History Documentary Research Centre, Macquarie University; Warminster Wiltshire: Aris & Phillips, 1984. 2 v. DT73.S3 E9 1984.

A3.495. *Fouilles à Saqqarah: la pyramide d'Aba* / Gustave Jéquier. Cairo: Organisation égyptienne generale du livre, 1984. 38, 29 p. DT73.S3 J374 1984.

A3.496. *Late period pottery from the New Kingdom Necropolis at Saqqara: Egypt Exploration Society-National Museum of Antiquities, Leiden, excavations 1975–1995* / David A. Aston and Barbara G. Aston. London: Egypt Exploration Society, 2010. 266, 60 p. DT57.E323 no.92.

A3.497. *Lauer et Sakkara* / Claudine Le Tourneur d'Ison. Paris: Tallandier; Paris: Historia, 2000. 143 p. PJ1064.L38 L48 2000. Biographical study of Jean Philippe Lauer (1902–2001).

A3.498. *The lost tombs of Saqqara* / Alain Zivie. Ankhtawy: Cara.cara Edition, 2007. 151 p. DT73. S3 Z5913 2007. English language translation of *Les tombeaux retrouvés de Saqqara* / Alain Zivie. Monaco: Rocher, 2003. 155 p. DT73.S3 Z59 2003.

A3.499. *The mastaba of Neferseshemptah* / A. B. Lloyd, A. J. Spencer, and A. El-Khouli. London: Egypt Exploration Society, 2008. 38, 44 p. DT57.E323 no.41.

A3.500. *The Mastabas of Meru, Semdenti, Khui and others* / A. B. Lloyd, A. J. Spence, and A. El-Khouli. London: Egypt Exploration Society, 1990. 53, 36 p. DT57.E323 no.40.

A3.501. *The Memphite tomb of Horemheb, commander-in-chief of Tutankhamun* / Geoffrey Thorndike Martin. London: Egypt Exploration Society, 1989. 1 v. + CD-ROM. DT57.E323.

A3.502. *Mereruka and his family* / N. Kanawati and M. Abder-Raziq. Oxford: Aris and Phillips, 2004. DT73.S3 M47 2004, pt.1, text + CD-ROM, pt.2.

A3.503. Mission archéologique de Saqqâra Sous titre. http://www.diplomatie.gouv.fr/fr/enjeux-internationaux/echanges-scientifiques-recherche/archeologie-sciences-humaines-et/les-carnets-d-archeologie/afrique-arabie/egypte-saqqara/.

A3.504. *Les pyramides de Sakkara: la pyramide à degrés, la pyramide de l'Horus-Sekhem-Khet, la pyramide d'Ounas, la pyramide d'Ouserkaf, la pyramide de Téti, le sérapeaum et les mastabas de Ti et de Ptah-Hotep; the pyramids of Sakkara: the step pyramid, the pyramid of Horus Sekhem-Khet, the pyramid of Unis, the pyramid of Userkaf, the pyramid of Teti, the serapeum and the mastabas of Ti and Ptah-Hotep* / Jean-Philippe Lauer. 6 ed. Le Caire: Institut Français d'Archéologie Orientale, 1991. 145 p. DT73.S3 L37 1991.

A3.505. Queen's Pyramid Discovered at Saqqara. http://guardians.net/hawass/Press%20Releasesqueens_pyramid_saqqara_11-08.htm.

A3.506. *The sacred animal necropolis at North Saqqara: the Mother of Apis and baboon catacombs: the archaeological report* / Sue Davies. London: Egypt Exploration Society, 2006. 160, 82 p. DT57.E323 no.76.

A3.507. *The sacred animal necropolis at North Saqqara: the falcon complex and catacomb: the archaeological report* / Sue Davies and H. S. Smith. London: Egypt Exploration Society, 2005. 158, 30 p. DT57.E323 no.73.

A3.508. *The sacred animal necropolis at North Saqqara: the southern dependencies of the main temple complex* / Geoffrey Thorndike Martin. London: Egypt Exploration Society, 1981. 204, 49 p. DT57.E323 no.50.

A3.509. *Saqqarah abra al-uṣur* / Zahi Ḥawass. Cairo: Wizarat al-Thaqafah, al-Majlis al-Alá lil-Athar, 2006. 101, 18 p. DT73.S3 S275 2006.

A3.510. *Saqqara II: pottery of the late old kingdom; funerary pottery and burial customs; ceramika poznego starego pantswa ceramika grobowa i zwyczaje pogrzebowe* / Teodozja Rzeuska. Varsovie: Editions Neriton, 2006. 596, 15 p. + CD-ROM. DT73.S3 R94 2006.

A3.511. *Saqqara tombs*. London: Egypt Exploration Society, 1984. 3 v. DT57.E323 no.36, 40, 41; DT57. E323 1984.

A3.512. *The sculpture from the Sacred Animal Necropolis at North Saqqāra, 1964–76* / Elizabeth Anne Hastings. London: Egypt Exploration Society, 1997. 87, 44 p. DT57.E323 no.61.

A3.513. *The temple furniture from the Sacred Animal Necropolis at North Saqqara, 1964–1976* / Christine Insley Green. London: Egypt Exploration Society, 1987. 131 p. DT57.E323 no.53.

A3.514. *The Teti cemetery at Saqqara* / N. Kanawati and A. Hassan. Sydney: Australian Centre for Egyptology. Warminster, England: Aris and Phillips, 1996. DT73.S3 K36 1996.

A3.515. *Les textes de la pyramide de Pépy Ier* / Jean Leclant. Le Caire: Institut francçais d'archéologie orientale, 2001. 2 v. DT57.F8 t.118.

A3.516. *The tomb-chapels of Paser and Raia at Saqqara* / Geoffrey Thorndike Martin. London: Egypt

Exploration Society, 1985. 63, 37 p. DT57.E323 no.52.

A3.517. *The tomb of Pay and Raia at Saqqara* / Maarten J. Raven. Leiden: National Museum of Antiquities. Leiden; London: Egypt Exploration Society, 2005. 171, 160 p. DT73.S3 R38 2005.

A3.518. *Tomba di Bakenrenef (L. 24): attività del Cantiere scuola, 1985-1987* / E. Bresciani. Pisa: Giardini, 1988. 87 p. DT73.S3 T65 1988.

A3.519. *Tomba di Boccori: La galleria di Padineit, visir di Nectanebo I* / E. Bresciani. Pisa: Giardini, 1983. 119, 64 p. DT73.S3 T66 1983.

Sayyalah (Sayyalah)

A3.520. *Nag El-Scheima: eine befestigte christliche Siedlung und andere christliche Denkmäler in Sayala-Nubien* / Manfred Bietak und Mario Schwarz. Wien: Verlag der Österreichischen Akademie der Wissenschaften, 1987. 2 v. AS142.V32 Bd.191. Ancient burial site of the Nubian oligarchy.

A3.521. *Die römischen Gräberfelder von Sayala, Nubien* / Fathi Afifi Bedawi. Wien: Verlag der Österr. Akad. d. Wiss., 1976. 99, 20 p. AS142.V32 Bd.126.

Serabit El-Khadim

A3.522. The Mines of the Pharoahs-Serabit El-Khadim, Sinai, Egypt. http://www.hhgs.org.uk/monthly_meetings/previous_meetings/mines_of_pharaohs/mines_of_pharaohs.htm.

Sinai

A3.523. *An archaeological investigation of the central Sinai, Egypt* / Frank W. Eddy and Fred Wendorf. Cairo, Egypt: American Research Center in Egypt; Boulder: University Press of Colorado, 1999. 340 p. DT137.S55 E33 1999. A triangular-shaped peninsula situated between the Mediterranean Sea and the Red Sea and serves as a land bridge between the continents of Asia and Africa.

A3.524. *Archaeological survey of the Rāya/al-Ṭūr area on the Sinai Peninsula, Egypt, 2002* / Mutsuo Kawatoko. Tokyo: Committee for Islamic Archaeology in Egypt, Middle Eastern Culture Center in Japan, 2003. 92, 4 p. DT137.S55 A734 2003. Continued by: *Archaeological survey of the Rāya/al-Ṭūr area on the Sinai Peninsula, Egypt, 2003* / Mutsuo Kawatoko. Tokyo: Committee for Islamic Archaeology in Egypt, Middle Eastern Culture Center in Japan, 2004. 119 p. DT137.S55 A734 2004; *Archaeological survey of the Rāya/al-Ṭūr area area on the Sinai Pen-*

insula, Egypt, 2004 / Mutsuo Kawatoko. Tokyo: Committee for Islamic Archaeology in Egypt, the Middle Eastern Culture Center in Japan, 2005. 103, 4 p. DT137.S55 A734 2005.

A3.525. *Archaeology of Sinai: the Ophir expedition* / Itzhaq Beit-Arieh. Tel Aviv: Emery and Claire Yass Publications in Archaeology, Institute of Archaeology, University of Tel-Aviv, 2003. 454 p. DT73.S58 B45 2003.

A3.526. *Forschungsbericht: Palästina und Sinaihalbinsel* / Karl Jaroš; *Die kyprominoischen Schriftsysteme* / Stefan Hiller. Horn, Austria: F. Berger, 1985. 102 p. DS111.J37 1985; DS111.J37 1985.

A3.527. *God's wilderness: discoveries in Sinai* / Beno Rothenberg. London: Thames and Hudson, 1961. 196 p. DS110.5.R6813 1961.

A3.528. *The inscriptions of the Ways of Horus* / Abdul Rahman Al-Ayedi. Ismailia, Egypt: Obelisk Publications, 2006. 166 p. PJ1526.S56 A53 2006.

A3.529. *Monastic settlements in South Sinai in the Byzantine period: the archaeological remains* / Uzi Dahari. Jerusalem: Israel Antiquities Authority, 2000. 250 p. DT137.S55 D349 2000.

A3.530. *Nabatean archaeology today* / Avraham Negev. New York: New York University Press, 1986. 155 p. Center for Advanced Judaic Studies Lib, DS154.22.N44 1986; DS154.22.N45 1986.

A3.531. *Pelusium: prospection archéologique et topographique de la région de Kana'is: campagne internationale pour l'étude et le sauvegarde des sites archéologiques du Nord-Sinai* / Horst Jaritz. Stuttgart: F. Steiner, 1996. 225, 15 p. NA215.B4 Hft.13.

A3.532. *Researches in Sinai: ancient Egypt and Palestine* / W. M. Flinders Petrie. London; New York: Kegan Paul, 2003. 280 p. DT137.S55 P48 2003.

A3.533. *Le Sinaï: de la conquête arabe à nos jours* / Jean-Michel Mouton. Le Caire: Institut français d'archéologie orientale, 2001. 227 p. DT137.S55 S55 2001.

A3.534. *Sinai: excavations and studies* / Zeév Meshel. Oxford: Archaeopress: Hadrian Books distributor, 2000. 161 p. DT137.S55 M47 2000.

Tanis

A3.535. Mission archéologique Française de Tanis. A settlement on the Tanitic branch of the Nile river in the Nile delta, northeast Egypt. http://www.diplomatie.gouv.fr/fr/enjeux-internationaux/echanges-scientifiques-recherche/archeologie-sciences-humaines-et/les-carnets-d-archeologie/afrique-arabie/egypte-tanis/.

A3.536. *Tanis: travaux récents sur le tell Sân el-Hagar: Mission française des fouilles de Tanis* / Philippe

Brissaud and Christiane Zivie-Coche. Paris: Noêsis, 1998. 3 v. DT73.T2 M56 1998, v.1–3.

Tebtunis (Theodosiopolis)

A3.537. *Tebtynis* / Claudio Gallazzi. Le Caire: Institut français d'archéologie orientale, 2000. DT57. G36 2000, v.1–5. A Ptolemaic Egyptian settlement at the modern village of Tell Umm el-Baragat in the Al Fayyum governorate famed for the many papyri in Demotic and Greek.

Tell el-Herr

A3.538. Tell el-Herr, Mission archéologie Franco-Egyptienne du Nord-Sinaï. http://www.diplomatie.gouv. fr/en/france-priorities_1/archaeology_2200/archaeology- notebooks_2202/africa-arabia_2240/ egypt-tell-el-herr_2253/index.html.

Terenouthis

A3.539. *Portals to eternity: the necropolis at Terenouthis in Lower Egypt: the University of Michigan's Reconnaissance Expedition to Kom Abou Billou, the necropolis of ancient Terenouthis (March to April 1935)* / R. V. McCleary. Ann Arbor: Kelsey Museum of Archaeology, University of Michigan, 1987. Located near the Greco-Roman sanctuary at Medinet Maadi, the ruins of Terenouthis is known for the illegal excavation of the Coptic-Manichaean codes.

Thebes

A3.540. *Aegeans in the Theban tombs* / Shelley Wachsmann. Leuven: Uitgeverij Peeters, 1987. 146, 70 p. DT73.T3 W2 1987. An ancient settlement on the east bank of the Nile located within modern Luxor some 800 kilometers south of the Mediterranean. The Theban necropolis is situated nearby on the west bank of the Nile.

A3.541. *Die Doppelgrabanlage "M" aus dem Mittleren Reich unter TT 196 im Tal el-Asasif in Theben-West* / Erhart Graefe. Aachen: Shaker, 2007. 202, 145 p. DT73.T3 G734 2007.

A3.542. Egyptian Theban Desert-Photography / Yarko Kobylecky. http://www.museumphotography.com/.

A3.543. *Five years' explorations at Thebes: a record of work done 1907–1911* / the Earl of Carnarvon and Howard Carter. London; New York: Kegan Paul, 2004. 100, 79 p. DT73.T3 C3 2004.

A3.544. *Fouilles de la vallée des rois (1898–1899)* / Georges Daressy. Le Caire: Institut français d'archéologie orientale, 1902. 311 p. DT57.2 v.3.

A3.545. *Das Grab des Hui und des Kel: Theben Nr. 54* / Daniel Polz. Mainz am Rhein: P. von Zabern, 1997. 148, 18 p. DT57.D47 no.74.

A3.546. *Das Grab des Padihorresnet, Obervermögensverwalter der Gottesgemahlin des Amun (Thebanisches Grab Nr. 196)* / Erhart Gräfe. Bruxelles: Fondation égyptologique reine Elisabeth; Turnhout: Brepols, 2003. 2 v. DT73. T3 G73 2003.

A3.547. *Die Gräber des Nacht-Min und des Men-cheper-Ra-seneb: Theben Nr. 87 und 79* / Heike Guksch. Mainz am Rhein: P. von Zabern, 1995. 180, 65 p. DT57.D47 no.34.

A3.548. *Die Gräber des Vezirs User-Amun Theben Nr.61 und 131* / Eberhard Dziobek. Mainz am Rhein: P. von Zabern, 1994. 106, 48 p. DT57.D47 no.84.

A3.549. *Eine ikonographische Datierungsmethode für thebanische Wandmalereien der 18. Dynastie* / Eberhard Dziobek, Thomas Schneyer, and Norbert Semmelbauer. Heidelberg: Heidelberger Orientverlag, 1992. 85, 8 p. ND2863.D95 1992.

A3.550. *Et maintenant ce ne sont plus que des villages: Thèbes et sa région aux époques hellénistique, romaine et byzantine: actes du colloque tenu à Bruxelles les 2 et 3 décembre 2005* / Alain Delattre and Paul Heilporn. Bruxelles: Association égyptologique Reine Elisabeth, 2008. 201 p. DT73.T3 E86 2008.

A3.551. *Preliminary report: Archaeological expedition on the area of the Temple of Amenophis II, Western Thebes, December 2001–January 2002* / Angelo Sesana. Como: CFB, 2002. 46, 6 p. DT73.T3 P745 2002. Continued by: *Preliminary report: 5th archaeological expedition on the area of the temple of Amenophis II, Western Thebes, December 2002–January 2003* / Angelo Sesana. Como: CFB, 2003. 46, 5 p. DT73.T3 P7452 2003.

A3.552. *Proceedings of the colloquium on Theban archaeology at the Supreme Council of Antiquities, November 5, 2009* / Zahi Hawass, Tamás A. Bács, and Gábor Schreiber. Cairo: Conseil Supreme des Antiquités de l'Égypte, 2011. 160 p. DT73.T3 C65 2011.

A3.553. *Tebe* / Sergio Donadoni. Milano: Electa, 1999. 210 p. DT73.T3 D66 1999.

A3.554. Theban Mapping Project (American University in Cairo). The Theban Mapping Project includes the Valley of the Kings, and the Necropolis at Thebes has been working to prepare a comprehensive archaeological database of Thebes. http://www.thebanmappingproject.com/.

A3.555. *The Theban Necropolis: past, present and future* / Nigel Strudwick and John H Taylor. London: British Museum, 2003. 250, 64 p.

A3.556. Theban Royal Mummy Project. http://members. tripod.com/anubis4_2000/mummypages1/intro. htm.

A3.557. *Das thebanische Grab Nr. 136 und der Beginn der Amarnazeit* / Alfred Grimm and Hermann A. Schlögl. Wiesbaden: Harrassowitz, 2005. 56 p. DT73.T3 G756 2005.

A3.558. Tom Van Eynde: Thebes Photographic Project. http://oi.uchicago.edu/museum/collections/pa/thebes/.

A3.559. *The tombs of Amenhotep, Khnummose, and Amenmose at Thebes: (nos. 294, 253, and 254)* / Nigel Strudwick. Oxford: Griffith Institute, Ashmolean Museum, 1996. 2 v. DT73.T3 S87 1996.

Tunat al Jabal

A3.560. *Tuna el-Gebel 1: die Tiergalerien* / Joachim Boessneck. Hildesheim: Gerstenberg, 1987. 221, 27 p. DT73.T85 T85 1987. This necropolis on the West Bank was found to include a labyrinth of underground streets and catacombs associated with cults sacred to Thoth. The necropolis also contained the tomb of Petosiris, high priest of Thoth at the time of Alexander the Great.

A3.561. *Tuna el-Gebel II: die Paviankultkammer G-C-C-2* / Dieter Kessler. Hildesheim: Gerstenberg, 1998. 187, 85 p. DT73.T85 T852 1998.

Tur (Al-Tur, At-Tur, Tur Sinai, Raithu)

A3.562. *Archaeological survey of the Rāya/al-Ṭūr area on the Sinai Peninsula, Egypt, 2005 and 2006: the first Japanese-Kuwaiti Archaeological Expedition (2006)* / Mutsuo Kawatoko. Tokyo: Islamic Archaeological Mission, the Middle Eastern Culture Center in Japan; Kuwait: Dar al-Athar al-Islamiyyah: National Council for Culture, Arts and Letters, 2007. 179, 4 p. + CD-ROM. DT73.T87 A73 2007. Continued by: *Archaeological survey of the Rāya/al-Ṭūr area on the Sinai Peninsula, Egypt, 2007: the second Japanese-Kuwaiti Archaeological Expedition (2007)* / Mutsuo Kawatoko. Tokyo: Islamic Archaeological Mission, Research Institute for Islamic Archaeology and Culture; Kuwait: Dar al-Athar al-Islamiyyah: National Council for Culture, Arts and Letters, 2008. 107, 4 p. DT73.T87 A733 2008. The name of the settlement comes from the Arabic name of the mountain (Jabal Al Tor) where the prophet Moses received the tablets from God.

Umm el-Qaab

A3.563. *Umm el-Qaab. 7, Private stelae of the early Dynastic period from the royal cemetery at Abydos* /

Geoffrey Throndike Martin. Wiesbaden: Harrassowitz, 2011. 219, 90 p. DT57.D47 no.123. Umm el-Qaab (Umm el Qa'ab; Umm el Ga'ab) is the necropolis of Early Dynastic Abydos.

A3.564. *Umm el-Qaab II: Importkeramik aus dem Friedhof U in Abydos (Umm el-Qaab) und die Beziehungen ägyptens zu Vorderasien im 4. Jahrtausend v. Chr.* / Ulrich Hartung. Mainz am Rhein: P. von Zabern, 2001. 481, 37 p. DT57.D47 no.92.

Valley of the Kings

A3.565. *Atlas of the Valley of the Kings / Theban Mapping Project* / Kent R. Weeks. Cairo, Egypt: American University in Cairo Press, 2000. Atlas (1 port, 72 plates) + pamphlet. G2492.V35 T44 2000. Valley of the Kings (Wadi al Muluk, Valley of the Gates of the Kings, Wadi Abwab al Muluk) is a valley where between the sixteenth and eleventh centuries BCE, tombs were constructed for the pharaohs and other powerful elites of the New Kingdom. The valley is on the west bank of the Nile, opposite Thebes and the Theban necropolis, and is most well-known for the discovery of the tomb of Tutankhamun.

A3.566. *The complete Valley of the Kings: tombs and treasures of Egypt's greatest pharaohs* / Nicholas Reeves and Richard H. Wilkinson. New York: Thames and Hudson, 1996. 224 p. DT73.B44 R43 1996.

A3.567. *Due libri dei morti del principio del nuovo regno il lenzuolo funerario della principessa Ahmosi e le tele del Sa-Nesu Ahmosi* / Paolo Ronsecco. Torino: Ministero per i beni culturali e ambientali. Soprintendenza al Museo delle antichità egizie, 1996. 272, 94 p. PJ1557.R658 1996.

A3.568. *Das geheimnisvolle Grab 63: die neueste Entdeckung im Tal der Könige; Archäologie und Kunst; The mysterious tomb 63: the latest discovery in the Valley of the Kings; art and archaeology* / Susan Osgood, Eberhard Dziobek, Michael Höveler-Müller, and Christian E. Loeben. Rahden/Westf.: VML, Verlag Marie Leidorf, 2009. 240 p. DT73.B44 G444 2009.

A3.569. *Das Grab Nr. 55 im Königsgräbertal: sein Inhalt und seine historische Bedeutung* / Wolfgang Helck. Mainz: Philipp von Zabern, 2001. 67 p. DT73.B44 H45 2001.

A3.570. *Das Grab Ramses' X. (KV 18)* / Hanna Jenni. Basel: Schwabe & Co. AG, 2000. 133, 7 p. DT73. B44 G733 2000.

A3.571. *In the valley of the kings: Howard Carter and the mystery of King Tutankhamun's tomb* / Daniel Meyerson. New York: Ballantine, 2009. 230 p. PJ1064.C3 M49 2009.

A3.572. *King Tutankhamun: the treasures of the tomb* / Zahi Hawass. New York: Thames & Hudson, 2008. 296 p. DT87.5.H395 2008.

A3.573. *KV 5: a preliminary report on the excavation of the tomb of the sons of Rameses II in the Valley of the Kings* / Kent R. Weeks. rev. ed. Cairo: American University in Cairo Press, 2006. 201 p. DT73.B44 W38 2006.

A3.574. The *lost tomb: the greatest discovery at the Valley of the Kings since Tutankhamun* / Kent R. Weeks. New London: Weidenfeld & Nicolson, 1998. 330, 24 p.; New York: William Morrow, 1998. 330, 24 p. DT73.B44 W43 1998. DT73. B44 W43 1998b.

A3.575. *Research in the Valley of the Kings and the area of Ancient Thebes-University of Arizona.* http:// egypt.arizona.edu/content/fieldwork.

A3.576. *Theodore M. Davis' excavations: Bibân el Molûk* / Theodore M. Davis. London: A. Constable, 1904–1912. 7 v. 913.32 D293; DT62.T6 D3.

A3.577. *Tomb KV39 in the Valley of the Kings: a double archaeological enigma* / John Rose. Bristol: WASP, 2000. 158 p. DT73.B44 R68 2000.

A3.578. *The tomb of Thoutmôsis IV* / Howard Carter and Percy E. Newberry. London: Duckworth, 2002. 150, 28 p. DT61.28 2001.

A3.579. *The tomb of Tutankhamen* / Howard Carter. Washington, D.C.: National Geographic Society, 2003. 286 p. DT87.5.C4 2003.

A3.580. *The treasures of the Valley of the Kings: tombs and temples of the Theben West Bank in Luxor* / Kent R. Weeks. Cairo, Egypt: American University in Cairo Press, 2001. 434 p. DT73.B44 T74 2001.

A3.581. *Tut-ankh-amen: the politics of discovery* / Howard Carter. London: Libri, 1998. 149 p. DT87.5.C42 1998.

A3.582. *Tutankhamun: the Exodus conspiracy: the truth behind archaeology's greatest mystery* / Andrew Collins and Chris Ogilvie-Herald. London: Virgin, 2002. 338, 12 p.

A3.583. *The Tutankhamun deception: the true story of the mummy's curse* / Gerald O'Farrell. London: Sidgwick & Jackson, 2001. 233, 16 p. DT87.5.O33 2001.

A3.584. *Tutankhamun's tomb: the thrill of discovery* / Susan J. Allen. New York: Metropolitan Museum of Art; New Haven: Yale University Press, 2006. 103 p. DT87.5.B868 2006.

A3.585. *University of Basel King's Valley Project: Preliminary Report, 2012.* http://egyptology. blogspot.com/2012/05/university-of-basel-kings-valley.html.

A3.586. Valley of the Kings Foundation. http://www. nicholasreeves.com/item.aspx?category=Archae ology&id=138.

A3.587. Valley of the Kings; World Monuments Fund. http://www.wmf.org/project/valley-kings.

A3.588. *The Valley of the Kings rediscovered: the Victor Loret excavation journals (1898–1899) and other manuscripts* / Patrizia Piacentini and Christian Orsenigo. Milano: Università degli studi di Milano, 2005. 64 p. DT73.B44 P533 2004 supp. English language translation of *La Valle dei Re riscoperta: i giornali di scavo di Victor Loret, 1898–1899 e altri inediti* / Patrizia Piacentini and Christian Orsenigo. Milano: Skira: Università degli Studi di Milano, 2004. 334, 14 p. DT73. B44 P533 2004.

Wadi es-Subua (Wadi al-Sabua)

A3.589. *Le temple de Ouadi es-S eboua* / Henri Gauthier. Le Caire: Imprimerie de l'Institut Français d'archéologie orientale, 1912. 2 v. 913.32 T245.2. Two New Kingdom temples located 140 kilometers south of the High Aswan Dam in the west bank of the Nile. When the High Dam was being constructed in the 1960s, one of the temples built by Rameses II (Temple of Wadi al-Sabus, House of Amun) was salvaged and moved to an elevated position. The other, earlier temple of Amenhotep III, was left submerged beneath Lake Nasser.

Wadi Kubbaniya

A3.590. *Wadi Kubbaniya (17,000–15,000 BC).* http:// www.metmuseum.org/toah/hd/wadi/hd_wadi. htm.

Western Desert

A3.591. *Djara: zur mittelholozänen Besiedlungsgeschichte zwischen Niltal und Oasen, Abu-Muharik-Plateau, Ägypten* / Karin Kindermann. Köln: Heinrich-Barth-Instut, 2010. 2 v. GN865. E3 K56 2010, Teil 1, 2. The vast Libyan desert extends some 1,100 kilometers east-west and 1,000 kilometers north-south. The desert is unpopulated although settlements exist at oases in southeastern Libya.

A3.592. *Oasis égyptiennes: les iles des bienheureux* / Françoise Dunand and Roger Lichtenberg. Arles: Actes sud, 2008. 157 p. DT73.Z39 G43 1989, t.1, 2.

FRANCE

Ain

A3.593. *L'Ain* / André Buisson. Paris: Ed. Académie des inscriptions et belles-lettres, 1990. 192 p. DC611.

A27 B84 1990. In 58 BCE Julius Caesar's military action against the Helvetians in the territory of modern Ain in the Rhone-Alpes region marked the beginning of the Gallic Wars.

Aléira

A3.594. *Aleria: nouvelles donnees de la necropole* / Jean Jehasse and Laurence Jehasse. Lyon: Maison de l'Orient Mediterraneen-Jean Pouilloux, 2001. 2 v. DC801.A336 J44 2001. Located between the southern end of the Etang de Duiane and the Tavignano River (Rhotanos), Alaie controlled the district, including the mouth of the river. The east coast of Corsica was colonized by Greeks, Etruscans, Carthaginians, and Romans.

Alise-Sainte-Reine

A3.595. *Alésia: fouilles et recherches franco-allemandes sur les travaux militaires romains autour du Mont-Auxois (1991–1997)* / Ph. Barral. Paris: Académie des inscriptions et belles-lettres; Paris: De Boccard, 2001. 3 v.+ CD-ROM. DC801.A34 A5 2001. Located in the Cote-d'Or department in Bourgogne, eastern France, was possibly the site of the ancient site of Alesia, where Caesar defeated the Gauls at the Battle of Alesia.

A3.596. *Alesia: vom nationalen Mythos zur Archäologie* / Michel Reddé. Mainz: P. von Zabern, 2006. 171 p. DC62.R4315 2006.

A3.597. *Fouilles d'Alise-Sainte-Reine, 1861–1865* / Joël Le Gall. Paris: Diffusion de Boccard, 1989. 2 v. DC611.C845 F68 1989.

A3.598. *Un quartier de commerçants et d'artisans d'Alésia: contribution à l'histoire de l'habitat urbain en Gaule* / Michel Mangin. Paris: Belles Lettres, 1981. 2 v. DC801.A34 M36 1981.

A3.599. *Contribution a l'étude de la céramique métallescente recueillie à Alésia* / Robert Sénéchal. 2 ed. Dijon: Centre de recherches sur les techniques gréco-romaines, 1975. 84, 5 p. NK3850.S46 1975.

Amiens

A3.600. *Amiens romain: Samarobriva Ambianorum* / Didier Bayard and Jean Luc Massy. Amiens: Revue archéologique de Picardie, 1983. 374 p. DC801.A51 B38 1983. The Roman Samarobriva was the main settlement of the Ambiani, one of the Gallic tribal groups issuing coinage in the first century BCE.

Apt

A3.601. *Le trésor d'Apt: un ensemble de vaisselle métallique gallo-romaine* / Odile Cavalier, Ma-rie-Pierre Foissy-Aufrère, Christian Loury, and Marie-Noëlle Baudrand. Avignon: Fondation du Muséum Calvet, 1988. 119 p. DC801.A65 M87 1988. Located north of Aix-en-Provence and the Durance River in the Calavon River valley, Apt was once the primary settlement of the Vulgi-entes, a Gallic group. The site was destroyed by the Romans ca. 125 BCE and restored by Caesar, who named it Apta Julia.

Ardèche

A3.602. *Oppida helvica: les sites fortifiés de hauteur du plateau de Jastres, Ardèche* / Claude Lefebvre. Paris: De Boccard, 2006. 487 p. DC611.A67 L444 2006. The capital of a Gaulish group of Helvii, part of Gallia Narbonensis.

A3.603. *Carte et texte du Département de l'Ardèche* / André Blanc. Paris: Éditions du CNRS, 1975. 100, 8 p. DC63.C374 fasc.15.

Arles

A3.604. *Arles, Crau, Camargue* / Marie-Pierre Rothé and Marc Heijmans. Paris: Académie des inscriptions et belles-lettres, 2008. 906 p. DC801.A71 R68 2008. Initially occupied by Ligurians and Celts, Arles was an important Phoenician trading port before being taken by the Romans. The Roman legion Legio VI Ferrata was based here.

Armorica

A3.605. *Les tombes romaines d'Armorique: essai de sociologie et d'économie de la mort* / Patrick Galliou. Paris: Editions de la Maison des Sciences de l'Homme, 1989. 204 p. DC611.B85 G34 1989. Armorica or Aremorica is the name given in ancient times to the part of Gaul that includes the Brittany peninsula and the territory between the Seine and Loire rivers, extending inland down the Atlantic coast.

Autun

A3.606. *Autun* / Alain Rebourg. Paris: Académie des inscriptions et belles-lettres; Ministère de la culture; Diffusion, Fondation Maison des Sciences de l'Homme, 1993. 2 v. DC801.A94 R43 1993. Founded during the reign of Augustus, Autun was the civitas capital of the Celtic Aedui, allies with the Romans before Caesar's conquest of Gaul.

Barzan

A3.607. *Thermae Gallicae: les thermes de Barzan (Cha-rente-Maritime) et les thermes des provinces*

gauloises / Alain Bouet. Bordeaux: Ausonius: Fédération Aquitania; Paris: Diffusion de Boccard, 2003. 761 p. DC801.B18922 T44 2003. Barzan is situated in the Charente-Maritime department (Poitou-Charentes region) in the west of France.

Bibracte

A3.608. *La bataille de Bibracte* / Norbert Guinot. Gueugnon: N. Guinot, 1989. 132 p. DC62 .G85 1989. A Gaulish oppidum, or fortified city, was the capital of the Aedui and one of the most important hillforts in Gaul.

Bliesbruck

A3.609. *Vivre en Europe romaine: de Pompéi à Bliesbruck-Reinheim* / Jean-Paul Petit and Sara Santoro. Paris: Errance, 2007. 246 p. DG70.P7 V755 2007. Situated in the Moselle department in Lorraine in northeastern France and the German municipality of Gersheim (Saarland), an archaeological site with Celtic and Roman occupations.

A3.610. *Le complexe des thermes de Bliesbruck, Moselle: Un quartier public au coeur d'une agglomération secondaire de la Gaule Belgique* / Jean-Paul Petit. Paris: Exé; Metz: Serpenoise, 2000. 465 p. DG59.M74 C667 2000.

Bordeaux

A3.611. *Ausonius of Bordeaux: genesis of a Gallic aristocracy* / Hagith Sivan. London; New York: Routledge, 1993. 242 p. PA6223.S58 1993. Originally settled ca. 300 BCE by a Celtic tribe named the Bituriges Vivisciu; the settlement was occupied by the Romans, ca. 60 BCE, as a commercial center for tin and lead.

Boucheporn

A3.612. *La sigillée de Boucheporn, Moselle* / Marcel Lutz. Paris: Éditions du Centre National de la Recherche Scientifique, 1977. 200 p. DC801.B738 L87. A commune in the Moselle department in Lorraine in northeastern France.

Bourbon-Lancy

A3.613. *Bourbon-Lancy (Saône-et-Loire): un atelier de figurines en terre cuite gallo-romaines (les fouilles du Breuil: 1985–1986)* / Micheline Rouvier-Jeanlin, Martine Joly, and Jean-Claude Notet. Paris: Editions de la Maison des Sciences

de l'Homme, 1990. 223 p. NB1265.R688 1990. A commune in the Saone-et-Loire department in eastern France. It is a spa town with thermal springs known since Roman times.

Bourbonne-les-Bailns

A3.614. *Coins, cult and cultural identity: Augustan coins, hot springs and the early Roman baths at Bourbonne-les-Bains* / Eberhard Sauer. Leicester: School of Archaeology and Ancient History, University of Leicester, 2005. 324, 9 p. DC801. B778 S38 2005. The location of thermal springs known to the Gauls and the Romans who constructed baths.

Boussagne

A3.615. *Essai d'onomastique césarienne des tènements ruraux de la fortresse ruteno-romaine de Boussague, Hérault* / Gabriel Alphonse Duch. Paris: A. et J. Picard, 1969. 52 p. DC801.B8224 D8.

Caen

A3.616. Caen-Model of Rome. http://www.unicaen.fr/cireve/rome/pdr_maquettephp?fichier=histoire&langue=en.

Charente

A3.617. *La Charente* / Christian Vernou. Paris: Académie des inscriptions et belles-lettres, Ministère de la culture, avec le concours de l'Association pour les fouilles archéologiques nationales: Diffusion, Fondation Maison des Sciences de l'Homme, 1993. 253 p. DC611.C52 V47 1993. A department in southwestern France.

A3.618. *L'estuaire de la Charente de la protohistoire au moyen: La Challonnière et Mortantambe (Charente-Maritime)* / Luc Laporte. Paris: Editions de la Maison des Sciences de l'Homme, 1998. 228 p. DC611.C52 E88 1998.

Ensérune

A3.619. *Ensérune (Nissan-lez-Ensérune, Hérault): les céramiques grecques et de type grec dans leurs contextes, VIe–IVe s. av. n. è* / Cécile Dubosse. Lattes: Association pour le développement de l'archéologie en Languedoc-Rousillon, 2007. 567, 1 p. DC801.E536 D82 2007. The oppidum d'Enserune is an ancient hill town occupied continuously between the sixth century BCE and the first century CE.

Gergovia

A3.620. *La question de Gergovie: essai sur un problème de localisation* / Yves Texier. Bruxelles: Latomus, 1999. 417 p. DC801.G34 T49 1999. The chief oppidum of the Arverni. In 52 BCE Gallic forces won a battle here against a Roman Republican army, led by proconsul Julius Caesar.

Languedoc-Roussillon

A3.621. *Le trophée de Pompée dans les Pyrénées (71 avant J.-C.): col de Panissars, Le Perthus, Pyrénées-Orientales, La Jonquera, Haut Empordan (Espagne)* / Georges Castellvi, Josep Maria Nolla, and Isabel Rodá. Paris: CNRS Editions, 2008. 261 p. DC611.L294 T76 2008. One of the twenty-seven regions of France, comprises five departments and borders Provence-Alpes-Cote d'Azur, Rhone-Alpes, Auvergne, Midi-Pyrenees, Spain, Andorra, and the Mediterranean Sea.

Marseille

A3.622. *Marseille grecque: 600–49 av. J.-C.: la cité phocéenne* / Antoine Hermary, Antoinette Hesnard, and Henri Tréziny. Paris: Ed. Errance, 1999. 181 p. Founded in 600 BCE by Greeks from Phocaea as a trading port named Massalia. Facing an alliance of Etruscans, Cathage, and the Celts, the Greek colony allied itself with the expanding Roman Republic. The city thrived within a commercial network, including inland Gaul and Rome.

Strasbourg

A3.623. *Argentorate, Strasbourg* / Jean-Jacques Hatt. Lyon: Presses universitaires de Lyon, 1993. 143 p. DC801.S77 H38 1993. The Romans under Nero Claudius Drusus established a military outpost (Argentoratum) at Strasbourg. The Roman camp was destroyed by fire and rebuilt six times between the first and fifth centuries CE. From ca. 90 CE the Legio VIII Augusta was permanently stationed here.

Uxellodunum

A3.624. *Uxellodunum: recherche et synthèse* / Jean-Marie Chaumeil. Le Faouët: Liv'éditions, 1995. 184 p. DC62 .C48 1995. An Iron Age hill fort located above the Dordogne River near Vayrac in the Lot department. According to Aulus Hirtius, the last revolt against Roman hegemony in Gaul occurred here.

Vienne

A3.625. Ancient Vienne. Ancient Vienne offers the history and archaeology of the Roman city in southeastern France that the poet Martial called pulchra [beautiful] Vienna. http://www.culture.gouv.fr/culture/arcnat/vienne/en/.

GERMANY

A3.626. *Studien zu römischen Dolchscheiden des 1. Jahrhunderts n.Chr.: archäologische Zeugnisse und bildliche Überlieferung* / Jürgen Obmann. Rahden/Westf.: Verlag M. Leidorf, 2000. 45, 78 p. U853.O27 2000.

Aachen

A3.627. *Aquae Granni: Beiträge zur Archäologie von Aachen* / Heinz Cuppers. Koln: Rheinland-Verlag; Bonn: in Kommission bei Rudolf Habelt, 1982. 213, 98 p. DD801.R72 R5 Bd.22. Aachen (Bad Aachen) is a spa town in North Rhine-Westphalia in Germany. The hot springs have been channelled into baths since Roman times.

Altenstadt

A3.628. *Die Kastelle in Altenstadt* / Hans Schönberger und Hans-Günther Simon, mit Beiträgen von Dietwulf Baatz, Hans-Gert Bachmann und Hartmut Polenz. Berlin: Gebr. Mann, 1983. 201, 73 p. DD901.A373 S36 1983. A Roman military installation 5 kilometers from Glauberg, the seat of a Celtic prince.

Altlussheim-Hubwald

A3.629. *Das römische Gräberfeld von Altlussheim-Hubwald (Rhein-Neckar-Kreis)* / Gabriele Dreisbusch, Herausgeber. Stuttgart: Kommissionsverlag K. Theiss, 1994. 193, 117 p. DD901.A384 D74 1994. Location of an ancient Roman road and burial ground.

Augsburg

A3.630. *Die Ausgrabungen in St. i.e. Sankt Ulrich und Afra in Augsburg: 1961–1968* / Joachim Werner. München: Beck, 1977. 2 v. DD901.A92 A927. In 15 BCE as Augusta Vindelicorum, this garrison camp soon became the capital of Roman Raetia because of its strategic position at the confluence of the Lech and Wertach rivers and its direct access to important Alpine passes.

Bad Nauheim

A3.631. *Römerlager Rödgen*. Berlin: Gebr. Mann, 1976. 264, 42 p. DD901.R719 R63. A town in the Wetteraukreis district of Hesse known for its therapeutic salt springs.

Baden

A3.632. *Urgeschichte des badischen Landes: bis zu Ende des siebenten Jahrhunderts* / F. J. Mone. Karlsruhe: C. Macklot, 1845. 2 v. DD801.B145 M66 1845. A historical region on the east bank of the Rhine River in southwest Germany.

Baden-Baden

A3.633. *Die römischen "Soldatenbäder" in Baden-Baden (Aquae Aureliae)* / Pétra Mayer-Reppert and Britta Rabold. Stuttgart: Theiss, 2008. 132 p. DD901.B13 M39 2008. Also known as Aurelia Aquensis, a spa town located on the western foothills of the Black Forest on the banks of the Oos River near Karlsruhe.

Baden-Wurttemberg

A3.634. *Die Römer in Baden-Württemberg: Römerstätten und Museen von Aalen bis Zwiefalten* / Dieter Planck. Stuttgart: Theiss, 2005. 400 p. DD801.B2345 R67 200. Located in southwestern Germany, Baden-Wurttemberg was occupied by the Romans in the first century, who defended their position by constructing a limes (fortified boundary zone). In the third century the Alemanni forced the Romans beyond the Rhine and Danube rivers.

A3.635. *Römerzeitliche Geländedenkmäler* / Martin Luik and Dieter Müller. Stuttgart: Kommissionsverlag, K. Theiss, 1995. DD801.B2345 L85 1995, 1–2, 4.

A3.636. *Römerzeitliche Pflanzenreste aus Baden-Würtemberg: Beiträge zu Landwirtschaft, Ernährung und Umwelt in den römischen Provinzen Obergermanien und Rätien* / Hans-Peter Stika. Stuttgart: Rommissionsverlag K. Theiss, 1996. 207, 129 p. DD801.B2345 S755 1996.

Bavaria

A3.637. *Prähistorische Staatssammlung, Museum für Vor- und Frühgeschichte München: die Funde aus Bayern* / Herman Dannheimer. München: Schnell & Steiner, 1980. 160 p. DD801.B345 P72 1980. Part of the Roman provinces of Raetia and Noricum, a federal state in southern Germany.

A3.638. *Die Römer in Bayern* / Wolfgang Czysz. Stuttgart: Theiss, 1995. 594 p. DD801.B345 R653 1995.

Brandenberg

A3.639. *Die römische Kaiserzeit im Oder-Spree-Gebiet* / Achim Leube. Berlin: Deutscher Verlag d. Wiss., VEB, 1975. 227 p. GN36.G32 P65a Bd.9. A federal state located in eastern Germany.

Butzbach

A3.640. *Das Lagerdorf des Kastells Butzbach, die relifversierte Terra Sigillata* / Gustav Müller. Berlin: Gebr. Mann, 1968. 136 p. DD901.B978 M8. A town in the Wetteraukreis district in Hessen, located 16 kilometers south of Giessen and 35 kilometers north of Frankfurt am Main.

Munich

A3.641. *Die frühkaiserzeitlichen Körpergräber von Heimstetten bei München und die verwandten Funde aus Südbayern* / Erwin Keller. München: C. H. Beck, 1984. 77, 23 p. DD801.B345 K29. The largest city in the state of Bavaria, located on the River Isar north of the Bavarian Alps.

Oder River Valley

A3.642. *Forschungen zu Mensch und Umwelt im Odergebiet in ur- und frühgeschichtlicher Zeit* / Eike Gringmuth-Dallmer and Lech Leciejewicz. Mainz am Rhein: P. von Zabern, 2002. 468 p. DK4600.O333 F67 2002. The Oder (Odra) River is one of the most important rivers in the catchment basin of the Baltic Sea in east-central Europe.

Rhine River Region

A3.643. *Regio archaeologica: Archäologie und Geschichte an Ober- und Hochrhein; Festschrift für Gerhard Fingerlin zum 65. Geburtstag* / Christel Bücker. Rahden/Westf.: Leidorf, 2002. 440 p. DD801.R745 R44 2002. The Rhine flows from Grisons in the eastern Swiss Alps to the North Sea in the Netherlands. The Rhine and the Danube formed most of the northern inland frontier of the Roman Empire.

GREAT BRITAIN

A3.644. *The best training-ground for archaeologists: Francis Haverfield and the invention of Romano-*

British archaeology / P. W. M. Freeman. Oxford: Oxbow; Oakville: David Brown, 2007. 688 p. DA93.H3 F74 2007.

A3.645. *Romanitas: essays on Roman archaeology in honour of Sheppard Frere on the occasion of his ninetieth birthday* / edited by R. J. A. Wilson. Oxford: Oxbow Books, 2006. 242 p. DA145.R66 2006.

Abingdon

A3.646. *Saved from the grave: Neolithic to Saxon discoveries at Spring Road Municipal Cemetery, Abingdon, Oxfordshire, 1990–2000* / T. G. Allen and Z. Kamash. Oxford: Oxford University School of Archaeology for Oxford Archaeology, 2008. 106 p. DA690.A14 A443 2008. A market town in Oxfordshire, the site has been occupied from the Early-Middle Iron Age to the Late Iron Age, when a Roman defensive enclosure (oppidum) was in use.

Alcester

A3.647. *Roman Alcester series.* York: Council for British Archaeology, 1994. DA690.A285 R65 1994. Contents include 1. *Roman Alcester: southern extramural area: 1964–1966 excavations.* York: Council for British Archaeology, 1994. 2 v. + 9 microfiche. DA690.A285 R65 1994 v.1; 2. *Roman Alcester: defences and defended area: Gateway Supermarket and Gas House Lane* / Stephen Cracknell. York: Council for British Archaeology, 1996. 162 p. DA690.A285 R65 1994 v.2. A Roman market town situated at the junction of the Alne and Arrow rivers in Warwickshire.

Ashford, Kent

A3.648. *The Roman roadside settlement at Westhawk Farm, Ashford, Kent: excavations 1998–9* / Paul Booth, Anne-Marie Bingham, and Steve Lawrence. England: Oxford Archaeology, 2008. 420 p. + CD-ROM. DA670.K3 B65 2008. An early settlement established in 893 CE by inhabitants escaping a Danish Viking raid in the town of Great Chart (Seleberhtes Cert). Later, a Roman road passed through here to the iron-making area to Canterbury.

Barrhill (Baurhill)

A3.649. *Bar Hill: a Roman fort and its finds* / Anne Robertson, Margaret Scott, and Lawrence Keppie. Oxford: British Archaeological Reports, 1975. 184 p. DA777.7.B3 R6. A village in South Ayrshire, Scotland.

Bath (Aquae Suilis)

A3.650. *Archaeology in Bath, 1976–1985* / Peter Davenport. Oxford: Oxford University Committee for Archaeology; Bloomington: D. Brown, 1991. 166 p. + 2 microfiches. DA147.B3 A73 1991. A spa settlement with baths and a temple structure established by the Romans in the 60s CE about twenty years after arriving in Britain.

A3.651. *Archaeology in Bath: excavations 1984–1989* / Peter Davenport and Gerry Barber. Oxford: Archaeopress, 1999. 168 p. DA147.B3 A73 1999.

A3.652. *Descriptions and explanations of some remains of Roman antiquities dug up in the city of Bath: in the year MDCCXC; with an engraving from drawings made on the spot* / Thomas Pownall. Bath: printed by and for R. Cruttwell, and sold by C. Dilly, Poultry and Cadell and Davis, strand, London; and by the sellers of Bath, 1795. 29, 1 pages.

A3.653. *Roman Bath discovered* / Barry Cunliffe. rev ed. London; Boston: Routledge & K. Paul, 1984. 232 p. DA147.B3 C85 1984.

A3.654. *The temple of Sulis Minerva at Bath* / Barry Cunliffe and Peter Davenport. Oxford: Oxford University Committee for Archaeology, 1985. DA147.B3 C86 1985, v. 1(1–2).

Beddington, Surrey

A3.655. *Prehistoric landscape to Roman villa: excavations at Beddington, Surrey, 1981–7* / Isca Howell. London: Museum of London Archaeology Service, 2005. 135 p. DA677.1.P58 2005. An Anglo-Saxon settlement between the London boroughs of Sutton and Croydon.

Bedfordshire

A3.656. *Farm and forge: late Iron Age/Romano-British farmsteads at Marsh Leys, Kempston, Bedfordshire* / Mike Luke and Tracy Preece. Bedford: Albion Archaeology, 2011. 198 p. DA670.E14 E27 no.138. A county in the southern midlands of England. Roman settlement was concentrated in the southern part of the county, with Dunstable (Durocobrivae) as an important commercial center.

Berkshire

A3.657. *Early settlement in Berkshire: Mesolithic-Roman occupation sites in the Thames and Kennet*

Valleys / I. Barnes. Salisbury: Wessex Archaeology/Oxford Archaeological Unit, 1995. 148 p. GN774.22.G7 E37 1995. A county in southeast England, located west of London.

A3.658. *The Maddle Farm project: an integrated survey of prehistoric and Roman landscapes on the Berkshire Downs* / Vincent Gaffney and Martin Tingle. Oxford: British Archaeological Reports, 1989. 262, 7 p. GN776.22.G7 G13 1989.

Besthorpe, Nottinghamshire

A3.659. *Three Iron Age and Romano-British rural settlements on English gravels: excavations at Hatford (Oxfordshire), Besthorpe (Nottinghamshire) and Eardington (Shropshire) undertaken by Tempvs Reparatvm between 1991 and 1993* / R. J. Zeepvat. Oxford: Archaeopress; Hadrian Books, 2000. 144 p. DA690.H3615 T47 2000. A Romano-British settlement in the Newark and Sherwood district of Nottingham, England.

Biddenham

A3.660. *Life in the loop: investigation of a prehistoric and Romano-British landscape at Biddenham loop, Bedfordshire* / Mike Luke. Bedford: Albion Archaeology, 2008. 320 p. DA670.E14 E27 no.125.

Birmingham

A3.661. *Romano-British livestock complex in Birmingham: excavations 2002–2004 and 2006–2007 at Longdales Road, King's Norton, Birmingham* / Alex Jones. Oxford: Archaeopress, 2008. 107 p. DA690.B6 R66 2008.

Bishopsgate

A3.662. *Roman burials, medieval tenements and suburban growth: 201 Bishopsgate, City of London* / Dan Swift. London: Museum of London Archaeology Service, 2003. 88 p. DA685.B57 S95 2003.

Brancaster

A3.663. *Excavations at Brancaster, 1974 and 1977* / John Hinchliffe. Norfolk: Norfolk Archaeological Unit, Norfolk Museums Service, 1985. 244, 14 p. DA670.E14 E27 no.23. A Roman settlement (Holingdom) on the north coast of the English county of Norfolk. The garrison at Brancaster was made up of cavalry from Dalmatia.

Brentford

A3.664. *2000 years of Brentford* / Roy Canham. London: H. M. Stationery Off., 1978. 158 p. DA690.B76 C36. Located at the confluence of the Thames and Brent rivers in suburban west London, settlement at Brentford predates the Roman occupation of Britain. It has been suggested that Julius Caesar crossed here during his invasion of Britain in 54 BCE.

Bristol (Abona)

A3.665. *Kings Weston Roman villa* / George C. Boon. Bristol: Department of Archaeology: 1967. 23 p. Evidence of human activity includes a Paleolithic occupation, Iron Age hill forts, and a Roman settlement connected to Bath by a Roman road. There are also isolated Roman villas and small forts and settlements throughout the area.

Brittany

A3.666. *La Bretagne romaine* / Louis Pape. Rennes: Editions Ouest-France, 1995. 308 p. DC611.B85 P36 1995. Brittany occupies the northwest peninsula of continental Europe in northwest France. It is bordered by the English Channel to the north, the Celtic Sea and the Atlantic Ocean to the west, and the Bay of Biscay to the south. The peninsula was a center of Neolithic megalithic construction and the territory of several Celtic groups, including the Veneti. After the conquest of Gaul by Julius Caesar the area was known as Armorica, and its transformatioin into Brittany occurred in the Late Roman period.

Brough-on-Noe, Derbyshire (Anovio)

A3.667. *Navio, the fort and vicus at Brough-on-Noe, Derbyshire* / Martin J. Dearne. Oxford: Tempus Reparatum, 1993. 179 p. UG430.B7 N3 1993. A hamlet in northwestern Derbyshire and the site of a Roman fortress.

Caerleon, Gwent (Isca Augusta)

A3.668. *The Caerleon canabae: excavations in the civil settlement 1984–90* / Edith Evans. London: Society for the Promotion of Roman Studies, 2000. 537 p. DA147.2 E9 2000. The South Wales location of an Iron Age hill fort and a Roman legionary fortress (castra) named Isca Augusta. The Roman remains include a military amphitheater, thermar (baths), and barracks.

A3.669. *Roman Gates, Caerleon: the 'Roman Gates' Site in the fortress of the Second Augustan Legion at Caerleon, Gwent: the excavations of the Roman buildings and evidence for early Medieval activity* / D. R. Evans and V. M. Metcalf. Oxford: Oxbow Books; Glamorgan-Gwent Archaeological Trust, 1991. 210 p. DA745.165 E83 1991.

Caister-on-Sea, Norfolk (Caister)

A3.670. *Caister-on-Sea: excavations by Charles Green, 1951–55* / Margaret J. Darling. Gressenhall, Derenham, Norfolk: Field Archaeology Division, Norfolk Museums Service, 1993. 290 p. + 4 microfiche. DA670.E14 E27 no.60. Location, in Norfolk, of a fort built as a base for a unit of the Roman army.

Cambridgeshire

A3.671. *Roman Cambridgeshire* / David M. Browne. Cambridge: Oleander Press, 1977. 48 p. DA147.24 B76.

Camerton

A3.672. *Camerton: the late Iron Age and early Roman metalwork* / Ralph Jackson. London: British Museum Publications, 1990. 96, 47 p. DA690.24 J33 1990. A village in Somerset, southwest of bath, which is the site of a Roman hill fort.

Carlisle (Luguvalium)

A3.673. *The Carlisle millennium project: excavations in Carlisle, 1998–2001* / John Zant. Lancaster: Oxford Archaeology North; Oxford: Oxbow Books, 2009. 2 v. + DVD-ROM. DA690.C335 Z36 2009. A Roman settlement established to serve the forts on Hadrian's Wall in northwest England.

A3.674. *Carlisle and Cumbria: Roman and medieval architecture, art and archaeology* / Mike McCarthy and David Weston. Leeds: British Archaeological Association: Maney Publishing, 2004. 290, 16 p. DA690.C335 C37 2004.

Carmarthen

A3.675. *Roman Carmarthen: excavations, 1978–1993* / Heather James. London: Society for the Promotion of Roman Studies, 2003. 398 p. DA147.244 J36 2003. Probably the location of Moridunum or Moridunum Demetarum, a Roman fort and settlement in the Welsh county of Carmarthenshire.

Carrawburgh (Brocolitia, Brocolita, Procolita)

A3.676. *The Temple of Mithras at Carrawburgh* / I. A. Richmond and J. P. Gilla. Newcastle upon Tyne: Society of Antiquaries, 1951. DA147.2465 R53 1951. An auxiliary Roman fort on the northernmost point on Hadrian's Wall.

Catterick

A3.677. *Cataractonium: Roman Catterick and its hinterland: excavations and research, 1958–1997* / P. R. Wilson. York: Council for British Archaeology, 2002. 2 v. + 2 CD-ROMs. DA690. C446 W45 2002. A Roman fort and settlement in northern England.

A3.678. *Iron Age and Roman burials in Champagne* / I. M. Stead, J.-L. Flouest, and Valery Rigby. Oxford: Oxbow; Oakville: David Brown, 2006. 345 p., 20 p. DC611.C453 S84 2006.

Chedworth

A3.679. *The Roman villa, Chedworth* / Roger Goodburn. London: National Trust, 1986. 39, 16 p. DA147.293 G6 1986. A village in Gloucestershire, England, best known as the location of Chedworth Roman villa, one of the largest Romano-British homes in England, including mosaics, bathhouses, hypocausts (underfloor heating), and a water shrine and latrine.

Chelmsford (Caesaromagus)

A3.680. *The mansio and other sites in the south-eastern sector of Caesaromagus* / P. J. Drury. London: Chelmsford Archaeological Trust, 1988. 146 p. + 4 microfiches. DA690.C447 D78 1988. A Roman fort was built here 60 CE, and a civilian town grew up around it.

A3.681. *The temple and other sites in the north-eastern sector of Caesaromagus* / N. P. Wickenden. London: Council for British Archaeology, 1992. 149 p. DA690.C447 W53 1992.

Chepstow, Gwent

A3.682. *The excavation of a late prehistoric and Romano-British settlement at Thornwell Farm, Chepstow, Gwent, 1992* / Gwilym Hughes. Oxford: Tempus Reparatum, 1996. 125 p. DA745.C46 H83 1996. The Romans constructed a bridge across the Wye at a crossing between the Roman towns at Gloucester (Glevum) and Caerwent (Venta Silurum).

Chester (Deva Victrix)

A3.683. *Roman Chester: city of the eagles* / David J. P. Mason. Stroud, Gloucestershire: Tempus; Charleston, SC: Arcadia, 2001. 224, 16 p. DA147.C38 M378 2001. Chester was founded as a Roman fort (castrum) on the banks of the River Dee close to the border with Wales.

A3.684. *Excavations at Chester: the Elliptical Building: an image of the Roman world?: excavations in 1939 and 1963–9* / David J. P. Mason. Chester: Chester City Council, 2000. 187, 17 p. DA147. C38 M37 2001.

Chicester, Sussex (Noviomagus Reginorum)

A3.685. *Roman Chichester* / Alec Down. Chichester, Sussex: Phillimore, 1988. 118 p. DA690.C53 D695 1988. Roman military storage structures are situated in nearby Fishbourne Roman palace, and a Roman road connects Chichester with London.

Chieveley, West Berkshire

A3.686. *Bronze Age, Roman and later occupation at Chieveley, West Berkshire: the archaeology of the A34/M4 road junction improvement* / Andrew Mudd. Oxford: Archaeopress, 2007. 95, 2 p. DA690.C545 M83 2007. An Iron Age hill fort is located in Snelsmore.

Chiltington

A3.687. *The Roman pottery production site at Wickham Barn, Chiltington, East Sussex* / Chris Butler and Malcolm Lyne. Oxford: Archaeopress, 2001. 98 p. DA147.C47 B87 2001.

Dragonby

A3.688. *Dragonby: report on excavations at an Iron Age and Romano-British settlement in North Lincolnshire* / Jeffrey May. Oxford: Oxbow Books, 1996. 2 v. GF552.D7 M39 1996.

Eardington

A3.689. *Three Iron Age and Romano-British rural settlements on English gravels: excavations at Hatford (Oxfordshire), Besthorpe (Nottinghamshire) and Eardington (Shropshire) undertaken by Tempvs Reparatvm between 1991 and 1993* / R. J. Zeepvat. Oxford: Archaeopress; Hadrian Books, 2000. 144 p. DA690.H3615 T47 2000. A small village in Shropshire, England.

Exeter

A3.690. *The legionary bath-house and basilica and forum at Exeter; with a summary account of the legionary fortress* / Paul T. Bidwell. Exeter: Exeter City Council: University of Exeter, 1979. 263, 24 p. DA147.E87 B52. The southernmost Roman fortified settlement (Isca Dumnoniorum) in Great Britain.

Hatford

A3.691. *Three Iron Age and Romano-British rural settlements on English gravels: excavations at Hatford (Oxfordshire), Besthorpe (Nottinghamshire) and Eardington (Shropshire) undertaken by Tempvs Reparatvm between 1991 and 1993* / R. J. Zeepvat. Oxford: Archaeopress; Hadrian Books, 2000. 144 p. DA690.H3615 T47 2000. The location of Bronze and Early Iron Age occupations and at least one Roman villa.

Lancastershire

A3.692. *Roman forts in the Fylde: excavations at Dowbridge, Kirkham* / C. Howard-Davis and K. Buxton. Lancaster: Centre for North West Regional Studies, Lancaster University, 2000. 106 p. DA147.D69 H68 2000. There were several Roman forts in this northwest English county at Manchester, Lancaster, Ribchester, Burrow, Elslack, and Castleshaw.

Little Oakley

A3.693. *Excavations at Little Oakley, Essex, 1951–78: Roman villa and Saxon settlement* / P. M. Barford. Chelmsford: Heritage Conservation, Essex County Council, 2002. 213 p. + microfiche. DA670.E14 E27 no.98. Located northeast of Colchester, includes an Iron Age settlement and a Roman villa.

London

A3.694. *The temple of Mithras, London: excavations by W. F. Grimes and A. Williams at the Walbrook* / John D. Shepherd. London: English Heritage, 1998. 261 p. DA677.1.S54 1998. The Roman city of London (Londinium) was established about 43 CE and served as a major imperial commercial center until its abandonment during the fifth century.

Somerset

A3.695. Lopen Roman Mosaic. The chance discovery, excavation, and reconstruction of part of a mosaic from about CE 360 in Somerset, England, are documented in this website. http://www.lopen-mosaic.co.uk/.

Vindolanda

A3.696. Vindolanda Trust. Incorporates two sites, Vindolanda and the Roman Army Museum. http://www.vindolanda.com/Vindolanda-Trust.

A3.697. *Burial caves and sites in Judea and Samaria: from the Bronze and Iron ages* / Hananya Hizmi and Alon De-Groot. Jerusalem: Staff Officer of Archaeology, Civil Administration for Judea and Samaria: Israel Antiquities Authority, 2004. 324, 8 p. DS110.W47 B87 2004.

A3.698. *The West Bank survey from Faras to Gemai* / William Y. Adams. Oxford: Archaeopress, 2005. DT159.6.N54 A324 2005.

GREECE

Aegean Islands

A3.699. Aegean Civilization. http://www.mlahanas.de/Greeks/History/AegeanCivilization.html.

A3.700. *Archaeological excavations in the Greek islands* / Dorothy Leekley and Robert Noyes. Park Ridge, NJ: Noyes Press, 1975. 130 p. DF895.L43. A group of islands in the Aegean Sea with mainland Greece to the west and north and Turkey to the east; the island of Crete is to the south; Rhodes, Karpathos, and Kasos are to the southeast.

A3.701. *The final revival of the Aegean Bronze Age: a case study of the Argolid, Corinthia, Attica, Euboea, the Cyclades and the Dodecanese during LH IIIC Middle* / Marina Thomatos. Oxford: Archaeopress, 2006. 346 p. DF220.T49 2006.

A3.702. *Mollusk shells in Troia, Yenibademli, and Ulucak: an archaeomalacological approach to the environment and economy of the Aegean* / Canan Cakırlar. Oxford: John and Erica Hedges, 2009. 194 p. GN845.A34 C35 2009.

A3.703. *Nēsia tou Aigaiou: archaiologia* / Andreas G. Vlachopoulos. Athena: Ekdotikos Oikos Melissa, 2005. 464 p. DF261.A177 N47 2005.

A3.704. Prehistoric Aegean Archaeology (Dartmouth College). This site contains information about the prehistoric archaeology of the Aegean region. It traces the cultural evolution of humanity in the Aegean basin from the era of hunting and gathering (Palaeolithic-Mesolithic) through the early village farming stage (Neolithic) and the formative period of Aegean civilization into the age of the great palatial cultures of Minoan Crete and Mycenaean Greece. http://www.dartmouth.edu/~prehistory/aegean/.

A3.705. Prehistory: Aegean Prehistory Course. http://www.otsf.org/.

A3.706. *Troie I: matériaux pour l'étude des sociétés du Nord-Est égéen au début du Bronze ancien* / Michel Séfériadès. Paris: Editions Recherche sur les civilisations, 1985. 290 p. DF220.S39 1985.

Aegina Island

A3.707. *Alt-Aegina* / Hans Walter. Mainz: P. von Zabern, 1974. DF261.A18 A39. Bd. 1(1–3), 2(1–4), 3(1), 4(1–3). One of the Saronic Islands in the Saronic Gulf some 27 kilometers from Athens.

A3.708. *People of ancient Aegina: 3000–1000 BC* / Hans Walter. Athens: Archaeological Society at Athens, 2001. 170 p. DF261.A18 W35 2001. German edition: *Die Leute von alt-Aegina, 3000–1000 v. Chr.* / Hans Walter. 2 ed. Athenai: Archaiologike Hetaireia, 2001. 170 p. DF221.A35 W35 2001. Greek edition: *Ho kosmos tes archaias Aiginas: 3000–1000 p.Ch.* / Hans Walter. Athenai: Archaiologike Hetaireia, 2004. 147 p. DF221.A35 W35155 2004.

Agios Petros

A3.709. *Agios Petros: a neolithic site in the northern Sporades: Aegean relationships during the Neolithic of the 5th millennium* / Nikos Efstratiou. Oxford: British Archaeological Reports, 1985. 428 p. GN770.22.G8 E48 1985.

Agna Graecia

A3.710. *Poseidonia-Paestum: atti del ventisettesimo Convegno di studi sulla Magna Grecia: Taranto-Paestum, 9–15 ottobre 1987*. Taranto: Istituto per la storia e l'archeologia della Magna Grecia, 1988. 3 v. DG55.M3 C64 1987.

Aigeira (Hyperesia)

A3.711. *Die österreichischen Ausgrabungen von Aigeira in Achaia. Aigeira I: die mykenische Akropolis. Faszikel 3, Vormykenische Keramik, Kleinfunde, archaözoologische und archaöbotanische Hinterlassenschaften, naturwissenschaftliche Datierung* / Eva Alram-Stern and Sigrid Deger-Jalkotzy. Wien: Verlag der Österreichischen Akademie der Wissenschaften, 2006. 234, 40 p. AS142.V32 Bd.342.

A3.712. *Fremde Zuwanderer im spät̃mykenischen Griechenland: zu einer Gruppe handgemachter Keramik aus den Myk. III C Siedlungsschichten von Aigeira* / Sigrid Deger-Jalkotzy. Wien: Verlag der Österreichischen Akademie der Wissenschaften, 1977. 89 p. AS142.V31 Bd.326.

Aigina

A3.713. *Studies in the population of Aigina, Athens and Eretria* / Mogens Herman Hansen. Copenhagen: Kongelige Danske Videnskabernes Selskab, 2006. 99 p. AS281 .D214 Bd.94. One of the Saronic Islands, Aegina was a rival to Athens, the great sea power of the era.

Amorgos Island

A3.714. *Amorgos I: he Minoa: he polis, ho limen kai he meizon periphereia* / Lilas I. Marankou. Athenai: Athenais Archaiologike Hetaireia, 2002. 392 p. DF901.A56 M37 2002. Amorgos Island (Yperia, Olatagy, Pagali, Pischia, Karkisia, Amolgon, Amourgon, Amorgian, Amourgian) island is the easternmost island of the Greek Cyclades island group. A temple to Aphrodite stood in the part of the island known as Aspis.

A3.715. *Amorgos II: hoi archaioi pyrgoi* / Lilas I. Marankou. Athenai: Athenais Archaiologike Hetaireia, 2005. 392 p. DF901.A56 M372 2005.

A3.716. *Mapkianh Amopoy; Markiani, Amorgos: an early bronze age fortified settlement: overview of the 1985–1991 investigations* / Lila Marankou. London: British School at Athens, 2006. 296 p. GN780.22.G8 M37 2006.

Amphipolis (Amfipoli)

A3.717. *Amphipolis* / Dēmētrios Lazaridēs. Athens: Ministry of Culture, 1997. 124 p. DF261.A47 L392 1997. In modern Macedonia, an ancient Greek city constructed on a raised platform overlooking the east bank of the Strymon River about 3 kilometers from the Aegean Sea.

Andros Island (Andro)

A3.718. *Zagora 1; excavation season 1967; study season 1968–9* / Alexander Cambitoglou. Sydney: Sydney University Press; Australian Academy of the Humanities, 1971. 84 p. DF261.A5 Z3. Continued by: *Zagora 2: excavation of a geometric town on the island of Andros: excavation season 1969, study season 1969–1970* / Alexander Cambitoglou. Athens: Athens Archaeological Society, 1988. 2 v. DF261.A5 Z33 1988. The northernmost island of the Greek Cyclades archipelago.

Antiparos Island (Oliaros)

A3.719. *Excavations at Saliagos near Antiparos* / J. D. Evans and Colin Renfrew. Athens: British School of Archaeology at Athens; London: Thames & Hudson, 1968. 227 p. GN776.G8 E9. A small island in the Cyclades archipelago in southern Aegean.

Arcadia

A3.720. *Hearkadike Alipheira kai ta mnemeia tes* / Anastasios K. Orlandos. Athenais: Archaiologike Hetaireia, 1967–1968. 274 p. DF261.A38 O7. Ancient Arcadia occupied the highlands at the center of the Pelopennese. Herodotus stated that the inhabitants of Arcadia were Arcado-Cypriot–speaking Pelasgians, the indigenous inhabitants of Greece before the arrival of the Hellenic tribes.

Archanes

A3.721. *Archanes* / J. A. Sakellarakis and E. Sapouna-Sakellarakē. Athens: Ekdotike Athenon, 1991. 158 p DF221.A66 S241 1991. An ancient Minoan hub settlement in central Crete connected by roads to Juktas, Anemospilia, Xeri Kara, and Vathypetro.

Argilos (Palaiokastro)

A3.722. *Argilos: a historical and numismatic study* / Katerini Liampi. Athens: Society for the Study of Numismatics and Economic History, 2005. 337, 27 p. CJ429 .L53 2005.

A3.723. *The tomb of Agamemnon* / Cathy Gere. Cambridge: Harvard University Press, 2006. 201 p. DF221.M9 G47 2006.

Arta (Nome, Ambracia) and Preveza

A3.724. *Landscape archaeology in southern Epirus, Greece I* / James Wiseman and Konstantinos Zachos. Princeton: American School of Classical Studies at Athens, 2003. 292 p. DF901.P72 L36 2003. Arta and Preveza are located in the Epirus region of northwestern Greece. The ancient settlement of Nicopolis is located 7 kilometers north of the city.

Asine

A3.725. *Asine and the Argolid in the Late Helladic III Period: a socio-economic study* / Birgitta L. Sjöberg. Oxford: Archaeopress: Hadrian Books, 2004. 157 p. DF221.A78 S58 2004. An ancient Greek settlement of Argolis was the first mentioned by Homer as part of the kingdom of Diomedes, king of Argos.

A3.726. *Asine II: results of the excavations east of the Acropolis, 1970–1974* / Carl-Gustaf Styrenius and Soren Dietz. Stockholm: Svenska institutet i Athen; Lund: Paul Äströms Förlag, 1976. DF261. A7 A83, fasc.1–3, fasc.4 pt.1–3, fasc.6 pt.1–2. Continued by: *Asine III: supplementary studies on the Swedish excavations, 1922–1930* / Robin Hägg, Gullög C. Nordquist, and Berit Wells. Stockholm: Svenska institutet i Athen; Jonsered, Sweden: distributor Paul Aströms, 1996. 2 v. DF261.A7 A833 1996, fasc.1–2.

A3.727. *Asine: en svensk utgral`vningsplats i Grekland* / Carl-Gustaf Styrenius. Stockholm: Medelhavsmuseet, 1998. 80 p. DF261.A7 S7 1998.

A3.728. *Asine: Results of the Swedish excavations, 1922–1930* / Otto Frödin and Axel W. Persson. Stockholm: Generalstabens Litografiska Anstalts Förlag i Distribution, 1938. 452 p. 3.381 As44 S91.

A3.729. *New research on old material from Asine and Berbati: in celebration of the fiftieth anniversary of the Swedish Institute at Athens* / Berit Wells. Stockholm: Paul Äströms, 2002. 155 p. DF261. A7 N39 2002.

Athens (Athina, Athinai, Katharevousa)

A3.730. Acropolis. http://www.grisel.net/acropolis_museum.htm. Classical Athens was a powerful city-state. A center for the arts, learning, and philosophy and home of Plato and Aristotle, it is referred to as the cradle of Western civilization and the birthplace of democracy.

A3.731. Acropolis: Old Temple. http://www.ancient-greece.org/architecture/old-temple.html.

A3.732. Acropolis: A Virtual Tour. http://www.dkv.columbia.edu/vmc/learning/.

A3.733. Acropolis: WebAcropol. http://www.ne.jp/asahi/daikannw/network/webacropol/guided_tour_acropolis.html.

A3.734. Acropolis Project (in English, Russian, and Turkish). http://www.acropolisproject.com/.

A3.735. Ancient Athens. http://www.sikyon.com/athens/athens_eg.html.

A3.736. Ancient City of Athens (IU-Bloomington). The Ancient City of Athens is a photographic archive of the archaeological and architectural remains of ancient Athens (Greece). It is intended primarily as a resource for students and teachers of classical art and archaeology, civilization, languages, and history as a supplement to their class lectures and reading assignments and as a source of images for use in term papers, projects, and presentations. http://www.stoa.org/athens/index.html.

A3.737. Athenian Agora Excavations. Excavations of the Agora by the American School of Classical Studies. http://www.agathe.gr/.

A3.738. Ancient City of Athens: Topography and Monuments. http://www.stoa.org/athens/essays/topography.html.

A3.739. Athenian acropolis. http://witcombe.sbc.edu/sacredplaces/acropolis.html.

A3.740. Hekatompedon Inscription Reconsidered (Acropolis). http://mkosian.home.xs4all.nl/hekat.html.

A3.741. Parthenon. http://www.ancient-greece.org/architecture/parthenon.html.

A3.742. Parthenon Marbles. greece.org/parthenon/marbles.

A3.743. Temple of Athena Nike. http://www.ancient-greece.org/architecture/athena-nike.html.

A3.744. Temple of the Olympian Zeus (Athens). http://www.athensguide.org/athens-museums.html.

A3.745. *Illustrated guide of the National Museum* / V. Staïs. 2 ed. Athens, Printing office "Hestia," 1926. 733 At45.2., v. 2. Catalog of sculpture and bronzes at Ethnikon Archaiologikon Mouseion.

Berbati-Limnes

A3.746. *Berbati-Limnes archaeological survey, 1988–1990* / Berit Wells. Jonsered, Sweden: P. Astroms, 1996. 457 p. DF221.P77 B47 1996.

Brauron (Vravrona, Vravronas)

A3.747. *L'arkteia di Brauron e i culti femminili: materiali della Giornata di approfondimento organizzata dal Seminario avanzato sul tema Il politeismo, promosso dall'insegnamento di Storia delle religioni del mondo classico (A.A. 1999/2000): 5 luglio 2000* / Dario M. Cosi. Bologna: s.n., 2001. 95, 14 p. BL820.D5 A75 2000. The sanctuary of Artemis at Brauron is an early sacred site on the east coast of Attica near the Aegean Sea.

A3.748. *La dea, la vergine, il sangue: archeologia di un culto femminile* / Marco Giuman. Milano: Longanesi, 1999. 291, 16 p. BL820.D5 G58 1999.

A3.749. *Le orse di Brauron: un rituale di iniziazione femminile nel santuario di Artemide* / Bruno Gentili and Franca Perusino. Pisa: ETS, 2002. 271 p. BL820.D5 O77 2002.

Calydon

A3.750. *Das Heroon von Kalydon* / Ejnar Dyggve, Frederik Poulsen, and Konstantinos Rhomaios. Kobenhavn: Levin & Munksgaard, 1934. 145, 157 p. 913.381 139D.2. An ancient Greek city in Aetolia, situated on the west bank of the Evenus River. The city housed an important Aetolian sanctuary (Laphrion) dedicated to Artemis Laphria and Apollo Laphrios.

Chersonesos and Metaponto

A3.751. *The study of ancient territories: Chersonesos and Metaponto: 2004 annual report* / Joseph Coleman Carter. Austin: Institute of Classical Archaeology; Oxford: Oxbow, 2006. 90 p. DK508.95. C54 S78 2004. The town is best known for the ruins of the ancient Greek city of Metapontum.

Clazomenae (Klazomenai)

A3.752. *Klazomenai, Teos and Abdera: Metropoleis and Colony: Proceedings of the International Symposium held at the Archaeological Museum of Abdera: Abdera, 20–21 October 2001* / A. Moustaka. Thessaloniki: 19th Ephorate of Prehistoric and Classical Antiquities of Komotini: University Studio Press, 2004. 359 p. DF261.C6 K53 2001. An ancient Greek city of Ionia and a member of the Ionian Dodecapolis; it was one of the first cities to issue silver coinage.

Corinth

A3.753. Corinth Computer Project (University of Pennsylvania). Incorporates historical, literary, and archaeological information from the Roman city of Corinth, Greece. http://corinthcomputerproject.org/. A city-state (polis) on the Isthmus of Corinth, a narrow land that joins the Peloponnesus to mainland Greece, roughly halfway between Athens and Sparta.

A3.754. Corinthian page. http://aabbeatv.com/Corinthians.html.

A3.755. Eastern Korinthia Archaeological Survey. http://www.und.nodak.edu/instruct/wcaraher/EKAS-Page/EKASHome.html.

A3.756. Life in Ancient Greece Reflected in the Symbols of the Coinage of Corinth. http://americanhistory.si.edu/collections/numismatics/corinth/.

A3.757. INSTAP Study Center for East Crete. http://instapstudycenter.net/.

A3.758. *Il vino dell'anima: storia del culto di Dioniso a Corinto, Sicione, Trezene* / Giovanni Casadio. Roma: Il calamo, 1999. 231 p. BL820.B2 C373 1999.

A3.759. *A new temple for Corinth: rhetorical and archaeological approaches to Pauline imagery* / John R. Lanci. New York: Peter Lang, 1997. 155 p. BS2675.2.L36 1997. DR1521.N55 2010.

Cumae (Cuma, Kyma)

A3.760. *Eoli ed Eolide: tra madrepatria e colonie* / Alfonso Mele, Maria Luisa Napolitano, and Amedeo Visconti. Napoli: Luciano, 2005. 600 p. DF78 .E55 2005. An ancient Greek settlement located northwest of Naples in the Italian region of Campania. Cumae was the first Greek colony on mainland Italy (Magna Graecvia).

Cyzicus (Kyzikos)

A3.761. *Deioco di Proconneso: gli argonauti a Cizico* / Luigi Vecchio. Napoli: Luciano, 1998. 157 p. PA3948.D34 Z92 1998. An ancient town of Mysia in the Balikesir province of Anatolia.

Delos Island

A3.762. *Delos, Carthage, Ampurias: the housing of three Mediterranean trading centres* / Birgit Tang. Roma: L'Erma di Bretschneider, 2005. 396, 3 p. NA277 .T35 2005. The island of Delos, near Mykonos, near the center of the Cyclades archipelago, is one of the most important mythological, historical, and archaeological sites in Greece.

Delhi

A3.763. Image of Delhi. http://www.perseus.tufts.edu/hopper/image?img=1990.33.1040.

Delphi (Krisa)

A3.764. *L'Amphictionie pyléo-delphique: histoire et institutions* / François Lefèvre. Athènes: École française d'Athènes; Paris: De Boccard, 1998. 359 p. D5 .B4 fasc.298. Located on southwest Mount Parnassus in the Phocis Valley, Delphi was the site of the Delphic oracle, the most important oracle in the classical Greek tradition and a major site for the worship of Apollo.

A3.765. *Anecdota delphica* / Ernestus Curtius. Berolini, G. Besser, 1843. 104 p. DF261.D35 C9 1843.

A3.766. *La Colonne des Naxiens et le Portique des Athéniens* / Y. Fomine, K. Tousloukof, and R. Will. Paris, E. de Boccard, 1953.128 p. DF261. D35 F67 t.2 pt.1 fasc.4.

A3.767. *Corpus des inscriptions de Delphes* / École française d'Athènes. Paris: de Boccard, 1977. CN385.D44 C67, t.1; CN385.D44 C67, t.1–3.

A3.768. *Delfi och Olympia* / Erik J. Holmberg. Goteborg: P. Äström, 1976. 103, 17 p. DF261.D35 H55 1976.

A3.769. *Delfi: tekster og artikler om Apollons helligdom* / Ole Wagner. Odense: Odense Universitetsförlag, 1997. 313 p. DF261.D35 D399 1997.

A3.770. *Delphes* / Pierre de la Coste-Messelière. Paris: Hachette 1957. 331 p. 913.381 D38E 1957.

A3.771. *Delphes cent ans après la grande fouille: essai de bilan: actes du Colloque international: organisé par l' École française d'Athènes: Athènes-Delphes, 17–20 septembre 1992* / Anne Jacquemin. Athènes: École française d'Athènes, 2000. 455 p. DF261.D35 D386 2000.

A3.772. *Delphes: centenaire de la "grande fouille" réalisée par l' École française d'Athènes, 1892–1903: actes du colloque Paul Perdrizet, Strasbourg, 6–9 novembre 1991* / J.-F. Bommelaer. Leiden; New York: E. J. Brill, 1992. 376, 42 p. DF261.D35 D383 1992.

A3.773. *Delphes: oracles, cultes, et jeux.* Dijon: Archéologia, 1990. 76, 5 p. CC3 .H478 no.151.

A3.774. *Delphi* / Frederik Poulsen. London: Gyldendal, 1920. 338 p. DF261.D35 P7; 913.381 D38Po.ER.

A3.775. Delphi Stadium. http://www.ancient-greece.org/architecture/delphi-stadium.html.

A3.776. Delphi Tholos. http://www.ancient-greece.org/architecture/delphi-tholos.html.

A3.777. *Études sur les comptes de Delphes* / Jean Bousquet. Athènes: École Française d'Athènes; Paris: De Boccard, dépositaire, 1988. 232 p.

A3.778. *De fano Apollinis Delphico: dissertatio inauguralis* / Ludovicus Hahne. Gottingae: Typis expressit officina Hoferiana, 1872. 52 p. 913.38 H123.

A3.779. *Les Galates en Grèce et les Sôtéria de Delphes: recherches d'histoire et d'épigraphie hellénistiques* / Georges Nachtergael. Palais des académies, 1977. 545 p. AS242. .B325 t.63 fasc.1.

A3.780. *Les inscriptions de la terrasse du Temple et de la région nord du Sanctuaire.* Paris: Boccard, 1930. DF261.D35 F67 t.3 fasc.4; DF261.D35 F67 t.3 fasc.4.

A3.781. *Marmaria: le sanctuaire d'Athéna à Delphes* / Jean-François Bommelaer. Paris: École Française d'Athènes; Electricité de France; Dépositaire, De Boccard Edition-Diffusion, 1997. 141 p. DF261. D35 M37 1997.

A3.782. *Monuments figurés: sculpture.* Paris: Fontemoing, 1906. DF261.D35 F67 t.1–7; DF261.D35 F67, fasc. 4.

A3.783. *New measurements and observations of the treasury of Massaliotes, the Doric treasury and the Tholos in the sanctuary of Athena Pronaia at Delphi* / J. Ito, with contributions of Y. Hayashida et al.; translated by J. Yoneoka. Fukuoka, Japan: Kyushu University Press, 2004. 2 v. DF261. D35 I86 2004.

A3.784. *Offrandes monumentales à Delphes* / Anne Jacquemin. Athènes: École française d'Athènes, 1999. 434 p. D5 .B4 fasc.304.

A3.785. *Orakel der Mächtigen: Untersuchungen zur Geschichte, Funktion und Bedeutung des delphischen Orakels in arc haischer Zeit* / Marcos José de Araújo Caldas. Bonn: R. Habelt, 2003. 180 p. DF261.D35 A73 2003.

A3.786. *Die Pythais: Studien zur Geschichte der Verbindungen zwischen Athen und Delphi* / Axel Boethius. Uppsala: Almquist & Wiksells, 1918. 172 p. 913.38 B632.

A3.787. *Roman Delphi and its Pythian games* / Robert Weir. Oxford: J. and E. Hedges; Hadrian Books, 2004. 233 p. GV24 .W45 2004.

A3.788. *Le Sanctuaire d'Athèna Pronaia (Marmaria). Troisième fascicule (texte). Topographie du Sanctuaire* / R. Demangel. Paris: E. de Boccard, 1926. 144, 2 p. DF261.D35 F67 t.2 pt.2 fasc.3 text.

A3.789. Sanctuary of Apollo, plan and elevation. http://www.oneonta.edu/faculty/farberas/arth/ARTH209/Archaic_architecture.htm.

A3.790. *Sculptures du Trésor des Athéniens* / Pierre de la Coste-Messelière. Paris: de Boccard, 1957. 2 v. DF261.D35 F67 t.4 fasc.4.

A3.791. *Les statuettes de bronze: t. 5. Monuments figurés* / Claude Rolley. Paris: Boccard, 1969. 224 p. DF261.D35 F67 t.5 1969.

A3.792. *Les temples de tuf* / R. Demangel. Paris: E. de Boccard, 1923–1926. 112 p. DF261.D35 F67 t.2 pt.2 fasc.1. Study of Temple of Athena Pronaia.

A3.793. *La terrasse d'Attale I* / Georges Roux. Paris: Boccard, 1987. 2 v. DF261.D35 F67 t.2 pt.1 fasc.1 1987.

A3.794. *Les terres cuites architecturales* / Christian Le Roy; *La sculpture décorative en terre cuite* / Jean Ducat. Paris: Boccard, 1967. 282, 135 p. DF261. D35 F67 t.2 pt.5.

A3.795. *Le territoire de Delphes et la terre d'Apollon* / Denis Rousset. Athènes: École Française d'Athènes; Paris: De Boccard, 2002. 343, 23 p. D5 .B4 fasc.310.

A3.796. *La Tholos* / J. Charbonneaux. Paris: E. de Boccard, 1925. 35 p. DF261.D35 F67 t.2 pt.2 fasc.2. Temple of Athena Pronaia (Delphi).

A3.797. *The treasuries at Delphi: an architectural study* / Elena C. Partida. Jonsered: Paul Äströms Förlag, 2000. 333, 72 p. DF261.D35 P37 2000.

A3.798. *Le trésor de Cyrène* / Jean Bousquet and Youry Fomine. Paris: E. de Boccard, 1952. 112 p. DF261.D35 F67 t.2 pt.1 fasc.3.

A3.799. *De variis anathemathum Delphicorum generibus* / Lionel von Donop. Gottingae: Typis expressit Officina Academica Dieterichiana, 1868. 35 p. BL790 .C76 1872.

A3.800. *Über das Collegium der Thyiaden von Delphi* / L. Weniger. Eisenach: Hofbuchdruckerei, 1876. 21 p. BL790 .C76 1872.

Demetrias

A3.801. *Pagasai und Demetrias, beschreibung der reste und stadtgeschichte* / Friedrich Stählin, Ernst Meyer, and Alfred Heidner. Berlin und Leipzig, W. de Gruyter, 1934. 273 p. 938.2 St.131. Demetrias was an ancient settlement in Magnesia, east-central Greece, founded by Demetrius Poliorcetes, one of the successors of Alexander the Great.

Didaskalia

A3.802. Didaskalia Home Page. http://www.didaskalia. net/studyarea/visual_resources/visualresources. html.

Dikili Tash

A3.803. Grèce: Dikili Tash. http://www.diplomatie. gouv.fr/fr/enjeux-internationaux/echanges-scientifiques-recherche/archeologie-sciences-humaines-et/les-carnets-d-archeologie/europe-maghreb/grece-dikili-tash/.

Dion (Dio)

A3.804. *Multiple concealments from the sanctuary of Zeus Olympios at Dion: three Roman provincial coin hoards* / Sophia Kremydi-Sicilianou. Athens: Kentron Hellēnikēs kai Rōmaïkēs Archaiotētos Ethnikon Hydryma Ereunōn; Paris: Diffusion de Boccard, 2004. 158, 16 p. CJ893.D53 K745 2004. Located in the Pieria region of Greece, Dion is known for its archaeological site at the base of Mount Olympus and the Archaeological Museum of Dion.

Dionysus

A3.805. Theater of Dionysus. http://www.didaskalia.net/ studyarea/visual_resources/dionysus3d.html.

Edessa

A3.806. *Macedonian Edessa: prosopography and onomasticon* / Argyro B. Tataki. Athens: Kentron Hellenikēs kai Rōmaikēs Archaiotētos, Ethnikon Hidryma Ereunōn; Paris: Diffusion de Boccard, 1994. 128 p. DF261.E34 T38 1994. Edessa is a settlement in the central Macedonian region in northern Greece.

Eleutherna

A3.807. *The anthropology of tomb A1K1 of Orthi Petra in Eleutherna: a narrative of the bones: aspects of the human condition in geometric-archiac Eleutherna* / Anagnostis Pan. Agelerakis. Rethymnon, Crete: N. Chr. Stampolidis, University of Crete, 2005. 448 p. DF261.E413 A54 2005. Eleutherna (Apollonia) was an ancient city-state in Crete.

A3.808. *Eleutherna; Eleutherna: polis, acropolis, necropolis* / Nikolaos Chr. Stampolidis. Athens: Ministry of Culture; University of Crete; Museum of Cycladic Art, 2004. 317 p. DF261.E413 E5413 2004.

Elis (Eleia, Elean)

A3.809. *Elis und Olympia in der Kaiserzeit: das Leben einer Gesellschaft zwischen Stadt und Heiligtum auf prosopographischer Grundlage* / Sophia B. Zoumbaki. Athen: Diffusion de Boccard, 2001. 450 p. DF261.E423 Z68 2001. An ancient district located in southern Greece on the Peloponnesos peninsula, bounded on the north by Achaea, east by Arcadia, south by Messenia, and west by the Ionian Sea.

A3.810. *Elische Keramik des 5. und 4. Jahrhunderts* / Jürgen Schilbach. Berlin; New York: de Gruyter, 1995. 143, 58 p. NK3840 .S34 1995.

A3.811. *Totenkult und elische Grabkeramik spatklassischer und hellenistischer Zeit* / Anastasia Georgiadou. Thessaloniki: University Studio Press, 2005. 2 v. DF261.E42 G46 2005.

Ephesus (Ephesos, Efes)

A3.812. *A bibliography of ancient Ephesus* / Richard E. Oster. Philadelphia: American Theological Library Association; Metuchen Scarecrow Press, 1987. 155 p. DF261.E5 O87 1987. A Greco-Roman city on the west coast of Asia Minor, near modern Selcuk, Izmir province, Turkey.

A3.813. *Funde aus Ephesos und Samothrake* / Wolfgang Oberleitner. Wien: Kunsthist Museum; Heidelberg: Ueberreuter, 1978. 152 p.

Epidaurus (Epidavros)

A3.814. *The Epidaurian miracle inscriptions* / Lynn R. LiDonnici. Atlanta, GA: Scholars Press, 1995. 155 p. BL793.E93 L53 1995; Van Pelt Bly793 .E93 L53 1995. Epidaurus is a small Greek polis on the Saronmic Gulf.

A3.815. *Epidauros: ta glypta ton romaikon chronon apo to hiero tou Apollonos Maleata kai tou Asklepiou* / Stylianou E. Katake. Athenai: He en Athēnais Archaiologike Hetaireia, 2002. 2 v. NB91.E6 K383 2002.

A3.816. *Fünf Wundergeschichten aus dem Asklepieion von Epidauros* / Werner Peek. Berlin: Akademie-Verlag, 1963. 8 p. 63 L53p6 Bd.56 hft.3.

A3.817. *Inschriften aus dem Asklepieion von Epidauros* / Werner Peek. Berlin, Akademie-Verl., 1969. 256, 58 p. AS182 .S211 Bd.60 hft.2.

A3.818. Theatre of Epidaurus. http://www.didaskalia.net/ studyarea/visual_resources/epidaurus3d.html.

Erechtheion

A3.819. Erechtheion. http://www.ancient-greece.org/architecture/erechtheion.html.

Eretria

A3.820. *L'aire sacrificielle au nord du Sanctuaire d'Apollon Daphnéphoros: un rituel des époques géométrique et archaique* / Sandrine Huber. Gollion: École suisse d'archéologie en Grèce: In, 2003. 2 v. DF221.E7 E7 no.14. An important polis in ancient Greece, located on the west coast of Euboea, south of Chalcis facing the coast of Attica.

A3.821. *Boire pour Apollon: céramique hellénistique et banquets dans le Sanctuaire d'Apollon Daphnéphoros* / Stephan G. Schmid. Lausanne: École suisse d'archéologie en Grèce; Gollion: In, 2006. 166 p. DF221.E7 E7 no.16.

A3.822. *Décrets érétriens de proxénie et de citoyenneté* / Denis Knoepfler. Lausanne: Payot, 2001. 490 p. DF221.E7 E7 no.11.

A3.823. *Eretria-Nea Psara: eine klassizistische Stadtanlage über der antiken Polis* / Ferdinand Pajor. Lausanne: École suisse d'archéologie en Grèce; Gollion: In, 2006. 2 v. DF221.E7 E7 no.15 Bd.1–2.

A3.824. *Das Gymnasion* / Elena Mango. Gollion: École suisse d'archéologie en Grèce, 2003. 174 p. DF221.E7 E7 no.13.

A3.825. *Klassischen und hellenistischen Wohnhäuser im Westquartier* / Karl Reber. Lausanne: Editions Payot, 1998. 270 p. DF221.E7 E7 no.10.

A3.826. *Le quartier de la Maison aux mosaïques* / Pierre Ducrey, Ingrid R. Metzger, and Karl Reber. Lausanne: Payot, 1993. 190, 5 p. DF221.E7E7 no.8.

A3.827. *Rotfigurige und weissgrundige Keramik* / Kristine Gex. Lausanne: Payot, 1993. 136, 110 p. DF221.E7E7 no.9.

A3.828. *Das Theater: Grabungen 1997 und 1998* / Hans Peter Isler. Lausanne: École suisse d'archéologie en Grèce; Gollion: In, 2007. 174 p. DF221.E7 E7 no.18.

A3.829. *Untersuchungen zum Lelantischen Krieg und verwandten Problemen der frühgriechischen Geschichte* / Victor Parker. Stuttgart: F. Steiner, 1997. 189 p. DF261.C4 P37 1997.

Geraki

A3.830. Dutch Archaeological Fieldwork Project at Geraki. http://users.hol.gr/~geraki/dutch.htm.

Gortyna (Gortys)

A3.831. *La grande iscrizione di Gortyna: centoventi anni dopo la scoperta: atti del I Convegno internazionale di studi sulla Messarà: Scuola archeologica italiana di Atene: Atene-Haghii Deka, 25–28 maggio 2004* / Emanuele Greco and Mario Lombardo. Atene: Scuola archeologica italiana di Atene, 2005. 222 p. CN420 .C66 2004. The ancient city Gortys was located in the valley of the Lousios River and known for its Temple of Asclepius.

A3.832. *Gortina di Creta: prospettive epigrafiche per lo studio della forma urbana* / Giovanni Marginesu. Atene Greece: Scuola archeologica italiana di Atene, 2005. 149 p. DF261 G64 M37 2005.

A3.833. *Il teatro romano di Gortina* / Gilberto Montali. Padova: Bottega d'Erasmo; A. Ausilio. 327, 11 p. DF261.G64 M66 2006.

Goyulandris

A3.834. Goyulandris Museum of Cycladic and Ancient Greek Art (Athens). http://www.athensguide.org/ athens-museums.html.

Grotta

A3.835. *He Naxos kai to kreto-mykenaiko Aigaio: stromatographia, keramike, oikonomike organose tou hysteroelladikou I–IIIB oikismou tes Grottas* / Mich. V. Kosmopoulos. Athena: Panepistemio Athenon, Philosophike Schole, 2004. 224, 48, 17 p. NK3843 .K67 2004.

Halai and East Lokris

A3.836. Cornell Halai and East Lokris Project. http://halai.arts.cornell.edu/wwwroot/chelp/home.htm.

Halieis/Portokhellion

A3.837. *Excavations at ancient Halieis.* Bloomington: Indiana University Press, 2005. DF261.H25 E93 2005. 2 v. An ancient Greek harbor city in the Argolid (across from the modern village of Porto Cheli) that was abandoned toward the end of the fourth century BCE.

Ialysos, Kameiros, Rhodes Ialysos (Trianta)

A3.838. *From cremation to inhumation: burial practices at Ialysos and Kameiros during the mid-Archaic period, ca. 625–525 B.C.* / Charles Gates. Los Angeles: Institute of Archaeology, University of California, Los Angeles, 1983. 91 p. DF261.I34 G38 1983. The ancient city of Ialysos, extending around the hill of Philerimos on the island of Rhodes, in the Dodecanese, Greece. It has an acropolis with Archaic, Byzantine, and Crusader remains. The Temple of Athena Polias dates to the third and second centuries BCE.

Imathia

A3.839. Prefecture of Imathia-Hellas (Greece). http://www.visitgreece.gr/en/history/history_of_imathia_prefecture_.

Isthmia

A3.840. Isthmia: Ohio State University Excavations Site. http://isthmia.osu.edu/.

A3.841. University of Chicago Excavations at Isthmia. http://lucian.uchicago.edu/blogs/isthmia/Excavations at Isthmia.

Itanos

A3.842. Grèce: Itanos. http://www.diplomatie.gouv.fr/fr/enjeux-internationaux/echanges-scientifiques-recherche/ archeologie-sciences-humaines-et/les-carnets-d-archeologie/europe-maghreb/grece-itanos/.

A3.843. Palace at Itanos. http://www.ancient-greece.org/images/ancient-sites/itanos/index.htm.

Kalapodi

A3.844. *Kalapodi: Ergebnisse der Ausgrabungen im Heiligtum der Artemis und des Apollon von Hyampolis in der antiken Phokis* / Rainer C. S. Felsch. Mainz: P. von Zabern, 1996. DF261.P55 K34 1996. An ancient sanctuary in central Greece with cult worship as early as the late Bronze Age.

Kameiros

A3.845. *I bronzi della stipe di Kamiros* / Chiara Bernardini. Atene: Scuola archeologica italiana di Atene, 2006. 123 p. NK7907.3 .B48 2006. An ancient city on the island of Rhodes in the Dodecanese, Greece. The area was inhabited by Mycenaean Greeks, but the city itself was founded by the Dorians. The city was destroyed by earthquakes in 142 BCE and 226 BCE.

A3.846. *Chronologie de deux listes de prêtres kamiréens* / Jakob Benediktsson. København: E. Munksgaard, 1940. 64 p. 913.06 D238 v.2 no.6.

Kouphovouno

A3.847. Grece: Kouphovouno. http://www.diplomatie.gouv.fr/fr/enjeux-internationaux/echanges-scientifiques-recherche/archeologie-sciences-humaines-et/les-carnets-d-archeologie/europe-maghreb/grece-kouphovouno/.

Lakonia (Laconia, Lacedaemonia)

A3.848. *Prosopographie der Lakedaimonier bis auf die Zeit Alexanders des Grossen* / Paul Porella. Breslau, Kommissions-Verlag von J. Max, 1913. 172 p. DF261.S8 P67. Lakonia is one of the regional units situated in the southeastern part of the Peloponnese peninsula of Greece. Its administrative capital is Sparti (Sparta).

Megara

A3.849. *Greek bronze coins from a well at Megara* / Frederick O. Waage. New York: American Numismatic Society, 1935. 42 p. 737 Am36 no.69–77. An ancient city in Attica, Greece, situated in the northern section of the Isthmus of Corinth opposite the island of Salamis. Megara was also a trade port, its people using their ships and wealth as a way to gain leverage on armies of neighboring poleis. Megara specialized in the exportation of wool and other animal products, including livestock such as horses.

Melos

A3.850. Aghia Kyriaki, Melos Project (Greece). http://www.gla.ac.uk/schools/humanities/research/ar-

chaeologyresearch/projects/industrialminerals/
melos/agkyriakisurveys/.

Messene (Messini)

A3.851. *Aristomenes of Messene: legends of Sparta's nemesis* / Daniel Ogden. Swansea, Wales: Classical Press of Wales; Oakville: David Brown, 2004. 244 p. BL820.A834 O44 2004. Most of the area of ancient Messene contains the ruins of the large classical city state of Messene founded in 369 BCE. Ancient Messene, was constructed over the ruins of Ithome, an ancient city originally of Achaean Greeks, destroyed previously by the Spartans and abandoned.

A3.852. *Hellenistic Messenia.* http://classics.uc.edu/prap/messenia/messym.html.

A3.853. *Heroes at ancient Messene* / Petros G. Themelis. Athens: The Archaeological Society at Athens, 2003. 79, 7 p. DF261.M45 T44 2003.

A3.854. *Messene: to Artemisio kai hoi oikoi tes dytikes pterygas tou Asklepeiou* / Elenes-Annas Chlepa. Athenai: He en Athenais archaiologike Hetaireia, 2001. 104, 3 p. DF261.M45 C55 2001.

Midea

A3.855. *Excavations on the Acropolis of Midea: results of the Greek-Swedish excavations under the direction of Katie Demakopoulou and Paul Åström* / Gisela Walberg. Stockholm: Svenska institutet i Athen; Jonsered, Sweden: Paul Åströms förlag, 1998. DF221.M54 W3 1998. Midea is a village and a former municipality in Argolis, Peloponnese, Greece. Within the boundaries of the municipal unit are two significant archaeological sites, Dendra and Midea, dating to the Bronze Age or earlier.

Mycenae

A3.856. *Anaskaphes Mykenon. I, he voreodytike synoikia* / Spyrou E. Iakovide. Athenai: He en Athenais Archaiologike Hetaireia, 2006. 187, 43 p. DF221.M9 I35 2006. An archaeological site located about 90 kilometers southwest of Athens, in the north-eastern Peloponnese. In the second millennium BCE Mycenae was one of the major centers of Greek civilization, a military stronghold that dominated much of southern Greece. The period between 1600 BCE to 1100 BCE is called Mycenaean.

A3.857. *Archaeological atlas of Mycenae* / Electra Andreadi. Athens: Archaeological Society of Athens, 2003. 70, 39 p. G2004.M9 E15 2003.

A3.858. *Chamber tombs at Mycenae* / A. J. B. Wace. Oxford, Printed by J. Johnson for the Society of Antiquaries, 1932. 242 p. 913.381 M99W.

A3.859. *Grave circle B of Mycenae* / George E. Mylonas. Lund: C. Bloms, 1964. 10 p. DF221.M9 M92.

A3.860. *The "ivory houses" at Mycenae* / Iphiyenia Tournavitou. London: British School at Athens, 1995. 341, 41 p. + 9 microfiche. DF221.M9 T68 1995.

A3.861. *Hoi thalamotoi taphoi ton Mykenon, anaskaphes Chr. Tsounta (1887–1898); Les tombes à chambre de Mycènes, fouilles de Chr. Tsountas (1887–1898)* / Agnes Xénaki-Sakellariou. Paris: Diffusion de Boccard, 1985. 366, 144 p. DF221.M9 X45 1985. Tomb excavations at Mycenae by Chrestos Tsountas (1857–1934).

A3.862. *Die kretisch-mykenische Kultur* / D. Fimmen. 2 ed. Leipzig: Teubner, 1924. 224, 203 p. 913.38 F487.2 1924.

A3.863. *Kretische Paläste, mykenische Burgen* / Heimo Rau. Stuttgart: H. E. Günther 1957. 15 p. DF220 .R383.

A3.864. *The latest sealings from the palace and houses at Knossos* / Mervyn R. Popham and Margaret A. V. Gill. London: British School at Athens, 1995. 65, 48 p. CD5363 .P67 1995.

A3.865. *The latest sealings from the palace and houses at Knossos* / Mervyn R. Popham and Margaret A. V. Gill. London: British School at Athens, 1995. 65, 48 p. CD5363 .P67 1995.

A3.866. *Mycenae: Agamemnon's capital: the site in its setting* / Elizabeth French. Stroud, Gloucestershire; Charleston: Tempus, 2002. 160 p. DF221.M9 F74 2002.

A3.867. *Mycenaean domestic architecture* / Ione Mylonas Shear. Bryn Mawr: Shear, 1968, 1969. 3 v. NA7352 .S493 1976.

A3.868. *The Mycenae tablets IV* / Jean Pierre Olivier. Leiden: E. J. Brill, 1969. 43 p. P1035 .O38.

A3.869. *Mykenae: Bericht über meine Forschungen und Entdeckungen in Mykenae und Tiryns* / Heinrich Schliemann. Leipzig: F. A. Brockhaus, 1878. 447, 34 p. 913.381 M99S.

A3.870. *Das Mykenische Hellas: Heimat der Helden Homers.* Athens: Kulturministerium Griechenlands, ICOM Sektion Griechenland; Berlin: Buchhandelsausgabe, Dietrich Reimer Verlag, 1988. 277 p. DF221.M9 B47 1988.

A3.871. *Die Palaststilkeramik von Knossos: Stil, Chronologie und historischer Kontext* / Wolf-Dietrich Niemeier. Berlin: Mann, 1985. 271, 29 p. DF221. C8 N53 1985.

A3.872. *The Panagia Houses at Mycenae* / Ione Mylonas Shear. Philadelphia: University Museum, University of Pennsylvania, 1987. 171, 52 p. DF221. M9 S54 1987.

A3.873. *Parthenon and the Mycenaean city on the heights* / J. A. Bundgaard. Copenhagen: The National Museum of Denmark, 1976. 194, 11 p. DF287. P3 B85.

A3.874. *Philokypros: mélanges de philologie et d'antiquités grecques et proche-orientales: dédiés à la mémoire d'Olivier Masson* / Laurent Dubois and Emilia Masson. Salamanca: Universidad de Salamanca, 2000. 316, 8 p. P1035 .M512 no.16.

A3.875. *Regional Mycenaean decorated pottery* / P. A. Mountjoy. Rahden/Westf.: M. Leidorf, 1999. 2 v. NK4646 .M69 1999.

A3.876. *Scripta minoa: the written documents of Minoan Crete: with special reference to the archives of Knossos by Arthur J. Evans.* Oxford: Clarendon Press, 1909–1952. 2 v. 913.3918 Ev12.6; 913.3918 Ev12.6; Van Pelt 913.3918 Ev12.6.

A3.877. *Tithemy: the tablets and nodules in Linear B from Tiryns, Thebes and Mycenae: a revised transliteration* / José L. Melena and Jean-Pierre Olivier. Salamanca, España: Ediciones Universidad de Salamanca; Vizcaya, España: Servicio Editorial, Universidad del País Vasco, 1991. 92 p. P1035 .M512 no.12.

A3.878. *Well built Mycenae: the Helleno-British excavations within the citadel at Mycenae 1959–1969* / W. D. Taylour, E. B. French, and K. A. Wardle. Warminster, Wiltshire, England: Aris & Phillips, 1981. Microform. DF221.M9 W45, fasc.1, 7, 10, 13, 16, 17, 24, 36 + CD-ROMs.

Naucratis (Naukratis)

A3.879. *Funde aus Naukratis* / Hugo Prinz. Leipzig: Dieterich, 1908. 153 p. 930P K684 sup. v.7. Naucratis was a city in ancient Egypt, on the Canopic branch of the Nile River, 70 kilometers southeast of the final Ptolemaic capital of Alexandria.

Nea Nikomedeia

A3.880. *Nea Nikomedeia: the excavation of an early neolithic village in northern Greece, 1961–1964, directed by R.J. Rodden* / K. A. Wardle. London: The British School at Athens, 1996. DF221.N43 N43 1996. Macedonia shows evidence of human habitation as early as the Palaeolithic (Petralona cave) and the earliest known settlements, such as Nea Nikomedeia in Imathia. The Neolithic houses at Nea Nikomedeia were constructed of wattle and daub on a timber frame.

New Halos (Alos)

A3.881. *Housing in New Halos: a Hellenistic town in Thessaly, Greece* / H. Reinder Reinders and Wietske Prummel. Exton: A. A. Balkema Publishers, 2003. 331 p. DF261.N48 R45 2003. An ancient Greek city located ten kilometers south of modern Almyros. The city is mentioned by Herodotus as one of the places where the Persian king Xerxes stayed in 480 CE during his attack on Greece. The site of the classical city, which was destroyed in 346 during the Third Sacred War has been identified, but not excavated. The city was refounded in 302 by Demetrius Poliorcetes.

A3.882. *Po-ti-ni-ja: l'élément féminin dans la religion mycénienne (d'après les archives en linéaire B)* / Cécile Boelle. Nancy: A.D.R.A.; Paris: De Boccard, 2004. 273 p. BL793.M8 B64 2004.

Nikopolis (Nicopolis, Actia Nicopolis)

A3.883. *Foundation and destruction, Nikopolis and Northwestern Greece: the archaeological evidence for the city destructions, the foundation of Nikopolis and the synoecism* / Jacob Isager. Athens: Danish Institute at Athens; Århus; Oakville: University Press, 2001. 277 p. DS156.N53 F68 2001. Kikiopolis was an ancient city of Epirus on the west coast of Greece; it was later the capital of Epirus Vetus.

A3.884. *La sculpture architecturale byzantine dans le thème de Nikopolis du Xe au début du XIIIe siècle: Épire, Étolie-Acaranie et Sud de l'Albanie* / Catherine Vanderheyde. Athènes: École française d'Athènes, 2005. 183, 46 p. NA3551. N55 V36 2005.

A3.885. *To mnemeio tou Oktavianou Augoustou ste Nikopole: to tropaio tes naumachias tou Aktiou* / Konstantinos L. Zachos. Athēna: Hypourgieo Politismou, 2001. 78 p. DF261.N55 Z33 2001.

Oeniadae (Oiniades)

A3.886. *Die Theater von Oiniadai und Neupleuron* / E. Fiechter. Stuttgart: W. Kohlhammer, 1931. 23, 12 p. 913.387 L535 hft.2. A strategically important site in Aetolia-Acarmania, western Greece.

Olympia

A3.887. *Athletes and oracles: the transformation of Olympia and Delphi in the eighth century BC* / Catherine Morgan. Cambridge, England; New York: Cambridge University Press, 1990. 324 p. DF261.D35 M57 1990. A sanctuary site of ancient Greece is known as the site of the Olympic games in classical times.

Olynthus

A3.888. *Household and city organization at Olynthus* / Nicholas Cahill. New Haven: Yale University Press, 2002. 383 p. DF261.O53 C3 2002. An ancient city of Chalcidice, constructed on two flat-topped hills in a fertile plain at the head of the Gulf of Torone, about 2.5 kilometers from the sea and about 10 kilometers from Poteidaea.

A3.889. *Olynthe et les Chalcidiens de Thrace: études de numismatique et d'histoire* / Selene Psoma. Stuttgart: Steiner, 2001. 311, 22 p. CJ547.O53 P865 2001.

Oropos

A3.890. *Das Theater in Oropos* / E. Fiechter. Stuttgart: W. Kohlhammer, 1930. 27, 8 p. 913.387 L535 hft.1. Oropos was founded by colonists from Eretria; it was a border city between Boeotia and Attica and an Attic town during the Roman empire. The actual harbor, called Delphinium, was at the mouth of the Asopus, about 1.6 kilometers north of the city.

Ostia

A3.891. *The cults of Ostia* / Lily Ross Taylor. Bryn Mawr: J. H. Furst; Balitmore, 1912. 100 p. 378.73 B84M.2 v.11. The harbor city for ancient Rome.

Paestum

A3.892. *Der alte Heratempel in Paestum und die archaische Baukunst in Unteritalien* / Dieter Mertens. Mainz am Rhein: P. von Zabern, 1993. 193, 97 p. NA285.P3 M47 1993. A major Graeco-Roman city in the Campania region of Italy, located in the north of Cilento, near the coast about 85 kilometers northwest of Naples.

Palekastro

A3.893. Palekastro. http://www.ancient-greece.org/archaeology/palekastro.html.

Patrai (Patras)

A3.894. *Ta ergasteria ton romaikon lychnarion tes Patras kai to Lychnomanteio* / Michales Petropoulos. Athena: Tameio Archaiologikon Poron kai Apallotrioseon, 1999. 204, 72 p. DE61.L34 P48 1999. Patras flourished during the Mycenean period (1580–1100 BCE) with the unification of Patras,

Antheia, and Mesatis. In Roman times it became an important port.

Pellana

A3.895. *Traité entre Delphes et Pellana: étude de droit grec* / Bernard Haussoullier. Paris: É. Champion, 1917. 189 p. AS162 .B6 fasc.222.

Peloponnese

A3.896. Peloponnese. http://www.mlahanas.de/Greece/Regions/Peloponnese.html.

A3.897. Peloponnese: Corinthia Prefecture. http://peloponnesetravel.com/corinthia.htm.

Phaistos (Phaestos, Festos, Phaestus)

A3.898. *Der Diskos von Phaistos: Fremdeinfluss oder kretisches Erbe?* / Torsten Timm. Norderstedt: Books on Demand, 2005. 238 p. P1036 .T57 2005. Phaistos is a Bronze Age site at Faistos in south-central Crete.

A3.899. *Phaistos* / Despina Hadzi-Vallianou. Athens: Ministry of Culture, Archaeological Receipts Fund, ca. 1989. 47 p. DF221.C8 H33 1989.

Philippi

A3.900. *Philippi* / Peter Pilhofer. Tübingen: J. C. B. Mohr, 1995. 2 v. BS2705.2 .P54 1995. Bd.1, 2. A city in eastern Macedonia, established by Philip II in 356 BCE and abandoned in the fourteenth century CE after the Ottoman invasion.

A3.901. *Philippi: Stadt und Christengemeinde zur Zeit des Paulus* / Lukas Bormann. Leiden; New York: E. J. Brill, 1995. 248 p. BS2705.2 .B67 1995.

A3.902. *Women and worship at Philippi: Diana/Artemis and other cults in the early Christian era* / Valerie A. Abrahamsen. Portland: Astarte Shell Press, 1995. 252 p. BL793.P48 A27 1995.

Phourni (Fourni)

A3.903. *Das Tholosgrab E von Phourni bei Archanes: Studien zu einem frühkretischen Grabfund und seinem kulturellen Kontext* / Diamantis Panagiotopoulos. Oxford: Archaeopress, 2002. 219, 76 p. DF951.A73 P36 2002. A Minoan cemetery in Crete.

Plataia

A3.904. Battle of Plataia (479 BC). http://www.fanaticus.org/DBA/battles/plataea.html.

Poliochni

A3.905. *He Poliochne kai he proimeepoche tou Chalkou sto Voreio Aigaio: diethnes synedrio Athena, 22–25 Apriliou 1996 / Poliochni e l'antica età del bronzo nell'Egeo settentrionale: convegno internazionale Atene, 22–25 Aprile 1996* / Chr. G. Doumas and V. La Rosa. Athena: Scuola archeologica italiana di Atene, 1997. 691 p. DF221.P68 P65 1997. Poliochni, on the east coast of Limnos, was an ancient metallurgical center abandoned at the end of the Early Aegean II period.

A3.906. *Poliochni: the earliest town in Europe* / Santo Tine and Antonella Traverso. Athens: Archaeological Society at Athens. 82 p. DF221.P68 T56 2001.

A3.907. *Poliochni, città preistorica nell'isola di Lemnos* / Luigi Bernabò-Brea. Roma: L'Erma di Bretschneider, 1964. DF261.L35 B47. 2 v.

Pseira Island

A3.908. *Architecture of Pseira* / John C. McEnroe. Philadelphia: The University Museum, University of Pennsylvania, 2001. 99, 39 p. DF221.C8 M36 2001. Pseira is an islet in the Gulf of Mirabello in northeastern Crete associated with Minoan and Mycenean remains.

A3.909. *Building AC (the "Shrine") and other buildings in Area A* / Philip P. Betancourt and Costis Davaras. Philadelphia: University Museum, University of Pennsylvania, 1998. 151, 56 p. DF221.C8 B74 1998.

A3.910. *Minoan buildings in areas B, C, D, and F* / Philip P. Betancourt and Costis Davaras. Philadelphia: University Museum, University of Pennsylvania, 1999. 346, 97 p. DF221.C8 M53 1999.

A3.911. *Minoan buildings on the west side of Area A* / Philip P. Betancourt and Costis Davaras. Philadelphia: University Museum, University of Pennsylvania, 1995. 174, 52 p. DF221.C8 M54 1995.

A3.912. *Plateia Building* / Cheryl R. Floyd. Philadelphia: University Museum, University of Pennsylvania, 1998. 329, 68 p. DF221.C8 F57 1998.

A3.913. *Pseira Cemetery* / Philip P. Betancourt and Costis Davaras. Philadelphia: Institute for Aegean Prehistory Academic Press, 2003. 2 v. DF221.C8 P75 2003.

Pylona

A3.914. *Mycenaean cemetery at Pylona on Rhodes* / Efi Karantzali. Oxford: Archaeopress, 2001. 253 p. DF221.P94 K37 2001.

Pylos (Navarino)

A3.915. *A guide to the Palace of Nestor: Mycenaean sites in its environs and the Chora Museum* / Carl W. Blegen and Marion Rawson. Princeton, NJ: American School of Classical Studies at Athens, 2001. 68 p. NA277 .B54 2001. Mycenean Pylos is an important Mycenean archaeological site located on the western coast of the Peloponnese in Greece.

A3.916. Pylos Regional Archaeological Project. http://classics.uc.edu/prap/.

Pyrgouthi

A3.917. *Pyrgouthi: a rural site in the Berbati Valley from the Early Iron Age to late antiquity: excavations by the Swedish Institute at Athens, 1995 and 1997* / Jenni Hjohlman, Arto Penttinen, and Berit Wells. Stockholm: Svenska institutet i Athen, 2005. DF261.P97 H65 2005. A rural site in the Berbati Valley dating from the early Iron Age to late antiquity.

Rhamnous

A3.918. *Ho dēmos tou Ramnountos: synopsē tōn anaskaphōn kai tōn ereunōn (1813–1998)* / Vasileiou Ch. Pétrakou. Athenai: Hē en Athēnais Archaiologikē Hetaireia, 1999. 2 v. DF261.R4 P472 1999. A fortified garrison located 40 kilometers northeast of Athens overlooking the Euboean Strait in northeastern Attica, dominates two important harbors into which grain was imported for Athens during the Peloponnesian War.

A3.919. *Rhamnous* / Vasileios Pétrakos. Athens: Archaeological Receipts Fund, 1991. 56 p. DF261.R4 P4713 1991.

Selinus (Selinunte)

A3.920. *Selinunte: le metope dell'Heraion* / Clemente Marconi. Modena: F. C. Panini, 1994. 355 p. N5630 .M372 1994. An ancient Greek archaeological site on the south coast of Sicily contains five temples centered on an acropolis.

Sicyon

A3.921. *Das Theater in Sikyon* / E. Fiechter. Stuttgart: W. Kohlhammer, 1931. 32, 6 p. 913.387 L535 hft.3. An ancient Greek city situated in the northern Peloponnesus between Corinth and Achaea.

Sitagroi

A3.922. *Excavations at Sitagroi: a prehistoric village in northeast Greece* / Colin Renfrew, Marija Gimbutas, and Ernestine S. Elster. Los Angeles: Institute of Archaeology, University of California, Los Angeles, 1986. 2 v. GN776.22.G7 E83 1986. An important Late Neolithic and Early Bronze Age site in the Drama region, east Macedonia and Thrace, Greece.

Solygeia

A3.923. *Solygeia: he anaskaphe tou 1957–1958* / Rozalindes Lorandou-Papantoniou. Athēnai: He en Athenais Archaiologike Hetaireia, 1999. 500, 28 p. DF261.S65 L67 1999. A place in Corinthia, Peloponnese, Greece.

Sparta (Lacedaemon)

A3.924. *Athens-Sparta* / Nikolaos Kaltsas. New York: Alexander S. Onassis Public Benefit Foundation; National Archaeological Museum, Athens, 2006. 319 p. N5650 .A84 2006. A prominent city-state in ancient Greece, situated on the banks of the Eurotas River in Laconia, south-central Peloponnese. It emerged as a political entity around the tenth century BCE, when the invading Dorians subjugated the local, non-Dorian population. From ca. 650 BCE it rose to become the dominant military land power in ancient Greece. Given its military preeminence, Sparta was recognized as the overall leader of the combined Greek forces during the Greco-Persian wars, and between 431 and 404 BCE, Sparta was the principal enemy of Athens during the Peloponnesian war. Sparta's defeat by Thebes in the Battle of Leuctra in 371 BCE ended Sparta's dominance.

A3.925. *Frühe lakonische Keramik der geometrischen bis archaischen Zeit (10. bis 6. Jahrhundert v.Chr.)* / Ingrid Margreiter. Waldsassen, Bayern: Stiftland Verlag, 1988. 2 v. NK3843 .M37 1988.

A3.926. *Geschichte der spartanischen und thebanischen Hegemonie vom Königsfrieden bis zur Schlacht bei Mantinea* / Ernst von Stern. Dorpat: H. Laakmann, 1884. 248 p. 938.06 St4.

A3.927. *Hellenistic and Roman Sparta: a tale of two cities* / Paul Cartledge and Antony Spawforth. 2 ed. London; New York: Routledge, 2002. 312 p. DF261.S8 C373 2002.

A3.928. *Kunstverwendung und Kunstlegitimation im archaischen und frühklassischen Sparta* / Reinhard Förtsch. Mainz: P. von Zabern, 2001. 270, 3, 94 p. N5630 .F67 2001.

A3.929. *The sanctuary of Artemis Orthia at Sparta, excavated and described by members of the British school at Athens, 1906–1910* / R. M. Dawkins. London, pub. by the Council, and sold on their behalf by Macmillan and Co., Limited, 1929. 420, 207 p. DF261.S8 D3.

A3.930. Sparta. http://www.ancientgreece.co.uk/sparta/home_set.html.

A3.931. *Sparta* / edited by Michael Whitby. New York: Routledge, 2002. 275 p. DF261.S8 S63 2002.

A3.932. *Spartan society* / Thomas J. Figueira. Swansea: The Classical Press of Wales; Oakville: The David Brown, 2004. 389 p. DF261.S8 S656 2004.

A3.933. *Spartanische Küche: das Gemeinschaftsmahl der Männer in Sparta* / Monika Lavrencic. Köln: Böhlau, 1993. 146 p. DF261.S8 L38 1993.

A3.934. *Spartiati all'estero: corrotti o denigrati?* / Caterina Romano. Galatina: M. Congedo, 2004. 148 p. DF261.S8 R56 2004.

A3.935. *Xenophon's Sparta: an introduction* / Gerald Proietti. Leiden; New York: E. J. Brill, 1987. 116 p. DF261.S8 P76 1987.

Sybrita

A3.936. *Sybrita, la valle di Amari fra Bronzo e Ferro* / Luigi Rocchetti. Roma: Gruppo editoriale internazionale, 1994. DF221.C8 S93 1994, fasc.1. An ancient settlement in the Amari basin on Crete existed between 1400 BCE to its destruction during the Arab conquest of the island in 824 CE.

Tanagra

A3.937. *Tanagrafiguren, Untersuchungen zur hellenistischen Kunst und Geschichte* / Gerhard Kleiner. Berlin: W. de Gruyter, 1942. 324, 60 p. DE2 .D52 v.15. Located north of Athens in Boeotia, was noted in antiquity for its mass-produced, mold-cast terra-cotta figurines.

A3.938. *Tanagras: de l'objet de collection à l'objet archéologique* / Violaine Jeammet. Paris: Picard: Musée du Louvre, 2007. 170 p. DF261.T15 T36 2007.

Tegea

A3.939. *Ta glypta tou Mouseiou Tegeas: perigraphikos katalogos* / Alkmenes A. Stauridou. Athēnai: He en Athenais Archaiologike Hetaireia, 1996. 105 p. NB87.A42 T438 1996. A settlement in Arcadiam Peloponnese, Greece.

A3.940. *Skopas of Paros* / Andrew F. Stewart. Park Ridge, NJ: Noyes Press, 1977. 183, 28 p. NB104 .S73.

Thessaloniki

A3.941. Thessaloniki: cultural capital of Europe 1997. http://www.louvre.fr/en/expositions/kingdom-alexander-great-%E2%80%93-ancient-macedonia.

Torone (Toroni)

A3.942. *The early Iron Age cemetery at Torone: excavations conducted by the Australian Archaeological Institute at Athens in collaboration with the Athens Archaeological Society* / John K. Papadopoulos. Los Angeles: Cotsen Institute of Archaeology at UCLA, 2005. 2 v. DF261.T75 P36 2005. Torone is an ancient Greek city and a former municipality in the southwest edge of Sithonia peninsula in Chalkidiki. Traces of prehistoric settlements of the third century BCE and many other ancient remains, including early Christian and Byzantine temples, and castles are evidence that the area was inhabited continuously from the Neolithic era.

A3.943. *Torone: the literary, documentary and epigraphical testimonia* / Alan S. Henry. Athens: Archaeological Society at Athens, 2004. 94 p. DF261.T67 H46 2004.

A3.944. *Torone I: the excavations of 1975, 1976, and 1978* / Alexander Cambitoglou, John K. Papadopoulos, and Olwen Tudor Jones. Athens: He en Athēnais Archaiologike Hetaireia, 2001. 3 v. DF261.T67 T67 2001, pt.1–3.

Thera Island

A3.945. *Thera: Pompeii of the ancient Aegean: excavations at Akrotiri, 1967–79* / Christos G. Doumas. London: Thames and Hudson, 1983. 168 p. DF261.T4 D73. Ancient Thera is an ancient city on a ridge of Messavouno mountain on the Greek island of Santorini. It was named after the mythical ruler of the island, Theras, and was inhabited from the ninth century BCE until 726 CE.

Vroulia (Prasonisi, Prassoníssi)

A3.946. *Vroulia* / K. F. Kinch. Berlin: G. Reimer, 1914. 275 p. DS53.R4 K5. A cape on the island of Rhodes. It is located 92 kilometers from Rhodes town and 40 kilometers from Lindos, at the southern-west part of Rhodes. Near Prasonisi is Vroulia, an ancient settlement that contains an old mosaic tiled floor. On the way to Prasonisi on the right-hand side, the archaeological site of Vroulia is found. It is an ancient coastal settlement that many believe to be the predecessor to modern day Kattavia known for its terra-cotta vessels called vessels of Vroulia.

HUNGARY

A3.947. *Tituli romani in hungaria reperti. Supplementum* / Péter Kovács. Bonn: R. Habelt; Budapest: Enciklopédia Kiadó, 2005. 404 p. CN615 .K68 2005.

Aquincum

A3.948. *Aquincum: das römische Budapest* / Klara Póczy. Mainz am Rhein: Philipp von Zabern, 2005. 144 p. DB987.P63 2005. The ancient city of Aquincum was situated on the northeastern borders of the Pannonia province within the Roman Empire. The ruins of the city can be found today in Budapest, the capital city of Hungary.

A3.949. *Aquincumi múmia-temetkezések* / Lajos Nagy. Budapest: Magyar nemzeti múzeum, 1965. 39 p. DB867 .N3.

A3.950. *Aquincum orvosi emlékei* / György Korbuly. Budapest: Magyar Nemzeti Múzeum, 1966. 48 p. DB867.K6.

Baranya Megye

A3.951. *Die römische Siedlung bei Babarc, Komitat Baranya, Ungarn: die Prospektionsarbeiten in den Jahren 1988–1991 und die Ausgrabungen der Jahre 1996–1999; The Roman settlement near Babarc, Komitat Baranya, Hungary: the surveys during the years 1988–1991 and the excavations in the years 1996–1999* / Ferenc Fazekas. Rahden/Westf.: Leidorf, 2007. 200, 30 p. DB975.B3 R66 2007.

Budapest

A3.952. *Out of Rome: Augusta Raurica/Aquincum: das Leben in zwei römischen Provinzstädten* / Paula Zsidi. Basel: Schwabe, 1997. 337 p. DQ851. A795 O93 1997. The history of Budapest began with Aquincum, originally a Celtic settlement that became the Roman capital of Lower Pannonia. Hungarians arrived in the territory in the ninth century. Their first settlement was pillaged by the Mongols in 1241–1242.

Dunántúl

A3.953. *Römerzeitliche Hügelgräber in Transdanubien (Ungarn)* / Sylvia K. Palágyi and Levente

Nagy. Budapest: Akadémiai Kiadó, 2002. 251 p. DB975.D8 P3515 2002. Transdanubia (Hungarian: *Dunántúl*) is a geographic term referring to the area of Hungary that lies between the Danube and the western borders of Hungary. Transdanubia has been populated since the Stone Age. Between 10 BCE and 434 CE, it was part of the Roman Empire. With some present-day Austrian and Croatian territories, it comprised the Province of Pannonia, a Romanized, Latin-speaking border region with important Roman towns (Scarbantia, Aquincum, Sopianae, Gorsium, Savaria) and rural villas.

Esztergom

A3.954. *Der spätrömische Limes zwischen Esztergom und Szentendre: das Verteidigungssystem der Provinz Valeria im 4. Jahrhundert* / Sándor Soproni. Budapest: Akadémiai Kiadó, 1978. 231, 50 p. DB999.E89 S6615. Esztergom is one of the oldest towns in Hungary. Esztergom, as it existed in the Middle Ages, now rests under today's town. The results of the most recent archeological excavations reveal that the Várhegy (Castle Hill) and its vicinity have been inhabited since the end of the Ice Age 20,000 years ago. The first people known by name were the Celts from Western Europe, who settled in the region in about 350 BCE. Under their center on the Várhegy (oppidum) lay their expansive flourishing settlement until the Roman legions conquered the region. Thereafter it became an important border province of Pannonia, known by the name of Solva.

Keszthely

A3.955. *Die Gräberfelder vor der Südmauer der Befestigung von Keszthely-Fenékpuszta* / Róbert Müller. Rahden, Westf.: Leidorf, 2010. 430 p. DB999. K47 M85. Though settled since at least Roman times (the Keszthely culture of Romance pannonian language), the first historical evidence of the town Keszthely dates from a 1247 document. Since 1421, Keszthely has been a market town.

Pannonia

A3.956. *Christianity in Roman Pannonia: an evaluation of early Christian finds and sites from Hungary* / Dorottya Gáspár. Oxford: Archaeopress: Hadrian Books, 2002. 311 p. BR133.H92 P24 2002; BR133.H92 P24 2002. Pannonia, province of the Roman Empire, corresponding to present-day western Hungary and parts of eastern Austria, as well as portions of several Balkan states. Pannonia was an ancient province of the Roman Empire bounded north and east by the Danube, coterminous westward with Noricum and upper Italy, and southward with Dalmatia and upper Moesia. Pannonia was located over the territory of present-day western Hungary, eastern Austria, northern Croatia, northwestern Serbia, Slovenia, western Slovakia, and northern Bosnia and Herzegovina.

A3.957. *Die eisernen Agrargeräte der römischen Kaiserzeit in Österreich: Studien zur römischen Agrartechnologie in Rätien, Noricum und Pannonien* / Reinhard Pohanka. Oxford: British Archaeological Reports, 1986. 390, 65 p. S431 .P65 1986.

A3.958. *Die letzten Jahrzehnte des pannonischen Limes* / Sándor Soproni. München: Beck, 1985. 127, 21 p. DG59.P2 S66 1985; DG59.P2 S66 1985.

A3.959. *Pannonische Architekturelemente und Ornamentik in Ungarn* / Ákos Kiss. Budapest: Akadémiai Kiadó: Vertrieb, Kultura, 1987. 192, 119 p. NA335.P36 K5 1987.

A3.960. *Pannonische Glasfunde in Ungarn* / László Barkóczi. Budapest: Akadémiai Kiadó, 1988. 223, 117 p. DB920 .B295 1988.

A3.961. *The ripa Pannonica in Hungary* / Zsolt Visy. Budapest: Akademiai Kiado, 2003. 165, 175 p. DG59.P2 V57 2003.

A3.962. *Der Untergang der Römerherrschaft in Pannonien* / Andreas Alföldi. Berlin; Leipzig: W. de Gruyter & Co., 1924–1926. 2 v. DG59.P2 A5.

Pécs

A3.963. *Roman cemeteries on the territory of Pécs (Sopianae)* / Ferenc Fülep. Budapest: Akadémiai Kiado, 1977. 64, 25 p. DB999.P4 F8315. The city Sopianae was founded by the Romans at the beginning of the second century, in an area peopled by Celts and Pannoni tribes. By the fourth century it became the capital of Valeria province and a significant early Christian center.

A3.964. *Sopianae: the history of Pécs during the Roman era, and the problem of the continuity of the Late Roman population* / Ferenc Fülep. Budapest: Akadémiai Kiadó; Atlantic Highlands: Humanities Press, 1984. 391 p. DB920 .A17 v.50.

Sopron

A3.965. *Die Reliefs der Stadtgebiete von Scarbantia und Savaria* / Marie-Louise Krüger. Wien: Verhandlungen der Österreichische Akademie der Wissenschaften, 1974. 46, 15 p. NB118.A9 C67 Bd.1 fasc.5. Known as Scarbantia, a city in western

Hungary. Its forum was located where the main square of Sopron can be found today. In the ninth through eleventh centuries Hungarians strengthened the old Roman city walls and built a castle.

A3.966. *Die Skulpturen des Stadtgebietes von Scarbantia und der Limesstrecke ad Flexum-Arrabona* / Zoltán Farkas und Dénes Gabler. Budapest: Akadémiai Kiadó, 1994. 94, 44 p. NB118.H86 F374 1994.

Sztalinváros

A3.967. *Les Syriens à Intercisa* / Jeno Fitz. Bruxelles: Latomus, 1972. 264 p. DB879.S96 F58. When Western Hungary was a Roman province under the name Pannonia, a military camp and a town called Intercisa stood in this place, at the border of the province. The Hungarians conquered the area in the early tenth century. The village Pentele, named after the medieval Greek saint, Pantaleon, was founded shortly after.

Tác

A3.968. *Animal husbandry and hunting in Tác-Gorsium: the vertebrate fauna of a Roman town in Pannonia* / S. Bökönyi. Budapest: Akadémiai Kiadó, 1984. 237 p. DB999.T3 B65 1984. During the Roman Empire it was known as Gorsium-Herculia.

Vaspuszta

A3.969. *The Roman fort at Ács-Vaspuszta on the Danubian limes* / D. Gabler. Oxford: British Archaeological Reports, 1989. 2 v. DB920 .R66 1989. A large Roman fort in northwestern Hungary.

A3.970. *Die ägyptischen Kulte zur Römerzeit in Ungarn* / V. Wessetzky. Leiden: E. J. Brill, 1961. 56, 17 p. 282.6 Et83 t.1.

IRAN

A3.971. *L'archéologie Française en Perse et les antiquités nationales (1884–1914)* / Nader Nasiri-Moghaddam. Paris: Connaissances et savoirs, 2004. 433 p. DS261.N37 2004.

A3.972. *Französische Archäologie heute: Einblicke in Ausgrabungen* / Rainer Vollkommer. Leipzig: Leipziger Universitätsverlag, 1997. 82 p. DS56. F74 1997.

Anshan

A3.973. *Early urban life in the land of Anshan: excavations at Tal-e Malyan in the highlands of Iran* / William M. Sumner. Philadelphia: University of Pennsylvania Museum of Archaeology and Anthropology, 2003. 357 p. DS262.A57 S86 2003. One of the early capitals of Elam, located northwest of Shiraz in the Zagros mountains; also known as Tall-i Malyan.

A3.974. *Excavations at Anshan (Tal-e Malyan): the middle Elamite period* / Elizabeth Carter. Philadelphia: University Museum of Archaeology and Anthropology, University of Pennsylvania, 1996. 137, 94 p. DS262.A57 C37 1996.

A3.975. *Feeding cities: specialized animal economy in the ancient Near East* / Melinda A. Zeder. Washington, D.C.: Smithsonian Institution Press, 1991. 280 p. DS262.A57 Z43 1991.

A3.976. *The glazed steatite glyptic style: the structure and function of an image system in the administration of protoliterate Mesopotamia* / Holly Pittman. Berlin: D. Reimer, 1994. 393, 30 p. CD5344 .P58 1994.

A3.977. *The proto-Elamite settlement at TUV* / Ilene M. Nicholas. Philadelphia: University Museum, University of Pennsylvania, 1990. 166 p. DS262. A57 N53 1990.

Chogha Mish

A3.978. *Excavations at the prehistoric mound of Chogha Bonut, Khuzestan, Iran: seasons 1976/77, 1977/78, and 1996* / Abbas Alizadeh. Chicago: Oriental Institute of the University of Chicago in association with the Iranian Cultural Heritage Organization, 2003. 159, 26 p. DS324.K49 A553 2003. Site of a Chalcolithic settlement in western Iran; Tappeh-ye Chogha Mish was occupied about 6800 BCE and continuously from the Neolithic to the Proto-Literate.

Dur-Untash

A3.979. *Archäologische Ausgrabungen und Untersuchungen in Čoğā Zanbil* / Behzad Mofidi Nasrabadi. Münster: Agenda-Verlag, 2007. DS262.D58 N37 2007; DS262.D58 N37 2007. An ancient Elamite complex of ziggurats, also known as Chogha Zanbil, in the Khuzestan province of Iran.

Hamun, Lake

A3.980. Treasures of Lake Hamun, Iran. http://www.iranian.com/Feb97/History/Hamun/Hamun.shtml.

Larsa

A3.981. *Contracts from Larsa, dated in the reign of Rim-Sin* / David Earl Faust. New Haven, Yale

University Press; London: H. Milford, Oxford University Press, 1941. 37, 39 p. PJ3711 .Y3 v.8.

Nisa

A3.982. *Sculture di metallo da Nisa: cultura greca e cultura iranica in Partia* / Antonio Invernizzi. Lovanii: Peeters, 1999. 236 p. DK939.5.N57 I583 1999. An ancient city, also known as Parthaunisa, located near modern Bagir village, 18 kilometers southwest of Ashgabat, Turkmenistan; it has been described as one of the early Parthian capitals.

Oran

A3.983. *Fouilles de Sialk près de Kashan 1933, 1934, 1937* / R. Ghirshman. Paris: P. Geuthner, 1938. 2 v. NK3855.I7 G6.

Persepolis

A3.984. *Aramaic ritual texts from Persepolis* / Raymond A. Bowman. Chicago, University of Chicago Press, 1970. 194 p. PJ5208.P43 B6 1970. The ceremonial capital of the Achaemenid Empire (ca. 550–330 BCE), located 70 kilometers northeast of Shiraz in the Fars Province of Iran. The site was designated a UNESCO World Heritage Site in 1979.

A3.985. *L'Archive des Fortifications de Persépolis: état des questions et perspectives de recherches: actes du colloque organisé au Collège de France par la "Chaire d'histoire et civilisation du monde achéménide et de l'empire d'Alexandre" et le "Réseau international d'études et de recherches achéménides" (GDR 2538 CNRS), 3–4 novembre 2006* / Pierre Briant, Wouter Henkelman, and Matthew W. Stolper. Paris: De Boccard, 2008. 576 p. PJ3721.P4 A73 2008.

A3.986. *Ionians in Pasargadae, Studies in old Persian architecture* / Carl Nylander. Uppsala, Universitetet; Stockholm, Almqvist & Wiksell (distr.), 1970. 176 p. NA226.P3 N94.

A3.987. *Nineveh and Persepolis: an historical sketch of ancient Assyria and Persia, with an account of recent researches in those countries* / W. S. W. Vaux. 3 ed. London: Arthur Hall, Virtue, 1851. 494 p. 913.351 N63Vb; 913.351 N63Vb.

A3.988. *The palaces of Nineveh and Persepolis restored; an essay on ancient Assyrian and Persian architecture* / James Fergusson. London: J. Murray, 1851. 368 p. DS70 .F35 1851; DS70 .F35 1851; DS70 .F35. Reprint: *The palaces of Nineveh and Persepolis restored: an essay on ancient Assyr-*

ian and Persian architecture / James Fergusson. Delhi: Rare Reprints, 1981. 368 p. NA220 .F57 1981.

A3.989. *Persepolis: the archaeology of Parsa, seat of the Persian kings* / Donald N. Wilber. 2 ed. Princeton, NJ: Darwin Press, 1989. 129, 16 p. DS262. P4 W55 1989.

A3.990. *Persepolis, the archaeology of Parsa, seat of the Persian kings* / Donald N. Wilber. New York, Crowell, 1969. 120 p. DS325.P4 W5.

A3.991. *Persepolis II: contents of the treasury and other discoveries* / Erich F. Schmidt. Chicago: University of Chicago, 2010. 166, 94 p. DS262.P4 S27 2010.

A3.992. *Persepolis: glänzende Haupstadt des Perserreichs* / Heidemarie Koch. Mainz am Rhein: Philipp von Zabern, 2001. 106 p. DS262.P4 K63 2001.

A3.993. *Rekonstruktionen, der Wiederaufbau des Frauenpalastes, Rekonstruktionen der Paläste, Modell von Persepolis*. Berlin: Gebr. Mann, 1971. 124, 3 p. DS261 .T43 bd.3.

A3.994. *Die Reliefs der Gräber V und VI in Persepolis* / Peter Calmeyer. Mainz: von Zabern, 2009. 137 p. DS262.P4 C35 2009.

A3.995. *Seals on the Persepolis fortification tablets* / Mark B. Garrison and Margaret Cool Root. Chicago: Oriental Institute, University of Chicago, 2001. CD5391 .G37 2001.

A3.996. *Studies and restorations at Persepolis and other sites of Färs*. Rome: IsMEO, 1972. DS11.C43 v. 16, 18.

Seleucia

A3.997. *Coins from Seleucia on the Tigris* / Robert Harbold McDowell. Ann Arbor, University of Michigan Press, 1935. 248 p. CJ692 .M25 1935.

A3.998. *Figurines from Seleucia on the Tigris, discovered by the expeditions conducted by the University of Michigan with the cooperation of the Toledo Museum of Art and the Cleveland Museum of Art, 1927–1932* / Wilhelmina Van Ingen. Ann Arbor: University of Michigan Press; London: H. Milford, Oxford University Press, 1939. 374, 47 p. NB80 .V34.

Siraf

A3.999. *Siraf: history, topography and environment* / David Whitehouse. Oxford: Oxbow Books; Oakville: David Brown, 2009. 118 p. DS325. S583 W45 2009. The ancient Sassanid port on the Persian Gulf shipping route between the Arabian peninsula and India. Over time trade routes

shifted to the Red Sea, and the importance of Siraf faded.

Susa

A3.1000. *L'acropole de Suse, nouvelles fouilles: rapport préliminaire* / M.-J. Steve and H. Gasche. Leiden: E. J. Brill, 1971. 212 p. DS261 .F8 t.46. An ancient site of the Elamite, Persian, and Parthian empires located in the lower Zagros mountains about 250 kilometers east of the Tigris River.

A3.1001. *Les antiquités de la Susiane (Mission J. de Morgan)* / Maurice Pézard and Edmond Pottier. Paris: E. Leroux, 1913. 256 p. 913.355 P214.

A3.1002. *Archeologia dell'Iran antico: interazioni, integrazioni e discontinuità nell'Iran del III millennio a.C.* / E. Ascalone. Messina: Di.Sc.A.M., 2006. 196 p. DS261 .A84 2006.

A3.1003. *Les archives d'Igibuni: les documents Ur III du chantier B à Suse* / Katrien De Graef. Gand: Université de Gand, 2005. 175, 18 p. DS261 .F8 t.54.

A3.1004. *At Susa, the ancient capital of the kings of Persia. Narrative of travel through western Persia and excavations made at the site of the lost city of the lilies, 1884–1886* / Jane Dieulafoy. Philadelphia: Gebbie & Company, 1890. 266 p. DS258 .D56 1890.

A3.1005. *Le bitume à Suse: collection du Musée du Louvre; Bitumen at Susa: the Louvre Museum collection* / Jacques Connan and Odile Deschesne. Paris: Réunion des musées nationaux, 1996. 444 p. NK614.F8 P3 1996; NK614.F8 P3 1996.

A3.1006. *Cinq campagnes de Fouilles à Suse, 1946–1951* / Roman Ghirshman. Paris: Presses Universitaires de France, 1952. 18 p. 913.55 G347.

A3.1007. *La cité royale de Suse: trésors du Proche-Orient ancien au Louvre* / Annie Caubet. Paris: Réunion des musées nationaux, 1994. 316 p. N5336.F8 P3614 1994.

A3.1008. *La délégation en Perse du Ministère de l'instruction publique, 1897 à 1902* / J. de Morgan. Paris: E. Leroux, 1902. 157 p. 913.55 M822.

A3.1009. *Les figurines de Suse: de l'époque néo-élamite à l'époque sassanide* / Laurianne Martinez-Sève. Paris: Editions de la Réunion des musées nationaux, 2002. 2 v. DS262.S9 M37 2002.

A3.1010. *Les figurines de Suse* / Agnes Spycket. Paris: Gabalda, 1992. DS261.F8 t.52.

A3.1011. *Glyptique susienne des origines á l'époque des Perses achéménides, cachets, sceaux-cylindres et empreintes antiques découverts à Suse de 1913 à 1967* / Pierre Amiet. Paris: P. Guethner, 1972. 2 v. DS261 .F8 t.43.

A3.1012. *The iconography of pristine statehood: painted pottery and seal impressions from Susa, southwestern Iran* / Petr Charvát. Prague: Charles University in Prague, Karolinum Press, 2005. 322 p. DS262.S9 C43 2005.

A3.1013. *Métallurgie susienne I: de la fondation de Suse au XVIIIe avant J.-C.* / Françoise Tallon. Paris: Ministère de la culture et de la communication: Editions de la Réunion des musées nationaux, 1987. 2 v. DS262.S9 T35 1987.

A3.1014. *Nouveaux mélanges épigraphiques: inscriptions royales de Suse et de la Susiane: ville royale de Suse 7* / par M.-J. Steve. Nice: Editions Serre, 1987. 111, 18 p. DS261 .F8 t.53.

A3.1015. *Numismatique susienne, monnaies trouvées à Suse de 1946 à 1956* / R. Göbl. Paris: P. Geuthner, 1960. 145 p. DS261 .F8 t.37.

A3.1016. *Le palais de Darius à Suse: une résidence royale sur la route de Persépolis à Babylone* / Jean Perrot. Paris: PUPS, Presses de l'université Paris-Sorbonne, 2010. 620 p. DS262.S9 P35 2010 + CD-ROM.

A3.1017. *Le palais de Darius Ier à Suse, Ve siècle av. J.C.: simple notice* / M. L. Pillet. Paris: P. Geuthner, 1914. 106 p. 913.351 Su82P.

A3.1018. *La poterie islamique* / Myriam Rosen-Ayalon. Paris: Librairie orientaliste Paul Geuthner, 1974. 313, 36 p. DS261 .F8 t.50.

A3.1019. *Suse, dernières decouvertes.* Dijon: Archéologia, 1989. 90 p. CC3 .H478 no.138.

A3.1020. *Suse: site et musée.* Téhéran: Ministère, 1973. 84, 29 p. DS325.S9 I73.

A3.1021. *Suse sous les Séleucides et les Parthes, les trouvailles monétaires et l'histoire de la ville* / Georges Le Rider. Paris: Librairie orientaliste Paul Geuthner, 1965. 491 p. DS261 .F8 t.38.

A3.1022. *Textes littéraires de Suse* / R. Ghirshman. Paris: P. Geuthner, 1974. 263, 8 p. DS261 .F8 t.57.

A3.1023. *Tombes d'époque parthe: chantiers de la ville des artisans* / Remy Boucharlat and Ernie Haerinck. Leiden; Boston: Brill, 2011. 891, 35 p. DS261 .F8 t.35.

A3.1024. *Ville royale de Suse.* Leiden: E. J. Brill; Paris: P. Geuthner, 1973. DS261.F8 t.47, 50, 52, 53, 57.

Tale-e Malyan

A3.1025. Archaeological Excavations at Tal-e Malyan, Iran. http://penn.museum/sites/MalWebSite/index.html.

IRAQ

A3.1026. *Foundations in the dust; a story of Mesopotamian exploration* / Seton Lloyd. London: Oxford University Press, 1947. 237 p. DS70.L48.

A3.1027. *Heartland of cities: surveys of ancient settlement and land use on the central floodplain of the Euphrates* / Robert McC. Adams. Chicago: University of Chicago Press, 1981. 362 p. DS70 .A32 1981.

A3.1028. *Ruined cities of Iraq* / Seton Lloyd. 3 ed. Bombay; New York: Indian Branch, Oxford University Press, 1945. 70 p. DS69.5 .L563 1945.

Adab

A3.1029. *Early dynastic and early Sargonic tablets from Adab in the Cornell University collections* / Giuseppe Visicato and Aage Westenholz. Bethesda: CDL Press 2010. 124 p. DS70.5.A43 V57 2010. Adab, or Udab, was an ancient Sumerian city between Telloh and Nippur in the Wasit Governorate of Iraq.

Ashur

A3.1030. *Ägyptische und assyrische Alabastergefässe aus Assur* / Hans-Ulrich Onasch. Wiesbaden: Harrassowitz Verlag, 2010. 209, 34 p. DS70.5.A7 O538 2010. Ashur, Assur, or Assyria, located 280 kilometers north of Baghdad, was the first capital of the Assyrian Empire, which included Anatolia, Egypt, Iran, Iraq, Syria, and parts of Arabia.

A3.1031. *Alltagstexte aus neuassyrischen Archiven und Bibliotheken der Stadt Assur* / Betina Faist. Wiesbaden: Harrassowitz, 2007. 250 p. PJ3721.A69 F358 2007.

A3.1032. *Die älteren Ischtar-Tempel in Assur: Stratigraphie, Architektur und Funde eines altorientalischen Heiligtums von der zweiten Hälfte des 3. Jahrtausends bis zur Mitte des 2. Jahrtausends v. Chr.* / Jürgen Bär. Saarbrücken: Saarbrücker Druckerei und Verlag, 2003. 430, 147 p. DS70.5.A7 B27 2003.

A3.1033. *Der alte Palast in Assur: Architektur und Baugeschichte mit interaktiven Architekturplänen und Fotos auf CD-ROM* / Friedhelm Pedde und Steven Lundström. Wiesbaden: Harrassowitz, 2008. 2 v + CD-ROM. DS70.5.A7 P423 2008, Bd.1 + CD-ROM, 2.

A3.1034. *Archives and libraries in the city of Assur: a survey of the material from the German excavations* / Olof Pedersén. Uppsala: Uppsala University; Stockholm, Sweden: Distributed by Almqvist & Wiksell International, 1985–1986. 2 v. DS70.5.A7 P42 1985.

A3.1035. *Babylonian topographical texts* / A. R. George. Leuven: Departement Oriëntalistiek: Peeters, 1992. 504 p. PJ3701 .B25 1992; PJ3701 .B25 1992.

A3.1036. *La Babylonie au 17e siècle avant nôtre ère: approche archéologique, problèmes et perspectives* / H. Gasche; anthropologische Befunde, E. Burger-Heinrich. Ghent: University of Ghent, 1989. 160, 83 p. DS70.5.B3 G374 1989.

A3.1037. *Bilder eines Ausgräbers: die Orientbilder von Walter Andrae 1898–1919; Sketches by an excavator* / Ernst Walter Andrae and Rainer Michael Boehmer. 2 ed. Berlin: Gebr. Mann, 1992. 203, 152 p. N6888.A595 A4 1992.

A3.1038. *Divinatorische Texte* / Nils P. Heessel. Wiesbaden: Harrassowitz, 2007. PJ3791 .H44 2007.

A3.1039. *Ištar in Aššur: Untersuchung eines Lokalkultes von ca. 2500 bis 614 v. Chr.* / Wiebke Meinhold. Münster: Ugarit-Verlag, 2009. 568 p. BL1605.I8 M455 2009.

A3.1040. *Gräber und Grüfte in Assur* / Deutsche Orient-Gesellschaft. Wiesbaden: Harrassowitz, 2010. DS70.5.A7 G733 2010.

A3.1041. *Katalog der beschrifteten Objekte aus Assur: die Schriftträger mit Ausnahme der Tontafeln und ähnlicher Archivtexte* / Olof Pedersén. Berlin: SDV Saarbrücker Druckerei und Verlag, 1997. 344 p. DS67 .D425 nr.23.

A3.1042. *Kleinfunde aus Elfenbein und Knochen aus Assur* / Dirk Wicke. Wiesbaden: Harrassowitz Verlag, 2010. 268, 55 p. DS70.5.A7 W535 2010.

A3.1043. *Die Königsgrüfte im Alten Palast von Assur* / Steven Lundström. Wiesbaden: Harrassowitz, 2009. 360, 94 p. DS70.5.A7 L86 2009.

A3.1044. *Neuassyrische Rechtsurkunden* / Liane Jakob-Rost und Frederick Mario Fales. Berlin: Gebr. Mann, 1996. PJ3879 .J346 1996, v.1, 2, 3.

A3.1045. *Old Assyrian institutions* / J. G. Dercksen. Leiden: Nederlands Instituut voor het Nabije Oosten, 2004. 305 p. DS70.5.A7 D47 2004.

A3.1046. *Die Orthostaten Tiglat-Pilesers I. und Assurnasirpals II. aus dem Alten Palast von Assur* / Steven Lundström and Julia Orlamünde. Wiesbaden: Harrassowitz Verlag, 2011. 154, 22 p. PJ3721. A84 L954 2011.

A3.1047. *Royal inscriptions on clay cones from Ashur now in Istanbul* / Veysel Donbaz and A. Kirk Grayson. Toronto; Buffalo: University of Toronto Press, 1984. 79, 42 p. PJ3721.A69 D66 1984.

A3.1048. *Der Sin-Samas-Tempel in Assur* / Peter Werner. Wiesbaden: Harrassowitz, 2009. 57, 26 p. DS70.5.A7 W46 2009.

A3.1049. *Some considerations on the stelae of Assur* / Claudio Saporetti. Malibu: Undena, 1974. 12 p. DS70.5.A7 S26 1974.

A3.1050. *Die Stelenreihen in Assur* / Walter Andrae. Leipzig: J. C. Hinrichs, 1913. 88 p. 913.01 B458 Bd.24; DS70.5.A7 A51 1913.

A3.1051. *Die Terrakotten aus Assur im Vorderasiatischen Museum Berlin* / Evelyn Klengel-Brandt. Berlin: Deutscher Verlag der Wissenschaften, 1978. 117, 24 p. DS69.B4 V67 1978.

A3.1052. *Wiedererstehendes Assur: 100 Jahre deutsche Ausgrabungen in Assyrien* / Joachim Marzahn and Beate Salje. Mainz am Rhein: P. von Zabern, 2003. 202, 190 p. DS70.5.A7 W54 2003.

Babylon

A3.1053. *Aramaic and figural stamp impressions on bricks of the sixth century B.C. from Babylon* / Benjamin Sass and Joachim Marzahn. Wiesbaden: Harrassowitz, 2010. 259 p. PJ5208.B3 S388 2010. Babylon was an Akkadian city-state founded in 1867 BCE located in present-day Al Hillah, Babylon Province, Iraq, about 85 kilometers south of Baghdad.

A3.1054. *Archive und Bibliotheken in Babylon: die Tontafeln der Grabung Robert Koldeweys 1899–1917* / Olof Pedersén. Saarbrücken: In Kommission bei SDV, 2005. 349 p. DS67 .D425 nr.25.

A3.1055. *The archive of the Nappāhu family* / Heather D. Baker. Wien: Institut für Orientalistik der Universität Wien, 2004. 412 p. Van Pelt Judaica/Ancient Near East Seminar PJ3870 .B35 2004.

A3.1056. *Babylone* / Béatrice André-Salvini. Paris: Hazan; Musée du Louvre, 2008. 575 p. DS 71 .B23 2008.

A3.1057. *The Babylonian Expedition of the University of Pennsylvania: Series D, researches and treatises* / H. V. Hilprecht. Philadelphia: University of Pennsylvania, 1904–1910. 378.748 PZAM.2 Ser.D v.1, 3–5(1).

A3.1058. *Bagdad, Babylon, Ninive* / Sven Anders Hedin. Leipzig: F. A. Brockhaus, 1918. 410 p. DS70 .H4 1918.

A3.1059. *Les bibliothèques en Babylonie dans la deuxième moitié du Ier millénaire av. J.-C.* / Philippe Clancier. Münster: Ugarit-Verlag, 2009. 439 p. Z722.7 .C53 2009.

A3.1060. *Documents juridiques de l'Assyrie et de la Chaldée* / J. Oppert and J. Ménant. Paris: Maisonneuve, 1877. 366 p. 892.3 Op56.2.

A3.1061. *L'Expédition scientifique et artistique de Mésopotamie et de Médie, 1851–1855*. Paris: E. Champion, 1922. 176, 21 p. DS70.E8 P5.

A3.1062. *Family religion in Babylonia, Ugarit, and Israel: continuity and changes in the forms of religious life* / Karel van der Toorn. Leiden; New York: E. J. Brill, 1995. 491 p. BL1625.F35 T66 1995.

A3.1063. *The first of empires, "Babylon of the Bible" in the light of latest research: an account of the origin, growth, and development of ancient Babylonian empire, from the earliest times to the consolidation of the empire in B.C.* / W. St. Chad Boscawen. London; New York: Harper and Brothers, 1903. 355 p. DS73.1 .B6 1903.

A3.1064. *Iraq appeals to Berlin for return of Babylon gate*. http://www.guardian.co.uk/world/2002/may/04/iraq.babylon.

A3.1065. *Die Landschaft Babylonien im Zeitalter des Talmuds und des Gaonats: Geographie und Geschichte nach talmudischen, arabischen und andern Quellen* / Jacob Obermeyer. Frankfurt am Main: I. Kauffmann, 1929. 362 p. DS70.63 .O24 1929.

A3.1066. *Memoir on the ruins of Babylon* / Claudius James Rich. London: Printed for Longman, Hurst, Rees, Orme, and Brown, and J. Murray, by Richard and Arthur Taylor, 1815. 67 p. 913.351 B117R2.

A3.1067. *Die Metalle im Alten Orient: unter besonderer Berücksichtigung altbabylonischer Quellen* / Karin Reiter. Münster: Ugarit-Verlag, 1997. 471, 160 p. TN616 .R45 1997.

A3.1068. *Die Schenkungsurkunde des Königs Meli ši̯hu an seinen Sohn Marduk-aplam-iddina: Umschrift, Übersetzung und Erklärung in Zusammenhang mit den übrigen sogen. 'Grenzsteinen'* / Franz Steinmetzer. S.l.: Steinmetzer, 1909. 38 p. PJ3701 .S74 1909.

A3.1069. *Selected temple documents of the Ur dynasty* / Clarence Elwood Keiser. New Haven, Yale University Press, 1919. 54, 90 p. PJ3711 .Y3 Vol .4 1919; PJ4075 .K55 1919.

A3.1070. *The Seleucid and Parthian terracotta figurines from Babylon: in the Iraq Museum, the British Museum, and the Louvre* / Kerttu Karvonen-Kannas. Firenze: Casa editrice le lettere, 1995. 228, 50 p. NK3840 .K36 1995.

A3.1071. *Städtische Wohnarchitektur in Babylonien und Assyrien* / Peter A. Miglus. Mainz am Rheim: P. von Zabern, 1999. 352, 113 p. NA1467 .M55 1999.

A3.1072. *Der Tempelturm Etemenanki in Babylon* / Hansjörg Schmid. Mainz am Rheim: P. von Zabern, 1995. 154, 60 p. DS70.5.B3 S34 1995.

A3.1073. *The year-names of the first dynasty of Babylon* / Malcolm J. A. Horsnell. Hamilton, Ontario: McMaster University Press, 1999. 2 v. DS70.5.B3 H67 1999.

A3.1074. *Wiedererstehendes Babylon: eine antike Weltstadt im Blick der Forschung: Ausstellung des Museums für Vor- und Frühgeschichte der Staatlichen Museen Preussischer Kulturbesitz* / Kay Kohlmeyer and Eva Strommenger. Berlin: Das Museum, 1991. 95 p. DS70.5.B3 W533 1991.

Bet-Shemesh

A3.1075. *Beth Shemesh, 1928* / E. Grant. Preliminary excavations at Tepe Gawra / E. A. Speiser. New

Haven: American Schools of Oriental Research; Yale University Press, 1929. 94 p. DS101 .A45 v.9.

Bismya

A3.1076. *Bismya; or, The lost city of Adab: a story of adventure, of exploration, and of excavation among the ruins of the oldest of the buried cities of Babylonia* / Edgar James Banks. New York; London: G. P. Putnam's Sons, 1912. 457 p. 913.351 B117Ba. Bismya. Ancient Adab (Udab) is an ancient Sumerian site located at modern Bismaya between Telloh and Nippur.

Borsippa

A3.1077. *The Ezida temple of Borsippa: priesthood, cult, archives* / Caroline Waerzeggers. Leiden: Nederlands Instituut voor het Nabije Oosten, 2010. 803 + CD-ROM. PJ3721.B67 W347 2010. An important Sumerian city built 18 kilometers southwest of Babylon on the east bank of the Euphrates River. It is now called Birs Nimrud, identfying the site with Nimrod.

Calah

A3.1078. *Archives from the domestic wing of the northwest palace at Kalhu/Nimrud* / A. Y. Ahmad and J. N. Postgate. London: Nabu Publications, 2007. 83, 35 p. DS70.5.C3 A46 2007. Calah, also Kalhu or Kalakh, modern Nimrud, is an ancient Assyrian city located south of Mosul in northern Iraq.

A3.1079. *Assyrian reliefs from the palace of Ashurnasirpal II: a cultural biography* / Ada Cohen and Steven E. Kangas. Hanover: Hood Museum of Art, Dartmouth College: University Press of New England, 2010. 268 p. NB80 .A699 2010.

A3.1080. *Gräber assyrischer Königinnen aus Nimrud; Qubur al- malikat al-ashuriyat fi Nimrud* / Muayad Said Basim Damerji. Mainz: Verlag des Römisch-Germanischen Zentralmuseums, 1999. DS70.5.14 D36 1999.

A3.1081. *Ivories from the North West Palace (1845-1992)* / Georgina Herrmann and Stuart Laidlaw. London: British Institute for the Study of Iraq, 2008. 260, 137 p. NK5973.6.I72 C354 2008.

A3.1082. *Ivories from room SW 37, Fort Shalmaneser* / Georgina Herrmann. London: British School of Archaeology in Iraq, 1986. 2 v. NK5860 .M26 fasc.4; NK5860 .M26 pt.4.

A3.1083. *Literary texts from the temple of Nabu* / D. J. Wiseman and J. A. Black. London: British School of Archaeology in Iraq, 1996. 62, 157 p. DS70.5.C3 W57 1996.

A3.1084. *Neo-Assyrian texts from Nimrud: varied content: a preliminary catalogue* / Cinzia Pappi. Roma: Università degli studi di Roma "La Sapienza," Dipartimento di studi orientali, 2004. PJ3721. C35 P37 2004.

A3.1085. *The Nimrud letters, 1952* / Henry W. F. Saggs. London: British School of Archaeology in Iraq, 2001. 327, 64 p. PJ3881 .N55 2001.

A3.1086. *The reconstruction of the relief representations and their positions in the Northwest-Palace at Kalhu (Nimrud) III: (the principal entrances and courtyards)* / Samuel M. Paley and Richard P. Sobolewski. Mainz am Rhein: P. von Zabern, 1992. 56, 11, 13 p. DS70.5.N57 P35 1992.

A3.1087. *Die Reliefs Tiglatpilesars III. aus Nimrud* / Eckhard Unger. Konstantinopel: A. Ihsan, 1917. 32, 6 p. 913.496 Is78 no.1–5, 8–10, 12–13.

A3.1088. *The small collections from Fort Shalmaneser* / Georgina Herrmann. London: British School of Archaeology in Iraq, 1992. 146, 104 p. NK5860 .M26 pt.5.

Drehem (Puzrish-Dagan)

A3.1089. *Neo-Sumerian texts from the Royal Ontario Museum* / Marcel Sigrist. Bethesda: CDL Press, 1995. PJ4053.R66 S55 1995; PJ4053.R66 S55 1995. Drehem, a Sumerian city located southwest of Ur, served as a tax collection depot and produced numerous cuneiform tablets dating to the third dynasty of Ur (ca. 2112–2004 BCE).

Dur-Sharrukin (Khorsabad)

A3.1090. Excavations at Khorsabad. http://oi.uchicago. edu/research/projects/kho/. Dur-Sharrukin, present-day Khorsabad, was the Assyrian capital of Sargon II.

A3.1091. *Khorsabad, le palais de Sargon II, roi d'Assyrie: actes du colloque organisé au musée du Louvre par le Services culturel les 21 et 22 janvier 1994* / Annie Caubet. DS70.5.D94 K46 1995.

A3.1092. *A Mediterranean seascape from Khorsabad* / Pauline Albenda. Malibu: Undena Publications, 1983. 34, 8 p. DS73.8 .A52 1983.

Erech

A3.1093. Archaeological expedition mapping ancient city of Uruk. http://www.rferl.org/content/article/1099592.html. Erech, also known as Uruk, Orchoe, and Tall al-Warka, was an ancient Mesopotamian city located northwest of Ur in

southeastern Iraq. Urban life between ca. 3500 and 2900 BCE is more fully illustrated at Erech than at any other Mesopotamian city.

A3.1094. *Archaic administrative texts from Uruk: the early campaigns* / Robert K. Englund. Berlin: Mann, 1994. 232, 143 p. DS70.5.E65 N6 Bd.15.

A3.1095. *Artefacts of complexity: tracking the Uruk in the Near East* / J. N. Postgate. London: British School of Archaeology in Iraq, 2002. 258 p. DS70.5.E65 A784 2002; DS70.5.E65 A784 2002.

A3.1096. *Briefe aus Uruk-Warka, 1931–1939* / Arnold Nöldeke. Wiesbaden: Reichert, 2008. 347 p. 115. N65 A4 2008.

A3.1097. *The cults of Uruk and Babylon: the temple ritual texts as evidence for Hellenistic cult practises* / Marc J. H. Linssen. Leiden; Boston: Brill/Styx, 2004. 343 p. BL1620 .L556 2004.

A3.1098. *Cuneiform documents from the Chaldean and Persian periods* / Ronald H. Sack. Selinsgrove: Susquehanna University Press; London; Cranbury: Associated University Presses, 1994. 129 p. PJ3831 .S23 1994.

A3.1099. *Dritter vorläufiger Bericht über die von der Notgemeinschaft der Deutschen Wissenschaft in Uruk unternommenen Ausgrabungen* / Julius Jordan. Berlin: Verlag der Akademie du Wissenschaften, 1932. 37 p. AS182 .B34 1932.

A3.1100. *The earliest script of Uruk: (syntactic analysis)* / D. Silvestri, L. Tonelli, and V. Valeri. Naples: Herder Editrice, 1990. 2 v. PJ3193 .S558 1990.

A3.1101. *Hellenistic seal impressions in the Yale Babylonian collection* / Ronald Wallenfels. Mainz am Rhein: P. von Zabern, 1994. CD5344 .W35 1994, v.1.

A3.1102. *Die keramik von der Qal'a des Haggi Mohammed* / Charlotte Ziegler. Berlin: Mann, 1953. 88 p. DS70.5.E65 N6 Bd.5.

A3.1103. *Legal documents from Erech, dated in the Seleucid era (312–65 B.C.)* / Albert T. Clay. New York, 1913. 89, 57 p. PJ3719 .M7 1913. Babylonian records from the library of J. Pierpont Morgan.

A3.1104. *A Neo-Babylonian debenture* / Henry F. Lutz. Berkeley: University of California Press, 1940. 4 p. PJ3874 .L88 1940; PJ3002 .C3 v.10.

A3.1105. *Palmeraies et cultures de l'Eanna d'Uruk (559–520)* / Denise Cocquerillat. Berlin: Mann, 1968. 140 p. DS70.5.E65 N6 Bd.8.

A3.1106. *A recorded deposition concerning presentment for tax payment* / Henry F. Lutz. Berkeley: University of California Press, 1940. 6 p. PJ3861 .L88 1940; PJ3002 .C3 v.10.

A3.1107. *Ricerche sui sigilli a cilindro Vicino-Orientali del periodo di Uruk/Jemdet Nasr* / Elena Rova.

Roma: Istituto per l'Oriente C.A. Nallino, 1994. 331, 59 p. CD5344 .R68 1994.

A3.1108. *Seleucid archival texts in the Harvard Semitic Museum: text editions and catalogue raisonné of the seal impressions* / Ronald Wallenfels. Groningen: Styx, 1998. 179 p. PJ3870 .W35 1998.

A3.1109. *Tempel und Palast: die Beziehungen zwischen dem König und dem Eanna-Tempel im spätbabylonischen Uruk* / Kristin Kleber. Münster: Ugarit-Verlag, 2008. 403 p. DS70.5.E65 K543 2008.

A3.1110. *Les temps proto-urbains de Mésopotamie: contacts et acculturation à l'époque d'Uruk au Moyen-Orient* / Pascal Butterlin. Paris: CNRS éditions, 2003. 467, 24 p. DS69.5 .B87 2003.

A3.1111. *Die terrakotten von Warka* / Charlotte Ziegler. Berlin: Gebr. Mann, 1962. 227 p. DS70.5.E65 N6 Bd.6.

A3.1112. *Texte aus dem Rēs-Heiligtum in Uruk-Warka* / Jan Van Dijk. Berlin: Mann, 1980. 29, 52 p. PJ3193 .T49 1980.

A3.1113. *Untersuchungen zur Komposition der Stiftmosaiken an der Pfeilerhalle der Schicht IVa in Uruk-Warka*. Berlin: Gebr. Mann, 1968. 168 p. DS70.5.E65 B73.

A3.1114. *Uruk: Analytisches Register zu den Grabungsberichten* / Uwe Finkbeiner. Berlin: Gebr. Mann, 1993. DS70.5.E65 F558 1993, v.1.

A3.1115. *Uruk: früheste Siegelabrollungen* / Rainer Michael Boehmer. Mainz am Rhein: P. von Zabern, 1999. 214, 104 p. CD5348 .B64 1999.

A3.1116. *Uruk: die Gräber* / R. M. Boehmer, F. Pedde, and B. Salje. Mainz am Rhein: P. von Zabern, 1995. 236 p. DS70.5.E65 B62 1995.

A3.1117. *Uruk, Kampagne 35–37, 1982–1984: die archäologische Oberflächenuntersuchung (Survey)* / Uwe Finkbeiner. Mainz am Rhein: P. von Zabern, 1991. 2 v. DS70.5.E65 F56 1991, t.1, 2.

A3.1118. *Uruk, Kampagne 38, 1985: Grabungen in J–K/23 und H/24–25* / Rainer Michael Boehmer. Mainz: von Zabern, 1987. 99, 111 p. DS70.5.E65 B6 1987.

A3.1119. *Uruk: Kleinfunde I: Stein* / Andrea Becker. Mainz am Rhein: P. von Zabern, 1993. 141, 128 p. DS70.5.E65 B43 1993.

A3.1120. *Uruk: Kleinfunde II: Metall und Asphalt, Farbreste, Fritte/Fayence, Glas, Holz, Knochen/ Elfebein, Leder, Muschel/Perlmutt, Schnecke, Schilf, Textilien* / Margarete van Ess and Friedhelm Pedde. Mainz am Rhein: Verlag Philipp von Zabern, 1992. 314, 157 p. DS70.5.E65 E87 1992.

A3.1121. *Uruk: Kleinfunde III: Kleinfunde im Vorderasiatischen Museum zu Berlin: Steingefässe und Asphalt, Farbreste, Fritte, Glas, Holz, Knochen/ Elfenbein, Muschel/Perlmutt/Schnecke* / Elke

Lindemeyer und Lutz Martin. Mainz am Rhein: P. von Zabern, 1993. DS70.5.E65 L56 1993.

A3.1122. *Uruk: Kleinfunde IV: Metall* / Friedhelm Pedde. Mainz am Rhein: P. von Zabern, 2000. 213, 125 p. DS70.55.E65 P44 2000.

A3.1123. *Uruk: late Babylonian seal impressions on Eanna-tablets* / Erica Ehrenberg. Mainz am Rhein: Philipp von Zabern, 1999. 138, 14 p. CD5348 .E4872 1999.

A3.1124. *Uruk: Perlen, Ketten, Anhänger: Grabungen 1912–1985* / Klaudia Limper. Mainz am Rhein: P. von Zabern, 1988. 193, 61 p. DS70.5.E65 L55 1988.

A3.1125. *Uruk: spätbabylonische Wirtschaftstexte aus dem Eanna-Archiv* / Erlend Gehlken. Mainz am Rhein: P. von Zabern, 1990. DS70.5.E65 G44 1990, t.1, 2; PJ3721.E7 G4 1990, t.1, 2.

A3.1126. *Uruk: spätbabylonische Texte aus dem Planquadrat U 18* / Egbert von Weiher. Mainz am Rhein: P. von Zabern, 1993. 228 p. DS70.5.E65 W45 1993.

A3.1127. *Uruk, die Stratigraphie: Grabungen 1912–1977 in den Bereichen 'Eanna' und 'Anu-Ziqqurrat'* / Ricardo Eichmann. Mainz am Rhein: P. von Zabern, 1989. 233, 48 p. DS70.5.E65 E53 1989.

A3.1128. *Uruk: Urkunden aus Privathäusern; die Wohnhäuser westlich des Eanna-Tempelbereichs* / Karlheinz Kessler. Mainz am Rhein: P. von Zabern, 1991. DS70.5.U7 K47 1991; DS70.5.E65 K477 1991, t.1.

A3.1129. *Vorläufiger Bericht über die von dem Deutschen Archäologischen Institut und der Deutschen Orient-Gesellschaft aus Mitteln der Deutschen Forschungsgemeinschaft unternommenen Ausgrabungen in Uruk-Warka.* Berlin: Gebr. Mann, 1983. 32 v. DS79.9.E7 D4, 1. (1930),12. (1953/1954)-31./32. (1974/1974) Contents include *Zweiter vorl äufiger bericht über die von der Notgemeinschaft der deutschen wissenschaft in Uruk unternommenen ausgrabungen* / Julius Jordan. Berlin: Verlag der Akademie der wissenschaften, in kommission bei Walter de Gruyter, 1931. AS182 .B34 1930; *Dritter vorläufiger Bericht über die von der Notgemeinschaft der Deutschen Wissenschaft in Uruk unternommenen Ausgrabungen* / Julius Jordan. Berlin: Verlag der Akademie du Wissenschaften, 1932. 37 p. AS182 .B34 1932; *Dritter vorläufiger Bericht über die von der Notgemeinschaft der Deutschen Wissenschaft in Uruk unternommenen Ausgrabungen* / Julius Jordan. Berlin: Verlag der Akademie du Wissenschaften, 1932. 37 p. AS182 .B34 1932; *Vierter vorläufiger Bericht über die von der Notgemeinschaft der Deutschen Wissenschaft in Uruk unternommenen Ausgrabungen* / Arnold Nöldeke. Berlin: Verlag der Akademie du Wissenschaften, 1932. 47, 12 p. AS182 .B34 1932; *Sechster vorläufiger Bericht über die von der Notgemeinschaft der Deutschen Wissenschaft in Uruk-Warka unternommenen Ausgrabungen* / Ernst Heinrich. Berlin: Verlag der Akademie du Wissenschaften, 1935. 38, 32 p. AS182 .B34 1935; *Achter vorläufiger Bericht über die von der Deutschen forschungsgemeinschaft in Uruk-Warka unternommenen Ausgrabungen* / Arnold Nöldeke. Berlin: Verlag der Akademie du Wissenschaften, 1937. 61, 60 p. AS182 .B34 1936 nr.8/13; *Neunter vorläufiger Bericht über die von der Deutschen forschungsgemeinschaft in Uruk-Warka unternommenen Ausgrabungen* / Arnold Nöldeke. Berlin: Verlag der Akademie du Wissenschaften, 1938. 39, 40 p. AS182 .B34 1937.

Girsu

A3.1130. *Altsumerische Verwaltungstexte aus Girsu-Lagaš* / Joachim Marzahn. Berlin: Akademie-Verlag, 1991. 23, 1 p. PJ4051 .V6 1991; PJ4054.G5 M37 1991. Girsu, modern Tell Telloh, was an ancient Sumerian city located 25 kilometers northwest of Lagash.

A3.1131. *Haverford library collection of cuneiform tablets or documents from the temple archives of Telloh* / George Aaron Barton. Philadelphia: The John C. Winston Co., 1905–1914. 3 v. PJ4053 .H3 1905.

A3.1132. *Inventaire des tablettes de Tello conservées au Musée imperial ottoman.* Paris: E. Leroux, 1910. 5 v. Van Pelt Judaica/Ancient Near East Seminar PJ3193 .I88 1910, t.1, 2, 3(2), 4.

A3.1133. *Old Babylonian temple records* / Robert J. Lau. New York: Columbia University Press; London: Macmillan, 1906. 89, 41 p. PJ4075 .L38 1906. Reprint: Old Babylonian temple records / Robert J. Lau. Piscataway: Gorgias Press, 2008. PJ4075 .L3 2008.

Haradum

A3.1134. *Haradum I: une ville nouvelle sur le Moyen-Euphrate (XVIIIe–XVIIe siècles av. J.-C.)* / Christine Kepinski-Lecomte. Paris: Editions Recherche sur les civilisations, 1992. 456, 21, 23 p. DS70.5.H24 H37 1992. Haradum, modern Khirbit ed-Diniye, was an ancient city on the Euphrates River about 90 kilometers southeast of Mari.

A3.1135. *Haradum II: les textes de la période paléo-babylonienne, Samsu-iluna, Ammi-saduqa* / Francis Joannnès. Paris: Éditions recherche sur les civilisations, 2006. 190 p. DS70.5.H24 J63 2006.

Isin

A3.1136. *The historical inscriptions of Old Babylonian period: Isin-Larsa dynasties: a preliminary catalogue* / Giovanni Pettinato. Roma: Università degli studi di Roma "La Sapienza," Dipartimento di studi orientali, 2004. PJ4070 .P48 2004. Isin was an ancient city-state about 15 kilometers south of Nippur near modern Ishan al-Bahriyat.

A3.1137. *Isin, Išān Baḥrīyāt IV: die Ergebnisse der Ausgrabungen, 1986–1989* / B. Hrouda. München: Verlag der Bayerischen Akademie der Wissenschaften: In Kommission bei C. H. Beck, 1992. 211, 67 p. DS79.9.I85 H87 1992; AS182.M8175 n.F. hft.105.

Jemdat Nasr

A3.1138. *Cities, seals and writing: archaic seal impressions from Jemdet Nasr and Ur* / Roger J. Matthews. Berlin: G. Mann, 1993. 73, 32 p. CD5344 .M4 1993. Jemdet Nasr is a tell in Babil Governorate that is best known as the type site for the Jemdet Nasr period (3100–2900 BCE).

A3.1139. *The proto-cuneiform texts from Jemdet Nasr* / Robert K. Englund and Jean-Pierre Grégoire, with a contribution by Roger J. Matthews. Berlin: Mann Verlag, 1991. PJ3721.J46 E54 1991.

Jerwan

A3.1140. *Sennacherib's aqueduct at Jerwan* / Thorkild Jacobsen and Seton Lloyd. Chicago: University of Chicago Press, 1935. 52 p. DS70 .5.J43 J3. The location of part of an aqueduct network for Nineveh constructed between 704 and 681 BCE.

Karana

A3.1141. *The Old Babylonian tablets from Tell al Rimah* / Stephanie Dalley, C. B. F. Walker and J. D. Hawkins. London: British School of Archaeology in Iraq, 1976. 271, 112 p. PJ3826 .D34 1976. Karana, also known as Tell al-Rimah or Qattara, was an ancient city in the Sinjar region west of Nineveh.

A3.1142. *Tell Karrana* / Gernot Wilhelm and Carlo Zaccagnini. Mainz am Rhein: Verlag Philipp von Zabern, 1993. DS99.K365 T455 1993, v.3.

Lagash

A3.1143. *The exchange of goods and services in pre-Sargonic Lagash* / Rosemary Prentice. Münster: Ugarit-Verlag, 2010. 238 p. HF1019 .P74 2010. Lagash, modern Telloh, was an important Sumerian capital located between the Tigris and Euphrates rivers in southeastern Iraq.

A3.1144. *Gudea's temple building: the representation of an early Mesopotamian ruler in text and image* / Claudia E. Suter. Groningen: STYX publications, 2000. 437 p. PJ4027 .S88 2000.

A3.1145. *Presargonic period: (2700–2350 BC)* / Douglas R. Frayne. Toronto: University of Toronto Press, 2008. 464 p. PJ3824 .F73 2008.

A3.1146. *Studien zur Region Lagas: von der Ubaid- bis zur altbabylonischen Zeit* / Su Kyung Huh. Münster: Ugarit-Verlag, 2008. 916 p. DS70.5.T43 H94 2008.

A3.1147. *Untersuchungen zur Götterwelt des altsumerischen Stadtstaates von Lagas* / Gebhard Selz. Philadelphia: University of Pennsylvania Museum, 1995. 439 p. BL1615 .S44 1995.

Larsa

A3.1148. *Contracts from Larsa, dated in the reign of Rim-Sin* / David Earl Faust. New Haven: Yale University Press; London, H. Milford, Oxford University Press, 1941. 37 p. PJ3875 .F38 1941. An important Sumerian city located 25 kilometers southeast of Uruk in the Dhi Qar Governorate.

A3.1149. *Eight days in the Temples of Larsa: celebrations in the month of Shevat in the time of Abraham* / Joan Goodnick Westenholz. Jerusalem?: R. Sirkis, 1994. 31 p. DS70.5.L35 W47 1994.

A3.1150. *Larsa: travaux de 1985* / Jean-Louis Huot. Paris: Editions Recherche sur les civilisations, 1989. 195 p. DS70.5.I75 L37 1989.

A3.1151. *Larsa: travaux de 1987 et 1989* / Jean-Louis Huot. Beyrouth: Institut français d'archéologie du Proche-Orient, 2003. 440, 14 p. DS70.5.L35 L37 2003.

A3.1152. *Larsa (8ème et 9ème campagnes, 1978 et 1981) et Oueili (2ème et 3ème campagnes, 1978 et 1981): rapport préliminaire* / Jean Louis Huot. Paris: Editions Recherche sur les civilisations, 1983. 357 p. DS70.5.L35 L37 1983.

A3.1153. *Larsa (10e campagne, 1983) et Queili (4e campagne, 1983): rapport préliminaire* / Jean-Louis Huot. Paris: Editions Recherche sur les civilisations, 1987. 246, 85, 58 p. DS70.5.L35 L38 1987.

A3.1154. *Records from Ur and Larsa dated in the Larsa dynasty* / Ettalene Mears Grice. New Haven: Yale University Press, 1919. 56, 88 p. PJ4075 .G75 1919.

A3.1155. *Texte aus Larsa: die epigraphischen Funde der 1. Kampagne in Senkereh-Larsa 1933* / Daniel Arnaud. Berlin: D. Reimer, 1994. 25 p. DS70.5.L35 A763 1994.

A3.1156. *Water for Larsa: an Old Babylonian archive dealing with irrigation* / Stanley D. Walters. New Haven: Yale University Press, 1970. 202 p. PJ3721.S4 W3 1970.

Mashkan-Shapir

A3.1157. *The anatomy of a Mesopotamian city: survey and soundings at Mashkan-shapir* / Elizabeth C. Stone and Paul Zimansky. Winona Lake: Eisenbrauns, 2004. 504 p. DS70.5.M37 S76 2004. Mashkan-Shapir, modern Tell Abu Duwari, was an ancient city located 30 kilometers north of Nippur and 140 kilometers southeast of Baghdad.

Nagar

A3.1158. *Excavations at Tell Brak.* Cambridge: McDonald Institute for Archaeological Research; London: British School of Archaeology in Iraq; Oakville: David Brown, 1997. DS70 .E93 1997, v.1, 2, 4. Nagar, or Tell Brak, is a tell in the Upper Khabur region in Al-Hasakah. The site was occupied between the sixth and second millenia BCE. Tell Brak, with an area of about 320 acres, is one of the largest archaeological sites in northern Mesoamerica.

Nimrud

A3.1159. *New light on Nimrud: proceedings of the Nimrud Conference 11th–13th March 2002* / J. E. Curtis. London: British Institute for the Study of Iraq, in association with the British Museum, 2008. 297 p. DS70.5.C3 N55 2002. Nimrud, once known as Kalhu, was an ancient Assyrian city located on the Tigris River.

A3.1160. *Nimrud: an Assyrian imperial city revealed* / Joan and David Oates. London: British School of Archaeology in Iraq, 2001. 309, 12 p. DS70.5.C3 O28 2001.

A3.1161. *The published ivories from Fort Shalmaneser, Nimrud: a scanned archive of photographs* / Georgina Herrmann, Helena Coffey, and Stuart Laidlaw. London: British School of Archaeology in Iraq, 2004. 183 p. + CD-ROM. NK5860 .H44 2004.

Nineveh

A3.1162. *Assyrian discoveries: an account of explorations and discoveries on the site of Nineveh, during 1873 and 1874* / George Smith. New York: Scribner, Armstrong & Co., 1875. 461 p. DS70 .S73 1875. Nineveh was an ancient capital of the Neo-Assyrian Empire, located on the east bank of the Tigris River across from modern Mosul.

A3.1163. *The Babylonian story of the deluge and the epic of Gilgamish, with an account of the royal libraries of Nineveh.* 2 ed. London: The Trustees, 1929. 58 p. PJ3771.G5 E5 1929.

A3.1164. *A century of exploration at Nineveh* / R. Campbell Thompson and R. W. Hutchinson. London: Luzac & Co., 1929, 13, 146 p. DS70 .T5 1929.

A3.1165. *Discoveries among the ruins of Nineveh and Babylon: with travels in Armenia, Kurdistan and the desert: being the result of a second expedition undertaken for the trustees of the British Museum* / Austen H. Layard. New York: Harper & Brothers, 1875. 586, 6 p. DS70 .L435 1853a.

A3.1166. *Discoveries in the ruins of Nineveh and Babylon: with travels in Armenia, Kurdistan and the desert being the result of a second expedition undertaken for the Trustees of the British Museum* / Austen H. Layard. London: J. Murray, 1853. 686 p. DS70 .L435 1853; 913.351 N62L.2.

A3.1167. *L'impero di Babilonia e di Nineve: dalle origini fino alla conquista di Ciro descritto secondo i monumenti cuneiformi comparati colla Bibbia* / Giuseppe Brunengo. Prato: Tipografia Giachetti, 1885. 2 v. 935.2 B834.

A3.1168. *The monuments of Nineveh: from drawings made on the spot: illustrated in 100 plates first series* / Austen Henry Layard. London: J. Murray, 1853. 10, 102 p. 732 N622L.

A3.1169. *Nineveh: papers of the XLIXe Rencontre Assyriologique Internationale, London, 7–11 July 2003* / Dominique Collon and Andrew George. London: Published by the British School of Archaeology in Iraq (Gertrude Bell Memorial) with the aid of the MBI Foundation, 2005. 2 v. DS70.5.N47 R46 2003.

A3.1170. *Nineveh and its palaces: the discoveries of Botta and Layard, applied to the elucidation of Holy Writ* / Joseph Bonomi. Piscataway, NJ: Gorgias Press, 2003. 537 p. DS70.5.N47 B66 2003.

A3.1171. *Nineveh and its remains: with an account of a visit to the Chaldan Christians of Kurdistan, and the Yezidis, or devil-worshippers, and an enquiry into the manners and arts of the ancient Assyrians* / Austen Henry Layard. 6 ed. London: John Murray, 1854. 2 v. DS70 .L42 1854.

A3.1172. *Notes from Nineveh, and travels in Mesopotamia, Assyria, and Syria* / James P. Fletcher. Philadelphia: Lee and Blanchard, 1850. 366 p. DS70 .F61 1850.

A3.1173. *A popular account of discoveries at Nineveh* / Austen Henry Layard. New York: Harper, 1852. 360, 7 p. DS70.5.N47 L49 1852.

A3.1174. *Das prähistorische Ninive: zur relativen Chronologie der frühen Perioden Nordmesopotamiens* / Renate Vera Gut. Mainz am Rhein: P. von Zabern, 1995. DS70.5.N47 G88 1995, v.1, 2.

A3.1175. *A second series of the monuments of Nineveh: including bas-reliefs from the palace of Sennacherib and bronzes from the ruins of Nimroud: from drawings made on the spot, during a second expedition to Assyria* / Austen Henry Layard; seventy-one plates. London: J. Murray, 1853. 7, 71 p.

A3.1176. *The Sennacherib wall reliefs at Nineveh* / Carlo Lippolis. Firenze: Le Lettere, 2011. 144, 349 p. NB80 .S46 2011.

A3.1177. *Stolen stones: the modern sack of Nineveh.* http://www.archaeology.org/online/features/nineveh/.

Nippur (Niffer, Niffar)

A3.1178. *Beiträge zum Pantheon von Nippur im 3. Jahrtausend* / Marcos Such-Gutiérrez. Roma: Università degli studi di Roma "La Sapienza," Dipartimento di studi orientali, 2003. 2 v. BL1625. G6 S934 2003. Nippur is an ancient Mesopotamian site in southeastern Iraq. Although never a political capital, Nippur was dominant in the religious life in Mesopotamia.

A3.1179. *The earliest version of the Babylonian deluge story and the temple library of Nippur* / H. V. Hilprecht. Philadelphia: University of Pennsylvania, 1910. 65, 3 p. PJ3711 .P415 1910.

A3.1180. *Excavations at Nippur: plans, details and photographs of the buildings, with numerous objects found in them during the excavations of 1889, 1890, 1893–1896, 1899–1900* / Clarence S. Fisher. Philadelphia: Babylonian Expedition of the University of Pennsylvania, 1905. 56, 32, 26 p. DS70.5.N56 P45; 913.351 N63F.

A3.1181. *The Kassite glyptic of Nippur* / Donald M. Matthews. Freiburg, Schweiz: Universitätsverlag; Göttingen: Vandenhoeck & Ruprecht, 1992. 153, 42 p. CD5344 .M38 1992; CD5344 .M3 1992.

A3.1182. *Letters to Cassite kings from the Temple archives of Nippur* / Hugo Radau. Philadelphia: Published by the Dept. of Archaeology, University of Pennsylvania, 1908. 174, 11 p. PJ3711 .P4 1836 VOL .17 PT .1.

A3.1183. *Life at the bottom of Babylonian society: servile laborers at Nippur in the 14th and 13th centuries, B.C.* / Jonathan S. Tenney. Leiden; Boston: Brill, 2011. 268 p. HD4844 .T46 2011.

A3.1184. *Neo-Sumerian archival texts primarily from Nippur in the University Museum, the Oriental Institute, and the Iraq Museum (NATN)* / David I. Owen. Winona Lake: Eisenbrauns, 1982. 85, 213, 10 p. PJ4054.N5 O9 1982.

A3.1185. *Die Ninegalla-Hymne: die Wohnungnahme Inannas in Nippur in altbabylonischer Zeit* / Hermann Behrens. Stuttgart: Steiner, 1998. 164, 11 p. PJ4061 .N5615 1998.

A3.1186. *Nippur IV: the early Neo-Babylonian governor's archive from Nippur* / Steven W. Cole. Chicago: Oriental Institute of the University of Chicago, 1996. 458 p. PJ3828 .C65 1996.

A3.1187. *Nippur V: the early dynastic to Akkadian transition: the area WF sounding at Nippur* / Augusta McMahon. Chicago: Oriental Institute of the University of Chicago, 2006. 173, 193 p. DS70.5.N5 M36 2006; HD4844 .T46 2011.

A3.1188. *Nippur neighborhoods* / Elizabeth C. Stone. Chicago: Oriental Institute of the University of Chicago, 1987. 294, 94 p. DS70.5.N5 S76 1987; CB251 .C55 no.44.

A3.1189. *Old Babylonian inscriptions, chiefly from Nippur, pt. I and II* / H. V. Hilprecht. Philadelphia: Univ. of Pennsylvania, Dept. of Archaeology and Palaeontology, 1896. 2 v. 892.3 H566a.

A3.1190. *Old Babylonian inscriptions chiefly from Nippur* / H. V. Hilprecht. Philadelphia: American Philosophical Society, 1893–1896. 2 v. Q11.P6n.s. v.18, pt.1.

A3.1191. *Die Personennamen der kassitenzeitlichen Texte aus Nippur* / Monika Hölscher. Münster: Rhema, 1996. 306 p. PJ3545 .H657 1996.

A3.1192. *Proper names of the time of Artaxerxes I: from cuneiform tablets found in Nippur* / H. V. Hilprecht. Philadelphia: s.n., 1898. 43 p. 492.3 H568.

A3.1193. *Sculptures from the southwest Palace of Sennacherib at Nineveh* / Richard D. Barnett, Erika Bleibtreu, and Geoffrey Turner. London: Published for the Trustees of the British Museum by British Museum Press, 1998. 2 v. NB80 .B3193 1998.

A3.1194. *The so-called Peters-Hilprecht controversy: Part I: Proceedings of the committee appointed by the board of trustees of the University of Pennsylvania to act as a court of inquiry. Part II: Supplemental documents, evidence and statement* / H. V. Hilprecht. Philadelphia: A. J. Holman & Company, 1908. 357 p. UPT2 H655 1908. The Hilprecht Controversy was concerned with accusations by fellow team members that Hilprecht took inappropriate credit for the discoveries of others. This fierce controversy fought in newspapers and even lectures prevented most of the research of the acquired material for the next years.

A3.1195. *Terra-cottas from Nippur* / Leon Legrain. Philadelphia: University Museum, University of Pennsylvania Press, 1930. 52, 77 p. NK4267 .L44 1930; 892.3 Un34 v.16; PJ3711 .P5 v.16.

A3.1196. *Tablettes mathematiques de Nippur* / Christine Proust. Istanbul: Institut français d'études anatoliennes Georges Dumézil, 2007. 356 p. DS70.5.N5 P76 2007.

A3.1197. *The Ur III Temple of Inanna at Nippur: the operation and organization of urban religious institutions in Mesopotamia in the late third millenium B.C.* / Richard L. Zettler. Berlin: D. Reimer, 1992. 303 p. DS70.5.N56 Z482 1992.

Nuzi

A3.1198. *General studies and excavations at Nuzi 9/1* / D. I. Owen and M. A. Morrison. Winona Lake: Eisenbrauns, 1987. 723 p. DS70.5.N9 G453 1987; DS70.5.N9 G46 1987. Nuzi, also Nuzu and modern Yorghan Tepe, was an ancient Mesopotamian city southwest of Kirkuk near the Tigris River.

A3.1199. *Joint expedition with the Iraq Museum at Nuzi* / Ernest Lacheman and Maynard P. Maidman. Winona Lake: Eisenbrauns, 1989. 307 p. PJ3721. N8 L3 1989.

A3.1200. *Joint expedition with the Iraq Museum at Nuzi VII* / Ernest Lacheman and Maynard P. Maidman. Winona Lake: Eisenbrauns, 1989. PJ3721. N8 L3 1989, pt. 1.

A3.1201. *General studies and excavations at Nuzi 9/3* / Ernest R. Lacheman and David I. Owen. Winona Lake: Eisenbrauns, 1995. 357 p. DS70.5.N9 G453 1995, v.3.

A3.1202. *General studies and excavations at Nuzi 10* / edited by David I. Owen and Gernot Wilhelm. Bethesda: CDL Press, 1998. PJ3721.N8 G46 1998.

A3.1203. *General studies and excavations at Nuzi 10/2* / David I. Owen and Gernot Wilhelm. Bethesda: CDL Press, 1998. 396 p. PJ3721.N8 G46 1998.

A3.1204. *General studies and excavations at Nuzi 10/3* / David I. Owen and Gernot Wilhelm. Bethesda: CDL Press, 2002. 330 p. DS70.5.N9 G47 2002.

A3.1205. *General studies and excavations at Nuzi 11/1* / David I. Owen and Gernot Wilhelm. Bethesda: CDL Press, 2005. 261 p. DS70.5.N9 G46 2005.

A3.1206. *General studies and excavations at Nuzi 11/2: in honor of David I. Owen on the occasion of his 65th birthday, October 28, 2005* / Gernot Wilhelm. Bethesda: CDL Press, 2009. 734 p. DS70.5.N9 G48 2009.

A3.1207. *Joint expedition with the Iraq Museum at Nuzi* / Edward Chiera. Paris: P. Geuthner, 1927–1934. 6 v. PJ3721.N8 A5 1927.

A3.1208. *Joint expedition with the Iraq Museum at Nuzi VIII: the remaining major texts in the Oriental Institute of the University of Chicago* / M. P. Maidman. Bethesda: CDL Press, 2003. 207 p. PJ3870 .M35 2003.

A3.1209. Nippur Expedition. http://oi.uchicago.edu/research/projects/nip/.

A3.1210. *Nuzi; report on the excavation at Yorgan Tepa near Kirkuk, Iraq, conducted by Harvard University in conjunction with the American Schools of Oriental Research and the University Museum of Philadelphia, 1927–1931* / Richard F. Starr. Cambridge: Harvard University Press, 1937–1939. 2 v. DS70.5.N9 S8 1937; 913.56 St28.

A3.1211. Nuzi and the Hurrians; Semitic Museum, Harvard University. http:// http://isites.harvard.edu/icb/icb.do?keyword=k66717&pageid=icb.page327691.

A3.1212. *Nuzi texts and their uses as historical evidence* / Maynard Paul Maidman. Atlanta: Society of Biblical Literature, 2010. 296 p. PJ3721.N8 M347 2010.

A3.1213. *Les rapports entre Nuzi et Hanigalbat. The tallu measure of capacity at Nuzi* / Carlo Zaccagnini. Malibu: Undena Publications, 1979. 34 p. DS70.95 .Z32 1979.

A3.1214. *Die Zauberschalentexte in der Hilprecht-Sammlung, Jena, und weitere Nippur-Texte anderer Sammlungen* / Christa Müller-Kessler. Wiesbaden: Harrassowitz, 2005. 257, 51 p. PJ5208.A5 M85 2005.

Seleucia on the Tigris

A3.1215. *Figurines from Seleucia on the Tigris, discovered by the expeditions conducted by the University of Michigan with the cooperation of the Toledo Museum of Art and the Cleveland Museum of Art, 1927–1932* / W. V. I. Elarth. Ann Arbor: University of Michigan Press, 1939. Also known as Seleucia, one of the great Mesopotamian cities of the Hellenistic and Roman periods.

A3.1216. *Parthian pottery from Seleucia on the Tigris* / N. C. Debevoise. Ann Arbor: University of Michigan Press, 1934.

A3.1217. *Seleucia al Tigri: l'edificio degli archivi, lo scavo e le fasi architettoniche* / Vito Messina. Firenze: Le lettere, 2006. 194, 9 p. DS70.5.S45 M47 2006.

A3.1218. *Seleucia al Tigri: il monumento di Tell 'Umar: lo scavo e le fasi architettoniche* / Vito Messina. Firenze: Le lettere, 2010. 209 p. DS70.5.S45 M48 2010.

A3.1219. *Stamped and inscribed objects from Seleucia on the Tigris* / R. H. McDowell. Ann Arbor: University of Michigan Press, 1935.

Sippar, or Zimbir (Tell Abu Habbah)

A3.1220. *Altbabylonische Rechts- und Verwaltungsurkunden aus dem Musée du Louvre* / Daniel Arnaud. Berlin: D. Reimer, 1989. 18, 63 p. KL2211 .A8 1989, v.1. Sippar was an ancient city located on the east bank of the Euphrates River 60 kilometers north of Babylon and 30 kilometers southeast of Baghdad.

A3.1221. *Das archiv des Bēl-rēmanni* / Michael Jursa. Istanbul: Nederlands Historisch-Archaeologisch Instituut te Istanbul; Leiden, Nederland: Nederlands Instituut voor het Nabije Oosten distributor, 1999. 297 p. DS70.5.S55 J87 1999.

A3.1222. *Der Ebabbar-Tempel von Sippar in frühneubabylonischer Zeit (640–580 v. Chr.)* / Rocío Da Riva. Münster: Ugarit-Verlag, 2002. 486, 25 p. DS70.5.S55 D37 2002; DS70.5.S55 D37 2002.

A3.1223. *Garments of the Gods: studies on the textile industry and the Pantheon of Sippar according to the texts from the Ebabbar archive* / Stefan Zawadzki. Fribourg: Academic Press; Göttingen: Vandenhoeck & Ruprecht, 2006. 254 p. PJ37PJ3721.S57 Z393 2006.

A3.1224. *Die Landwirtschaft in Sippar in neubabylonischer Zeit* / Michael Jursa. Wien: Institut für Orientalistik der Universität Wien, 1995. 264 p. HD2065.Z9 S575 1995.

A3.1225. *The Neo-Babylonian Ebabbar Temple at Sippar: its administration and its prosopography* / A. C. V. M. Bongenaar. İstanbul: Nederlands Historisch-Archeologisch Instituut te İstanbul, 1997. 559, 6 p. DS70.5.S55 B66 1997.

A3.1226. *Old Babylonian real estate documents from Sippar in the British Museum* / Luc Dekiere. Ghent: University of Ghent, 1994. DS70.5.S55 D444 1994, pt.1, 5, 6.

A3.1227. *Old Babylonian texts from private houses at Abu Habbah ancient Sippir: Baghdad University excavations* / Farouk N. H. Al-Rawi and Stephanie Dalley. London: Nabu Publications, 2000. 168, 64 p. PJ3721.S57 A47 2000.

A3.1228. *Sippar-Amnanum: the Ur-Utu archive* / K. van Lerberghe and G. Voet. Ghent, Belgium: University of Ghent, 1991. 191, 81 p. DS70.5.S55 L48 1991.

A3.1229. *Some aspects of the hiring of workers in the Sippar region at the time of Hammurabi* / Mogens Weitemeyer. Copenhagen: Munksgaard, 1962. 145 p. PJ3875 .W4 1962; 913.354 W438.

A3.1230. *Der Tempelzehnt in Babylonien: vom siebenten bis zum dritten Jahrhundert v. Chr.* / Michael Jursa. Münster: Ugarit-Verlag, 1998. 145 p. HC34 .J87 1998.

A3.1231. *Vogelzucht und Vogelfang in Sippar im 1. Jahrtausend v. Chr.* / Bojana Janković. Münster: Ugarit-Verlag, 2004. 219 p. SF461.43.I72 J35 2004.

Suruppak

A3.1232. *The bureaucracy of Suruppak: administrative centres, central offices, intermediate structures and hierarchies in the economic documentation of Fara* / Giuseppe Visicato. Münster: Ugarit-Verlag, 1995. 165 p. DS70.5.S55 V57 1995.

A3.1233. *Fara: a reconstruction of the ancient Mesopotamian city of Shuruppak* / Harriet P. Martin. Birmingham: C. Martin, 1988. 309 p. DS70.5.S48 M368 1988.

A3.1234. *The final sack of Nineveh: the discovery, documentation, and destruction of King Sennacherib's throne room at Nineveh, Iraq* / John Malcolm Russell. New Haven: Yale University Press, 1998. 247 p. DS70.5.N47 R86 1998.

A3.1235. *Indices of early dynastic administrative tablets of Suruppak* / Giuseppe Visicato. Napoli: Istituto universitario orientale di Napoli, 1997. 136 p. PJ4054.S48 P65 1994 Index.

Umma

A3.1236. *Animal husbandry in the ancient Near East: a prosopographic study of third-millennium Umma* / Marek Stępień. Bethesda: CDL Press, 1996. 263 p. SF55.I63 S84 1996. Umma, modern Tell Jokha, was an ancient Sumerian city.

A3.1237. *The ruling family of Ur III Umma: a prosopographical analysis of an elite family in Southern Iraq 4000 years ago* / Jacob L. Dahl. Leiden: Nederlands Instituut voor het Nabije Oosten, 2007. 180 p. DS70.5.U44 D34 2007.

A3.1238. *Temple documents of the third dynasty of Ur from Umma* / George Gottlob Hackman. New Haven: Yale University Press; London: H. Milford, Oxford University Press, 1937. 34 p. PJ3719 .N5 1937; 892.3 Y14.3 v.5; PJ4054.U6 H3 1937.

A3.1239. *Umma in the Sargonic period* / Benjamin R. Foster. Hamden: Archon, 1982. 228, 42 p. Q11 .C85 v.20 F67 1982; DS70.5.U44 F67 1982.

Ur

A3.1240. *The archaeology of verbal and nonverbal meaning: Mesopotamian domestic architecture and its textual dimension* / Paolo Brusasco. Oxford: Archaeopress, 2007. 147 p. NA220 .B78 2007. An important Sumerian city-state located at the site of modern Tell el-Muqayyar. The site dates from the Ubaid period (ca. 3800 BCE) and is marked by the ruins of the ziggurat of Ur.

A3.1241. *Archaic seal-impressions* / L. Legrain. London: Published for the trustees of the two museums by Oxford University Press, 1936. 49, 58 p. DS70 .J6 v.3.

A3.1242. *An archive of kennelmen and other workers in Ur III Lagash* / Pietro Mander. Napoli: Istituto universitario orientale, 1994. 104 p. PJ3721.L3 M353 1994.

A3.1243. *Le clergé d'Ur au siècle d'Hammurabi: (XIXe–XVIIIe siècles av. J.-C.)* / Dominique Charpin. Genève: Librairie Droz, 1986. 519 p. DS70.5.U7 D6 C52 1986; DS70.5.U7 C52 1986.

A3.1244. *Death rituals, ideology, and the development of early Mesopotamian kingship: toward a new understanding of Iraq's royal cemetery of Ur* / Andrew C. Cohen. Leiden; Boston: Brill Academic Publishers, 2005. 244 p. DS69.6 .C64 2005.

A3.1245. *The early periods: a report on the sites and objects prior in date to the third dynasty of Ur discovered in the course of the excavations* / Leonard Woolley. Philadelphia: Published for the Trustees of the two museums by the aid of a grant from the Johnson Fund of the American Philosophical Society, 1955. 225, 42 p. DS70.J6 v.4.

A3.1246. *L'espace domestique en Mésopotamie de la IIIe dynastie d'Ur à l'époque paléo-babylonienne* / Laura Battini-Villard. Oxford: J. and E. Hedges, 1999. 2 v. NA220 .B37 1999.

A3.1247. *Excavations at Ur of the Chaldees, 1923/24–1933/34* / Leonard Woolley. London: Joint expedition of the British Museum and the Museum of the University of Pennsylvania to Mesopotamia, 1923–1934. 2 v. DS70.5.U7 W584. Reprinted from various issues of *The Antiquaries Journal*; v. 1, 1923/24–1926/27; v. 2, 1927/28–1933–34.

A3.1248. *The excavations at Ur and the Hebrew records* / C. Leonard Woolley. London: George Allen & Unwin, 1929. 61 p. DS70.5.U7 W66 1929.

A3.1249. *History and monuments of Ur* / C. J. Gadd. London: Chatto and Windus; New York: E. P. Dutton, 1929. 269 p. DS70.5.U7 G3.

A3.1250. *Die Königsinschriften der dritten Dynastie von Ur* / Ilmari Kärki. Helsinki: Finnish Oriental Society, 1986. 158 p. PJ9.S86 v.58.

A3.1251. *Die königlichen Frauen der III. Dynastie von Ur* / Frauke Weiershäuser. Göttingen: Universitätsverlag Göttingen, 2008. 342 p. DS69.6 .W45 2008.

A3.1252. *Lamentation over the destruction of Ur* / Samuel N. Kramer. Chicago: University of Chicago Press, 1940. 97 p. PJ4065.L3 K7; 492.34C C433 no.12.

A3.1253. *Literarische Texte aus Ur: Kollationen und Kommentare zu UET 6/1-2* / Marie-Christine Ludwig. Berlin; New York: Walter de Gruyter, 2009. 256 p. PJ4054.U7 L83 2009.

A3.1254. *The Old Babylonian period* / Leonard Woolley and Max Mallowan. London: Published for the trustees of the Joint Expedition of the British Museum and the Museum of the University of Pennsylvania by British Museum Publications, 1976. 260, 129 p. DS70.J6 v.7.

A3.1255. *The organization of power: aspects of bureaucracy in the ancient Near East* / McGuire Gibson and Robert D. Biggs. 2 ed. Chicago: Oriental Institute of the University of Chicago, 1991. 168 p. DS70.5.U7 O74 1991.

A3.1256. *Organisation und Verwaltung der Ur III-Fischerei* / Robert K. Englund. Berlin: D. Reimer, 1990. 253 p. PJ4075 .E54 1990.

A3.1257. *Pre-Sargonic and Sargonic texts from Ur; edited in UET 2, supplement* / Amedeo Alberti and Francesco Pomponio. Rome: Biblical Institute Press, 1986. 134 p. PJ4075.A428 1986.

A3.1258. *Rechts- und verwaltungsurkunden der III. dynastie von Ur, autographiert und mit inventarverzeichnis und namenlisten versehen* / Alfred Pohl. Leipzig: J. C. Hinrichs, 1937. 50, 11, 96 p. DS69. J42 no.1–2.

A3.1259. *Royal tombs of Ur of the Chaldees, the treasures discovered by the Joint Expedition of the University Museum and the British Museum* / Joint Expedition of the British Museum and the Museum of the University of Pennsylvania to Mesopotamia. Philadelphia: University of Pennsylvania Museum, 1929. 27 p. DS70.5.U7 P45; DS70.5.U7 W63 1929b; 913.358 P389.

A3.1260. *Seal cylinders* / L. Legrain, with an introductory note by Leonard Woolley. London: Publications of the Joint Expedition of the British Museum and the University Museum, University of Pennsylvania, Philadelphia, to Mesopotamia, 1951. 56, 43 p. DS70.5 .U7 1951; DS70 .J6 v.10.

A3.1261. *A season's work at Ur, al-'Ubaid, Abu Shahrain (Eridu), and elsewhere: being an unofficial account of the British Museum Archaeological Mission to Babylonia, 1919* / H. R. Hall. London: Methuen & Co., 1930. 299 p. 913.358 H14.

A3.1262. *Die Siegellegenden der Geschäftsurkunden der Stadt Ur in Chaldäa: Siegelrecht und Siegelpraxis in Südmesopotamien im 20. Jahrhundert vor Chr.* / Nikolaus Schneider. Brussel: Palais der Academiën, 1950. 38 p. PJ4054.U7 S36.

A3.1263. *Society and enterprise in Old Babylonian Ur* / Marc Van de Mieroop. Berlin: D. Reimer, 1992. 238 p. DS70.5.U7 V36 1992.

A3.1264. *Textes sumériens de la 3e dynastie d'Ur* / H. Limet. Bruxelles (Parc du Cinquantenaire 10):

Musées Royaux d'Art et d'Histoire, 1976. 130, 43, 2 p. PJ4053.M8 L5 1976.

A3.1265. *Texts from Ur: kept in the Iraq Museum and in the British Museum* / Jeremy A. Black and Gabriella Spada. Messina: Di. Sc. A.M., 2008. 125, 96 p. PJ4054.U7 B53 2008.

A3.1266. Treasures from the Royal Tombs of Ur. http://mcclungmuseum.utk.edu/custom404.shtml.

A3.1267. *Two lyres from Ur* / Maude de Schauensee. Philadelphia: University of Pennsylvania Museum of Archaeology and Anthropology, 2002. 125 p. ML1015.L89 S34 2002.

A3.1268. *Ur, la città del dio-luna* / Frances Pinnock. Roma: Laterza, 1995. 224 p. DS70.5.U7 P555 1995.

A3.1269. *Ur excavations, texts* / Joint expedition of the British Museum and of the Museum of the University of Pennsylvania to Mesopotamia. London: Printed by order of the Trustees of the two museums, 1928. Philadelphia: University of Pennsylvania Press. DS70.J62.

A3.1270. *Ur of the Chaldees; a record of seven years of excavation* / C. Leonard Woolley. New York: Charles Scribner's Sons, 1930. 210, 16 p. DS70.5.U7 W63 1930. Superseded by: *Ur of the Chaldees; a record of seven years of excavation* / C. Leonard Woolley. New York: W. W. Norton, 1965. 208 p. DS70.5.U7 W63 1965.

A3.1271. *Zur Datierung des Königsfriedhofes von Ur. Unter besonderer Berücksichtigung der Stratigraphie der Privatgräber* / Hans Jörg Nissen. Bonn: Rudolf Habelt, 1966. 200, 22 p. DS70.5.U7 N57 1966.

ISRAEL AND THE PALESTINIAN TERRITORIES

Situated at a strategic location between Egypt, Syria, and Arabia, and the birthplace of Judaism and Christianity, the region has a long and tumultuous history as a crossroads for religion, culture, commerce, and politics. The region has been controlled by numerous different peoples, including Ancient Egyptians, Canaanites, Israelites, Assyrians, Babylonians, Persians, Ancient Greeks, Romans, Byzantines, the Sunni Arab Caliphates, the Shia Fatimid Caliphate, Crusaders, Ayyubids, Mameluks, Ottomans, the British, and modern Israelis and Palestinians. Modern archaeologists and historians of the region refer to their field of study as Syro-Palestinian archaeology.

A3.1272. *Amot ha-mayim ha-ḳedumot be-Erets-Yiśra'el: ḳovets meḥḳarim* / Dayid Amit, Yizhar Hirshfeld, and Yosef Paṭrikh. Yerushalayim: Yad Yitsḥaḳ Ben-Tsevi, 1989. 12, 335 p. TD398.A66 1989. A study of Roman aqueducts.

A3.1273. *Arabia e Palaestina dall'impero al califfato* / Barbara Bianchi. Firenze: All'insegna del giglio, 2007. 248 p. DS56.B465 2007.

A3.1274. *The art of Hellenistic Palestine* / Adi Erlich. Oxford: Archaeopress, 2009. 139 p. DS111.8.E75 2009.

A3.1275. *The archaeology of Ancient Judea and Palestine* / Ariel Lewin and Dinu, Sandu, and Radu Mendrea. Los Angeles: J. Paul Getty Museum, 2005. 204 p. DS111.L4813 2005.

A3.1276. *Bene Israel: studies in the archaeology of Israel and the Levant during the Bronze and Iron ages in honour of Israel Finkelstein* / Alexander Fantalkin and Assaf Yasur-Landau. Leiden; Boston: Brill, 2008. 306, 50 p. GN778.32.P19 B45 2008.

A3.1277. *Biblical peoples and ethnicity: an archaeological study of Egyptians, Canaanites, Philistines, and early Israel, 1300–1100 B.C.* / Ann E. Killebrew. Leiden; Boston: Brill, 2005. 362 p. DS112.K476 2005b; DS112.K476 2005b.

A3.1278. *The history and archaeology of Jaffa* / Martin Peilsotcker and Aaron A. Burke. Los Angeles: Cotsen Institute of Archaeology Press, University of California, Los Angeles, 2011. 294 p. DS110. J3 H57 2011.

A3.1279. *The history of ancient Palestine from the Palaeolithic Period to Alexander's conquest* / Gösta W. Ahlström. Sheffield, England: JSOT Press, 1993. 990 p. DS117.A545 1993.

A3.1280. *Late Bronze and Iron Age chalices in Canaan and ancient Israel* / Robert Grutz. Oxford: Archaeopress, 2007. 240 p. DS111.9.G78 2007.

A3.1281. *Oil-lamps in the Holy Land: saucer lamps from the beginning to the Hellenistic period; collections of the Israel Antiquities Authority* / Varda Sussman. Oxford: Archaeopress, 2007. 493 p. NK4680.S87 2007.

A3.1282. *Religious communities in Byzantine Palestina: the relationship between Judaism, Christianity and Islam, AD 400–700* / Eliya Ribak. Oxford: Archaeopress, 2007. 234 p. DS123.5.R53 2007.

A3.1283. *Through the ages in Palestinian archaeology: an introductory hand* / Walter E. Rast. Philadelphia: Trinity Press International, 1992. 221 p. DS111. R27 1992.

A3.1284. *The towns of Palestine under Muslim rule: AD 600–1600* / Andrew Petersen. Oxford: Archaeopress, 2005. 243 p. DS111.P48 2005.

A3.1285. *The wilderness of Zin* / C. Leonard Wooley and T. E. Lawrence. rev ed. Winona Lake: Eisenbrauns; London: Stacey International, 2003. 290 p. DS101.W665 2003.

Adullam

A3.1286. Adullam. http://www.jewishvirtuallibrary.org/
jsource/judaica/ejud_0002_0001_0_00493.html.
Adullam was one of the royal cities of the Ca-
naanites. It stood on the old Roman road in the
valley of Elah, which was the scene of David's
memorable victory over Goliath. It was one of
the towns that Rehoboam fortified against Egypt.

Akeldama

A3.1287. Akeldama, From the Diaspora to Jerusalem.
http://www.jewishvirtuallibrary.org/jsource/
Archaeology/akeldama.html. Akeldama (Acel-
dama), the Aramaic name for a place in Jeru-
salem associated with Judas Iscariot, one of the
followers of Jesus.

Akhiv

A3.1288. *Mapat Akhziv (1) u-mapat Ḥanitah (2)* / Re-
fael Franḳel ye-Nimrod Getsov. Yerushalayim:
Rashut ha-Atiḳot, 1997. 233, 198 p. DS110.A43
F726 1997. Akhiv (or Akiva) and Hanitah is a
city located in the Haifa District, on the coastal
plain of Israel. It is located just inland from the
ancient port city of Caesarea and the Mediterra-
nean Sea, and to the north of the city of Hadera.
It is south of Haifa and north of Tel Aviv.

Akko

A3.1289. Akko: The Maritime Capital of the Crusader
Kingdom. http://www.jewishvirtuallibrary.org/
jsource/Archaeology/Akko.html. Akko (Acre) is
a city in the Western Galilee region of northern
Israel at the northern extremity of Haifa Bay.
Acre is one of the oldest continuously inhabited
sites in the country. Historically, it was a strategic
coastal link to the Levant.

Apollonia

A3.1290. Apollonia-Arsuf. http://www.jewishvirtualli-
brary.org/jsource/Archaeology/Apollonia.html.
Apollonia (Arsuf, Arsur) was an ancient city and
fortress located in Israel, about 15 kilometers
north of modern Tel Aviv, on a cliff above the
Mediterranean Sea.

Arad

A3.1291. Ancient Arad. http://www.jewishvirtuallibrary.
org/jsource/Archaeology/arad.html. Arad is
named after the biblical Canaanite town located

at Tel Arad (a site famous for the discovery of
ostraca), which is located approximately 8 kilo-
meters west of modern Arad.

A3.1292. Arad. http://www.jewishvirtuallibrary.org/
jsource/judaica/ejud_0002_0002_0_01218.html.

Ararat

A3.1293. Ararat. http://www.jewishvirtuallibrary.org/
jsource/judaica/ejud_0002_0002_0_01234.html.

Arbel

A3.1294. Arbel. http://www.jewishvirtuallibrary.org/
jsource/judaica/ejud_0002_0002_0_01243.html.
Arbel (Har Arbel) is a mountain in the lower
Galilee near Tiberias in Israel, with high cliffs,
views of Mount Hermon in the Golan Heights,
trails to a cave fortress, and ruins of an ancient
synagogue.

Ashdod

A3.1295. Tel Ashdod Excavation. http://www.jewishvir-
tuallibrary.org/jsource/Archaeology/tel_ashdod.
html. Ashdod is located in the southern district
of Israel, on the Mediterranean coast, located 32
kilometers south of Tel Aviv and 20 kilometers
north of Ashkelon and 53 kilometers west of Je-
rusalem. The first documented settlement in Ash-
dod dates to the Canaanite culture of seventeenth
century BCE, making the city one of the oldest in
the world. During its history the city was settled
by Philistines, Israelites, Byzantines, Crusaders,
and Arabs.

Ashkelon

A3.1296. Archaeology in Israel—Ashkelon. http://jewish-
mag.com/41mag/ashkelon/ashkelon.htm. Ash-
kelon (Ashqelon, Ascalon) is a coastal city in
southern Israel on the Mediterranean coast, 50
kilometers south of Tel Aviv and 13 kilometers
north of the border with the Gaza Strip. The
ancient seaport of Ashkelon dates back to the
Neolithic Age. In the course of its history, it has
been ruled by Canaanites, Philistines, Egyptians,
Israelites, Assyrians, Babylonians, Greeks, Phoe-
nicians, Hasmoneans, Romans, Persians, Arabs,
and Crusaders until it was destroyed by Mamluks
in 1270.

A3.1297. Ashkelon Excavations—The Leon Levy Expedi-
tion. http://ashkelonexcavations.blogspot.com.

Athlit

A3.1298. Athlit. http://www.jewishvirtuallibrary.org/jsource/judaica/ejud_0002_0002_0_01549.html. Athlit is an ancient port on the Mediterranean coast of Israel, 31 kilometers south of Cape Carmel. It has been identified with Kartha, a city of Zebulun. Excavations have shown that the site was inhabited in the Iron Age, probably by Phoenicians. A colony of Greek mercenaries settled at Athlit in Persian-Hellenistic times. The ruins of Athlit served as a quarry for the construction of Acre.

Avdat

A3.1299. Avdat. http://www.jewishvirtuallibrary.org/jsource/Archaeology/Avdat.html. Avdat (Abdat, Ovdat, Obodat) was the most important city on the incense route after Petra, between the first century BCE and the seventh century CE. It was founded in the third century BCE and inhabited by Nabataeans, Romans, and Byzantines. Avdat was a seasonal camping ground for Nabataean caravans traveling along the early Petra–Gaza road (Darb es-Sultan) in the third to late second century BCE.

Banyas (Panias)

A3.1300. Banyas. http://www.jewishvirtuallibrary.org/jsource/Archaeology/banyas.html. According to written sources, Banyas was first settled in the Hellenistic period. The Ptolemaic kings, in the third century BCE, built a cult center to counter the Semitic one at Dan to the south, which indeed gradually declined. Then, in 200 BCE, the Seleucid ruler Antiochus III defeated the Ptolemaic army in this region and captured Banyas. In 20 BCE, the region that included Banyas was annexed to the Kingdom of Herod the Great and was ruled by his successors until the end of the first century CE. In the year 2 BCE, Herod Philip founded a pagan city and named it Caesarea Philippi. It became the capital of a large kingdom that spread across the Golan and the Hauran. During the Roman period, the center of the city spread over a plateau, with natural features protecting it on three sides.

Bar'am

A3.1301. Bar'am Ancient Synagogue. http://www.jewishvirtuallibrary.org/jsource/Archaeology/Baram.html. Bar'am is a kibbutz located in northern Israel. Located approximately 300 meters from Israel's border with Lebanon, near the ruins of the ancient Jewish village of Kfar Bar'am.

Bashan (Basan)

A3.1302. *Atarim ya-ḥakhamim ba-Golan uva-Bashan bi-teḳufat ha-Mishnah yeha-Talmud* / Naḥum Kohen. Yerushalayim: Karmel, 2007. 104 p. DS99.G65 C65 2007. A place first mentioned in the biblical book of Genesis, extending from Gilead in the south to Mermon in the north, and from the Jordan River on the west to Salcah in the east. According to the Bible, the Israelites invaded Bashan and took it from the Amorites.

Be'er Shema

A3.1303. Be'er Shema-The Church of St. Stephen. http://www.jewishvirtuallibrary.org/jsource/Archaeology/Shema.html.

Be'er Sheva

A3.1304. Beersheba—the Southern Border of the Kingdom of Judah. http://www.jewishvirtuallibrary.org/jsource/Archaeology/beersheva.html.

A3.1305. Be'er Sheva: Prehistoric Dwelling Sites. http://www.jewishvirtuallibrary.org/jsource/Archaeology/Beersheva1.html.

Beit Alpha

A3.1306. Beit Alpha. http://www.jewishvirtuallibrary.org/jsource/Archaeology/Beitalpha.html.

Beit Govrin

A3.1307. Beit Govrin-A Roman Amphitheater. http://www.jewishvirtuallibrary.org/jsource/Archaeology/govrin.html.

Beit Mirsim, tell

A3.1308. *The excavation of Tell Beit Mirsim* / Willam Foxwell Albright. New Haven: American Schools of Oriental Research, 1932–1943. 3 v. DS101.A45; DS101.A45 v.17; DS101.A45 v.21–22. An archaeological site in the West Bank excavated by William F. Albright between 1933 and 1936.

Beit Shemesh

A3.1309. Beit Shemesh. http://www.jewishvirtuallibrary.org/jsource/Archaeology/Bet_Shemesh.html.

Beit She'an

A3.1310. Beit She'an. http://www.jewishvirtuallibrary.org/jsource/Archaeology/Beitshean.html.

Belvoir

A3.1311. Belvoir: A Crusader Fortress Overlooking the Jordan Valley. http://www.jewishvirtuallibrary.org/jsource/Archaeology/Belvoir.html.

Besor

A3.1312. *Mapat Urim (125)* / Dan Gazit. Yerushalayim: Rashut ha-atiḳot, ha-Agudah le-seḳer arkheologi shel Yisrael, 1996. 140, 83 p. DS110.B3729 G39 1996. Besor River is a wadi in southern Israel, beginning at Mount Boker and draining into the Mediterranean near Deir al-Balah in the Gaza Strip. The stream is the largest in the northern Negev.

Bet She'arim

A3.1313. Bet She'arim: The Jewish Necropolis of the Roman Period. http://www.jewishvirtuallibrary.org/jsource/Archaeology/Bet_Shearim.html.

Bethsaida

A3.1314. Bethsaida. http://www.jewishvirtuallibrary.org/jsource/Archaeology/Bethsaida.html; http://www.unomaha.edu/~bethsaida/.

Burga, tel

A3.1315. Tel Burga. http://www.jewishvirtuallibrary.org/jsource/Archaeology/tel_burga.html.

Caesarea

A3.1316. Caesarea. http://www.jewishvirtuallibrary.org/jsource/Archaeology/Caesarea.html.

A3.1317. Caesarea Harbor. http://hannover.park.org/Canada/Museum/caesarea/research.html.

A3.1318. Combined Caesarea Expeditions. http://www.digcaesarea.org/.

A3.1319. Excavation at Caesarea. http://people.usd.edu/~clehmann/caesarea.html.

Capernaum

A3.1320. Capernaum. http://www.jewishvirtuallibrary.org/jsource/Archaeology/Capernaum.html.

A3.1321. Capernaum Synagogue. http://www.jewishvirtuallibrary.org/jsource/Archaeology/capesyn.html.

Carmel

A3.1322. Carmel Caves: Dwellings of Prehistoric Man. http://www.jewishvirtuallibrary.org/jsource/Archaeology/carmel.html.

Cave of the Treasure

A3.1323. Cave of the Treasure. http://www.jewishvirtuallibrary.org/jsource/Archaeology/cave.html.

Cave of the Warrior

A3.1324. Cave of the Warrior. http://www.amnh.org/exhibitions/cave/.

Chorazin

A3.1325. Chorazin. http://www.jewishvirtuallibrary.org/jsource/Archaeology/chorazin.html.

Daliya (Dalia)

A3.1326. *Daliya map (31) 15–22* / Yaaqov Olami. Jerusalem: The Survey, 1981. 101, 14 p. DS111.O4 1981. A kibbutz in northern Israel located in Galilee approximately 30 kilometers southeast of Haifa.

Dan

A3.1327. Dan: The Biblical City. http://www.jewishvirtuallibrary.org/jsource/Archaeology/dan.html.

Dead Sea Scrolls

A3.1328. Dead Sea Scrolls. http://www.jewishvirtuallibrary.org/jsource/Archaeology/DeadSeaScrolls-toc.html.

A3.1329. Dead Sea Scrolls Exhibit—UNC Expo. http://www.ibiblio.org/expo/deadsea.scrolls.exhibit/intro.html.

Deir Mar Saba

A3.1330. *Mapat Deir Mar Saba (109/7)* / Yosef Patrikh. Yerushalayim: Rashut ha-atiḳot, 1994. 195, 103 p. DS110.D47 P28 1994.

Deir al-Balah

A3.1331. *Excavations at the cemetery of Deir El-Balaḥ* / Trude Dothan. Jerusalem: The Institute of

Archaeology, Hebrew University of Jerusalem, 1979. 114 p. DS110.D39 D6. Deir al-Balah (Dayr al-Balah) is a Palestinian city in the central Gaza Strip, dating to the late Bronze Age, when it served as a fortified outpost for New Kingdom Egypt. During the reign of Ramesses II (1303–1213 BCE) Deir al-Balah became the farthest east of six garrisoned fortresses in the eastern Mediterranean.

Dor, tel

A3.1332. Tel Dor. http://www.jewishvirtuallibrary.org/jsource/Archaeology/Tel_Dor.html.

Dothan

A3.1333. *Dothan* / Daniel M. Master. Winona Lake: Eisenbrauns, 2005. DS110.D69 D68 2005. Excavations of Joseph P. Free at Dothan between 1953 and 1964. Dothan (Dothaim) was a city located at north of Shechem and about 100 kilometers north of Hebron. It has been identified with Tel Dothan, located 10 kilometers southwest of Jenin.

Efrata

A3.1334. *Excavations at Efrata: a burial ground from the intermediate and middle bronze ages* / Rivka Gonen. Jerusalem: Israel Antiquities Authority, 2001. 153 p. DS109.912.G66 2001.

Eilat

A3.1335. Eilat Region. http://www.jewishvirtuallibrary.org/jsource/Archaeology/eilat.html.

Ein Gedi

A3.1336. Ein Gedi Archaeological Expedition. http://archaeology.huji.ac.il/eingedi/index.htm.

A3.1337. Ein Gedi: An Ancient Oasis Settlement. http://www.jewishvirtuallibrary.org/jsource/Archaeology/eingedi.html.

Ein Hatzeva

A3.1338. Ein Hatzeva: An Israelite Fortress on the Border with Edom. http://www.jewishvirtuallibrary.org/jsource/Archaeology/Hatzeva.html.

Ekron

A3.1339. Ekron: A Philistine City. http://www.jewishvirtuallibrary.org/jsource/Archaeology/Ekron.html.

Fari'ah, tell el-

A3.1340. *Tell el-Fari'ah* / Alain Chambon. Paris: Editions Recherche sur les civilisations, 1984. DS110.F37 C46 1984.

Galilee

A3.1341. *Researches in prehistoric Galilee, 1925–1926* / F. A. J. Turville-Petre. London: Council of the School, 1927. 119 p. 913.33 T869.

Gamla

A3.1342. Gamla: Jewish City on the Golan. http://www.jewishvirtuallibrary.org/jsource/Archaeology/gamala.html.

Gaza Strip

A3.1343. *L'archéologie palestinienne*. Dijon, France: Editions Faton, 1998. 165 p. CC3.H478 no.240.

Gerizim, Mount

A3.1344. *Mount Gerizim excavations* / Yitzhak Magen, Haggai Misgav, and Levana Tsfania. Jerusalem: Staff Officer of Archaeology, Civil Administration for Judea and Samaria: Israel Antiquities Authority, 2004. DS110.G475 M35 2004, v.1.

Gezer

A3.1345. Gezer. http://www.jewishvirtuallibrary.org/jsource/Archaeology/Gezer.html.

A3.1346. Gezer Calendar. http://www.jewishvirtuallibrary.org/jsource/judaica/ejud_0002_0007_0_07263.html.

Golan

A3.1347. Golan—A Unique Chalcolithic Culture. http://www.jewishvirtuallibrary.org/jsource/Archaeology/golan.html.

A3.1348. Golan Dolmens. http://www.jewishvirtuallibrary.org/jsource/Archaeology/GolanDolmens.html.

A3.1349. Golan: Rogem Hiri. http://www.jewishvirtuallibrary.org/jsource/Archaeology/Rogem.html.

Hadid, tel

A3.1350. Tel Hadid. http://www.jewishvirtuallibrary.org/jsource/Archaeology/tel_hadid.html.

Hamat Gader

A3.1351. Hamat Gader: Baths of Medicinal Hot Springs. http://www.jewishvirtuallibrary.org/jsource/Archaeology/Hamat.html.

Hatzor

A3.1352. Hatzor. http://www.jewishvirtuallibrary.org/jsource/Archaeology/Hatzor.html.

A3.1353. Hazor Excavations Project. http://unixware.mscc.huji.ac.il/~hatsor/.

Herodian

A3.1354. Herodian: King Herod's Palace-Fortress. http://www.jewishvirtuallibrary.org/jsource/Archaeology/Herodian1.html.

Herodium

A3.1355. *Herodium: an archaeological guide* / Ehud Netzer. Jerusalem: Cana, 1987. 48 p. DS110.H46 N49 1987.

Horbat Omrit

A3.1356. Horbat Omrit. http://www.jewishvirtuallibrary.org/jsource/Archaeology/Horbat.html.

Jericho

A3.1357. Jericho—The Winter Palace of King Herod. http://www.jewishvirtuallibrary.org/jsource/Archaeology/jericho.html.

Jerusalem

A3.1358. Byzantine St. Stephen's—Jerusalem. http://www.nd.edu/~stephens/description.html.

A3.1359. Church of the House of Peter. http://www.jewishvirtuallibrary.org/jsource/Archaeology/stpeter.html.

A3.1360. Church of the Seat of Mary (Kathisma). http://www.jewishvirtuallibrary.org/jsource/Archaeology/Kathisma.html.

A3.1361. Greek Orthodox Church of the Seven Apostles. http://www.jewishvirtuallibrary.org/jsource/Archaeology/greekchurch.html.

A3.1362. Western Wall Tunnels. http://www.jewishvirtuallibrary.org/jsource/Judaism/walltoc.html.

Kadesh

A3.1363. Kadesh. http://www.jewishvirtuallibrary.org/jsource/judaica/ejud_0002_0011_0_10530.html.

Katzrin

A3.1364. Katzrin. http://www.jewishvirtuallibrary.org/jsource/Archaeology/Katzrin.html.

Kefar ha-Shiloah

A3.1365. *Kefar-ha-Shiloaḥ: ir-ha-ḳevarim mi-teḳufat ha-melukhah* / David Ussishḳin. Yerushalayim: Yad Yits'ḥaḳ Ben-Tsevi: ha-Ḥevrah la-ḥaḳirat Erets-Yiśra'el ye-atiḳoteha, 1986. 311 p. DS110.K39 U88 1986.

Kfar Kana

A3.1366. Kfar Kana. http://www.jewishvirtuallibrary.org/jsource/Archaeology/kfarkana.html.

Kh Tinshemet

A3.1367. Kh Tinshemet. http://www.jewishvirtuallibrary.org/jsource/Archaeology/Tinshemet.html.

Khirbet Cana

A3.1368. Khirbet Cana excavations. http://www.jewishvirtuallibrary.org/jsource/Archaeology/arch0512-3.html.

Khirbet Qeiyafa

A3.1369. Khirbet Qeiyafa. http://www.jewishvirtuallibrary.org/jsource/Archaeology/arch0512-3.html.

Khirbet Sufa

A3.1370. Khirbet Sufa. http://www.jewishvirtuallibrary.org/jsource/Archaeology/khirbet_sufa.html.

Kiryat Sefer

A3.1371. Kiryat Sefer. http://www.jewishvirtuallibrary.org/jsource/Archaeology/Kiryat_Sefer.html.

Kursi

A3.1372. Kursi: Christian Monastery on the Shore of the Sea of Galilee. http://www.jewishvirtuallibrary.org/jsource/Archaeology/kursi.html.

Lachish

A3.1373. Lachish: Royal City of the Kingdom of Judah. http://www.jewishvirtuallibrary.org/jsource/Archaeology/lachish.html.

Masada

A3.1374. Masada: Desert Fortress Overlooking the Dead Sea. http://www.jewishvirtuallibrary.org/jsource/Archaeology/Masada1.html.

Megiddo

A3.1375. Megiddo—The Solomonic Chariot City. http://www.jewishvirtuallibrary.org/jsource/Archaeology/Megiddo.html.

A3.1376. Megiddo Summer Expedition. http://sites.google.com/site/megiddoexpedition/.

Metallurgy

A3.1377. Ancient Iron Smelting and Smithing, the Archaeology of Jordan, the West Bank, and Israel. http://www.ironsmelting.net/flash.html.

Migdal

A3.1378. Migdal. http://www.jewishvirtuallibrary.org/jsource/Archaeology/boat_migdal.html.

Monastery of Martyrius

A3.1379. Monastery of Martyrius. http://www.jewishvirtuallibrary.org/jsource/Archaeology/monastery.html.

Nabeh, tell en-

A3.1380. Tell en-Nabeh. http://www.jewishvirtuallibrary.org/jsource/Archaeology/nabeh.html.

Nag Hammadi

A3.1381. Nag Hammadi codices. http://www.jewishvirtuallibrary.org/jsource/judaicaejud_0002_0014_0_14462.html.

Nahal Be'er Sheva

A3.1382. Nahal Be'er Sheva. http://www.jewishvirtuallibrary.org/jsource/Archaeology/hellenistic.html.

Nahal Haggit

A3.1383. *Nahal Ḥaggit: a Roman and Mamluk farmstead in the southern Carmel* / Jon Seligman. Jerusalem: Israel Antiquities Authority, 2010. 270 p. DS110.2 S45 2010.

Nahal Refaiim

A3.1384. Nahal Refaiim: Caananite Bronze Age Villages near Jerusalem. http://www.jewishvirtuallibrary.org/jsource/Archaeology/Nahal_Refaiim.html.

Nasbeh, tell en-

A3.1385. *A manual of excavation in the Near East; methods of digging and recording of the Tell en-Nasbeh expedition in Palestine* / William F. Bade. Berkeley: University of California Press, 1934. 81p. DS109.B33 1934. Nasbeh, likely the biblical city of Mizpah in Benjamin, is a 3.2-hectare tell located 12 kilometers northwest of Jerusalem. The site lies adjacent to an ancient roadway connecting Jerusalem with the northern hill country. There are also archaeological remains at the site and in surrounding cave tombs that have been dated to the Early Bronze I (3500–3300 BCE), Iron I (1200–1000 BCE), Babylonian and Persian (586–323 BCE), and Hellenistic, Roman, and Byzantine (323 BCE–630 CE) periods.

A3.1386. Tell en-Nasbeh Research Project. http://www.arts.cornell.edu/jrz3/frames2.htm.

Nazareth

A3.1387. Nazareth. http://www.jewishvirtuallibrary.org/jsource/vie/Nazareth.html.

Nebi Samwil

A3.1388. Nebi Samwil. http://www.jewishvirtuallibrary.org/jsource/Archaeology/Nebisamwil.html.

Negev

A3.1389. Byzantine Churches in the Negev. http://www.jewishvirtuallibrary.org/jsource/Archaeology/byznegev.html.

Nimrod

A3.1390. Nimrod's Fortress: Muslim Stronghold in the Golan. http://www.jewishvirtuallibrary.org/jsource/Archaeology/Nimrod.html.

Nizzanah

A3.1391. Nizzanah. http://www.jewishvirtuallibrary.org/jsource/judaica/ejud_0002_0015_0_14890.html.

Pekiin

A3.1392. Pekiin: A Karstic Cave. http://www.jewishvirtuallibrary.org/jsource/Archaeology/pekiincave.html.

Qanah River Cave

A3.1393. *The Naḥal Qanah cave: earliest gold in the Southern Levant* / Avi Gopher and Tsvika Tsuk. Tel Aviv: Institute of Archaeology of Tel Aviv University Publications Section, 1996. 250 p. GN855.P3 G66 1996; GN855.P3 G66 1996. Nahal Qana begins in the hills of Mount Gerizim, reaches the Sharon plain near Jaljulia, and empties into the Yarkon just west of the Yarkon interchange. Nahal Qana served as the boundary between the Tribe of Ephraim and the Tribe of Manasseh. In the 1980s, a cave was discovered there.

Qasil, tel

A3.1394. Tel Qasile. http://www.jewishvirtuallibrary.org/jsource/Archaeology/Qasile.html.

Qumran

A3.1395. *The archaeology of Qumran and the Dead Sea Scrolls* / Jodi Magness. Grand Rapids: William B. Eerdmans, 2003. 238, 36 p. BM175.Q6 M34 2003.

A3.1396. *The excavations of Khirbet Qumran and Ain Feshkha: synthesis of Roland de Vaux's field notes* / J.-B. Humbert and A. Chambon. Fribourg, Switzerland: University Press; Göttingen: Vandenhoeck & Ruprecht, 2003. 109 p. DS110.Q8 V384 2003; DS110.Q8 V384 2003.

A3.1397. *Khirbet Qumran et Ain Feshkha. 2: études d'anthropologie, de physique et de chimie; Studies of anthropology, physics and chemistry* / Jean-Baptiste Humbert and Jan Gunneweg. Fribourg: Universitätsverlag; Göttingen: Vandenhoeck & Rupprecht, 2003. 483 p. DS110.Q8 K557 2003; DS110.Q8 K557 2003.

A3.1398. *Out of the cave: a philosophical inquiry into the Dead Sea Scrolls research* / Edna Ullmann-Margalit. Cambridge: Harvard University Press, 2006. 167 p. BM175.Q6 U45 2006.

A3.1399. *Qumran through (real) time: a virtual reconstruction of Qumran and the Dead Sea Scrolls* / Robert R. Cargill. Piscataway, NJ: Gorgias Press, 2009. 259, 71 p. DS110.Q8 C37 2009.

Ramat Rahel

A3.1400. Ramat Rahel. http://www.jewishvirtuallibrary.org/jsource/Archaeology/Ramatrahel.html.

Ramla

A3.1401. Ramla: Arab Capital of the Province of Palestine. http://www.jewishvirtuallibrary.org/jsource/Archaeology/Ramla.html.

Rehov, tel

A3.1402. Tel Rehov. http://www.rehov.org/.

Rogem Hiri

A3.1403. Rogem Hiri: An Ancient Mysterious Construction. http://www.jewishvirtuallibrary.org/jsource/Archaeology/Rogem_Hiri.html.

Safi, tell es

A3.1404. Tell es-Safi Archaeological Project. http://faculty.biu.ac.il/~maeira/.

Samaria

A3.1405. *The archaeology of Israelite Samaria* / Ron E. Tappy. Atlanta: Scholars Press, 1992. 2 v. DS110.S3 T37 1992. Samaria (Shomron) is a mountainous region in northern Palestine, roughly corresponding to the northern West Bank. The name derives from the ancient city Samaria, the capital of the Kingdom of Israel.

A3.1406. *Highlands of many cultures: the southern Samaria survey: the sites* / Israel Finkelstein, Zvi Lederman, and Shlomo Bunimovitz. Tel Aviv: Institute of Archaeology of Tel Aviv University, 1997. 2 v. DS110.S3 F56 1997.

A3.1407. *Landscape and pattern: an archaeological survey of Samaria, 800 B.C.–636 A.D.* / Shimon Dar. Oxford: British Archaeological Reports, 1986. 2 v. DS110.S3 D3713 1986.

A3.1408. *The Manasseh hill country survey* / Adam Zertal. Leiden; Boston: Brill, 2004. DS110.S3 Z4713 2004.

A3.1409. *Seker Har Menasheh* / Adam Zerṭal. Tel Aviv: Miśrad ha-biṭaḥon; Ḥefah: Universiṭat Ḥefah, 1992. 2 v. DS110.S3 Z47 1992.

Sepphoris

A3.1410. *Leroy Waterman and the University of Michigan excavations at Sepphoris, 1931: "The scientific test of the spade"* / E. K. Gazda, E. A. Friedland, and L. Waterman. Ann Arbor: Kelsey Museum of Archaeology, 1997. Sepphoris (Tzippori, Diocesaraea, Saffuriya) is located in the central Galilee, 6 kilometers north-northwest of Nazareth, in modern-day Israel. The site holds a rich and diverse historical and architectural legacy that includes Assyrian, Hellenistic, Judean, Babylonian, Roman, Byzantine, Islamic, Crusader, Arabic, and Ottoman influences.

A3.1411. *Preliminary report of the University of Michigan excavations at Sepphoris, Palestine, in 1931* / Leroy Waterman. Ann Arbor: University of Michigan Press, 1937.

Sha'ar ha-Golan

A3.1412. Archaeological excavations at Sha`ar Hagolan-A Neolithic Art Center in the Jordan Valley, Israel. http://archaeology.huji.ac.il/golan/index.htm. Excavations at Sha'ar ha-Golan unearthed an 8,000-year-old village and artifacts that include the first pottery cooking pots found in the Land of Israel. This Neolithic village was inhabited by the people who abandoned their nomadic lifestyle in favor of permanent settlement, marking the shift from hunting and gathering to agriculture.

A3.1413. Sha'ar Hagolan: A Neolithic Village. http://www.jewishvirtuallibrary.org/jsource/Archaeology/shaar.html.

A3.1414. *Sha'ar Hagolan.* Oxford: Oxbow Books, 2002. Jerusalem: Institute of Archaeology, Hebrew University of Jerusalem: Israel Exploration Society. GN776.32.I75 S33 2002.

Shechem (Sichem)

A3.1415. Shechem (Nablus). http://www.jewishvirtuallibrary.org/jsource/Society_&_Culture/geo/Shechem.html. A Canaanite city mentioned in the Amarna letters and mentioned in the Hebrew Bible as an Israelite city of the tribe of Manasseh and the first capital of the Kingdom of Israel. Traditionally associated with Nablus, it is now identified with the site of Tell Balatah in Balata al-Balad in the West Bank.

A3.1416. *Shechem IV: the Persian-Hellenistic pottery of Shechem/Tell Balaṭah* / Nancy L. Lapp. Boston: American Schools of Oriental Research, 2008. 337 p. DS110.S543 L37 2008.

Shiloh

A3.1417. *Shiloh: the archaeology of a biblical site* / Israel Finkelstein, Shlomo Bunimovitz, and Zvi Lederman. Tel Aviv: Tel Aviv University, Institute of Archaeology, 1993. 399 p. DS110.S26 F56 1993. Shiloh was an ancient city mentioned in the Hebrew Bible. Its site is at modern Khirbet Seilun, south of ancient Tirzah and 16 kilometers north of the Israeli settlement of Beth El in the West Bank. It was the capital of Israel before the first temple was built in Jerusalem.

Shilo, tel

A3.1418. Tel Shilo. http://www.jewishvirtuallibrary.org/jsource/Archaeology/Telshilo.html.

Shoham

A3.1419. Shoham Bypass Site. http://www.jewishvirtuallibrary.org/jsource/Archaeology/Shoham.html.

Sultan, tell es- (Jericho)

A3.1420. *Tell es-Sultan/Gerico, alle soglie della prima urbanizzazione: il villaggio e la necropoli del Bronzo Antico I (3300–3000 B.C.)* / Lorenzo Nigro. Roma: Università di Roma "La Sapienza," 2005. 211 p. DS110.J4 N54 2005. The earliest settlement was located at the present-day Tell es-Sultan (or Sultan's Hill), a few kilometers from the current city.

Taanach

A3.1421. *Taanach/Tell Tacannek: 100 Jahre Forschungen zur Archäologie, zur Geschichte, zu den Fundobjekten und zu den Keilschrifttexten* / Siegfried Kreuzer. Frankfurt am Main: Lang, 2006. 317 p. DS110.T13 T33 2006. Taanach (Tanach, Tell Tacannek), in the Bible, royal city of Canaan, central ancient Palestine, the modern Tell Ti'innik.

Tabgha

A3.1422. Tabgha: Church of the Multiplication of the Loaves and the Fishes. http://www.jewishvirtuallibrary.org/jsource/Archaeology/Tabgha.html.

Tiberias

A3.1423. Crusader fortress of Tiberias. http://www.jewishvirtuallibrary.org/jsource/Archaeology/fortress_tiberias.html.

A3.1424. Tiberias excavations: Galei Kinneret Hotel. http://www.jewishvirtuallibrary.org/jsource/Archaeology/excavation_tiberias.html.

A3.1425. Tiberias: The Anchor Church. http://www.jewishvirtuallibrary.org/jsource/Archaeology/Anchor.html.

Timna

A3.1426. Timna: Valley of the Ancient Copper Mines. http://www.jewishvirtuallibrary.org/jsource/Archaeology/timna.html.

Vadum Iacob

A3.1427. Templar Castle of Vadum Iacob [Jacobs' ford]. http://vadumiacob.huji.ac.il/.

Wadi Arabah

A3.1428. *Crossing the rift: resources, settlements patterns and interactions in the Wadi Arabah* / Piotr Bienkowski and Katharina Galor. Oxford: Council for British Research in the Levant and Oxbow; Oakville: David Brown, 2005. 258 p. DS110.A683 C767 2005. Wadi Arabah (Aravah) Valley is a section of the Jordan Rift Valley running in a north-south direction from the southern end to the Sea of Galilee to the Dead Sea and the Gulf of Aqaba. It includes most of the border between Israel to the west and Jordan to the east.

A3.1429. *The southern Ghors and northeast 'Arabah archaeological survey* / B. MacDonald. Sheffield: J. R. Collis, Dept. of Archaeology and Prehistory, University of Sheffield, 1992. 290 p. DS153.3.M324 S68 1992.

A3.1430. *Trois hauts lieux de Judée* / Ernest-Marie Laperrousaz. Paris: Paris Méditerranée, 2001. 125 p. DS111.L37 2001.

A3.1431. *Wadi Araba in classical and late antiquity: an historical geography* / Andrew M. Smith. Oxford: Archaeopress, 2010. 141 p. DS110.A683 S45 2010.

Wadi Hamam

A3.1432. Wadi Hamam. http://archaeology.huji.ac.il/Hamam/Default.aspx; http://www.magdala-project.org/WP/?p=83&langswitch_lang=en.

Yavneh-Yam

A3.1433. Yavneh-Yam Archaeological Project. http://www.tau.ac.il/~yavneyam/viewer.htm; http://www.jewishvirtuallibrary.org/jsource/Judaism/walltoc.html.

Yin'am

A3.1434. *Tel Yin'am I: the late Bronze age: excavations at Tel Yin'am, 1976–1989* / Harold A. Liebowitz. Austin: Texas Archeological Research Laboratory, the University of Texas at Austin, 2003. 432 p. DS110.Y564 L54 2003. Yin'am, tell, in Lower Galilee, has been continually inhabited by people for thousands of years, from the Neolithic to the Roman Empire. First archaeological excavations were carried out here during the late 1970s. The valley drops to around 57 meters below sea level and has been identified with biblical Yavne'el, a southern border town of the Naphtali tribe. The tell features a comparatively small, roughly distinct circular mound ca. 85 meters in diameter and 7 meters high, together with a huge, imprecisely defined far-off settlement of yet uncertain size and shape. There has been human occupation here from the Neolithic period (7000 BCE) through the Early Byzantine period (third–sixth centuries CE), with gaps in occupation during the Early Bronze II to Late Bronze I inclusive (2900–1550 BCE) and the Hellenistic and Early Roman (fourth–first centuries BCE) periods.

Yodefat

A3.1435. Yodefat. http://www.jewishvirtuallibrary.org/jsource/Archaeology/Yodefat.html.

Zeitah

A3.1436. Zeitah Excavations. http://www.zeitah.net/.

Zippori

A3.1437. Zippori. http://www.jewishvirtuallibrary.org/jsource/Archaeology/zippori.html; http://faculty.biu.ac.il/~maeira/.

A3.1438. Zippori Reservoir. http://www.jewishvirtuallibrary.org/jsource/Archaeology/zippori1.html.

ITALY

Abruzzo

A3.1439. *L'Abruzzo e il Molise in età romana tra storia ed epigrafia* / Marco Buonocore. L'Aquila: Libreria Colacchi, 2002. 2 v. DG55.A27 B858 2002. Abruzzo is a region in central western Italy east of Rome. Skeletal remains provide evidence that

the area has been inhabited since the Neolithic era. The first mention of the region in Roman history occurs around 90 BCE during the Social War. It was also the site of an important fortress during Ceasar's Civil War in 49 BCE.

Acquarossa

A3.1440. *Acquarossa: results of excavations conducted by the Swedish Institute of Classical Studies at Rome and the Soprintendenza alle antichità dell'Etruria Meridionale.* Stockholm: Svenska institutet i Rom; Lund: P. Åströms förlag, 1981. DG12 .S8 v.38, v.1(1–2), 2(1–2), 3, 4, 5(1), 6(1–2), 7. Acquarossa is the site of an ancient Etruscan settlement in what is modern-day Viterbo, Etruria. The site was abandoned during the second half of the sixth century BCE.

Acqui Terme

A3.1441. *La raccolta archeologica di Augusto Scovazzi: contributo alla conoscenza dell'antica Aquae Statiellae* / Alberto Bacchetta and Marica Venturino Gambari. Genoa: De Ferrari, 2008. 158 p. DG70.A254 R33 2008. Located in northern Italy, in the province of Alessandria. During the Roman period, the city was famous for its hot springs and ancient baths.

Agrigento

A3.1442. *Agrigento: la necropoli paleocristiana sub divo* / Rosa Maria Bonacasa Carra. Roma: L'Erma di Bretschneider, 1995. 429, 36 p. DG70.A3 A34 1995. Agrigento was originally inhabited by Greek settlers from Gela around 580 BCE and was known as Akragas. It became one of the richest and most famous cities of the Greek Magna Graecia. In 406 BCE the city was conquered by the Carthaginians. This started a long history of disputes between the Carthaginians and the Roman Empire beginning during the First Punic War. The Romans were able to seize the city in 262 BCE; however, the city was recaptured by the Carthaginians in 255 BCE. During the Second Punic Wars the Carthaginians and Romans continued to fight over control of the area. The city was eventually conquered again by the Romans in 210 BCE, and following the death of Julius Ceasar in 44 BCE, all of the city's citizens were given Roman citizenship.

A3.1443. *La cultura del Medio Bronzo nell'agrigentino ed i rapporti con il mondo miceneo* / Giuseppe Castellana. Agrigento: Museo archeologico re-gionale-Agrigento, 2000. 291 p. DG70.A3 C27 2000.

Alba Longa

A3.1444. *Alba Longa, histoire d'une légende: recherches sur l'archéologie, la religion, les traditions de l'ancien Latium* / Alexandre Grandazzi. Rome: École française de Rome, 2008. 2 v. D5 .B4 fasc.336. Alba Longa is an ancient city located 12 miles southeast of Rome. The city was part of the Latium region in central western Italy. It was destroyed in the seventh century BCE during a war between the Roman king Tullus Hostilius and the Alba Longa ruler Gaius Cluilius.

A3.1445. *Alba Longa: mito, storia, archeologia: atti dell'incontro di studio Roma-Albano Laziale, 27–29 gennaio 1994* / Anna Pasqualini. Roma: Istituto italiano per la storia antica, 1996. 356 p. DG70.A533 A53 1996.

Albe

A3.1446. *Alba Fucens* / Fiorenzo Catalli. Roma: Istituto poligrafico e zecca dello Stato: Libraria dello Stato, 1992. 119 p. DG70.A53 C38 1992.

Alesa

A3.1447. *Alesa Arconidea: ricerche su un'antica città della Sicilia tirrenica* / Antonino Facella. Pisa, Italy: Edizioni della Normale, 2006. 432 p. DG70.A545 F33 2006.

Altino and Veneto

A3.1448. *Orizzonti del sacro: culti e santuari antichi in Altino e nel Veneto orientale: Venezia, 1–2 dicembre 1999* / Giovannella Cresci Marrone and Margherita Tirelli. Roma: Quasar, 2001. 380 p. DG70.A57 O75 2001. Altino is the modern-day site of Altinum, located in northern Italy. It was an ancient coastal town inhabited by the Veneti. The site shows signs of human settlement as early as the sixth millennium BCE. During the Roman era the region gained importance from the construction of two roads that passed through the town, Via Annia and Via Claudia Augusta. In 452 BCE, the city was captured and burned by Attila the Hun.

Angera

A3.1449. *Angera Romana: scavi nell'abitato, 1980–1986* / Gemma Sena Chiesa and Maria Paola Lavizzari

Pedrazzini. Roma: G. Bretschneider, 1995. 2 v. DG70.A583 A542 1995. Angera, a town in the Lombardy region of northern Italy; also known as Angleria during Roman times. It was an important lake port and road station for the Roman Empire.

A3.1450. *Angera romana: scavi nella necropoli 1970–1979* / Gemma Sena Chiesa. Roma: G. Bretschneider, 1985. 2 v. DG70.A585 A53 1985.

Arpi

A3.1451. *La tomba del vaso dei Niobidi di Arpi* / Ettore M. De Juliis. Bari: Edipuglia, 1992. 141 p. DG225. D3 D4 1992. Arpi was an ancient city located in Apulia, Italy. It was captured by the Romans in 213 BCE by Quintus Fabius Maximus.

Artimino

A3.1452. *Artimino: il guerriero di Prato Rosello: la tomba a pozzo del tumulo B* / Gabriella Poggesi. Firenze: Morgana edizioni, 1999. 109 p. DG70. A753 A754 1999.

Bagno di Romagna

A3.1453. *Bagno di Romagna nell'antichità: le terme l'insediamento, il territorio* / Jacopo Ortalli. Firenze: All'Insegna del giglio, 2004. 79, 2 p. DG975.B2117 O78 2004. Bagno di Romagua is located in the Emilia-Romagna region in central Italy and was founded by the Romans. It was destroyed in 540 by the Ostrogoths.

Basilicata

A3.1454. *Il sacro e l'acqua: culti indigeni in Basilicata.* Roma: Edizioni de Luca, 1998. 62 p. DG55.B36 S23 1998. Basilicata is a region in southern Italy, also known as Lucania. The earliest evidence of humans in the region dates to the late Palaeolithic Age. The earliest Greek settlers began to arrive in the eighth century BCE and established the settlement of Siri. Romans began to enter the region during the fourth century BCE, and after the conquest of Tarantothe, the area was fully incorporated into the Roman Empire.

Basta

A3.1455. *Basta (Vaste): antica città salentina tra Messapi, Romani, Bizantini e Normanni (sec. X a.C.–sec. XII d.C.)* / Salvatore Rausa. Lecce: Edizioni del Grifo, 2000. 198 p. DG70.B37 R38 2000.

Bedriacum

A3.1456. *Bedriacum: ricerche archeologiche a Calvatone.* Milano: Edizioni Et, 1996. DG70.16 B427 1996, v.1(1–3). Bedriacum, a village in northern Italy close to the town of Cremona. The Battles of Bedriacum were fought between the towns of Bedriacum and Cremona, during the year of the Four Emperors, 69 CE.

Bessa

A3.1457. Roman Gold Mine of Bessa. http://spazioinwind. libero.it/bessapark/english.htm.

Blanda

A3.1458. *Il mausoleo di Blanda Julia* / Gioacchino Francesco La Torre. Soveria Mannelli: Rubbettino, 2003. 134 p. DG70.B53 L327 2003.

Bologna

A3.1459. *Bologna romana* / Franco Bergonzoni and Giovanna Bonora. Bologna: Istituto per la storia di Bologna, 1976. DG70.B7 B. Bologna is the seventh most populated city in Italy and the largest of the Emilia-Romagna region of Northern Italy. The earliest inhabitants of Bologna date back to the ninth century BCE. Beginning in the seventh century BCE the Etruscans began to move in and influence the area. In the fourth century BCE, Bologna was captured by the Celtic tribe Boii. The Gauls and Etruscans lived peacefully together until 196 BCE, when they were conquered by the Romans and accepted into the Roman Empire. Bologna gained importance in 187 BCE with the construction of the Via Aemilia, which connected Bologna to Arezzo and Aquileia. In 88 BCE, the city was named a municipium and included many temples, bath houses, theatres, and an arena. During the reign of Claudius the city was badly damaged by fire but was later rebuilt by the Emperor Nero.

A3.1460. *La rocca imperiale di Bologna: archeologia romana del sito, assetto urbano, documenti medievali* / Jacopo Ortalli, Carlo De Angelis, and Paola Foschi. Bologna: presso la Deputazione di storia patria, 1989. 111 p. DG70.B7 O7724 1989.

Bolsena

A3.1461. *Il santuario del Pozzarello a Bolsena (scavi Gabrici 1904)* / Valeria Acconcia. Roma: G. Bretschneider, 2000. 193 p. DG70.V64 A3 2000. Bolsena is an ancient town that was situated

along the Via Cassia. According to Pliny the Elder the entire city was destroyed by fire caused by lightning.

Boscoreale

A3.1462. *Göttliche Fürsten in Boscoreale: der Festsaal in der Villa des P. Fannius Synistor* / Michael Pfrommer. Mainz am Rhein: P. von Zabern, 1993. 107, 16 p. DG975.B735 P47 1993. An ancient Roman town located in the province of Naples, at the base of Mount Vesuvius. It was famous for its aristocratic villas and frescoes, which were preserved by the eruption of Vesuvius in 79 CE.

A3.1463. *Il Tesoro di Boscoreale e il suo scopritore: la vera storia ricostruita sui documenti dell'epoca* / Antonio Cirillo and Angelandrea Casale. Pompei (Napoli): Associazione Amici di Pompei, 2004. 198 p. DG70.B75 C57 2004.

A3.1464. *The wall paintings from the Oecus of the Villa of Publius Fannius Synistor in Boscoreale* / Frank G. J. M. Müller. Amsterdam: J. C. Gieben, 1994. 156 p. ND2575.M86 1994.

Calabria

A3.1465. *Viabilità romana in Calabria* / Vincenzo Cicerelli. Cosenza: Orizzonti meridionali, 2006. 80 p. DG28.5.C53 2006. Known as Bruttium during antiquity, it is the southernmost region of the Italian peninsula. The original settlers of Calabria were Oscan-speaking tribes, mainly the Oenotrians and the Itali. During the sixth and fifth centuries BCE an influx of Greek settlers created the first Italian cities of Rhegion and Sybaris, which combined with other Greek settlements along the coast, formed the Magna Graecia. The Greeks were conquered in the third century BCE by the Brutti from the north, who established sovereignty and founded the new city of Cosenza. Later in the third century BCE, the Romans gained control of the area despite strong Bruttian resistance and incorporated it into the Roman Empire region of Regio Ill Luciana et Brutti.

A3.1466. *Villae romanae nell'ager Bruttius: il paesaggio rurale calabrese durante il dominio Romano* / Simona Accardo. Roma: L'Erma di Bretschneider, 2000. 237 p. DG975.16 A23 2000.

Calvatone

A3.1467. *Calvatone romana: un pozzo e il suo contesto: saggio nella zona nord dell'area di proprietà provinciale* / Gemma Sena Chiesa. Bologna: Cisalpino, 1997. 282 p. DG70.16 C353 1997. Calvatone is a municipality in the northern Italian region of Lombardy. It is famous for being the site of the Battles of Bedriacum.

Calvados

A3.1468. *Le Calvados* / Florence Delacampagne. Paris: Edition Académie des Inscriptions et Belles-Lettres, 1990. 166 p. DC611.167 D44 1990.

A3.1469. *Cremona e Bedriacum in età romana* / Giuliana M. Facchini, Lynn Passi Pitcher, and Marina Volonté. Milano: Edizioni Et, 1996. 2 v. DG70. C74 C74 1996.

Camarina

A3.1470. *La necropoli di Passo Marinaro a Camarina: campagne di scavo 1904–1909* / Paolo Orsi and Maria Teresa Lanza. Roma: Accademia nazionale dei Lincei, 1990. 228 p. DG11 .M6 v.4. Camarina, also known as Kamarina, is located on the southern coast of Italy. It was founded in 599 BCE by Syracuse, but destroyed in 552 BCE. The city was rebuilt in 461 BCE by the Geloans and then destroyed again by the Carthaginians in 405 BCE. Camarina was again rebuilt, this time by the Timoleons in 339 BCE, but by 258 BCE it was ruled by the Romans. The site was completely destroyed in CE 853, and few modern remains are visible above ground.

Campagna di Roma

A3.1471. *Ville dell'Agro romano* / Marina De Franceschini. Roma: L'Erma di Bretschneider, 2005. 564 p. DG55.28 D44 2005. Campagna di Roma is a low-lying area in the Lazio region surrounding Rome. It served as in important agricultural and residential area during the Ancient Roman period. It was eventually abandoned in the Middle Ages due to malaria outbreaks and insufficient water supplies.

Campanaio

A3.1472. Campanaio Project: A Geophysical Survey (Sicily). http://apollo5.bournemouth.ac.uk/sicily/.

Capua

A3.1473. *Capua romana: ricerche di prosopografia e storia sociale* / Gennaro D'Isanto. Roma: Edizioni Quasar, 1993. 343 p. CN537.28 D57 1993. Capua

is a city and commune in southern Italy. The city was inhabited by Etruscans as early as 600 BCE, and the city was named after the Etruscan word *Capeva*, meaning "City of Marshes." In the fifth century the city was captured by Samnites and in 343 BCE formed an alliance with the Roman Empire to assist in fending off conquerers. In 312 BCE, the Via Appia was constructed and connected Rome to Capua, significantly increasing its importance in the region.

A3.1474. *Capuanische Grabsteine: Untersuchungen zu den Grabsteinen römischer Freigelassener aus Capua* / Michael Eckert. Oxford: British Archaeological Reports, 1988. 286 p. DG70.25 E35 1988.

Carlino

A3.1475. *Late Roman glazed pottery in Carlino and in central-east Europe: production, function and distribution: Proceedings of the Second International Meeting of Archaeology in Carlino (March 2009)* / Chiara Magrini and Francesca Sbarra. Oxford: John and Erica Hedges, 2010. 140 p. NK3850 .I58 2009.

Carnuntum

A3.1476. *Roma sul Danubio: da Aquileia a Carnuntum lungo la via dell'ambra* / M. Buora e W. Jobst. Roma: L'Erma di Bretschneider, 2002. 308 p. DG70.A6 R66 2002. Carnuntum was a Roman army camp located in lower Austria. The earliest mention of Carnuntum in history occurred during the reign of Augustus in 6 CE. It also lied along the Amber Road trading route and served as an amber market.

Carteia

A3.1477. *La necropoli meridionale di Eraclea* / Giampiero Pianu. Roma: Quasar, 1990. DG55.M3 P5 1990, v.1. Carteia was a Phoenician town originally founded around 940 BCE. It is located in the south of Spain at the head of the Bay of Gibraltar. During the second and third centuries BCE the town served as the location for the wars between Carthage and the Roman Republic. It was conquered by the Romans in 190 BCE and prospered as an urban settlement into the medieval period.

Castellammare di Stabia

A3.1478. *Tesori di Stabiae: arte romana sepolta dal Vesuvio; Treasures from Stabiae: Roman art buried by Vesuvius* / Domenico Camardon and Antonio Ferrara. Castellammare di Stabia (Napoli): N. Longobardi, 2004. 158 p. DG70.S77 T47 2004. Castellammare di Stabia is a commune in southern Italy in the province of Naples. It was located next to the ancient Roman city of Stabiae and was destroyed by the eruption of Vesuvio in CE 79.

A3.1479. *Villa San Marco a Stabia* / Alix Barbet and Paola Miniero. Napoli: Centre Jean Bérard; Roma: École Française de Rome; Pompei: Soprintendenza archeologica di Pompei, 1999. 3 v. NA327.C37 V55 1999.

Cavallino

A3.1480. *Cavallino.* Galatina: Congedo, 1979. DG70.C34 C38.

Chersonae

A3.1481. *The study of ancient territories: Chersonesos & Metaponto: 2003 field report.* Austin, TX: Institute of Classical Archaeology, The University of Texas at Austin, 2003. 88 p. DK508.95.C544 S78 2003.

A3.1482. *The study of ancient territories: Chersonesos and Metaponto: 2004 annual report* / Joseph Coleman Carter. Austin, TX: Institute of Classical Archaeology; Oxford: Oxbow distributor, 2006. 90 p. DK508.95.C54 S78 2004.

Comacchio

A3.1483. Comacchio wreck. http://www2.rgzm.de/navis/ships/Ship050/TheComacchioWreck.htm.

Cosenza

A3.1484. *Sibari IV i.e. quatro: relazione preliminare della campagna di Scavo, Stombi, Parco del Cavallo, Prolungamento Strada, Casa Bianca, 1972* / Roma: Accademia nazionale dei Lincei, 1974. 570, 8 p. DG70.S52 S54; DG70.S52 S54. Cosenza is situated in the Calabria region of southern Italy. It originally served as the capital of the Italic tribe of Bruttii and was the site of the Battle of Pandosia. It would later gain significance under Emperor Augustus as a stop along the via Popilia, which connected Calabria to Sicily.

Cosa

A3.1485. *Cosa: the Italian sigillata* / Maria Teresa Marabini Moevs. Ann Arbor: Published for the

American Academy in Rome by the University of Michigan Press, 2006. 170, 97 p. DG70.C63 M327 2006. Cosa was founded in 273 BCE in southwestern Tuscany. It was previously the site of the Etruscan colony of Cusi or Cosia. Following several wars in the area during the third century BCE, the town became prosperous until the 60s BCE, when it was vandalized. The town was rebuilt under the rule of Augustus. By 416 BCE, according to the poet Rutilius Claudius Namatianus, Cosa was deserted and in ruins.

A3.1486. *Cosa: the black-glaze pottery 2* / Ann Reynolds Scott. Ann Arbor: University of Michigan Press, 2008. 221, 63 p. DG70.C63 S26 2008.

A3.1487. *Cosa III: the buildings of the forum: colony, municipium, and village* / Frank Edward Brown, Emeline Hill Richardson, and L. Richardson, Jr. University Park: Published for the American Academy in Rome by Pennsylvania State University Press, 1993. 298, 115 p. DG12 .A575 v.37.

A3.1488. *Cosa IV: the houses* / Vincent J. Bruno and Russell T. Scott. University Park: American Academy in Rome by the Pennsylvania State University Press, 1993. 211 p. DG12.A575 v.38.

A3.1489. *Cosa V: an intertmittent town, excavations 1991–1997* / Elizabeth Fentress. Ann Arbor: Published for the American Academy in Rome by The University of Michigan Press, 2003. 400 p. DG70. C63 F46 2003.

A3.1490. *The Roman port and fishery of Cosa: a short guide; Il porto romano e la peschiera di Cosa: guida breve* / Anna Marguerite McCann. Rome: American Academy in Rome, 2002. 78 p. DG70. C63 M34 2002.

Cumae

A3.1491. *Cuma: le fortificazioni.* Napoli: s.n., 2005. DG70. C9 C86 2005. 2 v. Cumae was the first ancient Greek settlement on the Italian mainland. It was founded as early as the eighth century BCE along the Tyrrhenian Sea in Campania, Italy. The Cumaean alphabet was adopted first by the Etruscans, followed by the Romans, and it eventually became the Latin alphabet. Greek influence over Cumae ended in 421 BCE when the Oscans conquered the city. It fell under Roman rule in 338 BCE and was granted partial citizenship along with Capua.

A3.1492. *Cuma: studi sulla necropoli: scavi Stevens 1878–1896* / Nazarena Valenza Mele, Carlo Rescigno; con contributi di Nadia Barrella, Valentino Nizzo, Rosa Delli Paoli, Arianna Marchesano; prefazione di Fausto Zevi. Roma: L'Erma di Bretschneider, 2010. 388 p. + CD-ROM. DG70. C9 V35 2010.

Dorgali

A3.1493. *Dorgali: monumenti antichi* / Maria Rosaria Manunza. Oristano: SÀlvure, 1995. 231 p. DG975. D75 M368 1995.

Etruria

A3.1494. Inland Etruria and the Etruscan Nation. http://www.larth.it/pages_eng/land.htm.

Forum Novum

A3.1495. *Ager Foronovanus I: IGM 138 III SO / 144 IV NO* / Flaminia Verga. Firenze: L. S. Olschki, 2006. 119 p. DG431 .F63 v.44. Forum Novum was an ancient Roman foundation situated in the modern-day commune of Torri in Sabina. It originated as a forum or market during the Roman Republic period. By the first century CE it had been given the title of municipium. Forum Novum continued to function through the imperial period and also served as a market as late as the fourth century.

Forum Sempronii

A3.1496. *Domus di Forum Sempronii: decorazione e arredo* / Mario Luni. Roma: L'Erma di Bretschneider, 2007. 159 p. DG70.F725 D66 2007. An ancient roman town located east of Fossombrone and 164 miles from Rome. It was elevated to the rank of city hall during the first century BCE and flourished throughout the Middle Imperial era. The town was destroyed by the Goths in 409 CE.

Geridu

A3.1497. *Geridu: archeologia e storia di un villaggio medievale in Sardegna* / Marco Milanese. Sassari: C. Delfino, 2001. 87 p. DG975.G366 G47 2001.

Graviscae

A3.1498. *La ceramica comune* / Barbara Gori and Tiziana Pierini. Bari: Edipuglia, 2001. 2 v. DG70.G73 G67 2001. Graviscae, also known as Gravisca, is the port of the Etruscan city of Tarquinii. It was incorporated into the Roman colonies in 181 BCE.

Herculaneum

A3.1499. *The ancient theatre of Herculaneum* / Mario Pagano and Alfredo Balasco; translation, Colum Fordham. Naples: Electa Napoli, 2000. 111 p. DG70.H5 P34 2000. Herculaneum was an ancient Roman town in the Italian region of Campania. The area may have been settled as early as the sixth century BCE by Samnite tribes. The town was later influenced by the Greeks and established as a trading post due to its proximity to the Gulf of Naples. In the fourth century BCE, Samnites once again gained control of the region. It remained under Samnite control until 89 BCE, when it became a Roman municipium. In 79 CE, Herculaneum was destroyed by the eruption of Mount Vesuvius.

A3.1500. *La Casa dei Cervi a Herculanum* / Tran Tam Tinh. Roma: G. Bretschneider, 1988. 168, 137 p. DG 70.H5 T73 1988.

A3.1501. *La casa del colonnato tuscanico ad Ercolano* / Giuseppina Cerulli Irelli; con una appendice sulle monete di Enrica Pozzi Paolini. Napoli: distribuzione in esclusiva G. Macchiaroli, 1974 . 136, 59 p. DG70.H5 C38.

A3.1502. *Case, abitanti e culti di Ercolano* / Virgilio Catalano. Roma: Bardi, 2002. 24 248 p. DG70.H5 C34 2002.

A3.1503. *Dallo scavo di Ercolano allo svolgimento dei papiri: scritti e documenti inediti* / Amedeo Maiuri and Mario Capasso. Napoli: Ferraro, 1991. 77 p. DG70.H5 M165 1991.

A3.1504. *Ercolano 1738–1988: 250 anni di ricerca archeologica: atti del Convengo Internazionale Ravello-Ercolano-Napoli-Pompei, 30 ottobre–5 novembre 1988* / Luisa Franchi dell'Orto. Roma: L'Erma di Bretschneider, 1993. 692 p. DG70.H5 C66 1993.

A3.1505. *Ercolano e la cultura europea tra Settecento e Novecento* / Sergio Pace. Napoli: Electa, 2000. 133 p. DG70.H5 P334 2000.

A3.1506. *I fuggiaschi di Ercolano: paleobiologia delle vittime dell'eruzione vesuviana del 79 d.C* / Luigi Capasso. Roma: L'Erma di Bretschneider, 2001. 1089 p. DG70.H5 C36 2001.

A3.1507. *Herculaneum: past and future* / Andrew Wallace-Hadrill. New York: Frances Lincoln; Los Altos, CA: In association with the Packard Humanities Institute, 2011. 351 p. DG70.H5 W35 2011.

A3.1508. *Letter and report on the discoveries at Herculaneum* / Johann Joachim Winckelmann; introduction, translation, and commentary by Carol C. Mattusch. Los Angeles: J. Paul Getty Museum, 2011. 230 p. N5775 .W513 2011.

A3.1509. *Les lieux de métier: boutiques et ateliers d'Herculanum* / Nicolas Monteix. Rome: École française de Rome, 2010. 478 p. D5 .B4 fasc.344.

A3.1510. *Ercolano: i nuovi scavi (1927–1958)* / Amedeo Maiuri. Roma: Istituto poligrafico dello Stato, Libreria della Stato, 1958. 913.371 H416M.2.

A3.1511. *Rediscovering antiquity: Karl Weber and the excavation of Herculaneum, Pompeii, and Stabiae* / Christopher Charles Parslow. Cambridge; New York: Cambridge University Press, 1995. 394 p. DG70.P7 P37 1995.

A3.1512. *Verschüttet vom Vesuv: die letzten Stunden von Herculaneum* / Josef Mühlenbrock and Dieter Richter. Mainz am Rhein: P. von Zabern, 2005. 355 p. DG70.H5 V477 2004.

A3.1513. *Vesuvio 79 A.D: vita e morte ad Ercolano, mostra fotografica e di reperti archeologici, Napoli, Museo di antropologia, 13 maggio–13 luglio 2002* / Pier Paolo Petrone e Francesco Fedele. Napoli: Fridericiana editrice univerisitaria, 2002. 121 p. DG70.H5 V47 2002.

Himera

A3.1514. *Himera, III* / V. Alliata. Roma: L'Erma di Bretschneider, 1988. 2 v. DG55.S5 H56 1988. Himera was an ancient Greek city located along the northern coast of Sicily. It was the earliest Greek settlement on the north side of the island and was established as early as 648 BCE. In 480 BCE the city was the site of the Battle of Himera, one of the more important battles of the Greek-Punic wars, where Greek forces defeated the Carthaginians. They fought once again in 409 BCE, leading to the complete destruction of Himera after the Carthaginian army conquered the Greek forces. Himera was never rebuilt; however, some citizens were allowed to return to the region and established the town of Thermae.

La Castellina

A3.1515. *Italie: La Castellina.* http://www.diplomatie.gouv.fr/fr/enjeux-internationaux/echanges-scientifiques-recherche/archeologie-sciences-humaines-et/les-carnets-d-archeologie/europe-maghreb/italie-la-castellina/.

La Giostra

A3.1516. *Excavations at La Giostra: a mid-Republican fortress outside Rome* / Mette Moltesen and J. Rasmus Brandt. Rome: L'Erma di Bretschneider, 1994. 184 p. DG70.L28 M64 1994.

Lanuvio

A3.1517. *Lanuvium: avanzi di edifici antichi, negli appunti di R. Lanciani* / Manlio Lilli. Roma: L'Erma di

Bretschneider, 2001. 88 p. DG70.L35 L55 2001. Lanuvio is a commune located 30 kilometers southeast of Rome in the Latium region. It was the site of the ancient city of Lanuvium. The earliest evidence of settlement in the area dates back to the ninth century BCE. After fighting several wars with Rome, Lanuvium was eventually defeated in 338 BCE and was later given Roman citizenship.

Lavinium

A3.1518. *Virgile: l'antiquité vue par un poète: les fouilles de Lavinium: la fondation de Rome: l'Enéide dans les palais italiens.* Dijon: Archéologie, 1982. 90 p. CC3 .H478 no.68.

Lazio

A3.1519. *Il Lazio di Thomas Ashby, 1891–1930.* Roma: Fratelli Palombi, 1994. DG52 .A842 1994. A region in central Italy named after the flat lands of the Roman Campagna. The area was multi-ethnic and included Etruscans and Italics, including the Latini. Lazio was included in the eleven regions that Augustus brought together to create a unified Italia.

A3.1520. *Il sistema degli antichi acquedotti romani* / Antonio Mucci. Roma: Palombi, 1995. 48 p. TD398 .M822 1995.

Magara Hyblaea

A3.1521. *Un archeologo nel suo tempo: Georges Vallet* / Jacques Nobécourt. Siracusa: Ediprint, 1991. 246 p. CC115.V35 N63 1991. An ancient Greek colony on the southern coast of Sicily. According to the historian Thucydides it was most likely founded in the eighth century BCE. Not much is known about Megera until its destruction in 483 BCE by Gelon of Syracuse, who conquered the city and sold most of the population into slavery.

Marzabotto

A3.1522. *Marzabotto: recherches sur l'Insula V, 3* / sous Françoise-Hélène Massa-Pairault. Rome: École Française de Rome, Palais Farnèse, 1997. 257 p. DG975.M45 M379 1997. Marzabotto is a small town in the Emilia-Romagna region of northern Italy. It is the site of a fifth century Etruscan town that was situated along the Villa Aria.

Messapii

A3.1523. *Recherches sur les Messapiens: IV–IIe siècle avant J.-C.* / Jean-Luc Lamboley. Rome: École Française de Rome, 1996. 661 p. D5 .B4 fasc.292; D5 .B4 fasc.292. Messapii, also known as Messapians, were an Indo-European tribe that settled in the southeastern peninsula of Italy. They most likely migrated from Illyria, and their language was Messapian. They established many towns in the area, as early as the eighth century BCE, including Rudiae, Brundisium, and Hyria. The Messapii were eventually defeated by the Romans and incorporated into the Latin- and Greek-speaking population.

Metapontum

A3.1524. *La ceramica geometrica bicroma dell'Incoronata di Metaponto: scavi 1974–1995* / Marina Castoldi; con un contributo di Silvia Bruni e Vittoria Guglielmi. Oxford: John and Erica Hedges, 2006. 113 p. NK4104.M48 C37 2006. Metapontum was a major city of the Magna Graecia in southern Italy. Its exact origins are unknown but most likely started as an ancient Greek Archaean society.

A3.1525. *Discovering the Greek countryside at Metaponto* / Joseph Coleman Carter. Ann Arbor: University of Michigan, 2006. 287 p. DG70.M52 C373 2006.

A3.1526. *Excavations in the territory, Metaponto, 1980* / Joseph C. Carter. Austin: University of Texas at Austin, 1980. 27 p. DF261.M46 C37 1980.

A3.1527. *Metaponto* / D. Adamesteanu, D. Mertens, and F. D'Andria. Roma: Accademia nazionale dei Lincei, 1980. 2 v. DF261.M46 A32 1980.

A3.1528. *Metaponto ellenistico-romana: problemi topografici* / Maria Teresa Giannotta. Galatina: Congedo, 1980. 150 p. DG70.M53 G52 1980.

A3.1529. *Reflections from the dead: the metal finds from the Pantanello necropolis at Metaponto: a comprehensive study of grave goods from the 5th to the 3rd centuries B.C.* / by Marianne Proházka. 2 ed. Jonsered: Paul Åströms Förlag, 1995. 256, 53 p. DG70.M52 P76 1995.

A3.1530. *The Territory of Metaponto 1981–1982.* Austin: University of Texas at Austin, 1983. 52 p. DG70. M48 T47 1983.

Minturno

A3.1531. *Excavations at Minturnae* / Jotham Johnson. Philadelphia: University Museum by the University of Pennsylvania Press, 1933–1935. 2 v. DG70.M6 P4, v.1, 2; 913.456 P387, v.1, 2. Minturno is a city and commune in western Italy

that is situated along the Via Appia. It was one of the three towns that fought with Rome in 314 BCE, along with Ausona and Vescia. In 296 BCE it was named a colony.

Morzia

A3.1532. *La Statua marmorea di Mozia e la scultura di stile severo in Sicilia: atti della Giornata di studio, Marsala, 1 giugno 1986* / Nicola Bonacasa e Antonino Buttitta. Roma: L'Erma di Bretschneider, 1988. 150, 48 p. DG70.M67 S83 1988.

Motya

A3.1533. *Mozia* / Gaia Servadio. Palermo: D. Flaccovio, 2003. 303, 8 p. DG70.M67 .S4716 2003. Motya was an ancient city located on a small island off the western coast of Sicily. It was founded around the eighth century BCE by the Phoenicians but later became an important Carthaginian city and military stronghold. In 397 BCE, Dionysius I of Syracuse invaded the Carthaginian territories of Sicily and captured Motya, assisted by the use of the catapult for the first time. The following spring the Carthaginian general Himilcon returned to Motya and recovered possession of the city but soon after established a new city in nearby Lilybaeum. By the time of the First Punic wars, when the Romans conquered Sicily, Motya had lost most of its significance and was mainly inhabited by fishermen.

Mugello Valley

A3.1534. Mugello Valley Archaeological Project and Poggio Colla Field School. http://smu.edu/poggio/.

Muro Leccese

A3.1535. *Muro Leccese: sondages sur la fortification nord* / Jean-Luc Lamboley. Rome: École française de Rome, 1999. 116, 4 p. UG430.M85 L36 1999.

Musarna

A3.1536. *Musarna 2: les bains hellénistiques* / Henri Broise and Vincent Jolivet. Rome: École française de Rome, 2004. 374, 5 p. DG70.M87 M983 2004. Musarna is an Etruscan settlement located in the ancient city of Viterbo, in the Lazio region of Central Italy.

Naples

A3.1537. *Naples, from Roman town to city-state: an archaeological perspective* / Paul Arthur. London: Published by the British School at Rome, London in association with the Dipartimento di Beni Culturali, Università degli Studi di Lecce, 2002. 197 p. DG845 .A78 2002.

Narce

A3.1538. *A Faliscan town in South Etruria: excavations at Narce 1966–71* / T. W. Potter. London: British School at Rome, 1976. 331, 12 p. DG70.N37 P67. Narce is a settlement located 5 kilometers from modern-day Civita Castellana. It was inhabited as early as the second millennium until the third century BCE. During the Bronze Age the residents lived in huts in the low areas of the city, along the banks of the Treia River. During the Villanovan Iron Age inhabitants moved to the higher areas in the north and south and used the lower area exclusively for burials. Once the Romans incorporated the region in 241 BCE, most of the residents had left the city.

Nemi Lake

A3.1539. *Nemi, status quo: recent research at Nemi and the Sanctuary of Diana* / J. Rasmus Brandt, Anne-Marie Leander Touati, and Jan Zahle. Roma: L'Erma di Bretschneider, 2000. 194 p. DG70.N45 N46 2000. Nemi Lake is a small volcanic lake located in the Lazio region of Italy. It is the site of two sunken Roman ships built by Emperor Caligula in the first century CE. The ships are significant for both their size and the technological advances they displayed.

A3.1540. *A Roman villa by Lake Nemi: the finds: the Nordic excavations by Lake Nemi, loc. S. Maria (1998–2002)* / Mette Moltesen and Birte Poulsen. Roma: Quasar, 2010. 655 p. DG70.N45 R66 2010.

Oderzo

A3.1541. *Oderzo, forma urbis: saggio di topografica antica* / Maria Stella Busana. Roma: L'Erma di Bretschneider, 1996, 1995. 153 p. DG70.O33 B87 1996. Oderzo is a small town and commune in the northeast of Italy, 66 kilometers from Venice. It has been settled from at least the Iron Age. The Veneti occupied the site and are responsible for giving it its name. They remained close allies to Rome throughout their history, and the citizens were eventually romanized. After the completion

of the Via Postumia in 148 BCE, Oderzo gained importance as a significant crossroad. In 48 BCE the town was given the title of municipium.

Ostia

A3.1542. *Edificio con opus sectile fuori Porta Marina* / Giovanni Becatti. Roma: Istituto poligrafico dello Stato, 1969. 236, 67 p. DG70 O8 S3 v.6. According to local inscriptions Ostia was founded in the seventh century BCE by Ancus Marcius and may be Rome's first colonia. However, the oldest archaeological evidence found dates back to the fourth century BCE. Several ancient buildings still stand at the site, with the oldest dating back to the third century BCE.

A3.1543. *I Fasti Ostienses: documento della storia di Ostia* / Barbara Bargagli and Christana Grosso. Rome: Ministero per i beni culturali e ambientali, Soprintendenza archeologica di Ostia, 1997. 77 p. DG202 .B37 1997.

A3.1544. *Guide to the excavations of Ostia antica: with a section about the Renaissance Borgo* / Sonia Gallico. Roma: ATS italia editrice, 2000. 73, 7 p. DG70.O8 G28 2000.

A3.1545. *The mills-bakeries of Ostia: description and interpretation* / Jan Theo Bakker. Amsterdam: J. C. Gieben, 1999. 217, 39 p. TS2130 .B35 1999.

A3.1546. *Nuove testimonianze sul commercio dei marmi in età imperiale* / Paola Baccini Leotardi. Roma: Istituto italiano per la storia antica, 1989. 136, 138 p. DG70.O8 B33 1989.

A3.1547. *Ostia, port de la Rome antique* / Jacques Chamay. Genève: Georg éditeur: Ville de Genève, Dép. des affaires culturelles: Musée d'art et d'histoire Genève, 2001. 131 p. DG70.O8 C4 2001.

A3.1548. *Ostiensium marmorum decus et decor: studi architettonici, decorativi e archeometrici* / Patrizio Pensabene. Roma: L'Erma di Bretschneider, 2007. 715, 179 p. NA327.O78 P46 2007.

A3.1549. *'Roman Ostia' revisited: archaeological and historical papers in memory of Russell Meiggs* / Anna Gallina Zevi and Amanda Claridge. London: British School at Rome, in collaboration with the Soprintendenza archeologica di Ostia, 1996. 307 p. DG70.O8 R66 1996.

A3.1550. *Le terme del foro o di Gavio Massimo* / Pietro Cicerchia and Alfredo Marinucci. Roma: Istituto poligrafico e zecca dello Stato, Libreria, 1992. 286, 159 p. DG70 O8 S3 v.11.

Paestum

A3.1551. *Paestum*. Taranto: Istituto per la storia e l'archeologia della Magna Grecia, 1987. 61, 6 p. DG70.P3 M43 1987. Paestum is a Graeco-Roman city, originally known as Poseidonia, located in the Campania region of Italy. It was founded in the seventh century BCE by Greek settlers from Sybaris. The first mention of the city is in the fifth century BCE, when according to the historian Strabo, the city was conquered by the Luciani. Architectural evidence shows that the Greek and Oscan cultures were able to live among one another for several centuries. In 273 BCE the city was renamed Paestum, after the Romans defeated the Poseidonians' ally Pyrrhus.

A3.1552. *Paestum ad Aquileia: Aquileia, Museo civico del Patriarcato, 29 agosto–30 novembre 2003* / Maurizio Buora. Trieste: Editreg, 2003. 143 p. DG70.P3 P32 2003.

A3.1553. *Paestum e Roma quadrata: ricerche sullo spazio augurale* / Elio De Magistris. Napoli: Guida, 2007. 235 p. DG70.P3 D43 2007.

A3.1554. *Paestum: a reasoned archaeological itinerary* / Ernesto De Carolis. Torre del Greco (Na): T&M, 2002. 74 p. DG70.P3 D4 2002.

A3.1555. *The Poseidonian Chora: archaic Greeks in the Italic hinterland* / Mikels Skele. Oxford: Archaeopress, 2002. 115 p. DG70.P3 S44 2002.

A3.1556. *Poseidonia-Paestum* / recherches publiées par l'Istituto centrale per il catalogo e la documentazione. Rome: École Françaisee de Rome, 1980. NA335 .P67, v.1–3, 4.

A3.1557. *The Sanctuary of Santa Venera at Paestum* / J. G. Pedley. Roma: Bretschneider Editore, 1993. 2 v. DG70.P3 S362 1993.

Percorsi di Pietra

A3.1558. Percorsi di Pietra. http://www.provincia.fi.it/territorio/archivio-notizie/leggi/a/percorsi-di-pietra/?cHash=2c1f2108223d420ca0d61d9d6f047378.

Piazza Armerina

A3.1559. *Vizi, costumi e peccati nelle ville romane di Sicilia: il Casale di Piazza Armerina* / Liborio Centonze. Palermo: W. Farina, 1999. 251 p. DG70. P52 C46 1999.

Piemonte

A3.1560. *La città romana in Piemonte: realtà e simbologia della forma urbis nella Cisalpina Occidentale* / Elisa Panero. Cavallermaggiore: Gribaudo, 2000. 316 p. NA9204.P5 P3 2000. Piemonte is a region in the northwest of Italy, located at the foothills of the Alps. Its earliest inhabitants were Celtic-Ligurian tribes. By 220 BCE the Romans

controlled the region and had founded several Roman colonies, such as Augusta Taurinorum and Eporedia.

Pisa

A3.1561. Ancient Ships of Pisa. http://www.behindthetower.com/en/pisa/sights/ancientshipsofpisa.

A3.1562. Nautical Pompeii found in Pisa. http://www.thedailybeast.com/newsweek/2007/11/01/a-maritime-pompeii.html.

Poggio Gramignato

A3.1563. *A Roman villa and a late Roman infant cemetery: excavation at Poggio Gramignano, Lugnano in Teverina* / David Soren and Noelle Soren. Roma: L'Erma di Bretschneider, 1999. 687, 374 p. NA324 .R665 1999.

Pompeii

A3.1564. Anglo-American Project in Pompeii. http://www.rebecca-east.com/workondigs.html. Pompeii is a Roman city in the Campania region of Italy, near modern-day Naples. The city was founded between the seventh and sixth centuries BCE by the Oscans but was later conquered by the Cumae and Etruscans. The Samnites conquered the Campania region in the fifth century BCE, and Pompeii adopted their architectural rules. Following the Samnite Wars of the fourth century BCE, Pompeii was given the status of Roman socium and remained loyal to Rome during the Second Punic War. By 80 BCE the city was a Roman colony and given the name Colonia Cornelia Veneria Pompeianorum. In 79 CE the entire city was covered in 2 to 6 meters of ash and pumice from a volcanic eruption at Mount Vesuvius. The ash encapsulated the city and preserved a frozen moment of first-century Roman life.

A3.1565. *Antiquity recovered: the legacy of Pompeii and Herculaneum* / Victoria C. Gardner Coates and Jon L. Seydl. Los Angeles: J. Paul Getty Museum, 2007. 296 p. DG70.P7 A73 2007; DG70.P7 A73 2007.

A3.1566. *Archeobotanica: reperti vegetali da Pompei e dal territorio vesuviano* / Michele Borgongino. Roma: L'Erma di Bretschneider, 2006. 232 p. QE945.I8 B67 2006.

A3.1567. *Archeologia pompeiana: Pompei* / Umberto Pappalardo. Napoli: L'orientale, 2007. 243 p. + CD-ROM. DG70.P7 P358 2007.

A3.1568. *Art and history of Pompeii: 170 color photographs, 20 reconstructions of the city as it was 2000 years ago* / Stefano Giuntoli. Florence, Italy: Bonechi, 1989. 123 p. DG70.P7 G58 1989.

A3.1569. *Cabinet secret du Musee royal de Naples: peintures, bronzes et statues erotiques* / Stanislas Marie Cesar Famin. Paris: Editions Joelle, 1995. 158, 60 p. Erotic art of Pompeii and Herculaneum. N8217.E6 F36 1995.

A3.1570. *Casa degli Amorini dorati (VI 16,7.38)* / Florian Seiler; Photographien von Peter Grunwald und Wilhelm Gut; Wandgraphiken von Heide Diederichs und Judith Sellers. München: Hirmer, 1992. 149 p. DG70.P7 H34 1984 Bd.5.

A3.1571. *Casa dei Cei (I 6, 15)* / Dorothea Michel. München: Hirmer Verlag, 1990. 95, 58 p. DG70.P7 H34 1984 Bd.3.

A3.1572. *Die Casa del Fauno in Pompeji (VI 12)* / Adolf Hoffmann. Wiesbaden: Reichert, 2009. + 1 DVD-ROM. DG70.P7 H64 2009.

A3.1573. *Casa del Granduca (VII 4, 56) und Casa dei Capitelli figurati (VII 4, 57)* / Margareta Staub Gierow. München: Hirmer, 1994. 84, 50 p. DG70.P7 H34 1984 Bd.7.

A3.1574. *Casa del Labirinto: (VI, 11, 8–10)* / Volker Michael Strocka. München: Hirmer, 1991. 143, 92 p. DG70.P7 H34 1984 Bd.4.

A3.1575. *Casa delle Nozze d'Argento: (V 2, i)* / Wolfgang Ehrhardt; Photographien von Peter Grunwald und Johannes Kramer; Wandgraphiken von Wulfhild Aulmann, Lisa Bauer, Michael Sohn; Architekturzeichnungen von Athanassios Tsingas. München: Hirmer Verlag, 2004. DG70.P7 H34 1984 Bd.12.

A3.1576. *La casa di Giulio Polibio.* Tokyo: Centro studi arti figurative, Univeristà di Tokio, 2001. 2 v. DG70.P7 C28 2001.

A3.1577. *La ceramica invetriata in area vesuviana* / Emanuela Di Gioia. Roma: L'Erma di Bretschneider, 2006. 150 p. NK3850 .D54 2006.

A3.1578. *Cities of Roman Italy: Pompeii, Herculaneum and Ostia* / Guy de la Bédoyère. London: Bristol Classical Press, 2010. 123 p. DG31 .D44 2010.

A3.1579. *Contributi di archeologia vesuviana.* Roma: L'Erma di Bretschneider, 2006. DG70.P7 C6265 2006, v.1–3.

A3.1580. *Giornale degli scavi di Pompei* / Paola Poli Capri. Rome: s.n., 1997. 2 v. DG70.P7 P66216 1997.

A3.1581. *Ghosts of Vesuvius: a new look at the last days of Pompeii, how towers fall, and other strange connections* / Charles Pellegrino. New York: W. Morrow, 2004. 489 p. DG70.P7 P44 2004.

A3.1582. *Der Isis-Tempel in Pompeji* / Peter Hoffmann. Münster: Lit, 1993. 270 p. DG70.P7 H644 1993.

A3.1583. *The making of Pompeii: studies in the history and urban development of an ancient town* / Steven J.

R. Ellis. Portsmouth: Journal of Roman Archaeology 2011. 196 p. DG70.P7 M274 2011.

A3.1584. *Menander: la Casa del Menandro di Pompei* / Grete Stefani. Milano: Electa, 2003. 229 p. DG70.P7 M58 2003.

A3.1585. *Miscellanea pompeiana.* Pompei: Associazione internazionale amici di Pompei, 2007. 200 p. DG70.P7 M62 2007.

A3.1586. *Misteri svelati: immagini, forme e riti misteriosi a Pompei, Paestum e in Magna Grecia* / Lello Capaldo. Napoli: F. Fiorentino, 1994. 146 p. BF1999 .C362 1994.

A3.1587. *Museo secreto del arte erótico de Pompeya y Herculano* / Louis Barrel. Mexico: Frente de Afirmacion Hispanista, 1995. 303 p. Desk N8217.E6 B3718 1995.

A3.1588. *Neapolis: progetto-sistema per la valorizzazione integrale delle risorse ambientali e artistiche dell'area vesuviana* / Ministero per i beni culturali e ambientali, Soprintendenza archeologica di Pompei. Roma: L'Erma di Bretschneider, 1994. 3 v. DG70.P7 N426 1994.

A3.1589. *Nuove ricerche archeologiche nell'area vesuviana (scavi 2003–2006): atti del convegno internazionale, Roma, 1–3 febbraio 2007* / Pietro Giovanni Guzzo and Maria Paola Guidobaldi. Roma: L'Erma di Bretschneider, 2008. 578 p. DG70.P7 .N87 2008.

A3.1590. *Pitture erotiche delle Terme Suburbane di Pompei* / Luciana Jacobelli. Roma: L'Erma di Bretschneider, 1995. 132 p. ND2575.J326 1995.

A3.1591. *Pompei 1748–1980: i tempi della documentazione* / a cura dell'Istituto centrale per il catalogo e la documentazione; con la collaborazione della Soprintendenza archeologica delle provincie di Napoli e di Caserta e della Soprintendenza archeologica di Roma. Roma: Multigrafica Editrice, 1981. 210, 4 p. DG70.P7 P649.

A3.1592. *Pompei e la valle del Sarno in epoca preromana: la cultura delle tombe a Fossa* / Marisa dé Spagnolis. Roma: L'Erma di Bretschneider, 2001. 183 p. DG70.P7 C626 2001.

A3.1593. *Pompei ed Ercolano: (selezione di lettere e documenti)* / Paola Poli Capri. Roma: H. Van der Poel, 2006. 4 v. DG70.P7 P655 2006, v.1–4.

A3.1594. *Pompei, Ercolano, Napoli e dintorni: lettere e documenti* / Paola Poli Capri. Roma: H. B. Van der Poel, 2002. DG70.P7 A855 2002, v.1–6.

A3.1595. *Pompeii* / Alison E. Cooley. London: Duckworth, 2003. 160 p. DG70.P7 C627 2003.

A3.1596. Pompeii in Pictures. A searchable, pictorial catalogue of the city of Pompeii. http://www.pompeiiinpictures.com/.

A3.1597. *Pompeii-Insula I.IX* (British School at Rome; University of Auckland). Most of the excavation of this block of houses (Region I, Insula 9) was completed in 1951–1952. Since the 1990s it has been the subject of a research project of the British School at Rome. The site showcases aspects of the project, including 360-degree QuickTime VR panoramas and objects, 3D modeling, reconstructions, and artwork. http://www.proxima-veritati.auckland.ac.nz/insula9/.

A3.1598. Pompeii Interactive. http://www.pompeii.co.uk/.

A3.1599. *Pompeii AD 79: the treasure of rediscovery* / Richard Brilliant. New York: C. N. Potter: distributed by Crown Publishers, 1979. 305 p. DG70.P7 B73 1979.

A3.1600. Pompeii Forum Project. http://pompeii.virginia.edu/page-1.html.

A3.1601. *Pompei: gli scavi dal 1748 al 1860* / Antonio d'Ambrosio. Milano: Electa; Pompei (Napoli): Soprintendenza Archeologica di Pompei, 2002. 126 p. DG70.P7 P652 2002.

A3.1602. *Pompeii: the history, life and art of the buried city* / Marisa Ranieri Panetta. Vercelli: White Star: Rizzoli International Publications, 2004. 415 p.

A3.1603. *Pompeii: life in a Roman town* / Annamaria Ciarallo and Ernesto De Carolis. Milan: Electa, 1999. 351 p. DG70.P7 P66 1999.

A3.1604. *Pompeii: the life of a Roman town* / Mary Beard. London: Profile, 2008. 360, 16 p. DG70.P7 B44 2008.

A3.1605. *Pompeii: the living city* / Alex Butterworth and Ray Laurence. New York: St. Martin's Press, 2006. 354, 16 p. DG70.P7 B93 2006. N5770 .P66 2004.

A3.1606. *Pompei, vecchi scavi sconosciuti: la villa rinvenuta dal marchese Giovanni Imperiali in località Civita (1907–1908)* / Grete Stefani. Roma: L'Erma di Bretschneider, 1994. 118, 28 p. NA327.P6 S74 1994.

A3.1607. *Secrets of Pompeii: everyday life in ancient Rome* / Emidio de Albentiis. Los Angeles: J. Paul Getty Museum, 2009. 196 p. DG70.P7 D3718 2009.

A3.1608. Theatre of Pompey. http://www.didaskalia.net/studyarea/visual_resources/pompey3d.html.

A3.1609. *Vivre en Europe romaine: de Pompéi à Bliesbruck-Reinheim* / Jean-Paul Petit and Sara Santor. Paris: Errance, 2007. 246 p. DG70.P7 V755 2007.

A3.1610. *Pompei: l'Insula 1 della regione IX: settore occidentale* / Alessandro Gallo. Roma: L'Erma di Bretschneider, 2001. 156 p. DG70.P7 G253 2001.

A3.1611. *Pompei: la vita ritrovata* / Filippo Coarelli. Udine: Magnus, 2002. 404 p. DG70.P7 P6563 2002; DG70.P7 P6563 2002.

A3.1612. *Pompei: scavo stratigrafico nel settore orientale dell'Insula IX, 1: campagne 2004 e 2006: l'area sacro arcaico-ellenistica, l'occupazione dei lotti abitativi* / Alessandro Gallo. Pompei: Associazione internazionale amici di Pompei, 2010. 339 p. DG70.P7 G254 2010.

A3.1613. *Pompeian brothels, Pompeii's ancient history, mirrors and mysteries, art and nature at Oplontis & the Herculaneum 'Basilica'* / T. McGinn. Portsmouth, RI: Journal of Roman Archaeology, 2002. 165 p. DG70.P7 P67 2002.

A3.1614. *Pompeii* / Erich Lessing and Antonio Varone. Paris: Terrail, 1996. 205 p. Art of Pompeii. N5770.L477 1996.

A3.1615. *Pompeii* / Filippo Coarelli. New York: Riverside, 2002. 406 p. DG70.P7 P656313 2002.

A3.1616. *Pompeii: buried alive* / Benya Ben-Nun. New York: A&E Home Video, 1995. videocassette (50 min.). VHS DG70.P7 P6585 1995.

A3.1617. *Pompeii: letters and documents* / Paola Poli Capri. Rome: P. P. Capri, 1996. 10 v. DG70.P7 P665 1996.

A3.1618. *Pompeii: more letters and documents* / Paoli Poli Capri. Rome: H. B. Van der Poel, 1998. 12 v. DG70.P7 P666 1998.

A3.1619. *Pompeii: the new excavations, the "Villa dei Misteri," the Antiquarium* / Amedeo Maiuri. 9 ed. Roma: Istituto poligrafico dello Stato, Libreria, 1957. 182 p. 708.5 G943 no.3; 913.45 G943.

A3.1620. *Pompeii's living statues: ancient Roman lives stolen from death* / Eugene Dwyer. Ann Arbor: University of Michigan Press, 2010. 159, 24 p. DG70.P7 D89 2010.

A3.1621. *Pompeji: Archaologie und Geschichte* / Jens-Arne Dickmann. Munchen: C. H. Beck, 2005. 128 p. DG70.P7 D535 2005.

A3.1622. *Pompeji—Nola—Herculaneum: Katastrophen Am Vesuv* / Herausgeber Harald Meller and Jens-Arne Dickmann. München: Landesamt für Denkmalpflege und Archäologie Sachsen-Anhalt-Landesmuseum für Vorgeschichte: Hirmer Verlag 2011. 383 p. DG70.P7 P67 2011.

A3.1623. *Ricerche a Pompei: l'insula 5 della Regio VI dalle origini al 79 d.C.* Roma: L'Erma di Bretschneider, 1984. 2 v. DG70.P7 R49 1984.

A3.1624. *Ritratti romani da Pompei* / Raffaella Bonifacio. Roma: G. Bretschneider, 1997. 146 p. Roman portrait sculpture at Pompeii. NB116.P6 B66 1997.

A3.1625. *Rome, Ostia, Pompeii: movement and space* / Ray Laurence and David J. Newsome. Corby: Oxford University Press, 2011. 444 p. DG77 .R67 2011.

A3.1626. *Saggi nell'area del tempio di Apollo a Pompei: scavi stratigrafici di A. Maiuri nel 1931–32 e 1942–43* / Stefano De Caro. Napoli: Istituto universitario orientale, 1986. 145, 75 p. NA327.P6 D43 1986.

A3.1627. *Sequence and space in Pompeii* / Sara E. Bon and Rick Jones. Oxford: Oxbow Books, 1997. 157 p. DG70.P7 S46 1997.

A3.1628. *Strassen der antiken Stadt Pompeji: Entwicklung und Gestaltung* / Bjorn Gesemann. Frankfurt am Main; New York: P. Lang, 1996. 332 p. DG70.P7 G473 1996.

A3.1629. *Il tempio dorico del foro triangolare di Pompei* / J.A.K.E. De Waele. Roma: L'Erma di Bretschneider, 2001. 399, 10 p. DG70.P7 D49 2001.

A3.1630. *Vesuvius, A.D. 79: the destruction of Pompeii and Herculaneum* / Ernesto De Carolis and Giovanni Patricelli. Roma: L'Erma di Bretschneider, 2003. 135 p. DG70.P7 D375 2003. Italian language edition: *Vesuvio 79 d.C: la distruzione di Pompei ed Herculaneo* / Ernesto De Carolis and Giovanni Patricelli. Roma: L'Erma di Bretschneider, 2003. 129 p. DG70.P7 D372 2003.

A3.1631. *World of Pompeii* / edited by John J. Dobbins and Pedar W. Foss. London; New York: Routledge, 2007. 662 p. + CD-ROM. DG70.P7 W77 2007.

Portus

A3.1632. *Portus: an archaeological survey of the port of imperial Rome* / Simon Keay. London: British School at Rome, 2005. 360 p. DG70.P79 P678 2005. Portus was an ancient Roman harbor situated along the north bank of the mouth of the Tiber River. Originally built by Claudius, it was later expanded in 103 CE by Trajan.

Prima Porta

A3.1633. *Ad Gallinas Albas: Villa di Livia* / Gaetano Messineo. Roma: L'Erma di Bretschneider, 2001. 234 p. NA324 .A34 2001; NA324 .A34 2001. Prima Porta is a suburb of Rome located north of the city along the Via Flaminia. It was named after an arch from an aqueduct that passed over the Via Flaminia, which also served as the northern entry point into Rome. Prima Porta is also significant for being the site of Constantine's victory over Maxentius in 312 CE.

Rimini

A3.1634. *Domus romana: i tesori e i misteri del chirurgo* / Romano Bedetti. Rimini: P. Capitani, 2000. 140 p. DG70.R54 B46 2000. Rimini was a Roman city in the Emilia Romagna region situated along

the coast of the Asiatic sea. As early as the sixth century BCE the area had previously been inhabitated by the Gauls but became a Roman colony in 263 BCE during the Gallic wars and named Ariminum. The city served as a major crossroads connecting northern and central Italy by the Via Aemilia and Via Popilia. The Via Flaminia also ended in Ariminum and also was the site of the Arch of Augustus.

Rome

A3.1635. *Appunti degli scavi di Roma* / Antonio Maria Colini. Roma: Quasar, 1998. 2 v. DG65 .C65 1998. Rome is located in west-central Italy, in the Lazio region. It is the capital of Italy and Lazio. Archaeological evidence in the area shows human occupation dating back at least 10,000 years and provides evidence that Rome was formed from pastoral settlements on the Palatine Hill. The original settlement eventually evolved into the capital of the Roman kingdom, which was ruled by seven kings. In 510 BCE, the Roman Republic was established and was governed by the Senate. The republic grew and flourished, and by the third century BCE, Rome had become the most powerful city on the Italian peninsula. Rome extended its power beyond Italy by defeating Carthage during the Punic Wars and taking control of Sicily and Corsica et Sardinia. By the second century BCE, Rome had extended its reach to include parts of Spain. The Roman Republic established control over Greece by defeating it at the Battle of Corinth in 146 BCE. The Roman Empire was established in 27 BCE by Emperor Augustus, which created a great period of social, political, and economic reform and major construction projects in the city, as well as the Pax Romana. By combining military power, commercial dominance, and the assimilation of neighboring cultures, Rome was able to conquer most of western Europe and the Mediterranean. It was the most important and powerful city in the Western world for almost 700 years.

A3.1636. *Appunti di topografia romana nei Codici Lanciani della Biblioteca apostolica vaticana* / Marco Buonocore. Roma: Quasar; Città del Vaticano: Biblioteca apostolica vaticana, 1997. 5 v. DG68 .A668 1997.

A3.1637. *The archaeology of early Rome and Latium* / R. Ross Holloway. London; New York: Routledge, 1994. 203 p. DG63 .H57 1994.

A3.1638. *Archives & excavations: essays on the history of archaeological excavations in Rome and southern Italy from the Renaissance to the nineteenth century* / Ilaria Bignamini. London: British School at Rome, 2004. 308 p. DG65 .A755 2004.

A3.1639. *Beiträge zur römischen Topographie* / Otto Richter. Berlin: Druck von W. Büxenstein, 1903–1910. DG63 .R53 1903a.

A3.1640. Capitolium.org. The official site of the imperial forums is a source of live information on the archaeological site of the Imperial Forums. Day by day, online visitors can follow the development of the work that is being carried out by top-level scholars of Roman antiquity. http://capitolium.org/.

A3.1641. *Caput Africae*. Roma: Istituto poligrafico e Zecca dello Stato, Libreria dello Stato, 1993. 2 v. DG66.C36 1995.

A3.1642. *The city of Rome: its vicissitudes and monuments from its foundation to the end of the middle ages, with remarks on the recent excavations* / Thomas H. Dyer. 2 ed. London: G. Bell and Sons, 1883. 462 p. Ctr for Adv Judaic Studies Lib DG808 .D99 1883.

A3.1643. *Digging and dealing in eighteenth-century Rome* / Ilaria Bignamini and Clare Hornsby. New Haven; London: Yale University Press for The Paul Mellon Centre for Studies in British Art, 2010. 2 v. DG65 .B54 2010.

A3.1644. *The eagle and the spade: archaeology in Rome during the Napoleonic era* / Ronald T. Ridley. Lecce: Il Dipartimento: Congedo Editore, 1992. 2 v. DG55.A65 E922 1992.

A3.1645. *Early Rome* / Einar Gjerstad. Lund: C. W. K. Gleerup, 1953–1973. 6 v. DG12 .S8 v.17, v.1, 2, 3, 4(1, 2), 5, 6.

A3.1646. *La fattoria e la villa dell'Auditorium nel quartiere Flaminio di Roma* / Andrea Carandini. Roma: L'Erma di Bretschneider, 2006. 650, 43 p. DG63 .F38 2006.

A3.1647. *Forma urbis marmorea: aggiornamento generale 1980* / Emilio Rodriguez Almeida. Roma: Quasar, 1981. 172, 61 p. DG63 .R63 1981.

A3.1648. *Formae Urbis Romae: nuovi frammenti di piante marmoree dallo scavo dei Fori Imperiali* / Roberto Meneghini and Riccardo Santangeli Valenzani. Roma: L'Erma di Bretschneider, 2006. 212 p. DG66.5 .F67 2006.

A3.1649. *Le Forum romain et les forums de Jules César d'Auguste, de Vespasien, de Nerva et de Trajan: état áctuel des découvertes et étude restaurée* / Ferdinand Dutert. Paris: A. Lévy, 1876. 44, 14 p. Rare DG66.5 .D88 1876.

A3.1650. *I Fori imperiali e i Mercati di Traiano: storia e descrizione dei monumenti alla luce degli studi e degli scavi recenti* / Roberto Meneghini. Roma: Libreria dello Stato, Istituto poligrafico e Zecca dello Stato, 2009. 277 p. DG69 .M36 2009.

A3.1651. *Gli anni del governatorato (1926–1944): interventi urbanistici, scoperte archeologiche, arredo urbano, restauri* / Luisa Cardilli. Roma: Kappa, 1995. 223 p. NA109.I8 A556 1995.

A3.1652. *Guida archeologica di Roma: Foro romano, Palatino, Campidoglio e Musei capitolini, Fori imperiali, Colosseo, Domus aurea* / Adriano La Regina. Milano: Electa, 2007. 286 p. DG62 .G85 2007.

A3.1653. *Guida archeologica di Roma: la più grande metropoli dell'antichità, com'era e com'è* / Carlo Pavia. Roma: Gangemi, 2001 129, 254 p. DG62 .P38 2001.

A3.1654. *L'invenzione dei fori Imperiali: demolizione e scavi, 1924–1940.* Roma: Palombi Editori, 2008. 64 p. DG66.5 .I58 2008. *Rome: a living portrait of an ancient city* / Stephen L. Dyson. Baltimore: Johns Hopkins University Press, 2010. 467 p. DG62.5 .D97 2010.

A3.1655. Learning to Read Rome's Ruins, A Vatican exhibit. http://www.ibiblio.org/expo/vatican.exhibit/exhibit/b-archeology/Archaeology.html.

A3.1656. *Lexicon topographicum urbis Romae. Supplementum I.* Roma: Quasar, 2005. Reference DG63 .L493 2005.

A3.1657. *I materiali residui nello scavo archeologico: testi preliminari e Atti della tavola rotonda organizzata dall'École française de Rome e dalla Sezione romana "Nino Lamboglia" dell'Istituto internazionale di studi liguri, in collaborazione con la Soprintendenza archeologica di Roma e la Escuela española de historia y arqueología: Roma, 16 marzo 1996* / Federico Guidobaldi, Carlo Pavolini, and Philippe Pergola. Rome: École française de Rome, 1998. 310 p. CC51 .M38 1998.

A3.1658. *Mura di Roma dalla Porta Nomentana alla Tiburtina: separatum da Analecta Romana Instituti Danici, 25* / Lucos Cozza. Roma: L'Erma di Bretschneider, 1998. 113 p. NA325.W3 C69 1998.

A3.1659. *Il paesaggio suburbano di Roma dall'antichità al Medioevo: il comprensorio tra le vie Latina e Ardeatina dalle Mura Aureliane al III miglio* / Lucrezia Spera. Roma: L'Erma di Bretschneider, 1999. 531 p. DG65 .S74 1999.

A3.1660. Plan de Rome. http://www.unicaen.fr/cireve/rome/index.php.

A3.1661. Real-Time Computer Model of the City Center of Ancient Rome. http://msc.mellon.org/ Meetings/archaeology/project-descriptions/real-time-computer-model-of-the-city-center-of-ancient-rome.

A3.1662. Roma: A Virtual Community for Teaching and Learning Classics. The VRoma Project uses workshops and presentations to engage teachers and students in a virtual community dedicated to using Internet technology to foster the teaching and learning of Latin and Roman culture. This website features various types of resources created by VRomans, including a large archive of digital images relating to classical antiquity, help files and other materials about the MOO, teaching resources and course materials, information about the project and its participants, and relevant links to other sites. http://vroma.org/.

A3.1663. *Rom: ein archäologischer Führer* / Margit Brinke and Peter Kränzle. Stuttgart: Reclam, 2002. 281 p. DG62 .B75 2002.

A3.1664. *Roma, memorie dal sottosuolo: ritrovamenti archeologici, 1980/2006* / Maria Antonietta Tomei. Milano: Electa, 2006. 614 p. DG63 .R634 2006.

A3.1665. *Roma, lo scavo dei fori imperiali, 1995–2000: I contesti ceramici* / Roberto Meneghini and Riccardo Santangeli Valenzani. Rome: École française de Rome, 2006. 233 p. NK4104.R6 R67 2006.

A3.1666. *Romarcheologica: guida alle antichità della città eterna.* Roma: E. De Rosa, 1999. DG62 .R66 1999, v.1–27.

A3.1667. *Rome: an Oxford archaeological guide* / Amanda Claridge. Oxford; New York: Oxford University Press, 1998. 455 p. DG62 .C53 1998.

A3.1668. *The ruins and excavations of ancient Rome* / Rodolfo Lanciani; with a new foreword by Richard Brilliant. New York: Bell Pub. Co., 1979. 617 p. DG63 .L25 1979.

A3.1669. *The ruins & excavations of ancient Rome; a companion for students and travelers* / Rodolfo Lanciani. London: Macmillan, 1897. 631 p. 913.37 L223a; 913.37 L223a.

A3.1670. *Scavi dei Fori imperiali: il Foro imperiale: l'area centrale* / Roberto Meneghini and Riccardo Santangeli Valenzani. Roma: L'Erma di Bretschneider, 2010. 245 p. + CD-ROM. Van Pelt DG69 .S29 2010.

A3.1671. *Il territorio tra la via Salaria, l'Aniene, il Tevere e la via "Salaria vetus": Municipio II* / Cristiana Cupitò. Roma: L'Erma di Bretschneider, 2007. 231, 6 p. DG63 .C75 2007.

A3.1672. *La toponomastica archeologica della provincia di Roma* / Stefano Del Lungo. Roma: Regione Lazio, 1996. 2 v. DG804 .T586 1996.

A3.1673. *La tomba dei Nasonii* / Gaetano Messineo. Roma: L'Erma di Bretschneider, 2000. 88 p. ND2575 .M47 2000.

A3.1674. Topographical Dictionary of Ancient Rome / Samuel B. Platner. A selection of articles from Samuel Ball Platner's *A Topographical Dictionary of Ancient Rome* (London: Oxford University Press, 1929); this large volume of over 600 pages

was for many years the standard reference work, in the English-speaking world at least, on the city of Rome, its hills, streets, walls, and monuments. http://penelope.uchicago.edu/Thayer/E/ Gazetteer/Places/ Europe/ Italy/ Lazio/Roma/ Rome/_Texts/PLATOP*/home*.html.

A3.1675. *Via dell'Impero: nascita di una strada* / Fabio Betti. Roma: Palombi, 2009. 79 p. DG66.5 .V54 2009.

A3.1676. *A Victorian view of ancient Rome: the Parker collection of historical photographs in the Kelsey Museum of Archaeology* / Ann Arbor: Kelsey Museum of Archaeology, University of Michigan, 1980. 32, 6 p. DG63 .K44 1980.

A3.1677. *Villen und Gräber: Siedlungs- und Bestattungsplätze der römischen Kaiserzeit im Suburbium von Rom* / Jochen Griesbach. Rahden: VML Verlag Marie Leidorf, 2007. 228 p. DG65 .G75 2007.

Rome (Comitium)

A3.1678. *Il Comizio di Roma dalle origini all'età di Augusto* / Paolo Carafa. Roma: L'Erma di Bretschneider, 1998. 192 p. DG69 .C372 1998. Rome (Comitium) is the first public meeting space of ancient Rome. It was located in the northwest corner of the Roman Forum and was the center of most political and judicial activity in the city. The Comitium is also the site of many of Rome's earliest monuments, including the Rostra, Column Maenia, Graecostasis, and the Tabula Valeria.

Rome (Domus Aurea Neronis)

A3.1679. *Domus Aurea* / Irene Iacopi. Milano: Electa, 2001. 163 p. ND2575 .I1613 2001. Rome (Domus Aurea Neronis) was a large villa built in central Rome by Emperor Nero sometime between the great fire of 64 CE and his suicide in 68 CE. The villa was built into the slopes of the Palatine hills and was said to be covered in gold leaf and semiprecious stones. Soon after Nero's death the building and grounds were covered with dirt, and by 79 CE the Baths of Titus had been built over the site. Later the Baths of Trajan and the Temple of Venus and Rome were built on the grounds, and within forty years the entire house was destroyed and buried underneath new constructions.

Rome (Forum)

A3.1680. *Archeologia e città: storia moderna dei Fori di Roma* / Italo Insolera and Francesco Perego.

Roma-Bari: Laterza, 1999. 398 p. N5760 .I47 1999. Rome (Forum) was a rectangular plaza located in the center of Rome, in the valley between the Palatine and Capitoline hills. It originally served as a marketplace but soon became the center of Roman public life. The forum was surrounded by Rome's oldest and most important structures, such as government buildings, statues, and monuments. The Roman kingdom's earliest temples, such as the Regia (eighth century BCE) and the Temple of Vesta (seventh century BCE), were built at the southeastern edge of the Forum. During the Roman republic period, the forum was expanded and continued to serve a larger role in judicial and political life. The Temple of Saturn and the Temple of Castor and Pollux were both constructed in the fifth century BCE. The forum was the location for two significant events in Roman history: the funeral oration for Julius Ceasar delivered by Marc Anthony and the burning of Caesar's body. Following Caesar's death, expansion continued in the Forum with the construction of the Temple of Divus Lulius and the Arch of Augustus. The Forum maintained its political importance until the fall of the Western Roman Empire in the fifth century.

A3.1681. *The imperial fora* / by Eugenio La Rocca. Rome: Progetti museali editore; ENEL, 1995. 297 p. DG66.6 .L2813 1995. Italian language translation: *I fori imperiali* / Eugenio La Rocca. Roma: Progetti museali editore: ENEL, 1995. DG66.5 .L28 1995.

A3.1682. *Recent discoveries in the Forum, 1898–1904; by an eyewitness, St. Clair Baddeley; a handbook for travellers, with a map specially made for this work by order of the director of the excavations, and 45 illustrations.* New York: The Macmillan Company, 1904. 115 p. 913.371 B143; 913.361 B143.

A3.1683. *Recent excavations in the Roman Forum, 1898–1904: a handbook by E. Burton-Brown.* New York: C. Scribner's Sons, 1904. 223 p. Stacks Mini DG66.5 .B769 1904. British imprint: *Recent excavations in the Roman Forum, 1898–1904 / a handbook by E. Burton-Brown.* London: Murray, 1904. 223 p. 913.371 R66Br.

Rome (Forum of Trajan)

A3.1684. *The Forum of Trajan in Rome: a study of the monuments in brief* / James E. Packer. Berkeley: University of California Press, 2001. 235 p. NA312 .P23 2001. Rome (Forum of Trajan) was an ancient piazza built in Rome and ordered by the Emperor Trajan. It was built by the architect

Apollodorus of Damascus with money gained from Trajan's conquest of Dacia. Construction was completed on the forum in 112 CE, and Trajan's column was erected and inaugurated in 113 CE.

Rome (Lucus Furrinae, Monte Giancolo)

A3.1685. *The Lucus Furrinae and the Syrian sanctuary on the Janiculum* / Nicholas Goodhue. Amsterdam: Adolf M. Hakkert, 1975. 175 p. DG133 .G66.

Rome (Meta Sudans)

A3.1686. *Meta Sudans I: un'area sacra in Palatio e la valle del Colosseo prima e dopo Nerone* / Clementina Panella. Roma: Istituto poligrafico e Zecca dello Stato, Libreria dello Stato, 1996. 234 p. DG69 .M42 1996. Rome (Meta Sudans) was a large monumental fountain built between 89 and 96 CE. It was constructed between the Colosseum and the Temple of Venus and Roma and is situated near the Arch of Augustus. It functioned as a turning point during Roman triumphal processions.

Rome (Palatine Hill)

A3.1687. *Archeologia in posa: cento anni di fotografie del Palatino* / Biblioteca vallicelliana; Soprintendenza archeologica di Roma. Roma: De Luca, 1994. 230 p. DG66 .A73 1994. Rome (Palatine Hill) is one of the seven hills of Rome and one of the oldest sections of the city. The original Romans inhabited the spot following their immigration from Sabines and the Albans. During the Republican period, Palatine Hill was home to many affluent Romans, and during the empire several emperors lived there. According to legend, the hill is the site where Romulus and Remus were kept alive by a she-wolf.

A3.1688. *Domus Tiberiana: analyses stratigraphiques et céramologiques* / Marie-France Meylan Krause. Oxford: Archaeopress, 2002. 309 p. DG68.1 .M49 2002.

A3.1689. *Palatino, Velia e Sacra via: paesaggi urbani attraverso il tempo* / Andrea Carandini. Roma: Edizioni dell'Ateneo, 2004. 95 p. DG68 .C37 2004.

A3.1690. *Il Palatino: area sacra sud-ovest e Domus Tiberiana* / Carlo Giavarini. Roma: L'Erma di Bretschneider, 1998. 426, 3 p. DG66 .P34 1998.

A3.1691. *Scavi francesi sul Palatino: le indagini di Pietro Rosa per Napoleone III (1861–1870)* / Maria Antonietta Tomei. Rome: École Française de

Rome: Soprintendenza archeologica di Roma, 1999. 555 p. DG66 .T65 1999.

A3.1692. *Scavi del Palatino I: l'area sud-occidentale del Palatino tra l'età protostorica e il IV secolo a.C., scavi e materiali della struttura ipogea sotto la cella del Tempio della Vittoria* / Patrizio Pensabene and Stella Falzone. Roma: L'Erma di Bretschneider, 2001. 286, 100 p. DG66 .S28 2001.

A3.1693. *The urban economy during the early dominate: pottery evidence from the Palatine Hill* / J. Theodore Peña. Oxford: Archaeopress, 1999. 231 p. DG66 .P46 1999.

Rome (Reggia)

A3.1694. *Architectural terracottas from the Regia* / Susan B. Downey. Ann Arbor: University of Michigan Press, 1995. 109 p. DG66.5 .D69 1995.

Rome (Syrian Temple)

A3.1695. *L'Area del "Santuario siriaco del Gianicolo": problemi archeologici e storico-religiosi* / Mirella Mele. Roma: Quasar, 1982. 115 p. DG133 .A67.

Rome (Temple of Castor and Pollux)

A3.1696. *The Temple of Castor and Pollux* / Inge Nielsen and Birte Poulsen. Roma: Edzioni De Luca, 1992. DG133 .T456 1992. Rome (Temple of Castor and Pollux) is an ancient temple built within the Roman Forum in 484 BCE and named after the twins of Gemini. It was originally built to commemorate victory at the Battle of Lake Regillus. During the Republican era it served as a meeting place for the Senate and also served as a speaker's platform. In the Imperial period it would house the office of weights and measures and was the depository for the state treasury. The temple was enlarged and reconstructed by Lucius Caecilius Metellus Dalmaticus in 117 BCE, in honor of his victory over the Dalmations. The temple was restored again in 73 BCE by Gaius Verres. In 14 BCE the temple was destroyed by fire but was rebuilt by Tiberius.

Rome (Temple of Concord)

A3.1697. *Aedes Concordiae Augustae* / Carlo Gasparri. Roma: Istituto di studi romani, 1979. 152, 30 p. DG68.1 .G33 1979. Rome (Temple of Concord) was an ancient temple built along the western end of the Roman Forum. Although it was vowed in

367 BCE by Marcus Furius Camillus it was not actually constructed until 167 BCE. Its original purpose was to commemorate the Leges Liciniae Sextiae, but it also served as an occasional meeting house for the Senate. The temple was rebuilt in 121 BCE, and restored in 7 and 10 CE by Tiberius. In 1450 CE the temple was torn down and its marble was repurposed.

Rome (Temple of Isis and Serapis)

A3.1698. *Das Iseum Campense in Rom: Studie über den Isiskult unter Domitian* / Katja Lembke. Heidelberg: Verlag Archäologie und Geschichte, 1994. 271, 48 p. DG133 .L46 1994.

Rome (Theater of Balbus)

A3.1699. Crypta Balbi / Museo nazionale romano. Milano: Electa, 2000. 95 p. DG68.1 .C78 2000. Rome (Theater of Balbus) was an ancient Roman theater built in the Campus Martius section of Rome. It was constructed by Lucius Cornelius Balbus in 13 BCE.

Sala Consilina

A3.1700. *Le crépuscule des marges: le premier âge du fer à Sala Consilina* / Pascal Ruby. Rome: École Française de Rome; Naples: Centre Jean Bérard, 1995. 2 v. D5.B4 fasc.290.

San Giovenale

A3.1701. *San Giovenale, results of excavations conducted by the Swedish Institute of Classical Studies at Rome and the Soprintendenza alle Antichità dell'Etruria Meridionale.* Lund: CWK Gleerup, 1972. DG12 .S8 v.26, v.1, 2(2, 4, 5), 3(1, 3), 4(1 + plan), 5(2 + plates), 6(4/5). San Giovenale is the modern name of the location of an ancient Etruscan settlement. It is located near the modern village of Blera, Italy.

Satricum

A3.1702. *Satricum: a town in Latium* / Barbara Heldring. Tonden, Netherlands: Foundation Dutch Centre for Latium Studies, 1998. 60 p. DG70.S28 H45 1998. Satricum was an ancient town in the Latium region of central western Italy, situated 60 kilometers southeast of Rome. The town was captured and lost several times by the Romans and was twice destroyed by fires. It was the site of the temple of Mater Matuta.

A3.1703. *Satricum in the post-archaic period: a case study of the interpretation of archaeological remains as indicators of ethno-cultural identity* / Marijke Gnade. Leuven; Dudley: Peeters, 2002. 244 p. DG70.S28 S279 2002.

A3.1704. *Settlement excavations at Borgo Le Ferriere (Satricum)* / Marianne Maaskant-Kleibrink. Groningen, Netherlands: E. Forsten, 1987. 2 v. DG70.S28 M3 1987.

A3.1705. *The southwest necropolis of Satricum: excavations 1981–1986* / M. Gnade. Amsterdam: Thesis Publishers, 1992. 600 p. DG70.S28 S68 1992.

Segesta

A3.1706. *Segesta III: il sistema difensivo di Porta di Valle: scavi 1990–1993* / Rosalia Camerata Scovazzo. Mantova: SAP, 2008. 767 p. DG70.S38 S44 2008. Segesta was located on the northwestern coast of Sicily and was one of the most important cities of the Elymians. The city was in regular battles with nearby Selinus, which eventually destroyed the city with the assistance of Carthage in 409 BCE. In 260 BCE, Segesta surrendered to the Romans and was granted a "free and immune" city. The city was conquered and destroyed by Vandals in the fifth century.

Selinus

A3.1707. *Les protomés féminines du sanctuaire de la malophoros à Sélinonte* / Elsbeth Wiederkehr Schuler; préface de Sebastiano Tusa; introduction de Francis Croissant. Naples: Centre Jean Bérard, 2004. 2 v. DG70.S4 W54 2004. An ancient Greek city located on the southern coast of Sicily. The city was founded around the seventh century BCE. The city contained five temples that were built around an acropolis; however, the "Temple E" is the only one standing, having been re-erected in the twentieth century.

A3.1708. *Selinus* / Dieter Mertens. Mainz: von Zabern, 2003. DG70.S4 M478 2003.

A3.1709. *Selinunte: necropoli di Manicalunga: le tombe della contrada Gaggera* / Anne Kustermann Graf. Soveria Mannelli (Catanzaro): Rubbettino, 2002. 439 p. DG70.S4 K87 2002.

Sentinum

A3.1710. *Sentinum: ricerche in corso* / Maura Medri. Roma: L'Erma di Bretschneider, 2008. 3 v. DG70.S42 S46 2008. An ancient town located in the modern-day Marche region of Italy. It was the site of the Battle of Sentinum in 295 BCE. In

41 BCE the city was conquered and destroyed by Salvidienus Rufus but was later rebuilt during the Roman Empire and given the status of municipium.

Sperlonga

A3.1711. *La villa Prato de Sperlonga* / Henri Broise and Xavier Lafon. Rome: École française de Rome, 2001. 218, 8 p. NA327.S6 B76 2001; NA327. S6 B76 2001. Sperlonga was an ancient Roman resort built in the province of Latina on the western central coast of Italy. It lies halfway between Rome and Naples and contained a villa and grottoes contructed by the Emperor Tiberius.

Spina

A3.1712. *Impronte nella sabbia: tombe infantili e di adolescenti dalla necropoli di Valle Trebba a Spina* / Anna Muggia. Firenze: All'insegna del giglio, 2004. 225 p. DG70.S66 M84 2004. Spina was an Etruscan city founded near the end of the sixth century BCE. It was a port city on the Adriatic coast at the mouth of the Po River.

A3.1713. *Spina e il delta padano: riflessioni sul catalogo e sulla mostra ferrarese: atti del Convegno internazionale di studi "Spina: due civiltà a confronto," Ferrara, Aula magna dell'Università, 21 gennaio 1994* / Fernando Rebecchi. Roma: L'Erma di Bretschneider, 1998. 358, 49 p. DG70. S66 C66 1994.

Stabiae

A3.1714. *In Stabiano: cultura e archeologia da Stabiae, la città e il territorio tra l'età arcaica e l'età romana, catalogo della mostra, Castellammare di Stabia, Palazzetto del mare, 4 novembre 2000–31 gennaio 2001* / Giovanna Bonifacio and Anna Maria Sodo. Castellammare di Stabia (Na) i.e. Napoli: N. Longobardi, 2001. 177 p. DG70. S77 I6 2001.

A3.1715. *In Stabiano: exploring the ancient seaside villas of the Roman elite* / Angelo Pesce. Castellammare di Stabia (Napoli): N. Longobardi: Soprintendenza archeologica di Pompei, 2004. 155 p. DG70.S77 I57 2004.

A3.1716. *Stabiae: guida archeologica alle ville* / Giovanna Bonifacio and Anna Maria Sodo. Castellammare di Stabia (Napoli): N. Longobardi, 2001. 215 p. DG70.S77 B66 2001.

A3.1717. *Stabiae: storia e architettura: 250. anniversario degli scavi di Stabiae 1749–1999: Convegno internazionale, Castellammare di Stabia, 25–27 marzo 2000* / Giovanna Bonifacio and Anna Maria Sodo. Roma: L'Erma di Bretschneider, 2002. 221 p. DG70.S77 S73 2002.

A3.1718. *Tesori di Stabiae: arte romana sepolta dal Vesuvio; Treasures from Stabiae: Roman art buried by Vesuvius* / Domenico Camardo and Antonio Ferrara. Castellammare di Stabia (Napoli): N. Longobardi, 2004. 158 p. DG70.S77 T47 2004.

A3.1719. *La Villa San Marco a Stabia* / Alix Barbet and Paola Miniero. Napol: Centre Jean Bérar; Roma: École Française de Rome; Pompe: Soprintendenza archeologica di Pompei, 1999. 3 v. NA327.C37 V55 1999.

Suessula

A3.1720. *Suessula: storia, archeologia, territorio* / Marina Antonella Montano. Napoli: Libreria Dante & Descartes, 2008. 163 p. DG70.S85 S84 2008. Suessula was an ancient city located in the Campania region of southern Italy. It was the site of several battles during the Samnite and Punic wars.

Sulcis

A3.1721. *Il Museo archeologico comunale "F. Barreca" di Sant'Antioco* / Piero Bartoloni. Sassari: C. Delfino, 2007. 141 p. DG70.S86 B367 2007. A Phoenician city in the southwestern region of Sardinia.

Temesa

A3.1722. *Un tempio arcaico nel territorio dell'antica Temesa: l'edificio sacro in località imbelli di Campora San Giovanni* / Gioacchino Francesco La Torre. Roma: Giorgio Bretschneider editore, 2002. 388 p., 70 p., 34 p. DG70.T36 L386 2002.

Terni

A3.1723. *Terni-Interamna Nahars: nascita e sviluppo di una città alla luce delle più recenti ricerche archeologiche* / Claudia Angelelli and Laura Bonomi Ponzi. Rome: École française de Rome, 2006. 326 p. DG975.T44 T4685 2006. Terni is a city located in central Italy, in the modern-day Umbria region. Evidence shows habitation as early as the Bronze Age; however, the city was founded in the seventh century BCE by the Umbrians. The city was conquered by Romans in the third century BCE and renamed Interamna, meaning "in between two rivers." The city was given the title of municipium and gained importance by its location along the Via Flaminia.

Tivoli

A3.1724. *Hadrien: trésors d'une villa impériale* / Jacques Charles-Gaffiot and Henri Lavagne. Milano: Electa, 1999. 376 p. NA327.T5 H33 1999. Tivoli, also known as Tibur, is an ancient town situated in the Lazio region of central Italy. Archaeological evidence shows traces of settlement dating back to the thirteenth century BCE. During Etruscan times, Tibur served as the seat of Tiburtine Sibyl. In 361 BCE, Tibur allied itself with the Gauls; however, in 338 BCE the city was conquered by the Romans. In 90 BC the city was given Roman citizenship and became famous for its many villas.

Tuscany

A3.1725. Tuscan Archaeological Service. http://www. mega.it/archeo.toscana/esoparc.htm.

Tusculum

A3.1726. *Ager Tusculanus: (IGM 150 3. NE-2. NO)* / Massimiliano Valenti. Firenze: L. S. Olschki, 2003. 425, 2 p. DG431 .F63 v.41. Tusculum is an ancient Roman city situated on the Alban hills. It is located in the Latium region of Italy, along the northern edge of the Alban volcano. The site was inhabited since at least the seventh and eighth centuries BCE, evidenced by funeral urns found in the area. In 381 BCE, Tusculum was named the first *municipium cum suffragio* in the Roman Republic.

A3.1727. *Tusculum* / Elena Castillo Ramirez. Roma: L'Erma di Bretschneider, 2005–2006. 2 v. DG70. T8 C38 2005.

A3.1728. *Tusculum: Luigi Canina e la riscoperta di un'antica città* / Giovanna Cappelli and Susanna Pasquali. Roma: Campisano, 2002. 247, 6 p. DG70.T8 T88 2002.

Urbs Salvia

A3.1729. *La romanisation du Picenum: l'exemple d'Urbs Salvia* / Christiane Delplace; publié avec le concours du Centre National de la Recherche Scientifique. Rome: École Française de Rome, 1993. 413, 20 p. DG55.A83 D44 1993. Urbs Salvia was a city located in the modern-day region of Marche, Italy. It was originally founded as a colonia during the second century BCE. The site contains a large reservoir and aquaduct, as well as a Roman theater.

Val Camonica

A3.1730. Rock Art in Valcamonica. http://whc.unesco.org/en/list/94.

A3.1731. Rock art in the Alps: Valcamonica. http://www.rupestre.net/alps/valcamonica.html.

Vatican City

A3.1732. *Die heidnische Nekropole unter St. Peter in Rom* / Harald Mielsch and Henner von Hesberg. Roma: L'Erma di Bretschneider, 1986. DG103. M53 1986, v.1–2. Vatican City is a sovereign city-state that is situated within a walled enclave in Rome. During the first century CE, the area was uninhabited. Agrippina the Elder drained the land and built her gardens there. In 40 CE Caligula began construction of a circus at the site, which was later completed by Nero. The Vatican obelisk, the last visible remnant of Nero's circus, was brought from Heliopis by Caligula. In 64 CE, the city was the site of Christian persecution, as they were blamed for starting the Great Fire of Rome. The first church was built in the city in 326 CE on the site where many people believe the Tomb of Saint Peter was located. Popes have resided in Vatican City since 1377, after leaving the papal palace in Avignon, France. In 1929 the Lateran Treaty was signed, ending the conflict between the Holy See and the Kingdom of Italy and also establishing the independent state of Vatican City.

A3.1733. *Die Memorien für Petrus und Paulus in Rom: die archäologischen Denkmäler und die literarische Tradition* / Hans Georg Thümmel. Berlin; New York: W. de Gruyter, 1999. 102, 66 p. BS2515. T49 1999.

A3.1734. *La necropoli della via Triumphalis: il tratto sotto l'autoparco Vaticano* / Eva Margareta Steinby. Roma: Quasar, 2003. 227, 66 p. DG795.S74 2003.

A3.1735. *La topografia antica del Vaticano* / Paolo Liverani. Città del Vaticano: Monumenti musei e gallerie pontificie, m: Brepols, 2010. 350 p. DG795. L5713 2010. Supersedes: *La topografia antica del Vaticano* / Paolo Liverani. Città del Vaticano: Monumenti musei e gallerie pontificie, 1999. 179 p. DG795 .L58 1999.

A3.1736. *The Vatican necropoles: Rome's city of the dead* / Paolo Liverani and Giandomenico Spinola. Turnhout, Belgium, 1999. 179 p.: ill., maps; 35 cm. DG795.L58 1999.

A3.1737. *Il Vaticano nell'antichità classica* / Ferdinando Castagnoli. Vatican City: Biblioteca apostolica vaticana, 1992. 278 p. DG975.C37 1992.

Veii

A3.1738. *Cronache veientane: storia delle ricerche archeologiche a Veio* / Filippo Delpino. Roma: Consiglio nazionale delle ricerche, 1985. DG70. V3 D45 1985. Veii was an Etruscan city founded around the eighth century BCE, although evidence shows human presence in the area dating back to the tenth century. For over 300 years Veii was at war with the Romans. Veii was defeated by Rome's first king, Romulus, in the eighth century BCE, and then again in the seventh century by the Roman king Tullus Hostilus. In 509 BCE, after forming an alliance with the city of Tarquinii, Veii was again defeated by Rome in the Battle of Silva Arsia. The city was eventually captured in 396 BCE by the Roman general Camillus. The city never recovered after the Roman conquest and was eventually abandoned.

A3.1739. *Dalla capanna alla casa: i primi abitanti di Veio* / Iefke van Kampen. Roma: Formello, 2003. 141, 16 p. DG70.V3 D35 2003.

A3.1740. *La necropoli etrusca di Volusia* / A. Carbonara, G. Messineo, and A. Pellegrino. Roma: Istituto poligrafico e Zecca dello Stato, Libreria dello Stato, 1996. 136 p. DG70.V3 N43 1996.

A3.1741. *Il santuario di Portonaccio a Veio* / Giovanni Colonna. Roma: G. Bretschneider Editore, 2002. DG11 .M6 v.6(3), 13.

Velia

A3.1742. *Elea-Velia: le nuove ricerche: atti del Convegno di studi, Napoli, 14 dicembre 2001* / Giovanna Greco. Velia, also known as Elea during ancient times, is a town located in the Campania region of Italy. It was originally established by the Greeks around 538–535 BCE. In 273 BCE, Elea allied itself with Rome and was included in ancient Lucania.

A3.1743. *Neue Forschungen in Velia: Akten des Kongressess "La ricerca archeologica a Velia" (Rom, 1.–2. Juli 1993)* / Fritz Krinzinger and Giuliana Tocco. Wien: Verlag der Österreichischen Akademie der Wissenschaften, 1999. 138 p. AS142 .V32 Bd.268.

A3.1744. *Da Piacenza a Veleia: passeggiate archeologiche piacentine* / Maria Bernabò Brea. Reggio Emilia: Diabasis; Piacenza: Provincia di Piacenza, 2004. 178 p. DG975.P5 D28 2004.

A3.1745. *Velia: la visita della città* / Giovanna Greco. Pozzuoli (NA): Naus, 2002. 63 p.

Velleia

A3.1746. *Dalla scacchiera alla macchia: il paesaggio agrario veleiate tra centuriazione e incolto* / Ilaria Di Cocco and Davide Viaggi. Bologna: Ante quem, 2003. 215 p. DG70.V34 D53 2003.

Vescovio

A3.1747. Forum Novum—Vescovio. http://www.british-museum.org/research/research_projects/forum_novum,_vescovio.aspx

Volterra

A3.1748. *Volterra: scavi, 1969–1971* / Mauro Cristofani. Roma: Accademia nazionale dei Lincei, 1976. 290, 2 p. DG70.V65 C73. Volterra was an important Etruscan town situated in the Tuscany region of Italy. The town began as a Neolithic settlement. During the Roman era it was given the status of municipium.

Vulci

A3.1749. *Fouilles dans la nécropole de Vulci; exécutées et publiées aux frais de S. E. le prince Torlonia* / Stéphane Gsell. Paris: E. Thorin, 1891. 576 p. 913.36 G928. An Etruscan city and tribe in western-central Italy, just north of Rome. It was one of the twelve members of the Etruscan League. In 280 BCE, the Romans defeated the Vulci, disbanding the Etruscan League. This eliminated most of the city's power, and it was eventually abandoned.

A3.1750. *Ugo Ferraguti, l'ultimo archeologo-mecenate: cinque anni di scavi a Vulci (1928–1932) attraverso il fondo fotografico Ugo Ferraguti* / Francesco Buranelli. Roma: G. Bretschneider, 1994. 107, 89 p. DG70.V9 B874 1994.

A3.1751. *Vulci: scavi Mengarelli (1925–1929)* / Maria Teresa Falconi Amorelli. Roma: Borgia, 1987. 67, 9 p. DG70.V9 F35 1987.

JORDAN

A3.1752. *Caravan cities* / M. Rostovtzeff. New York: AMS Press, 1971. 232 p. DS49 .R83 1971. Commentary on Tadmur, Gerasa, Pétra, and Dura-Europos.

A3.1753. Field Projects in Jordan, Professor Dr. Zeodpun Al-Muheisen. http://muheisenz.webs.com/.

A3.1754. *Jordan, past & present: Pétra, Jerash, Amman* / E. Borgia. Roma: VISION, 2001. 74 p. DS153.3 .B6713 2001.

A3.1755. Preserving Ancient Statues from Jordan. http://asia.si.edu/jordan/html/jor_mm.htm.

Abila (Abila Dekapoleos, Abila in the Decapolis)

A3.1756. Abila Archaeological Project—Jordan. http://www.abila.org/. Location of two tells near the Hieromax River 25 kilometers east of the Sea of Galilee.

A3.1757. *Ancient Abila: an archaeological history* / John D. Wineland. Oxford: Archaeopress, 2001. 216 p. DS154.9.A25 W55 2001.

Abu Hamid Au Lendemain

A3.1758. Mission archéologique d'Abu Hamid Au lendemain du néolithique dans la vallée du Jourdai. http://www.diplomatie.gouv.fr/fr/enjeux-internationaux/echanges-scientifiques-recherche/archeologie-sciences-humaines-et/les-carnets-d-archeologie/orient-ancien/jordanie-abu-hamid/.

Aqaba

A3.1759. Roman Aqaba Project. http://history.ncsu.edu/.

Basta

A3.1760. *Basta* / Hans Jörg Nissen, Mujahed Muheisen, and Hans Georg K. Gebel. Berlin: Ex Oriente, 2004. 2 v. DS153.3 .B27 2004. 2 v. The well-preserved Neolithic farming village of Basta, located near as-Sadaqa, 25 kilometers south of Petra, produced beads of turquoise, bone, shell, and mother-of-pearl.

Gerasa (Jerash)

A3.1761. *A didactic case study of Jarash Archaeological Site, Jordan: stakeholders and heritage values in site management* / David Myers, Stacie Nicole Smith, and May Shaer. Los Angeles: Getty Conseration Institute; Amman, Jordan: Dept. of Antiquities, Hashemite Kingdom of Jordan, 2010. 77 p. DS154.9.G47 M94 2010. The site of the ruins of the Greco-Roman site of Gerasa. Also referred to as Antioch on the Golden River.

A3.1762. *Jerash Archaelogical Project* / Fawzi Zayadine. Amman, Jordan: Dept. of Antiquities of Jordan, 1986–1989. 2 v. DS154.9.G47 J47 1986.

A3.1763. *Spatial and religious transformations in the late antique polis: a multi-disciplinary analysis with a case-study of the city of Gerasa* / Charles March. Oxford: Archaeopress, 2009. 202 p. DS154.9.G47 M37 2009.

Handaquq, tell al- (one of the few excavated Chalcolithic sites in northern Jordan)

A3.1764. *Preliminary excavation reports Sardis, Idalion, and Tell el-Handaquq North* / William G. Dever. Cambridge: American Schools of Oriental Research, 1996. 154 p. DS101 .A45 v.53.

Hayyat, tell el-

A3.1765. *Bronze age rural ecology and village life at Tell el-Hayyat, Jordan* / Steven E. Falconer and Patricia L. Fall. Oxford: Archaeopress, 2006. 148 p. + 1 CD-ROM. DS154.9.T45 F36 2006. A Middle Bronze Age (ca. 2000–1500 BCE) about 7 kilometers southwest of Pella in the Jordan Valley.

Hesban, tell (Heshbon, Hesebon, Esebon, Esbous, Esebus)

A3.1766. *Hellenistic and Roman strata: a study of the stratigraphy of Tell Hesban from the 2d century B.C. to the 4th century A.D.* / Larry A. Mitchel. Berrien Springs, MI: Institute of Archaeology and Andrews University Press, 1992. 189 p. DS154.9.H47 M58 1992. An ancient town located east of the Jordan River within the historical territories of Ammon and ancient Israel.

Jabal Hamrat Fidan

A3.1767. Jabal Hamrat Fidan Project. http://ancientneareast.tripod.com/Jebel_Hamrat_Fidan.html.

Jawa

A3.1768. *Excavations at Jawa 1972–1986: stratigraphy, pottery and other finds: excavations and explorations in the Hashemite Kingdom of Jordan* / A. V. G. Betts. Edinburgh: Edinburgh University Press, 1991. 397 p. DS154.9.J38 E93 1991. The oldest known dam in the world is a masonry and earthen embankment at Jawa in the Black Desert of modern Jordan.

Karak

A3.1769. Virtual Karak Resources Project—Jordan. http://www.vkrp.org/.

Khirbet Iskander

A3.1770. Khirbet Iskander—Jordan. http://qeiyafa.huji.ac.il/.

Madaba Plains

A3.1771. Madaba Plains Project—Jordan. http://hesban. org/.

Pella of the Decapolis (Tabaqat Fahl)

A3.1772. *The chronology of the Jordan Valley during the Middle and Late Bronze Ages: Pella, Tell Abu Al-Kharaz, and Tell Deir Alla* / Peter M. Fischer. Wien: Verlag der Österreichishen Akademie der Wissenschaften, 2006. 261 p. DS153.3 .C47 2006. A Neolithic, Hellenistic, and Roman site located in the Jordan Valley 130 kilometers north of Amman in northwestern Jordan.

A3.1773. *The military architecture of Jordan during the Middle Bronze Age: new evidence from Pella and Rukeis* / P. Bruce McLaren. Oxford: Archaeopress, 2003. 147 p. DS153.3 .M35 2003.

A3.1774. *Pella decapolitana: Studien zur Geschichte, Architektur und Bildenden Kunst einer hellenisierten Stadt des Nördlichen Ostjordanlands* / Thomas Weber. Wiesbaden: In Kommission bei O. Harrassowitz, 1993. 99, 13 p. DS154.9.P4 W36 1993.

A3.1775. *Pella in Jordan, 1979–1990: the coins* / Kenneth Sheedy, Robert Carson, and Alan Walmsley. Sydney: Adapa, 2001. 183, 15 p. CJ277.P46 S484 2001.

A3.1776. *Society and polity at Bronze Age Pella: an Annales perspective* / A. Bernard Knapp. Sheffield, England: Sheffield Academic Press, 1993. 116 p. DS153.3 .K62 1993.

Pétra

A3.1777. American Expedition to Petra. http://www.cleovoulou.com/aep2000.htm. Historical and archaeological site in the Jordanian governorate of Ma'am famed for its rock-cut architecture and water conduit system. Petra was designated a UNESCO World Heritage Site in 1985.

A3.1778. *The architecture of Pétra* / Judith McKenzie. London: Oxford University Press for the British Academy, British School of Archaeology in Jerusalem and the British Institute at Amman for Archaeology and History, 1990. 209, 245 p. DS154.9.P48 M34 1990.

A3.1779. *Mountaintop sanctuaries at Pétra* / Zvi Uri Ma'oz. Qazrin, Israel: Archaostyle, 2008. 108 p. DS154.9.P48 M36 2008.

A3.1780. *Pétra* / Maria Giulia Amadasi Guzzo and Eugenia Equini Schneider. Milano: Electa, 1997. 202 p. DS154.9.P48 A42 1997.

A3.1781. *Pétra: Antike Felsstadt zwischen arabischer Tradition und griechischer Norm* / Thomas Weber and Robert Wenning (Hrsg.). Mainz am Rhein: P. von Zabern, 1997. 172 p. DS154.9.P48 P45 1997.

A3.1782. Petra. http://www.visitjordan.com/Default. aspx?tabid=63; http://whc.unesco.org/en/list/ 326.

A3.1783. Petra—The Great Temple Excavation. http:// www.brown.edu/Departments/Joukowsky_Institute/Petra/; http://opencontext.org/projects/A5D-DBEA2-B3C8-43F9-8151-33343CBDC857.

A3.1784. Petra—Myth and Reality. http://almashriq.hiof. no/jordan/900/930/petra/myth/.

A3.1785. *The 1981 Pétra excavations* / Nabil I. Khairy. Wiesbaden: O. Harrassowitz, 1990. DS154.9.P48 K59 1990.

A3.1786. *Pétra and the lost kingdom of the Nabataeans* / Jane Taylor. Cambridge: Harvard University Press, 2002. 224 p. DS154.9.P48 T39 2002.

A3.1787. *The Pétra church* / Zbigniew T. Fiema. Amman: American Center of Oriental Research, 2001. 446 p. DS154.9.P48 P487 2001.

A3.1788. *Pétra, la cité du désert* / Isabelle and Roger Normand. Annemasse: Éd. de la Boussole, 1997. 68 p. DS154.9.P48 N67 1997.

A3.1789. *The Pétra pool-complex: a Hellenistic paradeisos in the Nabataean capital: (results from the Pétra "lower market" survey and excavations, 1998)* / Leigh-Ann Bedal. Piscataway: Gorgias Press, 2003. 234 p. DS154.9.P48 B43 2003.

A3.1790. Photos of Petra. http://travel.nationalgeographic. com/travel/countries/petra-jordan-photos/.

A3.1791. *The pottery from Pétra: a neutron activation analysis study* / Khairieh Amr. Oxford: British Archaeological Reports, 1987. 332 p. DS154.9.P48 A47 1987.

A3.1792. *The small temple: a Roman imperial cult building in Pétra, Jordan* / Sara Karz Reid. Piscataway: Gorgias Press, 2005. 236 p. DS154.9.P48 R45 2005.

A3.1793. *Über Pétra hinaus: archäologische Erkundungen im südlichen Jordanien* / Manfred Lindner; im Auftrage des Deutschen Evangelischen Instituts für Altertumswissenschaft des Heiligen Landes; bearbeitet am Biblisch-Archäologischen Institut Wuppertal. Rahden/Westf: VML, Verlag Marie Leidorf, 2003. 272 p. DS154.9.P48 L56 2003.

A3.1794. *Il viaggio a Pétra di Giammartino Arconati Visconti (1865)* / Giancarlo Lacerenza. Napoli: Istituto Universitario Orientale, 1996. 49, 8 p. DS154.9.P48 L33 1996.

Sultan, tell es-

A3.1795. *Tell es-Sultan Jericho in the context of the Jordan Valley: site management, conservation, and*

sustainable development: proceedings of the international workshop held in Ariha 7th–11th February 2005 by the Department of Antiquities and Cultural Heritage, Ministry of Tourism and Antiquities UNESCO office-Ramallah Rome "La Sapienza" University / Lorenzo Nigro and Hamdan Taha. Rome: La Sapienza, 2006. 287 p. DS110.J4 T45 2006. The tell is located in the lower plain of the Jordan valley approximately 10 kilometers north of the Dead Sea and is the lowest town on earth (ca. 250 meters below sea level). The site of Tell es-Sultan is identified with ancient Jericho and is mentioned in ancient historical and biblical sources.

Tafila-Busayra

A3.1796. Tafila-Busayra Archaeological Survey (TBAS), Jordan. http://people.stfx.ca/bmacdona/TBAS-WEB/Welcome.htm.

Tell Abu al-Kharaz

A3.1797. Tell Abu al-Kharaz in Jordan. http://www.fischerarchaeology.se/?page_id=1.

Tell Nimrin

A3.1798. Tell Nimrin—Jordan. http://www.intute.ac.uk/cgi-bin/fullrecord.pl?handle=humbul9828.

Umm Qays (Umm Qais)

A3.1799. *Gadara, Gerasa und die Dekapolis* / Adolf Hoffmann und Susanne Kerner. Mainz: Verlag Philipp von Zabern, 2002. 150 p. DS154.9.G47 G333 2002. A town in northwestern Jordan near the site of ancient Gadara where the borders of Jordan, Israel, and Syria merge. The Hellenistic-Roman town of Gadara was also known as Antiochia, Antiochia Semiramis, and Seleucia.

Wadi Ziqlab

A3.1800. Wadi Ziqlab Project (Northern Jordan). http://homes.chass.utoronto.ca/~banning/Ziqlab/.

LEBANON

A3.1801. *A Journalist Investigates the Plundering of Lebanon's Heritage.* http://almashriq.hiof.no/ddc/projects/archaeology/berytus-back/berytus39/fisk/.

A3.1802. Archaeology in Lebanon Goes Begging. http://www.lebanonwire.com/0307/03073110DS.asp.

Anjaar

A3.1803. Anjaar, Lebanon. http://almashriq.hiof.no/lebanon/900/910/919/anjar/.

A3.1804. The Omayaad City of Anjaar, Lebanon. http://www.tracyanddale.50megs.com/anjaar/anjaar.html.

Ba'labakk

A3.1805. Baalbek. http://almashriq.hiof.no/lebanon/900/910/919/baalbek/; http://sacredsites.com/middle_east/lebanon/baalbek.html. Situated in the Beqaa Valley east of the Litani River, Baalbek is famous for large Roman temple structures when Baalbek was known as Heliopolis.

A3.1806. *Baalbek im Bann römischer Monumentalarchitektur* / Margarete van Ess and Thomas Weber. Mainz am Rhein: P. von Zabern, 1999. 151 p. DS89.B3 B335 1999.

A3.1807. *Histoire de Bérytos et d'Héliopolis d'après leurs monnaies, Ier siècle av. J.-C.-IIIe siècle apr. J.-C.* / Ziad Sawaya. Beyrouth: IFPO. Institut français du Proche-Orient, 2009. 409 p. CJ1095.B4 S393 2009.

A3.1808. *Le petit autel de Baalbek* / par Paul Collart and Pierre Coupel. Paris: P. Geuthner, 1977. 120, 34 p. NA221.B28 C64.

A3.1809. Virtual Baalbek. http://wwwtracyanddale.50megs.com/baalbeck/baalbeck1.html.

Beirut

A3.1810. Archaeology in the Reconstruction of Beirut. http://almashriq.hiof.no//lebanon/900/930/930.1/beirut/reconstruction/.

A3.1811. Urban Archeology in Beirut: A Preliminary Report. http://almashriq.hiof.no//lebanon/900/930/930.1/beirut/reconstruction/curvers_unesco_april.html.

Byblos

A3.1812. *La "nécropole énéolithique" de Byblos: nouvelles interprétations* / Gassia Artin. Oxford: Archaeopress, 2009. 219 p. DS89.B9 A78 2009. The Greek name of Gebal, the first city in Phoenicia. It is a UNESCO World Heritage Site.

A3.1813. *Byblos and Jericho in the early bronze I: social dynamics and cultural interactions: proceedings of the international workshop held in Rome on March 6th 2007 by Rome "La Sapienza" Univer-*

sity / Lorenzo Nigro. Rome: Università di Roma "La Sapienza," 2007. 133 p. DS110.J4 B95 2007.

Qadisha

A3.1814. Qadisha Valley. http://almashriq.hiof.no/lebanon/900/910/919/qadisha/.

Saida (Sidon) Lebanon

A3.1815. Saida-Etude Aerienne, au Sol et Sous-Marine. http://edmund2.hiof.no/general/900/930/933/saida-poidebard/.

Tyre

A3.1816. A Tophet in Tyre? http://almashriq.hiof.no/ddc/projects/archaeology/berytus-back/berytus39/seeden-tophet/.

A3.1817. City of Tyre. http://www.tracyanddale.50megs.com/Byblos/tyrsid.html.

Zarephath

A3.1818. *Recovering Sarepta, a Phoenician city: excavations at Sarafand, Lebanon, 1969–1974, by the University Museum of the University of Pennsylvania* / James B. Pritchard. Princeton: Princeton University Press, 1978. 162 p. DS89.S37 P74. A Phoenician town between Tyre and Sidon.

A3.1819. *Sarepta I: the late Bronze and Iron Age strata of area II, Y: the University Museum of the University of Pennsylvania excavations at Sarafand, Lebanon* / William P. Anderson. Beyrouth: Département des publications de l'Université libanaise, 1988. 707 p. DS89.S37 A633 1988; DS89.S37 A53 1988.

A3.1820. *Sarepta II: the late Bronze and Iron Age periods of area II, X: the University Museum of the University of Pennsylvania excavations at Sarafand, Lebanon* / Issam A. Khalifeh. Beyrouth: Distribution, Département des publications de l'Université libanaise, 1988. 436 p. DS89.S37 K43 1988; DS89.S37 K47 1988.

A3.1821. *Sarepta III: the imported Bronze and Iron Age wares from area II, X; the University Museum of the University of Pennsylvania excavations at Sarafand, Lebanon* / Robert B. Koehl. Beyrouth: Université libanaise: Library orientale, 1985. 209 p. DS89.S37 K63 1985; DS89.S24 K77 1985.

A3.1822. *Sarepta IV: the objects from area II, X: the University Museum of the University of Pennsylvania excavations at Sarafand, Lebanon* / James B. Pritchard. Beyrouth: Département des publica-

tions de l'Université libanaise, 1988. 325 p. DS89.S37 P743 1988; DS89.S37 P742 1988.

LIBYA

A3.1823. *Libye grecque, romaine et byzantine* / Jean-Marie Blas de Roblès. Aix-en-Provence: Edisud, 2005. 255 p. DT221 .B53 2005.

A3.1824. *Libya: the lost cities of the Roman Empire* / Robert Polidori. Cologne: Könemann, 1999. 256 p. DT221 .D58 1999.

Barqah

A3.1825. *Cirene e i Libyi*. Roma: L'erma di Bretschneider, 1987. 547 p. DT239.C9 C57 1987. The Arabic term for Cyrenaica (English), Cyrenaique (French), and Cirenaica (Italian). The Arab name is Barqah.

Cyrene

A3.1826. *La Cirenaica in età antica: atti del convegno internazionale di studi, Macerata, 18–20 maggio 1995* / Enzo Catani and Silvia Maria Marengo. Pisa; Roma: Istituti editoriali e poligrafici internazionali, 1998. 634, 76 p. DT238.C8 C57 1998. An ancient Greek colony and later a Roman city in modern Shahhat, Libya.

A3.1827. *Cirene "Atene d'Africa"* / Mario Luni. Roma: L'Erma di Bretschneider, 2006. 207 p. DT239.C9 C55 2006.

A3.1828. *Cyrène, Apollonia, Ptolemais: sites prestigieux de la Libye antique*. Dijon: Archéologia, 1992. 80 p. CC3.H478 no.167. Considers Cyrene, Susan, and Tolemaide.

A3.1829. *Extramural Sanctuary of Demeter and Persephone at Cyrene, Libya: final reports* / Donald White. Philadelphia: University Museum, University of Pennsylvania; Libyan Department of Antiquities, Tripoli, People's Socialist Libyan Arab Jamahiriya, 1984. DT239.C9 E98 1984, v.1–7.

A3.1830. *The four seasons of Cyrene: the excavation and explorations in 1861 of Lieutenants R. Murdoch Smith, R.E. and Edwin A. Porcher, R.N.* / Dorothy M. Thorn. Roma: L'Erma di Bretschneider, 2007. 313 p. DT239.C9 T48 2007.

A3.1831. *A gazetteer of the Cyrene necropolis: from the original notes of John Cassels, Richard Tomlinson and James and Dorothy Thorn* / Dorothy Thorn and James Copland Thorn. Roma: L'Erma di Bretschneider, 2009. 361 p. DT239.C9 G39 2009.

A3.1832. *Geschichte der Gründung und Blüthe des hellenischen Staates in Kyrenaika* / A. F. Gottschick. Leipzig, B. G. Teubner, 1858. 40 p. 939.75 G71.

A3.1833. *The necropolis of Cyrene: two hundred years of exploration* / James C. Thorn. Roma: L'Erma di Bretschneider, 2005. 829 p. DT239.C9 T56 2005.

A3.1834. *Recherches sur les cultes en Cyrénaïque durant le Haut-Empire romain* / Jean-Jacques Callot. Nancy: ADRA; Paris: de Boccard, 1999. 364 p. CC65 .E8 v.10; CC65 .E8 v.10.

A3.1835. *Statue iconiche femminili cirenaiche: contributi al problema delle copie e rielaborazioni tardoellenistiche e romano-imperiali* / Gustavo Traversari. Roma L'Erma di Bretschneider, 1960. 118, 34 p. 735.936 T699.

Leptis Magna (Lectis Magna, Lepcis Magna)

A3.1836. *Fontane e ninfei minori di Leptis Magna* / Francesco Tomasello. Roma: L'Erma di Bretschneider, 2005. 312, 15 p. NA335.L4 T663 2005. An important city during the Roman period. It is located 130 kilometers east of Tripoli on the Mediterranean coast where Wadi Lebda meets the sea.

A3.1837. *Leptis magna: la splendeur et l'oubli* / André Laronde and Gérard Degeorge. Paris: Hermann, 2005. 207 p. DT239.L4 L37 2005.

A3.1838. *Leptis Magna: dieci anni di scavi archeologici nell'area del Foro vecchio: i livelli fenici, punici e romani (Missione dell'Università di Messina)* / E. De Miro and A. Polito. Roma: L'Erma di Bretschneider, 2005. 405, 78 p. DT239.L4 D4 2005.

A3.1839. *Leptis Magna: una città e le sue iscrizioni in epoca tardoromana* / Ignazio Tantillo. Cassino: Università degli studi di Cassino, 2010. 576, 29 p. DT239.L4 L47 2010.

A3.1840. *Lepcis Magna unter den ersten Kaisern* / Detlev Kreikenbom. Wiesbaden: Harrassowitz Verlag, 2011. 32, 12 p. DT239.L4 K745 2011.

A3.1841. *Il teatro augusteo di Leptis Magna: scavo e restauro (1937–1951)* / Giacomo Caputo. Roma: L'Erma di Bretschneider, 1987. 148, 188 p. NA335.L5 C37 1987.

A3.1842. *I tre templi del lato nord-ovest del Foro Vecchio a Leptis Magna* / Antonino Di Vita and Monica Livadiotti. Roma: L'Erma di Bretschneider, 2005. 393 p. NA335.L4 T743 2005.

Sabrath (Sabratah, Siburata)

A3.1843. *L'area sacra di Ras Almunfakh presso Sabratha: le stele* / Luigi Taborelli. Roma: Consiglio nazionale delle ricerche, 1992. 198 p. DT239.S115 T33 1992. Located in the northwestern corner of Libya, was established ca. 500 BCE as a Phoenician trading depot that served as a costal outlet for products from the African hinterland. The extant archaeological site was inscribed as a UNESCO World Heritage Site in 1982.

A3.1844. *Gessi del Museo di Sabratha* / Giuseppina Barone. Roma: L'Erma di Bretschneider, 1994. 112, 24, 119 p. NB1180 .B267 1994.

A3.1845. *Guida di Sabratha* / Renato Bartoccini. Roma, Milano: Società editrice d'arte illustrata 1927. 77, 11 p. 913.61 B288.

A3.1846. *Il tempio a divinità ignota di Sabratha* / Elda Joly and Francesco Tomasello. Roma: L'Erma di Bretschneider, 1984. 196, 33 p. DT239.S115 J64 1984.

MACEDONIA

A3.1847. Ancient Macedonia. http://ancientmacedonia. com/.

A3.1848. Macédoine-Mission archéologique de Madzahari. http://www.diplomatie.gouv.fr/en/global-issues/ education-research/archaeology/archaeology-notebooks/europe-maghreb/macedonia-madzahari/.

A3.1849. Macedonia Rock Art Research Centre. http:// www.unet.com.mk/rockart/.

MALTA

A3.1850. *The archaeology of Punic Malta* / Claudia Sagona. Herent: Peeters, 2002. 1,165 p. DG989.5 .S24 2002; DG989.5 .S24 2002.

A3.1851. *L'arcipelago maltese in età romana e bizantina: attività economiche e scambi al centro del Mediterraneo* / Brunella Bruno. Bari: Edipuglia, 2004. 197 p. DG989.5 .B78 2004.

A3.1852. *I cartaginesi in Italia* / Sabatino Miscati. Milano: A. Mondadori, 1977. 360 p. DG225.C37 M67.

A3.1853. *Excavations in Malta* / M. A. Murray. London: B. Quaritch, 1923. 913.458 M962.

A3.1854. *La isla de Malta en época fenicia y púnica* / Pablo Vidal González. Oxford: Tempvs Reparatvm; Hadrian Books, 1996. 268 p. DG992 .V53 1996.

A3.1855. *Malta* / John Davies Evans. London: Thames and Hudson, 1959. 255 p. 913.458 Ev12a; DG992 .E8 1959.

A3.1856. *Malta: an archaeological guide* / D. H. Trump. London: Faber and Faber, 1972. 171 p. DG989 .T78.

A3.1857. *Missione archeologica italiana a Malta: rapporto preliminare della Campagne 1965* / Michelangelo Cagiano de Azevedo. Roma: Istituto di studi del Vicino Oriente, 1966. 182, 128 p. DG989.5 .M52 1966. Continued by: *Missione archeologica italiana a Malta: rapporto preliminare della Campagna 1966* / Michelangelo Cagiano de Azevedo. Roma: Istituto di studi del Vicino Oriente, 1967. 134, 90 p. DG989.5 .M525 1967; *Missione archeologica italiana a Malta: rapporto preliminare della Campagna 1967* / Clara Bozzi. Roma: Istituto di studi del Vicino Oriente, 1968. 115, 58 p. DG989.5 .M53 1968; *Missione archeologica italiana a Malta. Rapporto preliminare della campagna 1968* / Giuseppe Busuttil, Michelangelo Cagiano de Azevedo, Antonia Ciasca, Francesco D'Andria, Rosanna Del Monaco, Maria Giulia Guzzo Amadisi, Bice Olivieri Pugliese, and Maria Pia Rossignani. Roma: Consiglio nazionale delle ricerche, 1969. 124 p. DG989.5 .M54; *Missione archeologica italiana a Malta: Rapporto preliminare della campagna 1969* / di Michelangelo Cagiano de Azevedo, Caterina Caprino, Antonia Ciasca, Francesco D'Andria, Alberto Davico, Cristiano Grottanelli, Maria Giulia Guzzo Amadasi, Tea Martinelli Coco, and Maria Pia Rossignani. Roma: Consiglio nazionale delle ricerche, 1972. 138 p. DG989.5 .M55.

A3.1858. *Population, land use and settlement on Punic Malta: a contextual analysis of the burial evidence* / George A. Said-Zammit. Oxford: Archaeopress, 1997. 159 p. DG989.5 .S3 1997.

A3.1859. *Punic antiquities of Malta and other ancient artefacts held in ecclesiastic and private collections* / Claudia Sagona. Leuven; Dudley: Peeters, 2003–2006. 2 v. DG989.5 .S244 2003; DG989.5 .S244 2003.

A3.1860. *Roman and Byzantine Malta: trade and economy* / Brunella Bruno. Sta. Venera, Malta: Midsea, 2009. 254 p. DG989.5 .B7813 2009.

Gozo Island

A3.1861. *Ägyptisches Kulturgut auf den Inseln Malta und Gozo in phönikiischer und punischer Zeit: die Objekte im Archäologischen Museum von Valletta* / Günther Hölbl. Wien: Verlag der Österreichischen Akademie der Wissenschaften, 1989. 212, 26 p. AS142 .V31 Bd.538. A small island of the Maltese archipelago in the Mediterranean Sea. The island of Gozo has long been identified as Ogygia, the domain of the nymph Calypso in Homer's *Odyssey*.

A3.1862. Temples of Malta and Gozo. http://bradshaw-foundation.com/malta/.

Marsa

A3.1863. *Human-induced changes in the environment and landscape of the Maltese Islands from the Neolithic to the 15th century AD: as inferred from a scientific study of sediments from Marsa, Malta* / Katrin Fenech. Oxford: Archaeopress, 2007. 155 p. DG989.5 .F46 2007. A port was established at Marsa by the Phoenicians, and Roman constructions are found close to the town.

Skorba

A3.1864. *Skorba, excavations carried out on behalf of the National Museum of Malta, 1961–1963* / D. H. Trump. London: Society of Antiquaries; Malta, National Museum, 1966. 11, 55 p. DG989.5 .T7. The Skorba temples are megalithic remains from the Neolithic in northern Malta. The site's importance has led to its listing as a UNESCO World Heritage Site, a listing it shares with six other megalithic temples in Malta.

Xaghra Cliffs

A3.1865. *Mortuary customs in prehistoric Malta: excavations at the Brochtorff Circle at Xaghra (1987–94)* / Caroline Malone. Cambridge: McDonald Institute for Archeological Research; Oakville: David Brown, 2009. 521 p. GN845.M3 M67 2009. Ix-Xaghara is a village on the island of Gozo and home to the Gantija megaliths, Xaghra stone circle, Xerri's Grotto, and Ninu's Cave. It is probably the earliest inhabited part of Gozo.

MOROCCO

Basra

A3.1866. *Anatomy of a medieval Islamic town: Al-Basra, Morocco* / Nancy L. Benco. Oxford: Archaeopress, 2004. 106 p. DT329.B37 A53 2004. A medieval islamic city in northern Morocco, about 100 kilometers south of the Straits of Gibraltar and the Rif Mountains. A mint at al-Basra issued coins, and the city served as an administrative, commercial, and agricultural center for the Islamic civilization between ca. CE 800 and CE 1100. It produced many goods for the extensive Mediterranean and sub-Saharan trade market, including iron and copper, utilitarian pottery, glass beads, and glass objects.

Lixus

A3.1867. *Lixus: actes du colloque* / organisé par l'Institut des sciences de l'archéologie et du patrimoine

de Rabat avec le concours de l'École française de Rome, Larache, 8–11 novembre 1989. Rome: École Française de Rome, 1992. 420 p. DT329. L59 L59 1992. The site of an ancient city north of modern Larache on the banks of the Loukkos River; one of the major centers of the Roman province Mauretania Tingitana.

A3.1868. *Lixus: historia de la ciudad, guia de las ruinas y de la seccion de Lixus del Museo Arqueológico de Tetuán* / M. Tarradell. Tetuán: Instituto Muley el-Hasan, 1959. 78, 34 p. DT329.L59 T37 1959.

Rirha

A3.1869. Maroc: Rirha. http://www.diplomatie.gouv.fr/fr/ enjeux-internationaux/echanges-scientifiques-recherche/archeologie-sciences-humaines-et/les-carnets-d-archeologie/europe-maghreb/.

Volubilis

A3.1870. Maroc: Vixus/Volubilis. http://www.diploma-tie.gouv.fr/fr/enjeux-internationaux/echanges-scientifiques-recherche/archeologie-sciences-humaines-et/les-carnets-d-archeologie/europe-maghreb/maroc-lixus-volubilis/. Also known as Walilli, an archaeological site situated near Meknes, Morocco, between Fez and Rabat. Walili features the best preserved Roman ruins in this part of northern Africa. In 1997 the site was listed as a UNESCO World Heritage site.

A3.1871. *Volubilis: eine römische Stadt in Marokko von der Frühzeit bis in die islamische Periode* / Martina Risse. Mainz am Rhein: Verlag Philipp von Zabern, 2001. 120 p. DT329.V6 V65 2001.

NUBIA

A3.1872. *Amun temples in Nubia: a typological study of New Kingdom, Napatan and Meroitic temples* / Caroline M. Rocheleau. Oxford: Archaeopress, 2008. 96 p. DT159.6.N83 R63 2008.

A3.1873. *Egypt and Africa: Nubia from prehistory to Islam* / W. V. Davies. London: British Museum Press in association with the Egypt Exploration Society, 1991. 320, 16 p. DT149.6.N83 E39 1991.

A3.1874. *The Finnish Nubia expedition to Sudanese Nubia: 1964–65: the excavation reports* / Gustaf Donner. Helsinki: Suomen Muinaismuistoy-distys, 1998. 2 v. DK445.S7 nr.105.

A3.1875. Nubia Salvage Project. http://oi.uchicago.edu/ research/projects/nub/.

Berenice Pancrisia

A3.1876. *Das Goldland der Pharaonen: die Entdeckung von Berenike Pankrista* / Alfredo Castiglioni, Angelo Castiglioni, and Jean Vercoutter. Mainz: P. von Zabern, 1998. 192 p. DT159.9.B47 C377 1998. Berenike was founded by Ptolemy II Philadelphus in the mid-third century BCE as a place of commerce with Africa and Arabia and as a port for receiving elephants from Africa that were to be trained and used in war against the Indian elephants in the Seleucid army.

Buhen

A3.1877. *Buhen* / D. Randall-Maciver and C. Leonard Woolley. Philadelphia: University Museum, 1911. 2 v. DT135.N8 E19 v.7–8. An ancient Egyptian fortress located on the west bank of the Nile north of the Second Cataract.

Kulubnarti

A3.1878. *Kulubnarti III: the cemeteries* / William Y. Adams. Oxford: Archaeopress: Hadrian Books, 1999. 88, 8 p. DT159.6.K86 K85 1999. A small island in northern Sudan about 160 kilometers south of the Egyptian border.

Meroe

A3.1879. *The gold of Meroe* / Karl-Heinz Priese. New York: Metropolitan Museum of Art; Mainz: Verlag Philipp von Zabern, 1993. 49 p. NK7387.8.M47 P7513 1993. Meroe is an ancient city on the east bank of the Nile about 200 kilometers northeast of Khartoum. The city was the capital of the Kingdom of Kush and is remarkable for its more than 200 pyramids arranged in three groups. The kingdom began to fade as a power by the first or second century CE, sapped by the war with Roman Egypt and the decline of its traditional industries.

A3.1880. *Hellenizing art in ancient Nubia, 300 BC–AD 250, and its Egyptian models: a study in "acculturation"* / László Török. Leiden; Boston: Brill, 2011. 483 p. N5350 .T83 2011.

A3.1881. *Meroitistische Forschungen 1980: Akten der 4. Internationalen Tagung für Meroitistische Forschungen vom 24. bis 29. November 1980 in Berlin* / Fritz Hintze. Berlin: Akademie-Verlag, 1984. 620, 17 p. DT159.6.N83 I57 1980.

A3.1882. *Der meroitische Staat 1: Untersuchungen und Urkunden zur Geschichte des Sudan im Altertum* / Lásló Török. Berlin: Akademie-Verlag, 1986. DT73.M6 T6711 1986.

A3.1883. *Studia Meroitica 1984: proceedings of the Fifth International Conference for Meroitic Studies, Rome 1984* / Sergio Donadoni and Steffen Wenig. Berlin: Akademie-Verlag, 1989. 896, 23 p. DT159.6.N83 I55 1984.

Napata

A3.1884. *The inscription of Queen Katimala at Semna: textual evidence for the origins of the Napatan State* / John Coleman Darnell. New Haven: Yale Egyptological Seminar; Oakville: David Brown, 2006. 112, 8 p. PJ1526.N37 D37 2006. Napata was a city-state of ancient Nubia on the west bank of the Nile River, at the site of modern Karima, northern Sudan.

A3.1885. *The Kushite cemetery of Sanam: a non-royal burial ground of the Nubian capital, c.800–600 BC* / Angelika Lohwasser. London: Golden House, 2010. 150, 8 p. DT159.6.N83 L68 2010.

A3.1886. *Napata e Meroe: templi d'oro sul Nilo* / Alessandro Roccati. Milano: Electa, 1999. 174 p. N5350 .N37 1999.

Noricum

A3.1887. *Noricum* / Thomas Fischer. Mainz am Rhein: Philipp von Zabern, 2002. 157 p. DG59.N7 F573 2002.

Oxyrhynchus

A3.1888. Oxyrhynchus: A City and Its Texts. http://www. papyrology.ox.ac.uk/Poxy/Exhibition/exhib_ welcome.html.

A3.1889. POxy: Oxyrhynchus Online. http://www.papy-rology.ox.ac.uk/POxy/.

Qustul and Ballana

A3.1890. *Meroitic remains from Qustul cemetery Q, Ballana cemetery B, and a Ballana settlement* / Bruce Beyer Williams. Chicago: Oriental Institute of the University of Chicago, 1991. 2 v. DT135.N8 U54 v.8.

Sayyalah

A3.1891. *Nag El-Scheima: eine befestigte christliche Siedlung und andere christliche Denkmäler in Sayala-Nubien* / Manfred Bietak and Mario Schwarz. Wien: Verlag der Österreichischen Akademie der Wissenschaften, 1987. 2 v. AS142. V32 Bd.191. Qustul was an ancient Egyptian site near the modern border with Sudan. A cemetery of large tombs contained the first great royal monuments, and Qustul in Nubia may have been the seat of Egypt's founding dynasty. A total of 122 tombs were found at this cemetery of Ballana in Lower Nubia. They date to the time after the collapse of the Meroitic state but before the founding of the Christian Nubian kingdoms, around 350 to 600 CE.

Serra

A3.1892. *Excavations at Serra East: Parts 1–5: A-group, C-group, pan grave, New Kingdom, and X-group remains from cemeteries A–G and rock shelters* / Bruce Beyer Williams, George R. Hughes, and James E. Knudstad. Chicago: Oriental Institute of the University of Chicago, 1993. 236, 43 p. DT135.N8 U54 v.10. A fortress of the Egyptian New Kingdom, located on the east bank of the Nile 300 kilometers upriver from Philae.

OMAN

A3.1893. Oman Archaeology-German Archaeological Expedition to the Sultanate of Oman. http://www. ufg-va.uni-hd.de/forschung/yule_oman.html.

A3.1894. *In the shadow of the ancestors: the prehistoric foundations of the early Arabian civilization in Oman* / Serge Cleuziou and Maurizio Tosi. Muscat: Ministry of Heritage & Culture, Sultanate of Oman, 2007. 334 p. DS247.O63 C56 2007.

A3.1895. Oman Archaeology Network Project. http:// www.oman.org/arch00.htm.

A3.1896. Southern Oman yields ruins of an ancient city on the fabled frankincense route. http://www. archaeology.org/9705/abstracts/ubar.html.

A3.1897. *Studies in the archaeology of the Sultanate of Oman* / Paul Yule. Rahden: Verlag Marie Leidorf, 1999. 196 p. DS247.O63 S782 1999.

al Ain

A3.1898. Archaeology Bulletins at the Al Ain Chapter of the Emirates Natural History Group. http://www. enhg.org/subject/arch.htm.

A3.1899. Archaeology in Al Ain. http://www.enhg.org/b/ b30/30_17.htm.

A3.1900. Archaeological Sites of Bat, al-Khutm, and al-Ayn. http://www.tripadvisor.com/Attraction_ Review-g294006-d324112-Reviews-Archaeo-logical_Sites_of_Bat_Al_Khutm_and_Al_Ayn-Oman.html.

al-Khutum

A3.1901. Archaeological Sites of Bat, al-Khutm, and al-Ayn. http://www.tripadvisor.com/Attraction_Review-g294006-d324112-Reviews-Archaeological_Sites_of_Bat_Al_Khutm_and_Al_Ayn-Oman.html.

Bat

A3.1902. Archaeological Sites of Bat, al-Khutm, and al-Ayn. http://www.tripadvisor.com/Attraction_Review-g294006-d324112-Reviews-Archaeological_Sites_of_Bat_Al_Khutm_and_Al_Ayn-Oman.html.

Dhofar

A3.1903. *The land of incense: archaeological work in the Governorate of Dhofar, Sultanate of Oman 1990–1995; the project of the National Committee for Supervision of Archaeological Survey in the Sultanate Ministry of Information* / Juris Zarins. Oman: Sultanate of Oman, 2001. 192 p. DS248.D36 Z4713 2001. A mountainous region of southern Oman on the border with Yemen was a major exporter of frankincense in ancient times.

Ibri/Selme

A3.1904. *The metal hoard from Ibri/Selme, Sultanate of Oman* / Paul Yule and Gerd Weisgerber. Stuttgart: F. Steiner, 2001. 106, 51 p. DS247.O63 Y9542 2001. A city in the Ad Dhahirah region of northeast Oman. The ruins of Bat is a designated UNESCO World Heritage Site.

Khor Rori

A3.1905. Italian Mission to Oman-Excavation and Restoration of Khor Rori in the Dhofar Governorate. http://cat.inist.fr/?aModele=afficheN&cpsidt=14794064.

Magan

A3.1906. Digging in the Land of Magan. http://www.archaeology.org/9705/abstracts/magan.html.

Musandam Peninsula

A3.1907. *La Péninsule d'Oman de la fin de l'Age du Fer au début de la période sassanide, 250 av.–350 ap. JC* / Michel Mouton. Oxford: Archaeopress, 2008. 325, 162 p. DS247.O63 M68 2008. On the Strait of Hormuz, Musandam is separated from the rest of Oman by the east coast of the United Arab Emirates.

Samad al-Shan

A3.1908. *Die Gräberfelder in Samad al-Shan (Sultanat Oman): Materialien zu einer Kulturgeschichte* / Paul Yule. Rahden: Verlag Marie Leidorf, 2001. 2 v. DS247.O63 Y954 2001. A Late Iron Age site in Sharqiyah province, central Oman.

Sumhuram

A3.1909. *A port in Arabia between Rome and the Indian Ocean, 3rd C.BC–5th C.AD: Khor Rori report 2* / Alessandra Avanzini. Roma: L'Erma di Bretschneider, 2008. 742 p. DS247.4.S85 P678 2008. The most important pre-Islamic ancient site in the Dhofar region and an important station in the frankincense trading network.

Ubar (Wabar, Iram)

A3.1910. *The road to Ubar: finding the Atlantis of the sands* / Nicholas Clapp. Boston: Houghton Mifflin, 1998. 342 p. DS247.O63 C55 1998. Site excavation of a Bedouin well as Shisr in Dhofar province and examination of satellite photographs revealed the location of Ubar, or Iram of the Pillars, an ancient city destroyed by a natural disaster. T. E. Lawrence referred to Ubar as the "Atlantis of the Sands."

A3.1911. Search for Ubar—How Remote Sensing Helped Find a Lost City. http://www.omaninfo.com/people-and-society/how-remote-sensing-helped-find-lost-city-ubar.asp.

A3.1912. Ubar, Lost City Found. http://www.pbs.org/wgbh/nova/ubar/indextext.html.

A3.1913. Ubar Optical/Radar. http://www.jpl.nasa.gov/radar/sircxsar/ubar1.html; http://www.uaeinteract.com/history/e_walk/ew_strt.asp.

PORTUGAL

A3.1914. *Les Villes de Lusitanie romaine: hiérarchies et territoires: table ronde internationale du CNRS, Talence, le 8–9 décembre 1988*. Paris: Editions du Centre National de la Recherche Scientifique: Presses du CNRS, diffusion, 1990. 334 p. DP528 .V55 1990.

Braga

A3.1915. *Self-sufficiency and trade in Bracara Augusta during the Early Empire: a contribution to the*

economic study of the city / Rui Morais. Oxford: Archaeopress, 2009. 328 p. DP702.B51 M67 2009. The settlement, known as Bracara Augusta under the Roman Empire, was center of the province of Gallaecia.

Torre de Palma

A3.1916. Portugal: Torre de Palma. http://www.diplomatie.gouv.fr/fr/enjeux-internationaux/echanges-scientifiques-recherche/archeologie-sciences-humaines-et/les-carnets-d-archeologie/europe-maghreb/portugal-torre-de-palma/.

A3.1917. Portugal—La Villa de Torre de Palma (Alto Alentejo). http://www.diplomatie.gouv.fr/fr/enjeux-internationaux/echanges-scientifiques-recherche/archeologie-sciences-humaines-et/les-carnets-d-archeologie/europe-maghreb/portugal-torre-de-palma/.

ROMANIA

The ancient Romans exploited gold mines in Transylvania, building access roads and forts to protect them. The region developed a strong infrastructure and economy, based on agriculture, cattle farming, and mining. Colonists from Thracia, Moesia, Macedonia, Gaul, Syria, and other Roman provinces were brought in to settle the land, developing cities such as Apulum (Alba Iulia) and Napoca (Cluj Napoca) into municipiums and colonias.

Abrudbánya (Abrud)

A3.1918. *Libellus aurarius* / H. F. Massmann. Lipsiae, prostant apud T. O. Weigel, 1840. 153 p. A town located on the Abrud River in central Romania. A small fortification was founded by the Romans (Abruttus) as part of the defensive system associated with the neighboring gold mines.

Adamclisi

A3.1919. *Adamclisi* / V. Barbu. Bucuresti: Meridiane, 1965. 56, 24 p. 913.498 B233. A Roman castrum named Civitas Tropaensium was located in the Dobrogea region of Romania.

Bratei

A3.1920. *Populatia romaneasca in Transilvania in s* École *le VII–VIII: (cimitirul nr. 2 de la Bratei)* / Eugenia Zaharia. Bucuresti: Editura Academiei Republicii Socialiste Româna, 1977. 136, 1 p. DR296.B745 Z33.

Dobruja

A3.1921. *The army in Roman Dobrudja* / Andrei Aricescu. Oxford: British Archaeological Reports, 1980. 225 p. U35.A75.

A3.1922. *Local and imported ceramics in the Roman province of Scythia (4th–6th centuries AD): aspects of economic life in the province of Scythia* / Andrei Opait. Oxford: Archaeopress: Hadrian Books, 2004. 180 p. NK3850.O63 2004.

Sarmizegetusa

A3.1923. *Le forum vetus de Sarmizegetusa* / Ioan Piso. Bucarest: Académie roumaine, 2006. DR296.S26 F67 2006. Ulpia Traiana Sarmizegetusa was the Roman capital of Dacia constructed by the Roman Emporer Trajan. The military and political capital of the ancient Dacians, Sarmizegetusa, was located 40 kilometers away.

A3.1924. *Town-planning and population in Ulpia Traiana Sarmizegetusa* / Dorin Alicu and Adela Paki. Oxford: Tempus Reparatum, 1995. DR296.S26 A44 1995.

Sucidava

A3.1925. *Sucidava: une cité daco-romaine et byzantine en Dacie* / D. Tudor. Bruxelles: Latomus, 1965. 140 p. 880C C687 v.80. A Dacian and Daco-Roman historical site situated in Corabia, Romania, on the north bank of the Danube.

RUSSIA

A3.1926. *Antichnaia skul'ptura iz sobraniia Gosudarstvennogo muzeia izobrazitel'nykh iskusstv imeni A.S. Pushkina* / L. I. Akimova. va: Izobrazitel'noe iskusstvo, 1987. 2230 p. N312.M85 1987. Translation: Antique sculpture from the collection of the Pushkin fine arts museum in Moscow.

Phanagoria

A3.1927. *Attic fine pottery of the archaic to Hellenistic periods in Phanagoria* / Catherine Morgan. Leiden; Boston: Brill, 2004. 291, 68 p. DK651. P52 M67 2004. The largest Greek colony on the Taman peninsula, spreading along the Asian shore of the Cimmerian-Bosporus. The ancient city became the great emporium for all the traffic between the coast of the Palus Maeotis and southern Caucasus.

Tanais

A3.1928. *Nekropol Tanaisa: raskopki 1981–1995 gg.* / T. M. Arseneva, S. I. Bezuglov, and I. V. Tolochko. Moskva: Paleograf, 2001. 273, 100 p. DK651. T32 A754 2001. The site of Tanais was occupied long before the Milesians founded an emporium there. A necropolis of over 300 burial mounds near the ancient city indicates that the site was occupied since the Bronze Age and that mound burials continued through Greek and Roman times.

SARDINIA

A3.1929. *Africa ipsa parens illa Sardiniae: studi di storia antica e di epigrafia* / Paola Ruggeri. Sassari: EDES, 1999. 370 p. DT170.R84 1999.

A3.1930. Archaeological research in Sardinia. http://www.gla.ac.uk/schools/humanities/research/archaeologyresearch/projects/sardinia/.

A3.1931. Archaeology in Sardinia. http://ase.tufts.edu/classics/facultyguide/mbalmuth/sardinia.html.

A3.1932. *I fenici e i cartaginesi in Sardegna* / Piero Bartoloni. Sassari: C. Delfino, 2009. 286 p. DG55.S2 B369 2009.

A3.1933. *Los Foros romanos de las provincias occidentales.* Madrid: Ministerio de Cultura, Dirección General de Bellas Artes y Archivos, 1987. 236, 6 p. NA312.F67 1987.

A3.1934. *Logos peri tes Sardous: le fonti classiche e la Sardegna: atti del convegno di studi, Lanusei, 29 dicembre 1998* / Raimondo Zucca. Roma: Carocci, 2004. 189 p. DG55.S2 L64 2004.

A3.1935. *A prehistory of Sardinia, 2300–500 BC* / Gary S. Webster. Sheffield, England: Sheffield Academic Press, 1996. 224 p. DG55.S2 W43 1996.

A3.1936. *Sardegna* / Alberto Moravetti and Carlo Tozzi. Forlì: A.B.A.C.O., 1995. 240 p. DG55.S2 S25 1995. Guide.

A3.1937. *Sufetes Africae et Sardiniae: studi storici e geografici sul Mediterraneo antico* / Raimondo Zucca. Roma: Carocci, 2004. 224 p. DG55.S2 Z825 2004.

A3.1938. *Voluptatem spectandi non perdat sed mutet: observations sur l'iconographie du martyre en Afrique Romaine* / J. W. Salomonson. Amsterdam; New York: North-Holland, 1979. 100, 2 p. AS244.A52 n.r. deel-98.

Geridu

A3.1939. *Geridu: archeologia e storia di un villaggio medievale in Sardegna* / Marco Milanese. Sassari: C. Delfino, 2001. 87 p. DG975.G366 G47 2001.

Neapolis

A3.1940. *Da Qrthdsht a Neapolis: trasformazioni dei paesaggi urbano e periurbano dalla fase fenicia alla fase bizantina* / Elisabetta Garau. Ortacesus (Cagliari): Nuove grafiche Puddu, 2006. 346 p. DG70.N42 G37 2006. Remains of a Roman road and aqueduct located on the west coast in the comune of Guspini.

Nora

A3.1941. *Nora: guida agli scavi* / Gennaro Pesce. Cagliari: Editrice Sarda Fossataro, 1978. 140, 107 p. DG55.S2 P48 1978. An ancient Punic and Roman town located on a peninsula near Pula.

Nuraghi

A3.1942. *Arte militare e architettura nuragica: Nuragic architecture in its military, territorial and socio-economic context: proceedings of the first International Colloquium on Nuragic Architecture at the Swedish Institute in Rome, 7–9 December, 1989* / Barbro Santillo Frizell. Stockholm: Svenska institutet i Rom; Göteborg, Sweden: P. Äström, 1991. 195 p. DG12 .S8 v.48. The Nuragic civilization of Sardinia extended from the Bronze Age (18 century BCE–2 century CE). The characteristic monuments, nuraghe, were tower fortresses.

A3.1943. *Duos Nuraghes: a Bronze age settlement in Sardinia* / Gary S. Webster. Oxford: Archaeopress, 2001. DG55.S2 W433 2001.

A3.1944. *Nuraghe noeddos and the Bonu Ighinu Valley: excavation and survey in Sardinia* / David Trump. Oxford: Oxbow Books in association with the Ministero per i Beni culturali e ambientali, 1990. 67, 70 p. DG55.S2 T78 1990.

A3.1945. *Ricerche archeologiche nel Marghine-Planargia* / Alberto Moravetti. Sassari: C. Delfino, 1998. 2 v. DG55.S2 M66 1998; DG55.S2 M66 1998.

A3.1946. *La Sardegna preistorica e nuragica* / Ercole Contu. Sassari: Chiarella, 1997. 2 v. GN818.S3 C66 1997.

A3.1947. *Studies in Nuragic archaeology: village excavations at Nuraghe Urpes and Nuraghe Toscono in West-Central Sardinia* / Joseph W. Michels and Gary S. Webster. Oxford: British Archaeological Reports, 1987. 169 p. DG975.S3 S8 1987.

Porto Torres

A3.1948. *Turris Libisonis: fouille d'un site romain tardif à Porto Torres, Sardaigne* / Francoise Villedieu. Oxford: British Archaeological Reports, 1984.

350 p. DG55.S2 V55 1984. Turris Libyssonis is situated on the north coast of Sardinia about 25 kilometers east of Capo del Falcone.

Sirai Mountain

A3.1949. *Monte Sirai* / Piero Bartoloni, Sandro Filippo Bondì, and Luisa Anna Marras. Roma: Libreria dello Stato, Istituto poligrafico e Zecca dello Stato, 1992. 143 p. DG55.S2 B368 1992. A Punic and Phoenician stronghold located on the south coast of Sardinia. It protected access to the mining area of Iglesiente.

Tharros

A3.1950. *Tharros: la collezione Pesce* / Enrico Acquaro. Roma: Consiglio nazionale delle ricerche, 1990. 115, 31 p. DG70.T5 T36 1990. An ancient Phoenician-Roman port near Capo San Marcos.

A3.1951. *Tharros XXI–XXII* / E. Roma: Consiglio nazionale delle ricerche, 1995. 187, 22 p. DG70.T5 T43 1995.

SAUDI ARABIA

A3.1952. *Prehistory and protohistory of the Arabian Peninsula* / Muhammed Abdul Nayeem. Hyderabad, India: Hyderabad Publishers, 1990–1998. 5 v. DS211.N39 1990, v.1–5.

A3.1953. Written in Stone—Inscriptions from the National Museum of Saudi Arabia. http://www.mnh.si.edu/epigraphy/.

Tihama

A3.1954. *The Tihamah coastal plain of South-West Arabia in its regional context, c.6000 BC–AD 600* / Nadia Durrani. Oxford: Archaeopress; Hadrian Books, 2005. ix, 164 p. DS247.Y43 D87 2005. A coastal plain bordering the Red Sea, extends from Jeddah, Saudi Arabia, south to the Gulf of Aden, where it merges with the mountains of Asir and Yemen. The population of this area originally migrated from Yemen.

SERBIA

Gamzigrad

A3.1955. *Imperial mausolea and consecration memorials in Felix Romuliana (Gamzigrad, East Serbia)* / Dragoslav Srejović and Čedomir Vasić. Belgrade: Centre for Archaeological Research, Fac-

ulty of Philosophy, University of Belgrade, 1994. 195 p. DR2125.G35 S683 1994. Located near Zajecar, south of the Danube River. It is the site of the Felix Romuliana ruins, built by Emperor Galerius.

Gamzigrad, Naissus, Nis, Romuliana, Sirmium, and Sremska Mitrovica

A3.1956. *Roman imperial towns and palaces in Serbia: Sirmium, Romuliana, Naissus: catalog* / Dragoslav Srejović. Belgrade: Serbian Academy of Sciences and Arts, 1993. 401 p. DR1951.R5613 1993.

Horreum Margi

A3.1957. *Nalazi rimskog bronzanog novca IV i V veka iz municipijuma Horreum Margi, Ćuprija* / Miloje Vasić. Beograd: Arheoloski institut: Vojni institut, 1990. 120 p. CJ893.H67 V37 1990. A fort built by the Romans on the road from Constantinople to Rome.

Idimum

A3.1958. *Mansio Idimum: rimska postanska i putna stanica kod Medveđe* / Miloje Vasic, Gordana Milosevic. Beograd: Arheoloski Institut; Narodni muzej, 2000. 293 p. DR2125.I4 V37 2000.

Justiniana Prima

A3.1959. *Caricin Grad: recherches archéologiques franco-yougoslaves à Caracin Grad conduites par l'Institut archéologique de Belgrade, le Centre A. Merlin du Centre National de la Recherche Scientifique et l'École française de Rome sous la responsabilité de l'Institut pour la protection des monuments historiques de Nis* / Noel Duval. Belgrade: Institut archéologique de Belgrade; Rome: École française de Rome, 1984. DR2125.J87 C37 1984, v.1–2. A Roman city founded by Justinian I that served as the seat to the archbishopric. Located in southern Serbia, near Lebane.

Moesia

A3.1960. *Rimski predmeti od kosti i roga sa teritorije Gornje Mezije* / Sofija Petković. Beograd: Arheoloski institut, 1995. 150 p. CC79.5.B64 P48 1995. An ancient region and Roman province situated in the Balkans. It rests along the south bank of the Danube River.

Nis

A3.1961. *Medijana: rezidencija rimskih careva* / Petar Petrović. Beograd: Srpska akademija nauka i umetnosti arheoloski institut; Nis: Narodni muzej, 1994. 113 p. DR2125.N57 P48 1994. One of the main cities along the Via Militaris built by the Romans in the first century CE, considered to be a gateway between the East and the West; also the birthplace of Constantine the Great.

Ras

A3.1962. *Tvrđava Ras; The fortress of Ras* / Marko Popović. Beograd: Arheoloski institut, 1999. 449 p. DR2125.R37 P68 1999. Also known as Stari Ras. Founded between the eighth and ninth centuries, it is the site of numerous medieval monuments including fortresses, churches, and monasteries.

Ulpiana

A3.1963. *Rimska keramika Ulpijane* / Slobodan Fidanovski. Beograd: Univerzitet u Beogradu, Filozofski fakultet, 1990. 71, 35 p. NK3850 .F53 1990. Ulpiana (Justiniana Secunda) is located in modern-day Kosovo. Ulpiana flourished under the Roman Empire until it was destroyed in 479 by the Goths. In the sixth century it was rebuilt during the reign of Justinian and was renamed Justiniana Secunda.

Viminacium

A3.1964. *Viminacium: nekropola "Vise grobalja"* / Ljubica Zotović and Caslav Jordović. Beograd: Arheoloski institut: Republicki zavod za zastitu spomenika kulture, 1990. DR2125.V55 Z68 1990, v.1. A large Roman city and military camp situated along Via Militaris. It is located in East Serbia near the modern town of Kostolac.

SICILY

A3.1965. *Sicilia dal cielo: le città antiche* / Emilio Gabba and Giuseppe Giarrizzo. Catania: G. Maimone, 1994. 253 p. DG55.S5 S5 1994.

Camarina

A3.1966. *Camarina: le terrecotte figurate e la ceramica da una fornace di V e IV secolo a.C* / Marcella Pisani. Roma: L'Erma di Bretschneider, 2008. 249 p. DG70.17 P57 2008. An ancient city was founded by Syracuse in 599 BCE and destroyed fifty years later. It was refounded by the Geloans in 461 BCE and razed by the Carthaginians in 405 BCE, restored by Timoleon in 339 BCE, and controlled by the Romans in 258 BCE. The modern ruins include a small part of the wall of the Temple of Athena, a few house foundations, and an necropolis.

A3.1967. *La necropoli di Passo Marinaro a Camarina: campagne di scavo 1904–1909* / Paolo Orsi. Roma: Accademia nazionale dei Lincei, 1990. 228, 114 p. DG11 .M6 v.4.

Hierapolis

A3.1968. *La déesse de Hiérapolis Castabala, Cilicie* / André Dupont-Sommer and Louis Robert. Paris: A. Maisonneuve, 1964. 104 p. 913.3935 D928.

Marsala

A3.1969. Marsala Punic Warship. http://www2.rgzm.de/Navis/Ships/Ship056/NaveMarsalaEnglish.htm.

Motya

A3.1970. *Motya: unearthing a lost civilization* / Gaia Servadio. London: V. Gollancz, 2000. 260, 9 p. DG70.M67 S47 2000. Italian translation: *Mozia* / Gaia Servadio. Palermo: D. Flaccovio, 2003. 303, 8 p. DG70.M67 .S4716 2003. The Phoenician settlement of Motya, founded in the eighth century BCE as a trading center, is situated on a small island in a lagoon on the western part of Sicily. The site was sacked by an army commanded by Dionysius in 398 BCE.

Morgantina

A3.1971. *C'era una volta Morgantina* / Silvio Raffiotta. Enna: Papiro, 1996. 126, 14 p. DG70.M66 R324 1996. An archaeological site in east central Sicily 60 kilometers from the coast of the Ionian Sea.

Selinus (Silinus, Selinunte)

A3.1972. *Les protomés féminines du sanctuaire de la malophoros à Sélinonte* / Elsbeth Wiederkehr Schuler. Naples: Centre Jean Bérard, 2004. 2 v. DG70.S4 W54 2004. An ancient Greek archaeological site containing five temples centered on an acropolis on the south coast of Sicily.

SPAIN

Alav

A3.1973. *El oppidum de Iruña Alava memoria de las excavaciones* / Gratiniano Nieto Gallo. Vitoria: Consejo de Cultural de la excma. Diputacion Foral de Alava, 1958. 237 p. DP402.I72 N5. Alava is a province of Spain and part of the Basque autonomous community. The Roman road at Asturica Burdigalam runs through the province and is the site of the Roman mansion Alba.

Albacete

A3.1974. *Mosaicos romanos de Lérida y Albacete* / J. M. Blázquez. Madrid: Departamento de Historia Antigua y Arqueología, Centro de Estudios Históricos, Consejo Superior de Investigaciones Científicas, 1989. 124 p. NA3770.C665 fasc.8. A city and municipality in southeastern Spain. Although the origins of the city are unknown, Albacete was a Moorish village by the time of the first documented mention of the area in 1269. By 1241 the village had been conquered by Christian troops and was under the control of Alarcon. In 1375, Albacete gained independence from its neighbor Chinchilla and was given the title of borough. The cathedral of Albacete was built in the sixteenth century after Charles V gave the borough to his wife, Empress Isabella of Portugal. The title of town was not granted to the borough until 1862, by Isabel II. The population of the area tripled between 1900 and the end of the Spanish Civil war, and numerous public work projects were started during this time.

Alcudia

A3.1975. *Pollentia I: excavaciones en Sa Portella, Alcudia (Mallorca)* / Antonio Arribas, Miguell Tarradell, and Daniel E. Woods. Madrid: Ministerio de Educación y Ciencia, Dirección General de Bellas Artes, Comisaría General de Excavaciones Arqueológicas, 1973. 207, 23 p. DP44.E9 no.75–76. Alcudia, Majorca, is a township and municipality located in the north of Majorca. Although the area of Alcudia has been inhabited since the Bronze Age, it is most known for its Roman occupation. The Romans captured the island of Majorca in 123 BCE by entering from Alcudia Bay. They soon founded the capital of Palma and the city of Pollentia. Following the Roman dominance of the area, the city of Pollentia was attacked by the Vandals and eventually abandoned. A new city was created and named Pollenca, while the old city was left in ruins.

A3.1976. *Pollentia II: excavaciones en Sa Portella, Alcudia (Mallorca)* / A. Arribas, M. Tarradell, and D. Woods. Madrid: Ministerio de Educatión y Ciencia, Dirección General de Bellas Artes, Comisaría General de Excavaciones Arqueológicas, 1978. 230, 18 p. DP44.E9 no.98.

Almedinilla

A3.1977. *La villa romana de El Ruedo (Almedinilla, Córdoba): decoración escultórica e interpretación* / Desiderio Vaquerizo Gil and José Miguel Noguera Celdrán. Córdoba: Servicio de Publicaciones, Universidad de Córdoba: Diputación de Córdoba; Murcia: Universidad de Murcia, 1997. 246 p. DP402.A4325 V36 1997.

Ampurias

A3.1978. *Delos, Carthage, Ampurias: the housing of three Mediterranean trading centres* / Birgit Tang. Roma: L'Erma di Bretschneider, 2005. 396, 3 p. NA277 .T35 2005.

A3.1979. *The urban dialogue: an analysis of the use of space in the Roman city of Empúries, Spain* / Alan Kaiser. Oxford: Archaeopress: Available from Hadrian Books, 2000. 132 p. DP402.A47 K35 2000.

Andalusia

A3.1980. *The archaeological expedition along the Guadalquivir, 1889–1901* / George Edward Bonsor. New York: Printed by order of the trustees, 1931. 86 p. 913.468 B645.EP. A region in the south of Spain, centered between the Atlantic Ocean and the Mediterranean Sea. Its strategic location and agricultural resources have allowed the area to be inhabited since prehistoric times. Early influences on the region's history and culture include the Iberians, Phoenicians, and Greeks. Carthage took control of Andalusia between the first and second Punic Wars. They were later defeated by the Romans, and the region was incorporated into the Roman Empire and renamed Baetica.

Aragón

A3.1981. *Difusión del arte romano en Aragón* / Ma. del Carmen Lacarra. Zaragoza: Institución Fernando el Católico, Cátedra Goya, 1996. 296 p. N5862. A3 A723 1996. Aragon was a medieval and early modern kingdom on the Iberian Peninsula. It was

formed in 1035, when Sancho III of Navarre died and his kingdom was split in three parts. Aragon was inherited by Sancho's son, Gonzalo, and given the title of kingdom. During the twelfth and seventeenth centuries the *mudejar* architecture of Aragon was developed, and more than a hundred *mudejar* monuments were constructed in the area.

A3.1982. *La red viaria romana en Aragón* / María de los Angeles Magallón Botaya. Zaragoza: Diputación General de Aragón, Departamento de Urbanismo, Obras Publicas y Transportes, 1987. 305 p. DP302.A665 M34 1987.

Astorga

A3.1983. *Epigrafía y numismática de Astorga romana y su entorno* / Tomás Mañanes Pérez. León: Museo de los Caminos de Astorga; Salamanca, España: Ediciones Universidad de Salamanca, 1982. 294, 80 p. CN675.A79 M36 1982. Astorga is a small town in the north of Spain. Artifactual evidence shows habitation in the region that dates beyond the Paleolithic Age. During the Iron Age, the area was inhabited by the Celts and remained influenced by them until the Cantabrian Wars, when Emperor Augustus eliminated any Celtic resistance to the Roman Empire. In 14 BCE the Roman city of Asturica Augusta, modern-day Astorga, was founded and it became an important administrative and military center.

Baelo

A3.1984. *Baelo Claudia: une cité romaine de Bétique* / Pierre Sillières. Madrid: Casa de Velázquez, 1995. 237 p. DP402.B6 S58 1995. Baelo Claudia is an ancient Roman town located in southern Spain and situated on the shore of the Strait of Gibraltar. The city was founded in the second century BCE as a port for trade in North Africa. The city flourished during the first century BCE and the second century CE, but by the sixth century it had been abandoned due to earthquakes and pirates.

Bureba-Ebro

A3.1985. *Das Castro von Soto de Bureba: archäologische und historische Forschungen zur Bureba in vorrömischer und römischer Zeit* / Hermann Parzinger and Rosa Sanz. Rahden: M. Leidorf, 2000. 469, 85 p. DP302.B76 P37 2000.

Cáceres

A3.1986. *Cáceres el Viejo: ein spätrepublikanisches Legionslager in Spanisch-Extremadura* / Günter Ulbert. Mainz am Rhein: Verlag Philipp von Zabern, 1984. 319, 80 p. DP302.12 U36. Cáceres is located in western-central Spain, and its earliest signs of habitation date back to the late Paleolithic age. The city was named Castra Caecilia by Quintus Caecilius Metellus Pius and by 25 BC was a thriving Roman city. Remains from walls built by Romans during the third and fourth centuries still exist at the site.

Carmona

A3.1987. *La necrópolis romana de Carmona (Sevilla)* / Manuel Bendala Galán. Sevilla: Diputación Provincial, 1976. 2 v. DP402.C38 B46. Also known as Carmo, was a Roman stronghold of the Hispania Baetica. It was one of fourteen cities along the Roman Betica Route.

A3.1988. *Necrópolis de Carmona: memoria escrita en virtud de acuerdo de las Reales Academias de la Historia y de Bellas Artes de San Fernando* / D. Juan de Dios de la Rada y Delgado. Madrid: Imprenta y Fundición de Manuel Tello, 1885. 182, 25 p. 913.468 R112.

Cartagena

A3.1989. *Museo Teatromano de Cartagena; Roman Theatre Museum of Cartagena: guide* / Sebastián Ramallo Asensio. Cartagena: Cartagena Roman Theatre Foundation, 2010. 127 p. NA335.29 M87 2010. Originally named Mastia, the city was renamed Qart Hadasht by the Carthaginians in 228 BCE. The Romans conquered the city in 209 BCE and renamed it Carthago Nova. In 298 CE a new Roman province was created by Diocletian called Carthaginensis, and Cartagena was named the capital. It remained an important Roman city until it was destroyed in 435 CE by the Vandals.

Cástulo

A3.1990. *Cástulo IV* / José Ma. Blázquez, Rafael Contreras, and Jesús J. Urruela. Madrid: Ministerio de Cultura, Dirección General de Bellas Artes y Archivos, Subdirección General de Arqueología y Etnografía, 1984. 334 p. DP44 .E9 v.131. An Iberian town in the south of Spain, located in the Andalusian province. The area has been inhabited since as early as the Neolithic age. Castulo was part of the Carthaginian Empire until the residents of the city made an alliance with the

Romans, betrayed the Carthaginian rule, and became allies with the Roman Empire. It remained an important city until the fall of Andalusia during the Middle Ages.

Catalonia

A3.1991. *Industria y artesanado cerámico de época romana en el nordeste de Cataluña: época augústea y altoimperial* / Joaquim Tremoleda i Trilla. Oxford: J. and E. Hedges, 2000. 341 p. DP302.C615 T72 2000. An autonomous region in the northeast of Spain. The area was populated by Iberians before Roman rule and frequently traded with the Greeks and Carthaginians. Following the defeat of the Carthaginians by the Romans, Catalonia was the first section of Iberia to become part of Roman Hispania.

A3.1992. *Inscriptions romaines de Catalogne* / Georges Fabre, Marc Mayer, and Isabel Rodà. Paris: Diffusion de Boccard, 1984. 5 v. CN675.C3 F33 1984.

A3.1993. *Late Roman amphorae in the western Mediterranean: a typology and economic study: the Catalan evidence* / S. J. Keay. Oxford: British Archaeological Reports, 1984. 2 v. DP302.C615 K43 1984.

A3.1994. *La producción de ánforas romanas en Catalunya: un estudio sobre el comercio del vino de la Tarraconense (siglos I a.C.–I d.C.)* / Jordi Miró. Oxford: British Archaeological Reports, 1988. 366 p. DP302.C615 M5 1988.

Cordoba

A3.1995. *La decoración arquitectónica de Colonia Patricia: una aproximación a la arquitectura y urbanismo de la Córdoba romana* / Carlos Marquez. Córdoba: Universidad de Córdoba y Obra Social y Cultural Cajasur, 1998. 311 p. NA335. C68 M38 1998. A city in the Andalusian community of southern Spain. The earliest evidence of human presence in the region dates back to 32,000 BCE and the Neanderthal man. The first historical mention of the site dates back to the Carthaginian expansion into the area. Romans conquered the city in 206 BCE, and during the reign of Julius Caesar it was the capital of Roman Hispania.

Gava-Viladecans

A3.1996. Two bronze helmets of Etruscan typology from a Roman wreck found at the Les Sorres Anchorage (Gavà-Viladecans, Catalonia). http://www.abc. se/~m10354/publ/sorr-helm.htm.

Italica

A3.1997. *Die Architekturdekoration von Italica* / Sven Ahrens. Mainz am Rhein: Philip von Zabern, 2005. 354 p. NA3562.I83 A37 2005. Founded by the Romans in 206 BCE, after the defeat of the Carthaginians during the Second Punic War. Italica was home to the third largest amphitheatre in the Roman Empire.

A3.1998. *Itálica-Santiponce: municipium y colonia Aelia Augusta Italicensium* / Antonio Caballos Rufino. Roma: L'Erma di Bretschneider, 2010. 181, 3 p. DP402.I85 I83 2010.

A3.1999. *Mosaicos romanos de Italica* / Antonio Blanco Freijeiro. Madrid: Instituto Español de Arqueologia "Rodrigo Caro" del Consejo Superior de Investigaciones Cientificas, 1978–2011. 2 v. NA3770 .C665 fasc.2, 13.

A3.2000. *Sigillate pottery of the Roman Empire*. New York: Printed by order of the trustees of the Hispanic Society of America, 1937. 61, 41 p. 738 H625.6; 738 H625.6.

A3.2001. *El teatro romano de Itálica: estudio arqueoarquitectónico* / Oliva Rodríguez Gutiérrez. Madrid: Servicio de Publicaciones de la Universidad Autónoma de Madrid: Fundación Pastor de Estudios Clásicos; Seville: Diputación de Sevilla, Cultura y Deportes, 2004. 652 p. + CD-ROM. DP402.I85 R53 2004.

Laitolosa

A3.2002. Espagne: Labitolosa, une cité romaine des Pyrénées espagnoles. http://www.diplomatie.gouv.fr/ fr/enjeux-internationaux/echanges-scientifiques-recherche/archeologie-sciences-humaines-et/les-carnets-d-archeologie/europe-maghreb/espagne-labitolosa/.

Numantia

A3.2003. *The army of the Roman Republic: the second century BC, Polybius and the camps at Numantia, Spain* / Michael Dobson. Oxford: Oxbow Books, 2008. 436 p. DG89.D63 2008. An ancient Celtiberian settlement in north-central Spain. The Numantians battled with the Romans for twenty years, beginning in 153 BCE. In 133 BCE a Roman siege of 30,000 troops, led by Scipio Aemilianus Africanus, surrounded and erected fences around the city. Rather than be captured and forced into slavery, the Numantians,

preferring to die as free men, committed mass suicide and burned the city to the ground.

A3.2004. *Caracterización arqueométrica de la producción cerámica numantina* / Manuel García-Heras. Oxford: J. and E. Hedges; Hadrian Books, 1998. 230 p. DP95 .G36 1998.

A3.2005. *Die Funde aus den römischen Lagern um Numantia im Römisch-Germanischen Zentralmuseum* / Martin Luik. Mainz: Verlag des Römisch-Germanischen Zentralmuseum in Kommission bei Dr. Rudolf Habelt GmbH, Bonn, 2002. 405, 29 p. DP95 .L955 2002.

A3.2006. *Numancia, símbolo e historia* / Alfredo Jimeno Martínez y José Ignacio de la Torre Echávarri. Tres Cantos, Madrid: Akal Ediciones, 2005. 296 p. DP95 .J57 2005.

Tiermes

A3.2007. *Tiermes IV: la casa del acueducto: (domus alto imperial de la ciudad de Tiermes): campañas 1979-1986)* / José Luis Argente Oliver and Adelia Díaz Díaz. Madrid: Ministerio de Cultura, Dirección General de Bellas Artes y Archivos, Instituto de Conservación y Restauración de Bienes Culturales, 1994. 256 p. DP44.E9 v. 167.

A3.2008. *Karthago und die Iberische Halbinsel vor den Barkiden: Studien zur karthagischen Prasenz im westlichen Mittelmeerraum von der Grundung von Ebusus (VII. Jh. v. Chr.) bis zum Ubergang Hamilkars nach Hispanien (237 v. Chr.)* / Pedro A. Barceló. Bonn: Habelt, 1988. 201 p. DP92 .B37 1988.

SWITZERLAND

Aargau

A3.2009. *Ein spätrömischer Getreidespeicher am Rhein: die Grabung Rheinfelden-Augarten West 2001* / Markus Asal. Brugg: Kantonsarchäologie Aargau, 2005. 191 p. DQ310.3.A83 2005. A canton in northern Switzerland.

Alps

A3.2010. *Studien zur Alpengeschichte in antiker Zeit* / Gerold Walser. Stuttgart: F. Steiner, 1994. 138 p. DQ824.W35 1994. One of the great mountain ranges within the Roman Empire, stretching from the Danube River in the east to the Saonne River in the west and the Rhine River in the north. The Celtic tribes of the area were subjugated by successive Roman campaigns aimed at control of the strategic routes from Italy across the Alps to the Rhine and into Gaul. Under the Pax Romana, Switzerland was integrated into the empire as the Romans absorbed the Celtic population, enlisted their aristocracy to engage in local government, built a network of roads connecting their newly established colonial cities, and divided up the area among the Roman provinces. Roman civilization began to retreat from Swiss territory when it became a border area again after the third century. Roman control of most of Switzerland ceased in 401 CE, after which the area began to be occupied by Germanic groups.

A3.2011. *Geschichte des Alpenrheintals in römischer Zeit auf Grund der archäologischen Zeugnisse* / Bernhard Overbeck. München: Beck, 1973. 2 v. DQ34.O93.

A3.2012. *Beiträge zur Chronologie der Urnenfelderzeit nördlich und südlich der Alpen* / Hermann Müller-Karpe. Berlin: De Gruyter, 1970. 2 v. DQ824. M8 1970.

A3.2013. *Les Alpes occidentales romaines: développement urbain et exploitation des ressources des régions de montagne (Gaule narbonnaise, Italie, provinces alpines)* / Maxence Segard. Paris: Errance, 2009. 288 p. DQ825.S44 2009.

A3.2014. *Perviae paucis Alpes: viabilità romana attraverso i valichi delle Alpi Centrali* / Matteo Dolci. Oxford: J. and E. Hedges, British Archaeological Reports; Hadrian Books, 2003. 116 p. DG28.5.D65 2003.

Augst

A3.2015. *Ad arma!: römisches Militar des 1. Jahrhunderts n. Chr. in Augusta Raurica* / Eckhard Deschler-Erb. Augst: Römerstadt Augusta Raurica, 1999. 189, 46 p. DQ851.A795 D46 1999. Known as Augusta Raurica in Roman times, a Roman city in the canton of Basel in Switzerland.

A3.2016. *Ein Depot zerschlagener Grossbronzen aus Augusta Raurica: die Rekonstruktion der beiden Pferdestatuen und Untersuchungen zur Herstellungstechnik* / Bettina Janietz Schwarz and Dominique Rouiller. Augst: Römermuseum, 1996. 280 p. NB142.7.S9 S39 1996.

A3.2017. *Durchbrochene Messerfutteral-Beschläge (Thekenbeschläge) aus Augusta Raurica: ein Beitrag zur provinzial-römischen Ornamentik* / Ludwig Berger. Augst: Römerstadt Augusta Raurica, 2002. 122 p. DQ851.A795 B475 2002.

A3.2018. *Frauen in Augusta Raurica: dem römischen Alltag auf der Spur* / Dagmar Bargetzi. Augst: Römerstadt Augusta Raurica, 2001. 160 p. HQ1705.A94 F73 2001.

A3.2019. *Der Menora-Ring von Kaiseraugst: judische Zeugnisse römischer Zeit zwischen Britannien und Pannonien; The Kaiseraugst Menorah Ring: Jewish evidence from the Roman period in the northern provinces* / Ludwig Berger. Augst: Römerstadt Augusta Raurica, 2005. 246 p. DS122.B468 2005.

A3.2020. *Römische Tempel in den Rhein- und westlichen Donauprovinzen: ein Beitrag zur architekturgeschichtlichen Einordnung romischer Sakralbauten in Augst* / Markus Trunk. Augst: Römermuseum Augst, 1991. 257 p. NA335.S9 T78 1991.

A3.2021. *Römischen Amphoren aus Augst und Kaiseraugst: ein Beitrag zur römischen Handels- und Kulturgeschichte* / Stefanie Martin-Kilcher. Augst: Römermuseum Augst, 1987–1994. 3 v. DQ851.A795 M38 1987, Bd.1–3.

A3.2022. *Tituli Rauracenses / Römerstadt Augusta Raurica* / Peter-Andrew Schwarz and Ludwig Berger. Augst: Römermuseum, 2000. CN680.T58 2000, v.1.

Basel

A3.2023. *Basel in römischer Zeit* / Rudolf Fellman. Basel: Birkhäuser Verlag, 1955. 141 p. 913.494 F334. The settlement of Augustus Raurica was founded during the Roman empire 10 to 20 kilometers upstream from modern Basel.

Summus Poeninus

A3.2024. *Summus Poeninus: Beiträge zur Geschichte des Grossen St. Bernhard-Passes in römischer Zeit* / Gerold Walser. Wiesbaden: F. Steiner, 1984. 140, 18 p. DQ841.S15 W34 1984. Summus Poenius was constructed about 70 CE at the summit of the Grand-St. Bernard pass between Italy and Switzerland along the Roman road (Via Poenina) connecting Italy with the rest of the empire.

SYRIA

A3.2025. Les marges arides du Croissant fertile Mission de prospection géoarchéologique en Syrie. http://wikis.ifporient.org/archeologie/index.php/Marges_Arides_du_Croissant_fertile.

A3.2026. Le massif calcaire de la Syrie du Nord. http://www.diplomatie.gouv.fr/fr/enjeux-internationaux/echanges-scientifiques-recherche/archeologie-sciences-humaines-et/les-carnets-d-archeologie/orient-ancien/syrie-du-nord/.

Abu Hureyra

A3.2027. Abu Hureyra—Syria. http://www.syriatoday.ca/arch-abu-hureyra.htm.

Acharneh, tell

A3.2028. Tell Acharneh. http://www.acharneh.hst.ulaval.ca/english/frameInter.asp.

Al Mashrafah

A3.2029. *Al Mash Urban and natural landscapes of an ancient Syrian capital: settlement and environment at Tell Mishrifeh/Qatna and in central-western Syria: proceedings of the international conference held in Udine 9–11 December 2004* / Daniele Morandi Bonacossi. Udine: Forum, 2007. 350 p. DS99.M5 U78 2007.

Ashara-Terqa, tell

A3.2030. Tell Ashara-Terqa. http://www.diplomatie.gouv.fr/en/global-issues/education-research/archaeology/archaeology-notebooks/ancient-east/syria-tell-ashara-terqa/.

Beydar, tell

A3.2031. *Tell Beydar, three seasons of excavations (1992–1994): a preliminary report; Trois campagnes de fouilles à Tell Beydar (1992–1994): rapport préliminaire* / Marc Lebeau and Antoine Suleiman. Turnhout, Belgium: Brepols, 1997. 243 p. DS99.T315 T45 1997. An ancient near eastern city, also known as Nabada, that was first settled during the Early Dynastic period ca. 2600 BCE. It is located in the modern-day Al-Hasakah Governorate.

Djade el Mughara

A3.2032. Djade el Mughara: Un village du IXe millénaire avant J.-C. sur l'Euphrate.

Djezireh

A3.2033. Archéologie et art rupestre en Djezireh syrienne (Syria) (in French).

Dura-Europos

A3.2034. *My Dura-Europos: the letters of Susan M. Hopkins, 1927–1935* / Bernard M. Goldman and Norma W. Goldman. Detroit: Wayne State University Press, 2011. 310, 12 p. DS99.D8 H67

2011. Situated 90 meters above the right bank of the Euphrates River in the village of Salhiye. It was a border city during the Hellenistic, Parthian, and Roman eras. After it was abandoned in 256–257 CE, nothing was ever built over it, preserving the architectural features of the city.

Emar (Tell Meskene)

A3.2035. *Die Personennamen der Texte aus Emar* / Regine Pruzsinszky; edited by David I. Owen and Gernot Wilhelm. Bethesda: CDL Press, 2003. 311 p. Emar, modern Tell Meskene, was an ancient Amorite city in the Euphrates River; it has been the source of many Akkadian cuneiform tablets.

es-Sweyhat, tell

A3.2036. Tell es-Sweyhat—Syria. http://oi.uchicago.edu/research/projects/swe/.

Euphrates River Valley

A3.2037. *La Djéziré et l'Euphrate syriens: de la protohistoire à la fin du IIe millénaire av. J.-C.: tendances dans l'interprétation historique des données nouvelles* / Olivier Rouault and Markus Wäfler. Brepols: Turnhout, 2000. 358 p. DS94.5.D54 2000. The area surrounding the Euphrates River beginning in eastern Turkey and going through Syria and Iraq. The earliest part of the Euphrates River valley inhabited was the northern area, also known as the Fertile Crescent. There, remains of Homo Erectus were found and dated to about 450,000 years old. During the early Dynastic period the southern area saw a surge in the number of settlements, many of them located along canals from the Euphrates and Tigris rivers.

Halula, tell

A3.2038. Tell Halula—Syria. http://grupsderecerca.uab.cat/sappo/.

Hamoukar, tell

A3.2039. Tell Hamoukar—Syria. http://oi.uchicago.edu/research/projects/ham/.

Jebel Khalid

A3.2040. *Jebel Khalid on the Euphrates* / G. W. Clarke. Sydney: MEDITARCH, 2002. 2 v. DS99.J43 J43 2002.

Jerablus Tahtani

A3.2041. Jerablus Tahtani Project—Syria. http://www.arcl.ed.ac.uk/arch/jerablus/jerahome.html.

Jerf el Ahmar

A3.2042. Jerf el Ahmar: Un village aux origines de l'agriculture dans la vallée du Moyen-Euphrate. http://www.diplomatie.gouv.fr/en/france-priorities_1/archaeology_2200/archaeology-notebooks_2202/ancient-east_2224/syria-jerf-el-ahmar_2230/index.html.

Latakia

A3.2043. *Ras Schamra: ein Uberblick Funde und Forschungen* / Johannes Friedrich. Leipzig: J. C. Hinrichs, 1933. 38 p. DS42.A4 bd.33, hft.1/2. The principal port city of Syria, located on the Mediterranean Sea. It borders Tartus to the south, Hama to the east, and Turkey to the north. The city was first founded by the Seleucid Empire in the fourth century BCE. It was later ruled by the Romans, the Ummayads, and the Abbasids during the eighth to tenth centuries.

Mari

A3.2044. *Archives royales de Mari: Textes.* Paris: P. Geunthner, 1941–1960. 9 v. PJ3883.A66 1941; PJ3711.P2, v.1–9, t.22–30. Situated on the west bank of the Euphrates River, 11 kilometers northwest of the modern town of Abu Kamal. It may have been inhabited as early as the fifth millennium BCE. More than 25,000 Akkadian tablets have been found there.

A3.2045. *Archives royales de Mari* / André Parrot and Georges Dossin. Paris: Impr. nationale, 1950. PJ3721.M3 A7.

A3.2046. *Mari* / André Parrot. Neuchatel: Ides et calends, 1953. 96 p. 913.394 P248.4.

A3.2047. *Mari, capitale fabuleuse* / André Parrot. Paris: Payot, 1974. 217 p. DS99.M3 P312.

A3.2048. Mari, les débuts de la civilisation urbaine en Syrie. http://www.interbible.org/interBible/carrefour/actualite/2008/act_080208.html; http://www.diplomatie.gouv.fr/fr/enjeux-internationaux/echanges-scientifiques-recherche/archeologie-sciences-humaines-et/les-carnets-d-archeologie/orient-ancien/syrie-mari/.

A3.2049. *Mari, une ville perdue . . ., et retrouvée par l'archéologie Française* / André Perrot. Paris: Éditions "Je sers," 1936. 249 p. Van Pelt Judaica/Ancient Near East Seminar DS99.M3 P315.

A3.2050. *Mission archéologique de Mari* / André Parrot. Paris: P. Geuthner, 1956. 64 p. DS99.M3 P32, t.1, 2(1–3), 3–4; DS99.M3 P32, t.1, 5. Includes *Le temple d'Ishtar* / André Parrot. Paris: P. Geuthner, 1956. 246 p. DS99.M3 P32 t.1; Van Pelt Judaica/Ancient Near East Seminar DS99.M3 P32 t.1, 3. *Les temples d'Ishtarat et de Ninni-Zaza* / André Parrot and Georges Dossin. Paris: P. Geuthner, 1967. 351 p. DS99.M3 P32 t.3, 4. *Le trésor d'Ur* / André Parrot. Paris, Librairie orientaliste Paul Geuthner, 1968. 64 p. DS99. M3 P32 t.4, 5. *Tombes et nécropoles de Mari* / Jean-Marie Marylou. Beyrouth: Institut Français d'archéologie du Proche-Orient, 1999. 214 p. DS99.M3 P32 t.5, 6. *Basse vallée de l'Euphrate Syrien du Néolithique à l'avènement de l'Islam: géographie, archéologie et histoire* / Bernard Geyer and Jean-Yves Monchambert. Beyrouth: Institut Français du Proche-Orient, 2003. 2 v. GN855.S95 G496 2003.

A3.2051. *Les ors de Mari* / Gérard Nicolini. Beyrouth: Institut Français du Proche-Orient, 2010. 478 p. NK7173.6.S9 N53 2010.

A3.2052. *Studia Mariana* / André Parrot. Leiden: E. J. Brill, 1950. 138 p. DS99.M3 P33.

A3.2053. *Textes divers; offerts à André Parrot a l'occasion du XXXe anniversaire de la découverte de Mari* / G. Dossin. Paris, 1964. 183 p. PJ3721.M3 A7 t.13.

Palmyra

A3.2054. Photos of Palmyra. http://www.sacred-destinations.com/syria/palmyra-photos/.

Qarqur, tell

A3.2055. *Preliminary excavation reports and other archaeological investigations: Tell Qarqur, Iron I sites in the north-central highlands of Palestine* / Nancy Lapp. Boston: American Schools of Oriental Research, 2003. 218 p. DS101.A45 v.56. Located in the Orontes River Valley of Western Syria. It has been continuously occupied for more than 10,000 years, beginning with the pre-pottery Neolithic era.

A3.2056. Tell Qarqur, northwestern Syria Tell Qarqur, northwestern Syria. http://ancientneareast.tripod.com/Qarqur.html.

Qatna

A3.2057. Qatna, Syria: History of Archaeological Research. http://www.qatna.org/en-history-research.html.

Ras Shamra-Ugarit and Enkomi-Alasia

A3.2058. *Corpus des cylindres-sceaux de Ras Shamra-Ugarit et d'Enkomi-Alasia* / Claude F.-A. Schaeffer-Forrer. Paris: Editions Recherche sur les civilisations, 1983–1992. 2 v. CD5391.S32 1983.

Rouj Basin

A3.2059. The Rouj Basin Project. http://www.sakura.cc.tsukuba.ac.jp/~elrouj/rouj/.

Sabi Abyad, tell

A3.2060. Tell Sabi Abyad—Syria. http://www.sabi-abyad.nl/Page.aspx?pageType=page&pageID=315; http://www.rmo.nl/english/research/excavations/syria-tell-sabi-abyad.

Tabqa Dam

A3.2061. *Archeological reports from the Tabqa Dam project Euphrates Valley, Syria* / David Noel Freedman. Cambridge: American Schools of Oriental Research, 1979. 182 p. DS101.A45 Vol. 44 1979. Tabqa Dam, also known as al-Thawra Dam, is an earth-fill dam located on the Euphrates River built between 1968 and 1973. It is 25 miles upstream from the city of Ar-Raqqah. The construction of the dam created flooding in the Syrian Euphrates Valley and the formation of Lake Assad. Before the flooding several excavations took place in the area by Syrian, U.S., Italian, Dutch, Swiss, British, and Japanese archaeologists, with the support of UNESCO.

Tuneinir, tell

A3.2062. Tell Tuneinir—Syria. http://users.stlcc.edu/mfuller/tuneinir/.

Ugarit

A3.2063. *Ugarit: ein ostmediterranes kulturzentrum im Alten Orient; Ergebnisse und Perspektiven der Forschung* / Manfried Dietrich and Oswald Loretz. Münster: Ugarit-Verlag, 1995. DS99.U35 U34 1995. An ancient city in northern Syria located on the east of the Mediterranean. Founded as early as 6000 BCE and abandoned during the Late Bronze Age. It is significant because of its status as a port city and as the entrance to the inland trade route. It maintained steady connections with Egypt and Cyprus between the sixteenth and thirteenth centuries BC.

Umm el-Marra, tell

A3.2064. Tell Umm el-Marra, Syria. http://neareast.jhu. edu/.

THRACE

Demir Baba Teke

A3.2065. *The Thracian sanctuary at "Demir Baba Teke": (the second half of the first millenium BC)* / Ana Balkanska. Sofia: Svyat Nauka, 1998. 116 p. DF261.T6 B355 1998.

Karasura

A3.2066. *Karasura: Untersuchungen zur Geschichte und Kultur des alten Thrakien: 15 Jahre Ausgrabungen in Karasura. Internationales Symposium Cirpan/Bulgarien 1996* / Michael Wendel. Weissbach: Beier & Beran, 2001. 3 v. DR50.43. K37 2001. A late Roman way station (*statio milliaria*) in northern Thrace.

Marmara

A3.2067. *Prehistoric chipped stone assemblages from eastern Thrace and the south Marmara Region 7th–5th mill. B.C.* / Ivan Gatsov. Oxford: John and Erica Hedges, 2009. 136 p. GN434.G35 2009. The Sea of Marmara, also known as Propontis, is an inland sea that connects the Black Sea to the Aegean Sea.

Molyvoti

A3.2068. *The coins from Maroneia and the classical city at Molyvoti: a contribution to the history of Aegean Thrace* / Selene Psoma, Chryssa Karadima, and Domna Terzopoulou. Athens: Research Centre for Greek and Roman Antiquity, National Hellenic Research Foundation. Paris: Diffusion de Boccard, 2008. 297, 70 p. CJ559.M47 P78 2008.

Olynthus

A3.2069. *Olynthe et les Chalcidiens de Thrace: études de numismatique et d'histoire* / Selene Psoma. Stuttgart: Steiner, 2001. 311, 22 p. CJ547.O53 P865 2001. Olynthus was an ancient city of Chalcidice, constructed on two flat-topped hills at the head of the Gulf of Torone.

TUNISIA

A3.2070. *L'archéologie en Tunisie (XIXe–XXe siècles): jeux généalogiques sur l'Antiquité* / Clémentine Gutron. Paris: Karthala; Tunis: IRMC, 2010. 327 p. DT251.G87 2010.

A3.2071. *Studies on Roman pottery of the provinces of Africa Proconsularis and Byzacena: homage à Michael Bonifay* / J. H. Humphrey. Portsmouth: Journal of Roman Archaeology, 2009. 156 p. NK3850.S78 2009.

Acholla

A3.2072. *La maison du Triomphe de Neptune à Acholla (Botria-Tunisie)* / Suzanne Gozlan. Roma: École Française de Rome, 1992. DT269.A44 M35 1992, v.1. An archaeological site and Roman amphitheater located on the Tunisian coast, 45 kilometers north of the city of Sfax.

Althiburus

A3.2073. *Forum et maisons d'Althiburos* / Alfred Merlin. Paris: Leroux, 1913. 59, 6 p. 913.61 T838.2 v.6. An ancient numidian city located 9 kilometers southwest of what is known today as Medeina. It was situated on the road from Carthage to Theveste and was the home of a Roman town hall. It was given the status of municipality during the second century.

Ammaedara

A3.2074. Tunisie: Ammaedara http://www.diplomatie. gouv.fr/fr/enjeux-internationaux/echanges-scientifiques-recherche/archeologie-sciences-humaines-et/les-carnets-d-archeologie/europe-maghreb/tunisie-ammaedara/.

Batna

A3.2075. *La trinité carthaginoise; mémoire sur un bandeau trouvé dans les environs de Batna* / Philippe Berger. Paris: A. Lévy, 1880. 36 p. 492.71 B453.

Byrsa

A3.2076. *Byrsa I: rapports préliminaires des fouilles (1974–1976)* / Serge Lancel. Rome: École Française de Rome, 1979. 351, 6 p. DT269.C3 B97. The name of a walled citadel and the hill that it was built on in ancient Carthage. The citadel was situated above the harbor and formed the main

military installation of Carthage. It was destroyed during the Third Punic war in 146 BC.

Carthage

A3.2077. *Bir el Knissia at Carthage: a rediscovered cemetery church: report* / Susan T. Stevens. Ann Arbor: Kelsey Museum, 1993. DT269.C33 B6 1993. Located on the east side of Lake Tunis. Carthage was founded by Canaanite-speaking Phoenicians led by Elissa, also known as Queen Dido. Carthage had several rivals in the Mediterranean area, including Rome, Syracuse, and Numidia, which resulted in the Punic wars. Most of the culture from Carthage was destroyed in the Roman-Punic wars between 264 to 146 BCE. It remained a major Roman city until 698 CE, when Hasan ibn al-Nu'man defeated Emperor Tiberios III at the Battle of Carthage and destroyed the city during the Muslim conquest.

A3.2078. *Bringing Carthage home: the excavations of Nathan Davis, 1856–1859* / Joann Freed. Oxford, UK; Oakville: Oxbow Books, for the Department of Classical, Near Eastern and Religious Studies, University of British Columbia, 2011. 264 p. 269.C33 F74 2011.

A3.2079. *Carthage: results of the Swedish excavations 1979–1983* / Birgitta Sander and Carl-Gustaf Styrenius. Stockholm: Paul Äströms, 2002. DG12.S8 v.54.

A3.2080. *Carthage papers: the early colony's economy, water supply, a public bath, and the mobilization of state olive oil* / J. T. Peña. Portsmouth: JRA, 1998. N238 p. DT269.C33 C375 1998.

A3.2081. *Carthage: une métropole chrétienne du ive à la fin du viie siècle* / Liliane Ennabli. Paris: CNRS Editions, 1997. 176 p. DT269.C33 E55 1997.

A3.2082. *Catalogue des inscriptions latines païennes inédites du Musée de Carthage* / Zeineb Benzina Ben Abdallah and Leila Ladjimi Sebai. Rome: École Française de Rome, 2011. 400 p. CN730. T86 B46 2011.

A3.2083. *A cemetery of Vandalic date at Carthage* / Susan T. Stevens, Mark B. Garrison, and Joann Freed. Portsmouth, RI: Journal of Roman Archaeology, 2009. 366 p. + CD-ROM. DT269.C33 S74 2009.

A3.2084. *Ceramique a vernis noir de Carthage* / Fethi Chelbi. Tunis: Institut National d'Archéologie et d'Art: Fondation Nationale de la Recherche Scientifique, 1992. 279, 166 p. DT269.C33 C47 1992.

A3.2085. *The circus and a Byzantine cemetery at Carthage* / J. H. Humphrey. Ann Arbor: University of Michigan Press, 1988. DT269.C33 C57 1988, v.1.

A3.2086. *Damous-el-Karita: die österreichisch-tunesischen Ausgrabungen der Jahre 1996 und 1997 im Saalbau und der Memoria des Pilgerheiligtumes Damous-el-Karita in Karthago* / Heimo Dolenz. Wien: Österreichisches Archäologisches Institut, 2001. 253 p. DT269.C33 D65 2001.

A3.2087. *Excavations at Carthage* / J. H. Humphrey. Tunis: Cérès Productions, 1976. 7 v. DT269.C3 E96, v.1–7.

A3.2088. *Excavations at Carthage: the British mission.* Sheffield: Published for the British Academy from the University of Sheffield, Dept. of Prehistory and Archaeology, 1984. DT269.C33 E93 1984, v.1(1–2), 2(1–2).

A3.2089. *La grande insurrezione libica contro Cartagine del 241–237 A.C.: una storia politica e militare* / Luigi Loreto. Rome: École Française de Rome, Palais Farnèse, 1995. 238 p. DT269.C35 L67 1995.

A3.2090. *Hannibal ad portas: Macht und Reichtum Karthagos.* Karlsruhr: Badischen Landesmuseum Karlsruhe. 400 p. DT269.C33 H35 2004.

A3.2091. *Index général des inscriptions latines païennes de Carthage* / Leila Ladjimi Sebai. Tunis: Institut National du Patrimoine, 2002. 89 p. CN730.T8 L33 2002.

A3.2092. *La Maalga e i Porti Punici di Cartagine: una città e il suo territorio dalla fondazione fenicia alla dominazione romana* / Elisa Panero. Firenze: Le lettere, 2008. 193 p. DT269.C33 M33 2008.

A3.2093. *Karthago* / Werner Huss. Darmstadt: Wissenschaftliche Buchgesellschaft, 1992. 462 p. DT269.C35 K37 1992.

A3.2094. *Karthago: die alte Handelsmetropole am Mittelmeer: eine archäologische Grabung* / Hans Georg Niemeyer, Angela Rindelaub, and Karin Schmidt. Hamburg: Hamburger Museum für Archäologie und die Geschichte Harburgs (Helms-Museum), 1996. 65 p. DT269.C33 N54 1996.

A3.2095. *Karthago: die deutschen Ausgrabungen in Karthago* / Friedrich Rakob. Mainz am Rhein: P. von Zabern, 1991–1999. DT269.C33 K37 1991, v. 1(1–2), 2, 3.

A3.2096. *Karthago: die Ergebnisse der Hamburger Grabung unter dem Decumanus Maximus* / H. G. Niemeyer. Mainz: P. von Zabern, 2007. 2 v. DT269.C33 K38 2007.

A3.2097. *Karthago: det svenska deltagandet i UNESCO-utgravningarna; Carthage: the Swedish participation in the UNESCO excavations* / Carl-Gustaf

Styrenius. Stockholm: Medelhavsmuseet, 2003. 68, 2 p. DT269.C33 S79 2003.

A3.2098. *Pour sauver Carthage: exploration et conservation de la cité punique, romaine et byzantine* / Abdelmajid Ennabli. Paris: UNESCO; Tunis: Institut National d'Archéologie et d'Art, 1992. 251 p. DT269.C33 P68 1992.

A3.2099. *Preliminary excavation reports: Sardis, Meiron, Tell el Hesi, Carthage (Punic)* / David Noel Freedman. Cambridge: American Schools of Oriental Research, 1978. 190 p. DS101.A45 v.43.

A3.2100. *The sanctuary of Tanit at Carthage in the Roman period: a re-interpretation* / Henry Hurst. Portsmouth: Journal of Roman Archaeology, 1999. 135, 4 p. BL1665.T3 H87 1999.

A3.2101. *Le tophet de Salammbôà Carthage: essai de reconstitution* / Hélène Bénichou-Safar. Rome: École Française de Rome, 2004. 217, 53 p. DT269.C33 B465 2004.

Cillium

A3.2102. *Les Flavii de Cillium: étude architecturale, épigraphique historique et littéraire du Mausolée de Kasserine (CIL viii, 211–216)* / Groupe de recherches sur l'Afrique antique. Rome: École Française de Rome; Paris: diffusion de Boccard, 1993. 268, 28 p. DT269.C5 F6 1993.

Dougga

A3.2103. Tunisie: Dougga. http://www.diplomatie.gouv.fr/fr/enjeux-internationaux/echanges-scientifiques-recherche/archeologie-sciences-humaines-et/les-carnets-d-archeologie/europe-maghreb/tunisie-dougga/.

El Akarit

A3.2104. *Tunisie: El Akarit.* http://www.diplomatie.gouv.fr/fr/enjeux-internationaux/echanges-scientifiques-recherche/archeologie-sciences-humaines-et/les-carnets-d-archeologie/europe-maghreb/tunisie-el-akarit/.

Haydarah

A3.2105. *Recherches archéologiques à Haidra. Miscellanea.* Rome: École Française de Rome, 1974. DT269.H25 R42 1974.

Henchir el-Hami

A3.2106. *Le sanctuaire de Henchir el-Hami; de Ba'al Hammon au Saturne africain: Ier s. av. J.-C.–IVe*

s. apr. J.-C. / Ahmed Ferjaoui. Tunis: Institut National du Patrimoine, 2008. 480 p. DT269.H36 F47 2008.

Jebel Oust

A3.2107. Tunisie: Jebel Oust. http://www.diplomatie.gouv.fr/fr/enjeux-internationaux/echanges-scientifiques-recherche/archeologie-sciences-humaines-et/les-carnets-d-archeologie/europe-maghreb/tunisie-jebel-oust/.

Kerkouane

A3.2108. *Kerkouane, une cité punique au Cap-Bon* / Mhamed Hassine Fantar. Tunis: Maison Tunisienne de l'Édition: Institut National d'Archéologie et d'Art, 1987. 216, 7 p. DT269.K37 F36 1987. A Punic city located near Cap Bon in northeastern Tunisia. The city was abandoned during the First Punic War. The site is among the only remains of a Phoenicio-Punic city.

Leptis Minor

A3.2109. *Leptiminus (Lamta). Report no. 1: a Roman port city in Tunisia.* / N. Ben Lazreg and D. J. Mattingly. Ann Arbor: University of Michigan, 1992. 324 p. DT269.L47 L3 1992. Also known as Leptis Parva, was a Phoenician colony founded during the eighth century BCE. It was located on the east coast of Tunisia near the Gulf of Hammamet. After the first destruction of Carthage in 146 BCE, it was incorporated into the Roman Republic. It was one of the most important cities of North Africa until it was destroyed during the Muslim conquest of the seventh century CE.

A3.2110. *Leptiminus (Lamta). Report no. 2: the east baths, cemeteries, kilns, Venus mosaic, site museum and other studies* / L. M. Stirling, D. J. Mattingly, and N. Ben Lazreg. Portsmouth, RI: Journal of Roman Archaeology, 2001. 464 p. DT269.L46 S75 2001.

A3.2111. *Leptiminus (Lamta). Report no. 3: the field survey* / D. L. Stone, D. J. Mattingly, and N. Ben Lazreg. Portsmouth, RI: Journal of Roman Archaeology, 2011. 493 p. + CD-ROM. DT269.L46 S76 2011.

Pupput

A3.2112. *La nécropole romaine de Pupput* / Aicha Ben Abed and Marc Griesheimer. Rome: École Française de Rome, 2004. 242 p. DT251.N437 2004. A small settlement in northern Tunisia near

Hammamet. It became a Roman colony during the second century CE. It is the site of the largest Roman necropolis in Africa.

A3.2113. Tunisie: Pupput. http://www.diplomatie.gouv.fr/fr/enjeux-internationaux/echanges-scientifiques-recherche/archeologie-sciences-humaines-et/les-carnets-d-archeologie/europe-maghreb/tunisie-pupput/.

Qulaybiyah (Kelibia)

A3.2114. *Maisons de Clupea: exemples de l'architecture domestique dans un port de l'Afrique proconsulaire: les maisons de l'école de peche* / Jean-Marie Lassère and Hédi Slim. Paris: CNRS Editions, 2010. 192, 20 p. DT269.Q56 L37 2010. It was founded by the Carthaginians in the fifth century BCE in northeastern Tunisia near the Cap Bon peninsula.

Sidi Jdidi

A3.2115. *Sidi Jdidi I: La basilique sud* / Aicha Ben Abed-Ben Khader. Rome: École Française de Rome, 2004. 394 p. DT269.S545 S535 2004.

A3.2116. Tunisie: Sidi Jdidi. http://www.diplomatie.gouv.fr/fr/enjeux-internationaux/echanges-scientifiques-recherche/archeologie-sciences-humaines-et/les-carnets-d-archeologie/europe-maghreb/tunisie-sidi-jdidi/.

Sigillata

A3.2117. *Das spätantiken Sigillata- und Lampentopfereien von el Mahrine (Nordtunesien): Studien zur nordafrikanischen Feinkeramik des 4. bis 7. Jahrhunderts* / Michael Mackensen. München: C. H. Beck'sche, 1993. 2 v. DT269.C33 M33 1993.

Simithu

A3.2118. *Militärlager oder Marmorwerkstätten: neue Untersuchungen im Ostbereich des Arbeits- und Steinbruchlagers* / Simitthus Chemtou and Michael Mackensen. Mainz am Rhein: von Zabern, 2005. 170 p. DT269.S57 M335 2005. Located in northwestern Tunisia near the Algerian border, it was an ancient site known for its marble quarries.

A3.2119. *Die Steinbrüche und die antike Stadt* / A. Beschaouch, U. Hess, M. Khanoussi, Th. Kraus, F. Rakob, G. Röder, and J. Röder. Mainz am Rhein: P. von Zabern, 1993. 102, 87 p. DT269.S16 S7 1993.

Thapsus

A3.2120. *Recherches sur la ville portuaire de Thapsus et son territoire en Byzacène dans l'antiquité* / Ameur Younes. Tunis: Premier Ministère, Secrétariat d'Etat à la Recherche Scientifique et à la technologie: Centre d'Études et de Recherches e Économiques et Sociales, 1999. 2 v. DT269.T43 Y68 1999. An ancient marketplace founded by the Phoenicians that lies 200 kilometers southeast of Carthage.

Thignica

A3.2121. *Thignica (Ain Tounga): son histoire et ses monuments* / Habib Ben Hassen. Ortacesus (Cagliari): Nuove Grafiche Puddu, 2006. 165 p.DT269.T45 B46 2006. A Roman Catholic titular see that was located in Numidia. Its ruins are southwest of Testour, Tunisia.

Thugga

A3.2122. *Dougga (Thugga) études épigraphiques; études réunies* / Mustapha Khanoussi and Louis Maurin. Paris: Ausonius, 1997. 276 p. DT269.T584 D784 1997. Also known as Dougga, is an ancient Roman city located in northern Tunisia. Although it is best known for its history after the Roman conquest, it has several pre-Roman monuments. Its size, location, and well-preserved monuments qualified Dougga as a UNESCO World Heritage Site in 1997.

A3.2123. *Mourir à Dougga: recueil des inscriptions funéraires* / Mustapha Khanoussi and Louis Maurin. Bordeaux: Ausonius; Tunis: Ministère de la culture, Institut National du Patrimoine, 2002. 734, 164 p. DT269.T48 M69 2002.

A3.2124. *Rus Africum: terra, acqua, olio nell'Africa settentrionale: scavo e ricognizione nei dintorni di Dougga (Alto Tell Tunisino)* / Mariette de Vos. Trento: Università degli studi di Trento; Tunis: Institut National du Patrimoine de Tunis, 2000. 102, 51 p. DT269.T48 R87 2000.

A3.2125. *Thugga* / Mustapha Khanoussi and Volker Michael Strocka. Mainz: von Zabern, 2002. 2 v. DT269.T584 T58 2002.

Uchi Maius

A3.2126. *Uchi Maius 1: scavi e ricerche epigrafiche in Tunisia* / Mustapha Khanoussi and Attilio Mastino. Sassari: EDES, 1997. 389 p. DS156.U24 U244 1997. A Roman amphitheater located 120 kilometers southwest of Tunis.

Uthina

A3.2127. *Oudhna (Uthina): la redécouverte d'une ville antique de Tunisie* / Habib Ben Hassen and Louis Maurin. Talence: Ausonius; Paris: Diffusion, de Boccard, 1998. 251 p. DT269.U78 O94 1998. A Roman colony and titular see in the Roman Catholic Church. The site is also known as Henshir Oudna; remains include a fortress, aqueduct, amphitheater, and several mosaics.

TURKEY

A3.2128. *Das anatolische Chalkolithikum: eine chronologische Untersuchung zur vorbronzezeitlichen Kultursequenz im nördlichen Zentralanatolien und den angrenzenden Gebieten* / Ulf Dietrich Schoop. Remshalden: Verlag Bernhard Albert Greiner, 2005. 441, 187 p. GN778.32.T9.S366 2005.

A3.2129. *Ancient Turkey* / Antonio Sagona and Paul Zimansky. London; New York: Routledge, 2009. 420 p. DR431.S238 2009.

A3.2130. Archaeological Settlements of Turkey. http://www.tayproject.org/enghome.html.

A3.2131. *The Oxford handbook of ancient Anatolia, 10,000–323 B.C.* / Sharon R. Steadman and Gregory McMahon. Oxford; New York: Oxford University Press, 2011. 1174 p. DR431.O95 2011.

A3.2132. *Römische und frühbyzantinische Gebrauchskeramik im westlichen Kleinasien: Typologie und Chronologie* / Gundula Lüdorf. Rahden: VML, Verlag Marie Leidorf, 2006. 166, 27 p. NK3850. L83 2006.

A3.2133. *Sacred landscapes in Anatolia and neighboring regions* / Charles Gates, Jacques Morin, and Thomas Zimmermann. Oxford: Archaeopress, 2009. 112 p. DR431.S33 2009.

A3.2134. *Three great early tumuli* / Rodney S. Young. Philadelphia: University Museum, University of Pennsylvania, 1981. 326, 108 p. Center for Advanced Judaic Studies DS156.G6 G67 1981.

Aetolia

A3.2135. *Aetolia and the Aetolians: towards the interdisciplinary study of a Greek region* / Sebastiaan Bommeljé. Utrecht: Parnassus Press, 1987. 176 p. DF261.A2 A35 1987.

Alaca Hüyük

A3.2136. *Alaca-Höyük: Anadolu'nun etnografya ve folklorina dair malzeme; Das Dorf Alaca-Höyük,*

Materialien zur Ethnographie und Volkskunde von Anatolien / Hamit Zubeyr Kosay. Ankara: Türk Tarih Kurumu Basimevi, 1951. 105, 38 p. 949.6P 844.2 ser.7 no.2. The site of Neolithic and Hittite settlements located in northern Turkey. It has been continually occupied since the Chalcolithic age. The first excavations at the site were done in 1907, by Theodor Makridi Bey, and continue to this day.

A3.2137. *Ausgrabungen von Alaca Höyük, ein Vorbericht über die im Auftrage der Türkischen Geschichtskommission im Sommer 1936 durchgeführten Forschungen und Entdeckungen* / Hamit Zubeyr Kosay. Ankara, 1944. 186 p. 949.6P T844.2 ser.5 no.2a.

A3.2138. *Fouilles d'Alaca Höyük: enterprises par la Société d'histoire turque: rapport préliminaire sur les travaux en 1935* / Remzi Oguz Arik. Ankara, 1937. 119 p. 949.6P T844.2 ser.5 no.1.

A3.2139. *Tarih Kurumu tarafindan yapilan Alaca Höyük kazisi; 1940–1948 deki calismalara ve kesiflere ait ilk rapor* / Hamit Zubeyr Kosay and Mahmut Akok. Ankara: Türk Tarih Kurumu Basimevi, 1966. 230 p. 949.6P T844. 2 ser.5 no.6; 913.56 K8481.

A3.2140. *Türk Tarih Kurumu tarafindan yapilan Alaca Höyük kazisi: 1963–1967; Alaca Höyük excavations: preliminary report on research and discoveries, 1963–1967* / Hamit Zübeyr Kosay and Mahmut Akok. Ankara: Türk Tarih Kurumu Basimevi, 1973. 118 p. DS51.A26 K65.

Alishar Hüyük

A3.2141. *Inscriptions from Alishar and vicinity* / Ignace J. Gelb. Chicago: University of Chicago Press, 1935. 84 p. P956.6.G45 1935; DS155.C5 v.6. An ancient city near the modern village of Alisar in central Turkey. The site was originally occupied during the Chalcolithic Period and flourished during the Bronze Age and Hittite Empire. Several Hittite cuneiform tablets have been discovered there.

Amuq

A3.2142. Amuq Valley Regional Projects. http://oi.uchicago.edu/research/projects/amu/.

Anamur

A3.2143. *Anemurium: the Roman and early Byzantine pottery* / Caroline Williams. Toronto: Pontifical Institute of Mediaeval Studies, 1989. 125, 63 p. NK3850.W55 1989. Originally a Phoenician

city on the Mediterranean coast in southern Turkey, it was later occupied by the Assyrians and Hittites. The city fell under Macedonian rule in 333 BCE under Alexander the Great and then under the Romans. The city was presented as a wedding gift to Cleopatra from Mark Antony. The Byzantines occupied the city after Roman rule.

A3.2144. *Anamur Nekropolu, The Necropolis of Anemurium* / Elisabeth Alfoldi-Rosenbaum. Ankara, Türk Tarih Kurumu Basimevi, 1971. 195 p. DS156.A58 A44; DS156.A58 A44.

Antioch in Pisidia

A3.2145. *Antioch mosaic pavements* / Doro Levi. Princeton: Princeton University Press, 1947. 2 v. 729.7 L579. Located in the Turkish Lakes region, this city shows signs of habitation as early as the Paleolithic age. The city fell under Hellenistic control following the death of Alexander the Great. After the Hellenistic occupation the city was conquered by Romans. Due to its strategic military position it was appointed a capital city and renamed Colonia Ceasarea.

A3.2146. *Building a New Rome The Roman Colony of Pisidian Antioch (25 BC–300 AD).* Ann Arbor: Kelsey Museum of Archaeology 2011. 216 p.+ DVD. DS156.A557 B85 2011.

A3.2147. *The mosaics of Antioch* / Sheila Campbell. Toronto: Pontifical Institute of Mediaeval Studies, 1988. 103, 138 p. NA3770.C35 1988.

Blaundos

A3.2148. *Blaundos: Berichte zur Erforschung einer Kleinstadt im lydisch-phrygischen Grenzgebiet* / Axel Filges. Tübingen: Wasmuth, 2006. 350, 6 p. DS156.B7 B53 2006. Blaundos, an ancient city, located south of Usak, near the Buyuk Menderes River, was founded during the Hellenistic era by the successors of Alexander the Great.

Bursa

A3.2149. *Der Silberschatz von Brusa/Bursa im British Museum* / Hans v. Mangoldt. Oxford: Archaeopress; Hadrian Books, 2005. 93 p. NK7107.3.M36 2005. Bursa, a city in the northwest of Turkey was originally inhabited by the Greeks. It later became a part of the Roman Empire, and in 1326 it was captured from the Byzantines and became a capital city during the Ottoman Empire.

Cappadocia

A3.2150. *Kultepe-Kanis* / Tahsin Ozguc. Ankara: Türk Tarih Kurumu Basimevi, 1959. 2 v. DS156.C3 O53, v.1–2. Cappadocia is situated in the Nevsehir Province of central Anatolia. The region was originally inhabited by Hittites during the Bronze Age and later fell under the rule of Alexander the Great, and following the collapse of the Persian Empire, the area became a Roman province.

Çatalhöyük

A3.2151. *Çatalhöyük perspectives: reports from the 1995–99 seasons* / Ian Hodder. London: British Institute at Ankara; Cambridge: McDonald Institute for Archaeological Research, 2005. 245 p. DS156.C35 C38 2005. Çatalhöyük, located in southern Anatolia, it is the site of the largest Neolithic and Chalcolithic component ever discovered. The mound existed between 7500 BCE to 5700 BCE and was abandoned before the start of the Bronze Age. Beginning in 1993, the site was excavated by Ian Hodder and was the first test of his postprocessual archaeology technique.

A3.2152. *Changing materialities at Çatalhöyük: reports from the 1995–99 seasons* / Ian Hodder. London: British Institute at Ankara, 2005. 395 p. + 1 CD-ROM. DS156.C35 C53 2005.

A3.2153. *Excavating Çatalhöyük: south, north and KOPAL area reports from the 1995–99 seasons* / Ian Hodder. Cambridge: McDonald Institute for Archaeological Research; London: British Institute at Ankara, 2007. 588 p. + 1 CD-ROM. GN776.32.T9 E93 2007.

A3.2154. Çatalhöyük. http://www.telesterion.com/catal1.htm.

A3.2155. Çatalhöyük: Excavations of a Neolithic Anatolian Tell / Anja Wolle, Cambridge, England. Comprehensive website includes archive reports for previous years, microartefact distribution plots produced for Building 1 in 1997, Çatalhöyük papers presented at the Theoretical Archaeology Group Conference (TAG) in 1996, Excavation Diaries, Excavation Database, and North Area Excavations 1995–1999: Interim statement. catal.arch.cam.ac.uk/catal/catal.html.

A3.2156. Çatalhöyük Research Project. This website is designed for those interested in the ongoing excavations at Çatalhöyük, Turkey. Its aim is to provide information about the activities of the project and of the different aspects of the research being conducted at Çatalhöyük. The Neolithic site of Çatalhöyük was first discovered in the late 1950s and excavated by James Mellaart between 1961 and 1965. The site rapidly became famous

internationally due to the large size and dense occupation of the settlement, as well as the spectacular wall paintings and other art that was uncovered inside the houses. Since 1993 an international team of archaeologists, led by Ian Hodder, has been carrying out new excavations and research in order to shed more light on the people that inhabited the site. http://www.catalhoyuk.com/.

A3.2157. Focus on Çatalhöyük. http://www.focusmm.com/civcty/cathyk00.htm.

A3.2158. *The goddess and the bull* / Michael Balter. New York: Free Press, 2005. 400, 16 p. GN776.32.T9 B35 2005.

A3.2159. *Inhabiting Çatalhöyük: reports from the 1995–99 seasons* / Ian Hodder. Cambridge: McDonald Institute for Archaeological Research; London: British Institute of Archaeology at Ankara; Oxford: Oxbow Books; Oakville: David Brown, 2005. 446 p. + 1 CD-ROM. GN776.32.T9 I55 2005.

A3.2160. *The leopard's tale: revealing the mysteries of Çatalhöyük* / Ian Hodder. London: Thames & Hudson, 2006. 288 p. DS156.C35 H63 2006.

A3.2161. Mysteries of Çatalhöyük. The Science Museum of Minnesota's interactive site on one of the world's oldest cities and its archaeological exploration; includes activities for children. http://www.smm.org/catal/.

A3.2162. *On the surface: Çatalhöyük 1993–95* / Ian Hodder. Cambridge: McDonald Institute for Archaeological Research; London: British Institute of Archaeology at Ankara; Oakville: David Brown, 1996. 366 p. DS156.C38 O5 1996.

Cilicia

A3.2163. *Elaiussa Sebaste I: campagne di scavo, 1995–1997* / Eugenia Equini Schneider. Roma: L'Erma di Bretschneider, 1999. 439, 9 p. DS156.C5 E63 1999. Cilicia was originally inhabited during the Neolithic period. It remained a political entity from the Hittite era until the Byzantine empire.

Commagene

A3.2164. *Nekropolen und Gräber in der südlichen Kommagene* / Rifat Ergec. Bonn: Habelt, 2003. 208, 54 p. DS156.C6 E74 2003. Commagene was a small kingdom situated in south-central Turkey. It was conquered by the Persians in the sixth century BCE and later in the fourth century BCE was conquered by Alexander the Great. Following the fall of the Alexandrian empire, Commagene became a Hellenistic kingdom in 162 BCE.

A3.2165. *Patris pantrophos kommagene: neue Funde und Forschungen zwischen Taurus und Euphrat; Forschungsstelle Asia Minor im Semi nar für Alte Geschichte der Westfälischen Willhelms-Universität Münster* / Engelbert Winter. Bonn: Habelt, 2008. 293, 45 p. DS156.C6 P38 2008.

Cnidus

A3.2166. *Knidos: Beiträge zur Geschichte der archaischen Stadt* / Dietrich Berges. Mainz am Rhein: Verlag Philipp von Zabern, 2006. 211, 131 p. DS156.C55 B47 2006. Cnidus, also known as Knidos, was an ancient settlement in southwestern Turkey. The population most likely flourished during the Byzantine period, as many ruins and buildings were constructed in the Byzantine style.

Dereagzi

A3.2167. *The fort at Dereagzi: and other material remains in its vicinity; from antiquity to the Middle Ages* / James Morganstern. Tübingen: Ernst Wasmuth, 1993. 181, 28 p. DS51.D47 F67 1993.

Demirci Hüyük-Sarıket

A3.2168. *Die bronzezeitliche Nekropole von Demircihüyük -Sarıket: Ausgrabungen des Deutschen Archäologischen Instituts in Zusammenarbeit mit dem Museum Bursa, 1990–1991* / Jürgen Seeher. Tübingen: E. Wasmuth, 2000. 299, 28 p. GN778.32.T9 S44 2000.

Ephesus

A3.2169. *Das Theater in Ephesos* / R. Heberdey, G. Niemann, and W. Wilberg. Wien: A. Hölder, 1912. 230. 10 p. DF261.E5 O4 Bd.2. Ephesus is known as a Greek city located on the west coast of Asia Minor. It was initially occupied during the Neolithic period, and during the Bronze Age it was settled as part of the Mycenaean expansion. The city was founded by Androklos in the tenth century BCE after he fled Athens after the death of his father. The city was controlled by Persians during the classical period but was later liberated by Alexander the Great following the Battle of Granicus in 334 BCE. The city remained traditionally Greek through the Hellenistic era until it fell under Roman influence during the Roman period. The Goths destroyed the city in 263 CE, and it was later rebuilt by Constantine I during the Byzantine era. It remained an important city in the Byzantine Empire through the fifth and six centuries.

Eskisehir

A3.2170. *Çavlum* / A. Nejat Bilgen. Eskişehir: Anadolu Üniversitesi, 2005. 226, 92 p. DR701.C3 B55 2005. Eskisehir, located in northwestern Turkey on the banks of the Porsuk River, was founded by the Phrygians around 1000 BCE and is where many Phrygian artifacts and sculptures were found.

Euphrates River Valley

A3.2171. *Lower Euphrates basin: 1977 survey* / Mehmet Özdogan. İstanbul: Middle East Technical University, 1977. 241, 107 p. DS49.2.O92.

A3.2172. *The Neolithic in Turkey: new excavations & new research: the Euphrates basin* / Mehmet Özdoğan, Nezih Başgelen, and Peter Kuniholm. Galatasaray, İstanbul: Archaeology and Art Publications, 2011. 282 p. DR431.N46 2011.

Foca

A3.2173. *Phocée, 1913–1920: le témoignage de Félix Sartiaux* / Haris Yiakoumis. Paris: Kallimages, 2008. 318 p. DS156.F6 S377 2008.

Gazipasa

A3.2174. *Türk Tarih Kurumu tarafindan yapilan Pazarli hafriyati raporu, 1937–1938: Les fouilles de Pazarli entreprises par la Société d'histoire turque* / Hamit Zubeyr Kosay. Ankara, 1941. 21, 60 p. DS51.G3 K6 1941; 949.6P T844.2 ser.5 no.4. Located between the Mediterranean and the Taurus Mountains along the southern coast of Turkey, Gazipasa shows evidence of Hittite habitation dating back to 2000 BCE. By 628 BCE, the Greeks had built the city known as Selinus in the region, and in 197 BCE the Romans took control of the area and were quickly succeeded by the Byzantines.

Girikihaciyan

A3.2175. *Girikihaciyan: a Halafian site in southeastern Turkey* / Patty Jo Watson and Steven A. LeBlanc. Los Angeles: Institute of Archaeology, University of California, Los Angeles, 1990. 146 p. GN776.3.H34 W38 1990.

Gordion (Gordium)

A3.2176. Archaeological Investigations at Gordion. Gordion was originally settled by Thracians in the twelfth century BCE. Between the eighth and ninth centuries BCE, it was the capital city of Phrygia and ruled over most of Asia Minor. The site is well known for its tumuli. http://sites.museum.upenn.edu/gordion/archaeology.

A3.2177. *Archaeology of Midas and the Phrygians: recent work at Gordion* / Lisa Kealhofer. Philadelphia, PA: University of Pennsylvania Museum of Archaeology and Anthropology, 2005. 258 p. DS156.G6 A73 2005.

A3.2178. *Botanical aspects of environment and economy at Gordion, Turkey* / Naomi F. Miller. Philadelphia: University of Pennsylvania Museum of Archaeology and Anthropology, 2010. 272 p. + CD-ROM. DS156.G6 M55 2010.

A3.2179. Digital Gordion. http://sites.museum.upenn.edu/gordion/articles/myth/38-gordianknot.

A3.2180. Digital Gordion. http://sites.museum.upenn.edu/gordion/.

A3.2181. Digital Gordion: Archaeobotany. http://sites.museum.upenn.edu/gordion/archaeology/archaeobotany.

A3.2182. Digital Gordion: Archaeological Investigations at Gordion. http://sites.museum.upenn.edu/gordion/archaeology.

A3.2183. Digital Gordion. Architectural Terracottas. http://sites.museum.upenn.edu/gordion/articles/art/25-architecturalterracottas.

A3.2184. Digital Gordion: Chronology. http://sites.museum.upenn.edu/gordion/history/chronology.

A3.2185. Digital Gordion: Ethnoarchaeology. http://sites.museum.upenn.edu/gordion/archaeology/ethnoarchaeology.

A3.2186. Digital Gordion: Geomorphology. http://sites.museum.upenn.edu/gordion/archaeology/geomorphology.

A3.2187. Digital Gordion: Glass at Gordion. http://sites.museum.upenn.edu/gordion/articles/artefacts/30-glass.

A3.2188. Digital Gordion: The Gordion Knot. http://sites.museum.upenn.edu/gordion/articles/myth/38-gordianknot.

A3.2189. Digital Gordion: Hellenistic Gordion. http://sites.museum.upenn.edu/gordion/history/hellenistic.

A3.2190. Digital Gordion: Historical Overview. http://sites.museum.upenn.edu/gordion/history.

A3.2191. Digital Gordion: Iron Age Gordion. http://sites.museum.upenn.edu/gordion/history/ironage.

A3.2192. Digital Gordion: Mapping Project. http://sites.museum.upenn.edu/gordion/archaeology/mapping.

A3.2193. Digital Gordion: Midas in History and Legend. http://sites.museum.upenn.edu/gordion/articles/myth/32-midashistory.

A3.2194. Digital Gordion: Objects Conservation. http://sites.museum.upenn.edu/gordion/archaeology/objectsconservation.

A3.2195. Digital Gordion: Phrygian Cult Practice. http://sites.museum.upenn.edu/gordion/articles/myth/34-cultpractice.

A3.2196. Digital Gordion: Phrygian Sanctuary at Dümrek. http://sites.museum.upenn.edu/gordion/articles/history/27-sanctuary.

A3.2197. Digital Gordion: Regional Survey. http://sites.museum.upenn.edu/gordion/archaeology/regionalsurvey.

A3.2198. Digital Gordion: Seals at Gordion. http://sites.museum.upenn.edu/gordion/articles/artefacts/35-seals.

A3.2199. Digital Gordion: Textile Production at Gordion. http://sites.museum.upenn.edu/gordion/articles/artefacts/37-textiles.

A3.2200. *From Athens to Gordion: the papers of a memorial symposium for Rodney S. Young, held at the University Museum, the third of May, 1975* / Keith DeVries. Philadelphia: University Museum, University of Pennsylvania, 1980. 168 p. DF13.F76.

A3.2201. *Furniture from Tumulus MM* / Elizabeth Simpson. Leiden; Boston: Brill, 2010. 2 v. + CD-ROM. DS156.G6 S56 2010.

A3.2202. *Gordion, a guide to the excavations and museum* / Rodney S. Young. Ankara, The Archaeological Museum of Ankara, ca. 1968. 48 p. DS156.G6 Y68.

A3.2203. *Gordion: Ahsap eserler; wooden furniture* / Elizabeth Simpson and Krysia Spirydowicz. Ankara: Museum of Anatolian Civilizations, 1999. 174 p. NK2320.T93 S62 1999.

A3.2204. *Gordion; Ergebnisse der Ausgrabung im Jahre 1900* / Gustav Körte and Alfred Körte. Berlin: G. Reimer, 1904. 240 p. DE2.D52 v.3–5.

A3.2205. Gordion Doodles. http://sites.museum.upenn.edu/gordion/articles/art/26-doodles.

A3.2206. *Gordion excavations: final reports*. Philadelphia: University Museum, University of Pennsylvania, 1981. 181 p. University Museum Archives DS156.G6 G67. Contents include v. 1. *Three great early tumuli* / Rodney S. Young; v. 2(1). *The inhumations*; v. 3. *The Bronze Age* / Ann C. Gunter; v. 4. *The early Phrygian pottery* / G. Kenneth Sams.

A3.2207. *Gordion seals and sealings: individuals and society* / Elspeth R. M. Dusinberre. Philadelphia: University of Pennsylvania Museum, 2005. 179 p. CD5344.D87 2005.

A3.2208. *Hittite cemetery at Gordion* / Machteld J. Mellink. Philadelphia, University Museum, University of Pennsylvania, 1956. 60 p. DS66.M37.

A3.2209. *Incised drawings from early Phrygian Gordion* / Lynn E. Roller. Philadelphia: University of Pennsylvania Museum of Archaeology and Anthropology, 2009. 177 p. DS156.G6 R648 2009.

A3.2210. Legend of the Gordian Knot. http://www.gordianconstruction.com/index_files/Page297.htm.

A3.2211. *New chronology of Iron Age Gordion* / C. Brian Rose and Gareth Darbyshire. Philadelphia: University of Pennsylvania Museum of Archaeology and Anthropology, 2011. 181 p. DS156.G6 N49 2011.

A3.2212. *Nonverbal graffiti, dipinti, and stamps* / Lynn E. Roller. Philadelphia: University Museum, University of Pennsylvania, 1987. 100, 52 p. DS156.G6 R65 1987.

A3.2213. *Phrygian fibulae from Gordion* / Oscar White Muscarella. London: Quaritch, 1967. 91, 20 p. CC400.M8.

A3.2214. *Terracotta figurines and related vessels* / Irene Bald Romano. Philadelphia: University Museum, 1995. 90, 44 p. DS156.G6 R654 1995.

A3.2215. *Third century hoard of tetradrachms from Gordion* / Dorothy H. Cox. Philadephia, University Museum, University of Pennsylvania, 1953. 19 p. CJ393.G6 C6.

A3.2216. *Three great early tumuli* / Rodney S. Young. Philadelphia: University Museum, University of Pennsylvania, 1981. 326 p. DS156.G6 G67 1981.

Hattusha

A3.2217. Excavations at Hattusha / German Archaeological Institute. Hattusha, the capital of the Hittite Empire, is located 150 kilometers east of Ankara. From ca. 1650/1600 to 1200 BCE the great kings of Hattusha ruled an empire that extended across Turkey and into northern Syria. The Hittite empire conquered Babylon and Troy. The site has been restored to form an archaeological open air museum and is included in the UNESCO World Heritage List. http://www.hattuscha.de/English/english1.htm. An ancient Greco-Roman city located in Phrygia. The first temple was built by the Phrygians as early as the third century BCE. By the second century Hierapolis was used as a spa and was given by the Romans to the kingdom of Pergamon. In 133 BCE, after the death of Attalus III, Hierapolis was given back to the Romans. It was during this time that the city flourished and many of the existing structures, such as Roman baths, the gymnasium, and temples, were built.

Hierapolis

A3.2218. *An epigraphic guide to Hierapolis (Pamukkale)* / Tullia Ritti. Istanbul: Ege Yayinlari, 2006. 211 p. DS156.H53 R577 2006.

A3.2219. *Saggi in onore di Paolo Verzone* / Daria De Bernardi Ferrero. Roma: G. Bretschneider, 2002. 283 p. DS156.H53 S344 2002.

Horoztepe

A3.2220. *Horoztepe* / T. Ozguc. Ankara: Turk Tarih Kurumu Basimevi, 1958. 949.6P T844.2.

Ikiztepe

A3.2221. *Ikiztepe* / U. Bahadır Alkım, Handan Alkım, and Onder Bilgi. Ankara: Türk Tarih Kurumu Basımevi, 1988. GN778.32.T9 A45 1988.

A3.2222. *Ikiztepe kazıları'nın isığında M.O. 2. bin yıl oncesi Orta Karadeniz bolgesi sahil kesimi mimarisi: Ikiztepe yapıları* / Celal Tuna. Galatasaray, Istanbul: Arkeoloji ve Sanat Yayınları, 2009. 157 p. GN778.32.T9 T862 2009.

Ilipinar

A3.2223. *The Ilipinar excavations* / Jacob Roodenberg. Istanbul: Nederlands Historisch-Archaeologisch Institut, 1995. DS156.I44 I446 1995.

Karatas

A3.2224. *The early Bronze Age pottery of Karataş: habitation deposits* / Christine Eslick. Oxford: Archaeopress, 2009. 296, 99 p. GN778.22.T9 E85 2009. A small port city located on the Mediterranean coast of southern Turkey, Karatas has been inhabited since at least the Hittite era. The city was known to the Greeks as Megarsos and served as a military and commercial function.

Kazilar

A3.2225. *Elaiussa Sebaste: a port city between east und west* / Eugenia Equini Schneider. İstanbul: Homer kitabevi, 2008. 176 p. DS 156 E4 2008.

Konya Plain

A3.2226. Konya Plain Survey, Central Anatolia. http://www.liv.ac.uk/sace/.

Korucutepe

A3.2227. *Korucutepe I: 1973–1975 kazi yillarinda ele geçen Erken Hitit- İmparatorluk Çaği buluntulari* / Hayri Ertem. Ankara: Türk Tarih Kurumu Basimevi, 1988. 46, 71 p. DS156.K67 E7 1988.

Lidar Mound

A3.2228. *Geologisch-mineralogische Untersuchungen zur Technologie fruhbronzezeitlicher Keramik von Lidar Höyük (Sudost-Anatolien)* / Gabriele B. Klenk. Munchen: F. Pfeil, 1987. 64 p. GN778.32. T9 K55 1987.

Lycia

A3.2229. *Kızılbel: an archaic painted tomb chamber in northern Lycia* / Machteld J. Mellink. Philadelphia: University Museum, University of Pennsylvania; Bryn Mawr College, 1998. 70 p. DS156. K59 M45 1998.

A3.2230. *The Roman baths of Lycia: an architectural study; Likya'daki Roma hamamlari: mimari arastirmalari* / Andrew Farrington. London: British Institute of Archaeology at Ankara; Oxbow Books, 1995. 176, 73 p. DS156.L8 F377 1995.

Lykos

A3.2231. *Ricerche archeologiche turche nella valle del Lykos; Lykos Vadisi Turk arkeoloji arastırmaları* / Francesco D'Andria and Francesca Silvestrelli. Galatina (Lecce): Congedo, 2000. 492 p. DR431. R53 2000. Situated in the Black Sea region of modern Turkey, the Lykos or Kelkit river is the longest tributary of the Yesil River. The Lykos River valley was an important corridor from Armenia Minor to Bithynia during the Hellenistic era.

Magnesia ad Meander

A3.2232. *Theatron* / Orhan Bingol. Istanbul: Homer Kitabevi, 2005. 264 p. DS156.M3 B56 2005. An ancient Greek city destroyed sometime between 726 BCE and 660 BCE by the Cimmerians and later reoccupied by the Milesians and Ephesians. During the fifth century BCE, Magnesia was given to the Athenians by Artaxerxes. During the Roman era it was incorporated into the Pergamus kingdom.

Masat Mound

A3.2233. *Hethitische Briefe aus Maşat-Höyük* / Sedat Alp. Ankara: Türk Tarih Kurumu, 1991. 465, 18 p. P945.A76 1991.

Neandreia

A3.2234. *Neandreia: Kuzey Ege'de arkaik ve klasik çağlara ait bir şehir* / Aşkidil Akarca. Istanbul:

Edebiyat Fakultesi Matbaasi, 1977. 65, 55 p.
DS156.N42 A32.

Nemrud Dagi

A3.2235. Nemrud Dağı, Turkey. http://www.learningsites.
com/NemrudDagi/nemdagi-2.htm. Nemrud Dağı,
also known as Mount Nemrut, is a mountain in
southeast Turkey and the site of the royal tomb of
Antiochus I Theos of Commagene. The tomb was
constructed in 62 BCE and was significant for the
huge limestone statues that surround it. Because
of Commagene's wide range of cultural influ-
ences, Antiochus incorporated Greek and Persian
deities in his tomb. The statues were once seated
but have been badly damaged and are now scat-
tered throughout the site. Several of Antiochus's
successors also built their tombs on the mountain.

A3.2236. *Nemrud Dağı: the hierothesion of Antiochus I
of Commagene: results of the American excava-
tions directed by Theresa B. Goell* / Donald H.
Sanders. Winona Lake: Eisenbrauns, 1996. 2 v.
DS156.N45 N47 1996.

Nevali Çori

A3.2237. *Nevali Çori: Keramik und Kleinfunde der Ḥalaf-
und Frühbronzezeit* / Jörg Becker. Mainz: Zab-
ern, 2007. 314, 126 p. GN776.3.H34 B435 2007.
An early Neolithic settlement in southeast Tur-
key.

Paphlagonia

A3.2238. *At empires' edge: Project Paphlagonia: regional
survey in north-central Turkey* / Roger Matthews
and Claudia Glatz. London: British Institute at
Ankara, 2009. 273 p. DR431.A8 2009. Located
in northern Turkey along the coast of the Black
Sea, Paphlagonia was inhabited by the Kashka
during the Hittite era. It was later ruled by
Macedonian kings until the death of Alexander
the Great and then was given to Eumenes. From
183 BCE until 65 BCE, the entire province was
absorbed into the kingdom of Pontus. It was later
combined with the Roman province of Bithynia
and incorporated into the Roman Empire.

Pepouza and Tymion

A3.2239. *Pepouza and Tymion: the discovery and ar-
chaeological exploration of a lost ancient city
and an imperial estate* / William Tabbernee and
Peter Lampe. Berlin: W. de Gruyter, 2008. 338
p. DS156.P37 T33 2008. Pepouza (Pepuza) and

Tymion are ancient towns situated in Asia Minor
and were continually inhabited from the Hel-
lenistic era through Byzantine times. From the
second century CE to the sixth century, Pepuza
served as the center of the Christian church of
Montanism. Tymion was the site where the New
Jerusalem was to descend to earth, and Pepuza
was the site of the Montanist patriarch. Both
sites attracted pilgrims from all over the Roman
Empire.

Pergamon

A3.2240. Pergamon. http://www.bing.com/images/search?
q=Pergamon&qpvt=Pergamon&FORM=IGRE.

A3.2241. Pergamon. http://www.allaboutturkey.com/per-
gamum.htm.

A3.2242. Pergamon: L'altare di Pergamo / Il fregio di
Telefo. http://1stmuse.com/Pergamon/frieze.htm.

A3.2243. Pergamon: the city and its landscape. http://
www.dainst.org/en/project/pergamon?ft=all.

Pessinus

A3.2244. *Excavations in Pessinus: the so-called Acropolis:
from Hellenistic and Roman cemetery to Byzan-
tine castle* / John Devreker, Hugo Thoen, and
Frank Vermeulen. Gent: Academia Press, 2003.
416 p. DS156.B35 D474 2003. Pessinus is an
ancient site on the upper banks of the Sangarios
river in Asia Minor. By the third century BCE,
Pessinus was a temple state ruled by the clerical
oligarchy of Galloi. Romans became involved in
Pessinus after witnessing several meteor show-
ers in the area. They traveled to Pessinus and
removed the images of the Mother Goddess and
introduced the cult of the Great Mother of Ida
to the city. By the end of the third century BCE
Pessinus was under control of Pergamon. Christi-
anity did not reach the city until the third century
CE and the old temples were abandoned.

Phrygia

A3.2245. *Midasstadt in Phrygien: eine sagenumwobene
Stätte im anatolischen Hochland* / Dietrich
Berndt. Mainz am Rhein: P. von Zabern, 2002.
80 p. DS156.P5 B476 2002. Phrygia, an ancient
kingdom located along the Sakarya River in cen-
tral Anatolia. It was famous for its many kings
that were featured in Greek mythology, namely
King Gordias, King Midas, and King Mygdon.
During the eighth century BCE the Phrygian
kingdom, under King Midas, extended over most
of central and western Anatolia. Gordium served

as its capital until it was conquered and destroyed around 675 BCE by the Cimmerians. By 620 BC, after expelling the Cimmerians from Gordium, the area was controlled by the Lydians. In the 540s BCE Phyrgia was absorbed into the Persian Empire after Cyrus conquered Lydia. Phyrgia entered the Hellenistic world in 333 BC, when Alexander the Great traveled to Gordium and severed the Gordian Knot, fulfilling the Phrygian legend that whoever could do so would rule over Asia. In 133 BC Phyrgia was incorporated into the Roman Empire and divided into several provinces.

A3.2246. *Neue Funde und Forschungen in Phrygien* / Elmar Schwertheim and Engelbert Winter. Bonn: Habelt, 2008. 142, 32 p. DS156.P5 N48 2008.

Sagalassos

A3.2247. *Sagalassos V: report on the survey and excavation campaigns of 1996 and 1997* / M. Waelkens and L. Loots. Leuven: Leuven University Press, 2000. 2 v. DS156.S25 S35 2000. Sagalasso, an ancient city near the Taurus mountain range in southwest Turkey. The region shows signs of settlement as early as 8000 BCE. By the time Sagalassos was conquered by Alexander the Great in 333 BCE, the city was one of the wealthiest in Pisidia. After Alexander's death the area became part of the Pergamon kingdom and was eventually absorbed into the Roman Empire.

Sardis

A3.2248. *The archaeology of Lydia, from Gyges to Alexander* / Christopher H. Roosevelt. Cambridge; New York: Cambridge University Press, 2009. 314 p. DS156.L9 R66 2009. An ancient city in western Turkey, was a Lydian city during the eighth century BCE. It was taken by Cimmerians in the seventh century BCE, was conquered by Cyrus the Great and the Persians in the sixth century BCE, and was burned to the ground by the Athenians in the fifth century BC.

Side

A3.2249. *Side im Altertum: Geschichte und Zeugnisse* / Johannes Nollé. Bonn: R. Habelt, 1993. 2 v. DS156.S52 N644 1993. Sida is located along the Mediterranean on the southern coast of Turkey. The area was originally occupied by Greek settlers. In 333 BCE, Alexander the Great conquered Side and introduced it to Hellenistic culture. In 25 BCE Side was assigned to the Roman province of Galatia and absorbed into the Roman Empire.

Sos Hoyük

A3.2250. *Archaeology at the north-east Anatolian frontier VI: an ethnoarchaeological study of Sos Hoyük and Yigittası village* / Liza Hopkins. Louvain; Dudley: Peeters Press, 2003. 199 p. DS156.S67 H68 2003.

Troy (Illium, Ilion, Ilios, Troia, Wilusa, Truva)

A3.2251. *The discovery of the Greek Bronze Age* / J. Lesley Fitton. Cambridge: Harvard University Press, 1996. 212 p. DF220 .F54 1996. Troy (Illium, Ilion, Ilios, Troia, Wilusa, Truva) was a city, both factual and legendary, in northwest Anatolia, south of the Dardanelles. It is best known for being the setting of the Trojan War described in the Greek Epic Cycle and especially in the *Iliad*, one of the two epic poems attributed to Homer. In 1865, English archaeologist Frank Calvert excavated trial trenches in a field he had bought from a local farmer at Hisarlık, and in 1868, Heinrich Schliemann, wealthy German businessman and archaeologist, also began excavating in the area after a chance meeting with Calvert in Çanakkale. These excavations revealed several cities built in succession. Schliemann was at first skeptical about the identification of Hissarlik with Troy but was persuaded by Calvert and took over Calvert's excavations on the eastern half of the Hissarlik site. Troy VII has been identified with the Hittite Wilusa, the probable origin of the Greek λιον and is generally (but not conclusively) identified with Homeric Troy. Today, the hill at Hisarlik has given its name to a small village near the ruins, supporting the tourist trade visiting the Troia archaeological site. It lies within the province of Çanakkale, some 30 kilometers southwest of the provincial capital, also called Çanakkale. Troia was added to the UNESCO World Heritage list in 1998.

A3.2252. *Hadrian und die dionysischen Künstler: drei in Alexandria Troas neugefundene Briefe des Kaisers an die Künstler-Vereinigung* / Georg Petzl and Elmar Schwertheim. Bonn: Habelt, 2006. 119, 11 p. CN703.P482 2006.

A3.2253. *Heinrich Schliemanns "Sammlung trojanischer Altertümer": Beiträge zur Chronik einer grossen Erwerbung der Berliner Museen* / Geraldine Saherwala, Klaus Goldmann, and Gustav Mahr. Berlin: Volker Spiess, 1993. 259 p. DF212.S4 A4 1993.

A3.2254. *History of art in primitive Greece Mycenian art / Georges Perrot and Charles Chipiez.* London: Chapman and Hall, Limited, 1894. N5630 .P42 1894.

A3.2255. *Lost and found: the 9,000 treasures of Troy: Heinrich Schliemann and the gold that got away / Caroline Moorehead.* New York: Viking, 1996. 307, 4 p. DF221.T8 M58 1996.

A3.2256. *The Mycenaean age; a study of the monuments and culture of pre-Homeric Greece / Chrestos Tsountas.* Boston; New York: Houghton, Mifflin and Company, 1897. 417 p. DF221.M9 T8 1897; 913.381 M99Ts.

A3.2257. *Ein neuer Kampf um Troia: Archäologie in der Krise / Eberhard Zangger.* München: Droemer Knaur, 1994. 351 p. DF221.T8 Z34 1994.

A3.2258. New Excavations at Troy. http://www.uni-tuebingen.de/troia/eng/.

A3.2259. *Schliemann's discoveries of the ancient world / C. Schuchhardt.* New York: Avenel; Crown Publishers, 1979. 363 p. DF220.S3813 1979. Translation from the German Schliemann's *Ausgrabungen in Troja, Tiryns, Mykena.*

A3.2260. *Schliemann's excavations; an archaeological and historical study / C. Schuchhardt.* Translated from the German by Eugénie Sellers, with an appendix on the recent discoveries at Hissarlik by Dr. Schliemann and Dr. Dörpfeld / Walter Leaf. New York; London: Macmillan and Co., 1891. 363 p. 913.381 Sch78; 913.381 Sch78.

A3.2261. *Schliemann's excavations at Troia, 1870–1873 / D. F. Easton.* Mainz am Rhein: von Zabern, 2002. 419, 194 p. DF221.T8 E17 2002.

A3.2262. *Studia Troica / Eberhard-Karls-Universität, Tübingen, University of Cincinnati.* Mainz am Rhein: P. von Zabern, 1991– . 1/yr. DF221.T8 S883, Bd.1 (1991)–Bd.18 (2009).

A3.2263. *The treasure of Troy: Heinrich Schliemann's excavations.* Moscow: Pushkin Museum; Milan: Leonardo Arte, 1996. 239 p. DF221.T8 T74 1996.

A3.2264. *Le trésor de Troie: les fouilles d'Heinrich Schliemann / V. P. Tolstikov and M. Y. Treister.* Paris: Gallimard; Electa, 1996. 247 p. DF221.T8 T6514 1996.

A3.2265. *Troia, Homer, Schliemann: Mythos und Wahrheit / Michael Siebler.* Mainz am Rhein: P. von Zabern, 1990. 248, 32 p. DF221.T8 S42 1990.

A3.2266. *Troia/Wilusa: Überblick und offizieller Rundweg mit Informationstafeln verfasst von der Grabungsleitung / Manfred O. Korfmann and Dietrich P. Mannsperger.* 4 ed. Canakkale: Canakkale-Tübingen Troia Vakfi, 2012. 136 p. DF221.T8 K67 2012.

A3.2267. *Die Troas: neue Forschungen III / Elmar Schwertheim.* Bonn: R. Habelt, 1999. 180, 14 p. DS156.N43 T7 1999.

A3.2268. Turkey-Troy—Images. http://cascoly.com/trav/turkey/Troy.asp?lt=1.

Van Ili

A3.2269. *Urartu takıları / Oktay Belli.* Sisli, Istanbul: Turkiye Turing ve Otomobil Kurumu, 2010. 479 p.DS156.U7 B444 2010. Van Ili is a province located between Lake Van and the Iranian border in eastern Turkey. During the ninth century the area was inhabited by the Urartian kingdom. In the seventh century it came under control of the Armenian Orontids, followed by the Persians in the mid-sixth century. In the second century it became part of the Kingdom of Armenia and remained Armenian until the late nineteenth century, when the area was seized by the Ottoman Empire.

UKRAINE

Chersonese

A3.2270. *Crimean Chersonesos: city, chora, museum, and environs / Joseph Coleman Carter.* Austin: Institute of Classical Archaeology, University of Texas at Austin, 2003. 229 p. DK508.95.C544 C75 2003. An ancient Greek colony founded in the sixth century BCE on the shore of the Black Sea in southwestern Crimea by settlers from Heraclea Pontica.

A3.2271. *Polis et chora: cité et territoire dans le Pont-Euxin / Alexandre Chtcheglov.* Paris: Diffusion, Belles Lettres, 1992. 302 p. AS161.B39 v.476.

A3.2272. *The polychrome grave stelai from the early Hellenistic necropolis / Richard Posamentir.* Austin: University of Texas Press, 2011. 489 p. DK508.95.C544 P67 2011.

A3.2273. *Die spätklassische Münzprägung von Chersonesos Taurica / Sergei Kovalenko.* Berlin: Akademie Verlag, 2008. 156, 18 p. CJ673.C48 K68 2008.

A3.2274. *Studien zur Geschichte und Archäologie des byzantinischen Cherson / Alla I. Romancuk.* Leiden; Boston: Brill, 2005. 392 p. DK508.95.C544 R68515 2005.

Kiev (Kyiv) (the capital of Ukraine, located on the Dnieper River in the north-central part of Ukraine)

A3.2275. *Pamiatniki arkheologii pozdnerimskogo vremeni Pravoberezhnoi Kievshchiny: monografiia / N. M. Kravchenko.* Kiev: KNT, 2007. 452 p. DK508.928 K7 2007.

Nymphaion

A3.2276. *Archaeological map of Nymphaion (Crimea)* / T. Scholl and V. Zin'ko. Warsaw: Institute of Archaeology and Ethnology, Polish Academy of Sciences, 1999. 126 p. DK508.95.N95 A73 1999. Greek colonists established an emporium in the Crimean shore of the Cimmerian Bosporus in the sixth century BCE. The town issued its own coinage and prospered, as it controlled the cereal trade. Athens chose it as its primary military base in the region ca. 444 BCE. Later, during the Mithridatic Wars, the fortress was allied with the Roman Republic and withstood a siege by the army of Pharnaces II of Pontus.

Olbia

A3.2277. *Inscriptions grecques dialectales d'Olbia du Pont* / Laurent Dubois. Genève: Librairie Droz, 1996. 208 p. CN398.R9 D833 1996. A Milesian colony site on the shore of the southern Bug estuary was one of the main emporia on the Black Sea for the export of cereals, fish, and slaves to Greece, and for the importation of Attic goods to Scythia.

A3.2278. *Keramicheskaia tara iz Ol'vii: iz opyta izucheniia amfor VI–IV vv. do n.e* / N. A. Leipunskaia. Kiev: Nauk. dumka, 1981. 118 p. NK3855 .L44. Study of amphoras at the site of Olbia.

A3.2279. *The lower city of Olbia (sector NGS) in the 6th century BC to the 4th century AD* / Nina A. Lejpunskaja. Aarhus; Oakville: Aarhus University Press, 2010. 2 v. DG55.U37 L69 2010.

A3.2280. *Olbia: Geschichte einer altgriechischen Stadt am Schwarzen Meer* / Juri Vinogradov. Konstanz: Universitätsverlag, 1981. 47 p. DK651.O4 V56 1981.

A3.2281. *Olbia, cité antique du littoral nord de la mer Noire* / E. Belin de Ballu. Leiden: E. J. Brill, 1972. 205 p. DK651.O4 B45.

UNITED ARAB EMIRATES

A3.2282. Archaeology in the UAE—The Fourth and Third Millenium B.C. http://www.enhg.org/b/b20/20_13.htm.

Abraq, tell (Umm al-Qaywayn)

A3.2283. *A prehistoric mound in the Emirate of Umm al-Qaiwain, U.A.E.: excavations at Tell Abraq in 1989* / D. T. Potts. Copenhagen: Munksgaard, 1990. 157 p. DS247.T83 P68 1990; see also: A3.2268. http://sisinnew.blogspot.com/2011/09/lead-isotope-analyses-from-tell-abraq.html. A

transhipment site between Mesopotamia and the Indus Valley, occupied from the mid-third millennium BCE to just prior to Hellenistic times in the first millennium BCE.

Abu Dhabi Islands

A3.2284. Abu Dhabi Islands Archaeological Survey. http://www.adias-uae.com/.

Dur (Umm al-Qaywayn) (the largest pre-Islamic site on the Gulf coast of the United Arab Emirates)

A3.2285. *The glass vessels* / David Whitehouse. Leuven: Peeters, 1998. 89, 12, 15 p. NK5107.W48 1998.

Fujairah

A3.2286. Archéologie du Fujairah (EAU). http://anthro.unige.ch/lap/grap/grap5.html.

Hili

A3.2287. Hili Archaeological Park. http://www.abudhabi.ae/egovPoolPortal_WAR/appmanager/ADeGP/Citizen?_nfpb=true&_pageLabel=p584&lang=en&did=163136.

A3.2288. Hili, une oasis de l'âge du Bronze à Abou Dhabi. http://www.diplomatie.gouv.fr/fr/enjeux-internationaux/echanges-scientifiques-recherche/archeologie-sciences-humaines-et/les-carnets-d-archeologie/afrique-arabie/abou-dhabi-hili/.

A3.2289. 1979–80 Excavations at Hili. http://www.enhg.org/b/b11/11_10.htm.

Julfar

A3.2290. Digging up Julfar UAE. http://www.alshindagah.com/janfeb98/julfar.htm.

Mleiha

A3.2291. Mleiha, la période pré-islamique récente dans la péninsule d'Oman Mission archéologique Française aux Emirats Arabes Unis. http://www.diplomatie.gouv.fr/fr/enjeux-internationaux/echanges-scientifiques-recherche/archeologie-sciences-humaines-et/les-carnets-d-archeologie/afrique-arabie/emirats-arabes-unis-mleiha/; http://www.uaeinteract.com/docs/Ancient_settlement_unearthed_in_Mleiha/2385.htm.

Ommana and Mleiha

A3.2292. *Malihah wa-al-bahth an umanah; Meliha & the quest for Omana* / Munir Y. Taha. Bayrut:

Muassasat al-Riḥab al-Ḥadithah, 2005. 124, 3 p. DS247.T83 T346 2005.

Ra's al-Khaymah (historically known as Julfar, consists of a sizable tell with remnants of a Sassanid era fortification)

A3.2293. *Al-Baḥth an Julfar; The quest for Julfar* / Munir Y. Taha. Bayrut: Muassasat al-Riḥab al-Ḥadithah, 2005. DS247.R373 T346 2005.

A3.2294. *Shimal 1985/1986: excavations of the German Archaeological Mission in Ras Al-Khaimah, U.A.E.: a preliminary report* / Burkhard Vogt and Ute Franke-Vogt. Berlin: D. Reimer, 1987. 126, 66 p. DS247.R373 S54 1987.

Sufouh, al- (location of the extensive remains of a series of cremation episodes)

A3.2295. *Excavations at Al Sufouh: a third millennium site in the Emirate of Dubai* / J. N. Benton. Turnhout: Brepols, 1996. 245 p. DS247.S93 B45 1996.

Ujairah

A3.2296. Ujairah Petroglyphs (United Arab Emirates). http://anthro.unige.ch/galerie/petroglyphes/index.gb.html; http://fujairah.dubaicityguide.com/features/index.asp?id=2970.

United Arab Emirates

A3.2297. United Arab Emirates History Interactive. http://www.uaeinteract.com/history/e_muse/em_strt.asp.

A3.2298. UAE Interactive—A Walk Through Time

YEMEN

A3.2299. *Arabia Felix: Beiträge zur Sprache und Kultur des vorislamischen Arabien: Festschrift Walter W. Müller zum 60. Geburtstag* / Rosemarie Richter, Ingo Kottsieper, und Mohammed Maraqten. Wiesbaden: Harrassowitz, 1994. 328 p. DS247.Y43 A7195 1994.

A3.2300. *Arabia felix: un viaggio nell'archeologia dello Yemen* / Alessandro de Maigret. Milano: Rusconi, 1996. 378 p. DS247.A2 D452 1996.

A3.2301. *Au pays fabuleux de la reine de Saba: le Yemen et les grands empires antiques, les terres fertiles de l'Arabie heureuse, la route de l'encens, les trésors légendaires de la reine de Saba, premières religions monothéistes, art chrétien primitif et mosquées* / Jacqueline Pirenne. Dijon: Archéologia, 1979. 112 p. DS247.Y43 A8.

A3.2302. *Yémen: au pays de la reine de Saba: exposition présentée á l'Institut du monde arabe du 25 octobre 1997 au 28 février 1998* / Institut du monde arabe. Paris: Flammarion, 1997. 239 p. DS247.Y43 Y45 1997.

A3.2303. Yemen Expedition of the University of Heidelberg. http://www.zafar-himyar.com/.

A3.2304. Yemeni Megaliths. http://www.archaeology.org/online/news/yemen.html.

Hadramawt (Hadhramaut, Hadhramout, Hadramut)

A3.2305. *La préhistoire du Yémen: diffusions et diversités locales, à travers l'étude d'industries lithiques du Hadramawt* / Rémy Crassard. Oxford: Archaeopress, 2008. 227 p. DS247.H33 C73 2008. A sultanate including the south Arabian peninsula along the Gulf of Aden in the Arabian Sea, extending from Yemen to the Dhofar region of Oman.

A3.2306. *Qani: le port antique du Ḥaḍramawt entre la Méditerranée, l'Afrique et l'Inde: fouilles russes 1972, 1985–89, 1991, 1993–94* / J.-F. Salles and A. Sedov. Tournhout: Brepols, 2010. 553 p. DS247.H33 Q36 2010.

Hawlan at-Tiyal

A3.2307. *The Bronze Age culture of Hawlan aṭ-Ṭiyal and al-Ḥada (Republic of Yemen): a first general report* / Alessandro de Maigret. Rome: IsMEO, 1990. 2 v. DS11.C43 v.24.

Himyar

A3.2308. *Himyar: Spätantike im Jemen; Late antique Yemen* / Paul Yule. Aichwald: Linden Soft, 2007. 191 p. DS247.Y43 H56 2007.

Makhdarah, al- and Kharibat al-Ahjur

A3.2309. *South Arabian necropolises: Italian excavations at Al-Makhdarah and Kharibat al-Ahjur (Republic of Yemen)* / Alessandro De Maigret and Sabina Antonini. Roma: IsIAO, 2005. 149, 111 p. DS11.C43 n.s. v.4.

Shabwa

A3.2310. Shabwa, royal capital of Hadramaout. http://hadhramouts.blogspot.com/2011/01/shabwa-hadhramouts-western-neighbor.html.

Wadi Bayhan

A3.2311. *Une vallée aride du Yémen antique: le wadi Bayhan* / Jean-François Breton. Paris: Recherche sur les civilisations, 1998. 249, 6 p. DS247.A23 V366 1998.

Wadi al-Jubah

A3.2312. *The Wadi al-Jubah archaeological project* / American Foundation for the Study of Man; participating institutions, the American Schools of Oriental Research, the Peabody Museum, Harvard University; University Museum, University of Pennsylvania. Washington, D.C.: American Foundation for the Study of Man; Winona Lake: Eisenbrauns, 1984. DS247.Y43 W33 1984, v.1–5.

Wadi Masila

A3.2313. *A landscape of pilgrimage and trade in Wadi Masila, Yemen: al-Qisha and Qabr Hud in the Islamic Period* / Lynne S. Newton. Oxford: Archaeopress, 2009. 186 p. DS247.Y43 N49 2009. Wadi Masila is situated along the northern Indian Ocean coast; regional surveys have revealed Bronze and Iron Age, as well as Islamic period, sites.

Wadi Shumylya

A3.2314. Holocene Climate Change and Human Impact on the Landscape, Wadi Shumylya, Yemen. http://geology.usf.edu/research/paleoenvironmental/quaternary/projects/yemen/.

YUGOSLAVIA (FORMER)

Danube Region

A3.2315. *Beiträge zur Verbreitung ägyptischer Kulte auf dem Balkan und in den Donauländern zur Römerzeit, (mit besonderer Berücksichting des Quellenmaterials aus dem Gebiet des heutigen Staates Jugoslawien)* / Bernarda Perc. München, 1968. 294 p. DR311.P4. A long-standing frontier of the Roman empire, the Danube River originates in the Black Forest region of southern Germany and then flows southeast passing through modern Austria, Bulgaria, Croatia, Germany, Hungary, Moldova, Serbia, and Slovakia, before emptying into the Black Sea through the Danube delta in Romania and Ukraine.

Appendix 4
Paleography and Writing Systems

Many programs specializing in the ancient world emphasize textual rather than archaeological material. Such programs will emphasize philology, literature, linguistics, history, and so forth. The Mesopotamian script known as *cuneiform* is characterized by wedge-shaped marks made by stylus upon damp clay tablets. It was first used to record Sumerian. In the mid-third millenium BCE the script was adapted for the writing of Akkadian. Sumerian went out of everyday usage but was preserved as a classical written language. Akkadian cuneiform led in the second millenium BC to an abbreviated version of the script (from 2,000 to 700 characters), which lasted throughout the Assyrian and Babylonian kingdoms. A version of cuneiform was used by the Hittites in the late second millenium BCE, and other forms became common throughout the Near East.

The transition from a syllabary to alphabet marks the final stage in the development of writing. A large number of clay tablets from Ugarit, in what is known as the Ugaritic Cuneiform Alphabet, date from the middle of the second millenium BCE. The language is Ugaritic, and the script is alphabetic. Monumental stone inscriptions from Byblos show an alphabetic script in which two of the earliest examples belong to king Ahitam and date to the eleventh or twelve century BCE. The Phoenician alphabet borrowed by Greeks in the eighth century BCE was a descendant of the Byblos script.

Linear B is the most recent of the three scripts from the ancient world. Linear B is found principally on clay tablets recovered from numerous sites, foremost among which are Knossos in Crete and Pylos and Mycenae in Greece. The decipherment of Linear B by Michael Ventris in 1952 revealed the script to be a syllabary that was adapted to Mycenaean Greek. The texts are generally bureaucratic records, cataloging matters such as personnel, livestock, land use, equipment, and religious ritual. Linear B did not survive the breakdown of the Mycenaean regime.

PALEOGRAPHY

A4.1. *Fonti documentarie in scrittura latina: repertorio (sec. VII a.C.–VII d.C.* / Guglielmo Bartoletti and Ilaria Pescini. Firenze: L. S. Olschki, 1994. 295 p. CN520.F66 1994.

Bibliography

A4.2. *Indices librorum: catalogues anciens et modernes de manuscrits médiévaux en écriture latine* / François Dolbeau and Pierre Petitmengin. Paris: Presses de l'Ecole Normale Supèrieure, 1987–1995. 2 v. Z6605.L3 D65 1987.

A4.3. *Medieval Latin palaeography: a bibliographical introduction* / Leonard E. Boyle. Toronto; Buffalo: University of Toronto Press, 1984. 399 p. Z106.B68 1984.

Databases

A4.4. *APIS: electronic resource: Advanced papyrological information system.* New York: Columbia University. http://www.columbia.edu/cu/lweb/eresources/databases/3039490.html.

Egypt

A4.5. *Pictograms or pseudo script?: non-textual identity marks in practical use in ancient Egypt and elsewhere: proceedings of a conference in Leiden, 19–20 December 2006* / B. J. J. Haring and O. E. Kaper. Leiden: Nederlands Instituut voor het Nabije Oosten; Leuven: Peeters, 2009. 236 p. PJ1526 .E3 P53 2009.

A4.6. *Writing, teachers, and students in Graeco-Roman Egypt* [Electronic resource] / Raffaella Cribiore. Atlanta: Scholars Press, 1996. World Wide Web.

Egypt—Ethiopic

A4.7. *Ethiopic, an African writing system: its history and principles* / Ayele Bekerie. Lawrenceville: Red Sea Press, 1997. 176 p. Z115.5 .E85 A94 1997.

A4.8. *Introduction to Ethiopian palaeography* / Siegbert Uhlig. Stuttgart: F. Steiner, 1990. 118 p. Z155.5.E85 U36 1990.

Egypt—Greek/Latin—Catalogs

A4.9. *Stimmen aus dem Wüstensand: Briefkultur im griechisch-römischen Ägypten* / Claudia Kreuzsaler, Bernhard Palme, and Angelika Zdiarsky. Wien: Phoibos, 2010. 184 p. PA3042 .S85 2010.

Egypt—Israel and the Palestinian Territories

A4.10. *Palästinisches Hieratisch: die Zahl- und Sonderzeichen in der althebräischen Schrift* / Stefan Wimmer.Wiesbaden: Harrassowitz, 2008. 306 p. PJ1105 .W56 2008.

Greek

A4.11. *Attic script: a survey* / Henry R. Immerwahr. Oxford: Clarendon Press; New York: Oxford University Press, 1990. 214 p. PA522 .I45 1990.

A4.12. *Public records and archives in classical Athens* / James P. Sickinger. Chapel Hill: University of North Carolina Press. 274 p. CD996 .S53 1999.

Greek—Bibliography

A4.13. *Paleografia e codicologia greca: una rassegna bibliografica* / Paul Canart. Città del Vaticano: Scuola Vaticana di Paleografia, Diplomatica e Archivistica, 1991. 131 p. Z106 .C36 1991.

Greek—Handbooks

A4.14. *Handbuch der griechischen Paläographie* / Hermann Harrauer. Stuttgart: Hiersemann, 2010. 2 v. Z113.8 .H37 2010.

Handbooks

A4.15. *Ancient handwritings: an introductory manual for intending students of palaeography and diplomatic* / William Saunders. Walton-on-Thames: C. A. Bernau, 1909. 64 p. 417 SA89.

A4.16. *Early drama, art, and music documents: a paleography handbook* / John M. Wasson. Kalamazoo: Medieval Institute Publications, Western Michigan Unviersity, 1993. 135 p. Z115.E5 W37 1993.

Latin

A4.17. *Abbreviationes*. Bochum: Institut für Philosophie, Ruhr-Universität, 1993–2001. 1 computer optical disc; 4 3/4 in. + 1 user's guide (6, 282 p.). Z111.A33 1993.

A4.18. *The Latin manuscript book; an exhibition held on the occasion of the seminars in Latin palaeography sponsored by the Division of the Humanities of the University of Chicago and the Medieval Academy of America, summer MCMLXXIII, selected from the collections of the University of Chicago Library; The Joseph Regenstein Library, July through September, 1973.* Chicago, 1973. 55 p. Z114.C53 1973.

A4.19. *Roma e l'area grafica romanesca (secoli X–XII)* / Paola Supino Martini. Alessandria: Edizioni dell'Orso, 1987. 438 p., [133] p. of plates. Z115. I8 S97 1987.

Latin—Software

A4.20. *Abbreviationes*. Bochum: Institut für Philosophie, Ruhr-Universität, 1993–2001. 1 computer optical disc; 4 3/4 in. + 1 user's guide (6, 282 p.). Z111.A33 1993.

Semitic—Papyri

A4.21. *Semitic papyrology in context: a climate of creativity: papers from a New York University conference marking the retirement of Baruch A. Levine* / Lawrence A. Schiffman. Leiden; Boston: Brill, 2003. 285 p. PJ3091.S45 2003; PJ3091.S45 2003.

Semitic—Seals

A4.22. *Biblical period Hebrew bullae: the Josef Chaim Kaufman Collection* / Robert Deutsch. Tel Aviv: Archaeological Center Publication[s], 2003–2011. 2 v. CD5354.D48 2003.

Syriac

A4.23. *An album of dated Syriac manuscripts* / William Henry Paine Hatch. Piscataway: Gorgias Press, 2002. Z6605.S9 H38 2002. Supersedes: *An album of dated Syriac manuscripts* / William Henry Paine Hatch. Boston: American Academy

of Arts and Sciences, 1946. 286 p. Z115.5.S97 H38 1946; 492.4 H283.

A4.24. *Biblical and patristic relics of the Palestinian Syriac literature from mss. in the Bodleian Library and in the Library of Saint Catherine on Mount Sinai* / G. H. Gwilliam, F. Crawford Burkitt, and John F. Stenning. Oxford: Clarendon Press, 1896. 113, 3 p. BS714.3.G8 1893.

Terminology

A4.25. *Vocabulaire codicologique: répertoire méthodique des termes français relatifs aux manuscrits* / Denis Muzerelle. Paris: CEMI, 1985. 265, 59 p. Z111.M89 1985.

INSCRIPTIONS

Aegean Sea Region—Seals

A4.26. *Administrative documents in the Aegean and their Near Eastern counterparts: proceedings of the international colloquium: Naples, February 29–March 2, 1996* / Massimo Perna. Torino: Ministero per i beni e le attività culturali, Ufficio centrale per i beni archivistici: Paravia scriptorium, 2004. 436 p. DS155.A365 2004.

Akkadian

A4.27. *Abridged grammars of the languages of the cuneiform inscriptions, containing: I. A Sumero-Akkadian grammar. II. An Assyro-Babylonian grammar. III. A Vannic grammar. IV. A Medic grammar. V. An Old Persian grammar* / George Bertin. London: Trübner, 1888. 117 p. PJ4013 .B4 1888.

A4.28. *Les inscriptions de la Perse achéménide / traduit du vieux perse, de l'élamite, du babylonien et de l'araméen* / Pierre Lecoq. Paris: Gallimard, 1997. 327, 16 p. PK6128.A1 L43 1997.

A4.29. *Rulers of Babylonia: from the second dynasty of Isin to the end of Assyrian domination (1157–612 BC)* / Grant Frame. Toronto: University of Toronto Press, 1995. 350 p. PJ3831 .F73 1995.

A4.30. *The sculptures and inscription of Darius the Great on the rock of Behistûn in Persia: a new collation of the Persian, Susian, and Babylonian texts, with English translations.* London: British Museum, 1907. 223 p. 891.5 D244.

A4.31. *Textes élamites-sémitiques* / V. Scheil. Paris: E. Leroux; Chalon-sur-Laône: Impr. E. Bertrand, 1900. DS261 .F8 1900.

Akkadian—Catalogs

A4.32. *Mesopotamische Weihgaben der frühdynastischen bis altbabylonischen Zeit* / Eva Andrea Braun-Holzinger. Heidelberg: Heidelberger Orientverlag, 1991. 408 p. PJ3785.B73 1991.

Akkadian—Congresses

A4.33. *Fiscality in Mycenaean and Near Eastern archives: proceedings of the conference held at Soprintendenza archivistica per la Campania, Naples, 21–23 October 2004* / Massimo Perna. Paris: De Boccard, 2006. 284 p. P1038 .F583 2006.

Akkadian—Dictionaries

A4.34. *An adventure of great dimension: the launching of the Chicago Assyrian dictionary* / Erica Reiner. Philadelphia: American Philosophical Society, 2002. 140 p. Q11 .P6 v.92 pt.3.

A4.35. Akkadian Dictionary Online. The Association Assyrophile de France's dictionary of Akkadian with translations in French and English. http://www.premiumwanadoo.com/cuneiform. languages/dictionary/index_en.php.

A4.36. Akkadian-French/English Dictionary. Online dictionary of Akkadian with translations in French and English. http://www.premiumwanadoo.com/cuneiform.languages/dictionary/use_en.htm.

A4.37. *Akkadian language*. Home page on Akkadian collected by John Heise. Subjects considered include Mesopotamian prehistory, Akkadian texts, cuneiform writing system, Akkadian language, Akkadian dictionaries, and book references. http://www.sron.nl/~jheise/akkadian/Welcome. html.

A4.38. *An Akkadian lexical companion for biblical Hebrew etymological-semantic and idiomatic equivalents with supplement on biblical Aramaic* / Hayim ben Yosef Tawil. Jersey City: KTAV Pub. House, 2009. 503 p. PJ4831 .T38 2009.

A4.39. *Akkadische Lesestücke* / Theo Bauer. Roma: Pontificium Institutum Biblicum, 1953. 3 v. PJ3259 .B3 1953; 892.3 B332; PJ3259.

A4.40. *Das akkadische Syllabar* / Wolfram von Soden, Wolfgang Röllig. 4 ed. Roma: Pontificium Institutum Biblicum, 1991. 72, 21 p. PJ3251 .S53 1991.

A4.41. *Akkadisches Glossar: etwa 1700 häufige Wörter des Babylonischen und Assyrischen in praktischer Anordnung enthaltend nebst Angaben zur Etymologie* / Carsten Peust. Göttingen: Peust & Gutschmidt, 1999. 52 p. PJ3540 .P489 1999.

A4.42. *Akkadisches Handwörterbuch: unter Benutzung des lexikalischen Nachlasses von Bruno Meissner (1868–1947)* / Wolfram von Soden. Wiesbaden: Harrassowitz, 1965–1981. 3 v. PJ3540 .S63 1965.

A4.43. *Alphabetisches verzeichniss der assyrischen und akkadischen wörter der cuneiform inscriptions of western Asia, vol. II, sowie anderer meist unveröffentlichter inschriften. Mit zahlreichen engänzungen und verbesserungen und einem Wörterverzeichniss zu den in den Verhandlungen des VI. Orientalisten-congresses zu Leiden veröffentlichten babylonischen inschriften* / J. N. Strassmaier. Leipzig: J. C. Hinrichs, 1886. 1,144 p. 492.33 St84; PJ3540 .S8 1886a.

A4.44. *A concise dictionary of Akkadian* / Jeremy Black, Andrew George, and Nicholas Postgate. Wiesbaden: Harrassowitz, 2000, 1999. 450 p. PJ3525 .C65 2000; PJ3525 .C65 2000.

A4.45. *Deutsch-Akkadisches Wörterbuch* / Thomas R. Kämmerer and Dirk Schwiderski. Münster: Ugarit-Verlag, 1998. 589 p. PJ3540 .K36 1998.

A4.46. *An English-to-Akkadian companion to the Assyrian dictionaries* / Mark E. Cohen. Bethesda: CDL Press, 2011. 238 p. PJ3525 .C65 2011.

A4.47. *A lexicon of Accadian prayers in the rituals of expiation* / Cecil J. Mullo Weir. London: Oxford University Press, 1934. 411 p. PJ3525 .W44 1934; PJ4037 .W4.

A4.48. *Lexique assyrien-français* / Antoine Saubin. Paris: Maisonneuve, 1928. 361 p. PJ3223 .S23 1928.

A4.49. *Manuel d'épigraphie akkadienne: signes, syllabarie, idéogrammes* / Rene Labat. Paris: rie Orientalisle P. Geuthner, 1995. 346 p. PJ3193 .L3 1995.

A4.50. *Manuel de langue akkadienne: Lexiques akkadien, français et français, akkadien* / Florence Malbran-Labat. Louvain; Paris: Peeters; Louvain-la-Neuve: Université Catholique de Louvain, Institut Orientaliste, 2003. 235 p. PJ3540 .M34 2003.

A4.51. *Rückläufiges Wörterbuch des Akkadischen* / Karl Hecker. Wiesbaden: O. Harrassowitz, 1990. 316 p. PJ3453 .H42 1990.

Akkadian—Grammar

A4.52. *Akkadian grammar* / Arthur Ungnad. Atlanta: Scholars Press, 1992. 184 p. PJ3251 .U613 1992.

A4.53. *Grammar of Akkadian* / John Huehnergard. 3 ed. Winona Lake: Eisenbrauns, 2011. 660 p. PJ3251 .H84 2011; PJ3251 .H84 2011.

A4.54. *Grundriss der akkadischen Grammatik* / Wolfram von Soden. 3 ed. Roma: Pontificium Institutum Biblicum, 1995. 328, 55 p. PJ3251 .S63 1995; PJ3251 .S63 1995.

A4.55. *Introduction to Akkadian* / Richard Caplice. 4 ed. Roma: Editrice Pontificio Istituto Biblico, 2002. 108 p. PJ3251 .C3 2002.

A4.56. *Key to a grammar of Akkadian* / John Huehnergard. Atlanta: Scholars Press, 1997. 137 p. PJ3251 .H85 1997; PJ3251 .H85 1997.

Akkadian—Iran

A4.57. *Les inscriptions de la Perse achéménide / traduit du vieux perse, de l'élamite, du babylonien et de l'araméen* / Pierre Lecoq. Paris: Gallimard, 1997. 327, 16 p. PK6128.A1 L43 1997.

Akkadian—Iraq

A4.58. *Mesopotamische Weihgaben der frühdynastischen bis altbabylonischen Zeit* / Eva Andrea Braun-Holzinger. Heidelberg: Heidelberger Orientverlag, 1991. 408 p. PJ3785 .B73 1991.

Akkadian—Iraq—Cylinder Seals

A4.59. *Beschriftete mesopotamische Siegel der Frühdynastischen und der Akkad-Zeit* / Karin Rohn. Fribourg: Academic Press; Göttingen: Vandenhoeck & Ruprecht, 2011. 385, 66 p. CD5344.R64 2011.

Akkadian—Iraq—Haradum

A4.60. *Haradum II: les textes de la période paléobabylonienne, Samsu-iluna, Ammi-saduqa* / Francis Joannnès. Paris: Éditions recherche sur les civilisations, 2006. 190 p. DS70.5.H24 J63 2006.

Akkadian—Syria—Ras Ibn Hani

A4.61. *Word-list of the cuneiform alphabetic texts from Ugarit, Ras Ibn Hani and other places* / Manfried Dietrich and Oswald Loretz. 2 ed. Münster: Ugarit-Verlag, 1996. 232 p. PJ4150.Z77 K42 1996.

Akkadian—Syria—Ugarit

A4.62. *Corpus dei testi urartei* / Mirjo Salvini. Roma: CNR; Istituto di studi sulle civiltà dell'Egeo e del Vicino Oriente, 2008– . 3 v. P959 .S25 2008.

A4.63. *Sources for Ugaritic ritual and sacrifice* / David M. Clemens. Münster: Ugarit-Verlag, 2001. BL1640 .C54 2001.

A4.64. *Word-list of the cuneiform alphabetic texts from Ugarit, Ras Ibn Hani and other places* / Manfried Dietrich and Oswald Loretz. 2 ed. Münster: Ugarit-Verlag, 1996. 232 p. PJ4150.Z77 K42 1996.

Ammonite

A4.65. *A corpus of Ammonite inscriptions* / Walter E. Aufrecht. Lewiston: Edwin Mellen Press, 1989. 516 p. PJ4143.Z77 A9 1989.

Arabian Peninsula

A4.66. *Ancient records from North Arabia* / F. V. Winnett and W. L. Reed. Toronto: University of Toronto Press, 1970. 243 p. PJ6690.W47 1970; PJ6690.W47.

A4.67. *Handbuch der altarabischen Altertumskunde in Verbindung mit Fr. Hommel und Nik. Rhodokanakis* / Ditlef Nielsen. Kopenhagen: A. Busck, 1927. 272 p. DS211.N5 1927.

A4.68. *Epigraphische Denkmäler aus Arabien: Nach Abklatschen und Copieen des Herrn Professor Dr. Julius Euting in Strassburg* / D. H. Müller. Wien: Akademie der Wissenschaften, 1889. 92, 12 p. PJ7692.G1 M85 1889.

A4.69. *Documents épigraphiques recueillis dans le nord de l'Arabie* / Charles Doughty. Paris: Imprimerie nationale, 1884. 63, lvii p. CN1157.A7 D6 1884.

A4.70. *Süd-arabische chrestomathie. Minao-sabaische grammatik.—Bibliographie.—Minuische inschriften nebst glossar* / Fritz Hommel. München: G. Franz, 1893. 136 p. PJ6951.H7 1893.

A4.71. *Die Südarabischen Altertümer (Eduard Glaser Sammlung) des Wiener Hofmuseums: und ihr Herausgeber Professor David Heinrich Müller* / Fritz Hommel. München: G. Franz, 1899. 39 p. DS211.G53 H66 1899.

Arabic (Cufic)

A4.72. *Arabic lapidary Kufic in Africa, Egypt, North Africa, Sudan; a study of the development of the Kufic Script (3rd–6th century A.H./9th–12th century A.D.)* / Aida S. Arif. London: Luzac, 1967. 117, 36 p. Z115.1.A75.

Aramaic

A4.73. *Die alt- und reichsaramäischen Inschriften; The old and imperial Aramaic inscriptions* / Dirk Schwiderski. Berlin; New York: De Gruyter, 2004– . PJ5208.A5 A48 2004.

A4.74. *Aramaic inscriptions and documents of the Roman period* / John F. Healey. Oxford; New York: Oxford University Press, 2009. 369 p. PJ5208.A5 H43 2009.

A4.75. *Aramaic law and religion between Petra and Edessa: studies in Aramaic epigraphy on the Roman frontier* / John Healey. Burlington: Farnham, Surrey: Ashagate / Variorum, 2011. PJ5208.A5 H43 2011.

A4.76 *Die aramaischen Inschriften aus Assur, Hatra und dem übrigen Ostmesopotamien: (datiert 44 v. Chr. bis 238 n. Chr.)* / Klaus Beyer. Göttingen: Vandenhoeck & Ruprecht, 1998. 191 p. PJ5208. B48 1998.

A4.77. *A corpus of magic bowls: incantation texts in Jewish Aramaic from late antiquity* / Dan Levene. London; New York: Kegan Paul, 2003. 233 p. PJ5208.A2 L48 2003. PJ5208.A2 L48 2003.

A4.78. *Kanaanäische und aramäische Inschriften* / H. Donner and W. Röllig. Wiesbaden: Harrassowitz, 1962. 3 v. PJ3081 .D66 1962.

A4.79. *Nouvelles inscriptions araméennes d'Idumée* / A. Lemaire. Paris: Gabalda, 1996. 2 v. PJ5208 .A5 L463 1996.

Aramaic—Afghanistan

A4.80. *A bilingual Graeco-Aramaic edict by Aśoka, the first Greek inscription discovered in Afghanistan* / G. Pugliese Carratelli and G. Garbini. Roma: Istituto Italiano per il Medio ed Estermo Oriente, 1964. 62 p. PK1480.A74 1964.

Aramaic—Dictionaries

A4.81. *Lessico dei logogrammi aramaici in medio-persiano* / Mario Nordio. Venezia: La Tipografica, 1980. 63 p. PJ5205.N67 1980.

Aramaic—Egypt—Elephantine

A4.82. *La collection Clermont-Ganneau: ostraca, épigraphes sur jarre, étiquettes de bois* / Hélène Lozachmeur. Paris: Diffusion de Boccard, 2006. 2 v. PJ5208.E4 2006.

Aramaic—Grammar

A4.83. *Le nabatéen* / J. Cantineau. Paris: irie Ernest Leroux, 1930–1932. 2 v. PJ5239 .C35 1930.

Aramaic—Indexes

A4.84. *A synoptic concordance of Aramaic inscriptions (according to H. Donner & W. Roellig)* / Walter

E. Aufrecht. Missoula: Scholars Press, 1975. 158 p. PJ3081.D633 A8; PJ3081.D633 A8.

Aramaic—Indexes, Reverse

A4.85. *Retrograde Hebrew and Aramaic dictionary* / Ruth Sander and Kerstin Mayerhofer. Göttingen: Vandenhoeck & Ruprecht, 2010. 258 p. PJ4825 .S36 2010.

Aramaic—Iran

A4.86. *Les inscriptions de la Perse achéménide / traduit du vieux perse, de l'élamite, du babylonien et de l'araméen* / Pierre Lecoq. Paris: Gallimard, 1997. 327, 16 p. PK6128.A1 L43 1997.

Aramaic—Iraq

A4.87. *Amulets and magic bowls: Aramaic incantations of late antiquity* / Joseph Naveh and Shaul Shaked. 2 ed. Jerusalem: Magnes Press, Hebrew University, 1987. 300, 40 p. BM729.A4 N38 1987.

Aramaic—Iraq—Babylon

A4.88. *Aramaic and figural stamp impressions on bricks of the sixth century B.C. from Babylon* / Benjamin Sass and Joachim Marzahn. Wiesbaden: Harrassowitz, 2010. 259 p. PJ5208.B3 S388 2010; PJ5208.B3 S388 2010.

Aramaic—Iraq—Hadr

A4.89. *La cronologia di Hatra: interazione di archeologia e di epigrafia* / Roberto Bertolino. Napoli: Istituto universitario orientale, 1995. 76 p. DS70.5.H3 B47 1995.

A4.90. *Hatra* / Francesco Vattioni. Napoli: Istituto universitario orientale, 1994. 126 p. DS70.5.H3 V388 1994.

A4.91. *Inventaire des inscriptions Hatréennes* / Basile Aggoula. Paris: irie Orientaliste Paul Geuthner, 1991. 195, 36 p. PJ5208 .H3 A37 1991.

A4.92. *Le iscrizioni di Ḥatra* / Francesco Vattioni. Napoli: Istituto orientale di Napoli, 1981. 119 p. PJ5208.H3 1981.

A4.93. *Manuel d'épigraphie hatréenne* / Roberto Bertolino. Paris: Geuthner, 2008. 97 p. PJ5208 .H34 B47 2008.

A4.94. *Die Personennamen der Inschriften aus Hatra* / Sabri Abbadi. Hildesheim; New York: Olms, 1983. 217 p. PJ5208.H37 A22 1983; CS3050.A7 A23 1983.

Aramaic—Israel and the Palestinian Territories—'Arad

A4.95. *Arad inscriptions* / Yohanan Aharoni. Jerusalem: Israel Exploration Society, 1981. 200 p. PJ5034.8 .I8 A313 1981.

A4.96. *Ketovot 'arad/* Yohanan Aharoni. Yerushalayim, Mosad Byalik, 1975. 5, 221 p. PJ5034.I8 A3.

Aramaic—Israel and the Palestinian Territories—Dan

A4.97. *The Dan debate: the Tel Dan inscription in recent research* / Hallvard Hagelia. Sheffield: Sheffield Phoenix Press, 2009. 161 p. BS635.3.H34 2009.

Aramaic—Israel and the Palestinian Territories—Mount Gerizim

A4.98. *Aramaic and Hebrew inscriptions from Mt. Gerizim and Samaria between Antiochus III and Antiochus IV Epiphanes* / Jan Dusek. Leiden; Boston: Brill, 2012. 200 p. PJ5208.A5 D87 2012.

Aramaic—Israel and the Palestinian Territories—Palestine

A4.99. *Inscriptions of Israel/Palestine.* Providence: Scholarly Technology Group, Brown University. http://cds.library.brown.edu/projects/Inscriptions/.

Aramaic—Jordan—As Samra

A4.100. *Fouilles de Khirbet es-Samra en Jordanie* / Jean-Baptiste Humbert and Alain Desreumaux. Turnhout: Brepols, 1998. DS154.9.A76 F685 1998.

Aramaic—Jordan—Dayr Alla

A4.101. *Aramaic texts from Deir Alla* / J. Hoftijzer and G. van der Kooij. Leiden: E. J. Brill, 1976. 323, 19 p. PJ5208.D33 H6 1976; PJ5208.D33 A7.

A4.102. *The Balaam text from Deir Alla* / Jo Ann Hackett. Chico: Scholars Press, 1984. 147 p. PJ5208.D33 H32 1984; PJ5208.J63 H32 1984.

A4.103. *In pursuit of meaning: collected studies of Baruch A. Levine* / Andrew D. Gross. Winona Lake: Eisenbrauns, 2011. 2 v. BS1171.3 .L48 2011.

Aramaic—Middle East

A4.104. *Life and loyalty: a study in the socio-religious culture of Syria and Mesopotamia in the Graeco-Roman period based on epigraphical evidence* / Klaas Dijkstra. Leiden; New York: E. J. Brill, 1995. BL1600 .D54 1995; BL1600 .D54 1995.

Aramaic—Dead Sea Scrolls

A4.105. *Die aramäischen Texte vom Toten Meer. Ergänzungsband: samt den Inschriften aus Palästina, dem Testament Levis aus der Kairoer Genisa, der Fastenrolle und den alten talmudischen Zitaten* / Klaus Beyer. Göttingen: Vandenhoeck & Ruprecht, 1984. 779 p. PJ5201 .B49 1984; BM175. Q6 B57 1984. Superseded by: *Die aramäischen Texte vom Toten Meer. Ergänzungsband: samt den Inschriften aus Palästina, dem Testament Levis aus der Kairoer Genisa, der Fastenrolle und den alten talmudischen Zitaten* / Klaus Beyer. Göttingen: Vandenhoeck & Ruprecht, 1994. 450 p. PJ5201 .B49 1994 Suppl.

Aramaic—Saudi Arabia

A4.106. *Aramaic and Nabataean inscriptions from northwest Saudi Arabia* / Solaiman Abdal-Rahman al-Theeb. Riyadh: King Fahd National Library, 1993. 352 p. PJ5208.S33 D48 1993.

Aramaic—Syria—Palmyra

A4.107. *Sculptures et inscriptions de Palmyre à la Glyptothèque de Ny Carlsberg* / D. Simonsen. Copenhague: T. Lind, 1889. 63 p. 708.8 C793.4.FS.

Aramaic—Syria—Tell Halaf

A4.108. *Die Inschriften vom Tell Halaf: Keilschrifttexte und aramäische Urkunden aus einer assyrischen Provinzhauptstadt* / Johannes Friedrich, G. Rudolf Meyer, Arthur Ungnad, and Ernst F. Weidner. Berlin: Im Selbstverlage des Herausgebers, 1940. 84 p. PJ5208.T4 1940a; 892.3 In78; PJ5208.T4.

Aramaic—Syria—Safirah

A4.109. *The Aramaic inscriptions of Sefire* / Joseph A. Fitzmyer. rev. ed. Roma: Editrice Pontificio Istituto Biblico, 1995. 249, 19 p. PJ5208.S43 F5 1995.

A4.110. *Les inscriptions araméennes de Sfiré et l'Assyrie de Shamshi-ilu* / André Lemaire and Jean-Marie Durand. Genève; Paris: irie Droz, 1984. 150 p. PJ5208.S43 L45 1984.

A4.111. *Les inscriptions araméennes de Sfiré, stèles I et II* / André Dupont-Sommer. Paris: Impr. nationale, 1958. 151, 29 p. PJ5208.S43 D8 1958.

Aramaic—Syria—Tadmur

A4.112. *Choix d'inscriptions de Palmyre* / J. B. Chabot. Paris: Imprimerie nationale, 1922. 147 p. 913.3943 C342; PJ5229 .C5 1922.

A4.113. *From Palmyra to Zayton: epigraphy and iconography* / Iain Gardner, Samuel Lieu, and Ken Parry. Turnhout: Brepol; NSW Australia: Ancient History Documentary Research Centre, Macquarie University, 2005.278, 26 p. CN1191. T33 F76 2005.

A4.114. *Inventaire des inscriptions de Palmyre* / J. Cantineau. Beyrouth: Impr. catholique, 1930. PJ5229 .A1 1930, n.1.

A4.115. *Les notables de Palmyre* / Jean-Baptiste Yon. Beyrouth: Institut français d'archéologie du Proche-Orient, 2002. 378, 11 p. DS99.P17 Y66 2002.

A4.116. *Palmyrenisches* / J. Mordtmann. Berlin: W. Peiser. 1899. 50 p. DS41 .V8 v.4.

A4.117. *Palmyrenische Inschriften* / Moritz Sobernheim. Berlin: Wolf Peiser, 1905. 57 p. CN1191.P34 S62 1905; DS41 .V8 v.10.

A4.118. *Palmyrenische inschriften: nach abklatschen des herrn dr. Alois Musil* / David H. Müller. Wien: C. Gerold's sohn, 1898. 28 p. PJ5229 .M95 1898.

A4.119. *The ruins of Palmyra: otherwise Tedmor, in the desart* / Robert Wood. Westmead: Gregg International Publishers, 1971. 50, 60 p. NA335. P2 W8 1971. Supersedes: *The ruins of Palmyra, otherwise Tedmor, in the desart* / Robert Wood. London, 1753. 50, 57 p. NA335.P2 W8 1753.

A4.120. *Skulpturer og indskrifter fra Palmyra i Ny Carlsberg glyptothek* / D. Simonsen. Kjøbenhavn: Th. Linds boghandel, 1889. 59, 26 p. 708.8 C793.4.

A4.121. *Die Sprache der palmyrenischen Inschriften und ihre Stellung innerhalb des aramäischen* / Franz Rosenthal. Leipzig: J. C. Hinrichs, 1936. 114 p. DS41 .V8 Bd.41 Hft.1 1936.

Aramaic—Turkey—Zincirli (Gaziantep Ili)

A4.122. *Die Inschriften von Zincirli neue Edition und vergleichende Grammatik des Phönizischen, sama lischen und aramäischen Textkorpus* / Josef Tropper. Münster: Ugarit-Verlag, 1993. 350 p. PJ5208.Z56 T76 1993.

Armenian—Egypt—Sinai

A4.123. *Armenian inscriptions from Sinai: intermediate report with notes on Georgian and Nabatean inscriptions* / Michael E. Stone. Sydney: Maitland Publications, 1979. 21 p. CN1311.S56 A74 1979.

Assyrian

A4.124. *Aramaic epigraphs on clay tablets of the New-Assyrian period* / Frederick Mario Fales. Roma: Università degli studi "La sapienza," 1986. 287 p. DS16 .R6 n.s.2.

A4.125. *Assyrian primer, an inductive method of learning the cuneiform characters* / John D. Prince. New York: AMS Press, 1966 [1909]. 58 p. PJ3251 .P8 1966.

A4.126. *Assyrian royal inscriptions* / Albert K. Grayson. Wiesbaden: O. Harrassowitz, 1972–1976. 2 v. PJ3815 .G7.

A4.127. *Assyrian manual, for the use of beginners in the study of the Assyrian language* / D. G. Lyon. Chicago: American Publication Society of Hebrew, 1886. 138 p. PJ3181 .L98 1886.

A4.128. *Aspects of old Assyrian trade and its terminology* / K. R. Veenhof. Leiden: E. J. Brill, 1972. 487 p. HF368 .V4 1972.

A4.129. *Assyrian and Babylonian chronicles* / A. K. Grayson. Locust Valley: J. J. Augustin, 1975, 1970. 300 p. PJ3845 .G7 1975.

A4.130. *Assyrian and Babylonian contracts, with Aramaic reference notes* / James Henry Stevenson. New York; Cincinnati: American Book Company, 1902. 208 p. PJ3875 .S7 1902.

A4.131. *Assyrian and Babylonian literature; selected translations* / Robert Francis Harper. New York: D. Appleton, 1904 [1900]. 462 p. 892.3C As75 1904.

A4.132. *Assyrian and Babylonian religious texts; being prayers, oracles, hymns, and copied from the original tablets* / James A. Craig. Leipzig: J. C. Hinrichs, 1895–1897. 2 v. PJ3785 .C8 1895 v.1.

A4.133. *Assyrian and Hebrew hymns of praise* / Charles G. Cumming. New York: Columbia University Press, 1934. 176 p. BS1430 .C8 1934.

A4.134. *Assyrian eponym canon; containing translations of the documents, and an account of the evidence, on the comparative chronology of the Assyrian and Jewish kingdoms, from the death of Solomon to Nebuchadnezzar* / George Smith. London: S. Bagster and Sons, 1875. 206 p. CE33 .S658 1875.

A4.135. *Assyrian language; easy lessons in the cuneiform inscriptions* / L. W. King. New York: AMS Press, 1976. 216 p. PJ3193 .K5 1976.

A4.136. *Assyrian laws* / G. R. Driver and John C. Miles. Oxford: Clarendon Press, 1935. 534 p. CL110 D833; PJ3879 .D74.

A4.137. *Assyrian personal names* / Knut L. Tallqvist. Helsingfors, 1914. 327 p. PJ3545 .T33.

A4.138. *Assyrian rulers of the early first millennium BC I (1114–859 BC)* / A. Kirk Grayson. Toronto; Buffalo: University of Toronto Press, 1991– . v.1–2 + microfiche. PJ3815 .G7392 1991.

A4.139. *Assyrian texts, being extracts from the annals of Shalmaneser II., Sennacherib, and Assur-bani-pal* / Ernest A. Budge. London: Trübner, 1880. 44 p. PJ3259 .B8.

A4.140. *Babylonian and Assyrian laws, contracts and letters* / C. H. W. Johns. New York: C. Scribner's Sons, 1904. 424 p. DS75.L4 J7 1904; 892.3 J623.2.

A4.141. *Babylonian and Assyrian literature; comprising the epic of Izdubar, hymns, tablets, and cuneiform inscriptions* / Epiphanius Wilson. rev. ed. New York: Colonial Press, 1901. 309 p. PJ3751 .B3 1901; 892.3C W695.

A4.142. *Babylonian-Assyrian birth-omens, and their cultural significance* / Morris Jastrow. Giessen: A. Topelmann, 1914. 80 p. BL25 .J37 1914.

A4.143. *Babylonske og assyriske arkiver og biblioteker* / Mogens Weitemeyer. Kobenhavn: Branner og Korchs forlag, 1955. 103 p. 913.351 W438.

A4.144. *Eponyms of the Assyrian Empire, 910–612 B.C.* / Alan Millard. Helsinki: Neo-Assyrian Text Corpus Project, 1994. 153 p. PJ3545 .M55 1994.

A4.145. *Fifty Neo-Assyrian legal documents* / J. N. Postgate. Warminster: Aris and Phillips, 1976. 221 p. PJ3879 .F5.

A4.146. *Fruhdynastische Beterstatuetten* / Eva Andrea Braun-Holzinger. Berlin: Mann, 1977. 92 p. DS67 .D425 Nr.19.

A4.147. *Neo-Assyrian treaties and loyalty oaths* / Simo Parpola and Kazuko Watanabe. Helsinki: Helsinki University Press, 1988. 123 p. + 1 microfiche. PJ3861 .N46 1988.

A4.148. *Neo-Assyrian toponyms* / Simo Parpola. Kevelaer: Butzon and Bercker, 1970. 408 p. DS67.8 .P35.

A4.149. *Oath in Babylonian and Assyrian literature* / Samuel Alfred B. Mercer. Paris: P. Geuthner, 1912. 120 p. 892.3 M542.

A4.150. *Old Assyrian letters and business documents* / Ferris J. Stephens. New Haven: Yale University Press; London: H. Milford, Oxford University Press, 1944. 30 p. 892.3 Y14.3 v.6; PJ3719 .N5 v.6.

A4.151. *Old Assyrian laws* / Knut Tallqvist. Helsingfors: Helsingfors Centraltryckeri, 1921. 41 p. PJ3870 .T33.

A4.152. *Pennsylvania Old Assyrian texts* / W. C. Gwaltney. Cincinnati: Hebrew Union College-Jewish Institute of Religion, 1983. 160 p. PJ3879 .G82 1983.

A4.153. *References to prophecy in Neo-Assyrian sources* / Martti Nissinen. Helsinki: Neo-Assyrian Corpus Project, University of Helsinki, 1998. 194 p. PJ3835 .N57 1998.

A4.154. *Royal correspondence of the Assyrian empire / Leroy Waterman.* Ann Arbor, University of Michigan Press, 1930–1936. 4 v. PJ/3889/W3/ pt.1-4; PJ3889 .W3.

A4.155. *Semitic perfect in Assyria / J. F. McCurdy.* Leiden: E. J. Brill, 1884. 28 p. 492.328 M139.

A4.156. *Der sogenannte bauernkalender von Gezer / Johannes Lindblom.* Åbo: Åbo akademi, 1931. 25 p. 68 Ab78 v.7 no.5.

A4.157. *Studies on the Assyrian ritual and series bit rimki / Jørgen Læssøe.* København: E. Munksgaard, 1955. 112 p. PJ3941.R4 L33.

A4.158. *Taxation and conscription in the Assyrian empire / J. N. Postgate.* Rome: Biblical Institute Press, 1974. 441 p. PJ3861 .P6.

A4.159. *Textes syriens de l'age du Bronze récent / Daniel Arnaud.* Sabadell, Barcelona: AUSA, 1991. 220 p. PJ3197 .A757 1991g.

A4.160. *Untersuchungen zur Assyriologie und vorderasiatischen Archäologie.* Berlin: De Gruyter, 1960– . 913.35 Un83, Bd.4.

A4.161. *Use of numbers and quantifications in the Assyrian royal inscriptions / Marco de Odorico.* Helsinki: University of Helsinki, Neo-Assyrian Text Corpus Project, 1995. 206 p. PJ3835 .D4 1995.

Assyrian—Bibliothèque Nationale, Département des Médailles et Antiques, Paris

A4.162. *Catalogue des cylindres orientaux et des cachets assyro-babyloniens, perses et syro-cappadociens de la Bibliothéque nationale / Louis Delaporte.* Paris: E. Leroux, 1910. 384 p. 913.35 D372.

Assyrian—British Museum, London

A4.163. *Assyrian and Babylonian religious texts; being prayers, oracles, hymns andc., copied from the original tablets preserved in the British Museum / James A. Craig.* Leipzig: Zentralantiquariat der Deutschen Demokratischen Republik, 1974. 2 v. in 1. PJ3785 .C8 1974.

A4.164. *Assyrian doomsday book; or Liber censualis of the district round Harran; in the seventh century B.C. Copied from the cuneiform tablets in the British Museum / C. H. W. Johns.* Leipzig: J. C. Hinrichs, 1901. 82 p. PJ3861 .J6 1901.

A4.165. *Assyrian medical texts from the originals in the British Museum / R. Campbell Thompson.* London: H. Milford, Oxford University Press, 1923. 107 p. PJ3921.M5 T5. Reprint: *Assyrian medical texts from the originals in the British Museum / R. Campbell Thompson.* New York: AMS Press, 1982. 107 p. R127.5 .A87 1982.

A4.166. *Assyrian sculpture / Julian Reade.* Cambridge: Harvard University Press, 1983. 72 p. NB80 .B772 1983.

A4.167. *Assyrian sculpture in the British Museum / R. D. Barnett.* Toronto: McClelland and Stewart, 1975. 39, 179 p. NB80 .B3185.

A4.168. *Assyrian sculptures / C. J. Gadd.* London: Printed by order of the Trustees, 1934. 77 p. NB80 .B67 1934.

A4.169. *Dictionary of Assyrian botany / R. Campbell Thompson.* London: British Academy, 1949. 405 p. 580.9352 T375; Morris Arboretum PJ3547 .T4.

A4.170. *Guide to the Babylonian and Assyrian antiquities.* 3 ed. London: Printed by order of the Trustees, 1922. 286 p. 913.351 B117Br. Supersedes: *Guide to the Babylonian and Assyrian antiquities,* British Museum / E. A. Wallis Budge and L. W. King. 2 ed. London: Printed by the order of the Trustees, 1908. 275 p. 913.351 B117Br.

A4.171. *Guide to the Nimroud central salon.* London: Printed by order of the Trustees, 1886. 1 l., 128 p. 913.351 B117Br.2.

A4.172. *Ur III administrative tablets from the British Museum / Tohru Ozaki and Marcel Sigrist.* Madrid: Consejo Superior de Investigaciones Científicas, 2006. 2 v. PJ3711.B78 O935 2006.

Assyrian—British Museum—Department of Egyptian and Assyrian Antiquities

A4.173. *Assyrian sculptures / C. J. Gadd.* London: Printed by order of the Trustees, 1934. 77 p. NB80 .B67.

A4.174. *Guide to the Babylonian and Assyrian antiquities.* 3 ed. rev. and enl. London: Printed by the order of the Trustees, 1922. 286 p. DS69.L6 B7 1922.

Assyrian—British Museum—Department of Western Asiatic Antiquities—Kouyunjik Collection

A4.175. *Assyrian and Babylonian letters belonging to the Kouyunjik collections of the British museum, part I–XIV.* Chicago: University of Chicago Press, 1892–1914. 14 v. 892.3 B77, 14 v.; PJ3881 .H4 1977, pt.1–14.

A4.176. *Assyrian deeds and documents recording the transfer of property, including the so-called private contracts, legal decisions and proclamations preserved in the Kouyunjik Collections of the British Museum, chiefly of the 7th century B. C. / C. H. W. Johns.* Cambridge: Deighton, Bell; London: G. Bell and Sons, 1898–1923. 4 v. PJ3875 .J6 1924; PJ3875 .J6 1924a.

A4.177. *Bibliography of the cuneiform tablets of the Kuyunjik collection in the British Museum* / Erle Leichty. London: Trustees of the British Museum, 1964. 289 p. Z7055 .B7.

A4.178. *Catalogue of the cuneiform tablets in the Kouyunjik collection of the British Museum* / C. Bezold. London: Printed by order of the Trustees, 1889–1899. 5 v. PJ3711 .B7 1889. Supplemented by *Catalogue of the cuneiform tablets in the Kouyunjik collection of the British Museum; second supplement* / W. G. Lambert and A. R. Millard. London: Trustees of the British Museum, 1968. 98 p. PJ3711 .B7 Suppl .2.

A4.179. *Neo-Assyrian legal documents in the Kouyunjik Collection of the British Museum* / Theodore Kasman. Roma: Editrice Pontificio Istituto Biblico, 1988. 524 p. PJ3879 .B75 1988.

A4.180. *Neo-Assyrian treaties and loyalty oaths* / Simo Parpola and Kazuko Watanabe. Helsinki, Finland: Helsinki University Press, 1988. 123, 10 p. + microfiche. DS73.2 .N46 1988.

Assyrian—Dictionary

A4.181. *Assyrian dictionary* / Ignace J. Gelb. Chicago, 1964– . PJ3525 .C5, v.1(1–2), v.2–9, v.10(1–2), v.11(1–2), v.12–16, v.17(1–3), v.18, 21; PJ3525 .C5, v.1(1), v.2–9, v.10(1–2), v.11(1–2), v.12–16, v.17(1–3), v.18, 21; PJ3525 .C5, v.1(1), v.2–9, v.10(1–2), v.11(1–2), v.12–16, v.17(1–3), v.18, 21; PJ3525 .C5, v.1(1–2), v.2–9, v.10(1–2), v.11(1–2), v.12–16, v.17(1–3), v.18, v.19, v.21. See also *Adventure of great dimension; the launching of the Chicago Assyrian dictionary* / Erica Reiner. Transactions of the American Philosophical Society, 92(3). Philadelphia: American Philosophical Society, 2002. 140 p. Q11 .P6 v.92 pt.3.

A4.182. *Assyrian dictionary; intended to further the study of the cuneiform inscription of Assyria and Babylonia* / Edwin Norris. London: Williams and Northgate, 1868–1872. 3 v. PJ3525 .N67 1868 v.1–3; 492.33 N794.

A4.183. *Concise dictionary of the Assyrian language* / W. Muss-Arnolt. Berlin: Reuther and Reichard; New York: Lemcke and Büchner, 1905. 2 v. PJ3523 .M8 1905.

A4.184. *Dictionary from the Egyptian, Assyrian, and Etruscan monuments and papyri biographical, historical, and mythological* / W. R. Cooper. London: S. Bagster, 1882. 668 p. DS61 .C65 1882.

A4.185. *Dictionary of Assyrian chemistry and geology* / R. Campbell Thompson. Oxford: Clarendon Press, 1936. 266 p. 509.352 T375; Q127.A7 T5; PJ3547 .T42.

A4.186. *Oraham's Dictionary of the stabilized and enriched Assyrian language and English* / Alexander J. Oraham. Chicago: Consolidated Press. Assyrian Press of America, 1943. 576 p. PJ5491 .O7 1943.

Assyrian—Grammar

A4.187. *Assyrian grammar with paradigms, exercises, glossary, and bibliography* / Friedrich Delitzsch. Berlin: H. Reuther; New York: B. Westermann, 1889. 366, 80 p. 492.35 D323.EK.

A4.188. *Outline of Assyrian grammar, with a short sign-list, a list of late Babylonian forms of characters, and autographic reproductions of texts* / Theophilus G. Pinches. London: H. J. Glaisher, 1910. 64 p. 492.35 P653.

Assyrian—Iraq—Ashur

A4.189. *Assyrian origins; discoveries at Ashur on the Tigris; antiquities in the Vorderasiatisches Museum, Berlin* / Prudence O. Harper. New York: Metropolitan Museum of Art, 1995. 142 p. DS70.5.A7 V67 1995.

Assyrian—Iraq—Nineveh

A4.190. *Collations to neo-Assyrian legal texts from Nineveh* / Simo Parpola. Malibu: Undena Publications, 1979. 89 p. PJ3879 .P37 1979.

Assyrian—Iraq—Nimrud

A4.191. *Ivories in Assyrian style; commentary, catalogue and plates* / Max Mallowan and Leri Glynne Davies. London: British School of Archaeology in Iraq, 1970. 60, 46 p. NK5973.6.I7 I9 fasc.2.

Assyrian—Israel and the Palestinian Territories

A4.192. *Der sogenannte bauernkalender von Gezer* / Joh. Lindblom. Abo: Abo akademi, 1931. 25 p. 68 Ab78 v.7 no.5.

Assyrian—Musée d'Art et d'Histoire, Geneva

A4.193. *Assyrian documents in the Musée d'art et d'histoire, Geneva* / J. N. Postgate. Malibu: Undena Publications, 1979. 15 p. PJ3711.G46 P67 1979.

Assyrian—Musees Royaux d'Art et d'Histoire, Brussells

A4.194. *Recueil des inscriptions de l'Asie Antérieure de Musées Royaux du Cinquantenaire à Bruxelles; texte sumériens, babyloniens et assyriens* / Louis Speleers. Bruxelles: Vanderpoorten, 1925. 134 p. PJ3711.B78 R44 1925a.

Assyrian—New York Public Library

A4.195. *Assyria and Babylonia, a list of references in the New York Public Library* / Ida A. Pratt. New York, 1918. 143 p. Z3040 .N52 1918.

Assyrian—Syria—Saddikanni

A4.196. *Neo-Assyrian sculptures from Saddikanni (Tell Ajaja)* / Asad Mahmoud. Malibu: Undena Publications, 1983. 4 p. DS99.S22 M33 1983.

Assyrian—Turkey—Ashur

A4.197. *Assyrian rulers of the third and second millennia BC (to 1115 BC)* / A. Kirk Grayson. Toronto; Buffalo: University of Toronto Press, 1987. 355 p. PJ3815 .G73 1987.

A4.198. *Mittelassyrische Rechtsurkunden und Verwaltungstexte* / Helmut Freydank. Berlin: Akademie-Verlag, 1976–2011. 10 v. Akkadian cuneiform texts from the site of Ashur. PJ3879 .V67 1976.

A4.199. *Royal inscriptions on clay cones from Ashur now in Istanbul* / Veysel Donbaz and A. Kirk Grayson. Toronto; Buffalo: University of Toronto Press, 1984. 79, 42 p. PJ3721.A69 D66 1984.

Assyrian—University of Pennsylvania, University Museum of Archaeology and Anthropology, Philadelphia

A4.200. *Legal and commercial transactions dated in the Assyrian, Neo-Babylonian and Persian periods . . . chiefly from Nippur* / Albert T. Clay. Philadelphia: Department of Archaeology, University of Pennsylvania, 1908. 85 p. 378.748 PZAM.2 Ser.A v.8 pt.1.

Assyrian—Vorderasiatisches Museum (Staatliche Museen zu Berlin), Berlin

A4.201. *Altassyrische Tontafeln aus Kültepe; Texte und Siegelabrollungen* / Klaas R. Veenhof and Evelyn Klengel-Brandt. Berlin: Gebr. Mann, 1992. 60, 51 p. PJ3721.K36 V436 1992.

Babylonian

A4.202. *Abridged grammars of the languages of the cuneiform inscriptions, containing: I. A Sumero-Akkadian grammar. II. An Assyro-Babylonian grammar. III. A Vannic grammar. IV. A Medic grammar. V. An Old Persian grammar* / George Bertin. London: Trübner & co., 1888. 117 p. PJ4013 .B4 1888.

A4.203. *Assyrian and Babylonian chronicles* / A. K. Grayson. Locust Valley: J. J. Augustin, 1975, 1970. 300 p. PJ3845 .G7 1975.

A4.204. *Assyrian and Babylonian contracts, with Aramaic reference notes* / James Henry Stevenson. New York; Cincinnati: American Book Company, 1902. 208 p. Center for Advanced Judaic Studies PJ3875 .S7 1902; PJ3875 .S7 1902a.

A4.205. *Assyrian and Babylonian literature; selected translations* / Robert Francis Harper. New York: D. Appleton, 1904 [1900]. 462 p. 892.3C As75 1904.

A4.206. *Assyrian and Babylonian religious texts; being prayers, oracles, hymns, and copied from the original tablets* / James A. Craig. Leipzig: J. C. Hinrichs, 1895–1897. 2 v. PJ3785 .C8 1895 v.1.

A4.207. *Babylonia Judaica in the Talmudic Period* / Aharon Oppenheimer. Wiesbaden: L. Reichert, 1983. 548 p. BM509.G4 O66 1983.

A4.208. *Babylonian and Assyrian laws, contracts and letters* / C. H. W. Johns. New York: C. Scribner's Sons, 1904. 424 p. DS75.L4 J7 1904; 892.3 J623.2.

A4.209. *Babylonian and Assyrian literature; comprising the epic of Izdubar, hymns, tablets, and cuneiform inscriptions* / Epiphanius Wilson. rev. ed. New York: Colonial Press, 1901. 309 p. PJ3751 .B3 1901; 892.3C W695.

A4.210. *Babylonian-Assyrian birth-omens, and their cultural significance* / Morris Jastrow. Giessen: A.Topelmann, 1914. 80 p. BL25 .J37 1914.

A4.211. *Babylonske og assyriske arkiver og biblioteker* / Mogens Weitemeyer. Kobenhavn: Branner og Korchs forlag, 1955. 103 p. 913.351 W438.

A4.212. *Inscriptions de la Perse achéménide / traduit du vieux perse, de l'élamite, du babylonien et de l'araméen* / Pierre Lecoq. Paris: Gallimard, 1997. 327 p. PK6128.A1 L43 1997.

A4.213. *Neo-Babylonian legal and administrative documents: typology, contents, and archives* / Michael Jursa. Münster: Ugarit-Verlag, 2005. 189 p. KL2210 .J87 2005.

A4.214. *Oath in Babylonian and Assyrian literature* / Samuel Alfred B. Mercer. Paris: P. Geuthner, 1912. 120 p.892.3 M542.

Babylonian—Bibliothèque Nationale. Département des Médailles et Antiques, Paris

A4.215. *Catalogue des cylindres orientaux et des cachets assyro-babyloniens, perses et syro-cappadociens de la Bibliothéque nationale* / Louis Delaporte. Paris: E. Leroux, 1910. 384 p. Catalog of Assyrian and Babylonian seals. 913.35 D372.

Babylonian—British Museum, London

A4.216. *Guide to the Babylonian and Assyrian antiquities*. 3 ed. London: Printed by order of the Trustees, 1922. 286 p. 913.351 B117Br. Supersedes: *Guide to the Babylonian and Assyrian antiquities* / British Museum: E. A. Wallis Budge and L. W. King. 2 ed. London: Printed by the order of the Trustees, 1908. 275 p. 913.351 B117.

A4.217. *Neu babylonische Briefe; zwanzig Briefe in Cuneiform texts XXII. Teil 1* / Oswald Thompson Allis. Leipzig: Druck von A. Pries, 1913. 63 p. PJ3891 .A448 1913a.

A4.218. *Old Babylonian extispicy; omen texts in the British Museum* / Ulla Jeyes. Istanbul: Nederlands Historisch-Archaeologisch Instituut te Istanbul, 1989. 219 p. BF1762 .J49 1989.

Babylonian—Musee du Louvre, Paris

A4.219. *Altbabylonische Rechts- und Verwaltungsurkunden aus dem Musée du Louvre* / Daniel Arnaud. Berlin: D. Reimer, 1989. 18, 63 p. KL2211 .A8 1989.

Babylonian—Musees Royaux d'Art et d'Histoire, Brussells

A4.220. *Recueil des inscriptions de l'Asie Antérieure de Musées Royaux du Cinquantenaire à Bruxelles; texte sumériens, babyloniens et assyriens* / Louis Speleers. Bruxelles: Vanderpoorten, 1925. 134 p. PJ3711.B78 R44 1925a.

Babylonian—Iraq—Kish

A4.221. *Old Babylonian texts in the Ashmolean Museum; mainly from Larsa, Sippir, Kish, and Lagaba* / Stephanie Dalley. Oxford; Clarendon; New York: Oxford University Press, 2005. 69 p. PJ3711.O9 D36 2005.

Babylonian—Iraq—Lagaba

A4.222. *Old Babylonian texts in the Ashmolean Museum; mainly from Larsa, Sippir, Kish, and Lagaba* / Stephanie Dalley. Oxford; Clarendon; New York: Oxford University Press, 2005. 69 p. PJ3711.O9 D36 2005.

Babylonian—Iraq—Larsa

A4.223. *Old Babylonian texts in the Ashmolean Museum; mainly from Larsa, Sippir, Kish, and Lagaba* / Stephanie Dalley. Oxford; Clarendon; New York: Oxford University Press, 2005. 69 p. PJ3711.O9 D36 2005.

Babylonian—Iraq—Nippur

A4.224. *Nippur in late Assyrian times, c. 755-612 B.C.* / Steven W. Cole. Helsinki, Finland: University of Helsinki, Neo-Assyrian Text Corpus Project, 1996. 138 p. DS70.5.N56 C65 1996.

A4.225. *Old Babylonian inscriptions, chiefly from Nippur, pt. I and II* / H. V. Hilprecht. Philadelphia: University of Pennsylvania, Department of Archaeology and Palaeontology, 1896. 2 v. 892.3 H566.

A4.226. *Sumerian hymns and prayers to god Dumu-zi, or, Babylonian lenten songs: from the temple Library of Nippur* / Hugo Radau. München: s.n., 1913. 66 p. PJ3711 .P4 v.30 pt.1.

A4.227. *Tablettes mathematiques de la collection Hilprecht* / Christine Proust. Wiesbaden: Harrassowitz, 2008. 166 p. + CD-ROM. PJ4054.N5 P76 2008.

A4.228. *Tablettes mathematiques de Nippur* / Christine Proust. Istanbul: Institut français d'études anatoliennes Georges Dumézil, 2007. 356 p + CD-ROM. DS70.5 .N5 P76 2007.

Babylonian—Iraq—Sippur

A4.229. *Old Babylonian texts in the Ashmolean Museum; mainly from Larsa, Sippir, Kish, and Lagaba* / Stephanie Dalley. Oxford; Clarendon; New York: Oxford University Press, 2005. 69 p. PJ3711.O9 D36 2005.

Babylonian—Iraq—Telul Khattab

A4.230. *Old Babylonian cuneiform texts from the lower Diyala region; Telul Khattab* / Khalid Salim Ismäel. London: Nabu Publications, 2007. DS70.5.D57 I86 2007.

Babylonian—Israel and the Palestinian Territories

A4.231. *Der sogenannte bauernkalender von Gezer* / Joh. Lindblom. Abo: Abo akademi, 1931. 25 p. 68 Ab78 v.7 no.5.

Babylonian—New York Public Library

A4.232. *Assyria and Babylonia, a list of references in the New York Public Library* / Ida A. Pratt. New York, 1918. 143 p. Z3040 .N52 1918.

Babylonian—New York Public Library—Wilberforce Eames Collection

A4.233. *Catalogue of the cuneiform tablets of the Wilberforce Eames Babylonian collection in the New York Public Library, Tablets of the time of the third dynasty of Ur* / A. Leo Oppenheim. New Haven: American Oriental Society, 1948. 270 p. PJ4053.N4 O6.

Babylonian—University of Chicago—Oriental Institute

A4.234. *Late Babylonian texts of the Oriental Institute collection*/ David B. Weisberg. Malibu: Undena Publications, 1991. 87, 131 p. PJ3225 .W45 1991.

Babylonian—University of Pennsylvania, University Museum of Archaeology and Anthropology, Philadelphia

A4.235. *Legal and commercial transactions dated in the Assyrian, Neo-Babylonian and Persian periods . . . chiefly from Nippur* / Albert T. Clay. Philadelphia: Department of Archaeology, University of Pennsylvania, 1908. 85 p. 378.748 PZAM.2 Ser.A v.8 pt.1.

A4.236. *Old Babylonian legal and administrative texts from Philadelphia* / Karel van Lerberghe. Leuven: Department of Orientalistiek; Peeters, 1986. 55, 112 p. PJ3711 .P75 1986.

Bibliography

A4.237. *Guide de l'épigraphiste: bibliographie choisie des épigraphies antiques et médiévales* / François Bérard. 4 ed. Paris: Éditions Rue d'Ulm, 2010. 448 p. Z7018.I5 G85 2010. Supersedes: *Guide de l'épigraphiste: bibliographie choisie des épigraphies antiques et médiévales* / François Bérard. 3 ed. Paris: Editions Rue d'Ulm, 2000. 424 p. CN120.G85 2000; *Guide de l'épigraphiste: bibliographie choisie des épigraphies antiques et médiévales* / François Bérard. 2 ed. Paris: Presses de l'Ecole normale supérieure, 1989. 354 p. CN120.G85 1989.

Canaanite

A4.238. *Old Canaanite cuneiform texts of the third millennium* / Giovanni Pettinato. Malibu: Undena Publications, 1976. 17 p. DS99.E25 P47213.

A4.239. *Kanaanäische und aramäische Inschriften* / H. Donner and W. Röllig. Wiesbaden: Harrassowitz, 1962. 3 v. PJ3081 .D66 1962.

A4.240. *Kanaanäische Inschriften (Moabitisch, Althebräisch, Phönizisch, Punisch)* / Mark Lidzbarski. Giessen: A. Töpelmannn, 1907. 64 p. PJ4139 .L53.

Carian

A4.241. *Les hautes terres de Carie* / Pierre Debord and Ender Varınlıoglu. Pessac: Institut Ausonius, 2001. 329 p. DS156.C33 H398 2001.

A4.242. *Les inscriptions cariennes: histoire d'un étrange alphabet grec* / Jean Faucounau. Paris: Harmattan, 2009. 204 p. P946 .F393 2009.

Carian—Egypt

A4.243. *The Carian language* / Ignacio J. Adiego, with an appendix by Koray Konuk. Leiden; Boston: Brill, 2007. 526, 6 p. P946 .A35 2007.

A4.244. *Objets pharaoniques à inscription carienne* / Olivier Masson and Jean Yoyotte. Le Caire: Impr. de l'Institut Française d'Archéologie Orientale, 1956. 77, 9 p. 913.32 C128.7 t.15.

A4.245. *Studien zu Sprache und Geschichte der Karer in Ägypten* / Frank Kammerzell. Wiesbaden: Harrassowitz Verlag, 1993. 251 p. P946 .K36 1993.

Carian—Egypt—Sakkara

A4.246. *Carian inscriptions from North Saqqâra and Buhen* / Oliver Masson. London: Egypt Exploration Society, 1978. 102, 19 p. P946 .M37 1978.

Carian—Nubia

A4.247. *The rock inscriptions of lower Nubia (Czechoslovak concession)* / Zbynek Záb. Prague: Universita Karlova, 1974. 351, 229 p. GN865.N82 Z273.

Carian—Sudan—Buhen

A4.248. *Carian inscriptions from North Saqqara and Buhen* / Oliver Masson. London: Egypt Exploration Society, 1978. 102, 19 p. P946 .M37 1978.

Carian—Turkey—Caria

A4.249. *The Carian language* / Ignacio J. Adiego, with an appendix by Koray Konuk. Leiden; Boston: Brill, 2007. 526, 6 p. P946 .A35 2007.

A4.250. *Les inscriptions cariennes: histoire d'un étrange alphabet grec* / Jean Faucounau. Paris: Harmattan, 2009. 204 p. P946 .F393 2009.

Celtiberian

A4.251. *Ancient languages of the Hispanic peninsula* / James M. Anderson. Lanham: University Press of America, 1988. 144 p. P1081 .A53 1988.

A4.252. *Celtiberica* / Michel Lejeune. Salamanca: Universidad de Salamanca, 1955. 144 p. 913.46 L537.

A4.253. *Die erste Botorrita-Inschrift: Interpretation eines keltiberischen Sprachdenkmals* / Wolfgang Meid. Innsbruck: Institut für Sprachwissenschaft der Universität Innsbruck, 1993. 132, 8 p. P1081 .M44 1993.

A4.254. *Introducción al celtibérico* / Carlos Jordán Cólera. Zaragoza: Departamento de Ciencias de la Antigüedad, Area de Filología Griega, Universidad de Zaragoza, 1998. 259 p. P1081 .J67 1998.

A4.255. *Monumenta linguarum Hispanicarum* / Jürgen Untermann. Wiesbaden: L. Reichert, 1975. 5 v. P1081 .U5.

A4.256. *Die Sprachen der vorkeltischen Indogermanen Hispaniens und das Keltiberische* / Ulrich Schmoll. Wiesbaden: O. Harrassowitz, 1959. 130 p. 462.9 Sch58.

A4.257. *Die vorrömischen Sprachen der iberischen Halbinsel: Wege und Aporien bei ihrer Entzifferung* / Jürgen Untermann. Wiesbaden: Westdeutscher Verlag, 2001. 42 p. P1081 .U68 2001.

Celtiberian—Spain—Botorrita

A4.258. *Towards an interpretation of the Hispano-Celtic inscription of Botorrita* / Joseph F. Eska. Innsbruck: Institut für Sprachwissenschaft der Universität Innsbruck, 1989. 213 p. PB1014 .E75 1989.

Classical

A4.259. *Documents illustrating the reigns of Augustus & Tiberius* / Victor Ehrenberg and A. H. M. Jones. 2 ed. Oxford: Clarendon Press, 1955. 171 p. DG275 .E35 1955. Supersedes: *Documents illustrating the reigns of Augustus & Tiberius* / Victor Ehrenberg and A. H. M. Jones. Oxford: Clarendon Press, 1949. 159 p. 937.06 Eh831.

Classical—Catalogs

A4.260. *Catalogue des sculptures et inscriptions antiques (monuments lapidaires) des musées royaux du Cinquantenaire* / Franz Cumont. 2 ed. Bruxelles: Vromant, 1913. 268 p. 708.9 B836.

Crete—Gortyna

A4.261. *Leggi antiche della città di Gortyna in Creta* / F. Halbherr and E. Fabricius. Firenze: E. Loescher 1885. 59 p. P1035.L43 1885.

Cypro-Minoan

A4.262. *Ancient scripts from Crete and Cyprus* / Jan Best and Fred Woudhuizen. Leiden; New York: E. J. Brill, 1988. 131 p. P1021 .B47 1988; P1021 .A53 1988.

Cypro-Minoan—Cyprus—Alasija

A4.263. *Die sprache von Alasija* / Ferdinand Bork. Leipzig: O. Harrassowitz, 1930. 29 p. PJ5 .A6 bd.5 hft.1.

Cypro-Minoan—Cyprus—Enkomi

A4.264. *Etude de vingt-six boules d'argile inscrites trouvées à Enkomi et Hala Sultan Tekke* (Chypre) / Emilia Masson. Göteborg, P. Åströms, 1971. 38 p. CN430 .M38.

Cypro-Minoan—Cyprus—Hala Sultan Tekke

A4.265. *Etude de vingt-six boules d'argile inscrites trouvées à Enkomi et Hala Sultan Tekke* (Chypre) / Emilia Masson. Göteborg, P. Åströms, 1971. 38 p. CN430 .M38.

A4.266. *Cypro-Minoan inscriptions* / Silvia Ferrara. Oxford; New York: Oxford University Press, 2012. P1039 .F47 2012.

A4.267. *Forschungsbericht: Palästina und Sinaihalbinsel* / Karl Jaroš; *Die kyprominoischen Schriftsysteme* / Stefan Hiller. Horn, Austria: F. Berger, 1985. 102 p. DS111 .J37 1985.

A4.268. *Les inscriptions chypro-minoennes* / Jean Faucounau. Paris: Harmattan, 2007. 2 v. P1039 .F38 2007.

A4.269. *Linear B and related scripts* / John Chadwick. Berkeley: University of California Press; London: Publ British Museum Publications, 1987. 64 p. P1035 .C54 1987.

Cypro-Minoan—Cyprus—Kition-Bamboula

A4.270. *Kition dans les textes: testimonia littéraires et épigraphiques et Corpus des inscriptions* / Marguerite Yon. Paris: Editions Recherche sur les civilisations, 2004. 380 p. DS54.95.K58 K58 1982.

Cypro-Minoan—Greece—Crete

A4.271. *Le déchiffrement du disque de Phaistos: preuves et conséquences* / Jean Faucounau. Paris: L'Harmattan, 1999. 192 p. P1036 .F385 1999.

Cypro-Minoan—Syria—Ras Shamra Ugarit

A4.272. *Cyprominoica: Répertoires: Documents de Ras Shamra: Essais d'interprétation* / Émilia Masson. Göteborg: P. Aström, 1974. 64 p. P1035 .M28.

Cyprus

A4.273. *Cypriot inscribed stones* / Ino Nicolaou. Nicosia: Republic of Cyprus, Ministry of Communications & Works, Department of Antiquities, 1971. 37, 25 p. CN430 .C95.

Cuneiform

A4.274. Cuneiform Luvian Lexicon. Lexicon is still under copyright, but the author gives permission to print this pdf file out. This lexicon has a very modest aim: to furnish a provisional index, as exhaustive as possible, of all attested cuneiform Luvian lexemes. http://uz-translations.net/?category=ancdics-ancient&altname=cuneiform_luvian_lexicon.

A4.275. Cuneiform Digital Library. The Cuneiform Digital Library Initiative (CDLI) represents the efforts of an international group of Assyriologists, museum curators, and historians of science to make available through the Internet the form and content of cuneiform tablets dating from the beginning of writing, ca. 3350 BC, until the end of the pre-Christian era. World Wide Web.

A4.276. ETANA Core Texts. Electronic Tools and Ancient Near Eastern Archives. Digitized texts relating to the Ancient Near East. http://www.etana.org/coretexts.

A4.277. *Babylonische Rechtsurkunden aus dem 6. Jahrhundert v. Chr.* / Mariano San Nicolò and Herbert Petschow. München: Verlag der Bayerischen Akademie der Wissenschaften, in Kommission bei Beck, 1960. 122 p. 63 M92p5.2 n.F. hft.51.

A4.278. *Introduction into the inscriptions discovered by Mons. E. de Sarzec* / Ira M. Price. Munich: Academische buchdruckerei von F. Straub, 1887. 32 p. 892.3 F625.

A4.279. *Old Canaanite cuneiform texts of the third millennium* / Giovanni Pettinato. Malibu: Undena Publications, 1976. 17 p. DS99.E25 P47213.

Cuneiform—Metropolitan Museum of Art—Catalogs

A4.280. *Cuneiform texts in the Metropolitan Museum of Art.* New York: Metropolitan Museum of Art, 1988– . PJ3711 .M48 1988.

Cuneiform—University of Pennsylvania, University Museum of Archaeology and Anthropology—Catalogs

A4.281. *Bibliography of the tablet collections of the University Museum* / Pamela Gerardi. Philadelphia: University Museum; Distributed by the Babylonian Fund, 1984. 277 p. PJ3711 .U55 1984.

Egyptian

A4.282. *An account of some recent discoveries in hieroglyphical literature and Egyptian antiquities* [electronic resource]: *including the author's original alphabet, as extended by Mr. Champollion, with a translation of five unpublished Greek and Egyptian manuscripts* / Thomas Young. Worcester: Yare Egyptology, 2004. CD-ROM. PJ1095 .Y6 2004.

A4.283. *Ägypten: Kultur und Lebenswelt in griechisch-römischer Zeit; eine Darstellung nach den demotischen Quellen* / Friedhelm Hoffmann. Berlin: Akademie Verlag, 2000. 355 p. DT61.H566 2000.

A4.284. *For his ka: essays offered in memory of Klaus Baer* / David P. Silverman. Chicago: Oriental Institute of the University of Chicago, 1994. 332 p. CB251.C55 no.55.

A4.285. *I geroglifici fantastici di Athanasius Kircher* / Caterina Marrone. Roma: Stampa alternativa & Graffiti, 2002. 166 p. PJ1097 .M327 2002.

A4.286. *Habt Ehrfurcht vor der Gottheit NN: die śndn-Hymnen in den ägyptischen Tempel der griechisch-römischen Zeit* / Stefan Rüter. Gladbeck: PeWe-Verlag, 2009. 169 p. PJ1565 .R948 2009.

A4.287. *Die Hieroglyphische Schriftlehre und die Realität der hieroglyphischen Graphien* / Wolfgang Schenkel. Stuttgart: Hirzel, 2003. 38 p. AS182 .S213 Bd.138 hft.5.

A4.288. *The hieroglyphs of ancient Egypt* / Aidan Dodson. London: New Holland, 2001. 144 p. PJ1097 .D63 2001.

A4.289. *Hieroglyphics: the writings of ancient Egypt* / Maria C. Betrò. New York: Abbeville Press, 1996. PJ1097 .B4613 1996.

A4.290. *Inscriptions of the Nile monuments; a book of reference for tourists* / Garrett C. Pier. New York; London: G. P. Putnam's Sons, 1908. 357 p. DT61.P6.

A4.291. *Königliche Stelen in der Zeit von Ahmose bis Amenophis III* / Andrea Klug. Bruxelles: Fondation Egyptologique Reine Elisabeth, 2002. 580 p. DT62.S8 .K58 2002.

A4.292. *Language and writing in ancient Egypt* / David P. Silverman. Pittsburgh: Carnegie Museum of Natural History, 1990. 48 p. PJ1052 .S32 1990.

A4.293. *The Libyan anarchy [electronic resource]: inscriptions from Egypt's Third Intermediate Period* / Robert K. Ritner. Atlanta: Society of Biblical Literature, 2009. 622 p. DT89 .R58 2009; PJ408 .W758 no.21.

A4.294. *Masterpieces of Tutankhamen* / David P. Silverman. New York: Abbeville Press, 1978. 159 p. DT87.5 .S45.

A4.295. *Millions of jubilees: studies in honor of David P. Silverman* / Zahi Hawass and Jennifer Houser Wegner. Cairo: Conseil Supreme des Antiquités de l'Egypte, 2010. 2 v. DT60 .M55 2010.

A4.296. *Objets pharaoniques à inscription carienne* / Olivier Masson and Jean Yoyotte. Le Caire: Impr. de l'Institut française d'archéologie orientale, 1956. 77, 9 p. 913.32 C128.7 t.15.

A4.297. *Pictograms or pseudo script?: non-textual identity marks in practical use in ancient Egypt and elsewhere: proceedings of a conference in Leiden, 19–20 December 2006* / B. J. J. Haring and O. E. Kaper. Leiden: Nederlands Instituut voor het Nabije Oosten; Leuven: Peeters, 2009. PJ1526.E3 P53 2009.

A4.298. *Ein ptolemäisches Priesterdekret aus dem Jahr 186 v. Chr.: eine neue Version von Philensis II in Kairo* / Mamdouh Eldamaty. München: Saur, 2005. 92, 10 p. PJ1531.P55 P76 2005.

A4.299. *Reading Egyptian art: a hieroglyphic guide to ancient Egyptian painting and sculpture* / Richard H. Wilkinson. London: Thames and Hudson, 1992. 224 p. N5350 .W499 1992.

A4.300. *Sacred signs: hieroglyphs in ancient Egypt* / Penelope Wilson. Oxford; New York: Oxford University Press, 2003. 157 p. PJ1097 .W557 2003.

A4.301. *Les scribes dans la société egyptienne de l'ancien empire* / Patrizia Piacentini. Paris: Cybele, 2002. PJ1097 .P57 2002.

A4.302. *Searching for ancient Egypt: art, architecture, and artifacts from the University of Pennsylvania Museum of Archaeology and Anthropology* / David P. Silverman. Ithaca: Cornell University Press, 1997. 342 p. DT61 .U557 1997.

A4.303. *Texts from the pyramid age* / Nigel C. Strudwick. Atlanta: Society of Biblical Literature, 2005. 522 p. DT85 .S74 2005; PJ408 .W758 no.16.

A4.304. *Die Tributszenen des Neuen Reiches* / Silke Hallmann. Wiesbaden: Harrassowitz, 2006. 364, 16 p. DT87.H344 2006.

A4.305. *Urkunden der 18. Dynastie: Indices zu den Heften 1–22: Corrigenda zu den Heften 5–16* / Monika Hasitzka and Helmut Satzinger. Berlin: Akademie-Verlag, 1988. 119 p. DT87 .U7415 1988.

Egyptian—Abu Sir (Jizah)

A4.306. *The visitors' graffiti of dynasties XVIII and XIX in Abusir and Northern Saqqara* / Hana Navrátilová. Praha: Czech Institute of Egyptology: Set Out, 2007. 168, 56 p. PJ1526.A26 N382 2007 + CD-ROM.

Egyptian—Alexandria

A4.307. *Inscriptions des factions à Alexandrie* / Zbigniew Borkowski. Varsovie: Editions scientifiques de Pologne, 1981. 146, 28 p. DT73.A4 A37 v. 2.

Egyptian—Alexandria—Greek—Catalogs

A4.308. *Iscrizioni greche e latine* / Evaristo Breccia. Le Caire: Impr. de l'Institut français d'archeéologie orientale, 1911. 273, 61 p. DT57.C2 1911; DT57. C2 v.57.

Egyptian—Alexandria—Serapeum

A4.309. *Discovery of the famous temple and enclosure of Serapis at Alexandria* / Alan Rowe; *An explanation of the enigmatical inscriptions on the Serapeum plaques of Ptolemy IV* / Étienne Drioton. Le Caire: Impr. de l'Institut français d'archéologie orientale, 1946. 115 p. 913.32 C128.2 sup. no.2.

Egyptian—Amheida

A4.310. *Ostraka from Trimithis* / Roger S. Bagnall and Giovanni R. Ruffini. New York: New York University Press: Institute for the Study of the Ancient World, 2012. PA3371 .B34 2012.

Egyptian—Ashmolean Museum, Bodleian Collection, Oxford

A4.311. *Archives administratives et inscriptions cunéiformes; Ashmolean Museum, Bodleian Collection, Oxford* / Jean-Pierre Grégoire. Paris: irie orientaliste Paul Geuthner, 1996– . PJ3711 .G74 1996; v.1(1-3), v.3; PJ3711 .G74 1996.

Egyptian—Aswan

A4.312. *Assuan* / D. Foraboschi. Pisa: Giardini, 1978. 323 p. DT73.A88 A87.

Egyptian—Asyut

A4.313. *The necropolis of Assiut: a case study of local Egyptian funerary culture from the Old Kingdom to the end of the Middle Kingdom* / Marcel Zitman. Leuven: Peeters: Departement Oosterse Studies, 2010. 2 v. DT73.A89 Z58 2010; PJ1097 .H355 2006.

A4.314. *Zur Paläographie der Särge aus Assiut* / Rainer Hannig. Hildesheim: Gerstenberg, 2006. 930 p. PJ1097 .H355 2006.

A4.315. *The inscriptions of Siût and Dêr Rîfeh* [electronic resource] / F. L. Griffith. Worcester: Yare Egyptology, 2004. CD-ROM. PJ1526.A78 G75 2004.

A4.316. *Siut-Theben: zur Wertschätzung von Traditionen im alten Ägypten* / Jochem Kahl. Leiden; Boston: Brill, 1999. 401 p. DT61 .K3 1999.

Egyptian—Athribis

A4.317. *Der Tempel Ptolemaios XII, die Inschriften und Reliefs der Opfersäle, des Umgangs und der Sanktuarräume* / Christian Leitz, Daniela Mendel, und Yahya El-Masry. Le Caire: Institut français d'archéologie orientale, 2010. 3 v. DT73. A93 L45 2010.

Egyptian—Bibliography

A4.318. *Memphis, Herakleopolis, Theben. Die epigraphischen Zeugnisse der 7.–11. Dynastie Ägyptens* / Wolfgang Schenkel. Wiesbaden, Harrassowitz, 1965. 306 p. 913.32 Ae23 Bd.12.

Egyptian—Bibliothèque nationale et universitaire de Strasbourg—Collections—Catalogs

A4.319. *Catalogue des étiquettes de jarres hiératiques inédites de l'Institut d'égyptologie de Strasbourg* / Guillaume Bouvier. Le Caire: Institut français d'archéologie orientale, 1999–2003. 5 v. DT57 .C16 t.35, etc.

A4.320. *Documents cunéiformes de Strasbourg; conservés à la Bibliothèque nationale et universitaire* / Dominique Charpin and Jean-Marie Durand. Paris: Éditions A.D.P.F., 1981– . PJ3711 .B525 1981.

A4.321. *Les ostraca hiératiques inédits de la Bibliothèque nationale et universitaire de Strasbourg* / Yvan Koenig. Le Caire: Institut français d'archéologie orientale, 1997. 21, 135 p. DT57 .C16 t.33.

Egyptian—Biography

A4.322. *Cracking the Egyptian code: the revolutionary life of Jean-François Champollion* / Andrew Robinson. New York: Oxford University Press, 2012. 272 p. PJ1064.C6 R63 2012.

A4.323. *The last of the Egyptians* / Gérard Macé. Providence: Burning Deck, 2011. 80 p. PJ1064.C6 M3313 2011.

Egyptian—Birmingham City Museum, Birmingham

A4.324. *Catalogue of cuneiform tablets in Birmingham City Museum* / P. J. Watson. Warminster: Aris and Phillips; Atlantic Highlands: Humanities Press, 1986– . PJ3711 .C38 1986.

Egyptian—British Museum—Catalogs

A4.325. *Egyptian inscriptions, from the British Museum and other sources* / Samuel Sharpe. London: E. Moxon, 1837–1855. 3 v. Microfiche.

Egyptian—Canopus

A4.326. *Études égyptologiques: comprenant le texte et la traduction d'une stèle éthiopienne inédite et de divers manuscrits religieux, avec un glossaire égyptien grec du décret de Canope* / Paul Pierret. Paris: A. Franck, 1873. 125 p. 913.3978 P615.

Egyptian—Catalogs

A4.327. *A collection of hieroglyphs* [electronic resource]: *a contribution to the history of Egyptian writing* / F. L. Griffith. Worcester: Yare Egyptology, 2004. DT57 .E323 6th 2004.

A4.328. *Les stèles d'Horus sur les crocodiles* / Annie Gasse. Paris: Réunion des musées nationaux, 2004. 182 p. DT62.S8 G377 2004.

Egyptian—Dandara

A4.329. *Demotische Epigraphik aus Dandara: die demotischen Grabstelen* / Jan Moje. London: Golden House Publications, 2008. 77, 23 p. PJ1526.D32 M64 2008.

Egyptian—Dandara—Demotic

A4.330. *Demotische Epigraphik aus Dandara: die demotischen Grabstelen* / Jan Moje. London: Golden House Publications, 2008. 77, 23 p. PJ1526.D32 M64 2008.

Egyptian—Dandara—Temple of Hathor

A4.331. *Dendara: le temple d'Isis* / Sylvie Cauville. Louvain: Peeters, 2009. 2 v. PJ1526.D32 C378 2009.

A4.332. *Dendara V–VI: traduction* / Sylvie Cauville. Leuven: Peeters, 2004. 2 v. DT73.D4 C39 1999 v.5–6.

A4.333. *Le temple de Dendara* / Sylvie Cauville. Paris: Ifao du Caire, 2008. 2 v. DT73.D4 C38 2008.

Egyptian—Data Processing

A4.334. *Wege zu einem digitalen Corpus ägyptischer Texte: Akten der Tagung "Datenbanken im Verbund" (Berlin, 30. September–2. Oktober 1999)* / Ingelore Hafemann. Berlin: Achet, 2003. 310 p. PJ1483 .W444 2003.

Egyptian—Dayr al-Madainah

A4.335. *Donkeys at Deir el-Medina* / Jac. J. Janssen. Leiden: Nederlands Instituut voor het Nabije Oosten, 2005. 127 p. PJ1526.D39 J358 2005.

A4.336. *Les registres de recensement du village de Dier el-Médineh: (le Stato civile)* / Robert Demarée and Dominique Valbelle. Leuven; Walpole: Peeters, 2011. 148 p. DT73.D47 D46 2011.

A4.337. *The tomb of Sennedjem (TT1) in Deir el-Medina: palaeography* / Ben. J. J. Haring. Le Caire: Institut français d'archéologie orientale, 2006. 220 p. Z115.5 .E39 H37 2006.

Egyptian—Dayr al-Madainah—Catalogs

A4.338. *Catalogue des étiquettes de jarres hiératiques de Deir el-Médineh* / Yvan Koenig. Le Caire: Institut français d'archéologie orientale, 1979–1980. 2 v. DT57 .C16 t.21.

Egyptian—Decipherment

A4.339. *100 hieroglyphs: think like an Egyptian* / Barry Kemp. London: Granta, 2005. 256 p. DT61 .K442 2005b.

A4.340. *ABC of Egyptian hieroglyphs* / Jaromir Malek. Oxford: Ashmolean Museum, 1994. 48 p. PJ1097 .M3 1994.

A4.341. *Ancient Egyptian hieroglyphs: a practical guide* / Janice Kamrin. New York: Harry N. Abrams, 2004. 256 p. PJ1097 .K28 2004.

A4.342. *The art of Egyptian hieroglyphics* / David Sandison. New York: Barnes & Noble, 2006. 95 p. PJ1097 .S26 2006.

A4.343. *Cracking codes: the Rosetta stone and decipherment* / Richard Parkinson. Berkeley: University of California Press, 1999. 208, 16 p. PJ1531.R5 P37 1999.

A4.344. *Decoding Egyptian hieroglyphs: how to read the secret language of the pharaohs* / Bridget McDermott. San Francisco: Chronicle Books, 2001. 171 p. PJ1097 .M33 2001.

A4.345. *Hieroglyphs: a very short introduction* / Penelope Wilson. Oxford; New York: Oxford University Press, 2004. 130 p. PJ1097 .W557 2004.

A4.346. *How to read Egyptian hieroglyphs: a step-by-step guide to teach yourself* / Mark Collier and Bill Manley. rev. ed. Berkeley: University of California Press, 2003. 179 p. PJ1097 .C65 2003. Supersedes: *How to read Egyptian hieroglyphs: a step-by-step guide to teach yourself* / Mark Collier and Bill Manley. Berkeley: University of California Press, 1998. 179 p. PJ1097 .C65 1998.

A4.347. *The keys of Egypt: the obsession to decipher Egyptian hieroglyphs* / Lesley Adkins and Roy Adkins. New York: Harper Collins Publishers, 2000. 335, 16 p. PJ1097 .A35 2000.

A4.348. *La lecture des hiéroglyphes: Jean-François Champollion*. Monaco: Editions du Rocher; Lausanne: Trois-continents, 2000. 144 p. PJ1081 .L43 2000.

A4.349. *Tübinger Einführung in die klassisch-ägyptische Sprache und Schrift* / Wolfgang Schenkel. Tübingen: W. Schenkel, 1997. 368 p. PJ1111 .S32 1997z.

A4.350. *Understanding hieroglyphs: a complete introductory guide* / Hilary Wilson. Lincolnwood: Passport Books, 1995. 192 p. PJ1097 .W55 1995.

A4.351. *Write your own Egyptian hieroglyphs* / Angela McDonald. Berkeley: University of California Press, 2007. 80 p. PJ1097 .M35 2007.

Egyptian—Deir el-Medina

A4.352. *Les registres de recensement du village de Dier el-Médineh: (le Stato civile)* / Robert Demarée and Dominique Valbelle. Leuven; Walpole: Peeters, 2011. 148, 70 p. DT73.D47 D46 2011.

Egyptian—Dictionaries

A4.353. *The handbook of Egyptian hieroglyphs: a study of the ancient language* / Samuel A. B. Mercer. New York: Hippocrene Books, 1993. 184 p. PJ1135 .M4 1993.

Egyptian—Dictionaries—English

A4.354. *A concise dictionary of Middle Egyptian* / Raymond O. Faulkner. Oxford: Griffith Institute;

Ashmolean Museum, 1996. 327 p. PJ1425 .F3 1996.

A4.355. *A dictionary of late Egyptian* / Leonard H. Lesko. 2 ed. Providence: B. C. Scribe Publications, 2002. PJ1425 .D53 2002.

Egyptian—Dictionaries—French

A4.356. *Dictionnaire hiéroglyphes-français* / Ashraf Alexandre Sadek. Limoges: Le monde copte, 2006. 620 p. PJ1430 .S334 2006.

Egyptian—Dictionaries—German

A4.357. *Frühägyptisches Wörterbuch* / Jochem Kahl. Wiesbaden: Harrassowitz, 2002. 3 v. PJ1430 .K34 2002.

Egyptian—Eastern Desert

A4.358. *Pharaonic inscriptions from the southern Eastern Desert of Egypt* / Russell D. Rothe, William K. Miller, and George (Rip) Rapp. Winona Lake: Eisenbrauns, 2008. 504 p. PJ1526.E37 R67 2008.

Egyptian—Edfu

A4.359. *Die Dekoration der Saulen im Pronaos des Tempels von Edfu* / Dieter Kurth. Wiesbaden: Harrassowitz, 1983. 410 p. DT73.E33 K87 1983.

Egyptian—Edfu—Hymns

A4.360. "Habt Ehrfurcht vor der Gottheit NN": die snd-n -Hymnen in den ägyptischen Tempeln der griechisch-römischen Zeit / Stefan Rüter. Gladbeck: PeWe-Verlag, 2009. 169 p. PJ1565 .R948 2009.

Egyptian—Edfu—Temple of Horus

A4.361. *La création: poème pariétal; Die Schöpfung: ein Wandgedicht: la façade ptolémaïque du temple d'Esna: pour une poétique ptolémaïque* / Philippe Derchain and Daniel von Recklinghausen. Turnhout: Brepols; Bruxelles: Fondation égyptologique reine Elisabeth, 2004. 170 p. BL2443 .R57 v.10.

A4.362. *EDFU: die Darstellungen auf den Aussenseiten der Umfassungsmauer und auf dem Pylonen: Strichzeichnungen und Photographien* / Uwe Bartels. Wiesbaden: Harrassowitz Verlag, 2009. 22, 58 p. + DVD-ROM. PJ1526.I33 B34 2009.

A4.363. *The temple of Edfu: a guide by an ancient Egyptian priest* / Dieter Kurth. Cairo, New York: American University in Cairo Press, 2004. 89 p. DT73.I3 K8813 2004.

Egyptian—Esna

A4.364. *Les architraves du temple d'Esna: paléographie* / Dimitri Meeks. Le Caire: Institut français d'archéologie orientale, 2004. 366 p. PJ1526.I8 M445 2004.

Egyptian—Facsimiles

A4.365. *A corpus of inscribed Egyptian funerary cones* / M. F. Laming Macadam. Oxford: Griffith Institute at the University Press, 1957. 493.01 D283.

Egyptian—Fayyum

A4.366. *Hieroglyphic inscriptions from the Fayyum* / Marco Zecchi. Imola (Bologna): La mandragora, 2002. PJ1526.F39 Z43 2002.

Egyptian—Gebel es-Silsileh

A4.367. *Speos von Gebel es-Silsileh: Analyse der architektonischen und ikonographischen Konzeption im Rahmen des politischen und legitimatorischen Programmes der Nachamarnazeit* / Andrea-Christina Thiem. Wiesbaden: Harrassowitz Verlag, 2000. 2 v. DT73.G41 T554 2000.

Egyptian—Glyptothèque Ny Carlsberg—Catalogs

A4.368. *Recueil des inscriptions hiéroglyphiques de la Glyptothèque Ny Carlsberg* / Otto Koefoed-Petersen. Bruxelles: Fondation égyptologique reine Elisabeth, 1936. 115 p. PJ1025. B53 v.6.

Egyptian—Grammar

A4.369. *A concise grammar of Middle Egyptian: an outline of Middle Egyptian grammar by Hellmut Brunner* / Boyo G. Ockinga. rev. ed. Mainz: Philipp Von Zabern, 1998. 177 p. PJ1135 .O34 1998.

A4.370. *Grammaire égyptienne* / Jean-François Champollion. Arles: Actes Sud, 1997. PJ1135 .C45 1997.

A4.371. *Grammaire de l'égyptien hiéroglyphique: du moyen empire au début du nouvel empire* / Jean-Claude Goyon. Lyon: Éditions A.C.V., 2006. 311 p. PJ1135 .G69 2006.

A4.372. *Grammaire hiéroglyphique contenant les principes généraux de la langue et de l'écriture sacrée des anciens égyptiens* / Henri Brugsch. Nimes: Lacour, 2002. 135 p. PJ1135 .B7 2002.

A4.373. *The handbook of Egyptian hieroglyphs: a study of the ancient language* / Samuel A. B. Mercer. New York: Hippocrene Books, 1993. 184 p. PJ1135 .M4 1993.

A4.374. *Interrogative constructions with JN and JN-JW in Old and Middle Egyptian* / David P. Silverman. Malibu: Undena Publications, 1980. 144 p. PJ1201 .S54 1980.

A4.375. *Late Egyptian grammar: an introduction* / Friedrich Junge. Oxford: Griffith Institute, 2001. 391 p. PJ1135 .J86 2001.

A4.376. *Middle Egyptian: an introduction to the language and culture of hieroglyphs* / James P. Allen. 2 ed. Cambridge; New York: Cambridge University Press, 2010. 511 p. PJ1135 .A45 2010.

A4.377. *Middle Egyptian grammar* / James E. Hoch. Mississauga: Benben Publications, 1997. 307 p. PJ1135 .H63 1997a.

Egyptian—Grammar—Classifiers

A4.378. *The writing of gods: the evolution of divine classifiers in the Old Kingdom* / Racheli Shalomi-Hen. Wiesbaden: Harrassowitz, 2006. 198 p. PJ1191 .S53 2006.

Egyptian—Hajjaj Wadi

A4.379. *The inscriptions of Wadi Haggag, Sinai* / Avraham Negev. Jerusalem: Institute of Archaeology, Hebrew University of Jerusalem: Israel Exploration Society, 1977. 100 p. CN753.E3 N43.

Egyptian—Heracleopolis Magna

A4.380. *Excavaciones en Ehnasya el Medina (Heracleópolis Magna)* / María del Carmen Pérez-Die and Pascal Vernus. Madrid: Ministerio de Cultura, Dirección General de Bellas Artes y Archivos, Instituto de Conservación y Restauración de Bienes Culturales, 1992. 2 v. DT73.H44 P47 1992.

Imu—Tomb of Hsw the Elder

A4.381. *The tomb chamber of Hsw the Elder: the inscribed material at Kom-el-Ḥisn* / David P. Silverman. Winona Lake: American Research Center in Egypt; Eisenbrauns, 1988. DT73.H57 S56 1988.

Egyptian—John Rylands University Library, Manchester

A4.382. *Sargonic and pre-Sargonic tablets in the John Rylands University Library* / Benjamin R. Foster. Manchester: John Rylands University Library of Manchester, 1982. p. 457–480.

Egyptian—Karnak

A4.383. *The Great Karnak inscription of Merneptah: grand strategy in the 13th century BC* / Colleen Manassa. New Haven: Yale Egyptological Seminar, Department of Near Eastern Languages and Civilizations, The Graduate School, Yale University, 2003. 209, 15 p. PJ1526.K18 M36 2003.

Egyptian—Karnak—Temple of Amun

A4.384. *The gateway of Ramesses IX in the Temple of Amun at Karnak* / Amin A. M. A. Amer. Warminster: Aris & Phillips, 1999. 43, 18 p. DT73.K4 A64 1999.

Egyptian—Mathaf al-Qibti—Catalogs

A4.385. *Catalogue général des antiquités du Musée copte: nos. 1–253. Coptic funerary stelae* / Ibrahim Kamel. Le Caire: Lorganisation étyptienne générale du livre, 1987. 271 p. DT62.S8 M38 1987.

Egyptian—Mathaf al-Misri—Catalogs

A4.386. *Naos* / Günther Roeder. Worcester: Yare Egyptology, 2006. CD-ROM. DT57 .C2 v.75 2006.

Egyptian—Medinet-Abu

A4.387. *Medinet Habu* / Harold H. Nelson. Chicago: University of Chicago Press, 1930. 9 v. DT73. M3 C42, v.1–9.

A4.388. *Medinet Habu graffiti facsimiles* / William F. Edgerton. Chicago: University of Chicago Press, 1937. 6, 4, 103 p. PJ1526.M4 E4 1937.

Egyptian—Memphis

A4.389. *Corpus of inscriptions of the Herakleopolitan period from the Memphite necropolis: translation, commentary, and analyses* / Khaled Abdalla Daoud. Oxford: Archaeopress, 2005. 351 p. PJ1526.M46 D36 2005.

A4.390. *Wortschöpfung: die memphitische theologie und die siegesstele des Pije - zwei zeugen kultureller repräsentation in der 25. dynastie* / Amr El Hawary. Fribourg: Academic Press; Göttingen: Vandenhoeck & Ruprecht, 2010. 499 p. BL2441.3 .E54 2010.

Egyptian—Memphis—Papyri—Demotic

A4.391. *Demotic papyri from the Memphite necropolis (P. Dem. Memphis): in the collections of the National Museum of Antiquities in Leiden, the British Museum and the Hermitage Museum* / Cary J. Martin. Turnhout: Brepols, 2009. 2 v. PJ1845 .M37 2009.

Egyptian—Musée du Louvre—Catalogs

A4.392. *Ostraca démotiques du Musée du Louvre* / Didier Devauchelle. Le Caire: Institut français d'archéologie orientale du Caire, 1983. 2 v. PJ25. B6 t.92, etc.; PJ25 .B6 t.92.

Egyption—Musée du Louvre—Département des antiquités égyptiennes—Catalogs

A4.393. *La voix des hiéroglyphes: promenade au Département des antiquités égyptiennes du Musée du Louvre* / Christophe Barbotin and Didier Devauchelle. Paris: Musée du Louvre: Institut Khéops, 2005. 240 p.DT59.P2 M874 2005.

Egyptian—Museo archeologico di Milano

A4.394. *Sesh: lingue e scritture nell'antico Egitto: inediti dal Museo archeologico di Milano* / Francesco Tiradritti. Milano: Electa: Biblioteca di via Senato, 1999. 188 p. PJ1521 .S48 1999.

Egyptian—National Museum of Antiquities, Leiden—Catalogs

A4.395. *The demotic ostraca in the National Museum of Antiquities at Leiden* / M. A. A. Nur el-Din. Leiden: Brill, 1974. 680 p. PJ1829 .N8 1974.

Egyptian—Nubia—Napata

A4.396. *The inscription of Queen Katimala at Semna: textual evidence for the origins of the Napatan State* / John Coleman Darnell. New Haven: Yale Egyptological Seminar; Oakville: David Brown Book, 2006. 112 p. PJ1526.N37 D37 2006.

Egyptian—Petrie Museum of Egyptology—Catalogs

A4.397. *Mummy-cases and inscribed funerary cones in the Petrie Collection* / H. M. Stewart. Warminster: Aris & Phillips; Oak Park: Bolchazy-Carducci, 1986. 83, 32 p. DT62.T6 S73 1986.

Egyptian—Petroglyphs

A4.398. *Séhel entre Egypte et Nubie: inscriptions rupestres et graffiti de l'époque pharaonique: actes du colloque international, 31 mai–1er juin 2002, Université Paul Valéry, Montpellier* / Annie Gasse and Vincent Rondot. Montpellier: Publications de Montpellier III, 2004. 186 p. PJ1521 .S444 2004.

Egyptian—Rosetta Stone

A4.399. *The Rosetta Stone* / Richard Parkinson. London: British Museum Press, 2005. 64 p. PJ1531.R5 P27 2005.

Egyptian—Pushkin Museum of Fine Arts

A4.400. *The Egyptian reliefs and stelae in the Pushkin Museum of Fine Arts, Moscow* / Svetlana Hodjash and Oleg Berlev. Leningrad: Aurora Art Publishers, 1982. 309 p. DT59.M67 K45.

Egyptian—Saqqarah

A4.401. *The tomb of Hetepka: and other reliefs and inscriptions from the sacred animal necropolis North Saqqâra, 1964–1973* / Geoffrey Thorndike Martin. London: Egypt Exploration Society, 1979. 442 p. DT73.S3 M36.

A4.402. *Texts from the Baboon and Falcon galleries: demotic, hieroglyphic and Greek inscriptions from the sacred animal necropolis, North Saqqara* / J. D. Ray. London: Egypt Exploration Society, 2011. 374 p. PJ1526.S3 R39 2011.

A4.403. *The visitors' graffiti of dynasties XVIII and XIX in Abusir and Northern Saqqara* / Hana Navrátilová. Praha: Czech Institute of Egyptology: Set Out, 2007. 168, 56 p. PJ1526.A26 N382 2007 + CD-ROM.

Egyptian—Saqqarah—Mastaba

A4.404. *The mastaba of Ptahhetep and Akhethetep at Saqqareh* [electronic resource] / Norman de Garis Davies. CD-ROM. Worcester: Yare Egyptology, 2004. DT57 .E323 8th–9th 2004.

Egyptian—Saqqarah—Pyramid of Pepi I

A4.405. *Paroles d'éternité* / Serge Feneuille. Paris: CNRS, 2008. 261 p. PJ1553 .A11 2008.

Egyptian—Sehel Island

A4.406. *Les inscriptions de Sehel* / Annie Gasse and Vincent Rondot. Le Caire: Institut Francais d'

Archeologie Orientale, 2007. 607 p. PJ1526.S45 G377 2007.

Egyptian—Sinai

A4.407. *The alphabet, its rise and development from the Sinai inscriptions* / Martin Sprengling. Chicago: University of Chicago Press, 1931. 71 p. P211. S77 1931; 1 PJ3019.S67 1931; PJ2.C5 no.12.

A4.408. *Beiträge zur geschichte der Sinaiklosters im mittelalter nach arabischen quellen* / B. Moritz. Berlin: Verlag der Königl, akademie der wissenschaften, in kommission bei G. Reimer, 1918. 62 p. BR134.M67 1918.

A4.409. *Hebrew inscriptions: from the valleys between Egypt and Mount Sinai, in their original characters: with translations and an alphabet* / Samuel Sharpe. London: J. R. Smith, 1875–1876. 2 v. 492.76 Sh28.

A4.410. *The inscriptions of Sinai* / Alan H. Gardiner and T. Eric Peet. London: Egypt Exploration Society, 1917. 913.32 Eg95 v.36; *The inscriptions of Sinai* / Alan H. Gardiner and T. Eric Peet. London: Egypt Exploration Society, 1952–1955. 2 v. 913.32 Eg95 v.45. See also *The inscriptions of Sinai* [electronic resource] / Alan H. Gardiner and T. Eric Peet. Worcester: Yare Egyptology, 2006. CD-ROM. DT57.E32 mem.36 2006.

A4.411. *Les inscriptions protosinaitiques* / J. Leibovitch. Le Caire: Impr. de l'Institut français d'archéologie orientale, 1934. 107 p. DT43.I625 1934; 913.32 C127.2.1 t.24.

A4.412. *The Israelitish authorship of the Sinaitic inscriptions: vindicated against the incorrect "observations" in the "Sinai and Palestine" of the Rev. Arthur Penrhyn Stanley; a letter to the Right Honourable the Lord Lyndhurst* / Charles Forster. London: Richard Bentley, 1856. 98 p. PJ5034.9.F67 1856.

A4.413. *Die ḳenitischen Weihinschriften der Hyksoszeit im Bergbaugebiet der Sinaihalbinsel und einige andere unbekannte Alphabetdenkmäler aus der Zeit der XII. bis XVIII. Dynastie: eine schrift- und kulturgeschichtliche Untersuchung* / Robert Eisler. Freiburg im Breisgau: Herdersche Verlagshandlung, 1919. 179 p. PJ1526.S3 E57 1919; P211.E58.

A4.414. *The one primeval language: traced experimentally through ancient inscriptions in alphabetic characters of lost powers from the four continents: including the voice of Israel from the rocks of Sinai* / Charles Forster. London: R. Bentley, 1851. PJ3021.F675 1851.

A4.415. *Rock inscriptions and graffiti project: catalogue of inscriptions* / Michael E. Stone. Atlanta: Scholars Press, 1992–1994. 3 v. CN753.P19 R6 1992.

A4.416. *Sinai photographed, or, Contemporary records of Israel in the wilderness* / Charles Forster. London: Richard Bentley . . . publisher in ordinary to Her Majesty, 1862. 352, 26 p. DS110.5.F67 1862.

A4.417. *Sinaischrift und griechisch-lateinisches alphabet, ursprung und ideologie* / I. Zoller. Trieste: Selbstverlag, 1925. 68 p. P211.Z6 1925.

A4.418. *Der Sinaikult in heidnischer Zeit* / B. Moritz. Berlin: Weidmann, 1916. 64 p. PJ3085.M6 1916.

Egyptian—Sudan—Temple of Semna

A4.419. *The inscription of Queen Katimala at Semna: textual evidence for the origins of the Napatan State* / John Coleman Darnell. New Haven: Yale Egyptological Seminar; Oakville, CT: David Brown Book, 2006. 112 p. PJ1526.N37 D37 2006.

Egyptian—Tanis—Papyri

A4.420. *Two hieroglyphic papyri from Tanis* [electronic resource]. Worcester: Yare Egyptology, 2004. CD-ROM. Desk DT57 .E32 mem.9 2004.

Egyptian—Tell el-Amarna

A4.421. *Akhenaten and Tutankhamun: revolution and restoration* / David P. Silverman, Josef W. Wegner, and Jennifer Houser Wegner. Philadelphia: University of Pennsylvania Museum of Archaeology and Anthropology, 2006. 196 p. DT87.4 .S55 2006.

Egyptian—Tell el-Maskhuta

A4.422. *Ptolémée Philadelphe et les prêtres d'Atoum de Tjékou: nouvelle édition commentée de la "stèle de Pithom" (CGC 22183)* / Christophe Thiers. Montpellier: Université Paul-Valéry Montpellier III, 2007. 257 p. PJ1526.M3 T454 2007.

Egyptian—Thebes

A4.423. *Et maintenant ce ne sont plus que des villages: Thèbes et sa région aux époques hellénistique, romaine et byzantine: actes du colloque tenu à Bruxelles les 2 et 3 décembre 2005* / Alain Delattre and Paul Heilporn. Bruxelles: Association égyptologique Reine Elisabeth, 2008. 201 p. DT73.T3 E86 2008.

A4.424. *Ostraka and name stones from the tomb of Sen-Müt (no. 71) at Thebes* / William C. Hayes. New

York: Metropolitan Museum of Art, 1942. 57, 21 p. 913.32 N488 v.15.

A4.425. *Siut-Theben: zur Wertschätzung von Traditionen im alten Ägypten* / Jochem Kahl. Leiden; Boston: Brill, 1999. 401 p. DT61 .K3 1999.

A4.426. *Six temples at Thebes* [electronic resource] / W. M. Flinders Petrie. Worcester: Yare Egyptology, 2004. CD-ROM. Desk DT73.T3 P4 2004.

A4.427. *Thebanische Tempelinschriften aus griechisch-römischer Zeit* / Kurt Heinrich Sethe. Berlin: Akademie Verlag, 1957. 893 Ur45 Bd.8 hft.1.

A4.428. *The tomb of Nakht at Thebes* [electronic resource] / Norman de Garis Davies. Worcester: Yare Egyptology, 2006. DT73.T3 D3 2006.

A4.429. *The tomb of Puyemre at Thebes* [electronic resource] / Norman de Garis Davies. Worcester: Yare Egyptology, 2007. DT73.T3 D33 2007.

A4.430. *The tomb of Tjanefer at Thebes* / Keith C. Seele. Chicago: University of Chicago Press, 1959. 10 p. PJ1565 .S44 1959.

Egyptian—Thebes—Tombs

A4.431. *The tomb of Emenemhet* [electronic resource]: (no. 82) / Nina de Garis Davies and Alan H. Gardiner. Worcester: Yare Egyptology, 2004. DT73. T3 T5 no.1 2006.

Egyptian—Translation—English

A4.432. *Ramesside inscriptions. Translated and annotated. Notes and comments* / K. A. Kitchen. Cambridge: Blackwell, 1994. 3 v. PJ1521 .K58133 1994.

A4.433. *Ramesside inscriptions. Translated and annotated. Translations* / K. A. Kitchen. Oxford; Cambridge: Blackwell, 1993. 5 v. PJ1521 .K5813 1993.

Egyptian—Translation—German

A4.434. *Ein ptolemäisches Priesterdekret aus dem Jahr 186 v. Chr.: eine neue Version von Philensis II in Kairo* / Mamdouh Eldamaty. München: Saur, 2005. 92, 10 p. PJ1531.P55 P76 2005.

Egyptian—Trimithis

A4.435. *Ostraka from Trimithis* / Roger S. Bagnall and Giovanni R. Ruffini. New York: New York University Press: Institute for the Study of the Ancient World, 2012. PA3371 .B34 2012.

Egyptian—University of Chicago—Oriental Institute—Epigraphic Survey—Catalogs

A4.436. *The registry of the photographic archives of the Epigraphic Survey* / Epigraphic Survey. Chicago: Oriental Institute of the University of Chicago, 1995. 189 p. PJ2.C5 no.27.

Egyptian—Wadi el-Hol

A4.437. *Results of the 2001 Kerak Plateau Early Bronze Age survey* / Meredith S. Chesson. *Two early alphabetic inscriptions from the Wadi el-Hol: new evidence for the origin of the alphabet from the western desert of Egypt* / John Coleman Darnell. Boston: American Schools of Oriental Research, 2006. 124 p. DS101.A45 v.59.

Elamite—Cuneiform

A4.438. *Die Achämenideninschriften Zweiter Art* / F. H. Weisbach. Leipzig: Zentralantiquariat der Deutschen Demokratischen Republik, 1979. 126 p. P943.A5 W4 1979. Supersedes: *Die Achämenideninschriften zweiter art* / F. H. Weisbach. Leipzig: J. C. Hinrichs, 1890. 126 p. 495.95 W437.2.

A4.439. *Abridged grammars of the languages of the cuneiform inscriptions, containing: I. A Sumero-Akkadian grammar. II. An Assyro-Babylonian grammar. III. A Vannic grammar. IV. A Medic grammar. V. An Old Persian grammar* / George Bertin. London: Trübner & Co., 1888. 117 p. PJ4013 .B4 1888.

A4.440. *Corpus inscriptionum Elamicarum* / Ferdinand Bork and Georg Hüsing: 1. *Die altelamischen* / Wilhelm König. Hannover, Orient-Buchhandlung Heinz Lafaire, 1925. 30 p. P943 .A2 1975.

A4.441. *Drei altelamische Stelen* / Friedrich Wilhelm König. Leipzig: J. C. Hinrichs, 1925. 48 p. DS41 .V8 Bd.30.

A4.442. *Die elamischen Königsinschriften* / Friedrich Wilhelm König. Graz: Im Selbstverlage des Herausgebers, 1965. 248 p. P943 .A2 1965.

A4.443. *Elamische Studien* / G. Hüsing. Berlin: W. Pieser, 1898. 42 p. DS41 .V8 v.3; DS41 .V8 Bd.3 hft.7.

A4.444. *Eléments de grammaire élamite* / Françoise Grillot-Susini. Paris: Editions Recherche sur les civilisations, 1987 [1988]. 79 p. for Adv Judaic Studies Lib P943 .G75 1987; P943 .G75 1988.

A4.445. *Les inscriptions de la Perse achéménide* / *traduit du vieux perse, de l'élamite, du babylonien et de l'araméen* / Pierre Lecoq. Paris: Gallimard, 1997. 327, 16 p. PK6128.A1 L43 1997.

A4.446. *The sculptures and inscription of Darius the Great on the rock of Behistûn in Persia: a new collation of the Persian, Susian, and Babylonian texts, with English translations.* London: British Museum, 1907. 223 p. 891.5 D244.

A4.447. *Syllabaire elamite: histoire et paleographie* / M.-J. Steve. Neuchâtel: Recherches et Publications, 1992. 172 p. P943 .S7 1992.

A4.448. *Textes élamites-sémitiques* / V. Scheil. Paris: E. Leroux; Chalon-sur-Laône, Impr. E. Bertrand, 1900. DS261 .F8 1900: v.2, 4, 6, 10, 14; DS261 .F8 1900: v.1–10, 12–17, 19–30, 36.

A4.449. *Zur entzifferung der altelamischen inschriften* / Carl Frank. Berlin: Akademie der Wissenschaften, in Kommission bei Georg Reimer, 1912. 55 p. 495.95 F857.

A4.450. *Phonology and morphology of royal Achaemenid Elamite* / Herbert H. Paper. Ann Arbor: University of Michigan Press, 1955. 119 p. Center for Advanced Judaic Studies Lib P943 .P3 1955.

Elamite—Iran

A4.451. *Les inscriptions de la Perse achéménide / traduit du vieux perse, de l'élamite, du babylonien et de l'araméen* / Pierre Lecoq. Paris: Gallimard, 1997. 327, 16 p. PK6128.A1 L43 1997.

Elamite—Iran—Elam

A4.452. *Die einheimischen Quellen zur Geschichte Elams* / Georg Hüsing. Leipzig: J. C. Hinrichs, 1916. Ctr for Adv Judaic Studies P943 .H8 1916.

Elamite—Cuneiform—Iran—Persepolis

A4.453. *L'Archive des Fortifications de Persépolis: état des questions et perspectives de recherches: actes du colloque organisé au Collège de France par la "Chaire d'histoire et civilisation du monde achéménide et de l'empire d'Alexandre" et le "Réseau international d'études et de recherches achéménides" (GDR 2538 CNRS), 3–4 novembre 2006* / Pierre Briant, Wouter Henkelman, and Matthew W. Stolper. Paris De Boccard, 2008. 576 p. PJ3721.P4 A73 2008.

A4.454. *Persepolis fortification tablets* / Richard T. Hallock. Chicago: University of Chicago Press, 1969. 776 p. P943 .H25 1969.

A4.455. *Persepolis treasury tablets* / George G. Cameron. Chicago: University of Chicago Press, 1948. 216, 46 p. P943 .C36 1948.

A4.456. *Quelques nouvelles observations sur les documents économiques Élamitfs de Persépolis* / V.

O. Tiourine. Moskau: Édition de Littérature Orientale, 1960. 14 p. PK6129 .T56 1960.

A4.457. *Seals on the Persepolis fortification tablets* / Mark B. Garrison and Margaret Cool Root. Chicago: Oriental Institute, University of Chicago, 2001. CD5391 .G37 2001.

Elamite—Cuneiform—Iran—Susa

A4.458. *Nouveaux mélanges épigraphiques: inscriptions royales de Suse et de la Susiane: ville royale de Suse 7* / M.-J. Steve. Nice: Editions Serre, 1987. 111 p. DS261 .F8 t.53.

Eblaite

A4.459. *Old Canaanite cuneiform texts of the third millennium* / Giovanni Pettinato. Malibu: Undena Publications, 1976. 17 p. DS99.E25 P47213.

Etruscan

A4.460. *Mediterranean studies* / George Hempl. New York: AMS Press, 1967. 3 v. AS36 .L55 v.5 1967.

Etruscan—Catalogs

A4.461. *Etruscan inscriptions from the collections of Olof August Danielsson: addenda to CIE II, I, 4* / Charlotte Wikander and Örjan Wikander. Stockholm: Almqvist & Wiksell, 2003. 162 p. CN479 .W553 2003.

A4.462. *Oggetti iscritti di epoca orientalizzante in Etruria* / Giovanna Bagnasco Gianni. Firenze: L. S. Olschki Editore, 1996. 504 p. PA2391 .B5 no.30.

A4.463. *Saggio di lingua etrusca e di altre antiche d'Italia,: per servire alla storia de' popoli, delle lingue, e delle belle arti* / Luigi Lanzi. Roma: Nella stamperia Pagliarini, 1789. 3 v. P1078 .L36 1789.

Etruscan—Italy—Bolsena

A4.464. *Epigrafia di Bolsena etrusca* / Alessandro Morandi. Roma: L'Erma di Bretschneider, 1990. 126 p. CN479 .M67 1990.

Etruscan—Italy—Capua

A4.465. *Tabula Capuana: un calendario festivo di età arcaica* / Mauro Cristofani. Firenze: L. S. Olschki, 1995. 136, 21 p. PA2391 .B5 no.29.

Etruscan—Italy—Cortona

A4.466. *Tabula cortonensis* / Luciano Agostiniani and Francesco Nicosia. Roma: L'Erma di Bretschneider, 2000. 175 p. CN479 .A38 2000.

Etruscan—Italy—Etruria

A4.467. *Le tavole iguvine* / Aldo Prosdocimi. Firenze: L. S. Olschki, 1984. CN479 .P76 1984.

Etruscan—Italy—Perugia

A4.468. *Il Sepolcro dei Volunni scoperto in Perugia nel febbrajo del 1840: ed altri monumenti inediti etruschi e romani . . .* / Gio. Battista Vermiglioli. Perugia: Bartelli, 1840? 60 p. Rare Bk & Ms 913.45 V595.

Etruscan—Italy—Pyrgi

A4.469. *Lamine di Pyrgi e Cippo Etrusco di Perugia* / Alberto Ettore Santangelo. Milano: Proprietà Letteraria Riservata, 2008. 70 p. CN479 .S26 2008.

A4.470. *Le lamine di Pyrgi: la bilingue etrusco-fenicia e il problema delle origini etrusche* / Sergio Battaglini. Roma: Il Calamo, 2001. 86 p. CN479 .B383 2001.

Etruscan—Italy—Rubiera

A4.471. *Le iscrizioni etrusche dei cippi di Rubiera* / Carlo de Simone. Reggio Emilia: Comune di Reggio Emilia, Assessorato alle istituzioni culturali, 1992. 25 p. CN479 .D4 1992.

Etruscan—Italy—Tarquina

A4.472. *The cippus inscriptions of Museo nazionale di Tarquinia* / Jorma Kaimio. Roma: G. Bretschneider, 2010. 217 p. CN537.T3 K355 2010.

Gaulish

A4.473. *La langue gauloise: description linguistique, commentaire d' inscriptions choisies* / Pierre-Yves Lambert. Paris: Editions Errance, 1995. 239 p. PB3009 .L36 1995.

A4.474. *Les Gaulois, leurs écrits retrouvés: "Merde à César"* Jean-Paul Savignac. Paris: Editions de La Différence, 1994. 186 p. CN825 .G38 1994.

A4.475. *Zur Lesung und Deutung gallischer Inschriften* / Wolfgang Meid. Innsbruck: Institut für Sprachwissenschaft der Universität Innsbruck, 1989. 47 p. CN825 .M443 1989.

A4.476. *Recueil des inscriptions gauloises* / Paul-Marie Duval. Paris: Éditions du Centre National de la Recherche Scientifique, 1985. 4 v. CN825 .R43 1985.

A4.477. *Gallisch oder Lateinisch?: soziolinguistische und andere Bemerkungen zu populären gallo-lateinischen Inschriften* / Wolfgang Meid. Innsbruck: Institut für Sprachwissenschaft der Universität Innsbruck, 1980. 40 p. PB3006 .M4.

Gaulish—France—Millau—Graufesenque

A4.478. *Les graffites de la Graufesenque* / Robert Marichal. Paris: Editions du Centre National de la Recherche Scientifique, 1988. 286 p. NK3850 .M327 1988.

Georgian—Egypt—Sinai

A4.479. *Armenian inscriptions from Sinai: intermediate report with notes on Georgian and Nabatean inscriptions* / Michael E. Stone. Sydney: Maitland Publications, 1979. 21 p. CN1311.S56 A74 1979.

Greek

A4.480. *Die Abkürzung der Homonymität in griechischen Inschriften* / Reinhard Koerner. Berlin: Akademie-Verlag, 1961. 137 p. 63 B456 1961 nr.2.

A4.481. *Bemerkungen zu griechischen Inschriften* / Günter Dunst. Berlin: Akademie-Verlag, 1960. 52 p. 63 B456 1960 nr.1.

A4.482. *Initiation à l'épigraphie grecque et latine* / Bernard Rémy and François Kayser. Paris: Ellipses, 1999. 192 p. CN350 .R459 1999.

A4.483. *Sailing to classical Greece: papers on Greek art, archaeology and epigraphy presented to Petros Themelis* / Olga Palagia and Hans Rupprecht Goette. Oxford; Oakville, CT: Oxbow Books, 2011. 109 p. DF77.S148 2011.

A4.484. *Une défixion judiciaire au Musée d'Istanbul* / Paul Moraux. Bruxelles: Palais des Académies, 1960. 61 p. 69 Ac1425 t.54 fasc.2.

A4.485. *Varia epigraphica* / Günther Klaffenbach. Berlin: Akademie-Verlag, 1958. 31 p. 63 B456.2 1958 nr.2.

Greek—Aeolis

A4.486. *Researches in Lydia, Mysia and Aiolis* / Hasan Malay. Wien: Verlag der Österreichischen Akademie der Wissenschaften, 1999. 196, 179 p. AS142 .V32 Bd.279.

Greek—Africa, North

A4.487. *Les dédicaces d'ouvrages de défense dans l'Afrique byzantine* / Jean Durliat. Rome: École française de Rome, 1981. 123 p. UG435.B8 D77.

Greek—Albania—Apollonia

A4.488. *Grecs et Illyriens dans les inscriptions en langue grecque d'Epidamne-Dyrrhachion et d'Apollonia d'Illyrie: actes de la table ronde internationale, Clermont-Ferrand, 19–21 octobre 1989* / Pierre Cabanes. CN398.A43 G74 1993.

Greek—Albania—Durrës

A4.489. *Grecs et Illyriens dans les inscriptions en langue grecque d'Epidamne-Dyrrhachion et d'Apollonia d'Illyrie: actes de la table ronde internationale, Clermont-Ferrand, 19–21 octobre 1989* / Pierre Cabanes. CN398.A43 G74 1993.

Greek—Aphrodisias

A4.490. *Jews and godfearers at Aphrodisias: Greek inscriptions with commentary* / Joyce Reynolds and Robert Tannenbaum. Cambridge: Cambridge Philological Society, 1987. 149 p. CN415.A6 R49.

Greek—Cyprus

A4.491. *Sechs phönikische Inschriften aus Idalion* / Julius Euting. Strassburg: K. J. Trübner, 1875. 17 p. 492.71 Eu8.1.

Greek—Egypt—Sinai

A4.492. *The inscriptions of Wadi Haggag, Sinai* / Avraham Negev. Jerusalem: Institute of Archaeology, Hebrew University, 1977. 100 p. PJ5239 .N43.

Greek—Greece—Acamania

A4.493. *Inscriptiones Graeciae septentrionalis volvminibvs VII et VIII*. Berolini, apvd Georgivm Reimervm, 1897–1908. 2 v. CN360 .I6 vol.9.

Greek—Greece—Aegean Islands

A4.494. *Inscriptiones insvlarum maris Aegaei praeter Delvm*. Berolini, apvd Georgivm Reimervm, 1895–1939. CN360 .I6 vol.12.

Greek—Greece—Aetolia

A4.495. *Inscriptiones Graeciae septentrionalis volvminibvs VII et VIII*. Berolini, apvd Georgivm Reimervm, 1897–1908. 2 v. CN360 .I6 vol.9.

Greek—Greece—Arcadia

A4.496. *Inscriptiones Laconiae, Messeniae, Arcadiae . . ., Consilio et avctoritate Academiae litterarvm regiae borvssicae*. Berolini, apvd Georgivm Reimervm, 1913. 2 v. CN360 .I6 vol.5.

Greek—Greece—Athens

A4.497. *Cyriacus of Ancona and Athens* / Edward W. Bodnar. Bruxelles-Berchem: Latomus, 1960. 255 p. 880C C687 v.43.

Greek—Greece—Athens—Athenian Agora—Catalogs

A4.498. *Inscriptions: the dedicatory monuments* / Daniel J. Geagan. Princeton: American School of Classical Studies at Athens, 2011. 425 p., 80 p. of plates. DF287.A23 A5 v.18.

Greek—Greece—Attiki

A4.499. *Lettered Attica: a day of Attic epigraphy: actes du Symposium d'Athènes, 8 mars 2000; avec un mémoire* / Johannes Kirchner. Athens: Canadian Archaeological Institute at Athens; Institut canadien d'archéologie à Athenes, 2003. 167 p. CN380. A8 A84 2000.

Greek—Greece—Hymettus Mountain

A4.500. *A sanctuary of Zeus on Mount Hymettos* / Merle K. Langdon. Princeton: American School of Classical Studies at Athens, 1976. 117, 14 p. DF221.H94 L36.

Greek—Greece—Ionian Islands

A4.501. *Inscriptiones Graeciae septentrionalis volvminibvs VII et VIII*. Berolini: Georgivm Reimervm, 1897–1908. 2 v. CN360 .I6 vol.9.

Greek—Greece—Lakonia

A4.502. *Inscriptiones Laconiae, Messeniae, Arcadiae . . ., Consilio et avctoritate Academiae litterarvm regiae borvssicae*. Berolini: Georgivm Reimervm, 1913. 2 v. CN360 .I6 vol.5.

Greek—Greece—Peloponnesus

A4.503. *Inscriptiones Laconiae, Messeniae, Arcadiae . . ., Consilio et avctoritate Academiae litterarvm regiae borvssicae.* Berolini: Georgivm Reimervm, 1913. 2 v. CN360 I6 vol.5.

A4.504. *Roman Peloponnese* / A. D. Rizakis and S. Zoumbaki. Athens: Kentron Hellenikes kai Romaikes Archaiotetos; Paris: Diffusion de Boccard, 2001. PA2343 .R59 2001.

Greek—Greece—Sicily—Messenia

A4.505. *Inscriptiones Laconiae, Messeniae, Arcadiae . . ., Consilio et avctoritate Academiae litterarvm regiae borvssicae.* Berolini: Georgivm Reimervm, 1913. 2 v CN360 .I6 vol.5.

Greek—Greece—Locris

A4.506. *Inscriptiones Graeciae septentrionalis volvminibvs VII et VIII.* Berolini: Georgivm Reimervm, 1897–1908. 2 v. CN360 .I6 vol.9.

Greek—Turkey—Lydia

A4.507. *Researches in Lydia, Mysia and Aiolis* / Hasan Malay. Wien: Verlag der Österreichischen Akademie der Wissenschaften, 1999. 196, 179 p. AS142 .V32 Bd.279.

Greek—Greece—Mycenae

A4.508. *Philokypros: mélanges de philologie et d'antiquités grecques et proche-oritentales: dédiés à la mémorie d'Olivier Masson* / Laurent Dubois and Emilia Masson. Salamanca: Universidad de Salamanca, 2000. 316 p. P1035 .M512 no.16.

Greek—Greece—Phocis

A4.509. *Inscriptiones Graeciae septentrionalis volvminibvs VII et VIII.* Berolini, apvd Georgivm Reimervm, 1897–1908. 2 v. CN360 .I6 vol.9.

Greek—Greece—Thessaly

A4.510. *Inscriptiones Graeciae septentrionalis volvminibvs VII et VIII.* Berolini, apvd Georgivm Reimervm, 1897–1908. 2 v. CN360 .I6 vol.9.

Greek—Greece—Crete

A4.511. *Philokypros: mélanges de philologie et d'antiquités grecques et proche-oritentales:* *dédiés à la mémorie d'Olivier Masson* / Laurent Dubois and Emilia Masson. Salamanca: Universidad de Salamanca, 2000. 316 p. P1035 .M512 no.16.

Greek—Greece—Delos Island—Indexes

A4.512. *Inscriptions de Délos. Index* / Jacques Tréheux. Paris: Diffusion de Boccard, 1992. CN380.D4 I5 1992.

Greek—Greece—Myceneae

A4.513. *Philokypros: mélanges de philologie et d'antiquités grecques et proche-oritentales: dédiés à la mémorie d'Olivier Masson* / Laurent Dubois and Emilia Masson. Salamanca: Universidad de Salamanca, 2000. 316 p. P1035 .M512 no.16.

Greek—Malta

A4.514. *De inscriptione Melitensi Phoenico-Graeca: commentatio quam pro magisterii honoribus inter publica ob auspicatissimas celsissimorum principum Friderici Caroli Christiani et Guilelmae Mariae nuptias gaudia: rite obtinendis publico eruditorum examini in auditorio Collegii Elersiani, d. VII Nov. h. X.* / Jac. Chr. Lindberg. Havniae: Fabritius de Tengnagel, 1828. 92, 6 p. PJ4191 .L55 1828a.

Greek—Nubia

A4.515. *The rock inscriptions of lower Nubia (Czechoslovak concession)* / Zbyněk Žáb. Prague: Universita Karlova, 1974. 351, 229 p. GN865.N82 Z273.

Greek—Syria

A4.516. *Dédicaces faites par des dieux (Palmyre, Hatra, Tyr) et des thiases sémitiques à l'époque romaine* / J. T. Milik. Paris: Geuthner, 1972. 486 p. CN1153 .M598 1972.

A4.517. *Some interesting Syrian and Palestinian inscriptions* / J. Rendel Harris. London: C. J. Clay, 1891. 35 p. CN1190 .H37 1891; 378.73 H29M no.9–12.

Greek—Turkey—Gallipoli Peninsula

A4.518. *Die Inschriften von Sestos und der thrakischen Chersones* / Johannes Krauss. Bonn: Habelt, 1980. 123 p. CN415.S46 I57.

Greek—Turkey—Mysia

A4.519. *Researches in Lydia, Mysia and Aiolis* / Hasan Malay. Wien: Verlag der Öterreichischen Akademie der Wissenschaften, 1999. 196, 179 p. AS142 .V32 Bd.279.

Greek—Turkey—Sestos

A4.520. *Die Inschriften von Sestos und der thrakischen Chersones* / Johannes Krauss. Bonn: Habelt, 1980. 123 p. CN415.S46 I57.

Hadrami—Yemen

A4.521. *Carnegie Museum 1974–1975 Yemen expedition* / Albert Jamme. Pittsburgh: Carnegie Museum of Natural History, 1976. 224, 11 p. PJ6971 .J28.

A4.522. *Miscellanées d'ancient arabe* / A. Jamme. Washington, DC: Jamme, 1971. 11 v. PJ6953 .J3.

A4.523. *A propos des rois ḥaḍramoutiques de al-Uqlah* / A. Jamme. Washington, DC: A. Jamme, 1965. 53 p. PJ6971 .J27 1965.

A4.524. *The al-Uqlah texts* / A. Jamme. Washington, DC: Catholic University of America Press, 1963. 76 p. 492.85 J247.2; PJ6971 .J3.

Hebrew—Afghanistan

A4.525. *Die jüdisch-persisch-hebräischen Inschriften aus Afghanistan* / Eugen L. Rapp. München In Kommission bei J. Kitzinger 1965. 77 p. 492.1237 R188.

Hebrew—Afghanistan—Gur

A4.526. *Le iscrizioni giudeo-persiane del Gur (Afghanistan)* / G. Gnoli. Roma: Istituto italiano per il medio ed estremo Oriente, 1964. 70 p. PJ3091 .G6 1964.

Hebrew—Africa, North

A4.527. *Un voyage d'études juives en Afrique* / M. N. Slouschz. Paris: Imprimarie Nationale, 1909. 87 p. DS135.A25 S62 1909.

Hebrew—Cyrenaica—Indexes

A4.528. *Jewish inscriptions of Graeco-Roman Egypt: with an index of the Jewish inscriptions of Egypt and Cyrenaica* / William Horbury and David Noy. Cambridge; New York: Cambridge University Press, 1992. 378, 32 p. PJ5034.8.E3 H67 1992.

Hebrew—Egypt—Indexes

A4.529. *Jewish inscriptions of Graeco-Roman Egypt: with an index of the Jewish inscriptions of Egypt and Cyrenaica* / William Horbury and David Noy. Cambridge; New York: Cambridge University Press, 1992. 378, 32 p. PJ5034.8.E3 H67 1992.

Hebrew—Egypt—Sinai

A4.530. *Die altsinaitischen buchstaben-inschriften auf grund einer untersuchung der originale* / Hubert Grimme. Berlin: Reuther & Reichard, 1929. 134, 2 p. PJ5034.8 .E58 1929.

A4.531. *Die althebräischen Inschriften vom Sinai und ihre historische Bedeutung* / Daniel Völter. Leipzig: J. C. Hinrichs, 1924. 56 p. PJ5034.8.S5 V64 1924.

Hebrew—Indexes, Reverse

A4.532. *Retrograde Hebrew and Aramaic dictionary* / Ruth Sander and Kerstin Mayerhofer. Göttingen: Vandenhoeck & Ruprecht, 2010. 258 p. PJ4825 .S36 2010.

Hebrew—Jordan—Ghur

A4.533. *Le iscrizioni giudeo-persiane del Gur, Afganistan* / G. Gnoli. Roma: Istituto italiano per il Medio ed Estremo Oriente, 1964. 70 p. PJ5034.8.A3 G5.

Hebrew—Numismatics

A4.534. *Hebrew bullae from the time of Jeremiah: remnants of a burnt archive* / Nahman Avigad. Jerusalem: Israel Exploration Society, 1986. 139 p. CD5354 .A843 1986.

Hebrew—Israel and the Palestinian Territories

A4.535. *The invention of Hebrew* / Seth L. Sanders. Urbana: University of Illinois Press, 2009. 258 p. PJ4545 .S26 2009.

Hebrew—Israel and the Palestinian Territories—Arad

A4.536. *Arad inscriptions* / Yohanan Aharoni. Jerusalem: Israel Exploration Society, 1981. 200 p. PJ5034.8.I8 A313 1981.

A4.537. *Ketovot Arad* / Y. Aharoni. Yerushalayim: Mosad Byaliḳ, 1975. 221 p. PJ5034.I8 A3.

Hebrew—Israel and the Palestinian Territories—Bibliography

A4.538. *Hebrew inscriptions: a classified bibliography* / Robert W. Suder. Selinsgrove: Susquehanna University Press, 1984. 170 p. PJ5034.4 .S92 1984.

Hebrew—Israel and the Palestinian Territories—Concordances

A4.539. *Ancient Hebrew inscriptions: corpus and concordance* / G. I. Davies. Cambridge; New York: Cambridge University Press, 1991–2004. 2 v. PJ5034.8.P3 D38 1991.

Hebrew—Israel and the Palestinian—Grammar

A4.540. *A grammar of epigraphic Hebrew* / Sandra Landis Gogel. Atlanta: Scholars Press, 1998. 522 p. PJ4564 .G69 1998.

Hebrew—Israel and the Palestinian Territories—Mount Gerizim

A4.541. *Aramaic and Hebrew inscriptions from Mt. Gerizim and Samaria between Antiochus III and Antiochus IV Epiphanes* / Jan Dusek. Leiden; Boston: Brill, 2012. PJ5208.A5 D87 2012.

Hebrew—Israel and the Palestinian Territories—Numismatics

A4.542. *I superstiti della deportazione sono là nella provincia (Neemia 1,3)* / Francesco Bianchi. Napoli: Instituto orientale di Napoli, 1993. CD5354 .B53 1993.

Hebrew—Israel and the Palestinian Territories—Orthography

A4.543. *Matres lectionis in ancient Hebrew epigraphs* / Ziony Zevit. Cambridge: American Schools of Oriental Research, 1980. 43 p. PJ4583 .Z48 1980.

Hebrew—Israel and the Palestinian Territories—Ostraka

A4.544. *Inscriptions hébraïques* / André Lemaire. Paris: Cerf, 1977. PJ5034.8.P3 L4.

Hebrew—Israel and the Palestinian Territories—Palestine

A4.545. *Althebräische Inschriften transkribiert* / Wolfgang Richter. St. Ottilien: EOS-Verlag, 1999. 118 p. PJ5034.8.P3 R535 1999.

A4.546. *Handbuch der althebräischen Epigraphik* / Johannes Renz and Wolfgang Röllig. Darmstadt: Wissenschaftliche Buchgesellschaft, 1995. 3 v. PJ5034.8.P3 R46 1995.

A4.547. *Le iscrizioni antico-ebraiche palestinesi* / David Diringer. Firenze: F. Le Monnier, 1934. 361 p. AS222 .F5 1934.

A4.548. *Palestine inscriptions* / Th. C. Vriezen and J. H. Hospers. Leiden: E. J. Brill, 1951. 40 p. Box 1 PJ5034.8.P35 V7 1951; 492.7 V9631.

A4.549. *Schrift und Schreibertradition: eine paläographische Studie zum kulturgeschichtlichen Verhältnis von israelitischem Nordreich und Südreich* / Johannes Renz. Wiesbaden: Harrassowitz, 1997. 111 p. PJ5034.8.P3 R45 1997.

A4.550. *Sur la pierre et l'argile; inscriptions hébraïques et Ancien Testament* / Henri Michaud. Neuchatel: Delachaux et Niestlé, 1958. 127 p. 913.569 M583.

Hebrew—Israel and the Palestinian Territories—Sabastiyah

A4.551. *Aramaic and Hebrew inscriptions from Mt. Gerizim and Samaria between Antiochus III and Antiochus IV Epiphanes* / Jan Dusek. Leiden; Boston: Brill, 2012. PJ5208.A5 D87 2012.

Hebrew—Israel and the Palestinian Territories—Samaria

A4.552. *Aramaic and Hebrew inscriptions from Mt. Gerizim and Samaria between Antiochus III and Antiochus IV Epiphanes* / Jan Dusek. Leiden; Boston: Brill, 2012. PJ5208.A5 D87 2012.

Hittite—Turkey

A4.553. *Aspetti della regalità ittita nel XIII secolo a.C.* / Mauro Giorgieri and Clelia Mora. Como: New Press, 1996. 124 p. DS66 .G56 1996.

A4.554. *Corpus inscriptionum Hettiticarum* / L. Messerschmidt. Berlin: Zu beziehen durch W. Peiser, 1900–1906. 2 v. P945 .M4 1900; DS41 .V8 v.7, DS41 .V8 v.11.

A4.555. *Hattusilis, der Bericht über seine Thronbesteigung nebst den Paralleltexten* / Albrecht Götze. Leipzig: J. C. Hinrichs, 1925. 140 p. DS41 .V8 Bd.29.

A4.556. *Die hethitisch-akkadische bilingue des Hattusili I. (Labarna II.)* / Ferdinand Sommer and Adam Falkenstein. München: Verlag der Bayerischen akademie der wissenschaften, in kommission bei der C. H. Beck'schen verlagsbuchhandlung München, 1938. 288 p. AS182 .M8175 n.F. hft.16.

A4.557. *Hethitische Gelübde und Traumtexte sowie Rituale und Festbeschreibungen* / Horst Klengel. Berlin: Akademie-Verlag, 1986. 10, 50 p. PJ3721.B6 K4 hft.56.

A4.558. *Hethitische Götter nach Bildbeschreibungen in Keilschrifttexten* / Carl G. von Brandenstein. Leipzig: J. C. Hinrichs, 1943. 104 p. DS41 .V8 bd.46 hft.2.

A4.559. *Hethitische Orakeltexte* / Alfonso Archi. Berlin: Akademie-Verlag, 1979. PJ3721.B6 K4 v.49.

A4.560. *Die hettitische Inschrift, gefunden in der Königsburg von Babylon am 22. August 1899* / Robert Koldewey. Leipzig: J. C. Hinrichs, 1900. 8 p. 913.01 B458.

A4.561. *Die hetitischen Inschriften, Ein versuch ihrer entzifferung nebst einer das weitere studium vorbereitenden, methodisch geordneten ausgabe* / F. E. Peiser. Berlin: W. Peiser, 1892. 128, 6 p. P945 .P4 1892a.

A4.562. *Hethitische Keilschrift-Paläographie* / Christel Rüster. Wiesbaden: O. Harrassowitz, 1972. 42 p. P945.S65 hft.20.

A4.563. *Hethitische Keilschrift-Paläographie II: (14./13. Jh. v. Chr.)* / Erich Neu and Christel Rüster. Wiesbaden: Harrassowitz, 1975. 40 p.

A4.564. *Das hethitische nuntarriyasha-Fest* / Mitsuo Nakamura. Leiden: Nederlands Instituut voor het Nabije Oosten, 2002. 439 p. P945 .A2 2002.

A4.565. *Hethitische Rituale und Festbeschreibungen* / Maciej Popko. Berlin: Akademie-Verlag, 1988. 10, 50 p. PJ3721.B6 K4 hft.58.

A4.566. *Hittite hieroglyphic monuments* / Ignace J. Gelb. Chicago: University of Chicago Press, 1939. 40 p. P945 .A2 1939.

A4.567. *Hittite inscriptions, certain newly discovered inscriptions, together with revised copies of a number hitherto known and still in situ, representing a portion of the results of the Cornell expedition to Asia Minor and the Assyro-Babylonian Orient* / Benson Bush Charles. Ithaca, 1911. 49 p. P945 .C4 1911; 378.748 POP1910.12; 913.351 C382.

A4.568. *The Hittites* / A. E. Cowley. London: British Academy by H. Milford, Oxford University Press, 1920. 94 p. DS66 .C68 1920.

A4.569. *The Hittites: their inscriptions and their history* / John Campbell. London: J. C. Nimmo, 1891. 2 v. 939.45 C153.

A4.570. *Identité et altérité culturelles: le cas des Hittites dans le Proche-Orient ancien: actes de colloque, Université de Limoges, 27–28 novembre 2008* / Isabelle Klock-Fontanille, Séverine Biettlot, and Karine Meshoub. Bruxelles: Safran, 2010. 237 p. DS57 .I34 2010.

A4.571. *Les inscriptions hittites hiéroglyphiques; essai de déchiffrement, suivi d'une grammaire hittite hiéroglyphique en paradigmes et d'une liste d'hiéroglyphes* / Bedrich Hrozný. Praha: Orientální ústav. 1933–1937. 3 v. 491.541 H858.2.

A4.572. *Istanbul arkeoloji müzelerinde bulunan Bogazköy tabletlerinden secme metinler* / Hatice H. Bozkurt, M. Cig, and H. G. Güterborck. Istanbul: Maarif matbaasi, 1944–1947. 2 v. P945 .B66.

A4.573. *Kleine beiträge zur churritischen grammatik* / Johannes Friedrich. Leipzig: J. C. Hinrichs verlag, 1939. 67 p. P945 .F87 1939; DS41 .V8 Bd.42.

A4.574. *Die längsten bauinschriften in "hethitischen" hieroglyphen nebst glossar zu sämtlichen texten* / Piero Meriggi. Leipzig: J. C. Hinrichs'sche buchhandlung, 1934. 177 p. DS41 .V8 Bd.39.

A4.575. *Mémorial Atatürk: études d'archéologie et de philologie anatoliennes* / Institut français d'études anatoliennes. Paris: Editions Recherche sur les civilisations, 1982. 107 p. P945 .M38 1982.

A4.576. *Neue Bruchstücke zum grossen Text des Hattusilis und den Paralleltexte* / Albrecht Götze. Leipzig: J. C. Hinrichs, 1930. 88 p. G945 .G68 1930; DS41 .V8 Bd.34.

A4.577. *Staatsverträge des Hatti-Reiches in hethitischer Sprache* / Johannes Friedrich. Leipzig: J. C. Hinrichs'sche, 1926–1930. 2 v. P945 .A2 1926.

A4.578. *Travels and studies in the nearer East* / A. T. Olmstead, B. B. Charles, and J. E. Wrench. Ithaca, 1911. 49 p. 913.392 C814; P945 .T73.

A4.579. *Der Ulmitešub-Vertrag: eine prosopographische Untersuchung* / Theo van den Hout. Wiesbaden: Harrassowitz Verlag, 1995. 326 p. P945.S65 hft.38.

A4.580. *Die 1986 in Bogazköy gefundene Bronzetafel: zwei Vorträge: 1. Ein hethitischer Staatsvertrag des 13. Jh. v. Chr. 2. Zu den rechtlichen und religiösen Grundlagen des hethitischen Königtums* / Heinrich Otten. Innsbruck: Institut für Sprachwissenschaft der Universität Innsbruck, 1989. 35 p. DS66 .O77 1989.

Hittite—Turkey—Bibliography

A4.581. *Catalogue des documents royaux hittites du IIe millénaire avant J.-C.* / Hatice Gonnet. Paris: Éditions du Centre National de la Recherche Scientifique, 1975. 24 p. CD5357 .G66.

Hittite—Turkey—Boghazköy-Hattusa

A4.582. *Die Annalen des Mursilis* / Albrecht Götze. Leipzig: J. C. Hinrichs, 1933. 329 p. P945.A3 A5 1933; DS41 .V8 Bd.38.

A4.583. *Ankara Arkeoloji Müzesinde bulunan Bogazköy tabletleri: Bogazköy-Tafeln im Archäologischen*

Museum zu Ankar / Kemal Balkan. Istanbul: Milli Egitim Basimevi, 1948. 36 p. P945 .A2 1948.

A4.584. *Bögazköy* / Kurt Bittel and Hans Gustav Güterbock. Berlin: Akademie der wissenschaften, in kommission bei W. de Gruyter u. co., 1935–1938. 2v. AS182 .B34 1938.

A4.585. *Die Bronzetafel aus Bogazkoy: ein Staatsvertrag Tuthalijas IV* / Heinrich Otten. Wiesbaden: O. Harrassowitz, 1988. 94, 14 p. P945 .O88 1988.

A4.586. *Das Hurritische: eine altorientalische Sprache in neuem Licht* / Erich Neu. Mainz: Akademie der Wissenschaften und der Literatur; Stuttgart: F. Steiner Verlag Wiesbaden, 1988. 48 p. AS182 .M232 1988 Nr.3.

A4.587. *Hethitische Keilschrifttexte aus Boghazköy* / Friedrich Hrozný. Leipzig: J. C. Hinrichs, 1919. 245 p. P945 .H76 1919.

A4.588. *Hethitische Rituale und Festbeschreibungen* / Horst Klengel. Berlin: Akademie-Verlag, 1973. 4 v. PJ3721.B6 K4 v.44; PJ3721.B6 K4 hft.44, etc.

A4.589. *Hethitische Rituale und Festbeschreibungen* / Liane Jakob-Rost. Berlin: Akademie-Verlag, 1989. 50 p. PJ3721.B6 K4 hft.59.

A4.590. *Hethitische Rituale und Festbeschreibungen* / Liane Jakob-Rost. Berlin: Akademie-Verlag, 1965. 7 p. PJ3721.B6 K4 1965.

A4.591. *Hethitische Texte in Transkription: IBoT 4* / Detlev Groddek. Wiesbaden: Harrassowitz, 2007. 258 p. P945 .A2 2007b.

A4.592. *Hethitische Texte in Transkription. KBo 22* / Detlev Groddek. Wiesbaden: Harrassowitz, 2008. 287 p. P945 .A2 2008.

A4.593. *Hethitische Texte in Transkription KBo 30* / Detlev Groddek. Dresden: Verlag der TU Dresden, 2002. 275 p. P945.A2 G762 2002.

A4.594. *Hethitische Texte in Transkription: KBo 35* / Detlev Groddek und Alwin Kloekhorst. Wiesbaden: Harrassowitz in Kommission, 2006. 353 p. P945. A2 G7625 2006.

A4.595. *Hethitische Texte in Transkription KBo 39* / Detlev Groddek. Dresden: Verlag der TU Dresden, 2004. 380 p. P945 .A2 2004.

A4.596. *Hethitische Texte in Transkription. KBo 44* / Hanna Roszkowska-Mutschler. Wiesbaden: Harrassowitz, 2007. 257 p. P945 .A2 2007.

A4.597. *Hethitische Texte in Transkription: KBo 45* / Hanna Roszkowska-Mutschler. Wiesbaden: Harrassowitz, 2005. 361 p. P945 .A2 2005.

A4.598. *Hethitische Texte in Transkription KBo 47* / Detlev Groddek. Wiesbaden: Harrassowitz Verlag, 2011. 257 p. P945 .A2 2011.

A4.599. *Hethitische Texte in Transkription KBo 50* / Detlev Groddek. Wiesbaden: Harrassowitz, 2008. 222 p. P945 .A2 2008b.

A4.600. *Hethitische Texte in Transkription KBo 54* / Detlev Groddek. Wiesbaden: Harrassowitz, 2010. 203 p. P945 .A2 2010.

A4.601. *Hethitische Texte in Transkription, KBo 57* / Detlev Groddek. Wiesbaden: Harrassowitz Verlag, 2011. 177 p. P945.A2 G764 2011.

A4.602. *Hethitische Texte in Transkription KUB 2* / Detlev Groddek. Wiesbaden: Harrassowitz, 2009. 112 p. P945 .A2 2009.

A4.603. *Hethitische Texte in Transkription KUB 20* / Detlev Groddek. Dresden: Verlag der TU Dresden, 2004. 188 p. P945.A2 G763 2004.

A4.604. *Hethitische Texte in Transkription KUB 51* / Detlev Groddek. Dresden: Verlag der TU Dresden, 2004. 160 p. P945.A2 G762 2004.

A4.605. *Hethitische Texte in Transkription KUB 58* / José Virgilio García Trabazo und Detlev Groddek. Wiesbaden: Harrassowitz in Kommission, 2005. 300 p. P945.A2 V574 2005.

A4.606. *Hethitische Texte in Transkription KUB 59* / Detlev Groddek. Dresden: Verlag der TU Dresden, 2004. 137 p. P945.A2 G762 2004b.

A4.607. *Hethitische Texte in Transkription. KUB 60* / Detlev Groddek. Wiesbaden: Harrassowitz, 2006. 196 p. P945 .A2 2006c.

A4.608. *Hethitische Texte in Transkription, VS NF 12* / Detlev Groddek, Albertine Hagenbuchner, and Inge Hoffmann. Dresden: Verlag der TU Dresden, 2002. 221 p. P945.A2 G764 2002.

A4.609. *The hieroglyphic inscription of the sacred pool complex at Hattusa (Südburg)* / J. David Hawkins. Wiesbaden: O. Harrassowitz, 1995. 139, 126 p. P945 .H36 1995.

A4.610. *Die Prinzen- und Beamtensiegel der hethitischen Grossreichszeit auf Tonbullen aus dem Nisantepe-Archiv in Hattusa* / Suzanne Herbordt. Mainz am Rhein: von Zabern, 2005. 441 p. CD5357 .H47 2005.

Hittite—Turkey—Bogazköy-Hattusa—Catalogs

A4.611. *Ankara Arkeoloji Müzesinde Bulanan Boğazköy tabletleri II = Boğazköy tablets in the Archaeological Museum of Ankara II* / Rukiye Akdogan. Chicago: Oriental Institute of the University of Chicago, 2011. 52, 64 p. P945 .A2 2011b.

Hittite—Turkey—Bogazköy—Seals

A4.612. *Konkordanz der Keilschrifttafeln* / Silvin Kosak. Wiesbaden; O. Harrassowitz, 1992– . P945 .S65 hft.34, 39, 42, 43.

A4.613. *Siegel aus Bogazköy* / Hans Gustav Güterbock. Berlin: Im Selbstverlage des Herausgegebers,

1940–1942. 2 v. 490.5 Ar24 sup. no.7; CD5357 .G8.

Hittite—Turkey—Carchemish

A4.614. *Kar-Kemish: sa position d'après les découvertes modernes* / Joachim Menant. Paris: Impr. Nationale, 1891. 73 p. DS66 .M46 1891.

Hittite—Turkey—Catalogs

A4.615. *Catalogue des textes Hittites* / Emmanuel Laroche. Paris: Klincksieck, 1971. 273 p. P945 .A2 1971.

Hittite—Turkey—Karatepe

A4.616. *Zur Lesung von manchen Personennamen auf edn hieroglyphenhethitischen Seigeln und Inschriften, Hitit hiyeroglif mühür ve kitabelerindeki bazi sahis adlarinin okunuslari hakkinda* / Sedat Alp. Ankara, Türk Tarih Kurumu Basimevi, 1950. 104 p. AS348.A6 A2 no.65.

Hittite—Turkey—Seals

A4.617. *Die hethitischen Königssiegel der frühen Grossreichszeit* / Heinrich Otten. Mainz: Akademie der Wissenschaften und der Literatur; Stuttgart: Franz Steiner Verlag, 1995. 42 p. AS182 .M232 1995 Nr.7.

Hittite—Vocabulary

A4.618. *The Hittite instruction for the royal bodyguard* / Hans G. Güterbock and Theo P. J. van den Hout. Chicago: Oriental Institute of the University of Chicago, 1991. 99 p. PJ3125.C5 A75 1991; P945.A3 I5713 1991.

A4.619. *Konträr-Index der hethitischen Keilschriftzeichen: Materialien zum Hethitischen Zeichenlexikon II* / Christel Rüster and Erich Neu. Wiesbaden: Harrassowitz, 1993. 173 p. P945.S65 hft.40; P945 .Z8 1993.

Hurrian

A4.620. *Das Hurritische: eine altorientalische Sprache in neuem Licht* / Erich Neu. Mainz: Akademie der Wissenschaften und der Literatur; Stuttgart: F. Steiner Verlag Wiesbaden, 1988. 48 p. AS182 .M232 1988 Nr.3.

Hurrian—Grammar

A4.621. *Kleine beiträge zur churritischen grammatik* / Johannes Friedrich. Leipzig: J. C. Hinrichs Verlag, 1939. 67 p. P945 .F87 1939; DS41 .V8 Bd.42.

Iranian

A4.622. *Les quatre inscriptions du mage Kirdir: textes et concordances* / Philippe Gignoux. Paris: Union Académique Internationale: Association pour l'avancement des études iraniennes, 1991. 108 p. PK6081.K57 1991.

Iranian—Persepolis

A4.623. *Journal of the British embassy to Persia: embellished with numerous views taken in India and Persia: also, a dissertation upon the antiquities of Persepolis* / William Price. 2 ed. London: Published by Kingsbury, Parbury, and Allen, 1825. DS258.P94 1825.

A4.624. *Mémoires sur les antiquités de la Perse et sur l'histoire des Arabes avant Mahomet* / Silvestre de Sacy. Paris: Imprimerie de E. Duverger, 1808–1809. 782 p.

Iranian—Sassanids

A4.625. *Mémoires sur diverses antiquités de la Perse, et sur les médailles des rois de la dynastie des Sassanides; suivis de l'histoire de cette dynastie, tr. du persan de Mirkhond* / A. I. Silvestre de Sacy. Paris: Imprimerie nationale, exécutive du Louvre, 1793. 431 p. DS261.S5.

Iranian—Sassanids—Seals—Catalogs

A4.626. *Catalogue des sceaux, camées et bulles sasanides de la Bibliothèque nationale et du Musée du Louvre* / Bibliothèque Nationale. Paris: Bibliothèque Nationale, 1978. CD5344.C37.

A4.627. *Corpus inscriptionum Iranicarum.* London: Published on behalf of Corpus Inscriptionum Iranicarum by Lund Humphries, 1955–1990. 4 v. PK6081.C6.

Iraq—Haradum

A4.628. *Haradum II: les textes de la période paléo-babylonienne, Samsu-iluna, Ammi-saduqa* / Francis Joannnès. Paris: Éditions recherche sur les civilisations, 2006. 190 p. DS70.5.H24 J63 2006.

Iraq—Nippur

A4.629. *Tablettes mathematiques de Nippur* / Christine Proust. Istanbul: Institut français d'études anatoliennes Georges Dumézil, 2007. 356 p. DS70.5.N5 P76 2007 + CD-ROM.

Israel and the Palestinian Territories

A4.630. *Der sogenannte bauernkalender von Gezer* / Joh. Lindblom. Abo: Abo akademi, 1931. 25 p. 68 Ab78 v.7 no.5.

A4.631. *Some interesting Syrian and Palestinian inscriptions* / J. Rendel Harris. London: C. J. Clay, 1891. 35 p. CN1190 .H37 1891; 378.73 H29M no.9–12.

Israel and the Palestinian Territories—Afeq

A4.632. *Aphek-Antipatris, 1974–1977: the inscriptions* / M. Kochavi. Tel Aviv: Tel Aviv University, Institute of Archaeology, 1978. 64 p. CN1194.A34 A652.

Italy

A4.633. *Epigrafia 2006: atti della XIV Rencontre sur l'épigraphie in onore di Silvio Panciera* / Maria Letizia Caldelli, Gian Luca Gregori, and Silvia Orlandi. Roma: Edizioni Quasar, 2008. 3 v. CN510.R46 2006.

A4.634. *Rvpes loqventes: atti del Convegno internazionale di studio sulle iscrizioni rupestri di età romana in Italia, Roma-Bomarzo, 13–15. X. 1989* / Lidio Gasperini. Roma: Istituto italiano per la storia antica, 1992. 614 p. CD530.C5 1989.

Italy—Calabria—Bibliography

A4.635. *Lessico epigrafico della Regio III (Lucania et Bruttii)* / Antonio Zumbo. Roma: Istituto italiano per la storia antica, 1992. CN390.C3 Z86 1992.

Italy—Sardinia

A4.636. *Omines: dal neolitico all'età nuragica* / Gianni Atzori and Gigi Sanna. Cagliari: Castello, 1996. 152 p. DG55.S2 A89 1996.

Italy—Umbrian—Apennines—Indexes

A4.637. *Le iscrizioni nord-umbre antiromane della valle di Ospitale (Appennino Modenese)* / Adolfo Zavaroni. Oxford: Archaeopress; Hadrian Books, 2011. 233 p. CN485.Z39 2011.

Kataban

A4.638. *Himjarische inschriften in den Staatlichen museen zu Berlin* / J. H. Mordtmann and E. Mittwoch. Leipzig: J. C. Hinrichs'sche buchhandlung, 1932. 78 p. PJ1511.B47 H56 1932; DS41.V8 Bd.37.

Latin

A4.639. *Initiation à l'épigraphie grecque et latine* / Bernard Rémy and François Kayser. Paris: Ellipses, 1999. 192 p. CN350 .R459 1999.

A4.640. *Latino-Punic epigraphy: a descriptive study of the inscriptions* / Robert M. Kerr. Tübingen: Mohr Siebeck, 2010. 253 p. PJ4195 .K477 2010.

Latin—Africa, North

A4.641. *Les dédicaces d'ouvrages de défense dans l'Afrique byzantine* / Jean Durliat. Rome: Eçole Française de Rome, 1981. 123 p. UG435.B8 D77.

Latin—Databases

A4.642. Epigraphische Datenbank Heidelberg [electronic resource]: Forschungsstelle der Heidelberger Akademie der Wissenschaften. Heidelberg: Die Akademie, 1998. Provides revised and corrected versions of the texts published in AE between 1900 and 1990, with abbreviations expanded, fragmentary texts restored, and updated bibliographical references. http://www.uni-heidelberg.de/institute/sonst/adw/edh/indexe.html.

Latin—Nubia

A4.643. *The rock inscriptions of lower Nubia (Czechoslovak concession)* / Zbyněk Žáb. Prague: Universita Karlova, 1974. 351, 229 p. GN865.N82 Z273.

Latin—Syria

A4.644. *Dédicaces faites par des dieux (Palmyre, Hatra, Tyr) et des thiases sémitiques à l'époque romaine* / J. T. Milik. Paris: Geuthner, 1972. 486 p. CN1153 .M598 1972.

A4.645. *Some interesting Syrian and Palestinian inscriptions* / J. Rendel Harris. London: C. J. Clay, 1891. 35 p. CN1190 .H37 1891; 378.73 H29M no.9–12.

Linear A

A4.646. *Aegean writing and Linear A* / Maurice Pope. Lund: C. Bloms, 1964. 487.8 .P813.

A4.647. *The decipherment of the Minoan Linear A and pictographic scripts* / Simon Davis. Johannesburg: Witwatersrand University Press, 1967. 341 p. P1035 .D343.

A4.648. *Further discoveries of Cretan and Aegean script: with Libyan and Proto-Egyptian comparisons* / Arthur J. Evans. London: B. Quaritch, 1898. 913.3918 Ev12.3.

A4.649. *An introduction to Minoan Linear A* / John Marangozis. München: Lincom Europa, 2007. 137 p. P1037 .M37 2007.

A4.650. *Linear A: the decipherment of an ancient European language* / H. Zebisch. Schärding: H. Zebisch, 1987. 104 p. P1037 .Z4313 1988.

A4.651. *Linear B and related scripts* / John Chadwick. Berkeley: University of California Press; London: British Museum Publications, 1987. 64 p. P1035 .C54 1987.

A4.652. *Minoan Linear A* / David W. Packard. Berkeley, University of California Press, 1974. 272 p. P1035 .P28.

A4.653. *The Minoan roundel and other sealed documents in the Neopalatial Linear A administration* / Erik Hallager. Liège: Université de Liège, Histoire de l'art et archéologie de la Grèce antique; Austin: University of Texas at Austin, Program in Aegean Scripts and Prehistory, 1996. 2 v. DF220. A274 v.14.

A4.654. *Recueil des inscriptions en linéaire A* / École française d'Athènes. Paris: Dépositaire, P. Geuthner, 1976 5 v. DF221.C8 E4 t.21.

A4.655. *Some preliminary remarks on the decipherment of Linear A* / Jan G. P. Best. Amsterdam: Hakkert, 1972. 41 p. P1035 .B45.

A4.656. *Transcribing the "Linear B" and "Linear A" signs: using Nicholas A. Massouridis phonetic values of the "Linear B" signs to read the "Linear B" and "Linear A" script* / Pandelis N. Massouridis. Athens: Kapon Editions, 2005. P1038 .M37 2005.

Linear A—Greece—Ayia Triádha

A4.657. *Le epigrafi di Haghia Triada in lineare A* / Giovanni Pugliese Carratelli. Salamanca: Seminario de Filología Clásica, Universidad de Salamanca, 1963. 90 p. P1035 .M512 no.3.

Linear A—Greece—Crete

A4.658. *The administration of neopalatial Crete: a critical assessment of the Linear A tablets and their role in the administrative process* / Ilse Schoep. Salamanca: Ediciones Universidad de Salamanca, 2002. 230 p. P1035 .M512 no.17.

A4.659. *Evidence for the Minoan language* / Cyrus H. Gordon. Ventnor: Ventnor Publishers, 1966. 44, 12 p. P1035 .G58.

A4.660. *Die Minoische Schrift: Sprache und Texte* / Kjell Aartun. Wiesbaden: Harrassowitz, 1992. 2 v. P1035 .A27 1992.

A4.661. *Testi minoici trascritti: con interpretazione e glossario* / Carlo Consani. Roma: CNR, Istituto per gli studi micenei ed egeo-anatolici, 1999. 326 p. P1037 .T488 1999.

Linear A—Greece—Crete—Khania

A4.662. *Grammikē A sto Minōiko Archeio tōn Chaniōn* / Louis Godart and Jean-Pierre Olivier. Roma: Edizioni del'Ateneo, 1976. 260 p. P1037 .P3.

Linear A—Greece—Petras

A4.663. *Hieroglyphic archive at Petras, Siteias* / Metaxia Tsipopoulos and Erik Hallager. Aarhus: Aarhus University Press; Lancaster: Gazelle Drake Academic, 2007. 272 p. DF221.C8 T79 2010.

Linear A—Greece—Crete—Phaestus

A4.664. *Cretan pictographs and prae-Phoenician script: with an account of a sepulchral deposit at Hagios Onuphrios near Phaestos in its relation to primitive Cretan and Aegean culture* / Arthur J. Evans. London: B. Quaritch; New York: G. P. Putnam's, 1895. 146 p. 913.3918 Ev12.4.

Linear A—Greece—Mycenae

A4.665. Nestor [electronic resource]. Bloomington: Program in Classical Archaeology, Indiana University. An international bibliography of Aegean studies, Homeric society, Indo-European linguistics, and related fields, from the Paleolithic through the end of the Geometric period, covering the Aegean. 12/ yr. http://stream.blg.uc.edu/nestor/.

Linear A—Indexes

A4.666. *Index transnuméré du linéaire A* / Jacques Raison and Maurice Pope. Louvain: Peeters, 1977. 331 p. P1037 .R3 1977.

A4.667. *Index du linéaire A* / Jacques Raison. Roma: Edizioni dell'Ateneo, 1971. 318 p. P1035 .R3.

Linear B

A4.668. *Abbreviations and adjuncts in the Knossos tablets: Indices* / Heinz Geiss. Berlin: Akademie-Verl.

in Arbeitsgemeinschaft mit Hakkert, Amsterdam, 1970. 123 p. PA25 .A4 bd.56.

A4.669. *Aegean writing and Linear A* / Maurice Pope. Lund: C. Bloms, 1964. 487.8 .P813.

A4.670. *Diccionario micénico* / Francisco Aura Jorro. Madrid: Consejo Superior de Investigaciones Cientificas, 1999. 2 v. P1038 .A94 1999.

A4.671. *Fiscality in Mycenaean and Near Eastern archives: proceedings of the conference held at Soprintendenza archivistica per la Campania, Naples, 21–23 October 2004* / Massimo Perna. Paris: De Boccard, 2006. 284 p. P1038 .F583 2006.

A4.672. *Floreant studia Mycenaea: Akten des X. Internationalen Mykenologischen Colloquiums in Salzburg vom 1.–5. Mai 1995* / Sigrid Deger-Jalkotzy, Stefan Hiller, and Oswald Panagl. Wien: Verlag der Österreichischen Akademie der Wissenschaften, 1999.2 v. AS142 .V32 bd.274.

A4.673. *Further discoveries of Cretan and Aegean script: with Libyan and Proto-Egyptian comparisons* / Arthur J. Evans. London: B. Quaritch, 1898. 913.3918 Ev12.3.

A4.674. *Gli storici e la Lineare B cinquant'anni dopo: atti del convegno internazionale, Firenze 24–25 novembre 2003* / Michele R. Cataudella, Alessandro Greco, and Giuseppe Mariotta. Padova: S.A.R.G.O.N., 2006. 258 p. P1038 .S76 2006.

A4.675. *Index généraux du linéaire B.* Roma: Edizioni dell'Ateneo, 1973. 405 p. P1035 .I5.

A4.676. *Index inverse du grec mycénien* / Michel Lejeune. Paris: Centre National de la recherche scientifique, 1964. 116 p. P1035 .L38.

A4.677. *Konzept einiger Linear B Indices* / W. Merlingen. Wien: Verlag Notring der Wissenschaftlichen Verbande Osterreichs, 1959. 2 v. P1035 .M56 1959.

A4.678. *Lexiko tes Mykenaikes Hellenikes* / Giannes K. Prompona. Athena: Ekdoseis Offset, 1978– . P1035 .P7.

A4.679. *Linear B, a 1984 survey: proceedings of the Mycenaean Colloquium of the VIIIth Congress of the International Federation of the Societies of Classical Studies (Dublin, 27 August–1st September 1984)* / Anna Morpurgo Davies and Yves Dohoux. Louvain-La-Neuve: Cabay, 1985. 310 p. P1038 .F43 1985.

A4.680. *Linear B and related scripts* / John Chadwick. Berkeley: University of California Press; London: Published for the Trustees of the British Museum by British Museum Publications, 1987. 64 p. P1035 .C54 1987.

A4.681. *Linear B glossary: sorted by column 1 to the phonetic values of the signs by M. Ventris and J. Chadwick and edited by column 2 to the phonetic values of the signs by Nicholas A. Massouridis* / Pandelis N. Massouridis. Athens: Kapon Editions, 2005– . P1038 .M36723 2005.

A4.682. *Mémoires de philologie mycénienne* / Michel Lejeune. Paris: Centre National de la Recherche Scientifique, 1958–1972. 4 v. P1035 .L45.

A4.683. *Mykenaïka: Actes du IXe Colloque international sur les textes mycéniens et égéens organisé par le Centre de l'Antiquité Grecque et Romaine de la Fondation Hellénique des Recherches Scientifiques et l'École Française d'Athènes (Athènes, 2–6 octobre 1990)* / Jean-Pierre Olivier. Athènes: E.F.A.-K.E.R.A.; Paris: Diffusion de Bocard, 1992. 673 p. P1035 .I57 1992.

A4.684. *People of Pylos: prosopographical and methodological studies in the Pylos archives* / Margareta Lindgren. Uppsala: Universitet; Stockholm: Almqvist and Wiksell, 1973. P1035 .L5.

A4.685. *Proceedings of the Cambridge Colloquium on Mycenaean Studies* / L. R. Palmer and John Chadwick. Cambridge: Cambridge University Press, 1966. 309 p. P1035 .I57 1965.

A4.686. *Studia Mycenaea, proceedings of the Mycenaean Symposium, Brno, April [13th and 14th] 1966* / Antonín Bartoněk. Brno: Universita J. E. Purkyně, 1968. 260 p. P1035 .M925 1966.

A4.687. *Studies in Mycenaean inscriptions and dialect, 1965–1978: a complete bibliography and index incorporating the contents of volumes XI–XXIII published between 1965 and 1978 by the Institute of Classical Studies of the University of London and the British Association of Mycenaean Studies* / Lydia Baumbach. Roma: Edizioni dell'Ateneo, 1986. 516 p. Z7009.L5 B394 1986. Supersedes: *Studies in Mycenean inscriptions and dialect, 1953–1964* / Lydia Baumbach. Roma: Edizioni dell' Ateneo, 1968. 331 p. Z7023.I5 B39.

A4.688. *Tentative grammar of Mycenaean Greek* / Ebbe Vilborg. Göteborg: Almqvist & Wiksell; Stockholm, 1960. 169 p. 68 G713 v.66, no.2.

A4.689. *Transcribing the "Linear B" and "Linear A" signs: using Nicholas A. Massouridis phonetic values of the "Linear B" signs to read the "Linear B" and "Linear A" script* / Pandelis N. Massouridis. Athens: Kapon Editions, 2005. P1038 .M37 2005.

Linear B—Aegean Sea Region

A4.690. *Espace civil, espace religieux en Egée durant la période Mycénienne: approches épigraphique, linguistique et archéologique: actes des journées d'archéologie et de philologie mycéniennes tenues à la Maison de l'Orient et de la Méditerranée-Jean Pouilloux, les 1er février 2006 et 1er mars*

2007 / Isabelle Boehm and Sylvie Müller-Celka. Lyon: Maison de l'Orient et de la Méditerranée, 2010. 220 p. DF220.5 .E86 2010.

Linear B—Bibliography

A4.691. *Studies in Mycenaean inscriptions and dialect, 1965–1978: a complete bibliography and index incorporating the contents of volumes XI–XXIII published between 1965 and 1978 by the Institute of Classical Studies of the University of London and the British Association of Mycenaean Studies* / Lydia Baumbach. Roma: Edizioni dell'Ateneo, 1986. 516 p. Z7009.L5 B394 1986. Extends: *Studies in Mycenean inscriptions and dialect, 1953–1964* / Lydia Baumbach. Roma: Edizioni dell' Ateneo, 1968. 331 p. Z7023.I5 B39.

Linear B—Dictionaries

A4.692. *Lexiko tēs Mykēnaikēs Hellēnikēs* / Giannē K. Prompona. Athēna: [Ekdoseis Offset], 1978. P1035 .P7.

A4.693. *The Linear B glossary: sorted by column 1 to the phonetic values of the signs by M. Ventris and J. Chadwick* / Nicholas A. Massouridis and Pandelis N. Massouridis. Athens: Kapon Editions, 2005. P1038 .M36723 2005.

Linear B—Greece

A4.694. *Evidence for the Minoan language* / Cyrus H. Gordon. Ventnor: Ventnor Publishers, 1966. 44, 12 p. P1035 .G58.

Linear B—Greece—Knossos

A4.695. *Abbreviations and adjuncts in the Knossos tablets: indices* / Heinz Geiss. Berlin: Akademie-Verl. in Arbeitsgemeinschaft mit Hakkert, Amsterdam, 1970. 123 p. PA25 .A4 bd.56.

A4.696. *Corpus of Mycenaean inscriptions from Knossos* / J. Chadwick. Cambridge; New York: Cambridge University Press; Roma: Edizioni dell' Ateneo, 1986. 4 v. P1038 .C67 1986.

A4.697. *The Knossos tablets: a revised transliteration of all the texts in Mycenaean Greek recoverable from Evans' excavations of 1900–1904 based on independent examination* / Emmett L. Bennett, Jr., John Chadwick, and Michael Ventris. 2 ed. London: University of London: Institute of Classical Studies, 1959. 137 p. P1035 .B39 1959.

A4.698. *The Knossos tablets / a transliteration* / John T. Killen and Jean-Pierre Olivier. 5 ed. Salamanca, España: Ediciones Universidad de Salamanca, 1989. 487 p. P1035 .M512 no.11.

A4.699. *The Knossos tablets; a transliteration of all the texts in Linear B script found at Knossos, Crete, based upon a new collation of photographs and originals* / John Chadwick and J. T. Killen. 3 ed. London: University of London, Institute of Classical Studies, 1964. 218 p. P1035 .K5 1964.

A4.700. *The people of Knossos: prosopographical studies in the Knossos Linear B archives* / Hedvig Landenius Enegren. Uppsala: Acta Universitatis Upsaliensis, 2008. 219 p. DF209.5 .L36 2008.

A4.701. *The scribes of the room of the Chariot tablets at Knossos: interdisciplinary approach to the study of a linear B deposit* / Jan Driessen. Salamanca: Ediciones Universidad de Salamanca, 2000. 191 p. P1035 .M512 no.15.

A4.702. *The Knossos tablets; a transliteration of all the texts in Linear B script found at Knossos, Crete, based upon a new collation of photographs and originals* / John Chadwick and J. T. Killen. 3 ed. London: University of London, Institute of Classical Studies, 1964. 218 p. P1035 .K5 1964.

A4.703. *La Toponomastica cretese nei documenti in lineare B di Cnosso* / M. V. Cremona. Roma: Edizioni dell'Ateneo & Bizzarri, 1978. 134 p. DF221.C8 T66.

Linear B—Greece—Mycenae

A4.704. *Mycenaeae Graecitatis lexicon* / Anna M. Davies. Romae: In Aedibus Athenaei, 1963. 404 p. P1035 .M6.

A4.705. *The Mycenae tablets IV* / Jean P. Olivier. rev. ed. Leiden: E. J. Brill, 1969. 43 p. P1035 .38.

A4.706. *Po-ti-ni-ja: l'élément féminin dans la religion mycénienne (d'après les archives en linéaire B)* / Cécile Boëlle. Nancy: ADRA; Paris: De Boccard, 2004. 273 p. BL793.M8 B64 2004.

A4.707. *Studies in Mycenean inscriptions and dialect, 1953–1964* / Lydia Baumbach. Roma: Edizioni dell' Ateneo, 1968. 331 p. Z7023.I5 B39.

A4.708. *TITHEMY: the tablets and nodules in Linear B from Tiryns, Thebes and Mycenae: a revised transliteration* / José L. Melena and Jean-Pierre Olivier. Salamanca, España: Ediciones Universidad de Salamanca; Vizcaya, España: Servicio Editorial, Universidad del País Vasco, 1991. 92 p. P1035 .M512 no.12.

Linear B—Greece—Pylos

A4.709. *Les leveurs d'impôts dans le royaume mycénien de Pylos* / Louis Deroy. Roma: Edizioni dell'Ateneo, 1968.119 p. HJ221 .D47.

A4.710. *The people of Pylos: prosopographical and methodological studies in the Pylos archives* / Margareta Lindgren. Uppsala: Universitet; Stockholm: Almqvist & Wiksell, 1973. P1035 .L5.

A4.711. *Recherches sur la fiscalité mycénienne* / Massimo Perna. Nancy: ADRA; Paris: Diffusion, De Boccard, 2004. 364 p. HJ217 .P47 2004.

A4.712. *The scribes of Pylos* / Thomas G. Palaima. Roma: Edizioni dell'Ateneo, 1988. 287 p. P1035 .P34.

A4.713. *Le tavolette delle classi A, C, E, F, G di Pilo: saggio di traduzione* / Mario Negri. Roma: Il Calamo, 1993. 87 p. P1038 .N44 1993.

Linear B—Greece—Pylos—Palace of Nestor

A4.714. *Rethinking Mycenaean palaces II* / Michael L. Galaty and William A. Parkinson. rev. ed. Los Angeles: Cotsen Institute of Archaeology, University of California, 2007. 254 p. DF220.5 .R47 2007. Supersedes: *Rethinking Mycenaean palaces: new interpretations of an old idea* / Michael L. Galaty and William A. Parkinson. rev. ed. Los Angeles: Cotsen Institute of Archaeology, University of California, 1999. 119 p. DF220.5 .R47 1999.

Linear B—Greece—Tiryns

A4.715. *TITHEMY: the tablets and nodules in Linear B from Tiryns, Thebes and Mycenae: a revised transliteration* / José L. Melena and Jean-Pierre Olivier. Salamanca: Ediciones Universidad de Salamanca; Vizcaya: Servicio Editorial, Universidad del País Vasco, 1991. 92 p. P1035 .M512 no.12.

Linear B—Greece—Thebes

A4.716. *Die neuen Linear B-Texte aus Theben: ihr Aufschlusswert für die mykenische Sprache und Kultur: Akten des internationalen Forschungskolloquiums an der Österreichischen Akademie der Wissenschaften, 5.–6. Dezember 2002* Sigrid Deger-Jalkotzy und Oswald Panagl. Wien: Verlag der Österreichischen Akademie der Wissenschaften, 2006. 172 p. AS142 .V32 bd.338.

A4.717. *Les tablettes en linéaire B de Thèbes* / Louis Godart and Anna Sacconi. Roma: Edizioni dell'Ateneo & Bizzarri, 1978. 110 p. P1038 .G63.

A4.718. *Thèbes: fouilles de la Cadmée* / Vassilis L. Aravantinos, Louis Godart, and Anna Sacconi. Pisa: Istituti Editoriali e Poligrafici Internazionali, 2001. P1038 .A73 2001.

A4.719. *The Thebes tablets II* / Theodoros G. Spyropouloss and John Chadwick. Salamanca: Universidad de Salamanca, 1975. 116 p. P1035 .M512 no.4.

A4.720. *TITHEMY: the tablets and nodules in Linear B from Tiryns, Thebes and Mycenae: a revised transliteration* / José L. Melena and Jean-Pierre Olivier. Salamanca: Ediciones Universidad de Salamanca; Vizcaya, España: Servicio Editorial, Universidad del País Vasco, 1991. 92 p. P1035 .M512 no.12.

Linear B—Indexes

A4.721. *Index généraux du linéaire.* Roma: Edizioni dell'Ateneo, 1973. 405 p. P1035 .I5.

A4.722. *Index inverse du grec mycénien* / Michel Lejeune. Paris: Centre National de la Recherche Scientifique, 1964. 116 p. P1035 .L38.

A4.723. *Konzept einiger Linear B Indices* / W. Merlingen. Wien: Verlag Notring der Wissenschaftlichen Verbände Österreichs, 1959. 2v. P1035 .M56 1959.

Linear B—Spain

A4.724. *Sprachen und Inschriften, Studien zum Mykenischen, Lateinischen und Hispanokeltischen* / Antonio Tovar. Amsterdam: Grüner, 1973. 214 p. P27 .T64.

Luwian

A4.725. *Ancient scripts from Crete and Cyprus* / Jan Best and Fred Woudhuizen. Leiden; New York: E. J. Brill, 1988. 131 p. P1021 .B47 1988; P1021 .A53 1988.

Lycian

A4.726. *Die Lykier: ihre Geschichte und ihre Inschriften* / Theodor Kluge. Leipzig: Hinrichs, 1910. 32 p. DS5156.L8 K58 1910.

A4.727. *Neufunde lykischer Inschriften seit 1901* / Günter Neumann. Wien: Verlag der Österreichischen Akademie der Wissenschaften, 1979. 57, 8 p. AS142 .V32 bd.135.

A4.728. *Neue lykische studien* / Moriz Schmidt; *Das decret des Pixodaros* / W. Pertsch. Jena: Mauke (H. Dufft) 1869. 144 p. P1008 .S3 1869; 888C ISch5.4.

Lydian

A4.729. *Aus Lydien: epigraph.-geograph. Reisefrüchte* / Karl Buresch. Hildesheim; New York: Olms, 1977. 226 p. DS156.L9 B9 1977.

A4.730. *Neue epichorische Schriftzeugnisse aus Sardis, 1958–1971* / Roberto Gusmani. Cambridge: Harvard University Press, 1975. 132 p. P1009 .G83.

Lydian—Turkey

A4.731. *Die lydischen Kulte im Lichte der griechischen Inschriften* / Maria Paz de Hoz. Bonn: R. Habelt, 1999. 410 p. DS156.L9 H69 1999.

Lydian—Turkey—Sardis

A4.732. *Lydian inscriptions* / Enno Littmann. Leyden: E. J. Brill, 1916–1924. 2 v. DS156.S3 A6 v.6.

Mediterranean—Latin/Greek

A4.733. *L'epigrafia del villaggio* / Alda Calbi, Angela Donati, and Gabriella Poma. Faenza: F.lli Lega, 1993. 606 p. CN340.E65 1993.

Meroitic—Egypt—Congresses

A4.734. *The peopling of ancient Egypt and the deciphering of Meroitic script: proceedings of the symposium held in Cairo from 28 January to 3 February 1974.* Paris: UNESCO, 1978. 136 p. DT71 .S95 1974.

Meroitic—Egypt—Karanog

A4.735. *Karanòg: the Meroitic inscriptions of Shablûl and Karanòg* / F. L. Griffith. Philadelphia: University Museum, 1911. 181 p. DT135.N8 E19 v.6.

Meroitic—Egypt—Qasr Ibrim

A4.736. *The Meroitic temple complex at Qasr Ibrim* / P. J. Rose. London: Egypt Exploration Society, 2007. 170 p. DT57 .E323 no.84.

Meroitic—Nubia

A4.737. *The rock inscriptions of lower Nubia (Czechoslovak concession)* / Zbyněk Žáb. Prague: Universita Karlova, 1974. 351, 229 p. GN865.N82 Z273.

Meroitic—Nubia—Areika

A4.738. *Areika* / D. Randall Maciver and C. Leonard Woolley; *Meroitic inscriptions* / F. L. Griffith. Oxford: Printed by H. Hart, at the University Press, 1909. 56, 43 p. DT135.N8 E19 v.1.

Meroitic—Sudan

A4.739. *The Meroitic funerary inscriptions from Arminna West* / Bruce G. Trigger. New Haven: Peabody Museum of Natural History of Yale University, 1970. 71 p. DT73.M6 T7.

Meroitic—Sudan—Catalogs

A4.740. *Répertoire d'épigraphie méroïtique: corpus des inscriptions publiées* / Jean Leclant. Paris: Diffusion de Boccard, 2000. 3 v. DT73.M6 R47 2000.

Meroitic—Sudan—Dangel

A4.741. *The island of Meroë* / J. W. Crowfoot; *Meroitic inscriptions. Part I: Sôba to Dangêl* / F. L. Griffith. London; Boston: Egypt Exploration Fund, 1911. 94, 35 p. DT73.M47 C76 1911; DT73.M6 C7 1911; DT57 .E323 no.19.

Meroitic—Sudan—Meroë

A4.742. *The island of Meroë* / J. W. Crowfoot; *Meroitic inscriptions. Part I: Sôba to Dangêl* / F. L. Griffith. London; Boston: Egypt Exploration Fund, 1911. 94, 35 p. DT73.M47 C76 1911; DT73.M6 C7 1911; DT57 .E323 no.19. See also: *The Island of Meroë* [electronic resource] / J. W. Crowfoot; *Meroitic inscriptions. I, Sôba to Dangêl* / F. L. Griffith. Worcester: Yare Egyptology, 2006. CD-ROM. DT57 .E323 no.19 2004.

A4.743. *La langue du royaume de Méroé: un panorama de la plus ancienne culture écrite d'Afrique subsaharienne* / Claude Rilly. Paris: Champion, 2007. 617 p. AS162 .B6 fasc.344.

A4.744. *Meroitic inscriptions* [electronic resource]. *II, Napata to Philae and miscellaneous* / F. L. Griffith. Worcester: Yare Egyptology, 2004. CD-DOM. DT57 .E323 no.20 2004.

A4.745. *Studien zur meroitischen Chronologie und zu den Opfertalfeln aus den Pyramiden von Meroe* / Fritz Hintze. Berlin: Akademie-Verlag, 1959. 71 p. 493.01 H598.

Meroitic—Sudan—Musawwarat al-Sufrah

A4.746. *Die Inschriften des Löwentempels von Musawwarat es Sufra* / Fritz Hintze. Berlin: Akademie-Verlag, 1962. 47 p. 63 B456.2 1962 nr.1.

Meroitic—Sudan—Napata

A4.747. *Meroitic inscriptions. part II: Napata to Philae and miscellaneous* / F. L. Griffith. Oxford: University Press, 1978. 80, 48 p. DT73.M6 G7 1978; DT57 .E323 no.20.

Meroitic—Sudan—Naqa—Lion Temple

A4.748. *Der Löwentempel von Naqa in der Butana (Sudan)*. Wiesbaden: Ludwig Reichert, 1983. 4 v. DT159.9.N36 L63 1983.

Meroitic—Sudan—Philae

A4.749. *Meroitic inscriptions. part II: Napata to Philae and miscellaneous* / F. L. Griffith. Oxford: University Press, 1978. 80, 48 p. DT73.M6 G7 1978; DT57 .E323 no.20.

Meroitic—Sudan—Shablul

A4.750. *Karanòg: the Meroitic inscriptions of Shablûl and Karanòg* / F. L. Griffith. Philadelphia, University Museum, 1911. 181 p. DT135.N8 E19 v.6.

Meroitic—Sudan—Soba

A4.751. *The island of Meroë* / J. W. Crowfoot; *Meroitic inscriptions. Part I: Sôba to Dangêl* / F. L. Griffith. London; Boston: Sold at the Offices of the Egypt Exploration Fund, 1911. 94, 35 p. DT73.M47 C76 1911; DT73.M6 C7 1911; DT57 .E323 no.19.

Messapian—Italy—Bari—Catalogs

A4.752. *Epigrafi "mobili" del Museo archeologico di Bari* / Franca Ferrandini Troisi. Bari: Edipuglia, 1992. 138 p. CN355.B25 F477 1992.

Messapian—Italy—Messapii

A4.753. *Corpus inscriptionum Messapicarum* / Francesco Ribezzo. Bari: Edipuglia, 1978. 159 p. CN472 .C67.

Minaean—Yemen

A4.754. *Paléographie des inscriptions sud-arabes; contribution à la chronologie et à l'histoire de l'Arabie du sud antique* / Jacqueline Pirenne. Brussel: Paleis der Academiën, 1956. PJ6951 .P5.

A4.755. *La paléographie sud-arabe de J. Pirenne* / A. Jamme. Washington: Catholic University of America, 1957. 198 p. PJ6951 .P5 J3.

Minaean—Yemen—Baraqish

A4.756. *A Minaean necropolis at Barāqish (Jawf, Republic of Yemen): preliminary report of the 2005–2006 archaeological campaigns* / Sabina Antonini, Alessio Agostini, and Paola Pagano. Roma: IsIAO, 2010. 83, 52 p. DS11 .C43 n.s. v.9.

Minaean—Yemen—Grammar

A4.757. *Süd-arabische chrestomathie. Minäo-sabäische grammatik.—Bibliographie.—Minüische inschriften nebst glossar* / Fritz Hommel. München: G. Franz, 1893. 136 p. PJ6951 .H7 1893.

Minaean—Yemen—Ma'in

A4.758. *Les monuments de Maīn (Yemen)* / Mohammed Tawfik. Le Caire: l'Institut Français d'Archéologie Orientale, 1951. 40 p. PJ6958 .T3 1951.

A4.759. *Muṣri, Maīn Ein Beitrag zur Geschichte des ältesten Arabien und zur Bibelkritik* / Hugo Winckler. Berlin: W. Peiser, 1898. 56 p. PJ6953 .W5 1898; DS41 .V8 v.3.

A4.760. *Musri, Meluhha, Ma'in II: nachtrag zu M.V.A.G. 1898 1* / Hugo Winckler. Berlin: Peiser, 1898. 10 p. 490.6 B453 v.3 no.4.

Minoan—Crete

A4.761. *Lexicon Creticum: estudios sobre escritura y lengua Cretenses* / Benito Gaya Nuño. Madrid: Consejo Superior de Investigaciones Cientificas, Instituto Antonio de Nebrija, 1953. P1035 .G3.

Minoan—Crete—Knossos

A4.762. *Das Thron- und Szepterzeichen in den knossischen und pylischen Täfelchen* / Johannes Sundwall. Helsingfors, 1949. 11 p. 408 H367 v.15(1).

Minoan—Crete—Pylos

A4.763. *Aus den Rechnungen des mykenischen Palastes in Pylos* / Johannes Sundwall. Helsingfors, 1954. 8 p. H367 t.19.

A4.764. *The Pylos tablets, a preliminary transcription* / Emmett L. Bennett. Princeton: Princeton University Press for University of Cincinnati, 1951. 117 p. 913.381 P999B.

A4.765. *The Pylos tablets; texts of the inscriptions found 1939–1954* / Carl W. Blegen. Princeton: Princeton University Press for University of Cincinnati, 1955. 252 p. 913.381 P999B 1955.

A4.766. *Das Thron- und Szepterzeichen in den knossischen und pylischen Täfelchen* / Johannes Sundwall. Helsingfors, 1949. 11 p. 408 H367 v.15(1).

A4.767. *Über einige Sachzeichen in den pylischen Täfelchen* / Johannes Sundwall. Helsingfors, 1951. 7 p. 408 H367 t.17.

Nabatean

A4.768. *The inscriptions of Wadi Haggag, Sinai* / Avraham Negev. Jerusalem: Institute of Archaeology, Hebrew University, 1977. 100 p. PJ5239.N43.

A4.769. *Hebrew inscriptions, from the valleys between Egypt and Mount Sinai, in their original characters, with translations and an alphabet* / Samuel Sharpe. London: J. R. Smith, 1875. 108 p. PJ5239.S53 1875.

A4.770. *Le nabatéen* / J. Cantineau. Paris: irie Ernest Leroux, 1930–1932. 2 v. PJ5239 .C35 1930.

A4.771. *Personal names in the Nabatean realm* / Avraham Negev. Jerusalem: Institute of Archaeology, Hebrew University of Jerusalem, 1991. 228 p. PJ5239 .N435 1991.

Nabatean—Egypt—Sinai

A4.772. *Armenian inscriptions from Sinai: intermediate report with notes on Georgian and Nabatean inscriptions* / Michael E. Stone. Sydney: Maitland Publications, 1979. 21 p. CN1311.S56 A74 1979.

A4.773. *Hebrew inscriptions, from the valleys between Egypt and Mount Sinai, in their original characters, with translations and an alphabet* / Samuel Sharpe. London: J. R. Smith, 1875. 108 p. Special PJ5239 .S53 1875; 492.76 Sh28.

A4.774. *Sinaitische Inschriften* / Julius Euting. Berlin: G. Reimer, 1891. 92, 40 p. PJ5239 .E98 1891; 492.73 Eu8.

Nabatean—Egypt—Sinai—Hajjaj Wadi

A4.775. *The inscriptions of Wadi Haggag, Sinai* / Avraham Negev. Jerusalem: Institute of Archaeology, Hebrew University, 1977. 100 p. PJ5239 .N43.

Nabatean—Saudi Arabia

A4.776. *Aramaic and Nabataean inscriptions from northwest Saudi Arabia* / Solaiman Abdal-Rahman al-Theeb. Riyadh: King Fahd National, 1993. 352 p. PJ5208.S33 D48 1993.

A4.777. *Nabatäsche Inschriften aus Arabien* / Julius Euting. Berlin: G. Reimer, 1885. 97 p. PJ5239 .E9 1885; 492.73 Eu8.1.

Nabatean—Saudi Arabia—Mada 'in Salih

A4.778. *The Nabataean tomb inscriptions of Mada'in Salih* / John F. Healey. Oxford: Oxford University Press on behalf of the University of Manchester, 1993. 298, 55 p. PJ5239 .A1 1993.

Nubia—Napata

A4.779. *The inscription of Queen Katimala at Semna: textual evidence for the origins of the Napatan State* / John Coleman Darnell. New Haven: Yale Egyptological Seminar; Oakville: David Brown Book, 2006. 112 p. PJ1526.N37 D37 2006.

Numidian

A4.780. *Paläographische Studien über Phönizische und punische Schrift* / Wilhelm Gesenius. Leipzig: F. C. W. Vogel, 1835. 110 p. PJ4191 .G47 1835.

Numidian—Libya

A4.781. *Études berbères: Première partie. Essai d'épigraphie libyque* / J. Halévy. Paris: impr. nationale, 1875. 181 p. 493.2 H135.

Oscan

A4.782. *Le tavole di Gubbio e la civiltà degli Umbri: lo "scavo nelle parole" del testo iguvino mostra tutta la specificità della cultura umbra e fa emergere le tracce di una grande civiltà del passato, degna di stare alla pari di quella etrusca e di quella romana* / Augusto Ancillotti and Romolo Cerri. Perugia: Jama, 1996. 463 p. DG225. U42 A524 1996.

Palmyrene—Syria

A4.783. *Personal names in Palmyrene inscriptions* / J. K. Stark. Oxford: Clarendon Press, 1971. 152 p. PJ5229 .S8 1968.

Palmyrene—Syria—Tadmur

A4.784. *Tadmorea* / J. Cantineau. Paris: irie Orientaliste Paul Geuthner, 1933–1938. PJ5229 .C24 1933.

Pahlavi—Iraq—Paikuli

A4.785. *The Sassanian inscription of Paikuli* / Helmut Humbach and Prods O. Skjrvo. Wiesbaden: Reichert, 1978. 3 v. PK6193 .H85.

Parthian—Iraq—Paikuli

A4.786. *The Sassanian inscription of Paikuli* / Helmut Humbach and Prods O. Skjrvo. Wiesbaden: Reichert, 1978. 3 v. PK6193 .H85.

Phoenician

A4.787. *Paläographische Studien über phönizische und punische Schrift* / Wilhelm Gesenius. Leipzig: F. C. W. Vogel, 1835. 110 p. PJ4191 .G47 1835.

A4.788. *Philokypros: mélanges de philologie et d'antiquités grecques et proche-oritentales: dédiés à la mémorie d'Olivier Masson* / Laurent Dubois and Emilia Masson. Salamanca: Universidad de Salamanca, 2000. 316 p. P1035 .M512 no.16.

A4.789. *The Phoenician diaspora: epigraphic and historical studies* / Philip C. Schmitz. Winona Lake: Eisenbrauns, 2012. 146 p. PJ4191 .S44 2012.

Phoenician—Africa, North—Bibliography

A4.790. *Venti anni di epigrafia punica nel Magreb (1965–1985)* / Giovanni Garbini. Roma: Consiglio Nazionale Delle Ricerche, 1986. 90 p. PJ4191 .G37 1986.

Phoenician—Bible O.T.

A4.791. *Phoenician inscriptions and the Bible: select inscriptions and studies in stylistic and literary devices common to the Phoenician inscriptions and the Bible* / Yitzhak Avishur. Tel Aviv: Archaeological Center Publication, 2000. 228 p. PJ4195 .A9213 2000.

Phoenician—Byblos

A4.792. *Dynastensarkophage mit szenischen Reliefs aus Byblos und Zypern.* Mainz am Rhein: Philipp von Zabern, 2004–2005. 2 v. NB1810 .D96.

Phoenician—Dictionaries

A4.793. *Comparative Semitic lexicon of the Phoenician and Punic languages* / Richard S. Tomback. Missoula: Scholars Press for the Society of Biblical Literature, 1978. 361 p. PJ4185 .T65 1978a.

A4.794. *Dictionnaire de la civilisation phénicienne et punique.* Turnhout: Brepols, 1992. 502 p., DS81 .D533 1992.

A4.795. *Phoenicisches glossar* / A. Bloch. Berlin: Mayer & Müller, 1890. 64 p. PJ4185 .B56 1890.

A4.796. *Phönizisches Wörterbuch* / M. A. Levy. Breslau: Schletter, 1864. 50 p. PJ4185 .L48 1864.

A4.797. *Vocabulario fenicio* / María-José Fuentes Estañol. Barcelona: Biblioteca Fenicia, 1980. 250, 140 p. PJ4185 .F8 1980.

Phonecian—Catalogs

A4.798. *Alfabeto monetario de las cecas "libio-fenices": hacia un intento de interpretación de un alfabeto desconocido* / Josep M. Sola-Solé. Barcelona: Puvill, 1980. 91 p. CJ1379 .S64.

A4.799. *Cahiers de Byrsa.* Paris: Imprimerie Nationale, 1950–1961. 9 v. Continued by: *Mélanges de Carthage.* DT169 .C17, v.1 (1950/1951)–v.9 (1960/1961).

A4.800. *Carthage: a mosaic of ancient Tunisia* / Aïcha Ben Abed Ben Khader and David Soren. New York: American Museum of Natural History; W. W. Norton, 1987. 238 p. DT269.C32 C37 1987.

A4.801. *Carthage: l'histoire, sa trace et son écho: les Musées de la ville de Paris, Musée du Petit Palais, 9 mars–2 juillet 1995.* Paris: Paris-Musées: Association Française d'Action Artistique, 1995. 319 p. DT269.C32 C374 1995.

A4.802. *Études et documents d'archéologie* / République Libanaise, Ministère de l'education nationale et des beaux-arts, Direction des antiquités, t.2. PJ4173 .D8 1945.

A4.803. *Grabschrift Eschmunazar's, Königs der Sidonier: Urtext und Uebersetzung nebst sprachlicher und sachlicher Erklärung* / S. I. Kaempf. Prag: H. Dominicus, 1874. 83 p. DS80.A3 K34 1874; PJ4193.E7 K3 1874a.

A4.804. *Karthago.* Paris: E. de Boccard [etc.] DT269.C3 K3 t.5 (1954), t.9 (1958)–t.25 (2000) DT269.C3 K3.

A4.805. *Phönizische studien* / M. A. Levy. Breslau: F. E. C. Leuckart, 1856–1870. 4 v. PJ4191 .L5 1856.

A4.806. *Prosopographie der literarisch bezeugten Karthager* / Klaus Geus. Leuven: Peeters, 1994. 265 p. DT269.C35 G47 1994.

A4.807. *République libanaise.* Ministère de l'éducation nationale et des beaux-arts. Direction des antiquités. Études et documents d'archéologie, t.2 492.71 D912; PJ4173 .D8.

A4.808. *Rivista di studi fenici.* Roma: Consiglio Nazionale delle Ricerche. DS81 .R48, v.1 (1973)–v.33 (2005).

A4.809. *Sarcophages de Phénicie: sarcophages a scènes en relief* / Jean Ferron. Paris: irie orientaliste Paul Geuthner, 1992. 2 v. NB1810 .F468 199.2.

A4.810. *Specimen linguae punicae in hodierna melitensium superstitis orbi erudito offert* / Johann Heinrich Majus. Marburgi Cattorum: Apud Phil. Casim. Mullerum, 1718. 46 p. 492.7124 M287.

A4.811. *Syntactical study of the dialect of Byblos as reflected in the Amarna tablets* / William Lambert Moran. Baltimore, 1950. 191 leaves. PJ4139 .M6 1950a.

Phoenician—Cyprus

A4.812. *Cyprus: its ancient cities, tombs, and temples: a narrative of researches and excavations during ten years' residence as American consul in that island* / Louis Palma di Cesnola. London: John Murray, 1877. 448 p. 913.3937 C337a. American edition: *Cyprus: its ancient cities, tombs, and temples: A narrative of researches and excavations during ten years' residence in that island* / Louis Palma di Cesnola. New York: Harper & Brothers, 1878. 456 p. DS54.3 .C37 1878; 913.3937 C337.

A4.813. *Dynastensarkophage mit szenischen Reliefs aus Byblos und Zypern.* Mainz am Rhein: Philipp von Zabern, 2004–2005. 2 v. NB1810 .D96 2004.

A4.814. *Sechs phönikische Inschriften aus Idalion* / Julius Euting. Strassburg: K. J. Trübner, 1875. 17 p. 492.71 Eu8.1.

Phoenician—France—Marseille

A4.815. *Temple de Baal à Marseille, ou Grande inscription phénicienne découverte dans cette ville dans le courant de l'année 1845; Expliquée et accompagnée d'observations critiques et historiques* / J. J. L. Barges. Paris: Herman, 1847. 105 p. PJ4193.M36 B3.

Phoenician—Epigraphy

A4.816. *Correspondences between the Chinese calendar signs and the Phoenician alphabet* / by Julie Lee Wei. Philadelphia: Department of Asian and Middle Eastern Studies, University of Pennsylvania, 1999. 65 p.CE37 .W45 1999.

A4.817. *Development of the late Phoenician scripts* / J. Brian Peckham. Cambridge: Harvard University Press, 1968. 233 p. PJ4173 .P4 1968.

A4.818. *Iconografia simbólica de los alfabetos fenicio y hebraico; ensayo hermenéutico acera de las enseñanzas esotéricas cifradas en los respectivos nombres, figuras y vocablos del valor numeral de las XXII letras de ambos alfabetos* /José A. Alvarez de Peralta. Madrid: De Bailly-Bailliere é hijos, 1898. 215 p. 492.081 P41.

A4.819. *Mémoire sur l'origine égyptienne de l'alphabet phénicien* / M. le Vte Emmanuel de Rougé. Paris: Imprimerie nationale, 1874. 110 p. P211 .R7 1874.

A4.820. *Palaographische Studien uber Phönizische und punische Schrift* / Wilhelm Gesenius. Leipzig: F. C. W. Vogel, 1835. 110 p. PJ4191 .G47 1835.

A4.821. *Phönikische sprachlehre und epigraphic* / Isaak Rosenberg. Wein: A. Hartleben, 1907? 173 p. 492.71 R724.

Phonecian—Grammars

A4.822. *Byblia grammata; documents et recherches sur le développement de l'écriture en Phénicie* / Maurice Dunand. Beyrouth, 1945. 195 p. 492.71 D912.

A4.823. *Phoenician-Punic dictionary* / Charles R. Krahmalkov. Leuven, Belgium: Uitgeverij Peeters: Departement Oosterse Studies, 2000. 499 p. PJ4185 .K73 2000.

A4.824. *Phoenizisch-cyprische Loesung* / Adolf Helfferich. Frankfurt/M.: Christian Winter, 1869. 64 p. 492.71 H363.

A4.825. *Grammaire phénicienne* / A. van den Branden. Beyrouth: irie du Liban, 1969. 164 p. PJ4175 .B7.

A4.826. *Grammar of Phoenician and Punic* / Stanislav Segert. München: C. H. Beck, 1976. 330 p. PJ4175 .S45; PJ4175 .S45 1976a.

A4.827. *Grammar of the Phoenician language* / by Zellig S. Harris. New Haven: American Oriental Society, 1936. 172 p. PJ4175 .H3 1936.

A4.828. *Phoenician-Punic grammar* / Charles R. Krahmalkov. Leiden; Boston: Brill, 2001. 309 p. PJ4175 .K73 2001.

A4.829. *Phönizisch-punische Grammatik* / Johannes Friedrich and Wolfgang Röllig. Roma: Pontificium Institutum Biblicum, 1970. 188 p. PJ4175 .F74 1970. Supersedes: *Phönizisch-punische Grammatik* / Johannes Friedrich. Roma: Pontificium Institutum Biblicum, 1951. 181 p. PJ25 .A65 v.32; PJ4175 .F74 1951.

A4.830. *Phönizische sprache. Entwurf einer grammatik, nebst sprach- und schriftproben. Mit einem anhang, enthaltend eine erklärung der punischen stellen im Ponulus des Plautus* / Paul Schröder. Halle: Buchhandlung des Waisenhauses, 1869. 342 p. PJ4171 .S376 1869; 492.715 Sch75.

Phoenician—Italy—Pyrgi

A4.831. *Lamine di Pyrgi e Cippo Etrusco di Perugia* / Alberto Ettore Santangelo. Milano: Proprietà Letteraria Riservata, 2008. 70 p. CN479 .S26 2008.

A4.832. *Le lamine di Pyrgi: la bilingue etrusco-fenicia e il problema delle origini etrusche* / Sergio Battaglini. Roma: Il calamo, 2001. 86 p. CN479 .B383 2001.

Phoenician—Lebanon—Jubayl

A4.833. *Von Gott und den Göttern: Gesammelte Aufsätze zum Alten Testament* / Wolfram Herrmann. Berlin; New York: W. de Gruyter, 1999. 236 p. BS410 .Z5 bd.259.

Phoenician—Malta

A4.834. *De inscriptione Melitensi Phoenico-Graeca: commentatio quam pro magisterii honoribus inter publica ob auspicatissimas celsissimorum principum Friderici Caroli Christiani et Guilelmae Mariae nuptias gaudia: rite obtinendis publico eruditorum examini in auditorio Collegii Elersiani, d. VII Nov. h. X.* / Jac. Chr. Lindberg. Havniae: Fabritius de Tengnagel, 1828. 92, 6 p. PJ4191 .L55 1828a.

Phoenician—Turkey—Karatepe (Cilicia)

A4.835. *Corpus of hieroglyphic Luwian inscriptions.* Berlin; New York: W. de Gruyter, 1999. 2 v. P950 .C67 1999.

A4.836. *Discoveries at Karatepe: a Phoenician royal inscription from Cilicia* / Julian Obermann. Baltimore: American Oriental Society, 1948. 49 p. PJ2 .A612 no.9, 1948.

A4.837. *Recherches sur les inscriptions phéniciennes de Karatepe* / François Bron. Genève: Droz, 1979. 234 p. PJ4191 .B7.

Phoenician—Turkey—Zincirli (Gaziantep)

A4.838. *Die Inschriften von Zincirli: neue Edition und vergleichende Grammatik des phönizischen, samälischen und aramäischen Textkorpus* / Josef Tropper. Münster: UGARIT-Verlag, 1993. 350 p. PJ5208.Z56 T76 1993.

Phrygian—Turkey

A4.839. *Lykaonien und die Phryger* / Gertrud Laminger-Pascher. Wien: Verlag der Österreichischen Akademie der Wissenschaften 1989. 55 p. AS142 .V31 bd.532.

A4.840. *Corpus des inscriptions paléo-phrygiennes* / Claude Brixhe and Michel Lejeune. Paris: Editions Recherches sur les civilisations, 1984. 2 v. CN1155 .B7 1984.

Turkey—Cappadocia

A4.841. *Sculpture and inscriptions from the monumental entrance to the palatial complex at Kerkenes Dag, Turkey* / Catherine M. Draycott and Geoffrey D. Summers. Chicago: Oriental Institute of the University of Chicago, 2008. 87, 98 p. DS156.K47 D73 2008.

Phrygian—Turkey—Gordion

A4.842. *The incised drawings from early Phrygian Gordion* / Lynn E. Roller. Philadelphia: University of Pennsylvania Museum of Archaeology and Anthropology, 2009. 177 p. DS156.G6 R648 2009.

Phrygian—Turkey—Kerkenes

A4.843. *Sculpture and inscriptions from the monumental entrance to the palatial complex at Kerkenes Dağ, Turkey* / Catherine M. Draycott and Geoffrey D. Summers. Chicago: Oriental Institute of the University of Chicago, 2008. 87, 98 p. DS156.K47 D73 2008.

Phrygian—Turkey—Yozgat Ili

A4.844. *Sculpture and inscriptions from the monumental entrance to the palatial complex at Kerkenes Dağ, Turkey* / Catherine M. Draycott and Geoffrey D. Summers. Chicago: Oriental Institute of the University of Chicago, 2008. 87, 98 p. DS156.K47 D73 2008.

Punic

A4.845. *Emperor Hadrian's speeches to the African army: a new text* / Michael P. Speidel. Mainz: Verlag des Römisch-Germanischen Zentralmuseums, 2006. 106 p. DG295.S645 2006.

A4.846. *Handbook of Neo-Punic inscriptions* / Karel Jongeling. Tübingen: Mohr Siebeck, 2008. 435 p. PJ 4179 .J66 2008.

A4.847. *Le iscrizioni fenicie e puniche delle colonie in Occidente* / Maria Giulia Guzzo Amadasi. Roma: Istituto di studi del Vicino Oriente, Università, 1967. 209 p. PJ4191 .A42 1967; DS16 .R6 no.28.

A4.848. *Late Punic epigraphy: an introduction to the study of Neo-Punic and Latino-Punic inscriptions* / Karel Jongeling and Robert M. Kerr. Tübingen: Mohr Siebeck, 2005. 114 p. PJ4197 .L38 2005.

A4.849. *Latino-Punic epigraphy: a descriptive study of the inscriptions* / Robert M. Kerr. Tübingen: Mohr Siebeck, 2010. 253 p. PJ4195 .K477 2010.

A4.850. *Paläographische Studien über phönizische und punische Schrift* / Wilhelm Gesenius. Leipzig: F. C. W. Vogel, 1835. 110 p. PJ4191 .G47 1835.

A4.851. *The Phoenician diaspora: epigraphic and historical studies* / Philip C. Schmitz. Winona Lake: Eisenbrauns, 2012. 146 p. PJ4191 .S44 2012.

A4.852. *Punische Steine; mit XLVI autographirten Tafeln.* St.-Petersbourg, Commissionnaires de l'Académie impériale des sciences, 1871. 37 p. 492.72 Eu8.

A4.853. *Sammlung der carthagischen inschriften, hrsg. mit unterstützung der K. Akademie der wissenschaften zu Berlin* / Julius Euting. Strassburg: K. J. Trübner, 1883. 208 p. PJ4195 .E8 1883.

A4.854. *Le sanctuaire punique d'El-Hofra à Constantine* / André Berthier and René Charlier. Paris: Arts et métiers graphiques, 1955. 2 v. 913.65 B4681.

A4.855. *Scripturae linguaeque phoeniciae monumenta quotquot supersunt edita et inedita ad autographorum optimorumque exemplorum fidem edidit additisque de scriptura et lingua Phoenicum commentariis illustravit* / Guil. Gesenius. Lipsiae, sumptibus typisque F. C. G. Vogelii, 1837. 2 v. PJ419 .G5 1837; 492.71 G33.

Punic—Africa, North

A4.856. *Catalogue of Punic stelae in the British Museum* / Carole Mendleson. London: British Museum, 2003. 111 p. DT269.C33 M46 2003.

Punic—Algeria—Constantine

A4.857. *Le sanctuaire punique d'El-Hofra à Constantine* / André Berthier and René Charlier. Paris: Arts et métiers graphiques, 1952–1955. 2 v. 913.65 B4681.

Punic—British Museum

A4.858. *Catalogue of Punic stelae in the British Museum* / Carole Mendleson. London: British Museum, 2003. 111 p. DT269.C33 M46 2003.

Punic—Italy—Pyrgi

A4.859. *Uni—Hera—Astarte; Studien zu den Goldblechen* / Ambros J. Pfiffig. Wien: H. Böhlaus Nachf., Kommissionsverlag der Österreichischen Akademie der Wissenschaften, 1965. 53 p. 477.5 P483.2.

Punic—Italy—Sicily—Regina Grotto

A4.860. *Grotta Regina-I: rapporto preliminare della Missione congiunta con la Soprintendenza alle antichità della Sicilia occidentale* / Anna Maria Bisi, Maria Giulia Guzzo Amadasi, and Vincenzo Tusa. Roma: Consiglio nazionale delle ricerche, 1969. 67, 45 p. DS16 .R6 v.33.

A4.861. *Grotta Regina, II: le iscrizioni puniche: rapporto della missione congiunta con la Soprintendenza alle antichità della Sicilia occidentale* / Gianna Coacci Polselli, Maria Giulia Guzzo Amadasi, and Vincenzo Tusa. Roma: Consiglio nazionale delle ricerche, 1979. 117, 88 p. DS16 .R6 no.52.

Punic—Lebanon—Sidon

A4.862. *Mémoire sur le sarcophage et l'inscription funéraire d'Esmunazar, roi de Sidon* / H. d'Albert de Luynes. Paris: Typ. de H. Plon, 1856. 82 p. 492.71 L973.

Punic—Libya—Tarabulus—Tripolitania

A4.863. *Iscrizioni puniche della Tripolitania (1927–1967)* / Giorgio Levi Della Vida and Maria Giulia Amadasi Guzzo. Roma: L'Erma di Bretschneider, 1987. 167, 50 p. PJ4195 .L48 1987.

Punic—Malta

A4.864. *Mémoire sur le sarcophage et l'inscription funéraire d'Esmunazar, roi de Sidon* / H. d'Albert de Luynes. Paris: Typ. de H. Plon, 1856. 82 p. 492.71 L973.

Punic—Tunisia—Carthage

A4.865. *Catalogue of Punic stelae in the British Museum* / Carole Mendleson. London: British Museum, 2003. 111 p. DT269.C33 M46 2003.

A4.866. *Erläuterung einer zweiten Opferverordnung aus Carthago* / Julius Euting. Strassburg: K. J. Trübner, 1874. 9 p. PJ4195 .E98 1874.

A4.867. *Inscriptions in the Phœnician character now deposited in the British Museum, discovered on the site of Carthage during researches* / Nathan Davis. London: Printed by order of the trustees, 1863. 32, 33 p. PJ4195 .B7 1863.

Qatabanian—Saudi Arabia

A4.868. *Lexicon of inscriptional Qatabanian* / Stephen D. Ricks. Roma: Editrice Pontificio Istituto Biblico, 1989. 241 p. PJ6981 .R53 1989.

A4.869. *Die Personennamen in den qatabänischen Inschriften: Lexikalische und grammatische Analyse im Kontext der semitischen Anthroponomastik* / Hani Hayajneh. Hildesheim; New York: G. Olms, 1998. 416 p. PJ6981 .H39 1998.

Rome

A4.870. *Die Anfänge der Heiligenverehrung nach den römischen Inschriften und Bildwerken* / Peter Dörfler. München: J. J. Lentzner, 1913. 209 p. BX2333 .D6.

A4.871. *Art and inscriptions in the ancient world* / Zahra Newby and Ruth Leader-Newby. Cambridge; New York: Cambridge University Press, 2007. 303 p. N72.W75 A78 2007.

A4.872. *Bathing in public in the Roman world* / Garrett G. Fagan. Ann Arbor: University of Michigan Press, 1999. 437, 24 p. DG97 .F34 1999.

A4.873. *Dediche sacre nel mondo Greco-Romano: diffusione, funzioni, tipologie; Religious dedications in the Greco-Roman world: distribution, typology, use* / John Bodel and Mika Kajava. Roma: Institutum Romanum Finlandiae, 2009. 420 p. PA2019.F5 I523 v.35.

A4.874. *Inscriptiones Christianae urbis Romae septimo saeculo antiquiores* / Ioannes Bapt. de Rossi. Romae: Ex Officina ria Pontificia, 1861–1888. 2 v. CN753.I85 R6.

A4.875. *Monumenti cristiano-eretici di Roma* / Carl Cecchelli. Roma: Fratelli Palombi [1944]. 274 p. 913.37 C323.

Roman

A4.876. *Documents illustrating the reigns of Augustus & Tiberius* / Victor Ehrenberg and A. H. M. Jones. 2 ed. Oxford: Clarendon Press, 1976. 178 p. DG275 .E35 1976.

A4.877. *Fluchtafeln: neue Funde und neue Deutungen zum antiken Schadenzauber* / Kai Brodersen and Amina Kropp. Frankfurt am Main: Verlag Antike, 2004. 160 p. BF1558 .F58 2004.

A4.878. *Usi delle tavolette lignee e cerate nel mondo greco e romano* / Paola Degni. Messina: Sicania, 1998. 178 p. Z110.T2 D44 1998.

Roman—England—Databases

A4.879. *Avxilia epigraphica* [electronic resource] / M. Hainzmann and P. Schubert. Berlin; New York: Walter de Gruyter, 1999. CN110 .A89 1999.

Roman—France

A4.880. *Untersuchungen zu den Reichsstrassen in den westlichen Provinzen des Imperium Romanum* / Michael Rathmann. Mainz: von Zabern, 2003. 323 p. DG28.5 .R38 2003.

Roman—Germany

A4.881. *Antike Skulpturen und Inschriften im Institutum Archaeologicum Germanicum = sculture e iscrizioni antiche nell'Institutum Archaeologicum Germanicum* / Richard Neudecker, Maria Grazia, and Granino Cecere. Wiesbaden: Dr. L. Reichert, 1997. 196 p. N5760 .A57 1997.

A4.882. *Untersuchungen zu den Reichsstrassen in den westlichen Provinzen des Imperium Romanum* / Michael Rathmann. Mainz: von Zabern, 2003. 323 p. DG28.5 .R38 2003.

Sabaean—British Museum—Glaser Collection

A4.883. *Yemen inscriptions: the Glaser Collection in the British Museum* / Hartwig Derenbourg. London, 1888. 25 p. PJ6871 .Y6 D47 1888.

Sabaen—Yemen

A4.884. *Altjemenische Nachrichten* / Eduard Glaser. München: Verlag von Hermann Lukaschik: G. Franz'sche Hofbuchhandlung, 1908, ausgegeben 1910. 262 p. PJ6871 .G537 1910.

A4.885. *Altjemenische Studien* / Eduard Glaser. Leipzig: J. C. Hinrichs, 1923. PJ6958 .G5 1923; DS41 .V8 bd.28.

A4.886. *Himjarische inschriften in den Staatlichen museen zu Berlin* / J. H. Mordtmann and E. Mittwoch. Leipzig: J. C. Hinrichs'sche buchhandlung, 1932. 78 p. PJ1511.B47 H56 1932; DS41. V8 bd.37.

A4.887. *La paléographie sud-arabe de J. Pirenne* / A. Jamme. Washington: The Catholic University of America, 1957. 198 p. PJ6951 .P5 J3.

A4.888. *Paléographie des inscriptions sud-arabes; contribution à la chronologie et à l'histoire de l'Arabie du sud antique* / Jacqueline Pirenne. Brussels: Paleis der Academiën, 1956. PJ6951 .P5.

Sabaean—Yemen—Grammar

A4.889. *Süd-arabische chrestomathie. Minäo-sabäische grammatik; Bibliographie; Minäische inschriften nebst glossar* / Fritz Hommel. München: G. Franz, 1893. 136 p. PJ6951 .H7 1893.

Sabaean—Yemen—Ma'in

A4.890. *Les monuments de Ma'i'n* / Khalil Yahya Nami. Cairo: Institut francais d'Archeologie Orientale, 1952. 31 p. PJ6958 .T33 N3.

A4.891. *Les monuments de Ma'i'n (Yemen)* / Mohammed Tawfik. Le Caire: l'Institut francais d'archéologie orientale, 1951. 40 p. PJ6958 .T3 1951.

Sahara

A4.892. *Contributions à l'étude du Sahara occidental* / Théodore Monod. Paris: Larose, 1938. 916.61 M758.

Semitic

A4.893. *Bulletin d'épigraphie sémitique (1964–1980)* / Javier Teixidor. Paris: irie Orientaliste Paul Geuthner, 1986. 513 p. Z7049.S5 T44 1986; PJ3081 .T44 1986.

Semitic—Bibliography

A4.894. *Handbuch der nordsemitischen Epigraphik, nebst ausgewählten Inschriften* / Mark Lidzbarski. Weimar: E. Felber, 1898. 2 v. PJ3085 .L53 1898; 492.7 L623.2; PJ3085 .L6. Superseded by: *Handbuch der nordsemitischen Epigraphik, nebst ausgewählten Inschriften* / Mark Lidzbarski. Hildesheim, G. Olms, 1962. 2 v. PJ3085 .L6 1962.

Semitic—Bibliothèque Nationale—Catalogs

A4.895. *Catalogue des sceaux ouest-sémitiques inscrits de la Bibliothèque nationale, du Musée du Louvre et du Musée biblique de Bible et Terre Sainte* / Pierre Bordreuil. Paris: La Bibliothèque, 1986. 130 p. CD5344 .B67 1986.

Semitic—Dictionaries

A4.896. *Dictionary of the North-west Semitic inscriptions* / J. Hoftijzer and K. Jongeling. Leiden; New York: E. J. Brill, 1995. 2 v. PJ3085 .H63 1995.

Semitic—Egypt—Mount Serabit el Khadem

A4.897. *Excavations and Protosinaitic inscriptions at Serabit ei Khadem, report of the expedition of 1935* / Richard F. S. Starr and Romain F. Butin. London; Toronto: Christophers, [1936]. 42 p. 492.73 St28.

Semitic—Egypt—Sinai

A4.898. *Voyage dans la péninsule arabique du Sinaï et l'Egypte moyenne: histoire, géographie, épigraphie* / M. Lottin de Laval. Paris: Gide et Cie., éditeurs, 1855–1859. 3 v. DS110.5 .L88 1855.

Semitic—Egypt—Sinai—Alphabet

A4.899. *Die ḳenitischen Weihinschriften der Hyksoszeit im Bergbaugebiet der Sinaihalbinsel und einige andere unbekannte Alphabetdenkmäler aus der Zeit der XII. bis XVIII. Dynastie: eine schrift- und kulturgeschichtliche Untersuchung* / Robert Eisler. Freiburg im Breisgau: Herdersche Verlagshandlung, 1919. 179 p. P211 .E58.

Semitic—Iraq—Hatra

A4.900. *Dédicaces faites par des dieux (Palmyre, Hatra, Tyr) et des thiases sémitiques à l'époque romaine* / J. T. Milik. Paris: Geuthner, 1972. 486 p. CN1153 .M598 1972.

Semitic—Israel and the Palestinian Territories—Ostraka

A4.901. *Writings from ancient Israel: a handbook of historical and religious documents* / Klaas A. D. Smelik. Louisville: Westminster/John Knox Press, 1991. 191 p. PJ3091 .S613 1991.

Semitic—Lebanon—Tyr

A4.902. *Dédicaces faites par des dieux (Palmyre, Hatra, Tyr) et des thiases sémitiques à l'époque romaine* / J. T. Milik. Paris: Geuthner, 1972. 486 p. CN1153 .M598 1972.

Semitic—Musée Biblique de Bible et Terre Sainte—Catalogs

A4.903. *Catalogue des sceaux ouest-sémitiques inscrits de la Bibliothèque nationale, du Musée du Louvre et du Musée biblique de Bible et Terre Sainte* / Pierre Bordreuil. Paris: La Bibliothèque, 1986. 130 p. CD5344 .B67 1986.

Semitic—Musée du Louvre—Catalogs

A4.904. *Catalogue des sceaux ouest-sémitiques inscrits de la Bibliothèque nationale, du Musée du Louvre et du Musée biblique de Bible et Terre Sainte* / Pierre Bordreuil. Paris: La Bibliothèque, 1986. 130 p. CD5344 .B67 1986.

Semitic—Seals

A4.905. *Catalogue des sceaux ouest-sémitiques inscrits de la Bibliothèque nationale, du Musée du Louvre et du Musée biblique de Bible et Terre Sainte* / Pierre Bordreuil. Paris: La Bibliothèque, 1986. 130 p. CD5344 .B67 1986.

Semitic—Seals—Congresses

A4.906. *Seals and sealing in the ancient Near East: proceedings of the symposium held on September 2, 1993, Jerusalem, Israel* / Joan Goodnick Westenholz. Jerusalem: Bible Lands Museum, 1995. 145 p. CD5344 .B52 1995.

A4.907. *Studies in the iconography of Northwest Semitic inscribed seals: proceedings of a symposium held in Fribourg on April 17–20, 1991* / Benjamin Sass and Christoph Uehlinger. Fribourg, Switzerland: University Press; Göttingen: Vandenhoeck & Ruprecht, 1993. 336 p. PJ3081 .S78 1993.

Semitic—Seals—Josef Chaim Kaufman Collection—Catalogs

A4.908. *Biblical period Hebrew bullae: the Josef Chaim Kaufman Collection* / Robert Deutsch. Tel Aviv: Archaeological Center Publications, 2003–2011. 2 v. CD5354 .D48 2003.

Semitic—Syria—Palmyra

A4.909. *Dédicaces faites par des dieux (Palmyre, Hatra, Tyr) et des thiases sémitiques à l'époque romaine* / J. T. Milik. Paris: Geuthner, 1972. 486 p. CN1153 .M598 1972.

Semitic—Syria—Ugarit

A4.910. *The Claremont Ras Shamra tablets* / Loren R. Fisher. Roma: Pontificium institutum biblicum, 1972. 58 p. PJ4054.R3 C52 1972; PJ25 .A65 v.48.

A4.911. *Corpus des tablettes en cunéiformes alphabétiques découvertes à Ras Shamra-Ugarit de 1929 à 1939* / Andree Herdner. Paris: P. Geuthner, 1963. 2 v. PJ4150.Z77 H4 1963.

A4.912. *Entzifferung der Keilschrifttafeln von Ras Schamra* / Hans Bauer. Halle: Max Niemeyer, 1930. 77 p. PJ4150.Z77 B3 1930.

A4.913. *La légend de Keret, roi des Sidoniens, publiée d'apres une tablette de Ras-Shamra* / Charles Virolleaud. Paris: P. Geuthner, 1936. 102 p. PJ3085.R3 M5 1936 v.2.

A4.914. *La légende phénicienne de Danel: texte cunéiforme alphabétique avec transcription et commentaire / précédé d'une introduction à l'étude de la civilisation d'Ugarit* / Charles Virolleaud. Paris: P. Geuthner, 1936. 241 p. PJ3085.R3 M5 1936 v.1–2.

A4.915. *The loves and wars of Baal and Anat, and other poems from Ugarit; Translated from the Ugaritic and edited with an introduction* / Cyrus H. Gordon. Princeton: Princeton University Press; London: H. Milford, Oxford University Press, 1943. 47 p. PJ3085.R3 G6 1943.

A4.916. *Mission de Ras Shamra.* Paris: P. Geuthner, 1936. PJ3085.R3 M5.

A4.917. *Notes on the mythological epic texts from Ras Shamra, I–II* / James A. Montgomery. Philadelphia: American Oriental Society, 1933–1934. 492.762 M763a.

A4.918. *The Ras Shamra mythological texts* / James A. Montgomery and Zellig S. Harris. Philadelphia: American Philosophical Society, 1935. 134 p. 492.762 .M7631.

A4.919. *The Ras Shamra tablets; their bearing on the Old Testament* / J. W. Jack. Edinburgh, T. & T. Clark, 1935. 54 p. BS1110 .O45 no.1, 1935.

A4.920. *Les textes hippiatriques* / Dennis Pardee. Paris: Editions Recherche sur les Civilisations, 1985. 77 p. PJ4150.Z77 P37.

A4.921. *Ugarit* / Margaret S. Drower. Cambridge: University Press, 1968. 36 p. PJ4150 .D7 1968.

A4.922. *Votive inscriptions from Ras Shamra* / Julian Obermann. New Haven, CT: American Oriental Society, 1941. 45 p. PJ2 .A64 no.12.

Semitic—Syria—Ugarit—Anat

A4.923. *The loves and wars of Baal and Anat, and other poems from Ugarit* / Cyrus H. Gordon. Princeton: Princeton University Press; London: H. Milford, Oxford University Press, 1943. 47 p. PJ3085.R3 G6 1943.

Semitic—Syria—Ugarit—Baal

A4.924. *Baal in the Ras Shamra texts* / Arvid S. Kapelrud. Copenhagen: G.E.C. Gad, 1952. 156 p. BL1671 .K3 1952.

A4.925. *The loves and wars of Baal and Anat, and other poems from Ugarit; Translated from the Ugaritic* / Cyrus H. Gordon. Princeton: Princeton University Press; London: H. Milford, Oxford University Press, 1943. 47 p. PJ3085.R3 G6 1943.

Semitic—Syria—Ugarit—Grammar

A4.926. *Ugaritic grammar: the present status of the linguistic study of the Semitic alphabetic texts from Ras Shamra* / Cyrus H. Gordon. Rome: Pontificium institutum biblicum, 1940. 130 p. PJ4150 .G62 1940.

Semitic—Syria—Ugarit—Mythology

A4.927. *Les découvertes de Ras Shamra (Ugarit) et l'Ancien Testament* / René Dussaud. Paris: P. Geuthner, 1937. 128 p. PJ3085.U32 D87 1937; PJ3085.R3 D8.

A4.928. *La légende d'un temple phénicien d'après une tablette de Ra. Rhamra du XIVe siècle avant J.-C./origine phénicienne des dioscures* / Robert du Mesnil Du Buisson. Paris: irie orientaliste P. Geuthner, 1969? 55 p. BL1665 .D8.

A4.929. *Ras Samra mythologie und biblische theologie* / Ditlef Nielsen. Leipzig: Deutsche morgenländische gesellschaft, 1936. 117 p. PJ5 .D5 Bd.21.

A4.930. *The seasonal pattern in the Ugaritic myth of Balu, according to the version of Ilimilku* / Johannes C. de Moor. Kevelaer, Butzon & Bercker, 1971. 321 p. BL1605.B3 M65.

A4.931. *Ugaritic mythology: a study of its leading motifs* / Julian Obermann. New Haven: Yale University Press, 1948. 110 p. PJ3085.R3 O2 1948.

Sudan—Temple of Semna

A4.932. *The inscription of Queen Katimala at Semna: textual evidence for the origins of the Napatan State* / John Coleman Darnell. New Haven: Yale Egyptological Seminar; Oakville: David Brown Book, 2006. 112 p. PJ1526.N37 D37 2006.

Sumerian

A4.933. *The Claremont Ras Shamra tablets* / Loren R. Fisher. Roma: Pontificium institutum biblicum, 1971. 58 p. PJ25 .A65 vol. 48.

A4.934. *Die hethitisch-akkadische bilingue des Hattusili I. (Labarna II.)* / Ferdinand Sommer and Adam Falkenstein. München: Verlag der Bayerischen akademie der wissenschaften, in kommission bei der C. H. Beck'schen verlagsbuchhandlung München, 1938. 288 p. AS182 .M8175 n.F. hft.16.

A4.935. *Die sumerischen und akkadischen Königsinschriften* / F. Thureau-Dangin. Leipzig: J. C. Hinrich, 1907. Leipzig: Zentralantiquariat der DDR, 1972. 275 p. PJ4070 .T6 1972.

Sumerian—Catalogs

A4.936. *Mesopotamische Weihgaben der frühdynastischen bis altbabylonischen Zeit* / Eva Andrea Braun-Holzinger. Heidelberg: Heidelberger Orientverlag, 1991. 408 p. PJ3785.B73 1991.

Sumerian—Dictionary

A4.937. *Dictionnaire d'étymologie sumérienne et grammaire comparée* / Colman-Gabriel Gostony. Paris: E. de Boccard, 1975. 204 p. PJ4031 .G6.

A4.938. *Ecriture cunéiforme; syllabaire sumérien, babylonien, assyrien* / Lucien-Jean Bord and Remo Mugnaioni. Paris: P. Geuthner, 2002. 253 p. PJ3193 .B66 2002.

A4.939. *Index to the secondary literature: a collated list of indexes and glossaries to the secondary literature concerning the Sumerian language* / Steve Tinney. 3 ed. Philadelphia: [s.n.], 1993. 264 p. PJ4010 .I52 1993.

A4.940. *Inim Kiengi I: deutsch-sumerisches Glossar in drei Bänden* / Barbara Hübner and Albert Reizammer. Marktredwitz: A. Reizhammer, 1993–1995. 3 v. PJ4037 .H82 1993. Supersedes: *Inim Kiengi* / Barbara Hübner and Albert Reizammer. Marktredwitz: Selbstverlag A. Reizammer, 1984–1988. 3 v. in 5. PJ4037 .H822 1984.

A4.941. *Innsbrucker sumerisches Lexikon (ISL) des Instituts für Sprachen und Kulturen des Alten Orients an der Universität Innsbruck. Abteilung I, Sumerisches Lexikon zu den zweisprachigen literarischen Texten.* Innsbruck: Institut für Sprachwissenschaft der Universität Innsbruck, 1990. PJ4037 .I55 1990.

A4.942. *Keilinschriftliche studien; in zwangloser folge erscheinende abhandlungen aus dem gebiet de keilschriftliteratur, inbesondere der sumeriologie* / Maurus Witzel. Leipzig: O. Harrassowitz, 1918. PJ4047 .W58 1918.

A4.943. *Lexical texts in the Schøyen Collection* / Miguel Civil. Bethesda: CDL Press, 2010. 285 p. PJ3223 .C58 2010.

A4.944. *Mesopotamisches Zeichenlexikon* / Rykle Borger. 2 ed. Münster: Ugarit-Verlag, 2010. 736 p. PJ3223 .B62 2010. Supersedes: *Mesopotamisches Zeichenlexikon* / Rykle Borger. Münster: Ugarit-Verlag, 2004. 712 p. PJ3223 .B62 2004.

A4.945. *Sumerologie: Einführung in die Forschung und Bibliographie in Auswahl* / W. H. P. Römer. 2 ed. Münster: Ugarit-Verlag, 1999. 250 p. PJ4008 .R66 1999.

A4.946. *Sumerisches Lexikon* / Anton Deimel. Roma: 1925–1950. PJ4037 .D35 1930; 492.39 D367, v.1, v.2(1–4), v.3(1–2), v.4(1–2); 492.39 D367, v.1, v.2(1–4); PJ4037 .D352, v.1, v.2(1–4), v.3(1–2); PJ4037 .D352, v.1, v.2(1–4), v.3(1–2), v.4(1–2).

A4.947. *Sumerisches Lexikon zu George Reisner, Sumerisch-babylonische Hymnen nach Thontafeln griechischer Zeit (Berlin 1896) (SBH) und zu verwandten Texten* / Karl Oberhuber. Innsbruck: Verlag des Instituts fuü Sprachwissenschaft der Universität Innsbruck, 1990. 583 p. PJ4037 .O24 1990.

Sumerian—British Museum

A4.948. *Testi amministrativi neosumerici del British Museum (BM 13601–14300)* / Manuel Molina. Roma: Bonsignori editore, 2003. 248 p. PJ4053. B68 M65 2003.

Sumerian—College de France—Cabinet d'Assyriologie

A4.949. *Contribution au Thesaurus de la langue sumérienne* / Raymond Jestin and Maurice Lambert. Paris: College de France, Cabinet d'Assyriologie, 1954. PJ4035 .C75 1954.

Sumerian—Grammar

A4.950. *Abridged grammars of the languages of the cuneiform inscriptions, containing: I. A Sumero-Akkadian grammar. II. An Assyro-Babylonian grammar. III. A Vannic grammar. IV. A Medic grammar. V. An Old Persian grammar* / George Bertin. London: Trübner, 1888. 117 p. PJ4013 .B4 1888.

A4.951. *Études orientales* / Hilaire de Barenton. Paris: P. Geuthner, 1920–1937. 10 v. Includes grammars and dictionaries for Egyptian, Etruscan, and Sumerian languages. PJ27 .H5 1920.

Sumerian—Iraq

A4.952. *Mesopotamische Weihgaben der frühdynastischen bis altbabylonischen Zeit* / Eva Andrea Braun-Holzinger. Heidelberg: Heidelberger Orientverlag, 1991. 408 p. PJ3785 .B73 1991.

Sumerian—Iraq—Isin

A4.953. *The historical inscriptions of Old Babylonian period: Isin-Larsa dynasties: a preliminary catalogue* / Giovanni Pettinato. Roma: Università degli studi di Roma "La Sapienza," Dipartimento di studi orientali, 2004. PJ4070 .P48 2004.

Sumerian—Iraq—Larsa

A4.954. *The historical inscriptions of Old Babylonian period: Isin-Larsa dynasties: a preliminary catalogue* / Giovanni Pettinato. Roma: Università degli studi di Roma "La Sapienza," Dipartimento di studi orientali, 2004. PJ4070 .P48 2004.

Sumerian—Iraq—Shuruppak

A4.955. *Indices of early dynastic administrative tablets of Shuruppak* / Giuseppe Visicato. Napoli: Istituto universitario orientale di Napoli, 1997. 136 p. PJ4054.S48 P65 1994 Index.

Sumerian—Iraq Museum—Catalogs

A4.956. *Historical inscriptions from the Presargonic, Sargonic, and Lagash II periods; a preliminary catalogue* / Daria di Tullio. Roma: Università degli studi di Roma "La Sapienza," Dipartimento di studi orientali, 2004– . PJ4070 .D5 2004.

Sumerian—Museo Egizo di Torino

A4.957. *Testi cuneiformi di vario contenuto; nn. 0724–0793* / Alfonso Archi, Francesco Pomponio, and Marten Stol. Torino: Ministero per i beni culturali e ambientali, Soprintendenza al Museo delle antichità egizie, 1999. 101 p. PJ3711.T9 T488 1999.

Sumerian—Museo Egizo di Torino—Umma

A4.958. *Testi cuneiformi neo-sumerici da Umma, NN. 0413–0723/parte I, i testi* / Alfonso Archi and Francesco Pomponio; *parte II, le impronte di sigillo* / Giovanni Bergamini. Torino: Ministero per i beni culturali e ambientali, Soprintendenza al Museo delle antichità egizie, 1995. 420 p. PJ4054.U6 T47 1995.

Sumerian—Musees Royaux d'Art et d'Histoire

A4.959. *Recueil des inscriptions de l'Asie Antérieure de Musées Royaux du Cinquantenaire à Bruxelles; texte sumériens, babyloniens et assyriens* / Louis Speleers. Bruxelles: Vanderpoorten, 1925. 134 p. PJ3711.B78 R44 1925a.

Syria

A4.960. *Mission archèologique au Djebel Druze: le Musée de Soueida; inscriptions et mounuments figurés avec 36 planches* / Maurice Dunand. Paris: P. Geuthner, 1934. DS99.S8 D8.

A4.961. *Mission dans les régions désertiques de la Syrie moyenne* / René Dussaud. Paris: Imprimerie Nationale, 1903. 342, 55 p. PJ395.S9 D8 1903.

A4.962. *Some interesting Syrian and Palestinian inscriptions* / J. Rendel Harris. London: C. J. Clay, 1891. 35 p. CN1190 .H37 1891; 378.73 H29M no.9–12.

Syria—Cuneiform—Ras Shamra Ugarit

A4.963. *The cuneiform texts of Ras Shamra-Ugarit* / Claude F. A. Schaeffer. London: Published for the British Academy by H. Milford, Oxford University Press, 1939. 100, 39 p. 913.3941 Sch12.

A4.964. *La deuxième campagne de fouilles à Ras-Shamra (printemps 1930): rapport et études préliminaires* / F.-A. Claude Schaeffer, Charles Virolleaud, and François Thureau-Dangin. Paris: P. Geuthner, 1931. 357 p. DS99.R3 S254 1931.

A4.965. *La Sixième campagne de fouilles à Ras Shamra (Ugarit) (printemps 1934): rapport sommaire* / Claude F. A. Schaeffer. Paris: P. Geuthner, 1935. 113 p. DS99.R3 S56 1935.

Syria—Dura-Europos

A4.966. *Asien und Rom: neue Urkunden aus sasanidischer Frühzeit* / Franz Altheim and Ruth Stiehl.

Tübingen: M. Niemeyer, 1952. 87 p. 913.392 AL781.

A4.967. *Das erste Auftreten der Hunnen, das Alter der Jesaja-Rolle* / Neue Urkunden aus Dura-Europos / Franz Altheim and Ruth Stiehl. Baden-Baden: Verlag für Kunst und Wissenschaft, 1953. 90, 15 p. D141 .A4.

A4.968. *The excavations at Dura-Europos, preliminary report of 1st–9th season of work; conducted by Yale University and the French Academy of Inscriptions and Letters* / P. V. C. Baur and M. I. Rostovtzeff. New Haven: Yale University Press; London: H. Milford, Oxford University Press, 1929–1952. 9 v. DS99.D8 Y3 1929.

A4.969. *Fouilles de Doura-Europos (1922–1923) avec un appendice sur la céramique de Doura par m. et mme. Félix Massoul* / Franz V. M. Cumont. Paris: P. Geuthner, 1926. 533 p. 913.392 F845 v.9.

Syria—Nahr el-Kelb River

A4.970. *Die Denkmäler und Inschriften an der Mündung des Nahr el-Kelb* / F. H. Weissbach. Berlin; Leipzig: W. de Gruyter, 1922. 54, 2 p. DS42 .D4 hft.6.

Syria—Palmyra

A4.971. *Dictionaire des noms propres palmyréniens* / E. Ledrain. Paris: E. Leroux, 1886. 59 p. CS2955 .L47 1886.

Syria—Tadmur

A4.972. *Dictionaire des noms propres palmyréniens* / E. Ledrain. Paris: E. Leroux, 1886. 59 p. CS2955 .L47 1886.

A4.973. *A journey to Palmyra: collected essays to remember Delbert R. Hillers* / Eleonora Cussini. Leiden; Boston: Brill, 2005. 258 p. DS99.P17 J68 2005.

A4.974. *Palmyre* / Jean-Baptiste Yon. Beyrouth: Presses de l'IFPO, 2012. 518 p. CN1191.T33 Y86 2012.

Syria—Ugarit

A4.975. *The cuneiform texts of Ras Shamra-Ugarit* / Claude F. A. Schaeffer. London: Published for the British Academy by H. Milford, Oxford University Press, 1939. 100, 39 p. 913.3941 Sch12.

A4.976. *La neuvième campague de fouilles a Ras Shamra-Ugarit (printemps 1937)* / Claude F. A. Schaeffer; *Rapport sommaire suivi d'études sur les textes et inscriptions* / R. Dussard, Ch. Virolleaud, E. Dhorme, and A. Guérinot. Paris: P. Geuthner, 1938. DS99.R3 S27 1938.

Syria—Ugarit—Bibliography

A4.977. *La trouvaille épigraphique de l'Ougarit* / Pierre Bordreuil and Dennis Pardee. Paris: Editions Recherche sur les civilisations, 1989–1990. 2 v. DS99.U35 B67 1989.

Syriac—China—Quanzhou Shi

A4.978. *From Palmyra to Zayton: epigraphy and iconography* / Iain Gardner, Samuel Lieu, and Ken Parry. Turnhout: Brepol; NSW Australia: Ancient History Documentary Research Centre, Macquarie University, 2005. 278, 26 p. CN1191. T33 F76 2005.

Syriac—Jordan—As Samra

A4.979. *Fouilles de Khirbet es-Samra en Jordanie* / Jean-Baptiste Humbert and Alain Desreumaux. Turnhout: Brepols, 1998. DS154.9.A76 F685 1998.

Turkey

A4.980. *Epigraphica Anatolica* / Österreichische Akademie der Wissenschaften, Rheinisch-Westfälische Akademie der Wissenschaften, and Türk Tarih Kurumu. Bonn: R. Habelt, 1983– . http://ifa.phil-fak.uni-koeln.de/epiana.html?&L=1.

A4.981. *Kleinasiatische sprachdenkmäler, zusammengestellt* / Johannes Friedrich. Berlin: W. de Gruyter, 1932. 155 p. Center for Advanced Judaic Studies Box 1 CN1155 .F7 1932; 208 K674 no.163.

Turkey—Bithynia

A4.982. *Inschriften und Denkmäler aus Bithynien* / Friedrich Karl Dörner. Berlin: 1941. 127 p. CN1157. B57 D6.

Turkey—Bosporus

A4.983. *Constaninopolis und der Bosporos; Mit 120 griechischen, latienischen, arabischen, persischen und türkischen Inschriften, dem Plane der Stadt Constantinopel und einer Karte des Bosporos* / Jos. von Hammer. Osnabrück: Biblio Verlag, 1967. 2 v. DR719 .H3 1967.

Turkey—Edirne

A4.984. *Hadrianopolis I: Inschriften aus Paphlagonia* / Ergün Laflı and Eva Christof. Oxford: Archaeopress, 2012. 142 p. DR741.E4 L34 2012.

Turkey—Istanbul

A4.985. *Constaninopolis und der Bosporos; Mit 120 griechischen, latienischen, arabischen, persischen und türkischen Inschriften, dem Plane der Stadt Constantinopel und einer Karte des Bosporos* / Jos. von Hammer. Osnabrück: Biblio Verlag, 1967. 2 v. DR719 .H3 1967.

Turkey—Troy

A4.986. *Die Troas: neue Forschungen III* / Elmar Schwertheim. Bonn: R. Habelt, 1999. 180, 14 p. DS156.N43 T7 1999.

Turkey—Uigar

A4.987. *Ein Überblick über die ältesten Denkmäler der türkischen Sprachen* / Martti Räsänen. Helsingforsia, 1946. 21 p. PJ9 .S86 v.13.

Turkmenistan—Anau

A4.988. *Notes on the Anau inscription* / Victor H. Mair. Philadelphia: Department of Asian and Middle Eastern Studies, University of Pennsylvania, 2001. 93 p. DS56.M26 2001.

Ugaritic—Syria—Ugarit

A4.989. *Sources for Ugaritic ritual and sacrifice* / David M. Clemens. Münster: Ugarit-Verlag, 2001. BL1640 .C54 2001.

Umbrian

A4.990. *Iscrizioni umbre minori* / Giovanna Rocca. Firenze: L. S. Olschki, 1996. 169, 8 p. CN4 85 .R63 1996.

Umbrian—Italy—Avella

A4.991. *Il cippo abellano* / Annalisa Franchi De Bellis. Urbino: Università degli studi di Urbino: Edizioni QuattroVenti, 1988. 146 p. CN483 .F73 1988.

Umbrian—Italy—Capua

A4.992. *Le iovile capuane* / Annalisa Franchi De Bellis. Firenze: L. S. Olschki, 1981. 238, 18 p. CN483 .F7 1981.

Umbrian—Italy—Gubbio

A4.993. *Language and ritual in Sabellic Italy: the ritual complex of the third and the fourth tabulae Iguvi-*

nae / Michael Weiss. Leiden; Boston: Brill, 2010. 511 p. PA2461 .W45 2010.

A4.994. *Le tavole di Gubbio e la civiltà degli Umbri: lo "scavo nelle parole" del testo iguvino mostra tutta la specificità della cultura umbra e fa emergere le tracce di una grande civiltà del passato, degna di stare alla pari di quella etrusca e di quella romana* / Augusto Ancillotti and Romolo Cerri. Perugia: Jama, 1996. 463 p. DG225. U42 A524 1996.

Umbrian—Italy—Nola

A4.995. *Il cippo abellano* / Annalisa Franchi De Bellis. Urbino: Università degli studi di Urbino: Edizioni QuattroVenti, 1988. 146 p. CN483 .F73 1988.

Umbrian—Italy—Percorsi

A4.996. *Le tavole di Gubbio e la civiltà degli Umbri: lo "scavo nelle parole" del testo iguvino mostra tutta la specificità della cultura umbra e fa emergere le tracce di una grande civiltà del passato, degna di stare alla pari di quella etrusca e di quella romana* / Augusto Ancillotti and Romolo Cerri. Perugia: Jama, 1996. 463 p. DG225. U42 A524 1996.

Umbrian—Italy—Punta della Campanella—Athena Sanctuary

A4.997. *Punta della Campanella: epigrafe rupestri osca e reperti vari dell'Athenaion* / Mario Russo. Roma: Accademia nazionale dei Lincei, 1990. 104, 58 p. DG11 .M6 v.3 pt.5.

Urartian—Cuneiform

A4.998. *Abridged grammars of the languages of the cuneiform inscriptions, containing: I. A Sumero-Akkadian grammar. II. An Assyro-Babylonian grammar. III. A Vannic grammar. IV. A Medic grammar. V. An Old Persian grammar* / George Bertin. London: Trübner, 1888. 117 p. PJ4013 .B4 1888.

PAPYRI

Electronic Information Resources—Bibliography

A4.999. *Papyrus Collections World Wide: 9–10 March 2000 (Brussels-Leuven)* / Willy Clarysse and Herbert Verreth. Brussels: Koninklijke Vlaamse Academie van Belgiëvoor Wetenschappen en

Kunsten: Vlaams Kennis- en Cultuurforum, 2000. 118 p. Z6604.P36 2000.

Wooden Tablets

A4.1000. *Usi delle tavolette lignee e cerate nel mondo greco e romano* / Paola Degni. Messina: Sicania, 1998. 178 p. Z110.T2 D44 1998.

A4.1001. *Life and letters on the Roman frontier: Vindolanda and its people* / Alan K. Bowman. London: British Museum Press, 1994. 159 p. DA147.V56 B68 1994. See also: *Image to interpretation: an intelligent system to aid historians in reading the Vindolanda texts* / Melissa M. Terras, with a foreword by Alan K. Bowman and Michael Brady. Oxford; New York: Oxford University Press, 2006. 252 p. DA147.V56 T47 2006; *The Vindolanda writing-tablets (tabulae Vindolandenses II)* / Alan K. Bowman and J. David Thomas. London: British Museum Press, 1994. 408 p. DA690. V5 B7 1994; *The Vindolanda writing-tablets: (tabulae Vindolandenses III)* / Alan K. Bowman and J. David Thomas. London: British Museum, 2003. 184 p. DA147.V56 B723 2003.

Appendix 5
Numismatics

Numismatics is the study or collection of currency, including coins, tokens, and related objects. While numismatists are often characterized as students or collectors of coins, the discipline also includes the broader study of money and other payment media used to resolve debts and the exchange of goods. In the twentieth century, as well, the coins were seen more as archaeological objects. After World War II in Germany a project, *Fundmünzen der Antike* (Coin Finds of the Classical Period), was launched to register every coin found within Germany. This idea found successors in many countries, thereby enabling scholars working in public collections and universities acquire knowledge about monetary devices, their systems, their economy, and their historical context.

A5.1. *Ancient coinage* / A. N. Zograph. Oxford: British Archaeological Reports, 1977. 2 v. CJ233 .Z6313.

A5.2. *Antikes Geldwesen* / Walther Giesecke. Leipzig: Verlag Karl W. Hiersemann, 1938. 255 p. CJ233 .G5 1938; 737 G366.

A5.3. *Istituzioni di numismatica antica* / Ernesto Bernareggi. 3 ed. Milano: Cisalpino-Goliardica, 1973. CJ233 .B47 1973.

A5.4. *Liber amicorum Tony Hackens* / Ghislaine Moucharte. Louvain-la-Neuve: Association de numismatique professeur Marcel Hoc, 2007. 461 p. CJ35 .L53 2007.

A5.5. *Miscellanea numismatica: Cyrene to India* / Edward T. Newell. New York: American Numismatic Society, 1938. 101 p. 737 Am36 no.81–84.

A5.6. *Mithradates of Parthia and Hyspaosines of Characene: a numismatic palimpsest* / Edward T. Newell. New York: American Numismatic Society, 1925. 19 p. CJ692 .N494 1925; 737 Am36.

A5.7. *Der Munzfund von Viminacium* / Erik Gren. Uppsala: Almqvist and Wiksell, 1934. 64 p. AS284 .U62 Bd.29.

A5.8. *Nouveau manuel complet de numismatique ancienne* / J. B. A. A. Barthelemy. Paris: A la Libr. encyclopédique de Roret, 1851. 452 p. 737 B28.

A5.9. *Numismatica e antichita classiche*. Lugano: Arti Grafiche, Gaggini-Bizzozero, 1972– . N7149.T5 Q3. v. 1/3, 1972/1974– , v. 40, 2011.

A5.10. *La numismatique antique* / Jean Babelon. Paris: Presses universitaires de France, 1944. 127 p. 737 B113.

A5.11. *Scripta nummaria: contributions à la méthodologie numismatique* / Paul Naster. Louvain-la-Neuve: Société royale de numismatique de Belgique, 1983. 365, 26 p. CJ209 .N26.

AFGHANISTAN

A5.12. *Ariana antiqua; a descriptive account of the antiquities and coins of Afghanistan* / H. H. Wilson. Delhi: Oriental Publishers, 1971. 452 p. DS353 .W6 1971. Supersedes: *Ariana antiqua: a descriptive account of the antiquities and coins of Afghanistan* / H. H. Wilson. London: East India Company, 1841. 452, 22 p. DS353 .W6.

A5.13. *Dokumente zur Geschichte der iranischen Hunnen in Batrien und Indien* / Robert Goebl. Wiesbaden: O. Harrassowitz, 1967. 4 v. CJ1667 .G6.

Afghanistan—Ephthalites

A5.14. *Les Chionites-Hephtalites* / R. Ghirshman. Le Caire: Impr. de l'Institut Français d'Archéologie Orientale, 1948. 156, 8 p. 913.58 F842 t.13.

Afghanistan—Qunduz

A5.15. *Trésors monétaires de Qunduz* / Raoul Curiel and Gérard Fussman. Paris: Klincksieck, 1965. 93, 60 p. 913.58 F842 t.20.

Afghanistan—Sistan

A5.16. *The coinage of the second Saffarid dynasty in Sistan* / John Walker. New York: American Numismatic Society, 1936. 46 p. 737 Am36.

ARABIAN PENINSULA—SAN'A

A5.17. *Le trésor de San'a (monnaies himyaritiques)* / Gustave L. Schlumberger. Paris: E. Leroux, 1880. 65 p. 737 Sch37.

ARKEOLOJI MUZELERI—ISTANBUL

A5.18. *Catalogue des monnaies turcomanes Beni Ortok, Beni Zenguî, Frou' Atabeqyéh et Meliks Eyoubites de Meïyakarikîn* / I. Ghalib Edhem. Constantinople: Mihran, 1894. 175 p. 737 C768; CJ3804 .I814.

ARMENIA

A5.19. *Coinage of Cilician Armenia* / Paul Z. Bedoukian. New York: American Numismatic Society, 1962. 494 p. 737 Am36 n. 147.

ASIA, SOUTHWEST

A5.20. *The early cistophoric coinage* / Fred S. Kleiner and Sydney P. Noe. New York: American Numismatic Society, 1977. 128, 20 p. CJ1309 .K55.

AUSTRIA—STYRIA

A5.21. *Der antike Münzumlauf in der Steiermark* / Ursula Schachinger. Wien: Verl. d. Österr. Akad. d. Wissenschaften, 2006. 328 p. AS142 .V32, Bd.341.

ASTRONOMY

A5.22. *Astronomical symbols on ancient and medieval coins* / Marshall Faintich. Jefferson: McFarland, 2008. 225 p. CJ161 .A82 F35 2008.

AZERBAIJAN

A5.23. *Studies in Oriental coins* / Evgenij Aleksandrovic Pachomov; collected and reprinted by Fuat Sez-gin. Frankfurt am Main: Institute for the History of Arabic-Islamic Science at the Johann Wolfgang Goethe University, 2004. 342 p. CJ3410 .P33 2004.

BACTRIA

A5.24. *Greek and Indo-Scythian kings and their coins; translated from the German of Professor Christian Lassen* / H. Edw. Roeer and Henry Torrens. Delhi: Indological Book House, 1972. 185 p. DS353 .L3 1972.

A5.25. *Jainism, or, The early faith of Aşoka: with illustrations of the ancient religions of the East, from the pantheon of the Indo-Scythians . . .; to which is prefixed a notice on Bactrian coins and Indian dates* / Edward Thomas. London: Trübner, 1877. 82 p.

BALKAN PENINSULA

A5.26. *Coinage in the Balkans, 820–1355* / D. M. Metcalf. Chicago: Argonaut, 1966. 286, 16 p. HG243 .M4.

BIBLIOGRAPHY

A5.27. *Antike Numismatik* / Maria R.-Alföldi. Mainz: P. Von Zabern, 1978. 2 v. CJ233 .A55.

BIBLIOTECA APOSTOLICA VATICANA

A5.28. *Guida ai fondi manoscritti, numismatici, a stampa della Biblioteca vaticana* / Francesco D'Aiuto and Paolo Vian. Città del Vaticano: Biblioteca apostolica vaticana, 2011. 2 v. Z812 .B43 B54 2011.

BIBLIOTHEQUE NATIONALE, PARIS

A5.29. *La monnaie dans l'antiquité: le cons professées dans la chaire d'archéologie près la Bibliothèque Nationale en 1875–1877* / Francois Lenormant. Paris: A. Levy, 1878–1879. 3 v. CJ233 .L466 1878.

BRITISH MUSEUM. DEPARTMENT OF COINS AND MEDALS

A5.30. *A catalogue of the Greek coins in the British Museum. Italy.* / R. S. Poole. London: Woodfall and Kinder, 1873. 432 p. 737 B77 1873.

A5.31. *Catalogue of the Greek coins of Cyrenaica* / E. S. G. Robinson. London: Printed by order of the Trustees, 1927. 154 p. 737 B77 1927.

CIMMERIAN BOSPORUS

A5.32. *Coinage of the Bosporus VI–II centuries B.C.* / D. B. Shelov. Oxford: British Archaeological Reports, 1978. 216, 6 p. CJ672 .S5313.

A5.33. *Essays on the northern Black Sea region numismatics* / Nina Frolova. Ukraine: Polis Press, 1995. 184 p. CJ672 .F7613 1995. English language translation of *Ocherki po numizmatike Severnogo Prichernomoria.*

A5.34. *Histoire des rois de Thrace et de ceux du Bosphere cimmerien eclaircie par les medailles* / M. Cary. Paris: Desaint & Saillant, 1752. 2 v. CJ558 .C332.

A5.35. *Souvenirs de Kertsch et chronologie du royaume de Bosphore* / J. Sabatier. Saint-Pétersbourg, Impr. de la Confection des papiers de la couronne, 1849. 129 p. DK651 .K8 S2.

A5.36. *A tour, performed in the years 1795–6, through the Taurida, or Crimea, the antient [sic] kingdom of Bosphorus, the once-powerful republic of Tauric Cherson, and all the other countries on the north shore of the Euxine, ceded to Russia by the peace of Kainardgi and Jassy; by Mrs. Maria Guthrie, described in a series of letters to her husband, the editor, Matthew Guthrie. The whole illustrated by a map, with engravings of a great number of ancient coins, medals, monuments, inscriptions, and other curious objects.* London: T. Cadell, jun. & W. Davies, 1802. 446 p. DK511.C7 G9.

COLLECTIONS

A5.37. *Auctions-Catalog griechischer und römischer Münzen aus verschiedenem Besitz.* München: Hirsch, 1910. 81 p. 737 H618 no.26.

A5.38. *Auctions-Catalog einer schönen Sammlung römischer Münzen: einschliessend einen Fund GoldMünzen Constantins des Grossen und seiner Familie aus dem Besitze eines auswärtigen Architekten.* München: Jacob Hirsch, 1908. 20 p. 737 H618 no.22.

A5.39. *Monnaies grecques et romaines: quelques médailles de la renaissance et des temps modernes, pierres gravées, bibliothéque numismatique: catalogue.* Genève: Ars classica, 1926. 207 p. 737 Ar73.4.

A5.40. *Nummi familiar; Roman.* London?: s.n., 1787. 26 p.

Collections—Denmark—G. Philipsen Collection

A5.41. *Sammlung Gustav Philipsen in Kopenhagen: antike Müntzen von Griechenland, Asien, und Afrika.* München: J. Hirsch, 1909. 277, 38 p. 737 H618 no.25.

Collections—France—A. Sambon Collection

A5.42. *Sammlung Dr. Arthur Sambon.* Paris: Medaillen und Plaketten der Renaissance; München: Dr. Jacob Hirsch, 1914. 43 p. 737 H618 no.35.

Collections—Germany—O. Bally Collection

A5.43. *Sammlung Kommerzienrat Otto Bally, Säckingen: Münzen und Medaillen von Baden und den angrenzenden gebieten.* München: s.n., 1910. 89 p. 737 H618 no.27.

Collections—Germany—F. von Schennis Collection

A5.44. *Griechische, römische und byzantinische Münzen aus dem Besitze von Baron Friedrich von Schennis, Berlin, Dr. B.K. in M. und eines bekannten englischen Archaeologen.* München; Paris: Jacob Hirsch, 1913. 114 p. 737 H618 no.33.

Collections—Germany—A. Loebbecke Collection

A5.45. *Auctions-Catalog einer bedeutenden Specialsammlung griechischer Münzen von Hispania, Gallia, Italia, Sicilia, Carthago, aus dem Besitze eines bekannten nordischen Sammlers.* Anhang: Römische Goldmünzen; *Numismatische Bibliothek des Herrn Arthur Löbbecke in Braunschweig . . . Die öffentliche Versteirung findet statt: Montag den 28. Mai 1906 u. ff. Tage im Locale und unter Leitung des Experten Dr. Phil Jacob Hirsch.* München: J. Hirsch, 1906. 123 p. 737 H618 no.15.

Collections—Great Britain—P. Barron Collection

A5.46. *Griechische und römische Münzen aus dem Besitze des Rev. Percy Barron (Whyteleafe) und eines bekannten englischen Gelehrten.* München; Paris: Jacob Hirsch, 1911. 103 p. 737 H618 no.30.

Collections—Great Britain—Pembroke Collection

A5.47. *Numismata antiqua [electronic resource]: in tres partes divisa. collegit olim æri incidi vivens curavit Thomas Pembrochiæ et Montis Gomerici*

Comes. London: Prelo demum mandabantur AD, 1746. 10 p.

Collections—Greece—J. P. Lambros Collection

A5.48. *Griechische Münzen, Sammlung Jean P. Lambros, Athen. Römische Münzen aus alten Besitz. Numismatische Bibliothek*. München: J. Hirsch, 1910. 137 p. 737 H618 no.29.

Collections—Israel—L. Wolfe Collection

A5.49. *Wolfe family collection of Near Eastern prehistoric stamp seals* / Shua Amorai-Stark. Fribourg, Switzerland: University Press; Göttingen: Vandenhoeck & Ruprecht, 1997. 185 p. CD5344 .A467 1997.

Collections—Switzerland—F. Imhoof-Blumer Collection

A5.50. *Auctions-catalog der bedeutenden Sammlung römischer und byzantinischer Münzen des herrn. dr. Friedrich Imhoof-Blumer in Winterthur sowie einer ausgewählten sammlung griechischer Münzen aus dem Besitze eines auswärtigen Diplomaten u.A.* München: Hirsch, 1907. 151 p. 737 H618 no.18.

Collections—United States—T. Cleneay Collection

A5.51. *Catalogue of the large and valuable collection of ancient, foreign, English and American coins and medals of the late Thomas Cleneay, esq., of Cincinnati* / S.H. & H. Chapman, numismatists and antiquaries, . . . *Philadelphia . . . and to be sold at auction by Davis & Harvey, auctioneers, . . . Philadelphia, on . . . the 9th, 10th, 11th, 12th and 13th of December, 1890*. Philadelphia: S. H. & H. Chapman, 1890. 114 p. 737 C656.

Collections—United States—H. C. Hoskier Collection

A5.52. *Auctions-catalog einer höchst bedeutenden Sammlung griechischer und römischer Münzen sowie einer kleinen Serie neuerer Münzen des Herrn H.C. Hoskier in South Orange, New Jersey, U.S.A.* München: Hirsch, 1907. 68 p. 737 H618 no.20.

Collections—United States—C. P. Perkins Collection

A5.53. *Guide to the Catharine Page Perkins collection of Greek and Roman coins*. Boston: Museum of Fine Arts, 1902. 111 p. 737 B655.

CYPRUS

A5.54. *Some unpublished coins of eastern dynasts* / Edward T. Newell. New York: American Numismatic Society, 1926. 21 p. 737 Am36 no. 25–28, 30, 32–33.

Cyprus—Kourion

A5.55. *Coins from the excavations at Curium, 1932–1953* / Dorothy H. Cox. New York: American Numismatic Society, 1959. 125, 10 p. 737 Am36 no.144–146.

DENMARK

A5.56. *Late Roman and Byzantine solidi found in Sweden and Denmark* / Joan M. Fagerlie. New York: American Numismatic Society, 1967. 213 p. CJ3094 .F3 1967.

DICTIONARIES

A5.57. *Dictionary of numismatic names, with glossary of numismatic terms in English, French, German, Italian, Swedish* / Mark M. Salton. New York: Barnes and Noble, 1947. 311, 94 p. CJ67 .F7 1947.

A5.58. *The Macmillan encyclopedic dictionary of numismatics* / Richard G. Doty. New York: Macmillan, 1982. 355 p. CJ69 .D67 1982.

A5.59. *La moneta: vocabolario generale* / Edoardo Martinori. Roma: Multigrafica, 1977. 596 p. CJ67 .M3 1977.

DIRECTORIES

A5.60. *International numismatic directory*. London: J. J. Krasnodębski, 1973. CJ63 .I57.

GREEK

A5.61. *The dated Alexander coinage of Sidon and Ake* / Edward T. Newell. New Haven: Yale University Press, 1916. 72 p. CJ710 .N45 1916; 892.3 Y14 v.2.

A5.62. *Études de numismatique grecque* / Louis Robert. Paris: Collège de France, 1951. 245 p. 737 R545.

A5.63. *Greek numismatics and archaeology: essays in honor of Margaret Thompson* / Otto Morkholm and Nancy M. Waggoner. Wetteren: NR, 1979. 326, 41 p. CJ335 .G73.

A5.64. *An inquiry into the value of the ancient Greek and Roman money* / Matthew Raper. London: W. Bowyer and J. Nichols, 1772. 76 p.

A5.65. *La moneta in Grecia e a Roma: appunti di numismatica antica* / Renata Cantilena. Bologna: Monduzzi, 2008. 160 p. CJ335 .C24 2008.

A5.66. *Monnaies grecques, Types, légendes, magistrats monétaires et géographie* / Louis Robert. Genève; Paris: Droz, 1967. 149 p. CJ335 .R62 1967.

A5.67. *Numismatique grecque, romaine et celte*. Dijon: Editions Faton. 85 p. CC3 .H478 no.248.

Greek—Afghanistan—Bactria

A5.68. *Analysis of reasonings in archaeology: the case of Graeco-Bactrian and Indo-Greek numismatics* / Olivier Guillaume. Delhi; New York: Oxford University Press, 1990. 133 p. CJ668 .G8513 1990.

A5.69. *L'art monétaire des royaumes bactriens; essai d'interprétation de la symbolique religieuse gréco-orientale du IIIe au Ier s. av. J.C.* / Th. Allouche-Le Page. Paris: Didier, 1956. 246 p. 737 AL55.

A5.70. *Greek and Indo-Scythian kings and their coins*. Translated from the German of Professor Lassen by T. [i.e. H.] H. Edw. Roeer. Delhi: Indological Book House, 1972. 185 p. DS353 .L3 1972.

A5.71. *Le portrait d'Alexandre le grand: histoire d'une découverte pour l'humanité* / Osmund Bopearachchi and Philippe Flandrin. Monaco: Rocher, 2005. 267 p. CJ668 .B67 2005.

A5.72. *The rise and fall of the Graeco-Bactrian Kingdom* / H. Sidky. Jaipur, India: Illustrated Book Publishers, 1999. 146 p. DS374 .B28 S43 1999.

Greek—Asia, Southwest

A5.73. *Recueil général des monnaies grecques d'Asie Mineure I, 1–I, 4* / William Henry Waddington, Ernest Babelon, and Théodore Reinach. Hildesheim; New York: G. Olms, 1976. 640, 63 p. CJ575 .W2 1976.

Greek—Bibliography

A5.74. *A bibliography of applied numismatics in the fields of Greek and Roman archaeology and the fine arts* / Cornelius Clarkson Vermeule. London: Spink, 1956. 172 p. 737B V593.

A5.75. *A bibliography of Greek coin hoards* / Sydney P. Noe. New York: American Numismatic Society, 1925. 275 p. 737 Am36 no.25–28, 30, 32–33.

A5.76. *An inventory of Greek coin hoards* / Margaret Thompson, Otto Morkholm, and Colin M. Kraay. New York: International Numismatic Commission; American Numismatic Society, 1973. 408 p. Z6869.G8 T45 1973.

A5.77. *Repertorium zur antiken Numismatik im Anschluss an Mionnet's Description des médailles antiques* / Julius Friedlaender. Berlin: G. Reimer, 1885. 440 p. 737 F91.2.

Greek—Coin Hoards

A5.78. *An inventory of Greek coin hoards* / Margaret Thompson, Otto Morkholm, and Colin M. Kraay. New York: International Numismatic Commission; American Numismatic Society, 1973. 408 p. Z6869.G8 T45 1973.

Greek—Bibliography

A5.79. *A bibliography of applied numismatics in the fields of Greek and Roman archaeology and the fine arts* / Cornelius C. Vermeule. London: Spink, 1956. 172 p. 737B V593.

A5.80. *An inventory of Greek coin hoards* / Margaret Thompson, Otto Morkholm, and Colin M. Kraay. New York: International Numismatic Commission; American Numismatic Society, 1973. 408 p. Z6869.G8 T45 1973.

Greek—Egypt—Alexandria

A5.81. *Dieux égyptiens à Alexandrie sous les Antonins: recherches numismatiques et historiques* / Soheir Bakhoum. Paris: CNRS, 1999. 254 p. CJ739 .A44 B35 1999.

Greek—Gems

A5.82. *Tier- und pflanzenbilder auf Münzen und gemmen des klassischen altertums* / Friedrich Imhoof-Blumer and Otto Keller. Leipzig: B. G. Teubner, 1889. 168 p. 737 Im31.

Greek—Greece—Abdera

A5.83. *The coinage of Abdera (540–345 B.C.)* / J. M. F. May. London: Royal Numismatic Society, 1966. 288 p. CJ559.A2 M38.

Greek—Greece—Ambracia

A5.84. *The "Colts" of Ambracia* / Oscar Ravel. New York: American Numismatic Society, 1928. 180 p. 737 Am36 no.35, 37, 40–46.

A5.85. *Corinthian hoards (Corinth and Arta)* / Oscar Ravel. New York: American Numismatic Society, 1932. 27 p. 737 Am36 no.47, 49–50, 52–54.

Greek—Greece—Athens

A5.86. *The new style silver coinage of Athens* / Margaret Thompson. New York: American Numismatic Society, 1961. 2 v. 737.4 T375.2.

Greek—Greece—Attike

A5.87. *Two hoards of Attic bronze coins* / Alfred R. Bellinger. New York: American Numismatic Society, 1930. 14, 2 p. 737 Am36 no.35, 37, 40–46.

Greek—Greece—Corinth

A5.88. *Corinthian hoards (Corinth and Arta)* / Oscar Ravel. New York: American Numismatic Society, 1932. 27 p. 737 Am36 no.47, 49–50, 52–54.

A5.89. *On Corinthian iconography: the bridled winged horse and the helmeted female head in the sixth century BC* / Peter E. Blomberg. Uppsala: Ubsaliensis S. Academiae; Stockholm: Almquist & Wiksell, 1996. 106 p. NK4645 .B57 1996.

A5.90. *The symbols on staters of Corinthian type: a catalogue* / Jean B. Cammann. New York: American Numismatic Society, 1932. 130 p. 737 Am36 no.47, 49–50, 52–54.

Greek—Greece—Crete

A5.91. *A Cretan coin hoard* / Richard B. Seager. New York: American Numismatic Society, 1924. 55 p. 737 Am36 no.6, 14, 19, 21–23.

A5.92. *The iconography of late Minoan and Mycenaean sealstones and finger rings* / J. G. Younger. Bristol: Bristol Classical Press, 1988. 432 p. CD5369 .Y68 1988.

Greek—Greece—Euboea

A5.93. *Chalcis et la Confédération eubéenne: étude de numismatique et d'histoire, IVe–Ier siècle* / Olivier Picard. Athènes: École française d'Athènes; Paris: Diffusion de Boccard, 1979. 377, 32 p. D5 .B4 fasc.234.

Greek—Greece—Folis

A5.94. *The silver coinage of the Phokians* / Roderick T. Williams. London: Royal Numismatic Society, 1972. 139 p. CJ494 .W54.

Greek—Greece—Karystos

A5.95. *A hoard of silver coins from Carystus* / David M. Robinson. New York: American Numismatic Society, 1952. 62 p. 737 Am36 no.124–126.

Greek—Greece—Khalkis

A5.96. *Chalcis et la Confédération eubéenne: étude de numismatique et d'histoire, IVe–Ier siècle* / Olivier Picard. Athènes: École française d'Athènes; Paris: diffusion de Boccard, 1979. 377, 32 p. D5 .B4 fasc.234.

Greek—Greece—Lesbos

A5.97. *Phokäisches Elektron-Geld von 600–326 v. Chr.: Studien zur Bedeutung und zu den Wandlungen einer antiken Goldwährung* / Friedrich Bodenstedt. Mainz am Rhein: P. von Zabern, 1976. 170 p. CJ619.P45 B63 1976.

Greek—Greece—Megara

A5.98. *Greek bronze coins from a well at Megara* / Frederick O. Waage. New York: American Numismatic Society, 1935. 42 p. 737 Am36 no.69–77.

Greek—Greece—Melos Island

A5.99. *The Melos hoard of 1907* / J. G. Milne. New York: American Numismatic Society, 1934. 19 p. 737 Am36 no.59–67.

Greek—Greece—Olympia

A5.100. *The temple coins of Olympia* / Charles T. Seltman. Cambridge: Bowes & Bowes, 1921. 117 p. 737 Se47.

Greek—Greece—Samos

A5.101. *The silver coins of Samos* / John P. Barron. London: Athlone, 1966. 244, 32 p. CJ439 .B3 1966.

Greek—Greece—Sicyon

A5.102. *Greek bronze coins from a well at Megara* / Frederick O. Waage. New York: American Numismatic Society, 1935. 42 p. 737 Am36 no.69–77.

Greek—Greece—Siphnos Island

A5.103. *A hoard from Siphnos* / Edward T. Newell. New York: American Numismatic Society, 1934. 17 p. 737 Am36 no.59–67.

Greek—History

A5.104. *Money and its uses in the ancient Greek world* / Andy Meadows and Kirsty Shipton. Oxford; New York: Oxford University Press, 2001. 167, 20 p. HG237 .M66 2001.

Greek—Illyria

A5.105. *The coinage of Damastion and the lesser coinages of the Illyro-Paeonian region* / John Maunsell Frampton May. Aalen: Scientia, 1979. 207, 25 p. CJ514 .M35 1979.

A5.106. *Questions de numismatique illyrienne, avec un catalogue de monnaies d'Apollonie et de Durrhachium* / Hasan Ceka. Tirana, Université d'Etat de Tirana, Institut d'histoire, 1972. 199 p. CJ514 .C4413.

Greek—Indexes

A5.107. *A numismatic index to the Journal of Hellenic Studies, 1880–1969* / J. R. Jones. Cambridge: W. Heffer and Sons, 1971. 45 p. Z6869.G8 J65.

Greek—India

A5.108. *Analysis of reasonings in archaeology: the case of Graeco-Bactrian and Indo-Greek numismatics* / Olivier Guillaume. Delhi; New York: Oxford University Press, 1990. 133 p. CJ668 .G8513 1990. English language translation of *Analyse de raisonnements en archéologie*.

A5.109. *Kings and coins in India: Greek and Śaka self-advertisement* / R. Morton Smith. New Delhi: Harman Pub. House, 1997. 149 p. DS451 .S665 1997.

Greek—Israel and the Palestinian Territories—Acre

A5.110. *The dated Alexander coinage of Sidon and Ake* / Edward T. Newell. New Haven, Yale University Press, 1916. 72 p. CJ710 .N45 1916; 892.3 Y14 v.2.

A5.111. *Late Seleucid mints in Ake-Ptolemais and Damascus* / Edward T. Newell. New York: American Numismatic Society, 1939. 107 p. 737 Am36 no.81–84.

Greek—Italy

A5.112. *A catalogue of the Greek coins in the British Museum. Italy.* / R. S. Poole. London: Printed by Woodfall and Kinder, 1873. 432 p. CJ517 .B8 1873a.

Greek—Italy—Calabria

A5.113. *Calabria greca: Greek coins of Calabria* / Pasquale Attianese. Santa Severina: De Luca, 1974–1980. 3 v. CJ525 .A88.

Greek—Italy—Lucania—Heraclea

A5.114. *The earlier staters of Heraclea Lucaniae* / Eunice Work. New York: American Numismatic Society, 1940. 40 p. 737 Am36 no.85–92.

Greek—Italy—Sicily

A5.115. *Catalogue of Greek coins. Sicily.* / Reginald Stuart Poole. London: The Trustees, 1876. 292 p. 737 B77 1876.

A5.116. *Coins of ancient Sicily* / G. F. Hill. Westminster: A. Constable, 1903. 256 p. 737 H55.

A5.117. *Coins of Greek Sicily* / Kenneth Jenkins. London: British Museum, 1966. 31 p. CJ549 .J4.

A5.118. *Euainetos: eine Werkfolge nach Originalen des Staatlichen Münzkabinetts zu Berlin.* Berlin: W. de Gruyter, 1941. 64 p. 913.06 B455 v.101.

A5.119. *Die Künstlerinschriften der sicilischen Münzen* / Rudolf Weil. Berlin: G. Reimer, 1884. 32 p. CJ517 UF8 1883.

A5.120. *La monetazione greca della Sicilia antica* / Giacomo Cirami. Bologna: Edizioni dello Studio Numismatico Gamberini del Dott. Cesare Gamberini di Scarfèa, 1959. 2 v. 737.4 C498.

Greek—Italy—Sicily—Catalogs

A5.121. *Hochbedeutende Sammlung griechischer Münzen: vorzugsweise von Sicilia aus altem Besitz, sowie numismatische Bibliothek des Herrn Gustav Philipsen, Kopenhagen.* München; Paris: Jacob Hirsch, 1912. 58, 23 p. 737 H618 no.32.

Greek—Italy—Syracuse

A5.122. *Siracusa ellenistica: le monete regali di Ierone II, della sua famiglia e dei siracusani* / Maria Caccamo Caltabiano, Benedetto Carroccio, and Emilia Oteri. Messina: DiScAM, 1997. 255, 27 p. CJ550 .S9 C32 1997.

A5.123. *Victory issues of Syracuse after 413 B.C.* / Agnes Baldwin Brett. New York: American Numismatic Society, 1936. 6 p. 737 Am36 no.69–77.

Greek—Lexicography

A5.124. *Dalla premoneta alla moneta: lessico monetale greco tra semantica e ideologia* / M. Caccamo

Caltabiano and P. Radici Colace. Pisa: ETS, 1992. 217, 6 p. CJ351 .C25 1992.

Greek—Libya—Barqah

A5.125. *Catalogue of the Greek coins of Cyrenaica* / E. S. G. Robinson. London: Printed by order of the Trustees, 1927. 154 p. 737 B77 1927.

Greek—Macedonia

A5.126. *Alexander and the Hellenistic kingdoms: coins, image and the creation of identity: the Westmoreland collection* / K. A. Sheedy. Sydney: Australian Centre for Ancient Numismatic Studies, Macquarie University; Numismatic Association of Australia, 2007. 172 p. CJ545 .S34 2007.

A5.127. *Macedonian regal coinage to 413 B.C.* / Doris Raymond. New York: American Numismatic Society, 1953. 170, 15 p. 737 Am36 no.124–126.

Greek—Macedonia—Damastium

A5.128. *The coinage of Damastion and the lesser coinages of the Illyro-Paeonian region* / John Maunsell Frampton May. Aalen: Scientia, 1979. 207, 25 p. CJ514 .M35 1979.

Greek—Macedonia—Olynthus

A5.129. *The coins found at Olynthus in 1928* / David M. Robinson. Baltimore: John Hopkins Press, 1931. 129 p. DF261.O53 J6 pt.3.

Greek—Macedonia—Paeonia

A5.130. *The coinage of Damastion and the lesser coinages of the Illyro-Paeonian region* / John Maunsell Frampton May. Aalen: Scientia, 1979. 207, 25 p. CJ514 .M35 1979.

Greek—Museum of Fine Arts, Boston—Catharine Page Perkins Collection

A5.131. *Guide to the Catharine Page Perkins collection of Greek and Roman coins.* Boston: Museum of Fine Arts, 1902. 111, 5 p. 737 B655.

Greek—Silver

A5.132. *Hacksilber to coinage: new insights into the monetary history of the Near East and Greece* / Miriam S. Balmuth. New York: American Numismatic Society, 2001. 134 p. CJ208 .H32 2001.

Greek—Syria—Arwad

A5.133. *Arados hellénistique: étude historique et monétaire* / Frédérique Duyrat. Beyrouth: Institut français du Proche-Orient, 2005. 433 p. DS99. A85 D894 2005.

Greek—Syria—Damascus

A5.134. *Late Seleucid mints in Ake-Ptolemais and Damascus* / Edward T. Newell. New York: American Numismatic Society, 1939. 107 p. 737 Am36 no.81–84.

Greek—Themes

A5.135. *Pergameus Deus: archäologische und numismatische Studien zu den Darstellungen des Asklepios in Pergamon während Hellenismus und Kaiserzeit; mit einem Exkurs zur Überlieferung statuarischer Bildwerke in der Antike* / Peter Kranz. Möhnesee: Bibliopolis, 2004. 189 p. BL820.A4 K73 2004.

Greek—Turkey

A5.136. *Antik nümismatik ve Anadolu: arkaik ve klâsik çağlar* / Oğuz Tekin. Beyoğlu-İstanbul: Arkeoloji ve Sanat Yayinlari, 1992. 163, 24 p. CJ233 .T44 1992.

Greek—Turkey—Bergama

A5.137. *The Pergamene mint under Philetaerus* / Edward T. Newell. New York: American Numismatic Society, 1936. 34 p. 737 Am36 no.69–77.

Greek—Turkey—Perinthus

A5.138. *Griechisches Münzwerk; die Münzprägung von Perinthos* / Edith Schoenert-Geiss. Berlin: Akademie-Verlag, 1965. 277 p. 470.6 Ak12 Bd.45.

Greek—Turkey—Phocaea

A5.139. *Phokäisches Elektron-Geld von 600–326 v. Chr.: Studien zur Bedeutung und zu den Wandlungen einer antiken Goldwährung* / Friedrich Bodenstedt. Mainz am Rhein: P. von Zabern, 1976. 170 p. CJ619.P45 B63 1976.

INDEXES—*AMERICAN JOURNAL OF ARCHAEOLOGY*

A5.140. *A numismatic index to* American Journal of Archaeology *and* Hesperia, *1885–1932–1970* / J. R.

Jones. Cambridge: W. Heffer, 1972. 78 p. Z6866 .J66.

Indexes—American Numismatics and Archaeological Society

A5.141. *Catalogue of the numismatic books in the library ... with a subject index to the important articles in the* American Journal of Numismatics, *and other periodicals to the end of 1882.* New York, 1883. 31 p. 737 N483.2.

Indexes—Hesperia

A5.142. *A numismatic index to* American Journal of Archaeology *and* Hesperia, *1885–1932–1970* / J. R. Jones. Cambridge: W. Heffer, 1972. 78 p. Z6866 .J66.

IRAN

A5.143. *Album of coins, medals, and seals of the shahs of Iran, 1500–1948* / H. L. Rabino di Borgomale. Tehran: Iranian Numismatic Institute; Amir Kabir Publications Organization, 1974. 55, 48 p. CJ3756 .R32 1974.

A5.144. *The coinage of Lydia and Persia* / Barclay V. Head. San Diego: Pegasus, n.d. 55 p. CJ618 .H4.

A5.145. *The king and kingship in Achaemenid art: essays on the creation of an iconography of empire* / Margaret Cool Root. Leiden: Brill, 1979. 357, 37 p. NB80 .R6.

Iran—Parthia

A5.146. *Arsaciden-Münzen, Sammlung Petrowicz* / Alexander von Petrowicz. Graz: Akademische Druck- u. Verlagsanstalt, 1968. 206 p. CJ691 .P4 1968.

A5.147. *Chemical composition of Parthian coins* / Earle R. Caley. New York: American Numismatic Society, 1955. 104 p. CJ692 .C3 1955; 737 Am36 no.127–130.

A5.148. *The coinage of Parthia* / Joel L. Malter. San Diego: Malter-Westerfield, 1968. 68 p. CJ692 .G3 1968.

A5.149. *Coins from Seleucia on the Tigris* / Robert Harbold McDowell. Ann Arbor: University of Michigan Press, 1935. 248 p. CJ692 .M25 1935.

A5.150. *A view of the history and coinage of the Parthians, with descriptive catalogues and tables, with a complete set of engravings of coins, a large number of them unpublished.* Cork: Printed by J. Crowe, 1852. 250 p. 737 L645.

Iran—Parthia—Rhesaena

A5.151. *The coinage of Rhesaena in Mesopotamia* / Karel O. Castelin. New York: American Numismatic Society, 1946. 111 p. 737 Am36 no.102–109.

Iran—Persepolis

A5.152. *Excavation coins from the Persepolis region* / George C. Miles. New York: American Numismatic Society, 1959. 124 p. 737 Am36 no.140–143.

Iran—Rai

A5.153. *The numismatic history of Rayy* / George C. Miles. New York: American Numismatic Society, 1938. 240 p. CJ3429.R3 M5.

Iran—Sassanid

A5.154. *Arabosasanidische Numismatik* / Heinz Gaube. Braunschweig, Klinkhardt & Biermann, 1973. 170 p. CJ3764 .G3.

A5.155. *Sylloge Nummorum Sasanidarum: Paris-Berlin-Wien* / Michael Alram and Rika Gyselen. Wien: Verlag der Österreichischen Akademie der Wissenschaften, 2003. 3 v. AS142 .V32 Bd.317, 325, 422.

Iran—Susa

A5.156. *Coins from Seleucia on the Tigris* / Robert Harbold McDowell. Ann Arbor: University of Michigan Press, 1935. 248 p. CJ692 .M25 1935.

A5.157. *Numismatique susienne, monnaies trouvées à Suse de 1946 à 1956* / R. Göbl. Paris: P. Geuthner, 1960. 145 p. DS261 .F8 t.37.

ISRAEL AND THE PALESTINIAN TERRITORIES—EXHIBITIONS—CATALOGS

A5.158. *Das Heilige Land: Antike M ünzen und Siegel aus einem Jahrtausend jüdischer Geschichte* / Bernhard Overbeck. München: Staatlichen Münzsammlung, 1993. 191 p. CJ1375 .O9 1993.

Israel and the Palestinian Territories—Galilee

A5.159. *Tyrian influence in the Upper Galilee* / Richard S. Hanson. Cambridge: American Schools of Oriental Research, 1980. 89 p. DS89.T8 H36 1980.

Israel and the Palestinian Territories—Meron

A5.160. *The coins of ancient Meiron* / Joyce Raynor and Yaakov Meshorer. Cambridge: ASOR; Winona Lake: Eisenbrauns, 1988. 140 p. CJ707 .M47 R39 1988.

Israel and the Palestinian Territories—Palestine—Bible O.T.

A5.161. *On ancient Palestinian and other coins: their symbolism and metrology* / Ernst W. Klimowsky. Tel Aviv: The Israel Numismatic Society, 1974. 179, 7 p. CJ1375 .K55.

ITALY

A5.162. *Le caissier italien, ou L'art de connoitre toutes les monnoies actuelles d'Italie; ainsi que celles de tous les etats et princes de l'Europe, qui y ont cours. Avec le détail des productions de l'Italie, les usages pour les lettres de change, la maniere de faire les payemens, les poids, mesures, et autres objets rélatifs au commerce* / Jean Michel Benaven. Lyon, 1787. 2 v. CJ2910 .B5.

A5.163. *Considérations sur la numismatique de l'ancienne Italie, principalement sous le rapport de monumens historiques et philologiques* / James Millingen. Florence: J. Molini, 1841. 268 p. 737 M62.

A5.164. *Il linguaggio delle monete: motti, imprese e legende di monete italiane* / Mario Traina. Sesto Fiorentino (Firenze): Olimpia, 2006. 575 p. CJ2912 .T73 2006.

A5.165. *Vade-mecum del raccoglitore di monete italiane, ossia, Repertorio numismatico* / G. Bazzi and M. Santoni. Camerino: Mercuri, 1886. 215 p. 737 B3491.

Italy—Genoa

A5.166. *Della moneta antica di Genova; libri IV* / Gio. Cristoforo Gandolfi. Genova, Tipografia Ferrando, 1841. 2 v. Locked Cases 737 G153.

Italy—Sicily

A5.167. *Recherches sur la numismatique et la sigillographie des Normands de Sicile et d'Italie* / Arthur Engel. Bologna: Forni, 1972. 112 p. CJ1671 .E53 1972.

Italy—Sicily—Syracuse

A5.168. *Contributo alla storia della antica moneta bronzea in Sicilia* / Sebastiana Consolo Langher. Milano: Giuffre, 1964, 406, 172 p. CJ549 .C6.

A5.169. *The thirteen-months coinage of Hieronymos of Syracuse.* / R. Ross Holloway. Berlin: de Gruyter, 1969. 47 p. CJ550 .S8 H6.

Italy—Siris

A5.170. *Siris: recherches critiques sur l'histoire de la Siritide avant 433/2* / Jacques Perret. Paris: Société d'édition "Les Belles lettres," 1941. 306 p. 937.7 P428.

JORDAN

A5.171. *The coins of the Decapolis and Provincia Arabia* / Augustus Spijkerman; edited with historical and geographical introductions by Michele Piccirillo. Jerusalem: Franciscan Printing Press, 1978. 322 p. CJ3890.J6 S6 1978.

LEBANON—SIDON

A5.172. *The dated Alexander coinage of Sidon and Ake* / Edward T. Newell. New Haven: Yale University Press, 1916. 72 p. CJ710 .N45 1916; 892.3 Y14 v.2.

Lebanon—Tyre

A5.173. *Tyrian influence in the Upper Galilee* / Richard S. Hanson. Cambridge: American Schools of Oriental Research, 1980. 89 p. DS89.T8 H36 1980.

METHODS—METALS—ANALYSIS—CONGRESSES

A5.174. *Methods of chemical and metallurgical investigation of ancient coinage, a symposium held by the Royal Numismatic Society at Burlington House, London on 9–11 December 1970* / E. T. Hall and D. M. Metcalf. London: Royal Numismatic Society, 1972. 446 p. CJ223 .R696.

MINOAN—GREECE—CRETE

A5.175. *The iconography of late Minoan and Mycenaean sealstones and finger rings* / J. G. Younger. Bristol: Bristol Classical Press, 1988. 432 p. CD5369 .Y68 1988.

MOROCCO—TANGIER

A5.176. *Coins of Tingi with Latin legends* / Aline Abaecherli Boyce. New York: American Numismatic Society, 1947. 2. 737 Am36 no.102–109.

MYCENAEAN—GREECE—CRETE

A5.177. *The iconography of late Minoan and Mycenaean sealstones and finger rings* / J. G. Younger. Bristol: Bristol Classical Press, 1988. 432 p. CD5369 .Y68 1988.

NEAR EAST

A5.178. *La naissance de la monnaie: pratiques monétaires de l'Orient ancien* / Georges Le Rider. Paris: Presses universitaires de France, 2001. 286 p. CJ233 .L4 2001.

Near East—Silver

A5.179. *Hacksilber to coinage: new insights into the monetary history of the Near East and Greece* / Miriam S. Balmuth. New York: American Numismatic Society, 2001. 134 p. CJ208 .H32 2001.

OMAN

A5.180. *Coins and coinage of Yemen and Oman* / Fuat Sezgin. Frankfurt am Main: Institute for the History of Arabic-Islamic Science at the Johann Wolfgang Goethe University, 2004. 205, 6 p. CJ3463 .C65 2004.

PHOENICIAN

A5.181. *A dissertation upon the Phoenician numeral characters antiently used at Sidon [electronic resource]: In a letter to the Rev. Tho. Birch, D.D. Secretary of the Royal Society* / Rev. John Swinton, M. A. of Christ-Church, Oxon. F.R.S. London, 1759.

A5.182. *Tyrian influence in the Upper Galilee* / Richard S. Hanson. Cambridge, MA: American Schools of Oriental Research, 1980. 89 p. DS89.T8 H36 1980.

Phoenician—Alphabet

A5.183. *El alfabeto monetario de las cecas "libio-fenices": hacia un intento de interpretación de un alfabeto desconocido* / Josep M. Sola-Solé. Barcelona: Puvill, 1980. 91 p. CJ1379 .S64.

PORTRAITS

A5.184. *Le portrait dans l'antiquité d'après les monnaies; avec 308 reproductions de monnaies* / Jean Babelon. Paris: Payot, 1942. 206 p. 737 B113.2.

PUNIC

A5.185. *Punic coins of ancient Spain: and their bearing on the Roman Republican series* / E. S. G. Robinson. Chicago: Ares, 1978. 27 p. CJ1381 .R63 1978.

ROMAN

A5.186. *Description générale des monnaies de la République romaine communément appelées médailles consulaires* / H. Cohen. Paris: Chez M. Rollin, 1857. 359 p. 737 C663.2.

A5.187. *Dieux égyptiens à Alexandrie sous les Antonins: recherches numismatiques et historiques* / Soheir Bakhoum. Paris: CNRS, 1999. 254 p. Egyptian Collection CJ739 .A44 B35 1999.

A5.188. *Geschichte des römischen Münzwesens* / Theodor Mommsen. Graz: Akademische Druck- und Verlagsanstalt, 1956. 900 p. 737.4 M737.

A5.189. *Geschichte der römischen Kupferprägung vom Bundesgenossenkrieg bis auf Kaiser Claudius: nebst einleitendem Überblick über die Entwicklung des antiken Münzwesens* / Heinrich Willers. Leipzig; Berlin: B. G. Teubner, 1909. 228 p. 737 W663.

A5.190. *Histoire de la monnaie romaine* / Théodore Mommsen. Paris: Rollin et Feuardent, 1865. 737 M74.

A5.191. *Historical Roman coins: from the earliest times to the reign of Augustus* / G. F. Hill. London: Constable, 1909. 191 p. 737 H55.4.

A5.192. *Illustrium imagines: incorporating an English translation of Nota* / Roberto Weiss. Crestline, CA: George Frederick Kolbe, 2012. 35 p. Rare Bk & Ms ry Furness Collection Z239.B47 .W45 2001.

A5.193. *An inquiry into the value of the ancient Greek and Roman money.* / Matthew Raper. London: W. Bowyer and J. Nichols, 1772. 76p.

A5.194. *Italia numismatica; eine Geschichte der italischen Geldsysteme bis zur Kaiserzeit* / Walther

Giesecke. Leipzig: K. W. Hiersemann, 1928. 373 p. 737.4 G277.2.

A5.195. *The medallic history of imperial Rome [electronic resource]: from the first Triumvirate, . . . to . . . Constantine the Great* / William Cooke. London: Printed for J. Dodsley, 1781. 2 v.

A5.196. *La moneta in Grecia e a Roma: appunti di numismatica antica* / Renata Cantilena. Bologna: Monduzzi, 2008. 160 p. CJ335 .C24 2008.

A5.197. *Le monete delle antiche famiglie di Roma fino allo imperadore Augusto, inclusivamente co' suoi zecchieri dette comunemente consolari disposte per ordine alfabetico* / Gennaro Riccio. 2 ed. Napoli: Stamperia del Fibreno, 1843. 288 p. 737 R35.

A5.198. *Le monete dell'Italia antica* / Raffaele Garrucci. Roma: Coi tipi del cav. V. Salviucci, 1885. 2 v. 737 G198.

A5.199. *Numismatique grecque, romaine et celte*. Dijon: Editions Faton. 85 p. CC3 .H478 no.248.

A5.200. *Porträtköpfe auf römischen Münzen der republik und der kaiserzeit* / F. Imhoof-Blumer. Leipzig: B. G. Teubner, 1879. 16 p. 737 Im31.

A5.201. *Recherches sur la monnaie romaine depuis son origine jusqu'à la mort d'Auguste* / Pierre-Philippe Bourlier. Lyon: N. Scheuring, 1864–1869. 2 v. 737 Ai54.

A5.202. *Das römische Bildnis in Meisterwerken der Münzkunst* / L. M. Lanckoroński. Amsterdam: Pantheon, 1944. 115 p. 737 L277.

A5.203. *Rom im jahrhunderte des Augustus; oder, Reise eines Galliers nach Rom zur zeit von Augustus regierung und während eines teils der regierung Tibers* / L. Charles Dezobry. Leipzig: J. C. Hinrichs, 1837–1838. 4 v. 913.374 D53.GH.

A5.204. *Roman coins and their values* / David R. Sear. London: B. A. Seaby, 1964. 288 p. 737.4 Se13.

A5.205. *Roman coins from the earliest times to the fall of the western empire* / Harold Mattingly. London: Methuen, 1928. 300 p. 737 M434.

A5.206. *Six Roman bronze medallions* / Agnes Baldwin. New York: American Numismatic Society, 1923. 39 p. 737 Am36 no.17.

A5.207. *Tier- und pflanzenbilder auf Münzen und gemmen des klassischen altertums* / Friedrich Imhoof-Blumer and Otto Keller. Leipzig: B. G. Teubner, 1889. 168 p. 737 Im31.

A5.208. *Typenatlas der römischen Reichsprägung von Augustus bis Aemilianus* / Franziska Schmidt-Dick. Wien: Verlag der Österreichischen Akademie der Wissenschaften, 2002. 2 v. AS142 .V32 Bd.309, 428.

A5.209. *Zur abfolge der prägungen der kaiser Marcus und Verus* / Wilhelm Kubitschek. Wien; Leipzig: Hölder-Pichler-Tempsky, 1932. 153 p. 63 V67 p5 v.213 no.5.

Roman—Austria—Carnuntun

A5.210. *Numismata Carnuntina: Forschungen und Material; die antiken FundMünzen in Museum Carnuntinum* / Michael Alram and Franziska Schmidt-Dick. Wien: Verlag der Österreichischen Akademie der Wissenschaften, 2007. 3 v. + CD-ROM. AS142 .V32 Bd.353.

Roman—Austria—Kunsthistorisches Museum Wien

A5.211. *Non olet: das Geld der Römer* / Günther Dembski; herausgegeben von Wilfried Seipel: Kunsthistorisches Museum, 30. Mai bis 15. Oktober 2000. Milano: Skira; Wien: Kunsthistorisches Museum, 2000. 123 p. CJ815.A87 K86 2000.

Roman—Balkan Peninsula—Illyria

A5.212. *Questions de numismatique illyrienne, avec un catalogue de monnaies d'Apollonie et de Durrhachium* / Hasan Ceka. Tirana: Université d'Etat de Tirana, Institut d'histoire, 1972. 199 p. CJ514 .C4413.

Roman—Bibliography

A5.213. *A bibliography of applied numismatics in the fields of Greek and Roman archaeology and the fine arts* / Cornelius Clarkson Vermeule. London: Spink, 1956. 172 p. 737B V593.

A5.214. *Les moules de monnaies impériales romaines: essai bibliographique* / Marcel Jungfleisch and Jacques Schwartz. Le Caire: Impr. de l'Institut français d'archéologie orientale, 1952. 35 p. Egyptian Collection 913.32 C128.2 sup.no.19.

A5.215. *Repertorium zur antiken Numismatik im Anschluss an Mionnet's Description des médailles antiques* / Julius Friedlaender. Berlin: G. Reimer, 1885. 440 p. 737 F91.2.

Roman—Catalogs

A5.216. *Auctions-catalog der bedeutenden Sammlung römischer und byzantinischer Münzen des herrn. dr. Friedrich Imhoof-Blumer in Winterthur sowie einer ausgewählten sammlung griechischer Münzen aus dem Besitze eines auswärtigen Diplomaten u.A.* München: Hirsch, 1907. 151 p. 737 H618 no.18.

A5.217. *Auctions-Catalog einer bedeutenden Specialsammlung griechischer Münzen von Hispania, Gallia, Italia, Sicilia, Carthago, aus dem Besitze eines bekannten nordischen Sammlers. Anhang: Römische GoldMünzen; Numismatische Bibliothek des Herrn Arthur Löbbecke in Braunschweig*

. . . *Die öffentliche Versteirung findet statt: Montag den 28. Mai 1906 u. ff. Tage im Locale und unter Leitung des Experten Dr. Phil Jacob Hirsch.* München: J. Hirsch, 1906. 123 p. 737 H618 no.15.

A5.218. *Auctions-catalog einer höchst bedeutenden Sammlung griechischer und römischer Münzen sowie einer kleinen Serie neuerer Münzen des Herrn H.C. Hoskier in South Orange, New Jersey, U.S.A.* München: Hirsch, 1907. 68 p. 737 H618 no.20.

A5.219. *Auctions-Catalog einer schönen Sammlung römischer Münzen: einschliessend einen Fund GoldMünzen Constantins des Grossen und seiner Familie aus dem Besitze eines auswärtigen Architekten.* München: Jacob Hirsch, 1908. 20 p. 737 H618 no.22.

A5.220. *Auctions-Catalog griechischer und römischer Münzen aus verschiedenem Besitz.* München: Hirsch, 1910. 81 p. 737 H618 no.26.

A5.221. *Catalogo delle raccolte numismatiche.* Milano: Edizioni d'arte Emilio Bestetti, 1938–1940. 2 v. 737.4 M584.

A5.222. *Münzen zwischen Rom und Byzanz: studien zur spätantiken Numismatic* / Helmut Mostecky. Louvain-la-Neuve: Dépt. d'Archéologie et d'histoire de l'art, Séminaire de Numismatique Marcel Hoc, 1997. 196 p. CJ1009 .M67 1997.

Roman—Catalogs—Universität Wien, Institut fur Numismatik

A5.223 *Die Münzsammlung der Universität Wien, Institut f. Numismatik* / Barbara Czurda and Franziska Dick. Wien: Österreichische Akademie der Wissenschaften, 1980. 232 p. AS142 .V32 Bd.140.

Roman—Chronology

A5.224. *Studies in Constantinian chronology* / Patrick Bruun. New York: American Numismatic Society, 1961. 116 p. 737.4 B835; 737 Am36 no.144–146.

Roman—Croatia

A5.225. *Die FundMünzen der römischen Zeit in Kroatien* / Kommission für Geschichte des Altertums der Akademie der Wissenschaften und der Literatur Mainz; Arheološki Muzej u Zagrebu, Zagreb / Maria R.-Alföldi, Hans-Markus von Kaenel, and Ivan Mirnik. Mainz: P. von Zabern, 2002. CJ815 .C87 F86 2002, Abt.18.

Roman—Dacia

A5.226. *Numismatic aspects of the history of the Dacian state: the Roman Republican coinage in Dacia and Geto-Dacian coins of Roman type* / Maria Chitescu. Oxford, England: B.A.R., 1981. 367, 34 p. CJ1106 .C54 1981.

Roman—Dictionaries

A5.227. *A dictionary of Roman coins, republican and imperial* / commenced by the late Seth William Stevenson . . . revised, in part by C. Roach Smith . . . and completed by Frederic W. Madden. London: G. Bell and Sons, 1889. 929 p. 737 ST49.

Roman—Egypt—Alexandria

A5.228. *Dieux égyptiens à Alexandrie sous les Antonins: recherches numismatiques et historiques* / Soheir Bakhoum. Paris: CNRS, 1999. 254 p. CJ739 .A44 B35 1999.

Roman—Gems

A5.229. *Tier- und pflanzenbilder auf Münzen und gemmen des klassischen altertums* / Friedrich Imhoof-Blumer and Otto Keller. Leipzig: B. G. Teubner, 1889. 168 p. 737 Im31.

Roman—Germany—Indexes

A5.230. *Kritische Neuaufnahme der FundMünzen der römischen Zeit in Deutschland (FMRD), Cohen-RIC-Konkordanz* / Heinrich Chantraine. Bonn: Habelt, 1978. CJ1117 .K73.

Roman—Germany—Catalogs

A5.231. *Die FundMünzen der römischen Zeit in Deutschland* / Kommission für Geschichte des Altertums der Akademie der Wissenschaften und der Literatur, Mainz, Römisch-Germanische Kommission des Deutschen Archäologischen Instituts, Frankfurt a.M.; begründet von Hans Gebhart und Konrad Kraft / Maria R.-Alföldi. Berlin: Gebr. Mann, 1960–2011. CJ1117 .F8.

Roman—Germany—Cologne

A5.232. *Die römische Münzstätte Köln: ihre Entstehung, Entwicklung und Bedeutung für die Geldgeschichte des gallischen Sonderreiches: ihre stilistischen Besonderheiten, die Berücksichtigung ihrer Neugründungen Mailand und Trier* /

Carl-Friedrich Zschucke. Trier: Petermännchen-Verlag, 1993. 128 p. CJ1119.C69 Z84 1993.

Roman—Germany—Mainz (Rhineland-Palatinate)

A5.233. *Die römische Stadtmauer von Mogontiacum-Mainz: archäologische, historische und numismatische Aspekte zum 3. und 4. Jahrhundert n.Chr.* / Alexander Heising. Bonn: Habelt, 2008. 322, 32 p. DD901.M24 H45 2008.

Roman—Great Britain

A5.234. *Carausius: a consideration of the historical, archaeological and numismatic aspects of his reign* / Hugh P. G. Williams. Oxford: Archaeopress, 2004. 101 p. DA145.3.C37 W55 2004.

A5.235. *Coins of the Romans relating to Britain* / John Yonge Akerman. London: J. R. Smith, 1844. 170 p. 737 Ak3.6.

A5.236. *An essay on the Roman denarius and English silver penny: shewing their derivation from the Greek drachma of Ægina* / William Till. London: Royal Numismatics Society, 1837. 226 p. 737 T46.

Roman—History

A5.237. *Italia numismatica; eine Geschichte der italischen Geldsysteme bis zur Kaiserzeit* / Walther Giesecke. Leipzig, K. W. Hiersemann, 1928. 373 p. 737.4 G277.2.

Roman—Hungary—Pannonia Region

A5.238. *Der Untergang der Römerherrschaft in Pannonien* / Andreas Alföldi. Berlin; Leipzig: W. de Gruyter, 1924–1926. 2 v. DG59.P2 A5 1924a.

Roman—Indexes

A5.239. *A numismatic index to the* Journal of Roman Studies, *1911–1965* / J. R. Jones. Cambridge: W. Heffer and Sons Ltd., 1970. 48 p. Z6869.R6 J6.

Roman—Israel and the Palestinian Territories—Jerusalem

A5.240. *The coinage of Aelia Capitolina* / Yaakov Meshorer. Jerusalem: Israel Museum, 1989. 124 p. CJ1375 .M388 1989.

A5.241. *The coins of Aelia Capitolina* / Leo Kadman. Jerusalem, Universitas, 1956. 191 p. CJ1375.K11 C67 1956.

Roman—Israel and the Palestinian Territories—Palestine

A5.242. *City-coins of Eretz-Israel and the Decapolis in the Roman period* / Yaakov Meshorer. Jerusalem: The Israel Museum, 1985. 123 p. CJ1099.P19 M47 1985.

A5.243. *Numismatique de la Terre Sainte; description des monnaies autonomes et impériales de la Palestine et de l'Arabie Pétrée* / Louis F. J. C. de Saulcy. Paris: J. Rothschild, 1874. 406 p. CJ1375 .S38 1874; 737 Sa89.

Roman—Italy

A5.244. *Le monete dell'Italia antica raccolta generale del P. Raffaele Garrucci.* Roma: Coi tipi del cav. V. Salviucci, 1885. 2 v. 737 G198.

Roman—Italy—Friuli-Venezia Giulia

A5.245. *Della moneta propria, e forastiera ch'ebbe corso nel Ducato del Friuli dalla decadenza dell' Imperio romano sino al secolo XV* / Giangiuseppe Liruti di Villafredda. Venezia: Appresso Giambattista Pasquali, 1749. 216 p. HG1040.F75 L57.

Roman—Italy—Minturno

A5.246. *Excavations at Minturnae* / Jotham Johnson. Philadelphia: University Museum, University of Pennsylvania Press, 1933–1935. 2 v. DG70.M6 P4; 913.456 P387.

A5.247. *Two hoards from Minturno* / Edward T. Newell. New York: American Numismatic Society, 1933. 38 p. 737 Am36 no.59–67.

Roman—Italy—Rome

A5.248. *I piombi antichi raccolti dall'eminentissimo principe il Cardinale Lodovico Altieri* / Raffaele Garrucci. Roma: Tipografia de C. Puccinelli, 1847. 95 p. 737 G198.2.

Roman—Italy—Sicily

A5.249. *Kaiser, Heer und Städtisches Geld: Untersuchungen zur Münzprägung von Anazarbos und anderer ostkilikischer Städte* / Ruprecht Ziegler. Wien: Verlag der Österreichischen Akademie der Wissenschaften, 1993. 374, 36 p. AS142 .V32 Bd.234.

Roman—Macedonia—Catalogs

A5.250. *Silver coinage with the types of Aesillas the Quaestor* / Robert A. Bauslaugh. New York: American Numismatic Society, 2000. 119, 15 p. CJ546 .B38 2000.

Roman—Morocco—Zilil

A5.251. *Zilil. I, étude du numéraire: recherches archéologiques franco-marocaines à Dchar Jdid, Colonia Iulia Constantia Zilil* / Georges Depeyrot. Rome: Ecole française de Rome, 1999. 176 p. CJ893.M67 D46 1999.

Roman—Political Aspects

A5.252. *La Monnaie de Rome à la fin de la République: un discours politique en images* / Christine Pérez. Paris: Errance, 1989. 132 p. CJ941 .P47 1989.

Roman—Portraits

A5.253. *Profili imperiali romani dalla famiglia Giulia alla seconda dinastia Flavia* / Remo Cappelli. Milano: Mursia, 1963. 203 p. 737 C174.

Roman—Social Aspects

A5.254. *La Monnaie de Rome à la fin de la République: un discours politique en images* / Christine Pérez. Paris: Errance, 1989. 132 p. CJ941 .P47 1989.

Roman—Spain—Astorga

A5.255. *Epigrafía y numismática de Astorga romana y su entorno* / Tomás Mañanes Pérez. León: Museo de los Caminos de Astorga; Salamanca, España: Ediciones Universidad de Salamanca, 1982. 294, 80 p. CN675.A79 M36 1982.

Roman—Themes

A5.256. *Pergameus Deus: archäologische und numismatische Studien zu den Darstellungen des Asklepios in Pergamon während Hellenismus und Kaiserzeit; mit einem Exkurs zur Überlieferung statuarischer Bildwerke in der Antike* / Peter Kranz. Möhnesee: Bibliopolis, 2004. 189 p. BL820.A4 K73 2004.

Roman—Turkey

A5.257. *Die Homonoia-Verbindungen der Stadt Pergamon, oder, Der Versuch einer kleinasiatischen Stadt unter römischer Herrschaft eigenständige Politik zu betreiben* / Ursula Kampmann. Saarbrücken: Saarbrücker Druckerei und Verlag, 1966. 134 p. CJ1092.B47 K36 1996.

A5.258. *Numismatische Studien zur Chronologie der römischen Statthalter in Kleinasien (122 v. Chr.- 163 n. Chr.)* / Gerd R. Stumpf. Saarbrücken: Saarbrücker Druckerei und Verlag, 1991. 319 p. CJ1092 .S7 1991.

A5.259. *Das System der kaiserzeitlichen Münzprägung in Kleinasien: Materialien und Entwürfe* / Konrad Kraft. Berlin: Mann, 1972. 220 p. CJ1092 .K73.

Roman—Turkey—Izmir

A5.260. *Die Münzpragung von Smyrna in der römischen Kaiserzeit* / Dietrich O. A. Klose. Berlin: W. de Gruyter, 1987. 358, 63 p. CJ1092.S6 K66.

Roman—Turkey—Lycaonia

A5.261. *Münzen und Städte Lykaoniens* / Hans von Aulock. Tübingen: E. Wasmuth, 1976. 95 p. CJ609 .A8.

Roman—Turkey—Zile (Tokat Ili)

A5.262. *Zéla sous l'empire romain: étude historique et corpus monétaire* / Julie Dalaison, Bernard Rémy, and Michel Amandry. Pessac: Ausonius, 2009. 72 p. CJ1092.Z54 D342 2009.

ROMANIA

A5.263. *Description historique et chronologique des monnaies de la République romaine: vulgairement appelées monnaies consulaires* / Ernest Babelon. Paris: Rollin et Feuardent, 1885–1886. 2 v. 737 B112.

SPAIN

A5.264. *Las monedas hispanics antiguas* / Antonio Beltran Martinez. Zaragoza: IV Congreso Internacional de Ciencias Prehistóricas y Protohistóricas, 1954. 44 p. 737 B415.

Spain—Balearic Islands

A5.265. *Numismática balear: descripción histórica de las monedas de las Islas Baleares acuñadas durante las dominaciones púnica, romana, árabe, aragonesa y española* / Alvaro Campaner y Fuertes. Palma de Mallorca: Establecimiento Tip. de Pedro José Gelabert, 1879. 359 p. 737 C15.1.

Spain—Celtiberian

A5.266. *Ensayo sobre los alphabetos de las letras descon-ocidas, que se encuentran en las mas antiguas medallas, y monumentos de España* / Luis Joseph Velazquez de Velasco. Madrid: A. Sanz, 1752. 163, 20 p. CJ3194 .V55.

Spain—Phoenician

A5.267. *Ensayo sobre los alphabetos de las letras descon-ocidas, que se encuentran en las mas antiguas medallas, y monumentos de España* / Luis Joseph Velazquez de Velasco . . . de la Academia real de la historia. Escrito, rev., y pub. de orden de la misma Academia. Madrid: A. Sanz, 1752. 163, 20 p. CJ3194 .V55.

SYRIA—BALIS

A5.268. *Les monnaies de Bālis* / Gilles Hennequin and Abū-l-Faraj al-Ush. Damas: Institut français de Damas, 1978. 113 p. CJ3889.B34 H46.

Syria—Seleucia

A5.269. *Coins from Seleucia on the Tigris* / Robert Harbold McDowell. Ann Arbor: University of Michigan Press, 1935. 248 p. 737 M148.

A5.270. *Mémoire sur les monnaies datées des Séleucides* / M. de Saulcy. Paris: Au Siège de la Société Française de Numismatique et d'Archéologie, 1871. 89 p. DS94.5 .S38.

Syria—Tell Barri

A5.271. *Relazione preliminare sulle campagne 1980 e 1981 a Tell Barri/Kahat nel bacino del Habur* / Paolo Emilio Pecorella and Mirjo Salvini. Roma: Consiglio nazionale delle ricerche, Istituto per gli studi micenei ed egeo-anatolici, 1982. 102 p. DS99.B37 T44 1982 v.1.

THRACE

A5.272. *Coins of the ancient Thracians* / Yordanka Youroukova. Oxford: British Archaeological Reports, 1976. 129 p. CJ277 .B8 I8413.

A5.273. *Histoire des rois de Thrace et de ceux du Bos-phere cimmerien eclaircie par les medailles* / M. Cary. Paris: Desaint & Saillant, 1752. 2 v. CJ558 .C332.

TURKEY—ASSOS

A5.274. *Investigations at Assos; drawings and photo-graphs of the buildings and objects discovered during the excavations of 1881–1882–1883* / Joseph T. Clarke, Francis H. Bacon, and Robert Koldewey. Cambridge: Archæological Institute of America, 1902–1921. 315 p. 913.921 Ar22.

Turkey—Bergama

A5.275. *Das Bildnis des Philetairos von Pergamon: Corpus der Münzprägung* / Ulla Westermark. Stockholm: Almqvist & Wiksell, 1961, 1960. 82 p. 913.36 St93 v.1.

A5.276. *Die Fundmünzen aus der Stadtgrabung von Per-gamon* / Hans Voegtli. Berlin: de Gruyter, 1993. 106 p. DS156.P4P4 Bd.8.

Turkey—Ephesus

A5.277. *Die Münzpragung von Ephesos* / Stefan Karwi-ese. Wien: Böhlau, 1995. CJ607.E5 K378 1995.

Turkey—Lydia

A5.278. *The coinage of Lydia and Persia* / Barclay V. Head. San Diego: Pegasus, n.d. 55 p. CJ618 .H4.

Turkey—Pontus

A5.279. *Essai sur la numismatique des rois de Pont (dynastie des Mithridate)* / Théodore Reinach. Paris: C. Rollin and Feuardent, 1888. 54 p. CJ642 .R456 1888.

Turkey—Side

A5.280. *Sidenin milattan once V. ve IV. yuzyil Sikkeleri uzerinde arastirmalar; Untersuchungen über die sidetischen Münzen des V. und IV. Jahrhunderts v. Chr.* / Sabahat Atlan. Ankara: Turk Tarih Ku-rumu, 1967. 181, 6 p. CJ277 .S56 A88.

Turkey—Troy

A5.281. *Monnaies antiques en Troade* / Louis Robert. Genève: Droz; Paris: Minard, 1966. 141 p. CJ646 .R4.

Turkish—Iraq

A5.282. *Catalogue des monnaies turcomanes Beni Or-tok, Beni Zenguî, Frou' Atabeqyéh et Meliks Eyoubites de Meïyakarikîn* / I. Ghalib Edhem.

Constantinople: Mihran, imprimeur, 1894. 175 p. 737 C768; CJ3804 .I814.

UKRAINE—CHERSONES

A5.283. *The coinage of Chersonesus: IV century B.C.–XII century A.D.* / V. A. Anokhin. Oxford: British Archaeological Reports, 1980. 182 p. CJ3029. C47 A5613.

Ukraine—Kerch

A5.284. *Souvenirs de Kertsch et chronologie du royaume de Bosphore* / J. Sabatier. Saint-Pétersbourg: Impr. de la Confection des papiers de la couronne, 1849. 129 p. DK651 .K8 S2.

Ukraine—Krymskaia Oblast

A5.285. *A tour, performed in the years 1795–6, through the Taurida, or Crimea, the antient* [sic] *kingdom of Bosphorus, the once-powerful republic of Tauric Cherson, and all the other countries on the north shore of the Euxine, ceded to Russia by the peace of Kainardgi and Jassy; by Mrs. Maria Guthrie, described in a series of letters to her husband, the editor, Matthew Guthrie. The whole illustrated by a map, with engravings of a great number of ancient coins, medals, monuments, inscriptions, and other curious objects.* London: T. Cadell, jun. & W. Davies, 1802. 446 p. DK511.C7 G9.

UZBEKISTAN

A5.286. *Notes on the early coinage of Transoxiana* / Richard N. Frye. New York: American Numismatic Society, 1949. 49 p. 737 Am36, no.110–115.

YEMEN

A5.287. *Coins and coinage of Yemen and Oman* / Fuat Sezgin. Frankfurt am Main: Institute for the History of Arabic-Islamic Science at the Johann Wolfgang Goethe University, 2004. 205, 6 p. CJ3463 .C65 2004.

Index

Entry numbers in this index refer to chapter and entry (e.g., 8.126 refers to Chapter 8, entry number 126). Entry numbers prefaced by "A" indicate Appendix (e.g., A5.72 would be entry 72 in Appendix 5).

archaeology, Bronze Age, A3.138, A3.141, A3.198; archaeology, Greek, A3.184; archaeology, Iron Age, A3.198; atlas, 15.37; bibliography, 6.17; inscriptions, A4.261, A4.511, A4.725; journal, 12.16; numismatics, A5.91–A5.92, A5.177; pictographs, A3.195

Cribiore, R., A4.6Criss, N. B., 8.149

Crimea, dictionary, 8.106; numismatics, A5.36, A5.285

Cristofani, M., 8.200, A3.1748, A4.465

Croatia, archaeology, A3.199–A3.206; archaeology, Greek, A3.201; archaeology, Roman, A3.200, A3.201, A3.203, A5.225; bibliography, 6.18; dictionary, 8.107; journal, 12.17–12.19

Croft, P., A3.225

Crook, J. A., 10.38

Crowder, M., 9.1

Crowfoot, J. W., A4.741, A4.742

Crum, W. E., 3.66

Cufic. *See* Arabic

Cults, A3.1097; Achilles, A3.109; Attis, A3.199; Cybele, A3.199; Diana/Artemis, A3.902; Ostia, A3.891

Cultural heritage and conservation, index, 11.32, 11.33; journal, 12.429–12.436

Cumae, A3.1491, A3.1492

Cumming, C. G., A4.133

Cumont, F. V. M., A4.260, A4.969

Cuneiform, A4.274–A4.281; bibliography, 5.10, 5.11, 5.26; handbook, 10.33; Syria, A4.425–A4.427. *See also* Inscriptions

Cunliffe, B., A3.653, A3.654

Cupitò, C., A3.1671

Cuppers, H., A3.627

Curiel, R., A5.15

Curium. *See* Kourion

Currelly, C. T., 3.66

Curtis, J. E., A3.1159

Curtius, E., A3.765

Curtius, L., 13.56

Curto, S., 13.116

Cussini, E., A4.973

Cyclades, A3.703

Cylinder seals, Cyprus, A3.218

Cypro-Minoan, inscriptions, A4.265–A4.269

Cyprus, archaeology, A3.207–A3.265; Archaic, A3.216; bibliography, 6.19; biography, 13.17; Bronze Age, A3.209, A3.214, A3.217, A3.218, A3.223, A3.231, A3.233, A3.248, A3.260, A3.264; burials, A3.216–A3.218; Chalcolithic, A3.246; dictionary, 8.108; inscriptions, A3.258, A4.450–A4.457, A4.725,

A4.792; Iron Age, A3.231, A3.252; journal, 12.20–12.23; maritime, A3.221; mining, A3.214; mosaics, A3.262; numismatics, A5.54–A5.55; pottery, A3.257; Preceramic, A3.227; Roman, A3.239, A3.249, A3.260

Cyrene, A3.1826–A3.1835

Cyzicus, A3.761

Czech Republic, A3.266–A3.271; archaeology, Roman, A3.266–A3.269, A3.271; bibliography, 6.20; burials, A3.271; journal, 12.24

Czerner, R., A3.454

Czurda-Ruth, B., A3.78, A5.223

Czysz, W., A3.638

D'Aiuto, F., A5.28

D'Ambrosio, A., A3.1601

D'Ancona, C., biography, 13.81

D'Andria, F., A3.1527, A3.1857, A3.2231

D'Aversa, A., 8.41

D'Isanto, G., A3.1473

Dacia Parolissensis. *See* Dacia

Dacia. *See* Romania

Dacia Superior. *See* Dacia

Dacia, A3.272, A3.273; archaeology, Roman, A3.273; burials, A3.272; funerary monuments, A3.272; numismatics, A5.226

Daftary, F., 8.209, 9.58

Dagnall, P., 10.62

Dahari, U., A3.529

Dahmus, J., 8.216

Dahshur, A3.364

Dalaison, J., A5.262

Daliya, A3.1326

Dalley, S., A3.1141, A3.1227, A4.221–A4.223, A4.229

Daly, M. W., 6.86

Damascus, numismatics, A5.134

Damastium, numismatics, A5.128

Damerji, M. S. B., A3.1080

Dan, A3.1327

Dandara, A3.363; inscriptions, A4.330–A4.333

Danel, A4.914

Dangel, inscriptions, A4.741

Daniel, G., 13.46

Danielsson, O. A., A4.461

Dannheimer, H., A3.637

Danube, Ad.74, A3.2313

Daoud, K. A., A4.389

Dar, S. R., A3.4, A3.1407

Darbyshire, G., A3.2211

Daremberg, C., 8.233

Daressy, G., 3.66, A3.544

Darius the Great, A4.30, A4.446

DaRiva, R., A3.1222

Darling, M. J., A3.670

Darnell, J. C., A3.1884, A4.396, A4.419, A4.437, A4.779, A4.932

Darvill, T., 8.155

Daszewski, W. A., A3.370

Davaras, C., A3.909–A3.911, A3.913

Davenport, P., A3.650, A3.651, A3.654

Davico, A., A3.1857

David, B., 10.10

Davies Evans, J., A3.1855

Davies, A. M., A4.679, A4.704

Davies, G., 9.32, A4.539

Davies, J. K., 13.20

Davies, L. G., A4.191

Davies, Nina de G., A4.431

Davies, Norman de G., A4.404, A4.428, A4.429

Davies, S., A3.506, A3.507

Davies, W., 13.135, A3.1873

Davis, M. C., 13.167

Davis, N., A3.2051 A4.867

Davis, S., A4.647

Davis, T. M., A3.576

Davoli, P., A3.341

Dawkins, R. M., A3.929

Dawletschin, C., 6.65

Dawson, W. R., 13.52

Day, A., 6.35

Dayr al-Madainah, inscriptions, A4.335–A4.338, A4.352

Dead Sea scrolls, A3.1328, A3.1329, A4.105. *See also* Areamai, Qumran

DeAngelis, C., A3.1460

Dearne, M. J., A3.667

Debevoise, N. C., A3.1216

Debono, F., A3.391, A3.397

Debord, P., A4.241

Debrunner, A., 8.50

Decapolis, numismatics, A5.171, A5.242

DeCaro, S., A3.1626

DeCarolis, E., A3.1554, A3.1603, A3.1630

Déchelette, J., biography, 13.113

DeFranceschini, M., A3.1471

Degeorge, G., A3.1837

Deger-Jalkotzy, S., A3.711, A3.712, A4.672, A4.716

Degni, P., A4.878, A4.1000

DeGraef, K., A3.1003

Deimel, A., 8.89, A4.946

Deir Alla. *See* Dayr Alla

Deir Chelouit. *See* Deir Shalwit

Deir el-Balah, A3.1331

Deir el-Medina. *See* Dayr al-Madainah

Deir Mar Saba, A3.1330

Deir Shalwit, A3.383

Deissmann, A., biography, 13.114

Deities, encyclopedias, 9.86

DeJuliis, E. M., A3.1451

Dekiere, L., A3.1226

Del Lungo, S., A3.1672